ART OF AFRICA

JACQUES KERCHACHE

JEAN-LOUIS PAUDRAT

LUCIEN STÉPHAN

ART OF

The Principal Ethnic Groups of African Art *by Françoise Stoullig-Marin*

Translated from the French by Marjolijn de Jager

HARRY N. ABRAMS, INC., PUBLISHERS

AFRICA

Project Manager, English-language edition: Sharon AvRutick
Editor, English-language edition: Carey Lovelace
Designer, English-language edition: Judith Michael

LIBRARY OF CONGRESS CATALOGING-IN-PUBLICATION DATA

Kerchache, Jacques.
[Art africain. English]
Art of Africa / Jacques Kerchache, Jean-Louis Paudrat, Lucien
Stéphan. The principal ethnic groups of African art / by Françoise
Stoullig-Marin ; translated from the French by Marjolijn de Jager.
p. cm.
Includes bibliographical references and index.
ISBN 0−8109−0628−7
1. Sculpture, Black—Africa, West. 2. Sculpture, Primitive—
Africa, West. I. Paudrat, Jean-Louis. II. Stéphan, Lucien.
III. Stoullig-Marin, Françoise. Principal ethnic groups of African
art. 1993. IV. Title.
NB1098.K4713 1993
730′.0967—dc20 92−27689
 CIP

Originally published in France under the title *L'Art Africain*

Colorplates and black-and-white illustrations printed in France
Text printed in Germany
Bound in Germany

The objective study of Africa's past has suffered from two firmly entrenched prejudices. The first stems from the absence of sources or written documents; without these, any study is impossible. The second, more insidious, arises from colonialization and slavery. By opposing Whites and Blacks, the latter were quickly assimilated into the category of an exploitable people, then further reduced to the status of subhumans.

As for African art, along the same lines, it was long—indeed for much too long—regarded as nothing more than folk art or, at best, as craft. Happily, things have changed considerably and, for about twenty years now, systematic archeological digs and field research have delivered masses of major information and shed new light on African art.

It was high time to examine its contributions, qualities, and specificities. But how to approach the field? To represent all the specialists who have recently studied a given region or ethnicity seemed to us to be both difficult and frustrating. Therefore, we opted for another solution, one that lies between (as Jean-Louis Paudrat puts it in his introduction) "the convincing documents of ethnography" and "the seductive traps of aestheticism." Then, we asked Lucien Stéphan to question, compare, oppose, and combine. He devotes himself with intelligence and rigor, sometimes even with mischief, to the task. Next, Jacques Kerchache's assignment was to choose the objects. There are more than a thousand of them and, although no claims of objectivity or exhaustiveness are made here, it may nevertheless be confirmed that this choice has aroused our enthusiasm as well as that of those to whom we showed it. Between these authors and, to a great extent at the origin of this selection, one man acted, as it were, as the cement in a natural stone wall—binding and unifying, going from one to the other, and clarifying one through the other: Jean-Louis Paudrat has played an important part in the construction of this edifice and in spotlighting the role of each participant. Finally, we were anxious to take stock of the current research on different African ethnicities, and it was Françoise Stoullig-Marin who took charge of this task. As with every book, a surprising journey resulted. From the strange hostility, the feeling of magic, almost of an evil spell, which is exuded by statuettes of nails, to the classic beauty of the Ife faces; from Fang expressionism to the long-limbed strangeness of the Mumuye— everything here is different. Hence the importance of the comparative approach. Hence the importance of the questions posed.

An old African adage says: "Foreigners see only what they know." If this adage is true, let us hope that this book, by helping us to know better, will allow us to see better and, consequently, to love better. If this adage is false, let us hope that the work of Jacques Kerchache, Jean-Louis Paudrat, and Lucien Stéphan, by proposing a revision of values and ideas, will finally allow African art to be placed on its true universal level.

ANNE DE MARGERIE

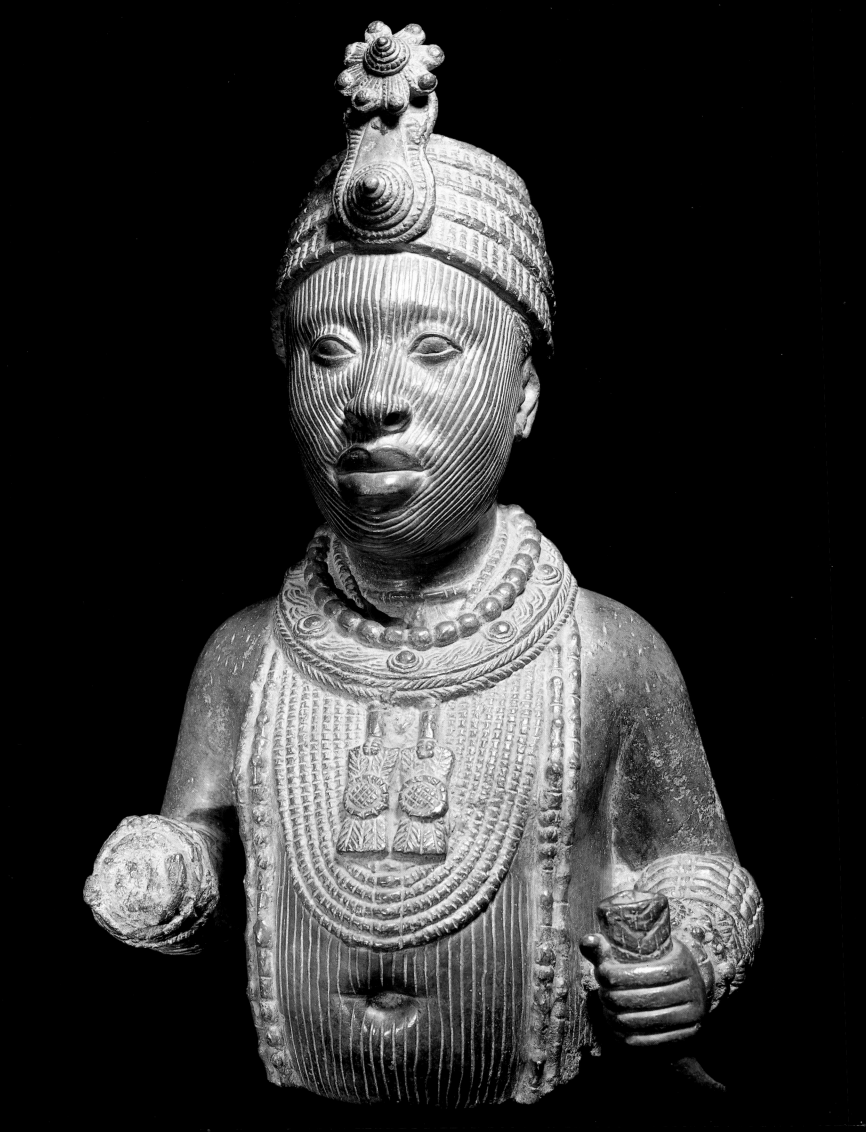

3

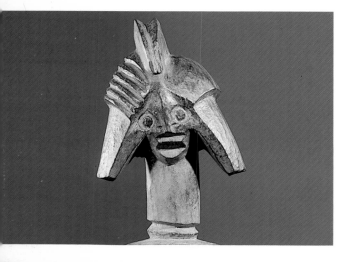

4

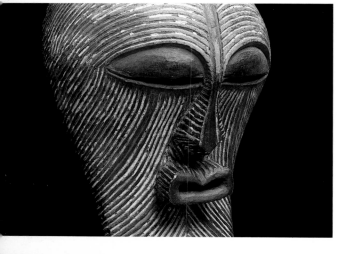

5

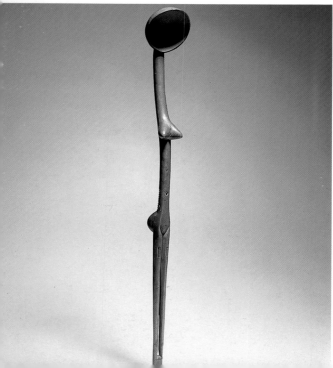

6

CONTENTS

Illustrations

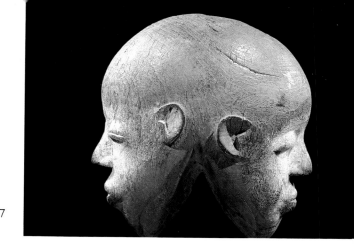

7

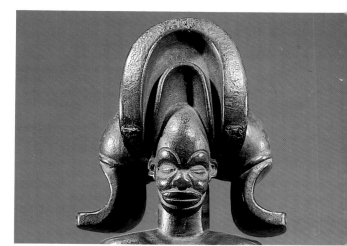

8

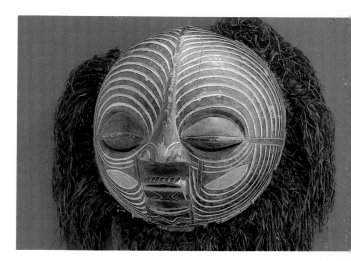

9

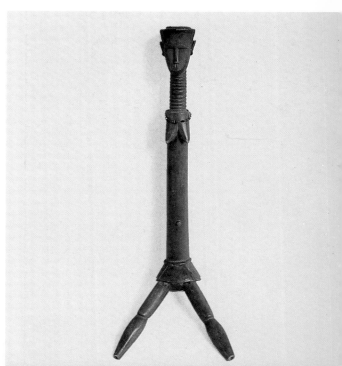

10

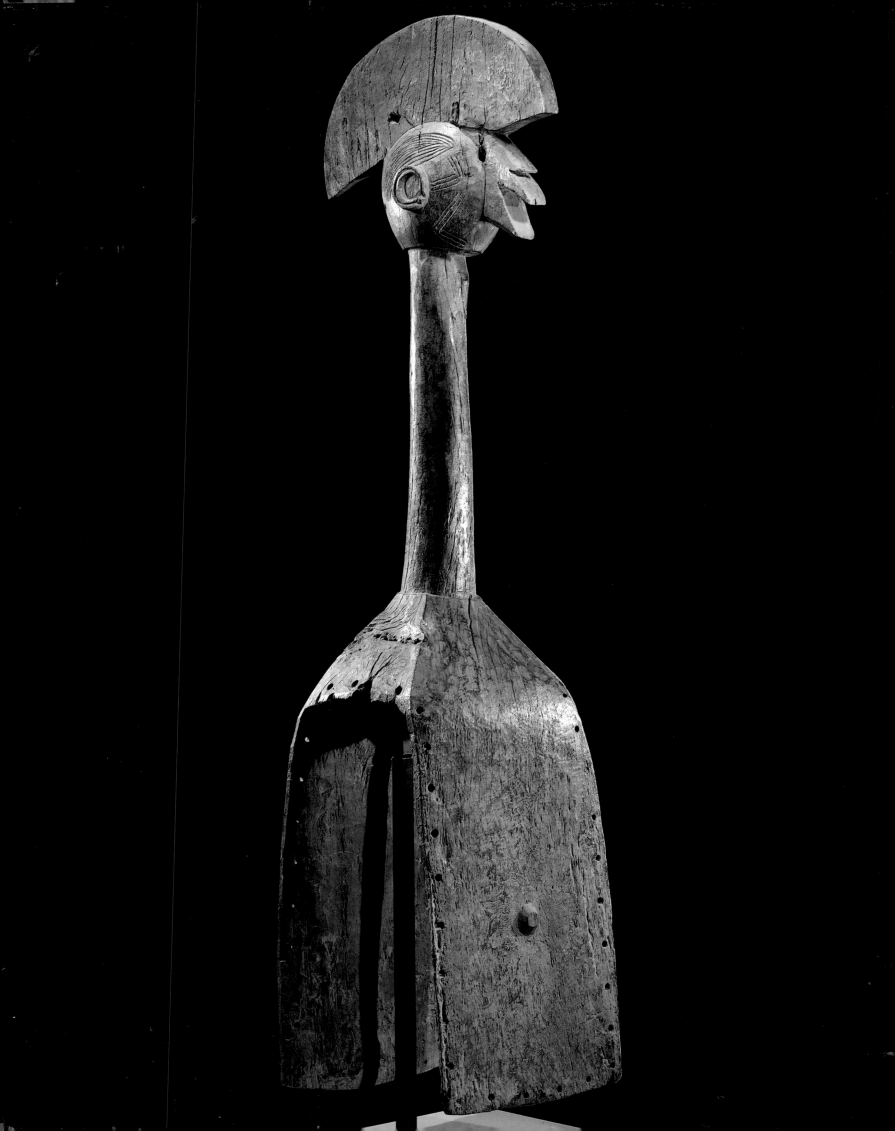

ART OF AFRICA

INTRODUCTION

There is nothing more to add, they say. Why then, at the outset of this work, reintroduce a debate that will seem to many out of date? African art has been irreversibly involved in a second destiny ever since, under the watchful eye of the "Moderns," its authentically creative dimensions were recognized and acclaimed; why should there now be any doubts as to its artistic legitimacy, any suspicions as to the validity of the qualities with which we invest it?

Exalted for the power of its expressiveness, praised for the subtlety of its formal arrangements, admired for its austere dignity and for the serenity that frequently emanates from it—might African sculpture not have lost, in this celebration, just a little of its "African-ness"?

Indeed, removed from the sites and rites in which it once functioned, pried loose from the meanings and roles that it held there, torn from the social, intellectual, and spiritual web that used to justify its elaboration, a residual fragment of an absent totality, can the African object still sustain a correct appreciation of what it once was?

Would it not be appropriate also, once its relationship to the cultural environment from which it stems is re-established, to wonder about what it represents, symbolizes, and signifies? By relying on the data which anthropology gathers and studies, ought we not to attempt an understanding of that to which it refers us: the cosmogonies the knowledge of which it brings into being, the divinities, ancestors, and heroes it commemorates, the cults of which it is the instrument, the institutions of which it is the emblem, the ranks and powers of which it is the badge—in short, the mores and the customs whose illustration it provides?

But, this time, immersed in the dense context of its determinations and functions, would African sculpture not have lost its strictly "artistic" function? And from then on, would we not have abandoned that which, in its own universe, African art as "art" establishes and which cannot be reduced to some kind of accessory ornamentation? Such a question suggests the orientation of this book, discovers its locus, begins to tackle what is at stake.

Between an immanent conception of African art—which, once the conditions, circumstances, and consequences of its function have been defined, forces the artistic phenomenon to be nothing but the material sign of a local, cultural fact—and the other, transcendent, conception—which, acting on the authority of art's universalist character, dissolves the

19

particular surroundings in favor of the work's singularity—one might clear another path that would avoid the misunderstandings of this alternative of: here, the convincing documents of ethnography, inert specimens of the categories of material culture, and there, the seductive traps of aestheticism (which, for example, cause "African Art" to be considered simultaneously as modernity's laboratory and as the first of the classicisms, as the flag of avant-garde provocation and as the banner of the return to order . . .).

To have African art seen within its context, which is artistic: thus could one of the principles that govern the approach here be formulated.

The works—no longer isolated in intangible autonomy but confronted in a space activated by their mutual relationships—respond to one another and allow a perception less of what they represent than of what they form and transform, through the play of oppositions and similarities, redundancies and variations, through the effect of omissions and substitutions.

The receptivity that African plastic art creates, defined this way, contrasts at one and the same time with the fascinated and devout contemplation that freezes works into "masterpieces" and with the somewhat condescending curiosity with which ethnographic "specimens" are often viewed.

So it is from this fluctuating world of African forms that Jacques Kerchache has endeavored to construct a vision of completeness. This vision, which in the name of simple common sense avoids any pretension of having exhausted all that is there, also does not base itself on submitting this diversity—the art of three-quarters of a continent from prehistoric times to the present day—to a few strong, classifying categories. But if both encyclopedic temptations and didactic uniformity have been cast aside, is it not the arbitrariness of preferred choices, of selective affinities, which now impose another kind of subjection?

Besides the fact that it would be difficult to suspect the mere exercise of personal preference in a selection containing around a thousand objects, barring unbridled eclecticism, the establishment and the problematized arrangement of so vast a corpus are not exactly "a question of taste." There is no doubt that the person able to organize it frequently shares the fervor of the impassioned admirer; nevertheless, he has not exercised any exclusions any more than obsessions here. Without displaying an immoderate enthusiasm for the Bamana antelope species, the Yoruba sets of twins, the "baroque" phase of the palatial art of Benin, among other related interests, he has nonetheless not underestimated the importance of their representation. And if it were still necessary to emphasize, in terms of the choices effected, the possibility of his having fallen victim to particular infatuations, it would only be to indicate that which was stated at the outset as a condition: a definite wish to escape from the fads and fashions that mark the history of taste for African art. Thus for a time, in the name of purity of style, were assemblages of heterogeneous materials neglected; then, later, when an appreciation was granted to these for their inventiveness, were ancestral figures rejected for what had become considered their obsolete academicism; only to then suppress, during the abusive consolidation of African classicism, anything that did not clearly correspond with it.

If on the one hand, to preserve the pluralistic character of African art, one refuses to be satisfied with discriminatory schemas that have been judged inappropriate or far too simplistic, and if, on the other, in order not to subordinate the art solely to its uses, one rejects the use of functional models—and if, finally, due to the incomplete character of the historical data, one can but rarely integrate the works into a precise,

chronological sequence, what organizational overview can one lay claim to?

Indeed, African art seems to thwart any attempt at a unitary presentation. A succession of entities of distinct contours, an accumulation of expressions specific to each of the particular cultures that comprise it, its description would only be the sum total of its disparities. And only a catalogue, followed by monographs, could be made out of this collection of independent experiences.

If a panoramic view offers only a vision of diversity, the focused gaze on the other hand leads one to identify discrete unities, bounded by the soil and the traditions in which they are rooted. Strictly delimited in this way, identities begin to change. And the homogeneity of vernacular styles can apparently be respected. "Tribal" art, the reflection of an interdependent and unanimous community, would then express the permanence and integrity of secular values whose system of symbols, constantly reiterated in works of art and in rituals, would respond to the univocality of the myth of the "tribe's" foundation.

Now, it is as if in contrast to this reassuring conception that substitutes images with fixed tribalities blocked out for a composite landscape, that Kerchache examines what opens it up, animates it, and sometimes divides it, at the edges as well as at the heart of a given ethnic style. More sensitive to the play of contrasts and differences than to what the art of a tradition, acting in unison, would seem to proclaim, he scrutinizes the complex progressions of forms, attentive to the transitions, passages, and junctions.

In addition, the approach he has adopted proceeds from this "opening of borders" craved by so many researchers concerned with breaking the tenacious idea of "tribal insularity." When it is no longer defined as a closed system, truncated from all those reciprocities that history weaves, in Africa as well as elsewhere, the ethnic group appears on the opened texture of the cultural area in which it inscribes itself as a field of interactive forces, at one and the same time a place of convergence and a center of propagation. It is at the price of this disenclosure that continuities manifest themselves, axes of diffusion are plotted, and the network of borrowings and influences is revealed within and beyond the "borders." It is on this screen of intra- and intersocietal relationships, made up of rivalries and alliances, of conquests and submissions, of inventions and appropriations, that the vitality of the African artistic context is founded. And it is, finally, by taking into consideration, upon this relational fabric, that which each work in its original way affirms, along with the connections it sets up, that one may hope progressively to erect a complete vision of African art, and it becomes possible to suggest a unity within it, beyond its extreme diversity.

Among the most vital images of African "authenticity" is one reproduced many a time: in the background a steep rocky wall, layered with long faults, some of which seem to have been purposely applied; in the foreground an ardent band of dancers, dressed up in skirts of yellow, red, and black fibers, shoulder belts dotted with multiple shells tied around the chest, and on the face, a wolf's mask of wood, with features prominent and crested with a flat pole with two branches as crossbars. Explicit or implicit in this stereotype is its commentary: entrenched in their natural fortress since time immemorial, the Dogon, resisting attacks and overtures of all kinds, have managed to preserve venerable customs that make this one of the last peoples of a "purely" traditional Africa.

If one increases, as is done in this book, the mass of material evidence of the supposed transhistoric oneness of the Dogon culture, it will be noticed that considerable dissimilarities cannot help but emerge both in the order of the thematics and in their treatment.

The commonly assigned ethnic name (Dogon) or toponym (land of the

Dogon) ought not lead one to believe in the existence of a homogeneous people or in the occupation of a clearly demarcated territory associated to a strong autochthony. Oral traditions and archeological and historical data invite one to situate the so-called Dogon culture in a vaster geographic and cultural totality, that of the western Sudan, and in a time period that is, if not exact, at least suggestive of the repercussions of the expansion followed by the breaking up of the great Sudanese kingdoms. The eastern border of Nigeria's central plateau appears to be the endpoint of what were sometimes very lengthy emigrations by several, successive groups of migrants from the eleventh century on. This plurality of origins is confirmed by the fact that today some twenty different languages are spoken within a space not exceeding one thousand square kilometers. These differential data urge one to put aside the idea of an art that would be specifically Dogon, definable both by its profound unity and its permanence. If plastic expressions from more distant horizons seem to be refracted in works that have undoubtedly emerged in the land of the Dogon, these works in turn may have radiated out and spread beyond the place in which they were formulated or reformulated. This, however, does not imply that one can subordinate artistic identities that are locally confirmed to the mere play of reciprocal influences. Thus, bringing together works that appear to be linked by certain shared formal characteristics has allowed identification not only of the style of a restricted group, but also of the activity of a workshop, indeed even of the talent of a single sculptor. One will then grasp why Kerchache has avoided any systematic hypotheses. While offering a selection that conforms to the variety of tendencies and orientations of the sculpture of the land of the Dogon, his aim is also to suggest that this diversity is not totally irreducible. For example, the choice of some six *hogon* figures illustrates this double viewpoint. These works are plastic expressions that are most different, although they are devoted to the same devotional ends, indexed upon the same sequences of the genesis narrative, incarnating an identical theme, that of the symbolic presence of the two vital, opposed principles, male and female "souls" within the same human being (in this case, the priest-king—the *hogon*). Either they show a hermaphroditic figure, placed on the seat of the world, or a man and woman clearly defined but linked as a couple. Now, this divergence in the iconographic treatment of the same subject is not necessarily based on interpretative variations from different locales. Indeed, three works in this series, one couple and two androgynous figures, are reported to have come from the same workshop, if not from the same artist's hand.

Thus it is understood that the totality of the Dogon work reproduced in this book was not organized according to properties that the figures might have in common. It certainly would have been possible, in view of the volume of the corpus of sculpture attributed to the Dogon, to construct a unifying, stable, and homogeneous pseudostyle and to present it as representative. If one considers the ensemble of Dogon objects presented here, one may notice that, apart from common features that are not pertinent (the fact that they are all fashioned from wood, for example), it is impossible to discover any one trait they all possess. Consequently, if one were to set up, as a hypothesis, a class defined by one characteristic (figures with arms raised, figures carrying another figure on their shoulders, figures leaning against a pole, and so on), no other significant characteristic could be found that would consistently be associated to the first. Inversely, if two sculptures have one characteristic in common (a person on the shoulders of another), the difference in their ethnic origin (Dogon, Tabwa) does not allow us to ascribe iconographically or functionally identical meanings to them. This holds true, for example, for

two perforated panels, both containing within them a figure with arms spread wide (Senufo and Holo).

One might contrast the selection Kerchache has made to that predominating in other compilations of African art. Each object reproduced seems to be there not so much for itself and its own originality as to represent an iconographic or functional group. Thus a "tribal" style was constructed by totaling up these categories, of which the photographed works were only examples. The Baoule style, for example, was presented in such a way that it appeared as the sum of several types: anthropomorphic figures said to be ancestors, zoomorphic figures labeled *gbékré,* masks associated with the *goli* dance, divination boxes, weavers' pulley heddles, and so on. The choice of one piece for its exemplifying value led to the exclusion of other pieces, which were then declared atypical, and to an underestimation of the differences among the actual works, since these differences were excluded by the definition of the type. The rigidity of the "tribal" style thus reappeared or was refracted in the definition of the group. And in the dialectic of diversity and unity, diversity was sacrificed to the unity of the iconographic or functional series just as it was to the "tribal" style.

The selection Kerchache has made is not a simple inversion of the preceding model. If diversity has been respected, unity has not, for all that, been sacrificed. But, if one does not rest content with merely profiting visually by his selection, if one attempts to interpret it, one must find a means through which to understand this unity, to understand it other than through "tribal" category or style; that is to say, beyond those definitions that note properties common to all works of a same "tribal" style or iconographic or functional type.

If we go from the choice of the reproduced objects back to the very processes of this selection, we find that the approach adopted by Jacques Kerchache is tacit and, partially, intuitive. The methodological inquiries pursued by Lucien Stéphan, which introduce the concepts of "family" and "predicates of resemblance," are verbal and, on those grounds, both explicit and discursively developed. But there is an agreement between this tacit, intuitive approach and the verbal and conceptual construct, explicitly laid out. It is this harmony that makes for the book's unity, the unity of what is offered to the eye and what is offered to the understanding.

There is nothing more to add: it is legitimate to speak of African art and to "picture" African art. Nonetheless, not all of the various ways of picturing it are legitimate. It is, therefore, a question of evaluating these ways in order to appreciate them and, in particular, to examine their claim to legitimacy.

Stéphan's essay borrows two important themes from the present state of art research. The theme of expectations is E. H. Gombrich's—as in the consideration of the gap between what is expected and what is encountered; the theme of family resemblances is, indirectly, Ludwig Wittgenstein's, through the mediation of its implicit use by two art historians, one specializing in African art, Frank Willett, the other in the Italian Renaissance, Mark Roskill. Even though, in terms of the latter designation, among objects or individuals described by the same "family" name or the same word, there may not be any one trait common to all, there nevertheless exists a network of similarities and differences between them that, through partial overlapping and intersection, binds them closer and closer together in such a way that they can, indeed, claim to belong to the same "family."

The analyses by Stéphan are based on the conjunction of these two themes: the predicates of family resemblance (FRPs) constitute the

structure of expectations that research must substitute for preconceptions that most often reveal themselves to be unacceptable by virtue of their ethnocentrism. Gombrich's thesis, applied here, allows a solution provided by Willett and Roskill to the particular question of authority to be brought to bear upon a rather impressive number of problems.

Generally speaking, according to this point of view, one is led to abandon dichotomies, and particularly dichotomies constructed by means of universal concepts with clear-cut boundaries—and one does so because they deform the reality under examination too coarsely. This reality ought not to be chopped up into distinct and discontinuous parts. By restoring continuous series, data may be inserted that would, otherwise, have been excluded. It is therefore important that partial similarities not arbitrarily be given preference over partial differences. Universal concepts are such precisely because they hold on exclusively to those characteristics that are common to the objects to which they are applied, that is to say the similarities between these objects, and because they leave their partial differences, which are still part of the data, out.

If it were necessary to furnish an example of these comfortable constructions with which the rejection of the dichotomies interferes, one might evoke the distinct opposition often thought to be found in the styles of the masks of the western Ivory Coast. On the one hand, there is the idealized realism, the classicism of the Dan, on the other, the expressionist extravagance of the We (Guere). The amplification of this division into a Manicheanism is just as frequent: serenity here, terror there. Two styles, therefore two visions of the world. Now, when the data of observation show both stylistic tendencies to be common to both ethnic groups, and that sometimes the production of each one of these two styles may emerge from the same workshop, one begins to suspect the model's validity as much as its interpretative implications. From the moment that the effects of such a bipolarization are attenuated by attentively taking into account multiple intermediary stages, the dichotomy progressively loses the pertinence some had attributed to it.

If in order to be scientific concepts must be universal concepts, the thought surrounding African art will have to abandon any claim to being part of science. But one must guard against an all-or-nothing approach. There is no strict alternative between speaking in a scientifically rigorous fashion and saying any old thing, no matter what. Because the sciences study different objects and can do nothing other than take these differences into account, they cannot study them all with the same degree of rigor. Now, a general type of solution is applicable to the question posed by the very title of this book *Art of Africa* and its two elements, "art" and "Africa." It is known that there is no commonly held concept of art that is unanimously accepted by the community of experts. Moreover, the diversity between African works cannot be rigorously contemplated by means of a universal concept of art: the word "art" is not associated with a clear-cut concept for here there is no clearly demarcated separation between art and non-art. When it is stated that the proper domain to which African objects should be assigned is not that of art, one may then retort, not only by distinguishing between purity and specificity, but also by observing that both the second and the first of these two notions presuppose a universal concept of art. One must be satisfied as well with a hypothesis that is less strong but more appropriate to the data: African visual art as well as other arts, often taken together, form a "family." Stéphan applies this hypothesis to the arts of the Yoruba, Baoule, and Fang cultures. The first two tend to suggest the pertinence of a naturalist, albeit relativized, conception of art, and it is not immaterial that they figure among those that are most readily appreciated by neophytes. In the

case of Fang sculpture, generalization becomes more difficult, and Stéphan, clarified by James W. Fernandez, has recourse to a conception of art focused on expression rather than mimesis. Thus he reminds us that, if we lack a concept, we still have several theories of art available to us, out of which we can deduct alternative expectations when preconceptions turn out to be unusable.

The same hypothesis leads to an examination of the opposition between universalism and historic and sociological relativism. The universalist conceptions of art lay claim to a definition by means of properties that would be true for all works of art, no matter what their origin in time and space. On the other hand, relativism vigorously denies this claim. The two theses are proposals of which the one affirms and the other denies the concept of art as universally applicable, that is to say, applicable to every work of art. But both of them presuppose this very concept, which would be a common concept with clearly marked borders. Following Wittgenstein, Stéphan stumbles up against this presupposition.

Consequently, he suggests limiting oneself to the search for certain properties that are common to certain works. On the other hand, since the study of the works leads to the generation of several conceptions of art, the hypothesis agrees with the diversity of the empiric, historical, or ethnographic data and leads to an outlook that might be called pluralist.

The aesthetic inquiry can then only be comparative and based on reconciliations between the empiric data. It cannot be simply speculative, in the sense that speculative aesthetics would claim to deduce from a universal conception of art properties found at work in the reality of the artistic context. Comparative aesthetics retains within the empiric data differences as much as similarities and reveals similar properties, even if these are not common to every work and every style.

Comparative aesthetics, whose methods Stéphan develops, distinguishes itself from ethno-aesthetics, and from art theory and art history. It borrows its materials from these disciplines but it is its interdisciplinary character that insures its specificity. As ethnology and art history furnish data that reveals itself to be diverse, should this be interpreted by taking recourse in art theories? But not one of these asserts itself as universal and unrivaled. The abandonment of the classic theory of mimesis has not left its place to any other universal aesthetics. Ought one leave the empiric data to its diversity? There again it would be a question of submitting oneself to the law of all-or-nothing.

Comparativism does not move toward a general aesthetics, unifying common characteristics drawn from all the data compared, any more than it does toward a speculative aesthetics that, beginning with a general reflection on art, must find empiric data that would illustrate it. From the concept to the data, from the data to the concept, in both cases one would be searching for a unique and universally applicable aesthetics. Comparativism contents itself with a more modest aim. On the other hand, that allows it to integrate the empiric data in all its wealth and diversity. If it aspires toward a pluralism, it does not, however, lose itself in eclecticism.

The choice of comparativism and its orientation permits the discovery that there is a good distance between a universalism that ignores, underestimates, or dissolves differences and a relativism that accentuates them.

In this way, the question of humanism can be posed: ethnocentrism being the most widely shared thing in the world, each culture tends to define itself as the standard for the others, through belief in its own superiority. Just so, comparativism leads to an admission that all cultures can legitimately claim this excellence. No position of supremacy can be

accorded to any culture, ours or another. And one cannot claim that recognizing the Other or the art of the Other will necessarily end in a "failure of thought."

If the unity of the textual and visual parts of this book shows through despite the duality of those responsible for them, it is because their common subject itself, African art, does not lack in unity. How to render this visible and how to interpret it? There is not a single Ariadne's thread that can link all African cultures and styles on a labyrinthine journey.

The approach developed by Kerchache, the epistemologic investigation led by Stéphan, both obey an intellectual process that can be summarized as the privilege accorded to "families" and to predicates of similarity. It is as if the expert and the aesthetician made this paradigm of Wittgenstein theirs: "In order for a rope to be solid, it is not necessary that even a single one of its fibers run through it from one end to the other."

African styles form one family. The totality of the works brought together by Jacques Kerchache paint its portrait. Leafing through this album creates a feeling of unity, even though no concept, no formal definition could be reconstructed out of it.

African art is neither enormously unitary nor irremediably diverse: it arises from a coherent pluralism.

JEAN-LOUIS PAUDRAT

PART ONE # Comparative Aesthetics and African Sculpture

I. THE "PILOT LOOK"

To Victor Goldschmidt
In memoriam

*Just as sharks are preceded by
their pilot fish, our gaze is preceded
by a "pilot look" that suggests the
meaning of what it is looking at. . . .
We very mistakenly believe that we are
free from this look.*

ANDRÉ MALRAUX, *L' Intemporel*

Orientation: Research and Results

A study of African sculpture begins quite naturally with some general considerations. Enough studies have been published that an ensemble of commonplaces has been established; one can neither simply reject them nor take them up again. The present inquiry will orient itself differently, drawing attention not only to objects but also to the mental constructs that are employed and the processes that are taken in approach to these objects. Thus, this essay will be, partly, methodological and epistemological. Its exposition will not separate the results of the investigations from their evolution, from the concepts they utilize, the methods they apply, or from the hypotheses or theories to which they lead or which they more or less openly presuppose. Besides the concern with avoiding the repetition of commonplaces, three reasons justify this approach.

Our knowledge of the African arts has grown considerably over the course of the past decades. On-site studies have multiplied, while research into and analysis of secondary sources—writings from various periods by travelers, missionaries, merchants, explorers, colonial administrators, and even military men—has developed considerably. This dual approach— contextual and textual—following the formula of Daniel Biebuyck (1975), has enriched the available data so spectacularly that it became clear that a synthesis that would be both complete and scientifically serious had become practically impossible. (J. Fry, 1985, W. Fagg, 1973, p. 151) The study of African art has thus experienced a common fate: the important,

speedy development of a discipline has led to its explosion and to specialization that has increased the difficulty of synthesis. Thus it has been noted (F. Willett, 1971, pp. 156–7; D. J. Crowley, 1971, p. 327) that "generalizations about Africa are almost inevitably false." More specifically, any general proposition—claiming to be true for all African styles—is either trivial or false: trivial because it states only vague generalities; false, because there is presently enough data that exceptions can always be found, cases that weaken any claim to generalization. Thus, wood sculptures are not *always* of one piece of wood: the jaws of certain masks are hinged on, as are the limbs of certain figures, and the panels of the Ijo indicate techniques of assemblage have been used.

On the other hand, the diversity of concepts, methods, and theories is less, by far, than that of the materials under study and, hence, less difficult to master. The concept of expectations (Chapters I and II) thus allows an important number of different questions to be treated in a related and coherent fashion. Methodological and epistemological research related to art history and especially to art ethnology is surprisingly rare. Thus we propose to begin to fill in that gap.

The third reason for our approach is of a didactic order. The methodological orientation of this essay intends to ease the entry of the enlightened amateur into these specialized disciplines. Generally speaking, the results of research are more readily, and also better, assimilated when one connects them to the methodically conducted process that permitted their discovery and establishment. To cut them off from this process often prevents their meaning and range from being grasped correctly. Readers must be brought into the inquiry itself, having the concepts, methods, and hypotheses that are at work within these specialized investigations revealed to them. This association of the reader with the researcher in the evolution of the research has the Platonic dialogue as its unsurpassed model. (V. Goldschmidt, 1947) That it is ancient does not make it obsolete: "It would undoubtedly be simpler to teach only the result. But the teaching of the *results* of science is never scientific teaching." (G. Bachelard, 1947, p. 234) Isolated results run the risk of being misunderstood by being badly assimilated with prescientific representations. And so we intend to avoid most particularly the more-or-less erudite compilation which, without a method, accumulates isolated and often fragmented results.

Research and Encounter

When we do research and expect something, then find that what we encounter is *different* from what we were expecting, we can react in three different ways.

Perhaps we transform that difference into negation. If, for example, we encounter a work of art that is different from what we were expecting, we might declare, not that it issues forth from a different kind of art, but that *it is not* art. The encountered work is thus thrown out of the realm under investigation. It is not recognized—recognized as a work of art—but misread. Such is the first form of misreading.

Or we might transform the difference between what we encounter and what we were expecting into an identity. But this assimilation is abusive; the difference, specificity, or originality of the encountered work is, this time again, misread. This second form of misreading is certainly less serious than the first one, for the encountered work is not rejected, but it is abusively integrated into our knowledge in such a way that we, quite wrongly, believe ourselves excused from considering it as an object of research and study. Thus, the research is thought to be finished before it has actually begun.

Or, finally, and this is the only scientifically correct attitude, the difference between what we encounter and what we were expecting is noted and respected; it is taken seriously and becomes itself the target of inquiry. But in order to then embark upon the research, it is indispensible that we be conscious of what we were looking for and expecting, that is to say concepts which, existing in *anticipation of* the object of the research, were making that research possible. But the well-known fact about the difference between our expectations and what we encounter invalidates our anticipatory concepts. These have, of course, served as *detectors of difference*, but they must now be abandoned and replaced, we must find alternative descriptive or explanatory concepts. That is when the scientific work truly begins.

This chapter proposes examples of these three possible reactions in encountering sculptures of traditional Black Africa. They have been chosen in such a way as to treat the themes that usually appear in introductions to works on African art. This brief description of the three reactions possible—negative misreading, assimilation, or recognition of and respect for difference—presupposes an understanding of the aesthetic perception generally accepted today that André Malraux summarizes by the metaphor of the "pilot look." The examples of misreading will allow detection of tenacious prejudices that create so many obstacles to our knowledge of African sculpture in its rich diversity, as well as to the pleasures that it offers us.

Misreadings

The Invention of African Arts

The discovery of the African arts by the West has been described from an historical perspective. It can also be described from an epistemological perspective, placing the emphasis on the forms of research; it then furnishes examples for the kinds of attitudes which we have just described. There is no coincidence, of course, between the stages of the historical account and the epistemological figures: history is not so easily reduced to a logical framework. But, *grosso modo*, the three figures follow one another.

The initial anticipatory system is set up by the conception of art that dominated in the West at the end of the nineteenth century: naturalism in its academicist form. It is obvious that African objects are quite different from works anticipated in this form; one begins, moreover, by judging the former *not to be* art, while they are only different from the art one was expecting. This negative reaction has been aptly named "denigration" by Jean-Louis Paudrat (unpublished thesis, 1974) in a study of the colonial discourse surrounding African arts. This transformation of difference into negation was institutionally translated into a refusal to include them in the fine arts museums collections and by their acceptance instead into museums of natural history, where, as in La Rochelle, France, they sometimes still remain.

The second attitude is illustrated by the relationship of certain European artists of the early twentieth century to so-called "Negro" art. Jean Laude (1968) has shown how some artists were considering African objects as solutions to plastic problems identical or close to those they themselves were trying to resolve. Ethnographic information did exist that would have allowed a respect for the differences and for their interpretation, but these artists did not turn to it. The advantage of this misreading through assimilation forced upon the negative misreading is clear: African works definitively acquired artistic status.

29

The Absence of History

It has been maintained that the African arts, like the societies in which they were produced, did not have any history. Not only was it said that the Africans had not developed any historical knowledge, but that their societies were fixed, unchanging over the course of time. Malraux in his *Musée Imaginaire de la Sculpture Mondiale* (1952–54), still placed the African arts "outside history."

Arts without history produced in societies without history: an illusion whose mechanism Claude Lévi-Strauss (1952) has dismantled. The observer belongs to an historical society, ours, that changes rapidly; but the societies being observed change slowly. An observer in a rapid train will have the impression that the slow train that is passed is immobile. Similarly, the Western observer who belongs to a rapidly changing society will have the impression that the more slowly changing societies are unchanging. In other words, expecting a rapid change in the name of history, but encountering a different kind of change, one would then negate, in this way, the historical character of that which one is attempting to define.

Thus, these societies and their arts were classified in a seminegative dichotomy: historical societies and arts or not. This dichotomy demarcated the respective domains of art history and art ethnology. Abandoning this dichotomy causes this manner of distinguishing the two disciplines to crumble.

In order to redirect the investigation, we must modify our preconceptions about historical time and change. The history of a society does not always involve rapid change. Culture within a society is not a simple thing; various cultural forms do not necessarily change either all at the same time or in the same rhythm. The so-called *Revue des Annales* school of history teaches us that historical change, rapid or slow, must be studied under its different cultural forms, over short or long periods of duration.

This pluralization of the preconceptions about time and change is not enough to resolve the difficulties encountered by the historian of African art. Over a short period of time, it is easy to recognize recent or present changes in the African arts. Unfortunately, through the fact of colonization alone, one notes either a loss of authenticity in traditional African art, or its disappearance pure and simple. The object vanishes under the scrutiny of the historian. In the long term, the difficulty is of a different nature. Traditional African societies are not familiar with the written word (*see* p. 11); direct, written documents, richer than oral traditions and above all lending themselves to methodical treatment, are lacking. The ethnographic data demands a specially adapted historical treatment. (J. Vansina, 1968) Archeological sources remain relatively poor. For various reasons, economic ones in particular, African archeology is developing slowly; "unauthorized" digs, aimed at contraband, compete all too efficiently with scientific digs. Thus, at this very moment, the terracotta pieces dug up in the Djenne region of Mali are appearing without any scholarly documentation on the Western art market.

Despite these difficulties, the history of Africa and the history of its arts does not cease to progress. An example, already classic, is furnished by an art history of the kingdom of Benin (Nigeria) undertaken by William Fagg and inserted by Frank Willett (1967) into a longstanding sequence that begins with the art of Nok, includes the art of Ife, the three periods of Benin art, and that ends with the art of the Yoruba, still very much alive.

But history can be negated in another way, implicit this time, by terming the arts and cultures which ethnology studies as primitive. (*see* p. 46) The

presupposition of an absence of history still weighs heavily on the study of African art. Catalogues, even the most scientific, only rarely mention the dates of objects. This "omission of the dates indicates how much art history in Africa, especially south of the Sahara, remains in its infancy." (J. Vansina, 1984, p. 21)

Societies Without Writing

"One should not define a given culture by what one refuses it, but rather by the peculiarities one recognizes in it that justify the attention one devotes to it." (C. Lévi-Strauss, 1973, p. 28) However, today the label "society without writing," manifestly associated with a negative idea, is given preference over the terms "primitive" or "without history." But this is a counterexample; for it's not that writing different from what one was expecting is encountered—thus there is no difference whatsoever to be transformed into a negation. A "statement of fact" is formulated (*ibid.*): the negation is direct and correctly declares a state of things.

Here the risk of error comes, rather, from abusive assimilation. The absence of writing is associated with positive traits: it seems "to exercise a kind of regulatory influence on a tradition that must remain an oral one." (*ibid.*) The risk is one of confusing elements of the oral tradition with written documents. Ethnology is inseparable from writing; oral information is transcribed and published. This transcription runs the risk of transforming that information into *texts*, in such a way that in the end we might think we will find what we were expecting. In this regard, the case of the myth is revealing. Pierre Bourdieu stresses (1987, pp. 99, 138) the risk of assimilating myths whose original status is an oral one with the written myths of our classical cultures and treating them abusively as texts. Lévi-Strauss observes on several occasions that field investigations most frequently collect *diverse* versions of a myth, not one of which ought to be treated as a canonical text. Jack Goody (1979) has undertaken the study of the forms of "domestication of savage thought," concentrating on "the effects of writing on the modes of thought . . . and the most important social institutions" (p. 31). In other words, our initial expectations are affected by their origination in a society that attaches great importance to the written word; they have, therefore, every chance of being ethnocentric.

This difficulty does not concern only myths. The latter serve as documents in the iconographic study of African art. In France, the students of M. Griaule, doing investigations among the Dogon, privileged mythology when they depended primarily on data furnished by a unique and exceptional informant named Ogotemmeli. (M. Griaule, 1966; M. Griaule and G. Dieterlen, 1965) Their interpretation of Dogon statuary caused hesitation on the part of the Anglo-Saxon specialists. We shall show later on (Chapter III) that this kind of interpretation, favoring myths and their autochthonous exegeses at the expense of the words of rituals, tends to bypass the ritual usage of plastic objects. But it is in their ritual usages that the plastic object and the word are directly linked. And ritual speech, because it is oral, fragmentary, and linked to a context that is extra-linguistic, is much more difficult to deal with as *text* than is the myth and its exegeses. One may wonder whether this type of an interpretation of Dogon sculpture does not fall apart in view of the preceding remarks.

If we now move on from iconography to the study of artistic production, it is proper to call attention to the existence of a link—which seems to have been studied very little—between writing and design. We are not talking about design on the surface of a figurative or utilitarian object, but on an independent base, like our sheets of paper. In the history of Western civilization, the passage to writing took place in Greece. In

ancient Greek, the same verb (*grapho*) means to engrave, to design, and to write. The equivocal "to design–to write" persists in modern European languages: in the "graphic arts" it means design, but in "graphology" it means writing—not to mention "calligraphy" or the metaphoric use of the word writing to designate one aspect of the style of design, as well as the recent term "graphism." But design on a separate surface plays an important role in the West in the process of artistic creation, as a recent exhibition, entitled *Première Idée [First Idea]* (J. Ramade, 1987) demonstrates, in which various kinds of design are shown, done as preparations for paintings and sculptures. In traditional Africa, the absence of design on a separate surface intervening in the process of artistic production corresponds to the absence of writing. What might be seen as preparatory design is not only reduced to a very simple form, it is executed on the material itself and limited to the beginning of the cutting of the wood. This suggests how the absence of writing may account, at least in part, for the forms of the artistic work that are different from those to which we are accustomed. This observation could be applied particularly to the question of proportions: the absence of "squaring," practiced in ancient Egypt (E. Panofsky, 1969, p. 60 and figs. 2 and 3), permits us to understand the absence of a systematic conception of proportions that very probably requires writing.

Anonymity of the Artist

In catalogues of African art, captions mention the names of artists as rarely as they do the dates of works. Until very recently, it was thus that "songs without singers, tales without storytellers, and sculpture without sculptors" (W. D'Azevedo, 1973, p. 1) were exhibited. Popular books and sales catalogues still speak of the anonymity of the African artist.

But the terms "anonymous" and "anonymity" have several meanings that correspond to various uses of the word "name" from which, by negation, they derive. The name in question here is the proper name, applied to one individual only, a specific artist in this case. But in "making a name for oneself" or "having a name," the word is equivalent to "renown." In our society, the proper name is not just spoken but written, and when it is written by the author's hand, it is called a "signature"; in this sense a work without a signature is anonymous; but art history teaches us that the practice of signing one's name is not a constant. In the end, then, anonymity may simply be the result of our ignorance.

When one speaks of the anonymity of African artists, one does not mean that they are not individuals, nor that they have no proper names, nor that we do not know their names. Nor is the absence of a signature, attributable to the absence of writing, the point. One means that the artists, as individuals or, more precisely, their artistic individuality manifesting itself through works, cannot be assigned and that, consequently, no renown can be attributed to the artists or their works even within the framework of their social group.

But it is obvious that, this way, all we are doing is describing the negative of artistic individuality as we have conceived of it and evaluated it in the West since the Renaissance. Searching in the African domain for artistic individualities thus conceived and encountering different forms of artistic creation and of the social status of the artist, one transforms these differences into a negation once again. The development of research has invalidated these ethnocentric representations.

In Africa, as elsewhere, the works demonstrate the individualities of their authors to a varying degree and with varying success. The first individual style recognized as such, that of the Buli Master, occurred

thanks not to on-site inquiry, but to a comparative study of forms inspired by the attribution method of Giovanni Morelli. It was only thereafter that field investigations researched and studied individual artists. This sequence emphasizes the fact that the prejudice against anonymity must be abandoned and that individual works must be researched in order to discover artists' identities. Such research has been particularly developed in the realm of the Yoruba under the instigation of Fagg. Attributions to individual artists, based either on on-site investigation or on formal comparisons, are today increasing rapidly in catalogues. As is the custom in art history, the proper name is used, or lacking that, a name that has been agreed upon.

Even examples of a "signature" can be mentioned, but in forms other than that of alphabetic writing. According to Fagg, the sculptor Olowe has the habit of "signing" his work with a rectangular, crosswise motif. (1981, p. 106; cf. p. 102) In the Yoruba town of Abeokuta, the *ibeji* (twin images) sculpted by Akinyode have marked three concentric squares on their base, while Ayo used to "sign" the great majority of his *ibeji* with a triangle cut into the inferior side of the base. (1982, p. 37)

In Africa, as elsewhere, certain artists enjoy renown that may well extend far beyond their group and call for foreign commissions and travel. Such renown and the capacity to recognize individual styles can be utilized by investigators in establishing individual attributions. (W. Fagg, 1981, p. 123) The functionalist approach (Chapter III) tends to favor use at the expense of production and producer, and to define object-types by their function at the expense of the individual elements of their style. The recognition by users of individual styles thus furnishes an argument against a functionalist interpretation tending to unite a doctrine with a method.

Goody (1979, p. 35) observes that a certain number of dichotomies, of which the second part is often negative due to ethnocentrism, coincide with the opposition between "us" and "them." The dichotomy individual renown–anonymity must not be used in this manner. For if the existence in Africa of individual styles and artists must be recognized, cases of anonymity must also be noted; but these should not be viewed in a negative and uniform manner. As a matter of fact, anonymity is a result of various factors.

In certain cases, artistic production is collective; Paul Bohannan (1971) describes an example of this which was observed among the Tiv; but anonymity is then no longer presupposed through ideology.

Cases can also be mentioned where identity has been usurped, such as when a traditional chief (*fon*) of the savannas of northern Cameroon attributed the works of a sculptor in his service to himself. But usurpation of this sort is of interest only by reason of the value of the renown attached to an individual work.

Two other factors may carry the anonymity of individual works in their wake; one concerns the usage of plastic objects, and the other the idea the users have of their origin. Quite a number of cases have been reported in which the artistic object, most often a mask, is held not as the representation or image of a sacred entity but as the entity itself. There is not representation here, but presentification. (*see* Chapter III) But if the mask *is* the spirit or the divinity, then one cannot ask who has produced it; it is not attributable to an individual artist. The same goes for the artistic object not attributed to a human producer. Among the Nyonyosi—an autochthonous part of the Mossi people—"each family has a myth that explains the origin of its masks. All the myths begin with a triggering event: when catastrophy threatened, an ancestor was given the mask by a ghost, by an animal, or by the God himself." (A. Schweeger-Hefel, 1981,

p. 34) According to Christopher D. Roy (1979), the Nyonyosi absolutely refuse to speak of the age of the masks and of the sculptors' identities; these are among the secrets most ferociously guarded by the members of the family and the clans, who do not want to admit the intervention of the human hand in the creation of these sacred or mythic beings. Christian iconography used to call these images not made by human hands "acheiropoietes." (*see* p. 53)

What these two types of anonymity, associated with presentification and/or the acheiropoietic image, have in common is the secret and the existence of a segregation inside the social group between those who know and those who are ignorant of the secret. In turn, this segregation is the result of various factors: of belonging to a so-called secret society, of initiation, or of sexual difference. Anonymity is thus institutionalized, but it may be said to be partial. These few examples suffice to demonstrate the deficiency of the negative concept of anonymity and its ethnocentrism; in a dichotomy it can only serve as a hold-all and cause the misreading of the rich diversity of observable facts.

Depreciations

When an initial anticipation is not a descriptive but a normative concept, it is matched to a positive value and the corresponding negation enters into a judgment of negative value: the encountered object is disparaged.

DEFORMATION AND AWKWARDNESS African sculptors have long been regarded as deforming the human body and, generally speaking, the things they were representing. "Deformation" is ambiguous: the word designates an operation and its result. The work is reproached with the deformation-that-is-result, the artist with the deformation-that-is-operation: they are accused of awkwardness, of lacking technique, of negligence, of an inability to faithfully imitate or represent the model. Of course, these reproaches are not directed only at African objects and artists but at all objects that come from a conception of art other than Classicism and imitation of nature. However, even though Classicism's claim to universality is henceforth held to be inadmissible, these reproaches escape, so to speak, from serious authors still.

The form-that-is-result is nothing but a form other than what one was expecting. One was expecting a form that faithfully imitated that of the human body; in encountering a different form, one transforms that difference into negation. Similarly, as the encountered form presents proportions that are different from those of the human body, one declares them to be disproportionate or ill-proportioned. (*see* p. 111)

If one goes back from the result to the operation, from the work to the artist, one relates the encountered form to an intention attributed to the sculptor. Supposedly, the artist wanted to imitate nature faithfully and was not able to, through technical incompetence, lack of craftsmanship or ability, or negligence.

But attributing an intention to imitate to the sculptor has no empirical basis whatsoever; it is not made legitimate by any ethnographic information; prior to the encounter with the object lies its anticipation, since one confuses this intention with that of a Classical or academic European sculptor. The double depreciation—deformation and awkwardness—thus links up with the two forms of misreading described previously. How and with what to replace these ethnocentric expectations?

First of all one must be attentive to the work encountered. One notices then what might be called, in the early stages, and in order to correct the notion of deformation before replacing it—*coherent deformations*. This way,

one moves from the comparison between the forms of the sculpture and those of the human body to a comparison of the forms of the parts of the sculpture among themselves. These then often impose the feeling of similarity, while their respective models should render them dissimilar. It is as if a single rule of deformation or, rather, of transformation had been applied by the sculptor in the rendering of the parts of the supposed model. This rule, unique for one work, varies with different works. There are as many coherent transformations of extra-artistic reality as there are styles. The coherence of deformations is a symptom or a manifestation of style. Thus we have moved from the (imitative) representation of (extra-artistic) forms to the (artistic) form of the representation. This process will be dealt with on several occasions in Chapter III.

Thus, certain masks or sculpted faces of the Bamileke [figs. 138, 556] show all the parts of the human face by means of clear-cut ridged patterns, and they all have the shape of segments of curves, arcs, and tightly spaced dimensions; a mask reproduced in fig. 11 shows this very clearly; it will be noted that the median ridge above the nose which, facing front, seems rectilinear, in profile shows itself to have a curvature comparable to the bridge of the nose. The Wurkum hairdo (*Sculptura Africana*, catalogue, pl. 43) suggests the same observations. Certain Dogon masks [fig. 26] present upright segments laid out at a right angle in such a way that partial rectangular shapes represent parts of a face that are both nonrectangular and dissimilar. One can discern in a Baga object known as *nimba*, reproduced in profile, similar and variously oriented curvatures of the crest, the bridge of the nose, and the notches where the bearer's shoulders go. The profile of a *tyi wara* hairdo, of Bamana origin (Musée National des Arts Africains et Océaniens, Paris) [fig. 302] presents a variation on the curve of the axes of all its plastic elements having different figurative values. One can easily find other examples.

In order to describe the similarities between partial forms having different representative values [figs. 38, 247], one may borrow Daniel H. Kahnweiler's (1946, p. 201 *ff.*) notion of the *plastic rhyme*. This metaphor is justified by an analogy. Identical sound forms (verbal rhymes) are associated with different significations and referents just as identical or similar visible forms (plastic rhymes) are associated with different representative values. A Baoule statuette [fig. 61] assigns to the face, to each of the breasts, to the outlines formed by scarifications above each breast, extended along the internal edge of the arms, and, finally, to the axes of the legs extended by the converging feet, the shape of a stretched-out heart, easily perceptible in these different values of representation.

The preconceptions, or initial expectations, are most often not isolated concepts but belong to more or less systematically conceptualized constellations (just as with the notions of fetish, idol, and idolatry). If the negative diagnostics of deformation and awkwardness thus mobilize the imitative or naturalist conception of art, into what conceptions of art can one integrate alternative concepts, introduced to correct these inappropriate diagnostics? Later in this essay we will show that we have three other general conceptions of art at our disposal that allow us to account for forms considered to be deformed in terms of naturalism, in order to account, in a positive way, for the gap we notice between African objects and the forms we all too often tend to expect. We are referring to the functionalist (Chapter III), the expressionist, and the formalist (Chapter IV) concepts of art.

IMPERFECTION AND PERFECTION Every depreciation, every flaw for which African objects may have been reproached, constitutes the same number of imperfections. In classical aestheticism

beauty and perfection are indissolubly linked. The imperfections of African art, then, run the risk of being nothing other than the negative formulation of the gap between aspects of African artworks and characteristics of classical beauty. Of what exactly does this perfection one expects and does not encounter consist?

The notion of perfection is elaborated by Aristotle within the framework of a philosophy of *technè*, a philosophy that does not distinguish between what we do with our two words "art" and "technique." (R. G. Collingwood, 1960) Just so, for Kant the judgment of perfection is not a judgment of taste; perfection is not an aesthetic value but a technical one. Artistic production is divided into two phases, conception (*noésis*) and execution (*poiésis*). The good technician conceives of his or her production clearly and completely before beginning its execution. If the conception or the project is a thought, then the execution is the making of it, and its perfection [Trans. note: per = thorough; facare = to do] is the result of a "thorough-making" or "making it through and through," a per-fecting; for the execution, the making, is perfected, finished, when the executed product conforms to the conception, plan, or intention of the agent; if the latter stops the execution before this end or this goal, the product—still inadequate in relation to the plan—is im-perfect, incomplete.

From the technical character of perfection thus defined result the limits of the correct application of its concept and its use as criteria. Objects coming out of forms or types of production different from technical production ought not to be assessed according to the criteria of perfection. To this former category belong all creations in which the project is not shaped intellectually and completely before execution. That is the "bricolage" which Lévi-Strauss makes reference to. (1962, p. 27) But it is also artistic creation as well, precisely to the extent that we distinguish it, as opposed to the custom of the ancients or the people of the Middle Ages, from technical production. Delacroix speaks of creative execution; for Braque "the idea is the cradle of the painting." The result is that the criteria of perfection can only be applied to the African arts once their modes of production and, in particular, the status of the plan or the nature of the artist's intention in this process of production, have been determined. This entails very specifically directed ethnographic investigations. But there is no reason whatsoever to assume that all African artists produce in the same manner. Moreover, the distinction between art and technique, as Greek *technè* and Latin *ars* already demonstrate, is not applicable to every period of art history. During certain periods and in certain places, technical perfection is inseparable from aesthetic quality. The refusal to consider perfection because it is technical as an aesthetic value comes from the conception of a *pure* art, cleansed of its technical elements. Now, no reason whatsoever permits us to assume a priori the existence of a pure art in Africa; quite the contrary, we award the status as a work of art in Africa to functional objects and to those whose function, in particular, is a practical one. (*see* Chapter III)

The judgment of perfection, *stricto sensu*, assumes a previous knowledge of the plan or intention of the artist. We have already seen, in addressing deformation, the conditions to which our appreciation of African works is thus subjected. We will resume these observations in examining another form of imperfection, the non-finished.

THE NON-FINISHED When the finished is conceived of as a perfection and the non-finished as an imperfection, this pair of concepts is integrated into the general conception of art as elaborated by the Greeks. But if we encounter works to which this conception of art is not applicable, and their non-finished character does not in any way prevent

our appreciating them, how do we justify this appreciation as an alternative to the depreciation that seeks perfection? Two paths are open: recourse to ethnographic data, or to the inventory of the theories of art that justify the non-finished. These latter solutions can only serve as alternative expectations that remain to be confronted with ethnographic data.

According to the classical theory of art, finishing, or finish, is the final stage of execution. To finish means, according to the French dictionary *Robert*, "to bring to its point of perfection," "to put the finishing touches on. . . ." It is chronologically the last condition of the perfecting process. According to Paul Valéry, this consists of "making all that shows or suggests the producing of a work disappear"; the artist must "sustain his effort until that point where the work has erased all traces of work." (*Degas, Danse, Dessin*) Since the nature of the work varies with the materials and tools, finishing operations vary with the arts. But one aspect of that which is finished seems common to all techniques: the traces of work are erased when the surface of the piece is regular, even, smooth, polished, "licked clean," or when it presents tangible properties, visual or tactile, as close to this as possible. In certain cases (*see* L. Perrois, 1972, p. 145), the African sculptor uses particularly rough-surfaced leaves as an abrasive with which to polish the hewn surface; this is the case, for example, with the Dan masks which are, indeed, called "classical." In other cases, though, the sculptor does not use these abrasives but finishes the work with a knife by very delicately and very evenly cutting minuscule facets that are to a smooth and continuous surface what a polygon, regular on a thousand sides, is to the circle it inscribes. Even though, by all rigorous standards, such a surface is not perfectly smooth, it must be allowed that it is finished and perfect insofar as the artist has clearly created what he or she had intended to create.

The classical theory of art conceives of art as a technique that imitates nature. Technique concerns the relationship between the work and the artist, imitation the relationship between the work and its natural model. From these two points of view, traces of work must be erased. The natural model obviously presents no trace whatsoever of human effort, since this did not create it; that trace must, therefore, be erased in the work in order that it be true to its model. Imitation tends to sever the relationship of the work to the artist in favor of the relationship of the work to the model. In the second place, all through its production the work still depends on the artist; it is only once it has been completed, perfected, that it becomes independent from the artist. Now, the Greeks accord more value to the work than to its production and, generally speaking, to a substance (*ousia*) than to its genesis. But, to the extent that African art does not come out of this naturalist conception of art, this justification of the finished is not pertinent.

The observation and comparison of certain African works of art, associated with ethnographic data, allow us to remove the naturalist justification of the finished and to give, as an alternative, at least two positive explanations of the non-finished.

The non-finishing of certain works originating in various regions of Africa may be described as partial. In one sculpture certain parts are finished and others are not. This aspect is enough to eliminate a diagnosis of awkwardness—for the same artist should then be considered capable for finishing certain parts and clumsy for not finishing others. Another explanation is needed.

In a more general way, it may be observed that quite often various parts of a similar figure are treated differently in Africa. These differences can affect style (J. Laude, 1978, p. 98)—sometimes certain parts are treated in

a naturalist fashion and others in an abstract or schematic way—whether that be in the proportions, or the use or absence of color. Globally, with sculptures in the round, certain parts are treated in relief, like the upper limbs of certain Baoule figures or the lower limbs of certain Luba or Hemba caryatids that are in relief on the base of stools. As for the partial finish, Marie-Louise Bastin, commenting on a Ovimbundu statuette (1969a, p. 34), notes that "the hands and the feet are roughly sketched out. Only the head and the trunk merited the care of the sculptor." This last remark suggests a hierarchic treatment of parts of the figure. A relationship of agreement or appropriateness is established between the degree to which parts of the sculpture are finished and the corresponding parts of the person represented, ordered according to a hierarchy of values that is socially recognized. The partial, or rather, differential, non-finished aspect, would thus be explained by the representation's submission to an extra-artistic hierarchy and by an application, a functionalist one, of the principle of appropriateness. We will see this interpretation again with hierarchical proportions (*see* p. 115) and the hierarchy of sizes (*see* p. 120).

And it is also within the framework of a functionalist conception of art that a certain kind of usage, generally qualified as magical, accounts for the partial finish. The best known of these magical statues are of Kongo, Teke, Luba, or Songhay origin. They receive their magic powers from an attachment to the sculpted work of various materials, chosen, prepared, and applied by an expert in magical operations. The sculpted piece by itself has no affect or power. This same object then presents two states and successive aspects, of which only the second one is conducive to use. The difference is sometimes manifested by the fact that users give two different names to the object. It is among the Teke that Robert Hottot (1972) gathered this kind of information for the first time, in 1906. Sculptors know the use of the piece they are cutting; they know that certain parts of it will be hidden by the magical materials that will cover them. They can, then, not only dispense with finishing them but be excused by the users from having to finish them in compliance with the demands of customary, ritual use. Thus one can no longer accuse them of either awkwardness or negligence. However, this difference in the finishing between parts can be attenuated or erased. The second producer, too, can carefully finish the parts that he or she adds. Zdenka Volavkova (1972, pp. 58, 59) in studying the *nkisi* figures of the Lower Congo, observed that sometimes the sculptor takes the future attachments to the statuette into account, while, reciprocally the *nganga* can adapt materials to the sculpted form whose suggestions he or she may seize upon.

The partial finish is readily noticeable on pieces that have been collected as they come out of the hands of the sculptor or at the beginning stage of their use (like the Kongo fetishes in which only a few nails or metal pieces have been implanted), or lastly on pieces stripped of their magical materials.

This explanation according to use is neither specific nor constraining. It is not specific because it is applicable to non-African objects, to uses other than magical ones, and to arts other than sculpture. It is not constraining since, in certain cases, those parts intended to be invisible are as finished as the other parts.

What still remains is to account for pieces that are completely non-finished. Their "sketchy style" is not enough to explain their aesthetic quality. The history of the theories of art offers several ways of justifying our appreciation of the best ones. The theory most frequently turned to calls these works expressionist. But it is one thing to interpret the non-finished or sketchy style in terms of expressionism, it is another to know, based on ethnographic information, whether the users of such pieces

appreciated them in such a way and whether they had terms available to them that would correctly translate into our expressionist vocabulary. For we have a tendency to lend an expressivity we expect to inexpressive objects (*see* Chapter II, p. 162), as with that skeleton piece that Valéry described as: "This empty skull and this eternal laughter." And so a question of comparative aesthetics has been raised. (*see* Chapter IV)

THE REPRESENTATION OF MOVEMENT It has been said that, for the most part, African sculptures do not represent the movement of the persons they depict; that, in the rare cases where this is attempted, they do not succeed, or only badly so. What was inferred is that the majority of African sculptors are incapable of representing movement. These reproaches are not specific; they are directed at all so-called "primitive" or "archaic" arts. Here again, the diagnosis that depreciates the pieces and the one that denigrates the sculptor must be differentiated. The first deals with observable objects, the second with intentions and abilities which cannot be sufficiently assessed from an observation of the pieces without ethnographic monitoring.

In the majority of cases, the first negative diagnosis seems legitimate. African statues do not represent movement because the function they exercise calls for the sacred immobility—the conventionalism—of the persons whose representation or presentification it demands. (*see* Chapter III) In a minority of cases, one recognizes the representation of movement without any difficulty; the best examples are furnished by the weights made to measure gold dust used by the Akan group and the statues coming from the chieftainries of the Cameroon savannnas (Bamileke, Bamum, etc.). There are, it seems to us, intermediary cases that lead one to wonder whether a negative diagnosis would not result, once again, from the transformation of a difference into a negation.

There are three cases in which the African sculptor may represent a movement different from those we are able to anticipate and expect: The movement represented may be different from those we are used to encountering in the extra-artistic reality of our own cultural environment. Or it might be different from what we have seen *represented* in the reality, the artistic one this time, that we know. Lastly, its difference may come from the fact that it is depicted differently from the way to which Western observers are accustomed. The first two cases are concerned with movement as the object, subject, or material of the representation; the third one with the form of representation, the figurative conventions of movement.

African dances, ceremonies, and rituals include movements with which most Western observers are not familiar but which the African sculptor is able to represent. African dances are so different from our own that we cannot assimilate them. Also, they are different from the idea of them we are able to conjure up. Thus it is difficult to avoid a negative diagnosis, whereas the researcher, having observed them, will be able to recognize their sculpted representation. Neither can we rely upon the impression of stasis that an isolated sculpture may call forth; for our impressions, too, cause expectations to intervene and their realm of pertinence, just as with our preconceptions, is reduced by that. From the fact that an isolated sculpture seems static to us, we may infer that it represents no movement at all. Thus the frontality and symmetry of certain Mossi statuettes give us a first impression of stasis. But, as Bastin (1984, p. 91) reports, Schweeger-Hefel has presented "photographs of dancing women, their arms slightly apart from their body, and has suggested that this discreet and elegant choreography might have inspired the body structure of women figures" as sculpted. Paudrat (1974) in a chapter entitled "The Forest is Dancing"

has shown how in the "colonial discourse," African dancing is associated with frenzy of movement, loose mores, and sexual excess. The Mossi example shows that African dancing cannot be reduced to the frenetic gesticulations which one, thus, cannot systematically expect. It also shows that the manner of representing movement is not necessarily imitative; more subtly, the movement of dance can "inspire the structure" of the image.

Photography, cinema, and television can remedy this ignorance. But photographic documentation is limited, for it too involves figurative conventions. "Human beings have the habit, every time they discover a similarity between two things, of attributing to both one and the other, even in what sets them apart, that which they have recognized as being true for one of them." (Descartes, *Regulae*, I) Even though a photograph and a sculpture are both immobile representations of movement, this does not mean they render it in the same fashion, by means of identical figurative conventions. Therefore, one cannot assimilate the sculpted representation of movement with its snapshot equivalent. The famous analysis by Rodin (1967, pp. 46–47) of *Marshall Ney* by François Rude is enough to demonstrate this and suggests more refined expectations. According to Rodin, Rude composed two instantaneous but partial observations, homogeneous as figurative conventions but different in their object: two different parts of the body in two different (successive) moments of movement. The analysis of the mode of the representation of movement thus distinguishes two levels, that of the parts and that of the whole. Now, as we have observed, it happens that the African sculptor treats the parts of the same sculpture differently, which would permit us to apply Rodin's process of analysis. An African sculpture may link the representations of a moving part and an immobile part. Certain Teke statuettes represent a motionless body and legs bent as they are in the men's dances called *nkibi*, according to Hottot. (1972, p. 20) Such a figurative convention, linking the representation of an immobile part to that of a moving part, may be inspired by the dances themselves. For, in certain African dances, some parts of the body may remain quasimotionless, where the vibration of the legs is linked to the immobility of the torso or, inversely, where the legs, frozen so to speak, are able to support a kind of vibrating of the torso and the breasts.

These brief remarks are designed to suggest the complexity of the question.

Terms, Meanings, Concepts

The critical road followed up to this point must be extended. For it is not enough to detect the expectations that interfere in our approach to African arts—their nature and epistemological state must also be examined. Initial expectations or preconceptions are conceptual outlines, insufficiently elaborated; but are the alternative concepts with which we replace them in pursuing this investigation truly scientific—in the way that the scientific intent of art ethnology demands?

A term, a word, or an expression is, from a linguistic point of view, linked to one or several meanings, and from a logical point of view, to one or several concepts. When the terms are applied to objects, the elements of their conceptual meaning help us apprehend the properties of these objects. One must examine the structure of the conceptual meaning, that is to say, the nature of the connections that are placed thus between properties. It will then be possible to wonder whether the concepts used are truly scientific and if they can be stated in the form of a logically correct definition.

A privileged example will serve as our point of departure. Its interest is multiple. It poses exactly the type of question we have just brought up and supplies it with an exemplary answer. It is the act of experts of recognized competence. It concerns the classificatory usage of terms and concepts. Finally, its character is that it deals with the important question of the authentic and the fake. The corpus of African works of art, the object of our investigation, presupposes a discrimination between authentic and fake pieces.

From the analysis of this example, we shall draw some general observations that will then be applied to several other questions, allowing us to pursue the determination of our realm of inquiry.

The Authentic and the Fake

Two art historians, one an expert in African art, the other in the Italian Renaissance, published in the same year and without referring to each other, two methodological texts that run so rigorously parallel that it is difficult not to assume their tacit common source.

DICHOTOMY AND SERIES According to Willett (1976, p. 8), a text published earlier in the review *African Arts* "seems to imply that a work of African art is either genuine or fake. This dichotomy, I think, is a gross oversimplification. As I see it, we are faced with a continuum rather than a dichotomy. One can attempt to slice up the continuum into separate categories, but always one finds something that does not quite fit into the categories one has established. . . . All classes in a system of classification invariably grade into each other, and different students will have different standards."

The dichotomic classification is too simple because the reality to be classified is not only complex but continuous. Therefore, it does not suffice to multiply the classes—by dividing genres into species, for example—they must be decompartmentalized by ceasing to use concepts that establish clear-cut demarcations that are insuperable between classes. These brief methodological remarks are matched by an application to African art. For the initial authentic-false dichotomy, Willett substitutes a series of nine classes that he characterizes as follows:

1. The most obviously authentic works which, all would agree, are those made by Africans for use by their own people and so used by them. However, this category can be subdivided, because the piece so made and used may be of superior, average, or inferior aesthetic quality.

2. A work made by Africans for use by their own people but bought by a foreigner before use.

3. A sculpture made by Africans in the traditional style of their own people for sale to a foreigner.

4. A sculpture made by Africans in the traditional style on commission by a foreigner.

5. A sculpture made by Africans in a poor imitation of the traditional style of their own people for sale to a foreigner.

6. A sculpture made by Africans in the style of a different African people (though it may be well done) for sale to a foreigner.

7. A sculpture made in the style of a different African people but badly done for sale to a foreigner.

8. A sculpture made by Africans in a nontraditional style for sale to a foreigner.

9. Finally, we have works made by a foreigner, i.e., a non-African, for sale to other non-Africans but passed off as being African. This, at the other end of the continuum, is the unquestionable fake.

Mark Roskill (pp. 155–56), historian of Renaissance art, asked himself the same question and answered it in the same spirit:

"But what exactly is a fake? Between a painting's being an original by a major master and its being an absolute fake made with the intent to deceive, there are many intermediate degrees." The author mentions the following "intermediate degrees":

a. A "school piece."

b. A piece by "a follower rather than the artist himself."

c. A piece "left unfinished and completed by another hand, possibly very much later."

d. A piece that may have been "substantially revised or retouched or prettied up at some later point, perhaps because of its poor condition or damage to it, or to make it more superficially attractive."

e. Works "by other artists of the same period" that "may get under the wrong name, and may simply be of less exalted authorship."

f. Finally there are "copies and imitations which were not originally made with any intent to deceive, but which may be passed off as originals subsequently on the art market, either by unscrupulous persons or simply by mistake.

"So where the label on a picture in a museum turns out to need changing as time goes on, in at least ninety-five cases out of a hundred there will be no question of a forgery."

In compliance with the intention of these two texts, a few categories may be added to Willett's series. When an original work is duplicated, one can distinguish between replicas made by the same hand done shortly after the original, which they resemble a great deal; versions clearly made at a later time, which often show the evolution of the manner or style of the artist; and finally, copies made by a hand other than that of the original artist. Various kinds of replicas, then, can be distinguished. There are those that have been commissioned by the same user or traditional patron as commissioned the original, from the same people as the sculptor. Such is the case with a throne of King Njoya, the original of which has remained in Foumban; a replica of it, done as faithfully as possible, was given in homage to a highly placed non-African visitor and is now in Berlin. (C. Geary, 1981, p. 37) This kind of replica could be inserted between categories 2 and 3 of Willett's series. Ethnographic samples bring to mind a second kind of replica. They are commissions from an ethnologist to a sculptor whose work and oeuvre the former is studying, done in order to keep the original *in situ* and to obtain as authentic a sample of it as possible, intended for a museum. Several ethnographic replicas commissioned by William Bascom (1973), for example, are by the hand of the sculptor Duga from the Yoruba town of Meko. The "ethnographic replica" could be inserted between categories 3 and 4.

One category, mentioned by Joseph Cornet (1975a) is more difficult to insert. An example would be the *kifwebe* mask of the Songhay. "On the advice of a European merchant of enlightened tastes, twenty or thirty years ago a local workshop was established that began to accentuate even more strongly the characteristic volumes of the masks, thus giving birth to an entirely new category. The close resemblance of the sculptural techniques, the almost infallible beauty of the proportions, the uniformly aged ornamentation, the careful boring of the holes for the fiber necklace (or at times the absence of such holes), everything indicates a single commercial center the commercial intent of which is beyond any doubt" (p. 55); this type would be inserted between categories 4 and 5. But, the author continues, "this new type of mask has left its mark on the authentic masks of the *kifwebe* society." (*ibid.*) It is more difficult to situate this authentic type, influenced by the commercial type, in the series. Now, this

42

difficulty raises two questions: what are the classifying criteria, that is to say, the properties that enter into the determination of categories, and how are these properties distributed in each category and each series?

CREATIVITY AND ETHNICITY The series proposed by Willett and Roskill present differences and similarities. They differ in the criteria or properties they use and they resemble each other formally in the way they distribute them.

Their difference raises the question of the relationship between art history and art ethnology. The question of what is authentic and what is fake, posed by both disciplines, is closely linked to the matter of attribution. In fact, one may provisionally define the authentic work as the object of a true attribution and the fake as that of a false one, of a mistake in attribution. This purely gnoseological definition accounts for Roskill's last observation: the same work, a fake under an imprecise attribution (or label), becomes authentic when its attribution is rectified—for example, "school of Giotto" instead of "Giotto." But this definition is insufficient: it is not applicable to all the categories in the two series. The works in the last category, the "absolute" fakes, do not become authentic once they have been uncovered; a forged Vermeer does not simply become an authentic Van Meegeren; it remains a forged Vermeer by the forger Van Meegeren, different from the paintings by that artist when he was not counterfeiting anyone. Moreover, the African pieces qualified as airport or tourist art, classifiable in category 8, once they have been clearly recognized as such, are no longer seen as authentically African; they are furthermore ignored by the collectors. Despite these limitations, our provisory definition is sufficient for tackling certain questions.

The attribution, in the art-historical sense, is a judgment of attribution, in the sense of Aristotelian logic, the canonic form of which is S and P. The logical subject, S, always designates a single given work and the predicate, P, a class associated with a classifying label, brought into being by the label. Now, in their respective series, Willett and Roskill use different predicates or attributive labels. In art history, attributive labels would be the names of individual creators, and in art ethnology, the "peoples" to which the artists belong, who therefore themselves remain anonymous. Thus, this question blends those of anonymity (*see* p. 35) and tribal art (*see* p. 48). Therefore, another way of distinguishing between the two disciplines must be found.

The difference between these two kinds of attributive labels results from two ways of conceiving of artistic production and the social organization around it. Roskill conceives of art as the creation by an individual artist, a master, endowed with exceptional creative powers, often called a genius, who realizes himself best when working alone. Decreasing degrees of authenticity correspond to decreasing degrees of this creativity. It is as if the master's creativity were losing its force as it diffuses. This diffusion presents two aspects: a multiplication of the number of individual producers working in collaboration, and dispersion in space (another studio) or across time (students, disciples, a school). The diffusion is made within the framework of this particular organization of production which is the studio centered around the great master (who, with Romanticism, disappeared, reduced to the master).

Willett, at least in this text, refers back to a functionalist conception of art. The emphasis is placed no longer on the creative individual, nor even on the studio, but on the social group to which belong patrons, producers, and users. Thus, the social organization of the production is the functional group: patron, producer, product, use, and user—within the context of the same "people." The quality that would correspond to individual

creativity, then, is ethnicity: that all these elements of the functional ensemble belong to one single social group, "people," or ethnicity (or tribe). The loss of authenticity again has its origin in a dispersion by multiplication, no longer of individuals, but of social groups to which partners of the functional group of artist, patron, and user (or buyer), belong. This loss of authenticity is stronger when the new partners are no longer even African.

But the idea of conjoining the first concept, the creativist one, with art history, and functionalism with ethnology, is untenable. Art history does not exclude taking the functional context of works into account. And art ethnology, as it has developed, has discovered individual creation and abandoned the ideology of anonymity. Furthermore, the intervention in Willett's series of criteria of aesthetic quality suggests the recognition of a differential creativity. The difference between the two disciplines comes rather from a difference in their development. (R. Goldwater, 1973)

As to the methodology of attribution, it has as a result that the two series of attributive labels are not exclusive. They could be linked, though not without appropriate rearrangements. Then, in full accord with Willett's programmatic intent, a series would be available that is at one and the same time more complex and more refined, allowing one to better respect the wealth and continuity of the field studied. Now, the possibility of such a linkage is furnished by the existence of a formal structure common to both series, very probably ascribable to a common source, which we must now clarify.

Family Resemblance Predicates (FRP)

Edmund R. Leach (1961) proposed the idea of "rethinking anthropology"; ten years later, a group of anthropologists around Rodney Needham (1971) began "rethinking kinship and marriage." "To rethink" means to change mental procedures while still studying the same thing and, to that end, Needham proposed an explicit recourse to philosophy and, more specifically, to a theme in Wittgenstein's *Philosophical Investigations*, the Family Resemblance Predicates, FRP, according to the tradition of Wittgensteinian exegesis. The same technique is directly applied to the study of African art by John Ladd (1977). It is as if our two texts were applying this program to the letter. The explanation of the FRP theme will be reduced here to the indispensable minimum permitting a generalization of the solution brought jointly by Willett and Roskill to the particular question of authenticity, in order to then apply this generalized solution to other specific questions raised by the study of African art.

The meaning (or connotation) of a term is the ensemble of the characteristics something must possess in order for that term to be applied correctly. Following Wittgenstein's *Logical Investigations* § 65 *ff.*), we can distinguish two types of terms according to the type of relationship they have with the things to which they are correctly applied. In accordance with a tradition that goes back to Socratic definitions, codified by Aristotle, the characteristics that constitute the meaning of a term (to be defined) must be possessed by all things to which it is correctly applied. These characteristics are, therefore, common ones and constitute a common concept associated with the term. Now, things either possess all of these characteristics and are linked to the concept or do not possess them all and are not linked with the concept. Thus a clear-cut demarcation is recognized between them.

But Wittgenstein notes that many terms, when correctly used, are not associated with a common concept. Things are not arbitrarily regrouped for all that; they may well share common characteristics but, on the one

hand, these may be common only to some of them and not to all and, on the other hand, they may not always be the same ones. Thus one can discover between these things a network of variable similarities that bring them closer and closer together, in the absence of one characteristic common to all of them. They form a family, and these characteristics are the predicates of family resemblance. Wittgenstein offers a paradigm—a rope made of braided fibers: "The strength of the rope does not reside in the fact that any one fiber runs through its full length"—by analogy with a predicate common to all the things—"but in the overlapping of numerous fibers." The term, thus associated with variable characteristics, does not permit a clear-cut demarcation to be drawn, as a common concept does. On the other hand, given two things of the same name but with no common characteristic, one can link them closer and closer through a series of intermediaries. Thus one can speak of terms or concepts that have an "open" structure or texture.

If one moves from the terms to their classificatory use, Aristotelian concepts engender dichotomic classifications whose theory goes back to Plato's *Sophist* and to the first book of Aristotle's treatise *Parts of Animals*. Such coordinated and subordinated dichotomies form a tree. The FRPs, for their part, can engender networks.

All this is so exactly suited to Willett's and Roskill's series that a fortuitous coincidence seems highly improbable.

The methodology of history leads to the same result. Thus, according to Paul Veyne (1971, p. 163), who takes "revolution" and "city" as his examples: "the concept does not have precise limits"; the revolution or the city "is made from all revolutions and all cities already known and awaits an enrichment from our future experiences, to which it remains definitively open."

Applications

One can recognize in many a term used in art ethnology not so much terms associated with neatly demarcated common concepts but with concepts of open texture or with FRPs. Our samplings will be limited to terms whose importance depends on the fact that they serve to demarcate our realm of inquiry. African art is described as being *primitive* or *tribal*; but one speaks first of all of art, and we are studying African sculpture. Now, not one of these terms is associated with a clearly demarcated common concept. If a scientific concept must fulfill this condition, not one of these terms is scientific. It is, nevertheless, difficult not to use them.

PRIMITIVE SOCIETIES AND ARTS African arts have been classified under the term "primitive." The notion of primitive art includes two elements. First, there is a conception of the relationships between various societies that permits one to call some primitive and others evolved or civilized; this is the evolutionist theory of societies. Then, there is a conception of the relationship between the art and the society in which it is produced that in turn permits one to transfer the property or the predicate "primitive" from a society to its art. These two conceptions having been abandoned today, the notion of primitive art has also been abandoned, at least in this evolutionist form.

The connection between art and society was conceived as a strict or causal determination. In producing its art, a society would transmit its properties to it. Such determinism is no longer accepted. Art certainly is not entirely independent from the society in which it is produced, otherwise the sociology of art would hardly have a clear object. But the properties of a society are not the necessary and sufficient conditions of

the properties of its art. The same criticism will be raised against the transfer of tribal characteristics from the tribe to its art.

The evolutionist theory of societies has also been criticized. We will borrow this criticism from Lévi-Strauss (1952) by reformulating it in terms of expectations. If one compares different societies to each other, while referring them to ours, one notes that they possess different properties, and one will observe that they do not possess the same properties as our society, to which we attach the idea of civilization. The notion of evolution allows us to determine the relationship between noncivilized societies and civilized society or societies. It is in the course of an evolution that these latter would have acquired and developed properties then that they did not have before. If one accords a positive value to these properties, this evolution is progress.

The process of evolution or progress requires time: these are forms of history. Societies deprived of these properties would be anterior to evolution or progress; they would, therefore, chronologically come first, which places them in a distant past. However, they are presently our contemporaries, which distinguishes them from prehistoric societies and justifies their being called "primitive." Their status is paradoxical: even though they can be observed in the present, theory sends them back to a distant past. A supplementary hypothesis resolves this paradox: they have not evolved but have preserved their first state throughout time. Thus the concept of evolution can only account for primitive societies on the condition that it not be applied to them. The negation has been redoubled: they are not civilized and have not evolved. We once again find the absence of history. Thus evolutionism engenders seminegative dichotomies that reveal its ethnocentrism, for it is always our society that serves as the mold for the affirmative and positive member of these dichotomies. What we expect and do not encounter are the properties of our society.

The concept of the primitive has likewise been applied to the arts. W. Deonna (1936) undoubtedly furnishes the most systematic application. He proposes a dichotomy between classical and primitive art; but the properties characterizing the latter are nothing but negations of the properties of the former, itself described according to the model of Greco-Roman art; again the dichotomy is seminegative and ethnocentric.

Must the notion of primitive art be abandoned, together with the theory of evolution that gave it its meaning? The notion of "first arts" has been proposed. (*Arts Premiers* catalogue, Brussels, 1977) But these arts have their own history, at the endpoint of which we are observing them. Furthermore, we are noting their disappearance under the influence of Western society, and this disappearance is so rapid that it makes their study quite urgent. (G. Balandier, 1961) The label "last arts" would suit them better.

But one can follow another path and attempt to isolate characteristics common to the primitive societies that have been directly observed by ethnography. Hsu (1964, cited by R. F. Thompson 1973b) enumerates the following fourteen properties:

1) absence of writing; 2) small-sized settlements; 3) isolation; 4) lack of historical documents; 5) low-level technological constructions; 6) social relations based primarily on family relationships; 7) nonindustrialization; 8) absence of literature; 9) relative homogeneity; 10) nonurban settlement; 11) general lack of time-telling techniques; 12) economy without money; 13) lack of economic specialization; and 14) possession of a super-powerful sense of reality, according to which daily facts have a religious and ritual significance.

One will notice that the majority of these criteria are overtly negative.

Moreover, Robert Farris Thompson shows that only four of them are applicable to Yoruba society (numbers 1, 6, 7, and 14). Other African societies would give rise to the same observation but the applicable criteria would change from one case to the next. All of this suggests that the ensemble of these properties does not constitute a clearly demarcated concept whose definition, thus constituted, would be applicable to all societies described as primitive; therefore they do not form a genus, in the manner of natural genera, but rather a family, in Wittgenstein's sense.

SOCIETIES AND TRIBAL ARTS The concept of tribal art has been suggested (W. Fagg, 1965) as a replacement for that of primitive art. Primitive societies are no longer being compared to those that are not, but rather, we find arts and their styles being distinguished one from the other through distinctions made among the tribes that produce these arts.

The obvious intention is to classify. As a matter of fact, most of the attributions use the names of "tribes" as labels or predicates.

According to Fagg, each tribe "forms a universe in itself from an artistic point of view": "These worlds are really closed off from one another and . . . their horizon ends at their own borders. . . . The tribe is a closed, exclusive group for whom art is one means, among others, through which to express its internal solidarity and its self-sufficiency and, inversely, to differentiate itself from the other groups" (pp. 10–11). Consequently, two traits oppose the tribe and our own society. First of all, since art is functional within a tribe, there is no separation whatsoever between the art and its public. Moreover, since the art is nonfunctional outside the tribe, the members of one tribe "are indifferent to the arts of other tribes," whereas our society is capable of accepting all arts (p. 12). To be fair, it must be said that Fagg blends nuances and restrictions into this thesis, which certain critiques, however, have turned against themselves. But the thesis presents a solid core, summarized in a canonical formula, "one tribe, one style," which has served as a target for number of critics (D. Biebuyck, 1966; F. Willett, 1971; S. Ottenberg, 1971; R. Bravmann, 1973; L. Siroto, 1976; J. Vansina, 1984; C. D. Roy, 1985, among others). The persistence of criticism is less a response to the use of tribal attributions than to their adequacy: they should be considered solely as approximate and provisional.

The solid core of the thesis contains three elements: a relationship and its two terms. The relationship is a bi-univocal correspondence, one = one: *one* tribe, *one* style. The terms are the various tribes classified under the general concept of tribe and their various arts under the general concept of style. The critics take aim at these three elements.

The correspondence between tribe and style—Generally speaking, the hypothesis of a bi-univocal correspondence may be invalidated in two complementary ways. We have mentioned observed cases in which one of the terms of one series corresponds not to a single but to two or more terms of the other series. In the present case, we shall mention instances of correspondence: 1) between a single tribe and two or more styles (thus, challenging the stylistic, intratribal homogeneity); 2) between a single style and two or more tribes (thus, challenging the stylistic, intertribal heterogeneity and the closing of borders). Indeed, examples of these two configurations abound in ethnographic literature to the extent that this thesis, which does not take them into account, shows itself to be an unjustifiable simplification of the examined reality.

First configuration: one tribe, two or more styles. Here, the tribal designation is provisionally accepted; on the other hand, we are not talking about substyles that would correspond to subgroups of the tribe, the bi-univocal correspondence being maintained between subtribes and

substyles. Thus one can contrast Yoruba art (S. Ottenberg, 1982, p. 51) where "regional stylistic variation clearly exists within a general aesthetic framework," while there is "no single art form typifying all of the Igbo." For example, the styles of Udi, Bende, Achi, and Afikpo masks are as different one from the other as each one is different from those of the Bini or the Yoruba. (W. Bascom, 1973, p. 102) There is no correspondence between the diversity of Igbo substyles and the cultural homogeneity of the ethnic group as a whole.

It is not only within the same tribe, but the same institution that very different styles may be observed. Among the Baoule, masks are used in the *goli* dance "so different in aspect that we would attribute them to different peoples . . . if we did not know otherwise." (G. N. Preston, 1985, p. 14) [figs. 388, 389, 390, 392] The styles of these masks differ according to three parameters: bi- or tridimensionality, simplicity or complexity, abstraction or naturalism. A style difference may be noted within a single, identical type of object and be justified by iconographic considerations. On the subject of the Dogon stool, known as *imago mundi*, Jean Laude (1973, p. 84, and 1978, p. 96) writes that all of the figures do not emerge from the same style—depending on whether they represent a priest (*hogon*) or certain mythical characters (*nommo*). [figs. 275, 276] In various groups of Benin bronzes, the divine king (*oba*) and a slave are not represented in the same style: their proportions, in particular, are very different [fig. 466]. The Yoruba mask of the *epa* type [fig. 439] is composed of a helmet-mask in a non-naturalistic style with a superstructure whose figures are related to the criterion of "relative mimesis." (R. F. Thompson, *see* p. 4) When stylistic differences emerge thus from iconography, it should be remembered that the "subject" represented may belong to the style. (N. Goodman, 1978, II, 2)

One must not draw the conclusion from this that the formula "one tribe, one style" is never applicable, but only that it is not in every case, and that it cannot therefore characterize African art in general. (*see* p. 31)

Second configuration: one style, two or more tribes. This amounts to stating that the area across which the style is distributed does not coincide with tribal territories, or rather, that the tribal borders overlap or cross and are not delineated or closed. The cases mentioned here can thus serve to challenge one of the properties that help to define the tribe.

In certain cases, the style under consideration is correlated with an institution common to various tribes that uses objects in that style. Thus, the helmet-masks produced by men but—a rare if not unique occurrence in Africa—worn by women are used by a female initiation society called the *sande* or *bundu*, which exists among the Mende of Sierra Leone [fig. 347] and among the Bassa, the Vai, the Gola, the Kpelle, and the Dei in Liberia. (M. Adams, 1982, pp. 62–69) Undoubtedly, "tribal" substyles may be distinguished, but they are subordinate to a common style correlated with the institution they hold in common, not with the tribes.

In other cases, it is a technique that is common to several tribes. In order to weigh gold dust, brass weights were used, in particular, figurative weights whose style is common to various tribes of the Akan group, such as the Baoule and the Asante. (In other respects, this style differs from that of the statuettes or masks of these tribes, which provides another example of the first configuration.)

One must then look for the reasons that cause these objects and their styles to straddle or cross borders, which is exactly what René A. Bravmann did in an essay entitled *Open Frontiers*. What must be remembered, in particular, is that there was a commercial circulation of objects previous to colonization and an existence of marketplaces whose clientele and tradespeople came from different tribes. With these kinds of

inquiries, we move from ethnology to the history of traditional African art.

The concept of tribe—We will leave aside those critiques (by Maurice Godelier, for example) bearing directly on the concept of tribe and we will deal only with those whose application focuses on art. Let there be, on the one hand, diverse social groups to whom the term tribe is applied and, on the other, the properties of these social groups coming under the definition of this concept. In order that this concept be a common one with clearly demarcated boundaries, it is necessary that all properties it comprises be true for each and, therefore, for all these social groups. At the very least, it is enough to show that one of these properties does not fulfill this condition.

According to the thesis, the tribe's borders are closed and because of that must be clearly demarcated. Now, not every group that is called a tribe has clear-cut borders. To expect clear-cut borders is, therefore, to project a modern European fact on traditional Africa. The borders of present-day states are results of colonization and frequently cut across the previous ethnic territories. Certain groups called tribes are the products of a regrouping of populations by colonial administrations.

The borders of a tribe would be the geographic limits of a territory occupied in a homogeneous fashion by all the members of one tribe and by them only. Thus, this homogeneous population is concentrated. (Concentration is distinct from density: a population of very weak density can be homogeneous and concentrated.) Now, in traditional Africa, the territorial distribution of populations does not occur in this form alone. A population may be dispersed; it may be divided into two or more homogeneous parts, separated by one or several other populations; it may be intermingled with different populations; one part of it may be homogeneous and concentrated and another part may be intermingled. For example, in certain regions of Zaire, dispersion and mixing are the most frequent form of distribution. (D. Biebuyck, 1985) The ethnologist who imposes clear-cut, closed borders upon such "tribes" reminds one of those who, in Jacques Prévert's words, "in their dreams plant bottle shards on top of the Great Wall of China" (*plantent en rêve des tessons de bouteille sur la Grande Muraille de Chine*). Bravmann, too, speaks of open frontiers. The property of having clear-cut and closed borders does not belong to every group called "tribe." Of course, one should not confuse the borders of tribes for the border of the concept tribe, that is, the literal and the metaphoric uses of the word. The property of having a clear-cut frontier (in the literal sense) not being common to all groups called tribe, it could not serve to define tribe by means of a clearly demarcated concept (in the metaphoric sense). This argument is applicable to other properties, such as language. (J. Vansina, 1984, pp. 31–32)

The concept of tribal style—Like that of the tribe, the concept of style may be examined in itself (M. Schapiro, 1982) or in its application to tribal art. Tribal style is determined by a morphological type that consists, in principle, of the characteristics common to all the works produced by the tribe. This type is either described verbally by means of common properties, or represented by a schematic drawing. It can be examined from two points of view. What is, first of all, the procedure used to determine the type? It is obtained through comparison and abstraction: one observes the largest possible number of concrete works and, through comparison, one abstracts common characteristics from among them. But one cannot have available all works produced by the tribe; the available material is therefore the result of a selection. This selection should contain pieces documented with great precision, otherwise one might confuse, for example, the production of a prolific studio with a tribal style represented by a few pieces. (J. Vansina, 1984, p. 29) Moreover, the selection must also

satisfy the conditions of statistical sampling; this condition is rarely fulfilled.

One may also call into question the intention of putting together morphological types conceived in this way. Since these types serve as predicates in the attributions, one can go back to a remark by Max J. Friedländer (1942). He analyzes, not the attributive proposal, but the intellectual and perceptive procedure that poses and verifies the attribution. One starts with the "assumption that the artist—whatever he experiences, whatever impulses he receives, however he may change his abode—at bottom remains the same, and that something which cannot be lost reveals itself in his every expression" (p. 200). The attentive and repeated observation of works of indisputable authenticity allows the "connoisseur" to form a generic image with which he or she confronts works about to be attributed, and which is, for an adherent of intuition like Friedländer, what type is for adherents of the method passed down by Morelli. But, he continues, this conviction is "often shaken by practical experience. . . . In spite of many disappointments, we persevere in our endeavour to discover something that is unchangeably solid, and in so doing often get into the position of a man who peels an onion and in the end realizes that an onion consists of peelings" (p. 200). This disappointment of the onion peeler is analogous to that of a person who, undoing Wittgenstein's rope, would be looking for a fiber running the full length of the rope. There is no type common to every work, no fiber running through the entire cord, no pit underneath the onion peels. "If," Friedländer goes on, "all pictures by Rembrandt had been lost, except one from 1627 and the one of 1660, it would be impossible to connect them with one another solely on the basis of style criticism. Only when we are familiar with the chain of many links which makes up the *oeuvre*—and that is the case with Rembrandt—can we join beginning to end" (p. 205). Between extremes lacking common properties, we find the continuous series of intermediaries described by Wittgenstein, Willett, and Roskill. This approach may be transposed from the individual artistic personality to the collective morphological type. Jan Vansina (1984, pp. 90–91) gives a beautiful example of the insertion of an intermediary between two stylistic entities with no common characteristics: "Consider the typical central style of Shaba (Luba) all built up in rounded volumes and then the typical style of northeastern Kasai (Songhay) with their angular blocked out geometrical volumes, almost cubistic. A transitional style is hard to imagine here. And yet it did exist and yielded some very striking masterpieces." (Musée Ethnographique, Antwerp, no. A E 744) [fig. 202] In the usual typologies, instead of introducing intermediaries or transitions, one speaks in terms of mixed types and classifies certain works as atypical, that is to say, unclassifiable.

From all this discussion of the notion of tribal art, two conclusions, not equally harsh, may be drawn. The most severe is that one must abandon, pure and simple, research into tribal types; tribal attributions would only be maintained if matched with an acknowledgment of ignorance: a classificatory order, even if bad due to ethnocentrism, being better than no order at all. "It is time to abandon this artificial nomenclature. . .objects should be labeled by their village and workshop of origin, if known, otherwise by reference to the institution to which they are associated." (J. Vansina, 1984, p. 33) Daniel Biebuyck (1985, p. 97) is less severe: he gives tribal nomenclature a heuristic value. This, in our terminology, amounts to seeing tribal art not as a scientific concept but only as a provisional outline allowing the inquiry to begin—in short, as an expectation.

SPECIFICITY AND PURITY It has been asserted that African objects do not stem from art but from religion. This negative diagnosis resulted from what one meant and expected by the term art. This involved either objects faithfully imitating a natural model (*see* Chapter II), or "art for art's sake."

The notion of "art for art's sake" is a vulgarization of the Kantian notion of finality without end. Strictly speaking, not only African works but all religious works would not be art. But these works emerge out of an art conceived in a different fashion from "art for art's sake." Either one recognizes the difference between two realms of art or, by transforming this difference into a negation, everything that does not come out of art for art's sake would be excluded from the realm of art. This exclusion presupposes a Kantianism that is popularized and misunderstood. In fact, Kant, who seems to be the bête noire of ethnologists, is not the problem. He does not assert that a work whose purpose is utilitarian is not a work of art, but only that it is not *purely* artistic. In the field of conceptual analysis, he purifies the notion of the work of art but does not claim that actual works must be perfectly adequate to that pure notion. In other words, he distinguishes between specificity and purity. By specificity we mean the ensemble of properties that define a work of art. But a definition is one thing, the concrete works thus defined another. These latter may be presented under two different conditions. Either they possess only the properties defining art and they are works of pure art, or again they possess these properties and are specifically artistic, but they possess in addition utilitarian or functional properties: they are not purely artistic. Purity implies specificity. Of these impure or functional works, one has the right to claim only specificity. The negative misreading here confuses specificity and purity and, expecting purity while encountering works that are impure, it throws the baby out with the bathwater. That works are utilitarian or functional is not sufficient reason to reject them from the realm of art, it only allows them to be excluded from the realm of pure art.

The distinction between these two states of purity and impurity is not purely conceptional, is not a simple view of the mind. The same work of art may present itself to us in both states. African objects observed in their place of origin and use are utilitarian or functional there; but these same objects, removed from this context and frequently stripped of what are considered to be secondary accessories, are regarded in the museum as purely artistic works, in total ignorance or in disregard of their functional properties. Certainly, not every functional work qualifies for this second status: artistic specificity is required, which is not necessarily linked to functional value. (*see* Chapter III)

We are immediately interested in two aspects of the concept of purity. The first one concerns the relationship between art and what is *other* than art—religion, politics, justice, magic, or technology. These other cultural forms constitute, for the work of art, so many factors or elements of impurity; but when we retain them rather than exclude them, we consider them as elements that assign the work its functions or uses. One understands how a functionalist approach to art accommodates itself badly to the notions of art for art's sake or of pure art.

The second application of the concept of purity concerns the relationship between one art and the other arts, for example, between architecture and sculpture or painting, or, in Africa, between sculpture and dance or music. Conjointly with the intention of creating pure art, an intention appeared in the West of creating pure poetry, pure painting, pure sculpture. In fact, the history of Western theories of art shows that the question of the relationship between different arts is a double one. On

the one hand, by dividing the genus art into its species, the different arts, one intends to give them all a classification and each one a definition. This classification separates the arts in the manner of natural species, and defines a state of purity for each one by eliminating hybrids. On the other hand, the arts are reunited by subordinating them one to the other and, finally, to one dominant, hegemonic, or architectonic art. According to R. G. Collingwood (p. 17 *ff.*), this second perspective is characteristic of functionalism (which he calls the technical theory of art). The product of each of the arts is utilized by another art to which it is, by this fact, subordinate. Thus, the architect uses sculpture as a decorative or iconographic element. In this way, one can see how an architectonics of the arts suits the functionalist approach.

So, in opposition to the search for a purity of the arts coexists the idea of a total art, such as the Wagnerian opera or the dance according to Serge Lifar, which is nothing other than a metamorphosis of the idea of an architectonic art. It is permissible then to wonder whether the two possible ways of regarding an African sculpture—out of context in a museum or in situ in use—would not match respectively, the notions of pure sculpture or of sculpture that is integrated in a functional whole consisting of rituals, ceremonies, or celebrations which would offer an African parallel to Western opera. As for this last point, two conditions are required. First, once again following Vansina (1984, pp. 126–29), there is the recognition of and emphasis on the existence of "performed" arts, such as dance and music, side by side with the plastic arts or in association with them, and then, the recognition of the artistic status of these performed activities, such as rituals, ceremonies, or celebrations—if not of all of them, at least of certain ones. The second perspective, the functionalist and/or architectonic one, will be explored in Chapter III and the first one, purist or formalist, in Chapter IV. But the notion of purity presupposes that of essence or nature. A thing is pure, when it contains exclusively elements constituting its nature or essence. Pure water contains nothing but water molecules, to the exclusion of any other dissolved bodies. Classically—since Plato—nature or essence is examined by the question: what is? The formal definition is the pertinent answer to this question. Thus, speaking of pure art, we implicitly presuppose that an essence of art exists and that we have a rigorous definition of art available to us—speaking of pure sculpture, that there is a rigorous definition of sculpture. This double presupposition does not seem well-founded. If we had such definitions, accepted by the community of experts, available to us, this, as Sartre says, would become known. A typically skeptical argument: there are as many different definitions as there are theories of art. We shall pose as a hypothesis that the reason for this is the nonexistence of an essence or nature of art or sculpture.

But to abandon these essentialist presuppositions does not necessarily render the distinction between specificity and purity null and void; it only demands that it be conceived of in another manner. A pure art and another, distinct, cultural form, such as religion, may be seen as the opposite poles of a series of intermediaries which allows them to be more and more closely linked. After all, if profane, nonreligious arts exist, is there a religion without art? Similarly, between sculpture independent from architecture and architecture without sculpture (which the international style produced and toward which Cistercian austerity tended), there exist intermediaries that may subordinate architecture to sculpture as well as sculpture to architecture. Furthermore, let us consider the genre of the equestrian monument, as illustrated by Donatello and Verrocchio. In what pigeonhole of purist classification do we place it? Neither of the two fits, or both fit with the same ease. One can force the

sculpture into it, but by exploding the unity of the work into two parts, the architectural pedestal and the equestrian statue. Similarly, if one allowed clearly defined Luba and Songhay types, one would have to dissociate the statue in the Antwerp Museum that Vansina (*see* p. 50) uses as an example of transition.

The preference accorded to purism in the study of the relationships either between art and other cultural forms, or between sculpture and the other arts, is ethnocentric or anachronistic. In modern Western society, the various cultural forms have a tendency to be truly separate, to be set up in distinct institutions, and to exist independently. A case in point is the autonomy of art, often considered as an achievement of the second half of the nineteenth century in Europe. Likewise, judicial and educational institutions separate themselves from religion, and, with more difficulty, from the State. Jacques Ellul (1954) has shown in a masterly fashion how technology became established as an autonomous cultural form. Inversely, in the traditional societies of yesterday and today in all parts of the world, the various institutions or cultural forms are intimately linked together. "The more we understand the old African culture, the more it becomes clear that everything is interwoven on many levels." (W. Fagg, 1971, p. 7) The status of specific arts, such as sculpture, calls forth the same observation. In both cases, the series of family resemblance predicates seem to us to better suit the African data than do clearly demarcated common concepts that claim to define natures or essences.

Fetish and Acheiropoietic Image

In our inventory of expectations that present a high risk of ethnocentrism, we have not yet reviewed specifically religious expectations. Their intervention is, however, foreseeable, because of the character, most often religious, of African art. And the objects called fetishes furnish a good example of this. They put us in the presence of the religion of the Other, of a religion that is Other, imposing upon us a very strong impression of strangeness, if not savagery. We propose to show that this notion of the fetish involves a way of conceiving of artistic production that intimately associates the very human ability we call art or technique with religious factors—other than human.

Two uses of the word fetish should be distinguished. It is, first of all, a neologism, based on the Portuguese *feitiçao*, a translation of the Latin *facticius*, "made" (that is, implicitly, by human hands), which in turn translates the Greek *cheiropoïètos*. [Trans. note: in English, "handmade"] Why this neologism and why did it gain currency? The original meaning having been abandoned, "fetish" is used today in the sense of "magical object." The first usage characterized the object by its producer, the hand, and, through metonymy, humans; the second, by its function, its use in operations of magic. Only the first usage will engage us, for it exemplifies our two themes perfectly: to detect an initial anticipation and its ethnocentrism, then, as an alternative solution, to replace a dichotomy by a series of the same type as those of Willett and Roskill.

For, despite its form, "fetish" is used in a negative sense, in a polemical context. The fetish is opposed to the acheiropoietic image, that is, *not* made by hand (by humans). The last word has been transcribed from the Greek. (Mark, 14.58; Paul, II Corinthians, 5.1) In Christian iconography, images not produced by a person but by miraculous intervention are termed thus; the best known one is the veil of Veronica, but there is a "considerable" (C. Von Schönborn, p. 206) number of them. The Christian who travels in Africa and encounters images held to be acheiropoietic, but which are different from those he or she was expecting, transforms this

difference into a negation and declares them not acheiropoietic, not "not-made" by human hands. While, in logic, a double negative and an affirmative are equivalent, this is no longer so from a polemic point of view. This is what causes the difference between "cheiropoiètos," that is to say, "made by hand," and "fetish."

In the polemics against "pagan" images, "fetish" is constantly associated with "idol" and "idolatry" (for example in the *Description of the Kingdom of the Congo* by Filippo Pigafetto and Duarte Lopez, cited by C. Fournet, 1972, p. 29). When it concerns the Other, the pagan, the acheiropoietic image is a fetish; it is not an image or an icon, but an idol, and the worship devoted to it is idolatry, a false worship. In a functionalist conception of art, these three oppositions, hardened into negations, form a system. The sacred object is successively considered in relation to its producer, human or not, to its model, and to its user. While, in its essence, the image is different from its model (since Plato's *Cratylus*), the idol is erroneously identified with its (sacred) model, in such a way that the worship, the idolatry, is an adoration erroneously directed toward images, instead of being reserved exclusively to the one God. A triple error, by mistake, regarding the producer, the nature, and the use of the image. Similarly, for Karl Marx (*Das Kapital*, book I), in the fetishism of merchandise, human relationships, between people, are mistakenly taken for nonhuman relationships, between things.

Despite its coherence, this piece of Christian iconography is, in its application to African objects, demonstrably ethnocentric. It is the Christian, acheiropoietic images that serve as the standard of truth, just as it is my religion that is true and the others are false—they are not religions but superstitions. The remedy for this ethnocentrism is methodological: putting the question of truth between parentheses and replacing it with research into signification and an investigation into function. The methodological distinction between truth and signification was established by Spinoza, in the beginning of modern historiography, in a passage of the *Tractatus Theologico-Politicus*, whose importance Tzvetan Todorov (1982) has stressed. In social anthropology, the distinction between truth and function has been formulated by E. E. Evans-Pritchard (1965, p. 60), who takes it back to Montesquieu. These methodological rules are not applicable only to images, but to ritual words, myths, legends, and proverbs gathered on-site and indispensable to the iconographic interpretation of African sculptures.

The ethnocentrism inherent in the polemical use of the concept of the fetish presents another aspect, the spotlighting of which allows the investigation to be given a new impetus. Christian iconography does not treat its own images and the pagan ones evenhandedly; the false does not merit as much consideration as the true. With pagans, simple dichotomies suffice; but when it is a question of Christian images, distinctions and subdivisions are elaborated. For example, in Byzantium, for the iconoclasts, if the sign of the Cross is given directly by God to humans, the Eucharist is at one and the same time given by Christ and consecrated by the clergy, and the Church is consecrated by the bishop (P. Brown, *The Cult of the Saints*); a rite of consecration raises the bread of the Eucharist from the rank of an object of *cheiropoiètos* to that of an object of *acheiropoiètos*. (Nicephorus, cited by P. Brown, 1982) Thus, a tripartition is substituted for the dichotomy human-produced or not: produced solely by God, produced by humans and consecrated, produced by humans. Joined to the idea of artistic production is the idea of consecration. The ritually effective object is attributable to one or two producers, who may be a sacred nonhuman being, a being solely human, the image-maker, or an intermediary, an expert in the sacred. It is fitting to remember here the

two aspects of the Platonic philosophy of art: artistic production is interpreted either as *technè*, art, or as an intervention of the god in humankind (*Ion*), or of this *daimôn*, the intermediary between the gods and people, such as Amor, Eros (*Banquet*), who engenders a creative delirium (*mania*). As so often, Aristotle secularizes Platonism, but the two traditions, Platonic and Aristotelian, have lasted throughout the Western philosophy of art.

Analogous subdivisions are applied to the use of sacred images; for example, between worship and worship of the saints, hyperdulia, worship of Mary, is inserted. (F. Pacheco, 1956) One may then attempt what the Christian commentators were careful not to do—to look for analogous subdivisions in the ethnographic information that relate to the manner in which Africans themselves represent the origins of their sacred images to themselves. Here we have to make do with suggestions; but the theme would merit being studied in its own right.

The point is not artistic creation, but the manner—once again, true or false, it matters little—in which Africans conceive of it. In a functional operation, the object is not attributable to the artist alone. Between the actual production and its use, there very often occurs a ritual act of consecration, necessary for the magical or religious ritual effectiveness of the object. This is particularly true for "fetishes," magical objects. Africans make a very clear distinction between objects that are human-made and those that are not, but they phrase it differently: for example, that which comes from the bush and that which comes from the village; the opposition bush/village has several values: nature/culture, non- or suprahuman/human. Furthermore, the attribution to a nonhuman agent takes very different forms. An African mask may be seen by the people of the village as having been given to them by a mythical being, a divinity, a primordial ancestor, or a civilizing hero; but it may also be seen as the prototype of which present masks are replicas or replicas of replicas. The collaboration of the sculptor and a suprahuman being may take other forms; the mask may have been revealed to the sculptor in a dream: then the dream image is the prototype, not-made by human hand, of the objects the hand of the sculptor will later carve.

These few examples oblige us to take into account not only the intervention of the sculptor and the agent of ritual consecration, in isolation or jointly, but also other forms of collaboration between human and nonhuman agents, a collaboration that itself is accomplished in various ways. Consequently, in classifying sacred objects, one can no longer content oneself with two dichotomic predicates, human-made or not; one must retain a series of other predicates, not one of which is applicable to all the products under consideration. In short, in order to interpret the way in which Africans represent the origin of their sacred objects to themselves, one must make do with the FRP and pose as a hypothesis that these various African conceptions form one family.

The concept of the fetish has engendered that of fetishism, which in the framework of an evolutionist conception, such as that of Auguste Comte, would characterize one stage in the evolution of humanity. One will understand that this concept has suffered the same lot as that of the "primitive" and that, with the first meaning of the word fetish having been abandoned, one speaks today of "fetishes without fetishism." (J. Pouillon, 1975)

12–13 Amratic Nagada
These two pieces are the earliest African
sculptures extant produced by settled hunter-
gatherer societies. Shale and breccia. 5th and 4th
millennia B.C. *Height: 50 cm and 31.4 cm.*
Musée Guimet, Lyon

14 Couple, Interior Niger Delta, Mali
Terra-cotta. 11th–14th century. Height: 24 cm.
Length: 38 cm. Private collection

15 Horseman, Interior Niger Delta, Mali
Terra-cotta. 14th–early 16th century. Height:
44 cm. Width: 16.5 cm. Depth: 29 cm. Private
collection

16 Kneeling Dignitary, Interior Niger
Delta, Mali
Terra-cotta. 14th–15th century. Height: 48 cm.
Private collection, Belgium

17 Mask of a Funerary Effigy (?), Interior
Niger Delta, Mali
Terra-cotta. 12th–13th century. Height: 55 cm.
Private collection

18 Proto-Dogon Maternity Figure, Mali
Wood. 11th–12th century. Height: 69 cm.
Private collection

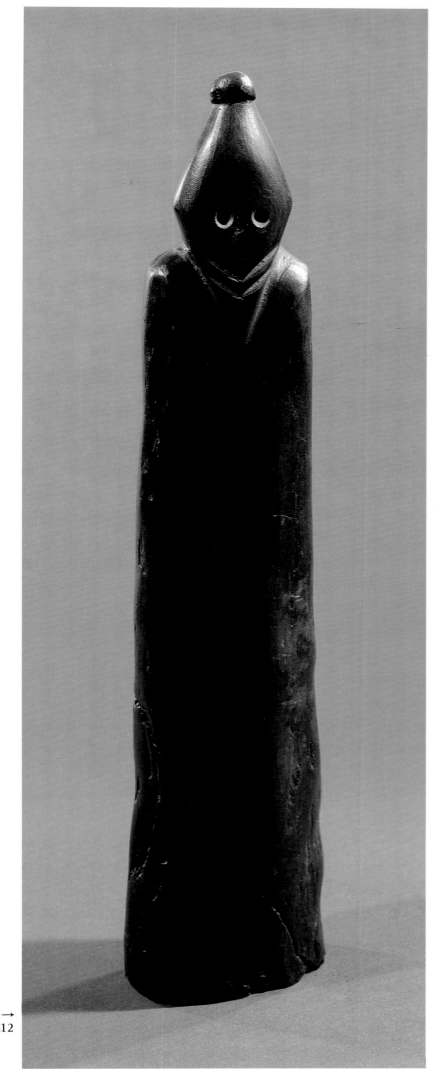

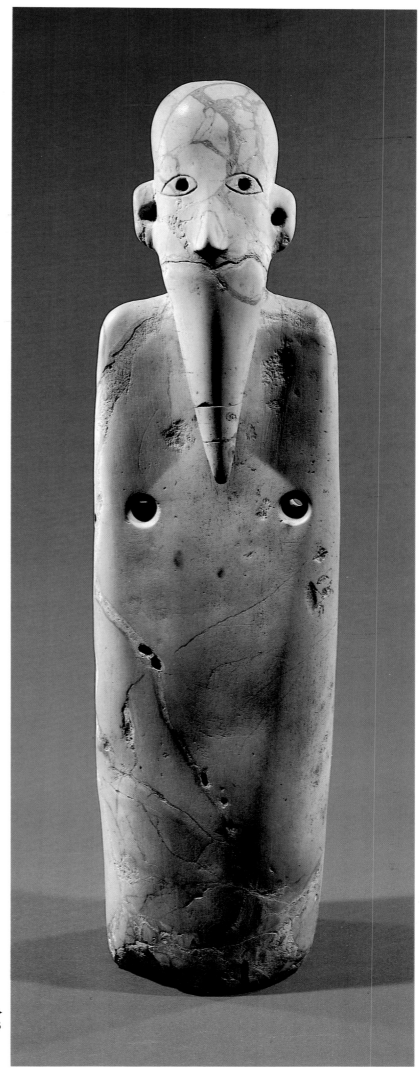

12

13

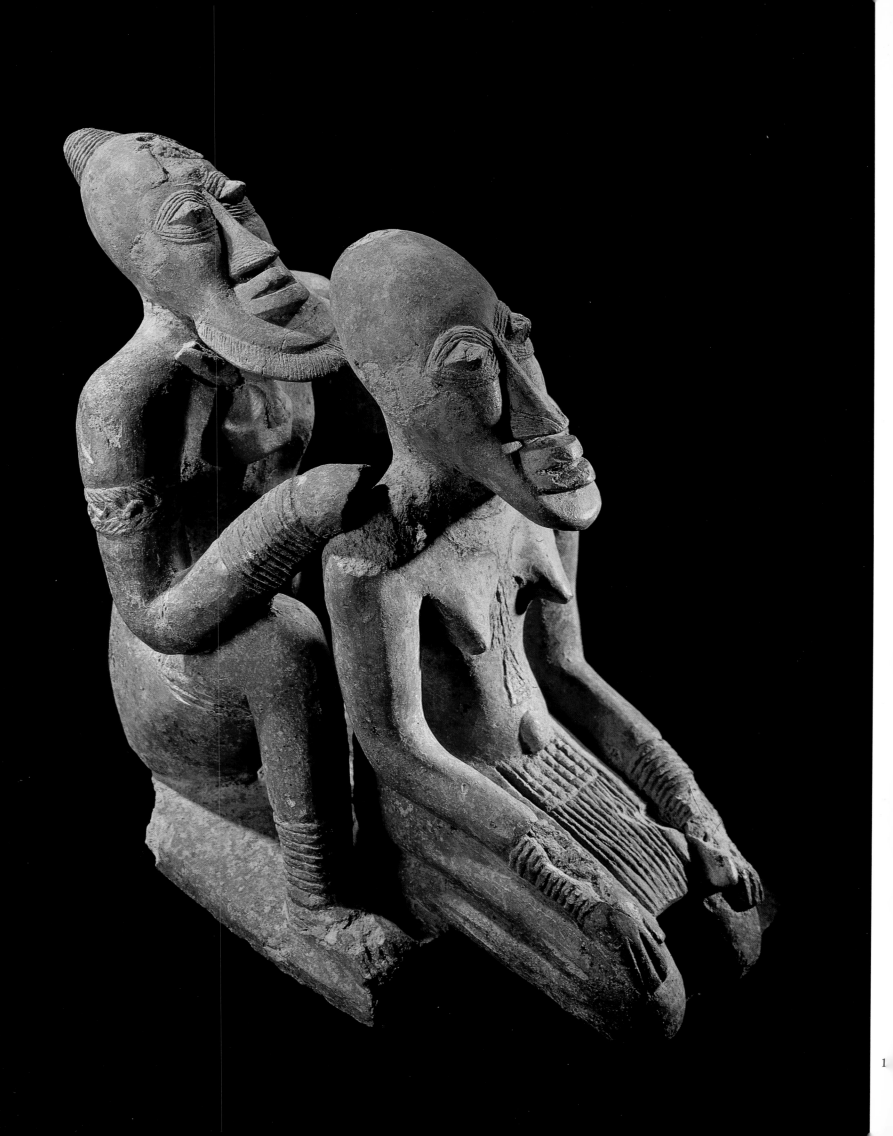

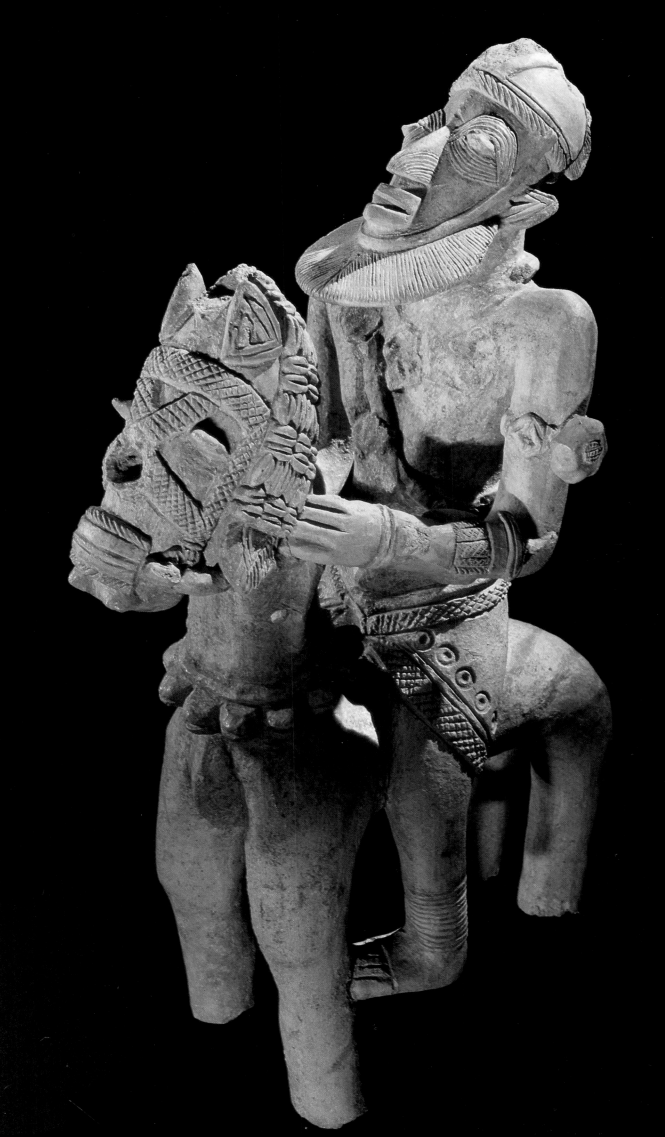

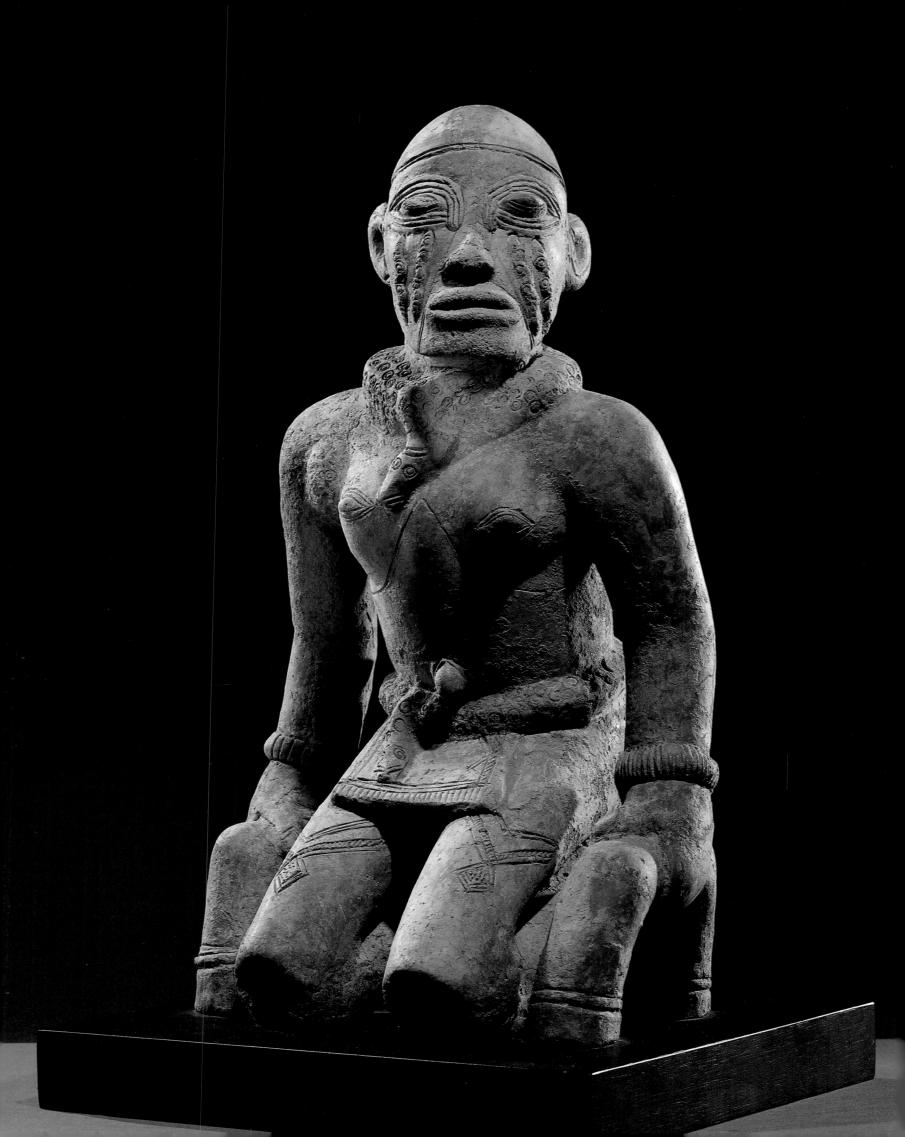

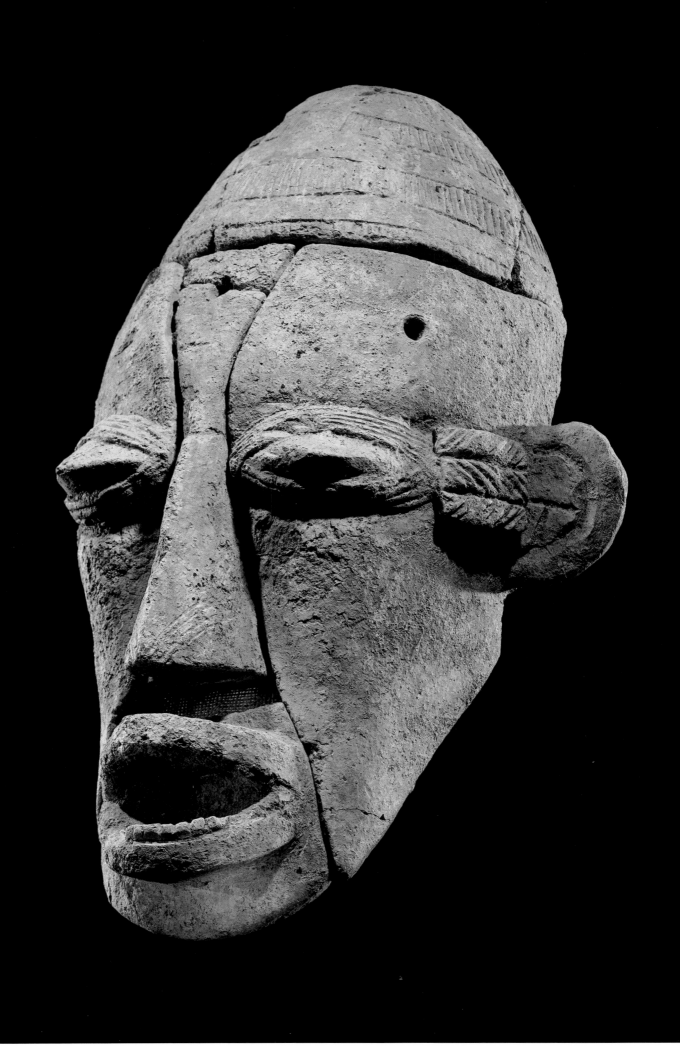

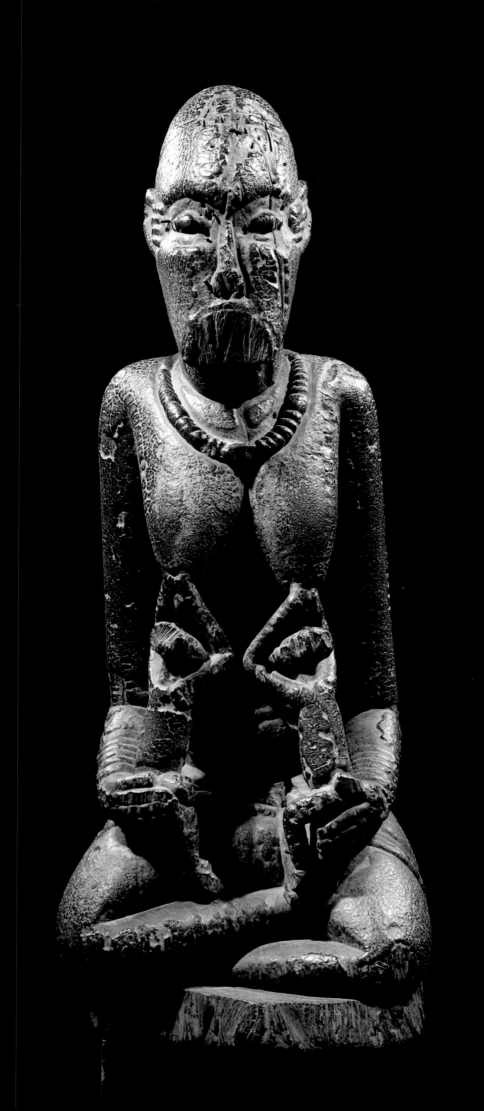

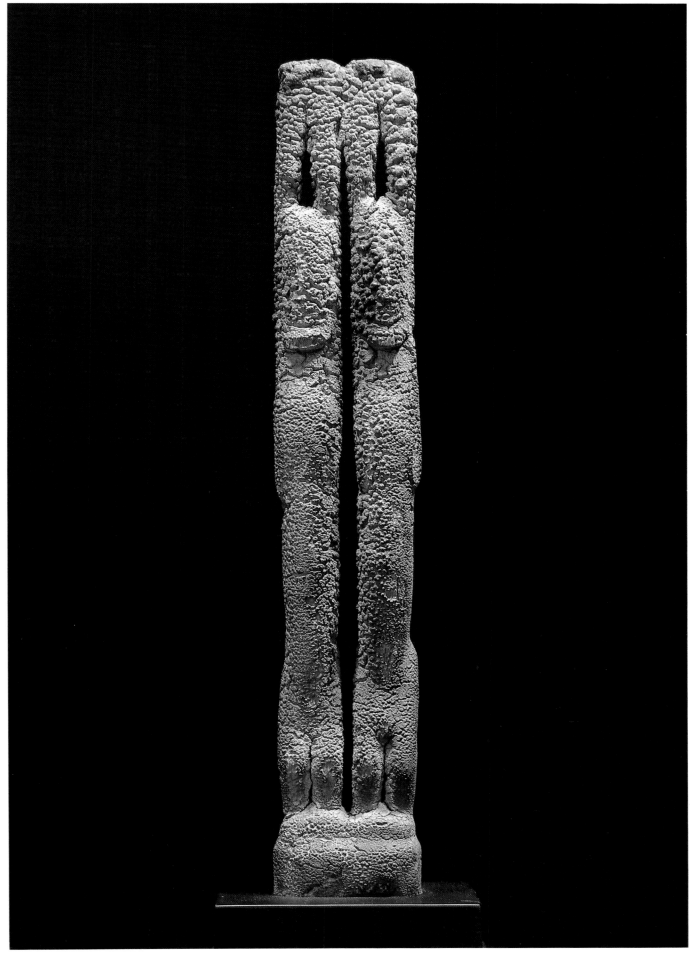

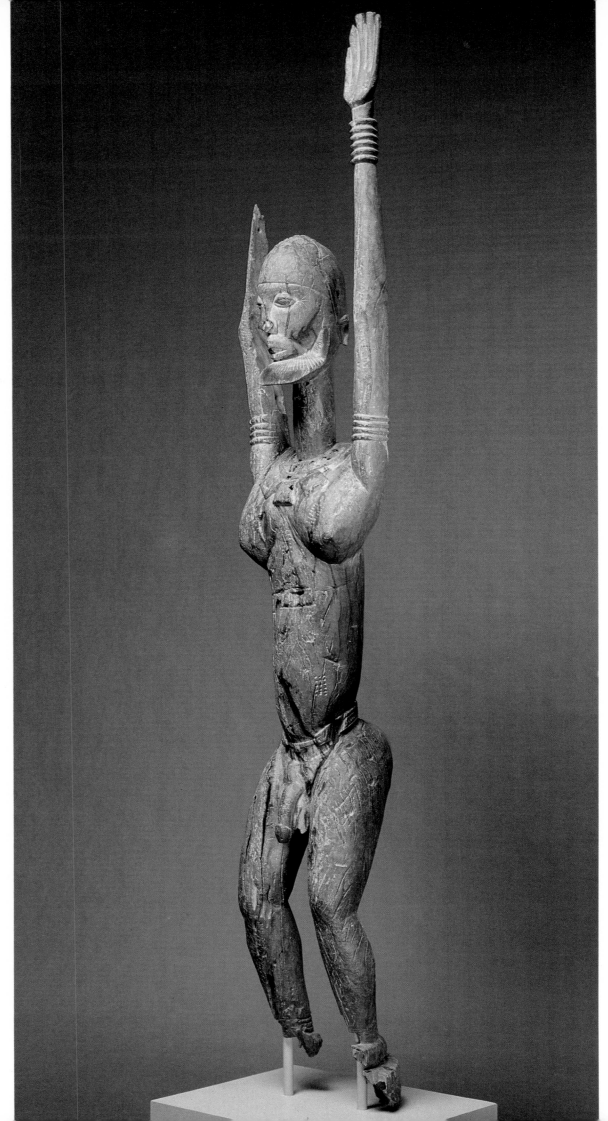

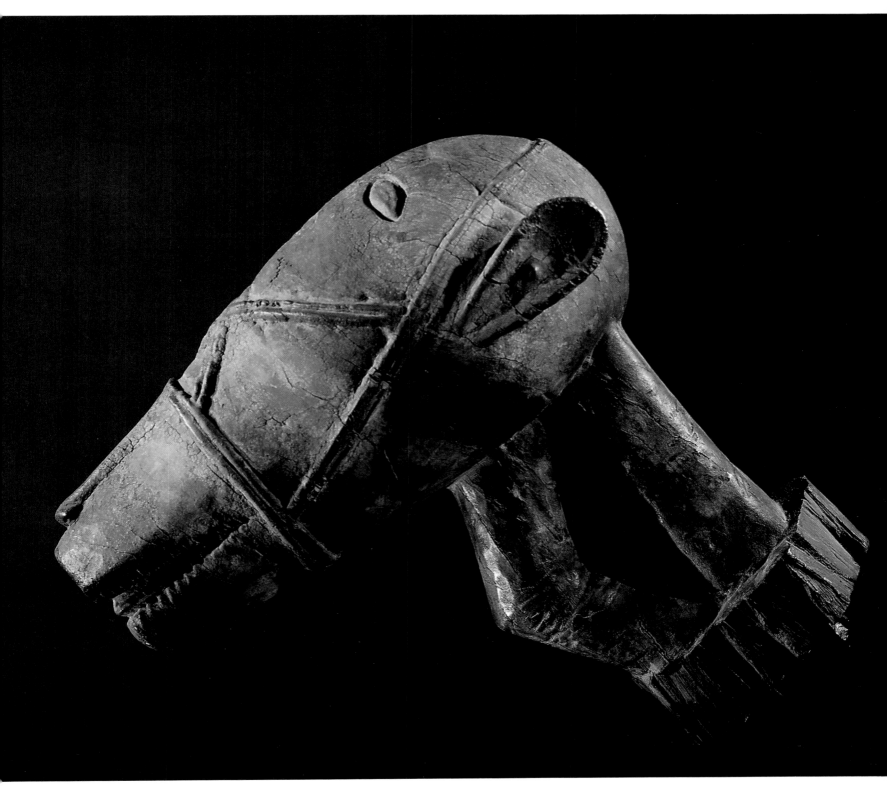

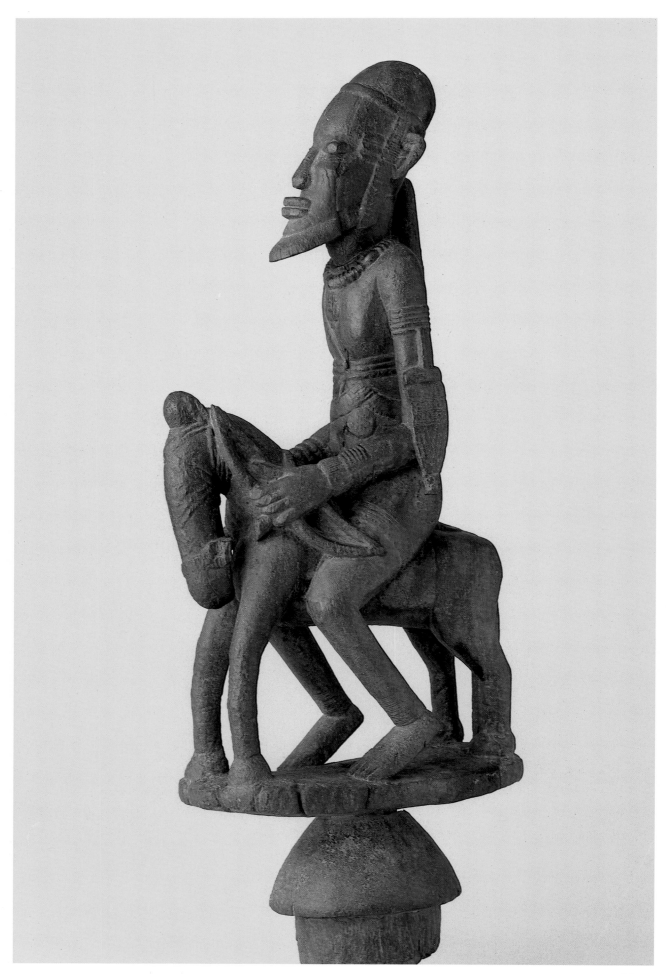

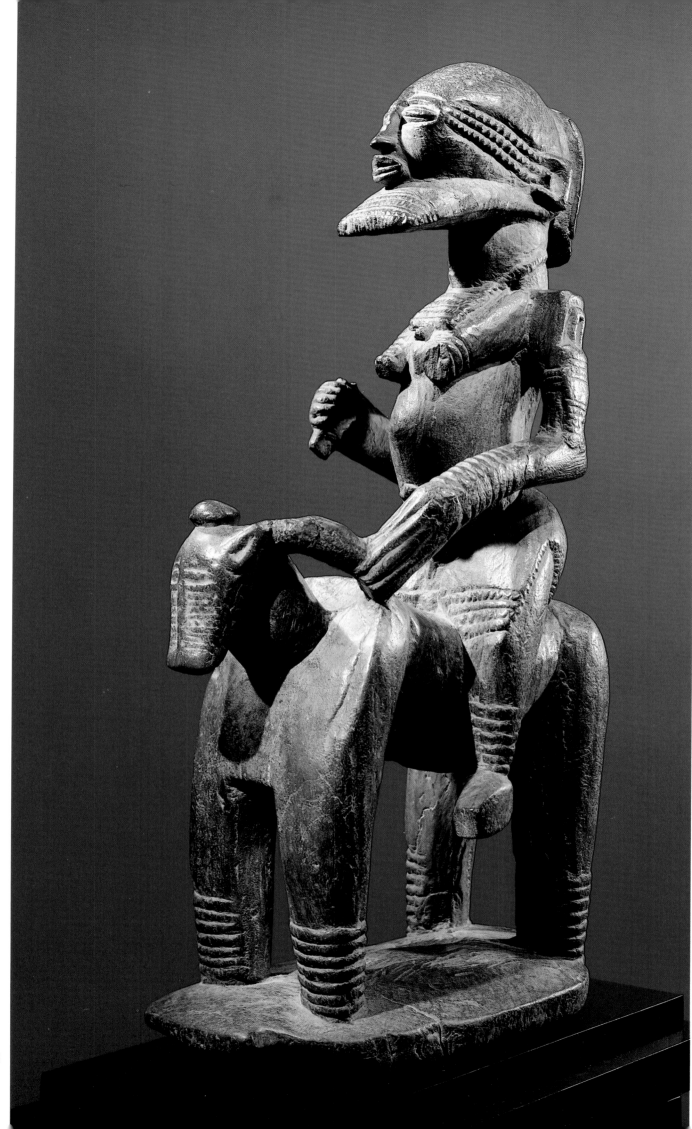

23

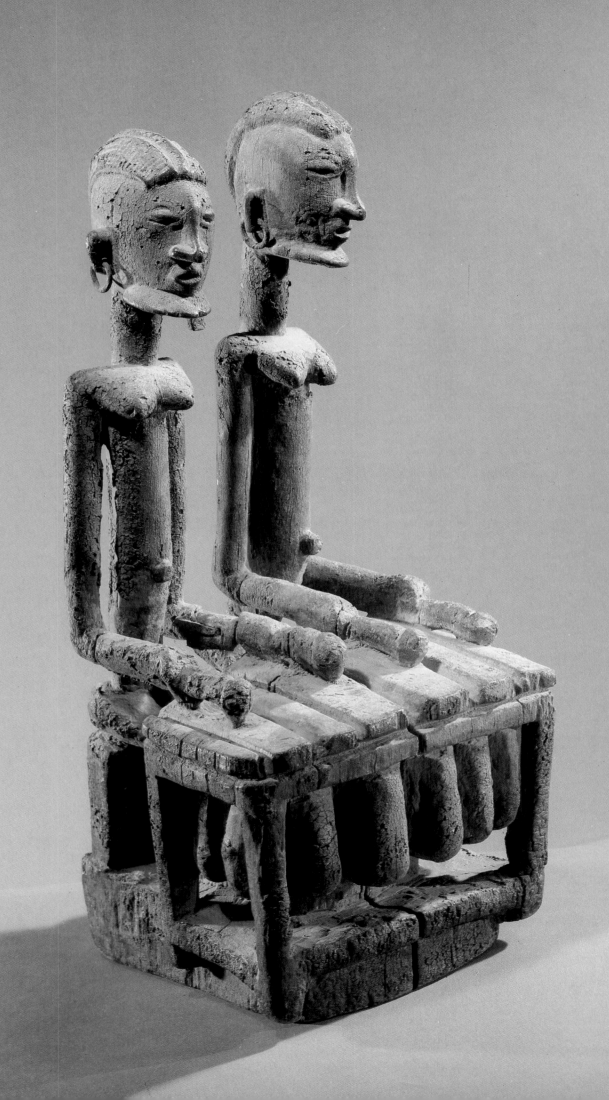

19 Tellem Couple, Bandiagara Cliffs, Mali
Wood, bat droppings, beeswax, sacrificial blood.
13th century. Height: 42 cm. Private collection

20 Tellem-Dogon Statue, Mali
Wood. 16th–17th century (?). Height: 210 cm.
The Metropolitan Museum of Art, New York

21 Head of a Horse, Front of a Ritual
Dogon Dish, Mali
Wood. 15th–17th century (?). Height: 50 cm.
Width: 45 cm. Private collection

22 Proto-Dogon Horseman, Mali
Wood. 10th–13th century. Height: 71.8 cm.
Minneapolis Institute of Art

23 Proto-Dogon Horseman, Mali
Wood. 11th–13th century (?). Height: 50 cm.
Private collection

24 Dogon Balafon Players, Mali
Wood. 15th–16th century. Height: 44 cm.
Private collection

25 Dogon Maternity Figure, Mali
Wood. Early 18th century. Height: 68 cm.
Private collection

26 Dogon Mask, Mali
Wood. 19th century. Height: 50.8 cm. Private
collection; formerly P. Loeb Collection

27 Dogon Primordial Couple, Mali
Wood. Height: 57.8 cm. Murray and Barbara
Frum Collection, Toronto

28 Person on the Shoulders of Another
(Aru on the Shoulders of Dyon?), Dogon,
Mali
Wood. 17th century (?). Height: 87 cm. Private
collection

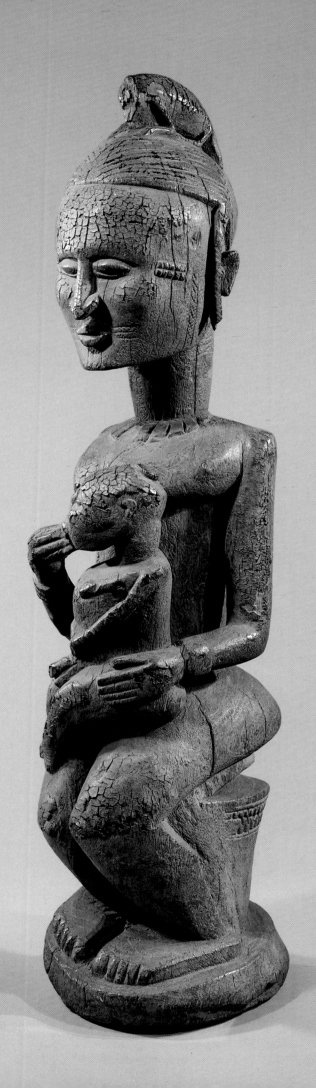

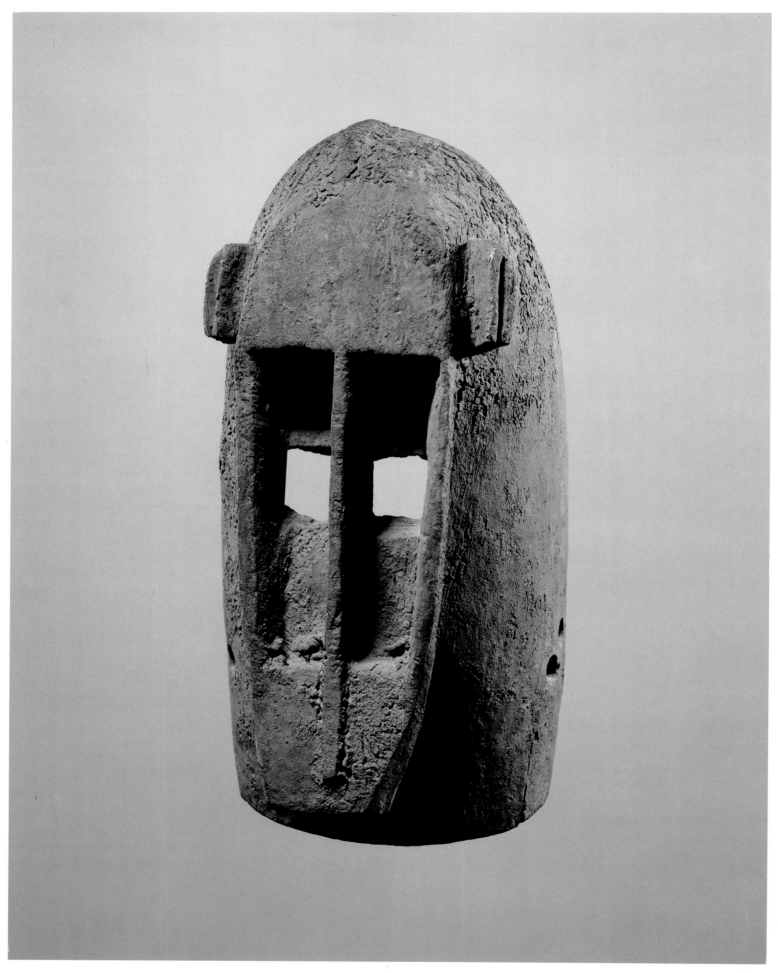

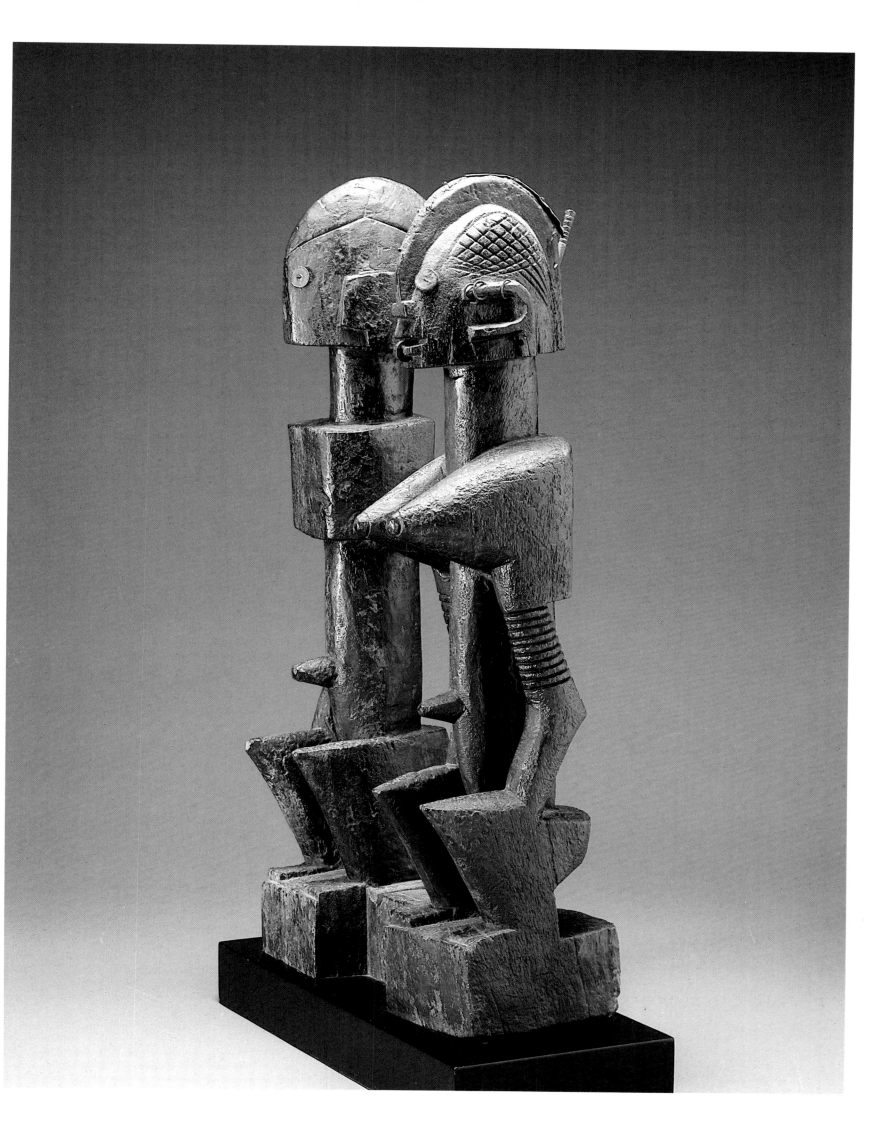

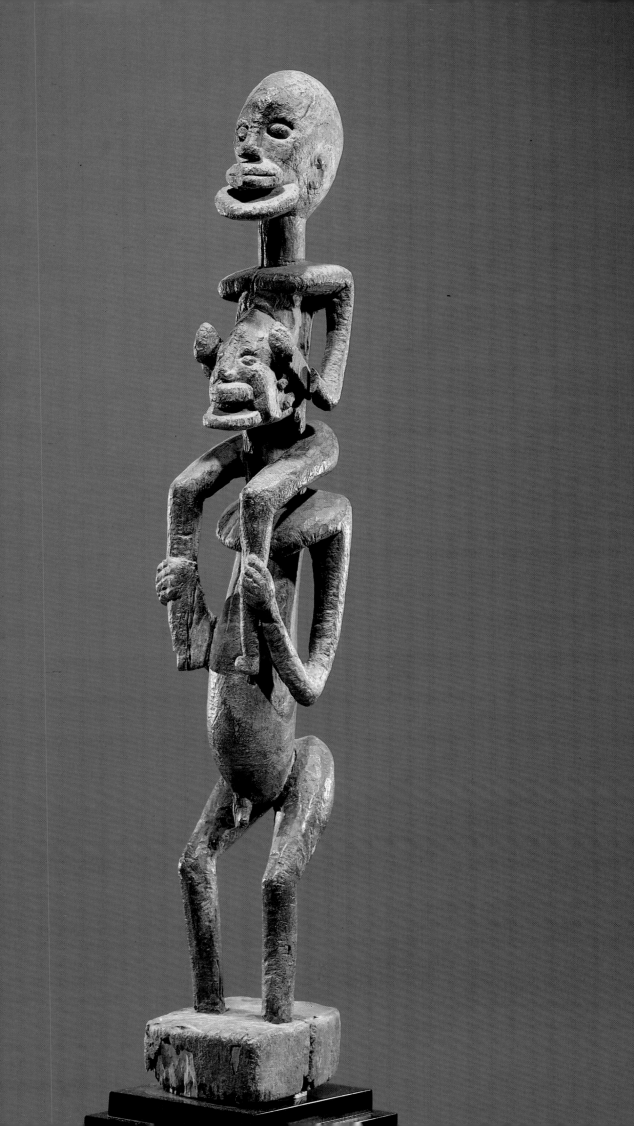

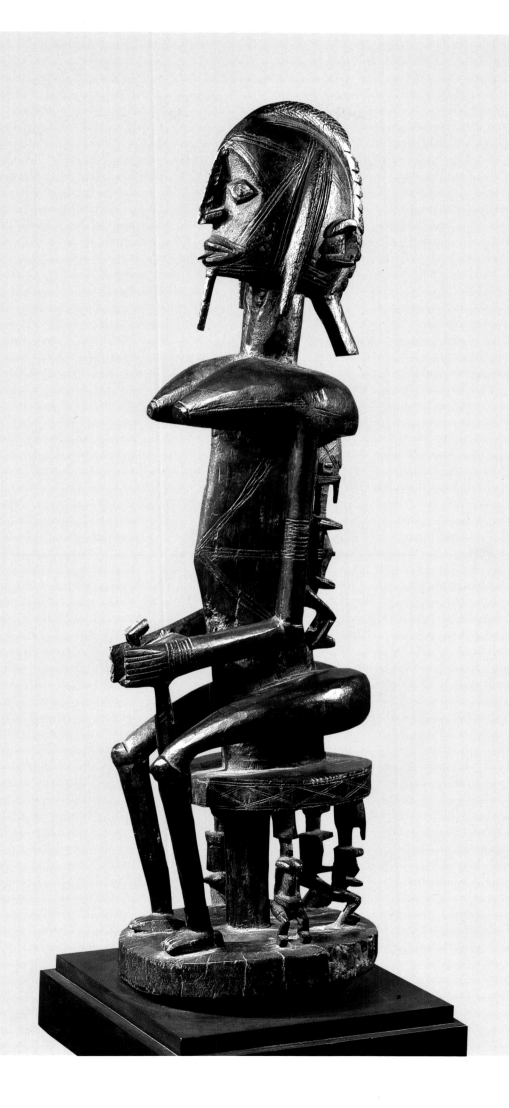

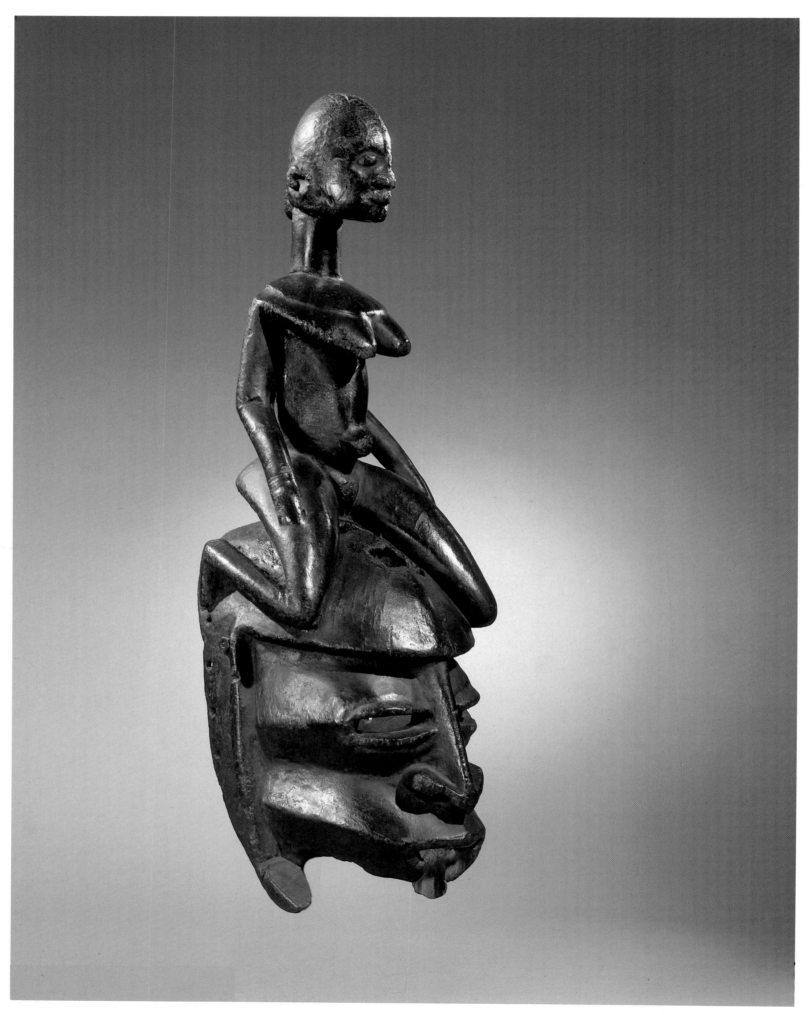

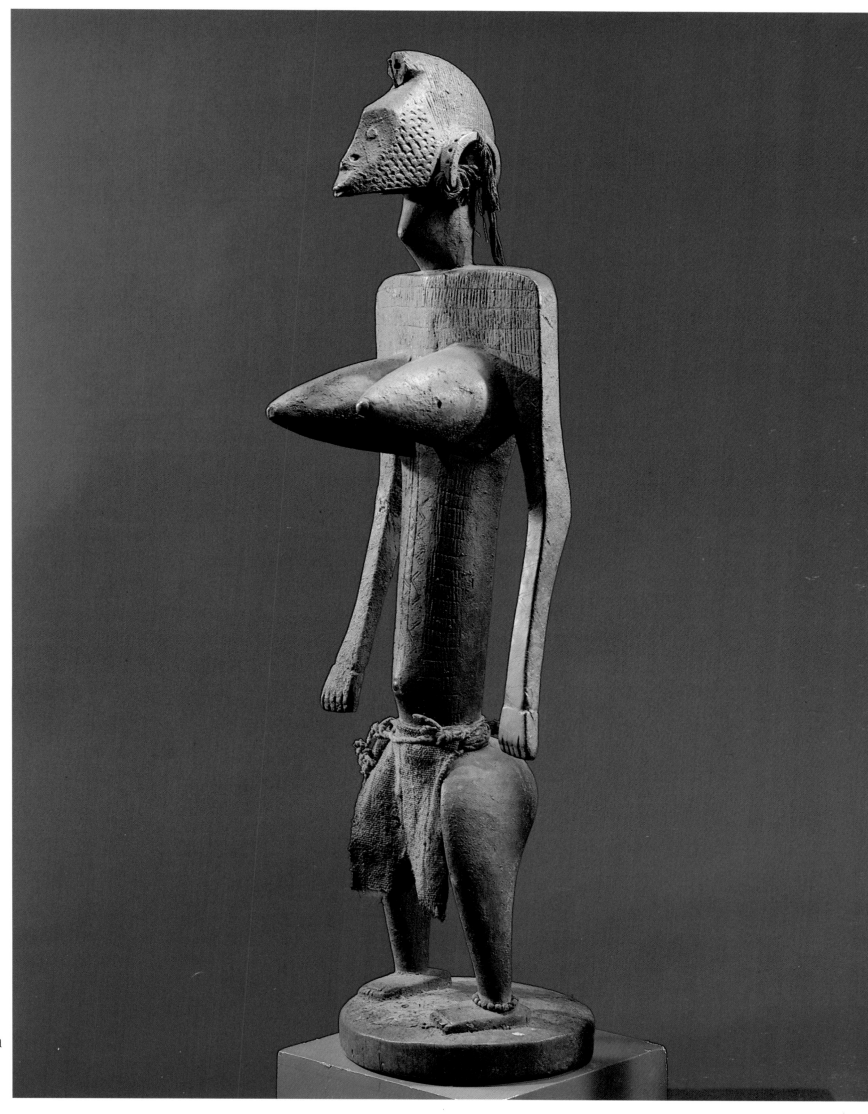

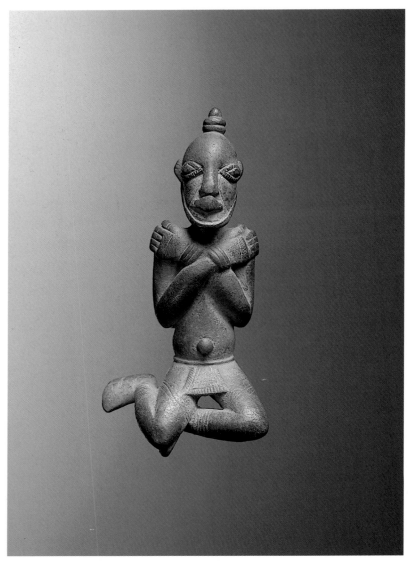

32

29 Dogon Statue, Mali
Wood. 18th century. Height: 77 cm. Private collection

30 Dogon Mask with Figure, Mali
Wood. 17th–18th century (?). Height: 58.4 cm. Private collection; formerly Rasmussen Collection

31 Bamana Statue, Mali
Wood. Height: 74 cm. Private collection

32 Proto-Dogon Pendant, Mali
Bronze and excavation patina. 12th–13th century. Height: 9.6 cm. Musée Barbier-Müller, Geneva

33 Ligbi Mask, Ivory Coast
Wood. Height: 47 cm. Private collection

34 *Deble* Statue, Senufo, Ivory Coast
Wood. 18th–19th century. Height: 47 cm.
Private collection

35 Ceremonial Scoop, Senufo, Ivory Coast
Wood. Height: 25 cm. Private collection

36 Gurunsi Statue (Nuna), Burkina Faso
Detail. Wood. 17th–18th century (?). Total
height: 115 cm. Private collection

37 Mossi Statue, Burkina Faso
Wood. Height: 47 cm. Private collection

38 Mossi Statue, Burkina Faso
Wood. Height: 73 cm. Private collection

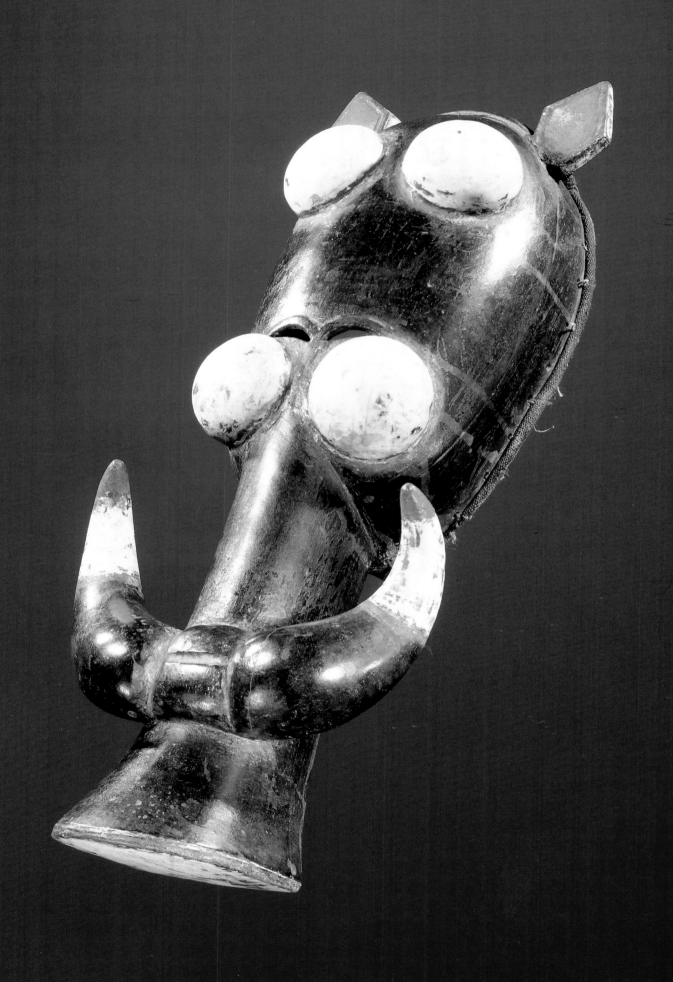

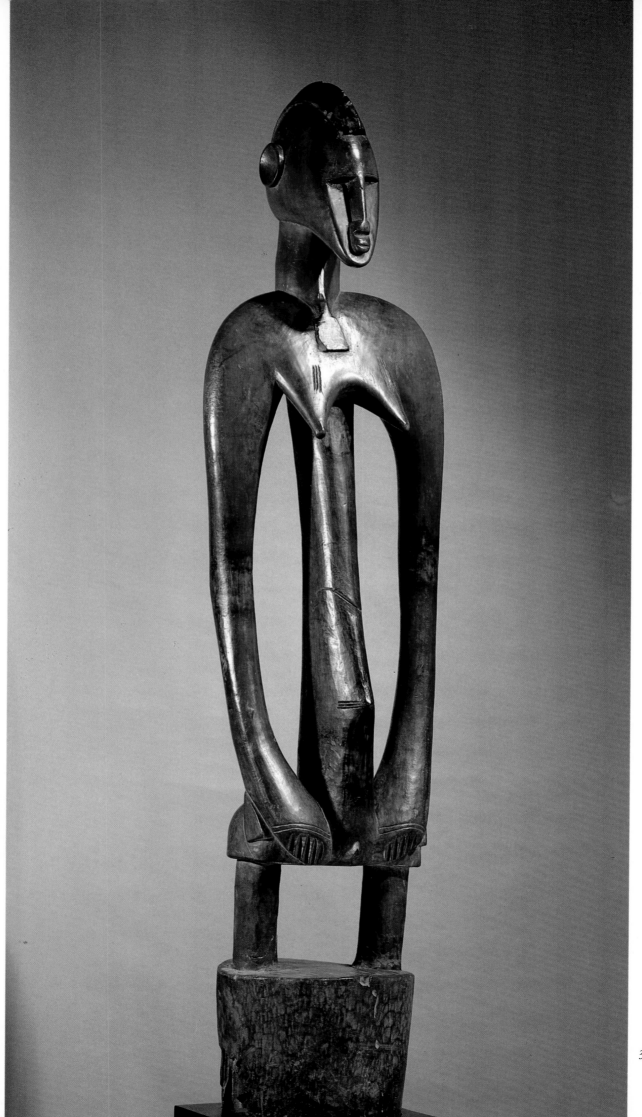

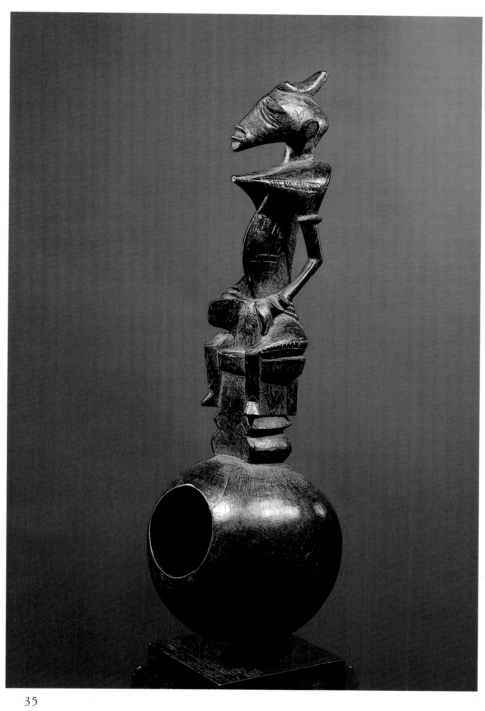

35

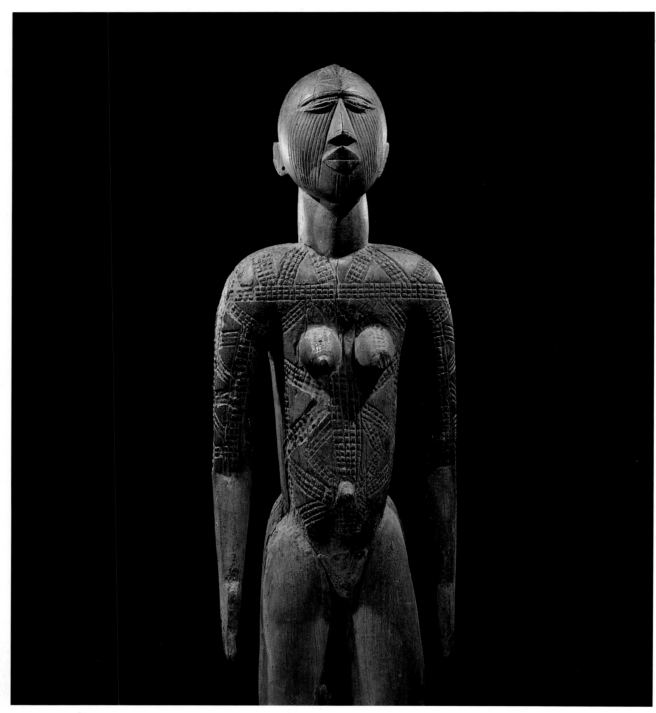

36

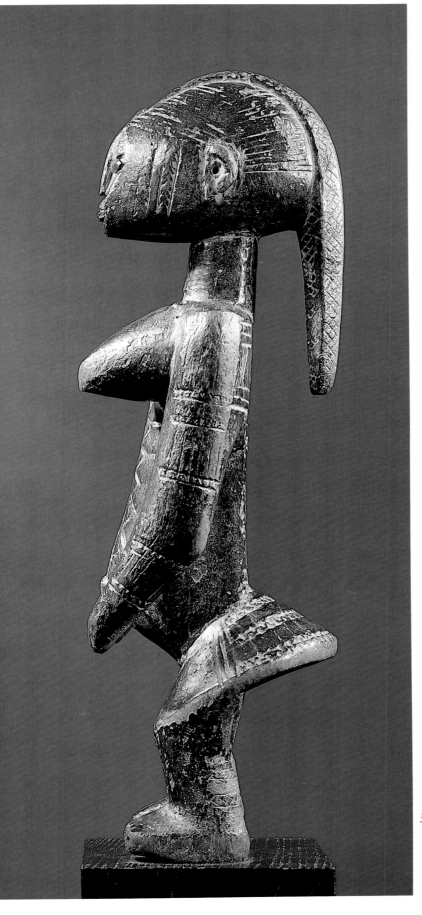

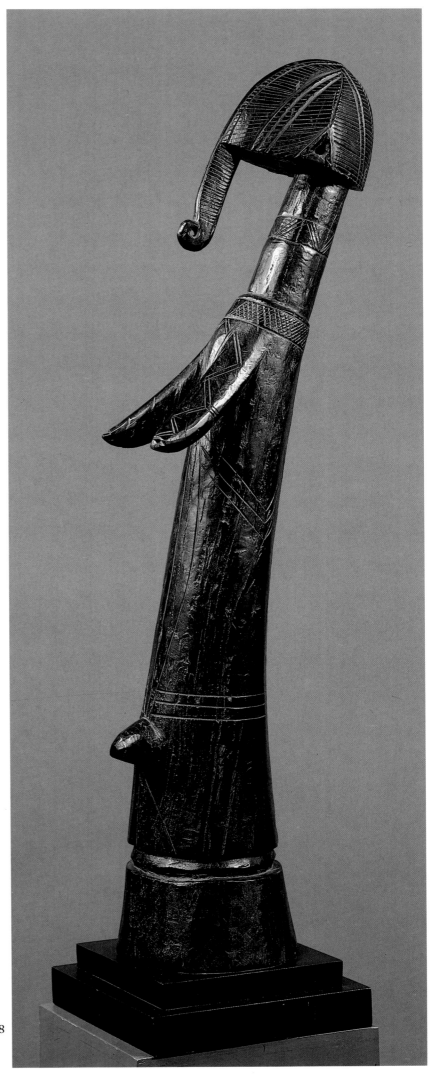

37

38

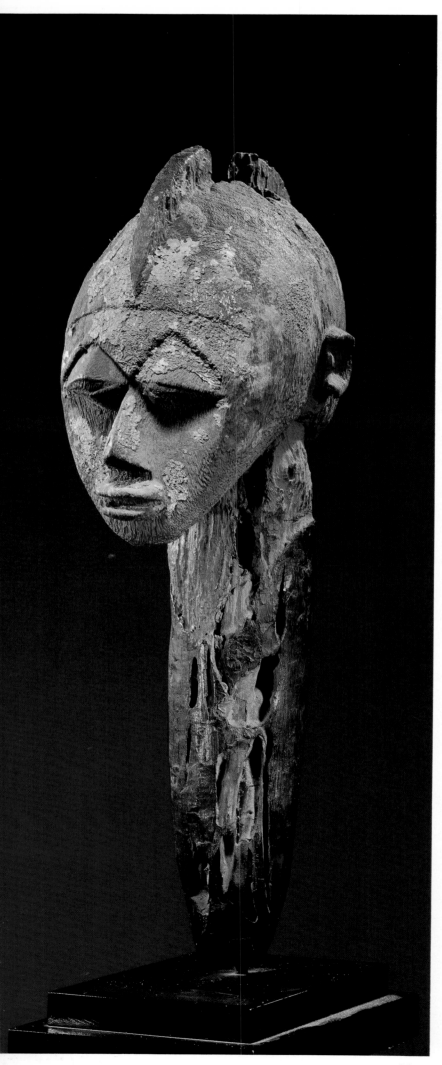

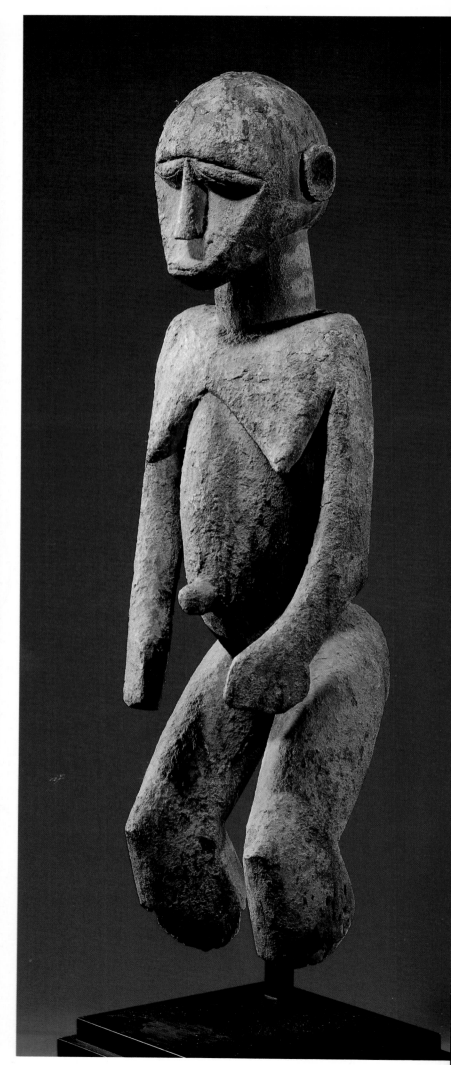

39

40

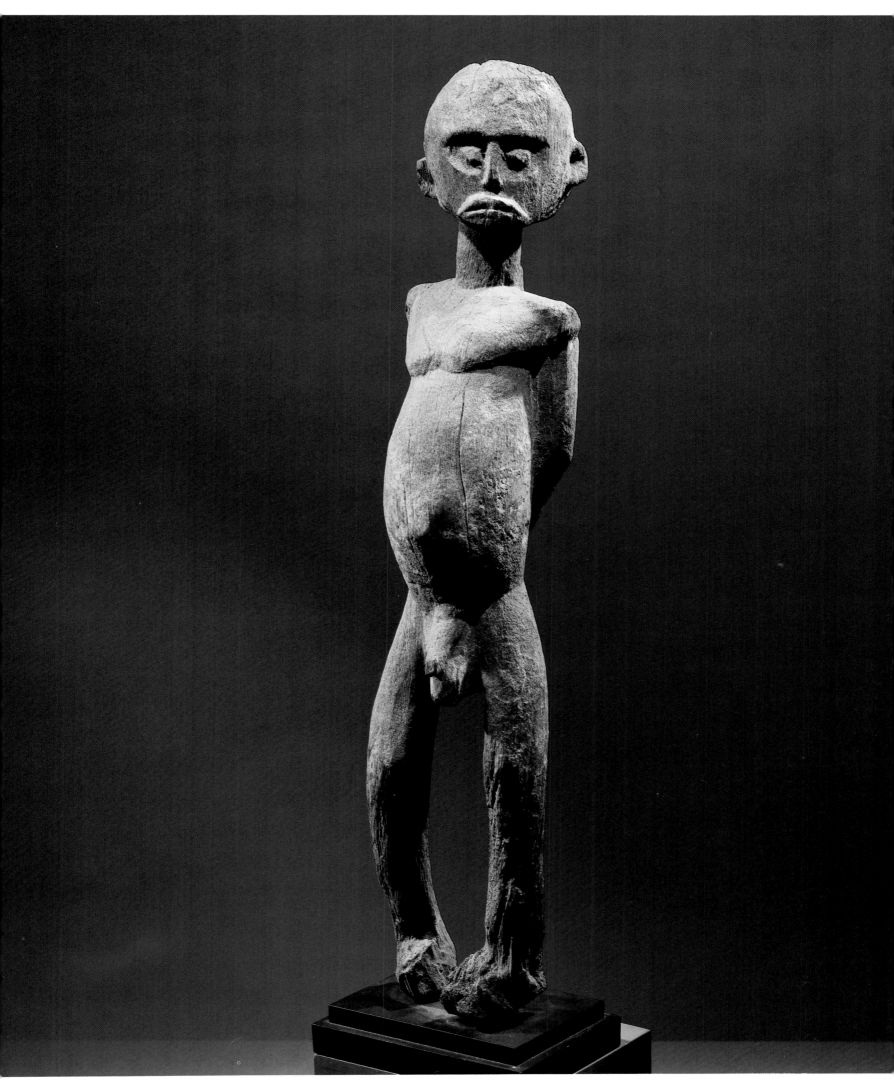

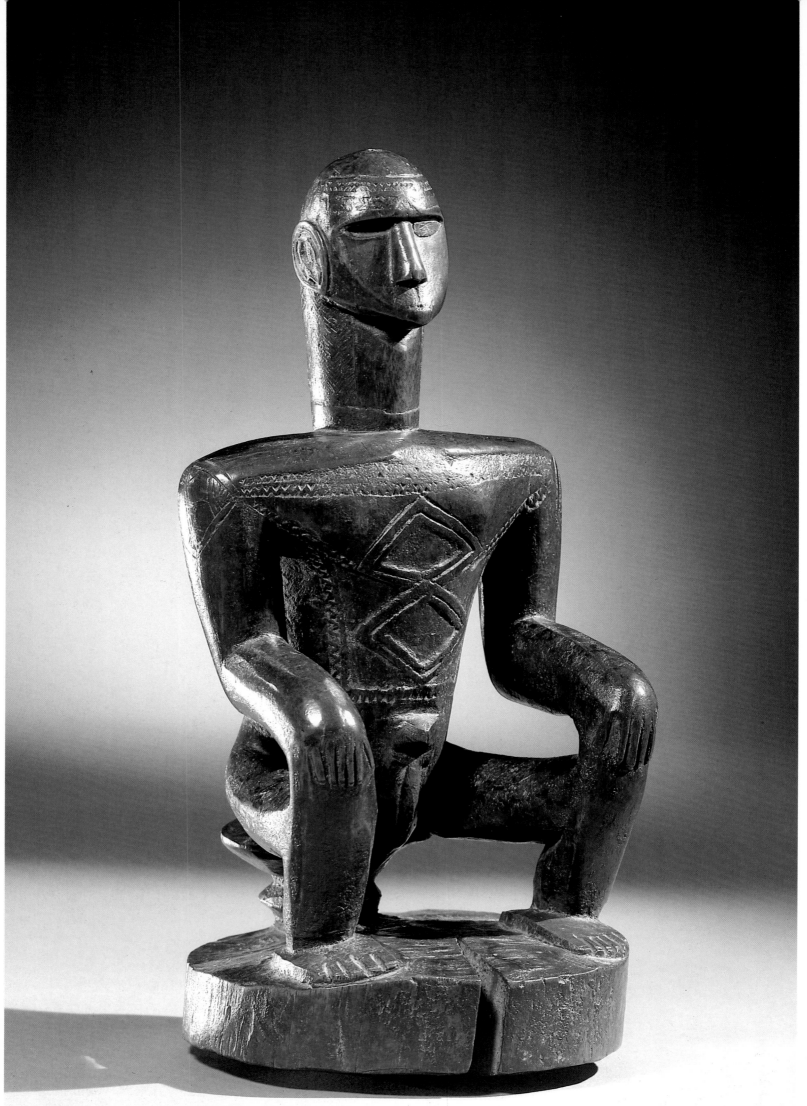

39 Lobi Head, Burkina Faso
*Wood. 19th century. Height: 40 cm. Private
collection*

40 Lobi Statue, Burkina Faso
*Wood. 19th century. Height: 59 cm. Private
collection*

41 Lobi Statue Representing a Captive,
Burkina Faso
*Wood. 19th century. Height: 78 cm. Private
collection*

42 Bissagos Statue, Bissagos, Guinea-Bissau
*Probably from Carache Island. Wood. 18th–early
19th century. Height: 37 cm. Private collection*

43 *Nomoli* Figure, Sierra Leone
Soapstone. Length: 36 cm. British Museum, London

44 Afro-Portuguese Cup, Sierra Leone
Ivory. Early 16th century. Height: 43 cm. Pigorini Museum, Rome

45 Mende Statue, Guinea
Wood. Height: 52 cm. Private collection

46 *Nimba* Shoulder-Mask, Baga, Guinea
Wood. 19th century. Height: 108 cm. Museum Rietberg, Zürich

47 *Nimba* Shoulder-Mask, Baga, Guinea
Wood, polychrome ornaments, brass, fibers. 19th century. Height: 140 cm. Musée d'Histoire Naturelle de Toulouse, France

48 *Bansonyi* Serpent, Nalu, Guinea
Wood. 18th century (?). Height: 210 cm. Private collection

49 *Bansonyi* Serpent, Nalu, Guinea
Wood. 19th century. Height: 250 cm. Lazard Collection, Paris

50 *Angbai* Mask, Toma, Guinea
Wood. Height: 54 cm. Private collection

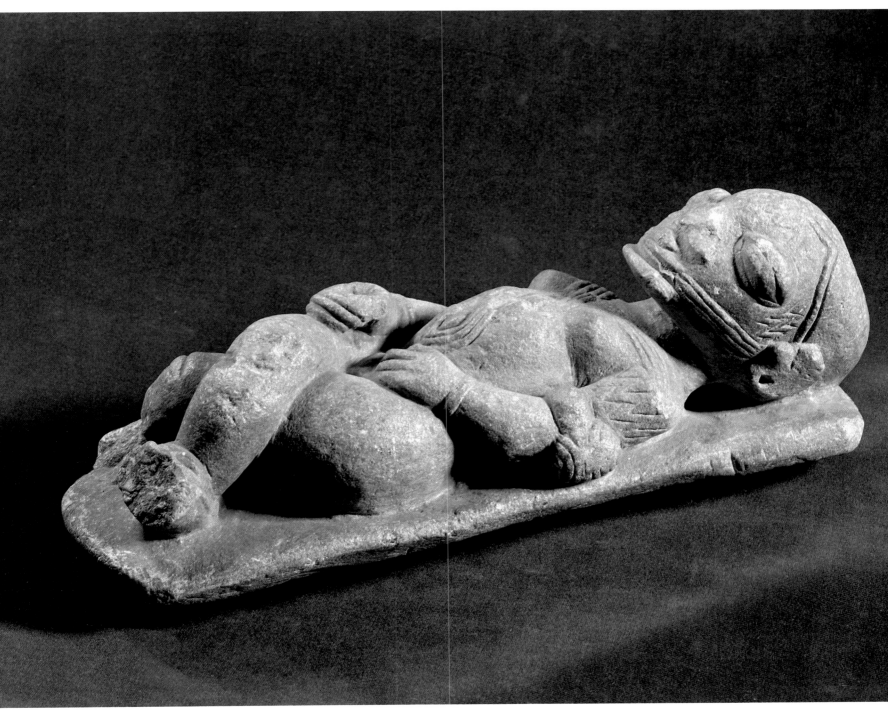

43

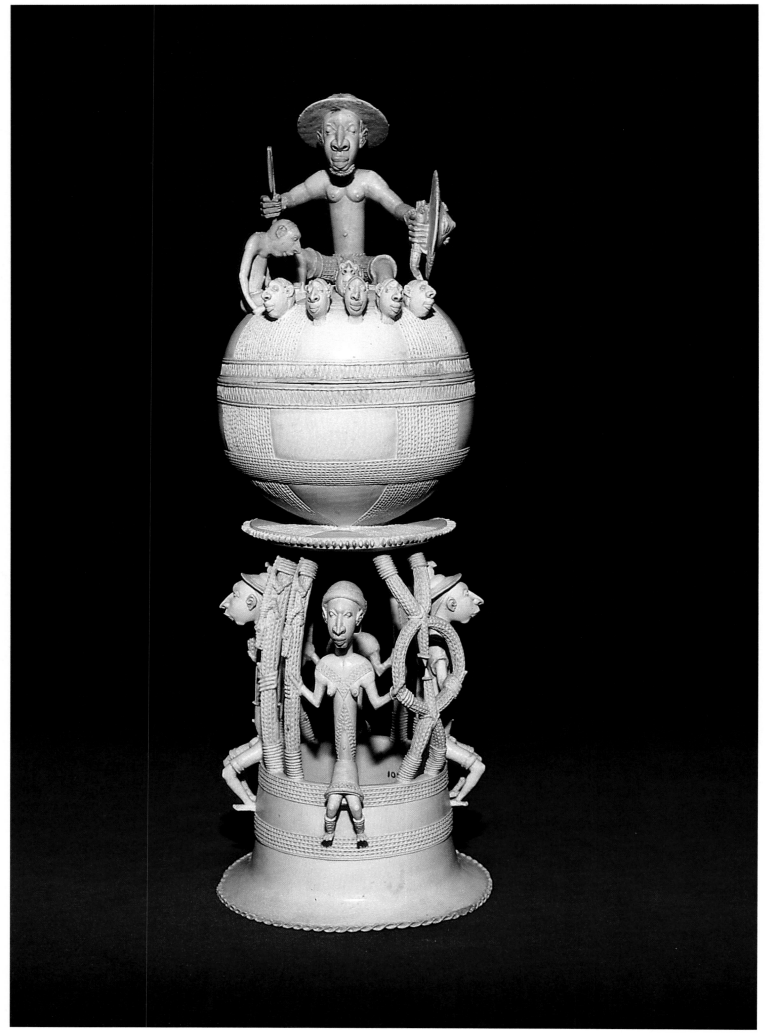

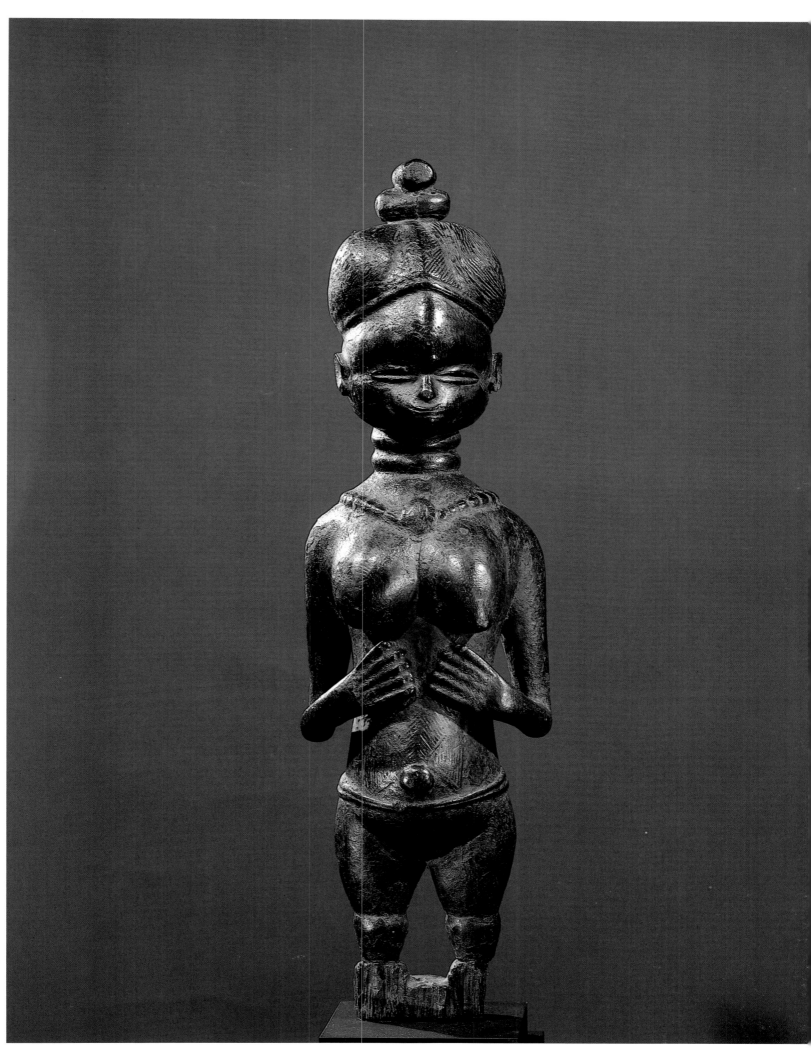

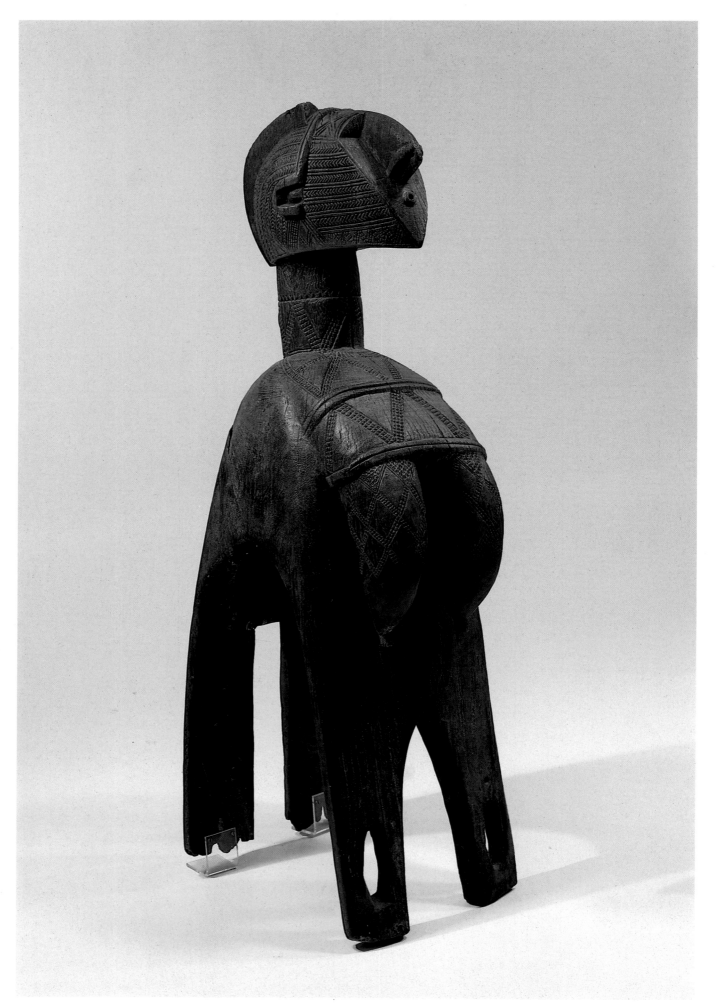

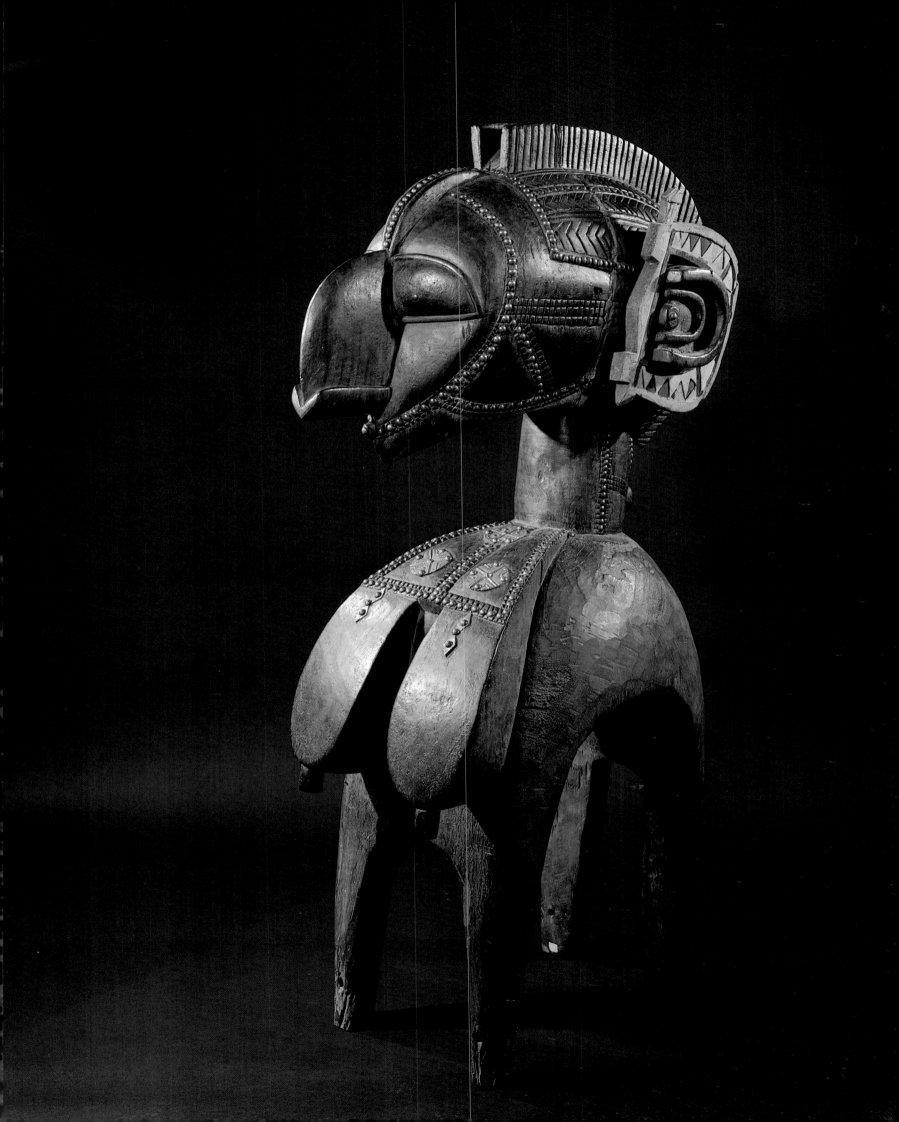

← 48
→ 49

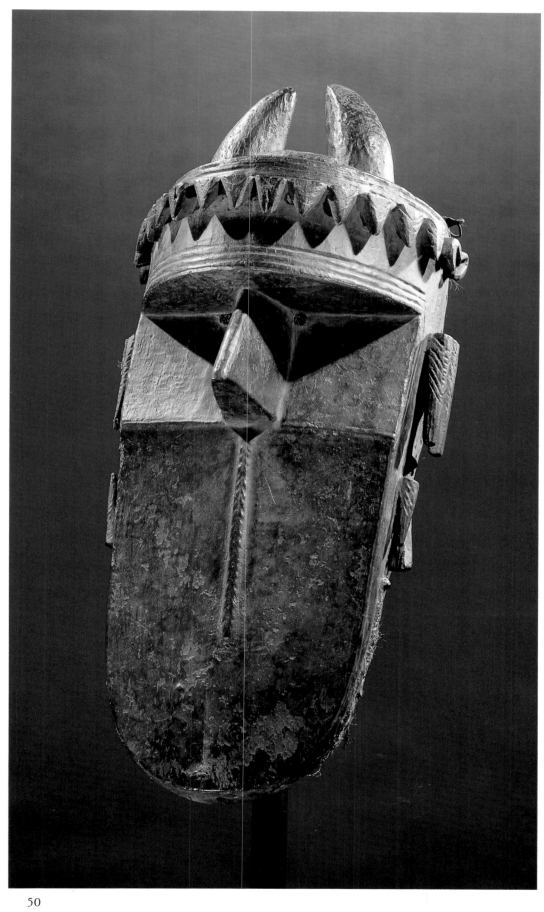

50

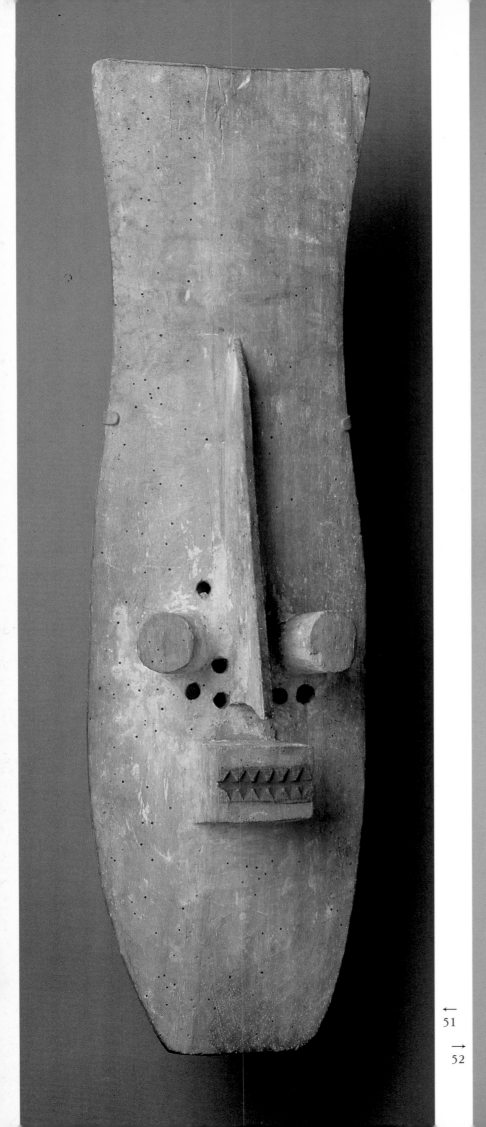

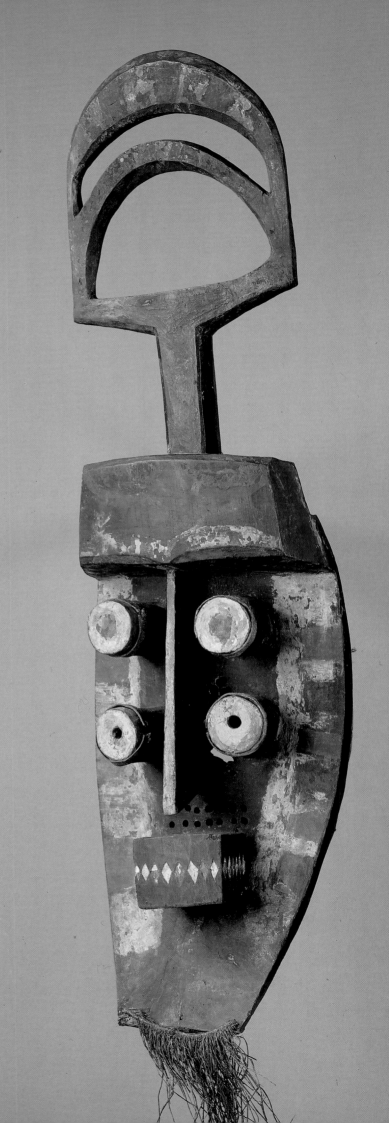

← 51

→ 52

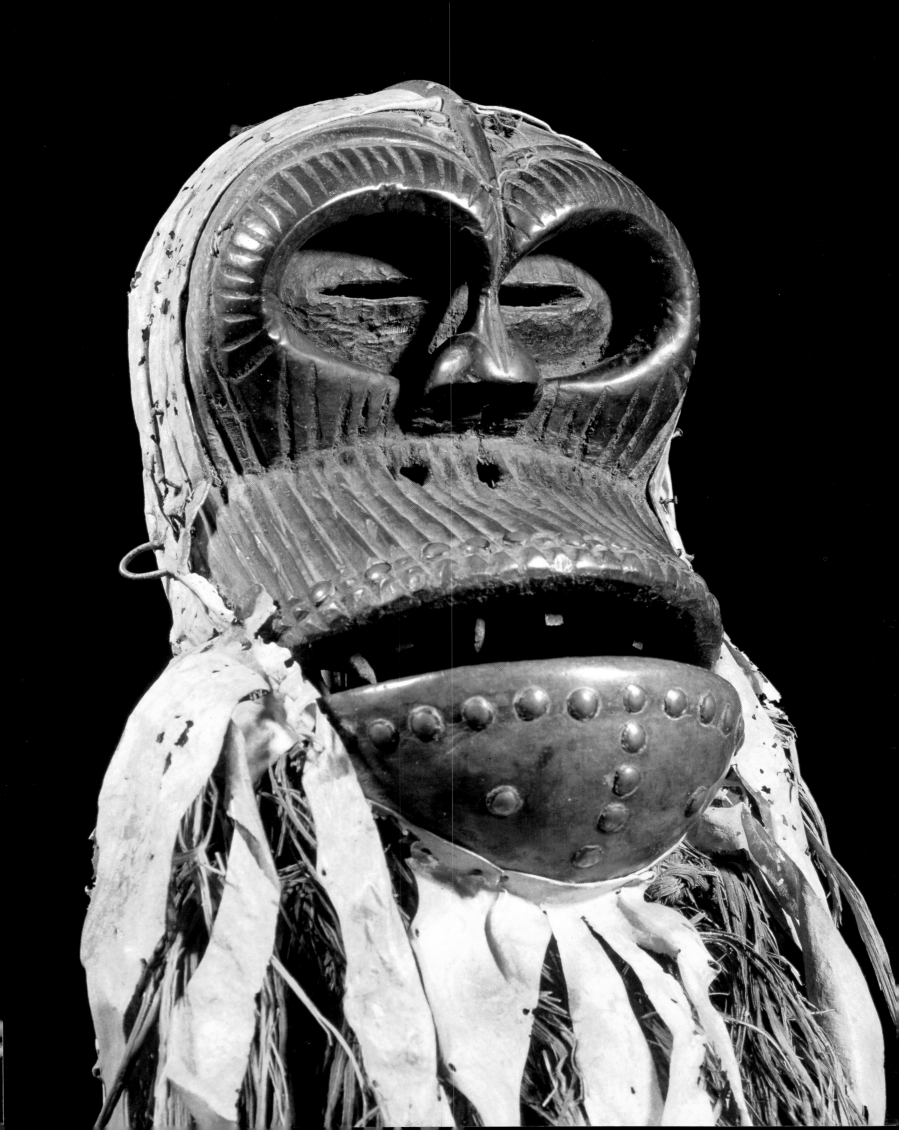

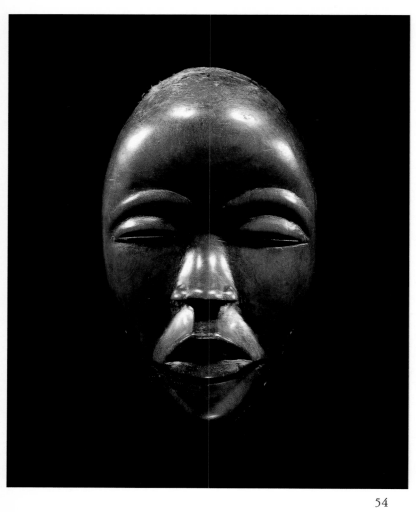

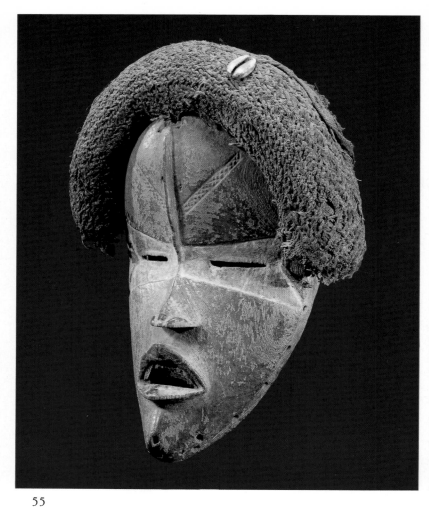

54

55

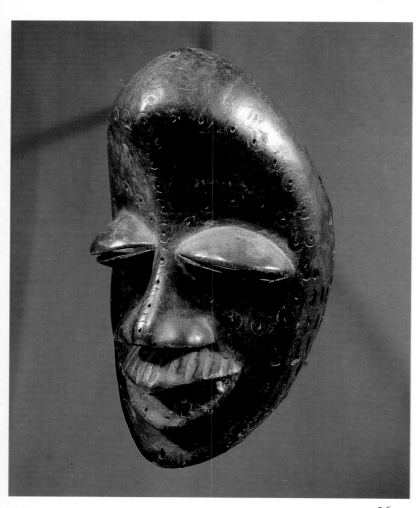

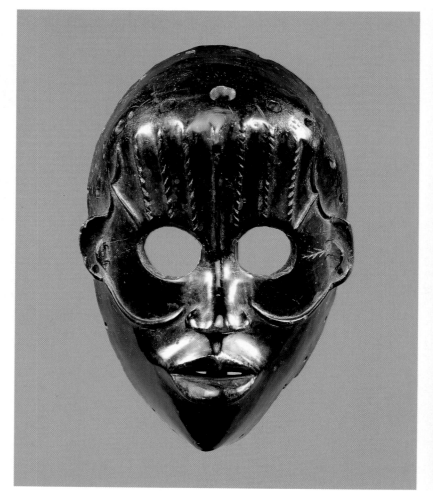

56

57

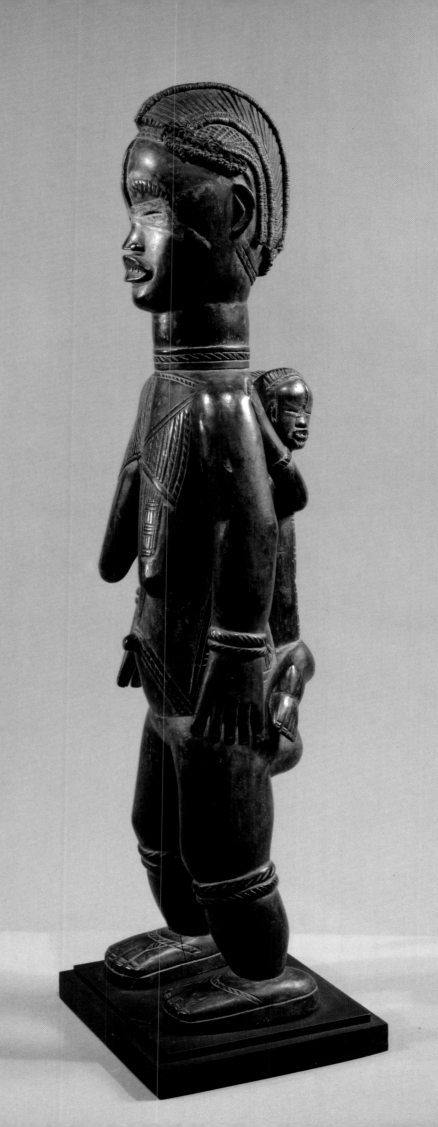

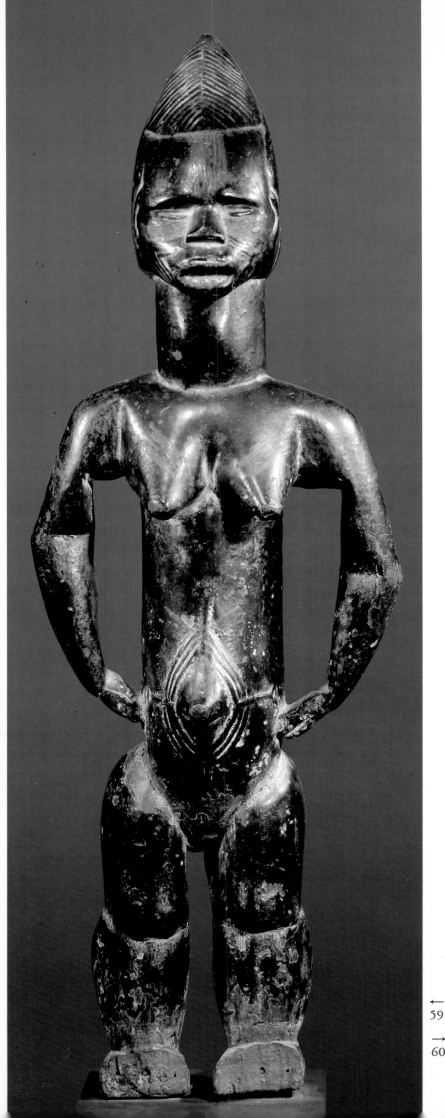
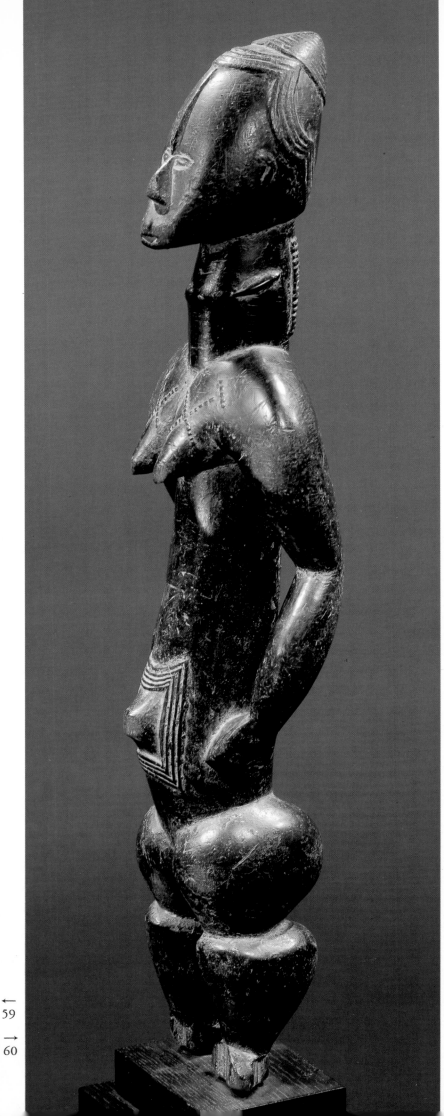

← 59

→ 60

51 Grebo Mask, Liberia
Wood. Height: 69.9 cm. The Metropolitan Museum of Art, New York

52 Grebo Mask, Liberia
Wood. Height: 74 cm. Museum für Völkerkunde, Berlin

53 We Mask, Ivory Coast
Wood, brass nails, parchment strips, plant fibers. Height: 60 cm. Musée des Arts Africains et Océaniens, Paris

54 Dan Mask, Ivory Coast
Wood. Height: 24 cm. Private collection

55 Dan Mask, Ivory Coast
Wood. Height: 22.5 cm. Private collection

56 Dan Mask, Ivory Coast
Wood. Height: 25 cm. Private collection; formerly Lefevre Collection

57 Dan Mask, Ivory Coast
Wood. Height: 25 cm. Private collection

58 Dan Statue, Ivory Coast
Wood, plant fibers. Late 19th century. Height: 64 cm. Private collection

59 Bete Statue, Ivory Coast
Wood. Height: 58 cm. Private collection

60 Bete Statue, Ivory Coast
Wood. Height: 61 cm. Private collection

II. THE NATURALIST ENCUMBRANCE

The Domination of Naturalism

The methodological remarks of the preceding chapter must be clarified, for a large number of the expectations with which we begin our approach to the traditional African arts are naturalist ones. That means that we are not dealing with isolated terms and concepts but with a more or less elaborate constellation of terms. It is necessary to be aware of this anticipatory system, if only to render it more precise in its role as a detector of differences that might allow it to change its function, in order to help us avoid ethnocentrism.

The predominance of naturalist conceptions is easily enough understood. We are surrounded by naturalistic images. We remain attached to an artistic heritage that, as a whole, is naturalist. Moreover, where a discussion of art is concerned, we have a vocabulary available to us that has been elaborated over the course of the last four or five centuries; André Chastel recently remarked that "every useful notion of art history has been formulated in connection with Italian art." (1983, p. 9) This naturalist character of our mental, verbal, and conceptual constructs thus runs the risk of bearing down heavily on our knowledge of the non-naturalist arts, such as many of the arts of traditional Black Africa. We must therefore remove this encumbrance; we begin by grasping it.

Specifying Naturalism

But this label is not applied merely to conceptions, theories, or philosophies of art. It is therefore not enough to characterize naturalism in general; its diverse forms must also be delineated. Generally speaking, a theory is called naturalist when it confers an explanatory role upon the concept "nature." This is true for the naturalist theory of art, and its shortest formulation is enough to demonstrate this: art imitates nature.

While a theory or a philosophy of art treats or claims to treat art in general, art criticism deals with specific works, encountered one by one in a tête-à-tête with the aesthetic experience. The English aesthetician Harold Osborne (1968, p. 38) characterizes naturalist criticism by the fact that one's sight does not come to rest on the work of art but crosses through it on its way to what it represents or imitates; furthermore, since it is under this naturalist form that art criticism developed in Western culture, the vocabulary it elaborates is a naturalist one: it is better adapted to the description of things represented than to the works of art themselves.

We shall also encounter a naturalist conception of expression, seeing the latter as a natural and therefore universal phenomenon. (*see* p. 161)

Naturalism can also, through the social sciences, take the form of a borrowing of concepts or theories from the natural sciences that serve as models because they are more advanced. This is so for the concept of function (*see* Chapter III), and more generally for the concepts of natural genera or the theory of evolution. In that very fine work *The Shape of Time*, George Kubler expresses on numerous occasions the art historian's distrust of "biological analogies."

Naturalist Expectations

What immediately interest us here are the naturalist conceptions of art that intervene as expectations and direct our inquiry toward the objects and their perception. But naturalism, then, appears in forms that are very unevenly developed. The formula "art imitates nature" is an ambiguous one, since both of its parts, "art" and "nature," are ambiguous, signifying both an ability to produce and its product. Thus the formula may signify that "the artistic ability imitates the productive ability of nature," but also that "works of art imitate natural things," resemble them or faithfully represent them. The first, more developed, meaning is less prevalent; it is the second meaning that engenders the majority of naturalist expectations. It is that one, in particular, that results in the character that Osborne ascribed to naturalist criticism. Consequently, less-developed naturalist expectations can coexist with conceptions that are not only different but incompatible.

"These conventionalized features" writes Frank Willett, for instance, "are most important in establishing the origin of the art style, for, once given the idea of naturalist representation, since human beings resemble each other, the works of naturalistic art will similarly resemble each other in a general way." (1967, p. 20; *see also* p. 127) Here it is the exoteric form of naturalism that intervenes: one thinks in terms of things, not faculties: the model is natural, and therefore universal; the imitation of this model engenders the identity of the copies. The author speaks of resemblance instead of identity; but his argument is conclusive only if the connection is transitive; either it is the identity that is transitive, or it is the resemblance that is not and the argument is not conclusive. Naturalism, in the second sense of the formula, coexists here with the notion of conventions, which is opposed, from the Sophists on, to the notion of nature, and which thereby can furnish us with one of the alternative expectations we are seeking.

Naturalist Conventions

If the naturalist theory of art is abandoned, the use of the word "naturalist" need not be prohibited, because it has several uses or meanings that are not all incompatible with the notion of *conventions*. It can define a theory of art and, as it claims to be universal, it is then incompatible with the convention that implies ideas of particularity and variation. It can also designate characteristics common to several historically distinct styles and the common category in which these have been placed; it then serves as a label for a "historico-aesthetic category." (E. Souriau, 1960) Finally, it can designate the characteristics common to the works of the same period, school, or artist; it then serves as a label for an "historical category." These three usages are also those of the word "expressionist" when applied to a general theory of art, to a style common to several arts (painting, sculpture, cinema) in different periods and

places, or to a school of cinematography of Northern Europe around the 1920s. In describing a particular style as naturalist, as is done for example with the styles of the arts of Ife, Benin, and of the Baoule, Luba, and Kongo, we are using the "historico-aesthetic" category, without, for all that, adopting the naturalist theory of art. In other words, only the first usage is incompatible with the notion of conventions; the two other usages alone allow us to speak without any contradiction of naturalist conventions.

The distinction between these three types of categories and the recognition of their epistemological level must be carried out by a comparative study of African art. "Criticism has borrowed part of its vocabulary from modern Western art. But to write of a Bamum mask that it is Expressionist (or Baroque), of a Bambara or Dogon or Senufo mask that it is Cubist, of an Ibo or Ibibio mask that it is Surrealist, makes no sense. . . . One cannot make universal aesthetic categories out of categories of art history without introducing serious confusions into the analysis." (J. Laude, 1966, pp. 216–17) This condemnation may be qualified. The confusions Jean Laude deplores may be avoided if 1) one avoids the use of these terms in terms of art theories or universal categories; and 2) in using them in the sense of historico-aesthetic categories, one distinguishes this usage from the use of the historical category; this requires that one respect and describe the differences between styles classified under the same historico-aesthetic category—that is to say, for example, not only between Bamileke and European expressionism, but also between Bamileke and the other African expressionisms. This is, after all, nothing more than bowing to the comparative rule as formulated by Descartes in order to avoid a misreading through abusive assimilation.

The conventional character of naturalist styles is attested to by a double diversity. First, in terms of the historical category, there is the diversity between all the styles one has decided to identify this way. The differences are often so clear that even a neophyte needs very little time to distinguish and recognize an Ife or a Benin head, a Dan or a Baoule mask; we noticed this on several occasions in the course of teaching an introductory class on the African arts. The second diversity, which involves the historico-aesthetic category, is between styles identified as naturalist and those that are not. In both cases, these categories are not clearly demarcated concepts; but that only means that certain styles cannot be classified in a univocal way—but the categories are usable in many cases. The styles, corresponding to these two categoric levels, must, then, be described in terms of family resemblance predicates, set up through figurative conventions.

But it must not be forgotten that the naturalist character of a figurative convention cannot be recognized and established merely on the basis of the observation of the plastic object alone isolated from its context of use. The naturalist character of a convention runs the risk that its conventional characteristic be forgotten and that we fall back into a naturalist interpretation.

Several pieces reproduced here represent faces covered with grooves. What do these grooves represent? To answer that, information must be available to us which these works themselves do not furnish. For example, the Ife faces [figs. 93, 95] are naturalist. One must learn that the grooves represent facial scarifications. It is up to the historian to establish this and inform us. Once we have learned this, we may be tempted to interpret an Ibibio mask [fig. 112] in the same manner. First we must be sure that it represents a human face; the mask alone is not enough to confirm that for us. "The striations on the surface, with the exception of the ridge leading from the top of the head to the bridge of the nose and the two lines running from the corners of the eyes to the jaw, are probably not

scarifications but a stylized depiction of hair" (A. L. Scheinberg, 1975, p. 21), for the mask probably represents a monkey's head. By "stylized representation," the author means what we would call a non-naturalist convention. Similar grooves are found on a chimpanzee mask of We origin [fig. 53]; this difference in origin prevents us from giving the same representative value to these grooves in the absence of ethnographic data and therefore on the sole basis of a resemblance between the two masks. Comparing objects allows us only to raise the possibility. In the case of the Sao head [fig. 923], archeology confirms this interpretation. (J. P. and A. Lebeuf, 1977, no. 69, p. 87) A fortiori, a comparison with "reality" may be most deceiving. In the lateral parts of a Luba mask—the Luba style having been termed naturalist—there seemed to be a representation of horns [fig. 188]; in fact, what's involved are "braids brought forward to the front of the head." (J. Cornet, 1972, p. 210)

The representative value is thus not an intrinsic property of the representation—which it would be if the representation were natural—for there would then exist a natural, and therefore an invariable, connection between the representation and its object; this connection is conventional and variable. Even more, the examination of the object alone does not allow us to know whether there is representation. Every detail of a representative figure is not necessarily representative. Of a detail of a Yoruba figure of a caryatid, Robert Farris Thompson (1978) writes: "The royal mother is shown dressed in a brief wrapper of velvet (aran), for the delicate cross-hatching of a carefully bordered area is a shorthand rendering in traditional Yoruba sculpture for the sheen and glitter of this expensive cloth" (p. 111). The metaphor of shorthand, a form of writing that stands in for the convention of longhand writing, emphasizes the conventional character of this kind of figuration. But in the absence of autochthonous information, summarized in the citation of the term Yoruba, we were not able either to identify what is represented nor even to know whether there is representation; we might have taken the cross-ruling as a decorative motif, that is to say as nonfigurative, or as the representation of the motif of the pagne's fabric; in the latter case, we would be committing a double mistake: in terms of the nature of what is represented and of the figurative convention: the motif of the fabric would seem to be represented in a naturalist fashion, while that of the shimmer and lushness of the velvet are in fact not.

Converting the Gaze

In a naturalist framework, vision crosses through the work toward what it represents. By converting the gaze and one's attention, we are returned to the plastic object itself. Such conversion is neither simple nor comfortable. It is difficult to rid oneself of old habits of looking and thinking. Looking at a work of art is not a simple business; neither is converting one's way of seeing. The hardest part comes at the beginning.

Since the involvement of expectations is inevitable, we must replace those that are not pertinent by discovering alternative concepts that are. But these can be chosen only by confronting them with the encountered object, while holding on to the traits of the latter that make it different from the object we expected due to our initial expectations. It is critical to retain these gaps instead of excluding them through negation or assimilating them by force. Taking advantage of what is available, we must then begin by using the initial expectations as detectors of differences and, to that end, gain as clear an awareness of them as possible.

To note differences and deviations already focuses our attention on the very object evidencing them. On the other hand, it allows one to give

direction to the search for comparative elements. In comparisons, the object examined is no longer related to what it represents, but to other works with which it has traits in common, chosen on the basis of deviations. Consequently, initial expectations also do not suit the comparative data. Now, the latter have already been studied, and when they have been studied correctly, they are matched with commentaries using pertinent concepts that, albeit provisionally or hypothetically, may be substituted for initial expectations.

To bring the comparative method into play, thus, can kill two birds with one stone: it furnishes means for converting our way of seeing by proposing new concepts able to be substituted for naturalist initial expectations.

Anatomy is a good example of a detector of differences. Most often our anatomical "knowledge" suffers a good deal from the imprecision of expectations and is used in naturalist descriptions. Read the notes in sales catalogues: descriptions of objects are crawling with anatomical terms; the same is true, moreover, for certain monographs boasting a morphological method. Vague notions, associated with terms known by everyone, enter into descriptions, not of a statuette, but of a human being which, represented by the former, would resemble it like a twin.

The imprecision of these notions and the poverty of the current vocabulary may be put forward as evidence thanks to the example of the ear, so dear to Giovanni Morelli. Try, without any living or photographed copy of an ear in sight, to describe, or if you prefer, to draw, an ear with some precision. You will probably be surprised by your own uncertainty, your hesitations and constraint, much like Socrates, with an admission of ignorance. Recourse to a treatise on anatomy will furnish expectations that are still naturalist, but more detailed and more precise, offering the words we lacked, which will permit us to register and describe with greater precision the deviations between these "anatomical" ears and the shapes of the parts of sculptures representing ears.

The shapes of the drawings of ears will reveal themselves to be surprisingly diverse—one of the reasons for Morelli's predilection. Let us note in passing how unfair it is to reproach his technique of attribution for corrupting, due to its analytical character, aesthetic perception; this technique may be the opportunity for a productive education of our way of seeing. One is then able to discern differences, not between the ears of statues and those of humans, but between the various shapes of the representations of ears, a diversity that reveals their conventional character.

The rest of this chapter will describe several aspects or forms of the conversion of our way of seeing related as closely as possible to actual works. We have chosen aspects of works that seemed to us to furnish naturalist interpretations with their most frequent opportunities for resistance and persistent images.

Representation of Proportions and the Proportions of Representation

The Question of Proportions

The proportions of a figure are obvious because they concern the figure globally perceived, because they can be intuitively grasped before any analysis, and because we have available to us simple and current terms to formulate them. Thus, judgments on proportions are expressed from the very first encounter with African sculpture. But often these judgments

merely obey the mechanism of misreading by reducing difference to negation, as described in Chapter I. One still comes across such negative judgments, even in specialized literature: the neck is too long, the legs are too short, the head is too large, the limbs are out of proportion, etc. Since such negative diagnoses are brought to works that otherwise, because of their quality, impress us with the mastery of the artists who produced them, these judgments do not hold up. We have noted that such diagnostics used classical, Greco-Roman conceptions of the proportions of the human body as the norm, while these very obviously are not suitable for African sculptures. Therefore, a certain number of alternative solutions have been proposed, either expanded to fit, or borrowed from other fields of art history, whose canon was not precisely applicable either.

The question then is: do these alternative solutions realize their true intention, do they succeed in ridding themselves of naturalist preconceptions? This question deals not with negative diagnostics and individual works but with general interpretations, with theories.

The Persistence of Naturalism

Hans Himmelheber (1960b, p. 53 *ff*.) describes a theory that perfectly exemplifies misreading by abusive assimilation using naturalist expectations. But his sophistication masks its naturalism. It brings together two principal ideas.

The proportions of statues are regarded as infantile, likened to the proportions of a small child's body, which are proportions as natural as those of the adult, although different. Thus the essence of naturalist theory is preserved: a natural model and a faithful imitation; it is enough to change the natural model, or more precisely, to specify and differentiate it. A natural difference between the child and the adult is to be found again as a difference between the statues' proportions and the classical (adult) canon.

The second idea introduces a relationship between the observer and this infantile model. It is assumed that the African sculptor produces an image that is identical to what a view of the model from above would offer. The two ideas can be brought together: Himmelheber reproduces the photo of a child seen from above. The apparent dimensions of the head are enlarged and those of the legs diminished. We make a distinction between the appearance and the reality of the model and we add an effect of perspective classically known as optical correction. One does not get off the subject of naturalism this way: optical corrections obey the natural laws of vision; historically they are a refinement of the naturalism of Greek art, and Plato condemned them as an imitation of appearance. Their application here has simply been inverted: statues, either when huge or when placed on high sections of a building, are generally viewed from below, while in this formulation of African art, a view from above is assumed.

These two elements of the thesis must be discussed separately, for they are not of equal importance. Optical corrections are a refinement of perspective, a sophistication of naturalism. They cannot be ascribed to arts that are indifferent to perspective. They imply a phenomenalist conception of representation: the model is rendered not as it is in reality, but as it shows or manifests itself (which is the meaning of the Greek verb from which the word phenomenon is derived) to an observer. To take the simplest example, in reality a cube has six identical, square sides, but it never shows more than three of them, of which only one at best can be seen as square and thus different from the others. Phenomenalism seems foreign to the totality of traditional African art.

Paedomorphism and Differential Proportions

The first element of the thesis, the infantile characteristic of the proportions of the statues, is the more interesting one, for it can be separated from naturalist presuppositions.

The notion of infantile proportions is a result of the association of two more general notions, that of differential proportions, a tool used in art history, and that of paedomorphism (taken from two Greek words meaning child and form) borrowed from the morphology of organisms by William Fagg. "Differential proportions are those . . . that take certain peculiarities of the represented subjects into account" (*Sculpture*, 1978, p. 687), among which are age and social condition. Age is a natural condition; the morphology of organisms describes forms and proportions that are different according to age: childhood, adulthood, or old age. Differences of proportion, imitated by art, will be reencountered as differential proportions of the representations, of the images. The thesis reported by Himmelheber is thus reformulated in the framework of the theory of differential proportions, which itself is a part of the naturalist theory of art.

The "peculiarities of the represented subjects" may also be provided by "social condition"; they do not stem from the morphology of organisms, then—they are not natural but cultural. This suggests that one dissociate the notion of differential proportions from the naturalist theory of art.

Two bronze groups from the royal shrines of Benin, in the Berlin Museum, are elements composed of, among others, one central figure and two lateral figures of very different proportions from those of the central one. [*see* fig. 466] Are these "different" proportions differential? And if so, in what sense? The difference is a twofold one: it involves the relationship between the height and size of the figures and also the relationship between the heights of the parts of the bodies representing respectively the head, the trunk, and the legs. These morphological observations do not permit one either to identify the represented persons, that is, to specify their identities or their differential iconographic value, nor, consequently, to know if the peculiarities of the represented subjects are natural or cultural. Yet, neither of the two morphological types here has proportions that come close to those of a natural human body; the central figure is clearly more stocky, the lateral figures clearly more slender, which suggests a cultural or social difference among the "subjects," a figurative convention whose meaning cannot be known without turning to ethnography and/or history. According to Fagg (1963, pl. 24), the central figure represents an *oba* (king) and the two lateral figures "foreign slaves"; the differential iconographic value clearly stems from the culture. Paula Ben-Amos (1983) has confirmed and developed Fagg's iconographic analysis by recognizing the individual identity of the *oba* and by pointing out the distinctive markings delineating the status of slave and foreigner.

Here then we are in the presence of differential proportions used in a non-naturalist context. A figurative convention establishes a relationship between the differences in proportions of the figures and the differences in the status or social rank of the persons represented. The conventional character of this relationship can be made more obvious, by means of the standard of variability, through two comparisons. Every case compared has a difference of proportions between the figures in common; it is their differential iconographic value that is variable.

The other Benin group [fig. 464] presents the same difference between a thickset central figure and two slender lateral figures; but if the central figure again represents an *oba*, the two lateral figures now represent neither foreigners nor slaves. Therefore, within the same cultural and artistic group there is no invariable connection between the proportions of

111

a figure and the social status of the person represented. The same is true when one compares works produced in different cultures. "An incontestable link can be established, for example, between the elongation of figures and their immaterial or spiritual character." (*Sculpture*, 1978, p. 411) (This heightens the confusion, characteristic of the language of naturalist criticism, between the figures and the persons they represent.) "In the twelfth century, the bodies of the elect are elongated to the degree that they come closer to the celestial Jerusalem." (*ibid.*, p. 411) In Romanesque art, as in the two Benin groups, what is represented are different ranks, different hierarchies, not actual proportions or the differences in proportion between people. But the two conventions are inverted: in Benin, the elongated proportions belong to an inferior rank, in Romanesque art to a superior rank.

Nature and Convention

The notion of differential proportions and one of its applications, the determination of proportions belonging to the child, are of naturalist origin. They are found in texts that are interesting documents, as much anatomical history and natural science as art history. It is the naturalist artists who, thus, integrate the natural sciences with the art of imitating nature. These sciences are anatomy, as above; optics and perspective; and finally the psychology of the passions and their expression. Infantile proportions are, first, those of the child and then, with works of art representing children, those of the representations. In order faithfully to represent or imitate children, one studies their morphology—this from the point of view of the creative artist. The fidelity of the representation allows the observer of the work to follow the order inversely: to go from the proportions of the representation to the differential identity of the represented person and his or her proportions. What is in question is the legitimacy of this inference. Naturalism, as we have just seen, warrants this inference through the knowledge of anatomy and the fidelity of the imitation, or, which is the same thing, the truth of the representation. But is this admissible in all cases?

Morphology scientifically elaborates a more or less vague and intuitive general knowledge of differential characteristics. On the other hand, as Konrad Lorenz has shown, the paedomorphic characteristics of a small animal function as the trigger for behavior that is specifically adult. Now, whatever the level of ability or competence, let us consider, not the organisms any longer, but the works of art representing the organisms. Let us suppose the abilities are there and that, therefore, the paedomorphic diagnostics brought to these representations are true. May one draw a conclusion from these diagnostics that pertains to the organisms or the represented persons?

There is no single answer to this question. Indeed, three possibilities may be delineated, shown in the chart below:

	A Plastic representation	(C) Representation (Relationship)	B Person represented
	Infantile/non-infantile proportions		Child or/not
(1)	+	(+)	+
(2)	+	(-)	-
(3)	-	(-)	+
(4)	-	(-)	-

The word "representation" is ambiguous: it signifies either a relationship (representing) or one of the terms of that relationship. On the model of the triad signifier-signification-signified, one might propose: Representer (A) — Representation (C) — Represented (B). The fourth line on the chart is to be excluded: it defines cases that do not correspond to the question posed. The first entry (1) is exemplified by the drawings of Jakob De Wit, that is to say, by the naturalist conception of differential proportions. Of the second and the third we shall only give African examples; but one could easily find them in many other sectors of art history, for there naturalism is not the rule.

Numerous statues or reliefs manifest infantile proportions but do not represent children, do not represent infantile proportions. That is very frequently the case with figures that are divided into three equal parts, representing respectively the head, trunk, and legs, proportions more different still from the canon regarding adults than the infantile canon in De Wit's system is. As to figures of heads, regarding a terra-cotta from Nok, an obvious paedomorphism has been noted side by side with the figuration of a beard, which means that it cannot represent a child. These cases are examples of the second possibility in the chart.

Inversely, it has been observed that when African sculptors represent children, they do not seek to render their truly infantile features or other aspects that differentiate them from adults or old people. Generally speaking, "for reasons which may have something to do with African concepts of time, African artists never seem to represent their subjects as being any particular age." (W. Fagg and M. Plass, 1964, p. 62) It has also been noted that sometimes figures of children are merely miniatures of adult figures or, more precisely, taking the preceding quote into account, figures that have no age. The dimensions are reduced but the proportions have been preserved. But since "being the miniature of" is a relative property, this figurative convention is not applicable to figures that are physically separate but normally together in the course of their ritual usage. These cases are examples of the third entry on the chart.

This discussion allows us to conclude that infantile proportions or characteristics of representation are neither a necessary condition (third entry) nor a sufficient one (second entry) to determine that a child or the proportions of a child are being represented. It also allows us to understand that the expression "infantile proportions" is doubly ambiguous. In its naturalist usage (first entry), the proportions are at one and the same time differential and representative, differential because representative. But in the two other cases, since they are not representative, can they be differential? One should not hasten to answer in the negative, for they may be differential in a way other than the one until now supposed. That is the first ambiguity and the question it raises. But the chart allows us to discover another ambiguity and impels us to come back to the initial diagnosis (A) of paedomorphism. This diagnosis is the result of a confrontation between the representative statues and the organisms. But it is *we* who make this comparison. Were the users and the producers doing so? An affirmative response, on the one hand, corresponds only to the first entry and, on the other hand, can be warranted only by ethnographic or historical information. A morphologic diagnosis must be regulated by historical or ethnographic inquiry.

Now, indeed, certain field investigations show the question to be more complex and permit us once again to pick up the preceding suggestion: paedomorphism could be differential but in another way. James Fernandez has established that the Fang not only recognize the characteristic of infantile proportions and of certain features of their statuettes, but also agree that they represent children. Thus they would

exemplify the first possibility. But the Fang also declare that they represent age, ancestors, and ancestral powers in human affairs. Consequently, Fang statuettes, as seen by the Fang, do not correspond to any of the three possibilities in the chart.

The reason for this is simple. Until now we have only posed the question in terms of literal representation. In doing so, we have not entirely removed the naturalist encumbrance. For, with the first possibility, the representation of proportions is literal. Thus we can make the preceding suggestion more precise: the differential character of the proportions is not necessarily associated with the literal character of the representation. This may be confirmed by the examination of another classical solution to the problem of proportions.

African Proportions

Fagg has proposed the concept of African proportions; the expression alone testifies to a respect for the distance from the classical canon and to a concern with avoiding ethnocentrism. The height of the head is between one-third and one-fourth of the total height of the figures, "in contrast to the 'normal' proportion, which varies between one-sixth and one-seventh. Hence the tendency to increase the volume of the head—assumed to be the principal seat of the life force—which is so common in recent African art and which has been well-established for two thousand years; and this allows us to refute the idea that the 'deformations' in present-day African sculpture are the result of the degeneration of some golden age of naturalism anterior to the arrival of the white man." (W. Fagg, 1963, p. 13)

This is a complex interpretation: 1) Polemical, it rejects a naturalist and negative interpretation (perfectly illustrating a negative misreading) and proposes an alternative solution; it is the perfect example of the road we propose to take. 2) It returns to the objects and determines their proportions (a third for the head). 3) The actual interpretation is iconographic; it acts in two ways. It connects the dimensions of the parts, the proportions of the figure, with the importance of the represented parts of the person, which are formed according to a hierarchical system. In similar cases, art historians speak of symbolic or hierarchical proportions. Thus the hierarchical principle here is the life force.

Three objections may be raised to this thesis. By extension, the morphological determination (one-third) is far from applicable to all African styles. If the proportions of the trunk and the legs were specified, this criticism would be strengthened. By comprehension, the morphological element may be given another interpretation; moreover, the nature of the relationship between the proportions and this significative term that is the life force has not been determined. On this last point, inquiry can be pointed in two directions: expression, and symbolic or figurative representation.

Expression

Himmelheber (1960a, p. 55) suggests the following explanation: "In general, the statue must be a supernatural being, an idol. Perhaps the [African] sees in these exaggerated and thickset shapes the expression of a physical force in a thickset human being." If, after having carefully looked at a large number of African statues, we "then go back to looking at passersby in the street, as nature has made them, the latter suddenly seem bland to us, without any strength, compared to these statues full of concentrated vigor—proof that the [African] artist has succeeded in loading his works with a particular force." (*ibid.*)

We find again one of the ambiguities noted above: it is we who are comparing the forms of the statues to the organisms "as nature has made them." And it is our knowledge of the expressive value of the thickset forms that is extrapolated, and doubly so: from the natural bodies to the statues, from us to the Africans, without any ethnographic monitoring. These two extrapolations are naturalist: the first one presupposes the imitation of nature, and the second, a naturalist conception of expression which we shall examine later on. (*see* p. 161) If one can retain this thesis, it is on the condition that the notion of expression be separated from this naturalist context.

Literal and Figurative Representation

In his study of the caryatids of the seats of Luba chiefs, J. D. Flam (1971) uses the analogous notions of metaphor and symbolism. The proportions of the caryatids are explained through a relationship of analogy between the respective dimensions of their parts and the values of the human body parts they represent, values hierarchically demanded within the framework of Luba culture. Since it is the head upon which the highest value is bestowed, it is represented on the largest scale. This is an interpretation of the same kind as that of Fagg's African proportions. In the specialized literature it is found quite frequently. For example, in Yoruba sculpture, according to William Bascom, "the human head is emphasized, probably because of its association with luck and destiny, with the result that the human figure is commonly portrayed as composed of three parts of approximately equal size—head, torso, and legs." (1969, p. 111) Elsy Leuzinger generalizes this interpretation. (1962, p. 45)

This particular symbolic meaning seems to be very widespread; in its simplest form, it can be found again in the metaphoric signification of "great" when applied to a man who is, literally, "small." As for figurative conventions, in art history this is termed symbolic or hierarchical proportions. As the word symbolic is used here in several senses—particularly in contrast to "literal"—it would be preferable to speak of "figurative" [Trans. note: as in a "figure of speech"] representation.

Thus the distinction between literal and figurative is transferred from the verbal to the visual realm, by generalizing the transference of a particular figure, the analogous metaphor or symbol identified by Flam in the Luba data. Would it be possible to identify were there only one other figure?

Ethnographic documentation is scarce, very probably because investigations have only rarely been directed in that exact manner. The research among the Fang by Fernandez (1971), cited earlier, is an exception. We have indicated that the infantile proportions of the Fang statuettes could not be satisfactorily interpreted in terms of literal representation. These statuettes certainly do represent children in the eyes of the users; but that only constitutes a part of their significance or representational value; these statues represent ancestors, in a nonliteral manner; moreover, the Fang recognize them to have another literal value, that of an aged human being or elder, which enlists a connection with the first literal value, the child, that the author calls the *opposition of complementarity*. The opposition between the two literal values reveals its complementarity by dissolving itself, in the last instance, into a single figurative value, the ancestor.

Now, given this structure of signification, called opposition of complementarity, we recognize in it the structure that characterizes the figure codified as *oxymoron* in rhetoric. Classical examples of this are: "learned ignorance" (N. De Cues), "obscure clarity" (Corneille), "repairing

the irreparable" (Racine). The word "oxymoron" is itself an oxymoron, as it is a compound of two Greek adjectives of contrary meaning, sharp-blunt. This figure joins two words associated with opposed or incompatible meanings; according to Henri Morier (*Dictionnaire*) it serves to express "precious values." This definition of the oxymoron is equivalent to Fernandez's interpretation. The two literal values, child-elder, are opposed but complementary, they dissolve into one valuable figurative value, ancestor.

Moreover, the author shows that this structure of signification, the opposition of complementarity, penetrates every sector of Fang culture and, in particular, serves to formulate one of the fundamental values of this culture, vitality, linked intimately not only to the ancestors, but also to the ethical and aesthetic values of the Fang. One would be tempted to characterize the Fang culture as a culture of the oxymoron. (Roman Jakobson has established the prevalence of this figure in the poetics of Fernando Pessoa.)

Organic Proportions and Technical Proportions

One single formula is undoubtedly not to be found. Research, then, ought not to take one single direction. Willett (1971, p. 161) suggests another one.

A work of art as a term may enter into two relationships, a relationship of representation with extra-artistic objects, and a relationship of production with the artist. Until now, our inquiry has privileged the first one; Willett takes the second into consideration. Field studies, he writes, "from many parts of Africa have shown that sculptors begin by dividing up the block of wood very carefully into separate parts which will *eventually* [our emphasis] be the head, body, and legs. The properties are thus deliberately established at the outset and are certainly not due to a lack of skill."

Erwin Panofsky differentiates technical proportions from organic proportions in order to account for deviations between certain works and the classical Western canon, which is precisely the goal of the present inquiry. This distinction corresponds to the one we have suggested between the proportions of representation and the proportions of the represented object. Proportions are said to be technical when they are attributable to the production technique of the plastic object that evidences them. This technique may take various forms: squaring the figures, as in ancient Egypt, is one; the initial tripartition of the block of wood is another. Let us note that the first example, in a society that had writing, proceeded in two ways: the design was squared on an independent surface, then transferred to the block; in Africa, however, where there is no writing, the partition is made directly on the block.

Proportions are said to be organic when they are those of an organism, a living body. Since this body has its properties and its proportions independent from the fact of its being represented, these organic proportions are extra-artistic; Panofsky says they are objective as well, since, when there is representation of an organism, the organic proportions become those of the object of the representation, which must not be confused with those of the representation itself—for technical and organic proportions may very well not coincide. Their coincidence, in other words, is subject to certain conditions which are not always realized. These two possibilities are in perfect accord with Willett's observation according to which the parts of the initial block may "possibly" receive a representational value later on in the work of the sculptor.

Techniques of Production and Techniques of Use

This analysis of Willett's is extremely interesting, for it suggests a new change in the position of the question of proportions. We have seen that it is not enough to pose the question in terms of literal or figurative representation, that it has to be posed in terms of production techniques; Willett suggests that it should also be posed in terms of function, or more exactly, of use. We then have to speak of technical proportions in a second sense. The functionalist theory of art classically distinguishes between techniques of production and techniques of use. The technical proportions, in Panofsky's sense, are such in the sense of techniques of the production of works of art. It so happens that the domain of art primarily studied by Panofsky, as well as his iconological orientation, led him to put the function or the use of the works between parentheses and to focus attention on their representational character.

Inversely, numerous African objects have been incorporated into private and public collections, and these objects, while representational, in their original context had a practical function. Let us agree to name such objects technico-figurative or technico-representative. They are amply illustrated in this work.

Let us call the form adapted to the practical use of an object, technical form. In itself, technical form is not representational. The form of a spoon, a drum, an automobile represents nothing. For reasons we shall examine in Chapter III, the majority of technical objects present in collections, the objects which early on caught the attention of field investigators, subsequently considered as works of art, are at the same time representational. Consequently, their shape and their proportions are not solely attributable to those of the organisms they represent, but also to the use to which they have been adapted. Thus, it is as if they were the result of a compromise between nonrepresentational forms and functional proportions (in the sense of use) and representational forms and proportions (themselves more or less naturalistic). The practical functionality of an object is a factor of disjointedness between the proportions of the representation and the representation of the proportions.

This case of technico-figurative objects should not be confused with the cases Panofsky mentioned, of coincidence between technical and organic proportions, first because in their case their proportions are technical in the sense of use and not production; then, because there is not a coinciding but a compromise. And this compromise accounts for their non-naturalist character, while in Panofsky, coincidence corresponds to naturalism.

As a guide, one can distinguish two kinds of compromise. The representational form may fuse, so to speak, with either the whole or a part of the technical form; this also applies to the proportions of the form. This distinction is implicitly present in the current labeling of African objects—whether that be, for example, the presently used labels "anthropomorphic or cephalomorphic bowl" or "stool with caryatids." One term designates the practical function, the other, the organic form represented (man, head of woman carrier); the suffix -morphic (form) renders the organic form represented specific, while no allusion whatsoever is made to the technical form—a symptom of the naturalist character of this terminology.

The anthropo- or cephalomorphic bowls show that the distinction between the whole and the part is not applicable merely to the technical form. In other words, the two dichotomic predicates technical/organic and whole/part are independent. The simplest of the combinations thus engenders four possibilities:

117

	Form (proportions)	
	Technical	*Organic*
(1)	whole	whole
(2)	whole	part
(3)	part	whole
(4)	part	part

These possibilities are not mere mental constructs. They may be used as examples by drawing from one single kind of object, palm wine bowls, produced within one single artistic group, the Kuba [figs. 735, 740, 742]. Indeed, one can recognize bowls that are (1) anthropomorphic, (2) cephalomorphic, (3) with anthropomorphic handles, (4) with handles that are cephalomorphic, or even in the shape of a hand.

This classification is minimal. In effect, quantitatively it involves one or more than one part of each of the forms, and qualitatively, some other kind of form that can come into the combinative. Therefore, the possibilities are innumerable—which corresponds very nicely to the impression of rich diversity that specific photographic documentation engenders.

The multiplication of the types of objects and of artistic styles makes exemplification even easier. It is hardly worth stating that this kind of combination of technical forms and of forms representative of organisms is far from being specific only to African sculpture.

It is obvious that the proportions of a figure will be very appreciably different if the representation pervades the entire bowl (1) or only its handle (3).

In the last three possibilities on this chart, parts of the plastic object are not all treated in the same manner—from the point of view of the relationship between organic form and technical form adapted to use. In certain cases, the difference is technical in the sense of production: certain (organic) parts are treated in relief on the rest of the figure, which is treated in-the-round. (*see* Chapter IV) Generally considered, the different treatment of the parts, Susan M. Vogel has suggested (1987a), is a characteristic of African sculpture. In the particular case mentioned here, it is, at least in certain instances, associated with the technique of the initial partition of the block. We find once again the link between production and use. Indeed, quite frequently at the beginning of the production of technico-figurative objects, the initial partition distributes the parts that will receive a figurative or technical form as the work progresses.

Representation of Space
and the Space of Representation
The Question of the Representation of Space

A certain familiarity with African sculpture ought to exclude the question of the representation of space, just as it does the notion of landscape. That it is posed at all is a result of naturalist prejudices; we pose it here in order to rid ourselves of these prejudices.

A sculpture in the round does not raise this question, for it *occupies* space but does not represent it. (L. R. Rogers, 1969) This question, therefore, concerns itself only with reliefs. Now, the vast majority of African reliefs do not represent space; the exceptions sometimes mentioned are debatable ones. Thus, African reliefs are likewise indifferent to perspective, which is a technique of the representation of

space, and it would be absurd to blame them for errors in perspective. On the contrary, perspective and representation of space belong to the Western naturalist tradition of relief that has existed since the Quattrocento and, in particular, since Donatello. Therefore, it is our naturalist expectations that induce us to raise this question.

But one should not entirely evade the matter. Besides the fact that it is not without value to rid oneself of prejudice, research does not obey the law of "all or nothing." It is possible to either transform the question by changing its terms, or to substitute another question for it.

One can first change the question and wonder why African art is indifferent to the representation of space and to perspective. In order to transform the question by changing its terms, it is an absolute requisite that a certain number of distinctions be introduced. Posed first as simple hypotheses in order to clarify the statement, they will ultimately be justified by analysis.

Perspective is a species whose genus is the representation of space. One can represent space without using perspective; inversely, perspective has as its goal the representation of space. This amounts to distinguishing two uses of the word "perspective": in the broader sense, here in variance to convention and equivalent to the "representation of space"; and in a narrower sense.

Next, it is proper to distinguish between representation of space and representation of things. The plastic arts can represent things without representing the space in which these extra-artistic things exist. In everyday reality, on the contrary, we always perceive things in space. The plastic arts, then, can either represent both things and space, imitating reality—and this is the goal of perspective—or they can represent only things without representing the extra-artistic space in which they exist.

It is appropriate also to distinguish the two ways of considering the plastic object. As a simple material thing, it possesses spatial properties— length, width, depth; painting or relief, it represents a surface on which the artistic work is applied, something which existed already. While the space, represented or not, in which things exist is extra-artistic, this space or material surface may be said to be infra-artistic, for it is encompassed within the artistic work. But the plastic object, no longer as simple material thing but as an artistic object, possesses its own space; this Pierre Francastel (1951) calls plastic space, which is different from the two preceding types of space. One may call it artistic. It is to be distinguished from the two preceding types, which are real, while this one is imaginary or focal. This focal characteristic may be clarified by a very simple example. Let's say a material surface is either covered with uniform color with the exception of one spot of another color, or that it is a flat surface, uniformly smooth, with the exception of one small protrusion. When these are viewed, one can apply to these objects the conceptual pair: figure (*gestalt*)/background. The so-called gestalt (form) psychologists use this to describe one of the fundamental structures of the perceptive field: the background seems to continue *behind* the figure that is shown *in front of* the background. Thus, this spatial structure becomes tridimensional and is therefore different from the simply two-dimensional surface of the material base. (This suggests a modification might be made of Maurice Denis's famous definition of a painting: "Essentially a flat surface covered with colors assembled in a specific order.") The third dimension serves as a criterion of distinction. In all three cases—extra-artistic, infra-artistic, and artistic or plastic space—space is perceived through sight. But if, in the first two cases, touch confirms the visual perception, in the third case it weakens it. One cannot put one's hand between the figure and the background.

A plastic object can be representational or not. If it is not, it represents neither things nor space and is beyond discussion here. The plastic objects we are discussing are representational, not only of things but of the extra-artistic space in which these things exist. There is one condition: the artistic or plastic space must itself represent the extra-artistic space. It is in this sense, still following Francastel, that one can say this plastic space is representational space. Representational space is a plastic or artistic space that carries out the function of representing extra-artistic space. It is appropriate also to distinguish between this representational space, which is the space of the representation, and its function, which is the representation of space. One can also say that there is representation of space when the spatial properties of the representation, of the plastic image, represent the (spatial) properties of the extra-artistic space, that is to say, the spatial relationships things have between them in extra-artistic reality. But the artistic space of the representation may very well not be a representational space—that is, it may not represent the extra-artistic space but something else. This allows us to put forward a hierarchy of sizes.

The Hierarchy of Sizes

A single property of the space of representation, the size or height of figures, may, according to different systems of figurative conventions, be representative in one system and not in another.

What Leonardo calls linear perspective or the perspective of the diminution in sizes, is the process that allows the size of figures to represent the spatial properties of the things represented by these figures, which would be their size and the distance separating them from the observer in the shared space. Theoretic perspective formulates this relationship mathematically: $f = k \frac{T}{D}$, in which f stands for the size of the figures, T for the size of things represented, and D for the distance that separates them from the observer. During production, this formula serves to code the representation that perception will decode as it sees the represented objects spaced in depth. Thus, the representation connects the spatial properties that each of its two terms, figure and thing represented, possesses; consequently, the representation may be said to be literal.

A Dogon granary door (in the Museum Rietberg in Zürich) is composed of two panels, each of which shows four superposed rows of seven figures of ancestors, sculpted in relief. Within each row the figures are approximately the same size; but that size decreases from top to bottom, from one row to the next. "It is not by accident," writes Leuzinger, "that . . . the rows of ancestors . . . become proportionately smaller as they approach the lower part of the panel. For the first ancestors are closest to the creator and have obtained the greatest part of his mystic vital form." (1960) What exactly does the difference in the size of figures represent? Differences in distance, not between the ancestors and ourselves, but between the ancestors and their creator; so, in this answer "distance," "distancing," or "proximity" are used metaphorically, for these determinations are not spatial but genealogical or temporal (in mythic time). In the extra-artistic reality, known by the myth, these differences in distance correspond to a temporal and hierarchical genealogical order; they are classified according to the part of this value, which is the life force, that decreases with each new generation of ancestors. The same idea is found in Plato: "The elders who were more worthy than we, for they lived closer to the gods." The figures may be classified in order of size; the ancestors are classified in order of worth. The two orders are not homogeneous; consequently, the first does not literally represent the second order. The spatial properties of the representation do not

represent the spatial properties of the persons represented: these panels do not represent ancestors lined up in four rows like soldiers in the courtyard of an army base. But these spatial properties are not devoid of representational value. What is represented, in the final analysis, are values, and their representation is not literal but figurative; the figure, as with hierarchical proportions, is a symbol or an analogous metaphor.

This figurative convention is far from being specifically Dogon. One finds it not only in most African styles but also in most of the arts we know through art history, and even in the so-called naturalist styles, such as the art of ancient Egypt, classical Greece, and Rome. It seems to be the rule and linear perspective the exception. It has had various names: the principle of the hierarchy of sizes, hierarchic or symbolic gradation, symbolic perspective. The preceding comparison shows that the last designation is an abusive one: it tends to assimilate into naturalism a convention which is completely different from it.

The hierarchy of sizes and hierarchical proportions are two distinct but coherent figurative conventions. The first concerns the relationship between whole figures, the second between the parts of a figure. They come out of a similar spatial "symbolism" that is to be found at work in modes of nonverbal communication other than sculpture in relief, as well as in verbal language.

Consolidation of the Surface

Focusing the attention on the plastic object and the space belonging to it, we should try to describe this plastic space of the representation. To this end, we should change comparative material, and not use perspective alone as a detector of difference, but bring African reliefs closer to comparable works annexed with commentaries that may suggest pertinent concepts to us—such as the concepts of the consolidation of mass and surface, coined by Panofsky to describe Medieval paintings and reliefs. (1976, pp. 63, 136–37)

The figure is conceived more in terms of mass than structure; its parts may be treated differently, in nonorganic fashion. On the other hand, it becomes linked with architecture, as with the Benin plaques or the sculpted doors (Dogon, Senufo, Baoule, Igbo, Yoruba, Tsogho, etc.), or with technico-figurative objects that have a relief surface.

This surface becomes the background for the relief. The figures never give the impression of being detached, even when the treatment is in high relief. The unity of material contributes to that impression—even when, exceptionally, the sculptor's technique is neither carving, molding, nor casting, but building, and all the parts are of wood.

The solid forms of the figures in relief never extend beyond the limits of the initial block. The distance between background and foreground coincides with the thickness of the initial block. The focal depth of the sculpture in relief, the dimension of the space of the representation, tends to coincide with this thickness; one never notices that kind of indefinite, in-depth lengthening-out that perspective engenders. The surface of the background remains a screen, is focally never carved out in depth or distance. It continues to show itself as surface, either because it remains undifferentiated, uniformly treated, or because it is decorated, or because it has been hollowed out. It is from there as starting point and moving *forward*, that this plastic space should be described, and parallel to the background surface, one can distinguish planes that focally divide, so to speak, the thickness of the initial block.

If the background texture is neutral (*ne . . . uter*), neither decorative nor representational, the focal surface of the background coincides with its

material surface. If the background is decorated, it divides into two focal planes, the plane of the decorative motifs and the plane of the (decorated) background. Representational figures tend to be seen on one and the same plane, which we shall call the figural plane. The relationship foreground-background is in these planes taken two by two, and is that of the figure to the background described by gestalt psychologists; in other words, the relationship of the figural plane to the background and the relationship of the motival plane to the background are not markedly different. If the background is neutral, there are two planes, if it is decorated, three parallel planes divide the focal space of the representation.

It is as if the presentation of the figures was intended not to break this parallelism, but, on the contrary, to consolidate the surface. Now, the principle of consolidation of the surface manifests itself in various ways.

The figures represent people from the front, in profile, rarely from the back, but never, so to speak, from a three-quarter angle. Intermediary presentations, between full face and profile, are made on oblique focal planes, "vanishing" in depth and establishing a link between frontal planes, in a direction that crosses through the background toward focal distances. (It is one of the characteristics of Baroque representation which Heinrich Wölfflin called recessional presentment, or presentation in depth). In the rare cases where figures are seen from the back, the observer does not identify with them, in "empathy," looking along with them into the distance—for there is nothing to see and the eye collides against the background.

When an action that involves several persons is represented, it unfolds parallel to the background, the figures of the persons tend to be presented only on the figural plane; the hierarchy of their sizes does not space them in depth.

It is also through this principle of consolidation of the surface that multiple points of view, as they are called, must be interpreted. In a relief depicting the sacrifice of a bull (Benin), seven out of the eight figures are seen full face and frontal; but the figure of the bull is composed of two profiles and a "view" of the upper part of the head. Speaking of multiple points of view implies the naturalist reference to principles of perspective. But the artistic construction of the figure is so different from the extra-artistic manner in which a real bull is seen that it is better to notice that this figure is exhibited on one and the same focal plane that it shares with the principal figure and which lies parallel to the background. It is as if the construction of the figure were implying no point of view at all. This trait is a paradox. (Its most abstract signification would be that of a representation that has an object but no subject; here, Panofsky takes from his master, Ernst Cassirer, the idea exactly that perspective implies the modern discovery of the subject-object relationship.) We will see this trait again when we consider frontality. (*see* Chapter IV) It is the same process of construction that more generally associates the front and profile of the parts of the represented person (as with Egyptian painting and relief). It is the obverse of a figurative convention whose negative reverse is the absence of foreshortening. It puts the figure on a frontal focal plane, the foreshortening on an oblique plane receding in depth.

Partial covering of one figure by another, which engenders a masking effect, is avoided: a partially covered figure is seen as behind the other. To avoid an overlap is to preserve the immediate relationship of each figure to the background; it avoids splitting up the plane of the figures.

The tendency to avoid both the division of planes and receding oblique planes may be demonstrated by the contrast between a verbal evocation of an acrobatic dance and its representation in relief. In the course of an *isuoko* ceremony in honor of Ogun, the god of iron and war, the *oba* and

the chiefs attend a performance by the *amufi* acrobats in which these display their skills. The preceding night, ropes have been secretly arranged in a tree in such a way that the acrobats, as they twirl and spin around, seem to be flying; this acrobatic dance is described as a war against the heavens. (P. Ben-Amos, 1980) In the relief [fig. 455], the third dimension of the shared space in which the dancers are whirling is reduced, and the figures of the tree, the trunk, the branches and leaves, the ropes, and the people seen from the front are on one focal plane; there is no overlap except for the feet of the ibis and the ropes rolled around the branches.

What we must avoid describing in terms—naturalist ones—of reduction and multiple points of view can be observed not only in one single figure but in different figures representing different things. Another plaque [fig. 98] depicts a musician and his drums. The horizontal plane of the ground, in the common space, on which the two drums placed on a crowned base are resting, and the vertical torso of the player, both merge in this relief into a single focal plane which cannot really be said to represent the first two. Perspective would distinguish between these two orthogonal planes; but another configuration made up of the legs and the two drums and their base would be needed to create foreshortening. The reduction of the two orthogonal planes in the common space to a single imaginary figural plane is a vivid demonstration of the principle of consolidation of the surface.

The differences in the sizes of figures do not serve to space them out in depth: for there is no observer from whom to measure distances who would determine the point of view. The division of the block into focal planes parallel to the background basically belongs to the structure of representation, but it is independent from an observer of the extra-artistic things represented. And these focal planes, corresponding to the perceptive effect figure-background (in which the object perceived is the relief and not the extra-artistic reality) are superimposed one on the other and on the background, while perspective would space the planes in depth. This inversion of orientation has been observed by Kahnweiler in certain Cubist works, especially those by Juan Gris (1946, p. 171); Kahnweiler speaks of superimposed planes and, in order to make allowances for this inversion, suggests inverting the profile of the classical settings in order to accompany the projection of the focal planes starting from the background.

The Subordination of Place to Person

Therefore, one must not expect African reliefs to represent the extra-artistic space in which, however (but undoubtedly only for us), at least certain things that they represent exist. But if we expected it less, perhaps we would in fact encounter it. This less-than-space is the place. Thus we change expectations.

Let us agree upon a definition of place: a portion of space determined or defined by the thing or things that occupy it. In order to use this definition in the analysis of African relief, we must draw four inferences from it: 1) The place is subordinate to the thing, substance, or person that defines it and differentiates it from other places. This subordination is hierarchic among values. 2) One can present a thing without representing its place, insofar as the properties of the thing do not depend on those of the place. 3) One cannot represent a place without the thing that defines it, since without it the place would be only a void without any qualities. 4) Certain things occupied by other things are their place, such as a seat or a dwelling.

123

As to space, it will be defined as the universal place, that is to say, the place occupied by absolutely all things. Since one cannot perceive all things in one glance, space cannot be perceived; it can only be conceived of intellectually. Inversely, place, be it a portion of space or some thing occupied by another thing, is perceived when we perceive this thing.

The two definitions show that the relationship container-contained is fundamental. Only a universal container, space, is able to embody the totality of things, which includes, among others, represented things, the representation (painting or relief) itself, and the observer (artist) and consequently renders possible the Albertian definition of painting (and relief) as the intersection of the "visual pyramid." Traditional Medieval thought was not interested in the relationship—in space—between the thing represented and the observer, as shown by the frequently cited precept of Cennino Cennini: in order to render mountains and their natural aspect well, the painter should obtain some big, rough-surfaced stones that have not been cleaned and copy them directly from nature (Chapter 78) by applying light and shadows as Chapter 75 recommends it be done. The only thing that interests Cennini, a good Aristotelian, is the substance, the stone, and the form of the mountain, not the spatial properties—interdependent for Alberti—that are its size (whether real mountain or stone) and its distance from the observer (in nature or in the studio).

For the most part, African reliefs represent people and some objects without representing their places; all the more reason that they do not represent universal place or space. But certain African reliefs represent both people *and* their places. These alone raise the question: why place and not space?

We have found a reason—without claiming it to be the only one—for this indifference to the representation of space: that is, the attention paid to the value relationships between things at the expense of spatial relationships between things or between things and their observer. This reason may be rephrased: things, their meanings, and the hierarchic relationship between the things themselves have more value than their spatial relationships that may well leave one indifferent.

The idea that all things deserve to be represented and studied in an egalitarian, democratic manner belongs to science. That is its neutrality or objectivity; it puts values, as distinguished from facts, between parentheses. In other forms of culture—politics, war, justice, religion, and art—things are given value and hierarchically arranged; that is one of the aspects of this "super-powerful sense of reality" (*see* p. 47): the invisible, the supernatural, the suprahuman are, so to speak, overburdened with meaning. But it is impossible to represent all things with all their properties; a choice has to be made. In every culture, every region, and in every time period, art elects certain things as "subjects" and excludes others, as a function of the hierarchical position society assigns to them. Thus, there is a kind of—unwritten—entitlement to the image or the representation by which not all things benefit, at least not equally, and which we shall meet with again when discussing the question of the portrait. If, within such hierarchies, people have more value than places, they alone will have a right to the image; if certain individuals have more value than others, they alone, or first of all, will have the right to the effigy or portrait.

In order for a place—or objects serving to delineate a place—to be represented without people, one must recognize it to have a value, independent from that of the people within it, that gives it entitlement to an image. In order for the artistic landscape—absent from African art—to accede to the dignity of a "genre," the extra-artistic landscape must deserve to be represented by taking on a value independent from that of human

beings—as nature, the object of a valued and valuing sentiment: the feeling for nature. The Benin plaques representing the forest are not landscapes; the forest is shown merely as a place for the action of the characters.

The value given to things and their hierarchic position affects the manner in which they are represented—that is the meaning of the so-called hierarchical proportions and of the principle of the hierarchy of sizes. Now, if representing people with and without their place are two different ways of representing them, these too should be related to a hierarchic ordering. The absence or presence of the representation of place depends on the manner in which the person is represented. A person may be represented in a condition or in an action. Two Benin plaques exemplify this distinction. One represents two hunters and two leopards without a place (Hamburg, MfV, C 2301); the figures of the leopards are simply juxtaposed against, not coordinated with, those of the hunters. The other (Berlin, MfV) [fig. 921] represents five hunters and two leopards and their location, the forest, shown by a sort of liana that compartmentalizes the surface and the frame; the figures are coordinated together. [*see* p. 207] A leopard hunter is a state of being, institutionalized in Benin into a guild. But hunting leopard is an action: the second plaque represents a hunting "scene." The representation of the place is subordinate to that of the person, as is the place of the action to the action itself, and the action to the condition. The same is true for the plaque showing the *amufi* acrobatic dancers [fig. 455]. Such examples suggest that the representation of a person in action, and not just in a condition, is the motivation for representing the place of that action, maintaining the principle of subordination of place to person all the way through. But this suggestion cannot be generalized: the plaque representing the sacrifice of a bull, while it represents an action, does not show its place.

In those cases where it is represented, the place is not depicted literally but through metonymy (*pars pro toto*): a single tree or a single liana stands for the forest—or, in another plaque, the door for the palace of the *oba*. The representation of place may be allegorical; a Roman relief, for example, represents the place that is the Field of Mars in the form of a young man. We have not found ethnographic data allowing us to interpret certain figures as allegorical representations of places; it seems, however, that investigators have not raised this question.

Presence and Representation

The question of place has until now only been posed in terms of representation. But in studying the function or use of the plastic object (*see* Chapter III), we shall borrow the distinction between presentification and representation from Jean-Pierre Vernant (1983), and we shall recognize in the former another use or function: conferring a *hic et nunc* presence upon invisible entities or forces in order to use them. The plastic object, then, does not need to represent the place insofar as it is *itself* the place of residence or activity of the entity or force. We shall see that the vocabulary of presentification consists of words or expressions that signify precisely the relationship of contained to container.

However, this function of presentification seems better suited to sculpture in the round than to relief. For if, on the one hand, the entity or the force *occupies* the plastic figure and if, on the other hand, the sculpture in the round *occupies* space, while relief can only (possibly) represent it, one understands that the former is more (if not the only method) appropriate to presentification. Moreover, presentification is often carried out by objects, such as certain fetishes, that in representing nothing do not represent any place.

61 Baoule Statue, Ivory Coast
Wood. Height: 43.5 cm. Private collection;
formerly Rasmussen Collection

62–63 Baoule Couple, Ivory Coast
Wood. Height: 55.4 cm and 52.5 cm. The
Metropolitan Museum of Art, New York

64 Divination Box, Baoule, Ivory Coast
Wood, skin, plant fibers. 19th century. Height:
25 cm. Musée de l'Homme, Paris

65 Animal Figure, Baoule, Ivory Coast
Wood. Before 1930. Height: 47 cm. Private
collection

66 Baoule Mask, Ivory Coast
Wood. Height: 152 cm. Australian National
Gallery, Canberra

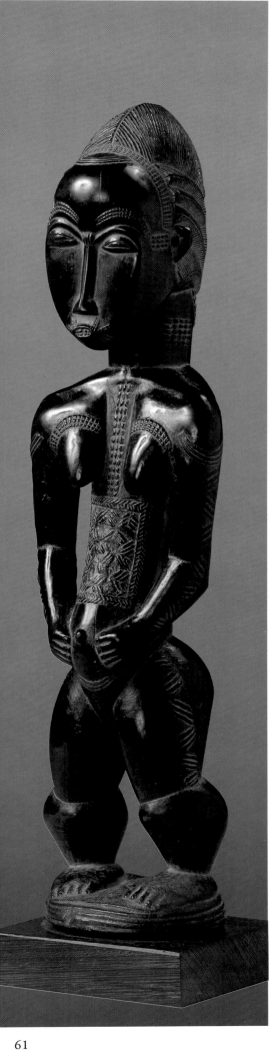

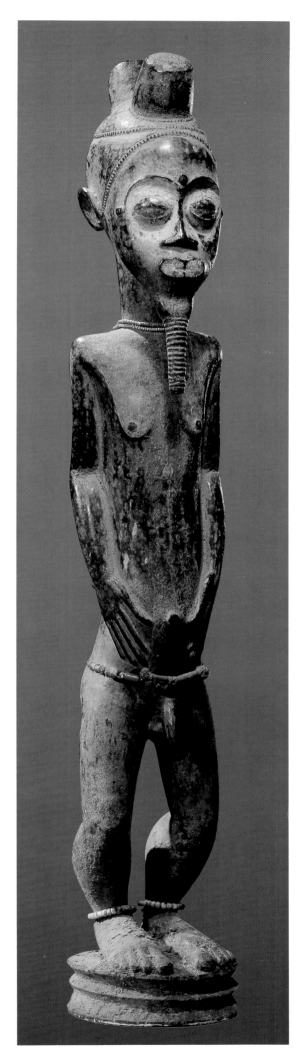

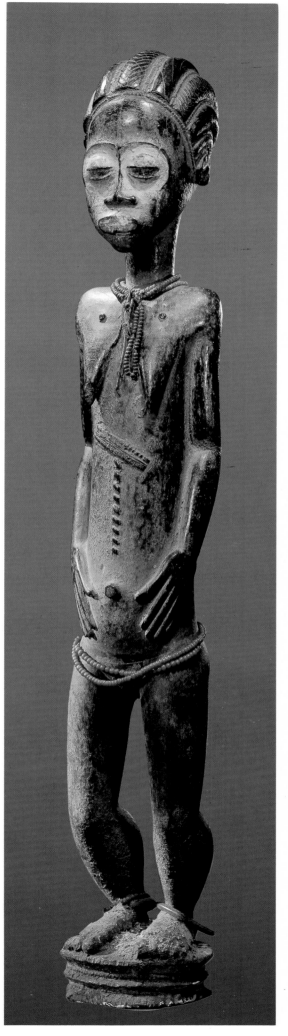

61

62

63

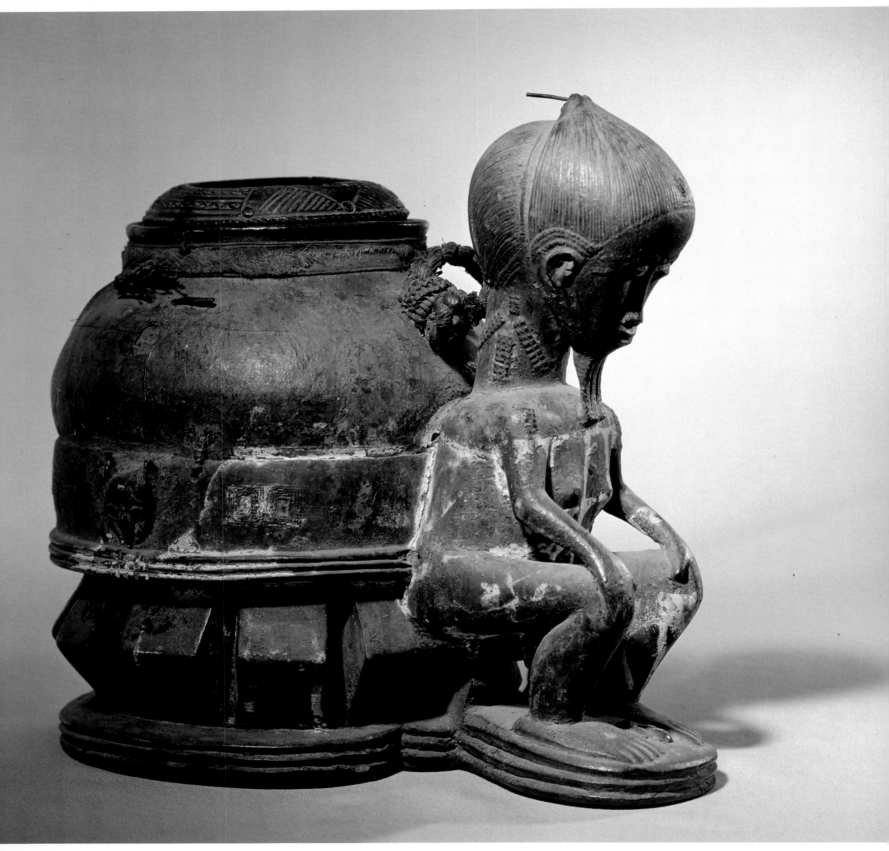

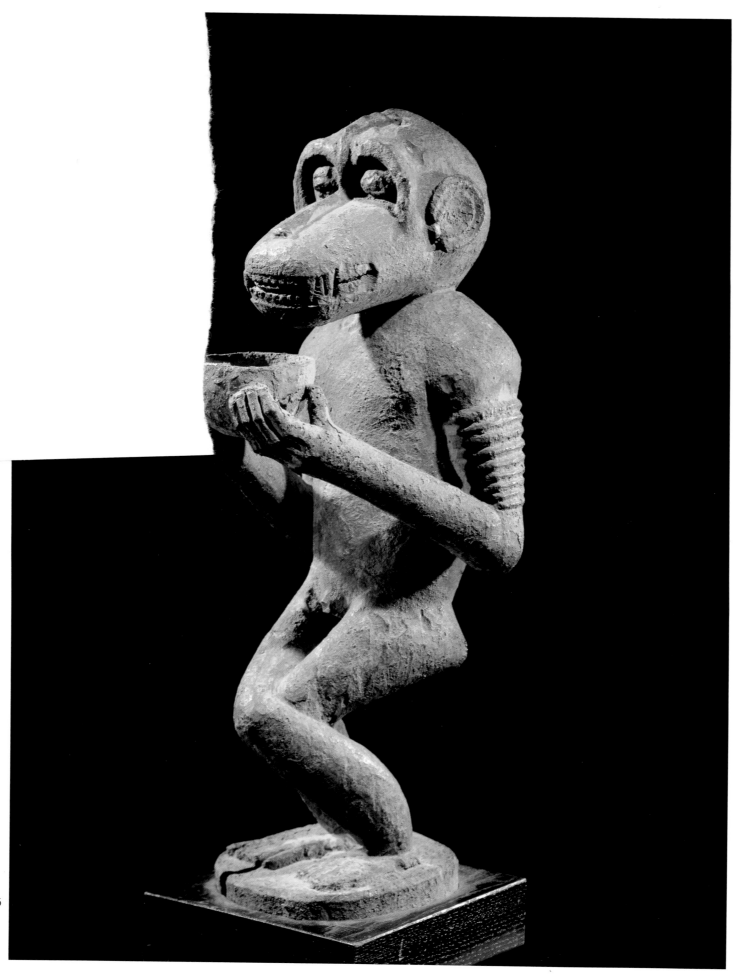

65

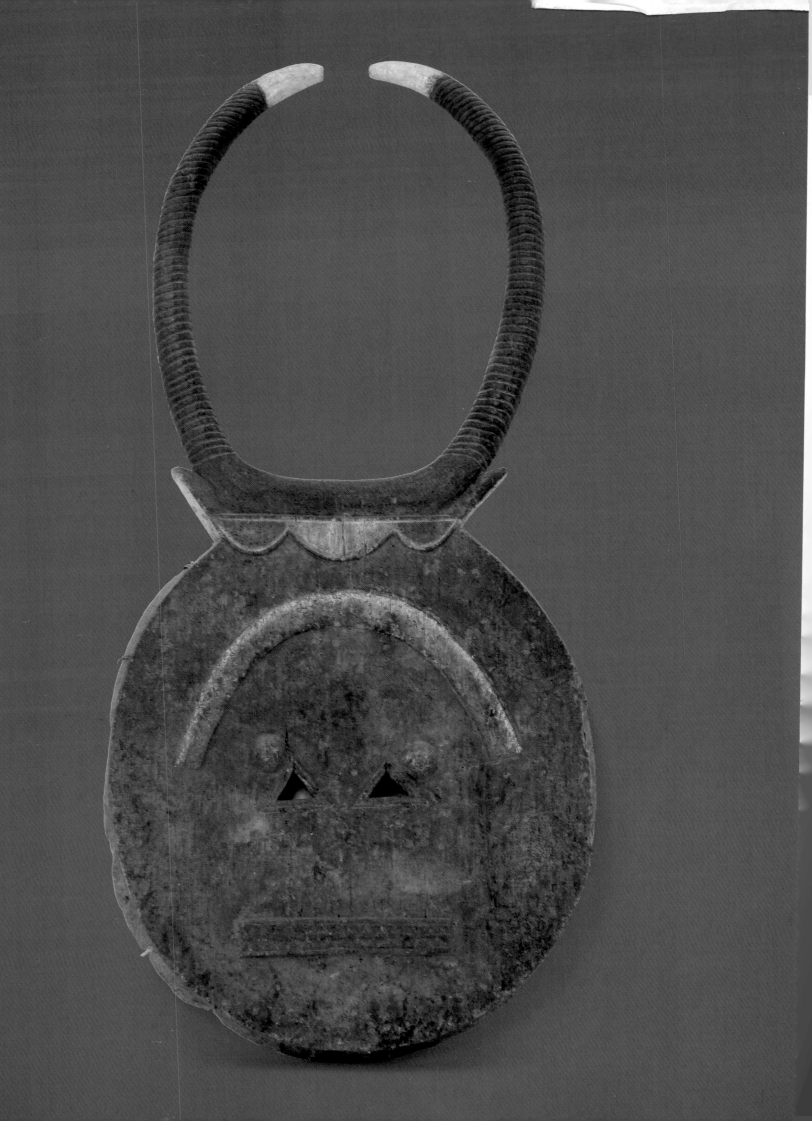

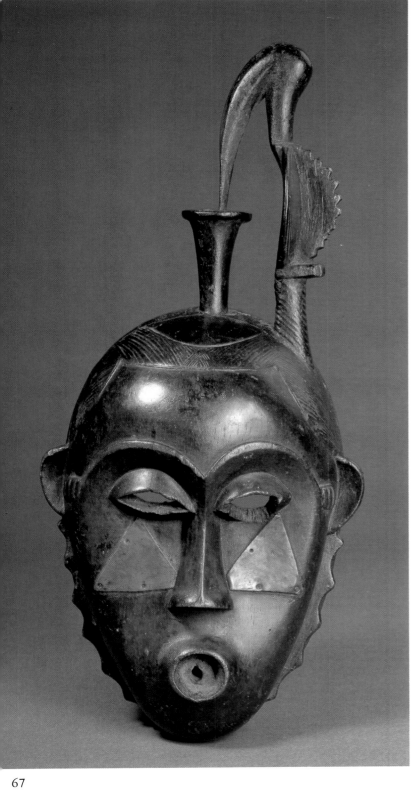

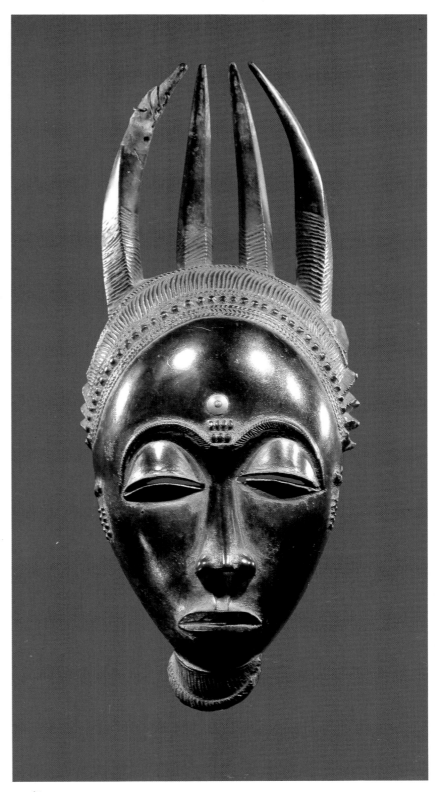

67

68

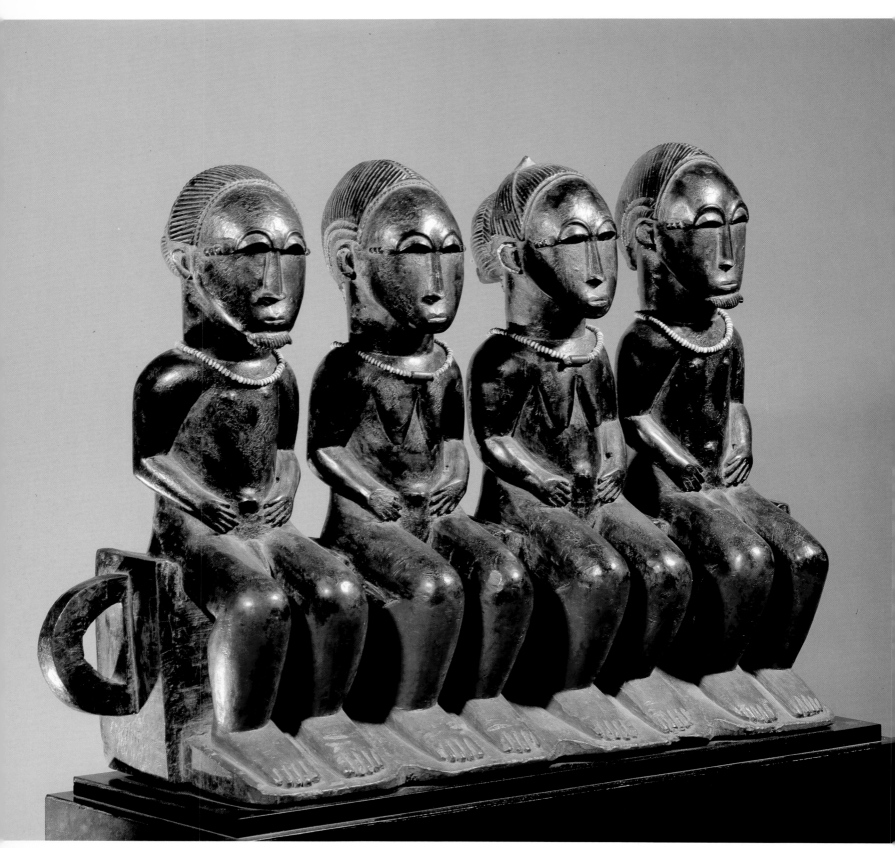

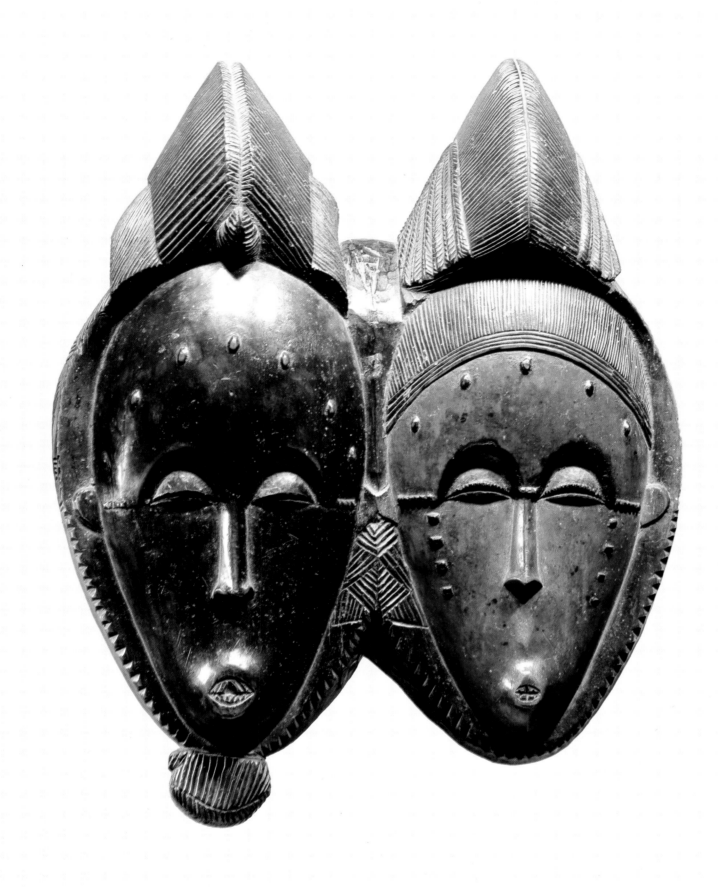

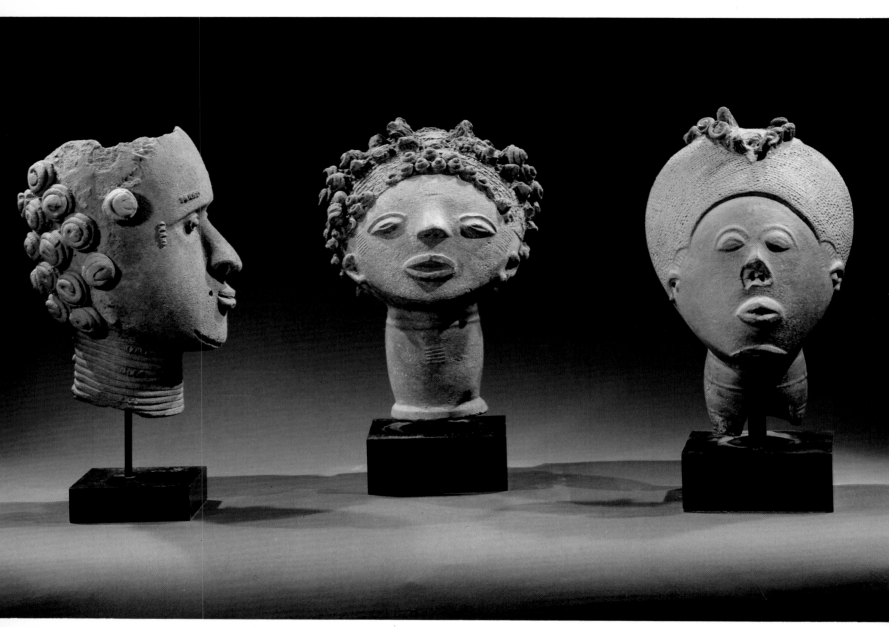

71-73

67 Yaoure Mask, Ivory Coast
Wood. Height: 40 cm. Musée des Arts Africains et Océaniens, Paris; formerly P. Guillaume Collection

68 Baoule Mask, Ivory Coast
Wood. Height: 38 cm. Private collection

69 *Akissi Ble* Figures, Baoule, Kouadjo Bonikro Village, Ivory Coast
Seized during the repression of the 1910 rebellion. Wood. 19th century. Height: 36 cm. Width: 47 cm. Private collection

70 Baoule Double Mask, Ivory Coast
Wood. 19th century. Height: 35 cm. Private collection; formerly P. Guillaume Collection

71–73 Akan Heads, Ghana
Clay. Height: 25.5 cm. Width: 16.5 cm. Aowin style, 18th century. Height: 28 cm. Width: 19 cm. Fomena Adauze style, late 18th century. Height: 27.5 cm. Width: 17 cm. Fomena style, 17th century. Private collection, Belgium

74 Asante Head, Treasure of King Kofi-Kakari (1867–74), Ghana
Gold and lost-wax casting. Height: 18 cm. Wallace Collection, London

75 Gu, the God of War, Fon, Republic of Benin
Forged iron. Height: 165 cm. Musée de l'Homme, Paris

76 *Vodun* Statue, Fon, Zaganado Village, Republic of Benin
Wood, iron, terra-cotta, blood. Height: 90 cm. Private collection

77 *Vodun* Statue, Fon, Ouidah, Republic of Benin
Wood, sacrificial patina. 19th century. Height: 44 cm. Private collection

78 Anago Abdominal Mask, for the *Gelede* Cult, Republic of Benin
Wood. 19th century. Height: 85 cm. Müller Foundation, Insel-Hombroick, Germany

79 Yoruba Shango Maternity Figure, Nigeria
Wood. Height: 71.5 cm. The Metropolitan Museum of Art, New York

80 Bini Ram's Head, Owo, Nigeria
Wood. 19th century. Height: 42 cm. Private collection

81 Yoruba Seat, Nigeria
Wood. Height: 47.5 cm. Private collection

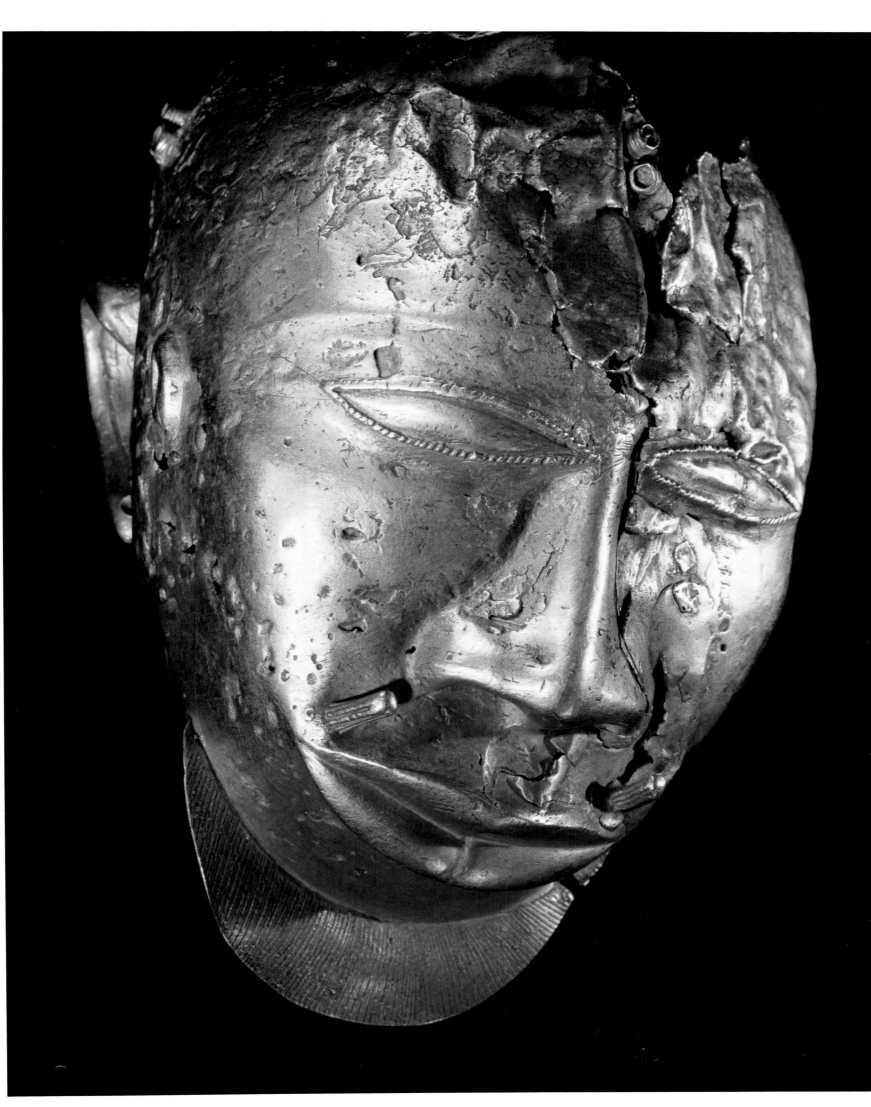

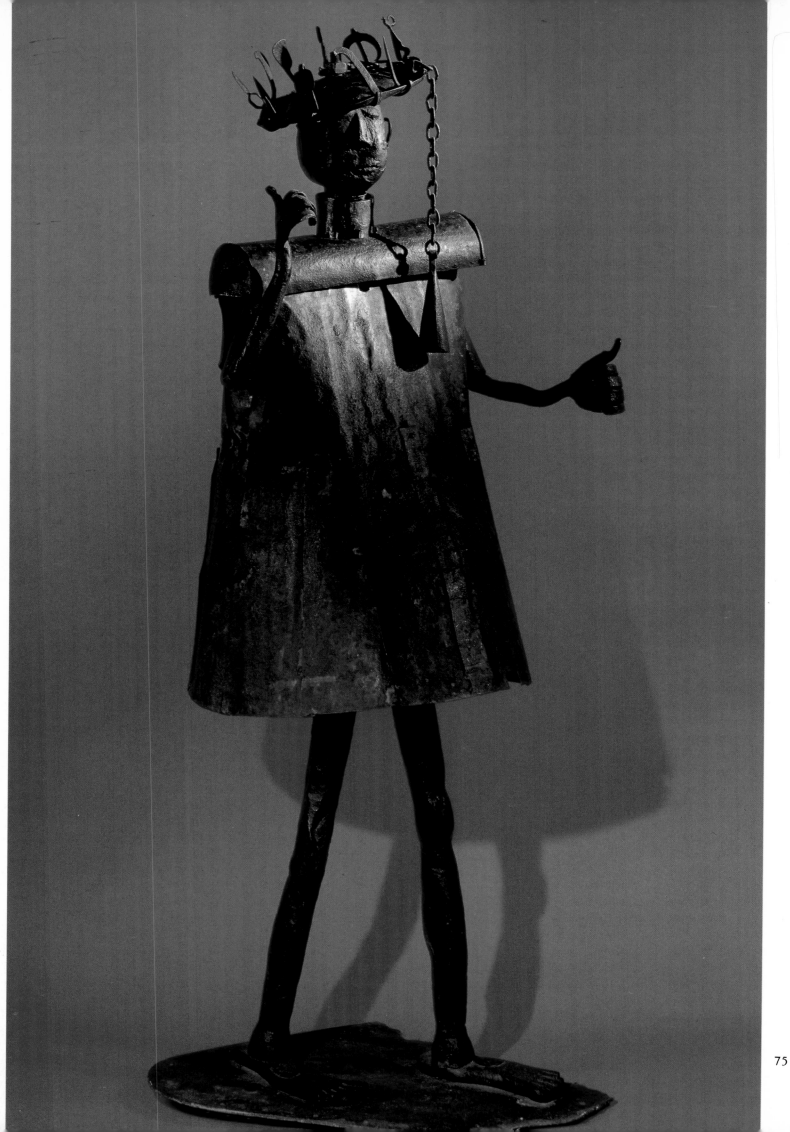

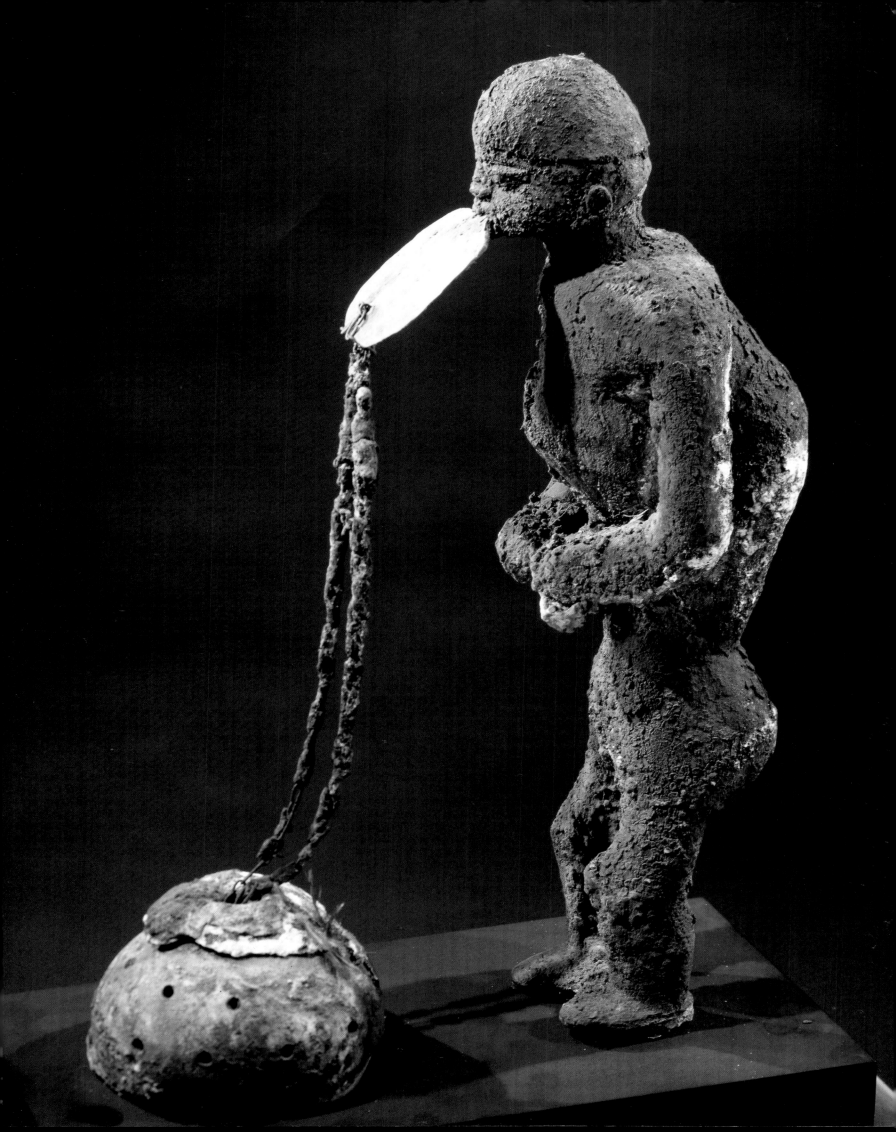

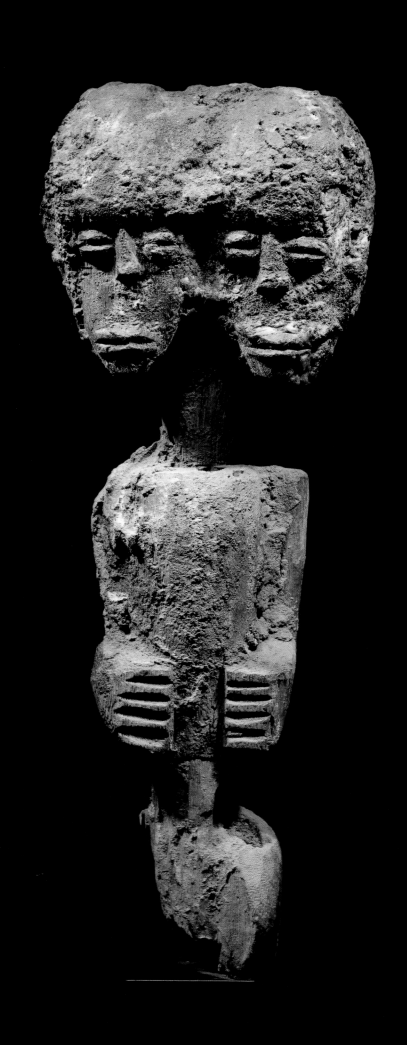

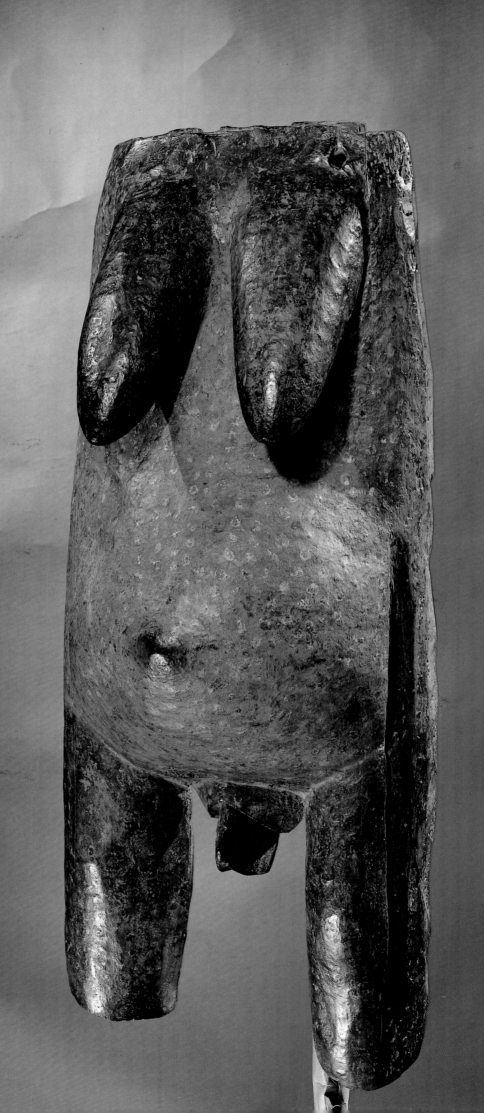

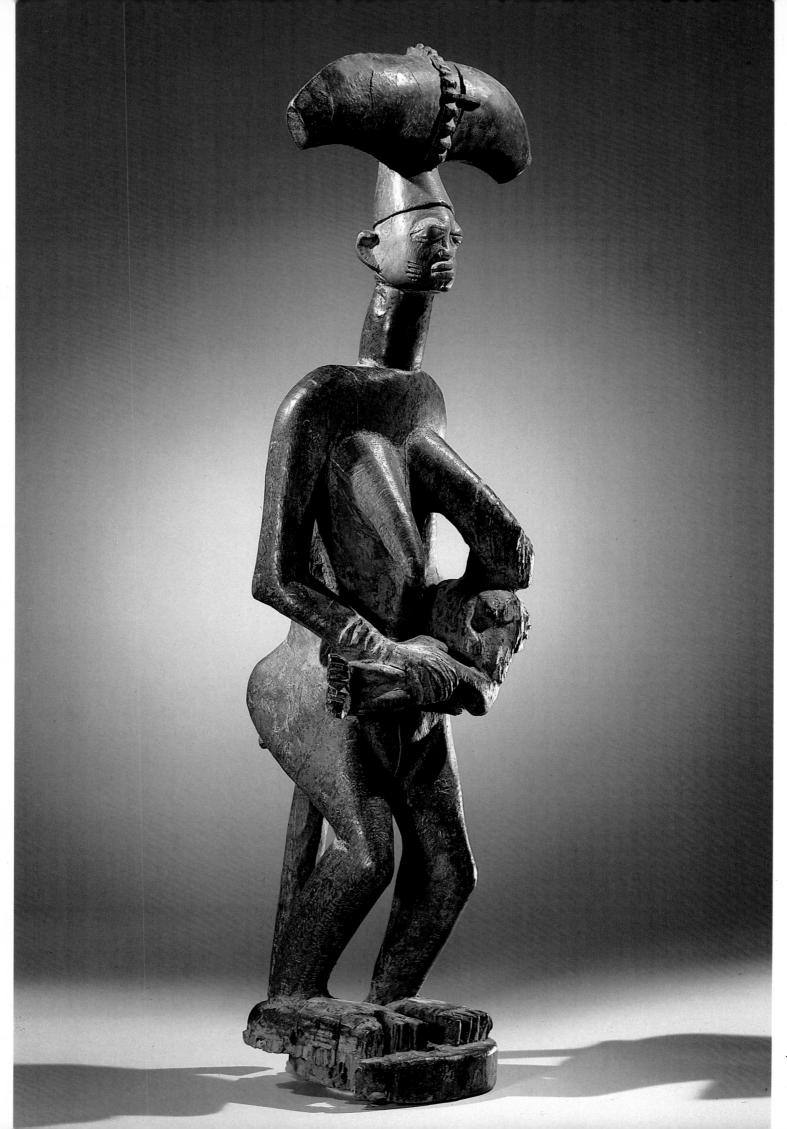

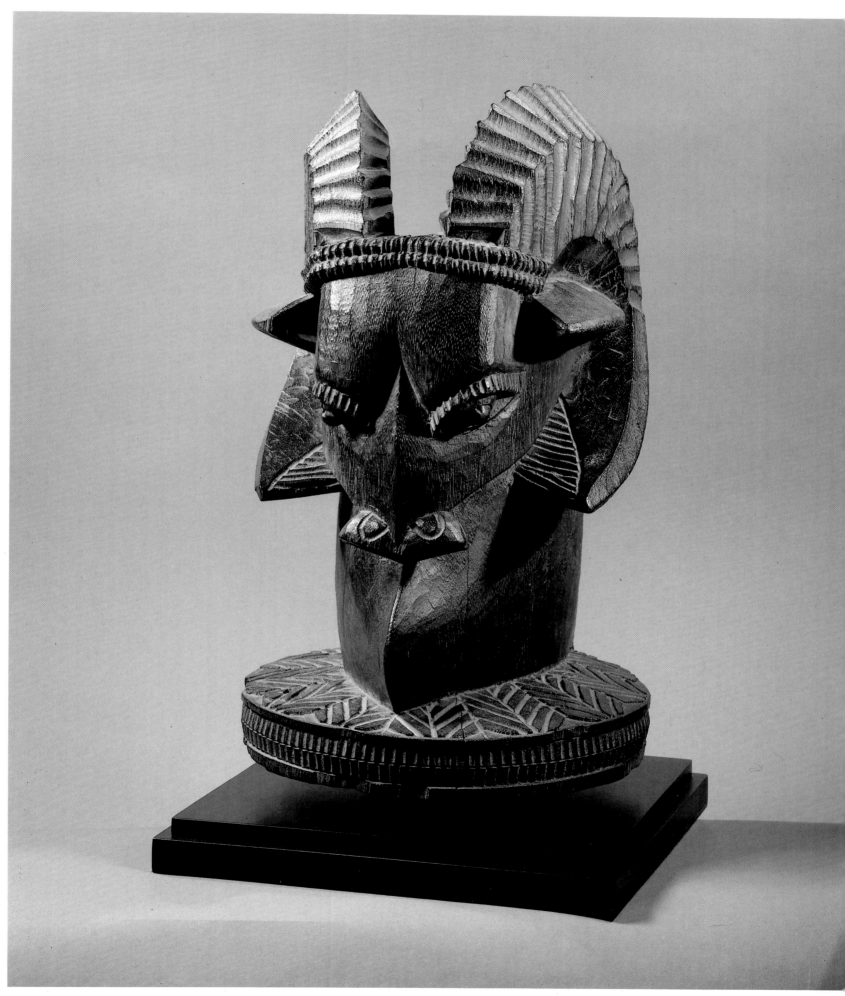

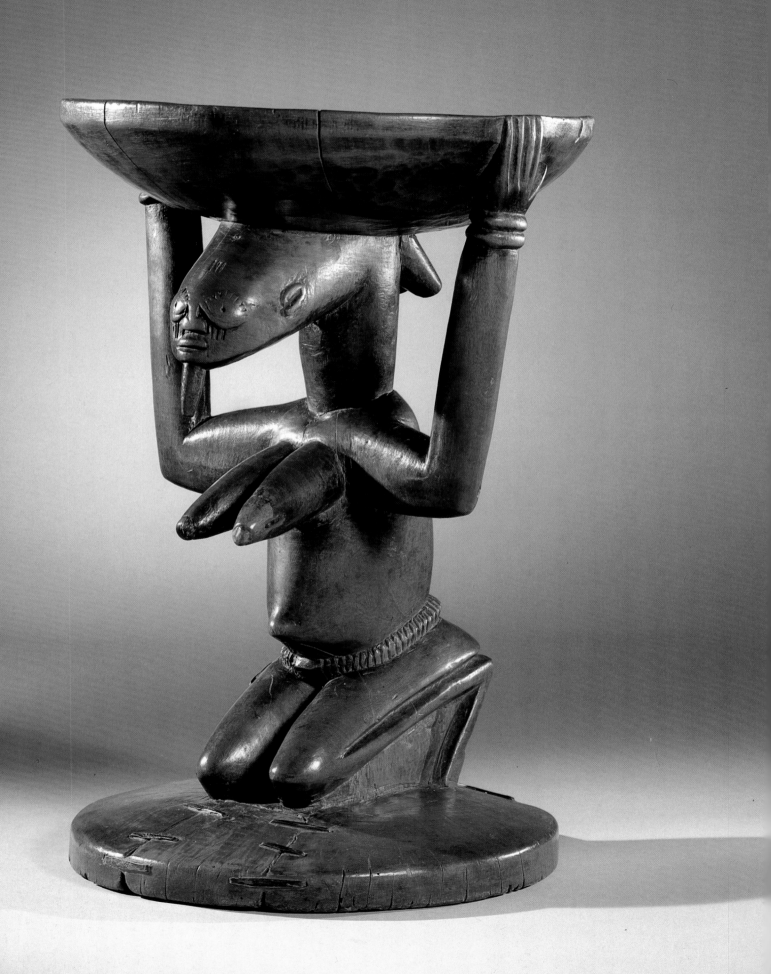

The Representation of the Individual

The Question of Portraits

Does traditional African art know portraiture? The answer depends on the meaning given to the word. (S. P. Blier, 1982) In a narrow sense, a portrait is a painted or sculpted representation of the physiognomy belonging to (most frequently) a human individual. Images thus defined are far from having been produced always and everywhere; those for which this definition was made belong primarily to two periods of Western art, both naturalist—Roman art and Christian art from the end of the Middle Ages. If the question uses "portrait" in this sense, it cannot avoid being ethnocentric. It is also not surprising that it is seriously raised about only a dozen or so African styles and that the answer remains uncertain: the use of the term is coupled with a series of restrictive suggestions intended to correct ethnocentrism.

In a broad sense, "portrait" designates simply the representation of an individual. Here, answering the question no longer raises a problem: in the majority of African styles, if not all of them, images exist that represent individuals, human or not. But works that are not only very different from Western physiognomic portraits but also from each other would be put in this category. If one no longer risks excluding works different from the European portrait, on the other hand one now ignores the differences between them by incorporating them all. That is falling from Charybdis into Scylla: the narrow sense is too narrow, the larger sense too large and too vague.

The broad sense defines a genus; the narrow, a species of that genus, the specific difference being the physiognomic resemblance. Thus, one can see that it is a question of two clearly demarcated concepts. (*see* Chapter I)

We propose to show that each one of the properties of the physiognomic portrait enters into an opposition and that between the two poles thus opposed intermediaries slip in. Therefore, we will have predicates of family resemblance available that permit us to sketch out a family of the portrait, or rather, a family of the individual effigy.

The Properties of the Physiognomic Portrait

The referent of the portrait is an individual. In logic, individual is the opposite of genus. So an image may represent a genus, having a generic referent, for example, a king, a saint, or a hunter in general, and not this king, that saint, that hunter. One speaks then in terms of representation, of a generalized image or effigy. But degrees of generalization exist: between the individual Socrates and a man in general are situated the Athenian and the Hellenic Greek. Thus, one distinguishes genus, species, subspecies, type, in decreasing order of generality. This logical and differential determination of the referent allows us to construct a series of intermediaries between the effigy with a general referent and the portrait with an individual referent.

Therefore, within the framework of a naturalist art, the effigy can, little by little, come closer to the portrait—so close, even, that it becomes difficult, if not impossible, to decide by looking at the sculpture alone whether it is a portrait or not in the strict sense. Leon Underwood (1949, pp. 27–28) distinguishes three "racial types"—in the sense of physical anthropology—among Ife heads, which he calls "Moorish," "more Egyptian," and Negroid. But within each of these types, differences between facial characteristics are perceptible. Do they correspond to actual, different models? The author notes, by comparison with a living person, that "the resemblance to the Oni's daughter is closer than just

racial resemblance"–thus suggesting an individual resemblance. But Willett (1967, p. 28) allows the hypothesis of a resemblance between individuals belonging to the same family; and so a familial type slips in between Underwood's racial types and individuals. The differences between sculpted heads may be the result of different artists' hands (F. Willett, 1967, p. 29) or of the fact that the same artist representing the same individual may not produce two perfectly identical works.

This last point must be emphasized. Contrary to what is often thought, even mass-produced products are not perfectly identical; a careful examination with appropriate means allows differences to be detected, which are tolerated as long as they do not interfere with functioning or use. (G. Simondon, 1969) This is all the more likely to be so when the production is a manual one; in this regard artistic production must be compared to natural production: two oak trees or two leaves of the same oak tree are very appreciably different. Without that, how can a well-done fake be distinguished from the authentic original? In other words, the product is a unique individual and if that product is a representation, a distinction must be made between the individuality of the representation and the individuality of the referent. Furthermore, the plastic object is individual even when it is not representational.

A second property of the portrait is physiognomic resemblance. The portrait represents in its individuality the physiognomy, the corporeal aspect, and, most specifically, the face of an individual. But resemblance is not identity; to act as if it were, is one of the illusions of coarse naturalism that engenders another: the statuary of cathedrals, observes Henri Focillon, "offers us more than one example of those human effigies that exude authenticity and whose physiognomic expression is so definite that they impose a feeling, illusory and despotic, of resemblance on us." (1947, p. 230) Physiognomic or individual resemblance is not an intrinsic property of the effigy, recognizable at the mere sight of that effigy— because resemblance admits of degrees. Also, Underwood, himself a sculptor, takes pains to compare a sculpted head and a face before deciding upon the degree of resemblance.

To the degree of logical generality of the referent correspond, in naturalist styles, degrees of resemblance, in such a way that it would be desirable to be specific by distinguishing resemblances of genus, species, type, etc. But if the diagnosis can only be comparative, it is all the more difficult and hazardous in the present case where the comparative, historical, and ethnographic data is more rare.

The other properties of the portrait are the outcome of the two preceding ones. The portrait is real; in order to render physiognomy, it must be observed and one can only observe a real individual, present in the flesh. Thus, the portrait is drawn from nature or life. Yet, an artist who has mastered the craft or art of portraiture is able to render and individualize the physiognomy of a referent who has never existed. Then the portrait is imaginary. It comes out of illusionism and furnishes one of the reasons behind Focillon's remark.

Now, between the imaginary portrait and the real portrait drawn from life, one can mention, gradually distancing oneself from the direct relationship between portraitist and model, the portrait made from a death mask or from a portrait drawn from life; from a more or less elaborate sketch; or from a replica of a portrait drawn from life from which one may draw yet another replica. The primary resemblance will probably be weakened.

The artist can also visualize verbal, written, or oral information. Certain societies greatly value information that comes from sources other than perception, such as dreams, visions, or apparitions. Our empirico-rational

notions of observation then, of reality and realism, are no longer completely pertinent. According to certain traditions, fidelity or resemblance is insured by ways other than the imitation of the observed model. This is the case with acheiropoietic images produced by direct contact between a face and the medium. In the Christian tradition, certain acheiropoietic images are seen as physiognomic portraits originating in a legendary or historical series of replicas of replicas. The referent of the effigy can also participate in its production by him or herself indicating, either through a dream or through the mediation of a diviner, the manner in which he or she wishes to be represented. Among the Baoule, according to Vogel (1980), certain spirits ask to be represented with traits opposite to those they possess. Finally, even that which seems to us to be an observation of the model may be used in a way other than what we expect, the observation of one individual serving to create the image of another. (S. P. Blier, 1982, p. 81)

Therefore, there are many ways of crossing the boundary one is tempted to draw between the real portrait and the imaginary portrait. The position of the boundary depends on the manner in which a social group conceives of reality.

Two other properties of the portrait, its realism, as opposed to idealization, and its literal or allegorical character, will be examined a little later on.

Individuality and Identity

An individual is unique; two individuals cannot be identical and indistinguishable. When one wants to classify individuals, one abstracts their differences in order to enter them as members into sets, classes, genera, species, and so on, to which they are said to belong. It is possible to define sets of only a single member thus determined or marked as an individual. Defined this way, individuality is a formal and logical property.

Let us agree to call identity the content corresponding to this form, that is to say, the properties that an individual, I, possesses, since it is by mentioning them that one will answer the question: who is that individual I?—a question aimed at finding that individual's identity. It is clear that identity is complex.

The notion of the portrait leads to distinguishing between, provisionally, physical or physiognomic identity and social identity, including other elements of identity. Indeed, it is the painted or sculpted portrait that suggests this distinction, for physiognomic identity is directly representable by the painting or the sculpture, while the elements of social identity are only indirectly so; inversely, the verbal or literary portrait does not have to treat corporeal and social identity differently.

The properties that constitute corporeal identity are physiognomic traits; those that constitute social identity are indirectly represented by things associated with them in a given social group; for example, a crown is associated with the property of being monarch, an element of the social identity of a given individual. In iconography, these objects—as well as their representation—associated in a conventional fashion with social properties are called attributes.

Nevertheless, this distinction between physiognomic properties and attributes must be refined; physiognomy and corporeal identity are not exactly the same thing. The etymology of the word physiognomy implies the idea of nature; strictly speaking, physiognomy would be the *natural* corporeal identity. Now, it is not certain that this, in its pure state, is observable; can one, for example, observe what a head of hair would be in its pure state, never having been groomed? The body is not left in its

natural state and development; it is modified by traditional techniques that vary from culture to culture. (D. Paulme and J. Brosse, 1956) These practices are known: mutilation of certain body parts such as the teeth; molding of the baby's skull (lengthening it among the Mangbetu) [figs. 653, 654, 656]; lowering and stretching of young women's breasts; dilating the lips or the earlobes by inserting objects of increasing diameter [fig. 339]; incising the skin in such a way as to control the shape of the scar tissue on various parts of the body [fig. 179]; and tattooing and body painting. Now, these modifications of the body, whether permanent, long-lasting, or ephemeral, very frequently are bodily inscriptions of certain elements of social identity. Scarifications, for example, indicate that one belongs to a tribe or a lineage. Among the Luba, the female hairdo, which is very elaborate and which may be kept for several weeks due to its structure and the use of a neck-rest during sleep, is a sign of high social rank [figs. 703, 711]. This list is by no means exhaustive.

These cultural modifications of the natural body must figure as intermediaries between physiognomic traits in the strict sense (such as the racial types Underwood uses) and attributes (clothing, jewelry, weaponry, utensils, etc.). Just as with physiognomic properties, they are directly representable; as with attributes, they come out of social identity. The three kinds of properties may be common among several individuals, or belong to only one, that is to say, are themselves individual.

Individuation of the Referent

Comprehensively, one defines a set by stating a property that each individual must possess in order to be a member of this set or to belong to it. The range of the set is the number of individuals who, by possessing this property, belong to it. The property is therefore generally true for or common to all its members. An individual possesses n (number of) properties and can belong to n sets. Let there be a property $p1$, defining the set $E1$, with a range of $e1$. . . and a property pn, defining En, of the range en. The conjunction of the properties $p1$, $p2$. . . pn defines the set I of the individuals possessing these n properties. So, this set I is the intersection of the sets $E1$, $E2$. . . En. When the number of properties grows, the range of the intersection I decreases. Then one can join properties p until the set I no longer has but a single member, i, who is then logically determined as an individual. Since each one of the properties p is a general or common one, one can see that common properties, joined in sufficient numbers, allow us logically to determine and refer to an individual. This procedure is a general and formal one; it is specified by giving the details of the content or nature of the various properties p used in conjunction ($p1$ and $p2$ and . . . pN). The effigy and the portrait use physiognomic (natural) properties, culturalized corporeal properties, and/or attributes. These three kinds of properties are numerous enough to suffice for the individuation of the referent.

In order to be able to represent these corporeal, natural, or culturalized traits and these attributes, they need a foundation or a substratum, if only a very simple schema of the *figura humana*. But lacking such a schema and by conjoining attributes, one can produce an image that refers to an individual. This is the case with the individual coat of arms that shows that the individuality of the referent of an image might not suffice to define the portrait (in the larger sense) without leading to an abusive use of the word.

If the representation of general properties allows the individuation of the referent, the result is not the exclusion of individual traits. The use of these may complete the process of individuation (as in the case of the royal

effigies of the Kuba, analyzed below), or may be redundant. Edmund R. Leach (1971, p. 243) emphasizes that in ritual sequences executed in their entirety, redundancies are numerous. On the other hand, according to the cultural context in which they work, and especially according to a demand by the users or commission from a patron, artists may stop this process of individuation before its end. They then produce a generic effigy which the specialized literature often calls the generalized image or representation. Of course, that is the case when the entity to be represented, an ancestor, spirit, or divinity, is itself not individualized (as with choirs of angels, or groups of cupids).

The best example—thanks to available documentation—of this individuation process is furnished by the royal statues (*ndop*) of the Kuba. These statues may be classified into several types according to the differences in what we have called the substratum. But in every case one can distinguish two kinds of attributes: constant, common attributes and one variable, individual attribute. The former, which are found with every sample, jointly have a referent identical to the expression "Kuba king." They consist of the following representations: 1) the cross-legged sitting position, an indication of superior rank; 2) a royal dais on which the figure sits; 3) the royal headdress with visor (*shody*); 4) a shoulder ornament (*paang angup*); 5) a bracelet around the upper arm (*shop*) and around the forearm (*ntshyaang*); 6) a cross-belt (*yeemy*) decorated with cowrie shells and running across the abdomen; 7) a covering for the buttocks (*mbyo*); 8) a royal sword held in the right hand. One sees the redundance of the determination "Kuba king" of the referent. A variable and individual attribute completes the individuation of the referent: the individual emblem (*ibol*) of each king. (J. Cornet, 1982) It is placed conspicuously in front of the anterior side of the royal dais. The corporeal aspects represented are not individual, with the exception of a slight indication of layers of fat in the neck in addition to the normal obesity, an ideal of Kuba kings. (J. Vansina, 1984, p. 111)

One can see how the representation of individuality and the individuality of representation are distinguished and deployed. The iconographic elements we have just reviewed and whose logical composition we have described are so many ways of representing a given Kuba king in his individuality. Let us now compare the various statuettes, their common iconographic elements, such as their belts or their headdresses: there are not two that are perfectly identical; they differ in the way they have been sculpted. It is those differences that individualize each one of the statuettes and also confer upon each one its different aesthetic value.

The individuation of the referent of generic effigies can operate through other means.

DENOMINATION First, there is the denomination, the verbal individuation of the referent. It may be written or oral, depending on whether the social group does or does not have written language. Aristotle observed that the "early painters" who had not yet mastered the art of imitation made up for that lack by inscribing the name, thus allowing for identification of what they were representing. (*Topics*, VI, 2) Verbal denomination is transmitted by tradition. Colonization introduced writing into Africa. Ulli Beier published (1960, pl. 9) a brass plaque, offered to the king (*oba*) by the traditional guild of smelters of the city of Benin to commemorate Queen Elizabeth's visit. There are four inscriptions in relief on a united background: "Royal Tour Visit. 9.2.56," which is the commemorative inscription proper; "Queen Elizabeth"; "Oba Akenzua II and Sir John Raki [. . . ?] Governor"; "Chief Awolowo Prime Minister."

Each inscription has two elements: one element of social identity, the political function, in redundancy with each effigy, and a proper name, which achieves individuation for the purpose Aristotle indicated.

In a manner that is both more traditional and more subtle, verbal individuation may take the form of a rebus which, "by means of pictured objects or arrangements, expresses the sounds of a word or an entire sentence." (*Littré*) The rebus requires oral denomination, the actual pronunciation of the proper noun, which circumvents the inscription. For example, a Fon image (J. Laude, 1966, p. 317) represents a butcher's meat hook, called *hu*, and a razor, called *ha*, the pronunciation of which contains the proper name *Huha*. In the city of Abomey, Cyprian Togudagba is a painter who adapts Western means to traditional intentions. Edna G. Bay has published (1975, p. 26) two paintings, one of which represents a lion and the other a ram, respectively matched with the inscriptions "Glélé" and "Guézo," two *noms de règne* of two Fon kings; here the inscription glosses a traditional allegory.

INDIVIDUATION AND USE Then, too, the individuation of a referent may be the fact of its use. Who does not remember having a doll or a stuffed bear which was considered to be the most irreplaceable of creatures; we wept over its disappearance and refused any replacement. Thus, some of our games individualize generic objects, sometimes giving them proper names.

We have a tendency to forget this manner of individuation, to exactly the same degree that we observe effigies isolated from their context of use; we then expect them to individualize their referent solely by representational means, while their use is a customary or ritual activity. By analogy with linguistics, the first kind of individuation comes from semantics and syntax, individuation through use from pragmatics.

Users may behave toward an effigy as they would toward the individual it represents in ritual or customary fashion codified by society. When the effigy's referent is not individualized by attributes, but when it is use that implies its individuality, one can assume it is the behavior of the user that achieves the individuation of the referent. Among the Yoruba, the images of twins (*ere ibeji*) [figs. 430–35] are not physiognomic portraits; they represent very young children without representing their childlike aspect. Yet, the mother of a deceased twin behaves, under certain defined circumstances, toward the image as she behaves toward the surviving twin and, thus, as she would behave toward the dead twin were he or she still alive: she dresses it, feeds it, and carries it on her back. (R. F. Thompson, 1971, Chapter XIII)

PRESENTIFICATION AND INDIVIDUALITY Restoring the effigy to its context of use leads to considering a relationship between the effigy and an extra-artistic individual, different from individuation through the behavior of the user or from representation: this is presentification. The invisible individual, present in the effigy, gives it its own individuality. Then the plastic object *is* an individual, and, in a totally coherent fashion, the user behaves toward it as toward an individual.

Presentification and representation may be joined or disjoint.

The finest example of presentification without representation is undoubtedly the golden stool of the Asante. According to a creation legend (H. Cole and D. H. Ross, 1977, p. 6) it descended from heaven one Friday: "this stool . . . contained the spirit of the whole Ashanti nation; it is called *Sika Dwa Kofi*, the golden stool born on Friday" (p. 137)

In a recent study of the Bamana *boli*, Jean Bazin shows how the production of the object and the individuation presentified therein

constitute one and the same process; a *boli* "has its own history . . . a completely unique history . . . that may be evoked by narratives" and, finally, "the principle that presides over its production is individuation, not representation" (pp. 260–64).

Two factors tend to make us forget these last two modes of individuation of the referent of the effigy: first, the isolation of the object, separated from its context of use; then, the naturalist interpretation that privileges representation.

Idealizations

An effigy is realistic to the extent that it represents its model exactly or faithfully without any intentional modification. But one can state that no real individual is devoid of flaws or imperfections and that the representation can and must eliminate or correct these. In order to eliminate flaws, one must first detect them and in order to detect them, one must have criteria of values available. Flaws are properties of the actual, individual model and vary from one individual to the next, while the values that serve to detect them are, in principle, applicable to all actual individuals; the result is that idealization tends to coincide with a certain generalization and leads one to speak in terms of an ideal type. Another result is also that idealization admits of degrees, individual flaws being more or less numerous and, consequently, the gap lesser or greater between individuals as they are and as they ought to be.

Since flaws or imperfections are corporeal traits, idealization affects corporeal identity. On the other hand, as a first approximation, one may consider the criteria applied to real individuals to be aesthetic: to idealize, then, is to embellish. But the aesthetic significance of these criteria must be specified. (*see* Chapter IV) In the societies studied here, values and criteria are not purely aesthetic but are associated with values that are, to us, utilitarian or functional: political, religious, magical, martial—in short, social values.

If aesthetic values are intimately linked to social values, since the latter vary from one society to the next, the aesthetic values and criteria intervening in the idealization will also vary. In fact, it is not only African aesthetics, but also the idealized forms among themselves that differ, and each one of these differs from Western aesthetics and idealization— assuming that Western idealization and aesthetics are singular. In fact, too, only Ife art presents a form of idealization that is comparable to Classical idealization.

Idealization affects corporeal identity by subordinating its representation to the elements of the individual's social identity. The mediation between corporeal identity and social identity is enacted through "aesthetic" values. On the one hand, these values (such as the "beautiful and good") are held as properties by the represented individual and, on the other, intervene as aesthetico-religious, political, and other criteria in the process of idealization.

individual	social identity (properties)	←	social values		cultural diversity
			↓		
	corporeal identity (idealization)	←	aesthetico-social criteria		

151

The interpretation of idealized form thus will have to determine, on the basis of ethnographic or historical data, the criteria of idealization by integrating them with different aesthetics, and possibly ones different from naturalist aesthetics. The present observations do nothing other than make room for further inquiry. (*see* Chapter IV) The Greek model associates idealization and naturalism. Therefore, forms of idealization must also be admitted that are associated with moderate naturalisms, and even dissociated from naturalism. Thus one understands how idealization, motivated by values important to a given social group, may take away any interest in representing an actual individual with his or her flaws and imperfections.

As "mixed," aesthetico-social, values vary culturally, so the misreading of these variations can engender misunderstandings or misinterpretations.

For example, let us consider the relationship between aesthetic properties and erotic values. Our society—and it is not the only one— assigns two ends or two functions to eros. First there is a biological function, the reproduction of the species, the condition for the survival of the social group; the value is a collective one. Then there is a hedonistic end; the value, which is pleasure, is an individual one. One may mention here the Freudian distinction between what is genital and what is sexual. In certain African societies, or more exactly in their ideologies, in the ways in which they represent their values (which ought not to be confused with daily practices), hedonist sexuality not only is not dissociated from reproduction, it is associated with other social behavior with which it shares the value of fertility. The fertility of women and the fertility of the earth, sexual behavior and agriculture, are thus united. Hence, the good health of the divine king, for example, jointly guarantees the abundance of births and harvests.

It is, then, proper to pluralize idealization, by reason of the plurality of ideal values that call forth idealized forms, and in order to be able by degrees to recognize idealization elsewhere than in naturalist styles. We are thinking, for example, of those effigies to which Fagg applies the terms *gravitas* (1964, p. 140) or *majestas* (1981a) and which, like some Dogon statues, one would be hard put to call naturalist. [fig. 276]

That idealization involves values that are not purely aesthetic results in its being selective in several senses. First, as we have seen, it selects the traits represented by eliminating flaws or imperfections. Signs of aging or illness are thus avoided; the same holds for aspects typical of childhood, insofar as the child is seen as an imperfect adult.

In the second place, the criteria of idealization not being aesthetically pure, elements of social identity—carriers of values—have a tendency to be favored over corporeal traits. Now, it is only to these latter that we attribute purely aesthetic properties. We shall come back to this point when we examine African aesthetics. (*see* Chapter IV)

Idealization is selective in another sense; no longer is it a question of selecting the traits of an individual that will be represented, but the individuals themselves. Social values put the individuals within a group into a hierarchy. The social inequality of the individuals takes the form of an inequality before the representation. The social hierarchy results in an *entitlement to the image* that is restrictive (*see* Chapter III) and whose truly judicial model is the Roman *jus imaginum*. (P. Bruneau, 1980)

Idealized representation may be reserved for individuals, human or not, who eminently possess the social values it involves, while those individuals who do not possess them or do to a lesser degree, will be pictured otherwise. In such cases two styles, one idealized and reserved for the depiction of an aristocracy, the other nonidealized, realistic, and reserved for the ordinary people, coexist not only within an artistic ensemble, but

possibly within the same sculptural group. In Ife art, and especially in that from Benin, effigies of the aristocracy are idealized, but slaves, foreigners, and victims of sacrifice come out of different figurative conventions. This selective characteristic of idealization, engendering such a duality of style, furnishes a new objection to the rigid formula "one tribe, one style." (*see* Chapter I)

Duplicity of the Referent

The individual is unique; by assigning an individual referent to effigies or portraits, we have assumed this referent to be unique. But, once more, one should not infer from the extra-artistic reality its representation. In fact, the existence of allegorical effigies and portraits forces us to abandon that assumption.

According to its etymology, "allegory" signifies something that speaks of something other than that which it speaks of directly. The allegorical effigy or portrait refers to an individual other than the one to which it (literally) refers; in other words the referent is a double one. Two formulas are generally in use: "effigy or portrait of x under the aspect of, with the traits of, or in the guise of y" and "effigy or portrait of y as x," in which x and y stand for individuals.

This genre is very widespread: through ancient Egypt and Greece, Rome, Western Christianity, etc. In France, for example, from the fourteenth century on, Saint Louis was traditionally represented with the features of the reigning king of France. (L. Réau, 1958, p. 817) Romanticism substitutes the symbol for the allegory, but the genre survived Romanticism in what we call academicism or official art. Viollet-le-Duc, when restoring Notre-Dame in Paris, had himself represented there as Saint Thomas, and Napoleon III gave his features to the Gallic chieftain Vercingétorix. Even today, Marianne, the personification of the French Republic (*see* M. Agulhon), has been successively represented with the features of media stars—Brigitte Bardot, Mireille Mathieu (1978), and Catherine Deneuve (1985).

In certain African works one can recognize individual allegorical effigies. Some Benin sculptures represent the divine king, the *oba*, by substituting fish for his legs. Fagg (1970, p. 10) comments upon a piece such as this in the Mankind Museum in London:

"This figure may represent a god in a semihuman aspect as an Oba of Benin, or an Oba in divine aspect, or an Oba of normal aspect but with somewhat fanciful reference to a pathological condition. The third explanation, preferred in Benin today, is the least likely and is probably a modern rationalization: namely, that the fourteenth-century Oba Ohen suffered paralysis of both legs during his reign, and gave out that he had 'become Olokun' (the sea god), his legs turning into mudfish, Olokun's symbol. It is perhaps safest to assume that it is a 'heraldic' representation of an Oba—perhaps any Oba—in divine aspect."

Fagg circles around the formula of the allegory. Two interpretations compete, and we do not know which one to settle on since we are not historians of Benin. Their alternative, however, raises a question of method. It is either an *allegorical* effigy of Olokun (x) under the aspect of the *oba* Ohen (y), or it is a *literal* representation of the metamorphosis of Ohen into Olokun. Let us generalize: how to distinguish the literal representation of a "real" metamorphosis of y to x from the allegorical representation of y to x (or of y under the aspect of y)? How, in the presence of the image alone, restore to the "real" what belongs to the real and to art what belongs to art.

Observing the object in isolation does not permit us to answer. In other

words, to be allegorical or to be literal is not an intrinsic property of an image that one would grasp from that image alone. It is an extrinsic or contextual property. The answer depends on the way in which, in a historic context or a social variable, one conceives of "reality" and in which one distinguishes it from fiction; is the supernatural, for example, included in reality or is it seen as fictional? Our conception of reality is an empirico-rationalist one: are only those things or events real that can be observed by everyone? In this way, we grant reality to the metamorphoses of insects, but not to that of Jupiter or of the legs of the *oba* Ohen into catfish. That is the reason Fagg describes one of the explanations he reports as a modern rationalization. If one believes in the reality of the metamorphosis of the *oba* into Olokun, the plaque is a literal representation; if not, this supposed metamorphosis is a political lie concealing an inadmissible illness. If one believes that the *oba* is truly divine, the representation is an allegorical one and visualizes this belief. Then the allegory is motivated by the belief in the reality of a specific connection between the *oba* and the god it renders visible.

In Benin, the elephant is linked to the power of the chief and the leopard to royalty. The *iyase* was one of the two supreme military leaders. The *iyase ne ode*, in particular, revolted against the *oba*; the base of his power was situated in the village of Oregbeni, homeland of the guild of elephant hunters; according to some legends, the *iyase ne ode* had the power to change himself into an elephant in order to conquer his enemies. Finally, the *oba* Akenzua I was the conqueror of this *iyase* and stabilized the rules for royal succession. (P. Ben-Amos, 1979, pp. 33–34) Now, the end of a scepter (Metropolitan Museum, New York) represents an *oba* standing on an elephant whose trunk is represented in the form of a hand. Let us suppose that the depiction of this *oba* on this elephant is an allegory of the victory of good over evil (as in the figures of Saint Michael slaying the dragon or of the Virtues triumphing over the Vices)—of the legitimate king over the usurper. The elephant depicted is either an allegory of the *iyase ne ode*, or the literal representation of his metamorphosis into an elephant in order to fight the *oba*. The figure of the elephant individualizes the referent, the *iyase ne ode*, by means of an individual attribute: his power to change himself into an elephant; integrated into the sculpted grouping, it individualizes the effigy of *this oba* Akenzua I onto *this iyase*. In short, on the one hand the group is allegorical, on the other, the individualization of the referent "*oba*" includes the taking into consideration of an historical event. As for this last point, a more recent study by Paula Ben-Amos shows how another *oba* effigy is individualized in reference to another historical event. (1983, p. 161) One could easily find other examples in Benin, and even outside of the art of the royal court. On the shrines of Olokun worship, clay figures represent this god under the aspect of an *oba* (W. Bascom, 1973, p. 95) with all his royal, ceremonial attributes, his entourage, and his wives.

Two allegorical effigies (J. Delange, 1967, p. 72) originating in the court of Abomey (Musée de l'Homme, Paris) represent, in one instance, the king Glélé as a lion, in the other, the king Behanzin as a shark [fig. 413]. Another allegorical effigy of a Fon king has been published by Claude Savary. (1978, pl. 17) An appliquéd fabric in the Musée de l'Homme depicts "Meviaso, God of Thunder, slaying the Nafe." (G. Balandier and J. Maquet, 1968, p. 159) According to Margaret Trowell (1960, pl. XXV): ". . . the king is given an animal form symbolizing strength"; these two interpretations are complementary to one another: this is an instance of an allegorical effigy of the king as Meviaso, a divinity who gives him the strength to slay his enemies.

Laude (1966, p. 188) mentions two Dogon statuettes representing the

mythic character Arou, under the aspect of a *hogon*, the Dogon priest. According to Pascal J. Imperato (1978, p. 76, no. 62), a doorlock represents "a *hogon*, i.e., a Dogan priest-chief, and, on a deeper plane of understanding, Lébé, the first *hogon* and first priest-chief of the Dogon people." This note suggests that, depending on the degree of the initiation of the exegete, the statuette is understood either simply as a literal representation or as an allegorical representation of Lébé with the features of a *hogon*; whereby we once again encounter the contextual character of the allegorical value of an image.

These few examples are enough to distinguish several kinds of allegorical effigies and portraits, depending on whether only one or both referents are individualized. A simple combinatory engenders four possibilities:

	Referent	
	literal	*allegorical*
(1)	+	+
(2)	+	-
(3)	-	+
(4)	-	-

In this chart, the individualized referent is marked +. The fourth entry would take us out of our realm of inquiry. These possibilities are exemplified by (1) the *oba* as Olokun; (2) Behanzin as shark, Glélé as lion, and the *iyase ne ode* as elephant; (3) a Fon king as Meviaso, and a *hogon* as Arou or Lébé.

The extrinsic or contextual character of allegorical signification, along with the vitality of allegorical thinking, may be illustrated by a phenomenon of acculturation: the Yoruba use of photographs instead of their traditional twin statuettes. The author of this study, Stephen F. Sprague (1978), distinguishes several cases of depiction. "The process becomes more complex when one of the twins dies before having been photographed. If the twins were of the same sex, the surviving one is photographed alone and the photographer makes two prints of the single negative, so that the twins appear side by side on the final photograph." In this kind of depiction, one of the prints is a literal portrait of the surviving twin and the other, by contextual effect, the allegorical portrait of the dead twin (not photographed) with the features of the survivor. Another kind of depiction: "If the twins were of opposite sex, the survivor is photographed once dressed as a boy and once dressed as a girl" (p. 57); one of the images is a literal portrait, the other an allegorical portrait of the dead twin with the features of his or her twin of opposite sex, but dressed as his or her own sex requires. The integration of a portrait into a context of socially codified usage thus changes a literal portrait into an allegorical portrait and introduces the new (allegorical) referent. Such a doubling of the image can be found in a reliquary ordered by Charles the Bold from the goldsmith Gérard Loyet. Side by side, following the traditional iconographic theme of the presentation by the saint, are Charles the Bold and Saint George; but the two faces are as identical as is possible, so that one is the literal portrait of Charles the Bold and the other the allegorical portrait of Saint George with the features of this duke of Burgundy who, in the chivalrous tradition in which he claimed membership, proclaimed himself "the new Saint George." As to the photographs of twins, they are, of course, not strictly traditional; but, according to Sprague, the Yoruba photograph "is an authentic expression

of the culture and shows how certain cultural values obtain a visual form" (p. 56). These new practices testify to the vitality of traditional allegorical thought, capable of integrating a foreign technology and of animating what might be called the iconographic or photographic imagination of the Yoruba.

Expression and the Representation of Expression

Expression and Expressionism

Are African artists, Himmelheber asks (1960b, p. 52), "capable of representing a specific expression and do they want to do so?" The response risks a misunderstanding between the informant or user and the European researcher: "It sometimes seems to us that they have tried to give a certain expression to the masks. When I questioned the artists on this subject, it turned out that generally this was a question of mere chance. First they have to think for a moment about what they should say—what expression is being discussed here. Then the [African] artist often sees a totally different expression than the one I notice. For example, he interprets as laughter what to us seems to be a mouth opened above menacing teeth or a plaintive mouth, for in both cases the teeth show." The author concludes: "The expression, in general, has no greater importance for the [African] artist than the body movement of those statues."

Inversely, other authors emphasize the expressive character of African sculpture and some of them describe certain works or certain groups of works as expressionist, taking recourse at times to the opposing historico-aesthetic categories of "classicism" and "expressionism."

The two attitudes are not contradictory, for "expression" and "expressionism" are not used in the same sense. Here again, before posing and in order to pose the question, we must agree on its terms. We propose to show that, at the very least, we must distinguish between expression, and more specifically psychological expression, as the object of imitation or representation (whereby one remains within the framework of naturalism), and one or more forms of expression no longer attributable to the model but to the artist or the work, and for which alone the label "expressionism" is suitable. Already it may be observed, in this regard, that Himmelheber poses the question in terms of representation.

Expression and Imitation

In *Memorabilia* (III, x), Xenophon reports a discussion between Socrates and the painter Parrhasios during the course of which Socrates, drawing him out, makes the painter aware of what he does without being conscious of it. Painting imitates what is visible; but the states or emotions of the soul are invisible; do they, then, evade imitation in painting or sculpture? Socrates then helps the painter recognize that these invisible, psychic states, since they manifest themselves through quite visible modifications of aspects of the face and body, can be imitated, and that some painters very effectively imitate the feelings of the soul. In *Platon et l'Art de Son Temps* [*Plato and the Art of His Time*], P. M. Schuhl established that Socrates was here interpreting certain innovations of the painting and sculpture of his era; but he speaks of expressionism (p. 86). Not one word in the Greek text is directly translatable as "expression" (derived from the Latin). In fact, this is a matter of imitation, the representation of psychological

expressions. Socrates does not leave the traditional framework of the imitative conception of art; he only widens the imitable domain by including the visible manifestations of the invisible soul. Expression is psychological and must be ascribed to the model; artists imitate—nothing suggests that they are expressing themselves. To speak of expressionism is a misconception. In order to be able to speak of an expressionist conception of art, we will have to wait several centuries, for Plotinus. (*see* A. Grabar)

The innovations evoked by this text are at the origin of an artistic Western tradition; the text itself is the origin of a theoretical tradition concerning the artistic representation of emotions and passions, one illustrated by Alberti, Leonardo, and Le Brun; in parallel fashion, certain parts of Aristotle's *Rhetoric* and *Ethics* are at the origin of a tradition we find again in treatises after Descartes's *Treatise on the Passions*. All conditions are therefore united so that with the word "expression" will be associated the idea of representing psychological expression and thus this idea can serve us as an anticipation. Thus, in a recent anthology, whose stated scientific goals are frequently fulfilled, we still find the following definition of expression: "The totality of the external manifestations, attitudes, gestures, facial movements that translate emotions, sentiments, intentions, or character" (*Sculpture*, 1978, p. 697)—as if art dealt only with that sort of expression, and as if art theory had made no steps forward since Socrates. This definition reduces the realm of artistic expression by attaching it to the naturalist or imitative conception of art. It engenders what philosopher Gilbert Ryle calls "categorial contempt": the works evoked by Socrates are placed under the category of artistic expression, while they should be put under that of imitation.

Just as a work can represent things without representing their extra-artistic space, all the while possessing its own plastic space, so can it represent people without representing their corporeal or physiognomic individuality, all the while possessing its own artistic individuality, and so it can represent people without representing their psychological expressions, all the while possessing an expressivity or its own expressive value. But in order to research and recognize this, one must have available a more general notion of expression than that of psychological expression, which will permit disjoining artistic expression from psychology.

The Naturalist Conception of Expression

It is all the more difficult to rid oneself of these traditional expectations because to the naturalist conception of *art*, a naturalist conception of extra-artistic expression is frequently associated, and because this association makes interpretation easy, even if the price for this ease is misunderstanding. Psychological expression—psychism through the body—can be regarded as a natural phenomenon and, as such, as spontaneous and universal. "Expressions are spontaneous but their depiction is most often artificial." (*Sculpture*, p. 697)

If the extra-artistic expression and its representation are both natural and therefore universal, my experience with psychological expression should allow me to immediately understand all expressions represented by every art in the world. Referring to contextual, historical, or ethnographic data would be needless. It is, then, as if observers were substituting a living double for the work of art, whose expression they would decipher as if on their neighbor's face.

Before looking for what exactly the represented expression is, it is necessary to ask whether the work represents an expression or not. The mere examination of the work does not permit a response. Two difficulties

make it clear that it is necessary to refer to contextual information. These two difficulties are raised by certain extra-artistic expressions, the delicate or subtle psychological expressions of certain weak or moderated emotional states, or of affective states that are intense but whose expression has been carefully held back, mastered, or even inhibited. In our daily life are we always able to distinguish between apathy, the zero degree of affective intensity, and lasting serenity, the willed mastery of intense emotion? How do we distinguish between the expression of an absence of emotion and the absence of an expression of emotion? This difficulty is doubled if the observer and the observed do not belong to the same culture. Thus, I have heard the French wife of a British academician say that, after many years, she still did not know whether her husband had mastered his emotions or did not feel any.

The second difficulty is a reinforcement of the first, since it no longer concerns interpreting a living face but a representation. How to distinguish between the representation of an inexpressive face and the absence of representation of an expressive face, between the absence of representation of expression and the representation of a very delicate, very slight expression? How to ascribe to reality what reverts to reality and to art what reverts to art?

These difficulties are not contrived. They have been raised by what Thompson (1973a) called "the aesthetic of the Cool." Often enough in Africa, and notably among the Yoruba of Nigeria and the Gola of Liberia (W. L. D'Azevedo, cited by F. Willett, 1971, p. 215), just as with the Ancients, an ethical value is attributed to moderation, self-mastery, to reserve or good manners. But how does one interpret the faces of the sculptures? For the means of faithfully and differentially representing these delicate and slight expressions belong to very complicated forms of naturalism. So, again according to Thompson (1973b), would one of the most important criteria of Yoruba aesthetics be "relative mimesis," the exact center between abstraction and an excessive naturalism?

Thus, indifference to the representation of very pronounced expressions, because they demonstrate very intense emotions that are condemned by certain ethics, might be considered a form of idealization. Among the Gola, the peak of success is the ability to remain nonchalant at the proper moment, to reveal no emotion whatsoever in situations where excitement or sentimentality would be acceptable, "to act, in other words, as if one's spirit were in another world." (W. L. D'Azevedo, loc. cit.) This last suggestion makes us think of "people as they ought to be." (Aristotle) "The academic standard face, which corresponds to the canon of Greek art, is experienced as beautiful . . . precisely because it lacks expression." (E. H. Gombrich, 1961, p. 351)

If the extra-artistic expression is subservient to conventions, as artistic representation is, only comparisons with contextual data allow us to answer these questions.

The Effects of Context

Let us consider the case in which the face of a mask, considered in isolation, represents no expression at all. One might believe that to attribute an expression to this face can only be illegitimate and ethnocentric. Not so, for reality does not let itself be locked into the dichotomy (once again seminegative) between a representation or lack of representation of expression.

The mask may be observed in isolation or in the context of its use. If, as a hypothesis, the mask represents no expression, it is only when it is in a museum that attributing an expression to it is illegitimate. E. H. Gombrich

(1985) refers back to the psychological concept of projection and shows with what ease we project an expressive and psychological value onto very simple, even rudimentary figures and recalls, inversely, that, according to Alberti, a painter feels the greatest of difficulties in differentiating a smiling face from a weeping one. The concept of projection inserts itself in the theory of expectations. When we "project," we abusively identify what we encounter with what we were expecting, and thus we believe we discover what we were expecting in what we encounter—while, in the case under consideration, it is not there. If the object and the observer belong to the same culture, the projection is intracultural and subjective. If they belong to different cultures, the inter- or transcultural projection is not only subjective but ethnocentric. It may call forth altogether fantastic remarks, as poetic as they might be—such as the captions by the sculptor Arman in the catalogue for the exhibit *Fragments du Sublime* [*Fragments of the Sublime*].

Paul Gebauer (1979, p. 156) comments on a mask that "itself has an expression somewhere between tears and laughter," its sculptor probably not even looking to overcome the difficulty Alberti takes so seriously. But "in order to appreciate the laugh the mask evokes, one must visualize it as worn by the dancer, dressed in a fashion to match that of a German director visiting the plantation." Himmelheber already suggested (1960a, p. 109) the same interpretation in a more general form: "When we see a masked person performing, we understand that some of the expressions of the mask's face are totally out of place. The mask, when in action, takes on different roles, each one of which gives it a different expression. The *ngedi* mask of the Dan, which imitates all sorts of actions of the people of the village, but also of the birds that pilfer the rice and of mischievous donkeys, changes its supposed expression every minute. It is a completely strange experience to see the mask in action and to have the impression that you are observing all the different expressions belonging to its diverse actions. The mask shows curiosity, has pity on someone, threatens the spectators. This being so, the artist gives the mask a neutral expression and leaves the interpretation to the imagination of the spectator." Are we thus reverting to the projection indicated by Gombrich?

That would be neglecting the effect of the context, which is not subjective. Now, gestalt psychology furnishes another solution. In this psychology of perception, the context of use becomes the perceptive field, the object a part of the field, and the effect of the context an effect of the field. Gestalt psychology establishes that a part of the perceptual field changes in aspect and significance depending on whether it is perceived in isolation or integrated into the totality, into the structure of the field. This is the way Maurice Merleau-Ponty (1948, pp. 281–82) interpreted Koulechov's famous experiment with the film scene reported by Jean Mitry:

"Taking a close-up of the actor Ivan Mosjoukine, whose rather vague look was purposely inexpressive, from an old film of Geo Bauer, he had three prints made of it. Then he successively spliced the first one to a shot showing a soup plate placed on the corner of a table; the second to a shot showing the corpse of a man lying face down; the third to a shot of a half-naked woman, stretched out on a sofa in a flattering and lascivious pose. Then, putting these three 'object-subject' bits together end to end, he showed the whole thing to viewers who had not been forewarned. Now, they all unanimously admired the talent of Mosjoukine, who 'so marvelously expressed the successive feelings of hunger, anguish, and desire.'"

It is obvious that the situation of the mask in the museum, canceling the effect of the context or field, makes room for subjective projection.

But the mask is not always an indeterminate substratum, receiving from its context of use one or various expressive values. It may share some expressive properties with other artistic elements of that context, the music and the dance (or the dancer, or better yet, the dancer dancing). Among the Baoule, four *goli* masks, coming out in pairs, represent male and female characters, younger and older, following a hierarchic order, at the summit of which the senior female mask appears. "Its movements and the accompanying music are a marvel of grace and harmony." (P. Nooter, 1985, p. 43) So, the face of this senior female mask is itself a borrowing from grace and harmony. Grace and harmony are expressive properties that do not have their own psychological value: they may be linked to very different psychic states, to objects without psychism, such as a tree, and they may belong to aesthetic objects coming from different arts. In the performed art that this masked dance is, these expressive properties are thus common to all three artistic elements—mask, dance, music—to the degree that the mask isolated from its context of use can preserve them. Thus, it is distinguished from the cases mentioned by Himmelheber and Gebauer, in that its expressive properties 1) do not represent those of its model; 2) are not expressive of psychological states; 3) are not "received," through the effect of the context or field, so that it can maintain them once extracted from this context. The first two differences show how the preceding interpretation remains linked to the idea of a representation of psychological expression.

There is an idea from which we must detach ourselves, as Laude has already advised (1968, p. 33): "The undeniable expressivity of African sculptors must be grasped, not on the level of depiction, of representation, imitation, or description, but on the level of an original arrangement of forms. . . . The expressive character does not come from feelings which the artist wanted to show demonstrably."

M. C. Dupré (1968) has shown that the *tsaye* (Teke) mask, round and flat, which presents an almost perfect symmetry, not only with respect to the vertical axis, as do the majority of masks, but also horizontally, is directly inspired by the dance for which it was produced. While dancing, the wearer of the mask turns cartwheels. This circular motion around a horizontal axis, abolishes the usual emphasis on verticality. Indeed, Jan Vansina mentions this case (1984, p. 127) in a passage expounding on the notion of performed arts.

One may wonder whether the tops of the *tyi wara* hairdos, worn by the Bamana dancers, do not share certain expressive properties with the dance, such as lightness, grace, a supple tension—in short, "grace and strength" (J. T. Brink, 1981, p. 25)—nonpsychological expressive properties that the antelope, which these sculptures represent, possesses, as does the dancer who wears them, imitating the leaps of the antelope. (This imitation is limited by the differences in corporeal configurations of human and animal, but the expressive properties related to the movement may be shared.) The notions of the performed arts and of expressive properties (L. R. Rogers, 1969) thus allow us, naturalism having been abandoned, to redirect our investigation.

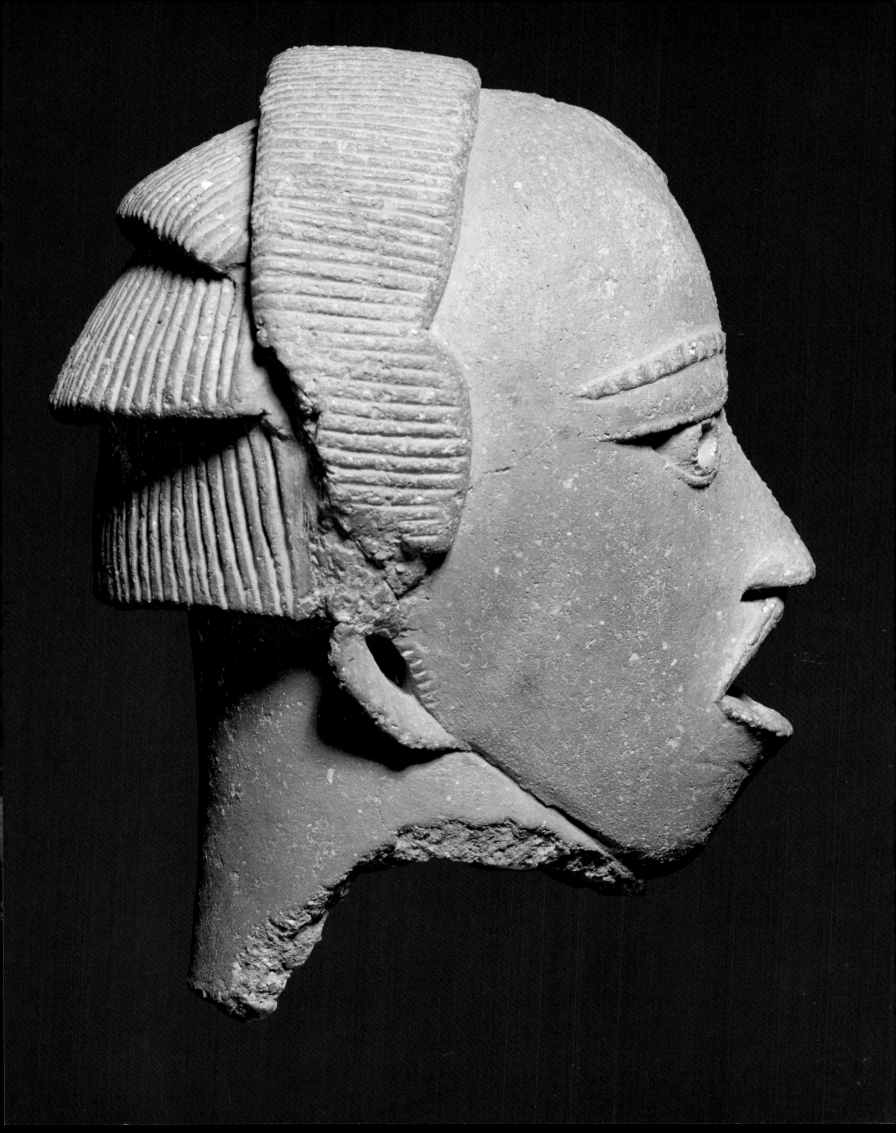

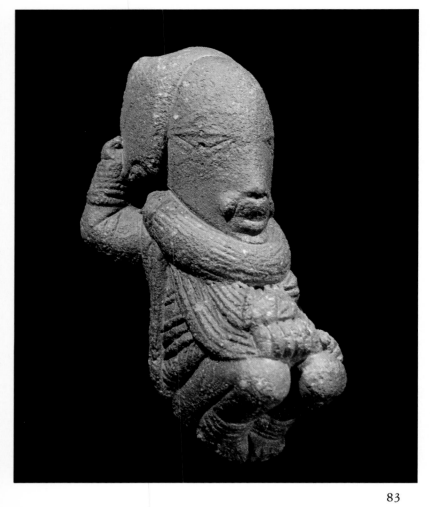

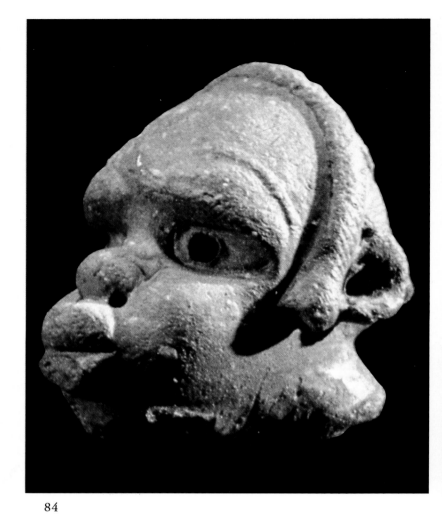

83

84

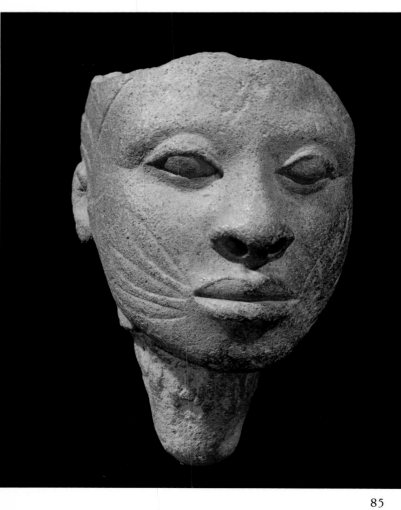

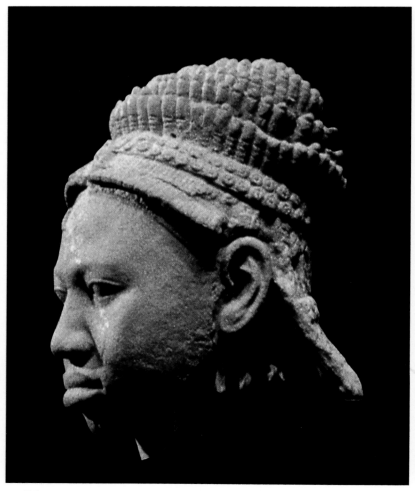

85

86

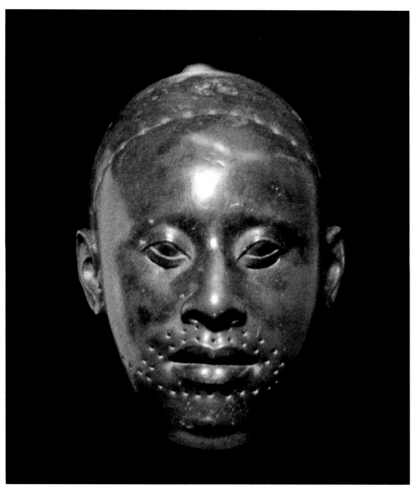

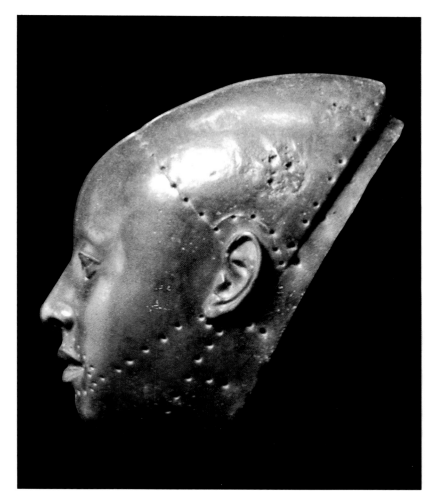

87 88

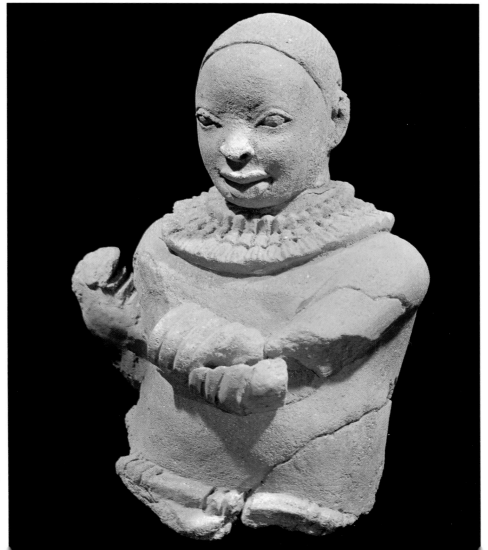

89

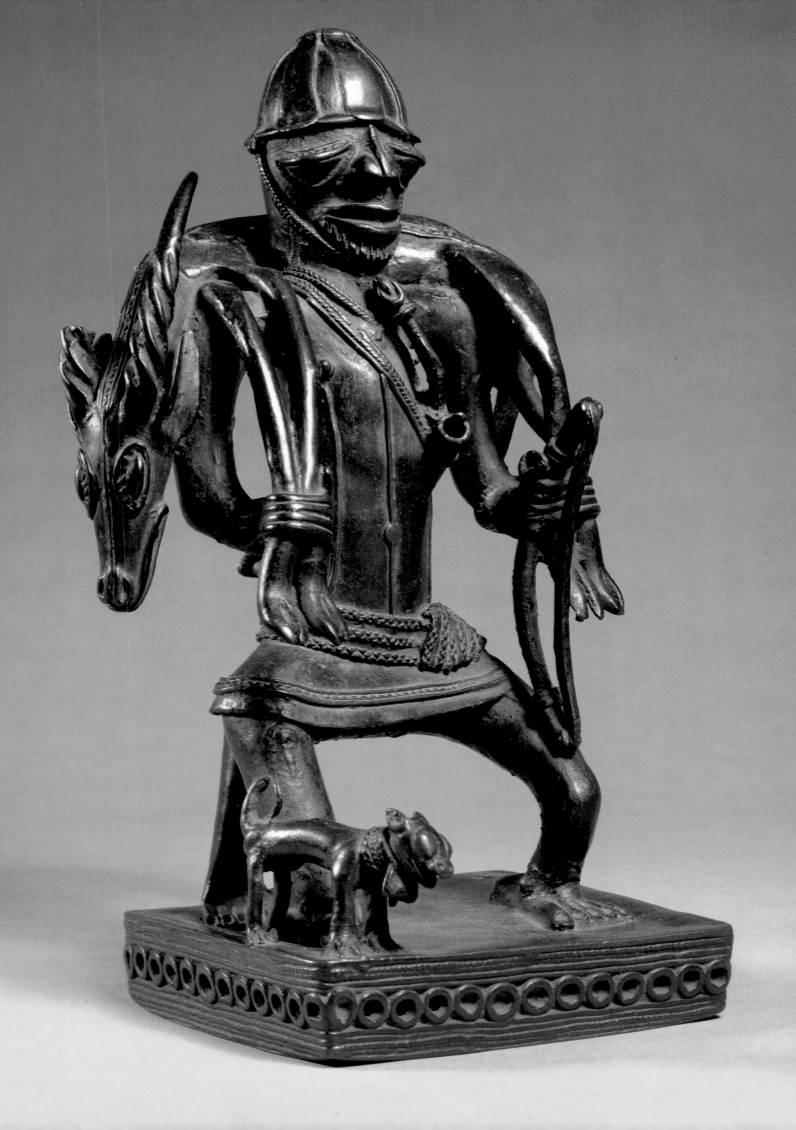

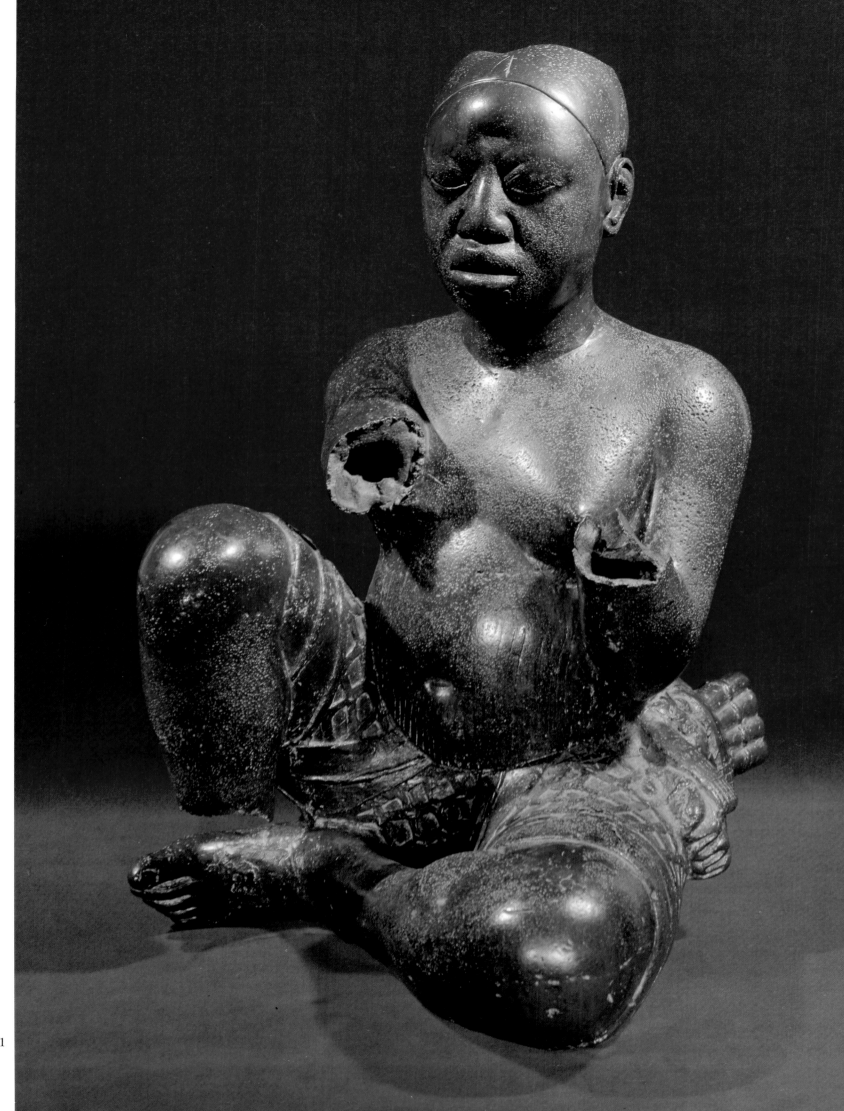

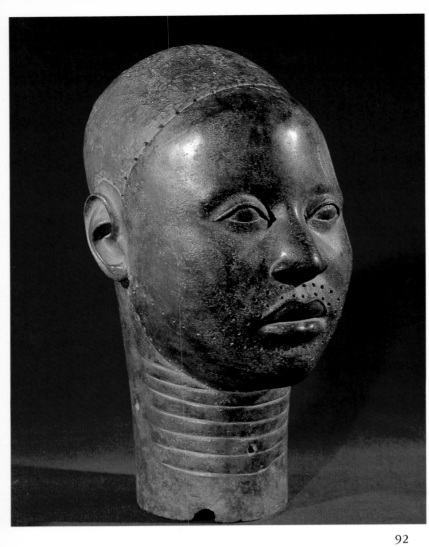

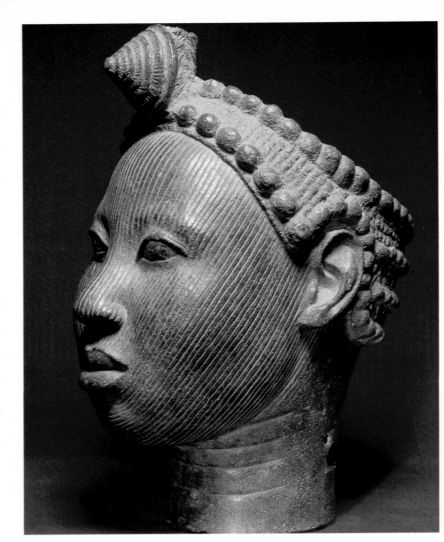

92 93

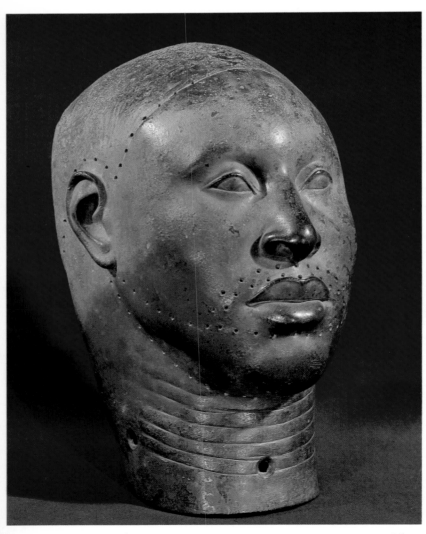

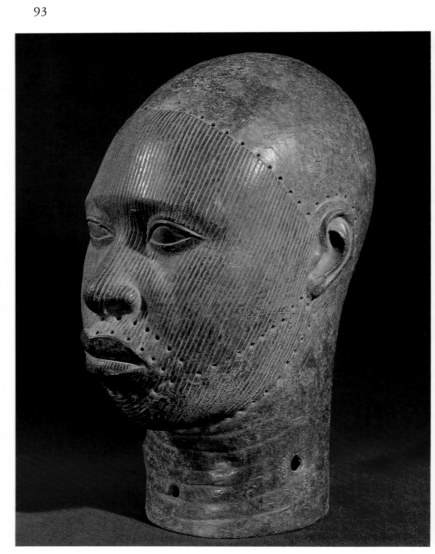

94 95

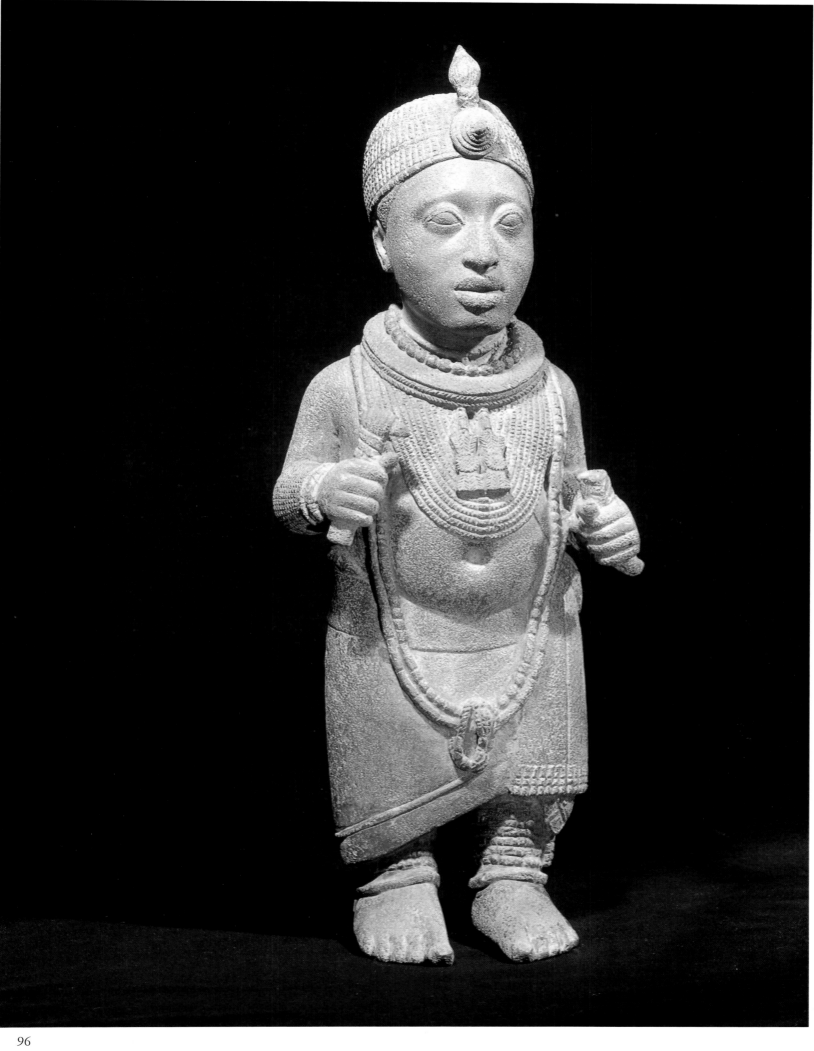

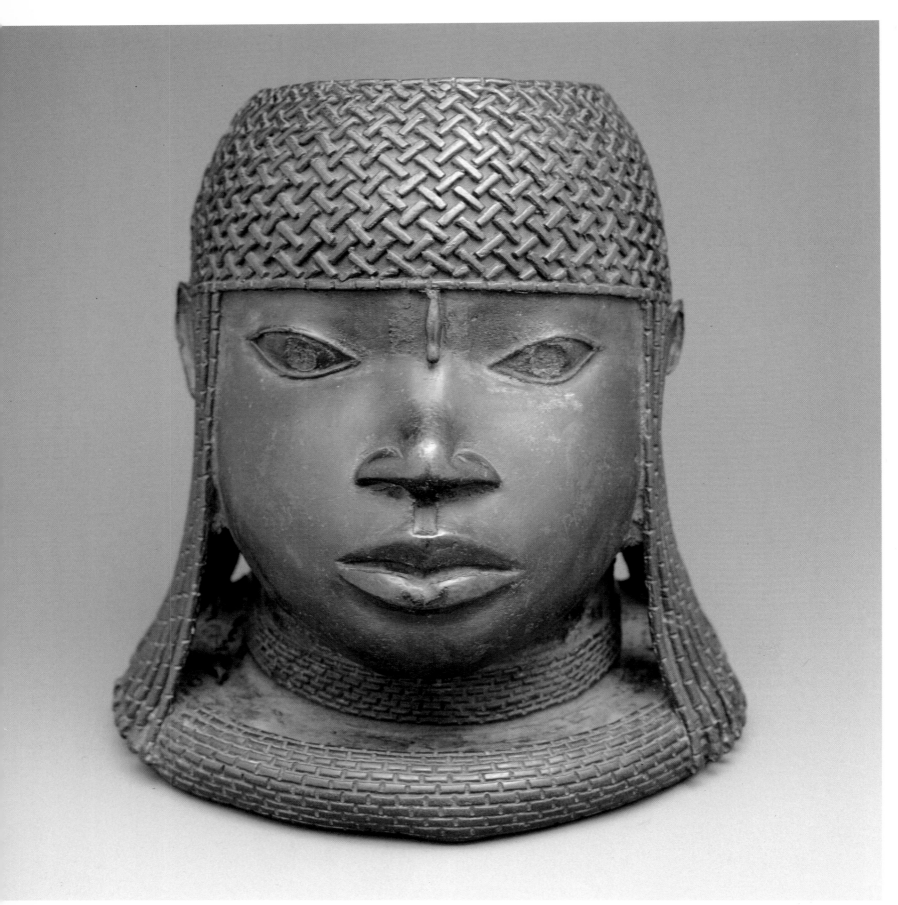

97

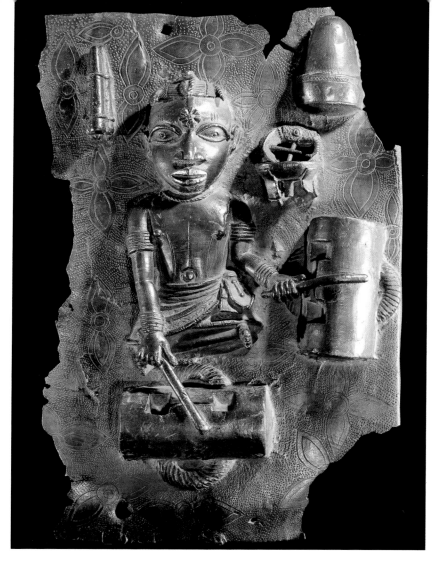

98

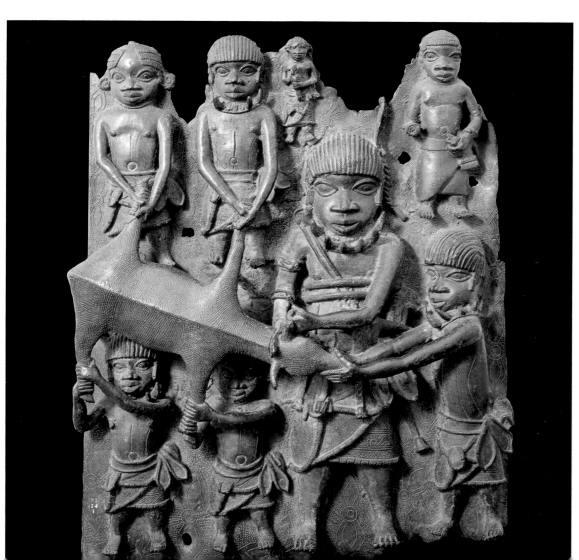

99

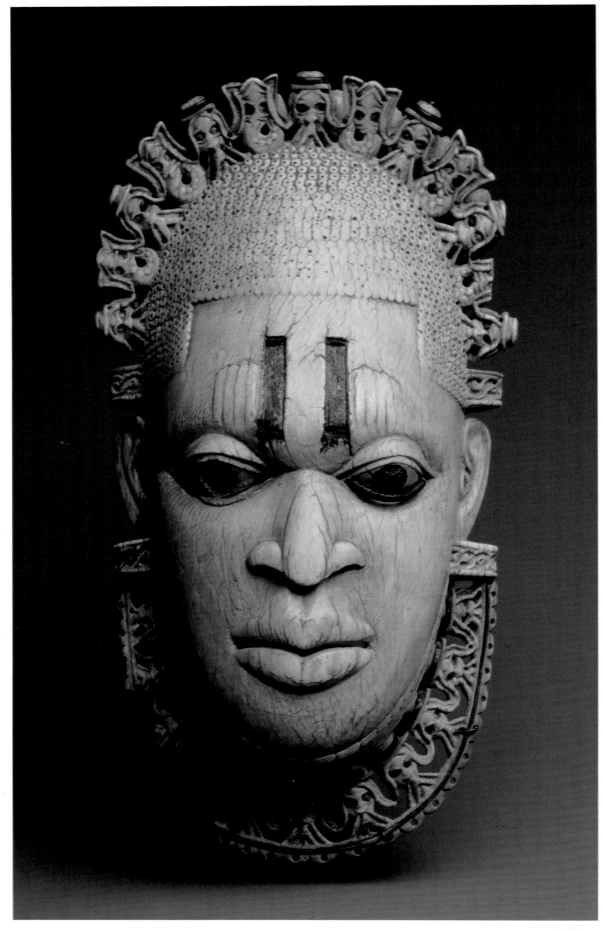

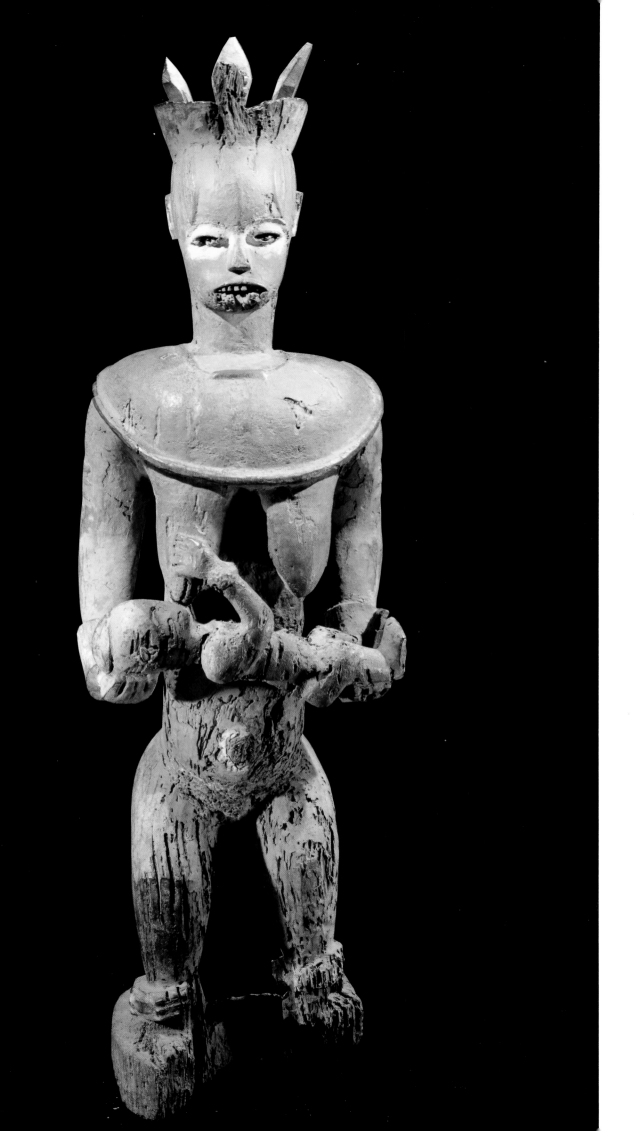

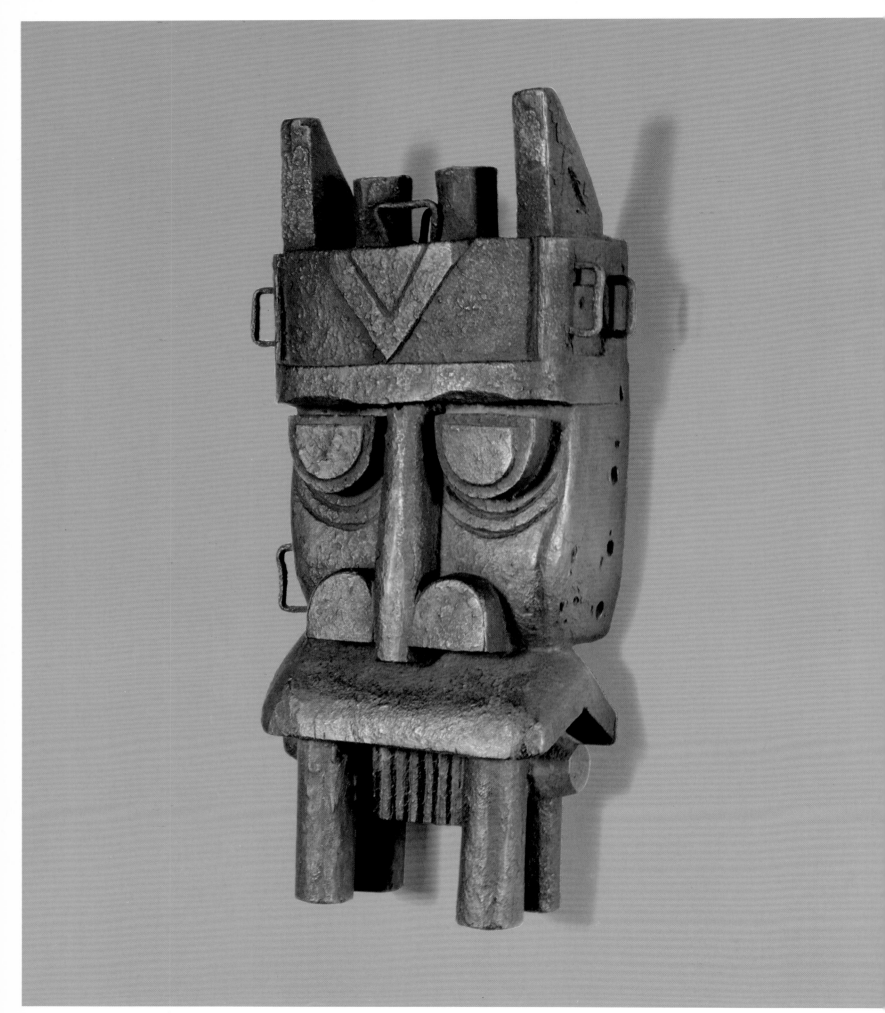

82 Nok Head, Jemaa (?), Nigeria
Found in 1943 in the Tsauni mine. Clay.
3rd–5th century B.C. Height: 25 cm. National
Museum, Lagos, Nigeria

83 Nok Pendant, Kneeling Figure
Discovered at Bwari. Terra-cotta. 500 B.C.–A.D.
200. Height: 10.6 cm. National Museum, Lagos,
Nigeria

84 Nok Head, Nigeria
Found at Jemaa. Terra-cotta. 500 B.C.–A.D. 200.
Height: 9.2 cm. National Museum, Jos, Nigeria

85 Ife Head, Nigeria
Terra-cotta. 12th–15th century. Height: 12.5 cm.
National Museum, Lagos, Nigeria

86 Head of a Queen of Ife, Nigeria
Found at Ita Yemo. Terra-cotta. 12th–13th
century. Height: 25 cm. Museum of the Ife
Antiquities, Nigeria

87–88 Ife Mask, of the *Oni* Obalufon (?),
Nigeria
Presumed to have brought the bronze-making
technique to Ife. Copper. 12th century. Height:
29.5 cm. Museum of the Ife Antiquities, Nigeria

89 Bust, Owo, Nigeria
Terra-cotta. Early 15th century. Height: 25 cm.
National Museum, Lagos, Nigeria

90 Hunter Carrying an Antelope, Lower
Niger, Nigeria
Found in Benin in 1897. Bronze. 16th century.
Height: 36 cm. British Museum, London

91 Seated Figure, from the Nupe Village
of Tada, Nigeria
Copper. 13th–14th century. Height: 53.7 cm.
National Museum, Lagos, Nigeria

92 Head of an *Oni*, Ife, Nigeria
Copper and zinc. 12th–15th century. Height:
31 cm. Museum of the Ife Antiquities, Nigeria

93 Crowned Head from Ife, Nigeria
Copper and zinc. 12th–15th century. Height:
24 cm. Museum of the Ife Antiquities, Nigeria

94 Ife Head, Nigeria
Bronze. 12th–15th century. Height: 30.9 cm.
Museum of the Ife Antiquities, Nigeria

95 Head of an *Oni*, Ife, Nigeria
Copper. 12th–15th century. Height: 29 cm.
Museum of the Ife Antiquities, Nigeria

96 Standing *Oni*, Ife, Nigeria
Brass with zinc. 14th–early 15th century. Height:
47.1 cm. Museum of the Ife Antiquities, Nigeria

97 Head from Benin, Nigeria
Bronze. Early 16th century. Height: 23 cm. The
Metropolitan Museum of Art, New York

98 Bronze Plaque from Benin: Drummer,
Nigeria
Bronze. 15th century. Height: 41.9 cm. Width:
25.4 cm. British Museum, London

99 Bronze Plaque from Benin: Sacrifice of
a Cow, Nigeria
Bronze. 16th century. Height: 51.9 cm. Width:
35.4 cm. British Museum, London

100 Bini Belt Mask, Nigeria
Found in 1897 by Ralph Moore. Ivory. 15th–
16th century. Height: 24 cm. The Metropolitan
Museum of Art, New York

101 Urhobo Maternity Figure, Nigeria
Wood. 19th century. Height: 168 cm. Private
collection

102 Ijo-Kalabari Hippopotamus Mask,
Degema Region, Nigeria
Wood. 19th century. Height: 47 cm. R. and
L. Wielgus Collection, Tucson, Arizona

103 Mask for the Top of the Head,
Representing a Skate, Ijo, Nigeria
Wood. 19th century. Width: 40 cm. Private
collection

104–05 Couple of Igbo Statues, Nigeria
Wood. Height: Male, 161 cm; Female, 166 cm.
Private collection

106 Igbo Statue, Nigeria
Wood. Height: 178 cm. Private collection

107 Igbo Statue, Nigeria
Wood. Height: 108 cm. Private collection,
Belgium

108–10 Igbo Statues, Nigeria
Wood. Heights: 70 cm, 50 cm, and 75 cm.
Private collection

111 Idoma Mask, Nigeria
Wood. Height: 23 cm. Develon Collection, Paris

112 Mask, Northern Igbo (?), Nigeria
Wood. Height: 20 cm. Private collection

113 Idoma Mask, Nigeria
Wood, fibers, fabric, hair. Height: 29 cm. Private
collection

114 Idoma Mask, Nigeria
Wood, fibers, hair. Height: 22 cm. Private
collection

115 Top of an Eket Mask, Nigeria
An object by the same artist is found in a Webster
catalogue of 1899. Wood. 19th century. Height:
73 cm. Private collection

116 Igbo *Ikenga*, Nigeria
Wood. Height: 98 cm. Private collection

117 Igbo-Izzi Mask, Abakaliki Region,
Nigeria
Wood. Height: 56 cm. Develon Collection, Paris

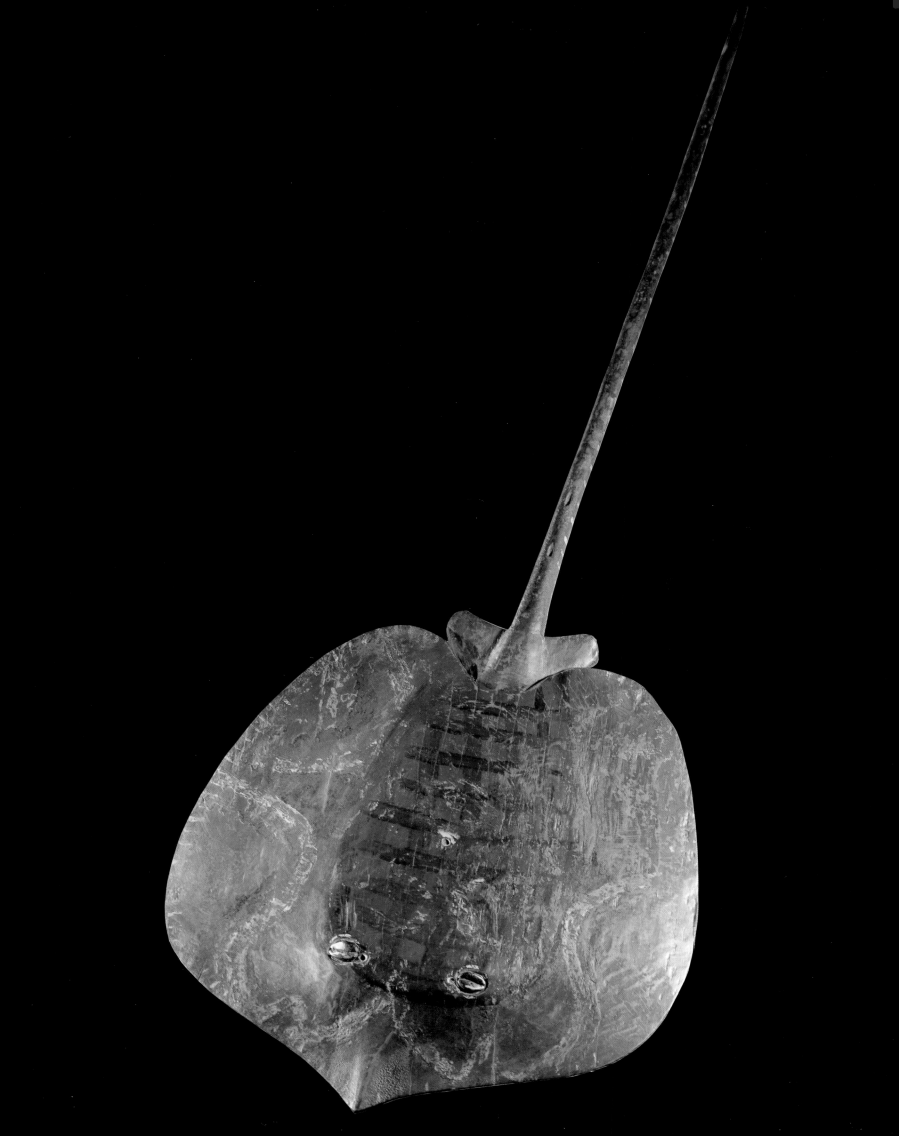

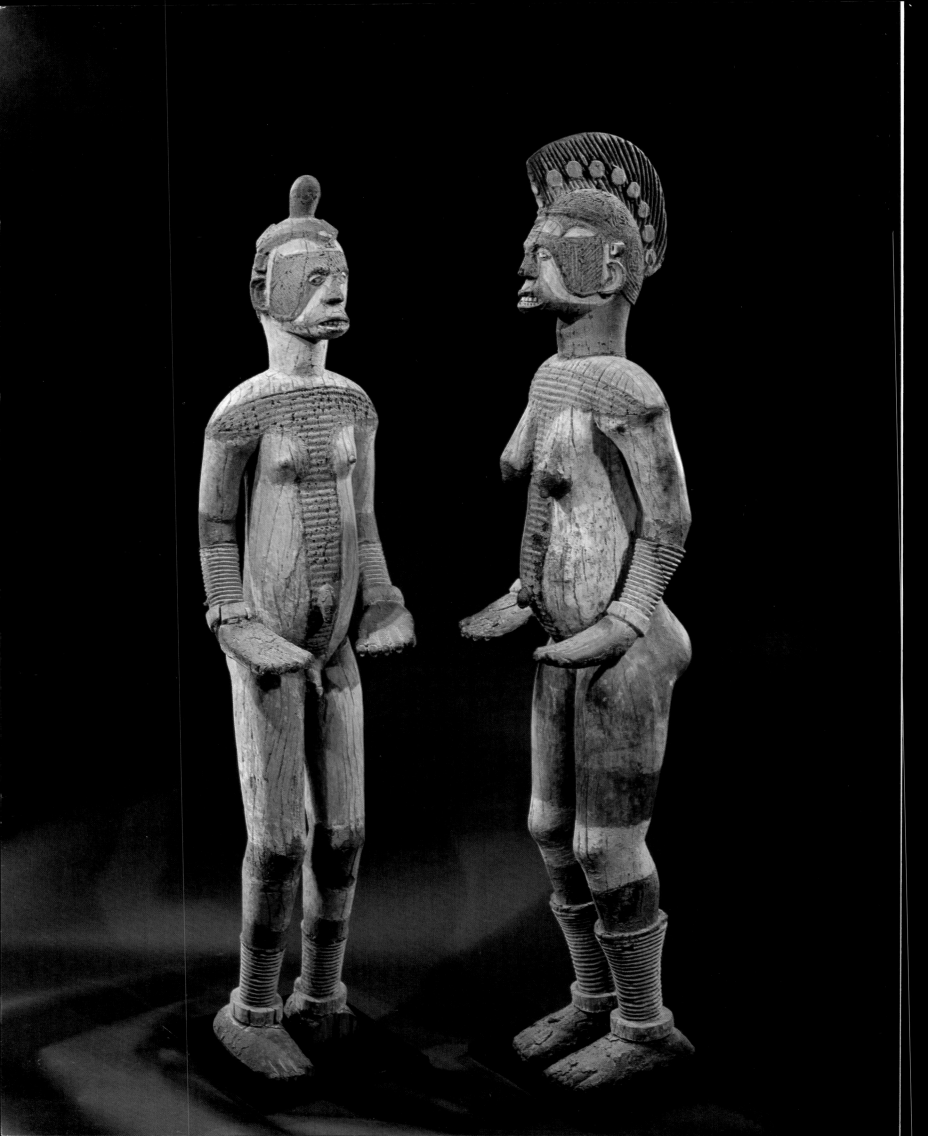

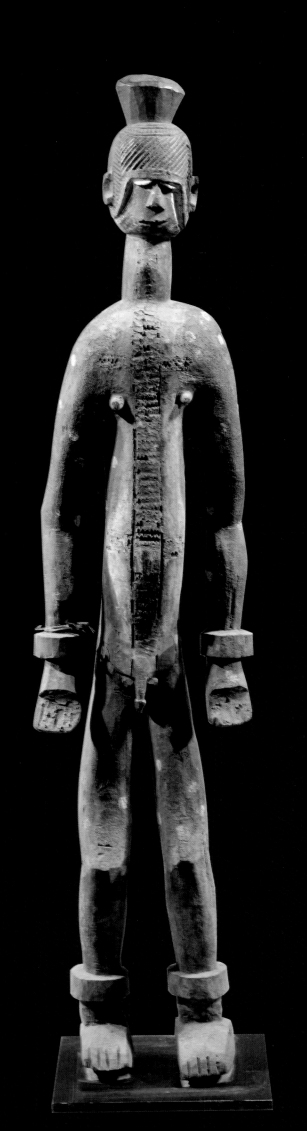

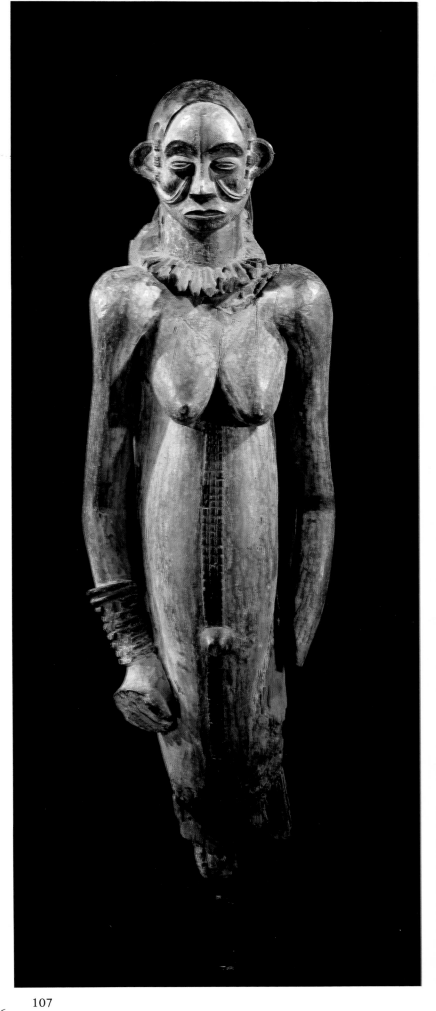

106

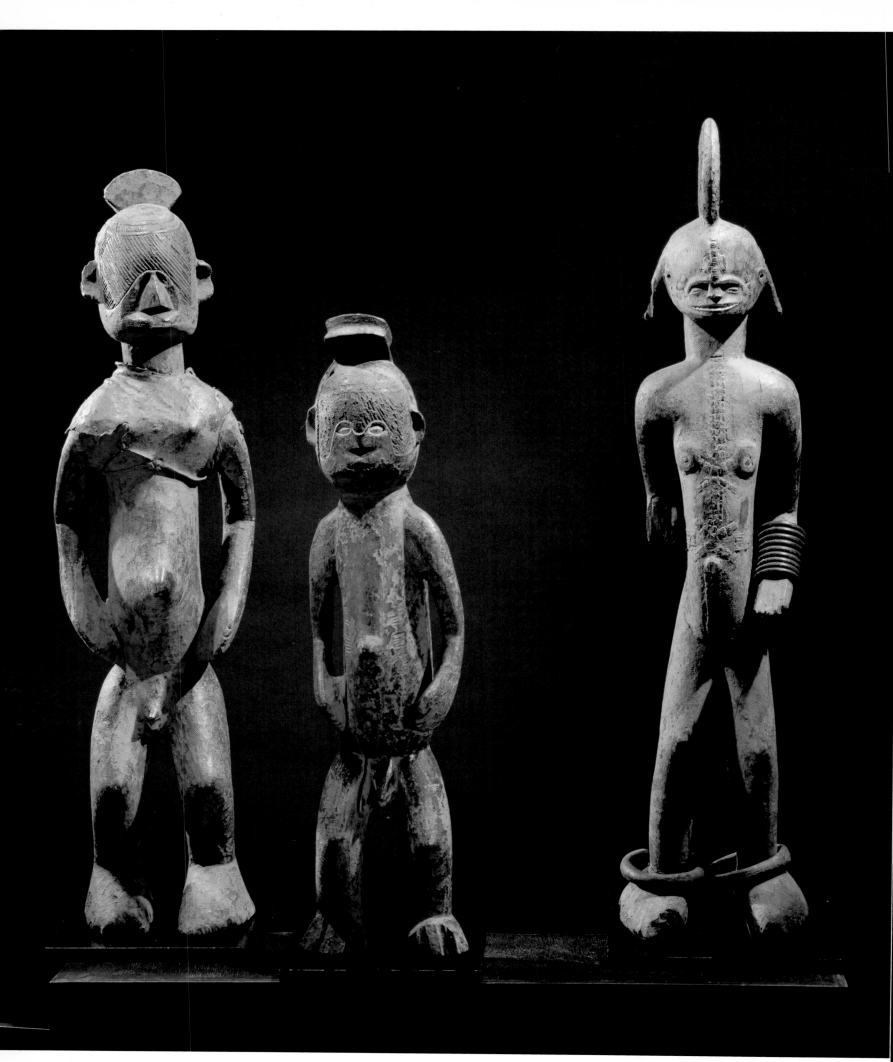

108 – 110

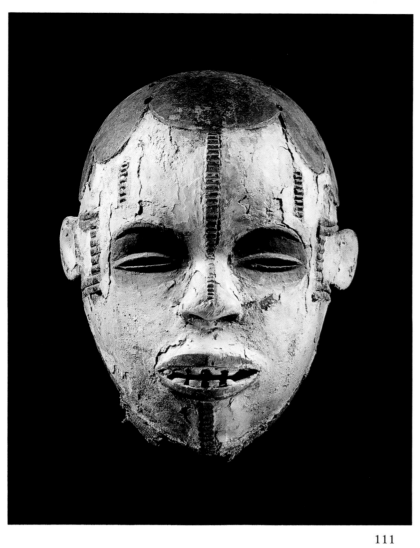

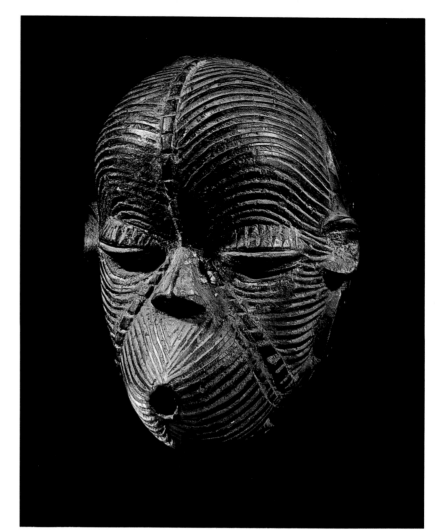

111

112

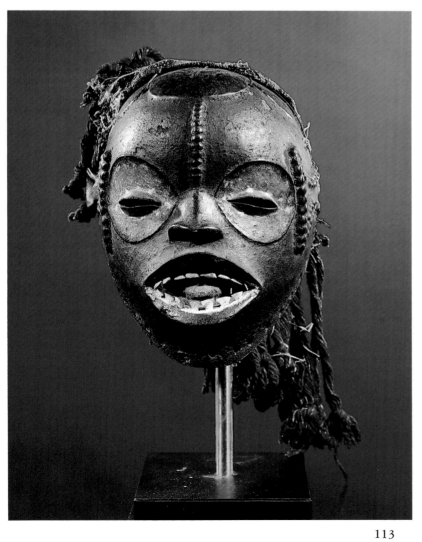

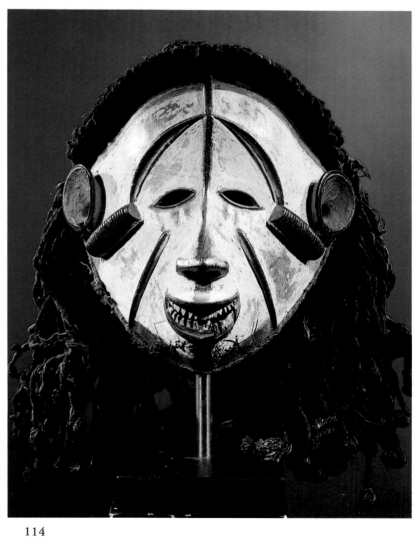

113

114

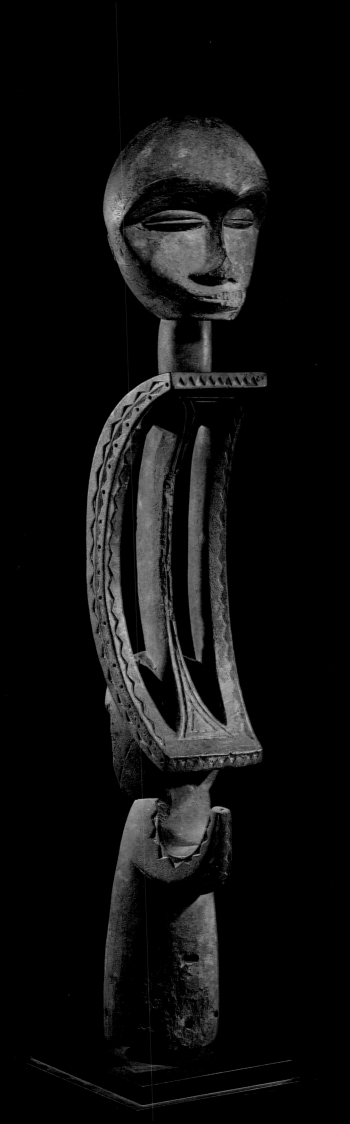

115

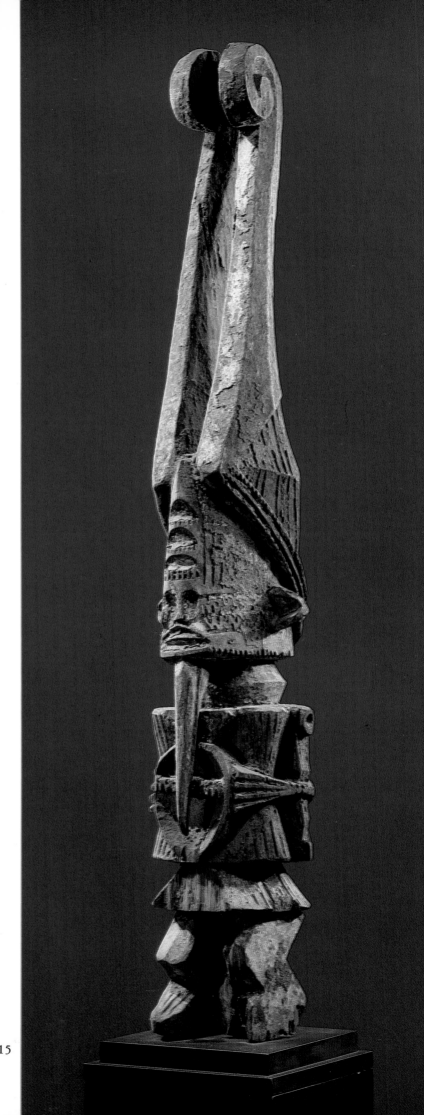

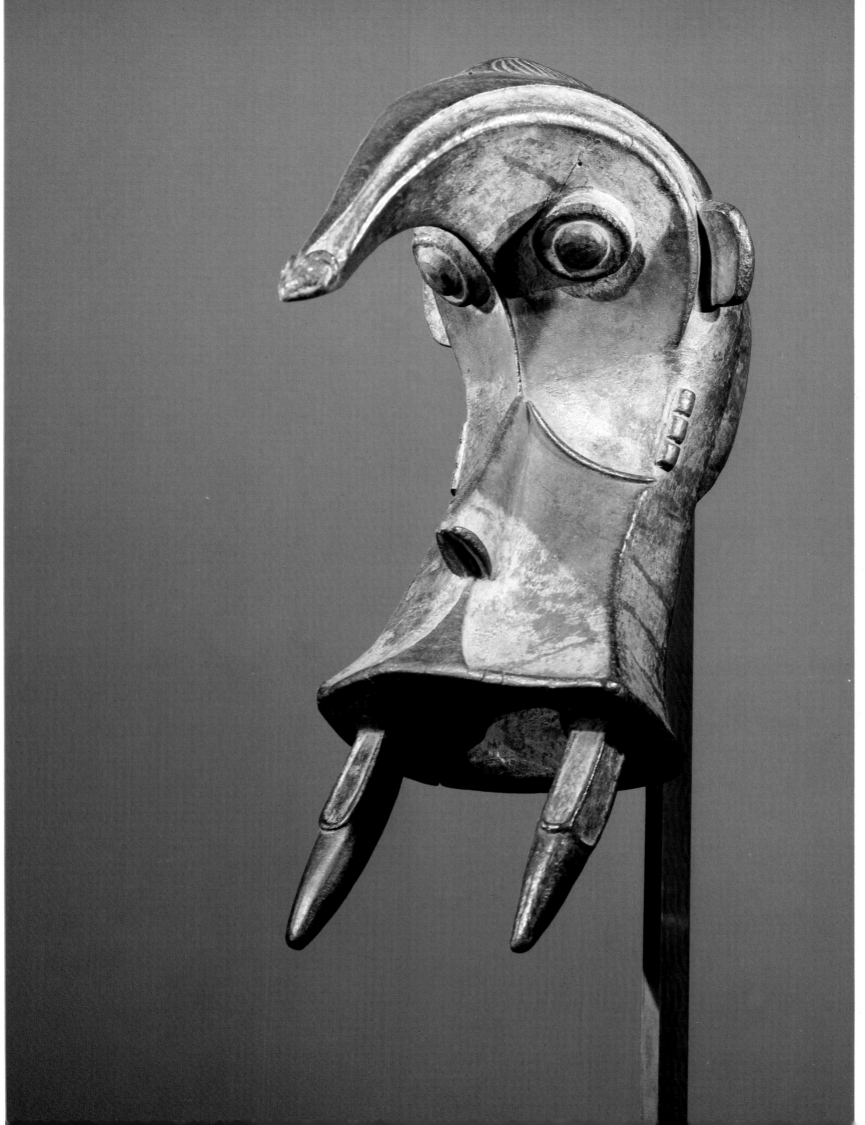

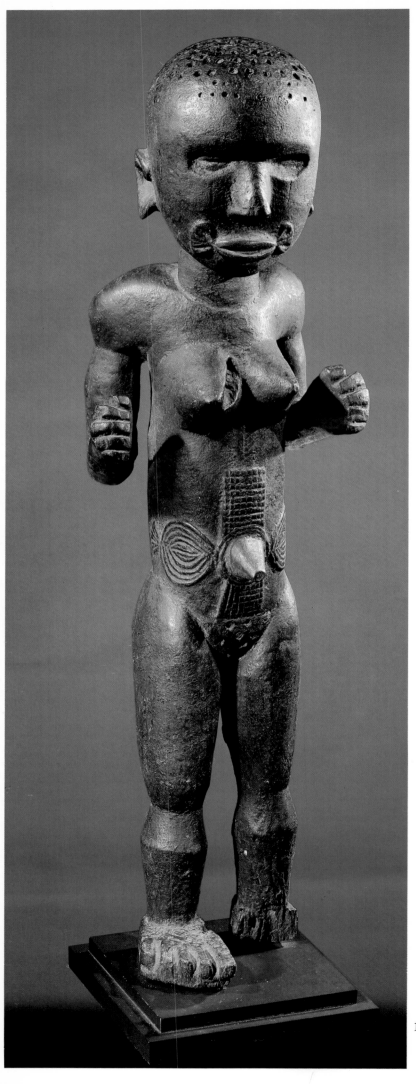

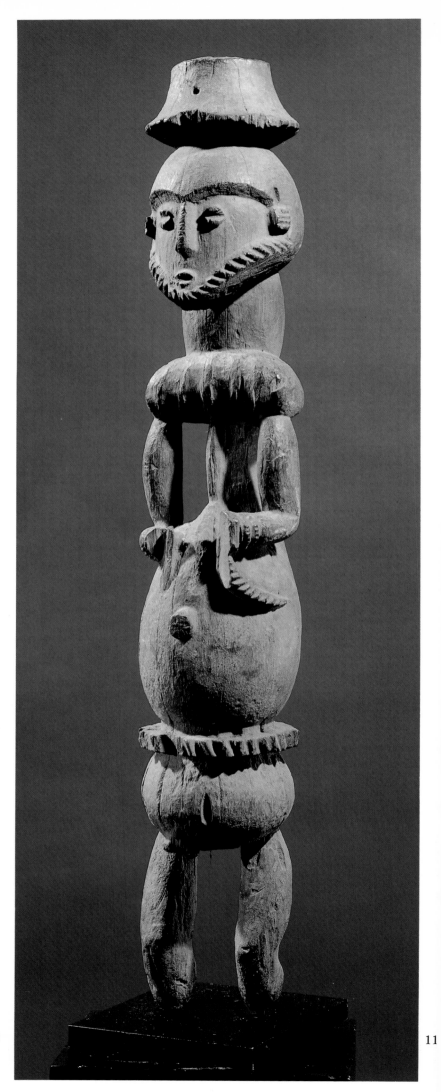

118

11

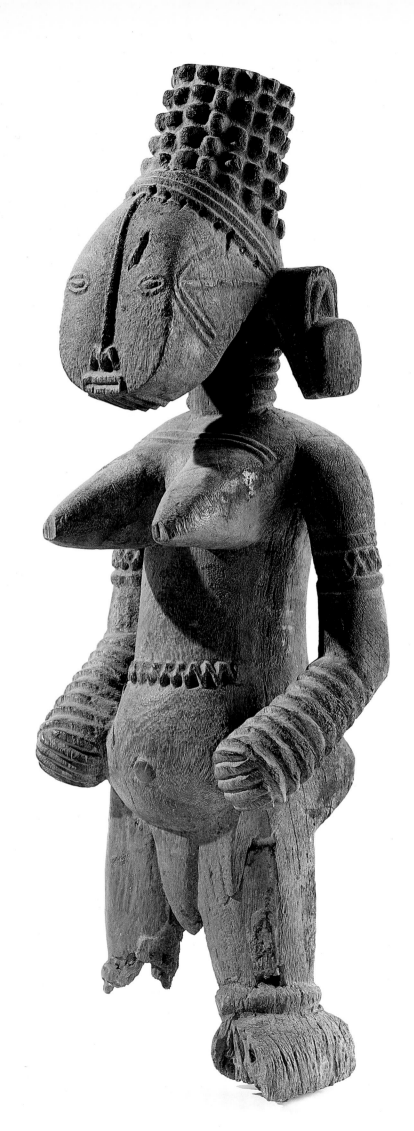

20

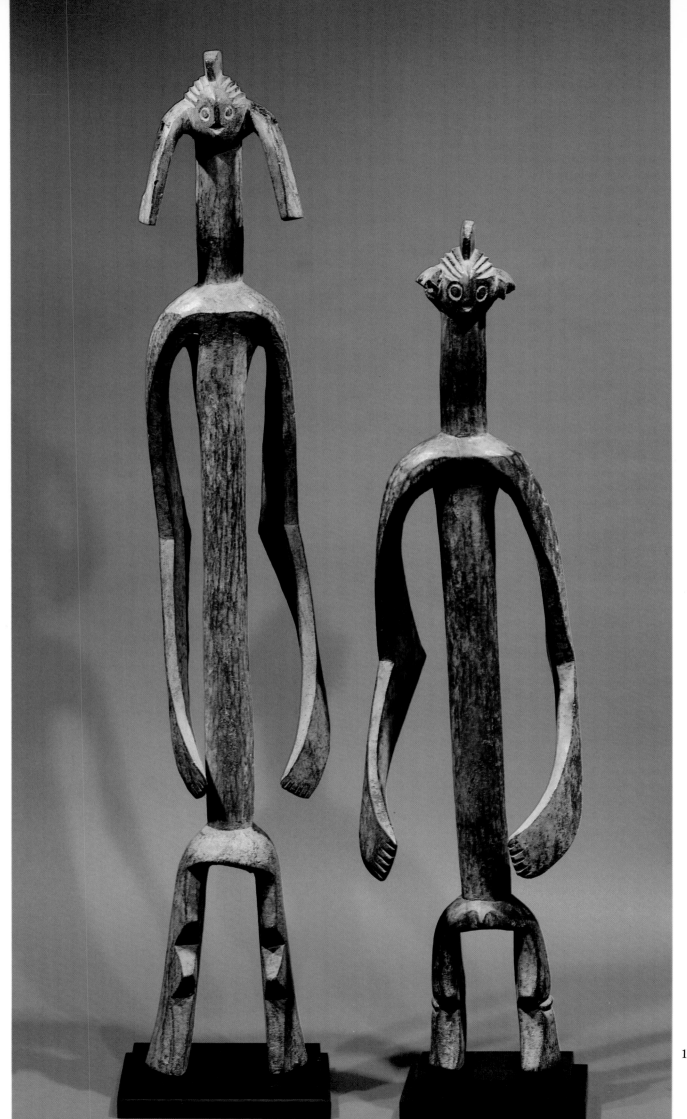

121-122

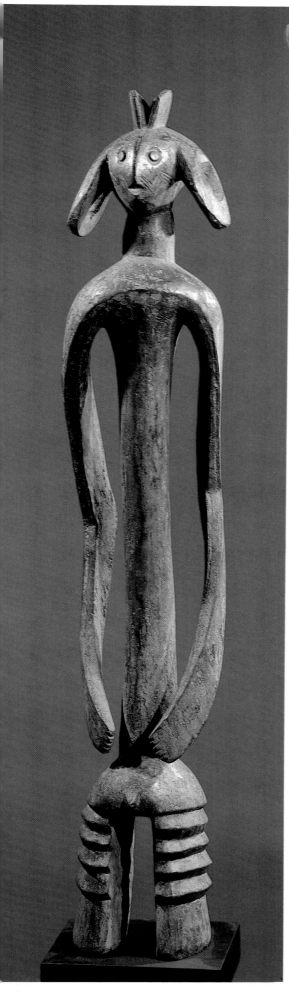

123

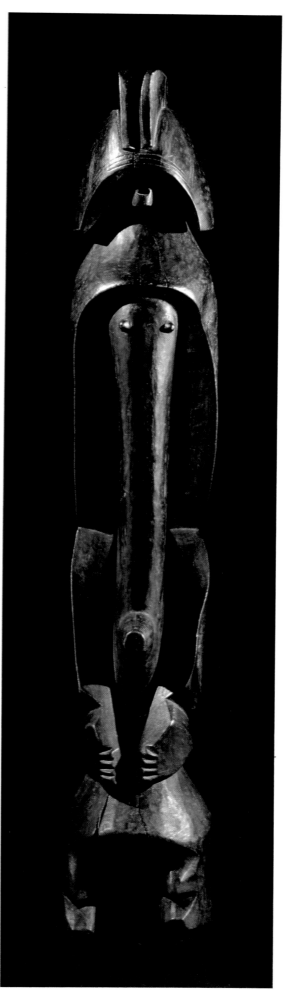

124

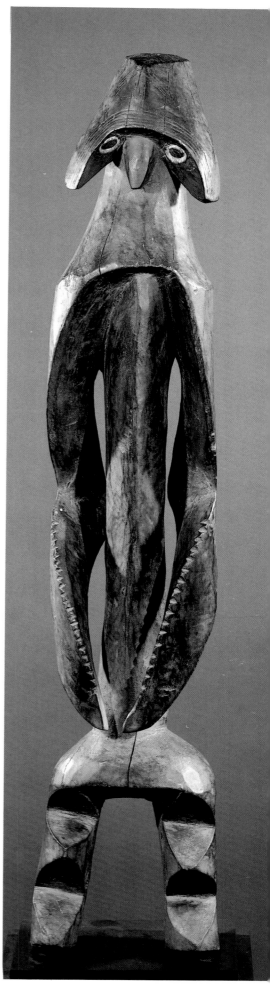

125

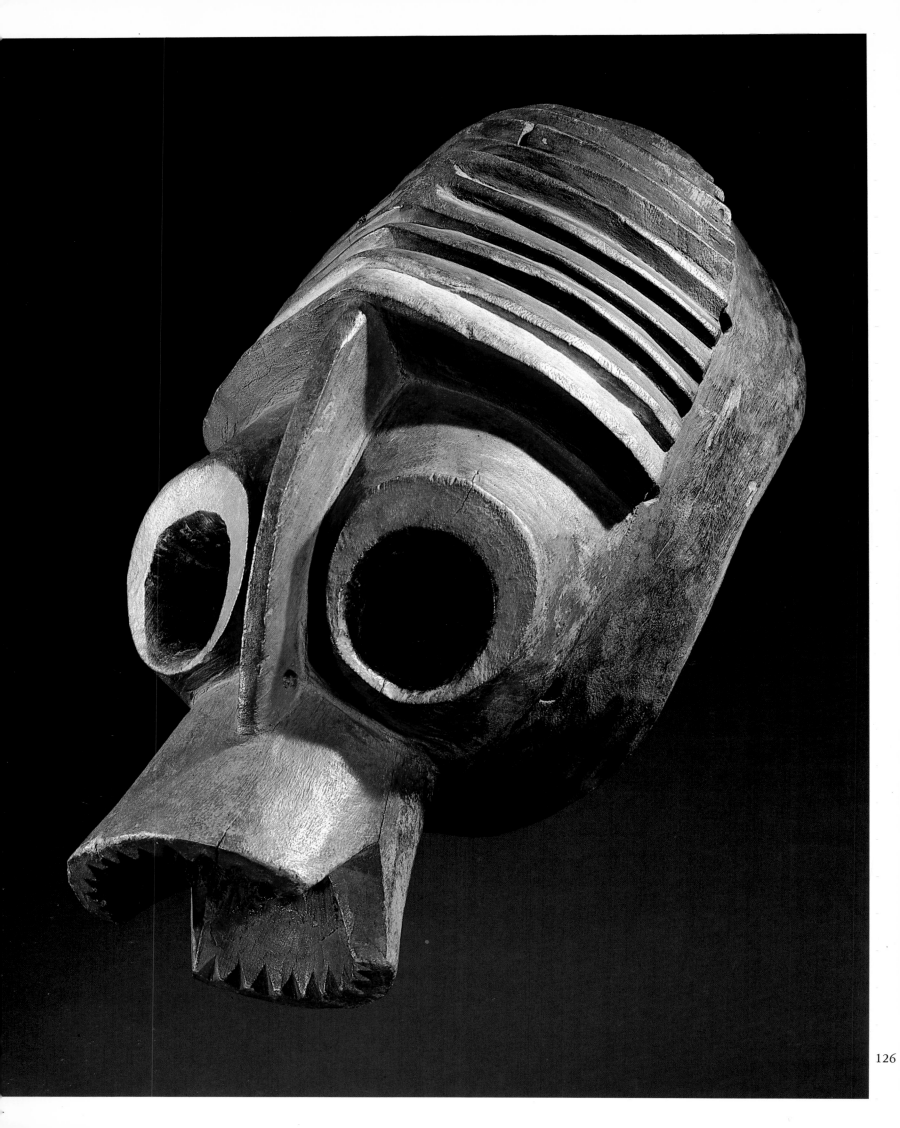

118 Tiv Statue, Nigeria
Wood. 19th century. Height: 60 cm. Private collection

119 Oron Statue, Nigeria
Wood. 18th–19th century (?). Height: 70 cm. Private collection

120 Jukun Statue, Wurbon Daudu Region, Nigeria
Wood. 19th century. Height: 59.7 cm. Width: 20 cm. Depth: 22.2 cm. De Menil Foundation, Houston

121–22 Mumuye Statues, Nigeria
Wood. 19th century. Heights: 122 cm and 99 cm. Private collection

123 Mumuye Statue, Nigeria
Wood. 19th century. Height: 110 cm. Private collection

124 Mumuye Statue, Nigeria
Wood. 19th century. Height: 120 cm. Jack Naiman Collection, New York

125 Mumuye Statue, Nigeria
Wood. 19th century. Height: 88 cm. Private collection

126 Mumuye Mask, Nigeria
Wood. Length: 44 cm. Private collection

III. THE FUNCTIONALIST APPROACH

The great majority of studies on African art claims an affinity with functionalism; structuralism, whose applicability to art is illustrated in Claude Lévi-Strauss's *Way of the Masks*, is rarely represented at all. Conforming to our intention to set forth the results of investigations by relating them to the methods and procedures that have engendered them, a word needs to be said about functionalism.

Forms and Functions

The term functionalist is given to a method or theory that confers primordial importance on the concept of function. More precisely, two themes characterize sociological functionalism: the association of the concept of function with that of form or structure, and the hypothesis of a dependence between form and function that permits one to infer a knowledge of form from that of function.

Societies and Organisms

Sociology, still in its early stages, borrows this conceptual system from a more advanced science, natural history or biology. (A. R. Radcliffe-Brown, 1965; E. E. Evans-Pritchard, 1987) An analogy justifies this borrowing. One can observe social forms and structures and assume that a relationship of the same nature exists in living beings and in societies. In the biological sciences, the forms and structures are those of organs or organisms, and these exercise functions; a distinction assigns to morphology the study of forms and to physiology the study of functions. By analogy, social morphology and social physiology would be constructed in the same way—and this is precisely what functionalist sociology is.

The organs, such as the heart or the lungs, or the bodily systems, such as the circulatory or respiratory systems, in exercising their functions satisfy the needs of the entire organism by sustaining life. By analogy, social functions satisfy social needs and ensure the continuing existence of a society. (B. Malinowski, 1944) The functions of the various organs are complementary; by analogy, those of the various social functions would be as well—which tends to make us underestimate the conflicts or antagonisms at the heart of a society.

Functionalist studies thus follow a procedure of integration. Just as the organ must be studied in its functional integration with the organism, so must a social form be considered not in isolation, but in its integration with the whole society; one must assess the connections it has with other social forms and with the society as a whole. Since conflicts or antagonisms oppose this integration, these tend to be underestimated or omitted; the principal criticisms of functionalism are directed against this tendency. (R. K. Merton, 1968)

Sociological functionalism, one sees, has no particular or selective affinity with art. What, then, is the reason for its predominance in art ethnology?

There is a functionalist theory of art, present throughout the history

of Western thought. (H. Osborne, 1968, p. 23 *ff*.) Between sociological functionalism and this artistic functionalism, a theoretic affinity and an empiric convergence can be found.

The two functionalisms share a crucial use of the concepts of form and function, as well as an intention of accounting for form through function. But art sociology and ethnology present themselves as disciplines for which a simply theoretical, abstract affinity that precedes observation would be not sufficient. An empiric convergence contributes the required confirmation.

Sociological or ethnographic research reveals that works of art exist in a functional system. They are not produced only, or even at all, for their own sake; they do not come out of the "art for art's sake" system. In the vast majority of cases observed or historically reconstructed, they were produced in order to be useful, useful by fulfilling functions and satisfying social needs that are not reducible to aesthetic satisfaction or pleasure. Such was, in particular, the system of Greek art when Greek art theory was born and developed. In that sense, the functionalist character of Greek art theory faithfully realizes the functional system of classical Greek art, which is demonstrated in the existence of a single word, *technè*, to designate that for which we need two words, art and technique. This empiric convergence, in studies on African art, is summarized by the frequent quotation of the Greek expression *kaloskagathos*, which means beautiful and good indissolubly, the good including all utilitarian or functional values. (L. S. Senghor, 1956, p. 50)

Therefore, when ethnology becomes specialized into art ethnology, it quite naturally tends to assimilate, more or less explicitly, the functionalist conception of art. This assimilation may be excessive, and the manner in which the relationship between form and function is understood should be examined.

The Relationship Between Forms and Functions

Artistic functionalism has changed in the course of its long history. One of its recent forms is an extreme one that establishes a functional relationship between form and function, one completely different from that which A. R. Radcliffe-Brown (1965) assigns to it.

$F = f(f)$: the form is a function of the function (P. Boudon, 1971, p. 31); in this formula, function (f) is taken in the everyday sense and in the mathematical sense (f), as in $y = f(x)$. This formula makes form a dependent variable of another variable, the function (f); inversely, the functional relationship (f) is constant. It is a relationship of bi-univocal (one–one) correspondence between the two variables, forms and functions (f). Thus, this formula expresses a law of the same type as natural laws: the invariance of the law's relationship corresponds to that of natural things. This functionalism is a naturalism.

But two theses are in conflict. One affirms and the other denies this bi-univocal correspondence between forms and functions. In the first proposition, one can recognize the function and the signification through the mere examination of the form. In the second, this is impossible. As we have already seen several times, ethnographic data confirms the second proposition. The relationships between forms and functions arise from convention and are culturally variable; they are not constant and natural.

Ethnographic data serves as an empiric basis for a line of argument that weakens the thesis of bi-univocal correspondence in two ways. Identical or comparable forms may exercise different functions at different places and times. Different forms may serve different goals and exercise different functions.

	Form	*Function*
(1)	one	one
(2)	one	two or n
(3)	two or n	one

In this chart, (1) summarizes the functionalist thesis, and (2) and (3) the double argument that invalidates this thesis. This argumentation was developed in a study by Gilbert Bochet (1965) of Senufo masks and has recently been resumed again. (M. D. MacLeod and J. Mack, 1985, p. 60) Democritus was already using it against the naturalist theory of language when he considered the relationships between words and things. André Leroi-Gourhan formulates it differently. (1965, Chapter XII) Cases involving practical objects are the most favorable to the functionalist thesis. The comparison between objects with the same function and different origins first of all highlights a fundamental functional form that is constant but abstract; but various concrete objects of various origins cause this form, which always appears in a decorative guise or in "non-functional wrapping," to vary (p. 128). There is always a gap between these actual forms and the fundamental form, a residue which the function prevents one from noticing and which Leroi-Gourhan ascribes to style and ethnic factors.

One concludes from this discussion that if the functionalist thesis can be sustained, it is not in this limited form which conceives the determination of form by function as a rigorous and mathematizable relationship and which presupposes that function, too, can be rigorously defined and determined. This last condition is only fulfilled by modern scientific-industrial technology; it cannot be where social functions are concerned, especially religious or magical ones. The functionalist analysis "most often is nothing other than the measure of a functional approximation." (A. Leroi-Gourhan, 1965, p. 124)

Functional Integration

Integration, the establishment of a relationship, through function, of the artwork with the society at large, cannot be both precise and direct at the same time; it must be mediated. Thus, one can distinguish intermediary levels of integration—functional subgroups or even functional contexts graspable on several levels. In this sense, John Boston (1977, p. 70) distinguishes between ritual context and social context, and G. Nelson Preston proposes a tripartition between *Sets, Series, [and] Ensembles in African Art* (1985). The function of an object operates in a context, but this context has to be specified. The same object may have more than one use and, therefore, more than one context in more than one ceremony. Thus the level of integration varies: ritual, ceremony, or cult. This has several consequences.

The signification of a plastic object is not intrinsic to it, but extrinsic or contextual; it is, therefore, relative to the level of integration in which it has either been observed while in use, or situated due to comparative data. The signification assigned to an object in a caption or description must therefore not be immediately seen as unique, unchangeable, or complete.

Secondly, it is necessary to distinguish, as Jan Vansina does (1984, pp. 82–83), between use and function. The use of the word function tends to cancel that of the word "use" and to allow that distinction to be omitted. The use for a pipe is the act of smoking, that of a lid to close a container; but a Kuba lid is decorated with complicated patterns, calling for three weeks of work, which only rich people can afford, so that this lid reveals

the social status of its owner. (Similarly, while the use for a car is locomotion, the object is also a sign of social rank.) The use of an object is not always recognizable by merely looking at its form. For example, we still do not know the use for stone figures from Sierra Leone and Guinea. Now, the function is more observable than the use; it is the effect of the use on social relationships. The object expresses these social relationships and has a communicative function. The classic example is that of ancestor worship. The objects utilized have a purpose there: to celebrate or commemorate the ancestors; that is their use. But this utilization may have one or more social effects: to confirm the authority of the ancestors over the young, and to reinforce the customary standards bequeathed by the ancestors against innovations. Vansina cites the funerary poles sculpted by the Miji Kenda in Kenya, which are used to mark a tomb and to commemorate the ancestors. It has been shown (M. Fortes and G. Dieterlen, 1966; C. Geertz, 1972, p. 20; V. Turner, 1968) that, generally speaking, the effect of ancestor worship has been a reinforcement of political structure and authority.

If uses can be observed, functions are inferred through the ethnologist's reasoning based on the observation of use. Consequently, the same object may have two interpretations, one by its user bearing on its use, the other by the ethnologist who assigns it one or several functions. Vansina concludes that the function must be accepted not as an observed fact, but as an ethnologist's interpretation.

This distinction between use and function coincides, approximately, with that between manifest and latent function. Certain functions are manifest: the user can know their nature and their purpose. But some effects of this manifest usage can escape the user; they are hidden; the function is a latent one.

If the effects and aims of function have signification, one may speak of functional signification and these remarks are also valid for this signification.

So the use is observed and the function inferred at different levels of integration. The employment of a single term for function, even when it is a question of use, engenders the frequent remark: an object is (over)decorated beyond its function. Most often what is being referred to are technico-figurative objects whose technical use requires neither figuration nor decoration—which their social function does require.

The third result is a double one: it is the possible difference, noted before, between the ethnologist's interpretation and the user's, as well as possible differences between interpretations by various autochthonous users.

If the manifest function is known to users and to members of the same group, the latent function, by definition, can only be known to the ethnologist. One cannot reproach the ethnologist for this: quite the contrary, for scientific research must break with customary knowledge, represented here by the knowledge of the users. But this does not mean that all information must be put in the same bag of prescientific knowledge.

One must distinguish between the members of the group studied, and most particularly between the informants, according to the extent and the wealth of their knowledge. The classic case is that of the blind old Dogon man, Ogotemmêli, Marcel Griaule's (1965) favorite informant. The exceptional richness of his knowledge of Dogon mythology has been exploited by Griaule and his students. But, according to Vansina, ethnologic interpretation must take the totality of local interpretations into account. These vary from one person to the next but "revolve around an intellectual and emotional core," which is why the notion of a collective

representation is seized upon. Even though the information furnished by Ogotemmêli seems to be the best possible—a hermeneutic exegesis by a person inside the group—other information from less knowledgeable sources must also be taken into account. One cannot extrapolate from mythology to sculpture, nor to sculptures originating in other Dogon localities. In other words, Ogotemmêli's interpretation is an authentic but individual one, and goes beyond the bounds of collective representations; one must make allowance for this. We shall see that, in particular, it has led to favoring a mythological exegesis, in an iconographic study, at the expense of an examination of the ritual usage of objects. (*see* p. 210)

The last result of the distinction between levels of functional integration concerns the interference between sociological functionalism and artistic functionalism. Indeed, one of the important pieces of the functionalist theory of art may be formulated in terms of integration. The ancients distinguished between the arts of production (*technai*) and arts of usage. The art of the carpenter produces the helm which the art of the steersman uses. Now, production is subordinate to use as a means is to its end. The object is produced with an eye on the end, which the user makes into a reality by using the product; thus users may know better than producers whether the product is adapted to its use or not; it is they who are better equipped to judge the functionality of the product. Various arts are subordinate one to the other in this manner. Since architecture serves as a model for this subordination, one can speak of an architectonics of the arts. It is a question of an essentially functionalist classification of the arts. According to R. G. Collingwood, this is a characteristic of the "technical"— we would say functionalist—conception of art formulated by the ancients. Although this thesis, in the last instance, integrates one art into the practice of another, a directing, leading, hegemonic, or architectonic one, it is not the same as sociological functionalism, which grants no privilege at all to artistic integration. In fact, here is another point on the subject of which one may note, between the two functionalisms, a theoretical affinity confirmed by an empiric convergence.

Caryatids

The investigation of context furnishes data without which iconographic questions cannot be resolved. The mere examination of a sculpted object does not allow us to know what or who is represented. But numerous African objects are not simply functional and, as such, representational; they are termed utilitarian in that they exercise a practical function that puts their physical or mechanical properties into play; but they are also representational, as masks or statues are. Examples are combs or hairpins, the various kinds of seats, beds, weapons of warfare or hunting (or instruments associated with weaponry, such as quivers), various receptacles, bowls or boxes, spoons, and so on. Iconography tends to be disinterested in their practical function and to attach itself merely to their representational value.

Luba sculptors produce stools with caryatids: J. D. Flam has published a very fine study (1972) on this type of object, which is at the same time both practical and figurative. His main objective, however, is iconographic: to determine exactly what is represented by the caryatid. In resuming this study we, then, will complete it by emphasizing the practical function of the stool itself, in order to show why it cannot be immaterial to the iconography.

Having posed the question of iconography, Flam answers it triply, in compliance with Panofsky's method. (1972, pp. 13–31) Most often the caryatid represents a woman. Information offered by Luba culture details

this first conclusion in two ways. Certain features represented in the sculpted figure—the very elaborate hairdo and bodily scarifications—identify it as a woman of high social rank. On the other hand, as the woman is literally represented in the act of carrying a burden, this identifies her as a slave, just as some European documents inform us that Luba chiefs in earlier days used to use actual, flesh-and-bone slaves as seats. The caryatid, then, literally represents a woman who is a slave and who is, at the same time, of high rank. But, lastly, she represents an ancestor who "carries" (metaphorically) her descendant, the chief, for whom the use of this type of seat with caryatids is reserved. The passage from a literal value to a symbolic or metaphorical value is achieved through analogy. Let us add that one can recognize an oxymoron in the composition of these two literal, antithetical values which engender the figurative value of "ancestor."

Even though Flam does not quote Vitruvius, this study cannot help but recall the interpretation the latter suggested for a Greco-Roman caryatid. Vitruvius explains why an architect must learn history:

"History furnishes him with the ways in which the majority of architectural ornaments are constructed, whose reasons he must know. For example, if instead of columns (*pro columnis*) he places marble statues in the shape of honorably dressed (*stolatas*) women, called caryatids, under the cantilevers and cornices, he will be able to teach those who do not know why this is done that the inhabitants of Caria, a town on the Peloponnesus, once allied themselves with the Persians who were waging war against the other peoples of Greece, and that the Greeks, who through their victories gloriously put an end to this war, then declared war on the Carians; that, their city having been taken and ruined, all the men were put to the sword, the women carried off as captives (*matronas . . . in servitudinem*), and that, in order to treat them more ignominiously, the upper-class women were not allowed to take off their usual dresses, nor any of their ornaments (*stolas neque ornatus matronales*); so that they would not just be taken away in triumph once only but would in some way carry the shame of seeing themselves in that position all their lives, always dressed as on the day of triumph, and that in this way they would bear the pain (*poenas pendere*) their city deserved; so that they would leave an eternal example of the punishment the Carians had been made to suffer and that they would teach posterity what their chastisement had been (*poena peccati*); this is why the architects of that time put these kinds of statues, instead of columns, on the public buildings." (*De Architectura*, I, 1, 5)

Because he is an architect and the architect cannot forget the practical function of the parts of a building, Vitruvius allows the preceding, strictly iconographical, interpretation to be completed. The parallelism of the two interpretations is most remarkable. It exists not only between levels, but between the majority of details. The identity is a double one: noble and slave. Answering to the Luba hairdo and scarifications are the *stola* and the ornaments belonging to the matron, while the act of carrying a burden identifies the slave. Since the Luba ancestor issues out of religion and the Carian woman from history, this difference must be nuanced. But, according to G. Dumézil, in the Roman ideological field the myth takes on the aspect of history. Now, art history informs the origin assigned by Vitruvius to the caryatid; in fact, this is a myth of origin. Furthermore, a Roman triumph is a religious ceremony. The two caryatids have a politico-religious and a commemorative function. By commemorating a female ancestor of the chief's lineage, [the Luba caryatid] manifests and guarantees his social rank and his political authority. The following two diagrams show the parallelisms of the two interpretations and the way in

which the practical function of support, for the Luba caryatid as well, is integrated with the literal and symbolic values of the representation.

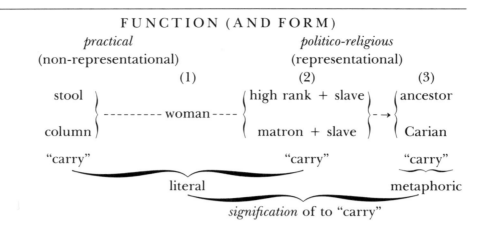

FUNCTION (AND FORM)

(1), (2), and (3): the level and stages of iconographic interpretation.

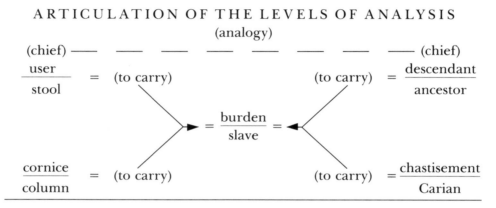

ARTICULATION OF THE LEVELS OF ANALYSIS

Let us note that it is in the use, when the chief sits down on the stool, that all the constitutive elements of the full significance are united. One must not forget the intervention of humans, as actual beings and as bearers of signification, in the context of the use. This remark takes on its full significance with the mask, which does not represent but presentifies a spirit. Here, the use joins together a visible user, the chief, and an invisible one, his ancestor. Of course, not all technico-figurative objects realize so complete an integration. Indeed, the following pages will seek to outline various modes of articulation between the levels of function and signification that have just been distinguished.

Function and Representation

African sculpted objects contained in collections are functional and representational. Their representational value is the result of certain properties of their form for which their function must account. Yet, also present in collections, though fewer in number, are objects that are functional but not representational. Why are there so few of these?

The Classical idea of sculpture makes a representational, imitative art of it, especially of the human form. (F. Hegel, t. III; H. Read, 1956, p. 25; E. Gilson, 1964, p. 91) This expectation leads to an exclusion of nonrepresentational objects. Inversely, twentieth-century sculpture imposed the idea of nonrepresentational sculpture; but, along with abandoning representation it abandoned function, so that nonrepresentational sculpted objects are rejected because they are functional. It is generally understood that functional, nonrepresentational sculpted objects are far more numerous in their original context, before this double selection. They interest us directly here because if some

functional objects are representational and others not, we must distinguish or specify functions in order to be able to account for this difference.

This way of posing the question, however, presupposes representation, with the results of a seminegative dichotomy between representation and its absence. Ethnographic research leads one to recognize that, in order to exercise their function, certain African sculptures do something other than represent: they presentify. Therefore, the question ought to be posed not only in terms of representation and function, but in terms of specified functions, and of representation or presentification.

Practical and Representational Objects

Frequently, the results of the investigation into context serve solely to resolve iconographic questions. But taking practical function into account can enrich and complement iconographic study.

It can enrich it by showing how a practical functional signification integrates itself with the functional significations associated with representation. It can complement it by permitting one to pass from an identification of what is represented to the manner in which it is represented, that is to say, to pass from the object or content of the representation to its form.

The Luba caryatid, for example, is a support and an image. As a support, it is subjected to very practical, formal requirements; even when it is figurative, the caryatid must sustain a form adapted to its mechanical function. In order to account for its observable form, at least two formal codeterminants must be admitted, a practical form and a representational form. Several consequences result.

First of all, since the form adapted to a practical function is not representational, nor, a fortiori, imitative, this permits an assessment of the gap between the form observed and the naturalist form one would, wrongly, expect.

Second, some sculptures have been analyzed in an analogous manner. But these are primarily so-called monumental sculptures. Henri Focillon has shown that Romanesque sculpture was subjected to the law of the architectural framework. A part of a building, its form defined by its function, would contribute to determining the form of the persons represented; this way one accounted, at least partially, for the non-naturalist character of Romanesque sculpture. The practical character of architecture is never forgotten, and thus the form of a pillar, a cornice, a lintel are taken into account. Why then omit that involved in the practical objects of everyday life? The law of the architectural framework must be transposed onto innumerable practical objects. Joseph Cornet applies it to Chokwe whistles: "Heads, masks in miniature, and animals are adapted with perfect ease to the general form of the whistle." (1972, p. 185)

Moreover, the two formal factors or codeterminants, practical and figurative, are not combined in a single and uniform fashion. Thus we have seen how Kuba bowls manifest several types of combinations of these two factors: which accounts for the diversity of objects of the same functional type.

Another consequence: one must not consider, per contra, the representational form as a gratuitous decoration added to the functional form; that would be favoring practical function and forgetting that the figurative "decoration" itself, too, has a functional motivation. Two symmetrical mistakes, thus, are to be avoided: neglecting either one or the other of the two functions of these type of objects.

Finally, the conjoining of the two codeterminants renders inapplicable the extreme form of artistic functionalism, discussed earlier. The

technological or technicist determination of form through a purely practical function and the manner in which religious or political function requires figurative form are not of the same nature.

But taking practical function into consideration can also complement iconographic study. It is not without interest to know that the signification of the Luba caryatid, for example, integrates the practical signification of the stool on the symbolic level. We have shown this by reviewing the various uses of the verb "to carry" called for by the analysis of the complete function of this type of object. Since the function of support is not the only practical function exercised by technico-figurative objects, one may expect to find other examples of similar integration. This is a first way in which to pose the question of relationships between the practical function of these objects and their symbolic signification.

Granary doors and the locks attached to them exercise a practical, mechanical function of security. As our own doors and locks show, this function does not require representation. Inversely, on Dogon granary doors, and on Dogon and Bamana doorlocks, people and animals are represented in relief or in the round. Now these people or animals are represented precisely because in extra-artistic reality they possess a protective value or signification. Among the Dogon, "the practical purpose of granary doors and locks is protection of the family's harvest, their most precious common possession. This physical protection is elaborated through magical protection symbolized in the sculptured forms of locks and doors"; the rows of ancestors symbolize an "enormous communal magical strength" which, according to the Dogon, is invested in the door. (P. J. Imperato, 1978, p. 31) Among the Bamana, doorlocks represent different beings depending on the nature of what is to be protected. Thus, two kinds of lizards, water and land lizards, protect one against thieves; male figures on the locks of married women protect them against infidelity. Figures with huge ears representing the fetish *komo* are used on the doors of the oldest women, who had had a large number of children: they protect women and children against sorcerers. (P. J. Imperato, 1972, p. 55)

The connection between practical function and symbolic representation can, so to speak, be expanded, and may be less strict than in the case of these locks, doors, and the caryatid of the Luba stools. Another theme is indirectly associated with practical function.

On some Dogon granary doors, breasts and a lizard are depicted, which symbolize fertility and growth. (P. J. Imperato, 1978, p. 31) This theme is linked to that of protective power; the contents of the granary, the precious family harvest are protected on the one hand; on the other, it is the product of another form of fertility and growth which provides the representation with its theme. That which is represented and its signification are indirectly linked to the practical function of protection, and directly to the contents to be protected. Thus, the representation may expand its link with the truly practical function of the object. This has two results.

Representational themes may be diversified on the level of symbolic signification. Given the same practical function, the representational forms of technico-figurative objects are more diversified than are the purely practical forms. (Thus again we encounter the critique of the extremist thesis of artistic functionalism.) Therefore, one understands why, inversely, the spirit of Western technology tends toward uniformity. So, this diversification is one of the factors that makes us appreciate technico-figurative objects aesthetically, and that makes us aware, by contrast, of the uniformity and banality of our purely practical objects.

In the second place, the derivation of the representative theme may be at the origin of a practical defunctionalization of the object.

Representation and Functional Context

Let us first consider images, and religious images in particular. Ethnographic research teaches us, in the first place, what they represent exactly—which may eventually allow a rectification of errors—and, in the second place, the reason it is represented. If, without any special information, we can recognize that a given Benin plaque represents a leopard hunt, we need, on the other hand, special information to know that another plaque, representing people held up by ropes attached to a tree, represents a ceremony specific to that culture.

Moreover, knowing precisely what is represented allows one to confront the representation with its object and to determine the manner in which the object is represented, that is to say the form or style of the representation.

Functionalist inquiry reintegrates the object into its utilitarian context, its close and direct context of use, or into a larger and indirect context such as the so-called social context. It is in these contexts that it finds what is represented and can identify it. What is represented may be visible and observable or invisible and known through verbal information provided by autochthonous informants: spirits and divinities belong to the functional context to no lesser degree than do very elaborate hairdos or bodily scarifications. As the main business of religion is to deal with the relationships between human beings and the invisible world, and as African art most often is religious, the importance of invisible beings cannot be underestimated. It is obvious that this double character—that that which is represented can be found and identified in the functional context and that it can involve an invisible entity—is not specifically African but very probably belongs to every religious art.

Thus, by allowing the object of the representation to be identified and to understand its signification, the inquiry into functional context attains the same result or the same goal as that which art history calls iconography (or iconology). It is proper to emphasize that the results of ethnographic investigations very frequently serve only to answer the iconographic question *par excellence*: what is represented? As if an image could do nothing other than represent.

THE ROLE OF REPRESENTATION What then is the functional value, utility, or role of representation arising from the very fact of representing?

"Representing" and "representation" are used here, as is "image," in a sense according to which the represented object is different from the representation and is present by virtue of merely thinking it: it is not present *hic et nunc*, in person, in the flesh. A signification is associated with it. Now, signification is of such a nature that thought can dissociate it from the existence of the extra-artistic object that possesses it. Thus, representation gives the object and its signification in its absence to thought, but to it alone. On the other hand, use is a human activity that, as such, possesses a signification. Now, if something which is part of the signification of the use is only the signification of a thing or a person, and not the effective presence of that thing or that person, it is understandable both that the use needs to represent that thing or that person by means of an image sculpted or painted, and that the image will fulfill that need. The image cannot offer the presence, but the image is sufficient if the aspect and the signification (the identity of a person) alone are required, but presence is not asked for. Sculpted objects that do something other or more than representing are functionally adapted to other uses that require the actual, effective presence.

197

THE ROLE OF THE IMAGE In this way, functionalist interpretation accounts for the existence of sculpted or painted representations, of plastic images—but it does so only in part. For all we have considered until now is the representational character of plastic images and not the fact that they are images—their plastic character.

In fact, not all representations are images. The signification required by use may be represented, offered to the user's thinking, not only through plastic representations but also through verbal representations. Therefore, one must ask oneself why certain uses require images and not merely verbal representations. The persistence of pagan uses of images that may be Christian as well as pagan forced Christian thought to control the use of religious images and, in order to control it, to define it, codify it, in a way that was both positive and excludes idolatry. The source of this doctrine can be found in Saint Thomas Aquinas in the *Commentary on the Sentences of Pierre Lombard* (III 9, 2, 3): "There were three reasons for introducing the image into the Church. The first was to instruct the ignorant, for images are used as books of a sort. The second reason was to better remind the faithful of the mystery of the Incarnation and of the examples set by the saints by representing them in front of their very eyes every day. The third was to nourish the feelings of devotion, for visible objects arouse greater excitement than those that are heard." The religious image is imitative or representational: in Christianity, presentification does not come from imagery. It has three functions: "To teach, to remember, to move." (*see* M. Baxandall, 1985, p. 66, and E. H. Gombrich, 1971, p. 152) These three functions may be practiced through the written or the spoken word. But doctrine assigns this task to images for illiterate users for whom the image is more suitable than the written or spoken word. It does so explicitly for the first function (*picturae quasi libri laicorum*); by allusion for the second one; and again explicitly for the third function.

Even though Christian society knows writing, because it assigns the image to users who are not literate, this doctrine is applicable, *mutatis mutandis*, to African imagery. African images are used in initiations, which are a form of teaching. Others are commemorative of ancestors or of civilizing heroes. If one leaves the Christian "feelings of devotion" out, one could be recording the emotions that certain African objects are meant to call forth. For example, among the Dan, certain masks are supposed to evoke fear, apprehension, or even terror, in order to exercise a function of social control, especially police control. Those images that exercise a guardian function must also evoke fear in order to dissuade users from contravening the prohibition associated with the guarded object. (Let us recall that that which evokes an emotion does not need to feel it, represent it, or even to express that emotion.)

Vansina (1984) has an answer to this question that is directly raised by traditional African imagery; he summarizes a study done by Ohnuki Tierney (1981): "It is known that visual concepts are more powerful than auditive stimuli because the memory codes them twice, once as a memory of sound and once as a memory of image. They are more immediate than most other types of memory because of their concreteness. Visual concepts of this type also persist more over time, because the object created lasts and acquires its own independent life, independent from any mind, unlike auditory stimuli which are *only* preserved in the mind. Hence visual images, icons, can have a great impact on concept formation" (p. 101). On the other hand, Vansina puts visual concepts in the sociological category of collective representations—in the sense that because African art, just as medieval European art, produces icons, and because its visual concepts are collective representations, these two arts may be qualified as communal arts (p. 102).

THE CAPRICES OF REPRESENTATION We cannot record everything that African sculptors have represented. To the extent that African sculpture is more often than not religious and that religion tends to organize the totality of human life, themes are innumerable. Furthermore, we do not have a corpus of African works available to us such as two centuries of art history on Ancient and Christian art have allowed us to construct. We will choose two extreme examples: the representation of the cosmos and of the sculpted object [representing] itself.

Among the Dogon, certain stools or certain objects said to be cultural or ritual (because we do not yet know by what cult or in what ritual they are used) represent the world: Laude (1978, p. 98 and 1973, fig. 47) uses the label *imagi mundi* for them [fig. 29].
Certain sculpted Senufo doors originating in the area of Kouto, north of Boundiali, are vertically divided into three compartments [fig. 334]. The central compartment, almost square, has a Saint Andrew's cross as its principal motif, its crossbars coinciding with the diagonals of the square; at the intersection of the two bars, a circular motif, hewn separately, protrudes. According to Anita J. Glaze (1975, pp. 65–66), the entire motif is borrowed from the scarifications around the navel of Senufo women and evokes the social order as it was established by the Creator. This iconographic theme appears elsewhere: the analogy of microcosm and macrocosm which involves the metaphor of the navel of the world.
(B. Holas, 1967, p. 50)

Of course, these two kinds of images, Dogon and Senufo, do not literally represent the cosmos.

The other extreme is something that, in the context of use, is closest to sculpture in use: the user him or herself is represented in the act of use, in such a way that the sculpted object represents itself.

Here, the functional object bearing a sculpted representation and the thing it represents are identical. In some cases, identity is simply generic: the functional object and the thing it represents are merely of the same functional type. A brass Tiv whistle, for example (*African Arts*, VI, 3, p. 20), represents a figure with a whistle at its mouth—but the real whistle is figurative while the represented whistle is not. In other, rarer, cases, identity is specific: the functional object and the thing it represents are very similar. We have noticed that African sculptors when they were representing things simplified them more than they would when they represented people. One has to differentiate, for the things themselves may be represented with various degrees of simplification.

The dancing-stick (*oshe shango*), hand-held by the followers of the worship of Shango, sometimes represents a follower who is holding an *oshe shango* in his hand [fig. 427]. Similarly, the stick (*ogo elegba*) used in the worship of Eshu, another Yoruba divinity (*orisha*), sometimes represents a person holding an *ogo elegba*. The Shango sticks are only of the type that simplifies representation; the Eshu sticks are of two types, some of which faithfully represent their model. The simplification that distinguishes between them consists most often of not having the represented person depicted by the whole object.

Again among the Yoruba, in the Owo style, the upper part of an ivory ceremonial sword, called *udamalore*, represents a chief in traditional dress who holds a sword of the state (*ada*) in his right hand and wears an *udamalore* in his belt. (R. Poynor, 1981, p. 133) A ceremonial stick [fig. 904], belonging to the royal art of Benin (P. Ben-Amos, 1980, fig. 33) represents the *oba* (king) holding a (simplified) ceremonial stick in his right hand, a ritual custom in Benin. In the case of the sticks consecrated to the worship of Eshu or Shango, the ritual hand for the Yoruba being the left one, the

user holds a stick in his left hand depicting a person holding an identical stick in his left hand. If, in the representation, a part redoubles the entire image, in the usage this redoubling is itself redoubled.

This very specific manner of depiction, common to all these examples, may be called "*mise en abyme*" ("putting in the fess point"), an expression borrowed from the vocabulary of heraldry. André Gide used it to describe one of the themes of his novel *The Counterfeiters*, in which one of the characters is a novelist in the process of writing a novel he plans to call *The Counterfeiters*. This expression can characterize the novel within a novel, the play within a play (*Hamlet*), the dialogue within a dialogue (Plato), the film within a film (*Day for Night* by François Truffaut), or the painting within a painting, as with the numerous versions of *Saint Luke Painting the Image of the Virgin* or in some variations of Magritte, especially the inscription *Ceci n'est pas une pipe* (*This Is Not a Pipe*), which Michel Foucault has discoursed on.

In catalogues, this very specific depiction is rarely noted—all the more reason to let its nature and signification pass without questioning. Is it a [rhetorical] figure? Does it have a general signification? Or must its particular signification be deciphered step by step?

In favor of the argument that it is a figure, let us note that it is contrasted with another figure, that of metonymy (*pars pro toto*). In metonymy only a part of the object is represented; here it is in its entirety (contingent on simplification, which only affects detail). In metonymy, the entire image represents a part of the extra-artistic object; here, part of the image represents the entire artistic object (and in addition its use). With metonymy, the extra-artistic object is divided by its representation; here, it is redoubled. This doubling suggests that the "*mise en abyme*" can be employed with a value of redundance. So, the use of these figures is ritualistic—and the multiplicity of redundancies in ritual behavior has been noted.

We have found only one suggestion about the particular signification of this kind of depiction. According to Vansina (1984, p. 110), "Sometimes narrative becomes mere anecdote, as in the Kuba cup portraying a man holding a cup which relates to an individual who was known for his propensity to imbibe." (A copy can be seen in L. Segy, 1975, fig. 320.)

This rare, and rarely studied, autofigurative theme seems to issue forth out of caprice. There are other whimsical representations. If one recognizes visual concepts side by side with verbal concepts, certain sculptures are equivalent to plays on words and are called visual puns, or better yet, audiovisual puns (F. Willett, 1971, p. 168); they are related to the rebus.

But perhaps a helpful piece of information would bring this whimsy into the realm of seriousness. For example, certain Baoule statuettes which seem to represent human beings in the full bloom of their beauty in reality represent deformed and hideous spirits. (*see* p. 147) This is not a whim on the part of the sculptor: the spirits themselves demand to be represented in this manner.

Practical Function and Symbolic Representation

The Luba caryatid, along with the one described by Vitruvius, actually has the function of carrying. As representation, it has a symbolic signification linked to its function in that it transfers the act of carrying from the actual function to the symbolic plane, which the commentary using "to carry" translates first in a literal sense, then in a metaphoric one. Is this link found in all types of objects that are both practical and symbolic?

One can consider this link as an application of a principle or a precept

of artistic functionalism. Fénelon, in his *Discourse to the Academy*, formulates this principle as follows: "In a building no part should be accepted as mere ornament . . . but . . . all parts necessary to support a building should be turned into ornaments." (quoted by J. Maritain, p. 81) The Venetian theoretician Fra Carlo Lodoli (1690–1761) writes: "Nothing should be made into a representation that does not truly fulfill a function." (quoted by B. Zevi, 1972, p. 995) It suffices to say that that which is valid for the sculpted parts in architecture is also valid for those of a portable object, in order to recognize that our caryatids conform to these principles—which is not to say that the Luba sculptor knew and applied them. Considered jointly, these two formulations can be analyzed in three phrases: 1) What is not functional should not be representational (Fénelon, Lodoli); 2) What is representational should be functional (Fénelon, Lodoli); 3) What is functional should be representational (Fénelon only). To "be functional" means in fact to carry out a function; to "be representational" means to be the object of a representation consisting of a sculpture that is part of the functional object. It is clear that the first two phrases confirm that "being functional" is the necessary condition for "being representational," and that the third phrase confirms that "being functional" is condition enough for "being representational." Two forms or states of this artistic functionalism can then be distinguished. A minimal state: being functional is only a necessary condition (Lodoli). A maximal state: being functional is a necessary condition, but also a sufficient one (Fénelon). The minimal form is the most frequent one; it is found, for example, with Eugène Delacroix (*Journal*, June 14, 1850) and among all the functionalist architects of the twentieth century, who rejected sculpture. According to Griaule, "It is not impossible that what we call beauty, for a Black [African], is nothing more than the adequacy of the object to be represented for that for which it has been created." (1951, p. 23) It is not impossible that this—not unambiguous—formula is an illustration of maximal functionalism.

To focus more closely on the question raised here, this minimal thesis comes down to saying that possessing a symbolic value, as representation, has as a necessary condition a literal value from which it derives and which consists of the actual exercise of the function determined.

This requirement implicitly intervenes in the treatment by Willibald Sauerländer (one of the most eminent specialists in Gothic sculpture) of the question: do the statue-columns of early Gothic art possess the symbolic value of the column? The response is negative. These statue-columns are improperly called columns, for they do not practice the function of carrying; it must be concluded that they cannot possess the symbolic value of the column. (1969, p. 86) But this line of argument implicitly allows precisely that principle to intervene that makes functional practice the necessary condition for symbolic value. These pseudocolumns do not fulfill the necessary condition and can therefore not bring the result to fruition. Inversely, the Luba caryatid, just as with the one cited by Vitruvius, does fulfill this condition. But one swallow does not a summer make. This minimal principle of artistic functionalism could very well see itself invalidated by cases in which the symbolic value is no longer associated with the literal functional value. Two specialists in traditional African art, Douglas Fraser and Herbert M. Cole (1972), are quoted in this regard: "Why does an art object become a valued symbol? One factor that apparently contributes to meaningfulness is *uselessness*. The symbolic value of art objects often seems to vary in inverse proportion to their functional utility. Thus, in Ghana the most important stool is the one which is *not* sat upon, the most effective weapons those *not* used in war. The efficacy of a Yoruba or Cameroon chief's housepost carvings is not a consequence of

their supporting capacity. But we must look beyond physical inutility to establish the full symbolic force of a leader's object" (p. 314).

The major interest of this thesis is not that it is theoretical but that it generalizes on the basis of ethnographic data—through which, as it proves incompatible with functionalist theory, can invalidate it. It invalidates both of its two forms. It invalidates the minimal form by mentioning cases where what is being symbolically represented is not functional: the condition is not necessary. And with the maximal form it shows that the effectiveness of the pillars in terms of their symbolic value is not the result of their carrying function, which is therefore not its sufficient condition.

Describing six sticks and clubs originating in Ita Yemo (Ife, Nigeria) five "represent the gagged victims of human sacrifice. It therefore seems likely that these particular objects were intended for use in some cult or ritual which involved the sacrifice of human lives." (F. Willett, 1967, p. 50) This (probable) inference causes an unformulated premise to intervene: what a functional object represents (probably) belongs to the context of its use. This premise is no different from Lodoli's precept: what is being represented (gagged victims of a sacrifice) was earlier functional— sacrificed in a ritual that included the use of the stick or the club.

One sees thus how this functionalist precept allows inferences to be made going from iconography to use. Why is this inference merely probable? Willett states elsewhere: "there are some products whose purpose is not clearly defined . . . which have no religious or didactic intent . . . and in this respect are to be considered examples of 'art for art's sake.' Yet they do have a social function which is entirely independent of the subject represented." (1971, pp. 164–65) As examples, the author cites the brass figurines from the Fon of Dahomey, which serve as signs of prestige, since brass is considered a semiprecious metal. In other words, it is not the represented form that assumes the function, but the material due to its recognized value. The principle, then, admits of exceptions and can only justify probable inferences.

Thus, one can specify that it is not artistic functionalism which the ethnographic data invalidates, but only the former's claim to universality. It is legitimately applicable to *some* cases, undoubtedly the most numerous ones, not to *all*. In order to apply this functionalism with complete accuracy, its ambiguity must be removed. It is often difficult to know whether it should be seen as an art theory with claims to universality or as a "poietic art," a collection of precepts that one practitioner addresses to other practitioners of his or her time and milieu.

PRACTICAL DEFUNCTIONALIZATION The process mentioned by Fraser and Cole manifests two aspects. A negative one: the suppression of usefulness, of practical functionality, that is to say, of the capacity to effectively exercise a practical function. And a positive aspect: the object exercises another nonpractical function. Let us call the negative aspect technical defunctionalization. We do not mean, consequently, a practical procedure, applied to the object, that suppresses its functionality; this procedure may be practical but it may also be magic or ritual.

Among the Chokwe, blacksmiths make a kind of elaborate and nonfunctional axe, used by chiefs and dancers. (D. J. Crowley, 1971, p. 321) William Fagg reproduces (1964, p. 49) an adze of Wongo origin (the Kuba group). The handle is a figure that is much too elaborate to be handheld while working. The blade has undergone an elongation that makes it unusable for cutting wood. "It is not a true tool," Fagg comments, "but a ceremonial development of a tool for parade purposes"; it serves the sculptor as an emblem. As for its signification, the right upper arm is much longer than the left one; by itself, the right upper arm is as long as

the left upper arm and forearm together; furthermore, the right forearm is even longer, going all the way to the chin. Now, the right hand is the one that uses the adze, it is the dominant hand. The blade is much longer than a functional blade and is placed in the figure's mouth. The elongation expresses importance. Fagg interprets these two characteristics as "expressions of the artistic power of the sculptor."

Among the Yoruba, the rattles for dancing consecrated to Shango, the divinity (*orisha*) of lightning—that is to say of lightning bolts and thunder—have the configuration of a double axe. Just as we speak of a thunderbolt or a bolt of lightning, for the Yoruba lightning is a "bolt" or a blow of the axe by Shango. In the extra-artistic reality of the Yoruba, Shango's axes are lightning stones which the rattles, devoted to Shango, usually represent in wood. But with some of them, while the handle is a sculpted figure, the blade is made of iron. This object, in itself functional, has been defunctionalized by being integrated with an object that is not practical but ritual.

Again among the Yoruba, an ivory whistle is one of the objects in the worship of the divinity Oko. This is a type of whistle used by hunters, but it cannot be blown. (J. Picton, 1981, p. 90) The form has been preserved but transformed into a "noble" material which gives it a functional value that is no longer practical but religious.

These facts are not true for Africa alone. "Throughout all civilizations," writes Pierre Francastel, "one notes the existence of material objects that are carriers of significations which divert from their original use without modifying their appearance." (1965, p. 107)

But their appearance, too, is often modified. The few preceding examples suffice to show that practical defunctionalization may operate under very different circumstances. Generally speaking, as for practical functionality itself, the unused object can, by hypothesis, either still be usable or be technically unusable—such as with the Wongo adze or the Yoruba whistle.

The majority of Asante stools are used initially. They maintain not only a relationship of exclusive property with their owners and users, but also a magic or mystical relationship with them, so that when their owner dies they must no longer be used; they are then blackened. On the other hand, they then have a religious use.

Without changing its form, the technical object can be miniaturized. Fagg (1963, note 39) suggests that miniaturization transforms the object being represented into an object of the same type. Sculpture in the round has a property which relief sculpture, painting, and drawing lack: "One can make statues of objects, but it is rare, and it is not even certain that the notion makes any sense. The sculpted or modeled representation of an inanimate object essentially differs in no way from that object itself. The statue of a marble seat is a marble seat, but the statue of a seated man is not a seated man." (E. Gilson, 1964, pp. 90–91) Sculpture in the round alone is capable of reproducing an inanimate object—reproducing in the sense of producing a second object—not in the sense of representing (as when one speaks of a photographic "reproduction," or, like Walter Benjamin, of mechanical reproduction of works of art). So, relief sculpture, painting, or drawing can reproduce an object in the second sense, that is to say, represent it, but not in the first sense, that is to say, produce a second sample of it. (We shall come back to this difference when we examine the capacity of the presentification of images; *see* p. 247.) According to Fagg's analysis, a miniaturization of an object is a reproduction of it in the second sense, a representation. In the case that concerns us directly here—objects that are not only inanimate but practical—this is subject to one condition: the reduction of the initial

object makes its "reproduction" incapable of exercising its practical function. The miniaturized masks of the Dan can be mentioned here in particular. The reduction of their dimensions makes them unable to exercise the physical function of masking the entire face. (E. Fischer and H. Himmelheber, 1984, p. 107) And, while women are forbidden to possess the actual masks, this is not true for the miniatures. (*ibid*.) This, at the very least, indicates a difference in function, since the miniature mask is no longer truly a mask.

The practical object can also be defunctionalized by the suppression of a part necessary to its functioning. Thus, affixed to Asante stools are bells without clappers so that they cannot be sounded. (H. M. Cole and D. H. Ross, 1977, p. 136)

If, in some cases, such as the Wongo adze, the object has been rendered useless by a transformation of the technical form into a figurative form, in other cases similar modifications do not have the same negative effect. We have seen how Kuba bowls, in various ways, have made a compromise or a fusion between practical and figurative forms without compromising the mechanical function of the receptacle. But, in other cases, the initial practical form has been so profoundly modified that one cannot recognize it in the absence of ethnographic information. Thus, among the Luba, "the very beautiful canes of chiefs are attributes of power. They are wider at the bottom and slightly concave in order to imitate the form of an oar, a symbol to remind one that the early Luba were fishermen." (J. Cornet, 1972, p. 210) This commentary suggests a complex transformation: the object has changed in nature, it is no longer an oar but a cane, so that one of its parts, useless to the practical function of the cane, is *representative* of the oar, the part being taken for the whole.

If practical defunctionalization tends to bring about the acquisition of symbolic value, it is because it enters into a double process of which it is only the negative aspect. On the other hand, a new function that is no longer practical comes to assign symbolic value to an object that has become figurative. One should not, therefore, confuse this practical defunctionalization with that practiced by some artists of the early twentieth century on various practical objects, such as Picasso's metamorphosis of the handlebar and saddle of a bicycle into the head of a bull, or certain "ready-mades" by Marcel Duchamp, such as the urinal or the bottle rack.

DEFUNCTIONALIZATION OF PRACTICAL ACTIVITIES Until now we have only considered defunctionalizations undergone by *objects*. But Griaule reports a case in which defunctionalization involves a practical *activity*, archery. "Undoubtedly, the mask has also helped to trigger aesthetic emotion in other parts of the funerary ritual. Spectators have become used to according a larger part to this sentiment, for example during archery exercises. In the latter case, the archer is not at all concerned with carefully aiming to reach the target; he knows that no eye in the crowd will follow the course of his shot but that everyone's attention will be on his clothing, his dodges, his physiognomic play. One witnesses here a complete disappearance of interest in technique." (1963, p. 795, note 2) The fact and its interpretation are most remarkable in at least two regards. It is a fortuitous coincidence, but archery also serves as an example to the Stoics in their analysis of action, or more exactly, of what directs action, of that at which it "aims." Aristotle made a distinction between production (*poiésis*) and action (*praxis*). Production is an activity whose end lies outside itself, in a product different from it, which begins to exist when production ceases and it pursues its existence alone. Action's end lies in

itself. The Stoics (V. Goldschmidt, 1953, p. 146) distinguish the end (*telos*), to shoot well and to hit the target, which belong to the action itself, from the goal (*scopos*), to win a prize, which is but a circumstance or an opportunity of the action. Griaule places us in the presence of a Dogon archer who is interested neither in the goal nor in the end: "He is not at all concerned with carefully aiming to reach . . . his target." And again, according to Griaule: his activity is aesthetic. He is not looking for a prize; he does not aim at the target, but awaits and elicits pleasure for and the aesthetic approval of the spectators. The concept of finality that suits him, thus, is not the goal, *scopos*, nor the end, *telos*, but the Kantian concept of "finality without end," which Kant indeed used in the analysis of aesthetic judgment. One could put "play" between this aesthetic activity and the action. The playful characteristic of aesthetic activity has been emphasized as has the aesthetic characteristic of playful activity (Huizinga). But the coming together of art and play is more often than not a coming together of objects and an activity. What is remarkable here is that the aesthetic emotion is directed not at objects but at an activity. This suggests that, in the study of the processes of practical defunctionalization, not only plastic objects but also the performed arts, which are activities, should be considered. Now, Griaule does more than just suggest this: the action of the ceremony called *awa* is one "of unification and individualization. . . . [It] bears principally on disciplines that appear diverse to European eyes but which, in reality and to the society studied, form a whole: cosmetics, sculpture, choreography, painting, poetry" (p. 788). That is already the theme in *African Art in Motion* by Robert Farris Thompson, as is the idea that certain institutions integrate the plastic arts and the performed arts into their activities.

The second remarkable point in this interpretation by Griaule: Fraser and Cole dealt with the passage from the practical to the symbolic, symbolism being one aspect or element of the second function of the object. It is as if Griaule, leaping over a still-functional symbolism, directly reached the formalist, nonfunctional status of the archer's activity. Jean-Louis Paudrat (in a personal communication) suggests there is disaccord between aesthetics with formalist tendencies described in this section devoted to the activity of the *awa* (p. 787 *ff.*) and the (previously cited) functionalist definition of the beautiful.

Image, Word, and Use

At the heart of context, we have until now primarily considered things, persons, or beings, visible or invisible, that are the objects of sculpted representations. But the context—the context of use or the social context—also includes elements that are not things, persons, or spirits, which are not represented by the sculptures either, and which nevertheless play a very important role in the interpretation of images. These elements come out of language. Ritual words, proverbs, fables, or myths are not represented by sculptures. What is represented are the visible or invisible beings to which these various words or images refer. What interests us now is the relationship between the images and words—and no longer reference or representation, even when it is achieved through images and words. In some cases, the images "illustrate" a proverb; but this particular case ought not to be held as generally so. One must therefore attempt to determine several modes of connecting images and words. A first attempt will assume a correspondence between the modes of composition of verbal entities and images, applying to the latter the concepts of narration and setting that are normally applied to the former.

ICONOGRAPHY AND COMPOSITION It has often been observed that African sculpture is not narrative. Groupings of figures, in the round or in relief, were supposedly never composed as stories. This is a negative determination: one was expecting narrative compositions and did not encounter them. Thus, one forges a dichotomy between narrative and non-narrative sculpture. Once again, such a seminegative dichotomy is incapable of accounting for the complexity of the data.

The observation and analysis of African images lead to making a distinction, at the minimum and provisionally, between three categories, going from the simple to the complex. At the simplest level, an isolated image represents a single person. This category is different from composition, which implies at least two figures. Let us agree to speak of figures in accord with one of the normal uses of the word. Examples are numerous, not only in African sculpture but in sculpture universally: "The vast majority of statues that fill museums represent only a single person." (E. Gilson, 1976, p. 94) This is the ratio one finds as well in the collection of works reproduced in this book. At a second level, the figures are composed into scenes or settings; at the third level, scenes are composed into stories and images are narrative. So, it is important to distinguish between a setting and a story, for, if sculpted settings are easily found, it is not certain that one can find in African sculpture an example of narrative composition. If this is indeed so, this absence raises questions.

But an arrangement of figures does not always engender narrative images. One must therefore introduce at least two other, intermediary, categories.

The elements, figures, or settings, can be composed in two ways, juxtaposition or coordination. In order for there to be a setting, it is necessary that the figures be coordinated and not simply juxtaposed; in order for the image to be narrative, it is necessary that the scenes be coordinated and not simply juxtaposed.

A rather simple criterion permits us to distinguish between juxtaposition and coordination of figures. In juxtaposition, the figures, simply placed contiguously, are not affected by the arrangement: they remain identical to what they would be in isolation. In certain cases, this identity can be monitored when one has two figures of the same iconographic value at one's disposal, one isolated, the other in association. For example, two or three Dogon figures are juxtaposed: one has seen identical figures in isolation. The identity of figures among themselves may serve as an index (Baoule). This criterion may be made specific, all the while remaining applicable, if not in every case at least in most of them. In Africa, an isolated figure representing a person in repose is not only frontal but symmetrical (contingent on an approximation to which we will come back later). The representation in action of a single figure preserves frontality but abandons symmetry: a small number of the parts of the figure representing gestures are no longer symmetrical; in the composition of the scene, these parts and these gestures serve to coordinate the figures. A fortiori, this is valid for the abandonment of frontality, but much less frequent. Moreover, in relief sculpture, the frontal presentation suits juxtaposition, and its abandonment (most often in favor of the profile, less frequently for a three-quarter view, and almost never for a back view) suits coordination: two figures in profile are composed face-to-face or back-to-back.

The coordination of scenes depends primarily on visually foregrounding the iconographic identity common to figures belonging to different scenes. This identity is that belonging to the agent (or agents) of a continuous action, itself composed of scenes or episodes and having a unitary significance. For example, on a Yoruba door several scenes are

represented: the sacrifice of an animal, an episode from a divination ritual, three scenes depicting an offertory to different divinities. (W. Fagg and J. Pemberton, 1982, p. 106) Iconographically these scenes refer to different cults, not to successive acts by the same cult. There definitely is thematic unity, the cult in general, but there is no narrative unity; throughout the five scenes, no single figure can be identified as an agent successively exercising the various acts or rituals of the same cult.

Thus, as an alternative solution to the initial dichotomy, we have a classification in five categories available to us:

1) Isolated figure (falling short of composition).

2a) Composition of figures in juxtaposition (short of the scene).

2b) Composition of figures in coordination: the scenic image.

3a) Composition of scenes in juxtaposition (short of narration), as in the Yoruba door we have just mentioned.

3b) Composition of scenes in coordination: the narrative image.

Somewhat more attention to African sculptures leads to the insertion of new intermediaries. In studying effigies and portraits, we made the distinction between the depiction of a person in a condition and one in an action. The depiction of a person in a condition juxtaposes the person and his or her attribute(s); the depiction in an action coordinates the person with objects or with a secondary person. That is the difference between the representation of a martyr and of martyrdom. Or, for example, of two figures: a person and a drum. A royal Kuba effigy juxtaposes these (Brooklyn Museum, New York): the drum is an individualizing attribute. A Benin plaque coordinates them: the person is playing the drum; the same is true, in the round, with the Mbala and Nkanu drum players.

"Maternity scenes" are frequent in African art: there is a central character, the mother, and a secondary character, the child. Certain maternity scenes juxtapose the two figures or, more precisely, the coordination between them is a partial, unilateral one. One of the figures can remain frontal, symmetrical, motionless. Such is the case in an Afo maternity scene in which only the face of the child is in coordination with the mother's, who is depicted as if she were alone, as a comparison with two isolated Bissagos figures shows. The same unilateral coordination exists in a Dogon maternity scene. Kongo maternities are sometimes juxtaposed; but sometimes they unilaterally coordinate mother and child, and sometimes bilaterally. The first two cases treat the child as an attribute. Thus, unilateral or partial coordination inserts itself between figuration in a condition and the scene. One Benin plaque could be entitled "leopard hunters" and another one "the leopard hunt."

Two observations need to be made here. First, unilateral coordination approaches the status of a scene more closely. Bilateral coordination is distinguished from the scene only if the secondary figure is there for iconographic reasons; this means that the demarcation between the two categories is not a sharp one. The depiction in action is preparatory to the scenic composition which coordinates the characters. Second observation: as for aesthetic appreciation, coordination should not be favored over juxtaposition. On the royal portal of Chartres, the statue-columns are juxtaposed; later, Gothic art begins coordinating statues in the portal splayings two-by-two in small scenes, the Annunciation or the Visitation: but one cannot, for this reason, prefer them over the earlier ones. Furthermore, the maternity theme has a strong emotional value for us: that of maternal feeling. For an African, its significance is linked to that of fecundity or fertility, not only of women but of the soil: the theme is no longer psychological and emotional but religious and cosmic. The African sculptor does not have the representation of maternal or filial feelings in mind; if that were the intention, juxtaposition would be a flaw, for the

staging of characters is a means of representing their expressions.

Figures that are simply juxtaposed appear frontally and symmetrically in an identical manner and make no gestures or make only gestures which are not coordinated. Two Dogon musicians [fig. 24] and the four Baoule figures [fig. 69] are juxtaposed in this way. The latter work offers an opportunity to specify that juxtaposition does not imply an absence of order. Repetition is not indefinite but limited by an arrangement in chiasmus (a–b–b–a) of the masculine figures (a) and feminine figures (b). It is symmetry, but more iconographic than visual; in other words, the repetition of the figures leaps to the eye immediately, while the sexual differentiation requires more attentive observation.

In relief sculpture, presentation in profile is not used to coordinate the figures; each figure appears from the angle that best shows its nature or condition: thus, the horse is shown in profile, the crocodile from above.

Coordination is frequently achieved by means of the arms; the arm of one figure is linked with another figure, as with two Dogon couples or a Djenne group. But even when bilateral, coordination remains partial when on the whole the figure remains frontal and symmetrical, the figures turning neither the torso nor the head. At first view the relief depicting a sacrifice of a cow seems entirely coordinated; in fact, six figures are coordinated with the animal through their arms, but two small figures remain in isolation. We have noted that the African sculptor often treats various parts of the same sculpture in a different fashion. Partial coordination makes this general remark more specific. In each figure, only one part serves to coordinate; as for figures among themselves, some may remain in isolation. In certain Benin plaques, it is as if coordination were a new mode of depiction that remained associated with the older approach of juxtaposition.

Also in Benin, the rotation of figures on their vertical axis permits coordination: the lateral figures turn toward a central figure, viewed frontally. This rotation engenders a three-quarter view or profile which has nothing to do with foreshortening (that is to say, with applying perspective to the figures): on the contrary, the exterior arms of figures are frequently lengthened in order to join with the central figure. These reliefs are conceived in the round. The figure in the round is divided into sections and joined to the background, the division engendering a three-quarter view or a profile; thus, with the exception of the arms, the figure remains frontal, symmetrical, and completely three-dimensional; the sectioning that diminishes its depth must not be confused with the reduction of depth traditionally serving to distinguish relief from sculpture in the round. Thus, in terms of sculpture theory, these reliefs are notable. While, according to Hildebrand, a grouping in the round may be conceived in relief, following the "principle of relief," in a symmetrical, inverted manner, such reliefs are conceived in the round. The division into sections of figures in the round and their attachment to the background are found also in the commemorative Ijo (Kalabari) screens called *duen fobara* [fig. 471].

The Benin plaque which represents the *amufi* acrobatic dance is a very fine example of scenic composition [fig. 455]. Yet two frontal figures, seen full face, are nonetheless coordinated. Their asymmetrical arms and legs are united by the ropes; moreover, although they are complete figures, they are symmetrical in relationship to the axis of the tree trunk. This symmetry is reencountered with the birds arranged on two symmetrical, horizontal branches. We have seen that the arrangement, tree and ropes, served as a site for the characters and that, in the strict sense of the word, there was no representation of space, the representation obeying the principle of consolidation of the surface; the coordination of the figures,

the "setting," is created on an imaginary frontal plane, parallel to the background. Perspective would create an imaginary depth that would allow a setting in depth. In African reliefs, scenic composition remains subservient to the consolidation of the surface.

Three objects need to be considered separately; while the preceding examples are purely representational, it is the technico-figurative objects that lead us to wonder whether scenic coordination takes practical demands into account. In examining this type of object (*see* p. 197), we have noted that practical forms and organic forms (representing an organism), whether of parts of or of the entire object, can be either juxtaposed or fused. This fusion corresponds here to coordination.

One of these objects [fig. 194] juxtaposes the practical form of the receptacle and the figures; the two figures are coordinated with the practical part: they hold the receptacle in their wide-open arms, but between them they are not coordinated. Inversely, in two neckrests, the coordination of the figures fuses with the coordination of the practical parts. In the first one (Luba-Shankadi) [fig. 711], the figures are coordinated by means of their arms and legs. From the practical point of view, each figure serves as a cylindrical base and the four arms function as braces reinforcing the bases. The practical connection of the two vertical bases by the upper strip upon which the neck of the user rests corresponds to the face-to-face position of the heads. In the second object [fig. 700], the two figures are upright, side by side, coordinated only by means of the inner arms: they hold each other by the waist. They are coordinated in scenes: two figures cooperating in carrying a common burden. The symmetry of two asymmetrical figures responds to this cooperative effort. The iconographic theme does not require the rupture of frontality. As in the caryatids of the stools, the practical function—to carry—is doubled by the representation of two people cooperating in the act of carrying. The scenic coordination integrates the functional coordination of the practical parts. Of course, all technico-figurative objects do not show such perfect integration.

IMAGE AND MYTH If coordination presents degrees, intermediaries may be inserted between the categories of the classification suggested previously. Thus, we have at our disposal a series of the same sort as that suggested by Willett and Roskill: the modes of composition form a family.

One may say loosely that, in this series, the examples to be ranked in each category are less and less numerous. It does not seem one can find one case of narrative composition. It is in the art of Benin and in Yoruba art that we find works that are the least distant from narrative composition.

But one cannot group several Benin plaques, scenically composed, into a unitary narrative sequence as one would group together the panels of an altar front or of a predella narrating the life of Christ or of a saint.

Margaret Thompson and Henry John Drewal (1987) describe the composition of Yoruba images as serial. The Yoruba give aesthetic preference to a certain form of composition and this form corresponds to their social organization. The structure of the arts and of society are homologues and, "what is more important," these structures are concrete manifestations of the conceptions the Yoruba have about the nature of existence and being. This "ontological thought" is formulated by some Yoruba thinkers, theologians, learned elders, priests, and diviners (p. 225). In other words, the Yoruba conception of the world is structured by categories outside of which this conception cannot take shape, and these formative categories of thought are, among certain Yoruba, the object of

thought about categories. The result is that some forms of composition in particular are inevitable. However, one finds them in every domain of culture and particularly in arts involving time and space. It is this form of composition that is described as serial. For example, each one of the reliefs in the series on the edge of a divination tray (*opon ifa*) represents an autonomous force in the Yoruba universe (p. 245). Iconographic analysis (W. Fagg and J. Pemberton, 1982, p. 106) provides identical analyses. This serial composition, when it is spatial, is the equivalent of what we have called juxtaposition. Each "autonomous force" is represented in action by the characters in the tray's reliefs, but the flip side of this autonomy is the absence of a unitary action in which all characters participate and which would then be the object of a narration. In short, the fundamental categories of Yoruba thought do not render possible a narrative composition. Let us recall that James Fernandez demonstrated, in the Fang culture, a fundamental category, the opposition of complementarity (for which the term "oxymoron" is appropriate); this would not admit narrative composition, while it does make scenic composition possible.

Now, in terms of language, a myth presents by definition a narrative composition. In Africa, then, there should be a lack of agreement between the narrative composition of a myth and the non-narrative composition of images. This disparity is particularly prominent in Dogon culture. On the one hand, there is a rich and complex mythology, collected by Griaule and his students; on the other, there are compositions in the round and relief sculptures that rarely go beyond the partial coordination of figures. The quality of this art is not in question: coordination or juxtaposition are not aesthetic criteria. But Dogon art raises in a particularly insistent fashion the question of the reason for this disparity. It also raises another question: is it legitimate to use such a complex mythology in the iconographic interpretation of figures in isolation or in simple coordination? These two questions cannot be treated in the framework of this essay: the second because it is too specific, the first because it is too complex. We shall only indicate a direction inquiry might take.

In this regard, one suggestion may be found in the way in which Lévi-Strauss connects masks and myths (1979). The content of the myths does not serve to determine the iconographic identity of the masks. The comparison is structural, formal: it has bearing on the connections between relationships; the contents of signification are the terms of these relationships. The masks certainly enter as terms in these relationships, but the relationships are very different from the ones that served to distinguish modes of composition of figures since they are not inherent in the images but are established by use.

Image and myth ought not to be confronted directly, but only through the mediation of usage—which is a way of allowing for the disparity of composition between images and myths, and particularly in ritual use. The majority of ritual words, compared to myths, consist only of fragments of the latter. (E. Ortigues, 1981, p. 79, *ff.*) The myth is the product of an exegetic activity that tends to become independent of ritual; in losing the practical character of ritual and the ritual word this exegesis becomes speculative and engenders a mythology. If sculpture remained more closely linked to its ritual use, it could not develop a narrative mode of composition parallel to that of the myth. Are we not finally saying, then, that the word liberates itself more easily from practical activity than does the image?

If that is indeed true, one understands how certain cultures which, as opposed to Dogon culture, do not include mythology, will not, a fortiori, know narrative image. Thus it is that Hugo Zemp, in reviewing the myths of the origin of musical instruments among the Dan, notes "a great

difference between the culture of the Dan and that of the Dogon" (p. 94). The Dogon make a distinction between mythical and historical narratives and tales and fables, and their myths, esoteric or exoteric, are placed at different levels of knowledge. "There is nothing like that among the Dan. As they possess no texts in a secret language or texts that are more religious than others, they also do not know the teaching of myths during the initiation period, any more than they know the narration of myths during rituals." (1971, pp. 94–95)

The hypothesis according to which the word frees itself more easily than the visual image from ritual activity and develops independently from it, finds confirmation in a recent study (D. Ben-Amos, 1987) of animal themes in the visual and the verbal arts of the Edo (a people of Nigeria whom foreigners call the Bini and their city Benin).

In Edo culture, there are at least two symbolic systems of animal metaphors, one independent from the other. The symbolic universe is divided, as if by a line dividing bodies of water, between the verbal and visual arts. Narratives do not necessarily offer an exegesis of visual images but concern a distinct group of animal symbols that do not appear visually (p. 296). Most often, the visual art represents the normal cosmology of animal symbolism in this society, while the verbal art offers a wider range by varying and manipulating the system, or even skirting it entirely (p. 297).

This marked division between verbal and visual forms depends at one and the same time on the context of use and the capacity inherent in verbal and visual arts in a society without writing. Visual art is involved in religious or civic rituals, stories about animals in educational context of the home. In terms of visual images, animals are symbols of supernatural powers or emblems of political authority. But in stories, animals bring an ethical message to the public. Yet the attitude of Edo culture towards these ethical messages is an ambivalent one; there, as elsewhere, acting correctly rarely leads to success (p. 300). Visual images lack the ability to represent ambivalent situations, while narratives can bring clear messages as easily as ambivalent significations (p. 301).

THE PROVERB: WORD AND IMAGE Let us now consider the connection between sculpted images and proverbs rather than myths. The two classic cases are the lids covered with illustrated proverbs in use among the Woyo (a Kongo subgroup) and the weights inscribed with proverb images in use among the Akan. One speaks of illustration: here, a scenic composition, found in the images, is supposedly matched with the content of a proverb.

On terra-cotta containers, Woyo wives place wooden lids which bear figures associated with proverbs.

The proverb and its images may be considered from three points of view. First, there is the iconographic or semantic point of view: the image is used as starting point, and one looks for the proverb in order to determine the identity of the characters and the signification of the scene depicted. The second point of view is that of the composition of the images. The third is that of their use. These three points of view correspond roughly to the tripartition of linguistics into semantics, syntax, and pragmatics. A study by Joseph Cornet (1980) and a note by Albert Maesen (1960, pl. 5) favor the "semantic" point of view; furthermore, these two authors, placing the objects in the category of pictography, tend to attenuate the difference between image and proverbial speech. As we are privileging the point of view of the user, we propose to emphasize the difference in use between proverbial image and proverbial speech.

"The majority of representations and signs relate to some proverb. The

211

sociocultural context gives its full value to the *semantic* function of this system. Among the Woyo, the position of women is reinforced by the matrilineal structure; the children born from a union are part of the mother's genealogical group. Under these conditions, it is not inconceivable that the woman feels freer vis-à-vis her husband.

"On the other hand, the Woyo adhere to the old African tradition which prescribes that the man and the woman not take their meals together. The men eat in the company of their children and male family members, of friends passing through, and neighbors. These meals are true *social rituals*, whose setting is not the darkness of the hut but rather a corner in the open air. The wife or a little girl serves the husband and his companions.

"When the weather is normal, a leaf or some woven wicker is placed on the receptacles as a cover in order to keep the contents warm and to guard them against impurities. However, when the wife feels the need, she places a wooden cover on the receptacle meant for her husband, *illustrated* with one or several proverbs whose meaning, which obviously escapes nobody's attention in the group, does not fail to *produce a certain effect* on the interested party. Most of the time, it concerns a reminder of some, not always pleasant, truth, whose *effectiveness* is increased by the mere fact of the presence of several witnesses.

"It is better to add that through this intermediary many tensions are relaxed and that this cathartic *function* definitely provides the *ideographic* decoration of the covers with its valorization." (A. Maesen, 1960, pl. 5, italics mine.)

Now, we must emphasize the effectiveness of proverbial language in a traditional society if we want to understand that of these lids. Vincent Guerry gives an excellent example of this:

"One day I came into a village and, wanting to go into a courtyard, I heard an old man cry: 'You, white man, you will not set foot in my courtyard.' Confused, I went toward another courtyard. Here I was perfectly welcome; so I explained what had just happened to me. I was told: 'Before, the white people had been very hard on that family: pillage, torture, rape; that's why they chased you away.' So I asked: 'Is there no way to appease this old rancor?' The man thought a while, then said to me: 'Go back to their courtyard and say to the chief: if the lizard retraces his steps, he will not break his back.' No sooner said than done: I simply repeated the proverb and the old Baoule man turned completely around: he smiled, had me sit down, and we talked for a long time" (pp. 21–22).

In proverbial speech, "to say is to do" (J. L. Austin): to counsel, to command, and so on. But this is not merely "to do," it is to have (others) do: the counsel is followed, the order obeyed. The interlocutor does not merely change his or her opinion but his or her behavior. The proverb not only possesses a cognitive capacity for persuasion, it can also have a practical effect. It is the equivalent of a maxim that has the power of being followed. It owes this double force to its status as a communal representation.

An "aesthetically very elaborate" lid (J. Cornet, p. 97) [fig. 987] has received different commentaries from Maesen and from Cornet. The two interpretations are not contradictory, for they deal with two uses, or more precisely, with two phases of use. According to Cornet: "it is given to a young woman to lavish her with advice" (p. 98); but Maesen considers it in terms of the use a young woman makes of it later in her conjugal relationship. The principal proverb Cornet mentions suits both of these phases: "If you have nothing available to prepare for your husband, put a few pieces of manioc in the plate" (p. 98). Yet, the image does not represent the woman putting some pieces of manioc in the plate: they are there already. It represents the husband, his hand pointed at the plate, his

chin up, turning his head toward his wife, and addressing her. According to the principle of the hierarchy of sizes, the husband's figure is larger than the wife's. She is depicted in a kneeling position, her hands on her knees, the traditional attitude of deference and respect. The composition is fully scenic. Knowing the proverb, the significance of the image is easy to understand (Maesen): the husband (authoritarian): 'Why are you serving me only three pieces of manioc?'—the wife (deferentially): 'If you have nothing to prepare for your husband, put a few pieces of manioc in the plate.' The scenic composition does not correspond to the proverb alone but to a short dialogue in which the proverb serves as an answer. Let us note that the wife, by this answer, follows the advice given her on the lid. All this as to the signification and composition. One question remains: why does the wife, in the (conjugal) "scene" where she uses the lid, answer not by quoting the proverb, but by presenting the lid? In other words, what is the specific use of the proverbial image?

Still according to Maesen, what is involved is most often a question of presenting "a not entirely pleasant truth" to the husband. Now, rhetoric has a [linguistic] figure adapted to such a situation: a way of saying something disagreeable by attenuating precisely that characteristic. This is euphemism: "the figure of rhetoric which consists of softening a harsh word." (*Littré*) Thus, there is conformity between the ambiguity of euphemism and that of the situation of the Woyo wife facing her husband. If her position as wife does not allow her to speak a harsh word harshly, her belonging to a matrilineal structure gives her the "liberty" of saying it in gentler terms. Hence the substitution of the plastic image for proverbial speech is functionally equivalent to the substitution of this linguistic figure of euphemism for a literal declaration. It makes the compromise between prohibition and permission real.

This interpretation cannot be generalized. Nevertheless, it can be brought closer to the use that M. D. MacLeod recognizes in the weights with proverbs of the Asante. "They surely served for discussion at Court, covertly and indirectly, of subjects laden with meaning and danger. They allowed various conflicting claims of political leaders to be debated, considered, and examined in every way, and adjusted without anyone ever referring to them directly. . . . In Asante life, the role of proverbs is generally that of aiding in an indirect discussion of difficult subjects." (1987, pp. 291–92)

By replacing speech, the mute image allows one to avoid a verbal dramatization of the conflicts which would make their resolution even more difficult.

127 Mambila Mask, Nigeria
Wood. 19th century. Height: 44.5 cm. The
Metropolitan Museum of Art, New York

128 Statue from a Mbembe Drum, Eastern
Nigeria
Wood. 14th–15th century. Height: 64.5 cm.
Musée des Arts Africains et Océaniens, Paris

129 Mbembe Statue, Eastern Nigeria
Wood. 14th–15th century. Height: 74 cm.
Private collection

130 Mboye Statue, from the Region
between Shani and Gombe, Nigeria
Wood. 14th–15th century. Height: 110 cm.
Private collection, Belgium

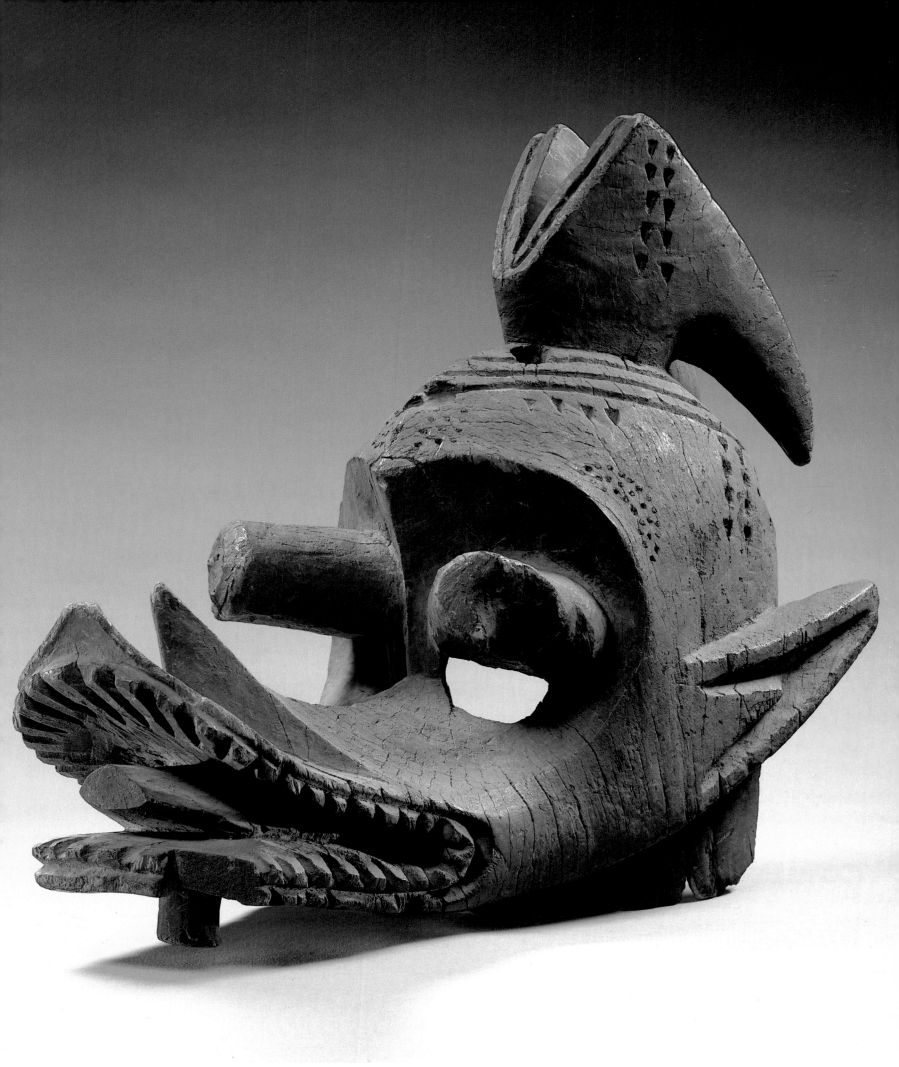

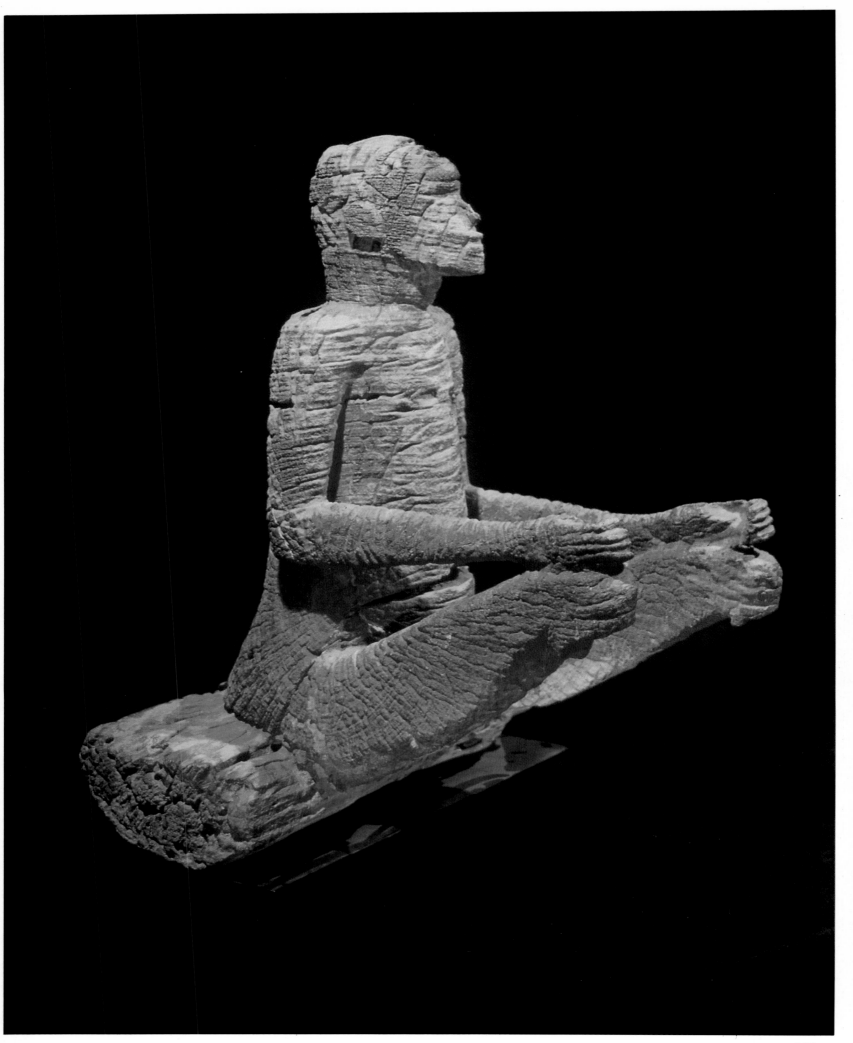

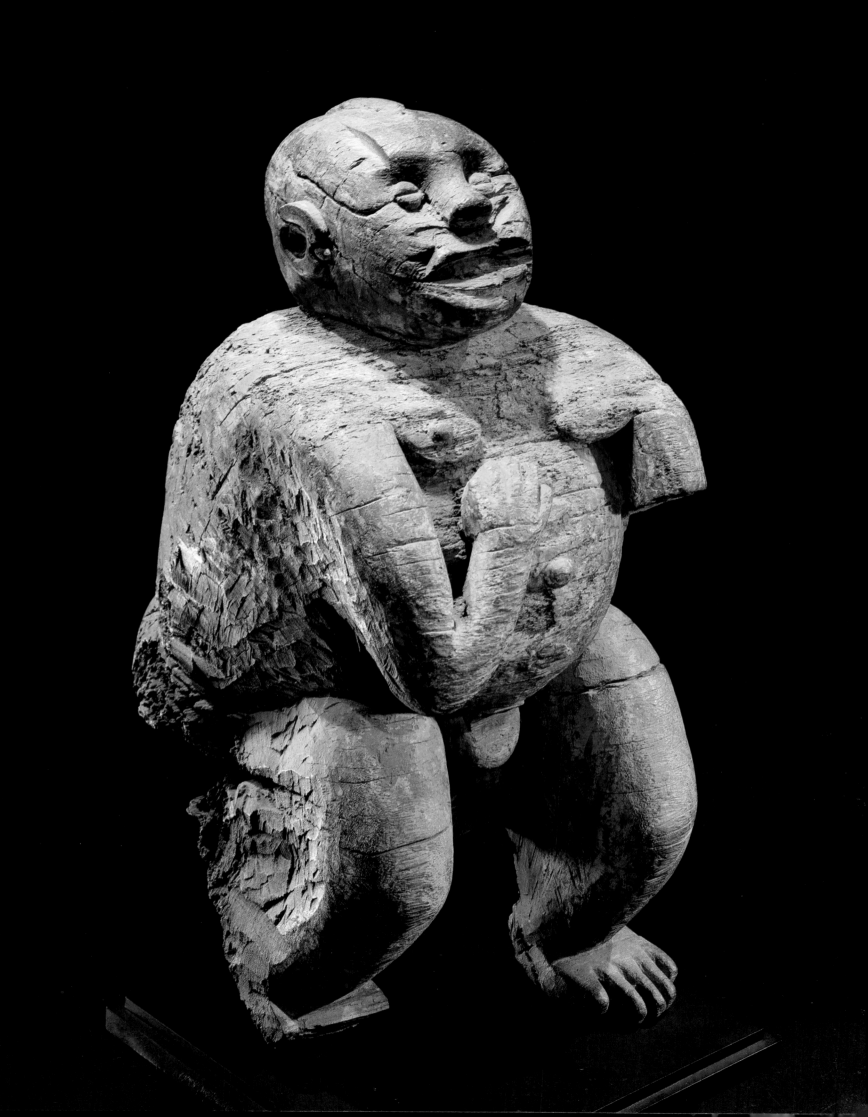

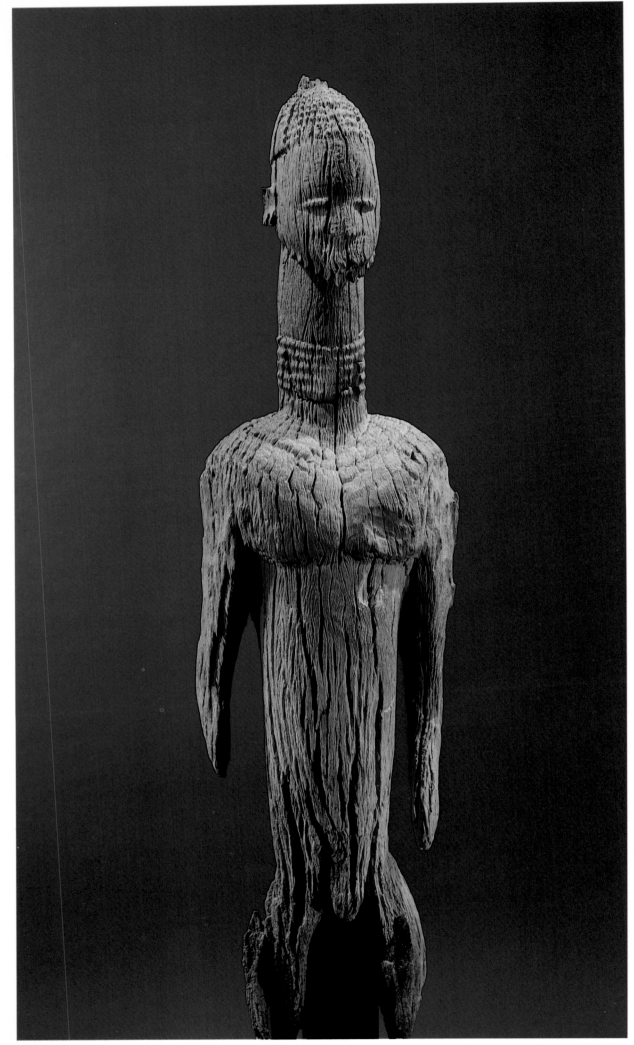

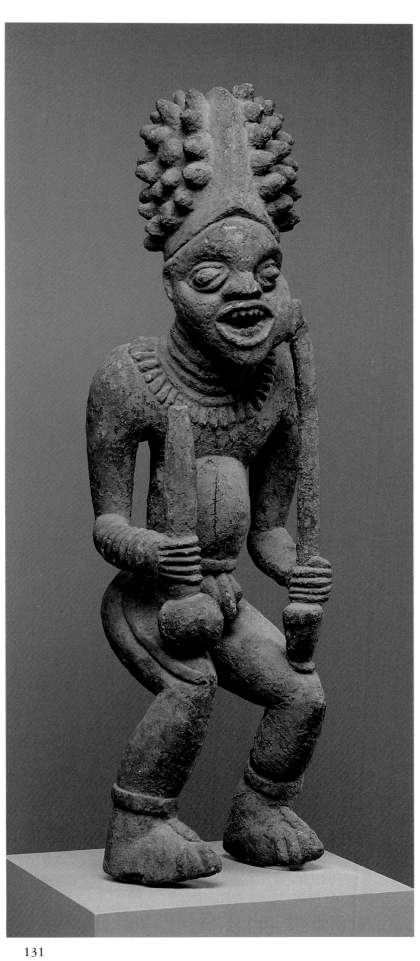

131

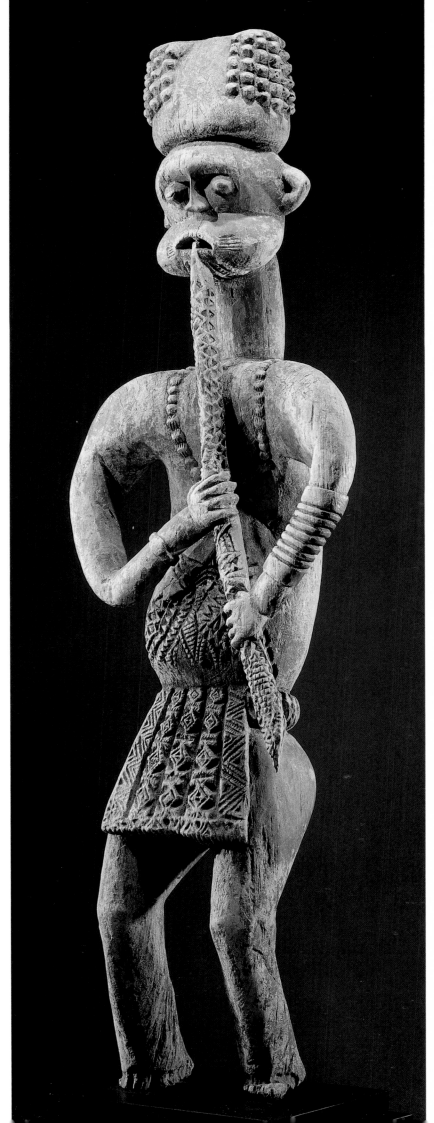

132

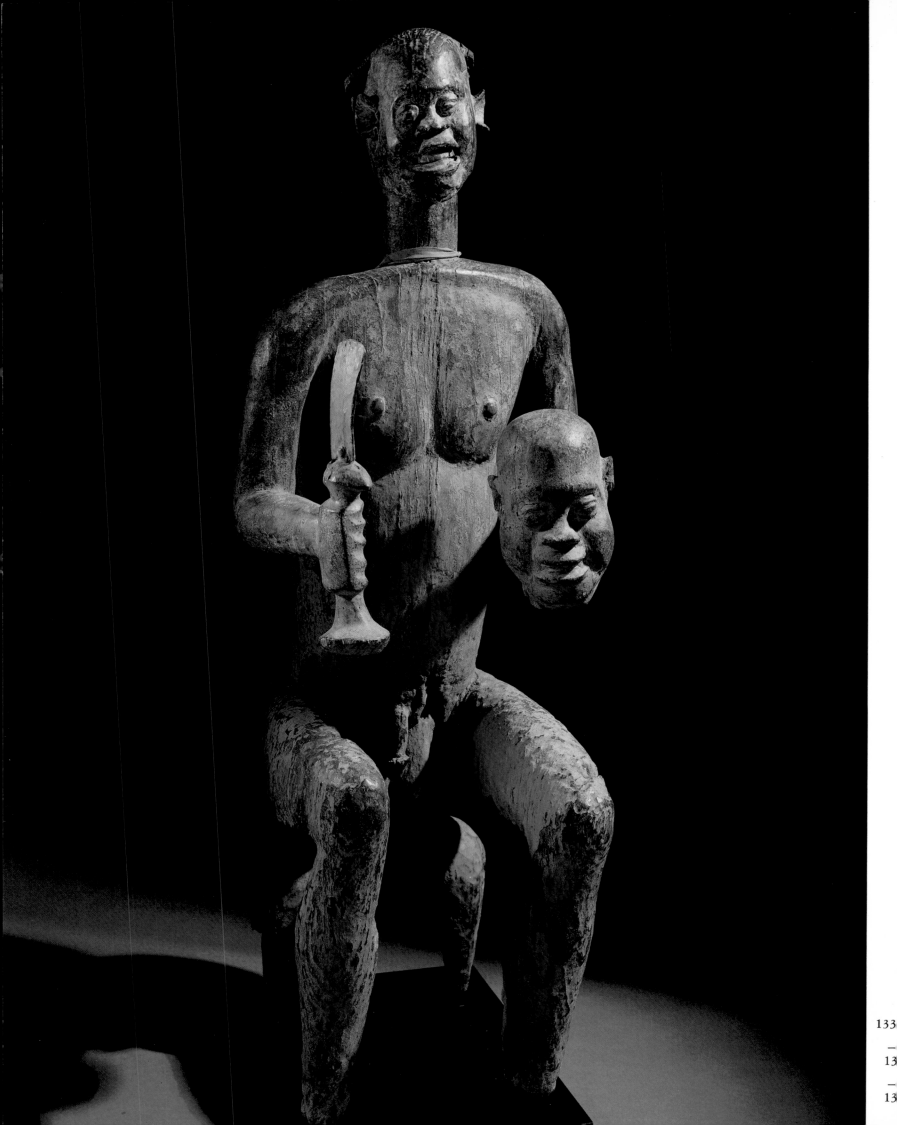

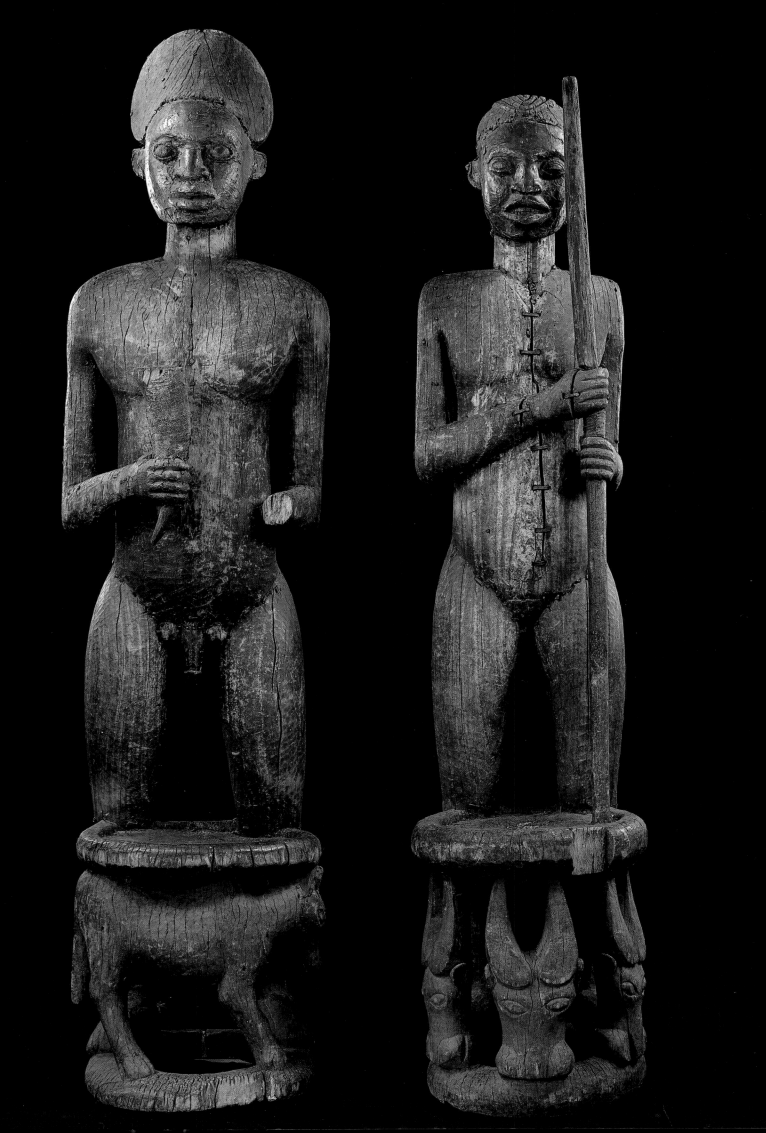

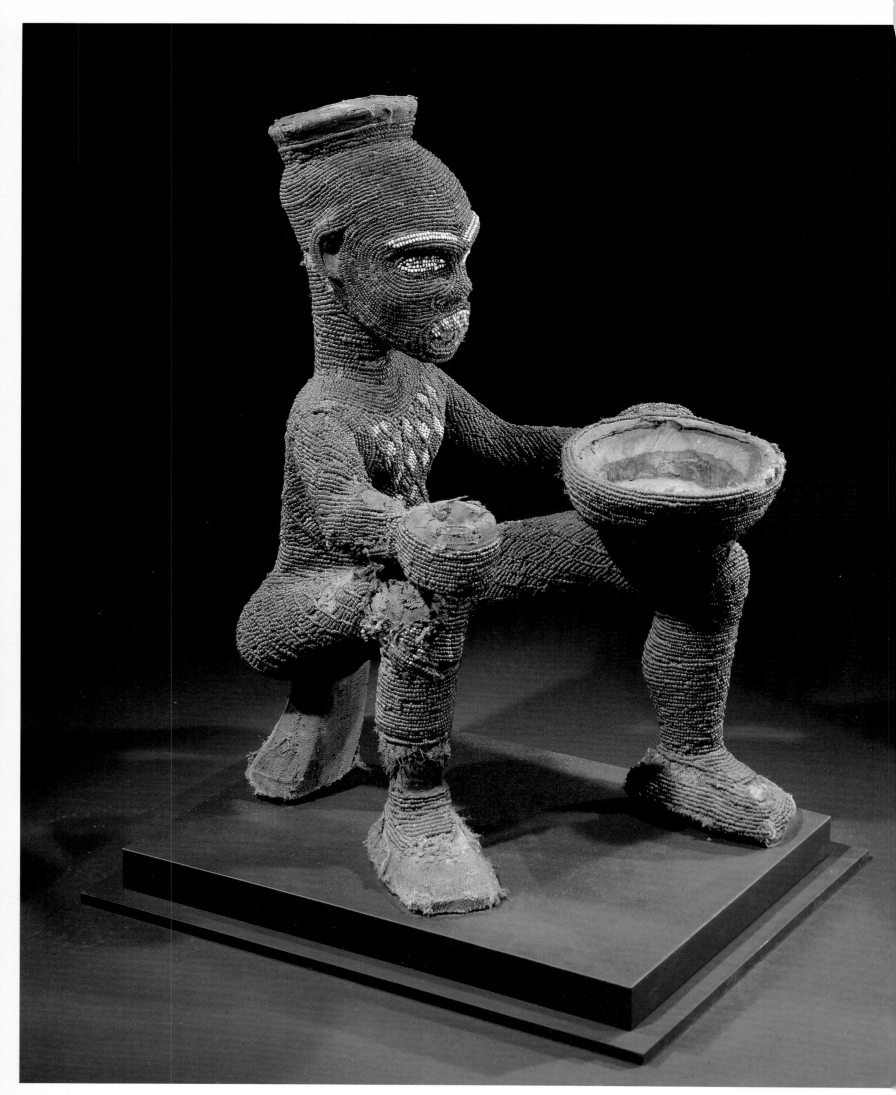

131　Bangwa Statue, Cameroon
*Wood. Height: 102 cm. The Metropolitan
Museum of Art, New York*

132　Bali Flute Player, Cameroon
*Wood. 19th century. Height: 148 cm. Private
collection*

133　Bafum Statue: a King Returning from
Victory, Bafum-Katse Region, Cameroon
*Wood, beads, hair, ivory, bone, fabric. Early 19th
century (?). Height: 115.9 cm. Paul and Ruth
Tishman Collection*

134–35　Bekom Couple, Throne Effigy,
Cameroon
*Collected by Von Putlitz in 1905. Wood and
copper. 19th century. Heights: 185 cm and 190
cm. Museum für Völkerkunde, Berlin*

136　Beaded Bamileke Statue, Chieftainry
of Baham, Cameroon
*Wood and beads. 19th century. Height: 67 cm.
Width: 80 cm. Private collection*

137 Bamileke Statue, Cameroon
Wood. Height: 81 cm. Private collection

138 Wum Mask, Cameroon
Wood. 19th century. Height: 38 cm. Width: 25 cm. Private collection

139 Batcham (?) Mask, Bamileke, Cameroon
Wood. Height: 95.5 cm. Width: 85 cm. Private collection

140 Bameka Drum, Bamileke, Cameroon
Wood. Height: 146.8 cm. Private collection; formerly Rasmussen Collection

141 Fang-Mabea Statue, Cameroon
Wood, copper, teeth. 19th century. Height: 67 cm. Private collection; formerly Fénéon Collection

142 Fang Statue, Equatorial Guinea
Wood, nails, copper, indigenous restoration. 19th century. Height: 48 cm. In storage at the Detroit Institute of Arts; formerly Mendès-France Collection

143 Fang-Okak Statue, Cameroon or Equatorial Guinea
Wood. 19th century. Height: 54.6 cm. Jack Naiman Collection, New York

144 Kwele Mask, Gabon
Wood. Height: 38 cm. Private collection

145–46 Bulu Statuette, Cameroon
Wood. 19th century. Height: 24 cm. Private collection

147 Kwele Mask, Gabon
Wood. Height: 45 cm. Musée des Arts Africains et Océaniens, Paris

148 Mahongwe Reliquary, Gabon
Wood, brass, copper. 18th–19th century. Height: 51 cm. Width: 26 cm. Private collection

149 Mahongwe Reliquary, Gabon
Wood, brass, copper. 19th century. Height: 52 cm. Private collection

150 Shamaye Reliquary, Gabon
Wood and brass. 19th century. Height: 22.6 cm. Private collection

151 Kota Reliquary, Gabon
Wood and copper. 19th century. Height: 55 cm. Murray and Barbara Frum Collection, Toronto

152 Kota Reliquary, Gabon
Wood and copper. 19th century. Height: 48 cm. Private collection

153–54 Kota Double Reliquary, Gabon
Found in 1900. Wood and copper. 19th century. Height: 63 cm. Private collection

155 Kota Reliquary, Gabon
Wood and copper. Height: 68 cm. Private collection; formerly Ratton Collection

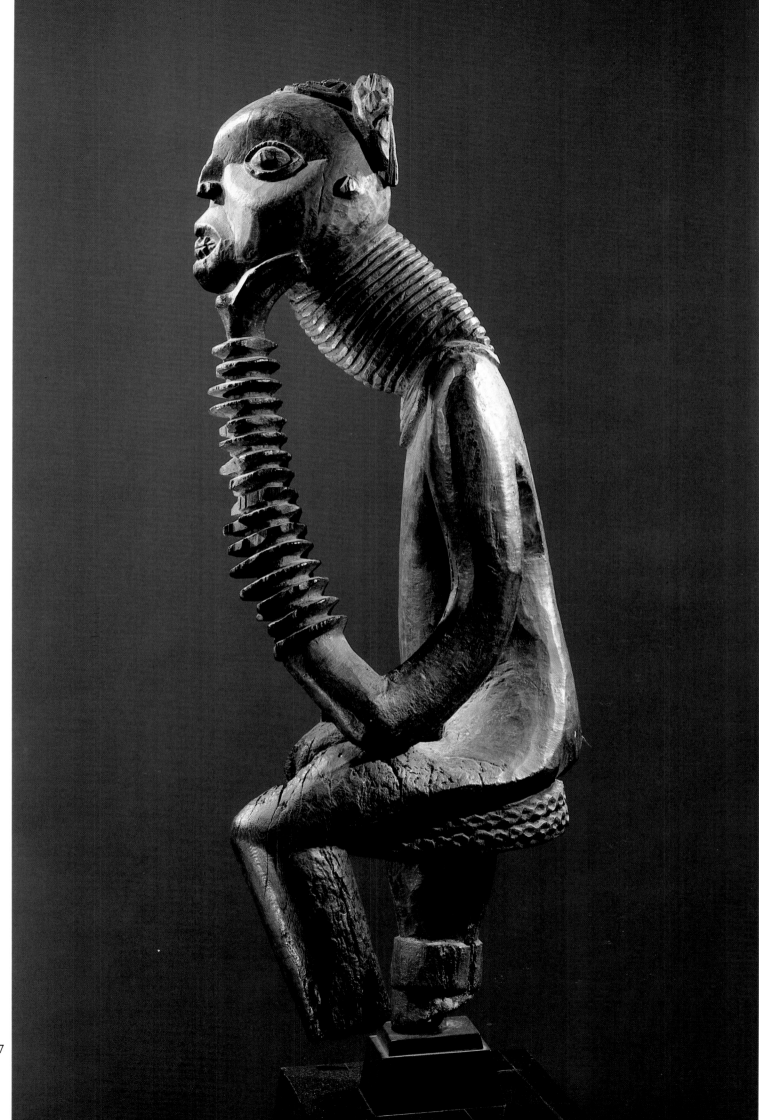

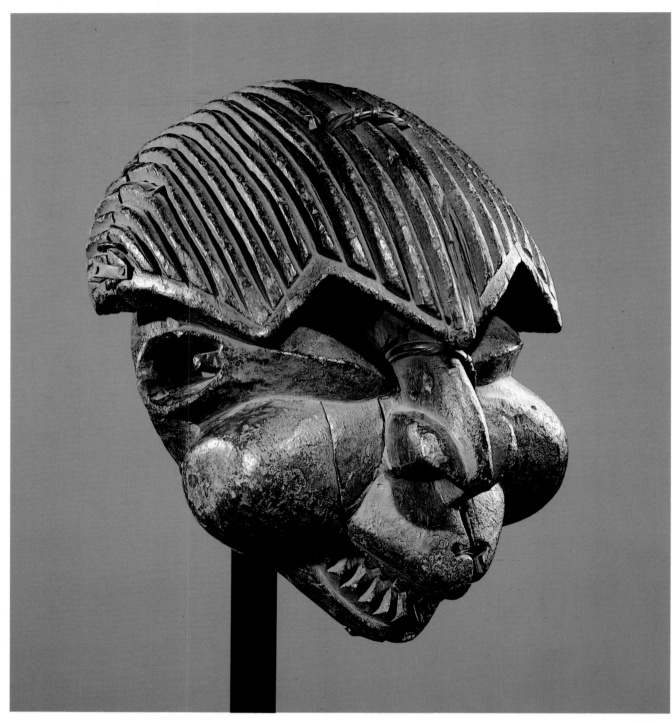

138

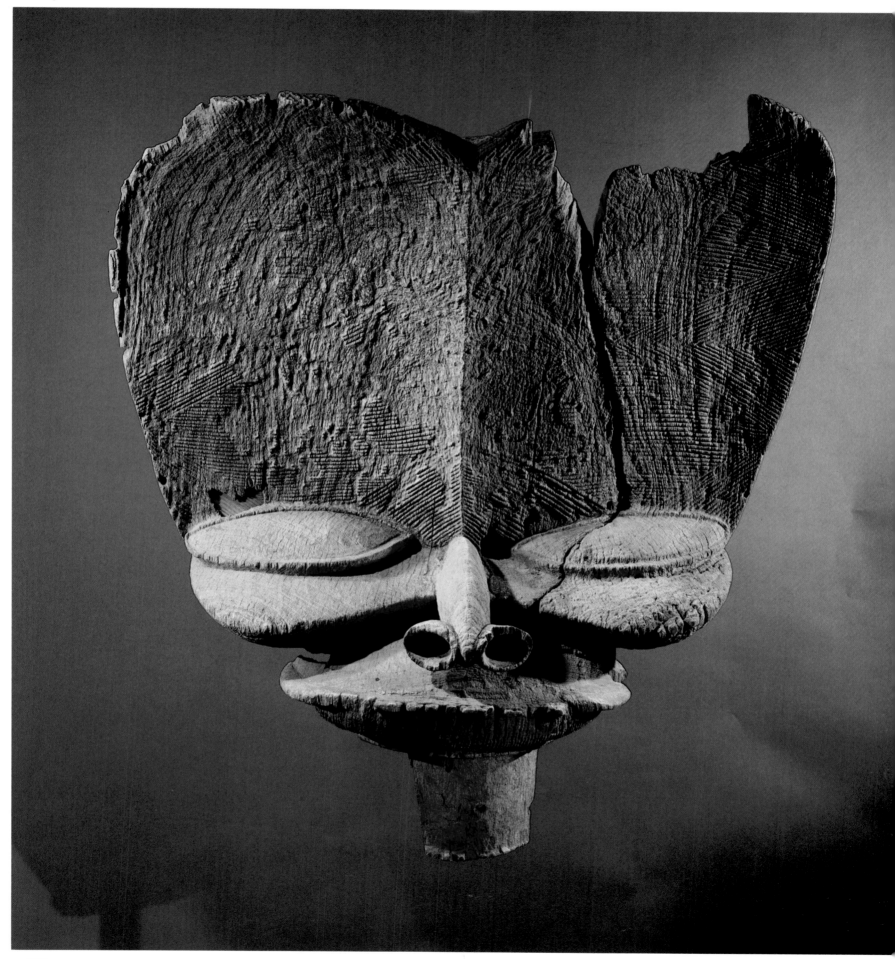

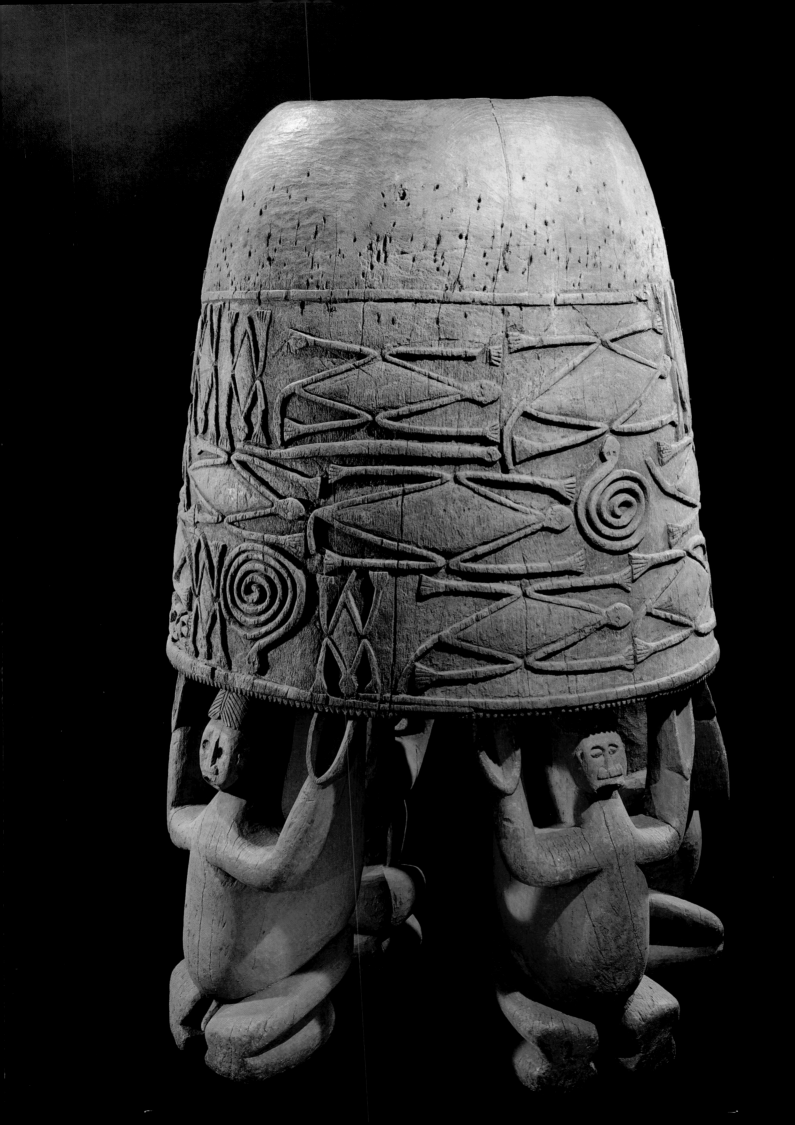

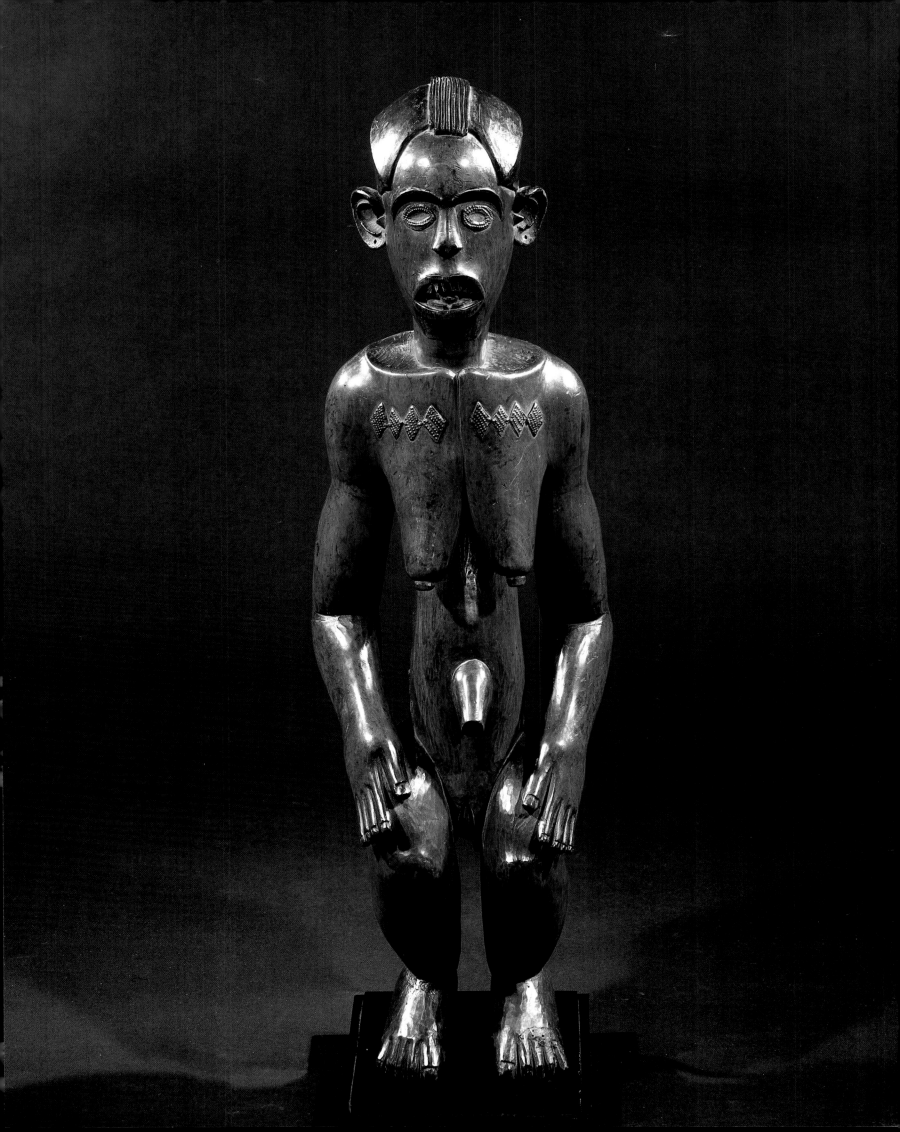

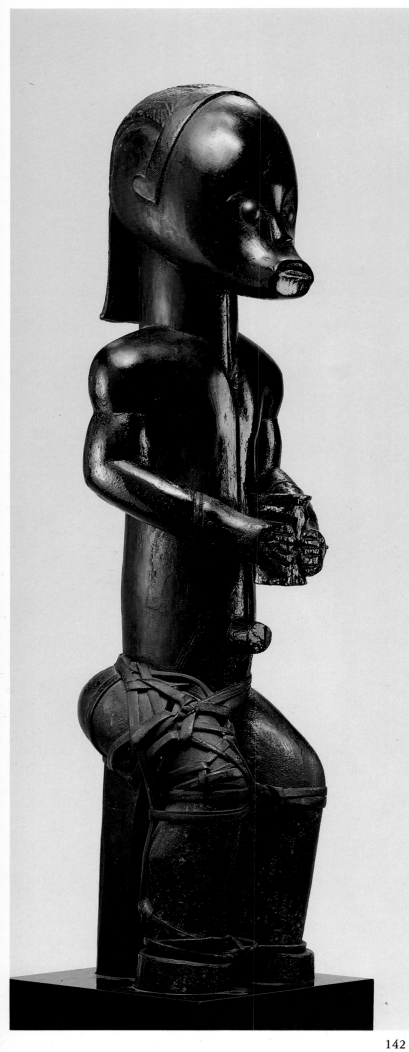

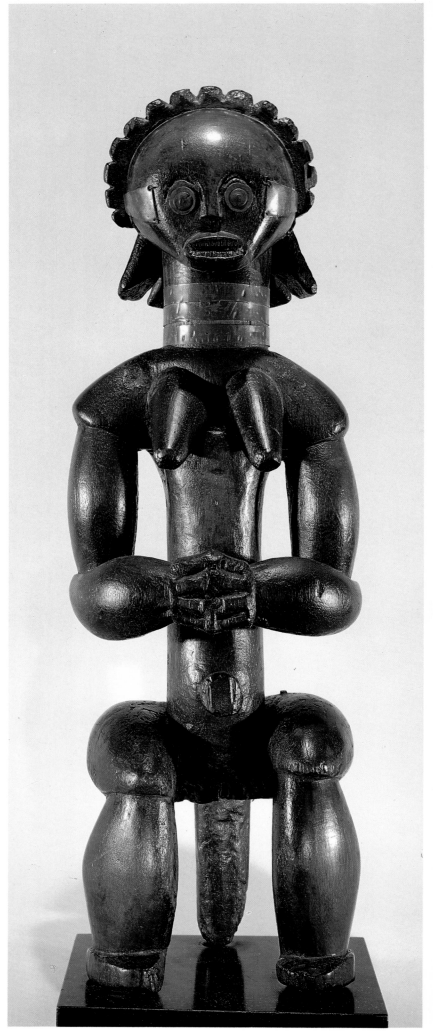

142

143

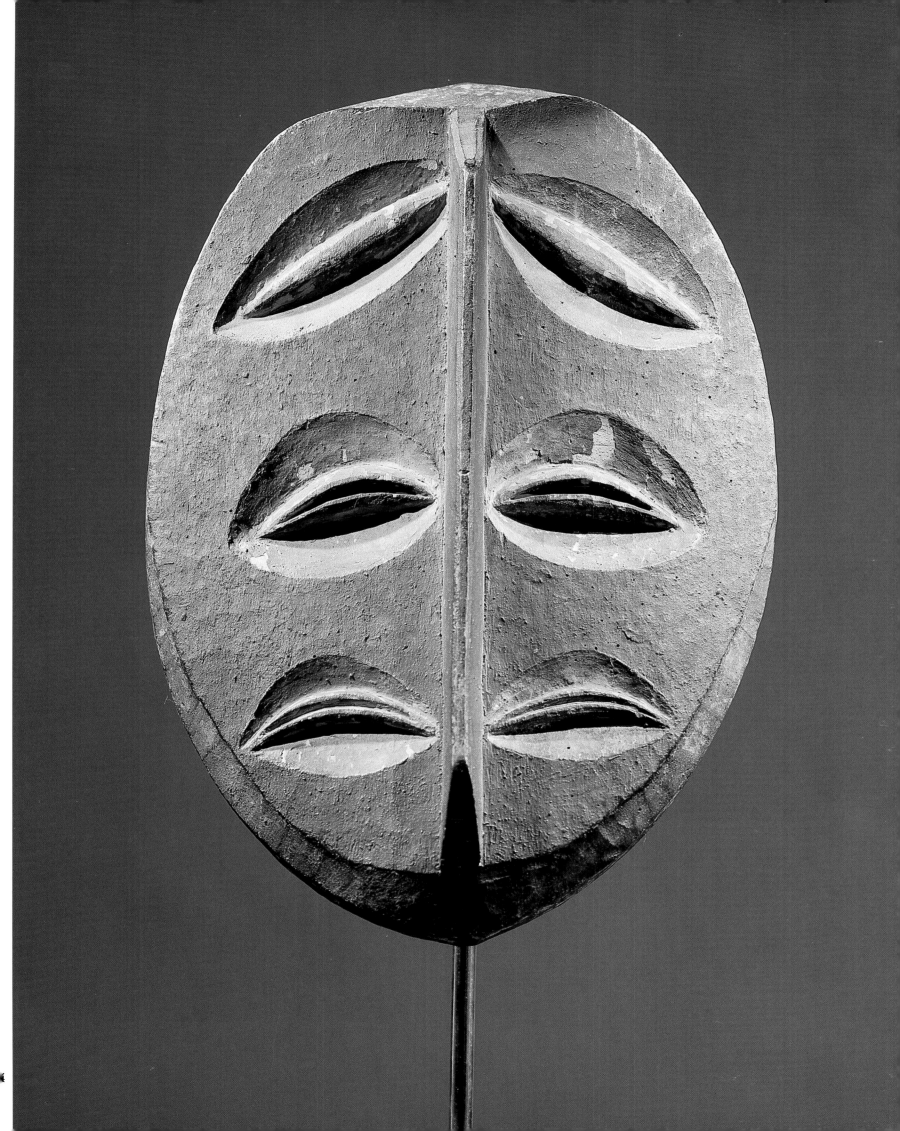

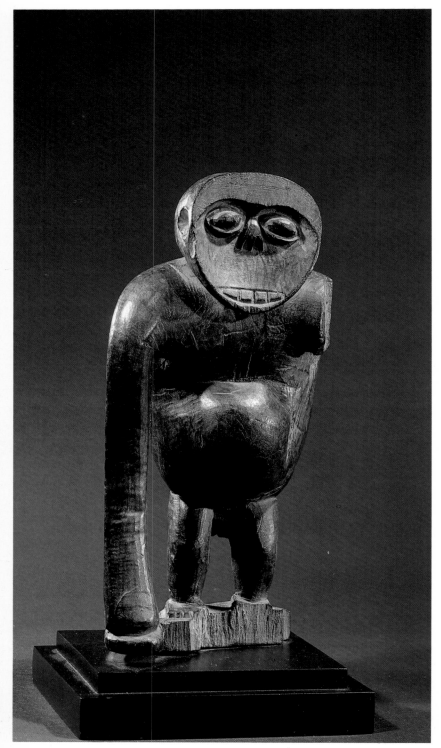

145

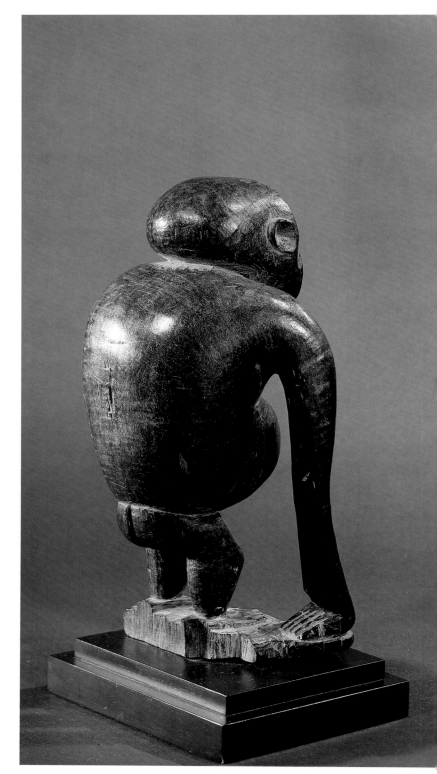

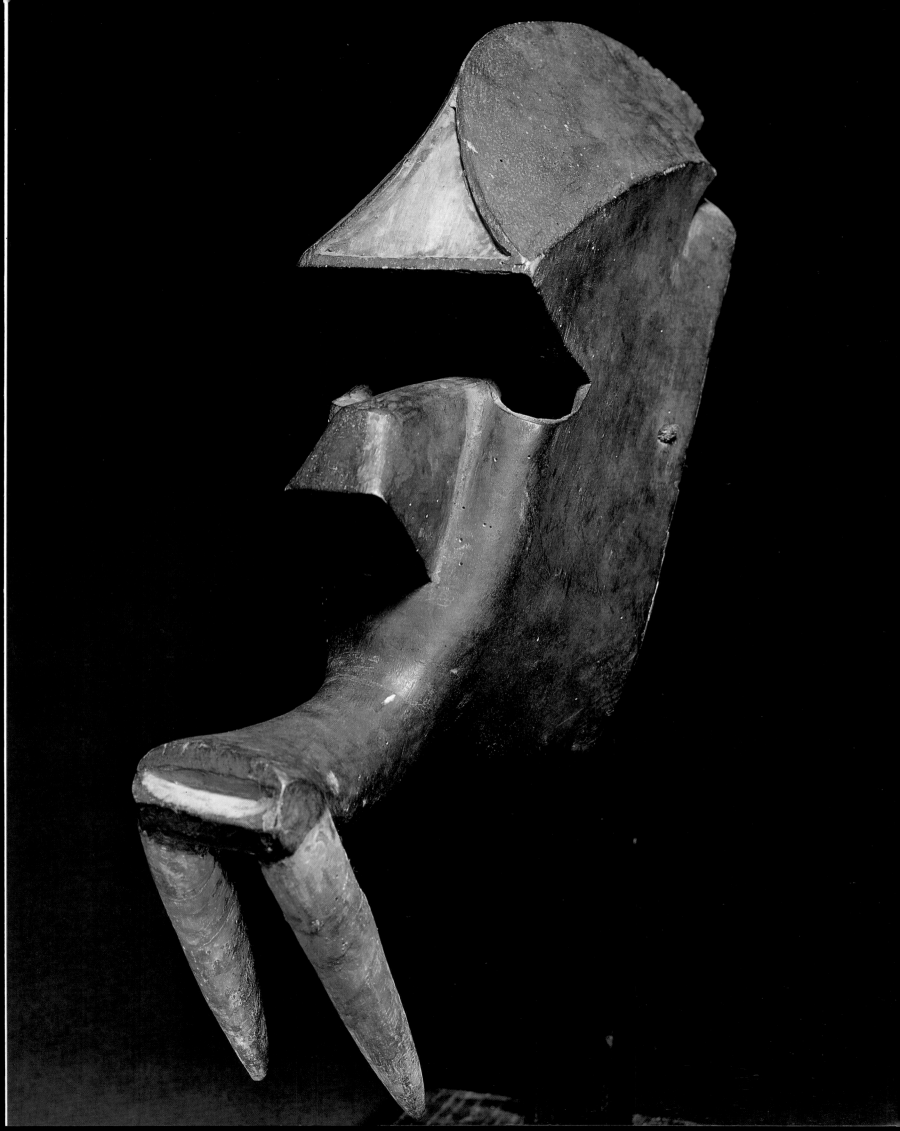

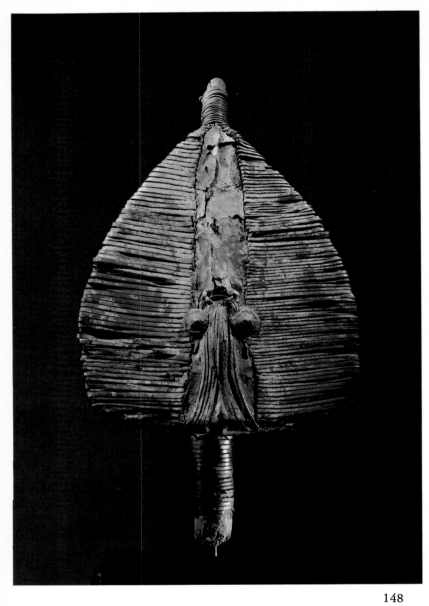

148

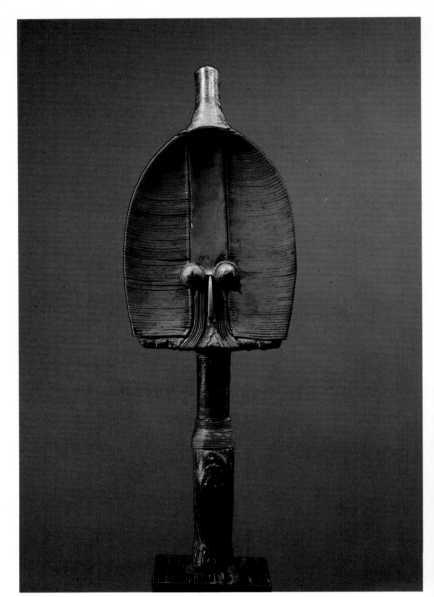

149

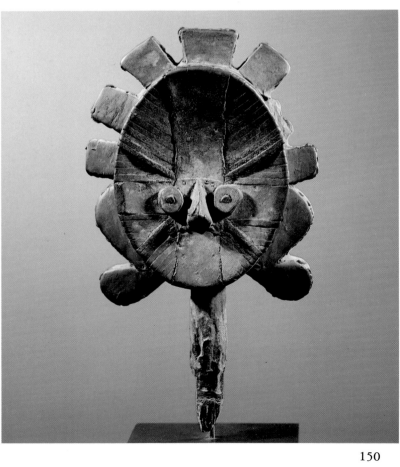

150

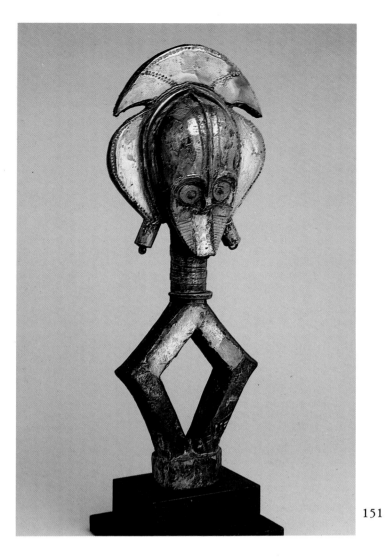

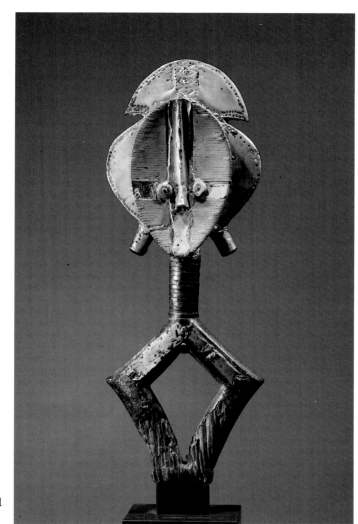

151

152

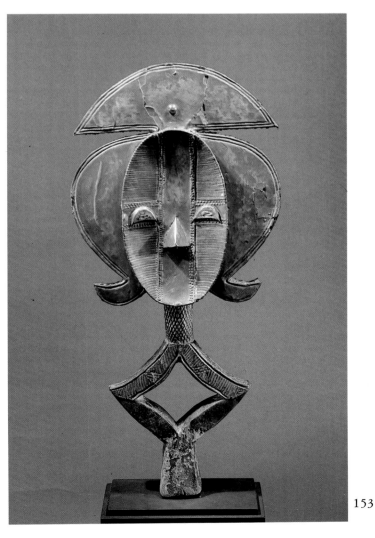

153

154

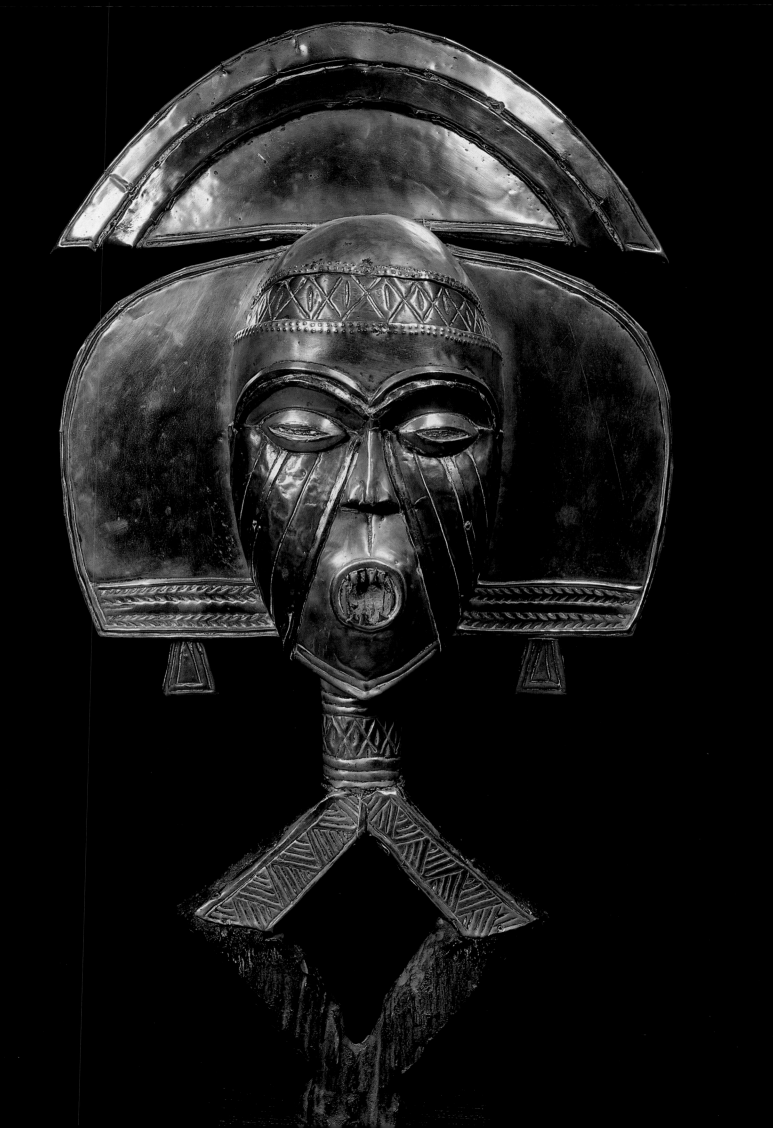

Presence and Power

The Presupposition of Representation

Functionalism often leads to a paradoxical attitude. On the one hand, it reintegrates the plastic object into its functional context, into its use, which is an activity. On the other, information gathered by on-site investigation, oriented toward the context of use, serves primarily to answer the iconographic question *par excellence*: what is represented? It is as if use were considered principally, if not exclusively, as providing representation with its ends. It is as if, for the plastic object, there were an alternative between representing elements of the context of use and acting, being active, that is to say, being in use—as if one opted for representation at the expense of activity. But this alternative and this option belong only to interpretation, not to observed use. Described thusly, the paradox makes obvious a presupposition that favors representation and whose origin can be understood.

Functionalist sociology may take art as an object, but art is not the only social form or structure that it studies; it must, therefore, adapt itself to this specificity. To that end, it must have recourse to a conception of art that allows it definitely to state social forms in terms of art forms and to distinguish them from other social or cultural forms. Now, the conception of art that remains the most usual presents two principal characteristics: it is functionalist, in such a way that there is an affinity between it and sociological functionalism, and it favors the notion of imitation or representation. This second trait accounts for the paradox.

Once again it is naturalism which encumbers the functionalist interpretation of art. The naturalist primacy of representation leads to considering use not as an activity but as providing representation with its objects. Inversely, recognizing the active character of use, and of the object in use, leads to subordinating the representation to it.

Some iconographic studies, criticized earlier, that short-circuited use by putting the plastic object in direct relation to myth come out of the same prejudice, from the same primacy given to representation. For, since myth is a verbal representation, these interpretations deal with homogeneous data, plastic and verbal representations, and underestimate or exclude heterogeneous data that come from actual use itself, the action or the activity. If, for example, the object turns out to be associated with power, political or magical, one must not presuppose that it is an image or representation of that power, and thus pass over to the side of the power of the image.

In order, in the functionalist perspective, to grant use the importance it deserves, one must abandon the naturalist primacy given to representation, recognize in the concept of representation an expectation that orients the inquiry badly, and, once again, seek an alternative expectation. Thompson, in studying African art in motion (1974) and therefore in use, redirected the inquiry. In an elegant essay on "technical sculpture," MacLeod and J. Mack questioned the pertinence of the concept of representation itself. (1985, p. 56) But it is Jean-Pierre Vernant, in a study previously cited (1983), who provides us with an alternative expectation that is precisely what we need: the notion of presentification. (*see* p. 155)

An historian specializing in late antiquity, Peter Brown (1982b), who is interested only indirectly in art but directly in the localization of the sacred, emphasizes two aspects, the *praesentia*, directly linked to an activity, and the *potentia*, the power of what is present being the necessary condition or the cause of the activity (pp. 113 and 137).

The notion of presentification, when faced with an object in use, allows

us to substitute the question: what does it do? for the iconographic question: what does it represent? For functional objects are made, produced, in order to make something in their turn. They are not merely produced to show, in the sense of to represent, but to act or to cause action. This new expectation allows a reinterpretation of an important contextual document.

Presentification

THE NOTION Most cultures, if not all, admit to the existence of an invisible world, different from the visible world of the everyday life of humans, and peopled with invisible entities. The connections between these two worlds is the business of religion. Let us agree that by "presence" we mean the *hic et nunc* existence in the visible world. A thing that is present is observable, visible, and tangible, here and now. It is this form of existence that the sons of the earth demanded in Plato's *Sophist*, as did Thomas the Apostle. Presentification is the action or the operation through which an entity that belongs to the invisible world becomes present in the visible world of humans. This change in state in the entity may be due to its own intiative, to that of humans, or to a collaboration.

Thus defined, presentification is distinguished from representation by two characteristics. Representation assumes observation and thus the anterior presentation of its object which, therefore, does not belong to the category of invisible entities. Representation is different from its object, which is present only in the mind and not in flesh and blood; what is presentified and what presentifies it are not different but constitute the same being.

While they are used to account for the function of certain plastic objects in use, these two notions must not engender a dichotomy or an alternative. For, as we shall see, the same object may, in one usage, "symbolically" represent an invisible something, and, in another, presentify it.

With presentification, the entity under consideration changes worlds. This changing of worlds may be executed in both directions: from the invisible to the visible, as with presentification, but also from the visible to the invisible, as when a human being, at death, leaves the visible world and, as a spirit of the dead or an ancestor, goes to reside in the invisible world. Religion rules over these connections between the two worlds in both directions.

This definition allows a review of terms and expressions, most often metaphorical, that convey the same signification, not without variations. These variations correspond to the choice of perceptible elements in the metaphors and thus express the noticeable fact that invisible entities become present in, by means of, or through variable visible and tangible aspects. A lexical review will sketch out a description of the aspects or modalities of presentification.

THE LEXICON One must treat separately cases in which presentification is clearly distinct from representation. They have the form "*x* is *y*," an expression distinct from "*x* represents *y*."

Among the Bobo, "the sacredness of the mask . . . derives from . . . the fact that the divinity is considered to be present in the mask and, through it, to be acting." *Praesentia et potentia.* The wearer is "depersonalized to the advantage of the mask that he animates. The result of this transference is so important in the eyes of the Bobo that it is the wording itself that has been retained as the name of the mask. In order for there to be a 'mask' (*sôwiye*), man (*so*) had to erase himself (*wiye*), that is to say, cease to be

himself, shed his individuality." (G. Le Moal, 1980, p. 255)

Among the Ngangela of Angola, the masks called *tungandi* "are spirits in the eyes of the women and uncircumcised, and custom takes careful pains that these apparitions cannot be seen save from far away." (M. L. Bastin, 1969b, p. 4)

Among the Dan, "the wooden mask and the costume that hides the wearer constitute the supernatural being of the mask. This combination is felt to be the real presence of that being, not its representation or symbol. It *is* the entity. Whether a distinction exists or is felt between the being manifest in the mask and the wearer of the mask is not clear." (A. A. Gerbrands, 1971, p. 377) This is confirmed by Fischer and Himmelheber: "It is incorrect to maintain that a spirit resides in the mask, because, according to Dan belief, the spirit created the mask, with the help of a human, as its material manifestation. The mask does not simply represent a spirit of the forest, it *is* that spirit. The spirit is active in the facial mask whether it is being worn or not." (1984, p. 8) Thus, not only are the concepts of literal or "symbolic" representation discarded, but also that of "residing," to the advantage of those of manifestation and identity.

Similarly, among the Idoma of Nigeria (the region of the Benue) "the masked ancestors (*alekwuafia*) do not represent a masquerade in the theatrical sense of the word; they really are spirits that have come back among the mortals." (F. Neyt, 1985, p. 95) Here, the word "representation" in the expression "theatrical representation" is discarded, which suggests a difference between the masked ritual in which the human wearer and the spirit are considered as identical and theatre in which the human actor "playing" a role is different from the character he or she "represents on the stage." This connection between two identities, one human and the other different, may take multiple forms ranging from possession to the allegorical effigy.

Identity is sometimes negatively formulated, as in "*x* does not represent *y*." Among the Makonde, during the initiation period, initiates were taught that the masks were not the spirits of the dead, but that they were worn by living men. (A. J. and M. Dias, 1961, cited by C. D. Roy, 1985, p. 194) This leads one to assume that, before their initiation, these young people used to believe that masks were spirits of the dead. This case may be generalized. One speaks of the secret of the masks, a secret often lifted during the initiation period, and which bears on the existence of the wearer, completely hidden by the mask and the costume. Another negative formulation, by M. C. Dupré, on the subject of the *kidumu* mask of the Tsaye (the Teke of the west): "Through a slit that is well hidden under the edge of the upper half (of the mask), the eyes allow the dancer-man to get his bearings. Kidumu is not a man; when he dances, he does not speak in order to not reveal that the mask is hiding a human being; he very clearly belongs to a supernatural order and inspires a kind of sacred reverence." (1968, p. 306) Two traits, hiding of the eyes and muteness, insure the "secret" of the mask.

Robert Hottot (1972, according to information gathered in 1906) tells us that the Tsaye (Sise) make a distinction between figures that have no power, whom they call *tege*, and figures whom they call *butti*, "of great mystic power" (p. 21). A *tege* becomes a *butti* through the addition of magical substances (*banga*). "The *butti* is not simply the specific representation of a deceased person, but the true substance of that person; it positively is that person. Consequently, each *butti* has its own name, just as a man has a name. It may be that of a male ancestor or of a well-known chief" (p. 25). This case shows that representation and presentification are not incompatible.

English contains two related words to designate either the mask alone,

or the human wearer masked and dressed in the costume that hides the wearer; by agreement, we shall use "mask" for the wooden face and "Mask" with a capital M for the totality of the mask, the costume, and the human wearer.

One notices, in these examples, that one single statuette appears for every few masks. Even though such a sampling is statistically quite insufficient, it is likely that this proportion is significant. We shall see that the mask is better suited to presentification than is the statue.

Presentification is not always as clearly distinguished from representation. Yet, one may consider it implicitly stated by a series of terms and expressions that we propose to review: to animate (the object), to capture (the spirit), to come (into the object), to contact (the object is a point of contact between the invisible and the visible), to contain (the spirit), dwelling (of the spirit), to embody, to enshrine (the spirit), to enter (into the object), to fix (the spirit), habitation, haunt, incarnation, to incarnate (the spirit), to incorporate, to inhabit, to live (in the object), to lodge (the spirit), to materialize (the spirit), presence (actual, real, raised up), present (making present), receptacle, recipient, to reside, to retain (the spirit), to shelter (the spirit), vessel, vehicle, visitation, vitalization.

In this list, the dominant meaning is that of a relationship between a thing and its place. This relationship is specified primarily in two ways. It becomes a relationship between content and container, then between a spirit or a soul and a body, which together constitute a single animated or living being. Thus, the presentification of an invisible spiritual entity in a visible body engenders a being formed according to the model of a living body: one recognizes that this is called animism. Now, Leon Siroto (1976), contrary to certain longstanding interpretations, has asserted that one should render back to animism (which he describes as the "lost dimension") the importance it has traditionally held in African ideologies.

The distinction explicitly made by Fischer and Himmelheber between "the mask is the spirit" and "the mask resides in the spirit" suggests that the expressions above, which maintain a distinction between the two elements, ought to be corrected. The animist ideology that unifies spirit and body inside an animated being would justify such rectifications.

PRESENTIFICATION AND SYMBOLISM One must also distinguish between presentification and symbolism, for their respective fields overlap enormously and this overlap tends toward their confusion. The symbol, as it has been conceived of since Goethe and Kant (T. Todorov, 1977), represents invisible entities for which no tangible presentation suffices. It represents them indirectly by literally representing tangible things that are analogous to them. The symbol, then, is a species of the genus of representation. It excludes the tangible presence of what it symbolizes and furthermore it does not even give a direct, tangible representation of it.

In the *Aesthetics*, Hegel clearly formulated this difference, calling it "unconscious symbolism" (*unbewusste Symbolik*), which is what Vernant calls "presentification."

"A first unitary phase . . . involves no difference whatsoever between soul and body, concept and reality; the corporeal and the tangible, the natural and the human are not solely the expression of a signification that supposedly is distinct from them, but exterior manifestations are themselves considered to be implying the *reality* and the *immediate presence* of the Absolute, in such a way that the latter would not have an existence independent from these manifestations, but would find itself *actually present in an object*, which as such *would be itself* god or the divine." (*Aesthetics*, II; italics mine.)

Among the ethnologists who use the words symbol and symbolism, some are careful to define them. Now, some of these definitions include presentification, others omit it. On the other hand, in order to elaborate upon these definitions, some ethnologists only take various uses of these words in their own language into account, as well as meanings elaborated by the theories of symbolism; but all these uses are in the language of the author or in other Western languages. Other ethnologists refer to information provided by vernacular languages or by ethnolinguistics. They will mention in particular the meaning or meanings which their knowledge of a vernacular language and their informants allow them to associate with the word or words they translate as "symbol." In doing so, they take into account Malinowski's or Evans-Pritchard's remarks on the importance and the difficulty of translation work in ethnology. Consequently, it is not surprising that those who give a definition of the symbol that includes presentification do so by restoring the signification of the vernacular terms they translate as "symbol."

Thus, according to Victor Turner, "the Ndembu consider symbols as objects or acts that 'make visible' or put into play the powers inherent in the things they signify." (1972, p. 92) Another study supports this definition: "The symbol is the smallest unity of a specific structure in the Ndembu ritual. The vernacular term is *chninjikikilu*, from *ku-jikijila*, 'to blaze a trail' by hewing marks on a tree with an axe or by breaking and bending branches to serve as guidelines during the return from the unknown brush to known paths. A symbol is therefore a trace or a reference mark, something that links the unknown to the known. . . . Furthermore, in examining their symbols with the Ndembu, one discovers that they constantly use the term *ku-solala*, 'to make visible' or to reveal." (V. W. Turner, 1965, p. 80) The presentifying function of certain symbols could not find better confirmation.

PRAESENTIA ET POTENTIA To presence is associated power. The invisible presentified possesses a power, a force, a capacity to act that renders active the visible things in which it is presentified. This idea seems to be essential to religion.

Epicurus and the Epicurians believed in the existence of the gods; nevertheless, they were continuously accused of atheism and impiety and not without reason. For their gods were inactive, idle gods: they concerned themselves neither with the world nor with people, whom they had not created; they did not intervene in the world, nor did they delegate any power there and thereby rendered worship, which the ancients called piety, useless or empty; to their adversaries, powerless and idle gods were not gods. Inversely, the more one recognizes the religious importance of worship, the more one emphasizes the presence and the power of the sacred.

Hegel finds examples of this "mystical entity" in the Eucharist, "This is my body . . ." and ". . . even in the miraculous statues of the Holy Virgin, the force of the divine acts as their immanent being, as if they were present in reality, instead of being simply attached to these statues as a meaning to its symbol" (*Aesthetics*). The symbol is not identical to the symbolized; in presentification it is: the divine or the spirit (in the ethnological sense) is actually present and acting, and in order to act it possesses a force, which is equally present. Praesentia et potentia.

Henri Bergson (1959, p. 1125) speaks of the feeling of an "effective presence"; the nature of this presence is of little importance, what is essential is its effectiveness. According to Paul Valéry (1941, p. 35): "In every religion *false gods* are understood to be the gods of others: they are called false not in order to deny them existence, but to deny them the greatest force or power, reserved for one's own."

In the traditional African domain, the notion that is pertinent in this regard is that of the object possessing a power—the power object. It is not only an object of power, in the sense that those who already have one power would want to appropriate this kind of object, for it is because they possess a power already that they want to own it in order to use it to increase that which they already possess. Thus, this notion of the immanent power of the sacred explains certain connections between political power and religion, as well as what has been called the traditional African pragmatism of religion and religious art—a pragmatism to which J. Weldon Smith assigns two characteristics: the absence of theory and the presence of solutions in action. (1978, p. 71) Of course, presence and power are not put into play and managed, so to speak, by religion alone, but also by magic. The magician, who frequently is a specialist, is so through the convocation, mastery, and manipulation of this presence and this power.

Christian iconography or, more precisely, the Christian doctrine of religious imagery and its function, tends to exclude presentification via images, condemning this as idolatry; it reserves this for sacred objects which are not images, such as the bread and the wine of the Eucharist, and the relics. According to Etienne Gilson (1963, p. 189), the source of this doctrine is in Saint Thomas Aquinas, in the *Commentary on the Sentences of Pierre Lombard*. This doctrine assigns three functions to the religious image: to teach, to remember, to move, all three of which are linked to representation (*see* pp. 190, 192). It is not impossible to apply this Christian tripartition to African religious imagery, but one risks forgetting presentification.

Theme and Variations

The forms of presentation are extremely varied. A few examples will give an idea of this diversity. The resemblance between the first two—the connection between political power and sacred images, which determines the specific theme—*a contrario* will bring out subtle variations. The third, dissimilar, one will illustrate a use of presentification that is actually magical.

INVESTITURES OF DIVINE KINGS The king of the Shilluk, a people of East Africa, is a divine king. Juok is the supreme god and Nyikang is an intermediary between Juok and humans. During the heroic era, Nyikang was the chief of the Shilluk; he led them to their present country and conquered it. He is a cultural hero, the first king of the Shilluk, creator of their nation, and founder of the dynasty: all kings are his descendants. The spirit of Nyikang dwells in each king, for it has passed from one king to the next throughout the lineage of his successors. It is present in the king and makes him the "double pillar of the Shilluk society: the political leader of the nation and the center of national worship." (E. E. Evans-Pritchard, 1974, p. 83) The incarnation of Nyikang in the living king elevates the king and kingship above private interests.

Each investiture insures the transmission of Nyikang from the dead king to his successor. Kings die but the kingship, identified with Nyikang, remains. An effigy of Nyikang is preserved in one of his mausoleums; at the moment of the ceremonies of succession, it is taken out by its priests and, together with the effigy of his son Dak, solemnly carried all along the frontiers of the Shilluk kingdom. In each district, as it passes, the people gather to show their respect to Nyikang, whom they accompany to the following district, for "the effigy of Nyikang contains the spirit of Nyikang, in fact is Nyikang himself" (p. 88). During a later phase of the investiture,

Nyikang is placed on a royal stool: a moment later he is picked up and the king sits down in his place; then the spirit of Nyikang enters him and causes him to tremble, he becomes king, that is to say, he is possessed by the spirit of Nyikang.

Among the Kuba, a commemorative statue is supposed to have been ordered with each new reign [figs. 178, 1028]. (J. B. Rosenwald, 1974) This practice might, according to Vansina (1972, p. 157), be the result of an evolution of beliefs: the kings were first conceived of as the priests of the spirits of nature. According to one of his titles, the king is "god on earth"; he is the depository of a power upon which the well-being of his people rests. (A. Maesen, 1960, pl. 19) When the sculptor was hewing the effigy, the king had to be present; but this presence should not be construed in terms of representation, of a physiognomic portrait drawn from nature, but rather, in terms of presentification. A narrow bond exists between the king and his effigy (*ndop*); if something happens to the person of the king, the *ndop* reflects it. Thus, when King Mboong a Leen was mortally wounded by a sword blow, a similar gash appeared on his *ndop* and is still visible there. (J. Vansina, 1972) The statue possesses a power of fertility; when a woman of the harem was about to give birth, the statue was placed near her in order to insure a normal delivery. The women had to behave toward the statue as they did toward the king: rub it with oil, caress it, and fondle it in the absence of their husband. After death, kings once again became spirits of nature. At the moment of the king's last illness, a statue was placed by his bedside in order to collect his strength. Before his investiture, the king's successor had to undergo a period of seclusion during which he lay down next to the statue and, by incubation, received the dying king's strength. (A. Maesen)

The comparison of the two rituals of investiture may be sketched out as follows:

In both cases, the royal-divine spirit is the crucial element; it does not provide a foundation (as in a kingship of divine right), it constitutes the very substance of royal power. Consequently, its transmission is necessary. But the effigy does not play the same role; among the Shilluk, it is the permanent substratum of this power. But above all, in the ritual of investiture, it is the royal stool that plays the role of relay, that is to say of transitory receptacle, which the Kuba effigy plays; the Shilluk effigy functionally corresponds to the dying Kuba king. As for the second stage of the relay, the trance and the incubation correspond. Quite frequently in traditional Africa, a seat such as this royal Shilluk stool also serves as a seat not in the usual practical sense, but in the sense of a receptacle of a spirit; the Akan stools, and most specifically the Asante ones, are the best known.

On the other hand, in a context of use different from that of investiture, the two effigies seem to guarantee in a permanent way the presence of the royal-divine spirit in the human world and to double its presence in the living king himself.

These two examples of presentification are variations on the double

theme of place—living king, effigy, and/or stool—and of time—permanent and/or transitory presence.

FETISH, PRESENCE, AND POWER Among the Kongo, the body is not the dwelling, the normal place of the spirits. Some spirits of nature (*nkita*) live in the waters: it is, so to speak, their natural place. But magicians can make them come out of the water and, by means of appropriate rituals, capture them inside a fetish (*nkisi*; plural: *minkisi*). However, sometimes these spirits choose a human in whom to reside and provoke specific maladies. Thus, the specific character of rituals appropriate to capture them and the maladies they engender correspond to the specific character of these spirits. The specific identity of the spirit is revealed through the body language of the possessed. Luc de Heusch (1971) mentions the *nkita* called Mwumbi-Masa who reveals his presence when a woman patient, after having taken retting manioc from the water on market day, is felled by a high fever and convulsions. She turns to a ritual of exorcism using an already existing *nkisi* fetish; the goal of this ritual is to transfer the pathogenic spirit to another place, a new *nkisi* having been made for this purpose.

During the exorcism ritual, the patient is coated with a red powder, the color of the *nkita* spirits; she drinks a potion containing ingredients of Mwumbi-Masa extracted from the fetish of the healer. According to a possession formula, she is "incorporated into the *nkita*." De Heusch emphasizes this reversal of language: the patient does not drink the spirit, she is drunk by the spirit. In a second phase of the ritual, the spirit is expelled from the patient's body and fixed inside the new *nkisi* that was made for this purpose. As so often at the end of an exorcism ritual, the patient becomes an adherent of the cult. She is the master of the second fetish, receives it at the end of the ritual, and from now on has possession of it. "The possessing spirit in the final analysis is itself possessed" (p. 263). (This reversal of the connection makes one think of the Hegelian dialectic of the master and the servant.)

This spirit may reside in three places. The spirit of nature resides in nature, in bodies of water. Captured, it resides in a *nkisi* fetish. These two are normal states: they come out of the orderly arrangement, with everything in its place. (M. Douglas, 1984) But when a *nkita* resides in a human body, where it does not belong, there is disorder and illness. The second fetish allows order and health to be restored.

The spirit captive inside a fetish is to the natural spirit of the waters what a domesticated animal is to the same animal in the wild. The place that is suitable to the wild animal is not the village, a human place, in the same way that the human body is not the proper place for a spirit. Inversely, just as the animal, once domesticated, can serve its master in the village, so can a spirit captured and mastered inside the fetish serve its master, be that the healer or the recuperated patient. The place of the spirit's presentification is therefore decisive, it determines whether there will be order or disorder, health or illness.

A second trait seems key: the artificial character of the fetish that opposes it to the waters, a natural place. This is a means of domesticating and mastering the spirit. The word fetish was forged [by colonialists] in order to remind the "natives" that it was not an acheiropoietic object but one made by human hands; the analysis of the use of this *nkisi* demonstrates this reminder was useless.

Yet, Robert F. Thompson (1978) has published some information that seems to contradict the fabricated character of the fetish: "The first *nkisi*, called Funza, comes from God, and Funza came with a large number of *minkisi* whom he spread across the country, each one invested with a

specific power in a particular field." Only the prototypes (mythical) are acheiropoietic. This information associates the specificity of the *minkisi* to their multiplicity and to the idea of order: an identity for each fetish, a name (?), a *potentia*, and an area of action. To capture the spirit in the second fetish requires the use of an already existing fetish; but if this one requires a previous one, one must go back to a fetish given to humans by the god who, at the same time, assigned the spirits of nature a normal dwelling place other than the water.

Presentification and Art

Until now we have primarily considered the impact of presentification on the use of sculptures; we must now consider its impact on artistic production and on the representation the autochthonous give of it.

PRESENTIFICATION AND INSPIRATION

Presentification affects artistic production in two ways. First, there is an actual, observable way that leads us to distinguish two phases or stages of the production of certain effective objects. It also intervenes in the manner in which the members of a culture conceive of artistic production, the sculptor's work—that is to say, the first of the two phases we have just mentioned.

It is important here to distinguish, in the ethnographic data, that which is the result of an observation of the behavior of the sculptor and of the specialist in magico-religious operations and objects, masks, statues, and magical ingredients, and that provided by informants on the fashion in which sculptors themselves, or certain members of their cultural group, account for and, in so doing, themselves interpret their own activity—that is to say, one or the other of the two phases of the production of an effective object.

As to the way in which a culture accounts for its artistic production while interpreting it, certain comparative data leads one to compare presentification and inspiration more closely. Here, one must remember the methodological distinction between signification and truth, for the comparison will have bearing only on signification. The truth of the conceptions, both Western and African, is placed between parentheses.

"Inspiration," according to Paul Valéry, "is the hypothesis that reduces the author to the role of observer." (1941, p. 29) This formula allows us to group together every conception of artistic creation that presents this common trait: to minimize, and at the extreme, to cancel, that which in artistic creation is ascribable to this human, conscious agent whom we call artist—and, on the other hand, to emphasize that part that arises from a non- or suprahuman agent or a psychological, unconscious process; the presence and the power, at the moment of creation, of someone other than the artist makes of the latter a simple spectator or observer of the activity of this productive power.

Thus, one can recognize a series of theories that runs through the entire history of Western conceptions of art in varying forms and formulations. They are all dualist: one part the artist's, one part a suprahuman agent's. In Plato, it is, on the one hand, the dualism between enthusiasm—the god in the soul of the artisan, or the demon called Eros—and, on the other, art—the *technè*. Plato is at the origin of a so-called Neoplatonic tradition that resurges, in Florence, with the notion of *furor divinus*. (A. Chastel, 1954, p. 129 *ff*.) It is, again, the distinction Kant made between craft and genius, which is nature in the artist. Finally, it is Heidegger's opposition of technique, which emerges out of subjectivism, and authentic *poetry*, which is the disclosure of Truth.

245

Now, the concept of presentification allows us to find this dualist trait again in the way in which certain African cultures conceive of artistic production. The part that is the artisan's is obvious; it is the other part that needs to be looked at. The spirit, presentified with its *potentia*, collaborates with the artisan and sometimes even removes him or her. Its intervention takes various forms.

It may be a divinity, or a mythical ancestor, or a civilizing hero who produces or brings the first mask or the first statue. This first object (in G. Kubler's sense, 1962), if it is not mythical, is not attributable to the artist whose work is reduced to being the reproduction of this prototype. It may also be a spirit who, in the artist's dream, comes to tell him to create a new mask, shows it to the artist, and announces what aspect it must take. This object is shown to the artist and is not reducible to a simple mental dream image, for it is attributable to the spirit, not to the imagination of the dreamer. Such a mask would also be a prototype.

In terms of function, one may notice, with Siroto (1976, p. 20), that such conceptions may be interpreted ethnologically as means by which to have the community accept artistic innovations. According to Edmond Ortigues, "divination art is the art of transforming the event undergone by the living into a sign willed by the dead; it gives the occult a language translatable into the words of the community." (1981, p. 62) Similarly, the intervention of the spirit transforms a human innovation into an initiative of this spirit, in such a way that the manifestation of this invisible spirit finds a visible form acceptable to the community. In still other cases, it is no longer given to the artist, but to the soothsayer to see the prototype and to be able to describe its characteristics to the artist.

Finally, in other cases, no part is left up to the sculptor. The "mask showed itself to him who was to wear it and indicated to him the place where he would be awaiting him in the bush." (H. Himmelheber, 1960a, p. 20) The mask reveals itself neither to the soothsayer nor to the sculptor, but to the wearer. It already exists, it will be said "to have come from the bush," which is an expression that permits us to classify it in our Western category of acheiropoietic objects, not made by human hands. It is a borderline case: the part attributable to the human, conscious producer is not only reduced, it is canceled. An opposing borderline case is our modern conception of technical production which tends to cancel that which is not attributable to the technician, to his conscious plan, and to the strict execution of that plan. The conceptions we have just compared, African or Western, occupy intermediary positions between these two boundaries.

THE AESTHETICS OF THE SPIRITS This active part ascribed to the spirits or the divinities in artistic creation has led to the notion of an aesthetics of the spirits. (M. Trowell, 1964; L. Siroto, 1976, p. 19) In the choice they make of objects or beings of the visible world in which they will presentify themselves or will be presentified, it is as if the spirits were applying aesthetic criteria. Visible things must possess properties that please the spirits.

The idea, according to which aesthetic values, along with moral or political ones, are conceived of as pleasing or suitable to the gods, is found in classical Greek thought. For example, in one of Plato's dialogues, an interlocutor of Socrates defines piety as that which pleases the gods; according to Epicurean theology, the gods can only have a human form, for, this being the most beautiful of all visible forms, it is the only one suitable to them.

In traditional Africa, this aesthetics is applied not only to objects that presentify spirits, but also to images that simply represent them. In this

regard, the aesthetic attitude of certain Baoule spirits is notable. This concerns spirits of nature called *Asie usu*. "The medicine man . . . gathers together the feathers of a certain bird, certain very specific plants, makes a small pile of them, and worships the spirit present inside this pile. At that moment, he sees how he is supposed to represent it. Now, in this vision, the *Asie usu* are always deformed, small, hunchbacked, with long hair that drags on the ground, and when the medicine man declares that he knows how the *Asie usu* must be represented, he indicates a statuette shape that is always very beautiful: the spirit has asked him to hide its deficiencies." (V. Guerry, 1965, p. 185) Vogel (1980) has confirmed this information in her studies on the aesthetics of the Baoule. It is as if the *Asie usu* were applying aesthetics not only to the statuettes that must satisfy these standards in order to be satisfactory, but also even to their own appearance by preferring inaccurate images of it.

African art does not depict landscapes; but from that one cannot infer that Africans are indifferent to their landscapes. Denise Paulme, investigating the Kissi of the forest regions of Guinea who possess numerous places of worship, personally found "these places of worship to be beautiful, but my informants spontaneously had me admire their beauty. . . . Were these places chosen to become sacred receptacles because of their beauty?" (1965, p. 191) The aesthetics of the spirits suggest that one add the question: if they were chosen because of their beauty, was it humans or spirits who chose them?

One must emphasize this aesthetics of the spirits. We have a tendency to oppose tradition and innovation and to closely link innovation and artistic creation, in such a way that tradition is seen as hampering artistic creation. But the aesthetics of the spirits belong to tradition. Consequently, a human who refuses an innovation required by a spirit opposes tradition itself. One can therefore not content oneself with too rigid a conception of tradition. This conclusion is allied to research on a totally different track. Recent studies, abandoning the notion of tribal art and dealing with artistic exchanges between ethnic groups, lead one to recognize that such exchanges belong to a tradition that can no longer be seen as a rigorous and rigid conformism. (P. MacNaughton, 1987) What has been called tradition is part of the conditions of artistic creation.

THE MASK, SCULPTURE, AND PAINTING Another aspect of presentification is directly involved with the Mask, sculpture, and painting. It concerns the variable capacity of presentification that these different arts possess.

Plastic objects, and more widely, the operators of presence, by reason of their different nature, possess different factors of tangible presence. The arts of surface, painting and relief, do not occupy space; in their works, density, if it can be seen, is virtual, it is not confirmed by the touch; it is visible but not tangible. Sculpture in the round occupies space; the visual data relating to the three dimensions is confirmed by the touch. Faced with a sculpture in the round, one can, as with Thomas the Apostle, see and touch it. It is the same for the Mask, but the wearers themselves add a supplementary parameter to it: the movement of life. As to the factor of tangible presence, of existence in our visible world, one can thus rank, in decreasing order, Mask, statue, relief, and painting. Now, with presentification, the sensitive operator can only give what is available to him. He gives the spirit a tangible presence whose coefficient is nothing other than his own. The result is that the variable capacity to presentify a spirit permits us to classify, in decreasing order, Mask, sculpture in the round, and the arts of surface.

That sculpture in the round is more appropriate to presentification than

painting is allows us to understand Lucien Febvre's remark (1962): When Christianity has bones to pick with idols, and then with "fetishes," it is almost invariably a question of statuary, not of painting which, on the contrary, is mentioned only in the Medieval conception of imagery. So, the difference between image and idol lies precisely in the fact that the image represents and the idol presentifies a spirit which the idolator worships in the statue.

Vansina (1984, pp. 101–3, 121–22) borrows the notion of visual concept from certain gestalt psychologists such as Rudolph Arnheim. In a sense, it is a modern way of dressing up the reasons Saint Thomas Aquinas gave for the use of religious imagery. The visual concept is an image which closely unites a signification with its visual aspect that the intellectual concept presents to the isolated state. Its tangible character confers upon it a psychological capacity the intellectual concept is deprived of. For the majority of people, a visual concept is easier to understand, easier to memorize and maintain; its tangible character confers upon it the capacity to stimulate affective states. This variation of the capacities of the visual or intellectual concept corresponds, in the realm of representation, to the variation of the coefficient of presence in the realm of presentification.

Now if, in terms of the capacity to presentify, painting is inferior to statuary, it is, on the other hand, superior in its capacity to represent. In his *Notebooks*, Leonardo addresses the classical theme of the comparison between sculpture and painting, completely to the profit of painting, which "embraces all the forms of nature" and is capable of representing an infinity of things and aspects of the visible world which escape sculpture; the sculptor's perspective, in particular, is inferior to that of the painter.

One may then risk a hypothesis. If painting is more suitable to representation, a culture that values presentification, and thereby imposes it upon painting, goes contrary to painting's vocation and hinders its development. That is perhaps one of the reasons for the strong predominance of statuary over painting in traditional African cultures. Similarly, the predominance of the isolated statue over group statuary would be explained at one and the same time by the strong presentifying capacity and the weak representational capacity of sculpture in the round.

A counterexample can confirm this hypothesis. According to Panofsky (1975, p. 181), "the perspectival vision forbids this region of magic, in which the work of art itself achieves miracles, to religious art." Perspective, one of the most powerful means of representation, and the magic image, which is *praesentia et potentia*, seem incompatible.

One should undertake a study of various traditional African paintings in order to see if it is possible to establish a correlation between their representational development and the decrease in their presentifying and magical capacities. For certain African paintings are "magical," and one should conceive of representation and presentification not in terms of contradiction but rather of polarity.

Functionalism and Artistic Production

Until now we have considered the work of art in terms of use; it must also be considered in terms of production and product. Artistic functionalism affirms the primacy of use and the user over that of production and the producer. The examination of this thesis provides us with the opportunity

to examine anew the convergence of the two functionalist theories: is there an agreement between this thesis, of Greek origin, and African ethnographic data?

The thesis, formulated by Xenophon, Plato, and Aristotle, distinguishes arts of production from arts of use. Production is subordinate to use. Generally speaking, a means is subordinated to the end that the means permits us to realize. The end of production is the product—for example a statue—which in turn has an end—for example, worship. Use realizes that end in such a way that it is the user who is able to know whether the product is good, well adapted to its end. Thus, in order to judge the value of a product, the user is more competent than the producer. Our Western contemporaries, on the other hand, affirm the primacy of creation over aesthetic perception, and the creator over the critic; thus, according to Henry Moore, "the public always lags behind the artist." (1983, p. 17) The functionalist thesis has two consequences; therefore, the confrontation with the ethnographic data will be made on three points.

The matter of the primacy of the user must be distinguished from that of the aesthetic criteria. It concerns knowing, not what the aesthetic criteria are that are normal in a given social group, but who, among the members of that group, are those who best know, apply, and formulate these criteria. In other words, who are the most competent informants for the ethnologist investigating the aesthetics proper to that group?

While studying the Tiv (Nigeria), Paul Bohannan (1971) was led to conclude that they are interested "in the art—not in the artist" (p. 175), that they "care who creates a given object as little as they care about the creative process. Art is, among them, an epiphenomenon to play, religion, prestige, and most other aspects of life" (p. 176). The author concludes from this that, in order to arrive at an aesthetics, it is more satisfying to study the connection between the work of art and criticism than that between the work of art and creation (p. 181). In short, art is an epiphenomenon of use, and so is criticism. In an essay on *Yoruba Artistic Criticism*, Thompson (1973b) accepts responsibility for these remarks of Bohannan's in quoting them (p. 24). The functionalist primacy of the user over the producer is supposedly confirmed by ethnographic inquiry. A more thorough study would lead to refining this conclusion, from which one ought not to generalize too quickly. Thompson himself takes the aesthetic information provided by the sculptors into account most strongly. Vogel, in a recent study (1987b), chooses, among "perspectives" on African art, that of the Baoule sculptor Lela Kouakou on Baoule art. The purpose of these brief suggestions is to bring the Western primacy of creation and the creative artist into question.

The functionalist thesis of the primacy of use, in the second place, permits us to take up the matter of the integration of the arts again, not into the social group but between the arts—the question of an architectonic classification. An art is subordinated to and integrated with another art when its products are put to use by a second art. An architectonic, hegemonic, or dominant art is that art which puts to use and subordinates *all* the other arts. (R. G. Collingwood, 1938, pp. 16–17 and 25–26) As such, it can be called a total art. Georges Balandier applies this notion to African art. (1961, p. 1745) The notion of a total art is to the integration of the arts what the notion of a total social act is to social integration in general. For Aristotle, it was architecture. In Africa, sculptures are integrated into activities, such as rituals, ceremonies, or celebrations, which, if they are recognized as having an artistic character, may be seen as the dominant or total art, analogous to architecture. The dominant art, then, is a "performed" art. (J. Vansina) Even if one refuses to see the ceremony or the celebration as an artistic genre, the fact

remains that sculpture integrated into a "performance" is aesthetically modified by it. Gilson gives an example of this, borrowed from Christian art: "When statues are carried in a procession, the procession may reveal a hallucinating, but always strange, beauty, such as those Spanish statues that oscillate with an almost living grace when they are carried in processional step" (1964, p. 82); the African step often is a dance step. That is one of the themes in Thompson's essay, *African Art in Motion*. A film by Guy Le Moal (*see* 1980, p. 499) stresses this aesthetic aspect of the "performance" of the bringing out of a mask of leaves used among the Bobo.

The primacy of use has a second consequence: the existence of a second phase of production. Certain uses require the product to have a specific quality or power. Often the sculptor does not have the capacity to give his product this quality or power; use requires the intervention of a second producer who does have that capacity. Between the actual sculptural production and the use, a specific act or labor is interpolated that is linked to production since it precedes the use that will require it.

If the use is religious, one may schematically say that, when the object is not active, this second phase is a consecration and, if it is, it is an activation implying presentification. To the two phases of production correspond two states of the same object, sometimes distinguished by two different names, as among the Teke, the Yaka, and the Bemba. Hottot (1972, p. 20) compares this second phase to initiation, which modifies the metaphysical identity of the initiate.

Here again there is no general rule. In some societies, the artist, or at least certain artists, hold a mystical power so that the object that comes from their hands does not need to be consecrated or activated; it is often the blacksmith whose art, in direct relationship with the earth and with fire, is irreducible to what we call technique. This second phase takes diverse forms, sometimes discreet, sometimes very visible, and often surprising to the Westerner. For example, among the Yoruba, the *gelede* mask is not worn over the face but on top of the head; it is therefore technically useless to pierce the eyes of the mask in order to allow the wearer to see well. But they are pierced in order to "give life" to the mask (A. Rubin, 1969, p. 22; W. Fagg and J. Pemberton, 1982, p. 37); this activation is comparable to the Egyptian ritual of opening the mouth or the eyes of statues, which associates technique and magic. (J. Yoyotte, 1961, p. 146) The addition of magical ingredients is sometimes very discreet: the Mbala place them in a cavity hollowed out between the legs of the statue. (D. Biebuyck, 1985, vol. I, p. 169). Often, the activation so profoundly modifies the aspect of the object that the concept of accumulative sculpture has been used. (A. Rubin, 1974) Since the sculptor foresees this second phase, it may account for the unfinished or the incomplete in his product. This second phase may consist in the application of colors (F. Willett, 1971, p. 161); one understands then that polychromy may be indifferent to naturalism.

When the object contains a power, with time and use, this may be used up, weakened, or annulled, and the object becomes unusable. It may then be abandoned and replaced by a new one. It may also be reactivated. In the case of a painting, it may be newly repainted in order to find its *potentia* again.

Finally, since the notion of authenticity is linked to that of production or creation, the primacy of use over that of production must be more or less explicitly relocated in a functionalist conception of authenticity; this is what we have brought out by examining the criteria mentioned by Willett.

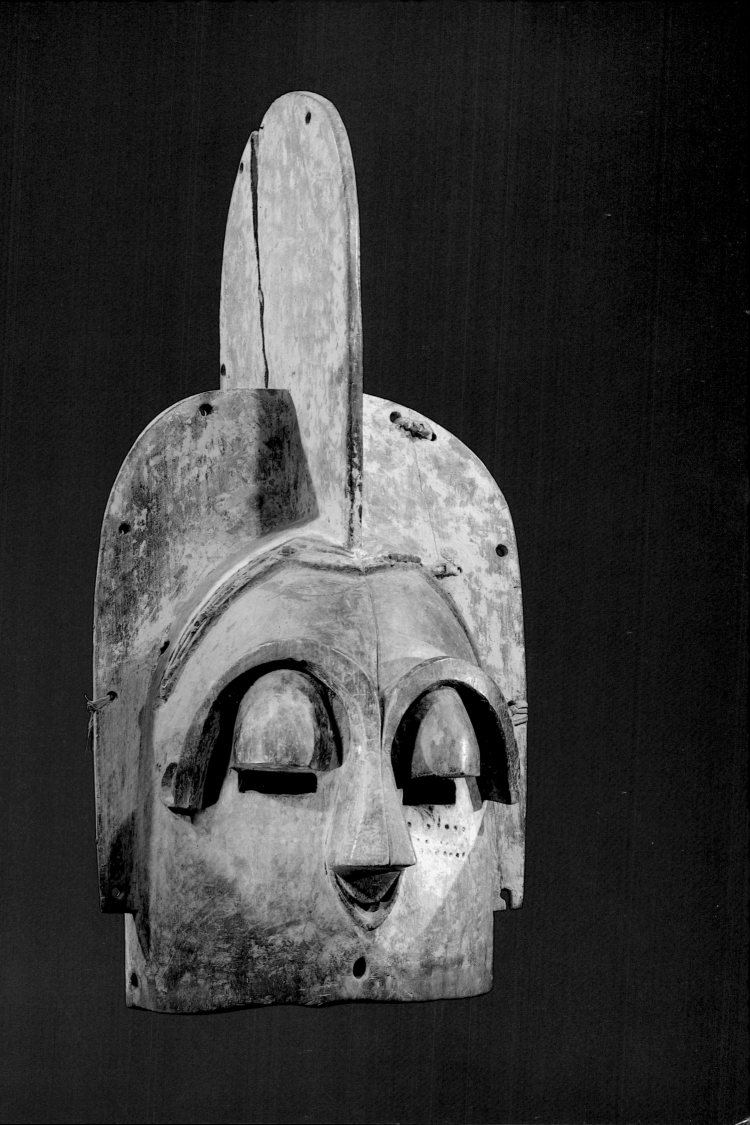

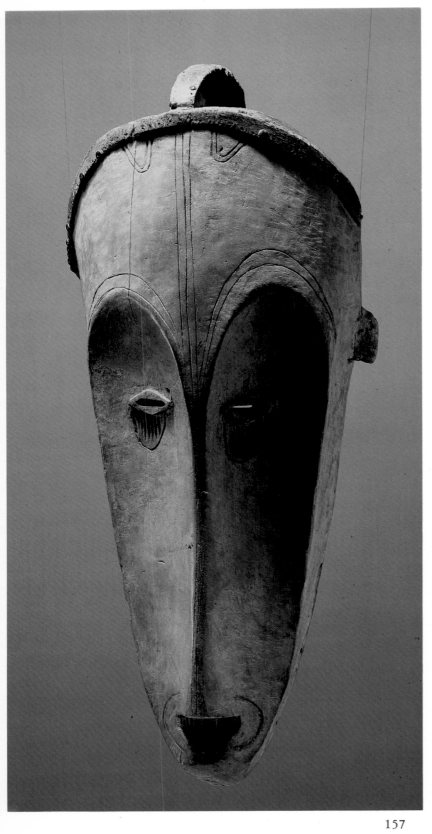

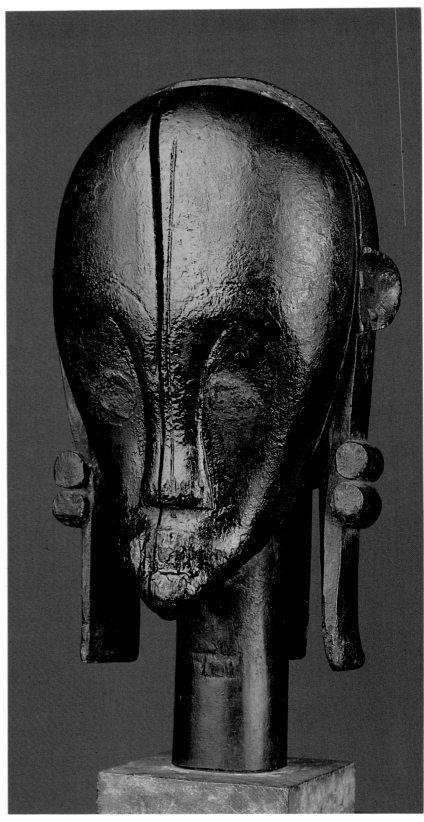

157

158

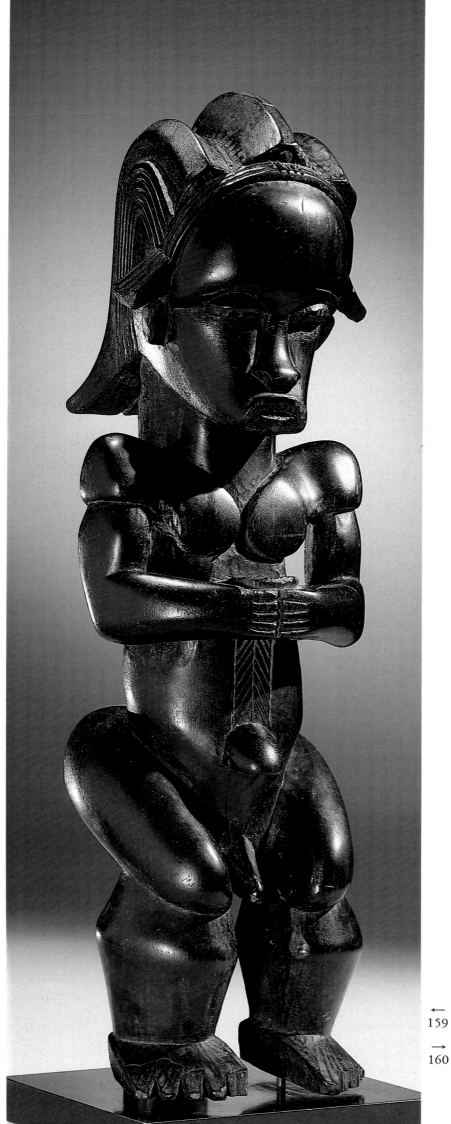

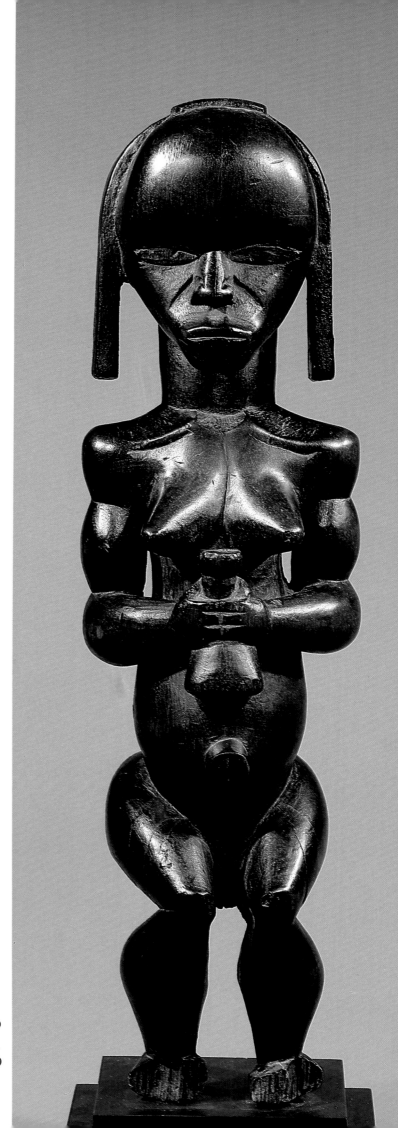

← 159

→ 160

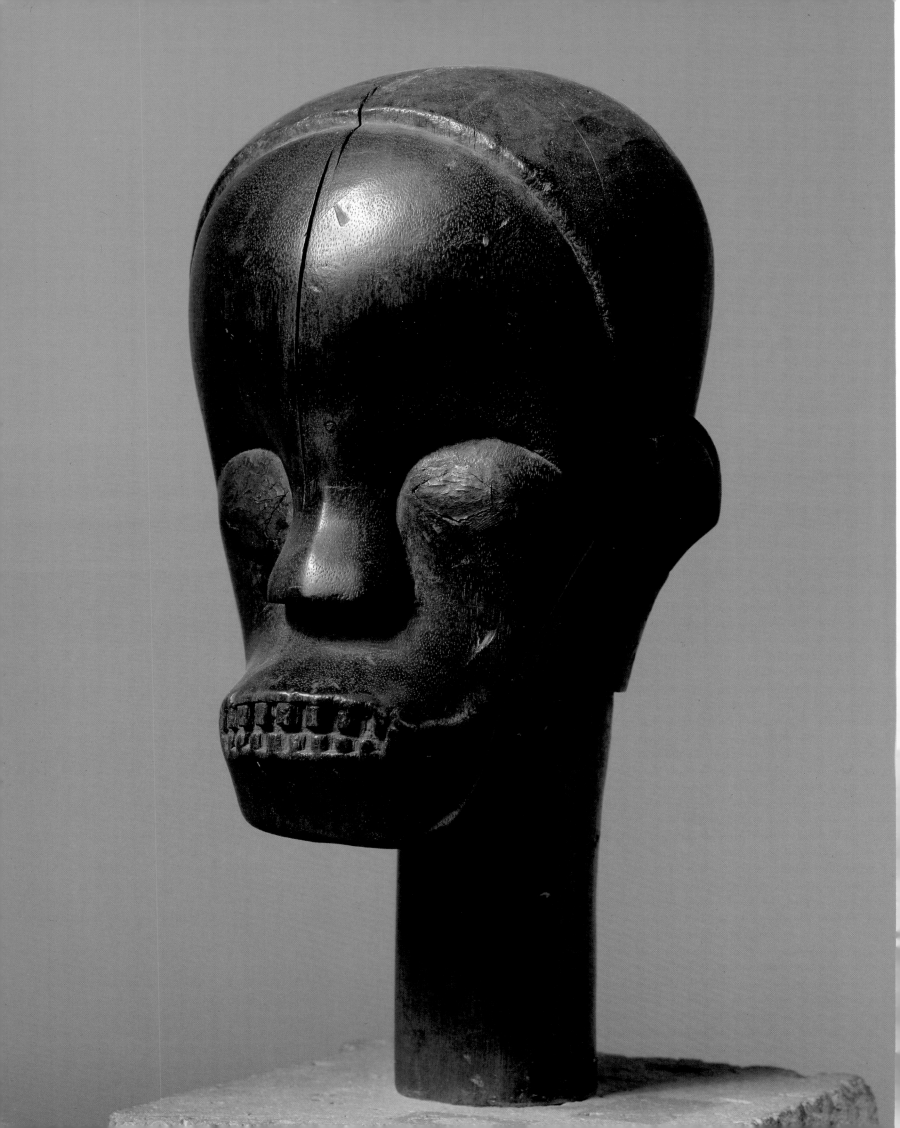

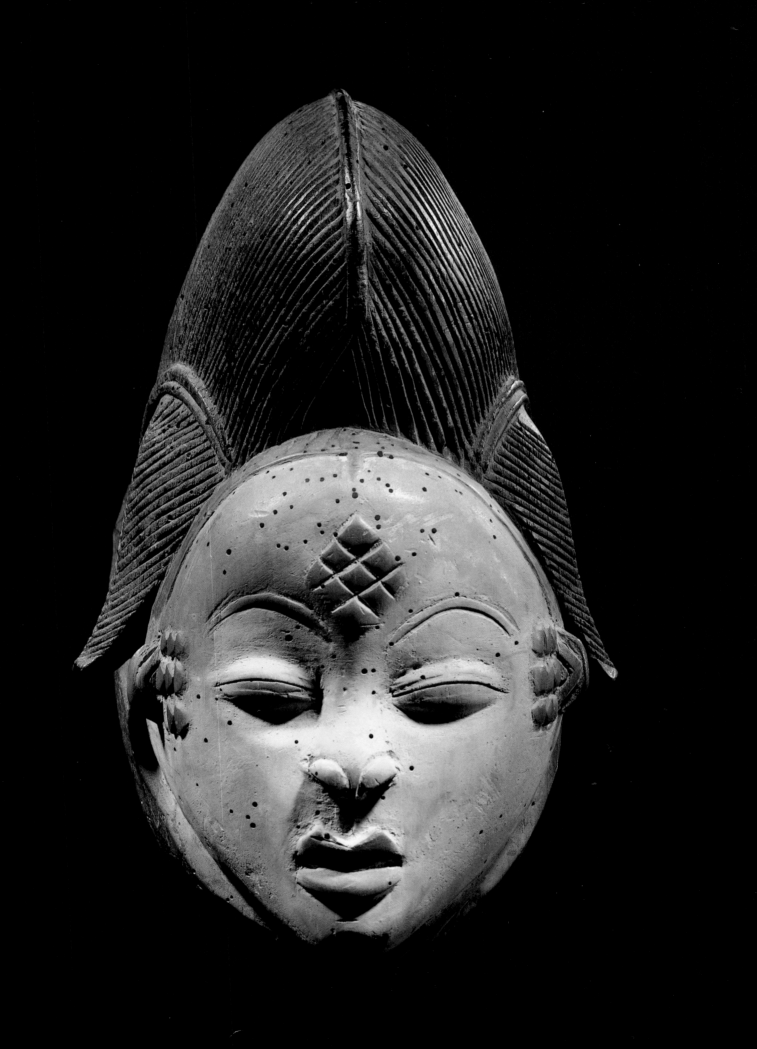

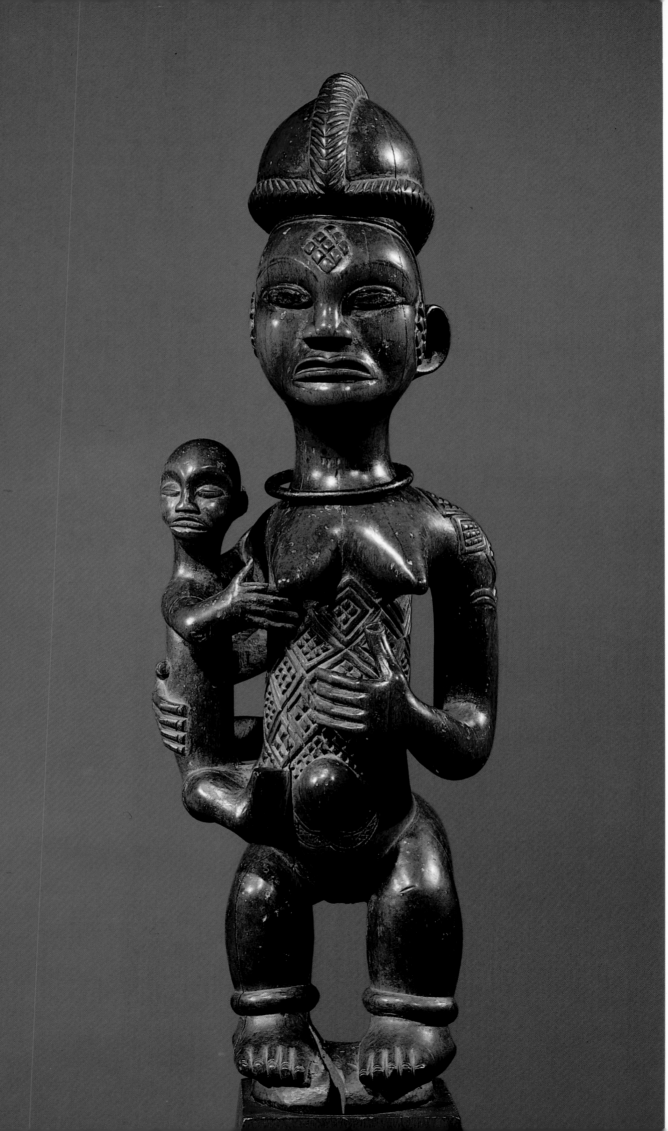

163

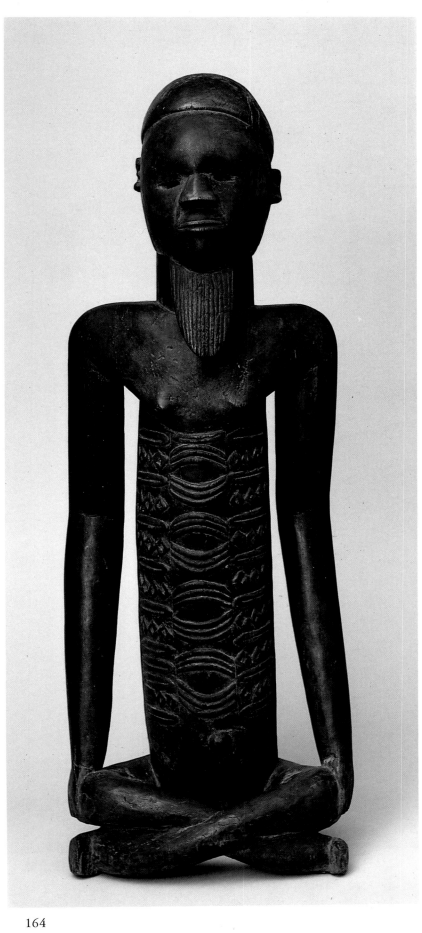

164

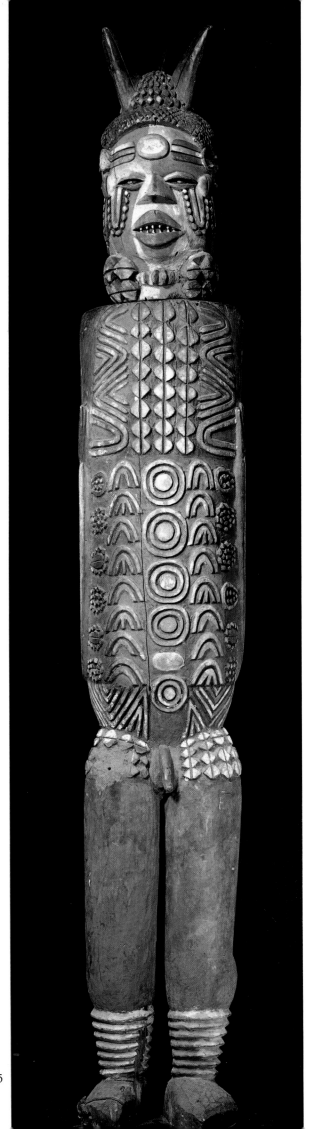

165

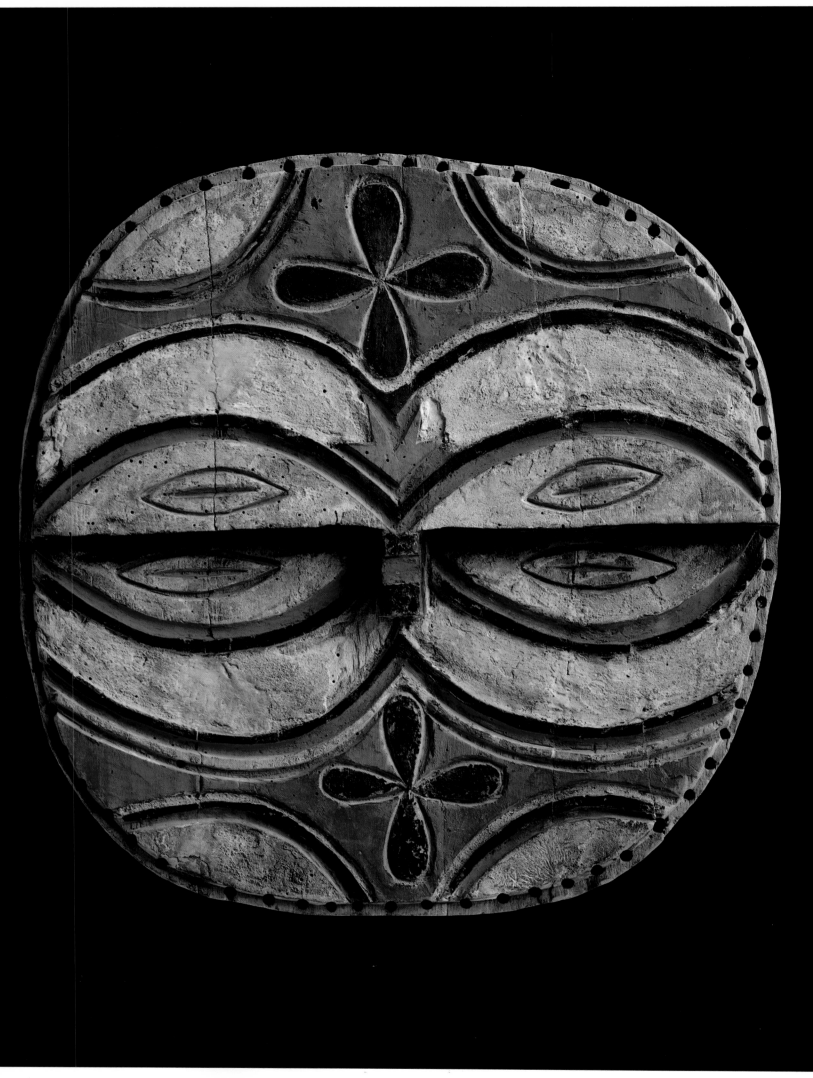

166

156　Kota *Mbuto* Helmet-Mask, Gabon
Wood. Height: 70 cm. Private collection

157　Fang *Ngil* Mask, Gabon
Wood. Height: 65 cm. Musée de l'Homme, Paris;
formerly Lefevre Collection

158　Fang Reliquary Head, Gabon
Wood. Height: 46.5 cm. The Metropolitan
Museum of Art, New York; formerly
P. Guillaume, J. Epstein collections

159　Fang Statue, Gabon
Wood. Height: 46 cm. Private collection

160　Fang Statue, Gabon
Wood. 19th century. Height: 49 cm. Private
collection; formerly P. Guillaume Collection

161　Fang Reliquary Head, Equatorial
Guinea
Wood. Height: 27 cm. Louise and Walter
Arensberg Collection, Philadelphia Museum of
Art

162　Punu *Okuyi* Mask, Gabon
Wood. Height: 27 cm. Private collection

163　Punu Statue, Gabon
Wood. Height: 33 cm. Private collection

164　Bembe Statue, Congo
Wood. 19th century. Height: 56 cm. Museum
Rietberg, Zürich

165　Kuyu Statue with Detachable Head,
Congo
Wood. Height: 136.5 cm. P. Vérité Collection,
Paris

166　Teke Mask, Congo
Wood. Height: 34 cm. Musée Barbier-Müller,
Geneva; formerly Devain Collection

167　Ngbandi Mask, Zaire
Wood, copper incrustation, teeth. Height: 36 cm.
Private collection

168　*Sanza*, Musical Instrument, Zande,
Zaire
Wood. 19th century. Height: 61 cm. Musée Royal
de l'Afrique Centrale, Tervuren, Belgium

169　Mbole Statue, Zaire
Wood. Height: 87 cm. Loed and Mia van Bussel
Collection, Amsterdam

170　Mbole Statue, Zaire
Wood. Height: 92 cm. Musée Royal de l'Afrique
Centrale, Tervuren, Belgium

171　Lega Statuette, Zaire
Wood. Height: 30.4 cm. De Young Memorial
Museum, San Francisco

172　Lega Mask, Zaire
Ivory. Height: 21.4 cm. The Metropolitan
Museum of Art, New York

173　Lega Head, Zaire
Ivory. 19th century. Height: 15 cm. Private
collection

174　Lega Statuette, Zaire
Ivory. 19th century. Height: 22 cm. Private
collection

175　Lega Statue, Zaire
Ivory. 19th century. Height: 24.5 cm. Collection
G. L., Paris

176　Lega Statuette, Zaire
Ivory. Height: 26.5 cm. Private collection

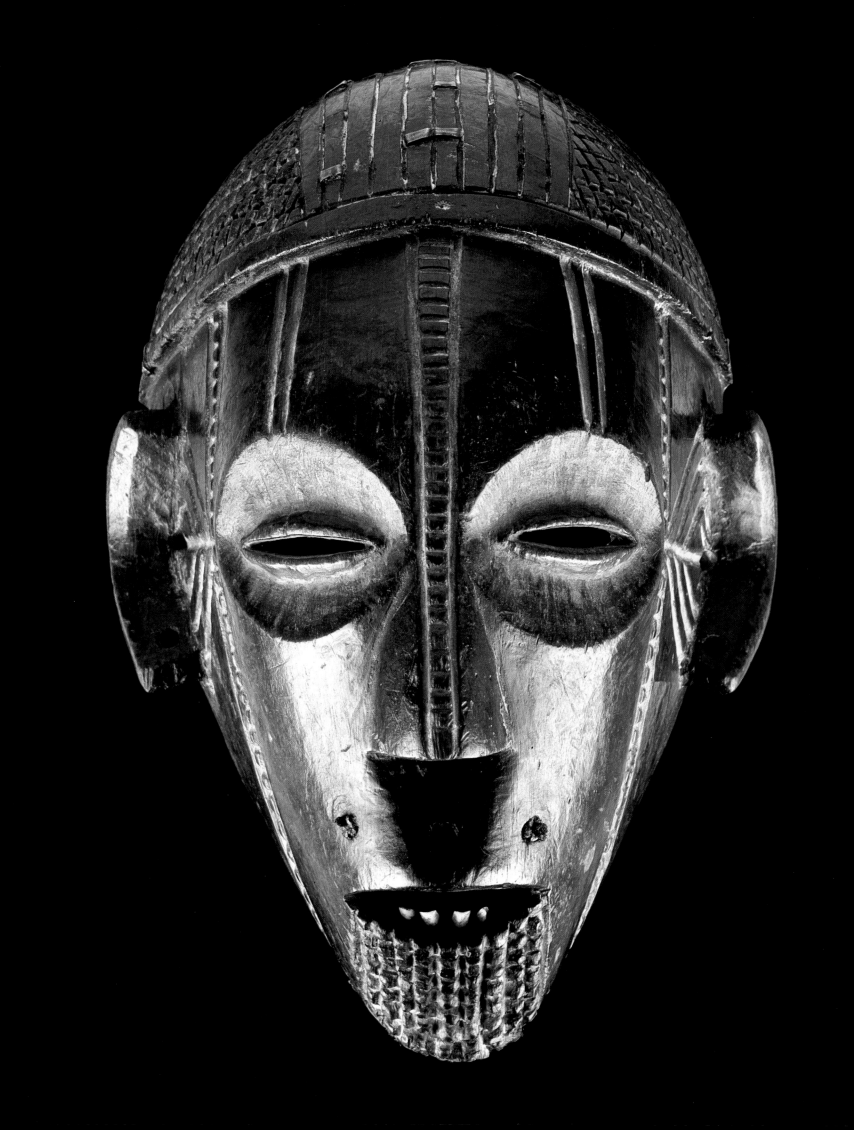

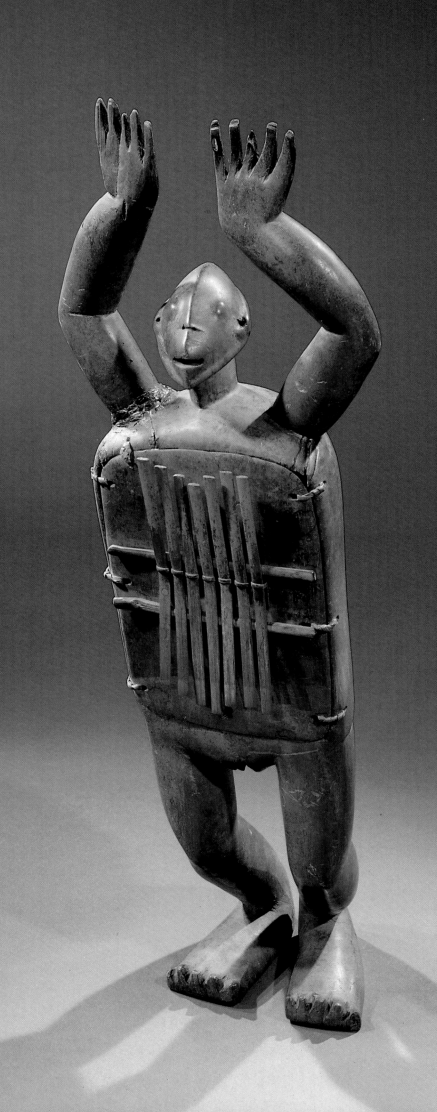

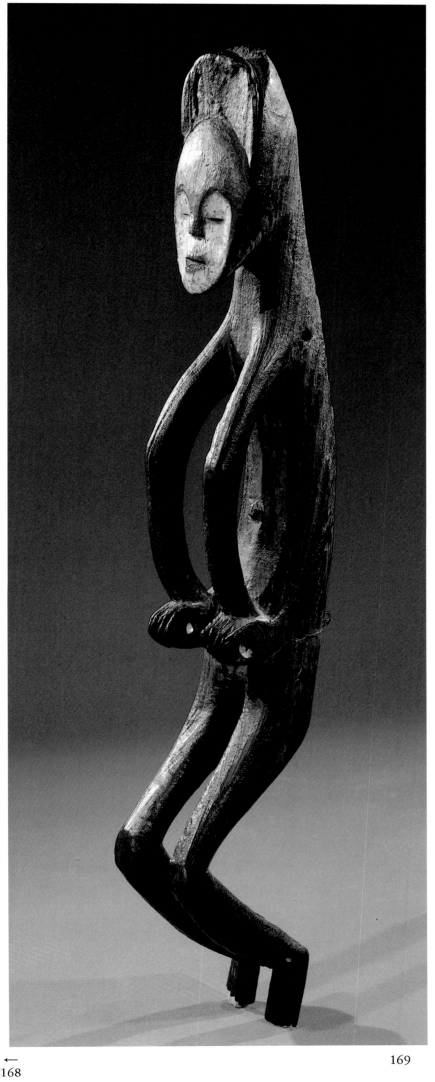

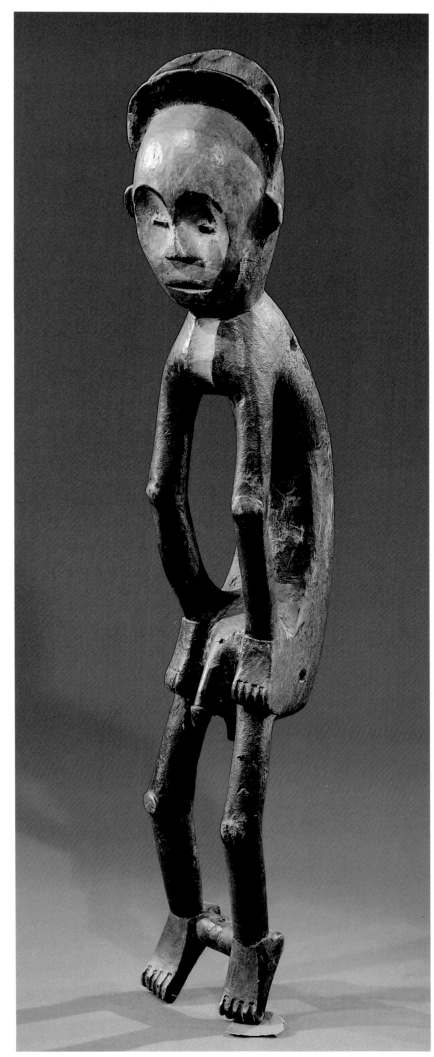

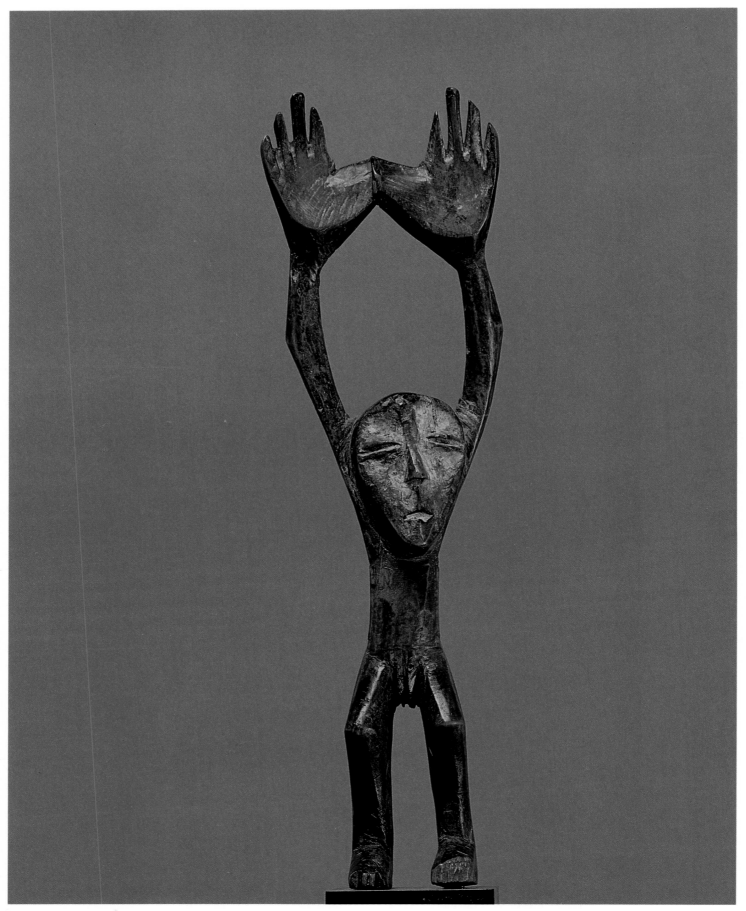

171

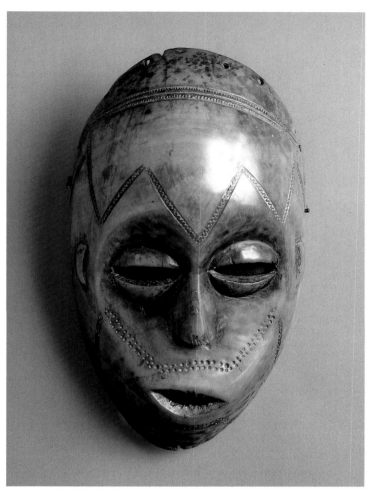

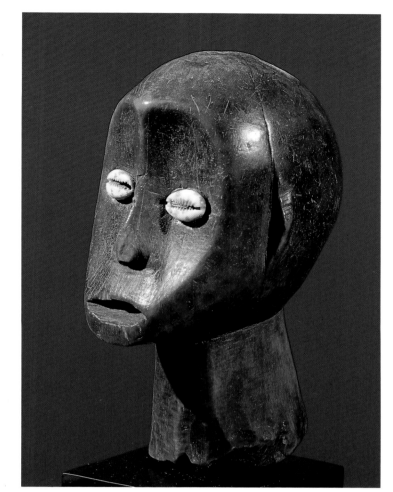

172

173

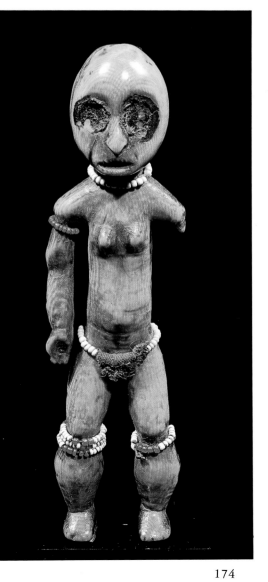

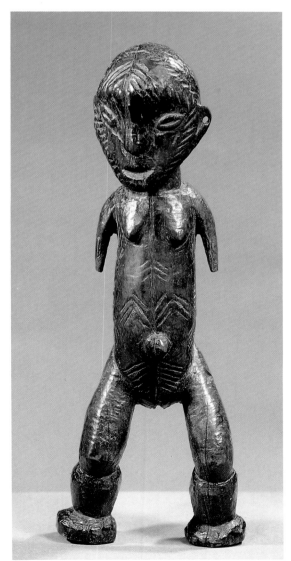

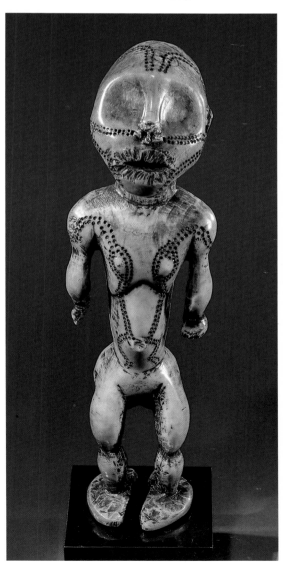

174

175

176

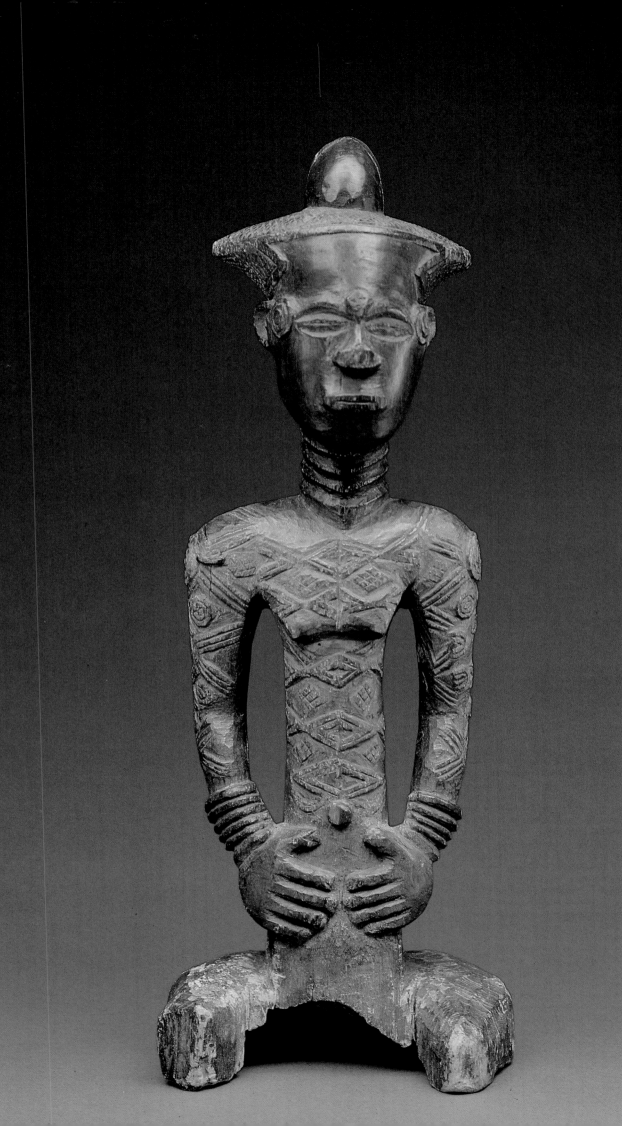

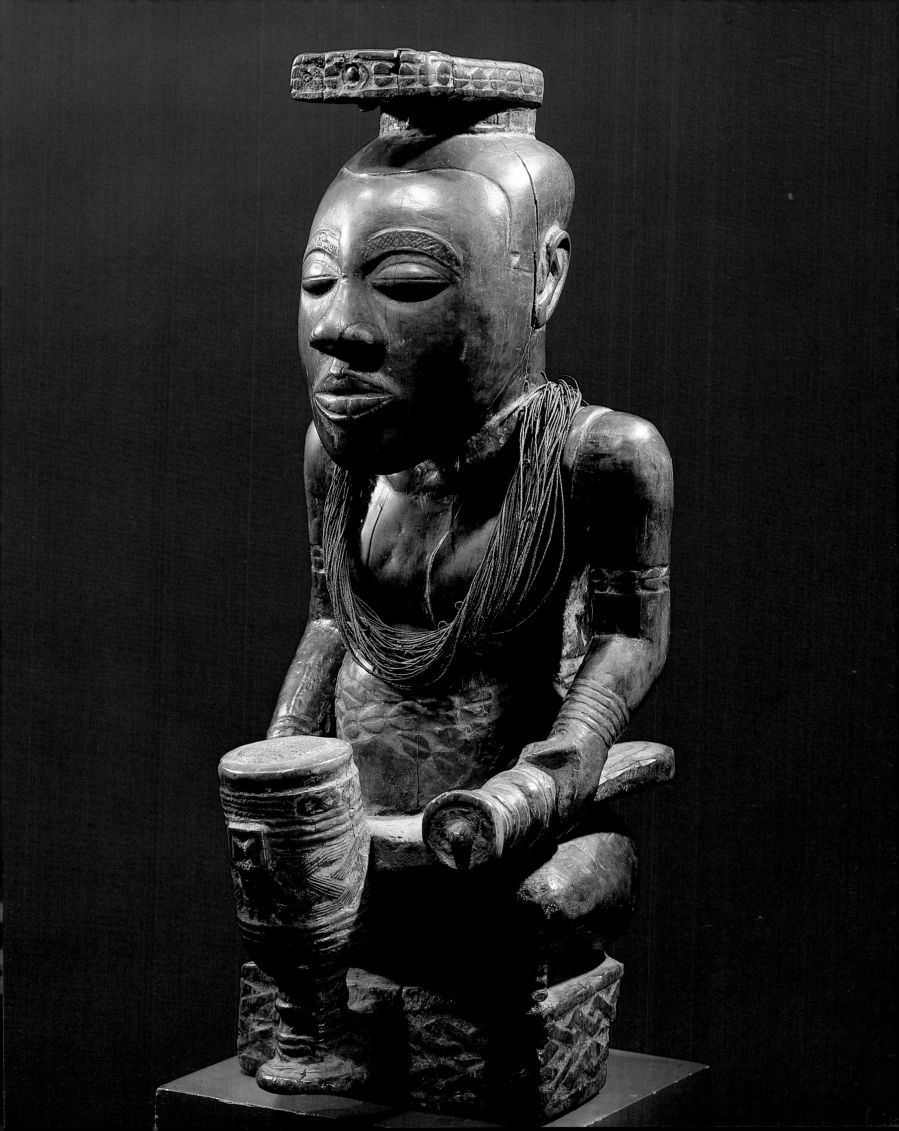

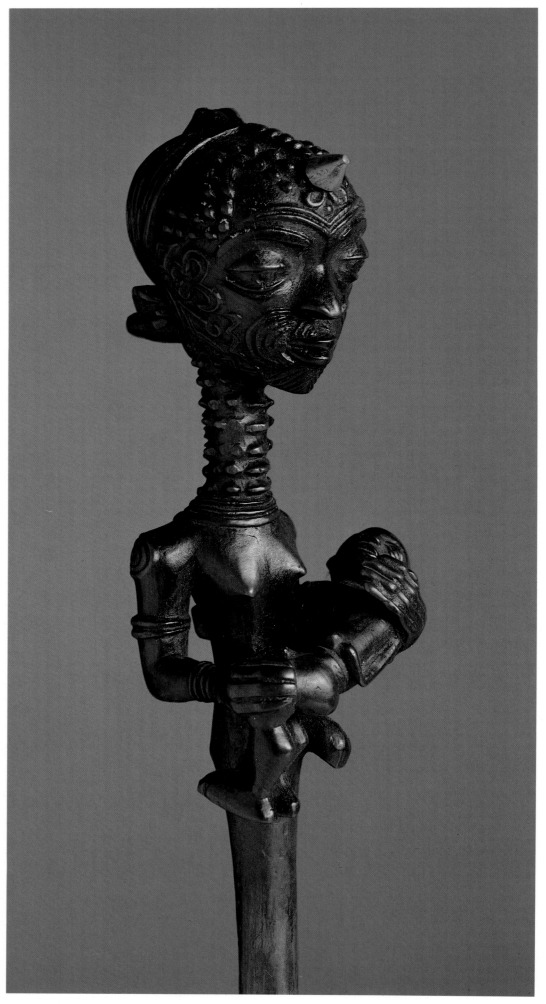

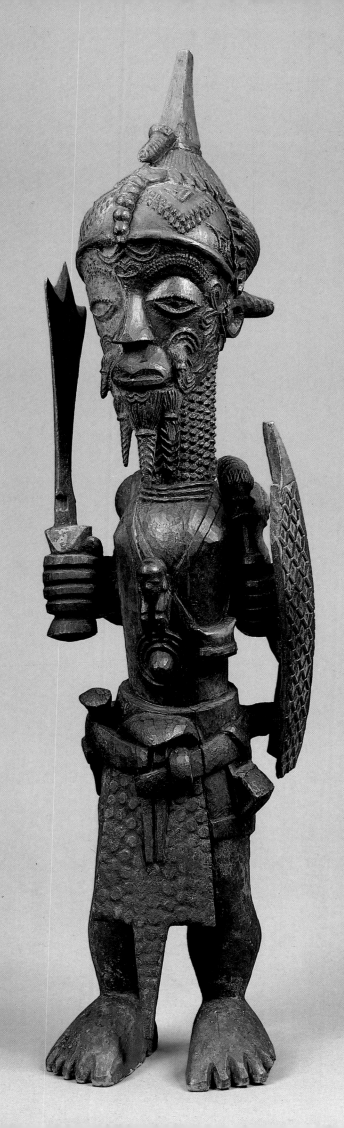

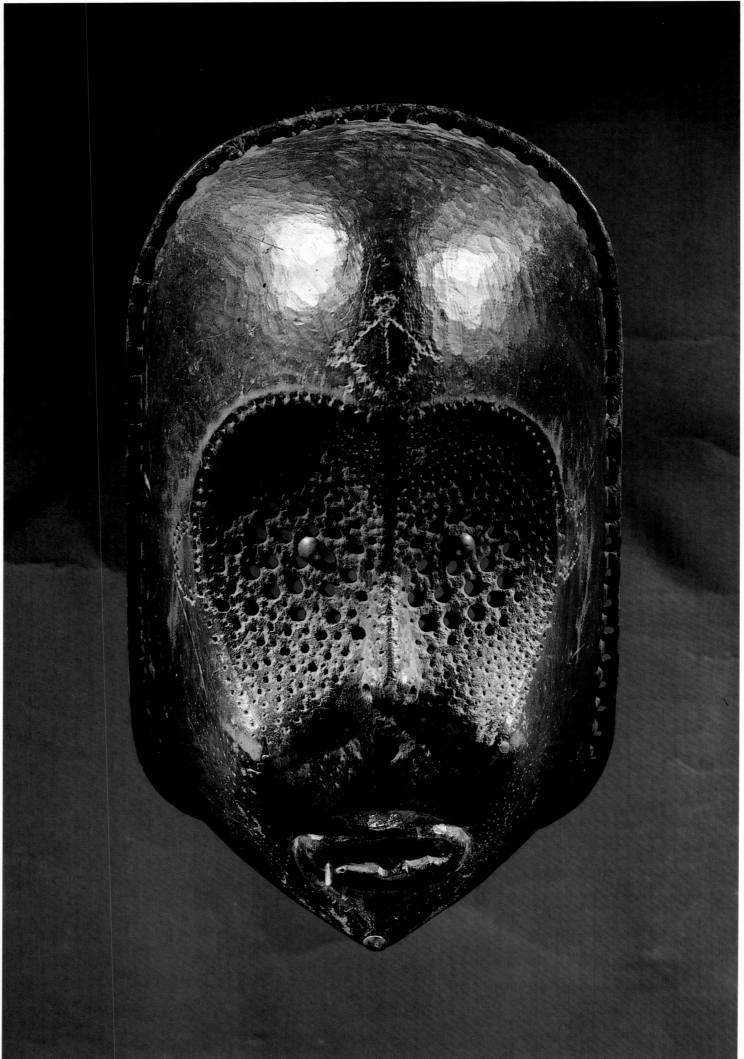

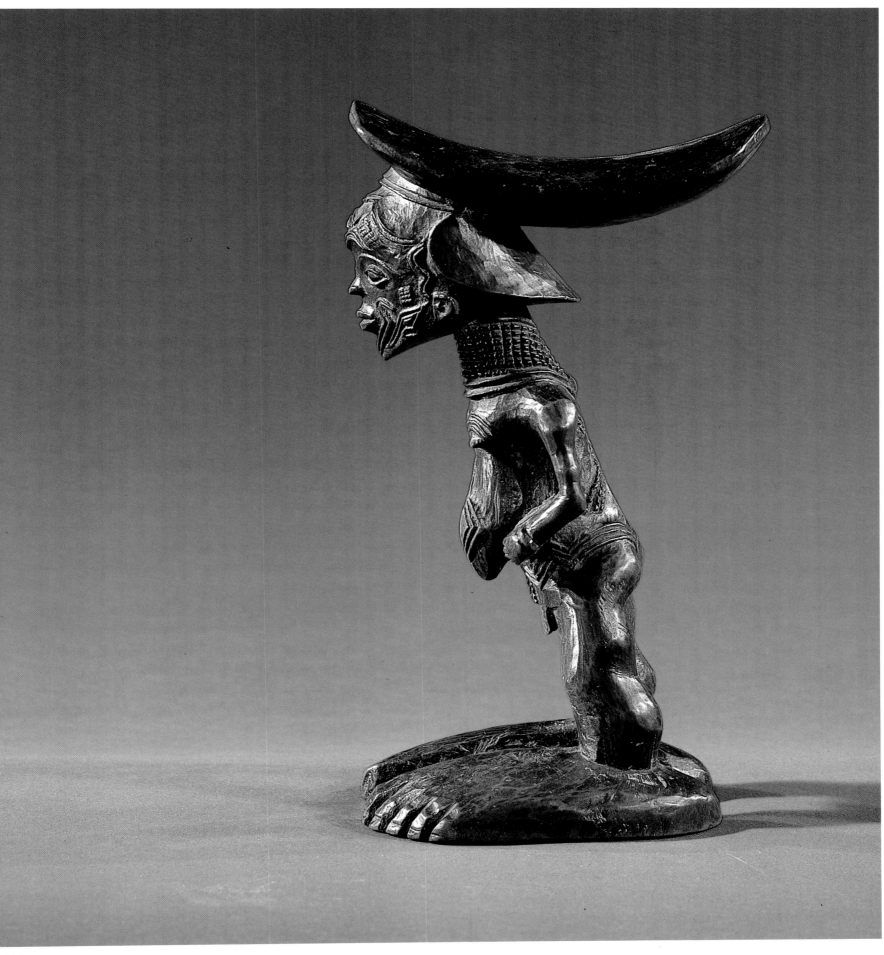

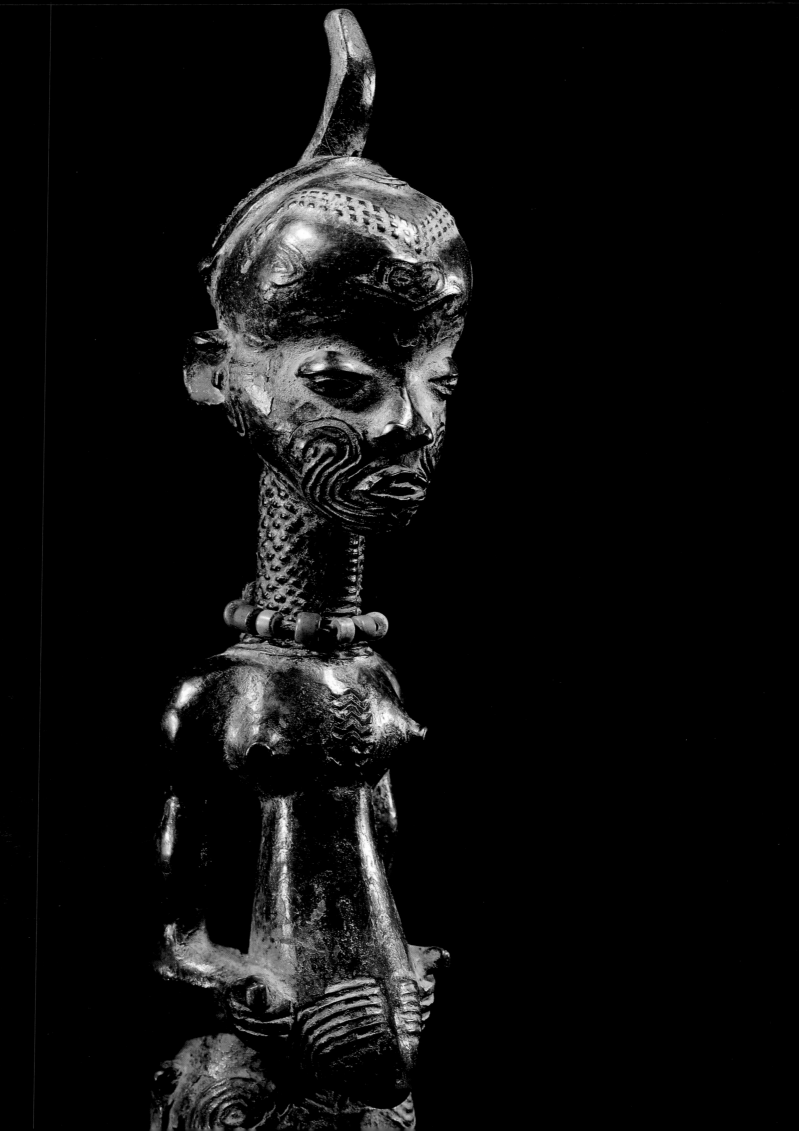

177 Dengese Statue, Zaire
Wood. Height: 52.5 cm. The Metropolitan
Museum of Art, New York

178 Effigy of the Bushong King Kot
A-Ntshey, Kuba, Zaire
Wood. Height: 51.1 cm. Musée Royal de l'Afrique
Centrale, Tervuren, Belgium

179 Lulua Maternity Figure, Zaire
Wood. 19th century. Height: 35.6 cm. The
Brooklyn Museum, New York

180 Lulua Statue, Zaire
Found by explorer Hermann von Wissmann in
1885. Wood. 19th century. Height: 74 cm.
Museum für Völkerkunde, Berlin

181 Mask from the Lulua Cultural Region,
Zaire
Wood. 19th century. Height: 28 cm. Private
collection

182 Lulua Neck-Rest, Zaire
Wood. 19th century. Height: 21 cm. Musée Royal
de l'Afrique Centrale, Tervuren, Belgium

183 Lulua Statue, Zaire
Detail. Wood. 19th century. Total height: 48 cm.
Musée Royal de l'Afrique Centrale, Tervuren,
Belgium

IV. THE PLEASURE OF SEEING

*I desire nothing besides what
I see.*

EUGÈNE DELACROIX, *January 25, 1857*

Orientation: The Ethnologist and the Aesthete

We have just sketched out a description of the functionalist approach to traditional African sculpture. The ins and outs of functionalism often elude, even oppose, a formalist mindset, which we now propose to reinstate, if only in part.

As a first step, we shall describe these two points of view in their maximal contrast, pushing each to its furthest limit. In a series of paired opposites, each term is descriptive but often also takes on a value in the name of which it condemns its opposite. All these partial oppositions form a dichotomic system summed up by the contrast between the ethnologist and the aesthete.

The object in the museum, defunctionalized and sometimes mutilated, is opposed to the object in use in its original context. In the museum, it is observed in isolation, for its own sake; the ethnologist, though, observes both its context of use and the object itself. Taken out of its context, it loses its functional significance and is looked at as pure form. Thus, the ethnologist reproaches the aesthete for ignorance of context and meaning and for an ethnocentrism that causes him or her to have the same attitude when looking at an African sculpture as when looking at a work of art created in his or her own culture; the aesthete applies concepts and aesthetic criteria to a foreign object which on-site observation of that object shows to be inappropriate. The aesthete replies by invoking an aesthetic sensitivity which the scholar either does not possess, or which he or she refuses to bring into play out of a concern with objectivity, with neutrality regarding values. By adapting a famous Kantian formula, one could say that the sensitivity of the aesthete is blind and the knowledge of the ethnologist is insensitive and therefore aesthetically empty. Each of them grants value to that which leaves the other indifferent. To the aesthete, the scholar does not look at the object and its form but at its use and context; to the ethnologist, the aesthete, by looking at the form of an object in isolation, loses sight of its use and its significance, and finally misses out on the rich human substance of art. The aesthete's attitude is explicit and is expressed in the formalist doctrine of "art for art's sake," unknown to the

users of objects. Ethnologists interpret art in terms of function and forbid themselves to account for the aesthetic quality of the works.

Implicitly or explicitly, the aesthete's attitude is universalist: receiving and appreciating works originating in every place and in all periods inside the museum, as André Malraux emphasized. The ethnologist observes art in use at a particular time and place, in an original culture; the inclination is toward relativism: the significance and value of an art are recognized only within its society and culture of origin and are thus relative to this society.

A union of these two opposing attitudes would result in the impossibility of a general aesthetics. "Art for art's sake" is surely an aesthetics, but its claim to universality is a vain one; the knowledge of the ethnologists may be scientific, but the aesthetic fact itself remains foreign to them. Pushed to the extreme, the two attitudes reveal a situation of antinomy.

But, in fact, museums exist and African works are making their entrance into them, slowly and not without difficulty, accompanied by information provided by ethnology—just as other works of art have been accompanied by the information provided by art history. These are facts that make the preceding antinomy appear ideological. Do the purely aesthetic attitude and its self-awareness within theoretical discourses exist only in the West and in relation to the institution of the museum, or are they observable, albeit in a different light, in the societies and cultures in which the works exist like fish in water? Ethnographic inquiries are establishing that there are in fact African aesthetics, which shifts and transforms the question. The museum exists and is universalist, but the aesthetics it engenders are not necessarily so as well. The recognition of the existence of African aesthetics occurs within a comparative framework, but it is also not necessary that this comparativism engender a radical relativism. Could comparative aesthetics not open a road in the middle of the two inimical ideologies, universalism and radical relativism?

In Search of an African Aesthetics

The last decades have seen an expansion, in number and understanding, in inquiries focused on African aesthetics, corresponding to the various arts known already. A comparison of these specific aesthetics has begun, as has an attempt even to isolate common characteristics from them in order to make a correspondence between an original African aesthetics and African art as a whole.

Only inquiries such as these allow the struggle against ethnocentrism to take place, by researching if and how members of a social group appreciate their own art, and by comparing the various arts by means of the diverse ways in which they are evaluated—no longer by relating them to our own aesthetics. Taking the viewpoint of Africans on the African arts seriously implies a central point of reference, several even, that is different from the Western center from which ethnocentrism stems. All we can give here is a brief sketch of the results of this research; but the choice of particularly representative samples will permit us to examine, if not the general orientation of these investigations, at least one of its principal directions.

Preliminary Definitions and Distinctions

The word aesthetics, as is true of the word art, is used in more than one sense. A work of art may be considered in relation either to its creator or to the person who looks at or uses it. Thus, art theory or philosophy

classically is divided into the theory of artistic creation and the theory of contemplation or aesthetic (*aisthesis*) perception. In a larger sense, "aesthetics" is seen as the equivalent of "art philosophy"; in a stricter (and etymological) sense, it designates only the second part of art philosophy. When we speak of an African aesthetics, it seems we are dealing with the second sense, but is this assessment a rigorous one? It is doubtful.

We call an "aesthetics" those philosophical or scientific works that are *written*. These cannot be found in societies without writing, such as the traditional African societies. Not to distinguish a third use of the word would amount to neglecting the important impact of the absence of writing on the various cultural forms and thus on the aesthetics of these societies. However, in order to distinguish this third sense, the word "ethno-aesthetic" has been created, which designates both traditional aesthetics and the discipline that specializes in their study. But this third sense poses a question: on what ground can these African ethno-aesthetics, despite their nonwritten status, be called aesthetics without an abusive assimilation with our written aesthetics?

Several kinds of investigations and publications must be differentiated. The distinction between ethnography and ethnology must be applied to the prefix "ethno-." As with ethnography, ethno-aesthetics can take a society and its specific aesthetics as its object; thus, Yoruba, Baoule, Fang, Chokwe, Tiv, and Asante aesthetics are studied. But other investigations, based on the results of the preceding ones, move on to comparisons; for example, Susan M. Vogel compares Baoule and Yoruba ethno-aesthetics, Simon Ottenberg compares those of the Yoruba and the Igbo. In such studies, the comparison is done from the outside, so to speak; but it can also be done from the inside, by investigating the way in which one society, within the framework of its own particular aesthetics, considers and appreciates the art of another society. We might agree to reserve the term "ethno-aesthetic" for ethnographic monographs that limit themselves to one particular aesthetics, and to call studies that compare two or several specific aesthetics "comparative ethno-aesthetics."

The comparative domain may be widened, while remaining African all the way through. On the basis of particular ethno-aesthetic monographs, one can compare, if not the totality of African aesthetics, since we are far from having studied them all, at least a number that seems sufficient to attempt a generalization; therefore, an African aesthetics is proposed as a hypothesis. (S. M. Vogel, 1987a) Thus, one must distinguish between specific aesthetics and more or less general aesthetics, according to the extent of the comparative domain.

Aesthetics and Criticism

The difference between African "aesthetics" and Western aesthetics is expressed by the use of the word "criticism" instead of "aesthetics." This choice is justified by the agreement between the method used by investigators and the Western notion of artistic criticism.

Investigators gather preferential judgments that are either spontaneous or elicited. Given a collection of objects, one observes the preference of the autochthones—who, for example, in the market prefer this piece over that other one; or one asks informants to classify objects in order of preference. These are what are called "beauty contests." (S. M. Vogel, 1979, n. 1) The objects to be judged exist on-site, or are brought by the investigator, or photographs are substituted. Then the researcher asks his or her informants to justify verbally their preferences and their classifications. The researcher must also take the agreements and disagreements between these preferences into account. Criteria for the

choices are demonstrated in the answers, which are, however, highly variable in clarity and precision. The interpretation begins with the explanation and translation of these criteria by the ethnologist. The aggregate constitutes the canon, or the "aesthetics," of the style under examination. (Let us note that the word "canon" is sometimes used in the same sense as "criterion.")

In the West, the word "criticism" is derived from a Greek verb which means to discern, to judge, to operate by discriminating; consequently, "criterion" is an operation of discrimination. In the artistic field, criticism is the activity that judges concrete, singular works of art by confirming or negating their value, applying value judgments to them. Aesthetics is distinguished from criticism in that it searches for general principles upon which the judgments of critical value are based. It does not itself pronounce such value judgments, but takes them as data whose principles must be sought, or simply mentions them as examples. It is, therefore, more general and more abstract than criticism.

Once this distinction between aesthetics and criticism has been made, it is clear that what ethnologists observe, interpret, and reconstruct is much more closely related to criticism than to aesthetics.

African Aesthetics

We have chosen three studies for their intrinsic value and the methodological questions they raise. Since no essay of this kind has been translated into French, we shall give a detailed account of them. The first study refers to two essays by Robert Farris Thompson (1971 and 1973b) on the art criticism of the Yoruba of Nigeria; the second one by Vogel (1977), a specialist in Baoule art, compares the art criticism of the Yoruba and the Baoule. These two authors are primarily concerned with the concept of representation, while James W. Fernandez, in two essays (1971 and 1973) on Fang aesthetics, resorts to an interpretation of art as expression. This notion remains a marginal one with the two preceding authors, but its importance and interest deserve to be recognized.

ART CRITICISM AMONG THE YORUBA Comprehensive and rich on-site documentation, gathered and interpreted by Thompson, assumes the form of an enumeration of a series of distinct and complementary criteria. These criteria not only intervene in the appreciation of Yoruba sculpture, the Yoruba themselves formulate them, most frequently in an explicit manner.

First criterion—The Yoruba term *jijora*, which is glossed: relative or median mimesis. It lies in the middle between two opposed extremes, total photographic resemblance and total abstraction. The Yoruba will say of a sculpture that it resembles someone. "Someone" (*enia*) is glossed by: a person, a character; it has moral connotations: character and virtue. This criterion clearly expresses a desire for generalization: the sculptures do not resemble individuals. (We would say that the individuation of the referent is made through the representation of the hairdo, scarifications, and dress.) The two extremes are *hypermimesis* and excessive abstraction.

A rejection of *hypermimesis* shows itself in the elimination of any suggestion of advanced age: the character is represented as if he or she were young. Thompson opposes a Yoruba legend to Western legends according to which an illusionist image becomes a living one. Two factors account for this rejection of illusionist naturalism, an aesthetic factor and a magical factor; the too-realistic features of a sculpted image might be transmitted to the face of the child whose birth the sculptor is awaiting.

Thompson applies this criterion to one sculpture and notes that emphasis is placed on certain parts of the sculpture, which makes one forget that other parts are treated much more abstractly. On the subject of Ife bronzes, Frank Willett notes that "some of the conventions are less naturalistic, according to our way of looking, than is the overall effect" (1967, p. 19)—this concerns the rendering of the eyes and ears.

As for the excess of abstraction, a master sculptor says of a house pillar that it resembles a box; his rival, Thompson comments, had not succeeded in animating the raw piece of wood with a human presence.

In this study of Thompson's one can distinguish two levels in terms of the ethno-aesthetic method: the glosses and the interpretations. The glosses translate and justify the translation of words and vernacular expressions. The interpretations isolate common characteristics from criteria and thus prepare the way for their systematization. Thus, in terms of this first criterion, Thompson formulates two remarks. First, the majority of Yoruba criteria must be described as "relative." Secondly, the canon, as opposed to a natural law (such as weight), is never followed to the letter. These two characteristics must not be confused with each other. When mimesis is said to be relative, the criterion is defined from the point of view of representation: one compares the sculpted image and its extra-artistic referent. When one distinguishes between canon and natural law, it is a matter of an application of the criterion: one confronts the criterion with certain corresponding aspects of the sculpture.

Second criterion—The Yoruba term *ifarahon* is glossed: relative visibility. Nonsculptors lack a specialized and detailed vocabulary which, according to Thompson, suggests that Yoruba criticism is "intellectually stratified." Let us note that, as with the first criterion, specifically aesthetic visibility is distinguished from certain functional properties that are associated with it; while, from the functionalist point of view, the user's appreciation is worth more than the artist's, from this specifically aesthetic viewpoint, it is the opposite.

For nonsculptors, what is involved is simply a question of the distinct rendering of details. Sculptors link this criterion to a division of their work into stages. Two sculptors formulate two slightly different divisions. According to Bandele Areogun (from the town of Isé-Ilorin), the sculptor 1) trims the block by isolating the principal masses; 2) divides these initial masses into smaller forms and bulges; 3) makes the forms smooth and shining; 4) carves the details and the small embellishments into the polished surfaces thus prepared. According to Alaga (from Odo-Owa), the sculptor 1) measures the wood; 2) trims the block down to the head, neck, chest, torso, buttocks, thighs, legs, and feet, in that order; 3) smooths and polishes all the masses; 4) cuts the details into the polished masses. According to this sculptor, it is "above all the shoulders and the head that must be easily visible." For the first phases the adze is used—are the principal masses visible? The knife is used for the last phases—are the embellishments and the small details visible? Linear precision is accomplished by working with the knife.

Visibility must not be excessive, as it would be if cruder parts protruded too much. Form and clarity of line are valued. On this clarity of line depends the relation between the smooth surface (*didon*) and the carved-in details (*fifin*). The smoothing and polishing of the surfaces makes them into a background against which the carved line stands out clearly. Let us note that these visible, clear lines, either at the intersections of the masses or parts of the figure, or on the surface of the volumes, are one of the characteristics that demonstrate the full tridimensionality of the sculptures. (*see* p. 323)

Among the traditional Yoruba there is a veritable connoisseurship

bestowed on the line—scarification lines or lines in sculptures. The idea of civilization, of imposing a human order on natural disorder, is associated with the line, particularly with the linear markings on human cheeks. In the eyes of the Yoruba, then, scarifications have a double importance, specifically aesthetic and functional, as markings of belonging to a lineage.

Third criterion—The relative luminosity of a surface that has been polished to a shine. When Yorubas invoke visibility, they also invoke luminosity. When Alaga has finished a piece, he studies the luster of its polished surfaces and the shadows in the spaces between the carved lines. The shine is obtained with the side of the knife blade. For each criterion the Yoruba prefer a relative or moderate articulation. Here they are concerned with an intermediary quality between a dull surface and the extreme luminosity of the bright surface of a mirror or brilliant brass. "Traditional Yoruba keep mirrors covered and, in the old days, believed that polished brass objects had the power of attracting lightning. The extremes bred danger." (1971, Chapter III)

According to Bandele, the sculptor must smooth the surface of the wood in such a way that it reflects the light and seems to shine as if from an interior source. This criterion allows us to understand why the relief surface of the facial features seems excessive to the taste of Western academicism. The rounded shapes of the face have been polished in order to reflect light whether that be in the sun or the shade. The Yoruba appreciate the differences in the intensity of shadows.

The taste for luminosity extends to the representation of dress. The mass of a turban, a hat, or a dress is exaggerated and carefully polished; by convention, the consistency of the drapery looks more like a sheet of metal than it does fabric.

Fourth criterion—"Emotional proportions," the "fusion of proportion and empathy." (1973, p. 2) The author jointly treats the hierarchy of sizes and the proportions of a figure. We have examined this question: this Yoruba criterion shows that users themselves assign an expressive value to non-naturalist proportions. These are controlled by measurements (rather approximate ones by Western standards), as the sculptor uses the blade of a knife, a finger or fingernail as a measuring tool.

Fifth criterion—Arrangement, the placement of the parts of the figure as one relates to the other. This is closely linked to proportions. Each part must be in its right place, "neither too high nor too low." Its application raises the question of elisions: sometimes certain parts of the body or the face are not represented; for example, the nose may not be separated from the lips. Elision is found also in the recitations of certain traditional ballads.

Sixth criterion—Composition. Arrangement concerns itself with the relationships between parts of the same figure, composition with the relationship between different figures representing individuals, things, or animals, or between certain parts of these different figures. The Yoruba in particular pay a great deal of attention to the relationship between hands and the bowl they hold, to the manner in which arms are detached from the body, and to the position of a child in the arms or on the back of the mother.

Seventh criterion—Delicacy, demonstrated most particularly in the art of the hairdo and in scarifications. Hair artistically arranged occupies space; delicacy is required for the spaces between the braids. The more closely arranged the braids are, the more refined and numerous they are in order to decorate the head. Delicacy is a property of the rendering of the small parts of the face, such as the cut and delineation of the eyes. It is a quality not of the volume but of line and, as such, a refinement of the line's visibility. Here again, excess is to be avoided: what is delicate and slim

must not be too small. The smallness of delicate details must be controlled and limited by the criterion of proportions.

The two following criteria, roundness and pleasing angularity, are opposites, but this opposition must not be seen as a contradiction; they are properties of parts and nothing requires that all parts of a figure be uniform.

Eighth criterion—Roundness, a property of contours and partial volumes. Thus, some sculptors apply this criterion to the lower part, the helmet of the *epa* mask, not to its superstructure; to the *gelede* mask (particularly the Keitou style), not to its possible superstructure. The sculptor Ogundeji (from Iseyin), for example, exaggerates the spheres of the eyes and rounds them off so that, when seen in profile, they match the rounded mass of the forehead. The sculptor Ogidi (from Igogo-Ekiti) rounds off all the elements of his images. As for the shape of the buttocks, roundness contrasts with the angularity of this protrusion as the human with the non-human.

Roundness may be concave or convex. Convex roundness is a particular case of protrusion. Protrusions must be moderate: it is these moderate bulgings that are seen as roundnesses. Displeasing protrusions or threatening bulges are unfavorably judged: a drooping mouth, flabby lips, pendulous cheeks are displeasing protrusions. Counterproof: the *egungun* cult uses satirical sculpture and the satire deliberately makes use of such effects. Humps whose curvature is considered excessive are seen as menacing. Of course, a pregnant woman's abdomen is an exception but it is rarely represented in sculpture.

Ninth criterion—A pleasing angularity, which, although opposed to roundness, may be justified by expressivity. Roundness is not "an immutable law. One of the strengths of the Yoruba aesthetic is its flexibility." (1973b, p. 52)

(We will come back to the two following criteria, briefly outlined below.)

Tenth criterion—Relative uprightness, a characteristic essential to a beautiful sculpture. It is a property of the straight stationary position and, by extension, of the elements of balance and symmetry. The relative character of rectitude is in opposition to the absolute character of Western mathematical rectitude: here, the criterion is flexible.

Eleventh criterion—Symmetry, which has "calming virtues": it leads to reducing agitated postures in the representation of a scene. The sculptor Alaga speaks of it from his sculptor's point of view, fusing it with rectitude and placement. (To position two elements symmetrically, they must be horizontally aligned.) In order to obtain symmetry, a sculptor from Keitou marks measurements on the block by notching it with the adze or the knife.

Symmetry is, again, linked to the rectitude of the stationary position. The latter is important in what might be called the aesthetics of the cult that uses the *epa* mask; on the one hand, this mask is very heavy, and it is dangerous to make it slant; on the other hand, it is important to maintain harmony between the attitudes of the dance and the architectonic form of the sculpted superstructure.

Twelfth criterion—The ability of the sculptors is also appreciated; it is expressed in praise names bestowed upon them.

Thirteenth criterion—Ephebism (youthfulness). For this series, Thompson intentionally translates *odo* by a word derived from the Greek. It is perhaps the most important criterion, the result of combining all the canons. It is the representation of people in the full bloom of youth. The critic poses the question: does this image make the subject seem young? It is a means of idealizing: one appreciates the fact that the image of an old man looks young; the cheeks are firm, the posture self-assured, the figure

slim and youthful, the chest muscular, sometimes even slightly androgynous. Faced with two images of twins treated differently, the question is asked: "Whom would you prefer as a spouse, a lovely young woman or an old man?"

As for the application of the criteria, it is the only one that gives rise to differences between the appraisal of the author and the Yoruba. Thompson gives two reasons for this. The informants pointed out the breasts; the breasts of an old woman were high and seemed shrunken and dried up, while those of the young girl were pendulous and gave an impression of fullness. The young breasts are of equal length, the breasts of old women frequently unequal, since the children as they nursed preferred one over the other. However, a more important reason for the difference of opinion was undoubtedly the erosion of features due to ritual washing. Time and use had worn away the facial features of "old" pieces. The primacy of youth does not, then, concern only images of people but the age of the sculpture itself. For ritual occasions, painting is frequently reapplied. The image that has deteriorated due to time, termites, or fire is thrown away, without any regard for the artistic qualities of the parts still intact. On this point, Yoruba aesthetics contrasts with the essence of the museum mentality of the Western connoisseur. (1971, Chapter III)

The criterion of youthfulness is linked to roundness: the human face becomes more angular with age; it is linked also to the rectitude of posture: the old person is bent over. It applies to the hairdo whose structure recalls the fresh beauty of a bride.

Most often, Africans do not represent the age of the characters they depict: Yoruba ephebism explains this tendency. It has a value of idealization, for physical beauty is at its height at the moment of youth, which is in the middle of two extremes, childhood and old age. The author quotes a Yoruba writer, Tutuola: "She truly was a beautiful woman; she was neither too tall nor too short, neither too black nor too yellow." (One cannot help but think of Plato here: fine speeches are neither long nor short, they are well measured. [*Phaedrus*, 267b])

The author concludes his study by emphasizing the idea of a middle between two extremes: abstraction and excessive resemblance, early childhood and old age, what is too visible or barely visible, the balance point between shadow and light, and he adds an example concerning color. The color preferred by the Yoruba is blue, which they place between red and black, for it is not as conspicuous as red nor as somber as black. (This suggests two observations. The Yoruba appreciate what we call tonal value. Blue is often placed on the hair; according to Plato, the most beautiful color should be placed on the most beautiful part of the body. [*The Republic*, 420C])

In short, three themes are of the essence: the flexibility of criteria, both in their conception and application; an association between aesthetic and moral properties; and value as the (perfect) center between the two extremes of excess and deficiency. Thompson's only reference to Greek thought is the word ephebism; but one would easily find these three themes in numerous Greek texts, particularly in Plato.

BAOULE AND YORUBA CRITICISM We have Vogel to thank for an essay on "beauty in the eyes of the Baoule" (1980) and a comparison (1977) between the artistic criticism of the Baoule and Yoruba. As this comparison reveals very few divergences, the preceding account permits us to be brief here. But first, the commentary of the Baoule sculptor Lela Kouakou on a Baoule figure will give an idea of a Baoule critic in action:

"I like that one because of its scarifications and its hair and because of the stool on which he sits. The bowl he holds is also good. He resembles a man of the village. His beard is good. In the old days men wore beards like that and had braided hair. Now only women braid their hair. I like it because of the scarifications on the neck.

"During a divination dance, this would be taken from its hiding place and put in public with the other objects of the divinity. I chose this figure. I would carve one like this. Just yesterday, I was carving a statue with hair braids like this. The bowl he is holding is made from a coconut shell. We take them for drinking wine. Maybe the carver put it here to remind us that when we drink we always pour the wine that remains last in the cup onto the earth for the ancestors. They enjoy palm wine." (S. M. Vogel, 1987b, p. 150)

Both peoples favor a moderate or "restrained" naturalism, with the exception of some types that are more abstract. In both societies, artists become professionals and their professional ability is much appreciated.

The Baoule condemn deficiencies in balance and proportions in terms comparable to those of the Yoruba.

They also appreciate visibility under its three aspects: the ease with which the represented objects can be recognized; the clarity of form arising from a clear separation between the principal volumes; and clarity of line. Clarity of form is never described by the informants, but it can be inferred by observation of the objects. The hairdos and scarifications, in particular, emerge out of a clarity of line. Moderation is advised: "neither too much nor too little."

A criterion of suitability also intervenes: scarifications are appropriate to the human figure, not to the surface of a piece of pottery. The form suits the subject. Thus, abstraction is suitable to the *kple kple* mask (as with the Yoruba *epa* mask), not to other types of sculpture.

A luminous softness, polish, luster are appreciated. Gnarled or encrusted surfaces are disliked as they are associated with illness. Smooth surfaces are associated with cleanliness, to which the Baoule attach a very high value (P. Etienne, 1968; *see* also V. Guerry, 1970)—as well as with good health. Luminous softness is one aspect of perfection which the Baoule expect to find in art.

Ephebism is also a Baoule criterion, but it is more readily applied to female figures. As among the Yoruba and the Chokwe (according to D. J. Crowley), the criterion of youthfulness is applied to sculpture itself.

Other criteria they have in common are: delicacy, correct placement of the parts, relative rectitude and straight posture (the two last criteria are associated with the vigor of youth and well-being), and roundness, particularly of the buttocks but also of the calves—no calf was ever declared to be too round. Let us note that in Africa, the legs are often the part treated the least carefully.

A significant difference concerns symmetry. The Baoule appreciate sculptures that are slightly irregular and asymmetrical. The asymmetry is balanced and often so subtle that the Western observer is uncertain: is it or is it not intentional? Asymmetry is found again in architecture (as is the relative rectitude of Yoruba architecture). This disparity is especially noticeable in sculpted doors: figures are organized in levels among the Yoruba, but on the surface of the Baoule doors they are distributed in a haphazard arrangement whose balance is fortuitous. (This divergence seems to us to be the result of the difference between two styles of composition, scenic and nonscenic, discussed earlier.)

This comparison leads the author to reinterpret certain data from Thompson—for example, relative mimesis. As excessive naturalism is never observable, it cannot be disparaged. Reproaches would signify,

rather, an absence of youthfulness and/or an inability on the part of the sculptor. Excessive abstraction would stem from the sculptor's incompetence since, for some types, it satisfies the criterion of suitability; it is then accepted not as abstraction but as a conformity with the traditional canon. Vogel, then, suggests interpreting relative mimesis not by relating the sculptures to the characters they represent but to the traditional canon: "Art imitates art far more closely than it imitates nature" (p. 318); the formula that something "looks like a person" would then signify "looking like a traditional sculpture of a person" (p. 319).

AN AESTHETICS OF EXPRESSION We owe Fang aesthetics to two studies by Fernandez (1971, 1973); this aesthetics extends to all forms of life and culture that the Fang appreciate aesthetically and applies, especially, to the guardians of the reliquaries which the Fang call *eyima byeri* (most often catalogued under the name *byeri*).

The Fang people had been in migration, from the north toward the south, for several centuries. The reliquary, consisting of a receptacle made of bark (*nsuk*) and containing the skulls of the ancestors, topped by a sculpture; it was easily transportable and better suited than the altar to the ancestor worship practiced by a migrating people. Migration caused changes in the form and use of the sculptures. The oldest ones were simply heads; then came half-figures and, finally, complete figures. In terms of this evolution in form, the hypothesis of a European religious influence ought not be discarded; but acculturation probably was indirect through the intermediary of the Vili and Lumbo peoples who lived on the coast of southern Gabon. The changes in attitude of the Fang toward their statuettes is an index of their change in function. At the beginning of the century, the Fang used to sell sculptures willingly, but it was impossible to obtain a reliquary. In the forties and fifties, it became difficult to buy or even to see the statuettes, which were kept in secret. Importance was transferred onto the sculptures, perhaps under the influence of the importance that Christianity attaches to religious imagery. In the course of the sixties, bits of skullbone were inserted in small cavities hollowed out in the sculptures. This new custom suggests a transfer of the reliquary's function to the statue. In the informants' responses a strong fear is expressed, which must be noted. It is "difficult to pronounce an adequate aesthetic judgment on what is, at the same time, sacred"; thus, informants' answers are truncated in front of those statuettes used in this way. Before the bone fragments are inserted, the statuettes are called *eyima byeri*, then *mwan bian* (literally, *medicine child*).

These statues are guardians; their use is to "defend the reliquaries." But also, once a year, during the cycle of initiation into the worship of the ancestors, they were taken away from the reliquaries and made to dance, like marionettes, above a thatched fence. What do they represent?

The informants compare them to our photographic portraits. But, says Fernandez, "I have come to believe, after lengthy discussions on this matter," (1971, p. 363) that the Fang recognize perfectly well what distinguishes statues from real persons, their proportions in particular. "They express, if they are well done, a fundamental principle of vitality." (*ibid.*) This proposition is the key to Fang aesthetics. The author specifies "that this is an inference developed from my informants' remarks." This interpretation substitutes the concept of expression for that of representation in a deliberate fashion: the titles of the two studies speak of the principle of vitality and of artistic expression. It is by reason of the vitality of the person that the Fang assimilate their statuettes with our photographic portraits. (Let us note, in passing, this case of misreading through forced identification which, this time, is not ascribable to the

ethnologist.) This interpretation rests on two categories of data, one bearing on notions of vitality, opposition, balance, and complementarity in the whole of Fang culture, the other provided by informants who were questioned on the statuettes.

As for ideology, the author prefers "opposition" to "contradiction," making use of the etymological meaning (contrary positions) which, by reason of a spatial connotation, suits the Fang who "have a spatial analogy in mind when they speak of what we would call contradictions." (1971, p. 359) Between two terms in opposition, two supplementary relationships are possible: equilibrium or complementarity. Two opposites are complementary when their conjunction is required by the existence of a third term. Thus the feminine principle, blood, and the masculine principle, sperm, are opposed but also complementary because both are required for reproduction. In the first form of the reliquaries, the receptacle containing the skulls was seen as the belly or the torso, the head of which was the sculpture. For the Fang, the stomach, the thorax, and sometimes the viscera, are the seat of power and thought, and the head, a function of direction; head and torso are opposites and their opposition could be summarized by our expression "your eyes are bigger than your stomach"; thus, eyes and stomach are complementary since voluntary action requires their collaboration. The result of the equilibrium or complementarity of opposites is a third term that possesses vitality, a property the Fang aesthetically appreciate in numerous sectors of their life and their culture, such as the placement of the village or the structure of the family. "What is aesthetically appropriate is socially necessary"; the various oppositions reviewed "form part of a wider design that guarantees social viability." (1971, p. 368)

Vitality is an aesthetic property especially appreciated by humankind in maturity. The vitality of the Fang statues would stem from the fact that they represent humans in their full maturity. But we may observe that they do not represent them literally or in a naturalist fashion, as do our photographic portraits. For the most part, in fact, they represent the features of a small child: a balloon belly and a herniated navel. A certain look of the eyes is sometimes obtained by nailing disks of white iron in the hollows of the sockets. One informant drew the author's attention to how the wide-open gaze of a small child resembled that of an *eyima*, and investigation confirmed this association. (This treatment of the eyes has another value: the reliquaries are kept in the shade in which the metallic part of the eyes shines, revealing the presence of the reliquary guardian.) Finally, the proportions of the statuettes "represent age, the ancestors, and their august power in their descendants' affairs" (1971, p. 366), but on the other hand they recognize the infantile properties of the statuettes themselves. Child and old person are opposite and complementary, and their complementarity engenders the ancestor value. Cosmological and theological explanations warrant this interpretation; newborns are felt to be especially close to the ancestors, from whom they will be separated little by little by time and initiation rituals which bring them to the status of man- and womanhood. The figure of the ancestor would not possess this vitality which the Fang appreciate aesthetically if it simply represented an old person or a small child.

The Fang ancestor, then, is not depicted literally. The author speaks in terms of the expression of vitality and avoids the confusion that is so habitual between artistic expression and representation of the expression of an extra-artistic referent: "those features that seemed to have what *we* would call movement or vitality were not those selected by my informants" (1971, p. 363), but rather general features whose rendering and posture were "impassive, formal, impartial, and, this is perhaps the best word,

controlled." As for the secondary use of the figures, as marionettes, this, too, is interpreted in terms of vitality: by making them dance one puts them in motion, gives them life. If movement is a manifestation or an expression of life, one might say the Fang give it actually to the statuettes; on the other hand, if it is true that the statuettes express vitality, they do not *literally* represent either vitality or motion.

As for the criteria for judgment of the sculptures, features that participate in the expression of vitality, the author, Fernandez, briefly mentions finish, smoothness, overall equilibrium, and equilibrium between opposite parts.

This aesthetics is not specific only to sculpture but is a "general" aesthetics, not in the sense that it would claim to go beyond the Fang culture, but that it is applicable to all the forms of that culture that are aesthetically appreciated. And for comparative aesthetics, it is of great interest as an aesthetics of expression. Might one discover in Africa other aesthetics of expression which our habit of interpreting African arts in terms of representation would have us misread?

Fernandez suggests this to be so. (1971, p. 366) He compares the opposition of small child and old person with the opposition of masculine and feminine that one finds in the androgynous sculpture originating specifically in the western Sudan. He recognizes that he has not found clear-cut examples of this among the Fang, but states that "the argument developed here may be applied to regions of Black Africa where such statues exist." This hypothesis seems to us to require great precautions and to raise one difficulty.

First, it must be monitored by specific data each time. The coexistence of two opposites or of two contraries cannot be systematically interpreted in terms of complementarity. It seems to suit the Luba caryatids very well, as we have seen: the opposition between slave and person of high rank finally engenders, as here, the value of ancestor. But in other cases the opposition is hardened, so to speak, into a contradiction or impossibility. Inside the basket of the Chokwe diviner, one finds a figure that is quite precisely hermaphroditic, named *citanga*, whose signification is impossibility. (M. L. Rodrigues de Areia, 1976, p. 113) Such a figure is comparable to the *adynata*, to things reputed to be impossible and therefore catalogued to serve in refutations by reduction to the impossible. (Lucretius, V, 128–30) Our popular culture provides examples of things that are notoriously impossible: "when pigs have wings," and so on. In addition to the Luba caryatid, an iconographic theme that is rather frequent among the Mayombe may be looked at: "the woman with hands tied behind her back, but adorned with rings and bracelets that attest that she belongs to the chief's lineage" (A. Maesen, 1972, p. 10)—these are found on the canes of chieftains, on the pommels of swords for display, and on small ivory scepters. "Among these matrilineal people it is a matter of evoking the privilege granted to women of royal rank, guilty of adultery, to have their head cut off with a sword, an emblem of dignity." (*ibid.*) This does not concern either depicting the impossible, nor representing an ancestor with a figure; it communicates the very specific meaning of a factual situation (comparable to that of the Carian matron that was recorded by Vitruvius).

In the second place, the difficulty is theoretical. We have proposed interpreting the Luba caryatid and the Fang statuettes by means of a figure called the oxymoron, which implies the idea of figurative, not literal, representation. But Fernandez refers back to the concept of expression. How do we trace the boundary between figurative representation and an expression, between a metaphoric representation and the expression which, according to Nelson Goodman, is a metaphoric

286

exemplification? Now, this difficulty is found again in an ambiguity of interpretation suggested by Fernandez: do the Fang statues metaphorically represent the vitality of an ancestor, or do they express vitality? Should they be interpreted in terms of representation or presentification? If they express it, they possess it. But the information probably does not bear such fine distinctions.

The fact remains that it would be good to wonder if the concept of expression would not better suit certain African aesthetics than that of representation, which maintains a strong naturalist connotation.

Orientations in Comparative Aesthetics

Vogel has proposed an "African aesthetics." (1987a) Since the concept of "African" is not an African concept, this aesthetics is an interpretation. It rests on two comparative bases: African objects and specific African aesthetics. We are of the opinion that such an enterprise, in the present state of research, is premature and that the author is submitting her data to a more or less implicit selection dictated by certain presuppositions that incorrectly orient the use of the comparative method.

The author estimates that ethno-aesthetic studies have been made in "many" (p. xiii) parts of Africa. She, in fact, uses a dozen cases (p. xvii, n. 1), while several hundred artistic styles exist (not to mention the fact that the latest field investigations have shattered the myth of "tribal" styles).

As for the orientation of the comparative process, the author writes: "Broad similarities in findings suggest that there is a shared basis for aesthetic judgments" (p. xiii) and cites her study of 1979; but that one deals with only the Baoule and the Yoruba. The comparison is manifestly slanted with an intention to favor resemblances: field studies "focused on single ethnic groups and did not explore similarities among them; my emphasis here, however, is on those very similarities because they point the way toward the definition of an African aesthetic" (p. xiii). Thus, it would be similarities that would direct comparisons toward a definition of African aesthetics in general. In fact, these similarities do not precede the comparisons, since they themselves have been deduced through comparisons. The privilege granted a priori to similarities leads the author to omit from her bibliography a study by Simon Ottenberg which compares Igbo and Yoruba arts, as the author stipulates, but which brings out their differences. This tendency reappears again in the results of the study: a moral basis for African aesthetics, a preponderance of the principle of moderation—this, however, does not seem applicable to those objects called "fetishes" which are today known as *power objects* and which come out of a type of behavior distinct from the moral of moderation: from an aesthetics in which "magic intensity" seems clearly to play "the role that beauty did in classical aesthetics." (A. Malraux, 1976, p. 275) Thus, the "definition" with which the author ends does not differ noticeably from the result attained in the comparison of the singular cases of the Baoule and Yoruba.

The same aim of unity, no longer the unity of this definition but that of the points of view of African and Western aesthetics, is expressed from the outset: "We would, however, like to think that the works we most admire are those that best fulfilled the artists' intentions, those that, when they were made, were considered excellent" (p. xi). Now, this intention inspires an argument that depends on the comparison between objects. "Because important commissions generally went to the most admired artists, we can

assume that ambitious works and large artistic programs represent the prevailing ideal" (p. xi). Artists were chosen by patrons who were the leaders of society and whose aesthetic choices expressed collective values. (As an example in antiquity, see Cicero, *On Invention*, II, II, 1–2.) One must complete the argument: we, too, admire these same important and ambitious works; then the author's wish would be realized. But from a comparative point of view, not only does this argument not apply specifically to Africa, above all, it does not apply to all of Africa. Now, a definition must fit *only* that which has been defined as well as *all* of what has been defined. This argument would be just as valid for Vézelay or Moissac, for Chartres or Reims, for Saint Peter's in Rome, Fontainebleau or Versailles. But, above all, it is not valid for all of Africa—which betrays the selection of the data. Important or ambitious works presuppose a specific social organization of artistic production which, in turn, is conditioned by a society that, politically, is strongly formed on the hierarchical system and that, economically, concentrates its wealth in the hands of patrons, which allows the realization of "vast artistic programs" executed by professional artists working full time. Now, these conditions are far from being met by every African society.

Moreover, comparisons and, particularly, the diagnostics of similarity cannot create the arrangement of concepts that, precisely, permit one to conceive of, that is, to recognize and apprehend, these similarities. Now, the author is satisfied with vague preconceptions and does not take care to develop them in order to adapt them to comparative materials. This results in some general proposals, but ones without any great significance. As an example let us take the use of the Greek expression *kaloskagathos* (beautiful-and-good); it permits the author to avoid saying in a banal way that African art is functional and to say in a more scholarly manner that "the moral basis of African aesthetics is fundamental" (p. xiii). The use of this Greek expression has become a commonplace. Originally, it was polemical. To those who scorned African art and admired Greek art, one used to reply: Greek art, like African art, was functional; therefore, find another criterion by which to condemn it. But here it becomes explanatory: it is a similarity to be retained in the definition.

About this preconception itself, the author hesitates: sometimes the concepts of beautiful and good fuse (p. xiii), sometimes they partially overlap (*ibid.*), which is not the same thing. Let us consider the linguistic situations. According to the author, in numerous African languages, the same word means beautiful and good. D. J. Crowley gives a magnificent example of this. The Chokwe have only the word *chibema* and Crowley admits not having been able to find any case in which "the Chokwe distinguished between the aesthetic and moral meanings that we distinguish between. . . . Thus, a physically ugly woman who was a good wife and mother was *chibema*, but so was a physically beautiful woman who was unfaithful and a poor mother. This problem became a popular subject of discussion among French-speaking informants." (1971, p. 323) This suggests that the absence of two words makes the distinction between the two concepts, which the knowledge of French facilitates, impossible. But in other respects, the Chokwe do not confuse physically beautiful and ugly women and use criteria of feminine physical beauty. One ought to take into account that which Thompson calls intellectual stratification by distinguishing two levels here: that of the criteria of physical beauty and their use, and that of general and abstract concepts of physical beauty and moral beauty.

Not all African languages have only one word for beautiful and good: Vogel chooses the most favorable cases. Since Greek has two words at its disposal, it is those African languages that have at least two words (for

example, H. Memel-Foté, 1967, and D. M. Warren and J. K. Andrews, 1977, p. 35) that ought to be compared to the Greek.

Also, one must not confuse words and concepts and, therefore, examine the effect of the linguistic situation on the conceptual situation. An examination of the Greek data, which seems rather unfamiliar to the author, shows not only that the latter favors the expression *kaloskagathos* excessively, but that this promotes her thesis by grossly simplifying the data. First of all, this expression is usually applied to a human being, such as Pericles, rather than to an object, such as the Parthenon. In the second place, Greek culture is intellectually stratified; if beautiful and good are often used interchangeably, the Greeks do not confuse physical beauty and moral beauty: the two most famous examples are Pandora, whom Hesiod qualifies as "beautiful evil" (*Theogonia*, v. 585), and Socrates in whom, although *kaloskagathos*, moral beauty and a legendary physical ugliness were joined. In the *Memorabilia* (III, x) of Xenophon, Socrates rejects an aesthetic definition of the beautiful (through the *symmetria* of Polycletus) and to it he prefers a "functionalist" definition of the beautiful through appropriateness and usefulness; now, to define what is beautiful by usefulness is one thing, to confuse them is something else. Furthermore, what was involved was very probably one of the paradoxes that Socrates had a habit of favoring, a point of view running counter to what was the current opinion, which, in this case, distinguished the beautiful from the useful. Having made these remarks, one might come back to the African linguistic data while abandoning the idea that it implies a fusion of the beautiful and the good, while keeping the idea that these notions may partially overlap, and wondering how they do so.

Let us summarize what has been said. If one accepts the tendency of the comparative method toward a general definition in the present state of research, the empiric bases do not seem sufficient to us. But must we accept this tendency itself?

Crowley concludes the study we have just cited by emphasizing that "[g]eneralizations about Africa, including this one, are almost inevitably wrong." (1971, p. 327) Is it not pointless to direct the comparative method toward a goal that will be "almost inevitably" a wrong one? Another orientation seems possible, which we propose briefly as a hypothesis or topic for research. Associated with an "African aesthetics," as with "play" according to Wittgenstein, there is no concept or definition common to all African aesthetics. These are neither totally different one from the other and incomparable, nor reducible to a "shared basis" or common definition: rather, they form a family. Indeed, we have seen that it was not required that the properties or predicates of family resemblance be common to all cases under consideration, but only to some of them. Thus, one could retain properties—aesthetic criteria, here—that, on the one hand, are shared by several aesthetics but, on the other, are different from criteria belonging to other aesthetics. This way, one could better account for the diversity of African aesthetics.

On the Usage of African Criteria

The examples of African art criticism we have given cannot be seen as a representative sampling of all of Black Africa. On the contrary, they have been chosen for their exceptional richness.

B. Hallen recently maintained that "one of the enduring characteristics of traditional cultures is the insignificance of their critical or reflexive character" (1979, p. 303); he reproaches Thompson for projecting his own conceptions on the Yoruba data. More prudently, Warren L. D'Azevedo observed a vast difference, in terms of the degree of explication, between

the Yoruba and the Bala whom he studied. (1973, p. 14)

Two extreme theses can be contrasted. On the one hand, the quasi-nonexistence of artistic or aesthetic criticism in Africa: its formulation would owe too much to the contribution of the researchers. On the other hand, one ought to appreciate works in the same fashion, by means of the same criteria as do their users. A knowledge of the judgments of the latter would lead to a revision of some of the judgments formulated by the best Western connoisseurs independently of these criteria. (R. F. Thompson, 1971, Chapter III, p. 4)

Once again, generalizations and extremist theses show themselves to be dangerous. Ottenberg proposes a middle road. He notes a remark by a researcher, Yoruba himself, Babatunde Lawal: "Once it is consecrated and placed on the shrine, Yoruba sculpture is thereafter no longer critiqued." (1974, p. 245) According to Ottenberg, both Igbo and Yoruba "are quite conscious of the aesthetic qualities of pieces but . . . once in use they little criticize or evaluate them in speech because of their spiritual aspects" (1983, p. 55); yet they can speak of them either in the course of making the work, or outside of the social context, as when an investigator shows a group of objects to some people in order for them to evaluate them. In other words, two attitudes by the same user must be distinguished according to whether or not he or she is presently involved in the use. (Similarly, a Western connoisseur may tolerate the usage of Sulpician imagery in a church.)

But if our three examples of African aesthetics are not representative, why choose them? It is because the interest of the study of African aesthetics is not unique. And it may not be purely speculative. It is, then, no longer a question of scientific knowledge in general and ethnologic in particular, or of comparative aesthetics. Those studies have a different importance: to enrich and refine our aesthetic perception of African sculptures. From this last point of view, the cases chosen are the most interesting by reason of their richness and their refinement, which make them exceptional. But how can familiarity with these cases enrich and refine our aesthetic perception of African sculptures? Generally speaking, they provide us with new expectations. In addition, we must make ourselves capable of assimilating these foreign criteria, that is to say, not only of understanding them in a purely intellectual way, but also of integrating them into our experience and our aesthetic sensibility.

How is this possible? In order to show this, let us consider the criterion of ephebism which the Yoruba and the Baoule use. We have been intentionally provided with a guideline in the word ephebism, taken from the Greek by Thompson. The expression the "bloom of youth" classically translates a metaphor that appears frequently in ancient Greek texts, of which the most notable is a passage in Plato's *Republic* (474 d–e). This expression indicates the beauty peculiar to youth, the beauty of a person who is beautiful merely because of his or her youth, since he or she can otherwise be ugly. It is this quality that adorns the young interlocutors of Socrates, this that we can still see on the *kouroi* and the *korai*. We find its concept in Plato, we can relive the experience in the Acropolis Museum. "Classical" culture, one might say, in adding the afterthought that to *classicus* is opposed *proletarius*. (Aulu-Gelle, *Attica Nights*, XIX, 8, 15) But since this culture does not necessarily cut us off from daily experience, we can also experience this specific beauty in what Pierre Bourdieu calls popular aesthetics. If, indeed, one grants that the latter finds formulation not only in the answers to a sociological questionnaire, but also in what are called popular expressions, one will recognize the criterion of ephebism in "the beauty of the devil" or "the devil was handsome when he was young" (*Littré*). *Littré* comments: "youth always has some beauty, even in ugly

people," by a process of dissociation identical to that which Plato uses.

Thompson stresses "the fact that African aesthetics is a door onto the African sensibility." (1973b, p. 19) Sensitivity to the devil's beauty, which for us would be more the situation of mature men confronted with young girls or mature women with growing boys, serves as a pretext for irony; similarly, in Plato's dialogues, his interlocutors gently make fun of the love of Socrates for the beauty of boys. This emotional connotation is not to be found among the Yoruba, who elevate this beauty, which for us is specific but pinpointed, to the level of their most important aesthetic criteria.

Thus, the assimilation of African aesthetic criteria is neither immediate nor purely intellectual. It is made possible by certain sectors or certain aspects of our aesthetic experience—narrower or wider, more or less intellectualized, more or less tacit or explicit. The same process could be described on the subject of other criteria, such as relative mimesis. We will come back to rectitude and symmetry, as well as to the "flexibility" of criteria. But such an assimilation of African criteria suffices to show that a trenchant opposition between the ethnologist and the aesthete would grossly simplify reality.

184 Luba Statue, Zaire
Wood. 19th century. Height: 46 cm. British Museum, London

185–86 Buyu Statue, Zaire
Back and front. Wood. Height: 99 cm. Private collection

187 Bemba Mask, Zaire
Collected in 1915, in Wamaza. Wood. Height: 40 cm. Private collection, New York

188 Luba Mask, Zaire
Wood. Height: 39 cm. Musée Royal de l'Afrique Centrale, Tervuren, Belgium

189 Cupbearer by the Buli Master, Luba-Hemba, Zaire
Wood. 19th century. Height: 37 cm. Length: 25 cm. Private collection

190–92 Luba Pipe, Zaire
Profile, back, and front. Wood. 19th century. Height: 60.9 cm. Musée Royal de l'Afrique Centrale, Tervuren, Belgium

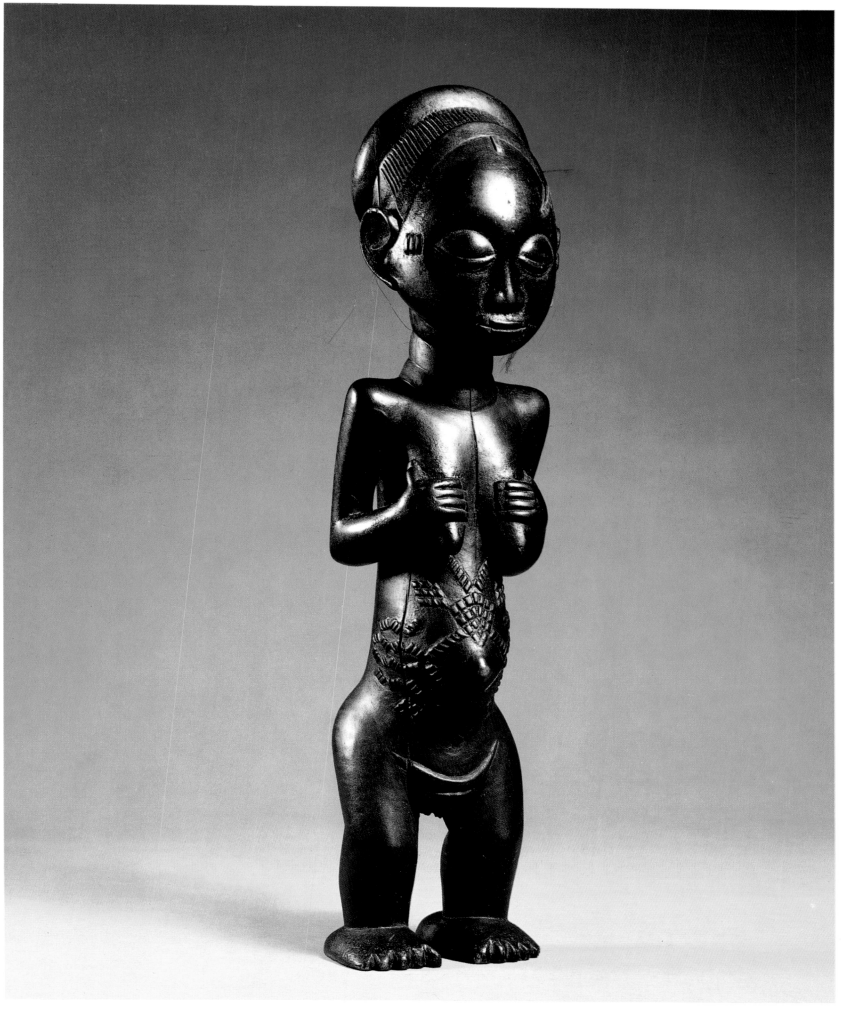

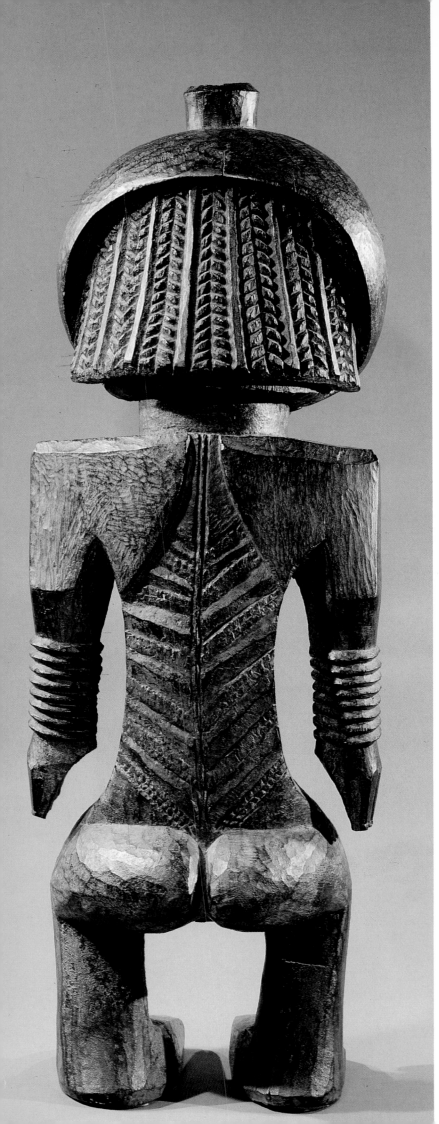
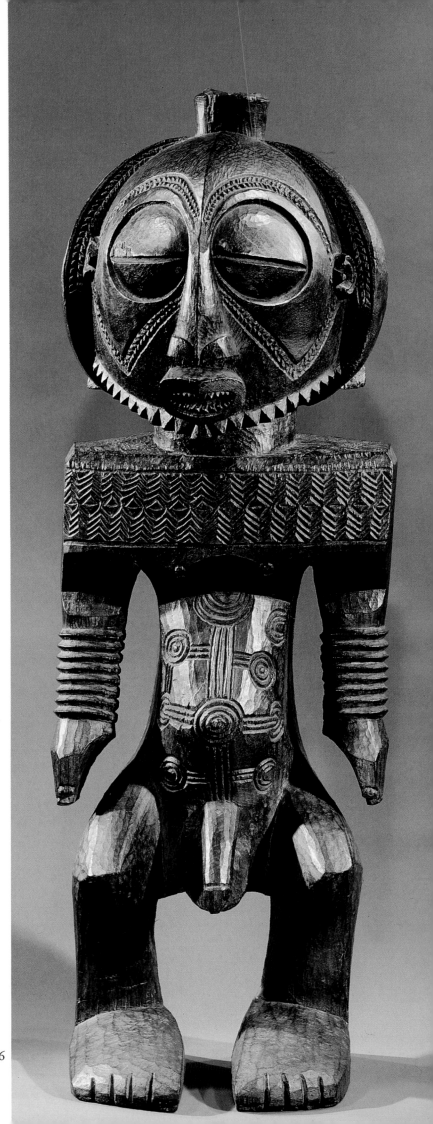

185

186

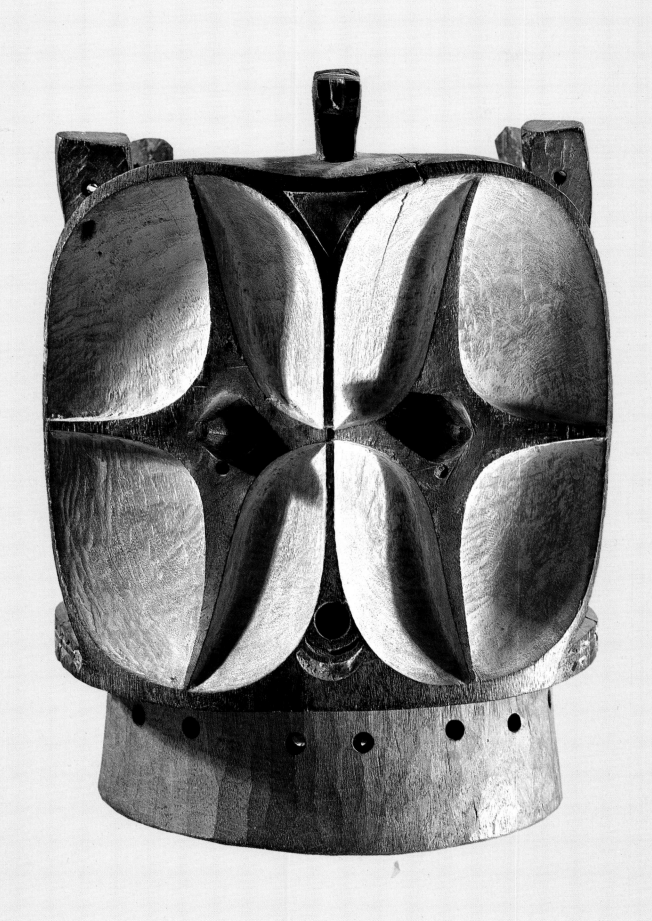

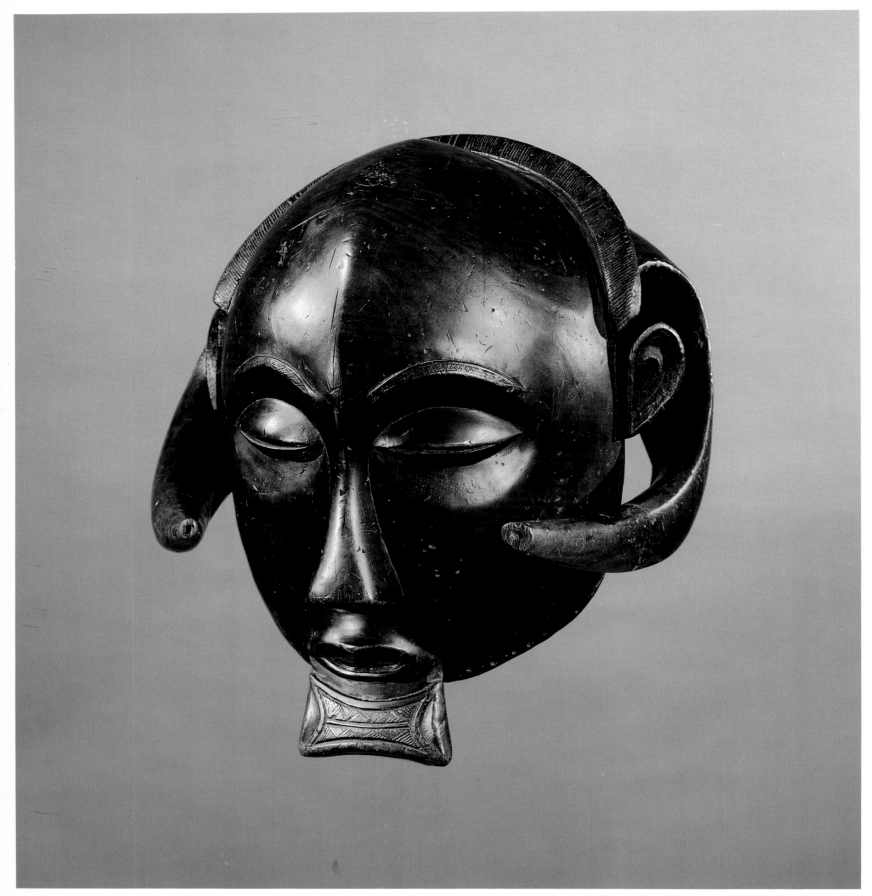

188

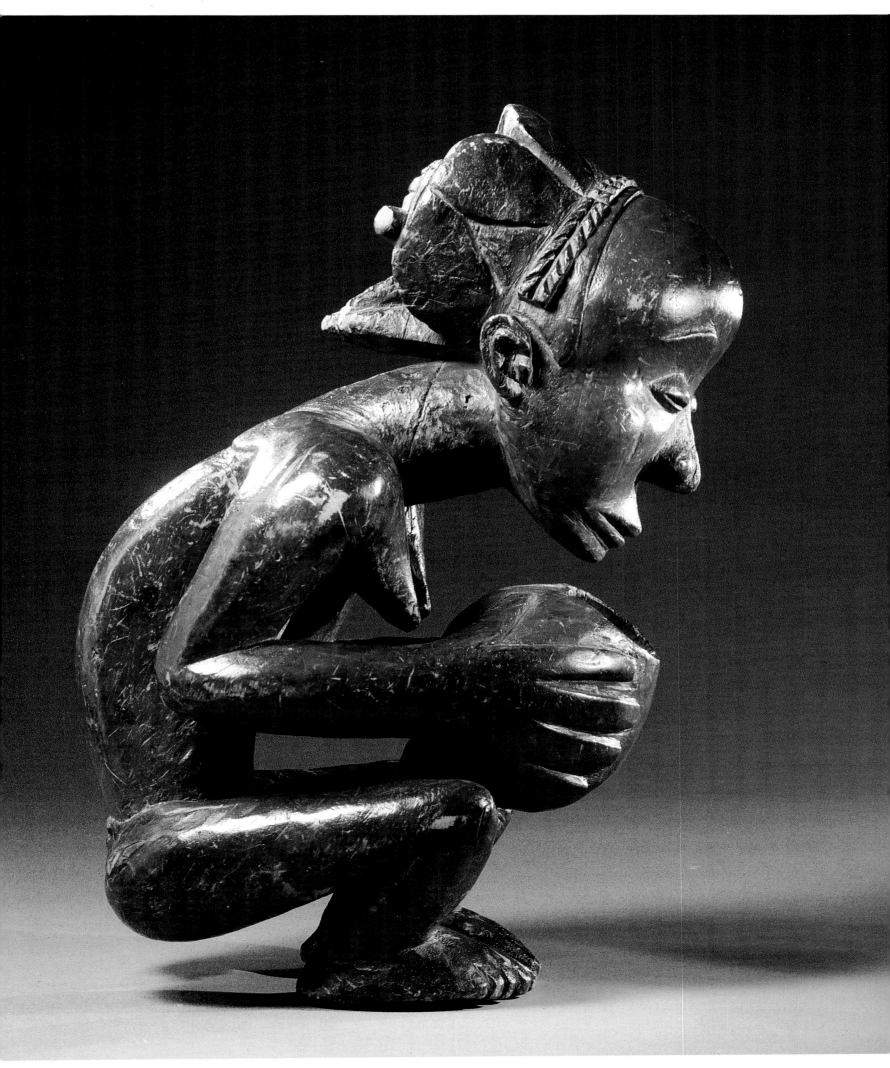

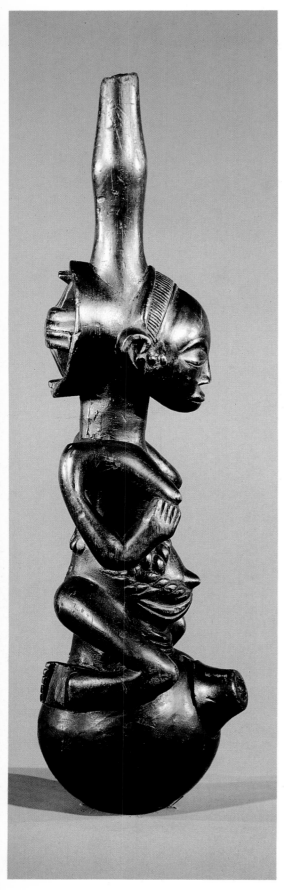

190

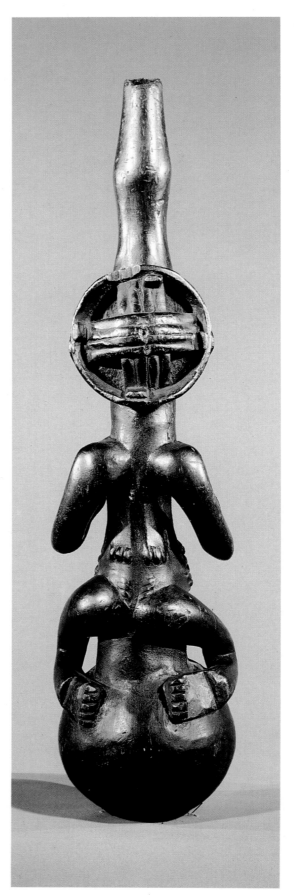

191

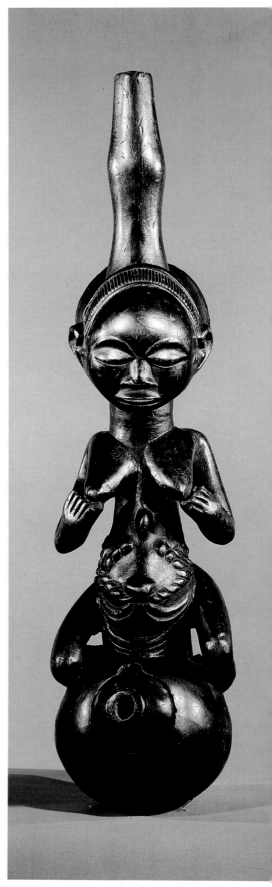

192

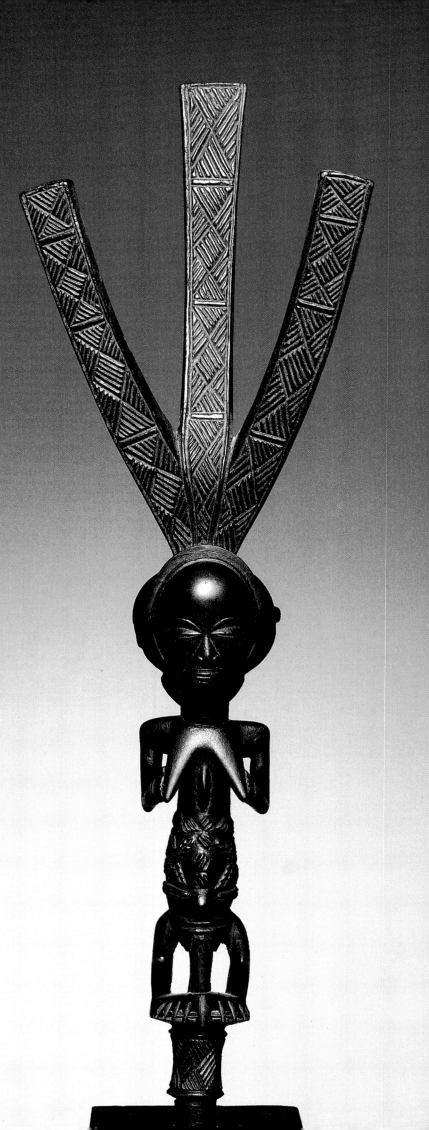

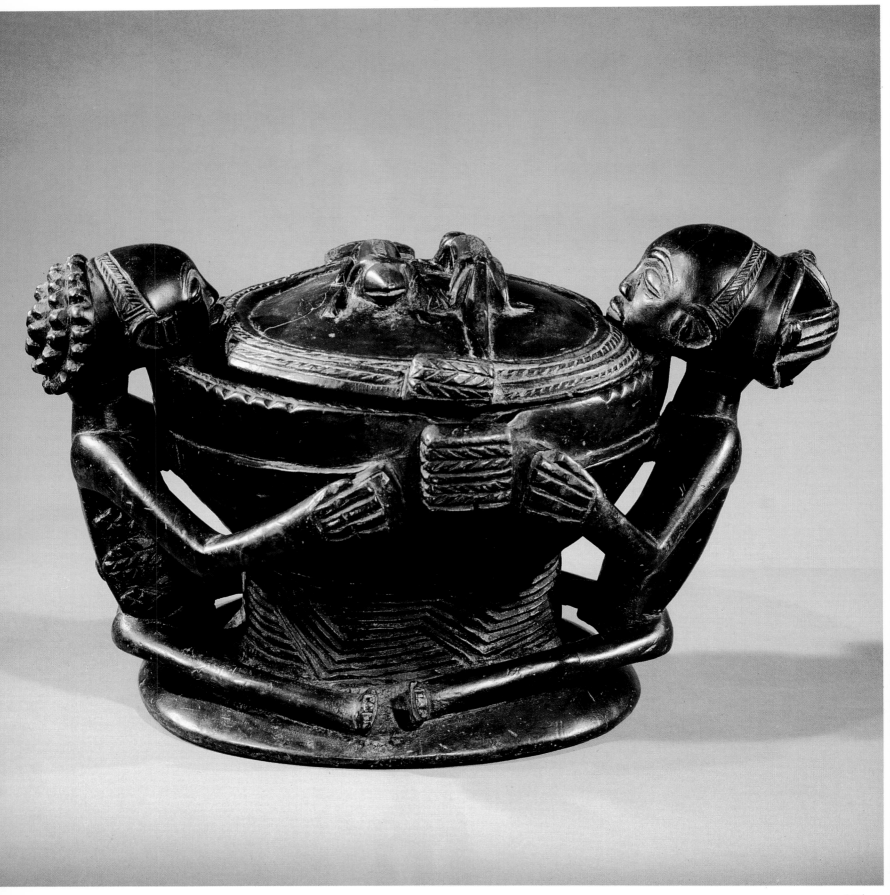

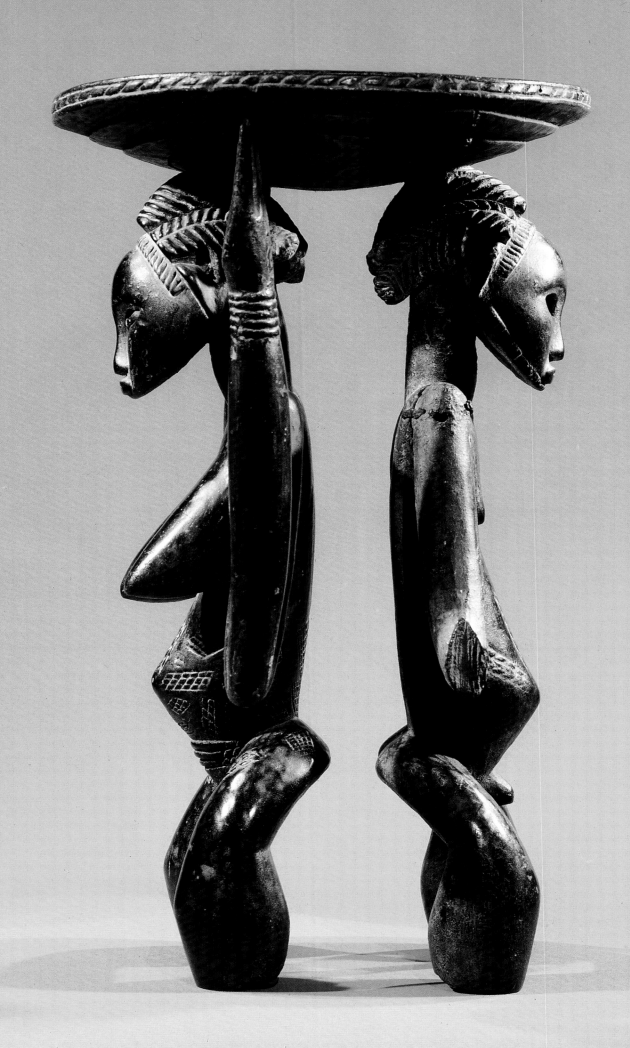

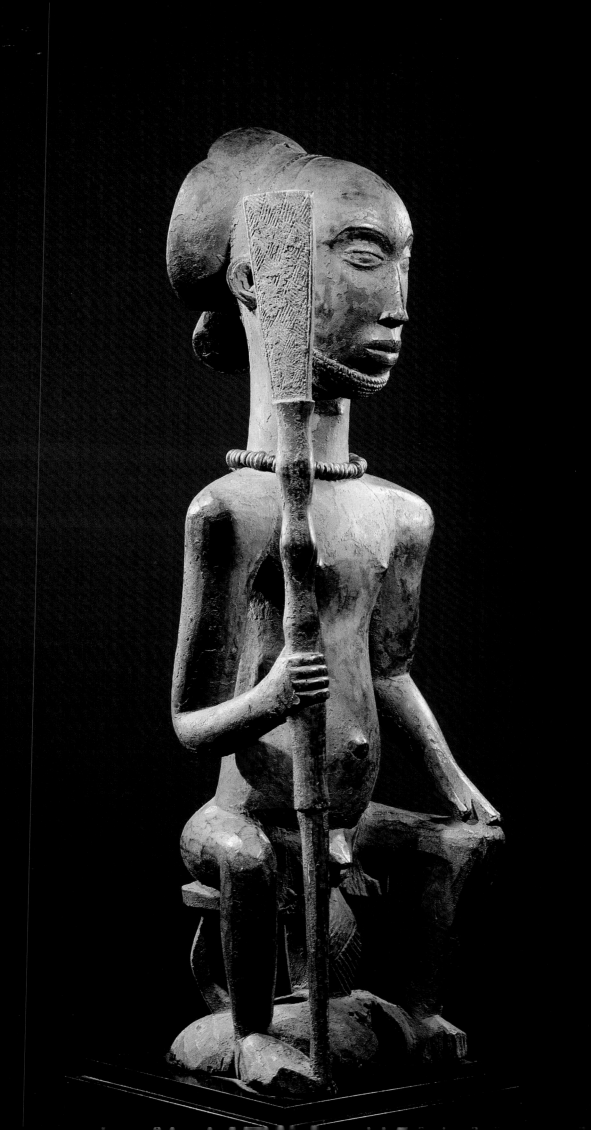

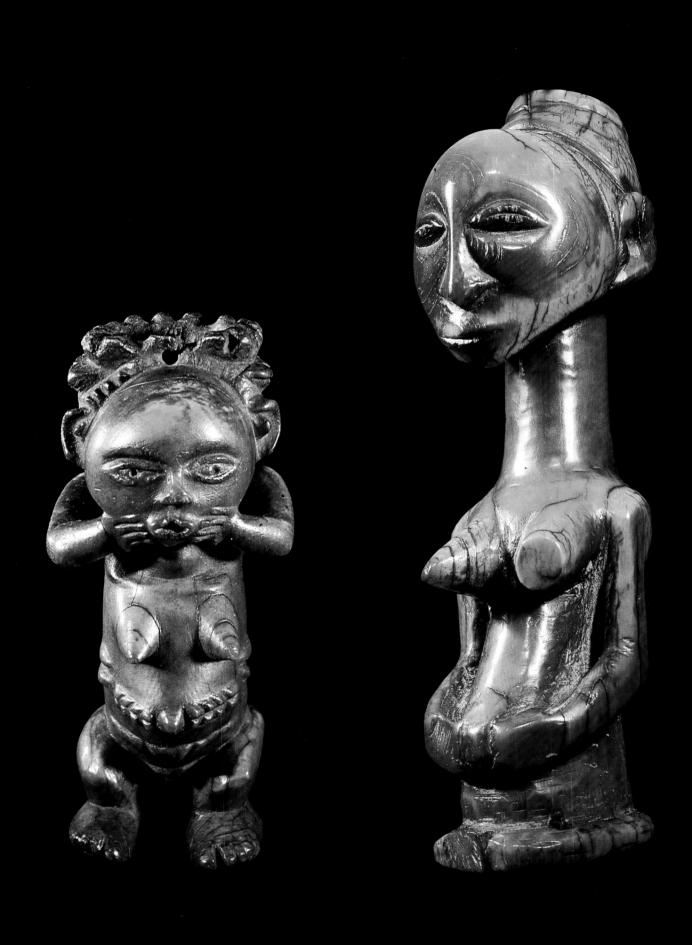

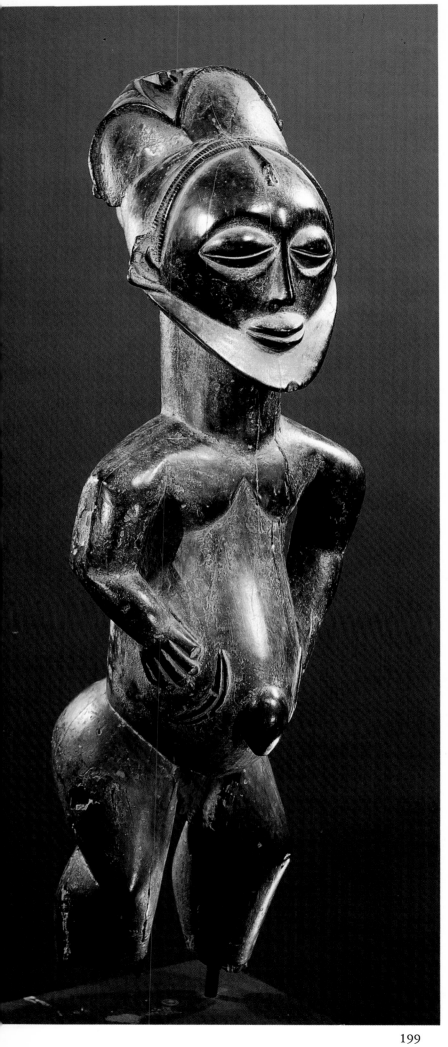

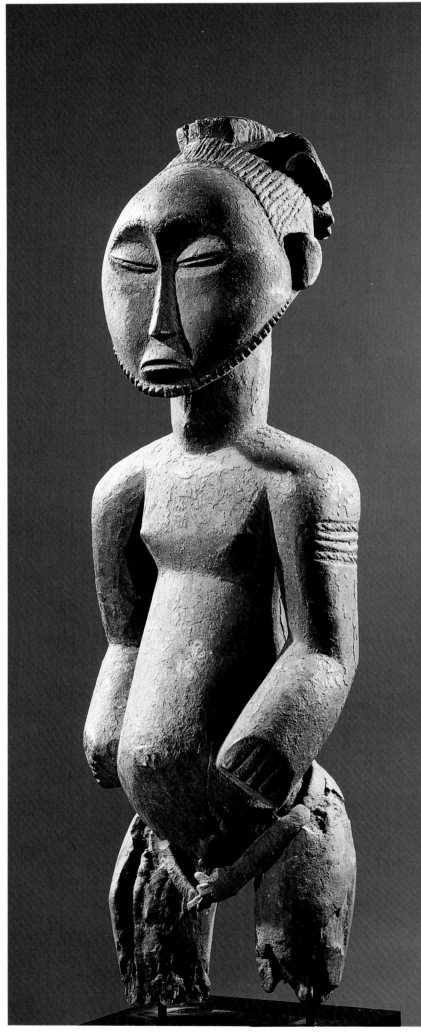

199

200

193 Luba Arrow Holder, Zaire
Wood. 19th century. Height: 64.4 cm.
C. Monzino Collection; formerly Mendès-France
Collection

194 Luba Cup, Zaire
Wood. 19th century. Height: 28.5 cm. Length:
44.1 cm. Musée Royal de l'Afrique Centrale,
Tervuren, Belgium

195 Hemba Seat, Zaire
Wood. 17th–18th century (?). Height: 47 cm.
Private collection

196 Hemba Statue, Zaire
Wood, beads. 17th–18th century (?). Height:
78 cm. Private collection

197 Suku (?) Statuette, Zaire
Ivory. 17th century. Height: 12 cm. Private
collection

198 Hemba Statuette, Zaire
Ivory. 17th century. Height: 20 cm. Private
collection

199 Hemba Statue, from Kaboja Village,
Zaire
Wood. 17th–18th century (?). Height: 74 cm.
Private collection

200 Hemba Statue, Zaire
Wood. 17th–18th century (?). Height: 66 cm.
Private collection

201 Hemba Statue, Zaire
*Wood. 18th century (?). Height: 66 cm. Private
collection*

202 Songhay Statue, Zaire
*Wood. 19th century. Height: 40.5 cm.
Etnografisch Museum, Antwerp*

203 Songhay Statue, Zaire
*Wood, fabric, nails. 19th century. Height: 33 cm.
Private collection*

204 Songhay Statue, Lomami, Zaire
*Wood, nails, beads, horn, fabric, fibers. 19th
century. Height: 87.3 cm. Musée Royal de
l'Afrique Centrale, Tervuren, Belgium*

205 Songhay *Kifwebe* Mask, Zaire
*Found in 1890. Wood. 19th century. Height:
35 cm. Private collection*

206 Songhay *Kifwebe* Mask, Zaire
*Wood and plant fibers. Height: 55.6 cm. Musée
Royal de l'Afrique Centrale, Tervuren, Belgium*

207 Tabwa Statue, Zaire
*Wood. 19th century. Height: 34.6 cm. Private
collection, Belgium*

208 Tabwa Statue, Zaire
*Wood. 19th century. Height: 56 cm. Black
Collection*

209 Suku Statue, Zaire
*Wood. 19th century. Height: 54.2 cm. Musée
Royal de l'Afrique Centrale, Tervuren, Belgium*

210 Suku Mask, Zaire
*Wood and plant fibers. 19th century. Height:
128 cm without embellishment, 250 cm with
embellishment. Private collection*

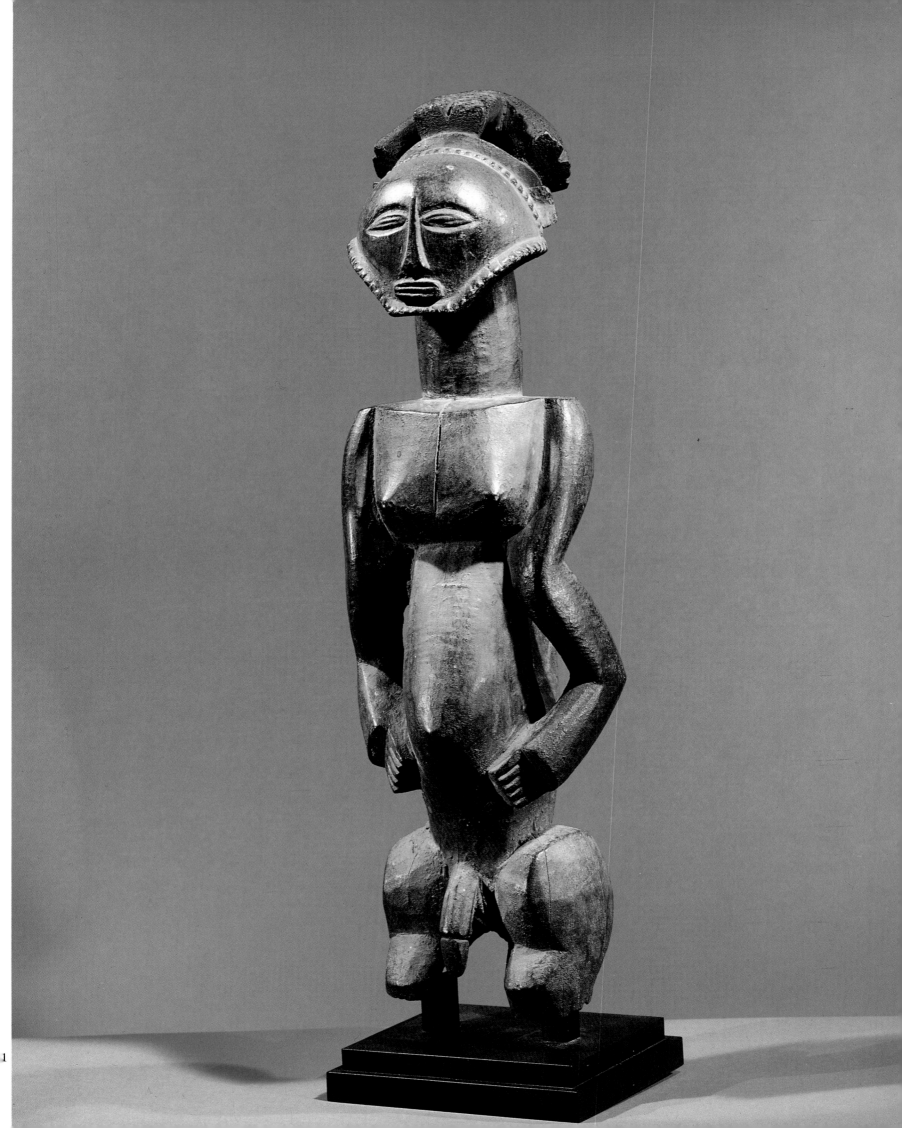

1

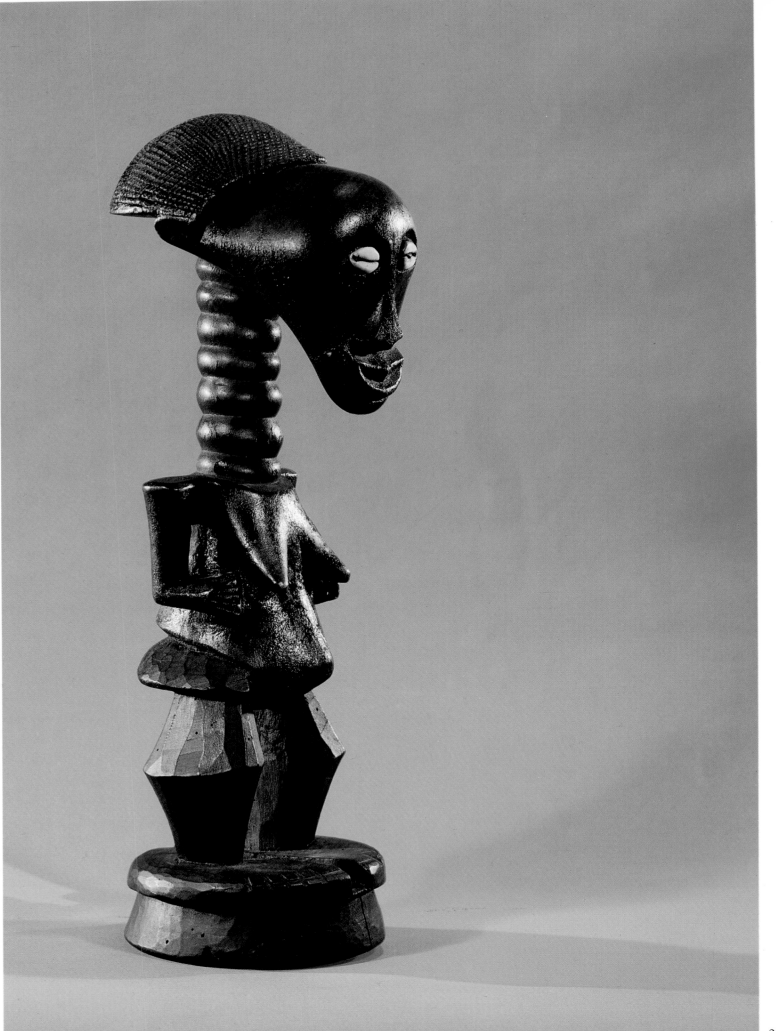

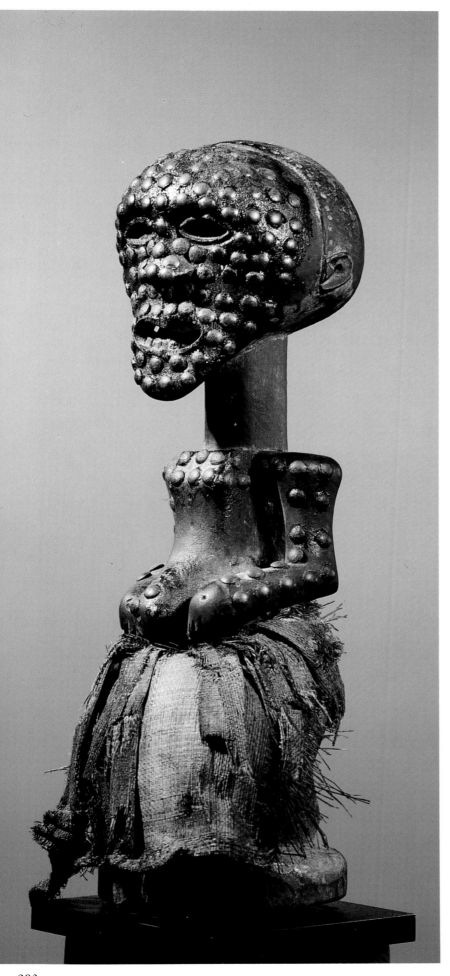

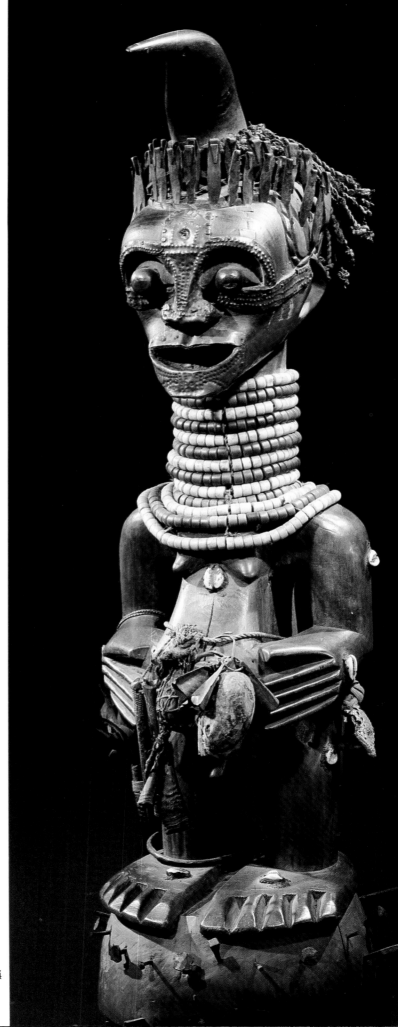

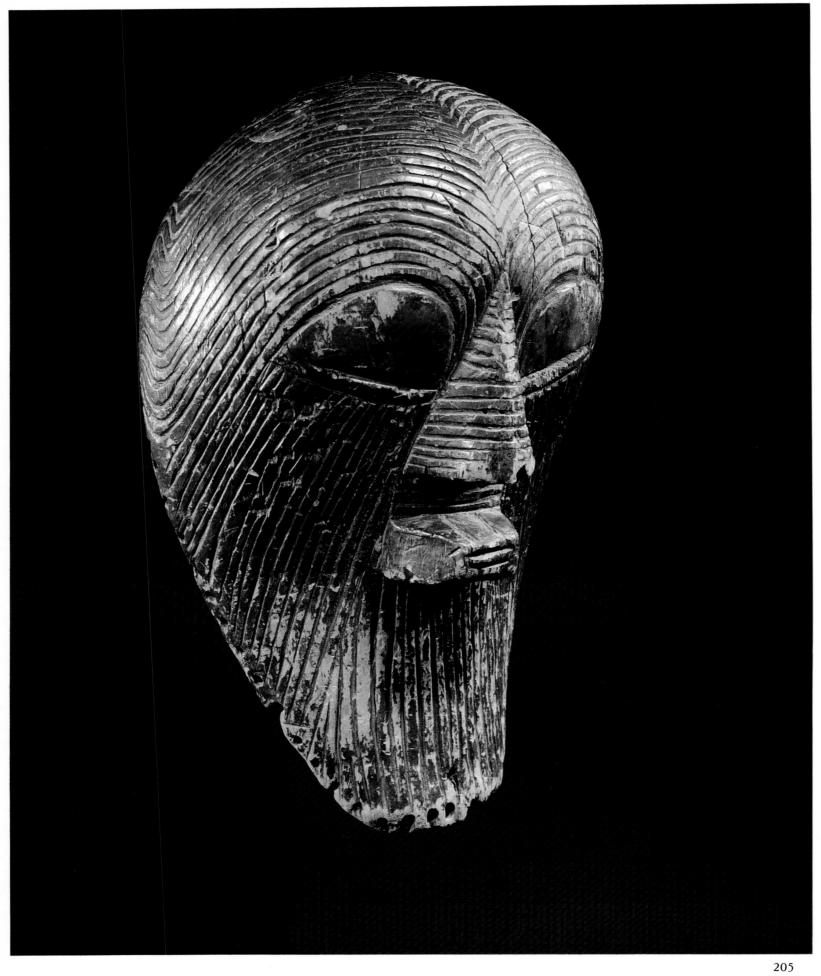

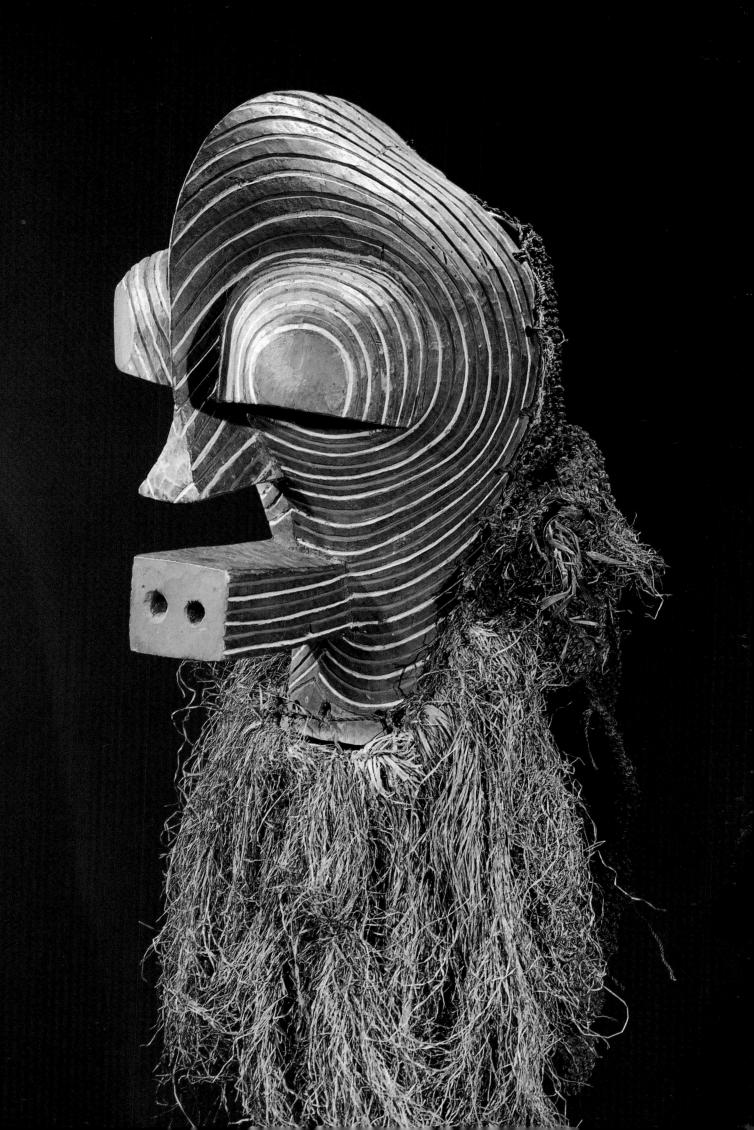

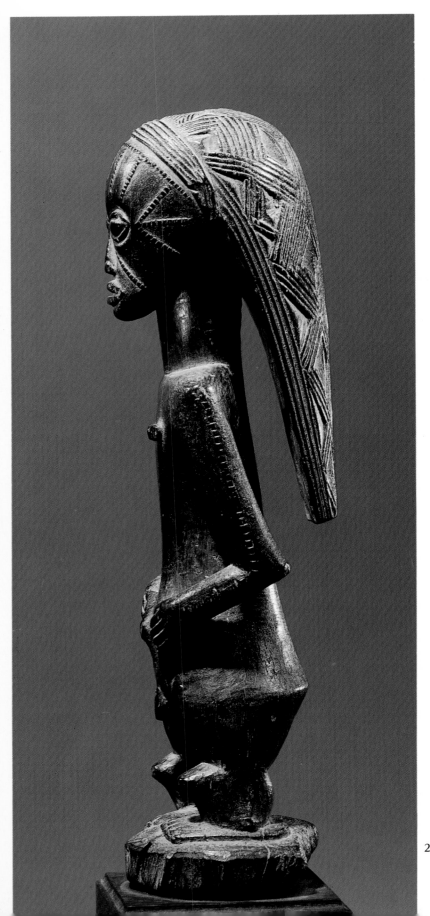

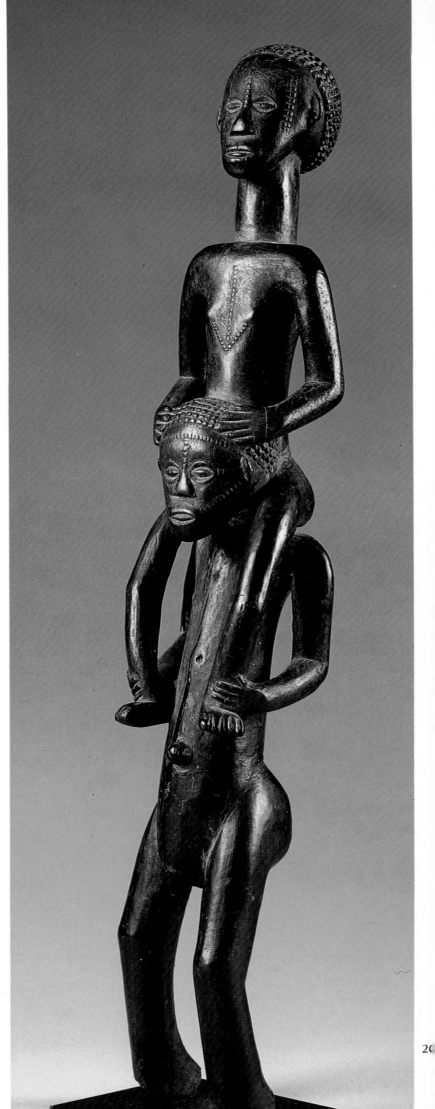

207

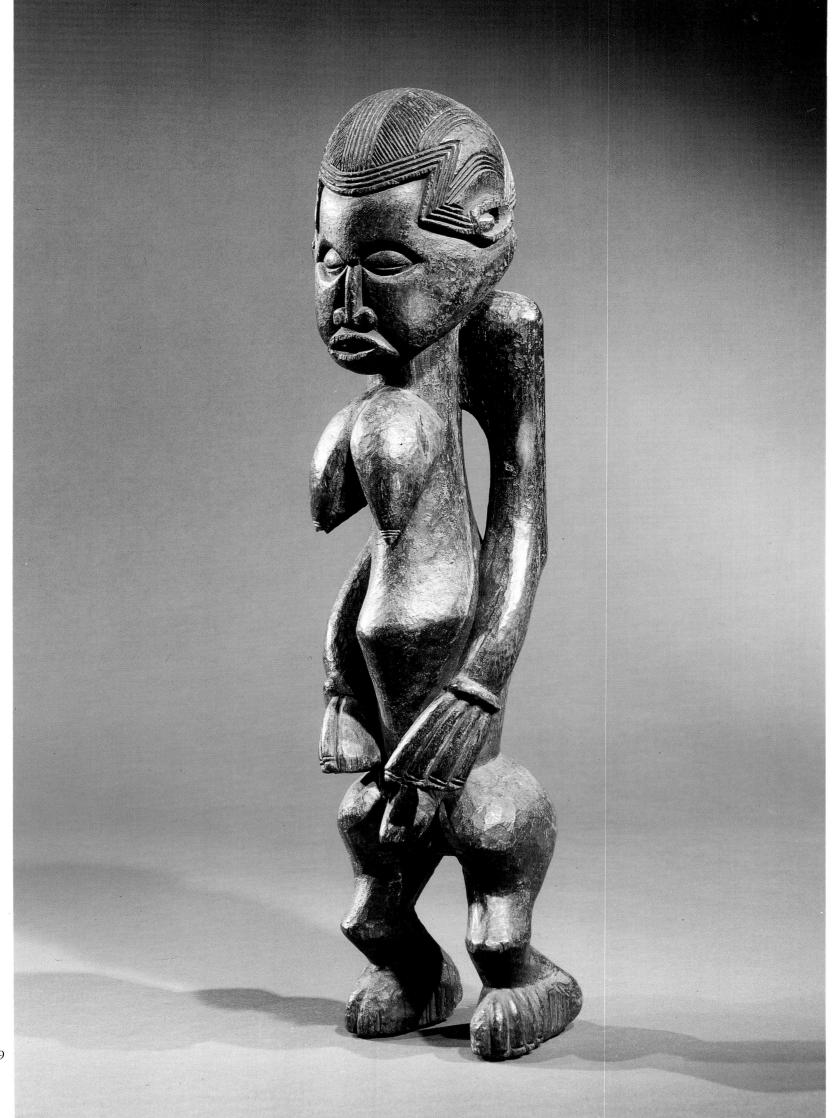

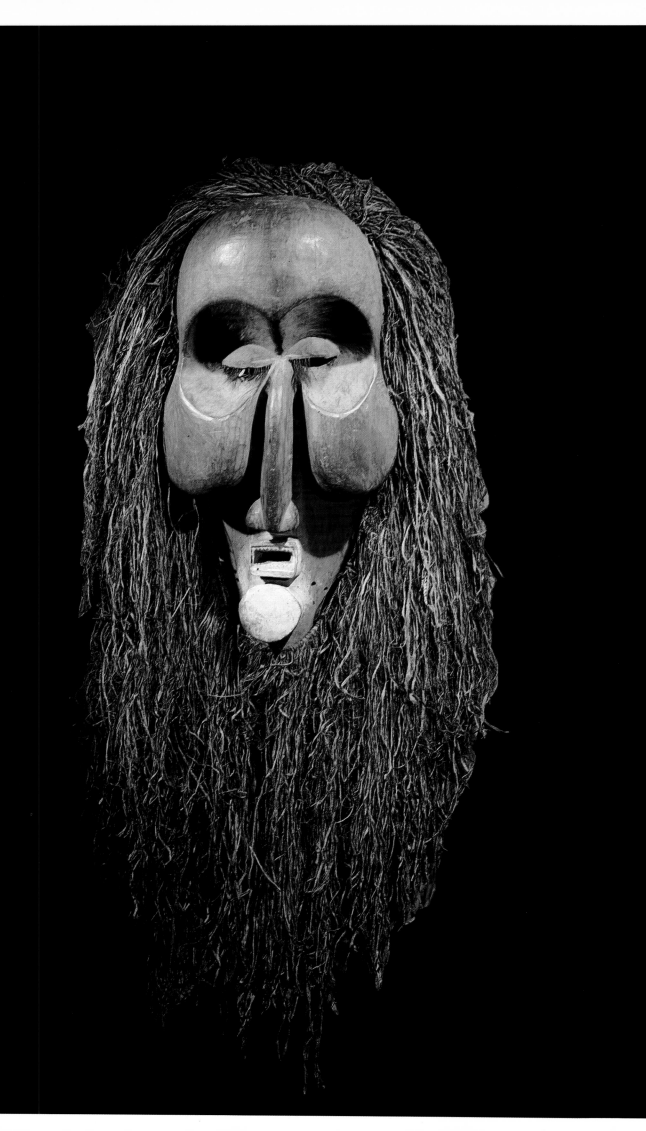

Forms

Limitations of the Ethnological Approach

We have followed the path of ethnology as far as it is able to lead us. But we have seen that with the study of African aesthetics or criticism this path was taking the same direction as Western aesthetics. Indeed, in order to set forth these African aesthetics or this criticism, ethnologists cannot be satisfied with recording the responses of their informants. They must translate and interpret them; now, we can verify that their interpretations use aesthetic concepts of Western origin. This fact is not a criticism: it corresponds to the fact that African sculptures are art, if not purely, at least specifically.

The question then is: should one, along this road, stop at the point where the ethnologists stop? That would be depriving ourselves, due to a principle, of all the resources of Western aesthetics. It would be, once again on principle, believing the aesthetic status of African sculpture, as it is institutionalzed in our culture, to be radically illegitimate and would cut our experience of African sculpture off from the rest of our aesthetic experience. Now, we have seen that precisely what we needed to do was precisely to integrate African criteria into our own aesthetic experience in order for them to become more than the object of purely ethnological knowledge. Consequently, these positions of principle seem to us to be unreasonable.

Let us accept them provisorily in order to examine some of their consequences. Thompson suggests to certain Western curators that they revise their appreciation of the Yoruba sculptures they have by absorbing Yoruba aesthetic criteria. It is certain that a knowledge of these criteria will not only modify but improve our appreciation of Yoruba works; if we have delved into Thompson's essay at such length, it is in order to allow readers to experience this improvement themselves. But no matter how completely we may integrate these criteria, we shall never look at Yoruba sculptures in exactly the same way as do the Yoruba, for we are integrating their criteria into an aesthetic experience quite different from theirs.

But if we cannot do it, should we wish we could? Each African aesthetics is a specific aesthetics, applicable to one art and, at most, another art that comes out of a related aesthetics—if, on this point, one believes the results of the comparison established by Vogel between the Baoule and Yoruba aesthetics. As we do not have an African aesthetics, despite this author's attempt, we cannot subordinate our aesthetic appreciation to it.

But, more radically, one must question the obligation to monitor in this way our aesthetic judgment through the data of art ethnology. That would be confusing the truth of ethno-aesthetic studies with that of our aesthetic judgments. Every ethnological study, as a scientific study, issues forth from the value of truth. But a scientific study is one thing, the objects it studies something else. The aesthetic judgments of the Yoruba constitute the objects of ethno-aesthetic studies; but in themselves they are aesthetic judgments that no more issue forth from truth than do ours—or that do not issue forth from them in the same way as do the scientific statements, ethnological ones in this case, that acquaint us with them. One might wonder, furthermore (J.-L. Paudrat, in a personal communication), if the need for the argument we are in the process of delivering is not a last residue of the denigration of which African arts have been the object for so long.

One must, therefore, make room for a place for aesthetics, as opposed to the ethnology of art. Consequently, we can invert the direction of our approach. We shall make the statements provided by Western aesthetics our point of departure in order to apply them to African sculpture, this

time under the monitoring of comparative data that go beyond African data alone.

Aesthetics of Irregularity

CONCEPTS AND WORKS In dealing with the question of perfection (*see* p. 38) we saw that one ought not to take the concepts we spontaneously apply to works of art for the intentions of the artists who created those works. One crucial reason is due to the nature of artistic creation which, as opposed to technical production, does not proceed from a complete, conceptually elaborated plan. This characteristic of artistic creation has several results related to a certain number of aesthetic concepts that must be treated as we did the concept of perfection.

A concept becomes a rule (*regula, kanôn*) when it directs an activity, either practical, when the rule is a moral one—or related to production, when the rule is a technical one. But artistic creation, to the extent that it does not proceed from a conceptually developed plan, likewise does not follow rules. (Kant) Regularity is a conformity to a rule and, thus, to a concept. In all strictness, an artistic work can therefore not be regular or perfectly regular. Yet, for all that, artistic creation is not anarchistic, without principles, or blind. It proceeds as does nature (Kant), that is to say, *as if* it were realizing a plan or applying rules. In order to account for works of art, one must, then, insert intermediaries between the completed project and its total absence, between strict regularity and its opposite.

Now regularity is a genre that includes several species, among which are frontality, symmetry, and rectitude. Geometrically defined, symmetry may serve as a rule for technical production, but works of art do not present this rigid symmetry, just as natural things do not, so that Roger Caillois (1973) inserts dissymmetry between symmetry and asymmetry, the importance of which Jean-Claude Bonne has shown in the study of Romanesque sculpture. (1984, p. 29) The same must be done for frontality.

When the concept of the straight line serves as the rule, regularity becomes rectitude. Between that which is perfectly or geometrically straight and that which is not straight at all, we have seen that the Yoruba prefer a rectitude that Thompson calls "relative." He also speaks of the flexibility of the Yoruba aesthetic criteria. For lack of the proper words, we shall distinguish between two types of frontality, regularity, symmetry, and of rectitude, one strict and geometrically defined, the other relative. On the subject of relative rectitude, the flexibility of the straight line, one might mention the proverbial "lead ruler of the architects of Lesbos," which served as a metaphorical expression for the moral laxness of the inhabitants of that island; literally, due to the malleability of lead, the ruler would adapt itself to the wall instead of the wall conforming to the ruler.

Thus we see how the consequences of a Western theory of art link up with the concepts the ethnologist uses in the interpretation of the data provided by his or her informants.

Let us now take each one of these concepts in their rigid and flexible forms in order to compare them with the works.

SYMMETRY AND FRONTALITY We are familiar with the concept of symmetry. That of frontality was introduced and defined by an archeologist, Julius Lange, in 1894. In a positivist context, it is made into a "law," and in an evolutionist context this law would allow that "primitive" sculpture be opposed to classical sculpture.

"Whatever position the figure may take, it is subjected to this rule that the median plane, which one may see as passing from the top of the head through the nose, the spine, the sternum, the navel, and the sexual organs, and which divides the body into two symmetrical halves, remains

invariable, neither bending nor turning to either side. A figure may, therefore, bend forward or backward, but the *median plane* does not cease to be a plane for that reason—no bending occurs, nor lateral twisting, whether in the neck or in the abdomen." (Lange, cited and translated in *Sculpture*, p. 417)

It is a "conventional constraint against nature"; it governs resting positions that are the least natural and hinders the representation of movement and human relationships (what we have called scenic composition).

To compare these two concepts to the works themselves quickly leads to distinguishing between two ways of using them.

"The symmetry of the Fang Byeri," writes Louis Perrois (1972), "is remarkable. Practically all the statues are *perfectly* symmetrical looked at face on." There is a "*perfect* regularity of the masses on either side of the median axis" (p. 150, italics ours). Now, of all the Fang statues that we have been able to look at, if they were all symmetrical, not a single one was perfectly so. One can look at a geometrically conceived object, expecting perfect symmetry, and, when encountering an object close to what one was expecting, ignore the slight discrepancies that prevent its symmetry from being perfect. Inversely, one must be aware of the fact that this symmetry is geometric, that the encountered objects are not figures of geometry and one must respect the discrepancies. It is then that one avoids speaking in terms of perfect symmetry.

A convenient way to detect these slight discrepancies between the figure and a perfect, rigorously geometrical symmetry, is to move a rectangular photographer's mask from bottom to top, parallel with the lower edge, across a photograph. The discrepancies are much more noticeable than when one looks at the whole photograph. Gestalt psychology explains this difference. In looking at the whole, the symmetrical structure of the totality modifies the aspect of the parts by lessening their slight dissymmetry; this effect of the whole on the parts is cancelled out by the photographer's mask, which isolates them from the whole.

Among the Degha, as often in Africa, the sexual division of work assigns pottery to the women; they "do not know the potter's wheel, but the skilled craftsmanship of these women is such that they produce an *almost* perfect symmetry in their household utensils." (R. A. Bravmann, 1970, p. 7) Perfect symmetry and its aesthetically sufficient approximation must be attributed to different forms of production.

These remarks on perfect or geometric symmetry generally hold true for what is called geometrization or geometric stylization. The sphere of the head of a figure is never perfectly spherical. It holds as well for frontality, otherwise defined in geometrical terms. As with the notion of symmetry, the geometric notion of plane must be looser, so to speak— which is easily possible, by the way, when speaking of the plane of the thorax, the arms, or the thighs of a figure. Certain elongated figures which the Yoruba sculptors, for example, carved from a tusk whose curvature they preserve, rigorously respect frontality, even though their median "plane" maintains the slight curvature of the tusk. Most often, the median plane is slightly out of true, as if each part of the sculpture respected it but worked a slight rotation on its own account: thus, the head of a Mende figure is very slightly turned toward the left. In this regard the Mumuye figures are most notable. These figures have been obviously composed of roughly anatomical parts: head, neck, shoulder mass, trunk, a mass that includes the pelvis and the legs; the two arms have been conceived as one single part enveloping the trunk and enveloped by the initial cylinder of the block. Each part is constructed on a median plane; but each one of these is slightly shifted in relationship to its neighbor: very slight rotations of the parts, in both directions, are

observable. The ensemble of these partial median planes is therefore not, in the sense of strict geometry, a plane. We find once again, in a new light, a characteristic that occurs very frequently in African sculptures: the clear-cut separation of the parts and their relatively independent treatment.

The classical theory of art (which is a theory of Classical art) opposes frontality with the two categories of *contrapposto* and *linea serpentina*, which both entail displacements of the horizontal axes involving the eyes, shoulders, hips, and possibly the nipples and knees. In our encounter with African sculptures, two reasons prevent us from speaking in terms of *contrapposto* or *linea serpentina*.

First is the importance of the displacements of the axes. They are so slight in African sculpture that the small dissymmetry that results may well escape the superficial glance; they are accentuated in Classical sculpture. In African figures, they are not associated with the representation of movement, whose means in Classical sculpture they provide. But, especially, they are not coordinated, but relatively independent. Inversely, they are coordinated in Classical sculpture and coordinated in an organic manner: just as shifts in skeletal parts are physiologically unified in extra-artistic human movement. Consequently, the distinction between the organic and the technical, applied by Erwin Panofsky to proportions, could be transposed here.

RECTITUDE The Yoruba criterion of "relative rectitude" is particularly significative. What is simpler to conceive and realize than a straight line?

"We are not talking about absolute mathematical straightness, but a moderate handling of the line as evidenced by a slight warp. . . ." (R. F. Thompson, 1974, Chapter III) The figures on sculpted doors are demarcated by rectangular frames whose sides are slightly bent straight lines. The same holds true for Senufo or Dogon doors, for the lateral faces of a ritual receptacle, or for edges of the pedestal of the horseback riders from Benin.

This aspect of what one could call the African straight line was at first the object of ethnocentric condemnation, an opportunity for a "denigration." (J.-L. Paudrat) Ling Roth, quoted by Thompson, wrote in 1903: "as regards the straightness of the streets it is one of the characteristics of a negro builder or joiner that he cannot make a straight line, and Europeans find it a most difficult matter to get him to make one even tolerably straight." Thompson notes the "facility with which one can show how Roth mistakes the absence of absolutely straight lines for an absence of canon *per se*." In architecture, "a warp or a curve enlivens what would be an absolutely straight wall in Western architecture." A "splendid example of relative straightness . . . is the plan" [which the author reproduces] "of the palace of the Abaye of the Efon Alaye. . . . Here the delightfully wavering lines of the traditional courts . . . stand in stark contrast to the absolutely straight lines of the modern wings of the palace. . . ." (1971, Chapter III) In the popular literature, blueprints of Notre-Dame in Paris show its pillars as perfectly aligned. But Marcel Aubert asserts, publishing and commenting on the [actual] blueprint of Notre-Dame: "The deviation of the axis of Notre-Dame is the result of two successive construction campaigns. . . . Furthermore, one may notice that the alignment of the piers is in no sense perfect: the spans of the nave and the aisles are out of alignment across the width of the church, as is the central nave across its length. The level of the bases, the capitals, and the abaci varies from one pier to another, from one column to the next. The architects of the Middle Ages were less preoccupied than are those of today with questions of parallelism and symmetry: their results were no less felicitous because of it." (1945, pp. 72–73) Like Roth, popular books

expect the perfectly straight line and do not encounter it. Roth transforms the discrepancy into a negation and ascribes the irregularity to an incompetence on the part of the Black African; popularizers transform it into an identity by rectifying (in the etymological sense) blueprints of Notre-Dame, thus rendered, into something identical to what they were expecting.

At least this anticipated perfection should be found in the Parthenon, the symbol of classical perfection. But there is classicism and classicism. According to Rhys Carpenter, the desire was to find the system of proportions of Palladio there, that is, arithmetically defined and precisely measurable relationships. There is none of this. But do the deviations, as related to an average, calculable norm, result from an indifference and lack of care in the approach to work or from a mathematical diagram using variable relationships that cannot possibly be rediscovered today? Neither of these two ideas is acceptable. The discrepancies, as related to an exact uniformity, are intentional and deliberately happenstance at the same time; they are intentionally not systematic. They were produced at random, and with a purely aesthetic intent, "in order to temper lifeless mathematical rigidity with those minute irregularities which distinguish the living organism from its abstract generic pattern." (1970, p. 15) These minute irregularities, related to those of the organism, express life. We shall come back to this.

André Grabar (1945) suggested that a prefiguration of aesthetics implicit in early Christian art can be seen in the Plotinian philosophy of art. Now, Plotinus, breaking with all of the ancient traditions, refuses to define what is beautiful by means of the mathematical concept of *symmetria*. Here is one of his arguments: the same face can be sometimes beautiful and sometimes ugly, even though it is always "symmetrical" (I, VI, 1): alive it is beautiful, dead it loses its luster "even before its proportions disappear because of the putrefaction of the flesh" (VI, VII, 22). Beauty is linked to life, together both disjointed from symmetry.

In a study of Medieval mosaics, Xavier Barral y Altet suggests an aesthetics of irregularity: "Contrary to the ancient mosaic, the result is purposely irregular in accordance with medieval aesthetics. . . . The laying of the cubes is most irregular. . . . This technical irregularity, moreover, is used by mosaicists to emphasize designs in a manner similar to that used by the master glaziers when working with lead (stained glass)." (1986, p. 257)

This comparative data revalidates irregularity by associating it with life. Between technical production and biological production, art inserts itself, but from life's side. The case of the mosaicists leads us to African decoration.

The words decor and decoration have several meanings. We retain here the meaning of decoration related to a repetition or reiteration of nonfigurative motifs. Their nonfigurative character neutralizes one variation factor, the difference between things or people represented. One should also set aside another variation factor: a significative value conventionally attributed to the motif, so that slight variations in form must be ascribed to differences of signification associated with them. This is the case of the "Kasai velvets," produced primarily by the Shoowa, a Kuba subgroup.

The motifs are not only reiterated, they are also distributed either in a single dimension, as on a frieze, or on the two dimensions of a surface, as on a checkerboard. Beyond the form of the motifs, their color must also be taken into consideration: What is its invariability as a repeated motif? Is it distributed in the same way as the motifs?

The result of the multiplicity of these opportunities for regularity is that it is very probably easier to detect discrepancies, even minimal ones, in the

319

repeated decor. Also, every expert concludes that, both in repetition and in distribution, the rule is relative irregularity, not perfect regularity.

In the decoration of woven fabrics, relative irregularity may be ascribed to the technical imperfection of the weaver's craft. But if weavers had wanted to perfect their products' regularity, a well-exercised competency would have permitted them to lessen the discrepancies, as with sculpture. Furthermore, a type of technique allows one to dissociate the regularity of motifs from that of their distribution. The motifs are woven separately and their regularity depends on the weaving craft: but they are then sewn together and their distribution no longer depends on the weaving craft. One can still observe irregularities in their distribution.

CRITERIA OF PERFECTION Should one abandon the criterion of perfection altogether? Such a prohibition would contradict the anti-universalist orientation of our entire inquiry. If there is no universal essence of art, nothing prevents perfection from being an aesthetic property of certain works of art. But in addition, and above all, the word "perfection" is used in another sense. Curiously, Kant in his *Critique of Judgment* considers only this finalist signification which implies the confrontation of the product with its complete plan. But Spinoza, who already defined this meaning in order to exclude it, gave it another one, which was that of "reality."

Now, throughout the history of Western art theory, perfection has been understood in another way than by relating it to its plan. A work is perfect if it is impossible to add anything to it or subtract from it, to modify it at all without diminishing its value. In addition, the necessity of a thing has been traditionally defined, ever since Aristotle, by the impossibility of its being anything other than what it is. Consequently, the perfection of a thing is identified with the necessity of the state in which it presents itself. Again according to Aristotle, that which possesses this property is a whole. (*Poetics, 8*) In the Middle Ages, this necessity became known as *integritas* and people saw in it one of the characteristics of the beautiful. (E. Gilson, 1963, p. 44 *ff.*)

This second notion of perfection manifestly has a function as a criterion: it permits one to decide, when encountering a work of art, whether it is possible to modify it in order to increase its value, in which case it is still imperfect, or whether this is impossible because it is perfect— and to do this without relating it to an initial intention or plan.

This criterion of perfection is to be found in Vitruvius (E. Panofsky, 1983, p. 68, n. 19), in the *De Re Aedificatoria* of Alberti (Chapter VI), in the Italian architects in *Architectural Principles in the Age of Humanism* (R. Wittkower, 1952, pp. 6–7 and 28, n. 2). Delacroix applies it to Shakespeare (February 23, 1858), Baudelaire to a Corot (1951, p. 579). Matisse links this criterion explicitly to the absence of a complete plan: "I'm going along, urged on by an idea that I truly become progressively familiar with only as it develops as the painting moves forward. As Chardin used to say: 'I put more back on (or take away, for I scrape a lot) until it feels right.'" (1972, p. 163; *see also* p. 160)

SYMMETRY AND BALANCE Frontality tolerates a slight or partial dissymmetry when seen head on; but it does not govern aspects seen in profile: the axes then may bend. On the other hand, one must, as always, distinguish between sculpture and what it represents. Now, most African sculptures represent humans or animals who are symmetrical head on and asymmetrical in profile. Let us agree to call that asymmetry of sculpture seen in profile, due to the person or beast represented, iconographic asymmetry. Even though they are rare, cases of iconographic

symmetry seen full face should be mentioned, as with a Pende mask that represents illness; and those forms called Janus figures, double figures consisting of two asymmetrical profiles symmetrically positioned, should also be set aside.

Now, if a figure that is frontal and symmetrical full face is iconographically asymmetrical in profile, does it not, because of this heterogeneity, run the risk of lacking this *integritas*, this property of being a whole, that defines perfection? Does not its unity of form run the risk of being dependent on the person or animal it represents, and of not being a specifically artistic unity? We propose to show that a certain kind of balance is, so to speak, a refraction, in an iconographically asymmetrical profile, of the frontality and symmetry of the full-face view.

To this end, it is appropriate to distinguish between two species of the genus of equilibrium. The scale may serve as paradigm; in English and in French the meanings of the words "equilibrium" and "balance" partially overlap.

A symmetrical scale, appropriately laden, remains symmetrical when in equilibrium. Let us agree to speak of symmetrical equilibrium: this is the equilibrium of a frontal and symmetrical sculpture seen from the front or the back. But an asymmetrical scale, such as the so-called Roman scale, may just as well be in equilibrium despite its asymmetry. It allows one to disassociate equilibrium from symmetry and to associate it with asymmetry. Dissymmetric equilibrium is realized when the inequality of the weight (W, w) is compensated for by the inequality of the length of the arms (l, L), according to the law: $Wl = wL$. Let us agree to speak of asymmetrical or compensated equilibrium. The whole of the sculptor's art consists of inventing—without a ruler—a compensation between the iconographically asymmetrical elements of the profile view.

Let there be a Yoruba figure holding a cup. Let us note incidentally that this work satisfies the majority of the Yoruba aesthetic criteria reviewed by Thompson; the "flexible" or "relative" criteria now under consideration are applicable to it.

Seen from the back, this figure is symmetrical but its symmetry is not perfect. Moreover, the rotation and the tilt of the axis of the head partially break the frontality, but they depict an attitude more than they do a movement. The sculpture is constructed in an approximate diamond-shape, two points of which are truncated: the upper point by the line of the shoulders, the lower point by the line of the heels. But the (virtual) upper angle of the diamond coincides with the ear from which three crests of hair spread out: the asymmetry of the head (turned in profile) is thus tempered—the principal crest of hair prolongs one side of the diamond and the forward edge of the hair prolongs the opposite, integrating the asymmetry of the head into the dominating geometric diagram which is this symmetrical diamond.

In profile, an asymmetrical equilibrium is obtained between two comparable, but very differently shaped, masses, the figure and the receptacle, and by a compensation for the symmetrical volume, horizontal and stable, of the spherical, massive receptacle by the rather slim figure whose vertebral axis is noticeably tilted backwards, a "tilt" accompanied by a rotation of the head (which prohibits the face from coming back toward the front). One could say, forcing the analogy a bit, that the small mass (w) of the head, multiplied by the length (L) of the ensemble of torso, neck, and head, equals the large mass (W) of the receptacle multiplied by half (l) of its diameter.

The profile of a Baoule figure, seated rather than kneeling, presents a form of compensation and asymmetrical equilibrium, the vertebral axis tilted forward this time. There is no general rule regarding compensation.

Aesthetics of Sculpture

We have just made use of a general conception regarding artistic creation. In order to have a tighter grasp on our subject, we must have recourse to the aesthetics of sculpture.

COMPLETE TRIDIMENSIONALITY The most recent aesthetics of sculpture (H. Read, 1956; E. Gilson, 1964; L. R. Rogers, 1969) are in agreement on regarding "complete tridimensionality" as a property essential to sculpture—in line, moreover, with the first aestheticians of African sculpture. (C. Einstein, 1915; D.-H. Kahnweiler, 1919 and 1948) Also, African sculpture is presented as the best theoretical example of this, but a polemic one as well: it is in opposition to that of the neoclassical sculptor and theoretician Adolph von Hildebrand (1873). This polemic is a double one: to Hildebrand's neoclassicism are jointly opposed the defenders of Rodin (R. Wittkower, 1977, p. 248) and the supporters of African art. From a polemic point of view, the support of the latter is associated, from the first, with the defense of modern sculpture against its neoclassical detractors.

From the theoretical point of view, the basic opposition is between real sculpture, whose volume is three-dimensional, and the surface arts. The surface arts, however, do not include only painting and relief sculpture, but also the sculpture in the round, which Hildebrand subjects to the principle of relief. The result is that the borderline passes through the inside of the realm of sculpture in the round and separates two aesthetics within it, one defining pure sculpture, the other an impure sculpture, the so-called pictorial, since it shares properties of the surface arts with painting.

Sculpture in the round subjected to the principle of relief favors one side, the frontal view; it constructs its figures on frontal planes. It seeks effect and its full aesthetic effect is from the front. Every effect is an effect for an observer who is thus integrated into the sculpted form that ceases to be independent, autonomous, self-contained. All these traits belong to relief and to painting. In order to formulate the opposition of these two aesthetics, Carl Einstein and his epigones borrow from philosophy the classical conceptual oppositions between reality and appearance (this is how Einstein speaks of the powerful realism of African sculpture), between the thing-in-itself and phenomenon, and they circle around the opposition between the absolute and relative.

Manifestations of Tridimensionality The great merit of L. R. Rogers is that he introduced between the general, abstract notion of tridimensionality and concrete, singular works a description of properties that make the full tridimensionality of the works tangible.

The principle of relief favors the frontal view and thus also the direction from which depth is reduced. Tridimensional sculpture treats depth and the other dimensions equally. The view of the anterior face of the statue, then, is crucial. From the point of view that, indeed, is favored by relief, one should be in a position to recognize the statues that do not privilege the frontal view but that, on the contrary, exploit depth and give it as much importance as width. In fact, volumetric or cubist structure may be clearly perceived, thanks to certain characteristics, without there being a need for moving around the statue or having it rotated in front of you.

A first characteristic, albeit a negative one, should be noted, for it involves a certain manner of photographing statues. The outline and silhouette have less importance than the forms of the parts and their thickness. In the strict sense of silhouette, only the outline is important, since it demarcates a surface of color or a uniform, undifferentiated value

contrasting with the background. William Fagg (1963), in commenting on the photographs of African sculptures by Herbert List, and Brassaï, in a conversation with Picasso, come to the same conclusions. List avoids strongly contrasting backgrounds, Fagg notes, and emphasizes the contours that are rarely on the same plane and which detract attention from formal qualities. By using somber backgrounds for somber objects, List blurs the silhouette, gives it the secondary importance that suits him, and in this way partially overcomes the limitations of the two-dimensional surface of photography (pp. 8–9). Secondly, in answering Picasso, who asks him: "Why is it so rare that statues are well photographed?" Brassaï says: "I do not know what stupid tradition would have a light statue up against a dark background and a dark statue against a white background. . . . This kills them. . . . They look flattened and can no longer breathe in space." (Brassaï, 1964, p. 69, a conversation dated the end of September, 1963) This way of photographing transforms the statue into a silhouette: the contrast heightens the outline. Brassaï continues: "In order for a statue to attain its full roundness, its light parts must remain lighter than the background and its darker parts darker." Brassaï rejects the effect of the silhouette by rejecting a pure and simple contrast between figure and background that reveals the contour. The fact remains that, even when photographed by List or Brassaï, volumetric statues lose more than those involving the principle of relief.

Second characteristic: the principal axis of the statue is not strictly vertical. Very often, it is slightly tilted forward or backward; a wide base permits the tilt to be emphasized. Sometimes it is very subtly rounded. This characteristic contributes to making certain technico-figurative objects into sculptures, such as with a Zande harp or a Tsangui spoon [fig. 982]; the rounding is not required by the functional form.

Third characteristic: the volumes of the parts are tilted in depth and give birth to planes—the planes of the thighs, of the base of the head, of the upper part of the skull, of the shoulders, the breasts, and the abdomen—sliding toward the back. A Nyamwezi statue and another one attributed to the Turka [fig. 291], as well as a Baoule figure, all share these oblique planes. In a Tsangui spoon, the lower oblique plane, defined by the edge of the bowl, belongs to the purely technical part of the object. While gliding over the oblique planes, one's sight moves in depth to the very interior of the thickness of the sculpture.

Fourth characteristic: the sculptor creates neat, clear lines on a plane that is horizontal or almost horizontal and thus perpendicular to the frontal plane. Now, two perpendicular planes suffice to engender three dimensions. These lines meet at two partial volumes. They are clear-cut because there is no linking, no softened or curved transition between the two masses; they are at an intersection in such a way that they make the section of at least one of them visible. In terms of representation, these lines are placed where the neck meets the base of the head and the shoulder mass, at the juncture of the abdomen and the loins as well as at the joints of the knees and the ankles. All these lines can be seen, for example, on Tabwa, Turka, Zande, or Songhay statues. This characteristic belongs to that of the clear-cut demarcation of parts seen in the majority of African sculptures; it is very easy to find examples of them.

Fifth characteristic: the sculptor creates a global volume, or partial volumes, whose depth is equal or superior to the width, as with a body of a hornbill or with a Turka figure. The representation of certain postures such as the seated position, or of certain gestures such as the offering of a cup, favor this super-thickness (Baoule). The strong frontal protrusions of certain parts of the torso (in other respects iconographically motivated) are involved in this super-thickness: the breasts, sometimes horizontal (Bamana); the sexual organs (Montol); the knees (Tabwa); and above all,

323

not only the abdomen, but the protruding navel on an already protruding belly (Kusu, Hemba).

Sixth characteristic: an opening up of the sculpture which liberates the legs and the arms in such a way that one may see them in their totality, as if surrounded by air. In some Mumuye figures [figs. 121–25], the torso is an elongated cylinder, enveloped, though at some distance, by flattened, curved arms, the curve echoing that of the torso's surface: the air and one's gaze circulate between the arms and torso.

Some sculptures possess all of these characteristics at the same time. For example, a maternity figure, a kneeling, seated figure, or a horseman, all Dogon in origin; and, Yoruba in origin, a stool's caryatid, a ritual object, an *oshe shango*, or a maternity.

If Hildebrand's classicism subjects sculpture in the round, physically defined, to the aesthetic principle of relief, certain Benin plaques, technically classified as reliefs, aesthetically are related to full tridimensionality. We have brought out the inverse symmetry between these two aesthetic treatments. From the point of view of the theory of sculpture, one must substitute, for the traditional dichotomy between sculpture in the round and relief, not only a tripartition, by inserting the principle of relief, but a quadripartition as depicted in the following chart:

	Determination	
	technical or material	aesthetic or formal
(1)	SR	SR
(2)	SR	Rf
(3)	Rf	SR
(4)	Rf	Rf

The first entry describes the completely three-dimensional sculpture, the fourth, the pictorial relief of Ghiberti or Donatello. The second expresses the application of sculpture in the round to the principle of relief. The third describes the very special form of these specific reliefs from Benin, or of some commemorative Ijo screens which can be found on certain masks.

The Block and Respect for the Block Let us go back from the parts showing tridimensionality and return to the overall form of the figures. The shape of a block is manifestly three-dimensional. But the notion of the block may be applied in two different ways: it may define either a finished sculpture, or the material from which it has been carved and whose shape persists, in some way, in the finished figure. Let us agree, in the second case, to speak of a "respect for the block" by analogy to the "respect for the surface" in painting, and, in the first case, of the block form by analogy with "massing," a term of the vocabulary of the painter's studio.

Several properties characterize a block. 1) It is a mass of solid material of stable form. A mass of wax or of clay, in this sense, is not a block, for these materials are chosen and utilized for their malleability, plasticity, and the absence of resistance to forms one gives them while modeling them. 2) The dimensions of a block are related to the human scale: a paving stone is a small block, but dimensions of about ten meters make an enormous block. 3) Its parts are either undifferentiated or as little differentiated as possible, so that the overall shape is much more important than the shape of the parts. 4) The overall shape is simple and compact—simple by reason of the relative indefiniteness of the parts and their strong subordination to the whole; compact in that protruding parts, standing apart from the center or the axis, are excluded.

The human body does not, in itself, have the shape of a block. But its capacity for transformation allows it to adopt this shape by rolling itself up. In figurative sculpture, a block statue is a figure rolled in upon itself. Certain positions shorten the vertebral axis by bending inward: the extremities are turned in upon themselves and rolled over the trunk. At the extreme, it is the position of a contortionist settled inside a box. Some African figures come close to this [figs. 256, 747]. Two Bena Lulua figures show this to different degrees. Unnoticeably one passes to an overall cylindrical form when the figure is seated, elbows on knees and head in hands (Chokwe), or to a pyramid-shaped trunk with the figure seated cross-legged, the hands on the knees (Bemba) [fig. 622]. The ovoid form becomes elongated when the figure is seated on a stool, but the quasi-absence of the neck, the displacement of the head and hairdo toward the front, create a vacuum between the head and the thighs inside which a musical instrument is positioned (Chokwe) [fig. 230]. The non-naturalist character of African figurative conventions, proportions, and "anatomy" facilitate the concentrated composition of the forms of the parts, allowing, for example, a bending of the rectilinear bony segments (Bena Lulua).

Often in Africa the form of the sculpted figure is cylindrical overall. Now, the cylinder is the form of the trunk of wood into which the figure has been cut. This overall cylindrical form is very frequently evident at first glance. Such an impression is verifiable: the extreme external parts of the figure are placed approximately on the virtual cylinder enveloping the figure, which is none other than the initial form of the trunk. That is when we speak of a "respect for the block." But a figure may be "block" without respecting the original block: two principal cases correspond to the two techniques of direct carving and of modeling. First a figure, such as the female cupbearer by the Buli Master [fig. 189], has an overall form that is no longer cylindrical but ovoid, and the principal axes of the two forms do not correspond. In the second, a "block" statue may have been modeled. The material to be modeled—earth, wax, or latex—does not have a shape of its own or at least no stable one that can be respected. Moreover, according to a classical distinction in sculpture theory, while direct carving involves taking away material, modeling proceeds by adding to an original small mass, little by little, other small masses which are incorporated in the initial one as they encompass it. In short, respect for the block has as a necessary condition the direct carving of a material that possesses a form; the simple block form is not subjected to this condition since it may be either modeled or hewn.

But then, why are modeled figures that owe nothing to the cylindrical block often cylindrical overall, as with the Ife or Benin standing figures? In Africa, the style is frequently the same whether the figure be carved or modeled. But, since direct carving and the use of wood is more prevalent in the production of figures than clay or wax modeling, one may well assume that the cylindrical blocking of the modeled figures was derived from wood sculpture.

The respect for the block presents variants. Some caryatids are cylindrical overall, as are the stools of which they are a part; the cylinder that envelops the figure echoes that of the one enveloping the entire stool. More subtly, certain Mumuye figures have an exterior cylindrical form that envelops an equally cylindrical interior form, that of the torso. Such a configuration shows that respect for the block does not exclude openings, nor does it demand a compactness of the figure.

The shape of the block does not suit the representation of movement. It gathers the forms of the extremities around the torso (it is centripetal); movement distances the extremities from the torso and causes their axes to diverge (it is centrifugal). One often observes a compromise solution: the movement is stopped in position or in a pose and the respect for the block

is limited to the ensemble of head-neck-trunk-legs, as the arms escape from this limitation (Bwende).

Relief, in styles described by art history as archaic, has a horror of the void: the figures occupy the largest possible part of the surface, reducing the background to a minimum. This *horror vacui* leads to adjusting as tightly as possible the exterior outline of the figures to the limits of the frame. The respect for the block is the three-dimensional analogue of this aspect of the horror of the void. It is as if the sculptor were keeping to a minimum that portion of space that will separate the figure from the initial block, while carving out the latter as little as possible, taking away the least possible material. Thus, the three-dimensional figure is wedded to the shape of the block just as the figures in relief are molded upon the limits of the frame.

The idea of respect for the block is thus linked with a more general characteristic. Similarly, the form of the original block is a specific case of form to be respected, the form given before the work of the sculptor begins. Forms other than those of the block or trunk of wood can be respected in this way.

The form to be respected may be part of a building: we reencounter the law of the architectural framework; it may be the functional form of a practical object: we reencounter the transposition of the law of the architectural framework from immovable to mobile objects. For example, the cylindrical form is the same for the trunk and the stool: some stools that have not been sculpted are simply stumps.

The initial form may be that of a material that keeps its shape, without being cylindrical for all that, such as ivory tusks; the sculpted figure sometimes preserves the slight curvature of the axis of the tusk and its elongated proportions [fig. 909]. It is not necessary to preserve the curve: by reducing the height and by sacrificing some ivory, the sculptor could make the figure upright.

The worked wood may be a trunk not sectioned off in blocks. When the form of the trunk is respected, one speaks of *Pfahlplastik*, of the plastic quality of the post or the pole. [fig. 790 sv., 925 sv., 927] The choice of material is demanded by the function; the sculpted pole when set becomes a commemorative post; if it exercises a carrying function it is a pillar and we reencounter the law of architectural framework. The material is this way because its form is identical, so to speak, to what is required by the practical function of the object to be sculpted. If function is emphasized, one speaks in terms of *Pfahlplastik*, to emphasize the respected form, one ought to speak of the plastic quality of the post. Still apropos to the tree, one might relate the plastic quality of the trunk to that of the branch: a Dogon figure manifestly respects the elongated and bent shape of the branch into which it has been carved. The branch might be forked and its form respected, either by a simply representational figure, such as certain Suku sculptures, or by a technico-figurative object such as the Luba arrow quivers or the pillars of certain architectures. In all cases, the form of the part of the tree that has been used is clearly recognizable. It must be noted that such cases remain fairly rare in Africa—which, according to Arnold Rubin (1987a, p. 58), distinguishes African art from South Seas art.

MONUMENTALITY If tridimensionality distinguishes statuary from the surface arts, it also brings it closer to architecture, from which it must now be differentiated. The concept of monumentality allows us to grapple with this question. Indeed, according to Malraux (1979), African sculpture is characterized by the absence of an architecture to which it could subordinate itself, unlike the arts of the so-called "great" civilizations. This proposition joins together the failings of generalization and negation. The concept of monumentality permits us to show that, in

Africa, the relationship of sculpture to architecture is more complex than that of a presence to an absence.

Taken in the etymological sense, "monument" defines an object by its commemorative function. This signification has been well-nigh forgotten, but the various meanings derived from this word correspond to properties that a work must possess in order to exercise this function. Commemoration comes out of the collective memory. The monument must be of a large size in order to impose itself on the view of a community; it commemorates an important person or event deserving to be preserved in the collective memory: the "greatness" (in the metaphoric sense) of this event or this person calls for a "great" edifice (in the literal sense). What is commemorated must be known and therefore represented (refer to the text by Vitruvius): the monument most often has sculpted figures. The memory of the past is present; the monument must ensure the permanence of the plastic, collective remembrance, much more durable than the mental, individual remembrance; the most durable materials available to the social group will be used. From these various properties various usages of "monument" and "monumental" are derived:

1) Generally a work, sculpture, or building of very large size is called monumental; this use extends to literary works.

2) The largest and most durable monuments are edifices; the word is often seen as strictly synonymous with architecture.

3) In a more restricted sense, "monument" designates only certain commemorative works consisting of a nonrepresentational architectural part and a representational sculpted part, such as equestrian statues, columns that superelevate the full-length figure they carry, or an architecture and relief work such as triumphal arcs or certain columns. It is this third use that stays closest to the etymological meaning.

4) In the sense that "monument" is synonymous with architectural work, two closely related uses of "monumental" and "monumentality" are derived. The derivation is made from the whole, the monument, to the part, the sculpture, which is then called "monumental"; this derivation is therefore metonymic. But this link between the whole building and the sculpted part may be material or formal.

4a) A sculpture is called monumental when it is materially unified with building [figs. 438, 960, 961, 965]; it is called architectural for the same reason. This physical link is not aesthetically pertinent, for it allows for many aesthetic possibilities.

4b) From the formal point of view, a sculpture is said to be monumental when its form is partially determined by, matches, or is adapted to the form of the part of the edifice it occupies. This is not a necessary link: a sculpture may be physically unified with a part of a building while its form is entirely independent from it. This monumental appropriateness is formal: it has been called the law of the architectural framework. It is applicable to sculpture in the round as well as to relief.

5) A last meaning is of immediate interest to sculpture in general and African sculpture in particular. Some sculptures are described as "monumental" which are not only totally independent from architecture in their conception, execution, and use—which distinguishes this category from all the preceding ones—but which are, furthermore, small in size—which distinguishes it also from the most generally used meaning (1) of the word. Thus, Fagg and Margaret Plass write about an Igbo sculpture, 16 cm. high, that "for all its small size, it is one of the most monumental sculptures we know" (1964, p. 41)—and about an Asante gold weight, 6.3 cm. high, of "the monumentality of its proportions which seems to overcome the limitation of size" (p. 29). (*See also* J. Laude, 1968, p. 211; W. Fagg, 1970, p. 20; A. Rubin, 1987, p. 47; E. Panofsky, 1972) These small-sized monumental figures, by eliminating largeness, facilitate the analysis

of this concept of monumentality [*see* figs. 647, 648, 649]. According to Henri Focillon, "there may be monumentality without a monument and a monument without monumentality." (1964, p. 36) It is, then, a property that can be common to buildings and sculptures, but which is shared by certain buildings only and only certain sculptures. As with monument taken in the narrow sense (3), this property straddles the clear-cut border that one often thinks can be traced between architecture and sculpture. "An isolated object can have these great, calm lines, this stable density, this solid compactness of durable things which we designate with the epithet: monumental." (*ibid.*)

Thanks to these properties, these statuettes "make us forget their format" (W. Schlamenbach, 1953), their scale of representation, which seems paradoxical or contradictory. But the scale is the relationship between the size of the sculpted figure and that of the figure represented. This monumentality does indeed reside in relationships, but different ones: the proportions of the sculpted figure, which are different from those of the figure represented, made up from the relationships between the dimensions of the parts of a single sculpted figure. These proportions, which may be shared by a sculpted figure and a building, are less gracefully shaped than those of the human body: comparatively, the sculpted figures are a bit squat [figs. 502, 504]. Since scale is an external relationship and proportions are relationships internal to the sculpted figure or edifice, these monumental proportions may "surmount the limitations of the size" (W. Fagg and M. Plass, *op. cit.*) of a statuette.

The proportions are the measurable metric aspect of the form or the structure. Qualitatively, monumentality also prizes simplicity of structure, which manifests itself in "great and calm" lines (Focillon) and by a stylization in the larger outlines. (A. Maesen, 1960, pl. 37)

The simplicity of the structure is that much less visible when small details are more numerous, and more visible when they are more rigorously eliminated. Now, seen from afar, the details of a large sculpture are not perceptible and, for this reason, are sometimes left out. If details are eliminated from a small sculpture that must be seen close up, an analogous effect of simplification is obtained by a small sculpture seen up close and a large sculpture seen from afar. While monumental proportions neutralize the scale that implies the relationship between the sculpted figure and the figure represented, simplification neutralizes the distances—the difference in distance between the large figure seen from afar and the small figure seen close up, and the distance from the figure to the observer. This simplification of form belongs to certain sculptures only and only to certain edifices.

It is the same for the finish, or more precisely for a moderate degree of finish, something between the look of a rough draft and the "licked clean" look. For a very elaborate finish, as is true of small details, is not noticeable from afar. Functional motivations may demand the representation of details such as bodily scarifications, bracelets, etc.—surface details that require a certain finish. But they may be rendered by accentuating or lessening their relief, by emphasizing or blurring their design; carved in reserve, their thickness may be reduced and they may be only lightly cut into the surface, in such a way as not to contradict the simplicity of the surfaces or planes.

The photographic reproduction, because it in itself contains no indication of scale, facilitates the perception of this monumentality. This book gives examples of it originating in every region of Africa.

EXPRESSIVE QUALITIES The expressionist theories of art have had less success in France than in other Western countries; this runs the risk of impoverishing French interpretations of sculpture and of

desiccating, so to speak, its formalist interpretations. Now, there is no incompatibility whatsoever between form and expression: L. R. Rogers speaks of the expressive qualities of form. Certainly, the expressivity of African sculpture has frequently been stressed, but lacking a clear conception of expression, more often than not the actual plastic, sculptural expression has been confused with an imitative representation of the psychological expression of an extra-artistic "model." As with tridimensionality, we must have a general, abstract notion available, this time of expression, and of a mediation between it and the concrete, singular works which the expressive qualities of the form provide us with.

According to Goodman (1969, Chapter II), expression is a metaphoric exemplification. An example exemplifies one property (or several). Snow, an example of something white, exemplifies the property of being white. The example does not represent (technically, does not denote) the property it exemplifies: snow does not represent whiteness, but it *is* white, it possesses this property. Inversely, it is the property that denotes (the meaning of "to represent" is so flexible that one could almost say: that represents) snow. This inversion of the direction is crucial: it forbids us to confuse expression with representation (of an expression).

Now an example may possess a property either literally or metaphorically. Literally, snow is white, and Peter or Paul is sad. But a landscape is not sad in the same way (it does not feel this emotion). A landscape is metaphorically sad: it metaphorically has the property of being sad. Expression, then, is 1) an exemplification: a sad landscape exemplifies or possesses the property of being sad; and 2) a metaphoric exemplification: this landscape is metaphorically sad. One might say that it expresses sadness.

The Greek *metaphora*, the Latin *translatio*, the French *transfert* or *transport* (and *transfer* in English) all have exactly the same composition and the same etymological significance. Expression includes a metaphor, that is to say, the "carrying over" of a linguistic element (in the wider sense, including plastic language) from one realm of reference to another. For example, the word "sad" is transferred from a person feeling an emotion to a landscape. Thus we can classify expressive properties according to the realms between which metaphoric transfers are performed. We shall limit ourselves to the expressive properties of sculpture; we will thus encounter the expressive quality in aspects of sculptures which we have a tendency to see as purely formal. This classification makes no claim whatsoever to being exhaustive.

Metaphoric transfer may be accomplished by the creative activity or gesture onto the work produced. This is how Action Painting comes out of an aesthetics of expression, how the properties of touch are expressive properties, and how one speaks of the "signature" [or "touch"] of a painter or a designer. The nonfinish that allows traces of the work to remain quite visible thus possesses expressive qualities, just as with that which we have called relative irregularities. By paraphrasing a formula of Paul Valéry's, one may say that the machine is that which does the work of the hand instead of the hand and better than the hand: its product is technically perfect, symmetrical, regular, rectilinear. But the work of the hand contrasts with that of the machine as does the living being with what is mechanical, and the expressive property of its product is called life or vitality. And so we find once again, by a different route, that same vitality which the Fang aesthetically value in their statuettes. In this category one can also place the delicacy of the modeling which can be appreciated, for example, on the white masks of Gabon's Ogooué region [fig. 162], on certain Yoruba masks of the *gelede* type, and on certain Fang figures. Let us remember that delicacy is one of the aesthetic criteria common to the Yoruba and the Baoule. One should also place the (logarithmic) curves of

horns in this category [figs. 538, 539, 544]; Fagg, indeed, interprets this geometric form as an expression of the vital force at work in the process of growth—an expression suitable for ideologies centered on the notion and value of the vital force. (1963, pp. 32–33)

Metaphoric transfer may also take place from a lived awareness, feeling, or emotion onto a plastic form. Tension of form, line, or contour is an expressive property. It is obvious that a sculpture cannot literally be made tense: it is not subjected to the traction of two forces going in opposite directions. Numerous African sculptures possess this tension; it may help serve to detect the finest Senufo pieces. Calm is an expressive property belonging to certain symmetrical and balanced frontal forms, appropriate to the depiction of persons who have realized a moral ideal of mastery and moderation. The lightness or heaviness of a sculpted figure or its forms also enter into this category; these are not literal properties: a bronze figure may be literally heavy and aesthetically light, while a wood figure may be aesthetically heavy. Certain Mbole figures possess this metaphorical lightness, which suits their use: they are meant to be hung [figs. 169, 170].

The third category of metaphoric transfer takes place from one sensorial realm to another: one recognizes here the theme of correspondences, so dear to Baudelaire. In this regard, sculpture comes out of two sensorial realms, the visual and the tactile. One sometimes tends to disassociate them and to think—as does Herbert Read—that tactile properties are more specifically sculptural than the visual properties shared by sculpture and painting. This is forgetting that it is not necessary to touch a sculpture in order to perceive some of its tactile properties— just as one says, metaphorically, that one's sight caresses or lightly strokes the skin of a sculpture.

Rogers (1969, p. 18) notes that the terms designating the expressive qualities of sculptural forms are more numerous than those designating their strictly spatial properties. The expressive qualities of African sculpture constitute a vast domain that remains to be systematically explored. Here, our intention is merely to propose pertinent expectations and an orientation. We have mentioned several examples of appropriateness between the expressive properties of certain sculptures and their use. We have remarked earlier that the question of the relationship between form and function (or use) was principally posed in terms of representation. Our examples, as well as the interpretation of Fang aesthetics by Fernandez, suggest another road: seeking a mediation between form and function, not in representation any longer, but in expression and expressive qualities. But then the matter of the relationship between expression and presentification would also have to be addressed.

The Two Pleasures

This entire study is but an essay: our course, declared at the outset, favors research on the results. Since all research begins with a question, we have raised more questions than we have provided answers for, and held up for questioning all results that seemed not fully adequate. This is to put ourselves under the aegis of Saint Augustine: *Si nemo a me quaerat, scio; si quaerente explicare velim, nescio* (If no one questions me, I know; if, when questioned, I want to explain, I no longer know).

But the very activity of research engenders a specific pleasure which we hope the reader, who has shared our inquiry, has enjoyed.

Now concluded, this leads us to the works themselves. In photographing them for this book, Igor Delmas has imposed an ascesis upon himself: he has made his art serve the sculptures, not the sculptures his art. This allows us to extend to the reader an *invitation to delectation*.

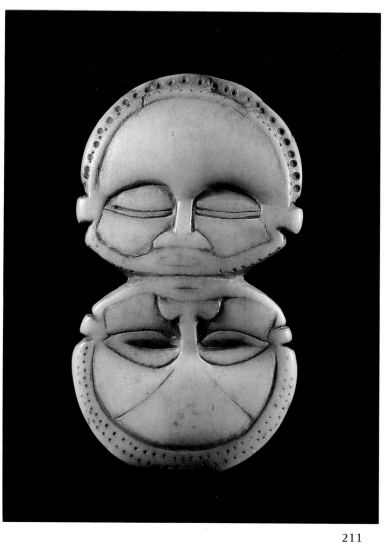

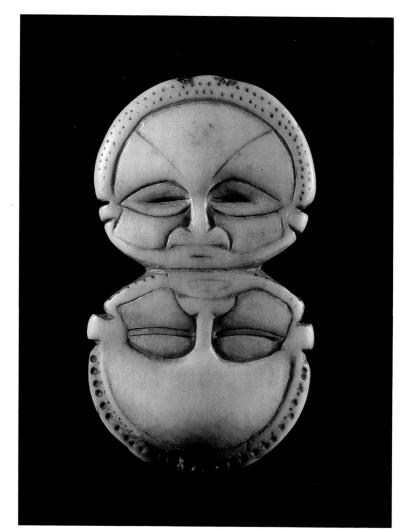

211

212

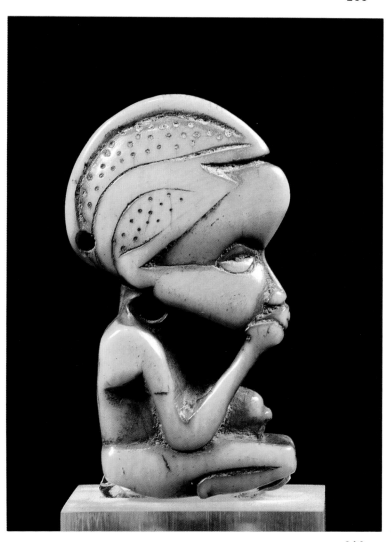

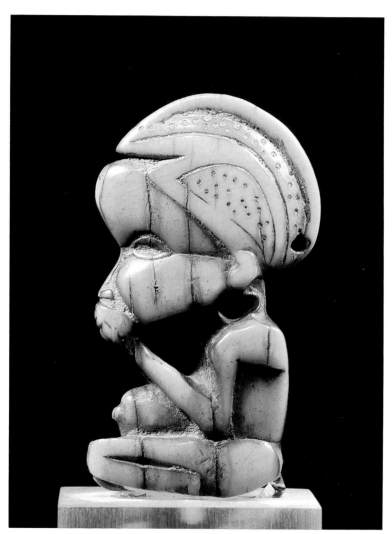

213

214

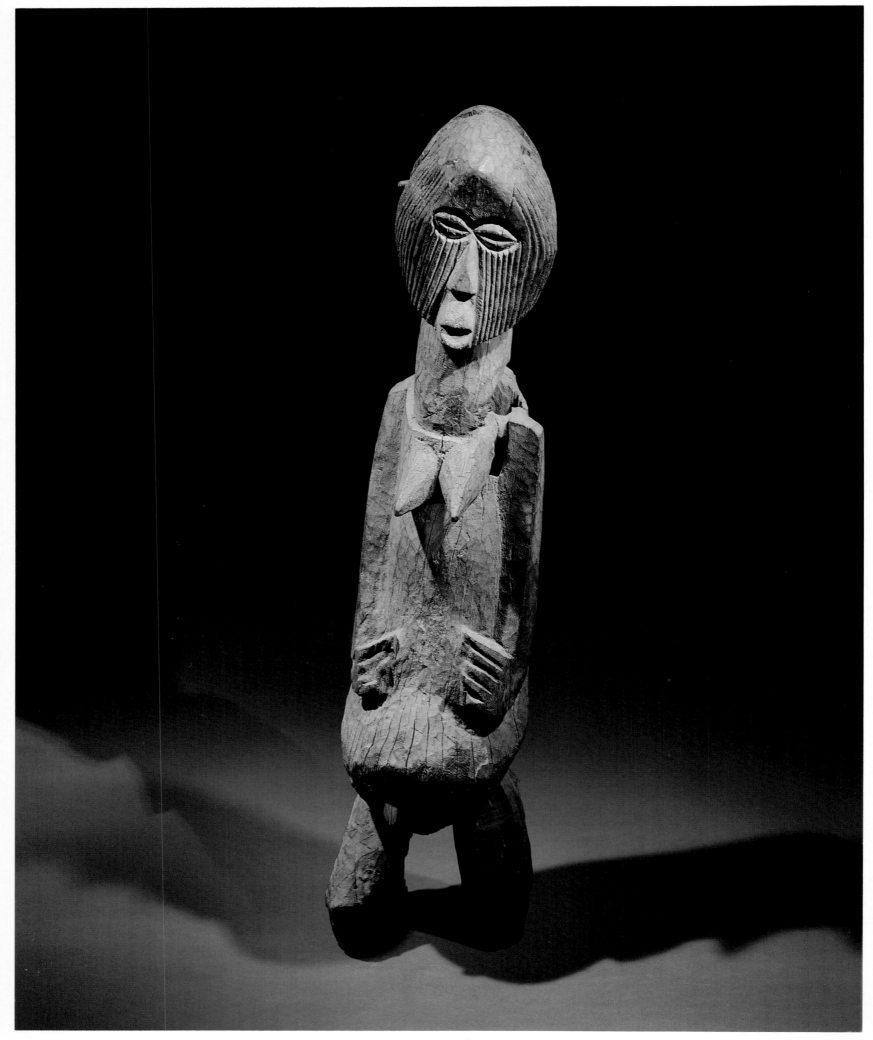

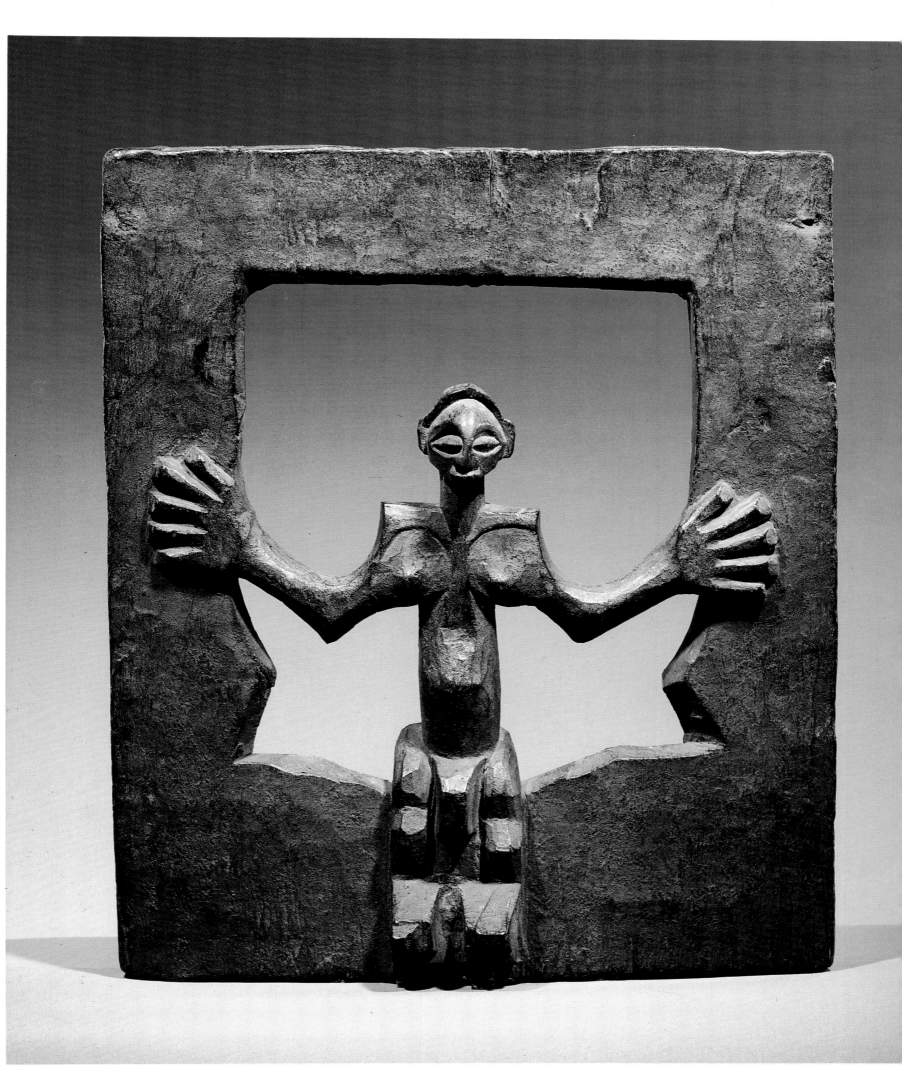

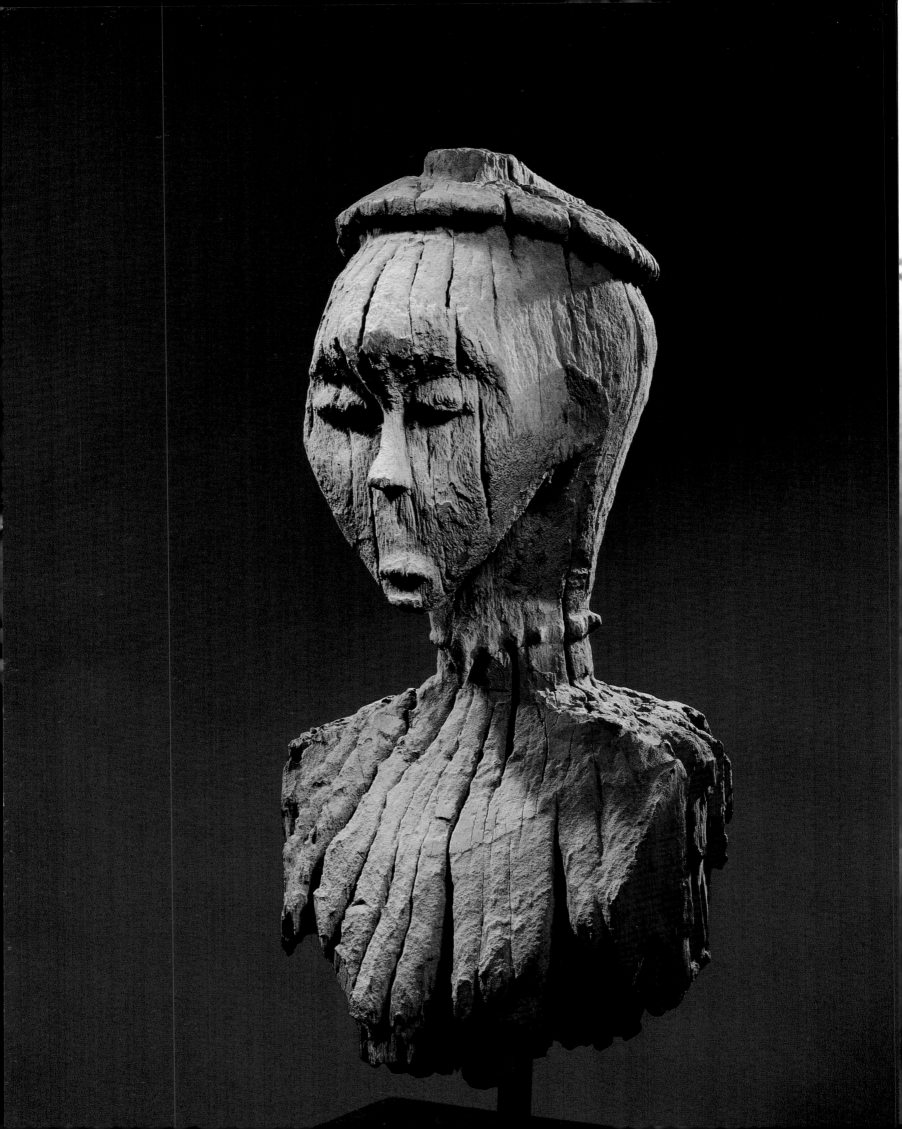

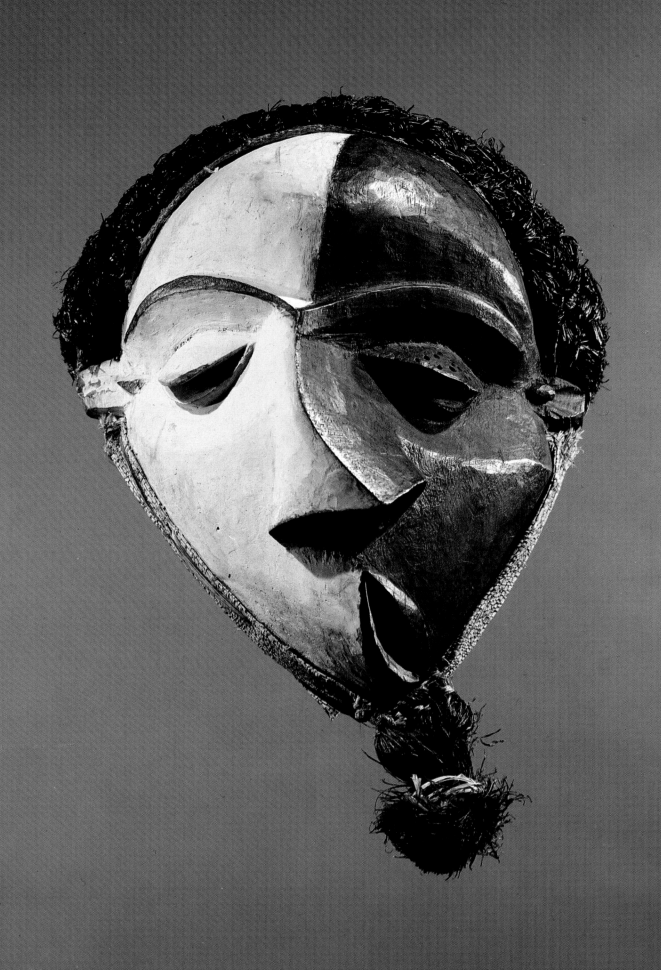

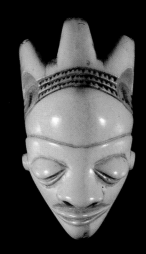
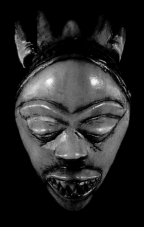
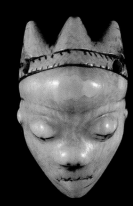
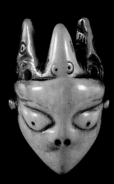

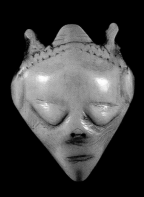

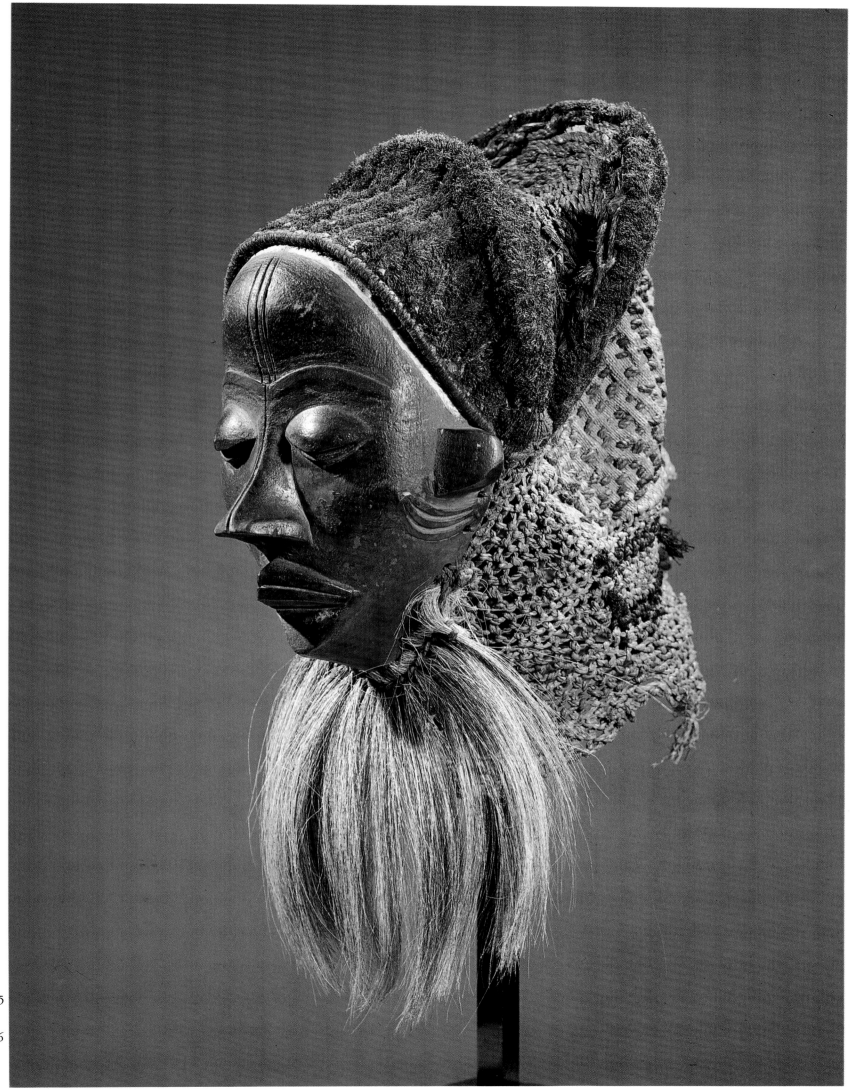

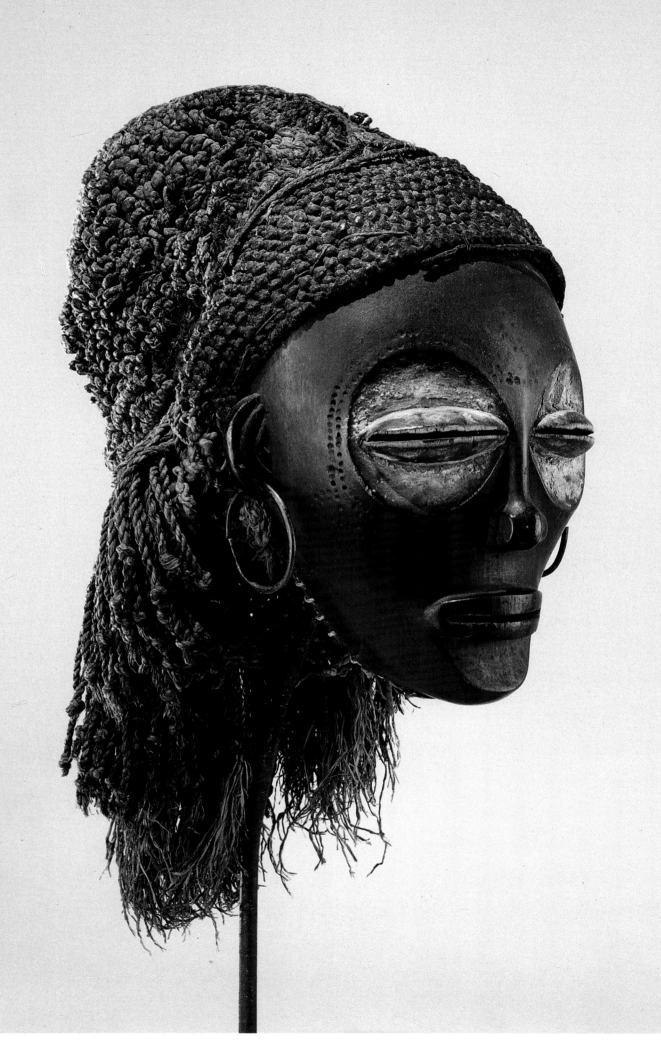

211–12 Hungaan Charm, Zaire
Ivory. Height: 8.2 cm. Musée Royal de l'Afrique Centrale, Tervuren, Belgium

213–14 Hungaan Charm, Zaire
Ivory. Height: 7.7 cm. Collection G. L., Paris

215 Yanzi Statue, North Kwango, Zaire
Wood. Height: 100 cm. Musée Royal de l'Afrique Centrale, Tervuren, Belgium

216 Holo Panel, South Kwango, Zaire
Wood. Height: 34.1 cm. Musée Royal de l'Afrique Centrale, Tervuren, Belgium

217 Pende Bust, Zaire
Wood. 18th–19th century (?). Height: 45.6 cm. Private collection

218 Pende Mask from the West, Kwilu Region, Zaire
Wood. Height: 26.6 cm. Musée Royal de l'Afrique Centrale, Tervuren, Belgium

219–25 Pende Ivories, Zaire
Heights: 4.5 to 7 cm. Private collection

226 Pende Mask from the South, Zaire
Wood, wicker, fibers. 19th century. Height: 46 cm. Private collection

227 Chokwe Mask, Angola
Wood, fibers, wicker. 19th century. Height: 27 cm. National Museum of African Art, Washington, D.C.

228 Ritual Bed (?), Chokwe Cultural
Region, Angola
Detail. Wood. Height: 131 cm. Private collection

229 Chokwe Statue, Angola
*Wood. 19th century. Height: 46 cm. Kimbell Art
Museum, Fort Worth, Texas*

230 Chokwe Statue of a Musician, Angola
*Wood, traces of hair implantations on the skull.
19th century. Height: 37 cm. Private collection*

231 Statue of a Chokwe Chief, Angola
*Wood, brass, human hair. 19th century. Height:
49 cm. Museu do Instituto de Antropologia da
Universidade, Porto, Portugal*

232 Kongo Mask, Zaire
*Wood. Height: 24.8 cm. Musée Royal de l'Afrique
Centrale, Tervuren, Belgium*

233 Kongo Statue, Zaire
Wood. Height: 28 cm. Private collection, Belgium

234 Kongo Statue, Zaire
*Wood. Height: 25 cm. National Museum of
African Art, Washington, D.C.*

235 Yombe Maternity Figure, People's
Republic of the Congo or Zaire
Wood. Height: 26 cm. Private collection

236 Kongo Statue, People's Republic of the
Congo or Zaire
*Wood, copper, nails, mirror chips. Height: 31 cm.
Arman Collection*

237 Kongo Statue, People's Republic of the
Congo or Zaire
*Wood. Height: 20 cm. The Metropolitan Museum
of Art, New York; formerly Ratton, Rubinstein
collections*

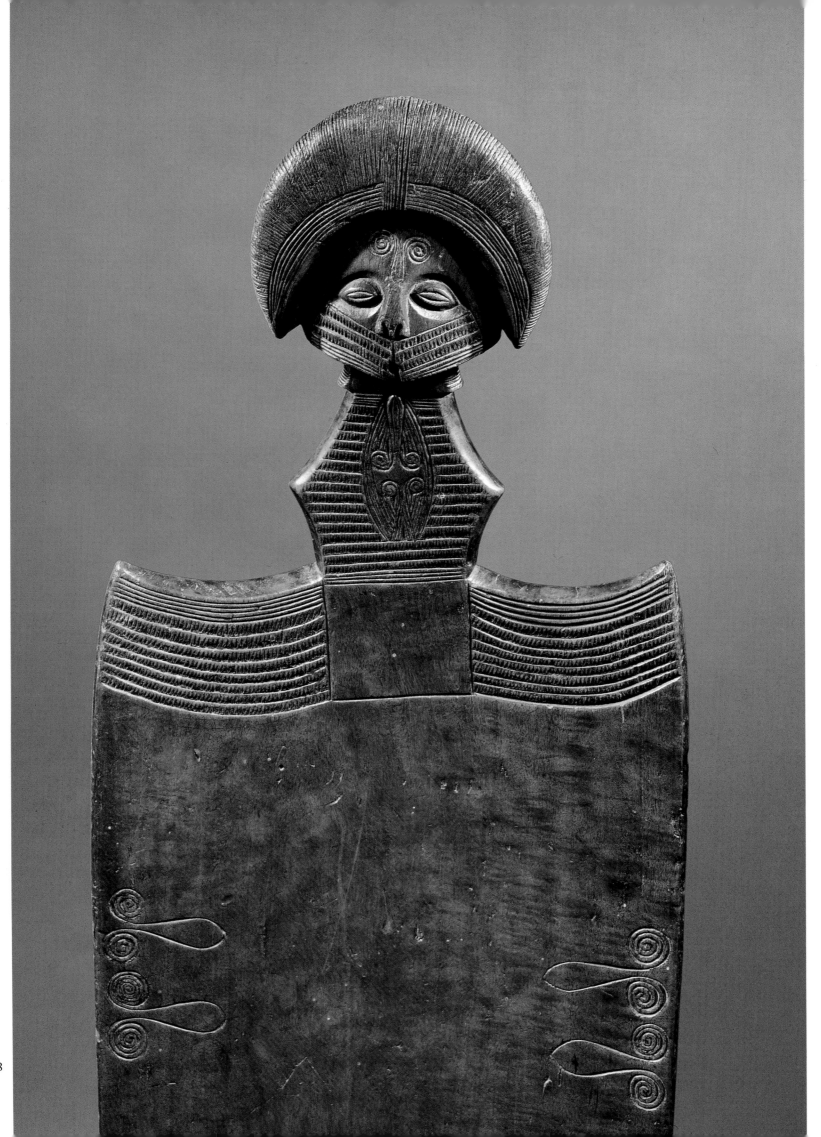

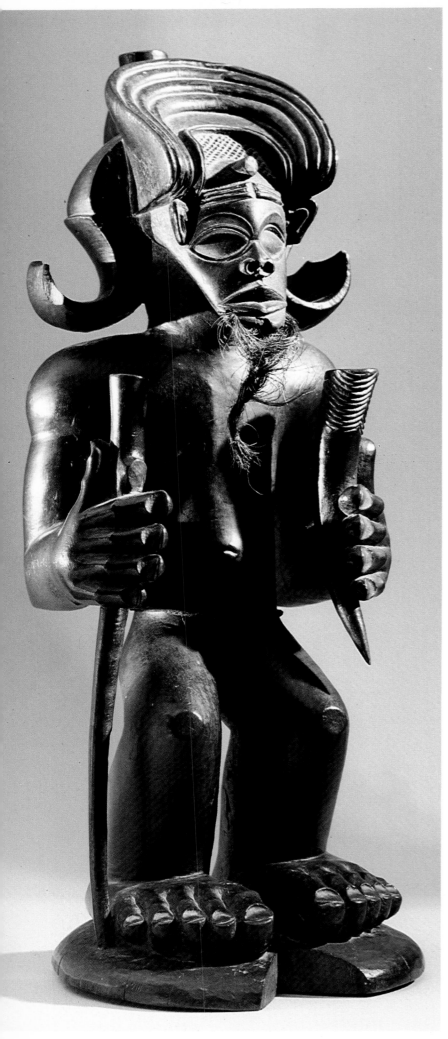

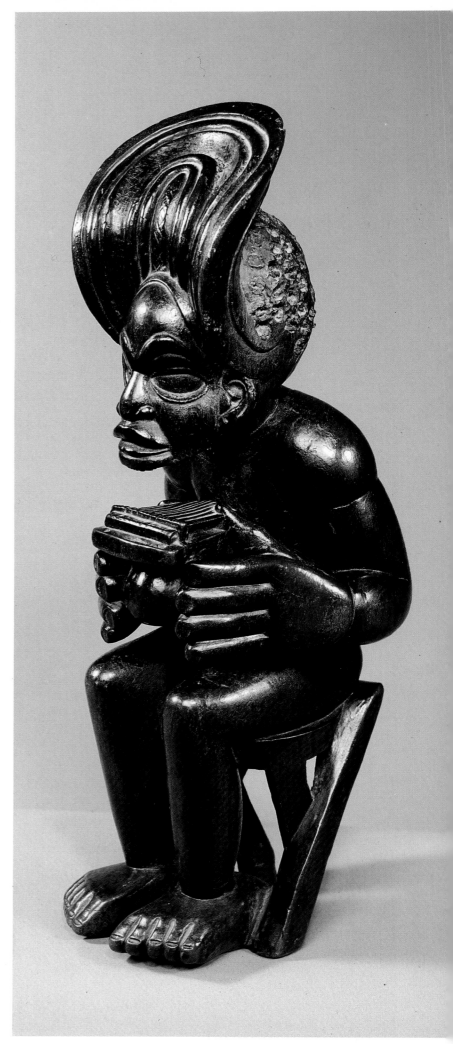

229

230

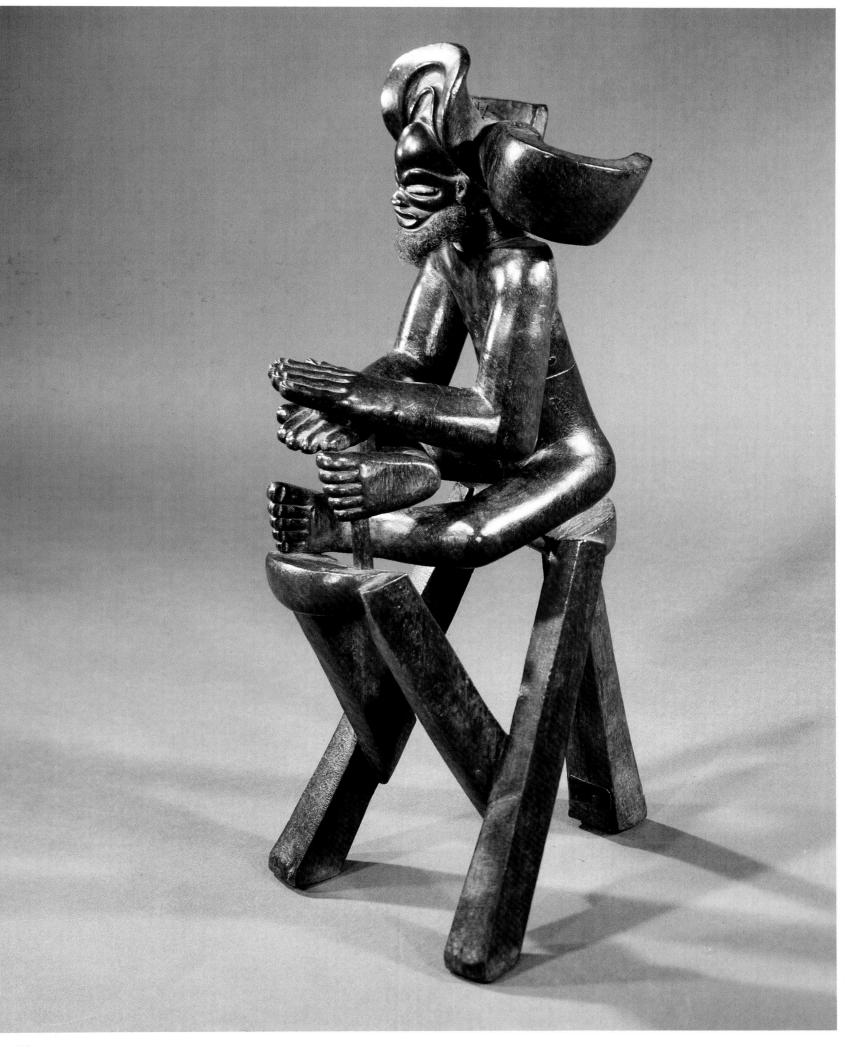

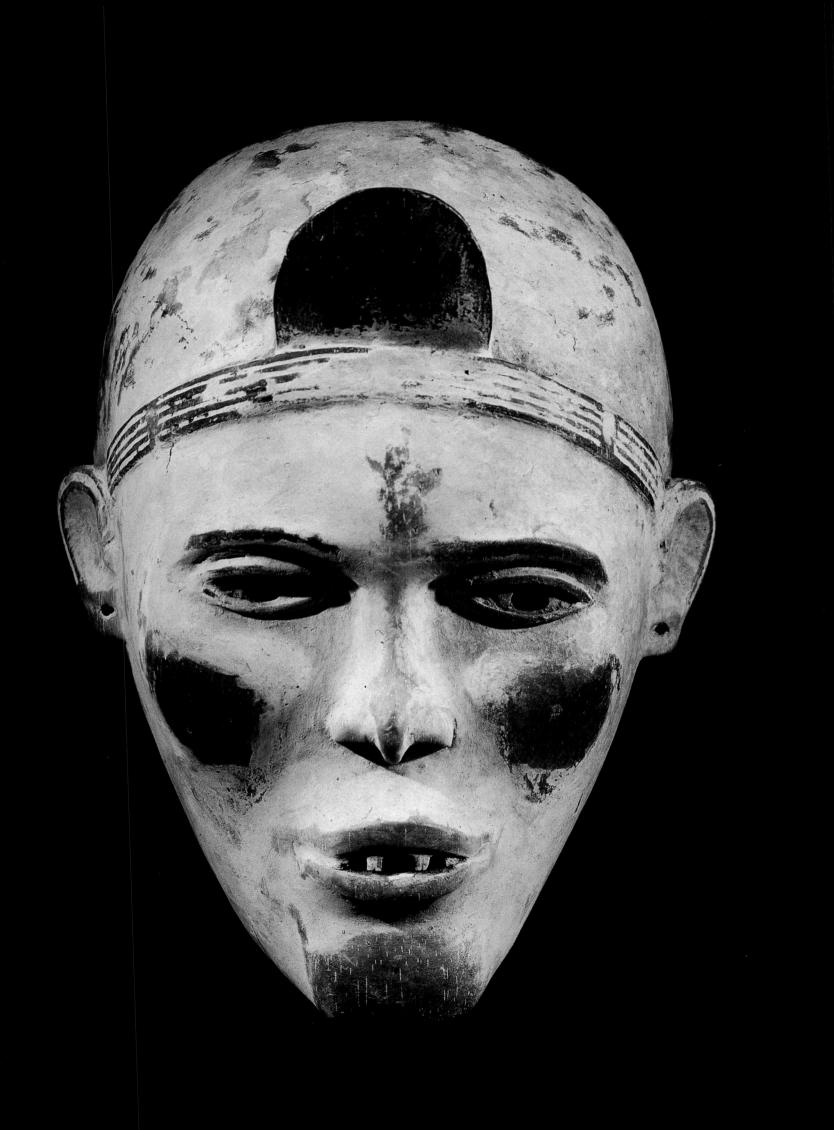

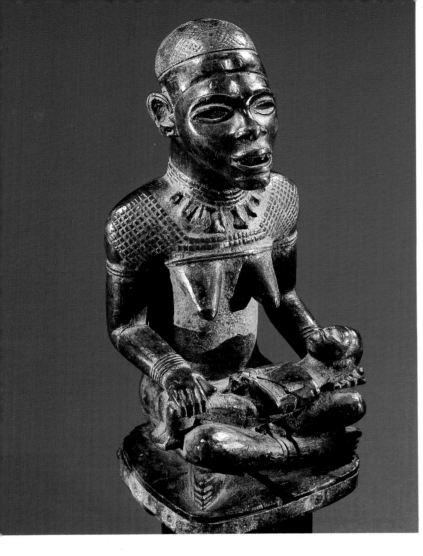

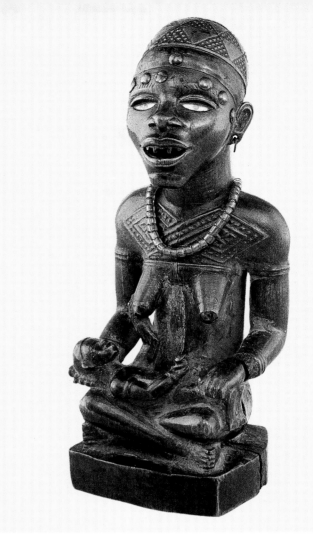

233

234

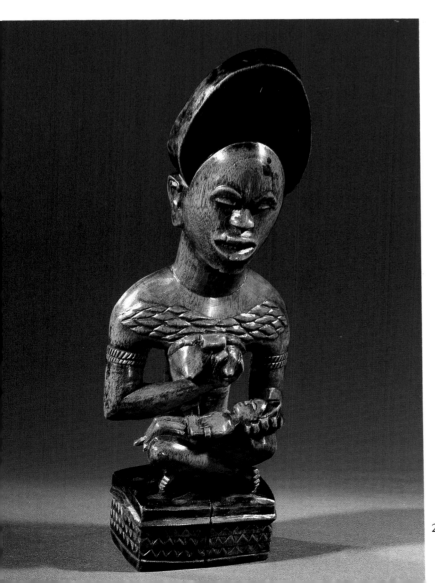

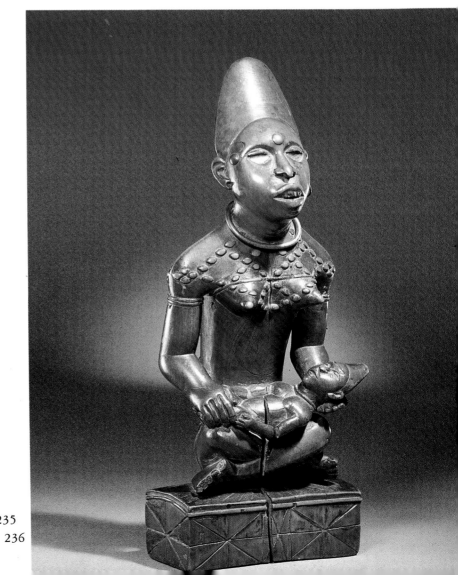

235

236

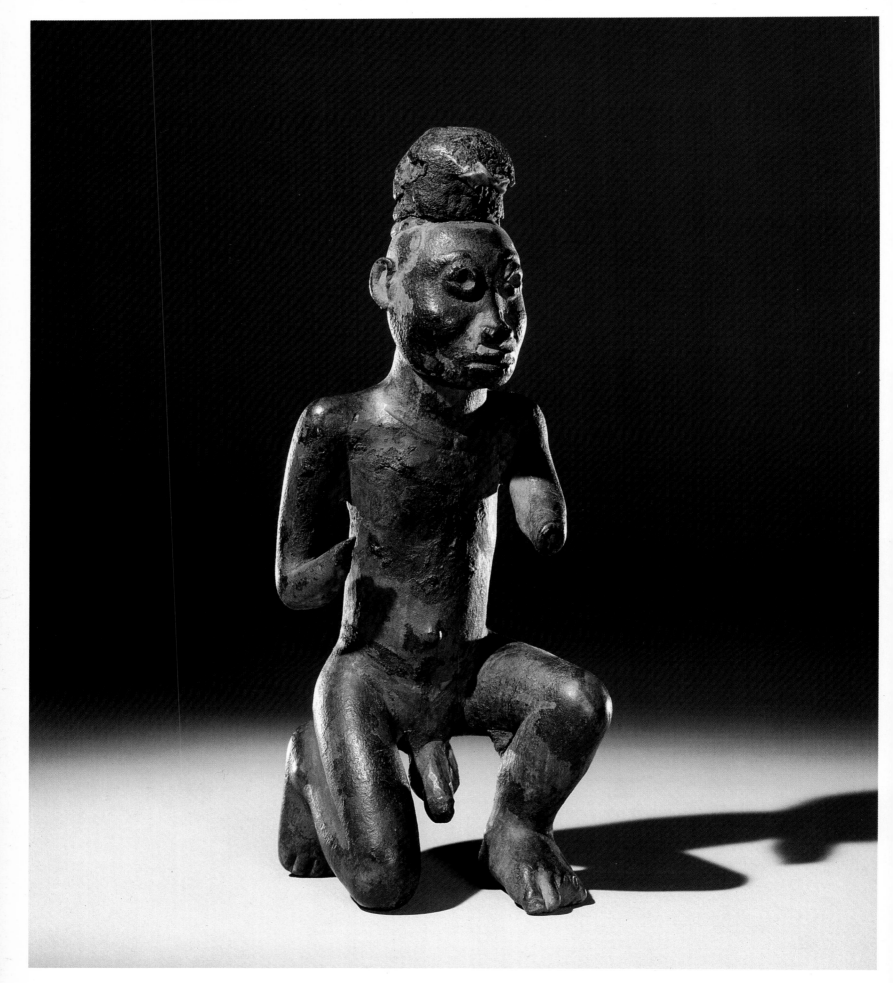

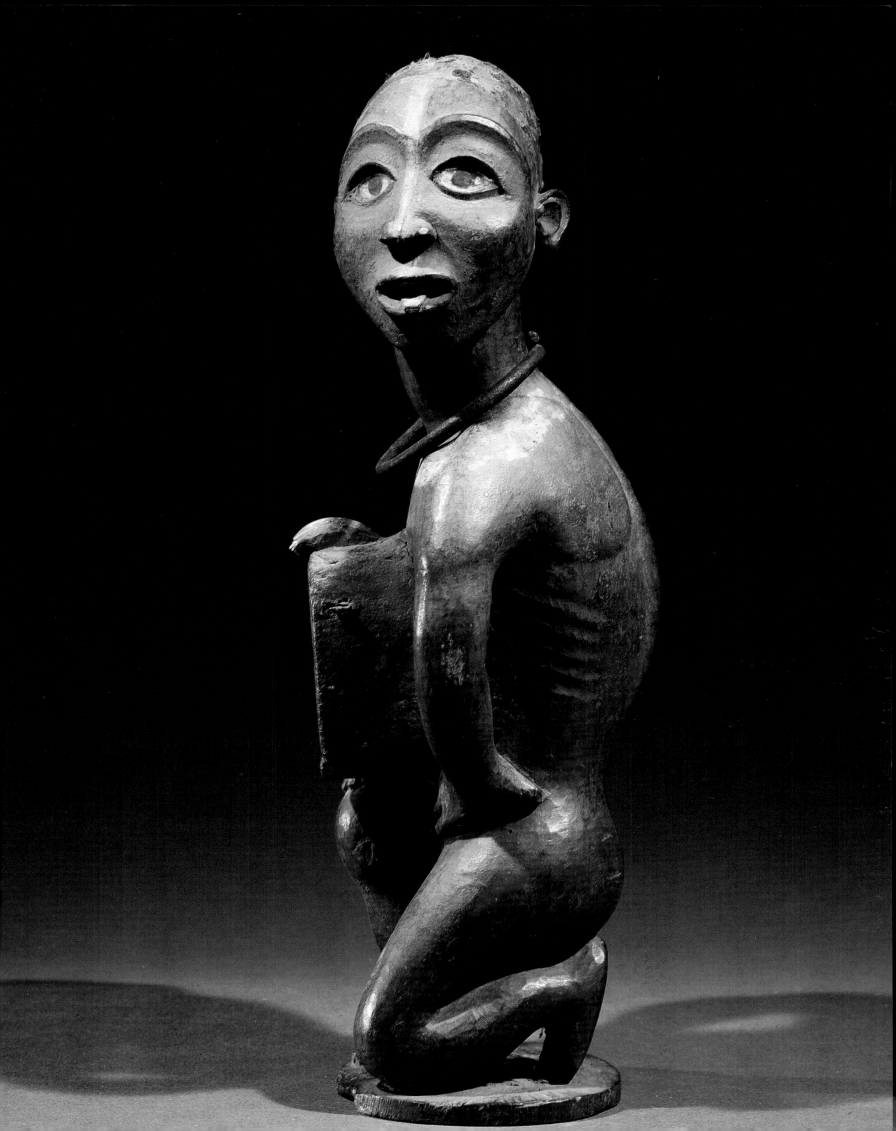

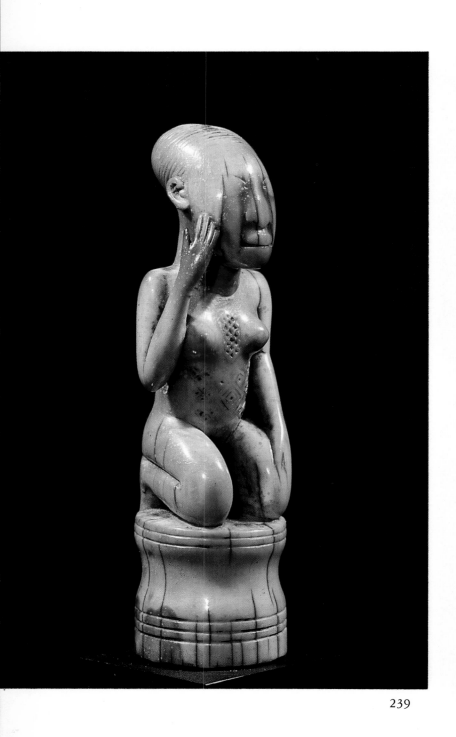

239

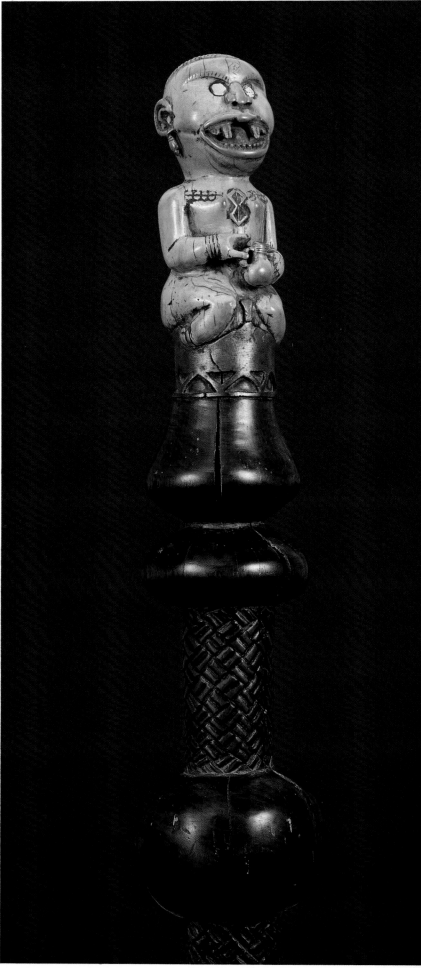

240

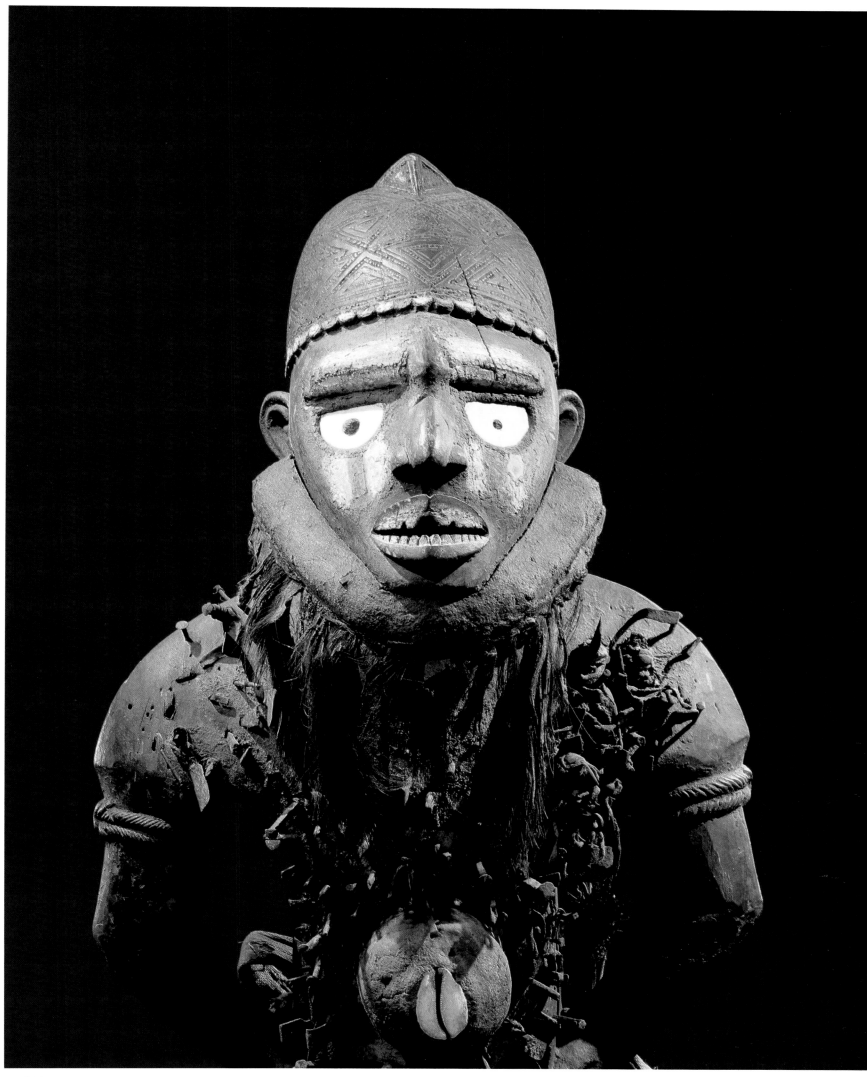

241

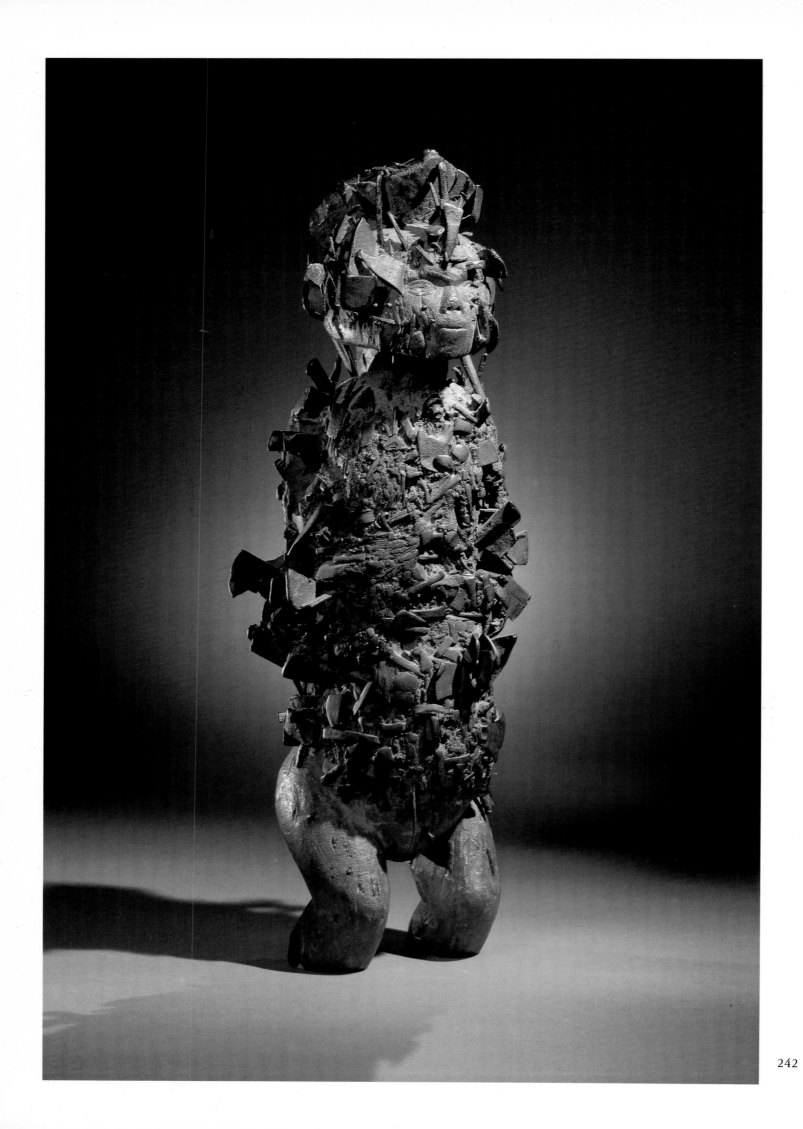

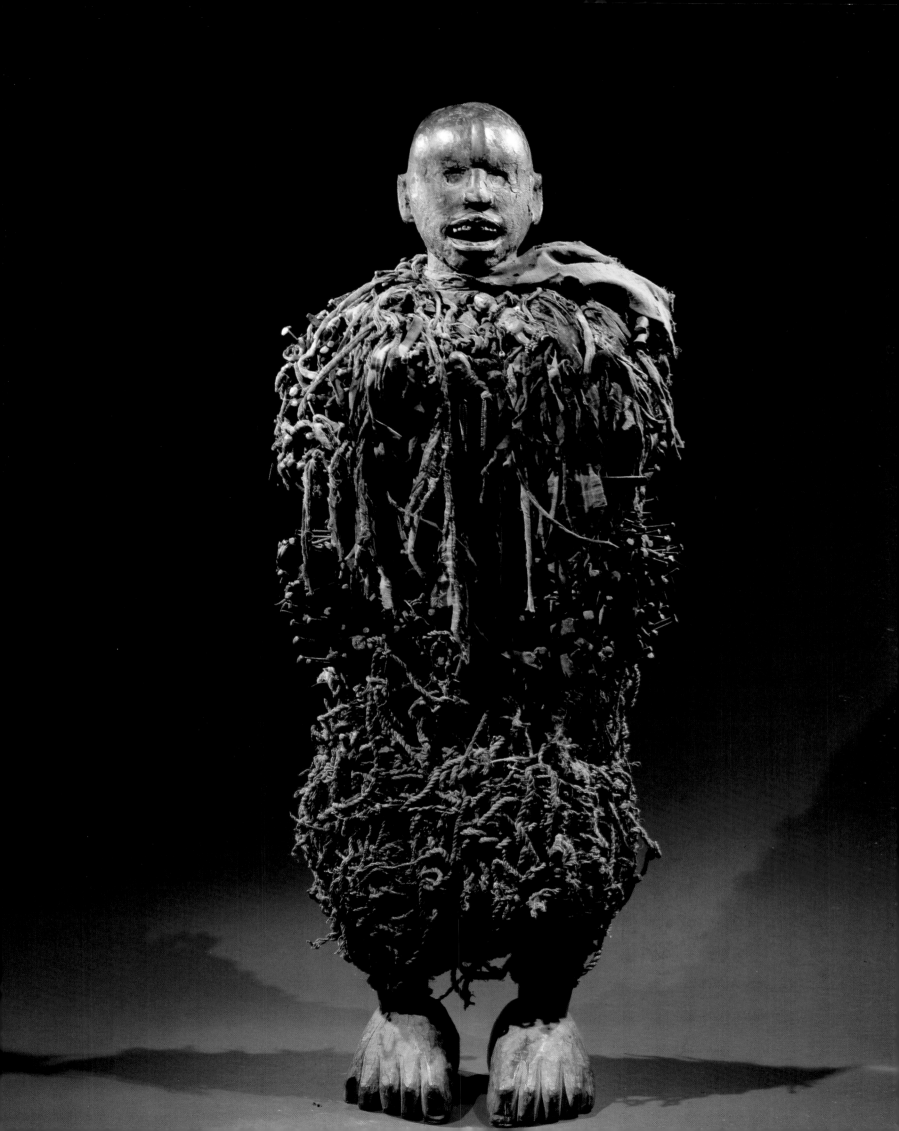

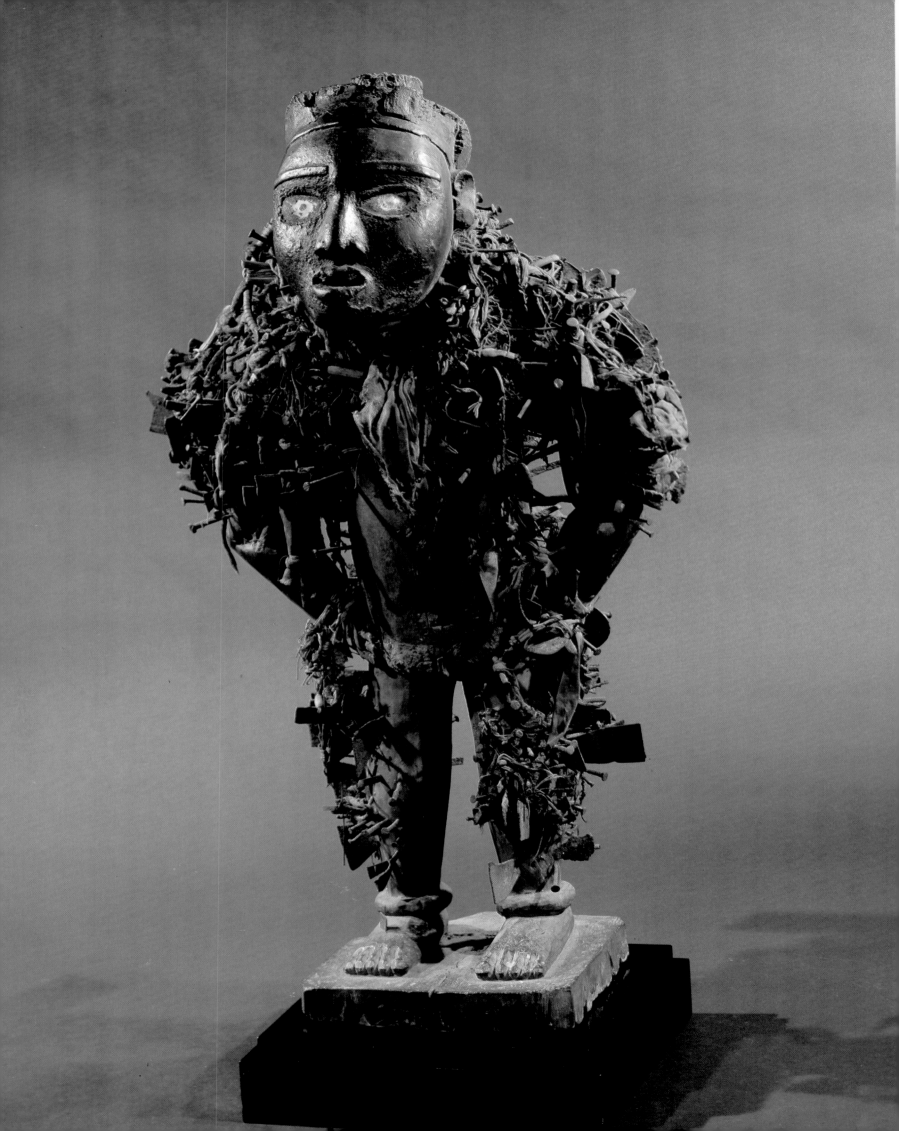

238 Kongo Statue, People's Republic of the Congo or Zaire
Wood. Height: 32.9 cm. Musée Royal de l'Afrique Centrale, Tervuren, Belgium

239 Woyo, Zaire or Angola
Ivory. Height of the figure: 15.5 cm. Private collection

240 Royal Scepter, Kongo, Zaire
Ivory. 19th century. Height: 78.7 cm. Paul and Ruth Tishman Collection

241 Yombe Fetish, People's Republic of the Congo
Detail. Wood, nails, strips, fabric, fibers, mirror. Height: 114 cm. Musée Royal de l'Afrique Centrale, Tervuren, Belgium

242 Vili Fetish with Nails, People's Republic of the Congo
Wood and nails. 18th century. Height: 59.7 cm. Private collection; formerly F. Fénéon, P. Guillaume, S. Chauvet collections

243 Yombe Fetish with Nails, Mayombe, People's Republic of the Congo
Wood, fibers, nails. Height: 117 cm. Musée Royal de l'Afrique Centrale, Tervuren, Belgium

244 Kongo Fetish, People's Republic of the Congo
Wood and nails. 19th century. Height: 80 cm. Private collection

245 Sakalava Funerary Post, Madagascar
Wood. 19th century. Height: 210 cm. Musée de l'Homme, Paris

246 Makonde Water Pipe, Northeast,
Mavia Region, Mozambique
Wood, coconut, bamboo, terra-cotta. 19th century. Height: 27 cm. Private collection

247 Zulu Statue, South Africa
Wood. Height: 62 cm. Wellcome Collection, Museum of Mankind, London

248 Konso Funerary Post, Ethiopia
Wood. 18th century (?). Height: 213 cm. Private collection

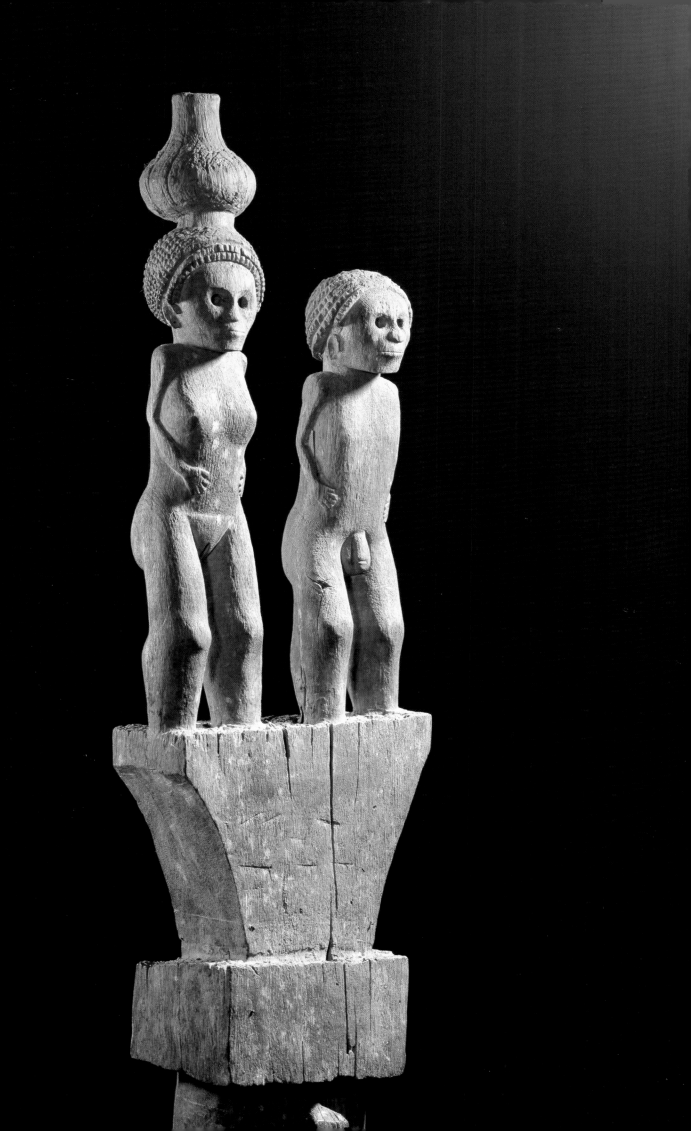

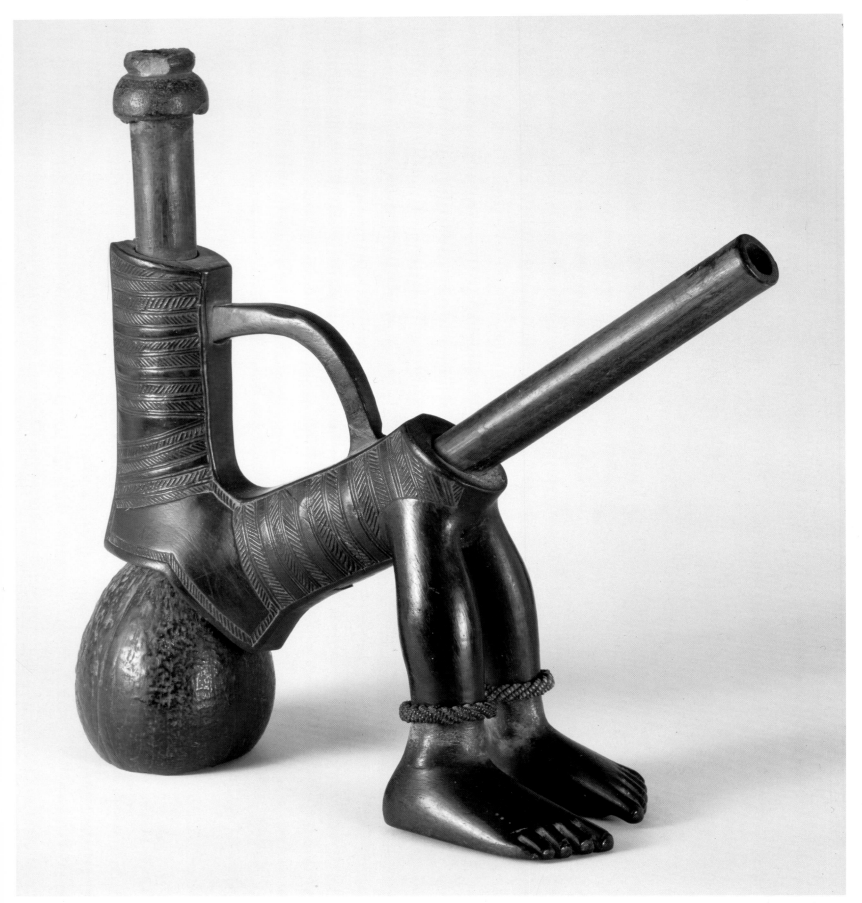

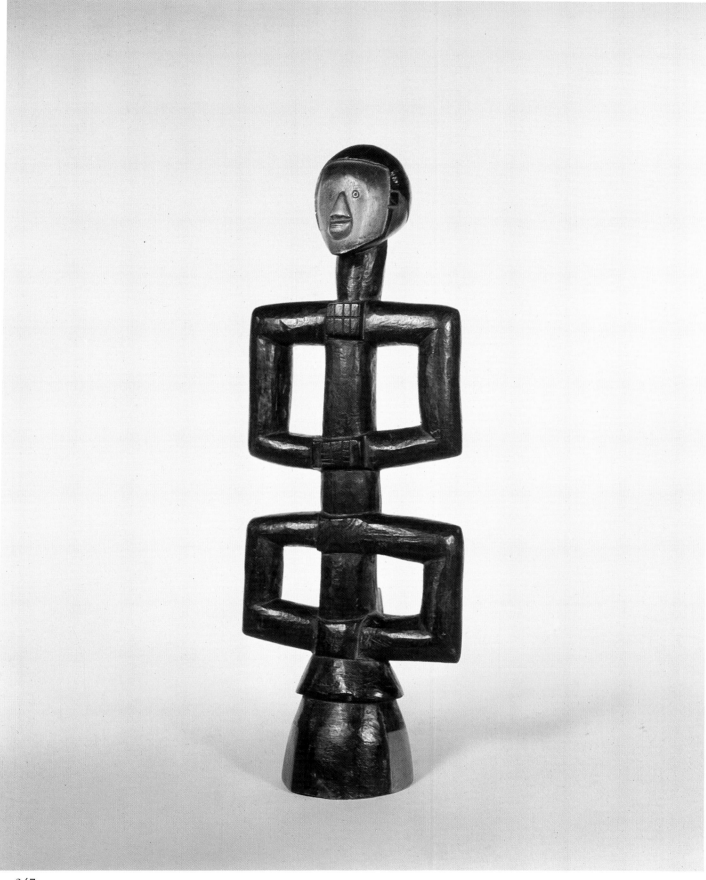

247

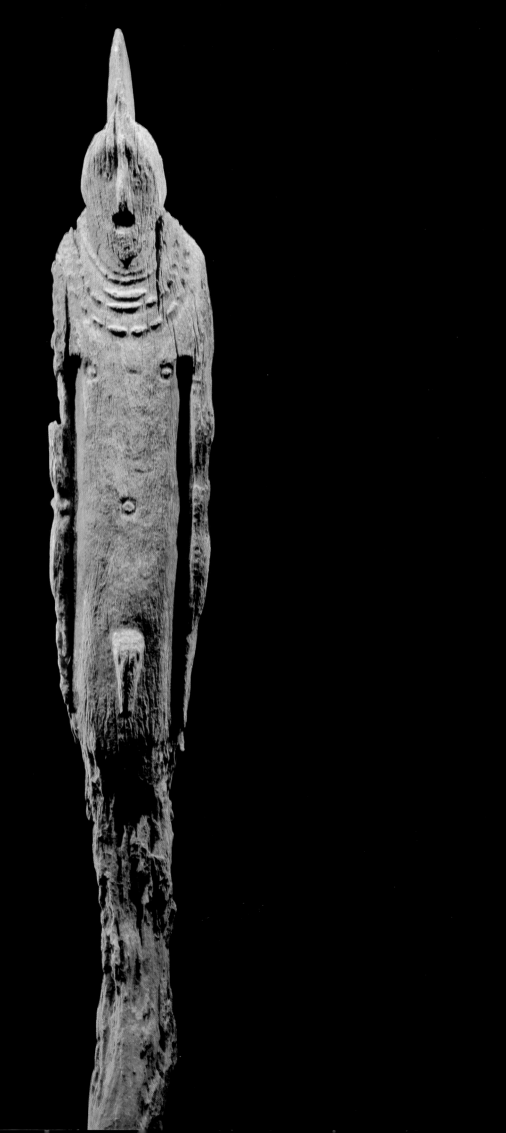

DOCUMENTS

PART TWO African Art: The Golden Age

THE WESTERN SUDAN
AND
THE COAST OF GUINEA

Djenne and the Inner Niger Delta.
Tellem. Dogon. Bamana (Bambara).
Turka. Bozo. Mossi. Bobo. Bwa.
Gurunsi. Kulango. Senufo. Lobi.
Nalu. Landuman. Mende. Bassa.
Temne. Bissagos. Toma. Mano. Grebo.
We (Gwere). Mao. Dan. Bete.
Guro. Baoule. Yaoure. Anyi. Akye.
Asante. Fon. Anago. Yoruba.

249

250 251

252 253

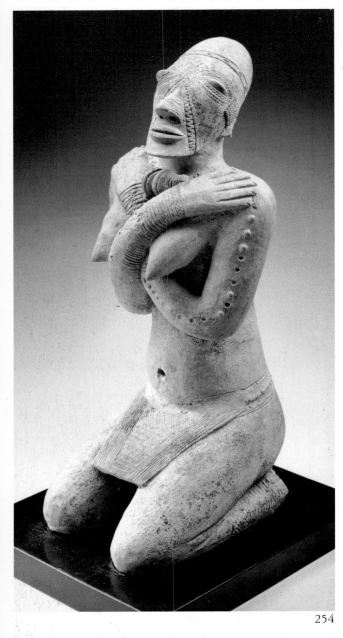

254 255

256 257

258

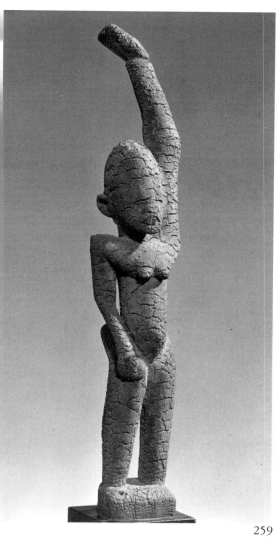

259

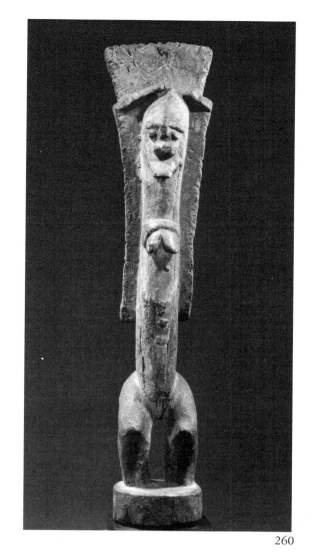

260

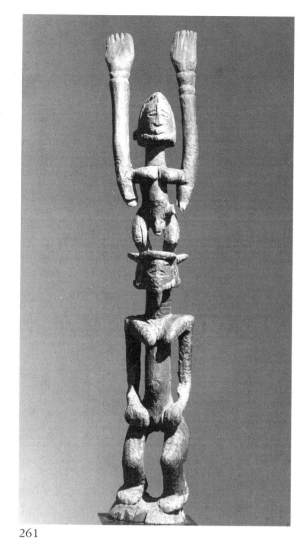

261

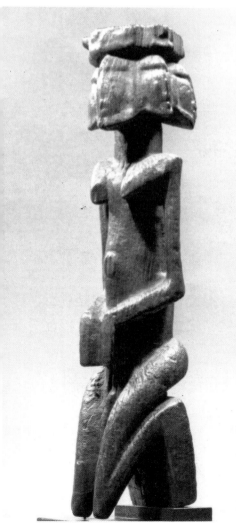

262

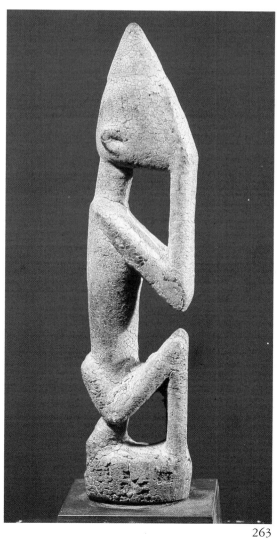

263

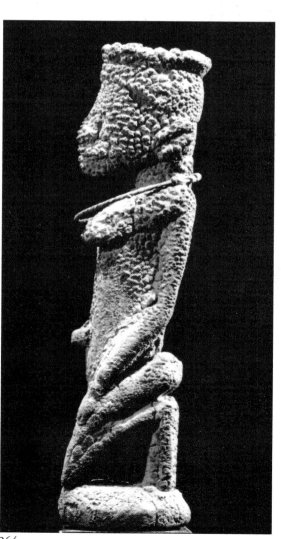

264

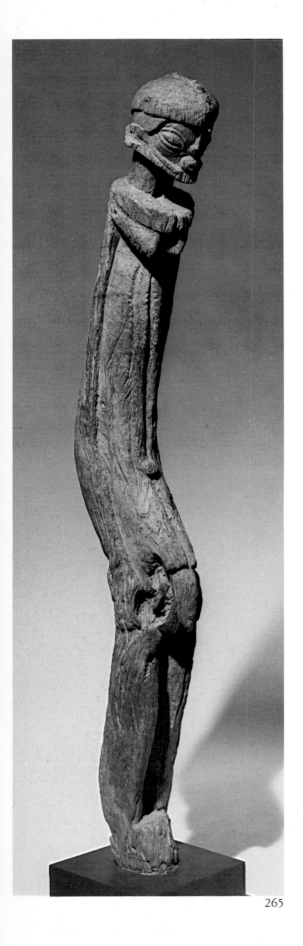

265

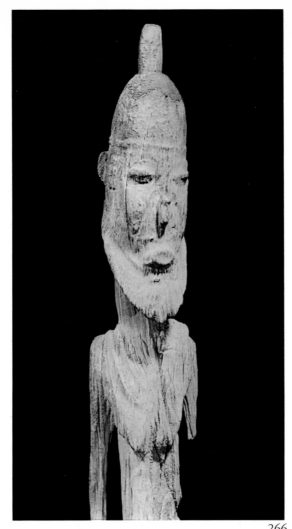

266

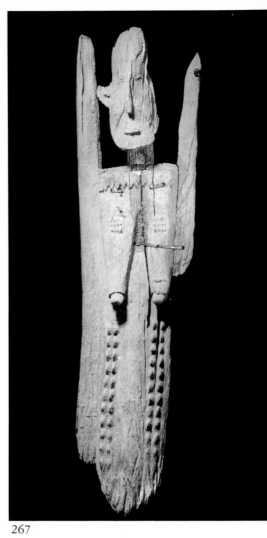

267

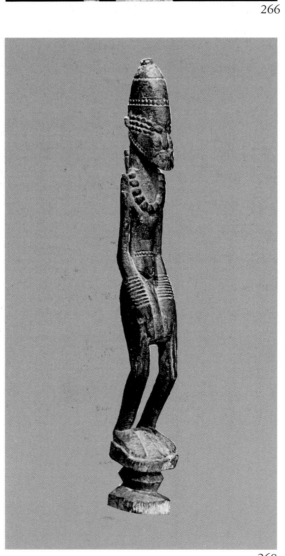

268

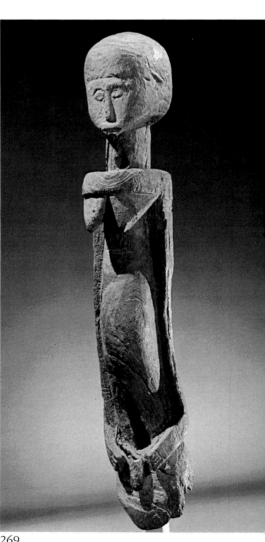

269

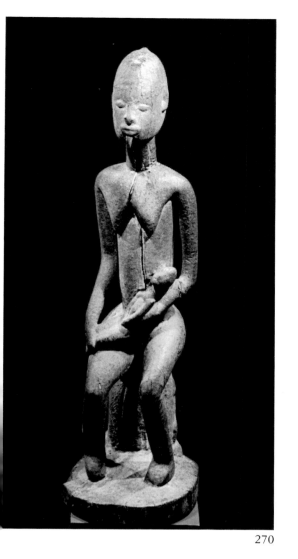

270

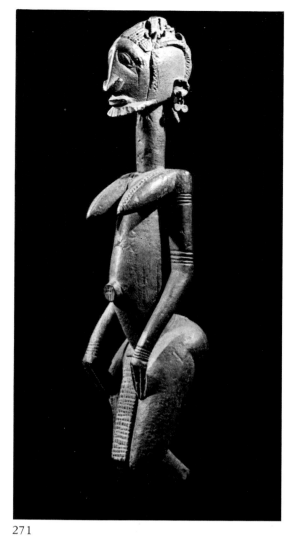

271

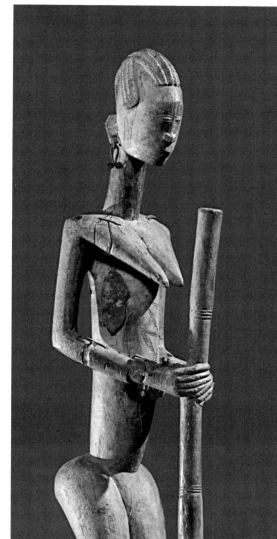

273

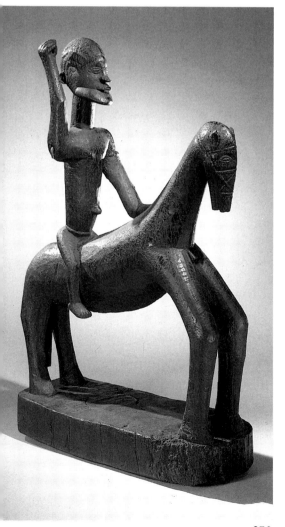

272

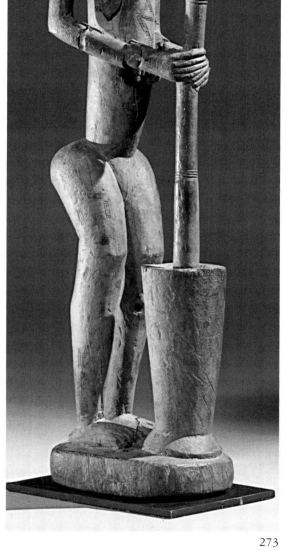

274

365

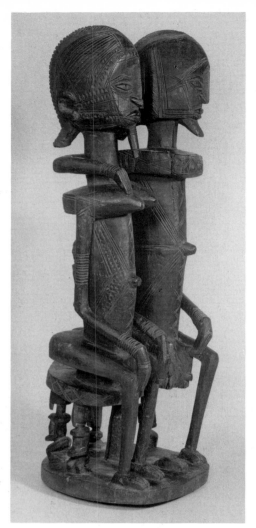

275

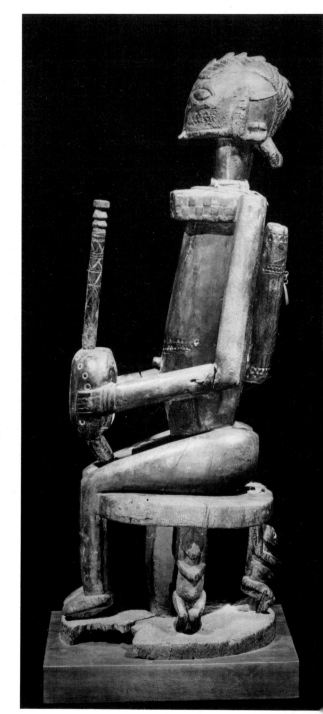

278

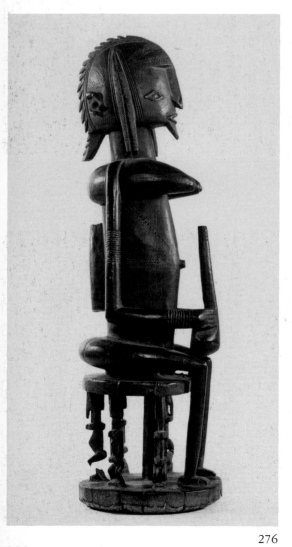

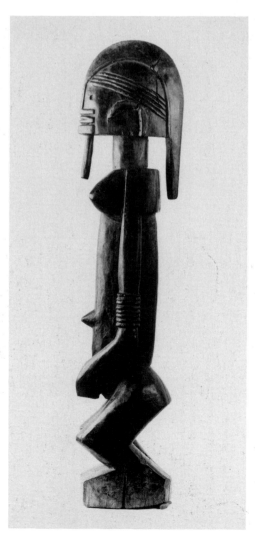

276 277

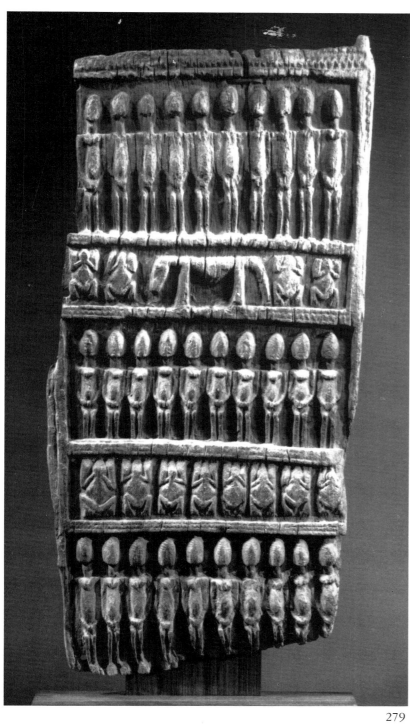

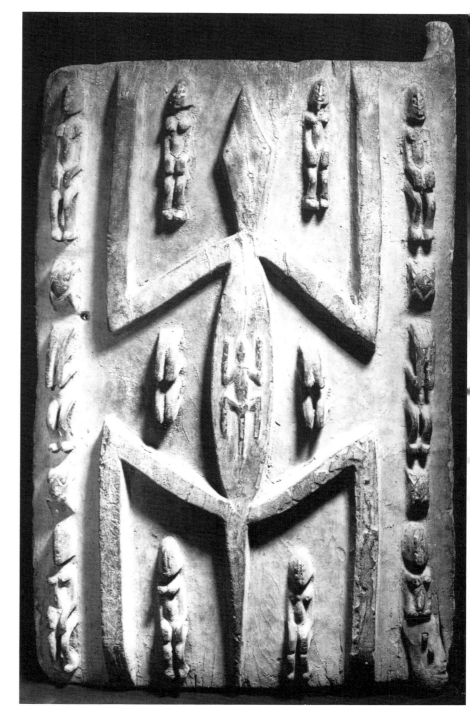

279

280

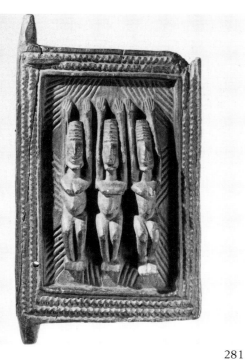

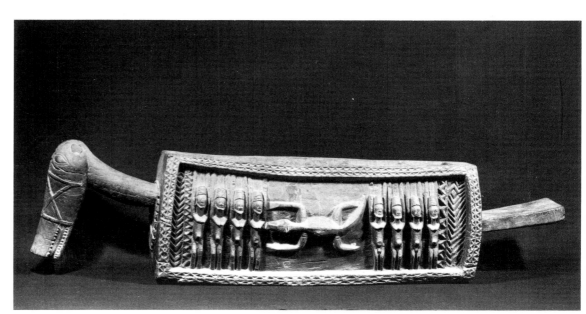

281

282

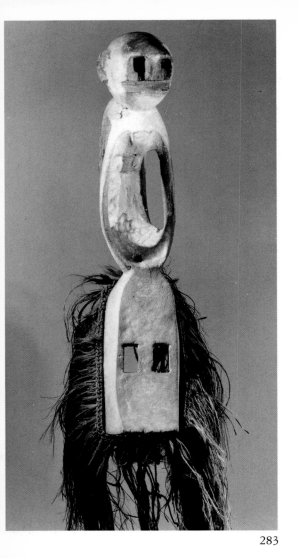

283

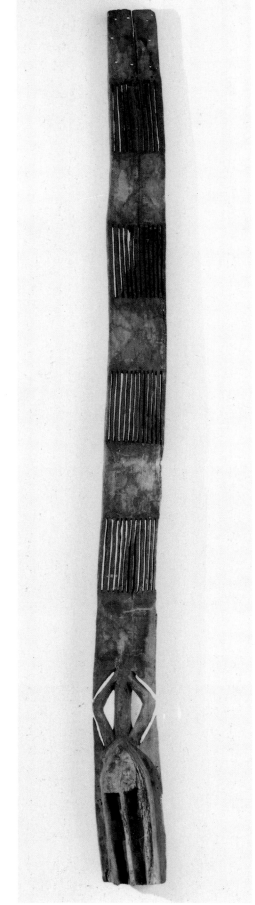

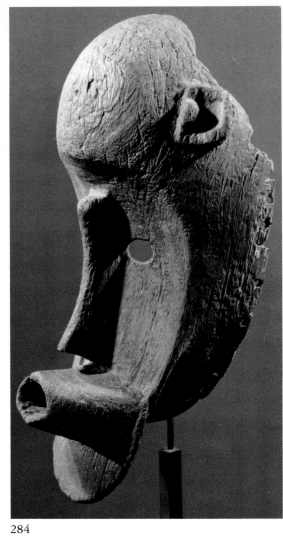

284

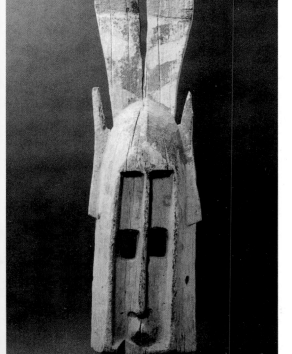

285

286

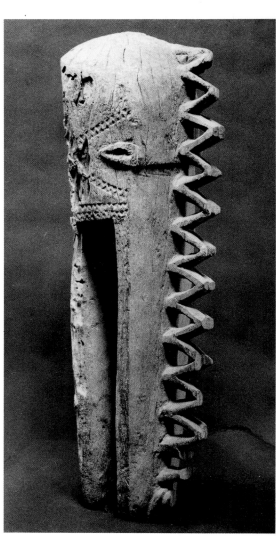

287

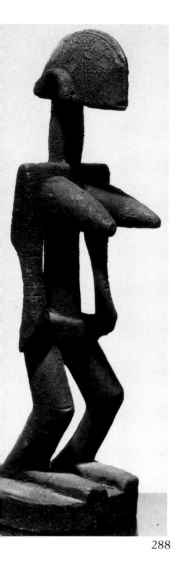
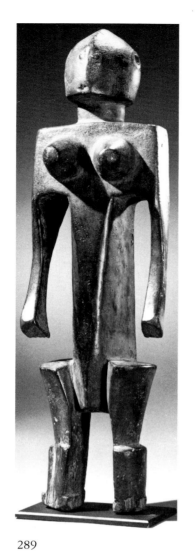
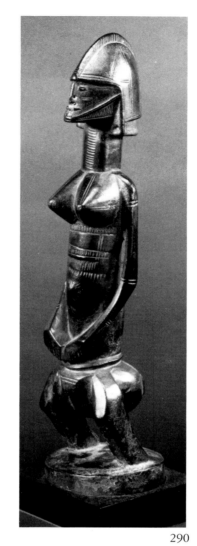
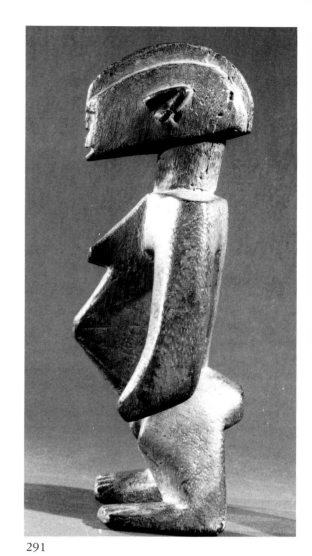

288 289 290 291

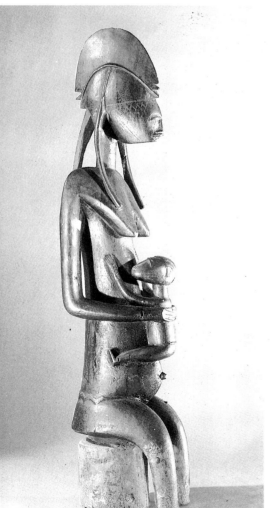
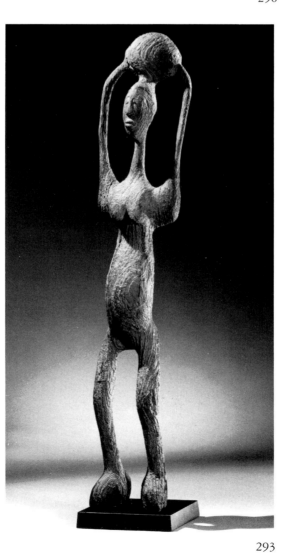
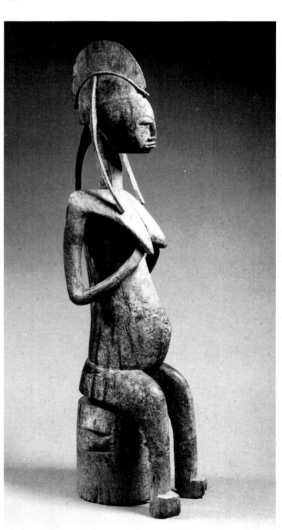

292 293 294

369

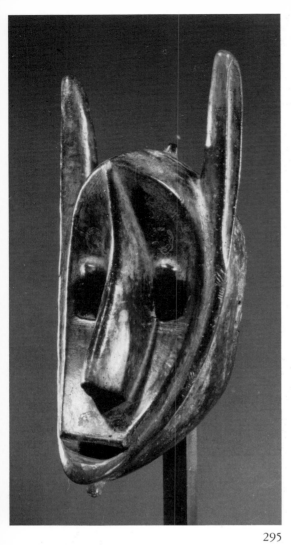

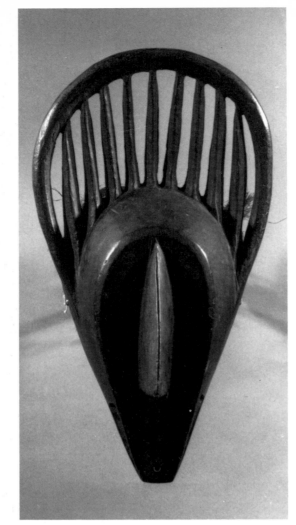

295 296 297

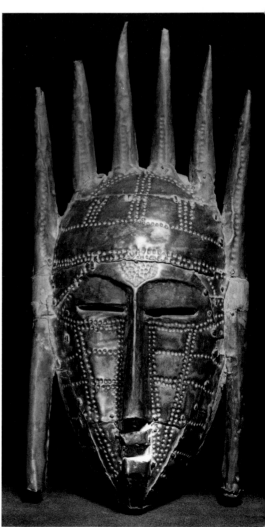

298 299

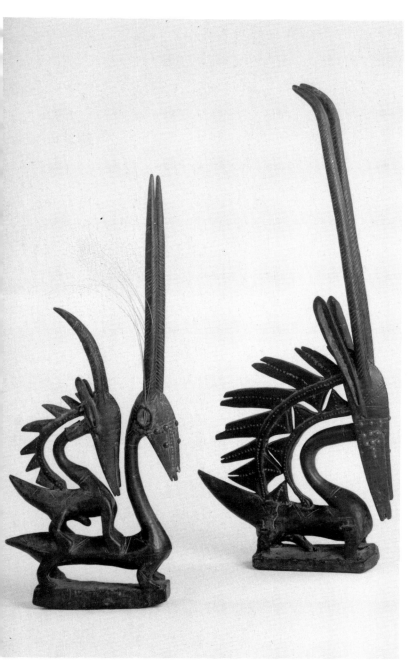

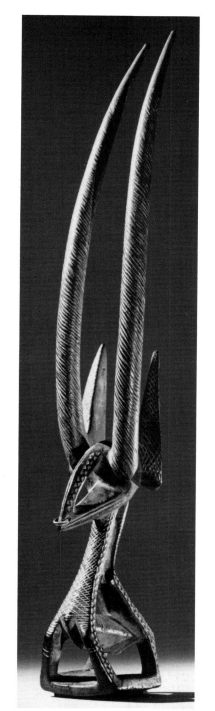

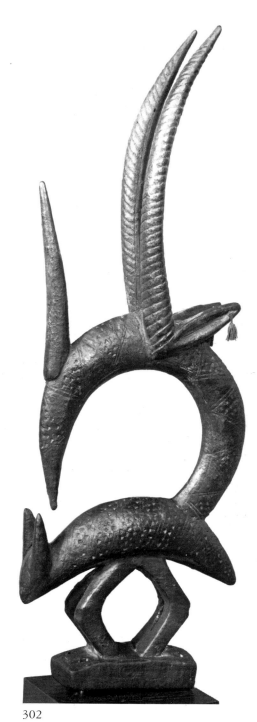

300

301

302

303

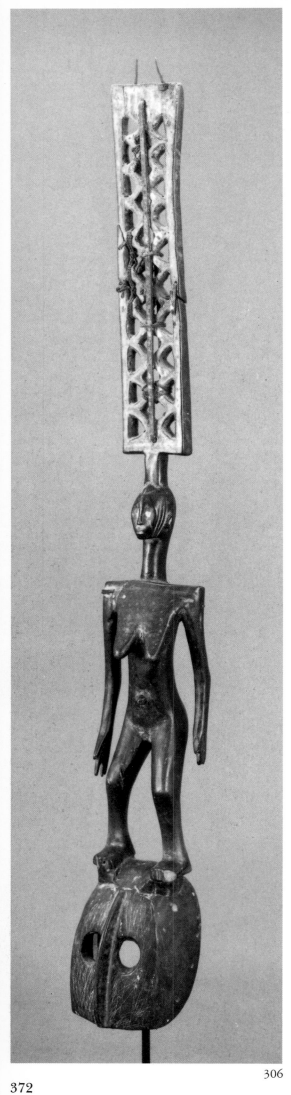

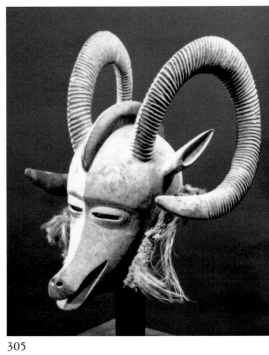

304

305

306

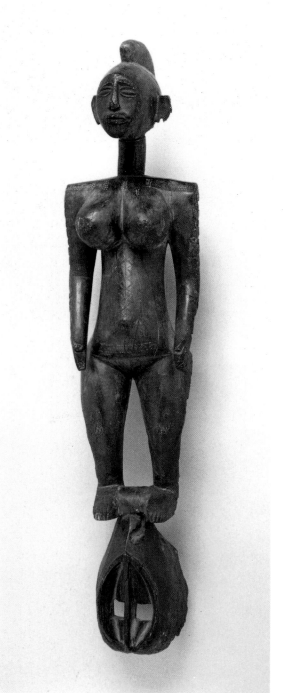

307

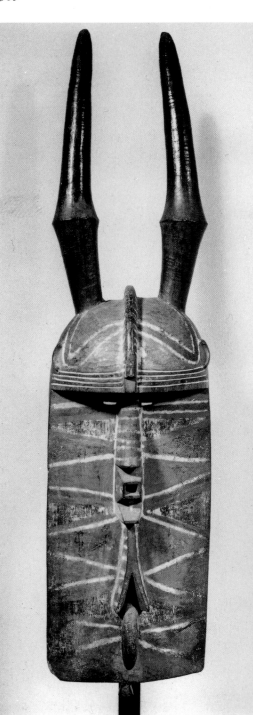

308

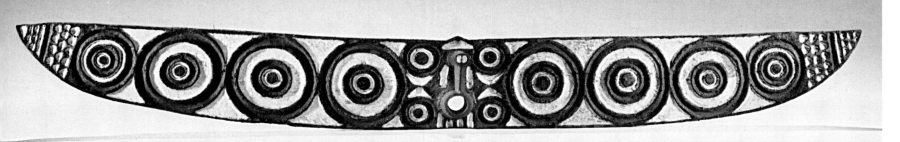

309

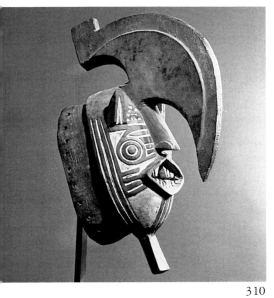

310

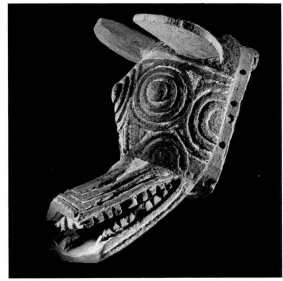

311

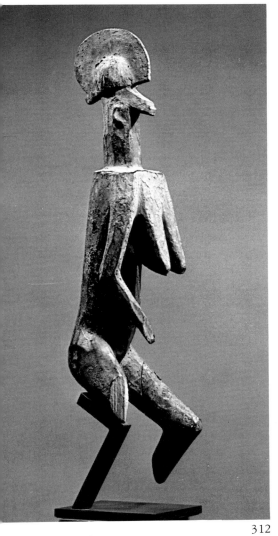

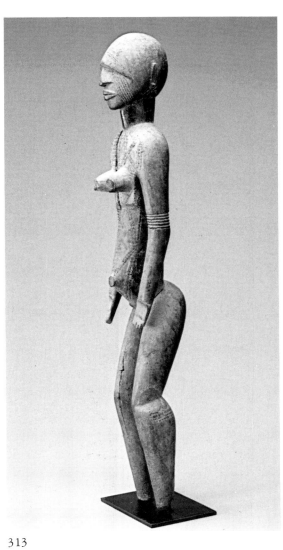

312 313 314

315　　　　316　　　　　　　　　　　317

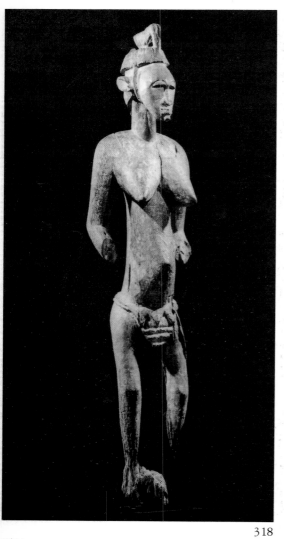
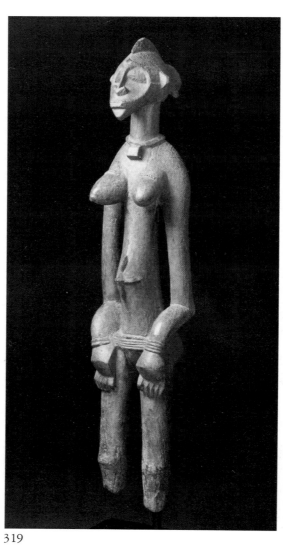
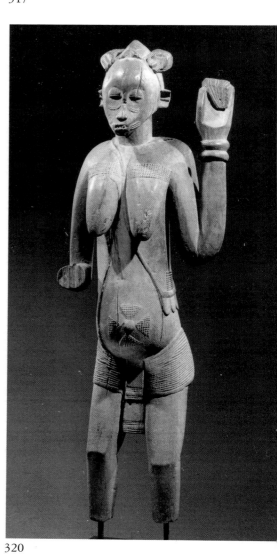

318　　　　319　　　　　　320

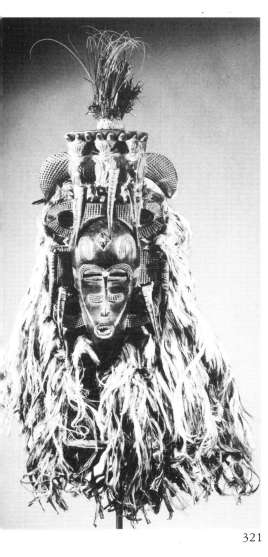

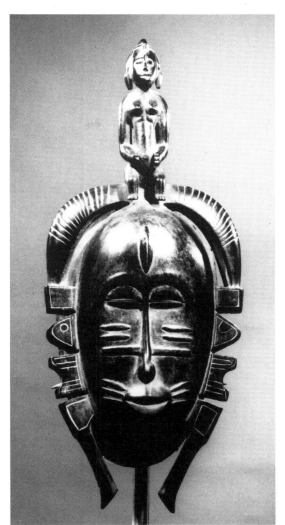

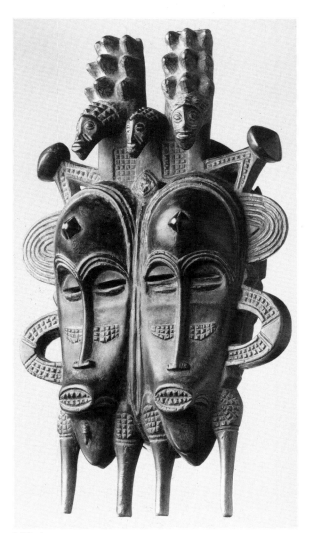

321

322

323

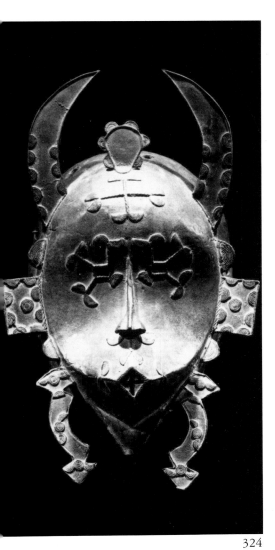

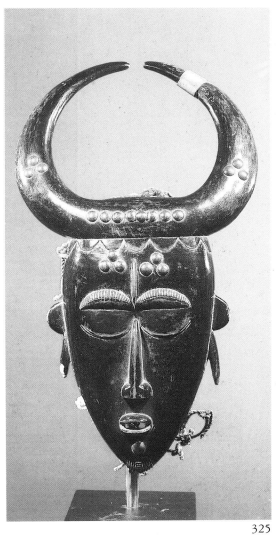

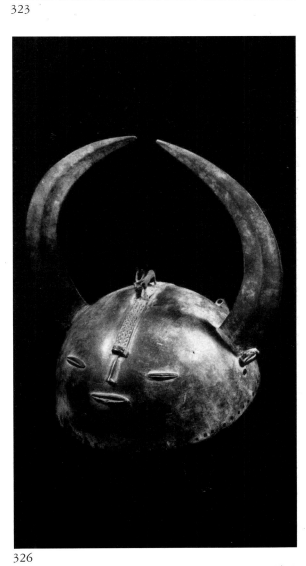

324

325

326

327 328 329

330 331 332

376

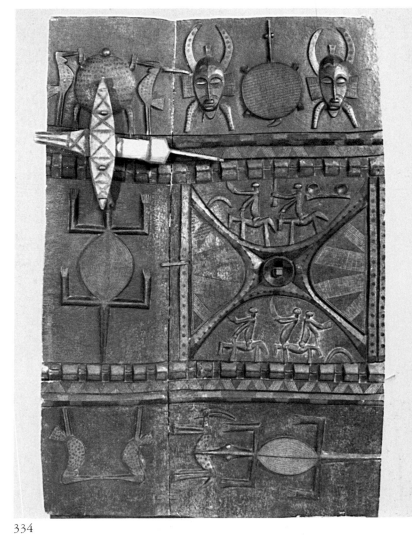

333 334

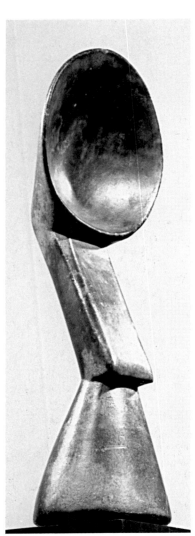

335 336 337

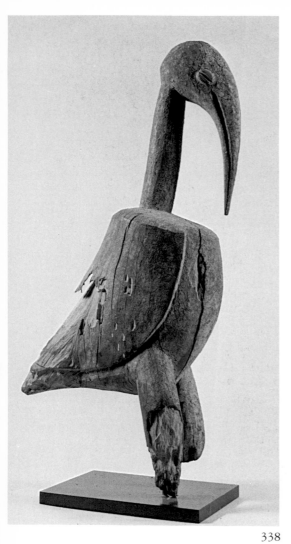

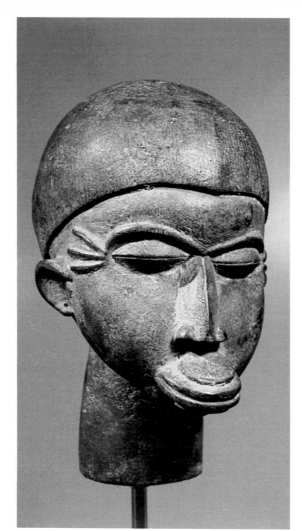

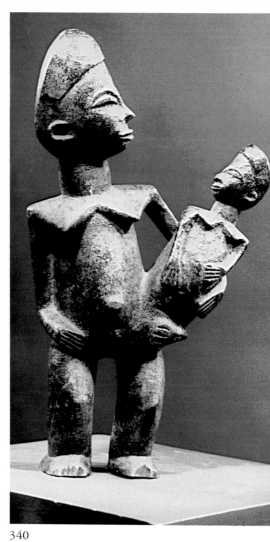

338 339 340

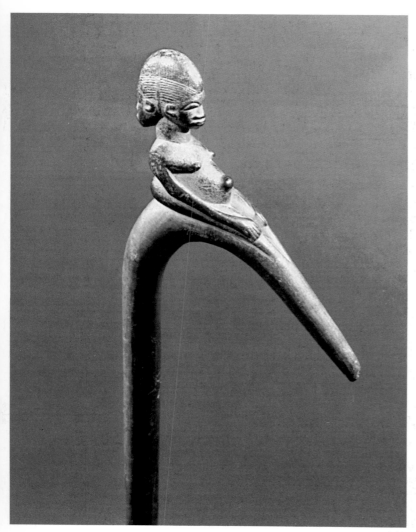

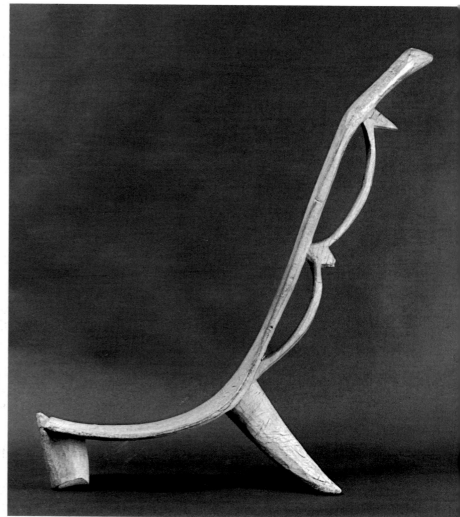

 341 342

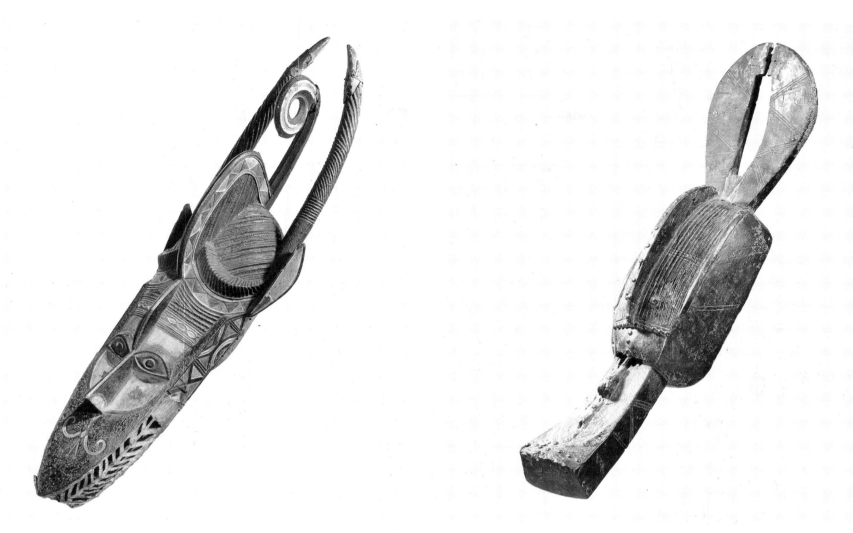

343 344

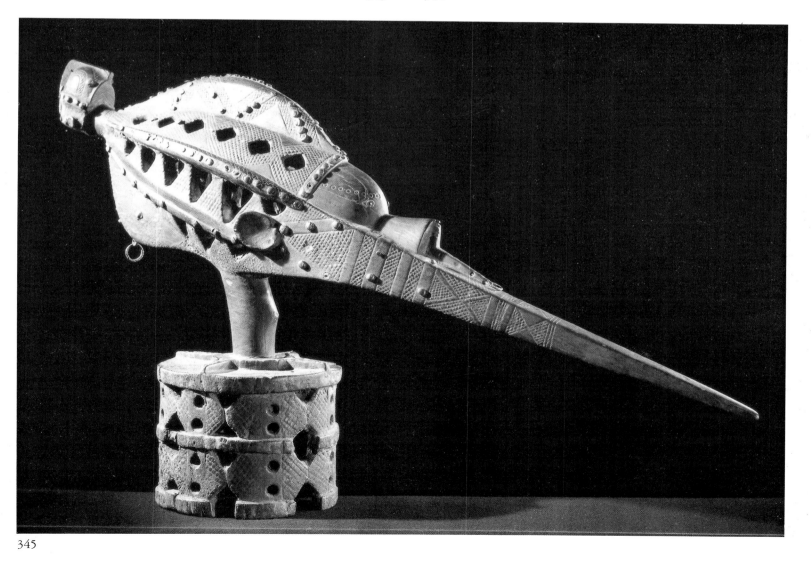

345

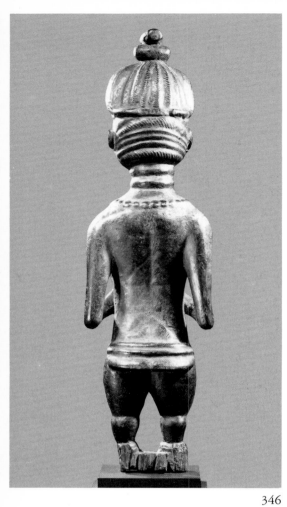

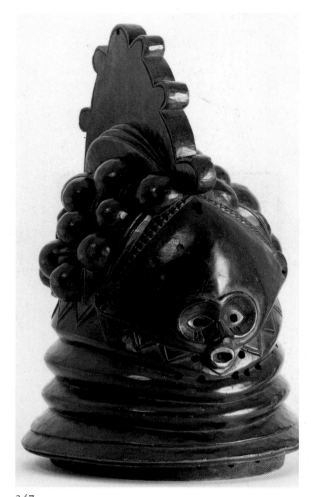

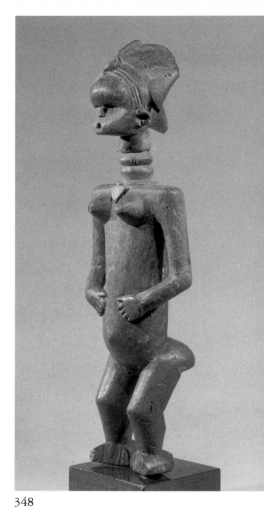

346 347 348

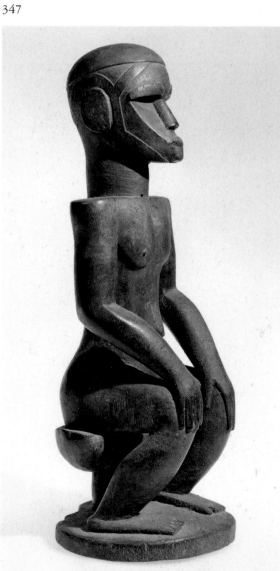

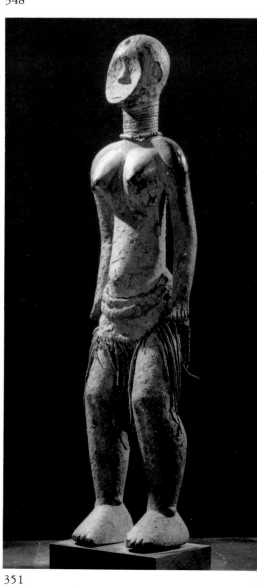

349 350 351

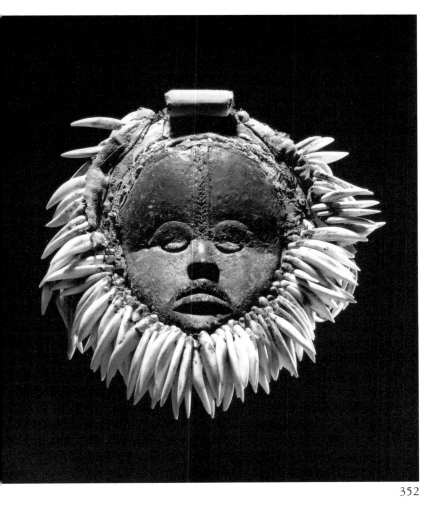
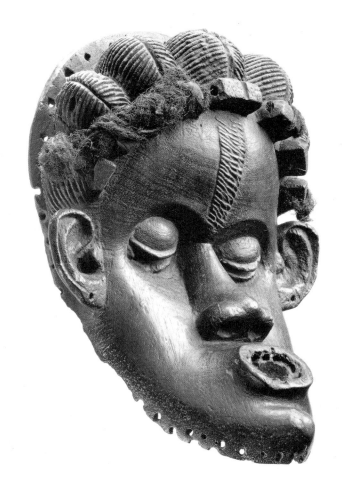

352 353

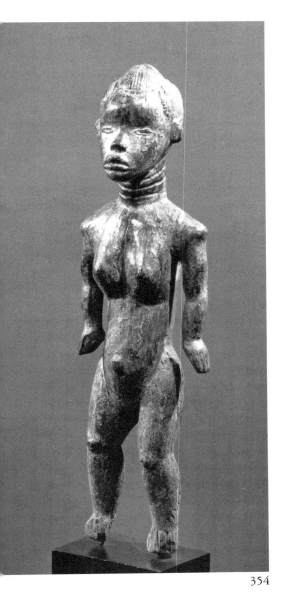
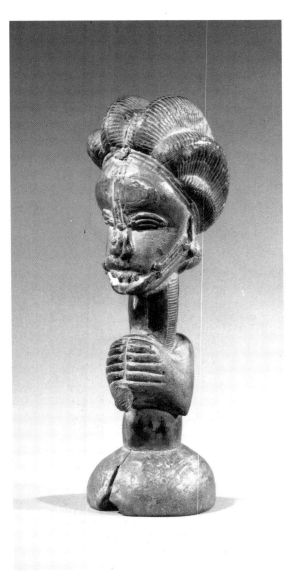
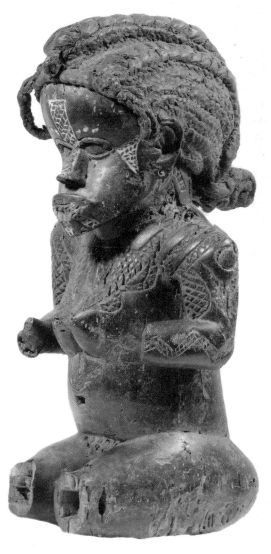

354 355 356

381

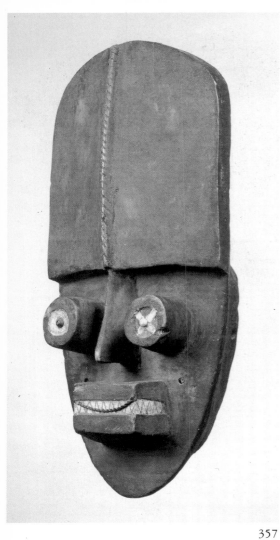
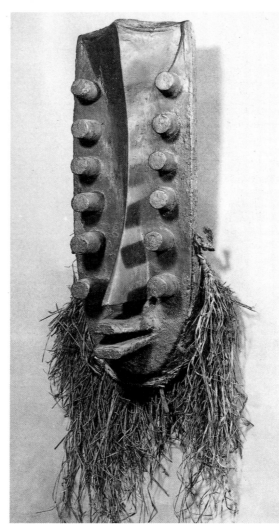
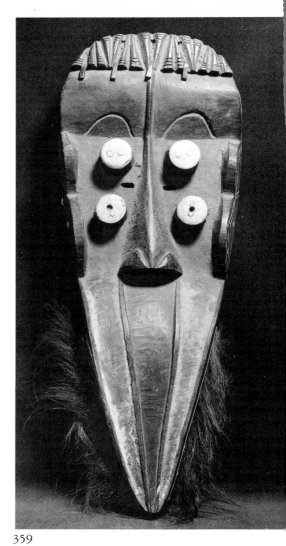

357 358 359

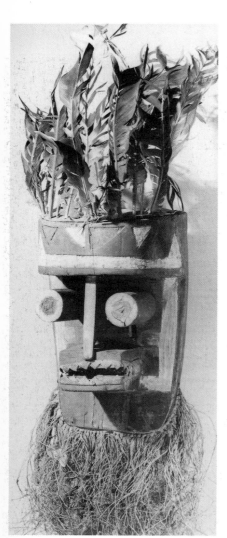
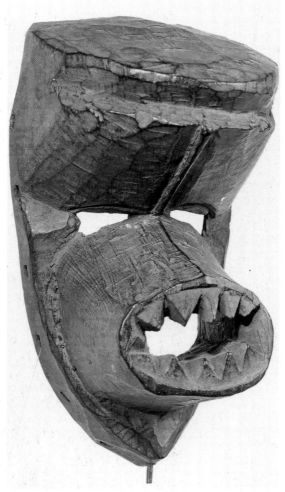
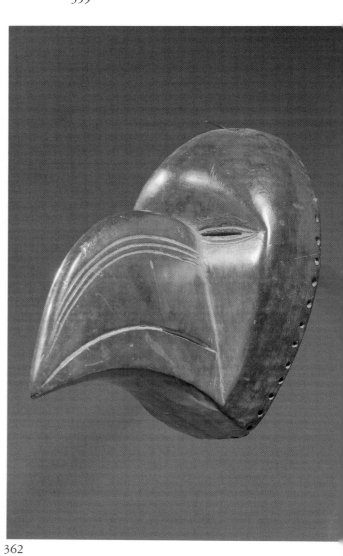

360 361 362

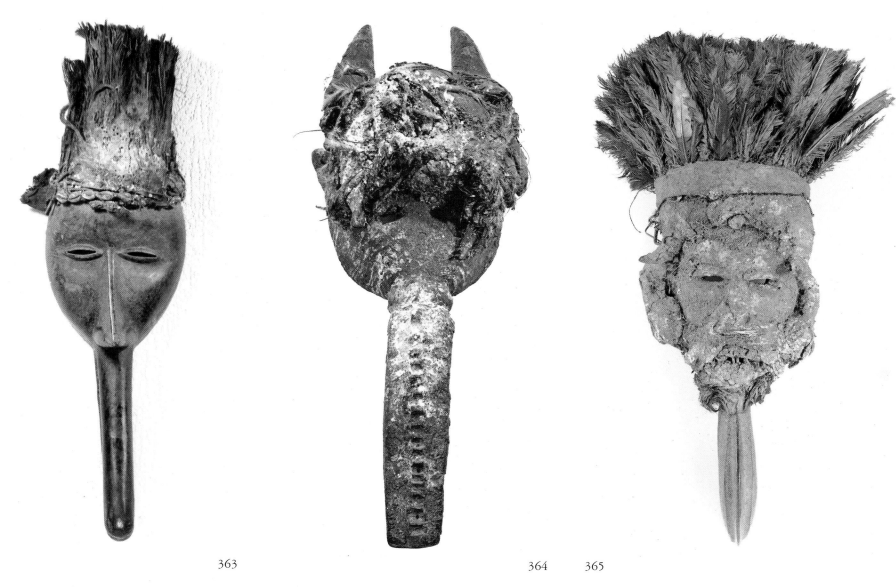

363

364 365

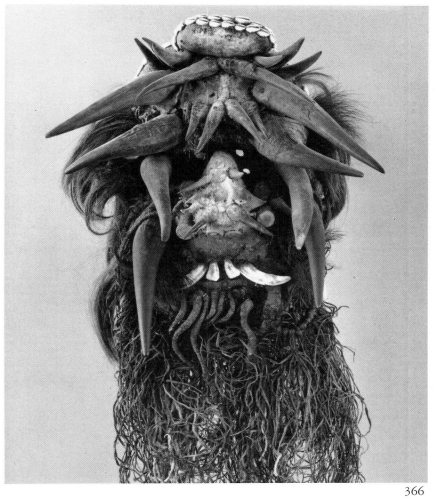

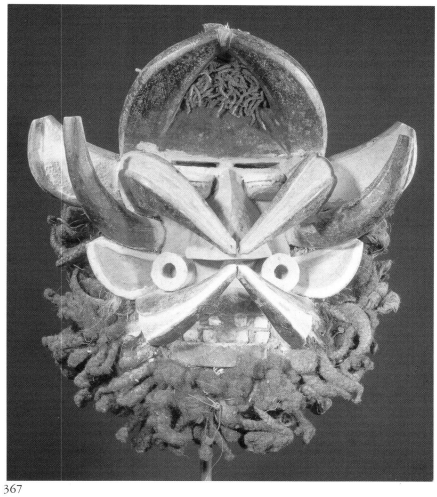

366 367

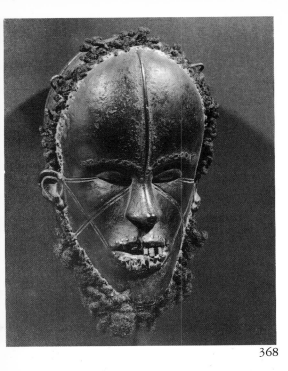

368

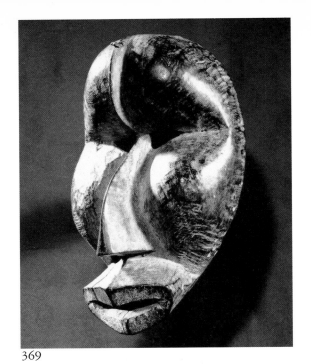

369

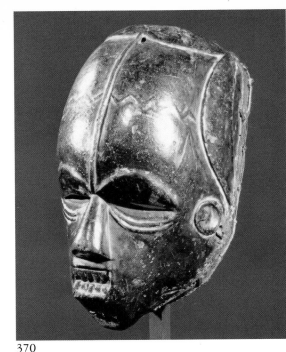

370

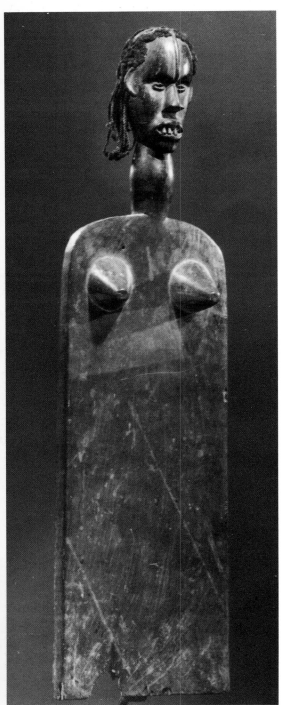

371

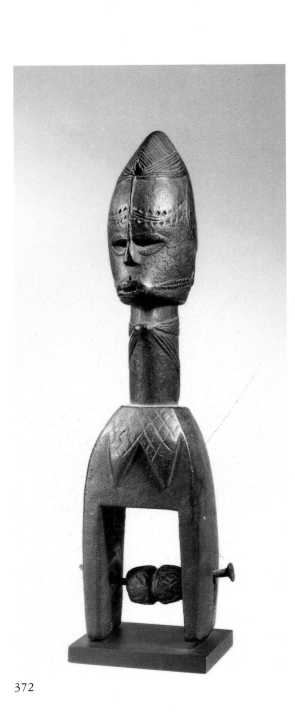

372

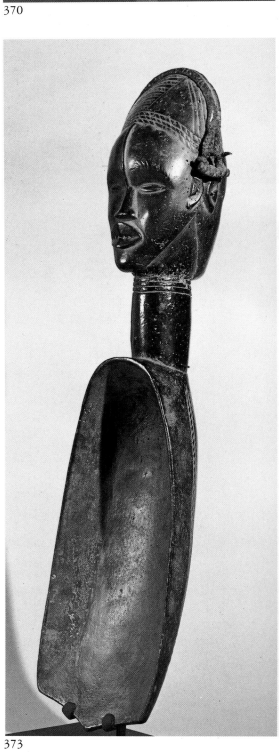

373

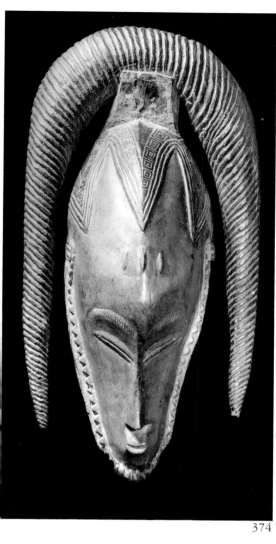

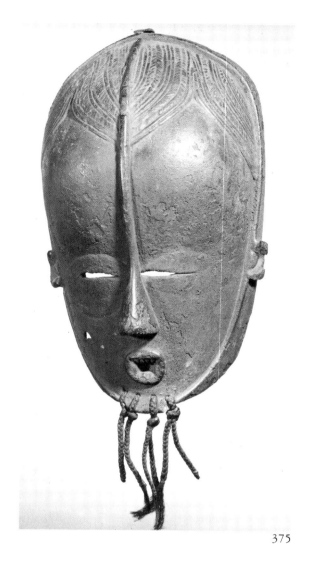

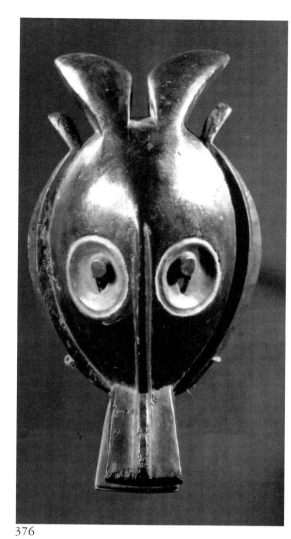

374

375

376

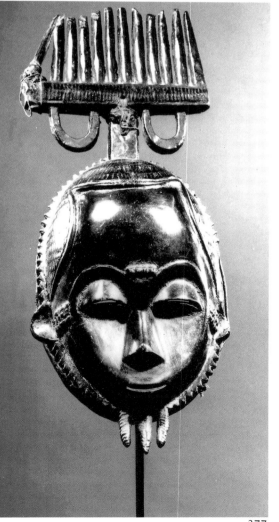

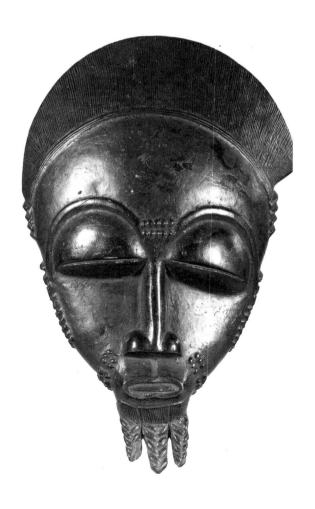

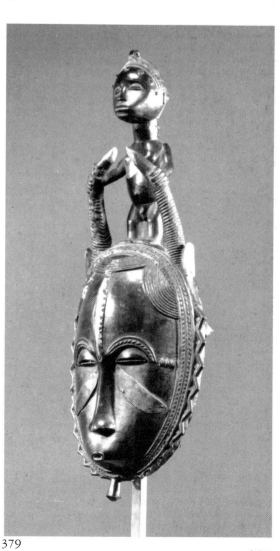

377

378

379

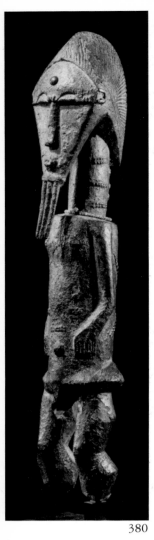

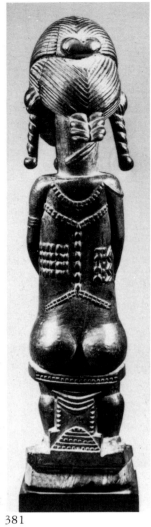

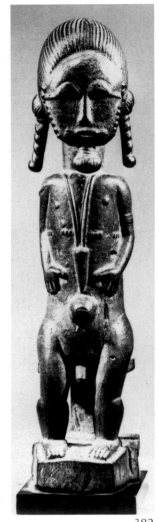

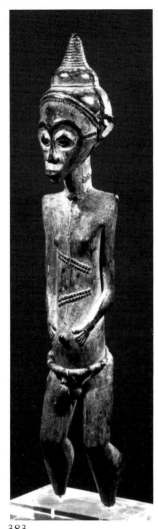

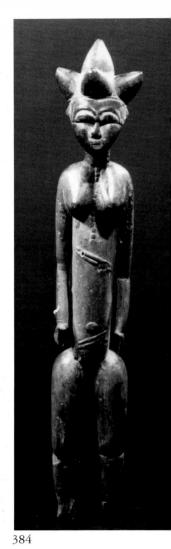

380 381 382 383 384

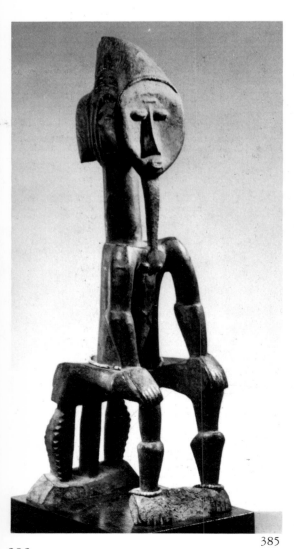

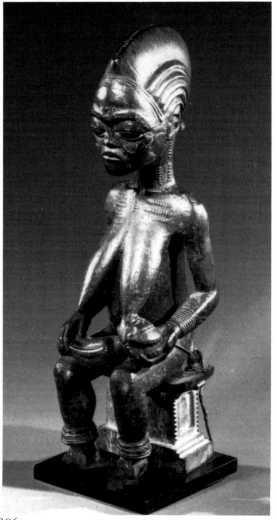

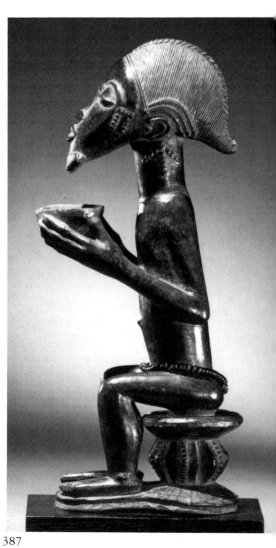

385 386 387

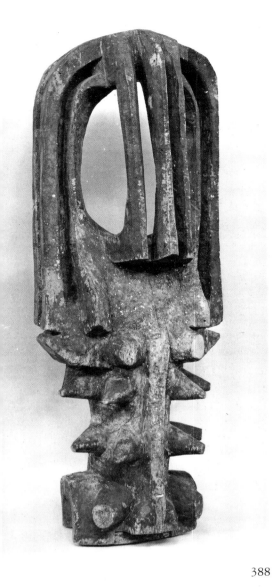

388

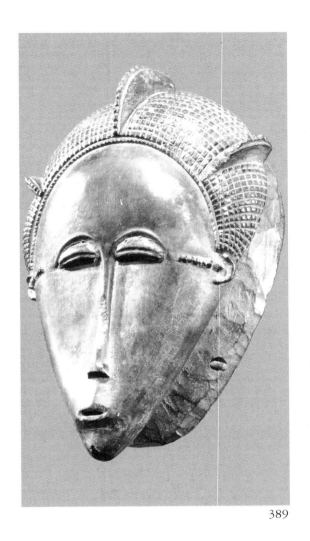

389

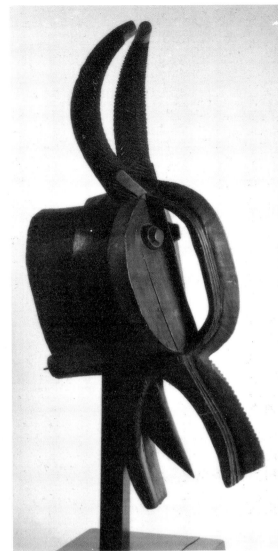

390

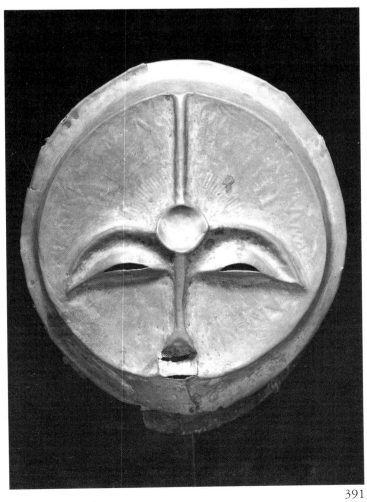

391

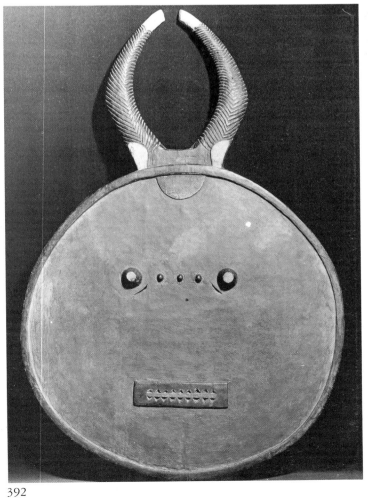

392

387

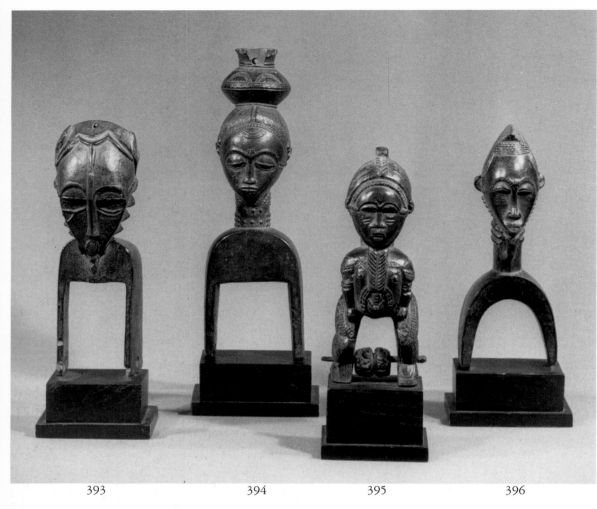

393 394 395 396

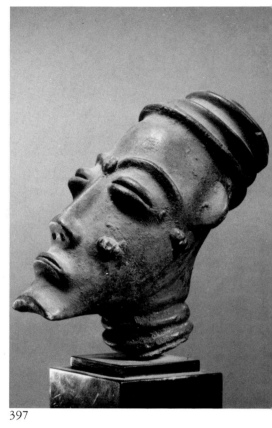

397

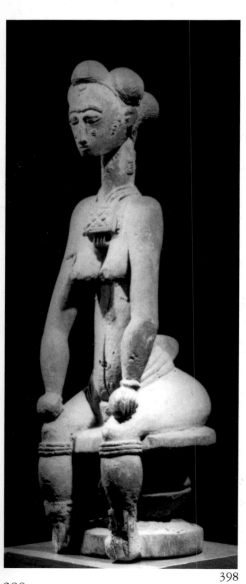

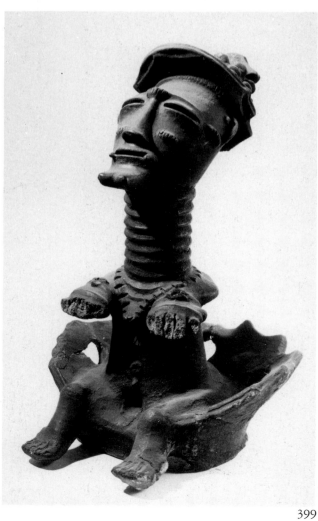

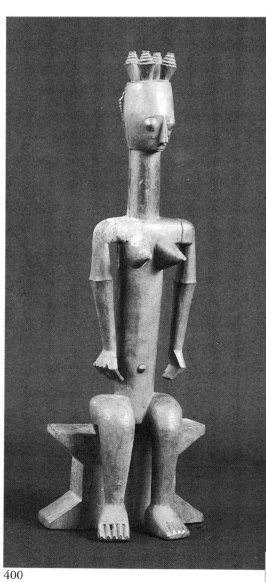

388 398 399 400

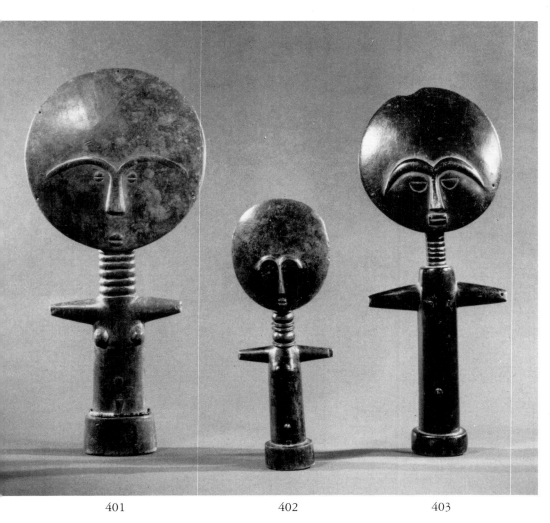

401 402 403

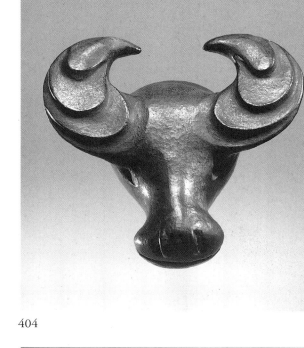

404

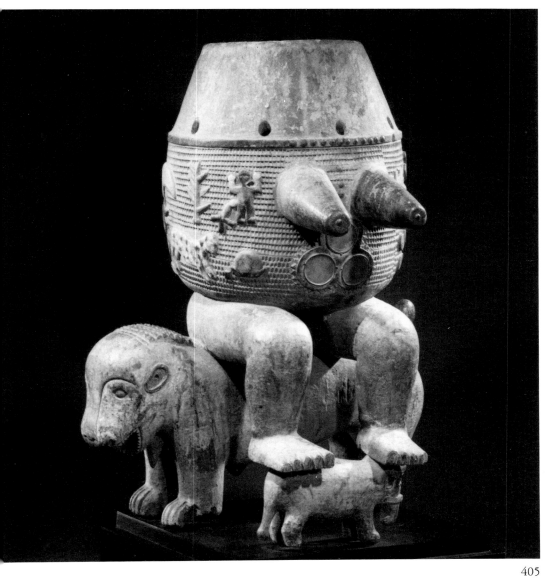

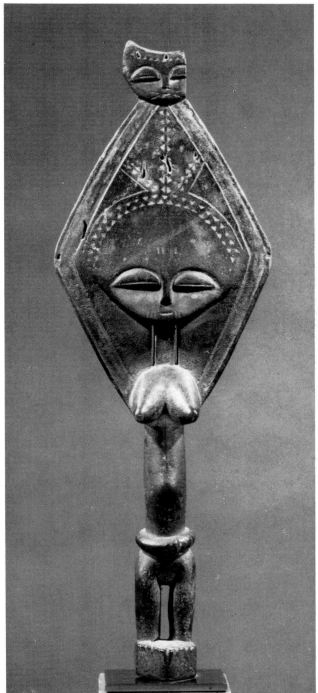

405 406

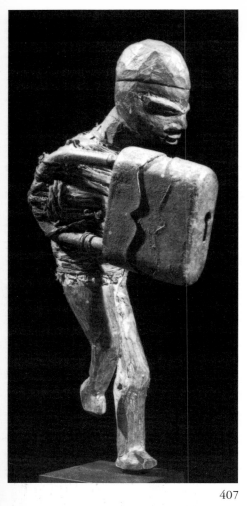

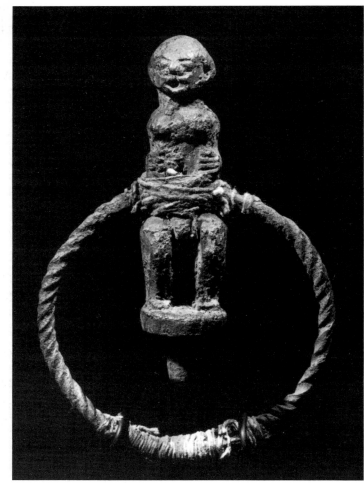

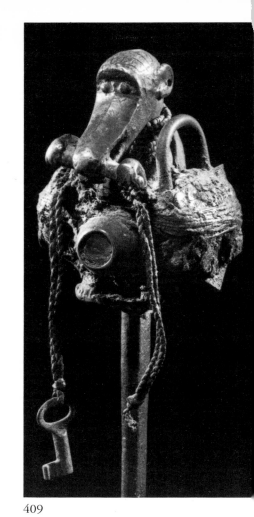

407 408 409

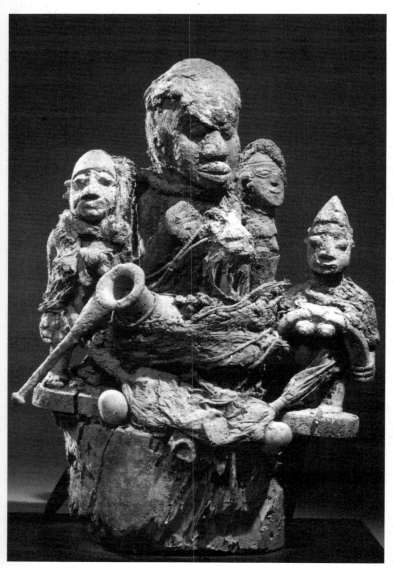

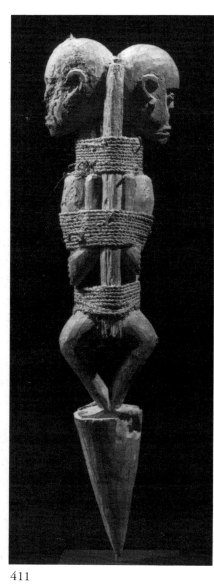

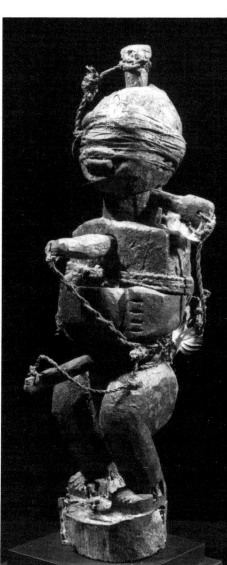

410 411 412

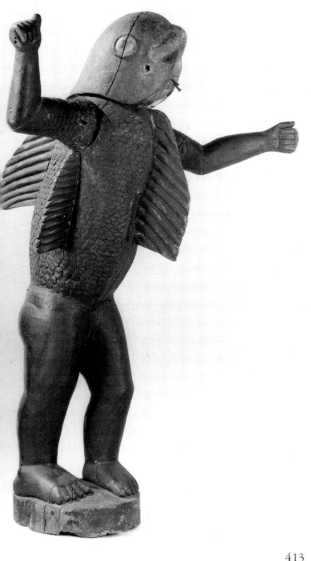

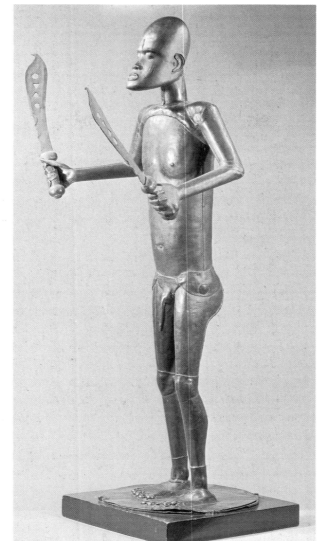
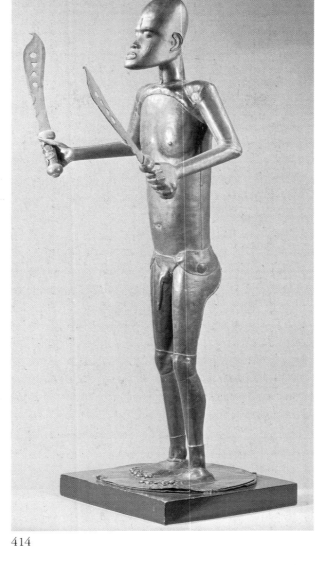

413 414

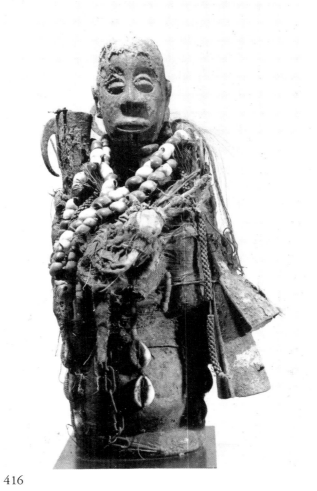

415 416

417

391

418

419

420

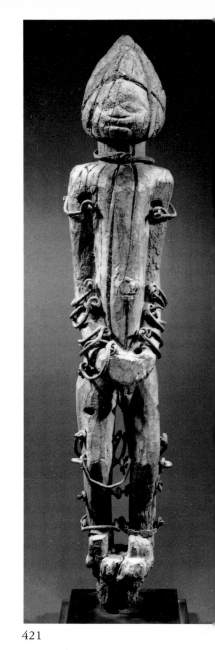

421

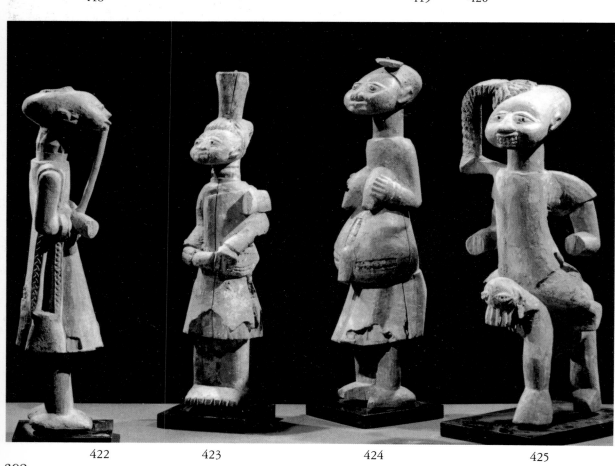

422 423 424 425

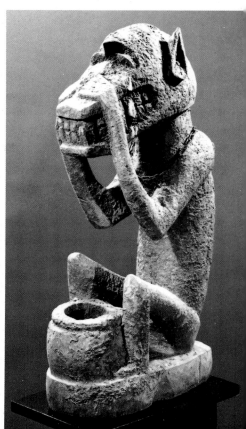

426

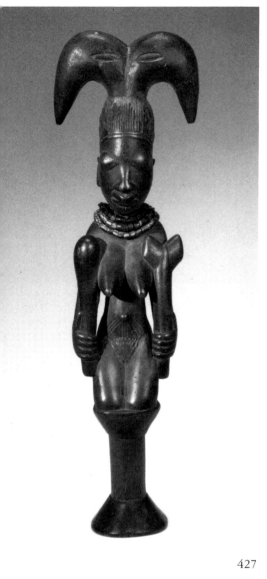

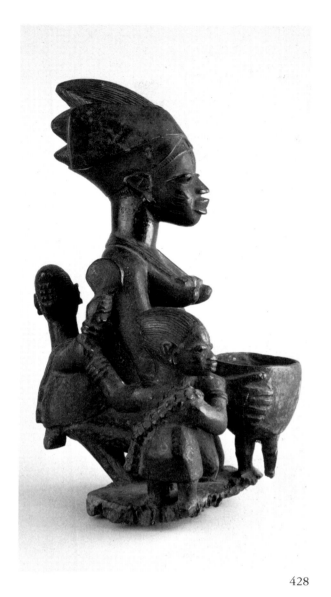

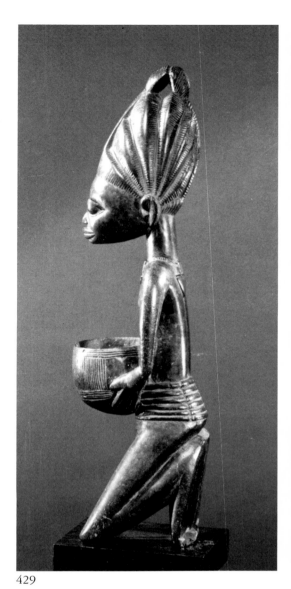

427

428

429

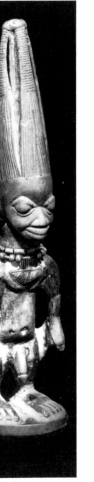

430 431

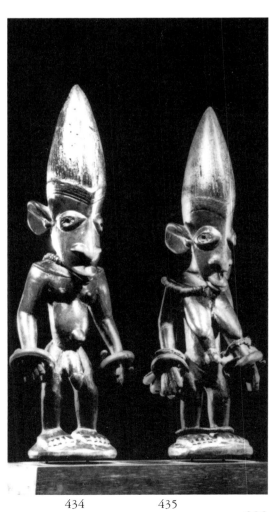

432 433

434 435

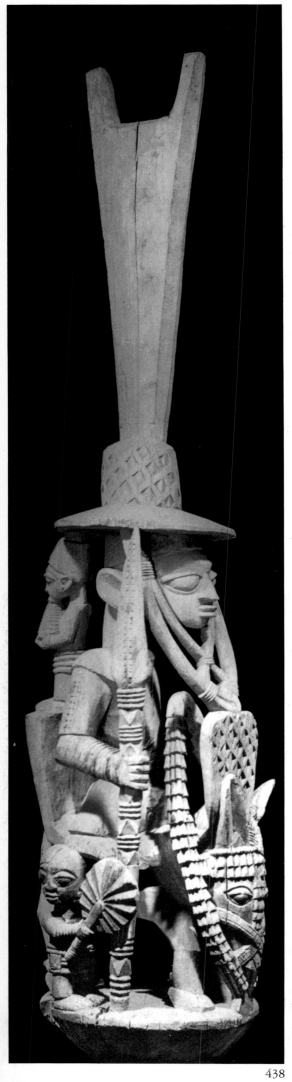

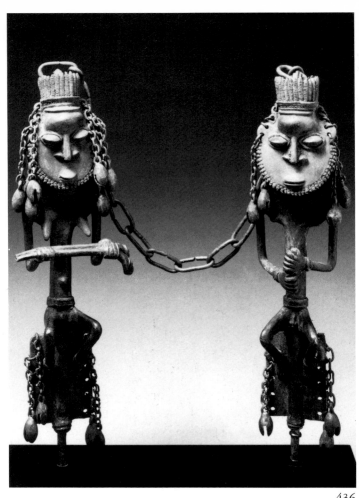

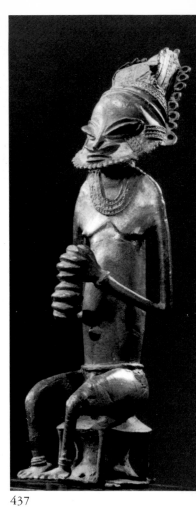

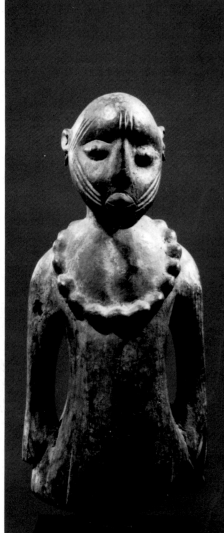

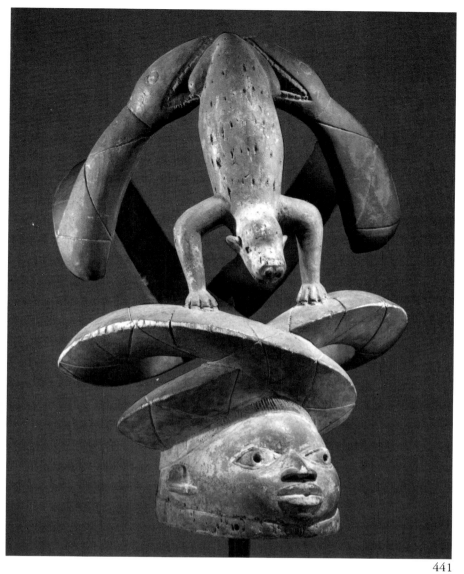

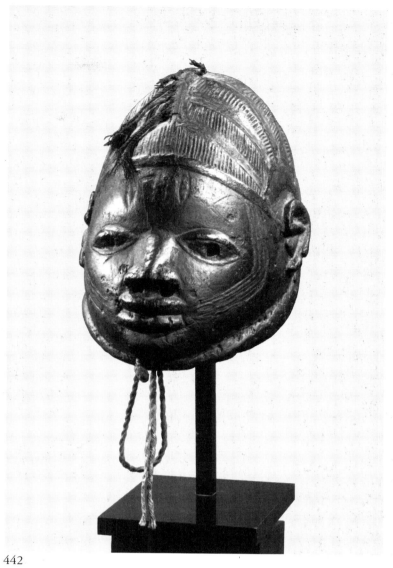

441

442

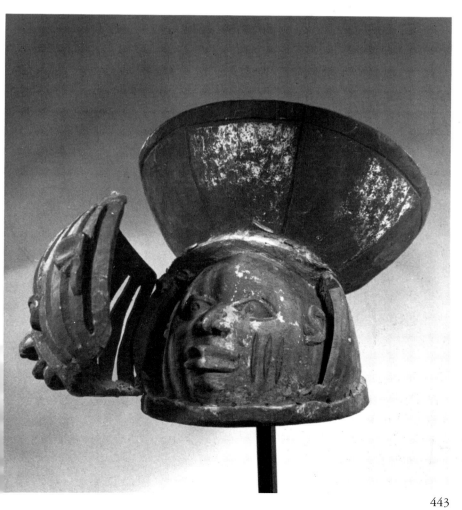

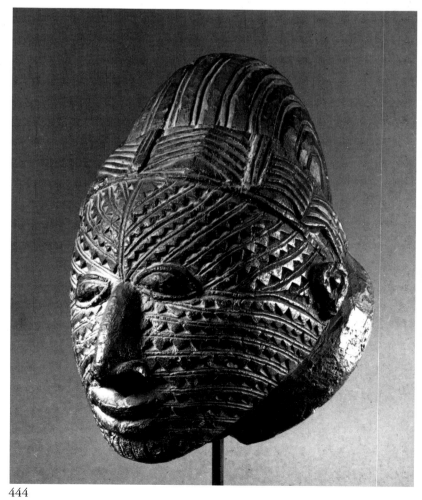

443

444

ARCHEOLOGY AND HISTORY IN NIGERIA

Nok. Yelwa. Ife. Igbo-Ukwu. Benin.

445 446

447 448 449

450　　451

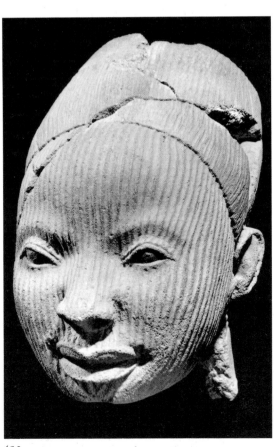

453

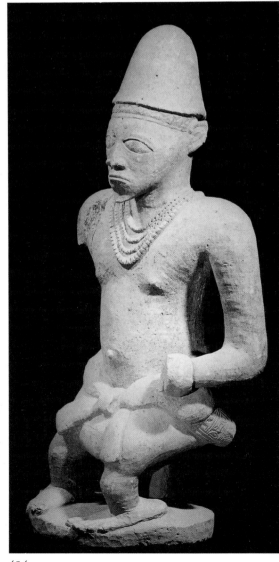

452　　　　　　　　　　　　　　　　　　454

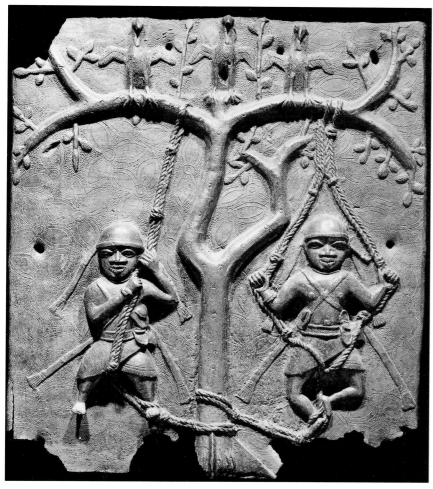
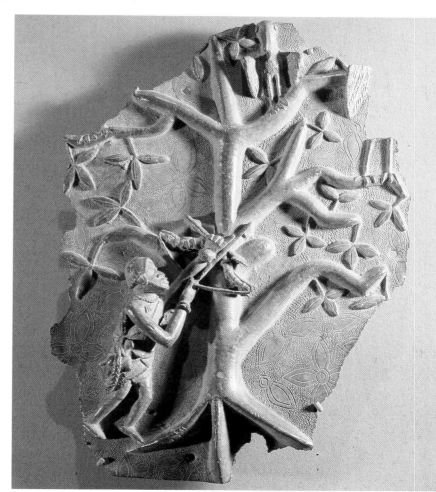

455 456

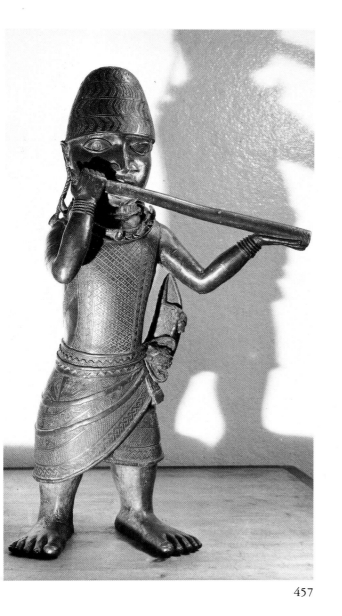
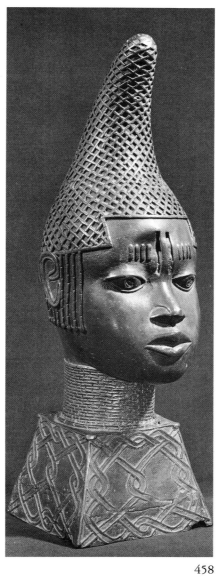
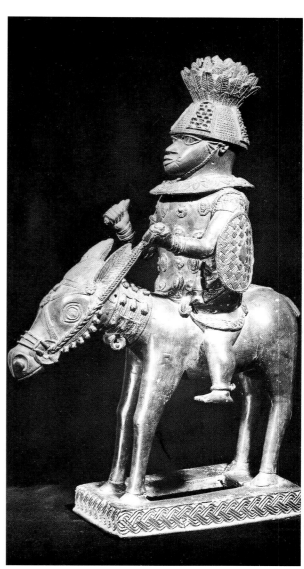

457 458 459

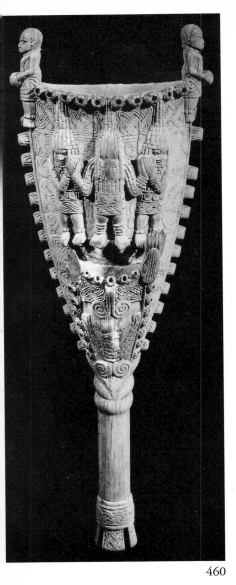

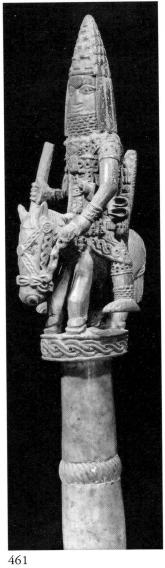

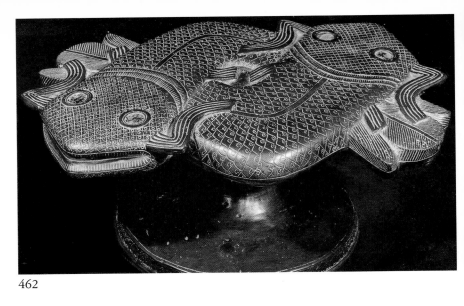

462

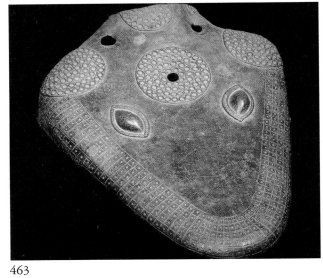

463

460 461

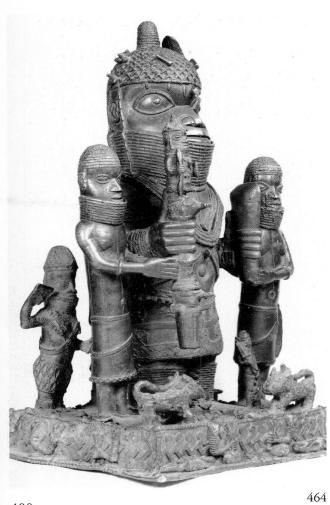

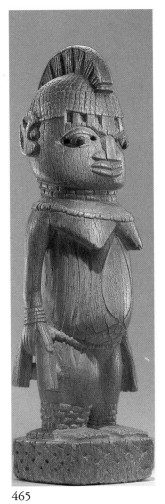

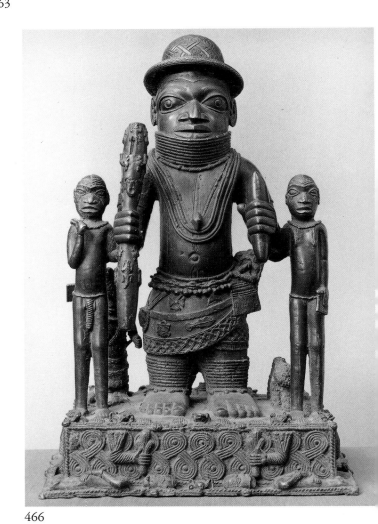

400

464 465 466

CENTRAL SUDAN, THE CROSS RIVER, THE GULF OF GUINEA, AND THE GRASSLAND OF CAMEROON

Ijo. Itsoko. Urhobo. Ibibio.
Eket. Igala. Igbo. Idoma. Afikpo.
Afo. Koro. Mama. Montol. Goemai.
Jibete. Jukun. Wurkum. Chamba.
Jompre. Mumuye. Mambila. Kaka.
Ejagham. Boki. Bamum. Bafo.
Duala. Bamileke. Bangwa.

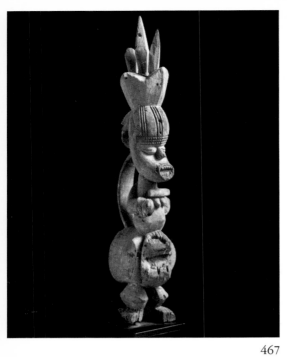
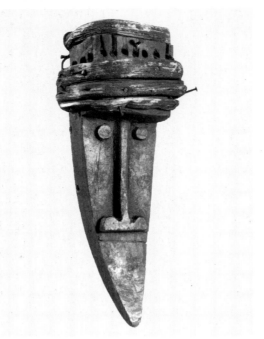
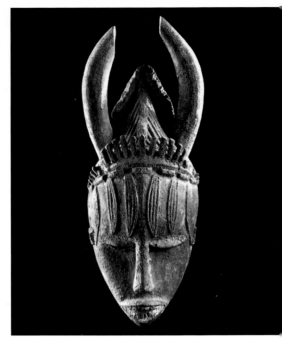

467 468 469

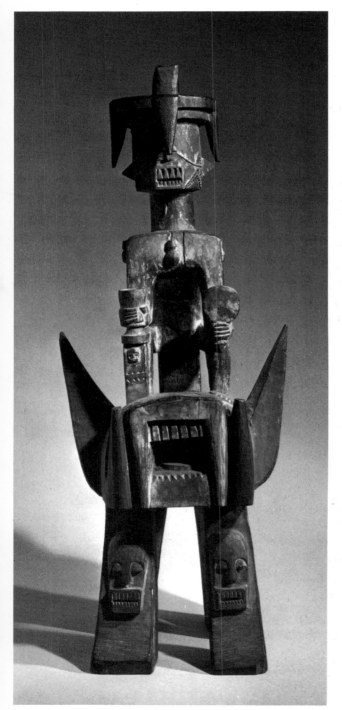
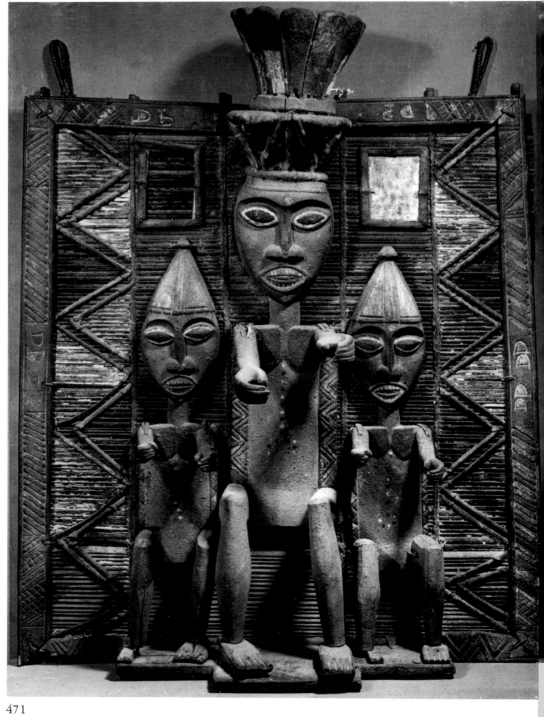

470 471

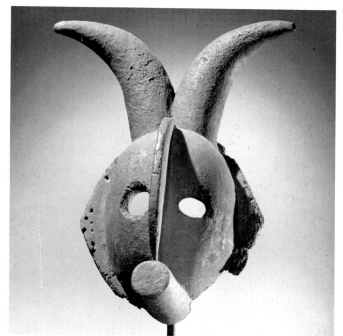

472 473

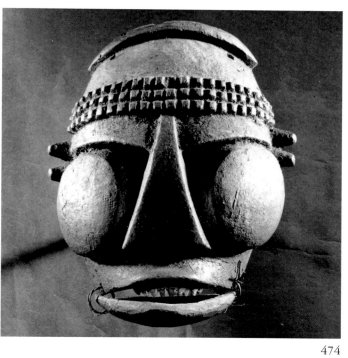
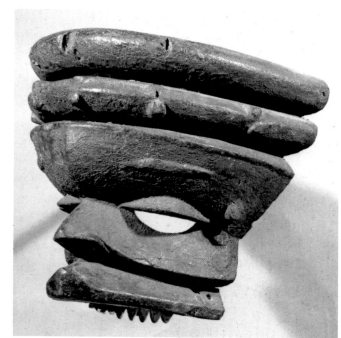

474 475

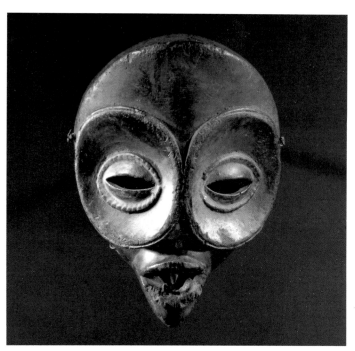
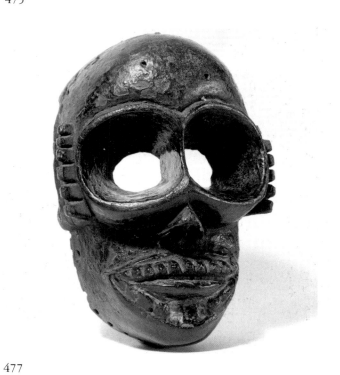

476 477

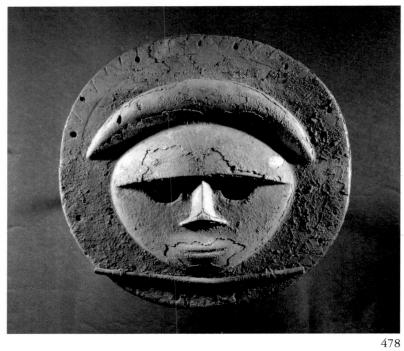

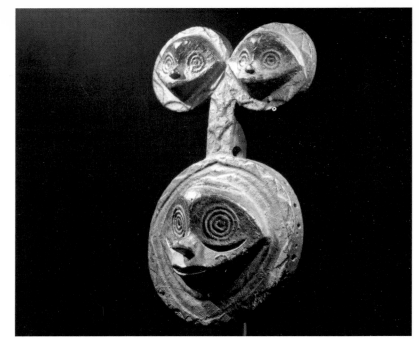

478 479

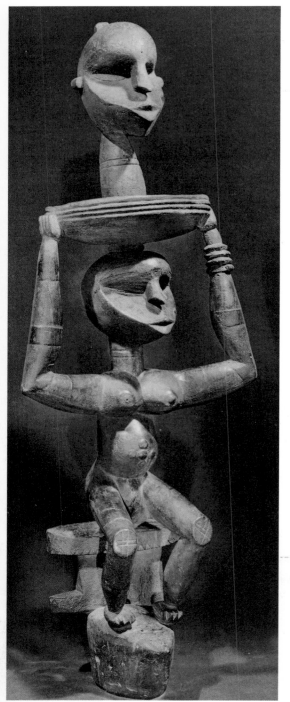

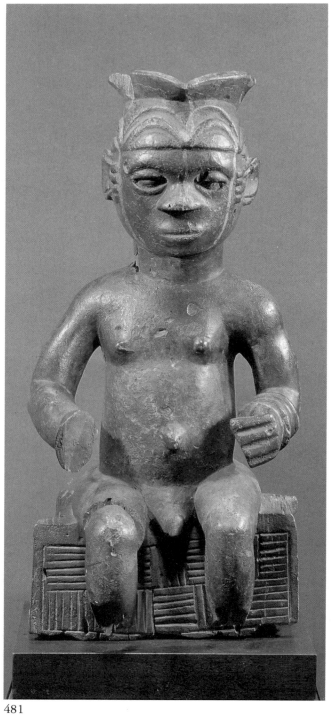

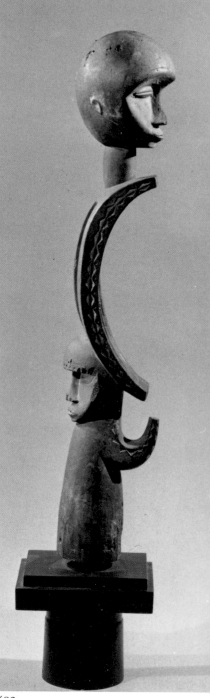

480 481 482

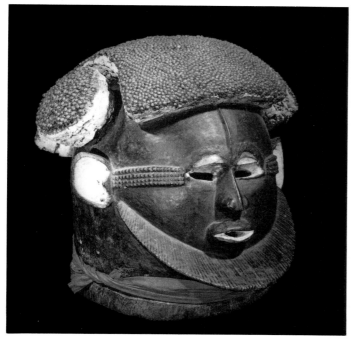

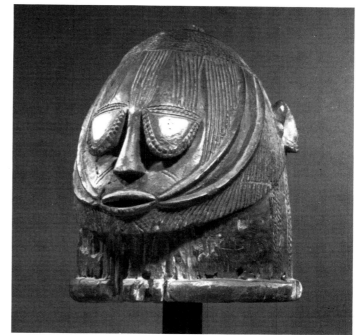

483 484

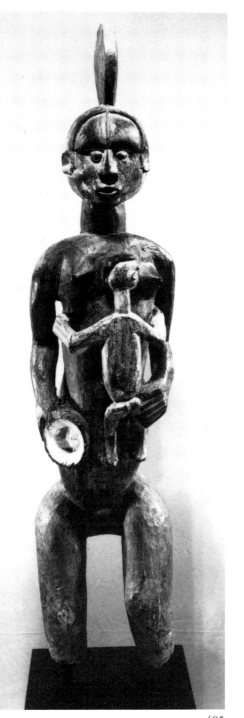

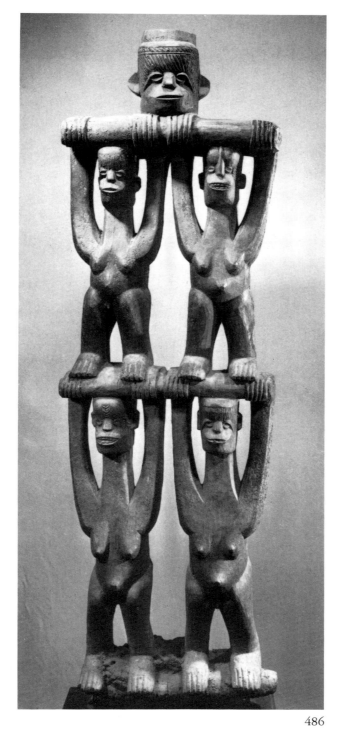

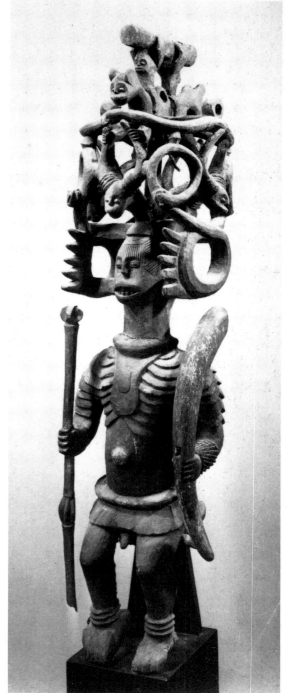

485 486 487

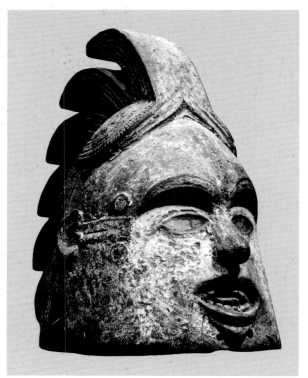

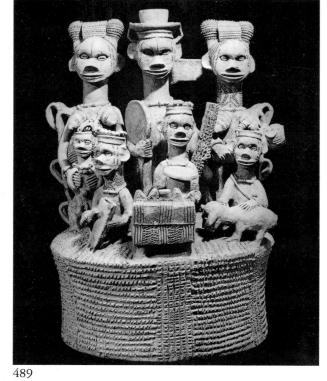

488 489

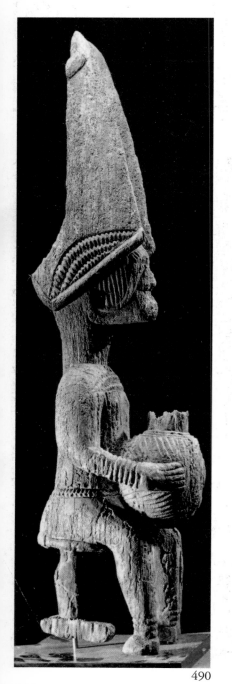

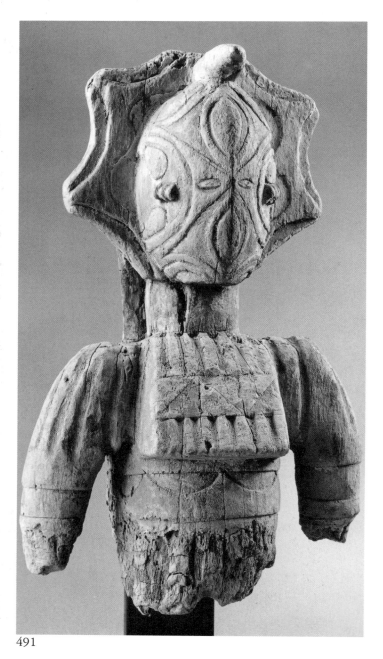

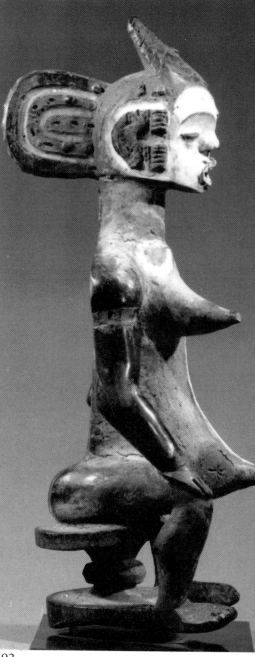

490 491 492

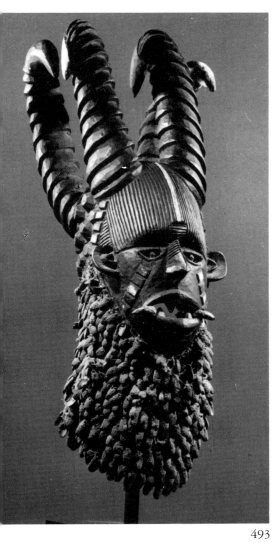

493

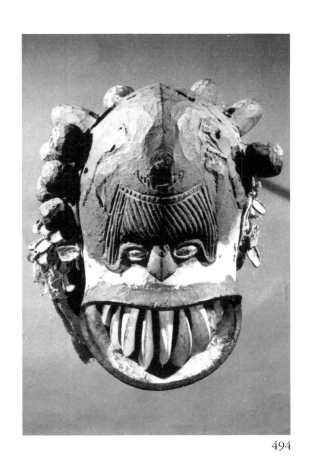

494

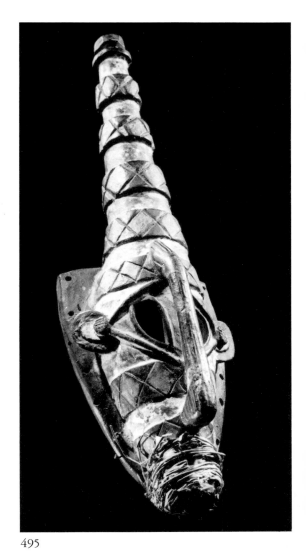

495

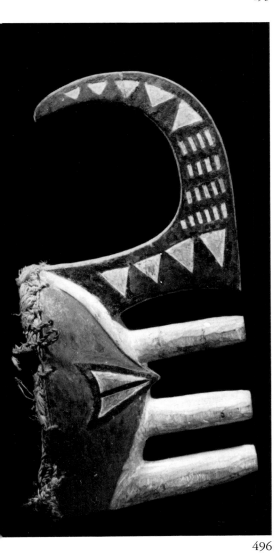

496

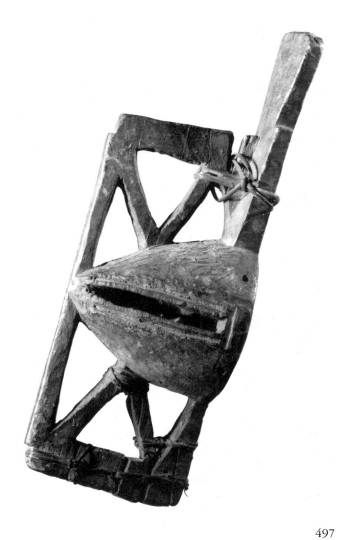

497

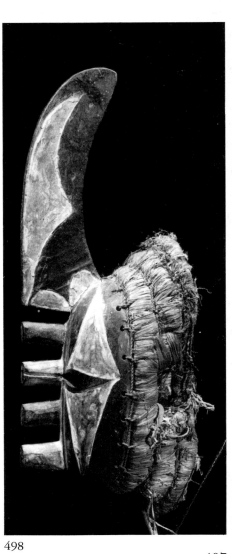

498

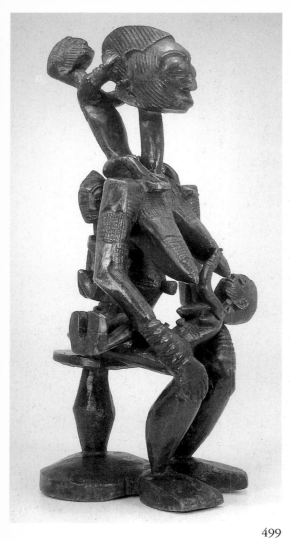
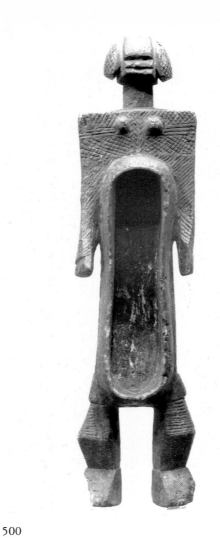
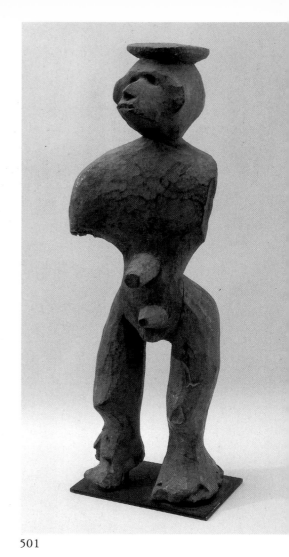

499 500 501

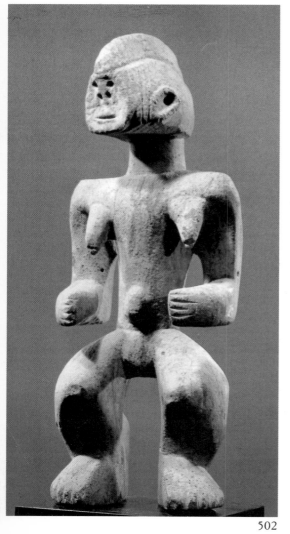
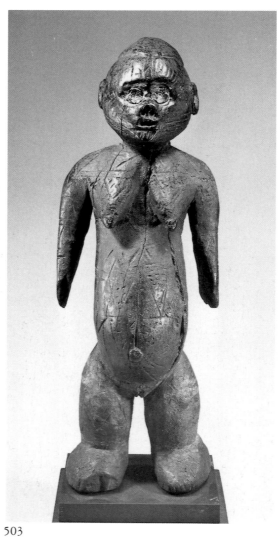
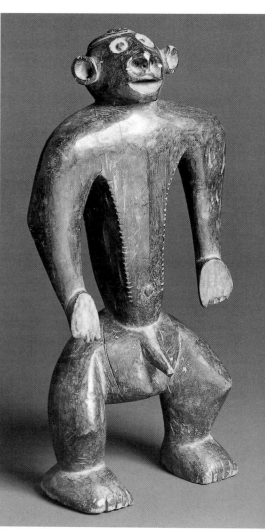

 502 503 504

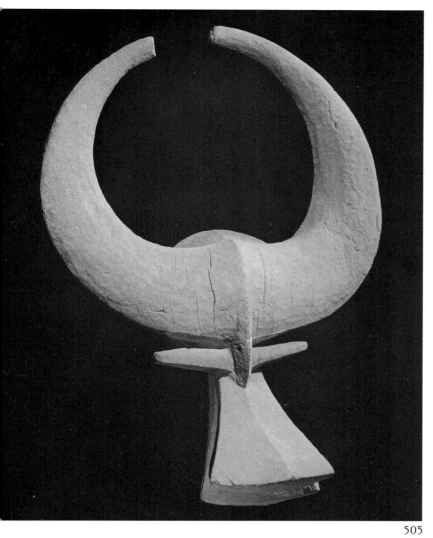

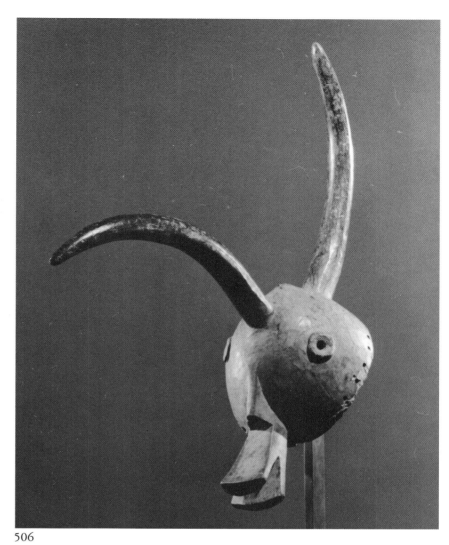

505

506

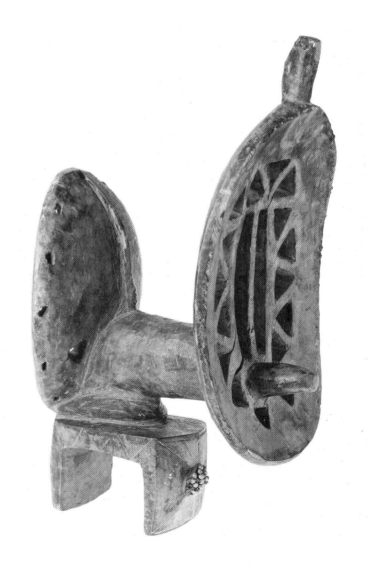

507

508

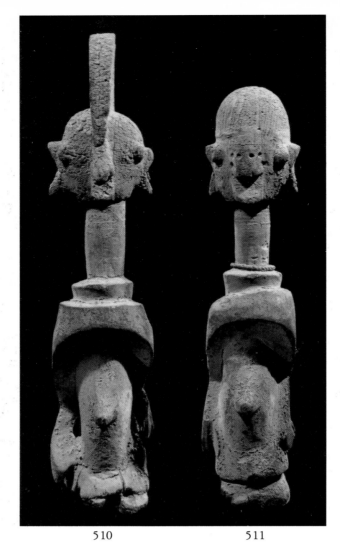

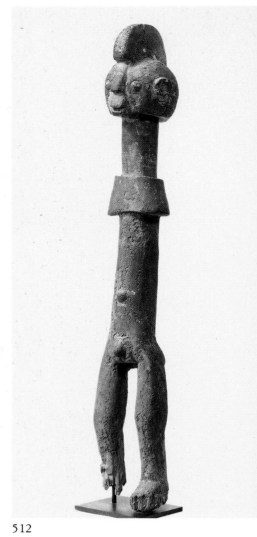

509

510

511

512

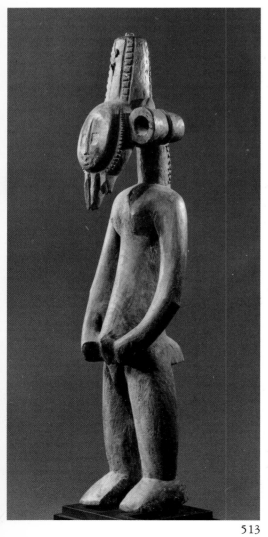

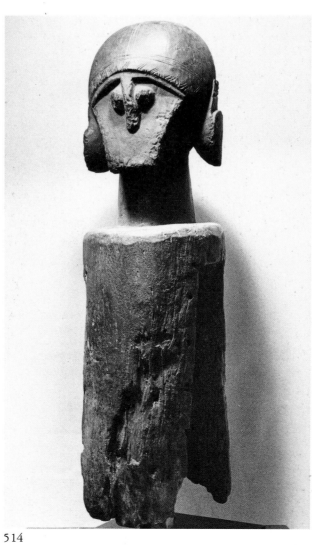

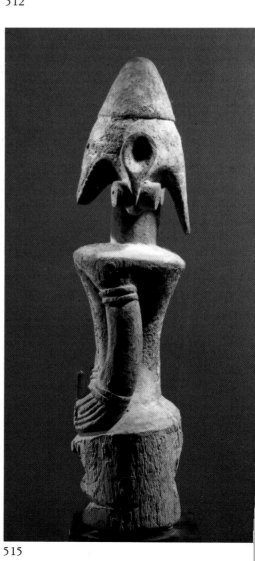

513

514

515

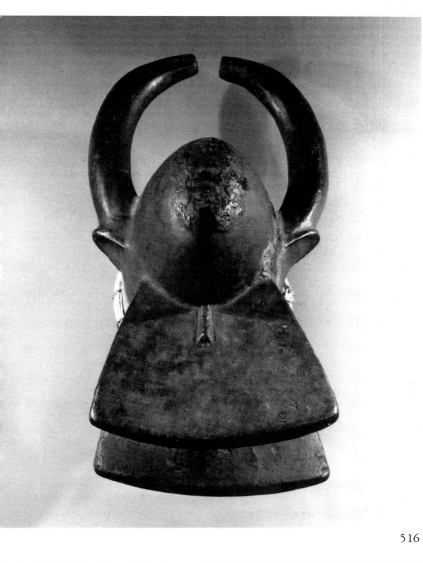

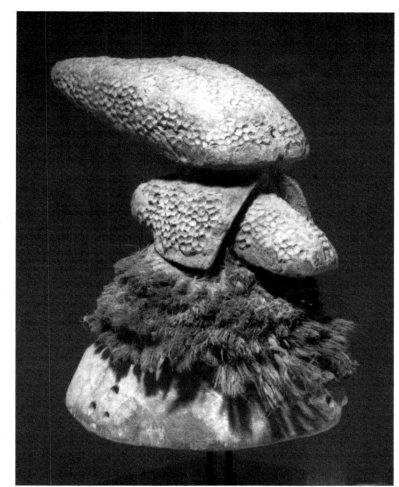

516 517

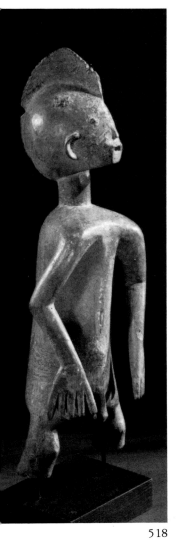

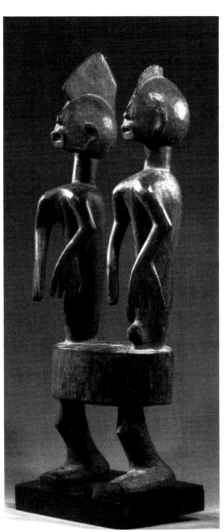

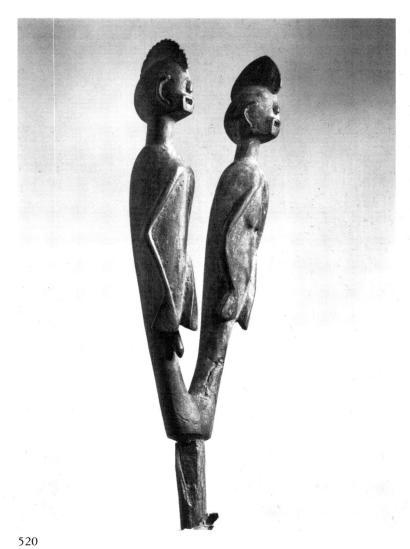

518 519 520

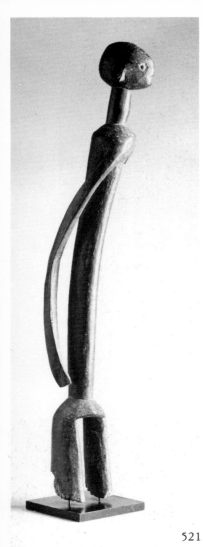

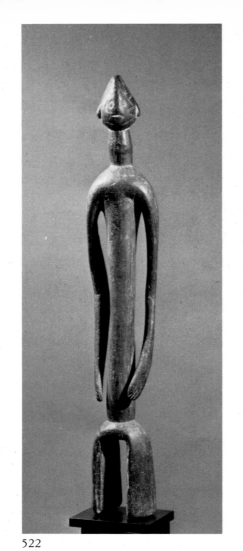

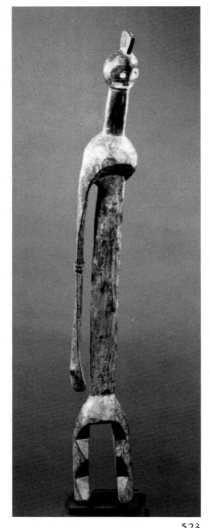

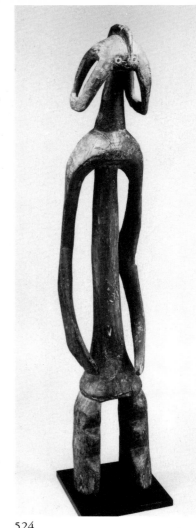

521 522 523 524

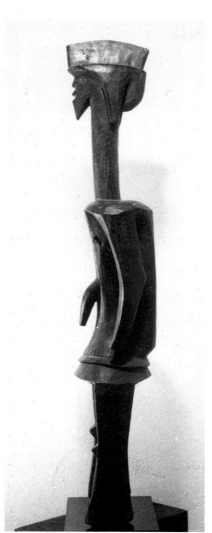

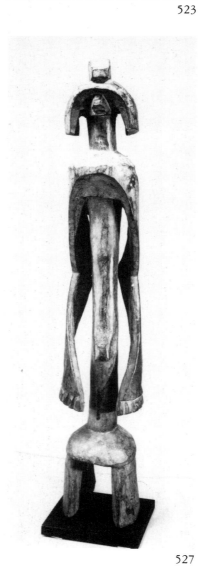

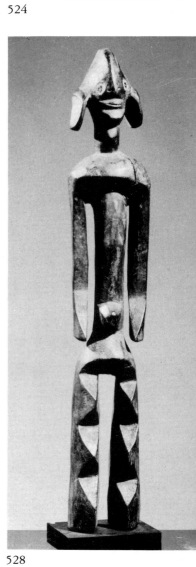

525 526 527 528

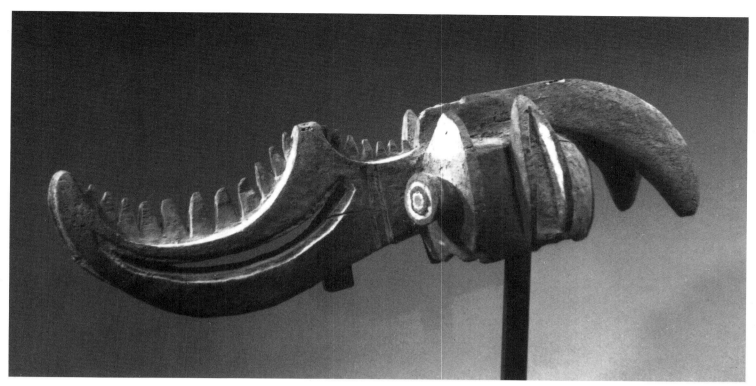

529

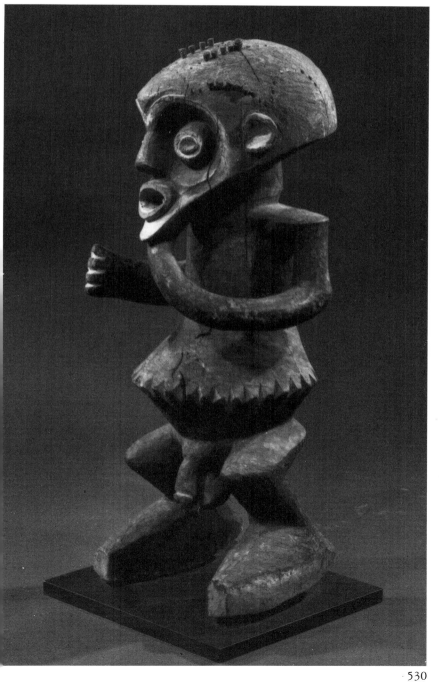

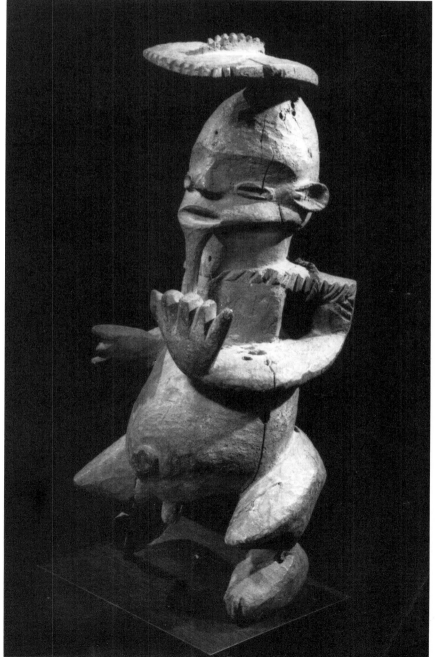

530 531

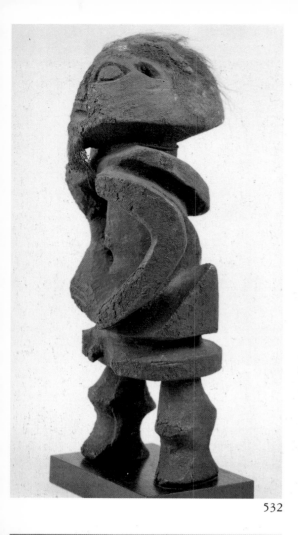

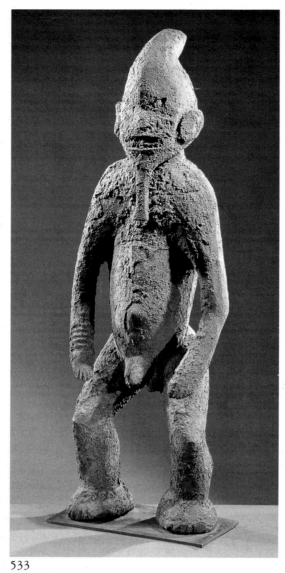

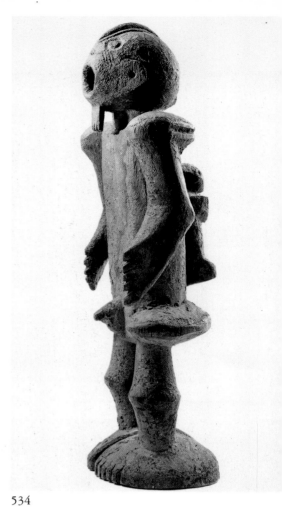

532

533

534

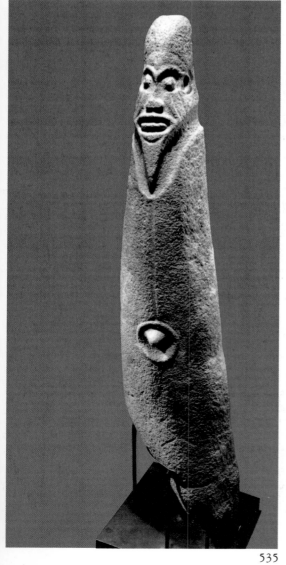

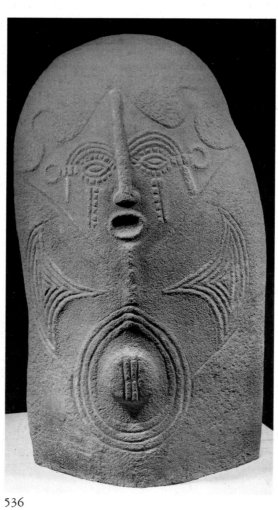

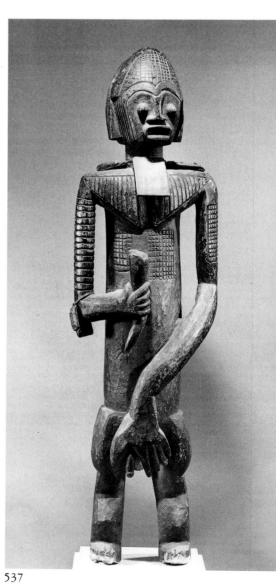

535

536

537

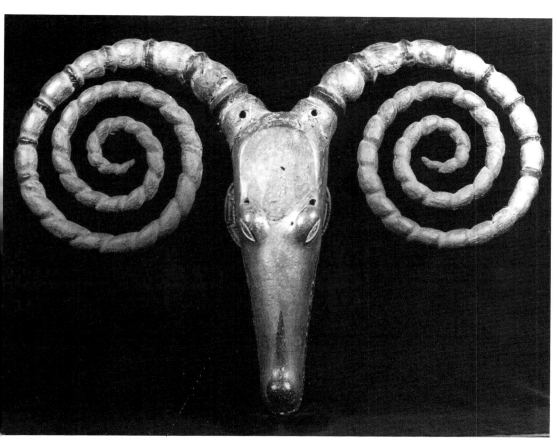

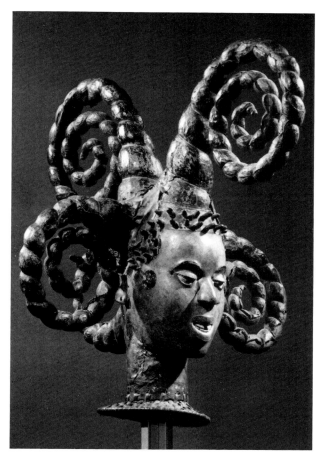

538 539

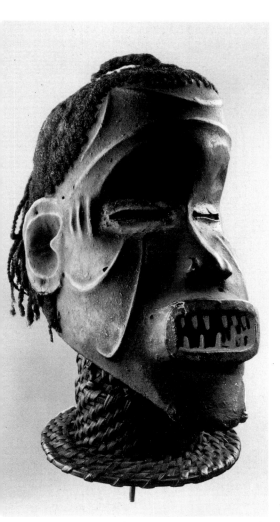

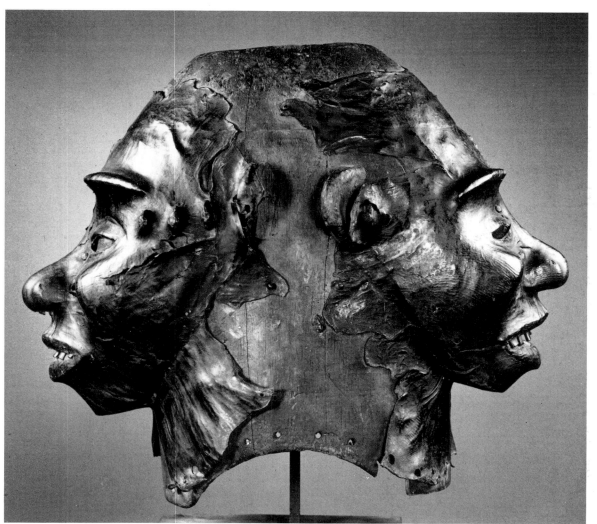

540 541

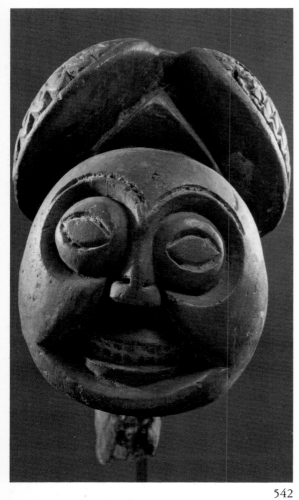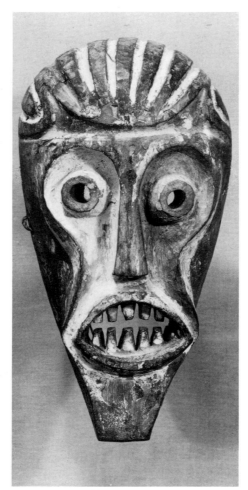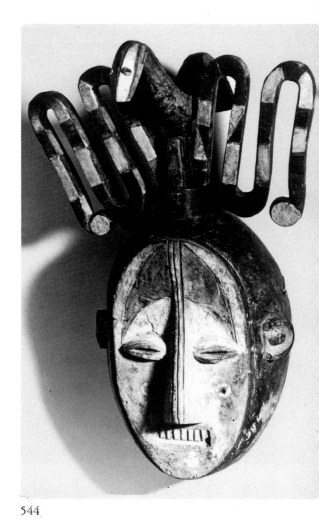

542　　543　　544

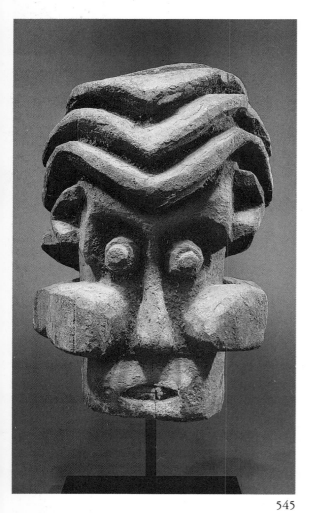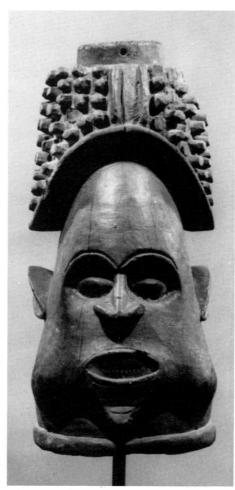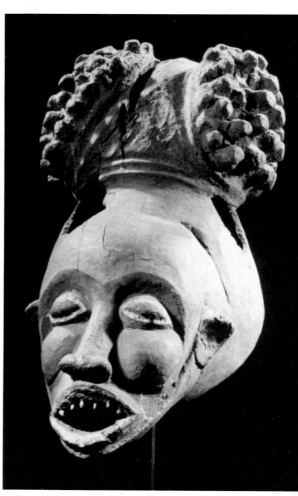

545　　546　　547

416

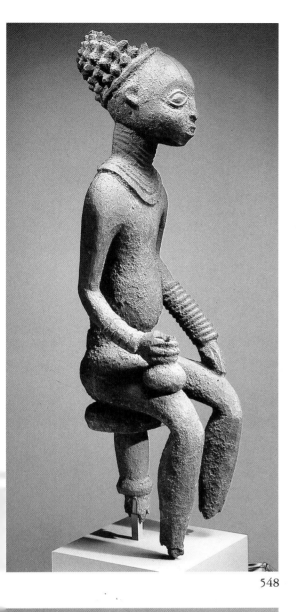

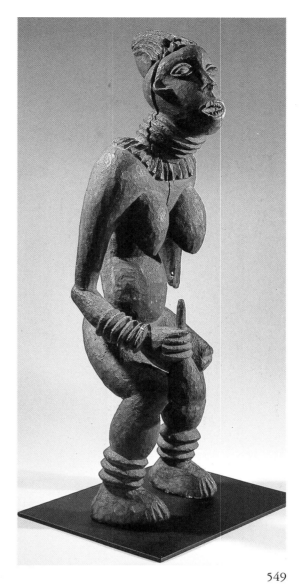

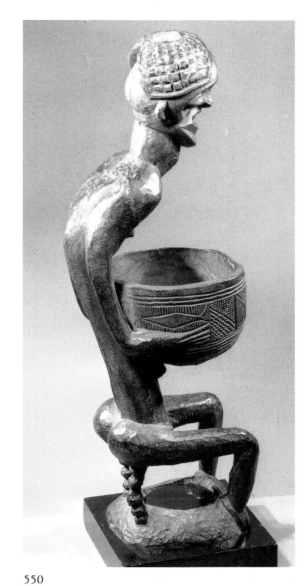

548

549

550

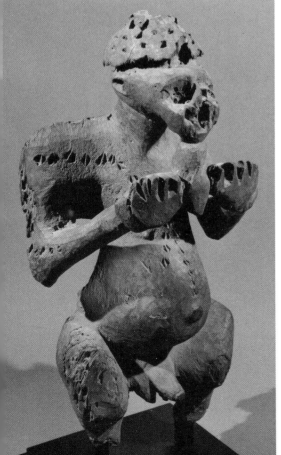

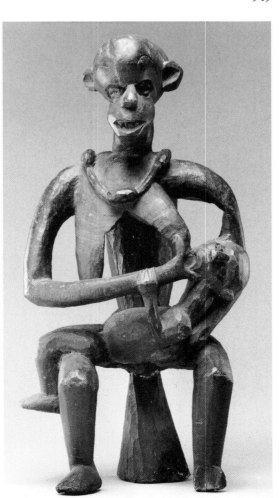

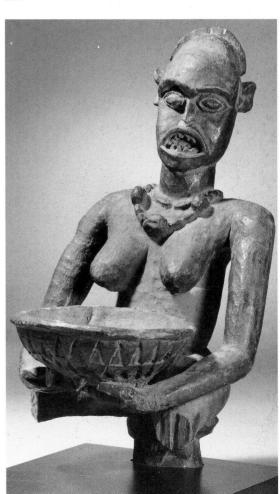

551

552

553

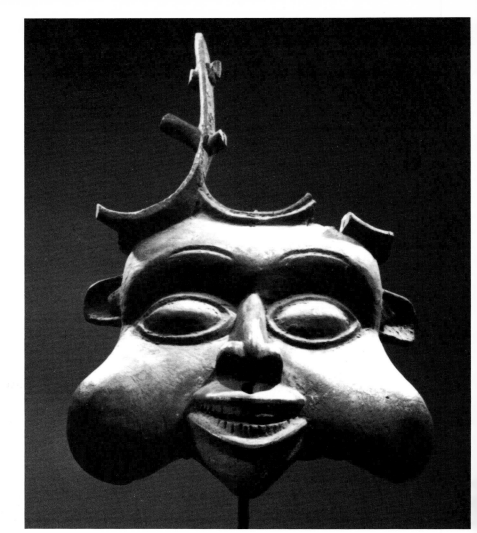

554

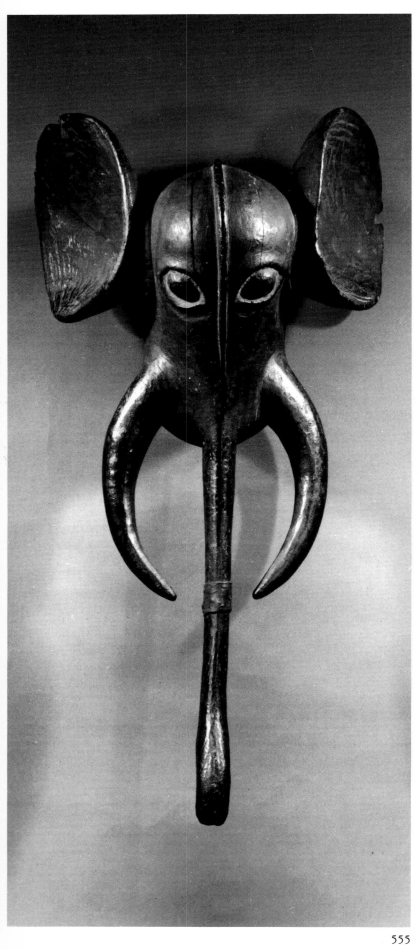

555

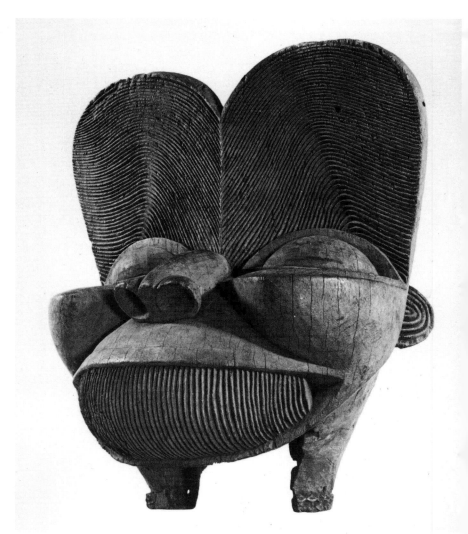

556

CENTRAL AFRICA

Fang. Bakwele. Tsogho. Mashango. Mbete.
Kota. Mahongwe. Shamaye. Punu. Lumbo.
Yombe. Vili. Bakongo. Bembe. Bwende.
Badondo. Teke. Kuyu. Yangere. Zande.
Ngbaka. Ngbandi. Ngombe. Mangbetu. Komo.
Mbole. Lengola. Lega. Basikasingo (Buyu).
Bemba. Hemba. Kusu. Luba. Tabwa.
Shankadi. Kanyok. Songhay. Dengese. Lele (Bashilele).
Kuba. Mbuun. Lulua. Salampasu. Mbagani. Lwalwa.
Yaka. Mbala. Hungaan. Pende. Chokwe.

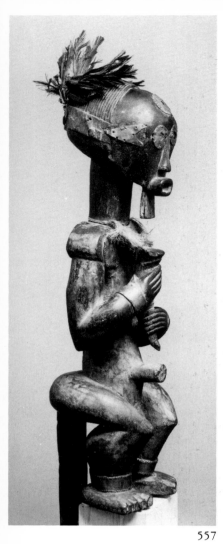 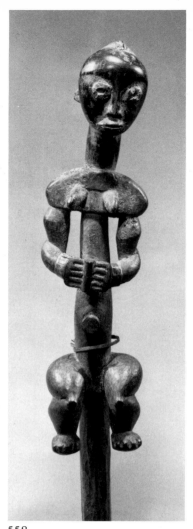 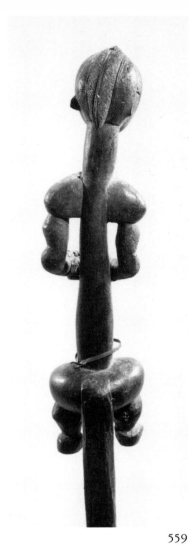 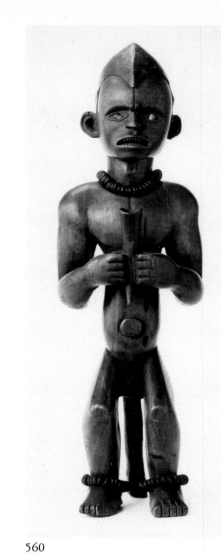

557 558 559 560

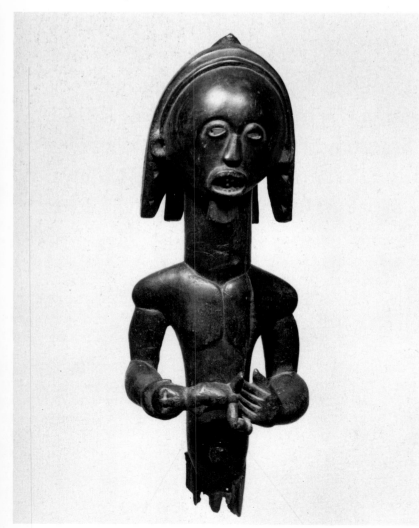

561 562

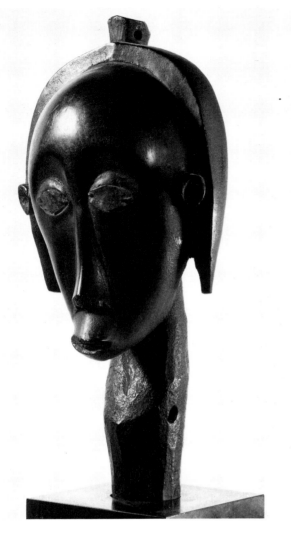
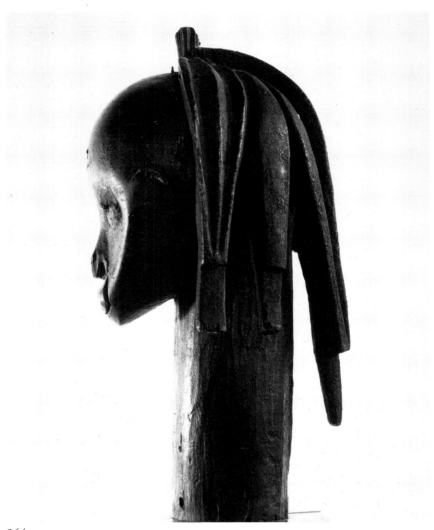

563 564

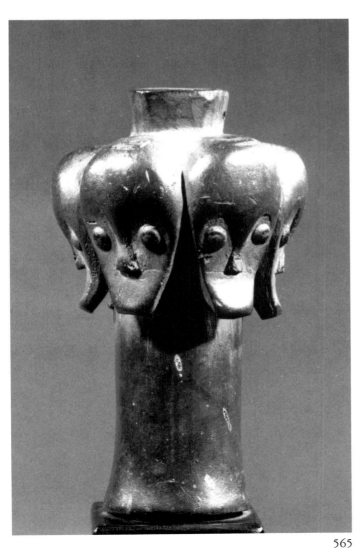
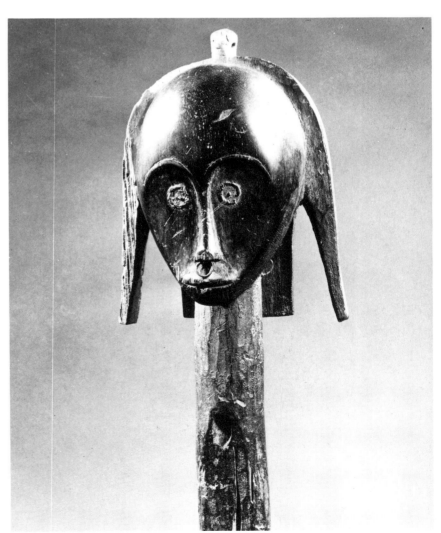

565 566

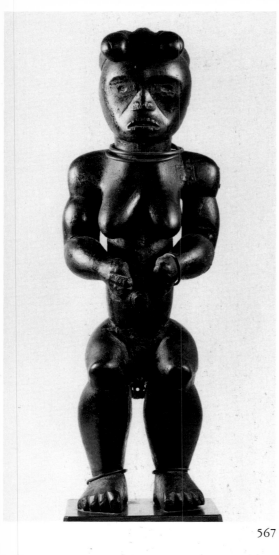

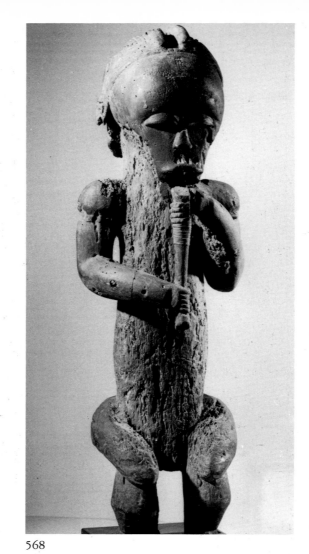

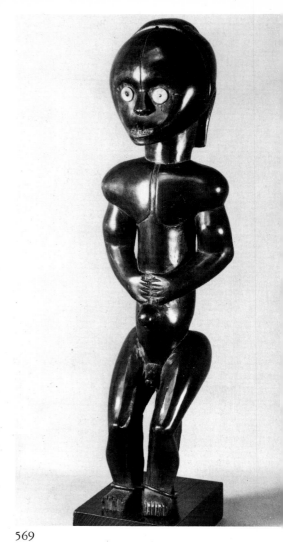

567

568

569

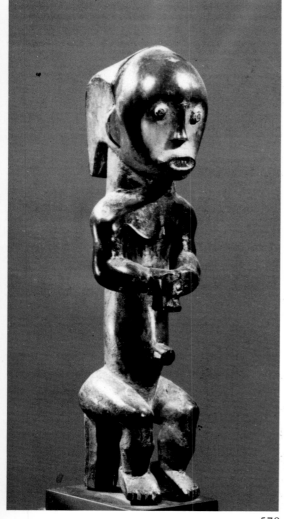

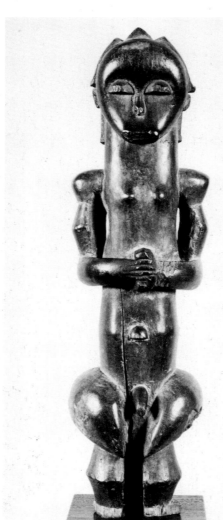

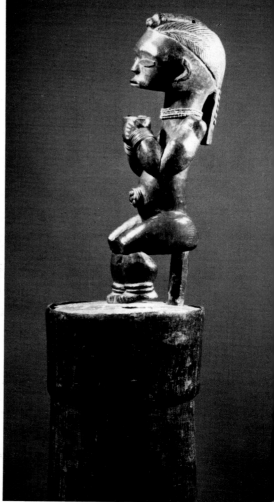

570

571

572

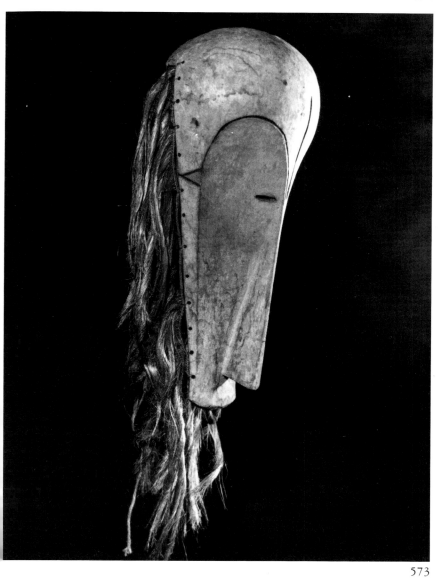

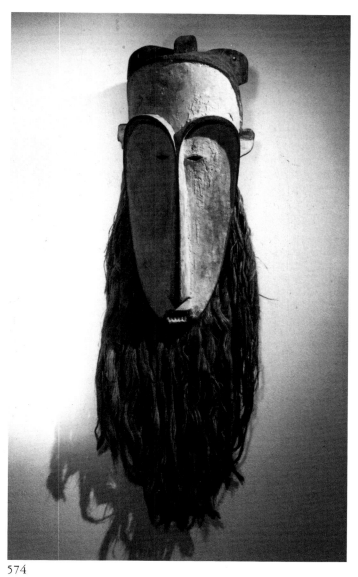

573 574

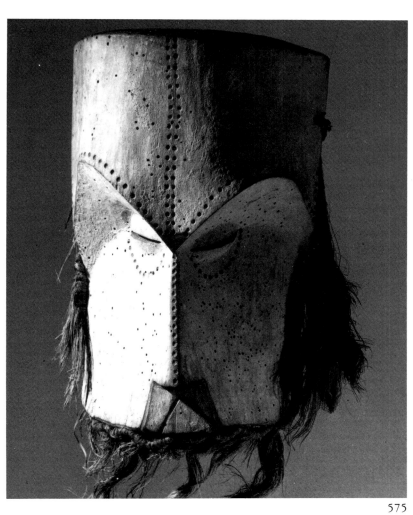

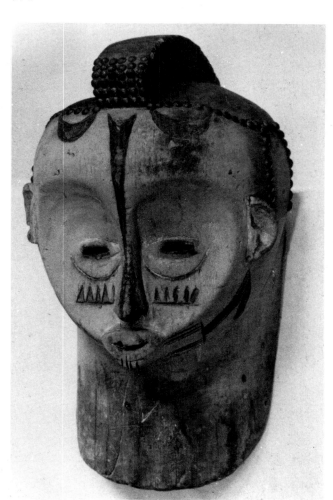

575 576

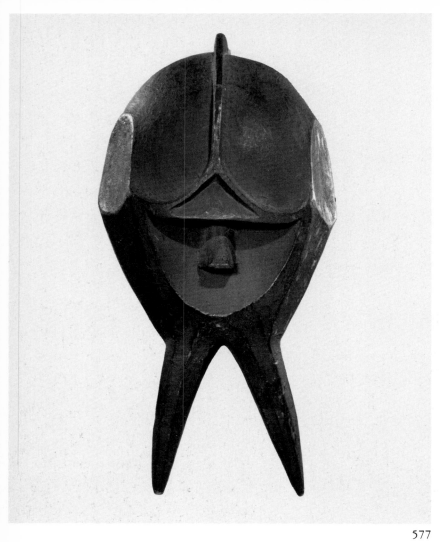

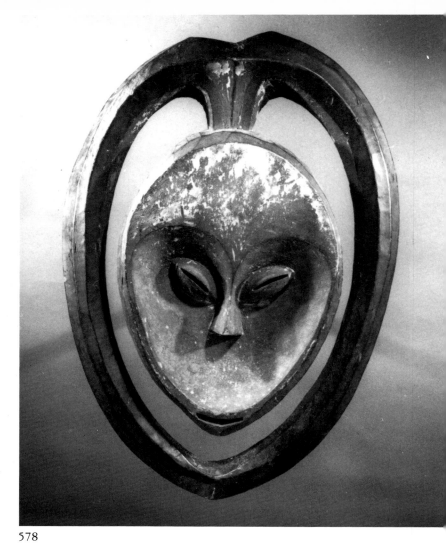

577 578

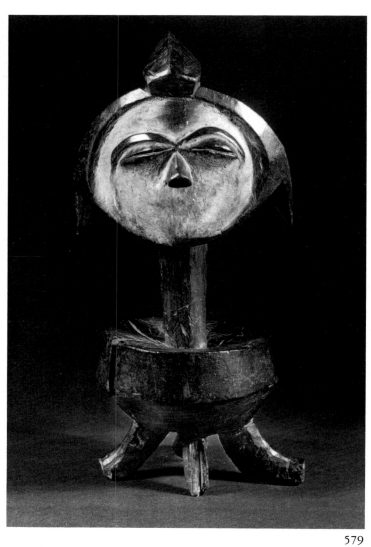

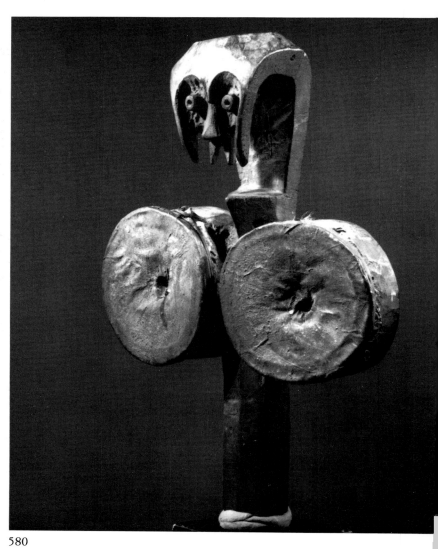

579 580

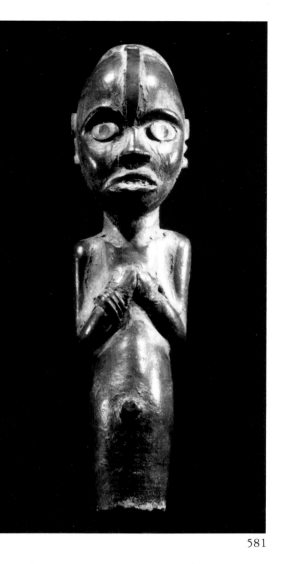

581

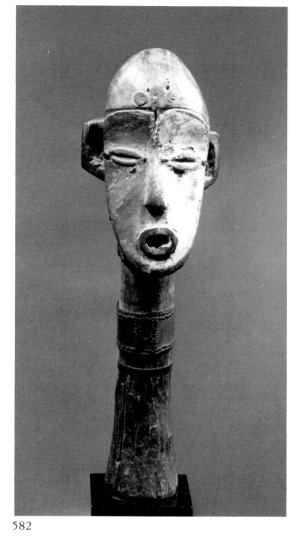

582

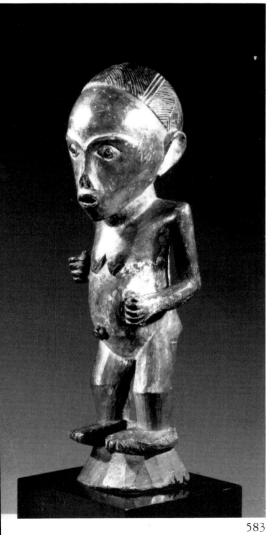

583

584

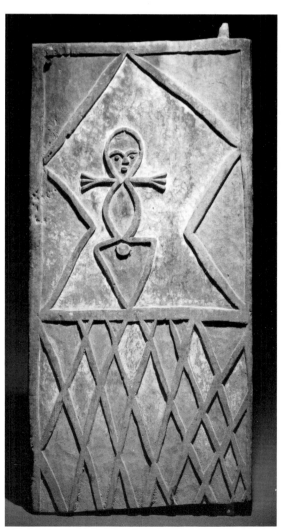

585

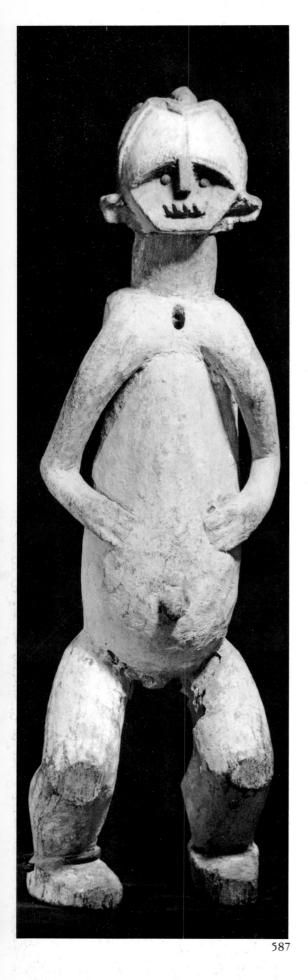

587

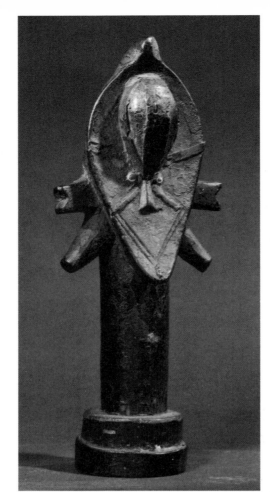

586

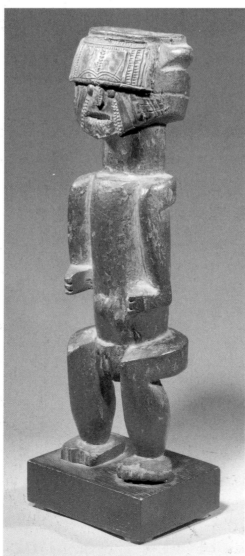

588

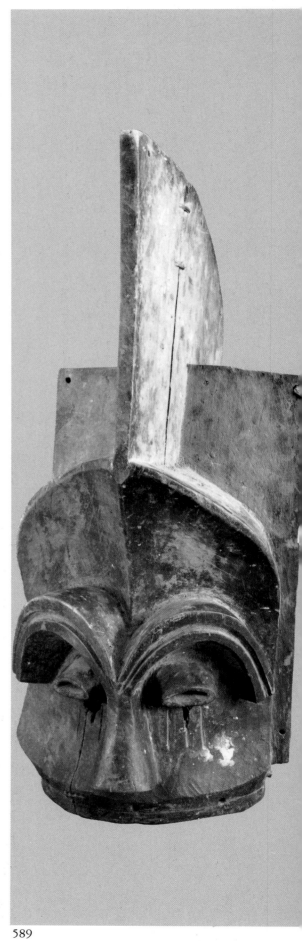

589

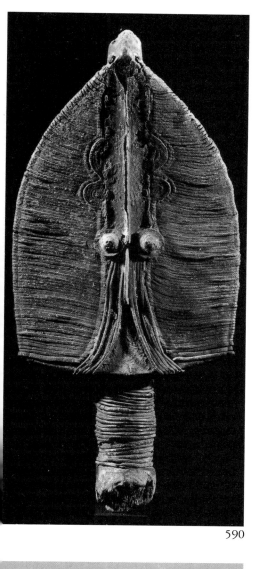

590

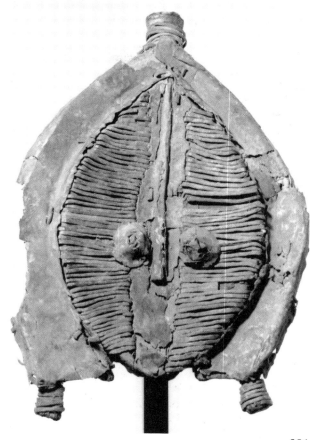

591

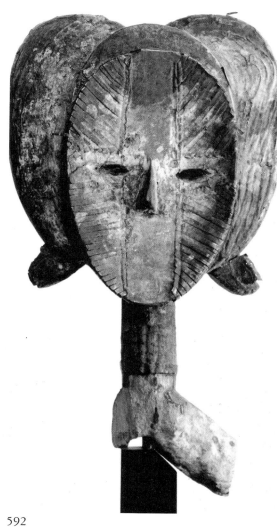

592

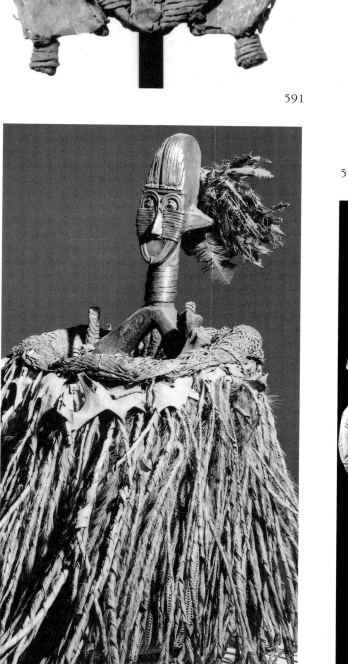

593

594

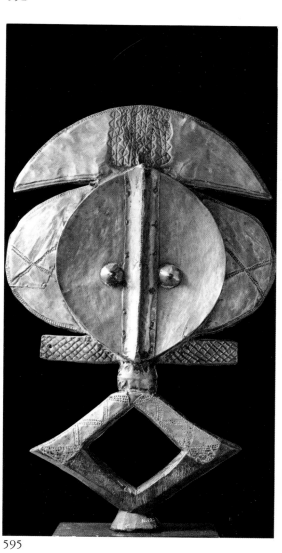

595

427

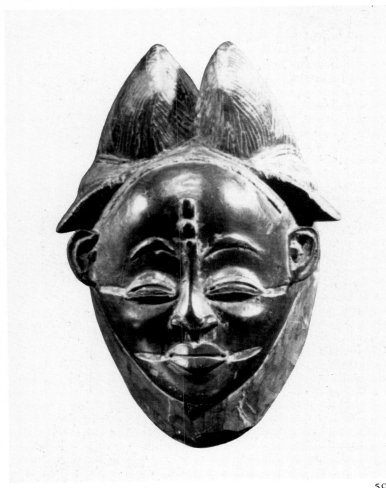

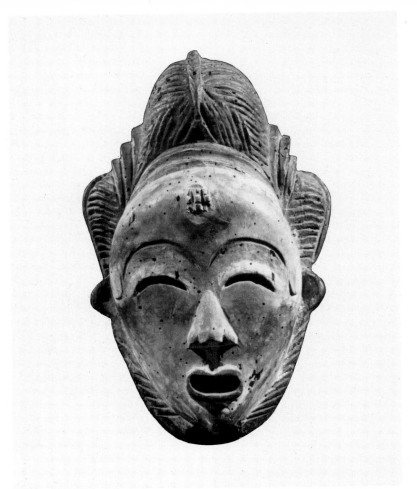

596 597

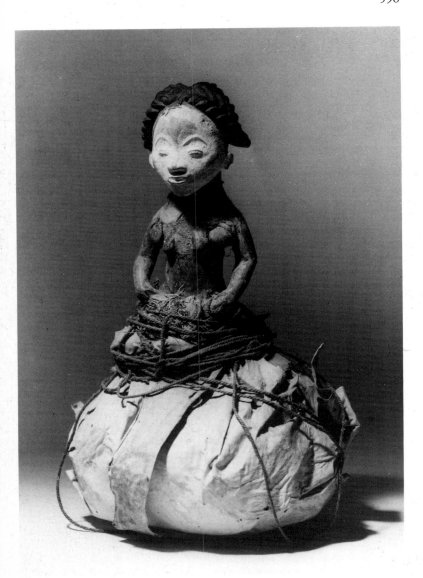

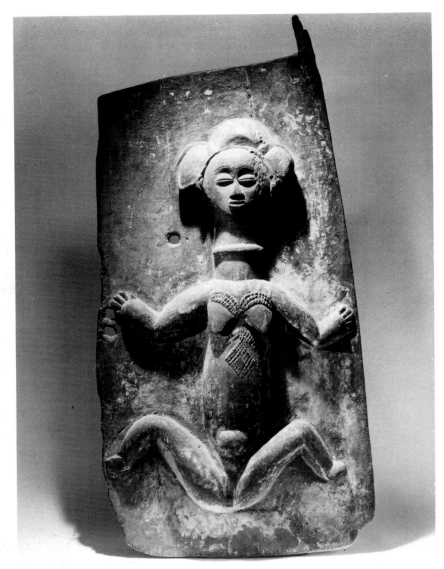

598 599

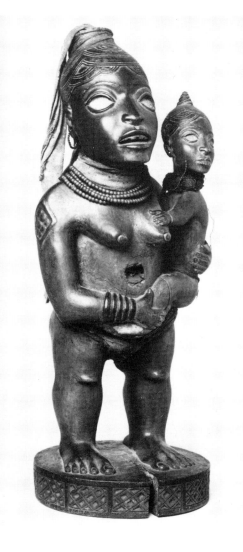

600

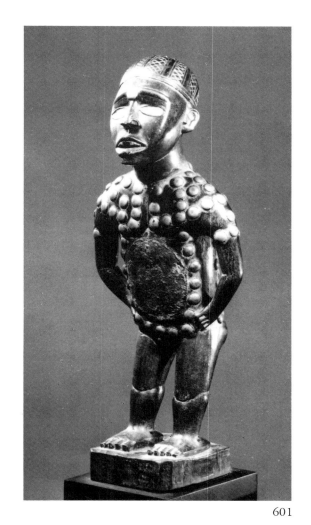

601

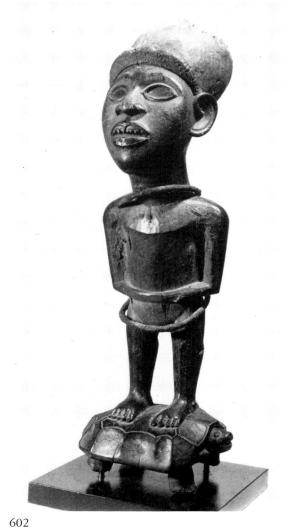

602

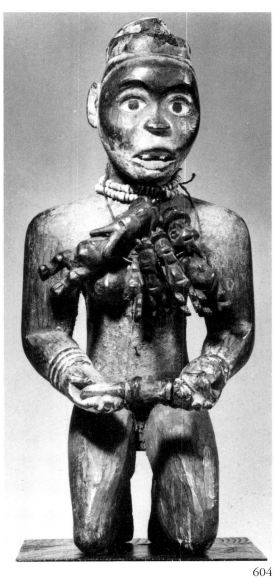

603

604

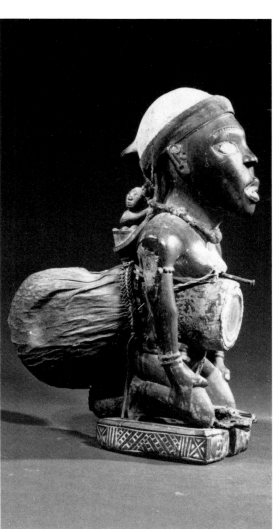

605

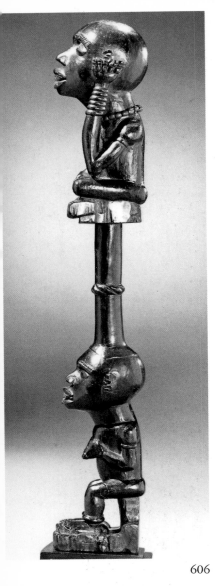

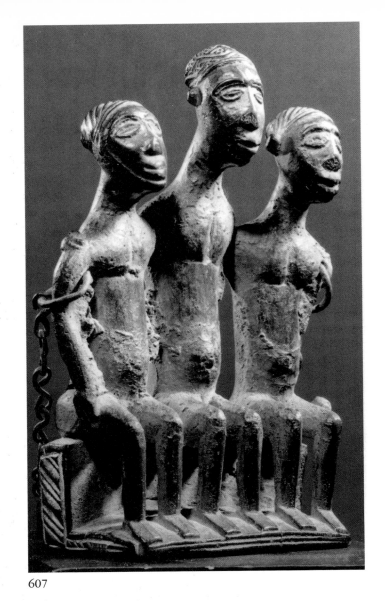

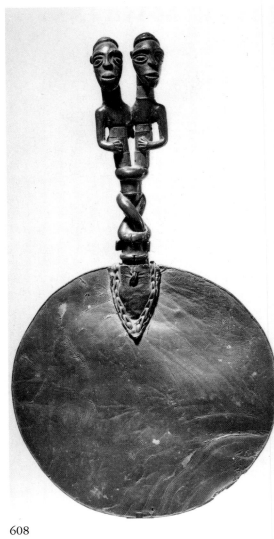

606

607

608

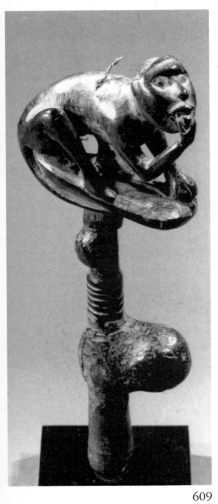

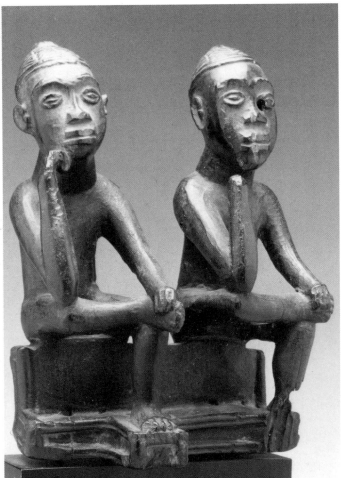

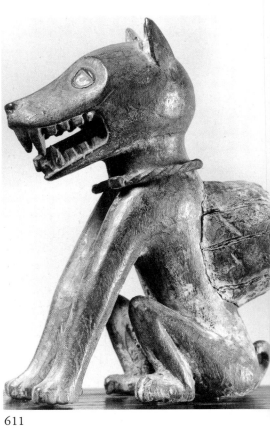

609

610

611

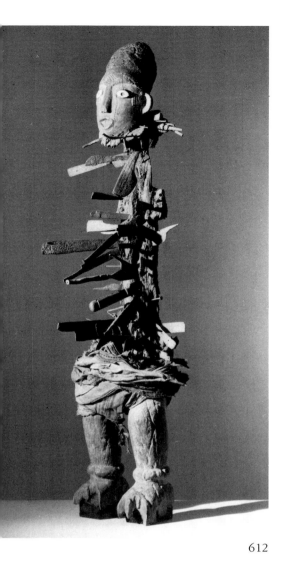

612

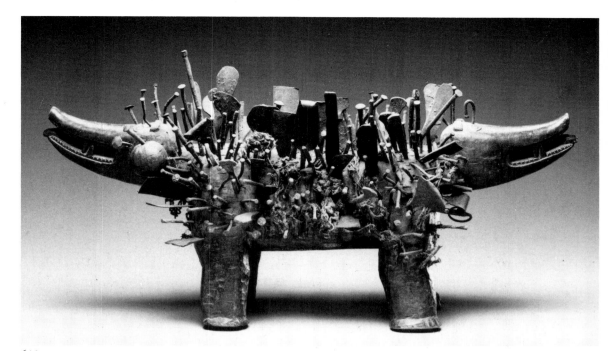

613

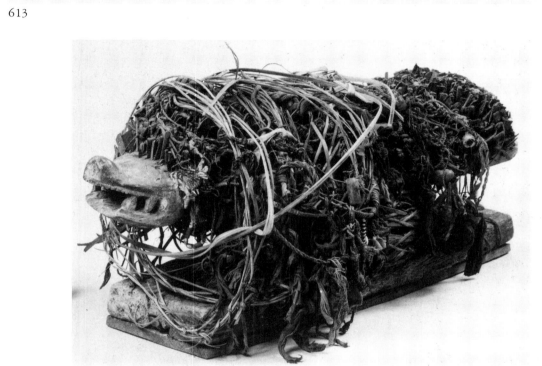

614

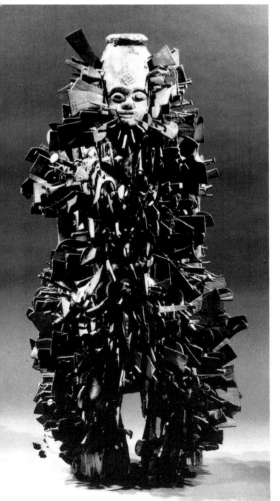

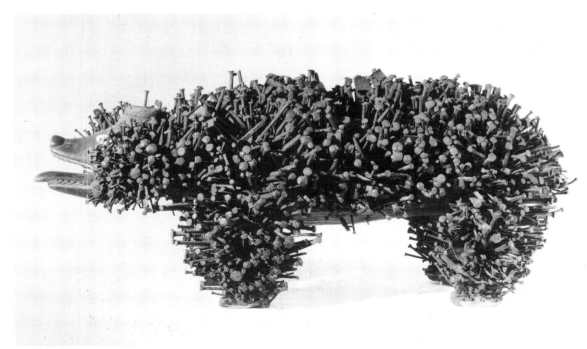

615

616

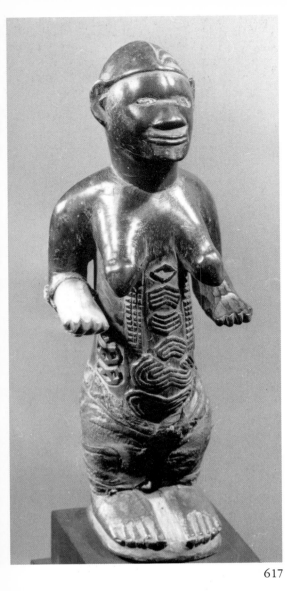

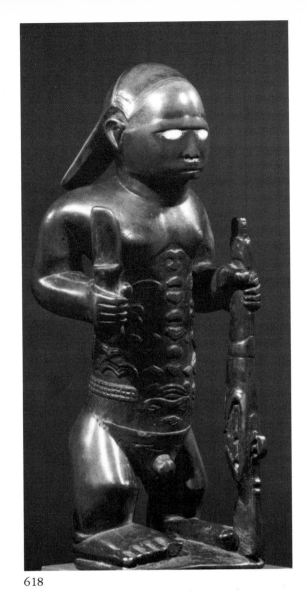

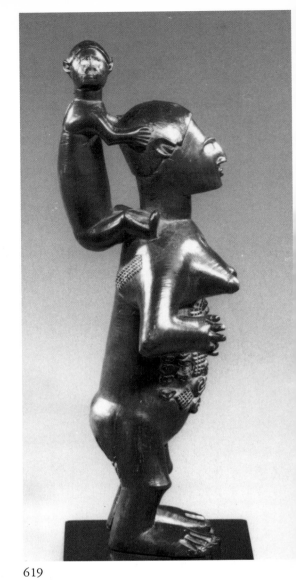

617

618

619

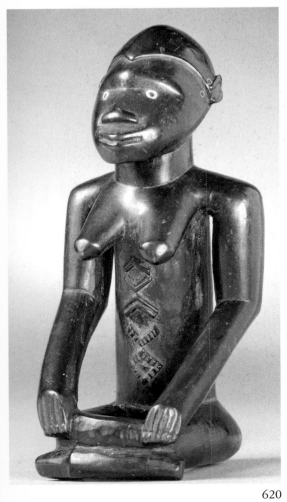

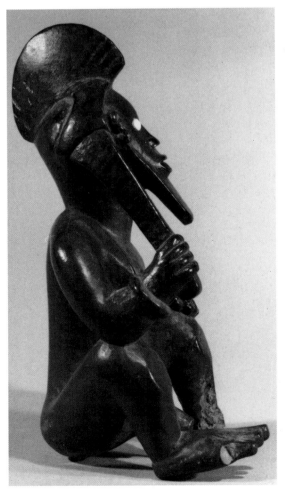

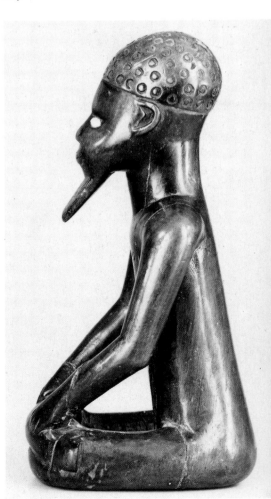

620

621

622

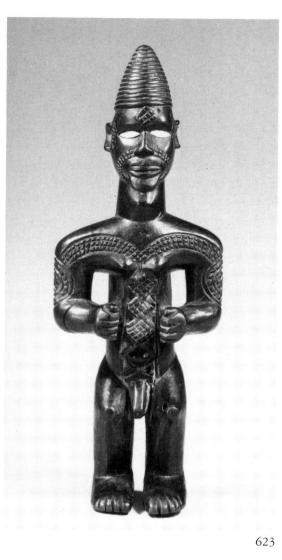

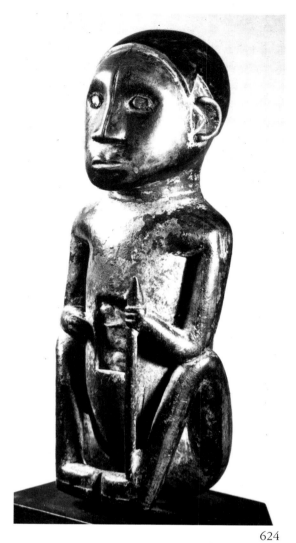

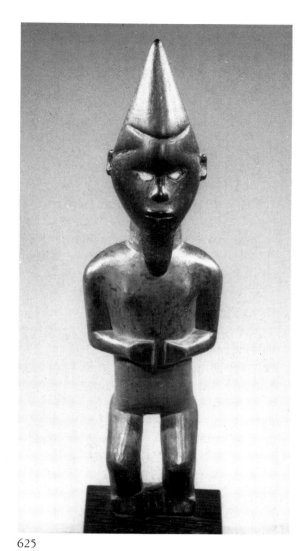

623

624 625

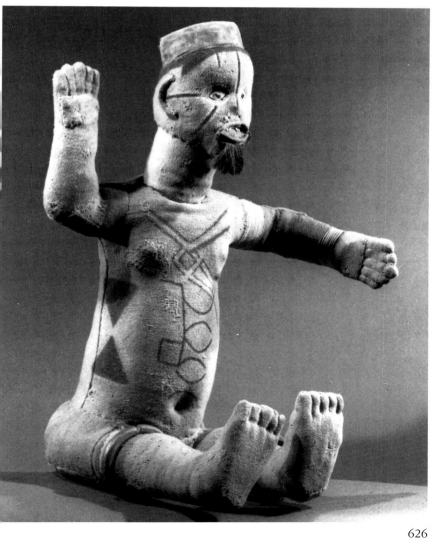

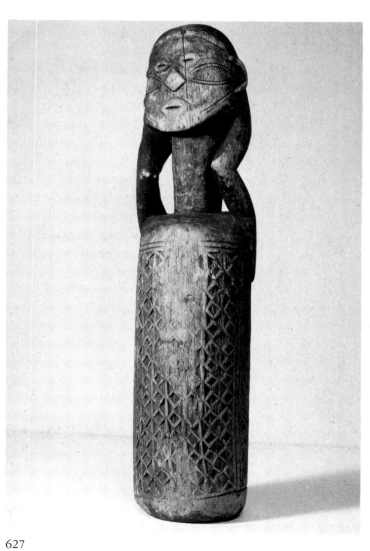

626 627

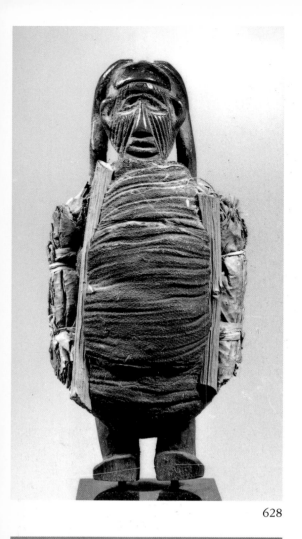

628

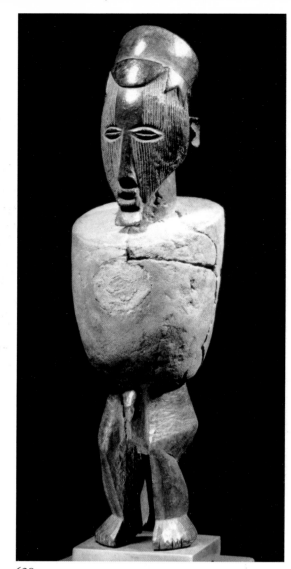

629

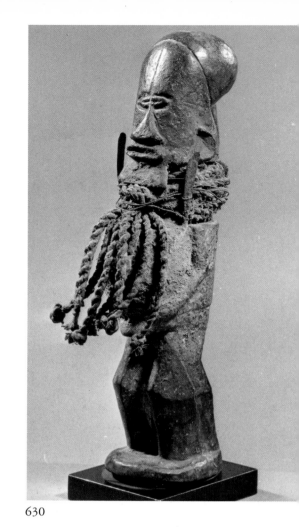

630

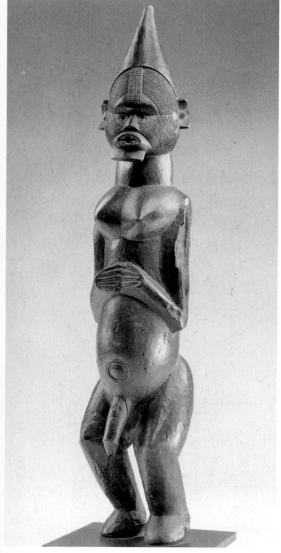

631

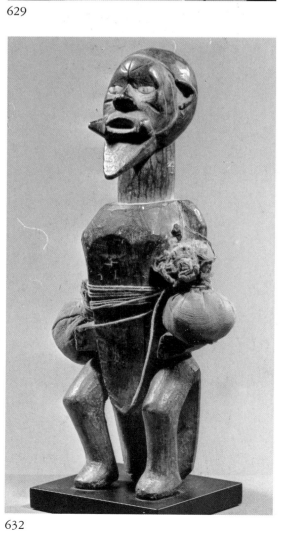

631 632

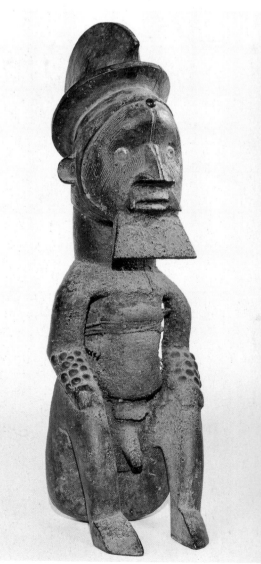

633

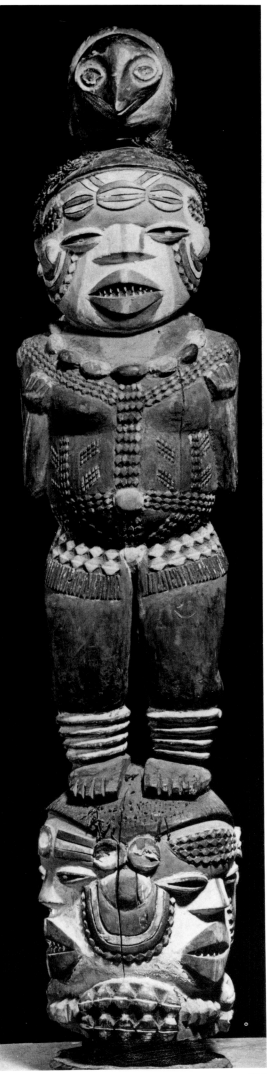

635

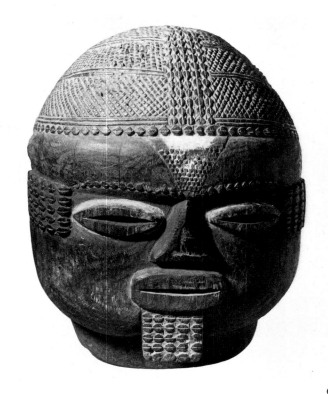

634

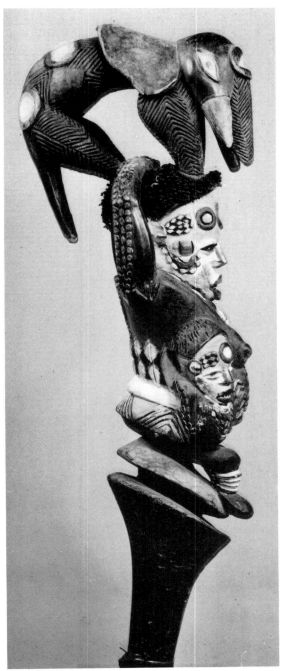

636

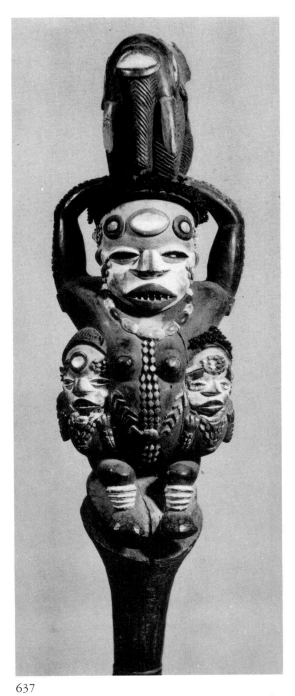

637

435

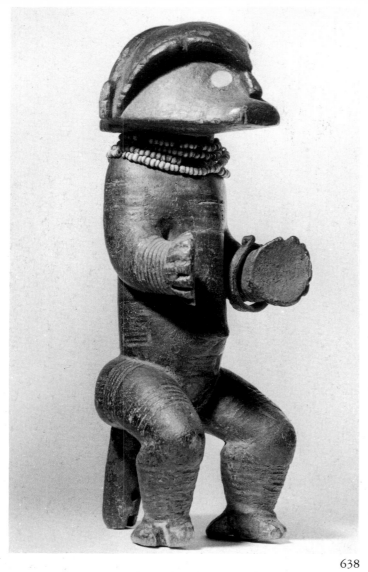

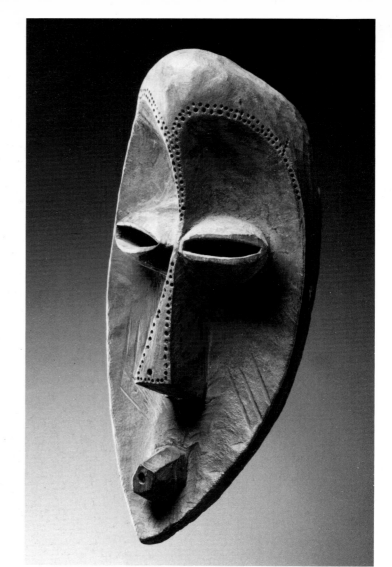

638 639

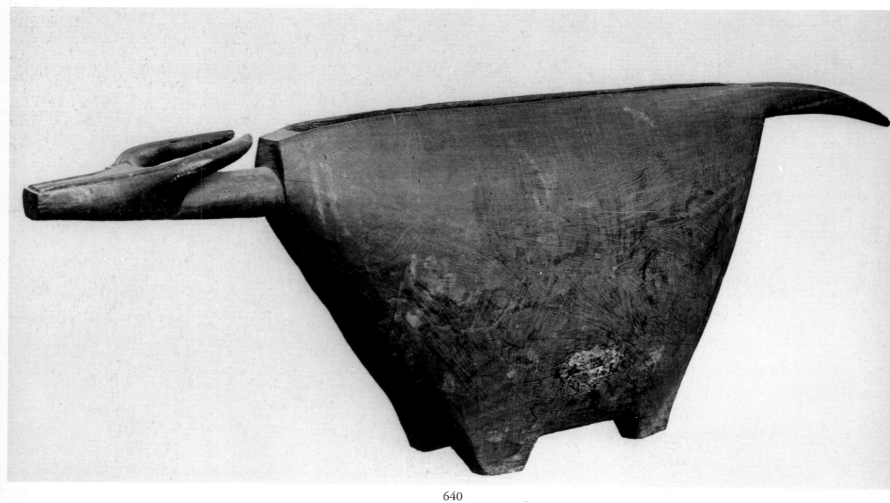

640

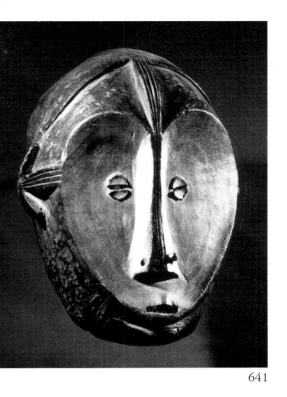

641

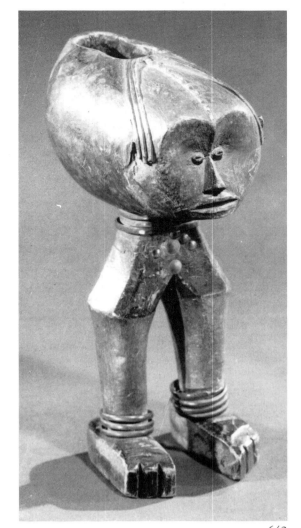

642

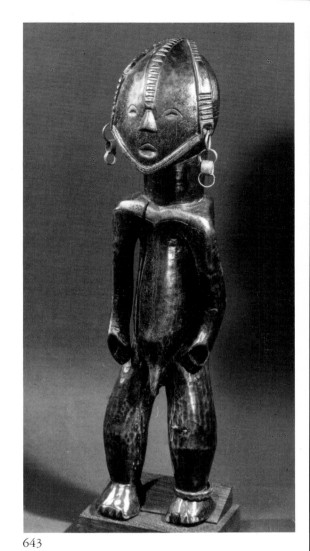

643

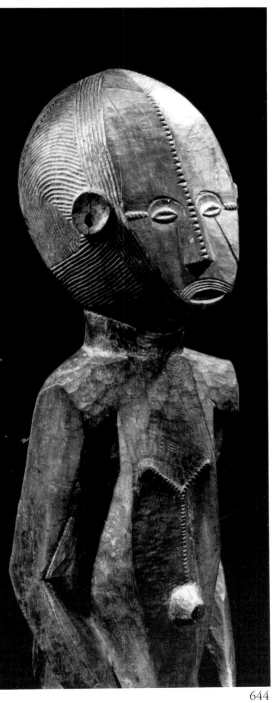

644

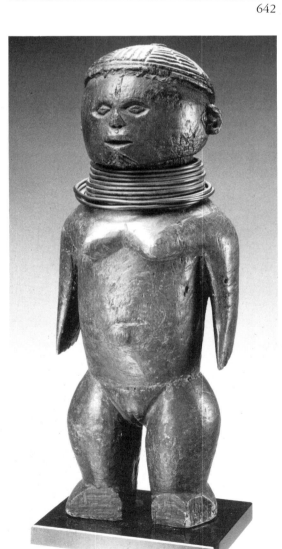

645

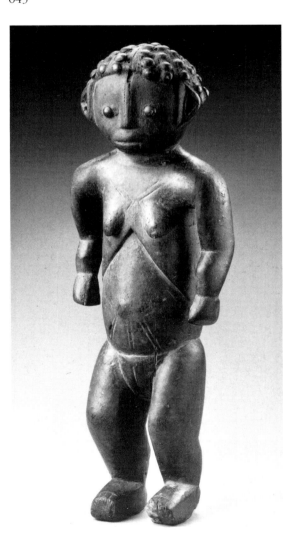

646

437

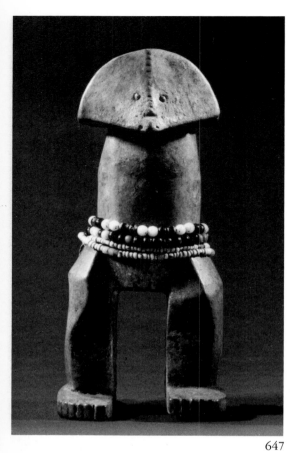

647 648

649

650 651

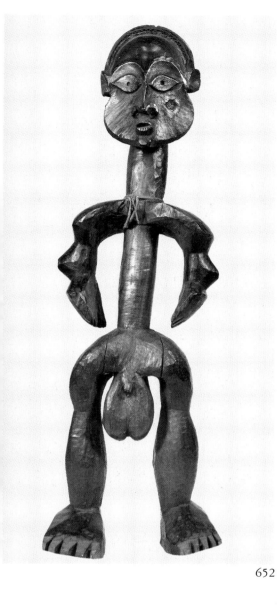

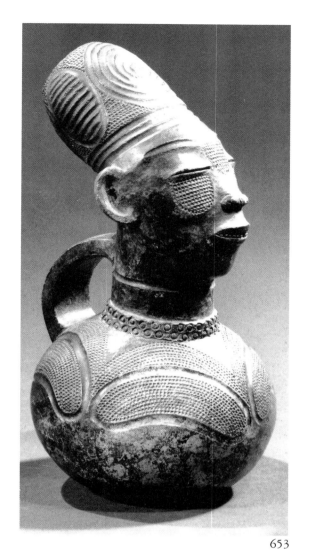

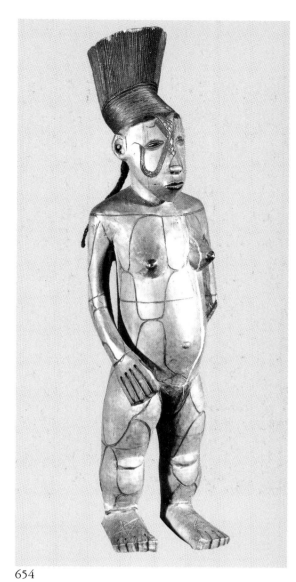

652

653 654

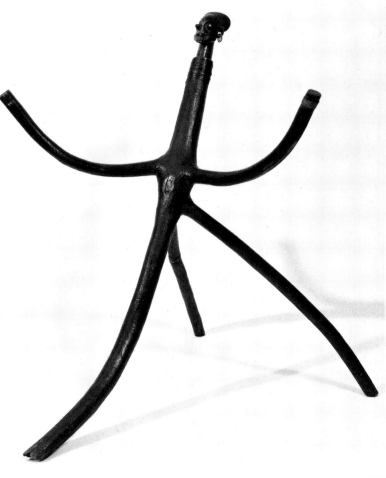

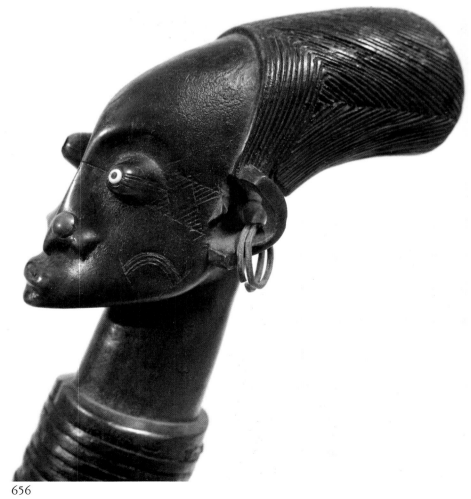

655 656

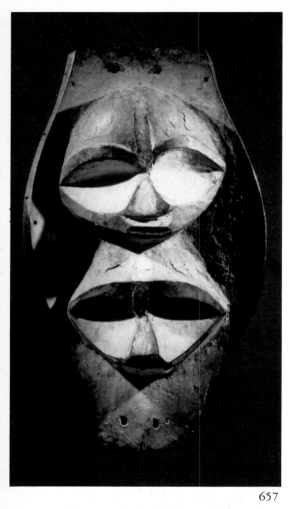

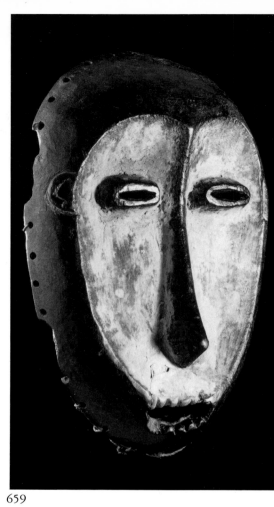

657

658

659

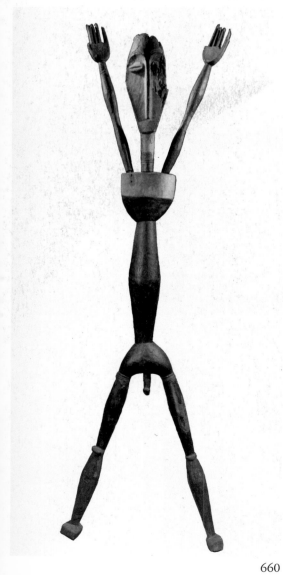

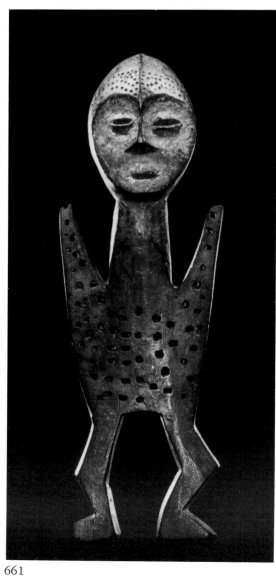

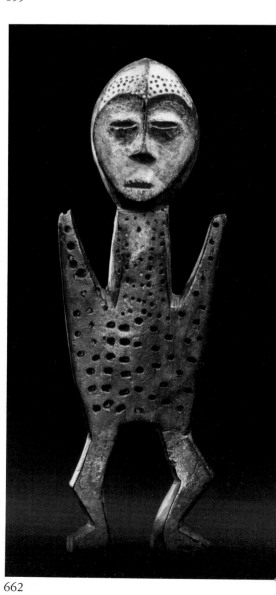

660

661

662

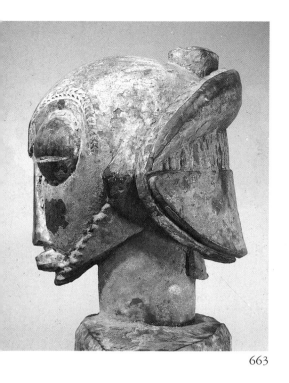

663

665

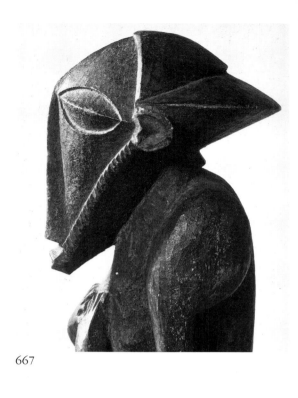

667

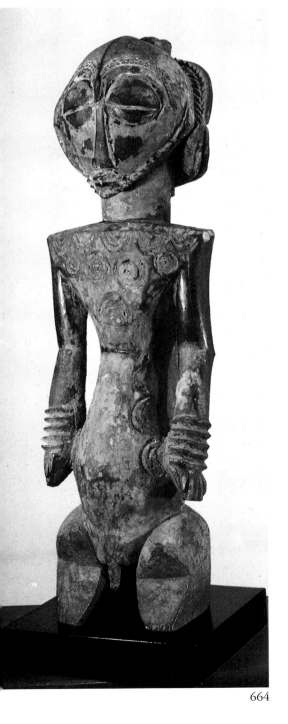

664

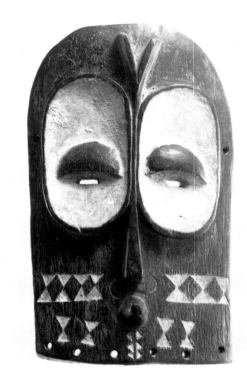

666

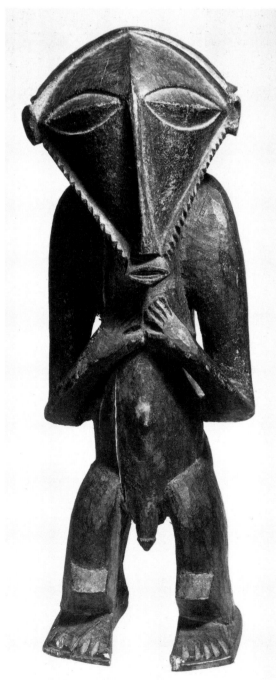

668

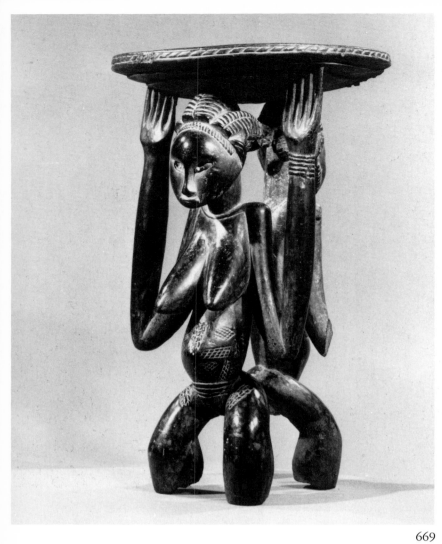

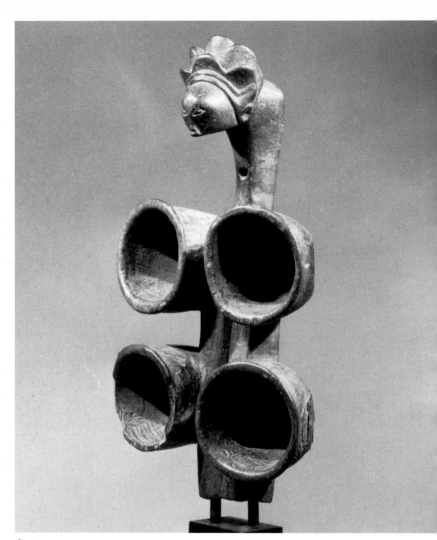

669 670

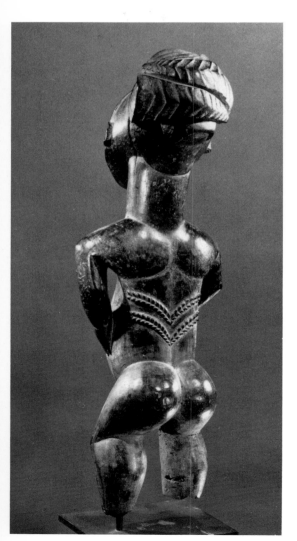

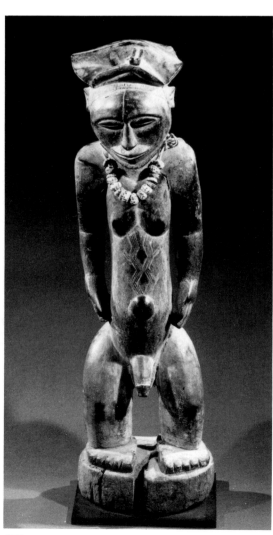

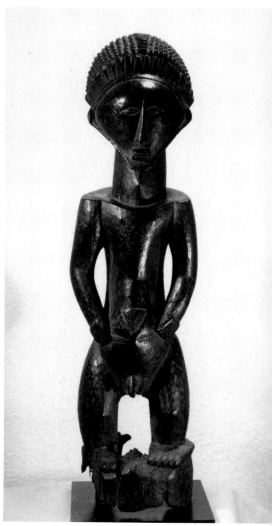

671 672

673

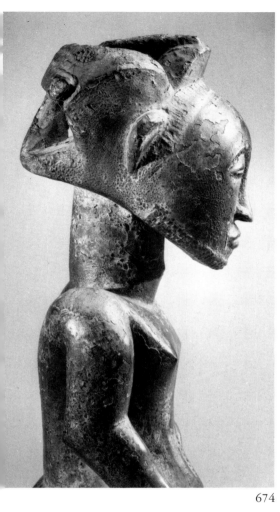
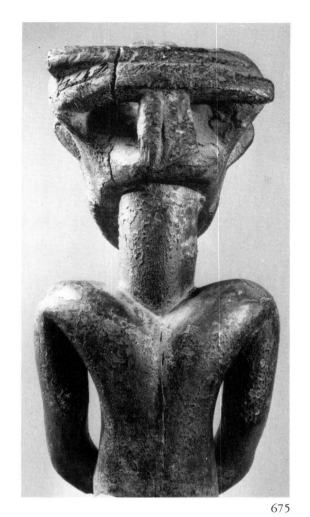
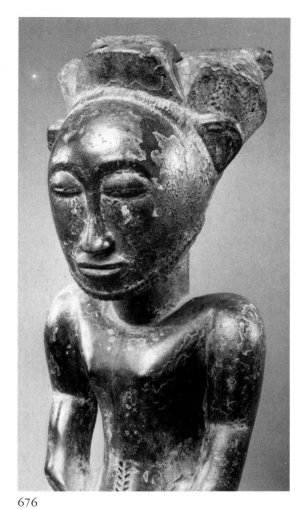

674

675 676

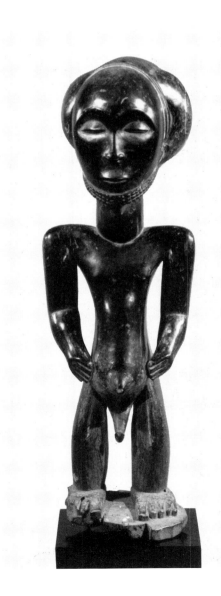
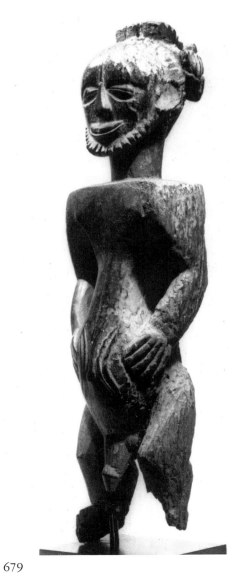

677

678 679

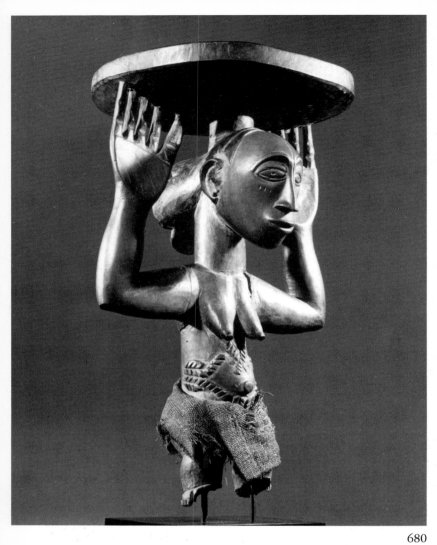

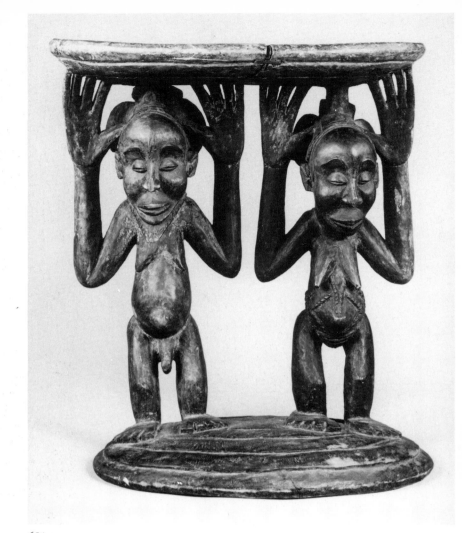

680 681

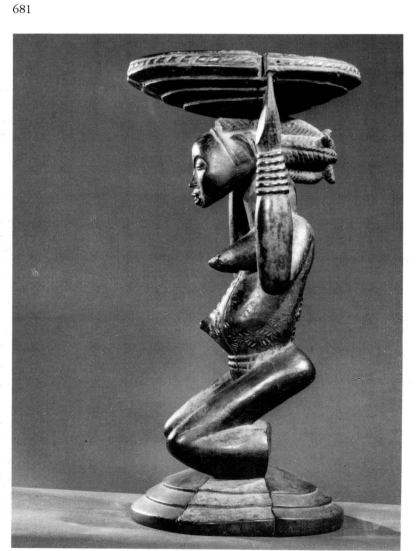

682 683

444

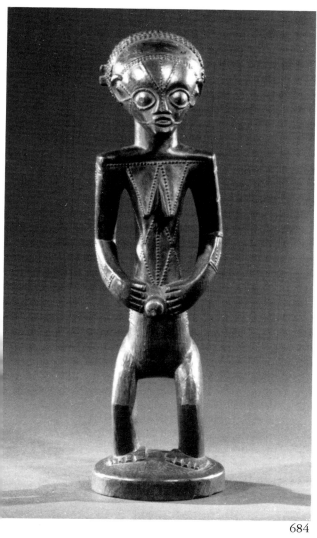

684

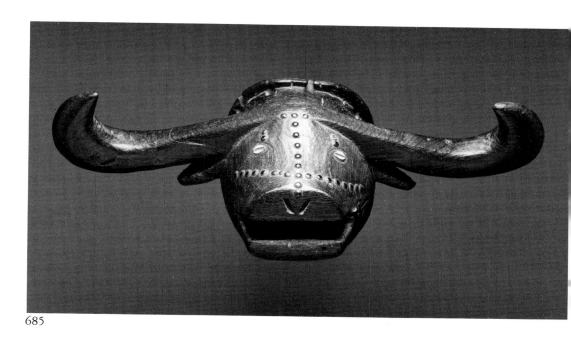

685

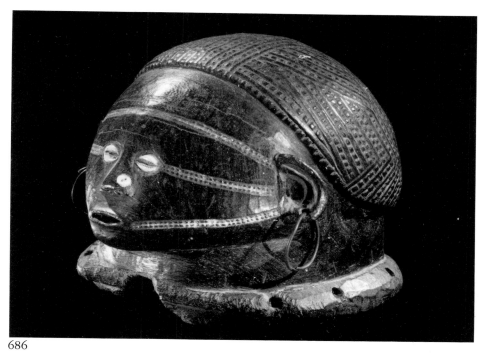

686

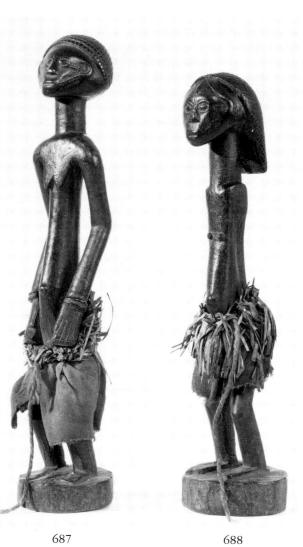

687 688

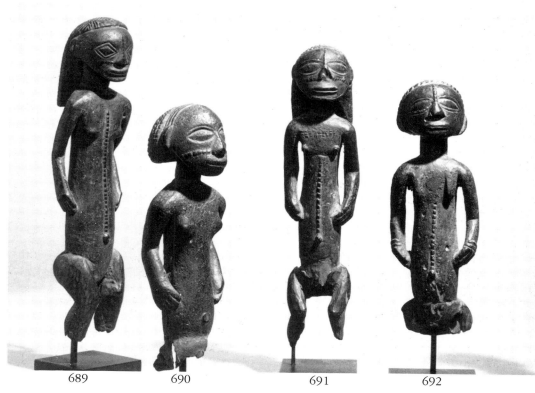

689 690 691 692

445

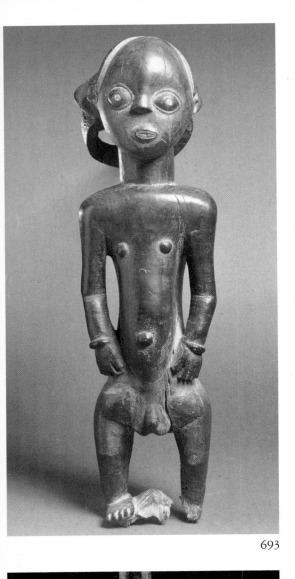

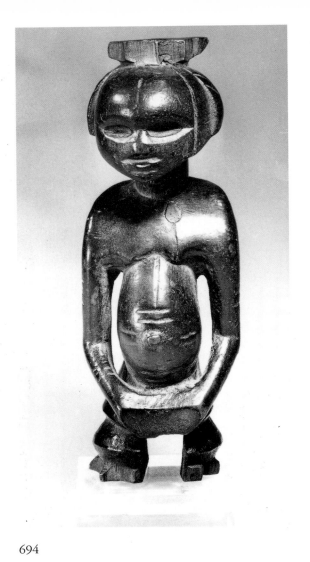

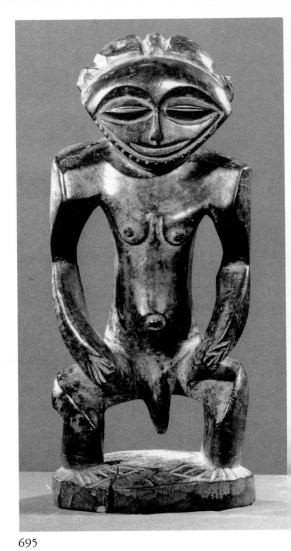

693 694 695

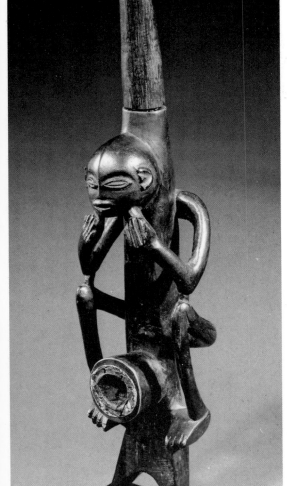

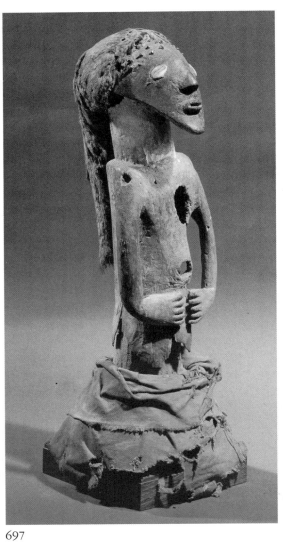

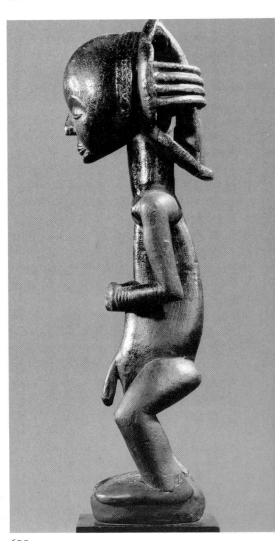

696 697 698

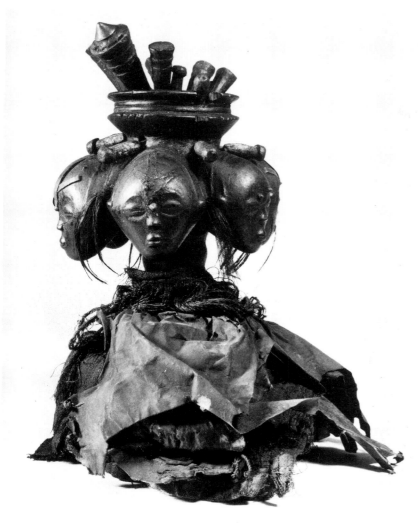
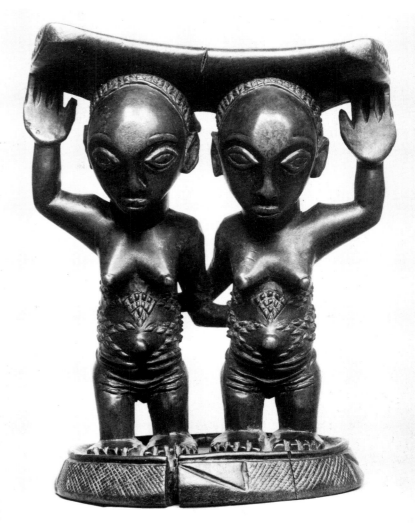

<div style="text-align:center">699 700</div>

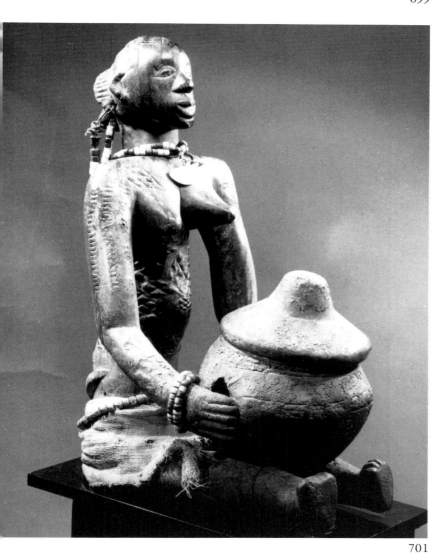
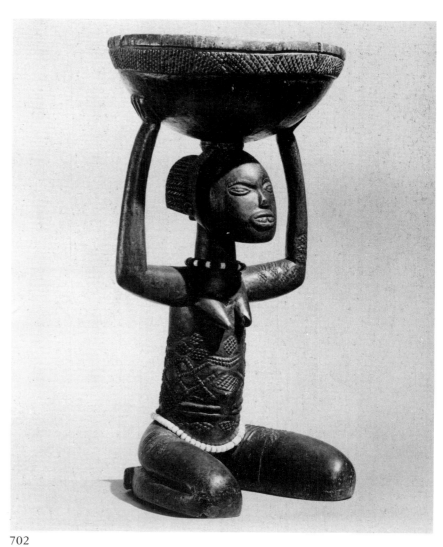

<div style="text-align:center">701 702</div>

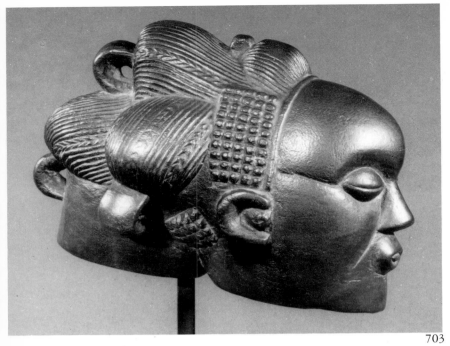
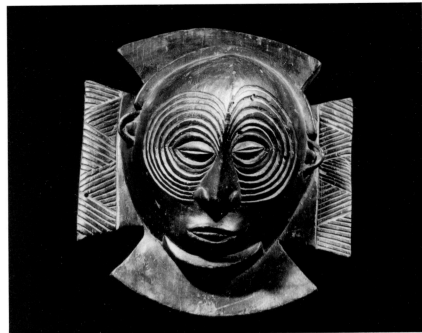

703 704

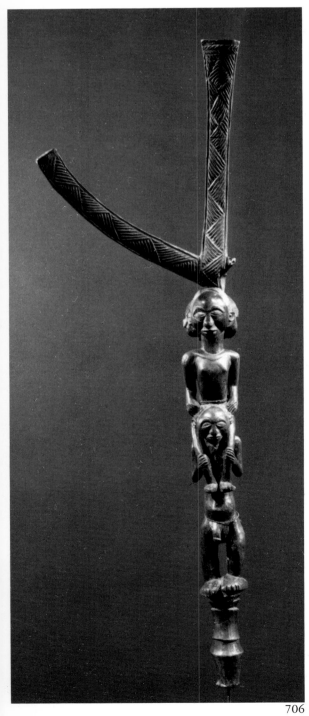

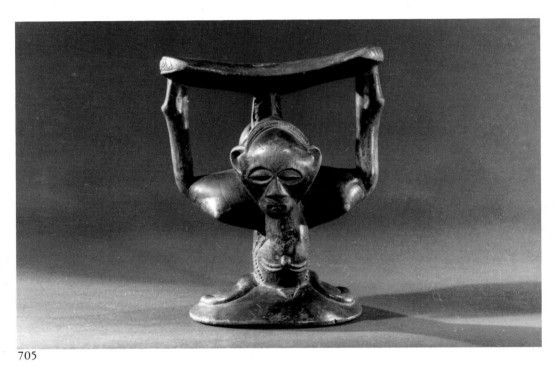

705

706 707

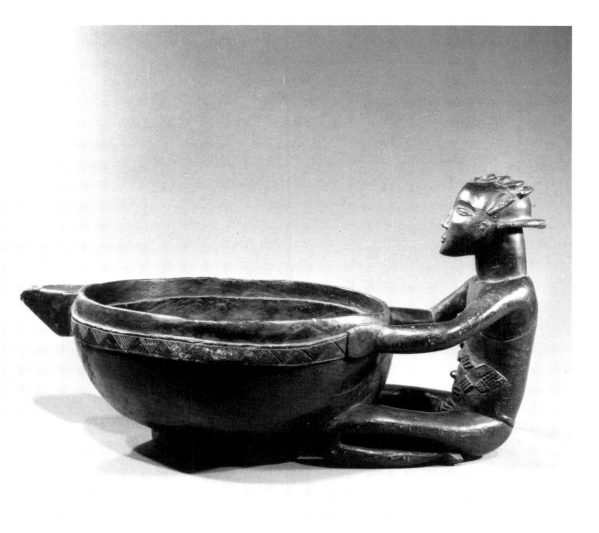
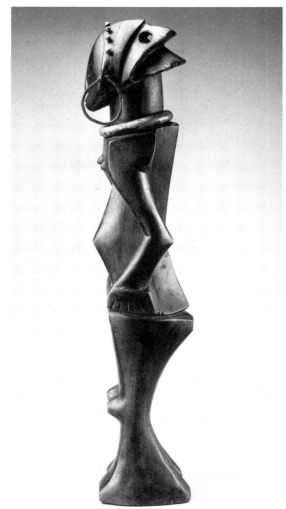

708 709

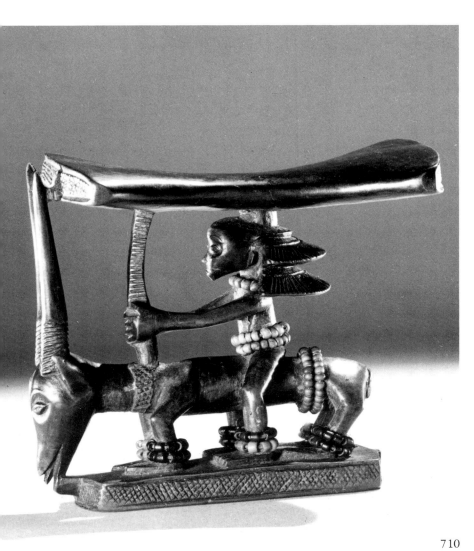
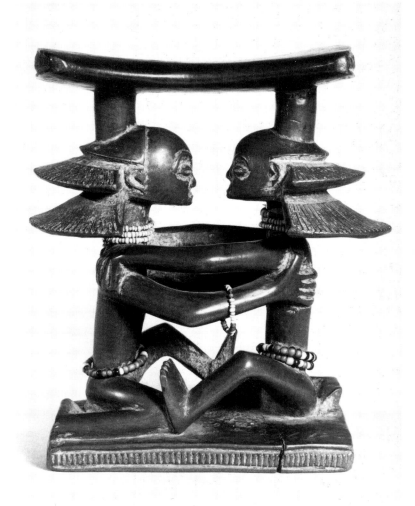

710 711

449

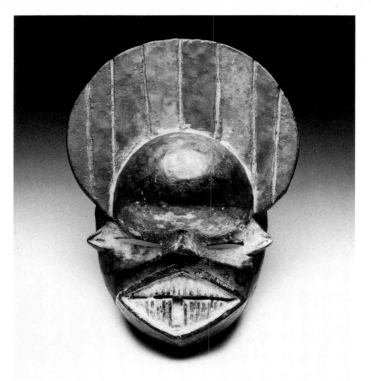

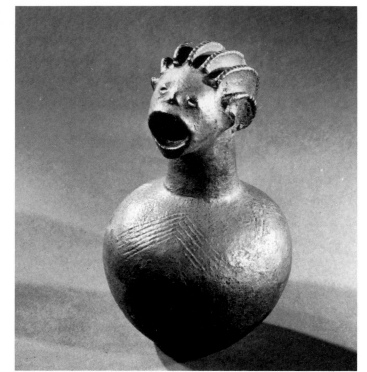

712 713

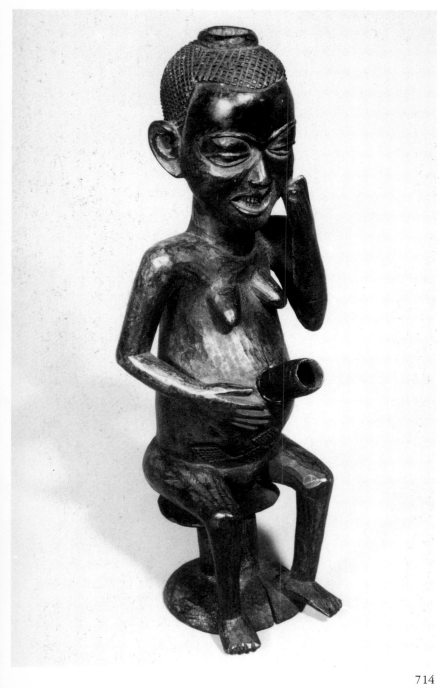

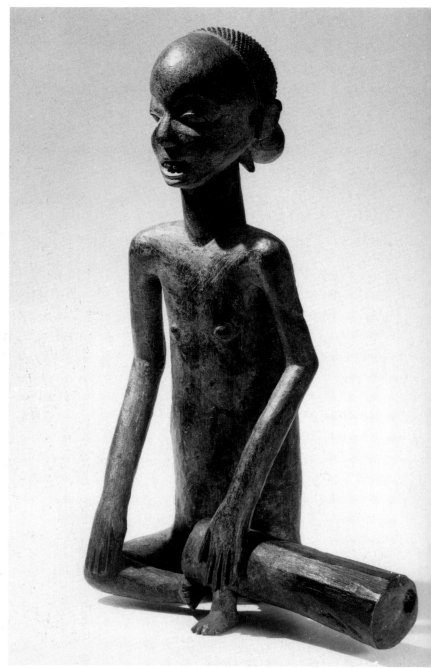

714 715

450

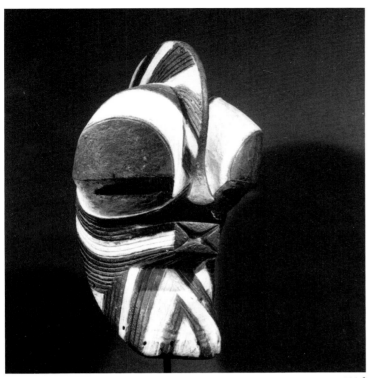

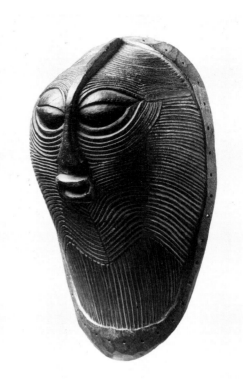

716 717

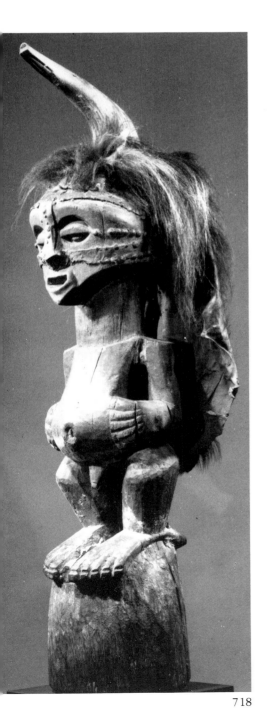

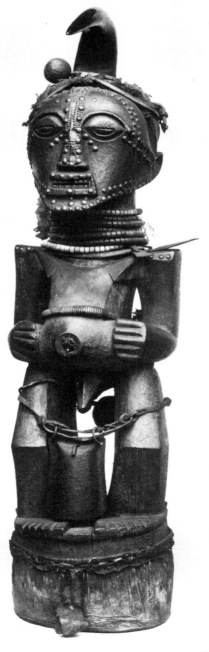

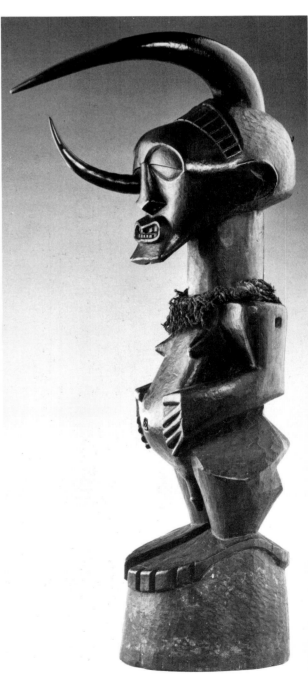

718 719 720

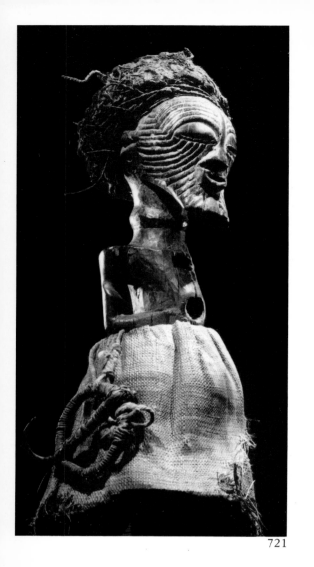
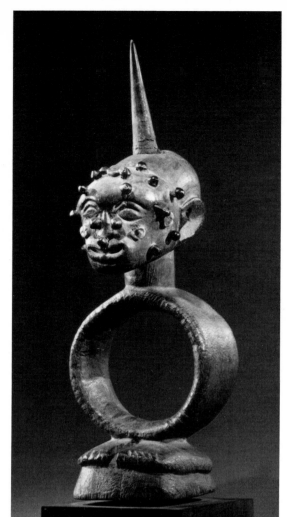
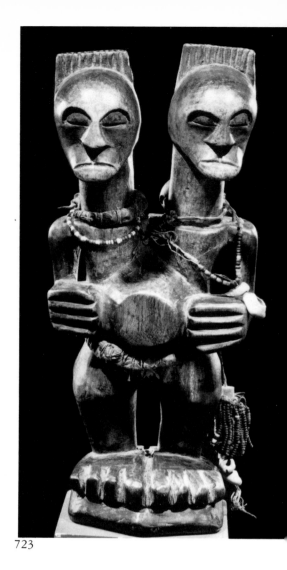

721 722 723

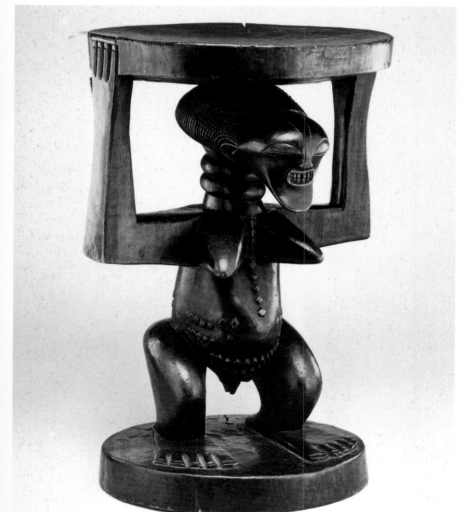
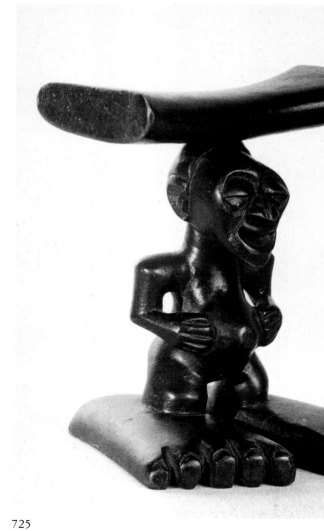

724 725

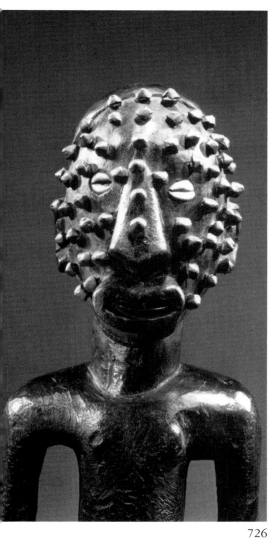

726

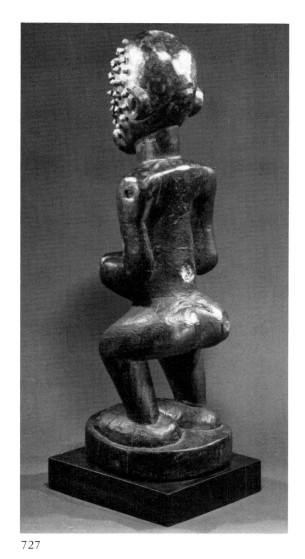

727

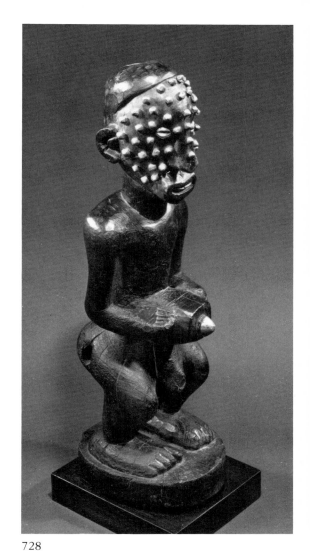

728

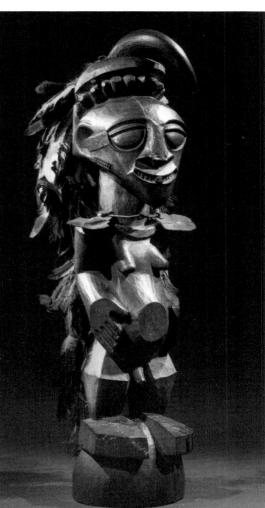

729

730

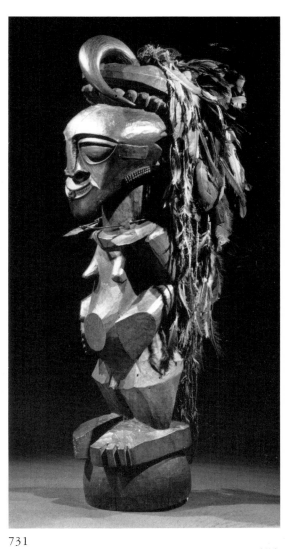

731

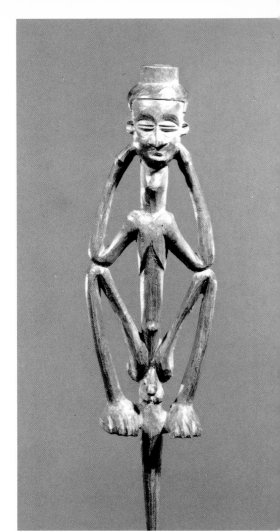

732

733 734

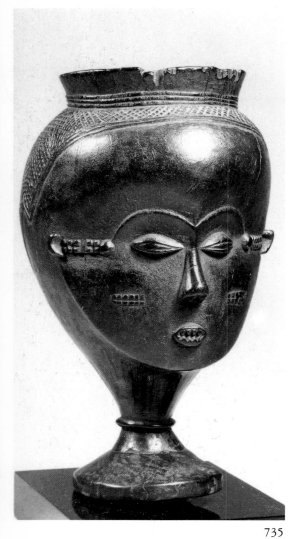

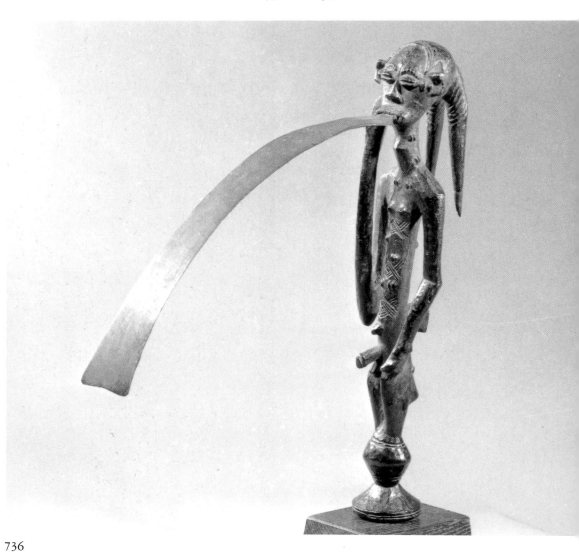

735 736

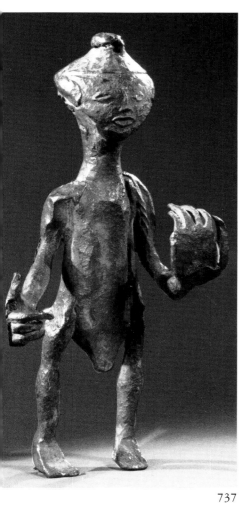

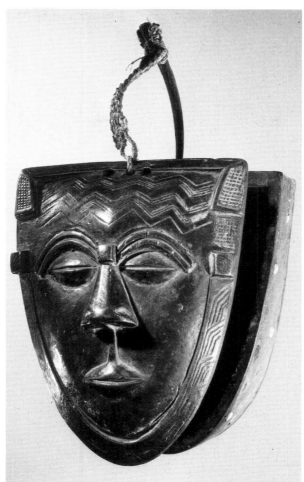

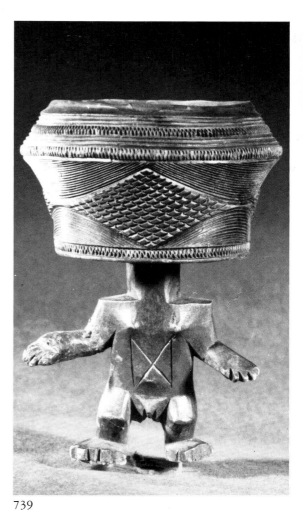

737 738 739

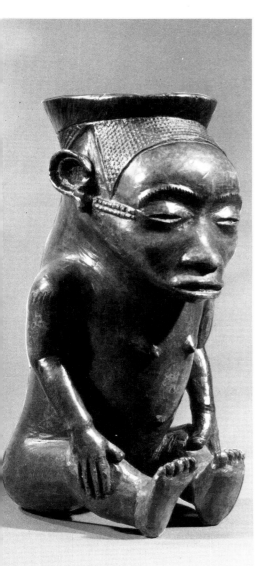

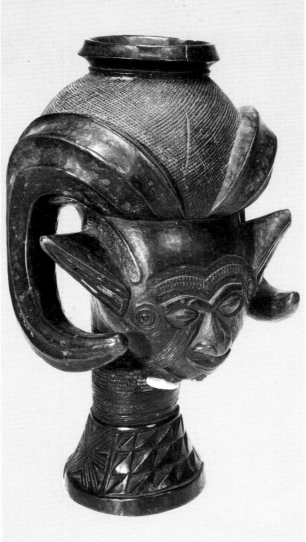

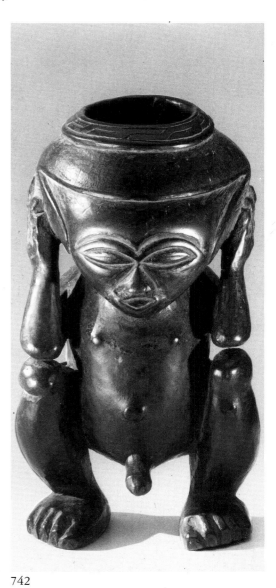

740 741 742

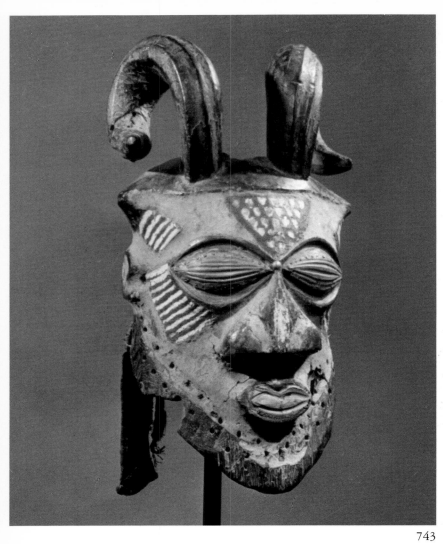

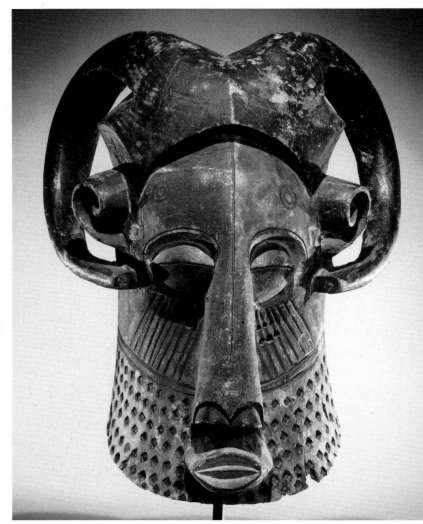

743 744

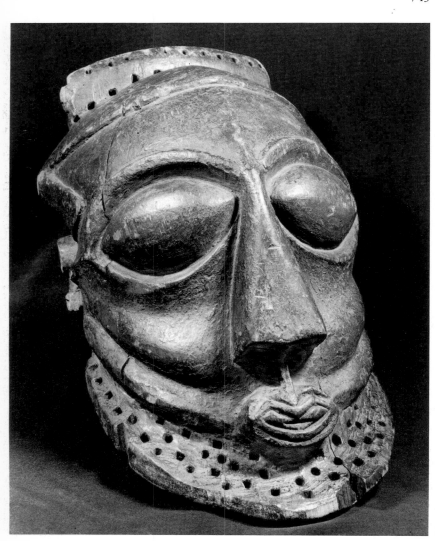

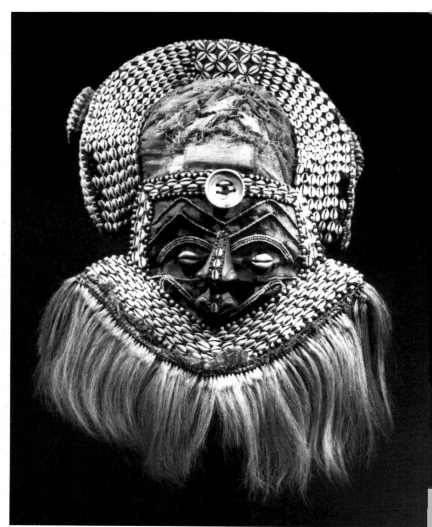

745 746

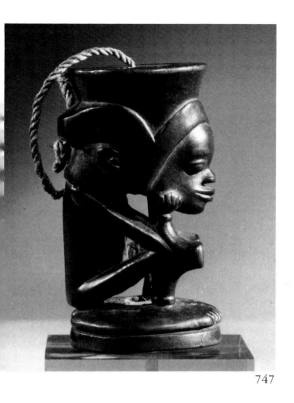

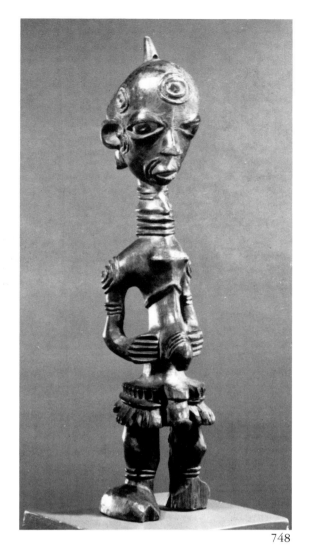

747

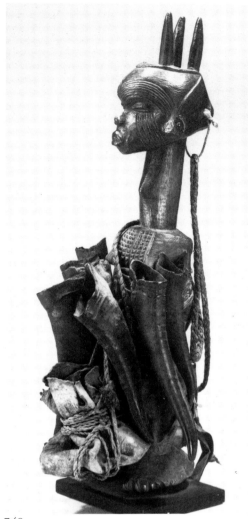

748 749

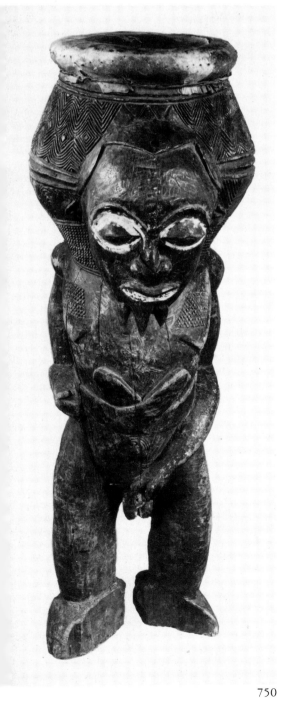

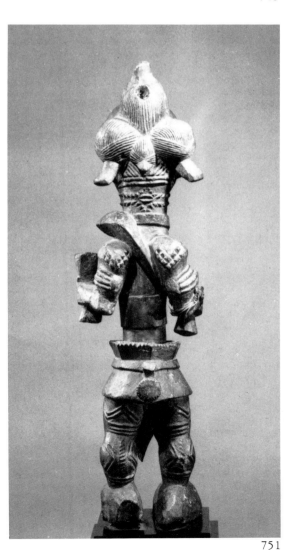

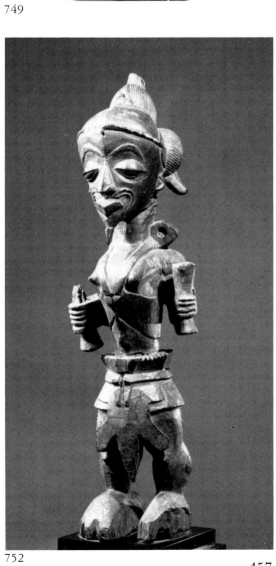

750

751 752

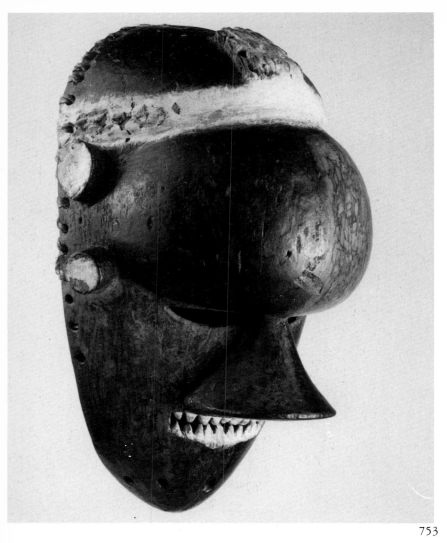

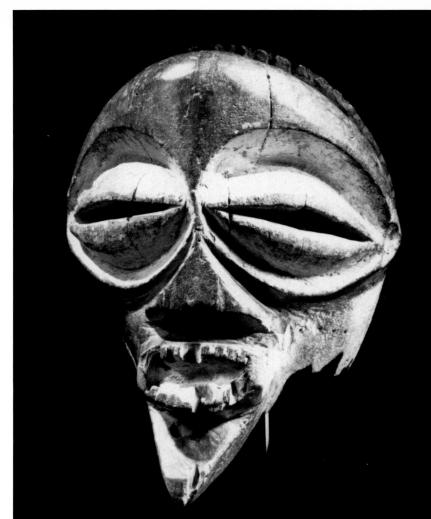

753

754

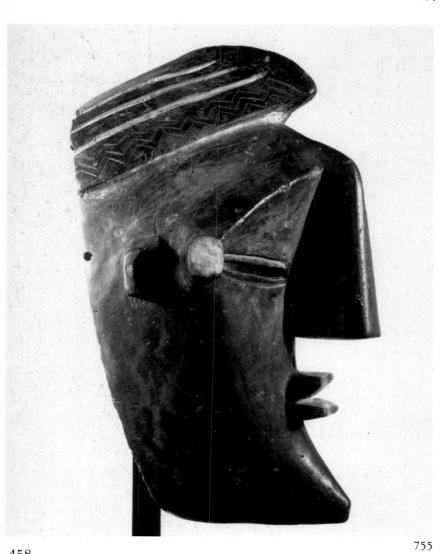

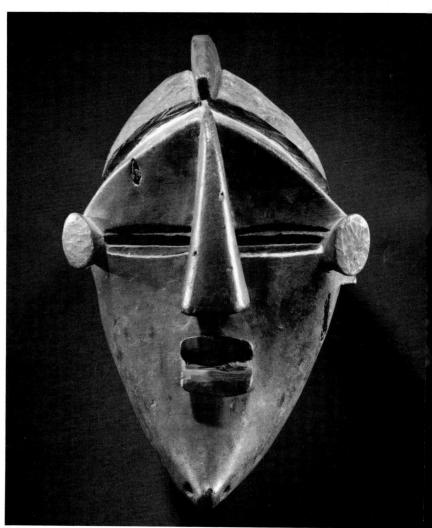

755

756

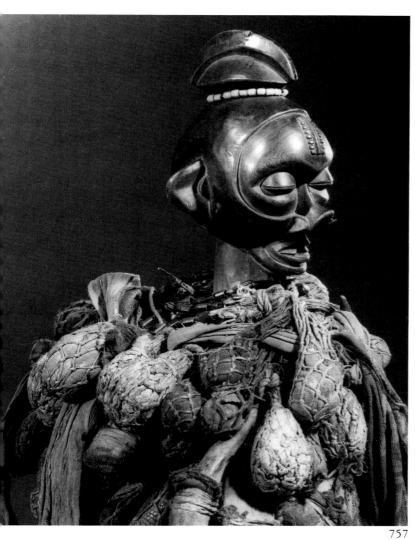

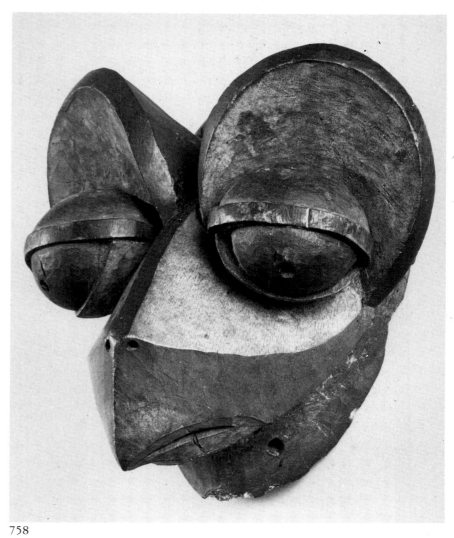

757 758

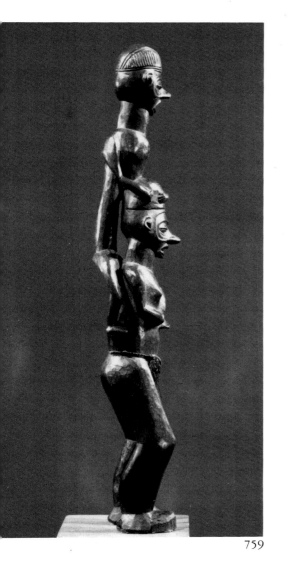

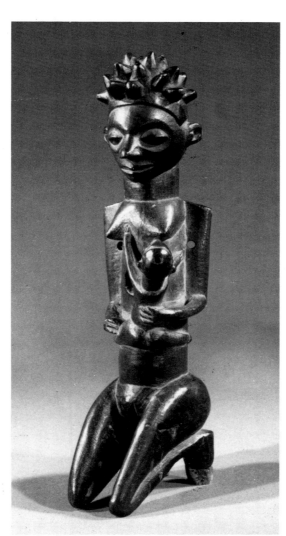

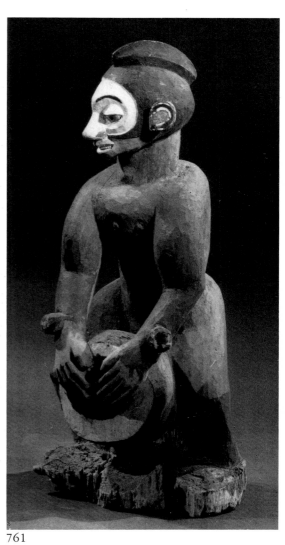

759 760 761

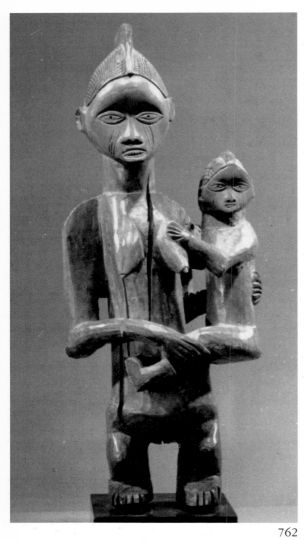

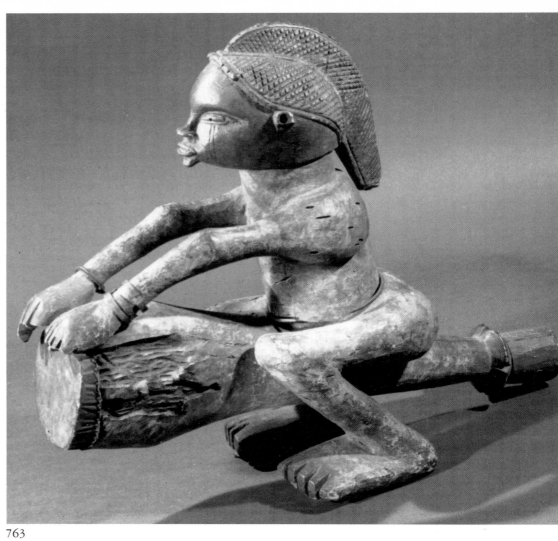

762 763

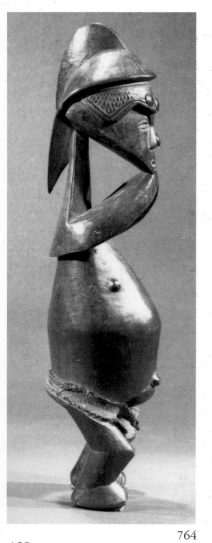

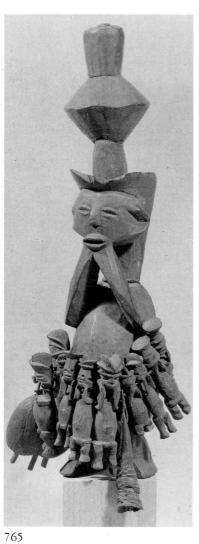

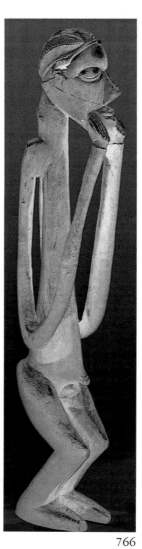

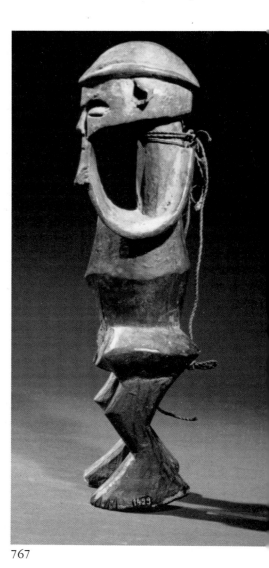

764 765 766 767

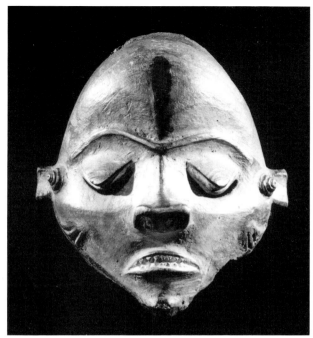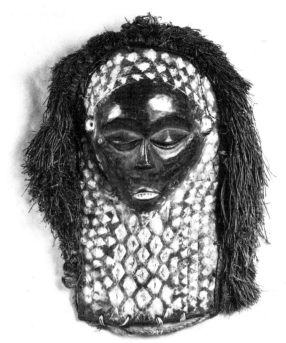

768 769

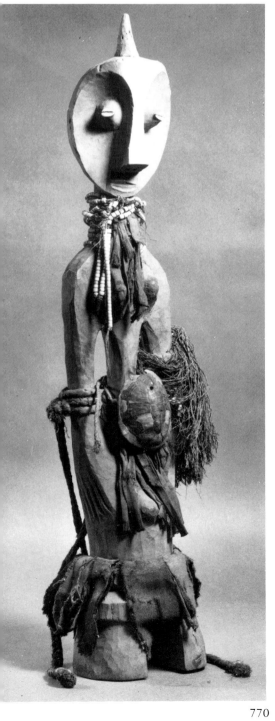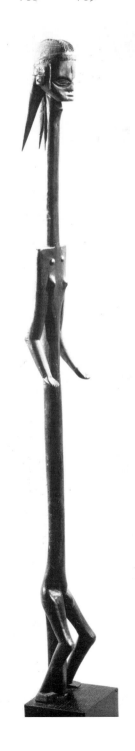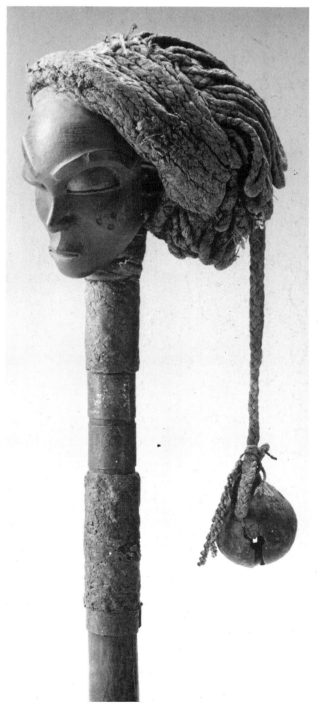

770 771 772

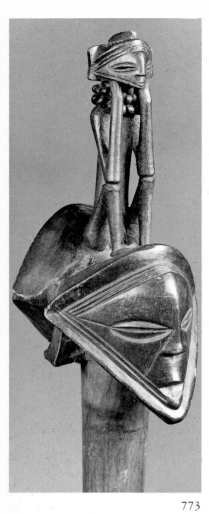
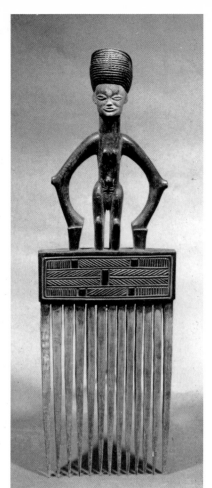
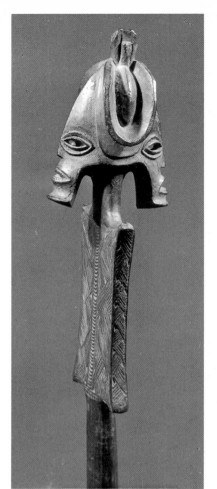

773 774 775 776

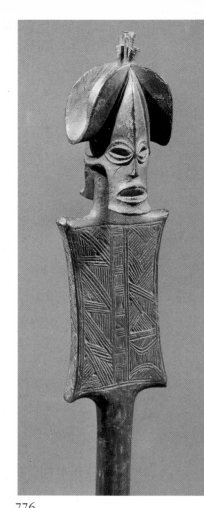

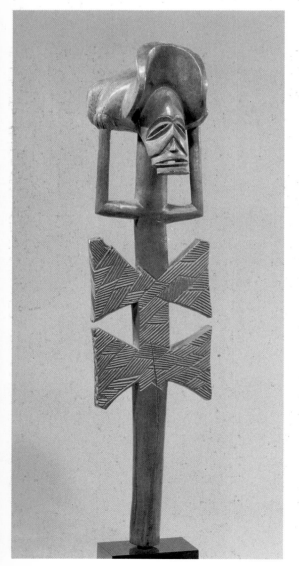
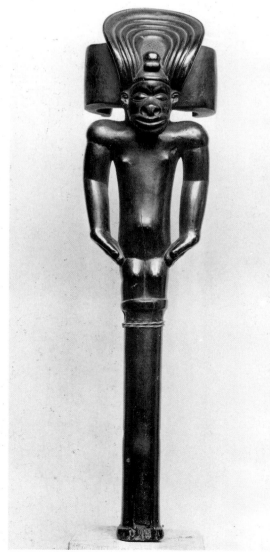
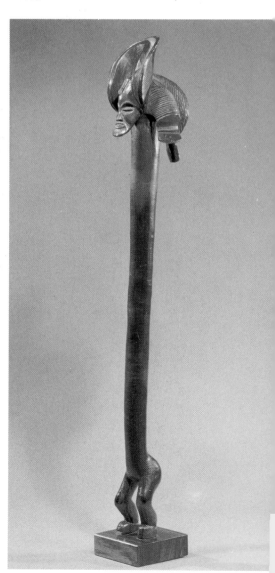

777 778 779

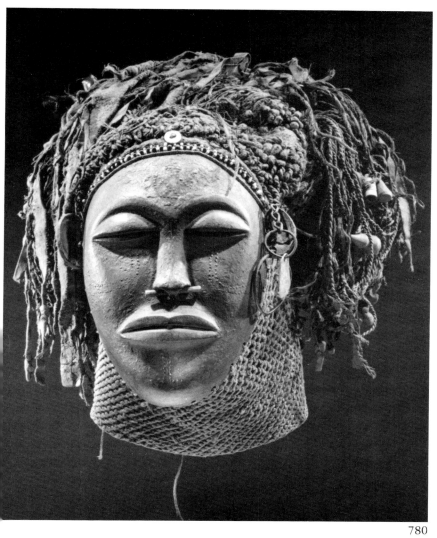

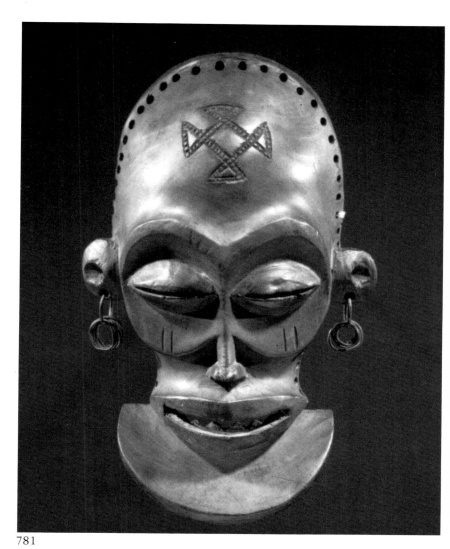

780

781

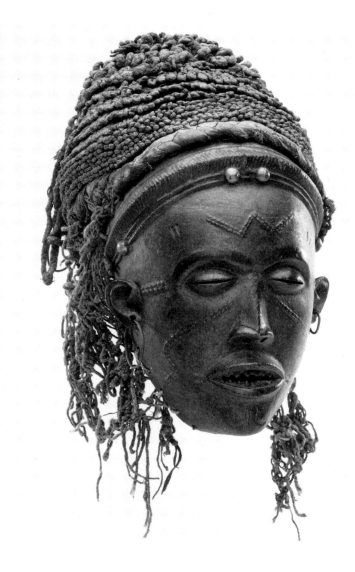

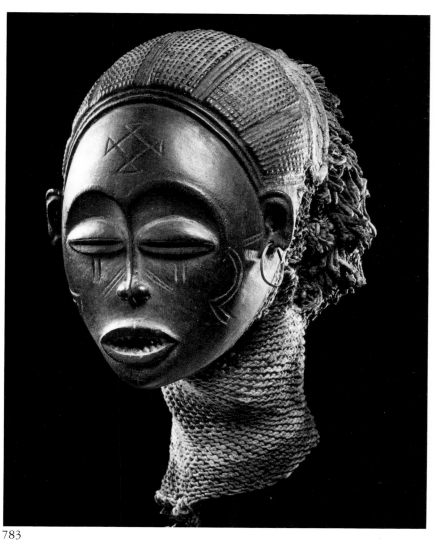

782

783

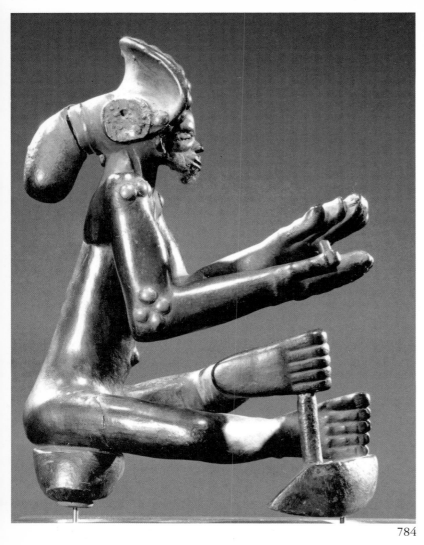

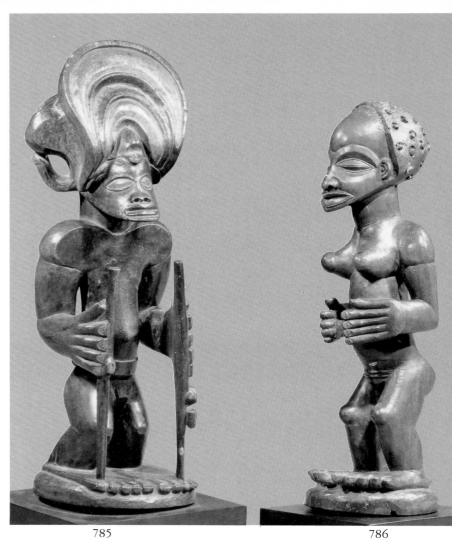

784

785

786

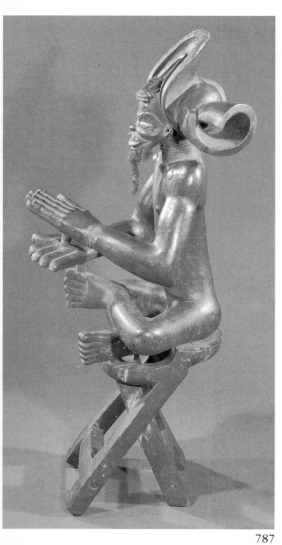

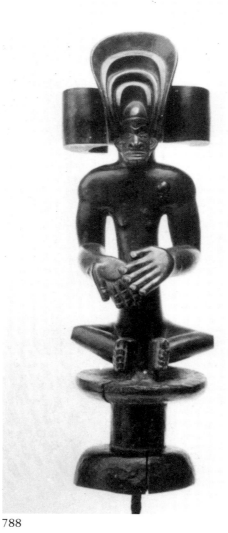

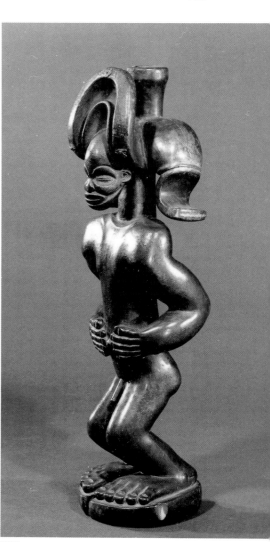

787

788

789

EASTERN AND SOUTHERN AFRICA, MADAGASCAR

Bongo. Gato. Giryama. Zaramo.
Karagwe. Nyamwezi. Makonde.
Zimbabwe. Zulu. Shona. Bara.
Sakalava. Mahafaly.

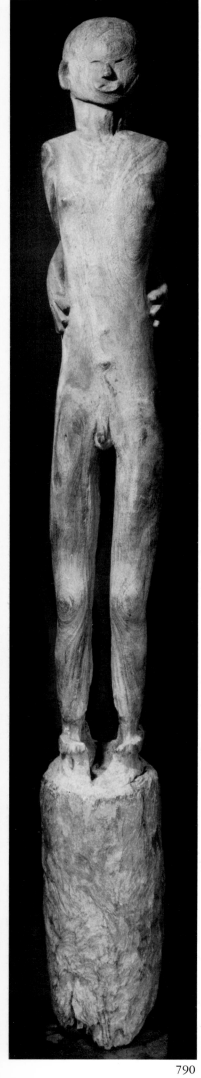

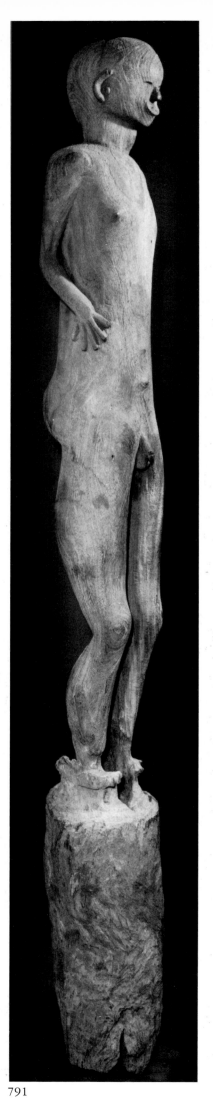

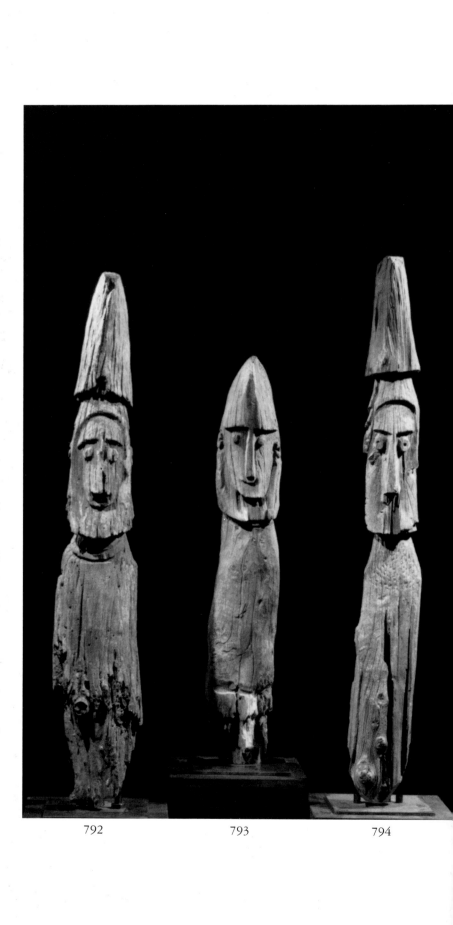

790

791

792

793

794

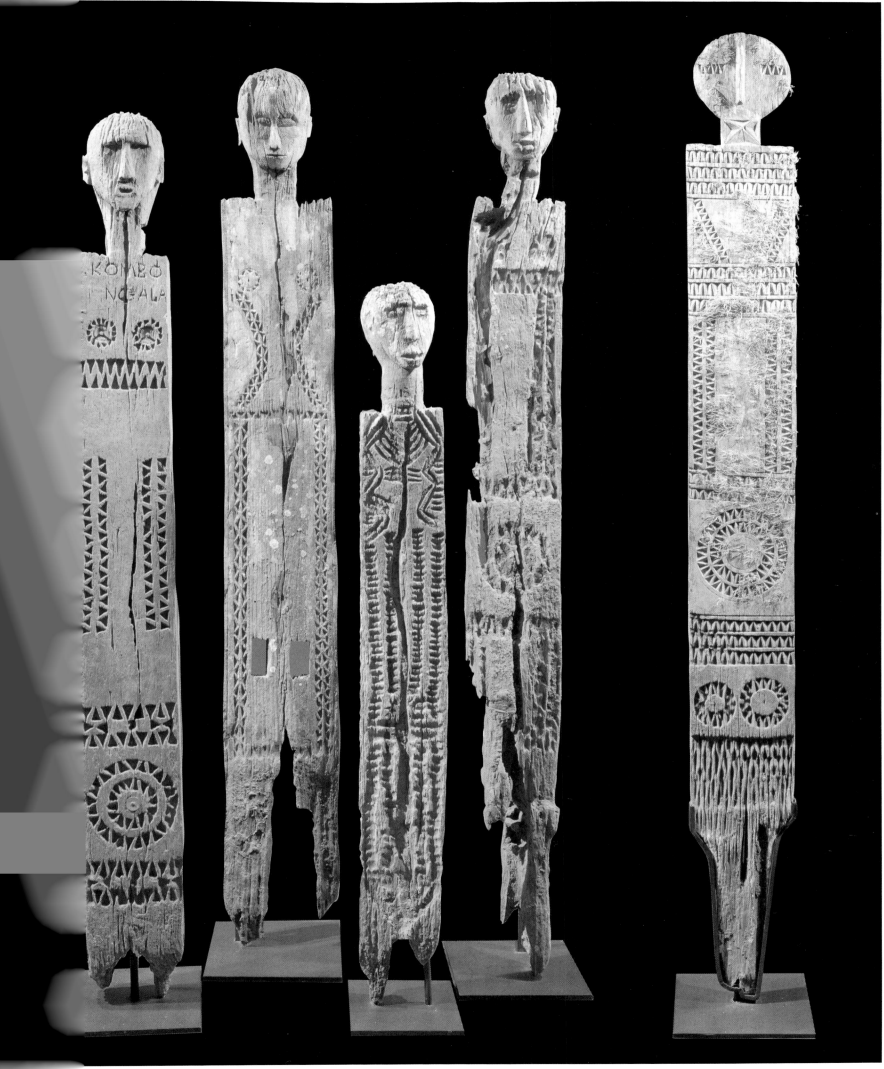

795 796 797 798 799

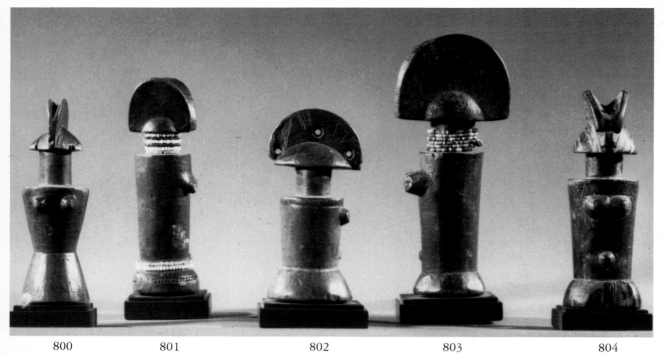

800 801 802 803 804

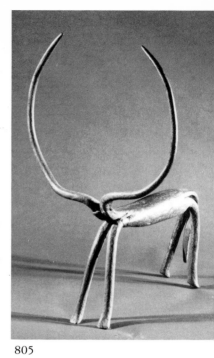

805

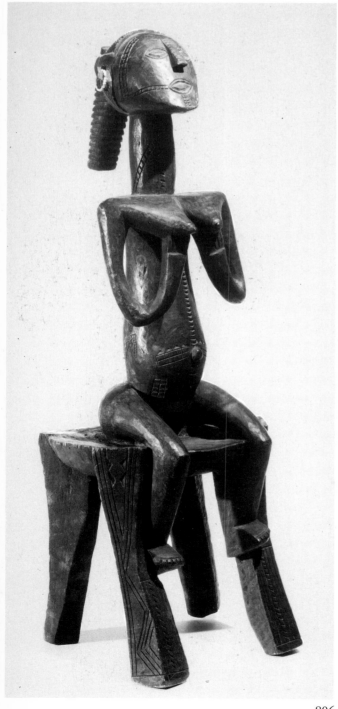

806 807 808

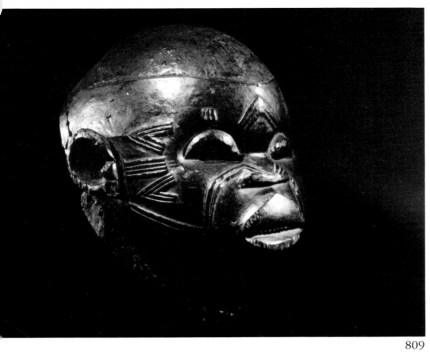
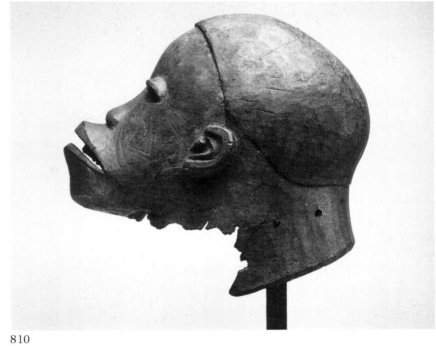

809 810

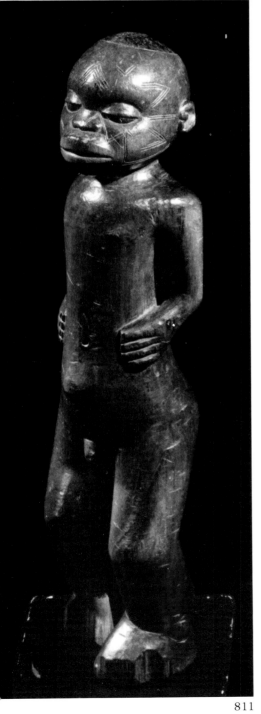
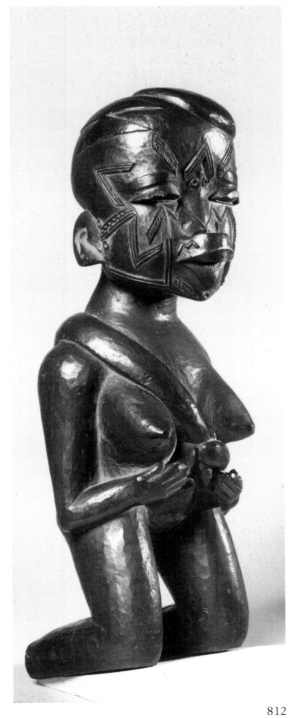
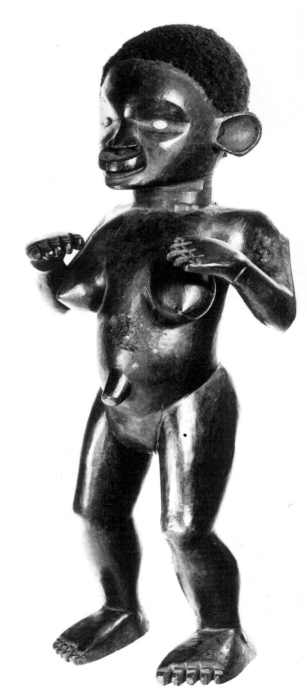

811

812 813

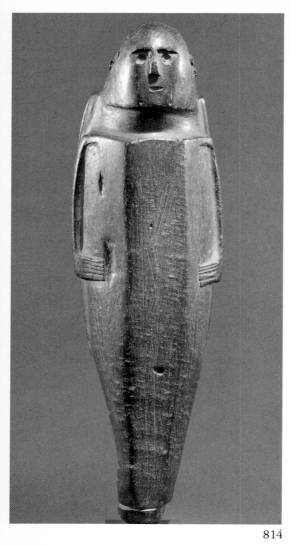

814

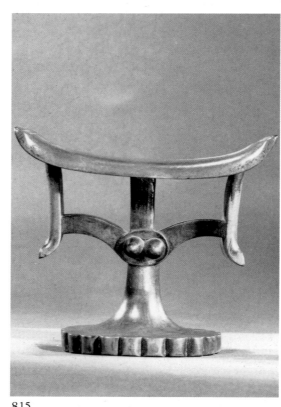

815

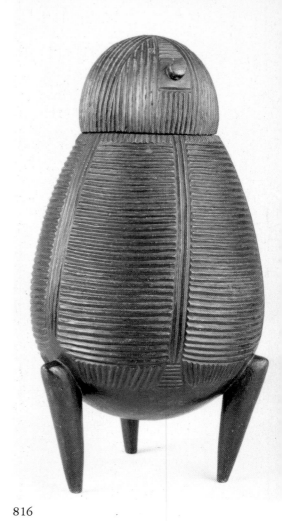

816

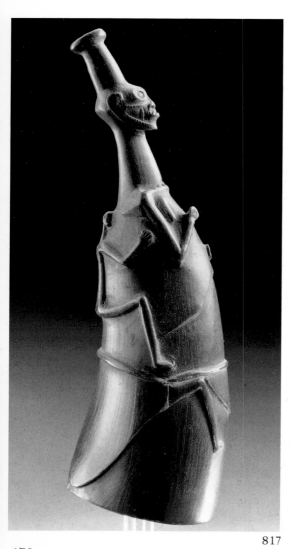

817

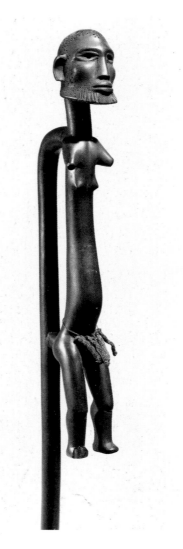

818

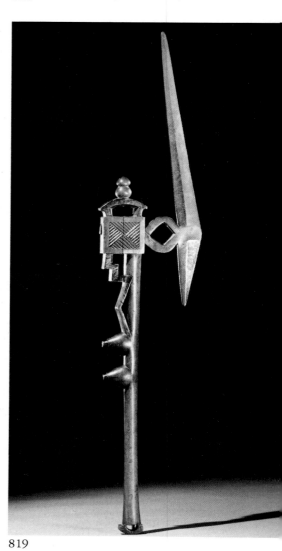

819

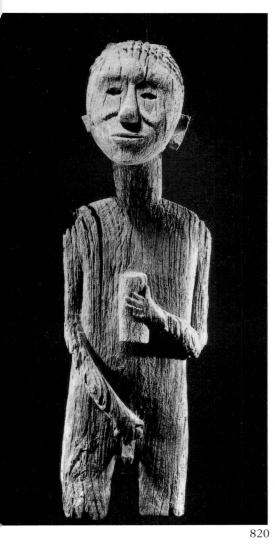

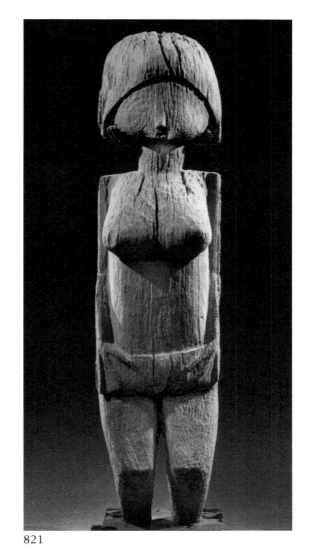

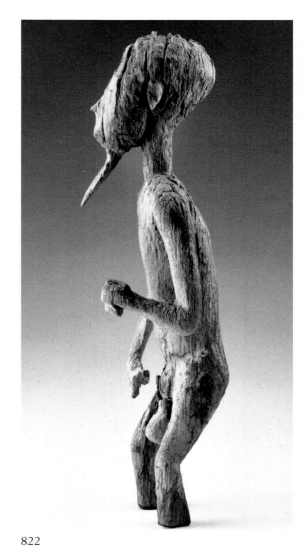

820 821 822

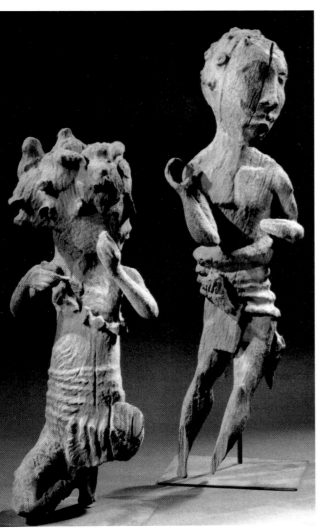

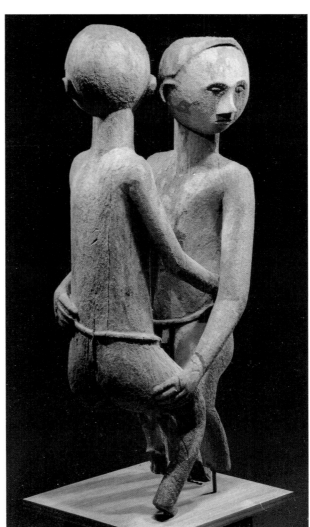

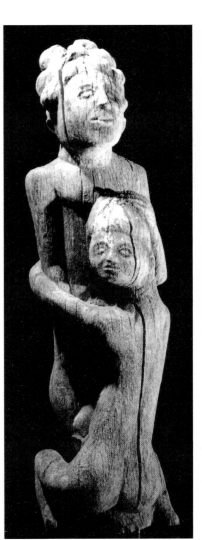

823 824 825

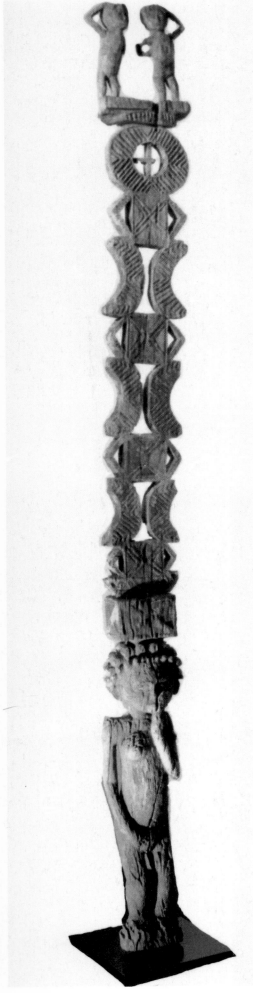
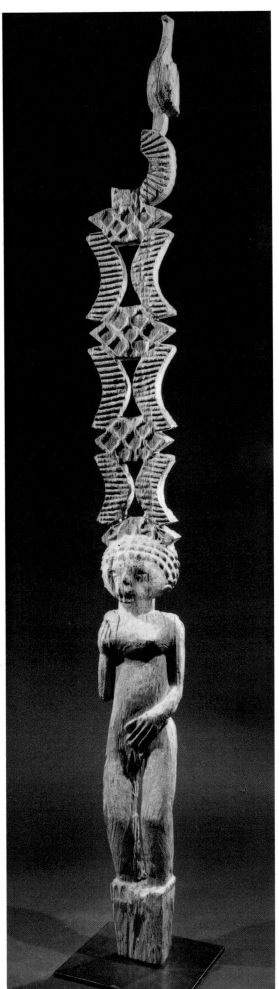
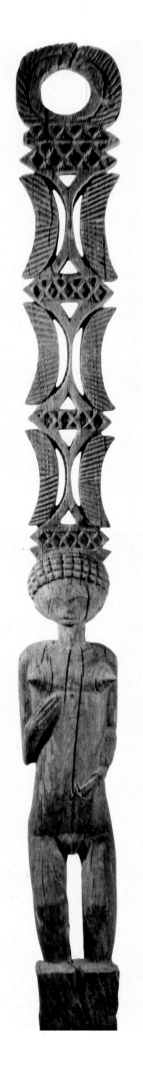

826 827 828

249 Bird-Goddess, Amratic Nagada
*Site of Mohameriah, Egypt. 5th–4th millennia
B.C. Height: 29.3 cm. The Brooklyn Museum,
New York. (Museum photograph)*

250 Amratic Nagada, Upper Egypt
*Black shale. 5th–4th millennia B.C. Height:
31.4 cm. Musée Guimet, Lyon. (Photograph Igor
Delmas)*

251 Head and Part of the Body of an
Anteater
*Found in a river near Liavela, Angola. Wood.
8th century, the oldest known wood sculpture from
sub-Saharan Africa. Height: 50.5 cm. Musée
Royal de l'Afrique Centrale, Tervuren, Belgium.
(Photograph Igor Delmas)*

252 Axe, Lagoon Region, Ivory Coast
*Polished flintstone. Height: 65 cm. Prehistoric
period. Private collection. (Photograph Igor
Delmas)*

253 Stone Lyre, Soto Village, Megalith
from Senegal
*Sandstone. 7th–8th century. Height: 240 cm.
Musée des Arts Africains et Océaniens, Paris.
(Photograph Réunion des Musées Nationaux)*

254 Kneeling Man, Interior Niger Delta,
Mali
*Terra-cotta. 14th–15th century. Height: 50.6 cm.
De Menil Foundation, Houston. (Photograph
Roger Asselberghs)*

255 Kneeling Figure, Interior Niger Delta,
Mali
*Terra-cotta. 11th–14th century. Height: 55 cm.
Width: 28.5 cm. Art Institute of Chicago.
(Photograph Roger Asselberghs)*

256 Seated Figure, Interior Niger Delta,
Mali
*Terra-cotta. 13th century. Height: 31.2 cm. De
Menil Foundation, Houston. (Photograph Roger
Asselberghs)*

257 Head, Interior Niger Delta, Mali
*Terra-cotta. 15th–16th century. Height: 20 cm.
Private collection, Guimiot Archives. (Photograph
Roger Asselberghs)*

258 Kneeling Figure, Interior Niger Delta,
Mali
*Terra-cotta. 14th–16th century. Height: 51 cm.
Private collection, Guimiot Archives. (Photograph
Roger Asselberghs)*

259 Tellem Statue, Mali
*Wood with thick patina. 13th–14th century.
Height: 44.8 cm. The Metropolitan Museum of
Art, New York. (Museum photograph)*

260 Tellem Statue, Bandiagara Cliffs, Mali
*Wood with patina. Height: 47 cm. Private
collection. (Photograph Igor Delmas)*

261 Tellem-Dogon Statue, Mali
*Wood. Height: 73.3 cm. The Metropolitan
Museum of Art, New York. (Museum photograph)*

262 Tellem-Dogon Altar, Mali
*Wood with patina. Height: 32 cm. Private
collection. (Photograph Igor Delmas)*

263 Tellem-Dogon Statuette, Mali
*Wood with patina. Height: 22 cm. Private
collection. (Photograph Igor Delmas)*

264 Tellem-Dogon Altar, Mali
*Wood with patina. Height: 35.5 cm. Private
collection. (Photograph Igor Delmas)*

265 Person of Rank, Proto-Dogon, Mali
*Wood. Height: 132 cm. Musée de l'Homme,
Paris. (Museum photograph)*

266 Statue of an Ancestor, Proto-Dogon,
Mali
*Detail. Wood. Total height: 102.5 cm. Private
collection. (Photograph André Held)*

267 Statue of an Ancestor, Proto-Dogon,
Mali
*Wood. Height: 120 cm. Private collection.
(Photograph André Held)*

268 Statue of an Ancestor, Proto-Dogon,
Mali
*Wood. Height: 67.5 cm. Musée des Arts Africains
et Océaniens, Paris. (Photograph Réunion des
Musées Nationaux)*

269 Proto-Dogon Statue, Mali
*Wood. Height: 110 cm. Private collection.
(Photograph Justin Kerr)*

270 Maternity Figure, Dogon, Mali
*Wood. Height: 75 cm. Private collection.
(Photograph Igor Delmas)*

271 Dogon Statue, Mali
*Wood. Height: 59.6 cm. Private collection, Paris.
(Photograph Igor Delmas)*

272 Dogon Horseman, Mali
*Wood. Height: 71 cm. The Metropolitan Museum
of Art, New York. (Photograph Justin Kerr)*

273 Woman Pounding Millet, Dogon, Mali
*Wood. Height: 98 cm. Private collection.
(Photograph Justin Kerr)*

274 Seated Figure, Dogon, Mali
*Wood. Height: 94 cm. Musée des Beaux-Arts,
Montreal. Bequest of H. and A. Townsend.
(Museum photograph)*

275 Dogon Couple, Mali
*Wood. Height: 75 cm. Barnes Foundation,
Merion, Pennsylvania. (Foundation photograph)*

276 Dogon Statue, Mali
*Wood. Height: 69 cm. C. Monzino Collection;
formerly J. Epstein Collection. (Photograph Eliot
Elisofon)*

277 Dege Dal Nda Statue, Dogon, Mali
*Wood. Height: 63.5 cm. Musée de l'Homme,
Paris. (Museum photograph)*

278 Statue of an Ancestor, Dogon, Mali
*Wood. Height: 80.5 cm. Private collection.
(Photograph André Held)*

279 Dogon Door, Mali
*Wood. Height: 100 cm. Private collection.
(Photograph Igor Delmas)*

280 Dogon Door, Mali
*Wood. Height: 71 cm; width: 46 cm. Private
collection. (Photograph André Held)*

281 Dogon Door, Mali
*Wood. Height: 48 cm. Musée de l'Homme, Paris.
(Museum photograph)*

282 Ritual Container, Dogon, Mali
*Wood. Length: 163 cm. Private collection.
(Photograph André Held)*

283 Monkey Mask, Dogon, Mali
*Wood. Height: 40 cm. Musée de l'Homme, Paris.
(Museum photograph)*

284 Dogon Mask, Mali
*Wood. Height: 42 cm. Private collection.
(Photograph Igor Delmas)*

285 Gomintogo Deer Mask, Dogon, Mali
*Wood. Height: 65.5 cm. Mr. and Mrs. Sam
Szafran Collection, Paris. (Photograph Igor
Delmas)*

286 Sirige Mask, Dogon, Mali
*Wood. Height: 256 cm. Private collection, Paris.
(Photograph Musée de l'Homme)*

287 Crocodile Mask, Dogon, Mali
*Wood. Height: 50 cm. Private collection.
(Photograph Igor Delmas)*

288 Bamana Statue, Mali
*Wood. Height: 55 cm. Private collection.
(Photograph Boccardi)*

289 Bamana Statue, Mali
*Wood. Height: 59 cm. M. and D. Ginzberg
Collection, New York. (Photograph Justin Kerr)*

290 Bamana Statue, Mali
*Wood. Height: 44 cm. Private collection.
(Photograph Igor Delmas)*

291 Turka Statuette, Mali
*Wood. Height: 27 cm. Private collection.
(Photograph Igor Delmas)*

292 Maternity Figure, Bamana, Mali
*Wood. Height: 118.1 cm. G. and F. Schindler
Collection, New York. (Photograph Werner
Forman)*

293 Woman Carrying Bowl, Bamana, Mali
*Wood. Height: 135 cm. Private collection.
(Photograph Justin Kerr)*

294 Bamana Statue, Mali
*Wood. Height: 102.2 cm. The Metropolitan
Museum of Art, New York, Michael C.
Rockefeller Memorial Collection. (Museum
photograph)*

295 Bamana Mask, Mali
*Wood. Height: 45 cm. Private collection.
(Photograph Igor Delmas)*

296 Bamana Mask, Mali
*Wood. Height: 45 cm. Private collection.
(Photograph Igor Delmas)*

297 Bamana Kono Mask, Mali
*Wood. Height: 48 cm. Private collection, Paris.
(Photograph Igor Delmas)*

298 Bozo Mask with Horns, Mali
*Wood, metal, plant fibers. Height: 49.5 cm.
Picasso Collection, Picasso Museum, Paris.
(Photograph Réunion des Musées Nationaux)*

299 Bolon Mask, Bamana, Marka (?), Mali
Wood and copper leaf. Height: 41 cm. P. Guerre Collection, Marseilles. (Photograph André Held)

300 Crown of a Headdress of the *Tyi Wara*, Bamana, Mali
Wood. Heights: 98.4 cm and 79.4 cm. Art Institute of Chicago, Ada Turnbull Hertle Fund. (Institute photograph)

301 Crown of a Headdress of the *Tyi Wara*, Bamana, Mali
Wood. Height: 75 cm. G. and F. Schindler Collection, New York. (Photograph Justin Kerr)

302 Crown of a Headdress of the *Tyi Wara*, Bamana, Mali
Wood. Height: 58.5 cm; length: 10.5 cm. Musée des Arts Africains et Océaniens, Paris. (Photograph Réunion des Musées Nationaux)

303 Crown of a Headdress of the *Tyi Wara*, Bamana, Mali
Varnished wood, metal, cowrie shells. Height: 83 cm; length: 35.5 cm; width: 12 cm. Musée des Arts Africains et Océaniens, Paris; formerly Louis Carré and Dr. Girardin collections. (Photograph Réunion des Musées Nationaux)

304 Mossi Flute, Burkina Faso
Wood. Height: 35 cm. Private collection. (Photograph Igor Delmas)

305 Bobo Mask, Mali
Wood. Height: 56.4 cm. Private collection. (Photograph Igor Delmas)

306 *Karan Wemba* Mask, Mossi, Burkina Faso
Wood. Height: 137.8 cm. Seattle Art Museum; formerly K. White Collection. (Museum photograph)

307 *Karan Wemba* Mask, Mossi, Burkina Faso
Wood. Height: 99 cm. Seattle Art Museum; formerly K. White Collection. (Museum photograph)

308 *Molo* Mask, Bobo, Burkina Faso
Wood. Height: 140 cm. Musée des Arts Africains et Océaniens, Paris. (Photograph André Held)

309 "Butterfly" Mask, Bwa, Burkina Faso
Wood. Height: 236 cm. Malichin Collection, Germany. (Photograph Bauer)

310 Bobo Mask, Mali
Wood. Height: 48 cm. Private collection. (Photograph Igor Delmas)

311 Gurunsi (Nuna) Mask, Bwa (?), Burkina Faso
Wood. Height: 41 cm. Malichin Collection, Germany. (Photograph Bauer)

312 Kurumba Statue, Burkina Faso
Wood. Height: 59 cm. Private collection. (Photograph Igor Delmas)

313 Gurunsi Statue, Burkina Faso
Wood. Height: 85 cm. Musée Barbier-Müller, Geneva. (Photograph P. A. Ferrazzini)

314 Mossi Post, Burkina Faso
Wood. Height: 173 cm. Musée des Arts Africains et Océaniens, Paris. (Photograph André Held)

315 Kulango Statue, Ivory Coast
Wood. Height: 65 cm. Musée des Arts Africains et Océaniens, Paris. (Photograph Réunion des Musées Nationaux)

316 Senufo Statue, Ivory Coast
Wood. Height: 34 cm. Tropenmuseum, Amsterdam. (Photograph Ferrante Ferranti)

317 *Deble* Statue, Senufo, Ivory Coast
Wood. Height: 108 cm. The Metropolitan Museum of Art, New York, Michael C. Rockefeller Memorial Collection. (Museum photograph)

318 Senufo Statue, Ivory Coast
Wood. Height: 105 cm. Private collection. (Photograph Igor Delmas)

319 Senufo Statue, Ivory Coast
Wood. Height: 118 cm. Musée Barbier-Müller, Geneva. (Photograph P. A. Ferrazzini)

320 Senufo Statue, Ivory Coast
Wood. Height: 104 cm. Private collection. (Photograph Igor Delmas)

321 *Kpele* Mask, Senufo, Ivory Coast
Wood. Height: 36 cm. The Metropolitan Museum of Art, New York, Michael C. Rockefeller Memorial Collection. (Museum photograph)

322 Senufo Mask, Ivory Coast
Wood. Height: 30 cm. Private collection. (Photograph Igor Delmas)

323 Senufo Double Mask, Ivory Coast
Wood. Height: 35 cm. Private collection. (Photograph Roger Asselberghs)

324 Senufo Mask, Ivory Coast
Bronze. Height: 31.5 cm. Private collection. (Photograph Igor Delmas)

325 Djimini Mask, Ivory Coast
Wood. Height: 45 cm. Private collection. (Photograph Igor Delmas)

326 Senufo Helmet, Ivory Coast
Bronze. Height: 24 cm. Private collection. (Photograph Igor Delmas)

327 Loom Heddle, Senufo, Ivory Coast
Wood. Height: 17 cm. Private collection. (Photograph Igor Delmas)

328 Loom Heddle, Senufo, Ivory Coast
Wood. Height: 20 cm. Private collection. (Photograph Igor Delmas)

329 Loom Heddle, Senufo, Ivory Coast
Wood. Height: 20 cm. Private collection. (Photograph Igor Delmas)

330 *Setyen* Hornbill
Wood. Height: 63 cm. W. Mestach Collection, Brussels. (Photograph Igor Delmas)

331 Senufo Bird, Ivory Coast
Wood. Height: 38 cm. Private collection. (Photograph Igor Delmas)

332 Hornbill, Senufo, Ivory Coast
Wood. Height: 151 cm. The Metropolitan Museum of Art, New York, Michael C. Rockefeller Collection. (Museum photograph)

333 Crest of a Senufo Headdress, Ivory Coast
Wood. Height: 86 cm. Musée des Arts Africains et Océaniens, Paris. (Photograph André Held)

334 Senufo Door, Ivory Coast
Wood. Height: 125 cm. University Museum, Philadelphia. (Museum photograph)

335 Ceremonial Axe, Senufo or Minianka or Bwa, Ivory Coast
Wood. Height: 98.4 cm. De Menil Foundation, Houston. (Photograph Taylor and Dull)

336 Kulango Spoon and Pestle, Ivory Coast
Wood. Height: 32 cm. Develon Collection, Paris. (Photograph Igor Delmas)

337 Crest of a Headdress, Senufo, Ivory Coast
Wood and metal. Height: 128.3 cm. Seattle Art Museum; formerly K. White Collection. (Museum photograph)

338 Lobi Bird, Burkina Faso
Wood. Height: 56 cm. Private collection, San Francisco. (Photograph Igor Delmas)

339 Lobi Head, Burkina Faso
Wood. Height: 31 cm. Private collection. (Photograph Igor Delmas)

340 Maternity Figure, Lobi, Burkina Faso
Wood. Height: 16 cm. Private collection. (Photograph Igor Delmas)

341 Commander's Staff, Lobi, Burkina Faso
Detail. Wood. Height: 102 cm. Private collection. (Photograph Igor Delmas)

342 *Dagalo* Chair, Nuna or Lobi, Burkina Faso
Wood. Height: 81 cm; length: 67 cm. Dakar Museum, Senegal, in storage at the Musée des Arts Africains et Océaniens, Paris. (Photograph Luc and Lola Joubert)

343 *Banda* Mask, Baga or Nalu, Guinea
Wood. Height: 112 cm. Museum Rietberg, Zürich. (Photograph Weinstein and Kauf)

344 Landuman Mask, Guinea
Wood. Height: 87 cm. Private collection; formerly Rasmussen Collection. (Photograph Igor Delmas)

345 Nalu Bird, Guinea
Wood and copper. Height: 95.9 cm. Museu de Etnologia, Lisbon. (Photograph Carlos Ladeira)

346 Mende Statue, Sierra Leone
Wood. Height: 53 cm. Private collection. (Photograph Igor Delmas)

347 Mende Mask, Sierra Leone
Wood. Height: 46 cm. Australian National Gallery, Canberra. (Museum photograph)

348 Mende or Bassa Statue, Liberia
Wood. Height: 46 cm. Private collection. (Photograph Igor Delmas)

349 Temne Statue, Sierra Leone
Wood. Height: 57 cm. University Museum of Pennsylvania, Philadelphia. (Museum photograph)

350 Bissagos Statue, Bissagos, Guinea-Bissau
Wood. Height: 42.5 cm. Museum Rietberg, Zürich. (Museum photograph)

351 Toma Statue, Southern Guinea, Border of Sierra Leone, Macenta Region
Wood. Height: 55 cm. Private collection. (Photograph Igor Delmas)

352 Mano Mask, Liberia
Wood, fibers, teeth. Height: 35 cm with the teeth. Private collection. (Photograph Igor Delmas)

353 Bassa Mask, Liberia
Wood. Height: 26 cm. Private collection, Guimiot Archives. (Photograph Roger Asselberghs)

354 Mano Statue, Liberia
Wood. Height: 54 cm. Private collection. (Photograph Igor Delmas)

355 Bassa Figure, Liberia
Wood. Height: 30.5 cm. André Schoeller Collection, Paris. (Photograph Igor Delmas)

356 Bassa Statuette, Liberia
Wood. Height: 44 cm. Private collection. (Photograph Studio-Contact)

357 Grebo Mask, Liberia
Wood. Height: 55.8 cm. Stanoff Collection, Los Angeles. (Collection photograph)

358 Grebo or Ubi Mask, Liberia or Ivory Coast
Wood and fibers. Height: 42 cm. Dakar Museum, Senegal, in storage at the Musée des Arts Africains et Océaniens, Paris. (Photograph Réunion des Musées Nationaux)

359 Grebo Mask, Liberia
Wood. Height: 53 cm. Peabody Museum, Cambridge, Massachusetts. (Photograph André Held)

360 Grebo Mask, Liberia
Wood. Height: 29 cm. Musée de l'Homme, Paris. (Museum photograph)

361 We Mask, Ivory Coast
Wood. Height: 24.5 cm. Musée de l'Homme, Paris. (Museum photograph)

362 Grebo Mask, Liberia
Wood. Height: 24 cm. Collection G. L., Paris. (Photograph Igor Delmas)

363 Mao Mask, Ivory Coast
Wood. Height: 60 cm. Private collection. (Photograph Igor Delmas)

364 Mao Mask, Ivory Coast
Wood. Height: 80 cm. Private collection. (Photograph Igor Delmas)

365 Mao or Tura Mask, Ivory Coast
Wood. Height: 62 cm without feathers, 82 cm with feathers. Private collection, Belgium. (Photograph Igor Delmas)

366 We Mask, Ivory Coast or Liberia
Wood, raffia, fabric, teeth, horn, feathers, hair, fibers, cowrie shells. Height: 81.3 cm. Seattle Art Museum; formerly K. White Collection. (Museum photograph)

367 We Mask, Ivory Coast
Wood. Height: 45 cm. Private collection. (Photograph Igor Delmas)

368 Grebo Mask, Liberia
Wood, fibers, teeth. Height: 25 cm. Private collection; formerly Rasmussen Collection. (Photograph André Held)

369 Dan Mask, Ivory Coast
Wood. Height: 24 cm. Private collection. (Photograph Igor Delmas)

370 Bete Mask, Ivory Coast
Wood. Height: 27 cm. Private collection; formerly P. Guillaume Collection. (Photograph Igor Delmas)

371 Grebo Board, Liberia
Fastened on the back of warriors during ritual dances. Wood. Height: 79 cm. Private collection. (Photograph Igor Delmas)

372 Bete Pulley Heddle, Ivory Coast
Wood. Height: 24 cm. Private collection; formerly H. Rome Collection. (Photograph Igor Delmas)

373 Dan Spoon, Double-Faced, Ivory Coast
Wood, fibers, metal. Height: 68.6 cm. New Orleans Museum of Art. (Museum photograph)

374 Guro Mask, Ivory Coast
Wood. Height: 42 cm. Private collection; formerly Lecorneur Collection. (Photograph André Held)

375 Guro Mask, Ivory Coast
Wood and fibers. Height: 34 cm. Musée des Arts Africains et Océaniens, Paris. (Photograph Réunion des Musées Nationaux)

376 Zaouli Mask, Guro, Ivory Coast
Wood. Height: 28 cm. Private collection. (Photograph Igor Delmas)

377 Yaoure Mask, Ivory Coast
Wood. Height: 31 cm. Private collection. (Photograph Igor Delmas)

378 Baoule Mask, Ivory Coast
Wood. Height: 34 cm. Private collection; formerly C. Ratton Collection. (Photograph Eliot Elisofon)

379 Yaoure Mask, Ivory Coast
Wood. Height: 44 cm. Private collection. (Photograph Igor Delmas)

380 Baoule Statue, Ivory Coast
Wood. Height: 44 cm. Private collection. (Photograph Igor Delmas)

381–82 Baoule Statuette, Ivory Coast
Back and front. Wood. Height: 27 cm. Private collection. (Photograph Igor Delmas)

383 Baoule Statuette, Ivory Coast
Wood. Height: 30 cm. Private collection. (Photograph Igor Delmas)

384 Baoule Statue, Ivory Coast
Wood. Height: 53 cm. Private collection. (Photograph Igor Delmas)

385 Baoule Statue, Ivory Coast
Wood. Height: 51 cm. The Metropolitan Museum of Art, New York. (Museum photograph)

386 Baoule Statue, Ivory Coast
Wood. Height: 47 cm. Private collection. (Photograph Igor Delmas)

387 Baoule Statuette, Ivory Coast
Wood. Height: 38.5 cm. M. and D. Ginzberg Collection, New York; formerly E. G. Robinson Collection. (Photograph Justin Kerr)

388 *Goli* Mask, Baoule, Ivory Coast
Wood. Height: 119 cm. Musée des Arts Africains et Océaniens, Paris. (Photograph Réunion des Musées Nationaux)

389 Baoule Mask, Ivory Coast
Wood and copper. Height: 50 cm. Private collection. (Photograph Igor Delmas)

390 Baoule Helmet-Mask, Ivory Coast
Wood. Height: 109 cm. Jan Krugier Collection; formerly Picasso Collection. (Photograph Patrick Goetelen)

391 Baoule Mask, Ivory Coast
Copper-covered wood. Height: 19 cm. Private collection. (Photograph Igor Delmas)

392 Flat *Kple-Kple* Mask, Baoule, Ivory Coast
Wood. Height: 99 cm. Private collection; formerly Duperrier Collection. (Photograph André Held)

393–96 Pulley Heddles, Baoule, Ivory Coast
Wood. Heights: 20 cm, 26 cm, 18 cm, and 19.5 cm. Private collection. (Photograph Igor Delmas)

397 Anyi Head, Krinjabo Region, Ivory Coast
Terra-cotta. Height: 20 cm; width: 12 cm. Private collection, Belgium; formerly H. Rome Collection. (Photograph Igor Delmas)

398 Akye Statue, Ivory Coast
Wood. Height: 48 cm. Private collection. (Photograph Igor Delmas)

399 *Mma* Funerary Figure, Anyi, Ivory Coast
Terra-cotta. Height: 36 cm. Musée de l'Homme, Paris. (Museum photograph)

400 Akye Statue, Ivory Coast
Wood. Height: 64 cm. National Museum, Abidjan, Ivory Coast. (Photograph Edipnetp)

401–03 Asante Dolls, Ghana
Wood. Heights: 42 cm, 28 cm, and 39 cm. Private collection. (Photographs Igor Delmas)

404 Ewe Buffalo Head, Togo
Terra-cotta. Height: 21.8 cm. The Metropolitan Museum of Art, New York. (Photograph Justin Kerr)

405 Asante Drum, Ghana
Wood. Height: 77 cm. Private collection.
(Photograph Igor Delmas)

406 Asante Statuette, Ghana
Wood. Height: 35.5 cm. Private collection.
(Photograph Igor Delmas)

407 Fon *Vodun* Statuette, Republic of
Benin
*Wood, string, padlocks. Height: 18 cm. Private
collection. (Photograph Igor Delmas)*

408 Fon *Vodun* Statuette, Republic of
Benin
*Wood, fibers, string. Height: 16 cm. Private
collection. (Photograph Igor Delmas)*

409 Fon *Vodun* Statuette, Republic of
Benin
*Bronze, fibers, padlocks. Height: 21 cm. Private
collection. (Photograph Igor Delmas)*

410 Fon *Vodun* Group, Ouidah, Republic
of Benin
*Wood, rope, fibers. Height: 53.5 cm. Private
collection. (Photograph Justin Kerr)*

411 Fon Double *Vodun* Statuette, Republic
of Benin
*Wood and string. Height: 39 cm. Private
collection. (Photograph Igor Delmas)*

412 Fon *Vodun* Statuette, Republic of
Benin
*Wood, string, fabric. Height: 41 cm. Private
collection. (Photograph Igor Delmas)*

413 Allegorical Portrait of King Behanzin,
Fon, Republic of Benin
*Wood. Height: 160 cm. Musée de l'Homme,
Paris. (Museum photograph)*

414 Gu, God of War, Fon, Republic of
Benin
*Iron. Height: 102 cm. Collection G. L., Paris.
(Photograph Igor Delmas)*

415 *Bochio*, Fon, Republic of Benin
*Wood. Height: 132 cm. Private collection.
(Photograph Igor Delmas)*

416 Fon *Vodun* Statuette, Republic of
Benin
*Wood, string, fibers. Height: 35 cm. Private
collection. (Photograph Igor Delmas)*

417 *Bochio*, Fon, Republic of Benin
*Wood. Height: 176 cm. Private collection.
(Photograph Igor Delmas)*

418 *Legba* Statue, Fon, Republic of Benin
*Wood. Height: 62 cm. Private collection.
(Photograph Igor Delmas)*

419 *Bochio*, Anago, Republic of Benin
*Wood. Height: 61 cm. Private collection,
Brussels. (Photograph Igor Delmas)*

420 Divination Paddle, Anago, Republic of
Benin
*Wood. Height: 43 cm. Private collection.
(Photograph Igor Delmas)*

421 *Bochio*, Anago, Republic of Benin
*Wood. Height: 48 cm. Private collection.
(Photograph Igor Delmas)*

422–25 Anago Statuettes, Republic of
Benin
*Wood. Heights: 39 cm, 38 cm, 42 cm, and 37
cm. Private collection, Belgium. (Photographs
Igor Delmas)*

426 Fon Monkey, Ouidah, Republic of
Benin
*Wood. Height: 51 cm. Private collection.
(Photograph Igor Delmas)*

427 Shango, Yoruba, Nigeria
*Wood. Height: 39.4 cm. Sainsbury Collection,
London. (Photograph James Austin)*

428 Maternity Figure, Yoruba, Cup for the
Ifa, Nigeria
*Wood. Height: 39 cm. National Museum of
African Art, Washington, D.C. (Museum
photograph)*

429 Woman Holding Bowl, Yoruba,
Nigeria
*Wood. Height: 49 cm. Private collection.
(Photograph Igor Delmas)*

430–31 *Ibeji* Statuettes, Yoruba, Nigeria
*Wood. Heights: 34.5 cm and 34.8 cm. National
Museum, Lagos, Nigeria. (Photographs André
Held)*

432–33 *Ibeji* Statuettes, Yoruba, Nigeria
*Wood. Heights: 27 cm and 28 cm. Private
collection, Guimiot Archives. (Photographs Roger
Asselberghs)*

434–35 *Ibeji* Statuettes, Yoruba, Nigeria
*Wood. Heights: 30 cm and 31 cm. Private
collection. (Photographs Igor Delmas)*

436 *Ogboni* Figures, Yoruba, Nigeria
*Bronze. Height: 29.5 cm. Stanley Collection,
University of Iowa Museum of Art, Iowa City.
(Museum photograph)*

437 *Ogboni* Figure, Nigeria
*Bronze. Height: 28.5 cm. Private collection.
(Photograph Igor Delmas)*

438 Veranda Post of Arejo D'Osi, Yoruba,
Nigeria
*Wood. 1920. Height: 170 cm. National Museum,
Lagos, Nigeria. (Photograph André Held)*

439 *Epa* Mask, Yoruba, Nigeria
*Wood. Height: 131 cm. National Museum,
Lagos, Nigeria. (Photograph André Held)*

440 Yoruba Torso, Nigeria
*Wood. Height: 48 cm. Private collection.
(Photograph Igor Delmas)*

441 *Gelede* Mask, Yoruba, Republic of
Benin
*Wood. Height: 61 cm. Paul and Ruth Tishman
Collection. (Photograph Jerry L. Thompson)*

442 *Gelede* Mask, Yoruba, Nigeria
*Wood. Height: 25 cm; width: 32 cm. Mr. and
Mrs. Sam Szafran Collection, Paris. (Photograph
Igor Delmas)*

443 Double-Faced *Gelede* Mask, Yoruba,
Republic of Benin
*Wood. Height: 22 cm. Private collection.
(Photograph Igor Delmas)*

444 *Gelede* Mask, Yoruba, Nigeria
*Wood. Height: 34 cm. Musée des Arts Africains
et Océaniens, Paris. (Photograph Réunion des
Musées Nationaux)*

445 Nok Head, Nigeria
*Terra-cotta. 3rd–4th century B.C. Height: 24.5
cm. National Museum, Jos, Nigeria. (Photograph
André Held)*

446 Elephant Head, Nok, Nigeria
*Terra-cotta. 6th century B.C.–A.D. 3rd century.
Height: 19 cm. National Museum, Jos, Nigeria.
(Photograph André Held)*

447 Human Figure, Yelwa, Nigeria
*Terra-cotta. 2nd–7th century. Height: 21.2 cm.
National Museum, Lagos, Nigeria. (Photograph
André Held)*

448 Seated Man, Yelwa, Nigeria
*Terra-cotta. 2nd–7th century. Yelwa mound.
Height: 20.5 cm. National Museum, Kaduna,
Nigeria. (Photograph André Held)*

449 Representation of a Human Head,
Nigeria
*Found at Abiri, close to Ife. Terra-cotta. 12th–
15th century. Height: 19.2 cm. Museum of the
Ife Antiquities, Nigeria. (Photograph André
Held)*

450 Receptacle, Igbo-Ukwu, Nigeria
*In the shape of a seashell surmounted by an
animal. Bronze and lead. 9th–10th century.
Height: 20.6 cm. National Museum, Lagos,
Nigeria. (Photograph André Held)*

451 Receptacle with Queen Mother, Ife,
Nigeria
*Bronze. 12th–15th century. Height: 12.4 cm.
National Museum, Lagos, Nigeria. (Photograph
André Held)*

452 Statue of an Archer, Jebba Island,
Nigeria
*Bronze. Early 14th–15th century. Height: 92 cm.
National Museum, Lagos, Nigeria. (Photograph
André Held)*

453 Igbo Laja Head, Owo, Nigeria
*Terra-cotta. 15th century. Height: 17.4 cm.
National Museum, Lagos, Nigeria. (Photograph
André Held)*

454 Esie Statue, Nigeria
*Stone. Height: 60 cm. Esie Museum, Ilorin,
Nigeria. (Photograph André Held)*

455 Plaque from Benin
*Bronze. Late 16th century. Height: 43.6 cm.
National Museum, Lagos, Nigeria. (Photograph
André Held)*

456 Plaque from Benin
*Bronze. 17th century. Height: 45.5 cm. Museum
für Völkerkunde, Berlin. (Photograph Werner
Forman)*

457 *Oba* Horn Player, Benin
Bronze. Around 1600. Height: 62.5 cm. Museum of Mankind, London. (Photograph Werner Forman)

458 Head of a Queen Mother, Benin
Bronze. 1515–50. Height: 51 cm. National Museum, Lagos, Nigeria. (Photograph André Held)

459 Horseman, Benin
Bronze. 17th–18th century. Height: 56 cm. National Museum, Lagos, Nigeria. (Photograph André Held)

460 Ceremonial Double Gong, Benin
Ivory. 16th century. Height: 36.5 cm. National Museum, Lagos, Nigeria. (Photograph André Held)

461 Scepter Surmounted by a Horseman, Benin
Ivory. 17th century. Height: 37.5 cm. National Museum, Benin City. (Photograph André Held)

462 Seat Decorated with Catfish, Benin
Bronze. 16th–17th century. Height: 34 cm. National Museum, Lagos, Nigeria. (Photograph André Held)

463 Head of a Snake, Benin
Bronze. 18th century. Height: 42 cm. National Museum, Lagos, Nigeria. (Photograph André Held)

464 Altar Grouping, Benin
Bronze. Height: 62 cm. Museum für Völkerkunde, Berlin. (Museum photograph)

465 Female Statuette, Benin
Ivory. 18th century. Height: 33 cm. The Metropolitan Museum of Art, New York, Michael C. Rockefeller Memorial Collection. (Museum photograph)

466 Altar Grouping: *Oba* and Two Foreigners, Benin
Bronze. 1750–1800. Height: 56 cm. Museum für Völkerkunde, Berlin. (Museum photograph)

467 Itsoko-Urhobo Statue, Nigeria
Wood. Height: 66 cm. Private collection, Guimiot Archives. (Photograph Roger Asselberghs)

468 Ijo Mask, Nigeria
Wood. Height: 36 cm. British Museum, London. (Photograph Eliot Elisofon)

469 Urhobo Mask, Nigeria
Wood. Height: 47 cm. Private collection, Guimiot Archives. (Photograph Roger Asselberghs)

470 Ijo or Urhobo Statue, Nigeria
Wood. Height: 64.6 cm. The Metropolitan Museum of Art, New York, Michael C. Rockefeller Memorial Collection. (Photograph Eliot Elisofon)

471 Ijo Funerary Screen, Serving as an Altar, Nigeria
Combination of various woods, found by Talbot at Abonnema. Height: 94 cm. British Museum, London. (Photograph André Held)

472 Ijebu Mask, Nigeria
Wood. Height: 54 cm; width: 32 cm. Private collection. (Photograph Igor Delmas)

473 Ogoni Mask, Nigeria
Wood. Height: 35.5 cm. Private collection. (Photograph Justin Kerr)

474 Ibibio Mask, Nigeria
Wood. Height: 30 cm. Private collection. (Photograph Igor Delmas)

475 Ibibio Mask, Nigeria
Wood. Height: 24 cm; width: 29 cm. Private collection. (Photograph Igor Delmas)

476 Ibibio Mask, Nigeria
Wood. Height: 28 cm. Private collection. (Photograph Igor Delmas)

477 Ibibio Mask, Nigeria
Wood. Height: 26 cm. Australian National Gallery, Canberra. (Museum photograph)

478 Ogoni Mask, Nigeria
Wood. Height: 34 cm. Private collection. (Photograph Igor Delmas)

479 Eket Mask, Nigeria
Wood. Height: 34 cm. Develon Collection, Paris. (Photograph Igor Delmas)

480 Igbo Mask-Headdress, Nigeria
Wood. Height: 81.4 cm. National Museum, Lagos, Nigeria. (Photograph André Held)

481 Ibibio Statue, Nigeria
Wood. Height: 48 cm. Private collection. (Photograph Igor Delmas)

482 Crest of a Headdress, Eket, Nigeria
Wood. 19th century. Height: 73 cm. Private collection. (Photograph Igor Delmas)

483 Igala Helmet-Mask, Nigeria
Wood. Height: 34.4 cm. National Museum, Lagos, Nigeria. (Photograph André Held)

484 Igala Helmet-Mask, Nigeria
Wood. Height: 31 cm. Private collection. (Photograph Igor Delmas)

485 Igbo Maternity Figure, Nigeria
Wood. Height: 155 cm. Private collection. (Photograph Igor Delmas)

486 Igbo Temple Statue, Nigeria
Wood. Height: 154 cm. Private collection. (Photograph Igor Delmas)

487 Igbo *Ikenga*, Nigeria
Wood. Height: 118 cm. Private collection. (Photograph Igor Delmas)

488 Idoma Helmet-Mask, Nigeria
Wood. Height: 25 cm. Private collection. (Photograph Igor Delmas)

489 Igbo Shrine Piece, Nigeria
Terra-cotta. Height: 48 cm. National Museum, Lagos, Nigeria. (Photograph André Held)

490 Igbo *Ikenga*, Nigeria
Wood. Height: 79 cm. Private collection. (Photograph Igor Delmas)

491 Igbo-Afikpo Statue, Nigeria
Wood. Height: 61 cm. Private collection, Guimiot Archives. (Photograph Roger Asselberghs)

492 Idoma *Ekwotame* Statue, Nigeria
Wood. Height: 75 cm. Private collection. (Photograph Igor Delmas)

493 Igbo Mask, Nigeria
Wood. Height: 75 cm. Private collection. (Photograph Igor Delmas)

494 Igbo Mask, Nigeria
Wood. Height: 36 cm; width: 29 cm. Private collection. (Photograph Igor Delmas)

495 Igbo-Afikpo Mask, Nigeria
Wood. Height: 52 cm. Develon Collection, Paris. (Photograph Igor Delmas)

496 Igbo-Afikpo Mask, Nigeria
Wood. Height: 43 cm. Private collection. (Photograph Igor Delmas)

497 Igbo-Afikpo Mask, Nigeria
Wood. Height: 48 cm; width: 14 cm. Private collection. (Photograph Igor Delmas)

498 Igbo-Afikpo Mask, Nigeria
Wood. Height: 49 cm. Private collection. (Photograph Igor Delmas)

499 Afo Maternity Figure, Nigeria
Wood. Height: 70.5 cm. Horniman Museum, London. (Museum photograph)

500 Koro Ceremonial Bowl, Nigeria
Wood. Height: 44.5 cm. Private collection. (Photograph Igor Delmas)

501 Mama Statue, Nigeria
Wood. Height: 56.9 cm. Private collection, Ottawa. (Collection photograph)

502 Montol Statue, Nigeria
Wood. Height: 47.5 cm. Develon Collection, Paris. (Photograph Igor Delmas)

503 Bura (?), Goemai (?) Statue, Nigeria
Wood. Height: 24 cm. Private collection. (Photograph Igor Delmas)

504 Montol Statue, Nigeria
Wood. Height: 48 cm. Musée Barbier-Müller, Geneva. (Photograph P. A. Ferrazzini)

505 Mama Mask, Nigeria
Wood. Height: 55 cm. National Museum, Lagos, Nigeria. (Photograph André Held)

506 Mama Mask, Nigeria
Wood. Height: 67 cm. Develon Collection, Paris. (Photograph Igor Delmas)

507 Djibete Mask, Nigeria
Wood. Height: 71 cm. Private collection. (Photograph Maud and René Garcia Archives)

508 Jukun Helmet-Mask, Nigeria
Found by Leo Frobenius in Wukari in 1912. Wood. Height: 27 cm. Museum für Völkerkunde, Berlin. (Museum photograph)

509 Wurkum Statue, Nigeria
Wood. Height: 41 cm. Private collection. (Photograph Igor Delmas)

510–11 Wurkum Statues, Nigeria
Wood. Heights: 46 cm and 42 cm. Private collection, Belgium. (Photographs Igor Delmas)

512 Wurkum Statue, Nigeria
Wood. Height: 106 cm. Private collection. (Photograph Roger Asselberghs)

513 Jukun Wurbo Statue, Nigeria
Wood. Height: 83 cm. Private collection. (Photograph Igor Delmas)

514 Jukun Shoulder Mask, Nigeria
Wood. Height: 117 cm. Private collection. (Photograph Igor Delmas)

515 Jukun Wurbo Statue, Nigeria
Wood. Height: 71 cm. Private collection. (Photograph Igor Delmas)

516 Chamba Mask, Nigeria
Wood. Height: 71 cm. André Schoeller Collection, Paris. (Photograph Igor Delmas)

517 Jompre Helmet-Mask, Nigeria
Wood and fibers. Height: 17 cm. Private collection. (Photograph Igor Delmas)

518 Chamba Statue, Nigeria
Wood. Height: 52 cm. Private collection. (Photograph Igor Delmas)

519 Chamba Statuette, Nigeria
Wood. Height: 47 cm. Private collection. (Photograph Igor Delmas)

520 Chamba Double Statuette, Nigeria
Wood. Height: 60 cm. Private collection, Guimiot Archives. (Photograph Roger Asselberghs)

521 Mumuye Statue, Nigeria
With one arm. Wood. Height: 88 cm. De Menil Foundation, Houston. (Photograph Roger Asselberghs)

522 Mumuye Statue, Nigeria
Wood. Height: 83 cm. Private collection. (Photograph Igor Delmas)

523 Mumuye Statue, Nigeria
With one arm. Wood. Height: 110 cm. Private collection. (Photograph Igor Delmas)

524 Mumuye Statue, Nigeria
Wood. Height: 115 cm. Private collection. (Photograph Igor Delmas)

525 Mumuye Statue, Nigeria
Wood. Height: 110 cm. Private collection. (Photograph Igor Delmas)

526 Mumuye Statue, Nigeria
Wood. Height: 120 cm. Private collection. (Photograph Igor Delmas)

527 Mumuye Statue, Nigeria
Wood. Height: 108 cm. Private collection. (Photograph Igor Delmas)

528 Mumuye Statue, Nigeria
Wood. Height: 105 cm. Private collection. (Photograph Igor Delmas)

529 Mambila Mask, Nigeria
Wood. Length: 58 cm. Private collection. (Photograph Igor Delmas)

530 Mambila Statue, Nigeria
Wood. Height: 62 cm. Loed and Mia van Bussel Collection, Amsterdam. (Photograph Igor Delmas)

531 Mambila Statue, Nigeria
Wood. Height: 43 cm. Private collection. (Photograph Igor Delmas)

532 Kaka Statue, Nigeria
Wood. Height: 43.2 cm. Paul and Ruth Tishman Collection. (Photograph Jerry L. Thompson, The Metropolitan Museum of Art, New York)

533 Kaka Statue, Nigeria
Wood. Height: 58 cm. Private collection. (Photograph Igor Delmas)

534 Kaka Statue, Nigeria
Wood. Height: 80 cm. Private collection. (Photograph Roger Asselberghs)

535 *Akwanshi* Monolith, Cross River, Nigeria
Stone. Height: 220 cm. Private collection. (Photograph Igor Delmas)

536 *Akwanshi* Monolith, Cross River, Nigeria
Stone. Height: 108 cm. National Museum, Lagos, Nigeria. (Photograph André Held)

537 Kaka Statue, Nigeria
Wood. Height: 120 cm. Private collection. (Photograph Igor Delmas)

538 Ejagham Mask, Nigeria
Wood, leather, skin, fibers. Height: 86 cm. Private collection. (Photograph André Held)

539 Ejagham Mask, Nigeria
Wood, rattan, skin. Height: 54 cm. Develon Collection, Paris. (Photograph Igor Delmas)

540 Ejagham Head, Nigeria
Wood, rattan, skin, teeth, hair. Height: 29 cm. Private collection. (Photograph Roger Asselberghs)

541 Double *Okum Ngbe* Helmet-Mask, Anyang, Cross River, Nigeria
Wood, skin, rattan, teeth, hair. Height: 35 cm; width: 51 cm. Private collection, Guimiot Archives. (Photograph Roger Asselberghs)

542 *Tu Ngunga* Crest, Bamum, Cameroon
Wood, fibers, horn, insect membranes. Height: 78.5 cm. Paul and Ruth Tishman Collection. (Photograph Jerry L. Thompson, The Metropolitan Museum of Art, New York)

543 Bafo Mask, Cameroon
Found by Conradt in the village of Ikilewindi in 1899. Wood. Height: 31.5 cm. Museum für Völkerkunde, Berlin. (Museum photograph)

544 Duala Mask, Cameroon
Wood. Height: 43 cm. Museum für Völkerkunde, Frankfurt. (Museum photograph)

545 Double-Faced Helmet-Mask, Bamileke, Bangwa, Cameroon
Wood. Height: 55 cm. Private collection. (Photograph Igor Delmas)

546 Bamileke Mask, Bangwa, Fosi-Monbin Village, Cameroon
Wood. Height: 46 cm. Private collection. (Photograph Igor Delmas)

547 Bamileke Mask, Bangwa, Cameroon
Wood. Height: 45 cm. Private collection. (Photograph Igor Delmas)

548 Bamileke *Lefem* Statue, Bangwa, Cameroon
Wood. Height: 79 cm. C. Monzino Collection, Italy. (Collection photograph)

549 Bangwa Statue, Cameroon
Found by Conradt in Foukas-Chacha in 1899. Wood. Height: 85 cm. Valerie Franklin Collection, Los Angeles. (Collection photograph)

550 Woman Carrying a Bowl, Bamileke, Cameroon
Wood. Height: 86 cm. Collection G. L., Paris. (Photograph Igor Delmas)

551 Bamileke, Wum (?) Statue, Front of a Drum (?), Cameroon
Wood. Height: 90 cm. Private collection. (Photograph Igor Delmas)

552 Bali Maternity Figure, Bawok, Cameroon
Wood. Height: 59 cm. Eleanor Clay Ford Fund, Detroit Institute of Arts. (Institute photograph)

553 Bamileke Woman Carrying a Bowl, Cameroon
Wood. Height: 46 cm. Mr. and Mrs. John Friede Collection, New York. (Photograph Justin Kerr)

554 Bamenda or Bamileke Mask, Cameroon
Wood. Height: 77 cm. Private collection, Belgium. (Photograph Igor Delmas)

555 Bamileke Elephant Mask, Cameroon
Wood. Height: 100 cm. Private collection, Belgium. (Photograph Igor Delmas)

556 Batcham (?) Mask, Bamileke, Cameroon
Collected in Bamenjo by Christol in 1937. Wood. Height: 53.5 cm. U.C.L.A., Los Angeles; formerly Wellcome Collection. (Photograph Richard Todd)

557 Fang Statue, Ngoumba, South Cameroon
Wood. Height: 71 cm. Museum für Völkerkunde, Berlin. (Museum photograph)

558–59 Fang Statue, Ntoumou, South Cameroon
Brought back in 1883. Front and back. Wood. Height: 60 cm. Private collection; formerly Museum of Leipzig Collection. (Photograph Igor Delmas)

560 Fang Statue, Mabea, South Cameroon
Wood. Height: 60 cm. Museum für Völkerkunde, Hamburg. (Museum photograph)

561 Fang, Okak (?) Statue, Equatorial Guinea
Wood. Height: 59.5 cm. Peabody Museum, Cambridge, Massachusetts. (Photograph Eliot Elisofon)

562 Fang, Okak (?) Statue, Equatorial Guinea
Wood. Height: 58 cm. Peabody Museum, Cambridge, Massachusetts. (Photograph Eliot Elisofon)

563 Fang Reliquary Head, Gabon
Wood. Height: 32 cm. C. Monzino Collection, Milan; formerly J. Epstein Collection. (Photograph Eliot Elisofon)

564 Fang Reliquary Head, Gabon
Wood. Total height: 63.5 cm; head: 34 cm. C. Monzino Collection, Milan; formerly J. Epstein Collection. (Collection photograph)

565 Six-Headed Reliquary, Fang, Equatorial Guinea
Wood. Height: 16 cm. Private collection. (Photograph Igor Delmas)

566 Fang Reliquary Head, Gabon
Wood. Height: 43.2 cm. Private collection; formerly E. G. Robinson Collection. (Photograph Eliot Elisofon)

567 Fang Statue, Okak, Equatorial Guinea
Wood. Height: 64 cm. The Metropolitan Museum of Art, New York; formerly A. Derain and J. Epstein collections. (Photograph Eliot Elisofon)

568 Fang Fluteplayer, Ntoumou, Border of South Cameroon and Equatorial Guinea
Collected in 1905 by the Cottes Mission. Wood. Height: 56 cm. Musée de l'Homme, Paris. (Museum photograph)

569 Fang Statue, Betsi, Gabon
Wood. Height: 60.3 cm. British Museum, London. (Museum photograph)

570 Fang Statue, Betsi, Gabon
Wood. Height: 43 cm. Private collection; formerly P. Guillaume Collection. (Photograph Igor Delmas)

571 Fang Statue, Mvai, Gabon
Wood. Height: 50 cm. Alberto and Susie Magnelli Collection, Meudon, France. (Photograph Igor Delmas)

572 Fang Statue, Okak, Gabon
Its reliquary box contains skullcaps. Wood, bone, bark. Height: 88 cm. Private collection. (Photograph Igor Delmas)

573 Fang Mask, Gabon
Wood, raffia, kaolin. Height: 54.7 cm. Denver Art Museum. (Photograph Eliot Elisofon)

574 Fang Mask, Gabon
Wood, fibers. Height: 64 cm. Schindler Collection, New York. (Photograph Justin Kerr)

575 Fang Mask, Gabon
Wood and fibers. Height: 32 cm. C. Laurens Collection; formerly G. Braque Collection. (Photograph Musée de l'Homme)

576 Fang Helmet-Mask, Gabon
Wood and copper nails. Height: 40 cm. Musée de l'Homme, Paris. (Museum photograph)

577 Bakwele Mask, Gabon
Wood. Height: 36 cm. Collection G. L., Paris. (Photograph Igor Delmas)

578 Bakwele Mask, Gabon
Wood. Height: 55 cm. Fondation Dapper, Paris. (Photograph Igor Delmas)

579 Bakwele Statue, Gabon
Wood. Height: 46 cm. Private collection. (Photograph André Held)

580 Bakwele Bellows, Gabon
Wood and skin. Height: 45.5 cm. Museum d'Histoire Naturelle de La Rochelle, France. (Photograph Igor Delmas)

581 Tsogho Reliquary Statue, Gabon
Wood. Height: 33 cm. Private collection; formerly J. Epstein Collection. (Photograph Igor Delmas)

582 Mashango Statue, Gabon
Wood. Height: 34 cm. Private collection; formerly Lefevre Collection. (Photograph Igor Delmas)

583 Tsogho Statue, Gabon
Wood. Height: 41.5 cm. Private collection. (Photograph Igor Delmas)

584 Tsogho Commander's Staff, Gabon
Detail. Wood. Height: 116 cm. Private collection. (Photograph Igor Delmas)

585 Tsogho Door, Gabon
Wood. Height: 139.7 cm. Paul and Ruth Tishman Collection. (Photograph Jerry L. Thompson, The Metropolitan Museum of Art, New York)

586 Handle of a Ritual Bell, Kota, Gabon
Wood. Height: 23.7 cm. W. Mestach Collection, Brussels. (Photograph Igor Delmas)

587 Mbete Reliquary Statue, Gabon
Wood. Height: 73 cm. Musée des Arts Africains et Océaniens, Paris. (Photograph André Held)

588 Kota or Mbete Statue, Gabon
Wood and copper leaf. Height: 45 cm. Alain Schoffel Collection, Paris. (Photograph Igor Delmas)

589 Kota Helmet-Mask, Gabon
Wood. Height: 68 cm. Seattle Art Museum; formerly K. White Collection. (Museum photograph)

590 Mahongwe Reliquary, Gabon
Wood core covered with copper leaf. Height: 26 cm. Private collection. (Photograph Igor Delmas)

591 Shamaye Reliquary, Gabon
Wood core covered with copper leaf. Height: 25 cm. Private collection. (Photograph Igor Delmas)

592 Shamaye Reliquary, Gabon
Wood core covered with copper leaf. Height: 24.5 cm. Private collection. (Photograph Igor Delmas)

593 Kota Reliquary, Gabon
Wood covered with copper. Height: 40 cm. Musée de l'Homme, Paris. (Museum photograph)

594 Kota-Ondumbo Reliquary, Gabon
Wood, copper, leather, basketry, feathers. Height: 58 cm. Musée de l'Homme, Paris. (Museum photograph)

595 Kota Reliquary, Gabon
Wood and copper leaf. Height: 63.4 cm. Private collection. (Photograph Eliot Elisofon)

596 Punu Mask, Gabon
Wood. Height: 30 cm. Private collection; formerly Vlaminck Collection. (Photograph Igor Delmas)

597 Lumbo Mask, Gabon
Wood. Height: 30 cm. Private collection. (Photograph Igor Delmas)

598 Punu Reliquary, Gabon
Wood and rattan. Height: 30 cm. Musée de l'Homme, Paris. (Museum photograph)

599 Punu Door, Gabon
Wood. Height: 108 cm. Musée de l'Homme, Paris. (Museum photograph)

600 Maternity Figure, Vili, Mayombe, People's Republic of the Congo
Wood. Height: 37.3 cm. Rijksmuseum voor Volkenkunde, Leiden, Netherlands. (Museum photograph)

601 Bakongo Statue, Zaire
Wood. Height: 41 cm. Arman Collection. (Photograph Igor Delmas)

602 Bakongo Statue, Zaire
Wood. Height: 35 cm. Private collection. (Photograph Igor Delmas)

603 Bakongo Statue, Zaire
Wood. Height: 28 cm. Musée Royal de l'Afrique Centrale, Tervuren, Belgium. (Photograph Igor Delmas)

604 Vili Statue, People's Republic of the Congo
Wood. Height: 23.5 cm. The Brooklyn Museum, New York. (Photograph Eliot Elisofon)

605 Vili Statue, People's Republic of the Congo
Wood. Height: 28 cm. Private collection. (Photograph Igor Delmas)

606 Commander's Staff, Bakongo, Zaire
Wood. Height: 41 cm. M. and D. Ginzberg Collection, New York. (Photograph Justin Kerr)

607 Vili Figures, People's Republic of the Congo
Wood. Height: 19 cm. Private collection. (Photograph Igor Delmas)

608 Bakongo Fan, Zaire
Wood. Height: 46.5 cm. Musée de l'Homme, Paris; formerly P. Guillaume Collection. (Museum photograph)

609 Vili Staff, People's Republic of the Congo
Wood. Height: 10 cm. Private collection. (Photograph Igor Delmas)

610 Vili Couple, People's Republic of the Congo
Wood. Height: 16 cm. Private collection. (Photograph Igor Delmas)

611 Vili Dog, People's Republic of the Congo
Wood and mirror. Height: 27 cm. Musée des Arts Africains et Océaniens, Paris. (Photograph Luc Joubert)

612 Bakongo Fetish with Nails, Zaire
Wood, metal strips, fabric. Height: 87 cm. Musée de l'Homme, Paris. (Museum photograph)

613 Bakongo Dog with Nails, Zaire
Wood, metal strips, nails. Length: 67.5 cm. Musée Barbier-Müller, Geneva. (Photograph P. A. Ferrazzini)

614 Vili Dog with Nails, Loango, People's Republic of the Congo
Found by Visser, in 1903. Wood, metal strips, fibers, string. Height: 80 cm. Museum für Völkerkunde, Berlin. (Museum photograph)

615 Vili Fetish with Nails, People's Republic of the Congo
Wood and metal strips. Height: 73 cm. Musée Royal de l'Afrique Centrale, Tervuren, Belgium. (Photograph Igor Delmas)

616 Bakongo Dog with Nails, Zaire
Found in 1893. Wood, European nails, indigenous metal strips. Length: 88 cm. Musée de l'Homme, Paris. (Museum photograph)

617 Bembe Statue, People's Republic of the Congo
Wood. Height: 17 cm. Private collection. (Photograph Igor Delmas)

618 Bembe *Mukuya* Statue, People's Republic of the Congo
Wood. Height: 19 cm. Private collection. (Photograph Igor Delmas)

619 Bembe Statue, People's Republic of the Congo
Wood. Height: 24 cm. Private collection. (Photograph Igor Delmas)

620 Bembe Statue, People's Republic of the Congo
Wood. Height: 19 cm. Private collection; formerly Fénéon Collection. (Photograph Justin Kerr)

621 Bembe *Mukuya* Statuette, People's Republic of the Congo
Wood. Height: 21 cm. Private collection. (Photograph Igor Delmas)

622 Bembe Statuette, People's Republic of the Congo
Wood. Height: 21 cm. Private collection; formerly Fénéon Collection. (Photograph Igor Delmas)

623 Bwende Statue, People's Republic of the Congo
Wood. Height: 23 cm. Private collection. (Photograph Igor Delmas)

624 Bembe Statuette, People's Republic of the Congo
Wood. Height: 27 cm. Private collection. (Photograph Igor Delmas)

625 Bembe Statue, People's Republic of the Congo
Wood. Height: 33 cm. Private collection. (Photograph Igor Delmas)

626 Bembe *Muziri*, People's Republic of the Congo
Fabric, wood, bone, iron, plant fibers, basketry, brass. Height: 63.7 cm; width: 46 cm; depth: 41 cm. Museum d'Histoire Naturelle de La Rochelle, France. (Photograph Igor Delmas)

627 Badondo Horn, People's Republic of the Congo
Found by Walden before 1910. Wood. Height: 64 cm. Göteborg Museum, Sweden. (Museum photograph)

628 Teke Statuette, People's Republic of the Congo
Wood, fabric, medications. Height: 11 cm. Private collection. (Photograph Igor Delmas)

629 Teke Statuette, People's Republic of the Congo
Wood, plaster, medications. Height: 37 cm. Private collection, Brussels. (Photograph Igor Delmas)

630 Teke Statuette, People's Republic of the Congo
Wood and plant fiber. Height: 27 cm. Private collection. (Photograph Igor Delmas)

631 Teke-Bwende Statue, People's Republic of the Congo
Wood. Height: 68 cm. Baselitz Collection, Germany. (Photograph Roger Asselberghs)

632 Teke-Bembe Statue, People's Republic of the Congo
Wood, string, plaster. Height: 21 cm. Private collection; formerly Fénéon Collection. (Collection photograph)

633 Statuette of a *Nganga*, Teke, Village of Mayama, People's Republic of the Congo
Wood and string. Height: 38.4 cm. Raoul Lehuard Collection. (Collection photograph)

634 Kuyu Head, People's Republic of the Congo
Wood. Height: 42 cm. Museum für Völkerkunde, Frankfurt. (Museum photograph)

635 Kuyu Statue, People's Republic of the Congo
Wood. Height: 96 cm. Vérité Collection, Paris. (Photograph André Held)

636–37 Kuyu Statue, People's Republic of the Congo
Profile and front. Wood. Height: 71 cm. Collection G. L., Paris. (Photograph Igor Delmas)

638 Statuette of Upper Sangha, People's Republic of the Congo
Wood. Height: 26.6 cm. Musée de l'Homme, Paris. (Museum photograph)

639 Mahongwe Mask, People's Republic of the Congo
Wood. Height: 35.5 cm. Musée Barbier-Müller, Geneva. (Photograph P. A. Ferrazzini)

640 Yangere Drum, Central African Republic
Wood. Height: 229 cm; width: 80 cm. Musée de l'Homme, Paris. (Museum photograph)

641 Ngbaka Mask, Zaire
Wood. Height: 36 cm. W. Mestach Collection, Brussels. (Photograph Igor Delmas)

642 Ngbandi Bowl, Zaire
Wood. Height: 27.8 cm. Musée Royal de l'Afrique Centrale, Tervuren, Belgium. (Photograph Igor Delmas)

643 Ngbandi Statue, Zaire
Wood. Height: 67 cm. Private collection. (Photograph Igor Delmas)

644 Ngbaka Statue, Central African Republic
Detail. Wood. Height: 94 cm. Private collection; formerly Chardonne Collection. (Photograph Roger Asselberghs)

645 Ngbaka Statue, Zaire
Wood. Height: 45 cm. Private collection, Guimiot Archives. (Photograph Roger Asselberghs)

646 Ngombe Statue, Zaire
Wood. Height: 32 cm. Private collection, Guimiot Archives. (Photograph Roger Asselberghs)

647 Zande Statuette, Zaire
Wood. Height: 22 cm. Private collection, Brussels. (Photograph Igor Delmas)

648 Ngbaka Statue, Zaire
Wood. Height: 40 cm. Private collection, Brussels. (Photograph Igor Delmas)

649 Zande Statue, Zaire
Wood. Height: 17.8 cm. M. Félix Collection, Brussels. (Photograph Igor Delmas)

650 Zande Harp, Zaire
Wood, skin, gut. Height: 87 cm. Private collection; formerly Hooper Collection. (Photograph Roger Asselberghs)

651 Maternity Figure, Zande, Zaire
Wood. Height: 59.7 cm. American Museum of Natural History, New York. (Photograph Eliot Elisofon)

652 Zande Statue, Zaire
Wood. Height: 80 cm. British Museum, London. (Photograph Eliot Elisofon)

653 Mangbetu Jar, Zaire
Terra-cotta. Height: 21 cm. Private collection. (Photograph Igor Delmas)

654 Mangbetu Statue, Zaire
Wood. Height: 48.5 cm. Musée Royal de l'Afrique Centrale, Tervuren, Belgium. (Museum photograph)

655–56 Mangbetu Resting Stool, Zaire
Complete object and detail. Wood. Arnold H. Crane Collection, Art Institute of Chicago. (Institute photographs)

657 Komo Mask, Zaire
Wood. Height: 50 cm. W. Mestach Collection, Brussels. (Photograph Igor Delmas)

658 Mbole Mask, Zaire
Wood. Height: 45.9 cm. Musée Royal de l'Afrique Centrale, Tervuren, Belgium. (Photograph Igor Delmas)

659 Lega Mask, Zaire
Wood. Height: 29 cm. Private collection. (Collection photograph)

660 *Ubanga Nyama* Statue, Lengola, Zaire
Wood. Height: 194 cm. W. Mestach Collection, Brussels. (Photograph Igor Delmas)

661–62 Lega Double Statuette, Zaire
Collected in 1926. Wood. Height: 35.8 cm. Private collection. (Collection photographs)

663–64 Buyu Statue, Zaire
Detail and complete object. Wood. Height: 86.4 cm. Schindler Collection, New York. (Photographs Werner Forman)

665 Bemba Mask, Zaire
Wood. Height: 32 cm. Private collection. (Photograph Igor Delmas)

666 Bemba Janus Mask, Zaire
Wood. Height: 60 cm. Private collection. (Photograph Justin Kerr)

667–68 Basikasingo Statue, Zaire
Detail, head, and complete piece. Wood. Height: 52 cm. Museum für Völkerkunde, Frankfurt. (Museum photographs)

669 Hemba Seat with Caryatids, Zaire
Wood. Height: 47 cm. Private collection. (Photograph Igor Delmas)

670 Kusu Bellows, Zaire
Wood. Height: 60 cm. Private collection. (Photograph Igor Delmas)

671 Hemba Statue, Zaire
Wood. Height: 74 cm. Private collection. (Photograph Igor Delmas)

672 Kusu Statue, Zaire
Wood. Height: 67 cm. Private collection, Belgium. (Photograph Igor Delmas)

673 Hemba Statue, Zaire
Wood. Height: 83 cm. Arman Collection. (Photograph Igor Delmas)

674–76 Hemba Statue, Zaire
Details. Wood. Total height: 62 cm. Private collection. (Photographs Igor Delmas)

677 Hemba Statue, Zaire
Wood. Height: 75 cm. Kimbell Art Museum, Fort Worth, Texas. (Photograph Igor Delmas)

678 Hemba-Luba Statue, Zaire
Wood. Height: 58 cm. Musée Royal de l'Afrique Centrale, Tervuren, Belgium. (Photograph Igor Delmas)

679 Hemba Statue, Zaire
Wood. Height: 72 cm. Private collection. (Photograph Igor Delmas)

680 Hemba Seat, Zaire
Wood. Height: 46 cm. Private collection. (Photograph Igor Delmas)

681 Double Seat, by the Buli Master (?), Luba-Hemba, Zaire
Found in 1902. Wood. Height: 55 cm. Museum für Völkerkunde, Berlin. (Museum photograph)

682 Hemba Seat, Zaire
Wood. Height: 47 cm. Private collection. (Photograph Igor Delmas)

683 Hemba Seat, Zaire
Wood. Height: 46 cm. Private collection, Belgium. (Photograph Igor Delmas)

684 Tabwa Statue, Zaire
Wood, glass, beads. Height: 33 cm. Musée Royal de l'Afrique Centrale, Tervuren, Belgium. (Photograph Igor Delmas)

685 Tabwa Buffalo Mask, Zaire
Wood, copper, cowrie shells. Width: 73 cm. Musée Barbier-Müller, Geneva. (Museum photograph)

686 Tabwa Helmet-Mask, Zaire
Wood. Height: 23.3 cm. Private collection. (Photograph Igor Delmas)

687–88 Tabwa Couple, Zaire
Wood, raffia, rope, fabric. Heights: 36.5 cm and 33.5 cm. Staatliche Museum für Völkerkunde, Munich. (Museum photographs)

689–92 Tabwa Female and Male Statuettes, Zaire
Wood. Heights: 18.4 cm, 24.8 cm, 20.3 cm, and 24.8 cm. Private collection, Belgium. (Photographs Igor Delmas)

693 Luba Statue, Zaire
Wood. Height: 48 cm. Private collection, Guimiot Archives. (Photograph Roger Asselberghs)

694 Hemba Statuette, Zaire
Wood. Height: 19 cm. Private collection. (Photograph Igor Delmas)

695 Luba Statue, Zaire
Wood. Height: 40 cm. Private collection, Belgium. (Photograph Igor Delmas)

696 Luba Pipe, Zaire
Wood. Height: 39 cm. M. Félix Collection, Brussels. (Photograph Igor Delmas)

697 Luba-Tumbwe Statue, Zaire
Wood. Height: 51 cm. Private collection. (Photograph Igor Delmas)

698 Luba-Hemba Statue, Zaire
Wood. Height: 43 cm. Private collection, Belgium. (Photograph Igor Delmas)

699 Group of Six Luba Heads, Zaire
Wood, horn, leather, fibers. Height: 47 cm. British Museum, London. (Museum photograph)

700 Luba Neck-Rest, Zaire
Wood. Height: 16 cm. British Museum, London. (Museum photograph)

701 Woman Carrying a Bowl, Luba-Shankadi, Zaire
Wood. Height: 50 cm; length: 40 cm. Private collection. (Photograph Igor Delmas)

702 Luba Bowl, Zaire
Wood and glass beads. Height: 59.1 cm. The Metropolitan Museum of Art, New York, Michael C. Rockefeller Memorial Collection. (Museum photograph)

703 Luba Double Bowl, Zaire
Wood. Height: 20 cm. M. Félix Collection, Brussels. (Photograph Igor Delmas)

704 Luba Mask, Zaire
Wood. Height: 27 cm. J.-F. and M.-A. Prat Collection, Paris. (Photograph Igor Delmas)

705 Luba Neck-Rest, Zaire
Wood. Height: 21 cm. Musée Royal de l'Afrique Centrale, Tervuren, Belgium. (Photograph Igor Delmas)

706 Luba Arrow Holder, Zaire
Wood. Height: 78 cm. Musée Royal de l'Afrique Centrale, Tervuren, Belgium. (Photograph Igor Delmas)

707 Luba Group, Zaire
Wood. Height: 20 cm. Private collection. (Photograph Igor Delmas)

708 Luba-Shankadi Bowl, Zaire
Wood. Height: 61 cm; width: 41 cm; depth: 33 cm. Collection G. L., Paris. (Photograph Igor Delmas)

709 Luba-Shankadi Statue, Zaire
Wood. Height: 35 cm. Private collection. (Photograph Roger Asselberghs)

710 Luba-Shankadi Neck-Rest, Zaire
Wood. Height: 15 cm. Arman Collection. (Photograph Justin Kerr)

711 Luba-Shankadi Neck-Rest, Zaire
Wood. Height: 19 cm. British Museum, London. (Museum photograph)

712 Kanyok Mask, Zaire
Found by Leo Frobenius in 1906. Wood. Height: 29 cm. Museum für Völkerkunde, Hamburg. (Museum photograph)

713 Kanyok Jar with Head, Zaire
Terra-cotta. Height: 22 cm. Private collection; formerly Lt.-General Wangermée Collection (governor of Zaire until 1914). (Photograph Igor Delmas)

714 Kanyok Pipe, Zaire
Wood. Height: 25.3 cm. British Museum, London. (Museum photograph)

715 Kanyok Figure of a Slave, Zaire
Wood. Height: 38.5 cm. Museum Rietberg, Zürich. (Museum photograph)

716 Songhay Mask, Zaire
Wood. Height: 50 cm. W. Mestach Collection, Brussels. (Photograph Igor Delmas)

717 Luba-Songhay Mask, Zaire
Wood. Height: 47 cm. Private collection. (Collection photograph)

718 Songhay Statue, Zaire
Wood, fibers, horn, plaster. Height: 88 cm. Private collection. (Photograph Igor Delmas)

719 Songhay Statue, Zaire
Wood, nails, copper, chain, horn. Height: 101.6 cm. British Museum, London. (Museum photograph)

720 Songhay Statue, Zaire
Wood, fabric, fibers, plaster. Height: 95 cm. Private collection. (Collection photograph)

721 Songhay Statue, Zaire
Wood, string, fibers, fabric. Height: 45 cm. Private collection. (Photograph Igor Delmas)

722 Songhay Bracelet, Zaire
Wood, inlaid teeth, nails, horn. Height: 31 cm with horns, 24 cm without. Private collection. (Photograph Igor Delmas)

723 Songhay Double Statue, Zaire
Wood, fabric, fibers. Height: 34 cm. Private collection. (Photograph Igor Delmas)

724 Songhay Seat, Zaire
Wood. Height: 52.7 cm. Robert H. Tannahill Foundation, Detroit Institute of Art. (Institute photograph)

725 Songhay Neck-Rest, Zaire
Wood. Height: 14 cm. Musée des Arts Africains et Océaniens, Paris. (Photograph Réunion des Musées Nationaux)

726–28 Songhay Statue, Zaire
Detail and complete object. Wood and copper nails. Height: 63.5 cm. Private collection. (Photographs Igor Delmas)

729–31 Songhay Statue, Zaire
Detail and complete object. Wood, fibers, horn. Height: 112.5 cm. W. Mestach Collection, Brussels. (Photographs Igor Delmas)

732 Dengese Divination Instrument, Zaire
Wood. Height: 32.5 cm. University Museum, Philadelphia. (Museum photograph)

733–34 Dengese Comb, Zaire
Wood. Height: 30.7 cm. Musée Royal de l'Afrique Centrale, Tervuren, Belgium. (Photographs Igor Delmas)

735 Lele Bowl, Zaire
Wood. Height: 17.5 cm. Private collection. (Photograph Igor Delmas)

736 Lele Scepter of a Leader, Zaire
Wood and iron. Height: 31 cm. Collection G. L., Paris. (Photograph Igor Delmas)

737 Kuba Statue, Zaire
Iron. Height: 19.5 cm. Etnografisch Museum, Antwerp. (Photograph Igor Delmas)

738 Kuba Box, Zaire
Wood. Height: 19 cm; width: 15 cm; depth: 13 cm. Musée de l'Homme, Paris; formerly Lefevre Collection. (Museum photograph)

739 Mbuun Bowl, Kwilu–Central Kasai, Zaire
Wood. Height: 12 cm. Musée Royal de l'Afrique Centrale, Tervuren, Belgium. (Photograph Igor Delmas)

740 Wongo-Lele Bowl, Zaire
Wood. Height: 19 cm. Private collection. (Photograph Igor Delmas)

741 Kuba Bowl, Zaire
Wood. Height: 20 cm. University Museum, Zürich. (Museum photograph)

742 Kuba Bowl, Zaire
Wood. Height: 23.5 cm. Museum Rietberg, Zürich. (Museum photograph)

743 Kuba Mask with Horns, Zaire
Wood. Height: 50 cm. Private collection. (Photograph Igor Delmas)

744 Kete Kuba Mask, Zaire
Wood. Height: 48 cm. Arman Collection. (Photograph Justin Kerr)

745 Kuba *Mboom* Mask, Zaire
Wood. Height: 43.5 cm. Musée des Arts Africains et Océaniens, Paris. (Photograph André Held)

746 Kuba Mask, Zaire
Rattan, cowrie shells, fibers, wood, copper. Height: 60 cm. Private collection; formerly F. Haviland Collection. (Photograph Igor Delmas)

747 Lulua Mortar with Hemp, Zaire
Wood and rope. Height: 8.5 cm. Etnografisch Museum, Antwerp. (Photograph Igor Delmas)

748 Lulua Statue, Zaire
Wood. Height: 31 cm. Musée Royal de l'Afrique Centrale, Tervuren, Belgium. (Photograph Igor Delmas)

749 Nsapo Statue, Zaire
Wood, horn, fibers, medications, string. Height: 37 cm. Private collection. (Photograph Igor Delmas)

750 Lulua Drum, Zaire
Wood. Height: 117.5 cm. Museum für Völkerkunde, Berlin. (Museum photograph)

751–52 Lulua Statue, Zaire
Back and front. Wood. Height: 59 cm. Private collection; formerly Olbrechts Collection. (Photographs Igor Delmas)

753 Salampasu Mask, Zaire
Wood. Height: 33 cm. M. Félix Collection, Brussels. (Collection photograph)

754 Mbagani Mask, Zaire
Wood. Height: 31 cm. Private collection. (Photograph Igor Delmas)

755 Lwalwa Mask, Zaire
Wood. Height: 34 cm. Private collection. (Photograph Igor Delmas)

756 Lwalwa Mask, Zaire
Found in 1930 in the Mboi district. Wood. Height: 35.6 cm. Musée Royal de l'Afrique Centrale, Tervuren, Belgium. (Photograph Igor Delmas)

757 Yaka Statue, Zaire
Wood, horn, sack, medications. Height: 50.8 cm. Musée Heverlee, Leuven, Belgium. (Photograph Igor Delmas)

758 Yaka Mask, Zaire
Wood. Height: 22.2 cm. De Menil Foundation, Houston. (Foundation photograph)

759 Yaka Statue, Zaire
Wood. Height: 47 cm. Musée Royal de l'Afrique Centrale, Tervuren, Belgium. (Photograph Igor Delmas)

760 Maternity Figure, Yaka, Zaire
Wood. Height: 25 cm. Musée Royal de l'Afrique Centrale, Tervuren, Belgium. (Photograph Igor Delmas)

761 Nkanu Drummer, North Kwango, Zaire
Wood. Height: 71 cm. Musée Royal de l'Afrique Centrale, Tervuren, Belgium. (Photograph Igor Delmas)

762 Maternity Figure, Mbala, Zaire
Wood. Height: 52 cm. Etnografisch Museum, Antwerp. (Photograph Igor Delmas)

763 Mbala Drummer, Zaire
Wood. Height: 41.5 cm. Musée Heverlee, Leuven, Belgium. (Photograph Igor Delmas)

764 Hungaan Statue, Zaire
Wood. Height: 32 cm. Fondation Dapper, Paris. (Photograph Igor Delmas)

765 Hungaan Statue, Zaire
Wood. Height: 40.5 cm. Museum für Völkerkunde, Berlin. (Museum photograph)

766 Hungaan Statue, Zaire
Wood. Height: 67 cm. Private collection. (Photograph Igor Delmas)

767 Hungaan Statue, Zaire
Wood. Height: 32.7 cm. Musée Heverlee, Leuven, Belgium. (Photograph Igor Delmas)

768 Pende Mask, Zaire
Wood. Height: 28.2 cm. Musée Royal de l'Afrique Centrale, Tervuren, Belgium. (Photograph Igor Delmas)

769 Pende Mask, Zaire
Wood and fibers. Height: 55 cm. Alberto and Suzie Magnelli Collection. (Photograph Musée National d'Art Moderne, Paris)

770 Pende Statue, Zaire
Wood. Height: 99.5 cm. Musée Heverlee, Leuven, Belgium. (Photograph Eliot Elisofon)

771 Pende Statue, Zaire
Wood. Height: 82.6 cm. Loran Collection, Berkeley, California. (Collection photograph)

772 Pende Scepter, Zaire
Wood. Afrika Museum, Berg-en-dal, Netherlands. (Museum photograph)

773 Chokwe, Mbundu, or Ngangela Staff, Angola
Wood. Total height: 117 cm. Height of the figure: 16.5 cm. Museum für Völkerkunde, Berlin. (Museum photograph)

774 Lwena Comb, Angola
Wood. Height: 17.3 cm. Musée Royal de l'Afrique Centrale, Tervuren, Belgium. (Photograph Igor Delmas)

775–76 Chokwe Scepter with Double Figure, Angola
Wood. Height: 67 cm. Deborah Kerchache Collection. (Photographs Igor Delmas)

777 Chokwe Scepter, Angola
Wood. Height: 40 cm. Private collection. (Photograph Igor Delmas)

778 Chokwe Scepter, Moxico, Angola
Wood. Height: 34 cm. Museum of Mankind, London. (Museum photograph)

779 Chokwe Scepter, Angola
Wood. Height: 55 cm. Maïa Kerchache Collection. (Photograph Igor Delmas)

780 Chokwe Mask, Angola
Wood, plant fiber, brass. Height: 23.5 cm. Musée Royal de l'Afrique Centrale, Tervuren, Belgium. (Photograph Igor Delmas)

781 Chokwe Mask, Angola
Wood, iron. Height: 24 cm. Musée Royal de l'Afrique Centrale, Tervuren, Belgium. (Photograph Igor Delmas)

782 Chokwe *Pwo* Mask, Region of Shassengue and Kakolo, Angola
Wood, plant fiber, brass. Height: 26 cm. Private collection. (Collection photograph)

783 Chokwe *Pwo* Mask, Region of Cucumbi, Chieftainry of Shamukamba, Angola
Wood, plant fiber, brass. Height: 22 cm. Private collection. (Collection photograph)

784 Chokwe Statue, Angola
Wood. Height: 29 cm. Private collection. (Photograph Igor Delmas)

785 Chokwe Statue of Tshibinda Ilunga, Angola
Wood. 19th century. Height: 38 cm. Private collection. (Photograph Igor Delmas)

786 Statue of a Chokwe Queen, Moxico, Angola
Wood. 19th century. Height: 35 cm. Private collection. (Photograph Igor Delmas)

787 Statue of a Chokwe Chief, Angola
Found before 1900. Wood, brass, beads, hair. 19th century. Height: 46 cm. Museu de Sociedade de Geografia, Lisbon. (Photograph Igor Delmas)

788 Statue of a Chokwe Chief, Angola
Wood, brass, hair. 19th century. Height: 49.5 cm. Museu Regional do Dundo, Angola. (Museum photograph)

789 Statuette of a Chokwe Chief, Angola
Wood. 19th century. Height: 35.5 cm. Museu de Etnologia, Lisbon. (Photograph Igor Delmas)

790–91 Bongo Funerary Effigy, East of Bahr el Ghazal, Sudan
Wood. Height: 242 cm. De Menil Foundation, Houston. (Photograph Speltdorn)

792–94 Gato Statues, Ethiopia
Wood. Heights: 105 cm, 85 cm, and 110 cm. Private collection. (Photographs Igor Delmas)

795–98 Giryama Posts, Kenya
Wood. Heights: 175 cm, 180 cm, 152 cm, and 180 cm. Private collection, Brussels. (Photographs Igor Delmas)

799 Giryama Post, Kenya
Wood. Height: 220 cm. Private collection. (Photograph Igor Delmas)

800–04 Zaramo and Kwere Fertility Dolls, Tanzania
Wood. Heights: 13.5 cm, 15.5 cm, 14.5 cm, 18 cm, and 15 cm. Private collection. (Photographs Igor Delmas)

805 Karagwe Gazelle, Tanzania
Iron. Height: 41 cm. M. Félix Collection, Brussels. (Photograph Igor Delmas)

806 Nyamwezi Statue, Tanzania
Wood. Height: 69 cm. British Museum, London. (Museum photograph)

807–08 Nyamwezi Staff, Tanzania
Complete object and detail. Wood. Height: 149 cm. W. Mestach Collection, Brussels. (Photographs Igor Delmas)

809 Makonde Mask, Mozambique and Tanzania
Wood. Height: 30 cm. M. Félix Collection, Brussels. (Photograph Igor Delmas)

810 Makonde Mask, Mozambique and Tanzania
Wood. Height: 30 cm. O. and P. Cobb Collection, Seattle. (Photograph Paul M. Macapia)

811 Makonde Statue, Mozambique and Tanzania
Wood. Height: 37 cm. Private collection, Belgium. (Photograph Igor Delmas)

812 Makonde Statue, Mozambique and Tanzania
Wood. Height: 36.8 cm. Kimbell Art Museum, Fort Worth, Texas; formerly Pitt-Rivers Collection. (Museum photograph)

813 Makonde Statue, Mozambique
Wood. Height: 74 cm. Linden Museum, Stuttgart. (Photograph Ursula Didoni)

814 Stone from Zimbabwe
Stone. Height: 33.6 cm. Paul and Ruth Tishman Collection. (Photograph Jerry L. Thompson)

815 Shona Neck-Rest, Zimbabwe
Wood. Height: 13.5 cm. Alain Schoffel Collection, Paris. (Photograph Igor Delmas)

816 Zulu Jar, South Africa
Wood. Height: 40.6 cm. Private collection. (Photograph Jeffrey Ploskonda/Art Museum, Princeton University)

817 Nyamwezi Zulu Powder Box, Tanzania, Zambia
Wood and horn. Height: 18 cm. Private collection. (Photograph Roger Asselberghs)

818 Sotho Stick, Botswana
Wood. Height: 114 cm. British Museum, London. (Museum photograph)

819 Shona Commander's Staff, Zimbabwe
Wood. Height: 72.8 cm. M. and D. Ginzburg Collection, New York. (Photograph Justin Kerr)

820 Mahafaly Statue, Madagascar
Wood. Height: 75.5 cm. Private collection. (Photograph Igor Delmas)

821 Mahafaly Statue, Mahabo Cemetery, Mourondaba Region, Madagascar
Wood. Height: 82 cm. Private collection, Belgium. (Photograph Igor Delmas)

822 Mahafaly Statue, Madagascar
Camphor-tree wood. Height: 68 cm. Private collection. (Photograph Igor Delmas)

823 Couple Dancing, Southeastern Group, Madagascar
Wood. Heights: 45 cm and 57 cm. Private collection, Belgium. (Photograph Igor Delmas)

824 Couple Wrestling or Dancing, Mahafaly or Vezo, Madagascar
Wood. Height: 72 cm. Private collection. (Photograph Igor Delmas)

825 Vezo Couple, Madagascar
Wood. Height: 80 cm. Private collection. (Photograph Igor Delmas)

826 *Aloalo* Funerary Post, Mahafaly, Madagascar
Wood. Height: 235 cm. Private collection. (Photograph Igor Delmas)

827 *Aloalo* Funerary Post, Mahafaly, Madagascar
Wood. Height: 210 cm. Private collection. (Photograph Igor Delmas)

828 *Aloalo* Funerary Post, Mahafaly, Madagascar
Wood. Height: 178.5 cm. Private collection. (Photograph Igor Delmas)

AN INITIATORY PASSAGE

In homage to Max-Pol Fouchet,
to my parents

Sculpture is form become emotion.

P. VALÉRY

With no preliminary method, the passion for Africa propelled me to the heart of Gabon, carried me from the Congo to Equatorial Guinea and from the Ivory Coast to Liberia, and led me from Burkina Faso to Mali, from Ethiopia to Benin, from Nigeria to Cameroon, and from Tanzania to Zaire. From these experiences, sometimes difficult, certainly physical, but above all intellectual and spiritual, from my participation in various ceremonies and handling of diverse objects, from my temporary but actual immersion in the voodoo cults of the former Slave Coast, all I can reconstruct today are feelings and impressions; I shall abstain from making any assertions.

Yet, when encountering African sculpture, one must cease to be afraid of being uninformed and must allow oneself to be overtaken by it; one must come closer to it, dwell with it, possess it, love it. One must give it one's time, open one's sexuality and dreams to it, surrender one's death, one's inhibitions to it, rediscover other things inside oneself—without cowardice, without hesitating to desacralize one's own cultural sources, without rejecting them. To take the veils from one's eyes—allowing oneself the pleasure, letting oneself be won over by the magic.

Even if we can contemplate this sculpture only in fragments, it is still rich enough to express that alphabet of mother-signs, matrices, into which humankind today can and must delve in its necessary quest for universality. For, at the end of the twentieth century, it would be dangerous to neglect the contribution of all the "first arts" that are, at the same time, the last ones; these are the ancestors of the future. The goal of the African arts is not to teach us a specific ideology, but to teach us to look differently. One must guard against subtle racism, that is to say, against thinking that one must be African in order to understand this sculpture—an exotic attitude that is no longer in circulation. Similarly, we cannot continue to be tied down by the historical events that marginalize major works of universal quality in the ghettos—that is, the laboratories

(what a word to use in speaking of a culture!) of natural history museums—placing them side by side with skulls, fetuses, clothing, footwear. . . . (How would you feel about looking at the works of Michelangelo, Leonardo da Vinci, Goya, and Matisse, exhibited side by side with their slippers and hats?)

Another recommendation: one must not approach African art biased by dates. First of all, whatever the culture observed, the age of a work has never been a guarantee of quality; minor, vulgar, and poor productions have abounded as much in the Greco-Roman, Egyptian, and Asiatic cultures as in eighteenth-century France or in the twentieth century. Then, one must go beyond the kinds of analyses (ethnomorphological, quantitative, and mathematical) undertaken by many researchers. Would you conceive of measuring the sculptures of Bernini or Picasso in order to determine their originality, emotion, or magic? And why use objects—without really looking at them—as a pretext for establishing a theory of a society? In fact, the beauty of a sculpture is not foreign to its social function, just as its ritual or magic role does not prevent an appreciation of its beauty by its users. The more important an object's function is, the more its aesthetic qualities are evident; a close bond unifies function and beauty, the one supporting the other by fostering its blossoming, and the second one magnifying the first by exalting it. Above everything else, one must avoid fixing an ensemble of objects inside one tribal unity, or doing the inverse, dispersing everything. Presently, an attempt of this order is being made with the Dogon.

Contrary to what certain ethnologists would have us think, Africa does not live in an eternal present. There is no single conception of history. There as elsewhere, customs have changed and evolved, and the same is true with the sculpture—just as, according to the origin of the clan or family of an on-site informant, a statue will be given different meanings. Just so, the homogeneity of the observed group will fluctuate as much as these ascriptions. The myth being changeable, the interpretation of the myth will be also. In this realm, nothing is ever definitive. An object, in Africa, is as mobile as the word, and African sculptures form the framework for speech.

But nothing prevents you, when encountering a sculpture of exceptional quality offering an original view of the world, from perceiving the sculptor's will to translate an idea.

Sculpture, Dimension, Speech

Naturalist works, such as the Ife heads, will be more readily accessible to you, for they will play on your cultural, visual, sensual, and tactile register. They are masterpieces, certainly, but are only one variety among the enormous sum of plastic solutions proposed by African sculpture. When discovering these heads in 1910, Leo Frobenius immediately linked them to Greece, believing he had found Atlantis. Juan Gris stated, in regard to African art, in *Action*, April 1920: "It is the opposite of Greek art, which based itself on the individual in order to try to suggest an ideal type." And to that I add: it would be to murder Greek art to see it as unique. The Ife works are completely African; if you look at them carefully, you will quickly conclude that you cannot confuse them with any other sculpture in the world.

But encountering African art, the more you feel attacked, baffled, the more it becomes necessary to pay attention; do not be afraid of disturbance, of shock. Before speaking your mind, do not look for signatures or dates. This is an attitude—branded by J.-M. Drot—of the systematic, "labeling" thought process of the Western world. African

sculptures do not have signatures and stand outside of our chronology. Retain what is there with your eye: "The eye should graze upon the surface, absorb it particle by particle, and put it back into the brain, which will store the impressions and make them into a whole. The eye follows the paths that are laid out for it within the work." (Paul Klee) Get close to what you can feel and grasp, such as the sensuality contained in African sculpture; do not think in terms of expressionism, Cubism, or realism, do not think of a mask as laughing or weeping. Do not let yourself be seduced by the materials, the gold, the bronze, the laquered patinas, or you will stay in the *Catalogue of Stylish Opinions*. There is also time needed to walk around a three-dimensional sculpture, indispensable to understanding it. What will perhaps be the most difficult for you is an active participation when encountering a statue, for we live today in the two-dimensional, the realm of images. That modifies our perception of sculpture. Sculpture is increasingly absent from our environment, except in the form of "monuments to the dead" or as a foil to architecture. It is a matter, then, of practicing one's eye in order to discover in this vast artistic production, in this labyrinth (in, more precisely, this book on African sculpture) the accented beats, the mother-signs, of so many expressions of the power of creation and technical mastery.

The choice suggested here is not an honor roll, but it will allow the "temple gates" to be opened to the uninitiated reader, and it will serve perhaps as a springboard for specialists. It does not evoke the question of *Primitivism in the Art of the Twentieth Century*, masterfully treated by William Rubin. This selection is meant to have great freedom, in the service of pleasure.

African sculpture, generally, is of small dimension, rarely exceeding beyond 1 meter in height, very rarely measuring 1.8 meters. Nevertheless, this does not prevent it from expressing a certain monumentality. These proportions are derived from its manipulation and its use inside the structures in which it appears. Yet if statuary has a truly communal role, it should and can be seen by everyone; this is the case when it is incorporated into architecture. But in those circumstances, it is very rarely encountered in Africa: in Bamileke chieftainries, Bamum palaces, Yoruba temples. Sculptures of large dimensions do exist on certain funerary sites, as among the Konso-Gato of Ethiopia, the Bongo of the Sudan, the Giryama of Kenya, and the Sakalava and the Bara of Madagascar, or as protection for the village, clan, or family, such as with the *bochio* of the Fon of Benin. But these remain the exception—while they are found in profusion in Polynesia, Melanesia, Micronesia, among the Native Americans, or in southeast Asia. For, contrary to the African ethnicities, these peoples live in a cultural space that is more communal on the social plane (dwelling) and mental plane (constructs). Similarly, monumental stone statuary, which exists to a certain extent all over the world—from the great Neolithic steles of Filitosa on Corsica to the megaliths of Easter Island, from the colossal, pre-Columbian statues to those of the pagan civilizations of Central Europe—is only rarely present in Africa: among the Ekoi of Nigeria, the Konso in Ethiopia, or in the great lyre-stones of the Neolithic Age in Senegal. Moreover, African artists have expressed themselves creatively least frequently in stone.

As opposed to sculptures, the mask, the use of which is often accessible to the entire community, at least the masculine community, can be developed at leisure in huge sizes, as among the Dogon, the Mossi, the Baga, and so forth. It even happens that these are made into "super-dimensions" by their wearers, who walk on stilts, as among the Dan of the Ivory Coast or the Punu of Gabon.

As is true everywhere in the world, three-dimensional African sculpture

appeared when people settled, the mastery of agricultural techniques permitting them to remain in one place: this can be seen throughout the Middle East, in the Mediterranean basin (the Cyclades, Malta, Cyprus), China, the Danube basin (Rumania, Czechoslovakia), and in Africa, in Niger, as the works of J. P. Roset have confirmed. These techniques were discovered and transmitted more or less slowly and were to end in an ensemble of particulars such as writing, the city, the State, the army, and architecture. These farming-hunting-fishing societies, more or less warriorlike depending on the circumstances, were to produce a three-dimensional sculpture that was generally very small and conceptually very close to African sculpture, at least on an aesthetic basis. All these statuettes bear witness to a refusal to be mere naturalist copies—in the arrangement of their shapes, in their volumes, in the precision of their lines, and in their reduction to the essential. They were to reach a degree of inventiveness that is rarely attained.

In contrast, wherever people are on the move, among hunter-gatherers or nomadic cattle breeders (Pygmies, Bochiman, Hottentot, Peul, Masai, the Australian aborigines, or the Plains Indians), three-dimensional sculpture does not exist, which does not prevent these societies from expressing themselves in just as fascinating a manner, in domains as diverse as the body arts, cave paintings, sand drawings, calabash engravings, leather decoration, weaving, choreography, music, dance and song, and myths. When humankind moves, they carry the essential with them in their bags.

At this point in our journey of understanding and pleasure, it is appropriate to put the work of art back into its sociocultural milieu: here, ethnologists and linguists allow us better to understand the context for stylistic inventions and better interpret them. Especially since from one region to another, from one cultural ensemble to another, the statue may contain a completely different signification or rather "the same function may be exercised by several different forms and, inversely, one single form may fulfill several different functions." (J.-L. Paudrat) Among the Senufo, very few signs allow us to distinguish between a given mask that is said to incite women to adultery and another said to suppress its practice.

So-called primitive societies did not make use of writing, hence the contempt with which they have been regarded. But the oral traditions, it has now been understood, were a substitute for writing, and writing's absence did not mean an absence of culture, but rather a conscious and deliberate rejection on the part of the wise in order to avoid transforming the myth's variations into an immovable dogma.

Furthermore, Africa has been in permanent, more-or-less violent, contact with Islam from the eighth century onward. Because of this, there obviously exist innumerable affinities between Black Islam and traditional Africa, events lived in common that are rediscovered in more-or-less delayed form in the myths and that also appear in the aesthetics. For example, the horse symbolizes the period of contact with Islam as it rushed across the continent; incorporated in the cosmogony of the peoples of the inner delta and the bend of the Niger River, it represents the necessity of finding the time of new words and of making new decisions. But the Islamization of Djenne, all along the Niger River, around 1043, did not prevent artistic production from developing along the entire river basin; nor was that to influence the Dogon in Mali, where the Songhay Empire reached its apogee in the fifteenth century. There were villages in which the Peul, Dogon, or Bamana, or peoples such as the Edo and the Yoruba from Nigeria lived together as a community, resisting the pressures of the Islamicized Fulani or Hausa. Yet, the spirit of abstraction and geometricization of Islam has certainly played a subtle role in the

realm of masks as well as in habitat. But this penetrating influence was undoubtedly fairly flexible, and if the Koran forbids any human representation, Islam in Africa may have wanted to destroy idols, but it never thought of destroying the sculpture. With a host of "regional forms of Islam," and the evolutionizing contacts between the eighth and the ninth centuries, one may well wonder whether it is not Africa that "Africanized" Islam.

The African oral tradition is not limited to tales of foundings, emigrations, or battles against invaders, it encompasses all aspects of life. It is a school of religion, knowledge, and natural sciences, initiation into a trade, history, and recreation: it involves humankind in its totality. One must learn to decipher sculpture, the material of speech, the material of myths in permanent evolution. Speech is sometimes of divine origin, it has a sacred character. According to Dogon mythology, "the first people were deprived of speech, incomplete, 'dry,' unhappy; they could not experience progress. Then Binou Serou received a teaching from the ancestor Nommo during the course of conversations. Their life-styles were transformed because of it; from gatherers of fruit they became growers, speech rendered them attentive to atmospheric phenomena and allowed them to organize their agricultural calendar." (G. Calame-Griaule, *Ethnologie et Langage: La Parole Chez les Dogon* [Ethnology and Language: The Word Among the Dogon]) Among the Bamana, the word is creator and possesses the double function of invention and destruction. The importance of words can be found everywhere in Africa; hence the ritual songs, the stories, the discussions, the encounters, and what results from all these—the marketplaces. Through the medium of words are transmitted the times of celebrations, the sacred times, and, periodically, the time of the coming of the spirits. All these moments are made ritually present through the visualized word, made material in certain objects: for example, in the glottis of the statues whose users are primarily men (the glottis being a feature that is physiologically more developed in the male), or in the spools of the weaving crafts. Does the African weaver not say: "The shuttle weaves the word"? One may also find this word signified by an oversized mouth, a tongue appearing between the lips, or an iron blade protruding from the mouth of a commander's cane or a speaker's baton.

Among Africans, the universe is conceived of as a fragile balance between two forces—culture, the order of the social institutions, and nature, an uncontrollable disorder that passes from fertility through growth to death. Just so, African sculpture represents one element of this social cohesion through its presence in realms as varied as the socio-political, the magico-religious, or the soldierly. Religion and politics, in the majority of societies, are closely linked; indeed, it is the elders, the "old fathers," the men of the class of superior age, having reached the highest degree of initiation, who make the decisions that concern the community's life. This long, formative initiation ends late, since, according to the philospher Hampate Ba, a man is not considered an adult for the Bamana and the Peul until the age of forty-two, and many do not even reach this age. Once again, it is a matter here of the word: in order to reach this degree of initiation, one must know how to ask the right questions. And, again, sculpture takes over from the word: even though "generally, African sculptures do not represent their subject as having a specific age" (W. Fagg), the beard, a mark of a class of age, of wisdom, of virility, of capital-memory and knowledge, is found on a large number of statues and masks. The pictorialization of this beard is quite obvious in all African sculpture, while one does not see it in the Paleolithic and practically never in the Neolithic Age: one exception is the statue of Beer Safad (4000 B.C.), found in Israel, which has a series of holes around the face that would

allow, as with the bronze Ife head of Obalufon, the attachment of a false beard—and that remains a hypothesis.

The beard, a conceptualization of the wisdom of the elders, themselves guardians of the oral tradition, finds form in statuary. Sculpture in Africa is word become form.

Surface Objects

What the Black people adore
is not the stone, the tree,
the river, but the spirit which
they believe resides therein.

J. THEILHARD DE CHARDIN
Upper Guinea and its Missions, 1889

The Life of Surface Objects

Ritual objects, masks, statues, and furniture used above ground play a much more important role in traditional African society than do funerary objects, destined for burial. To these must be added a small quantity of pieces that have a double use—jewelry, sacred furniture that accompany the dead person into the tomb, such as at Igbo-Ukwu in Nigeria, or certain funerary objects that were found fortuitously and used again above ground, such as among the Kissi in Guinea, those of the Nok culture, or of the Owo culture in Nigeria.

In Africa, spirits are present everywhere. People frequently become more important after death than they were during their lifetime. Surface signs function in sets and subsets in a narrow relationship between the role they play and the roles of their manipulators; there are communal objects (often masks), semicommunal ones (again masks and a small part of the statuary), and those objects—particularly statuettes—reserved for the wise, the living memory of the community. The elders continually re-actualize these objects in the relationships they maintain with the external world (historic events, contacts with Islam, Christianity, migrations, wars, alliances) and the interior world (spirits, death, dreams). Around the functions and uses, extremely complex systems of cyclical manipulation and protection are established.

You can spend your life in Africa without ever seeing a statue in use; they are hidden not only from the outsider but also from a large part of the community. During almost half a century of existence, the French Ethnological School, led by Marcel Griaule, had only occasional access to the Dogon statuary that was considered sacred. Members of the team saw (communal) masks and sculptures that had been desacralized, and they even inspired new compositions such as the "Madame" mask or the "ethnologist" mask.

From the seventeenth century to our day, we observe, thus, in the illustrations in travel accounts, the appearance of weapons, of communal musical instruments, furniture, jewelry, and some very rare documents that are more interesting: they show an African who has just had his behind kicked, surrounded by statues—in order to give the image a fetishist dimension. Let us not forget the newest arrival: the mask made for the tourist.

In reality, the majority of these "trompe-l'oeils" permit the concealment of sculpture considered sacred and the attitude of the users when

encountering this statuary. Users behave toward each statuette as toward an individual. In Africa, there still are innumerable statues carefully hidden, and they will appear only when there is no longer any interest in their handlers. For these are the beneficiaries of a very elaborate protective system.

The construction of a "surface sign" begins with the choice of the material (quality of the type of tree), of the moment when it will be cut down, the soaking techniques (bog, mud), the mixing of patinas (oil, honey, beeswax, smoke, paint); then comes the ritual sacrifices (of blood, millet beer). Then, there is the placement (in temple, family shrine, grotto, granary, coffer), the wrapping (often in enormous cloth packages far larger than the size of the object), and maintenance—certain men may be responsible for them upon their life. It can happen that when troublesome events occur, such as the rebellion of the Bamileke in Cameroon during the sixties, that kings entrust their sacred objects to notables who live very far from the chieftainry.

The construction of replacement objects also enters into the systems of protection: that is to say, the rapid fabrication of a statue that was not sacralized, one intended for missionaries, administrators, or ethnologists passing through. The sense of superiority that these latter people had caused them not to have any idea, for even one moment, that Africans were mocking them. Missionaries would reclaim idols, and during the night, having great fun, the Africans would construct a replacement object. The following day they would give up their Saint Sulpice virgin, holding on to their Romanesque virgin. Thus they slackened the pressure.

This practice still takes place. More than once, after nights of talking, some Africans presented me, very ceremoniously, with an enormous package that contained a mask or a statue. I would say to them: "You made this during the night, you think I am a child." We would all burst out laughing, thus establishing a link of magic complicity. How many tourists, visiting the Dogon, have been awakened in the middle of the night, taken away to a hut one after another, by an elder who, with a thousand precautions, would offer them the door of a granary with grains from the ancestors. The next morning, in the bus, all the tourists would have the same door, a fake object complete with traditional repairs. All these subterfuges in order to conceal the existence of authentic objects, thus to insure their preservation.

The Death of Surface Objects

I shall not speak of the destruction by natural disasters or by termites or rodents, which happens when objects are desacralized and abandoned. But most often, they are destroyed by the users themselves. In 1889, Father Noël Baudin was astonished: "In the first years of my stay on the Slave Coast, our neighbor, the great fetishist, having died, they put all his fetishes outside his hut . . . and when I asked the Black Africans why they treated their gods this way, they assured me that the gods were no longer there, and that therefore every statue and every other symbol of the gods, useless from here on in, had been thrown out of the hut." I have often seen, among the Fang of southern Cameroon, children play with very beautiful sculptures or, laughing, place a mask on their head. These objects, no matter what their authenticity, their past role, or their plastic quality, no longer meant anything to the community.

A mask may also be constructed for a specific ceremony, such as the *cikunza* masks among the Chokwe, then be destroyed the next day after its use. Others are thrown out because they have been damaged during use. Certain objects respond negatively to their users and disappear. And this is

without counting the masks or statuettes made of grass, mud, or foliage—ephemeral and thus perishable materials.

But political or religious decisions, too, weigh upon these surface signs. Several examples may illustrate this kind of destruction. Around 1400, after a conflict, a lineage abandoned the holy city of Ife and settled between this town and Benin. The Owo terra-cottas, marvels of delicacy and unique in their conception in Africa, were destroyed two generations later by the Benin army. During the conquest of the Edo territory by the Yoruba, entire villages, as well as every object in them, were annihilated. In 1897, the English vice-consul wished to visit the king of Benin during the Igue ceremonies. The latter refused, for he is not to be seen during this period. This gave rise to the punitive expedition of the English against the city and to the pillage of about four thousand objects. Put up for sale the following year in London, they are today primarily in the British Museum, in the Berlin Ethnographic Museum, and in numerous public 'd and private collections.

Let us add to the destructions by colonial armies the removal of thousands of surface signs during the Biafra war by the Hausa, and by Chief Mukenga Khalemba among the Bena Lulua, as well as the bombings by Kadhafi over N'Djamena, bringing in its wake the razing of the National Museum, the burning of the library, and the annihilation of neighboring archeological sites.

One can likewise evoke the destructions brought about by the propagation of Islam, the auto-da-fés of the missionaries, and the practices of syncretic cults: the "Mademoiselle" cult between 1940 and 1964 in Gabon and the Congo; the "Massa" cult among the Senufo in 1953; and the Spirit Movement between 1920 and 1930 in Nigeria. And, to end, let us mention the systematic collecting activities by the great ethnographic museums, as well as the sale by Africans themselves of certain pieces in order to respond to increasing demand. "In Cameroon, at the moment of Independence, one saw authentic ancient pieces appearing on the 'Primitive Arts' market, often objects of great importance, sold at very high prices by the monarchs themselves with full support from their notables." (P. Harter)

Obviously, we cannot set the past straight, but it is up to us to avoid new disasters. Had there not been the interest of artists and poets such as Picasso, Matisse, Derain, Apollinaire, Fénéon, or of the merchants and admirers in African art, the latter would not hold the place it now occupies in the cultural heritage of humanity. For the moment, the Africans are hardly interested in their objects in this way (furthermore, I do not know a single great lover of Black African art in Africa). Yet, the future of the African archeological heritage, situated in the basement, belongs to them. Let us leave it to the Africans to decide how they will develop the museography in their country; let us simply be available to collaborate with them, should they ask, in undertaking scientific digs, for example, such as those by Thurston Shaw at Igbo-Ukwu in Nigeria. Above all, let us make an effort to enoble the gaze we direct on Black African arts.

The African Artist

*For the Black sculptor, they say, the
best mask is the most effective; whence
comes its effectiveness, if not from
the fullness of its style?*

ANDRÉ MALRAUX

African artists have remained anonymous to us for a long time.
And yet, they play an essential role between the visible and the
invisible; they participate in the cohesion and the evolution of
their own cultural groups; through their creation, they may possibly touch
neighboring communities.

Training

In Africa, from childhood on, there is a communal education according to
age groups. It begins after the very early years, at the moment of passage
from adolescence to adulthood (with excision, circumcision), and therefore
at the point where the sexes are separated. The young man—for in Africa
only men can become artists—will, in principle, be directed toward
different sectors of social life by the wise men: toward the hunt, words,
speech, song or music, wood sculpture, or the trade of the blacksmith. He
will then be instructed in the appropriate techniques and corresponding
myths. The danger inherent in the hereditary system of the artist's metier,
which is found among numerous ethnic groups, is compensated for by
safety valves: despite the law of traditions, exceptions are noted. Thus,
among the Senufo, if the young male heirs of the trust should prove to
have little talent, the "instructor" artist may have distant cousins, captives
of the house—former prisoners of war or slaves—enter into an
apprenticeship. In other ethnic groups—the Chokwe, Dan, or Igbo—a
young man becomes a sculptor both by vocation and recognition of his
talent. A Bashilele, directed to this guild through dreams or trances, must
pay his initiator a right of admission. In Africa, whole families or entire
villages of artists are found under the tutelage of master sculptors. The
qualitative selection shows the undoubted possible existence of critical
feeling, even if the vocabulary to express it is not the same as ours.

The young male artist, as he continues to receive a general education,
enters an apprenticeship with a master, just as, during the Renaissance, a
painter's apprentice would start in the studio of the elder by cleaning
brushes, grinding colors, learning the language specific to the guild. Was
Michelangelo not placed in the studio of Domenico Ghirlandaio by his
father, and did Leonardo da Vinci not go to work for Verrocchio? Just so,
the young African makes his debut by sweeping, handing over tools,
working the bellows of the forge. But he will have to acquire two
languages: the profane, which corresponds to the objects used in the
household, which he will be able to make during his years of
apprenticeship, and the sacred, reserved for the ritual objects.

When he has attained an adequate level of knowledge of the myths, he
can be selected by his peers and entrusted with commissions that his
degree of initiation will allow him to fulfill. For example, he will have the
possibility of making an initiation mask after a model. These models,
technical, plastic, and mythological structures used by the master, do not
necessarily have the same dimension as the real objects nor their
characteristics (such as holes for attaching or wearing the masks).

According to the master's personality and the variability of the myth, the young sculptor will be able to express himself more or less freely, approach or move away from the suggested model. On this occasion, a spirit of competitiveness, a critical sense, and technical and creative abilities will be encouraged.

The young artists remain apprentices for between six and ten years in order to be prepared for the prohibitions, benefits, dangers, reponsibilities, and rights inherent in their guild. They will then be around thirty years old. It is, however, not impossible that a very gifted young man will skip some age classes of development. Yet, whether he remains with his master or becomes independent, it is unthinkable to ask him to produce a sculpture whose use and liturgical content are intended for men of a higher age class. Many of the sculptures presented in this book that seem to pose fundamental plastic questions must have been executed by mature artists, no longer burdened by technical problems, now absorbed by and concentrating in their creations on a quest for "excellence and originality" without ever neglecting the content and magical significance of their work.

Maturity of the African Artist

Leonardo da Vinci recommended that the artist "live in solitude in order to better concentrate on the essence of things." Nothing can summarize the attitude of the African artist more exactly as he faces his creation. He is solitary, marginal, and his function has a sacred character. In Africa, the sculptor most frequently executes his work in secret, under many constraints, for it is intended for a restricted public. Of course, it sometimes happens that he works or shows his sculptures to fellow artists, or that he listens to criticism while in the process of working. But it is always an "elite" of intellectuals, including artists themselves, who make these remarks, and since the works are not meant to be exhibited, the level of production depends on the quality of this initial criticism. But artists will encounter critiques not only before but also during the object's utilization, since the ones who assigned the work in question also judge its effectiveness.

One may then wonder what matters most for an artist's reputation, his magic power or his creative talent? Personally, I lean toward the talent: the intellectual elite is capable of seeing the link between effectiveness in the level of use and the quality of creation and execution; they are not so limited that they systematically hold artists responsible for the sometimes defective functioning of certain objects. Of course, they may take advantage of these events to try to disqualify or oust them, but those are matters of intrigue and rivalries. To conclude, one should note the rough, ongoing competition among clients to garner the services of an artist of high repute for themselves, and to take advantage of the works he makes to increase their own prestige. Among the Bamileke, "the names of artists were often intentionally kept secret. The artist was kept at the palace as long as a commission was not finished, and his works could be sold only through the intermediary of the king, who often would usurp their authorship [A]fter a masterpiece was finished, they [the sculptors] might be deported, sold as slaves, or even executed." (P. Harter) The rivalry between Bamana blacksmiths may go so far as to use poison or sorcery to destroy the family of a rival; one does not hesitate to use slander to reduce to nothing the privileged relationship between blacksmith and clients. "A blacksmith sculptor's 'name' or *Togo* was worth his life, since his sculptural achievements or failures were thought to be a matter of both individual and family honor, and thus a matter of life and

death." (S. Brett-Smith)

Artists' Dialogues and Dissidences

*When will I be done with the marble that
separates me from the sculpture!*

MICHELANGELO

Let us picture a Mumuye sculptor showing a new statuette to his
friends. Their immediate reactions may surely be compared to
those of the painters to whom Picasso showed *Les Demoiselles
d'Avignon*: "He is crazy!"—"One day he is going to hang himself." And
then, the first shock passes, and this Mumuye sculptor has to live in
intense competition with the other sculptors of his ethnic group, a little
like Braque, Picasso, and Juan Gris between 1911 and 1913: which caused
Braque to say that they had the impression they were "painting behind
each other's back, as on the famous poster of Ripolin." These sculptors
have certainly held impassioned conversations on the evolution of their
art. The artist who was creator of this form would justify the importance
of the pose of the arms and the use of space; a speaker, while retorting
that the links suggested between the volumes actually rendered the
"individual" more present, would ask for details on the risks of breakage,
wanting to create volutes endowed with a similar tension. The first one
would tell of the difficulty he had experienced in finding the proper
wood; the discussion would continue into the middle of the night to
determine whether it was better to leave the markings of the tool on the
surface or to spend hours and hours polishing the material with abrasive
leaves. And in the end, an old sculptor would intervene, indignant about
the young who no longer have respect for anything today and would do
better to do as they did when he was young, or in his father's day—that is
to say, to travel to the Chamba, the Jukun, or the Wurkum, in order to
learn from them. All this is only imaginary, but it brings us back to the
essential point: words, discussions, that have in mind the moving forward
of tradition.

African sculpture is an art without rough drafts, without studies,
without preparatory drawings. Artists go directly from concept to
execution. Moreover, the speed with which the work of the "producer" is
transmitted to the "consumer" is like lightning, it allows practically no time
for reflection. Criticism is immediate and definitive, the work is swallowed
up, digested, accepted or crushed if it is not satisfactory. The critical
power of the users has perhaps annihilated, among the Baoule, any
attempt at originality or evolution.

Fortunately, there are dissident artists who pass through the narrow
gaps of the net of traditionalist criticism. Inside some very structured
cultures such as the Ife, the Benin kingdom, the Yoruba, Luba, and
Baoule, in which any attempt at a new solution may be considered a feat,
or in more flexible societies such as those in eastern Nigeria, dissident
artists use everything as grist for their mill: the renewal of a cult, the
variation in a myth, emigration, alliances, social conflicts, commissions
from other communities, their reputations as magicians. They express
themselves in new forms, hoping thereby to establish them. And if the
power of the State is too constricting, they have one solution left: flight or
emigration, such as those undertaken by Tsoede and Ojugbelu.

African artists know how to take advantage of the Kuo, the right and
only moment according to the Chinese for the weaver to move the shuttle
through. They have shown that they are able to use every material
available to them with great felicity, and they also incorporate and use

every new material brought onto their continent. They have infiltrated themselves into the innermost depths of proportions, into the intertwining of rhythms made of repetitions without redundance. They have created variations of forms that are altogether remarkable. They have used shade and light admirably. As Jean Laude has said, they are capable of "thinking directly with forms inside forms and [of] making plays on forms as we make plays on words."

Every culture remains authentic
by enriching itself by contact
with other cultures.

CLAUDE LÉVI-STRAUSS

African sculpture is, before anything else, a materialization of speech. This characteristic confers tremendous importance upon it in field studies. But, in their relationships with their informants, certain ethnologists have a tendency to assert themselves too strongly. Perhaps they do not take the personality, age, or social position of their interlocutors enough into account. As one draws farther and farther away from the primary sources of inspiration, questions are posed whose answers are premeditated and the scars of history are ignored.

For example, how valid is the information gathered by a male who asks questions about objects that are handled solely by women? Sometimes I wonder whether some of these researchers do not leave for the field with the analysts' couches with them, afraid as they are of finding their innocence again. Africa has already been pillaged in every sense of the term (deportation, slavery, colonization, institutionalized racism), all it needs now are ethnologists who castrate it in their laboratories.

Furthermore, one ought to separate the notion of surface objects belonging like movable goods to their proprietors, from the archeological heritage. For, indeed, while we have a rather correct idea of the inventory of surface objects, the future of African art is in its basement.

Great artists are as rare in Africa as they are in all other societies, including our own. Within a complete oeuvre, there are powerful moments that correspond to the quality of the plastic question posed; few artists have been capable of posing several of them.

JACQUES KERCHACHE

THE PRINCIPAL ETHNIC GROUPS

MAURITANIA

MALI

Niger

DAKAR

SENEGAL

Senegal

Bani

BAMAKO

BURKINA FASO

GUINEA-BISSAU

GUINEA

BENI

Volta

SIERRA
LEONE

IVORY
COAST

TOGO

GHANA

Sassandra

Bandama

LIBERIA

ACCRA

LOMÉ

ATLANTIC OCEAN

Ethnic Groups Cited in this Chapter

WEST AFRICA

The Western Sudan

(Mali, Burkina Faso, Ivory Coast)

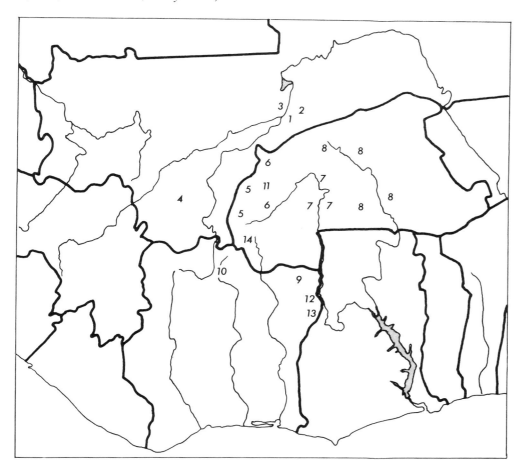

1 Djenne
2 Tellem, Dogon
3 Bozo
4 Bamana (Bambara)
5 Bobo
6 Bwa
7 Gurunsi
8 Mossi
9 Lobi
10 Senufo
11 Marka
12 Kulango
13 Ligbi
14 Turka

The Middle Niger

DJENNE AND THE INNER NIGER DELTA The ancient city of Djenne is related to the empires that succeeded one other in this region of Africa: the Ghana empire (the eighth to the eleventh centuries), the Mali empire (the thirteenth to the sixteenth centuries), and the Songhay empire (fifteenth and sixteenth centuries). Djenne's wealth was due to its role as a market city, a commercial center, and a crossroads for caravans moving south across the Sahara, bringing salt in exchange for gold and slaves. But the Portuguese, as they settled on the coast of Guinea, changed the direction of this great commercial flow; from then on it began to cross the seas.

According to M. Delafosse (cited by B. de Grunne, 1980), the city of Djenne is supposed to have been founded around the year 800; following the fall of the Ghana empire, a part of the Soninke people settled first on that site, then in Djoboro where the Bozo were already living. In 1200, other Soninke clans supposedly joined the first one. Charles Monteil does not establish a date for the founding of Djenne. The hypotheses about the sites and the origin of the populations are not verifiable in our present state of knowledge. De Grunne notes that the Islamization of West Africa was superficial and did not prevent animist cults.

In 1943, T. Monod discovered the first terra-cotta statuette of the Middle Niger civilization on the knoll of Kaniana, about two kilometers outside of Djenne, from which the name "Djenne terra-cottas" originates, in reference to the city, even though other terra-cottas come from the neighboring region of Mopti or from the inner delta of the Niger. Since 1943, numerous objects in clay, bronze, and gold have been found in burial mounds. They are products of a culture that presumably developed from the eighth to the eighteenth centuries.

These objects, for the most part representations of people, occasionally incorporating animal elements, have been shown by thermoluminescent tests to date from the twelfth to the eighteenth centuries. Their damaged and fragmentary state permit us to deduce a brutal, systematic destruction.

The image of the pregnant woman, a maternity figure frequently associated with the snake, recalls the great myths of fecundity, a theme foreign to Muslim art; this leads one to believe that the religion of Islam had only a superficial influence and that the countryside population remained faithful to its beliefs and rituals. One also finds horsemen and kneeling figures, some of them covered with pustules, others with snakes.

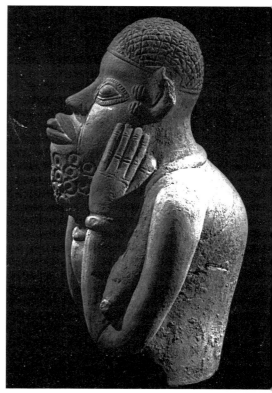

829 Bust, interior Niger Delta, Mali
Terra-cotta. Early 14th century. Private collection, Belgium

501

830 Djenne. The Great Mosque

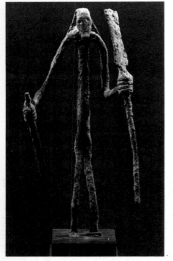

831 Ritual figure, interior Niger Delta, Mali
Iron. Height: 26 cm. Private collection

832 Dogon hermaphrodite horseman, Nini Village, Mali
Wood. Length: 36.5 cm. Musée de l'Homme, Paris

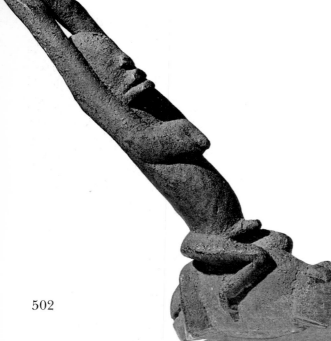

The art of the inner delta of the Niger, the region formed by the triangle of the cities of Mopti, Ke Macina, and Djenne, bears witness to an astonishing richness of invention and a lively concern with detail. In the south, in the area surrounding Bamako on the Bankoni site, other works have been found characterized by the cylindrical, long-limbed bodies of the figures.

Unfortunately, the objects became parts of collections haphazardly, through pillage. Not until 1974 were the University of Utrecht's Institute of Anthrobiology, on the one hand, and on the other, the archeologists R. and S. McIntosh able to undertake scientific research.

Regarding the art of the Niger's inner delta, De Grunne observes how difficult morphological or chronological classification is, noting some recurring themes: the kneeling position of figures, and the snake coiled around itself on the ground, sometimes used as a decorative motif, in the form of a zigzag line, or as a chevron on the persons depicted. At the same time, one finds figures sleeping, reclining, or tied up like prisoners. According to Germaine Dieterlen, the snake, in the oral tradition, is an image of immortality, a reference to the earliest ancestors.

The McIntoshes have hypothesized the existence of a commemorative ritual linked to the foundation legend. Indeed, according to tradition, at the time of the founding of the city a living young girl is supposed to have been walled in as an homage to the sacred serpent; each year a commemorative sacrifice was offered until one day, a young man in love with the sacrificial victim killed the serpent, thus provoking a great famine and the ruin of the city. This tradition is found also among the Bobo, who used to sacrifice a young virgin to insure abundant fishing; others used to immolate a young girl as a sacrifice to the mythical serpent of Wagadou.

The fact that no statuettes have been found directly associated with human bones excludes the notion of a purely funerary usage. Some vases found next to the statuettes, containing rice and boiled millet, might have been receptacles for offerings and would, at one and the same time, synthesize the function of receptacle and the image of the cult personage worshipped. But it is impossible to confirm the existence cults devoted to ancestors or divinities.

B. de Grunne, *Terres Cuites Anciennes de l'Ouest Africain* (Leuven, Belgium: Institut Supérieur d'Archéologie et d'Histoire de l'Art, 1980).
R. and S. McIntosh, "Terracotta Statuettes from Mali," in *African Arts*, 1979, XII, 2.

THE TELLEM The Dogon presently inhabit the Bandiagara cliffs in Mali; but they were preceded, from the eleventh to the thirteenth centuries, by the Tellem, who remain a very mysterious people to this day. According to Dogon tradition, they constituted a branch of the Kurumba, from the province of Yatenga; the Tellem themselves were to have chased out "small reddish-skinned people," whom the Dogon called Andoumboulou, probably ancestors of the present-day Pygmies. The definitive establishment on the site by the Dogon, who were fleeing from the Peul and Islamicization, can be dated back to the sixteenth century.

The Tellem left devotional and funerary objects that influenced their successors. The Dogon reused some of these objects and resacralized them. It is known that the Bandiagara cliffs have been inhabited since the third century B.C.; iron objects have been found there dating from the first and second centuries. Research by R. M. A. Bedaux (1977) allows us to pinpoint the arrival of the Tellem in the region of Sanga around the eleventh century. Small altars and wooden neckrests date from the twelfth century and figures made of very hard wood, kept under the overhangs of the cliffs and bound together by iron chains, date back to the thirteenth century.

The first Tellem exhibition took place in 1954. The discovery of the Tellem came late, even though the Dogon were aware of their statuettes. The figures are characterized by arms raised above the head; very elongated and stylized, reduced to the bare essentials, alone or in couples, they express, according to the Dogon, a prayer for rain (an explanation contested by several authors), or more generally are thought to be begging for forgiveness for errors committed. The granular quality of their surface is due to bat guano, which aided their preservation inside the caves. Access is very difficult to the Tellem caves, halfway up the Bandiagara cliffs; they served as places of burial. According to legend, the Tellem had the power to fly there by raising their arms to heaven. This same gesture is found on the figures on Dogon doors, arches, and on the legs of Dogon stools. Bedaux has shown that the Dogon (as well as the Kurumba) could not be descendants of the Tellem and that the disappearance of the latter around the fifteenth and sixteenth centuries had to be the result of the "military campaigns of the Songhay, who had annexed the Mali empire, against the inhabitants of the cliffs."

R. M. A. Bedaux, *Tellem* (Berg-en-Dal: Afrika Museum, 1977).
C. D. Roy, *The Dogon of Mali and Upper Volta* (Munich: Galerie Fred und Jens Jahn, 1983).

502

833 Paintings, Bandiagara Cliffs
Songho, Mali
In situ

THE DOGON The 250,000 Dogon settled during the fifteenth century in the south of Mali, in the bend of the Niger River on a plateau surrounded by the 200-kilometers-long Bandiagara cliffs, which overhang a plain. At first hunters, they now cultivate millet, sorghum, and wheat on the clifftops or on slopes, which they have had to convert due to the scarcity of water sources.

The population of Mali forms a cultural ensemble of close relationships and reciprocal internal influences. Similarities occur in myths between different groups: thus the theme of an original flaw redeemed by sacrifice is found among both the Bozo and the Dogon.

Encompassing several totemic clans, the Dogon village is under the authority of a council of elders. The *hogon* is the religious leader of a region, in charge of the cult of *lebe*, the mythical serpent. Assisted by the blacksmith, he presides over agrarian ceremonies. Master of trade and commerce, he does not work in the fields and may not leave his house, which is considered a sanctuary.

The clans are subdivided into lineages, or *ginna*, overseen by the patriarch, guardian of the clan's ancestral shrine and officiant at the totemic animal cult.

Beside this hierarchical system of consanguinity, male and female associations are entrusted with the initiations that take place by age group, *tonno*, corresponding to groups of newly circumcized or excised boys or girls. The members of an age group owe one another assistance until the day they die. Initiation of boys begins after their circumcision, with the teaching of the myths annotated by drawings and paintings. The young boy will learn the place of humans in nature, society, and the universe. Dogon mythology is so complex that a griot needs a week to recite it in its entirety.

The smiths and woodcarvers, who form a separate caste, transmit their profession by heredity (in theory). They may only marry within their own caste. Women are in charge of pottery making.

With its "Tellem style," Dogon sculpture recreates the hermaphroditic silhouettes of the Tellem, featuring raised arms and a thick patina made of blood and millet beer. The four Nommo couples, the mythical ancestors born of the god Amma, ornament stools, pillars of the *toguna* (men's meeting house), doorlocks, and granary doors. The primordial couple, a kind of *imago mundi*, is represented sitting on a stool, the base of which depicts the earth while the upper surface represents the sky; the two are interconnected by the Nommo. The seated female figures, their hands on their abdomen, are linked to the fertility cult, incarnating the first ancestor who died in childbirth, and are the object of offerings of food and sacrifices by women who are expecting a child. Kneeling statues of protective spirits are placed at the head of the dead to absorb their spiritual strength, *nyama*, and to be their intermediaries with the world of the dead, into which they accompany the deceased before once again being placed on the shrines of the ancestors. Horsemen are reminders of the fact that, according to myth, the horse was the first animal present on earth.

The Dogon style has evolved into a kind of cubism: ovoid head, squared shoulders, tapered extremities, pointed breasts, forearms, and thighs on a parallel plane, hairdos stylized by three or four incised lines, and numbers that signify, respectively, man and woman. "Dogon sculptures embody highly religious ideals, values, and feelings, and . . . constitute symbolic and esoteric entities." (J. Laude, 1973) They serve as a physical medium in initiations and as an explanation of the world. Hidden in sanctuaries or in the dwelling of the *hogon*, they serve to transmit an understanding to the initiated, who will decipher the statue according to the level of their knowledge.

834 Dogon granary, Bandiagara Region
In situ

835 Dogon shrine, Mali
Wood. Height: 43.5 cm. Nelson A. Rockefeller Collection, The Metropolitan Museum of Art, New York

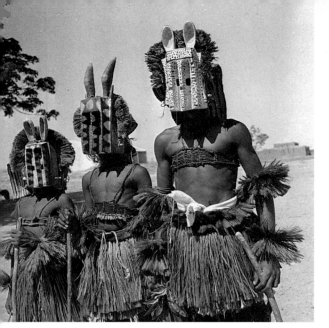

836 Dogon. Masked dancers

The men's association, the *awa*, responsible for initiations, also organizes the great masked ceremonies of the *dama*, or the closing of the mourning period, which may last for several days and which commemorate those deceased during the past two or three years. At that occasion, two principal masks are produced: the *sirige*, a "house" of several stories carried by one dancer, who mimes the creation myth and the descent of the ark; and the *kanaga* mask, a rectangular strip of wood surmounted by a cross of lorraine. Other animal-shaped masks accompany them—antelope, hare, buffalo, monkey, bird, hyena, and lion—as well as helmet-masks with horns and snout. These masks are enhanced by red, black, and white pigment.

The great *sigui* ceremony takes place every sixty years. Its symbol is a serpent-mask, and the entire community participates.

Dogon art also manifests itself in architecture and cult objects: tubs whose handles are shaped like the head and tail of a horse and ritual bowls containing a mixture of donkey and sheep meats consumed at the harvest feast; household objects (calabashes, mortars, pestles, and neckrests) may also be sculpted with Nommo or with geometric designs.

G. Calame-Griaule, *Words and the Dogon World* (Philadelphia: Institute for the Study of Human Issues, 1986).
 M. Griaule, *Arts de l'Afrique Noire* (Paris: Chêne, 1947).
————, *Conversations with Ogotemmêli* (London: Oxford University Press, 1965).
————, *Masques Dogons* (Paris: Institut d'Ethnologie, Musée de l'Homme, 1938).
M. Griaule and G. Dieterlen, *Le Renard Pâle* (Paris: Institut d'Ethnologie, Musée de l'Homme, 1965).
J. Laude, *African Art of the Dogon* (New York: Viking Press, 1973).

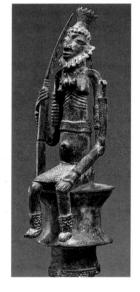

837 Proto-Dogon or Bozo bronze
Height: 75 cm.
The Metropolitan Museum of Art, New York

THE BOZO Neighbors of the Dogon who reside on the shores of the Niger River, the Bozo are the oldest inhabitants of this region in Mali. Basically fishermen, they were born of the "first twins," according to tradition, and worship Faro, the spirit of water. The ram, valued throughout this region, was sacrificed for the first time by God to redeem the errors committed by Mousso Koroni, the "ancient little woman." An era of disorder, violence, and sterility was followed by a period of prosperity, order, and peace. The *saga* mask represents the mythical ram; carved from one solid piece, it forms a rather heavy sculpted block with a narrow internal cavity. It may be painted white, black, or blue and is sometimes decorated with white metal sheets. It is attached to the end of a board, which the dancer manipulates as he dances. (G. Dieterlen and Y. T. Cissé.)

G. Dieterlen and Y. T. Cissé, "Le Masque Bozo," in *Vingt-cinq Sculptures Africaines* (Ottawa: J. Fry ed., National Gallery of Canada, 1978).

838 Proto-Bamana terra-cotta
Between 1345 and 1505. Height: 44 cm. Private collection, Guimiot Archives

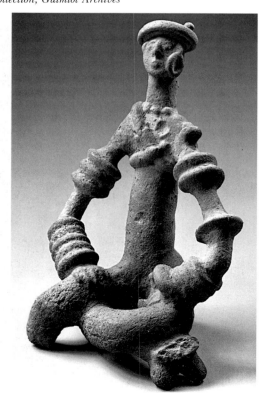

THE BAMANA (BAMBARA) The Bamana are one of the most studied groups of West Africa. They say that they are of Mandinke origin and have tightly interwoven themselves with their neighbors through marriage, commercial trade, political alliances, and religion. The triangle of the Bamana region, divided in two parts by the Niger River, constitutes the greater part of the western and southern Mali of today. The dry savanna permits no more than a subsistence economy, and the soil produces, with some difficulty, millet, rice, and beans.

Arabic texts of the ninth century give the history of cities such as Djenne and Timbuktu, whose inhabitants they call "Bambara." At the beginning of the twentieth century, they were colonized by the French.

Numbering 1.9 million, the Bamana are distributed over regions that comprise villages placed under the authority of one family, whose head, the *fama*, representing the founder, enjoys considerable powers. He also plays a primary role in the agrarian rituals.

In 1940, archeologists discovered the traces of an earlier kingdom and found terra-cotta figures that were dated through thermoluminescent tests to around the year 1000. These terra-cottas are proof of a long tradition of sculpture; the first wood figures date back to the fourteenth century.

The Bamana believe in the existence of spiritual forces which are activated by individuals, who are capable of creating an atmosphere of harmony, prosperity, and well-being. The Bamana have a very complex cosmology. Initiation takes place within the men's associations, which are more or less active depending on the village: the *n'tomo*, the *komo* that directs the life of the community; the *nama*, the *komo* that regulates morality violations; and the *korè* and the *tyi wara*, which organize young farmers. These societies, run by a few elders, act in political, economic, and medical capacity and exercise social control over the community.

In the south of the Bamana region, the *dyo* association welcomes men and women, but

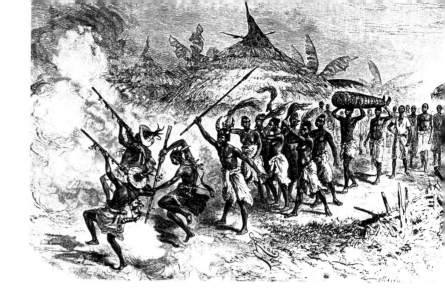

RIGHT:
839 "A Funeral of the Siene-Re"
Drawing by Riou in "From the Niger to the Gulf of Guinea," 1887–89, by Captain Binger, Le Tour du Monde, *1891*

CENTER:
840 Dance of the *tyi wara* society, Bamana, Mali

BELOW:
841 *Kono* Mask and sacrificial *boli* object, Bamana, Mali, in *The Bambara,* by the Abbé Joseph Henry, Münster, Germany, 1910

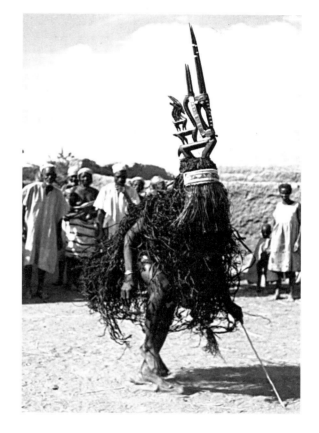

initiation is shorter and less difficult for the latter; initiation for men lasts for seven years and ends with their symbolic death and their rebirth. It terminates in great masked feasts in which the newly initiated participate, going from village to village. The initiates are divided into groups, and the sons of blacksmiths dance in the presence of statues called *nyeleni*—upright female figures with wide, flat shoulders, standing on small circular bases. Their cone-shaped breasts project frontally. (K. Ezra, 1986) During the feasts of *dyo* and the ritual of the *gwan*, linked to fertility, seated figures are exhibited. Statues of a woman with a child appeared on the market in the 1950s. Kept on the shrines throughout the year, the figures were cleaned, oiled, decorated with clothing and beads, and placed in groups of from two to five pieces. Naturalistic in style, they are of larger dimensions than the majority of Bamana sculpture. The bodies are massive, sculpted in the round, with wide shoulders, the features of the face treated with a sweetness and care for detail. In the same style, representations of musicians and of lance-carrying warriors are found. These statues illustrate the qualities that the future initiates must have: beauty, knowledge, and power. Each figure is "explained" to the initiates and conveys the vital force that contributes to the cohesion of the village. (K. Ezra)

During the agrarian feasts of the *tyi wara* association, farmers wear headdresses in the shape of an antelope, which represents the mythical character who taught them how to cultivate the land. In order to obtain an abundant harvest, they dance at the time of planting and harvesting by imitating the steps of the antelope. The horn is supposed to be the symbol of the millet's growth.

The *komo* association, run by the blacksmiths, welcomes all male adolescents after their circumcision. It has a mask characterized by a huge mouth and antelope horns to which various elements are added, such as animal jaws. The mask, worn only by blacksmiths, "dances" in front of the members of the *komo*. Its disquieting appearance evokes the bush, and its dangers and its force are such, they say, that it can kill an adversary.

Each association has its own masks, headdress crests, and marionettes. These masks appear at times of celebration: at weddings or inaugurations of a market or under other pretexts. With the help of music, poetry, and history as told by the griots, these celebrations are both a diversion and a reminder of the social values of the Bamana. For a young boy, dancing at the time of a celebration is an opportunity to show his personal abilities and to acquire prestige. But he will first have to prove his skill and obtain authorization from the elders to appear in public, which may subsequently be refused if his first performance is judged to be mediocre.

The Bamana sculpt lovely figures, less naturalistic than their maternity figures—statuettes representing twins, and doorlocks. Honored and kept in the village sanctuary or at its outskirts, the *boli* is an object whose magic ingredients are hidden in the center of a mixture of clay, wood, tree bark, roots, horn, jawbones, or precious metals. It may have human strength or assume the strength of a hippopotamus. It is handled only by the chief or a religious dignitary; it is "nourished" on blood and millet beer poured into a tube that goes all the way through it. (S. Brett-Smith.)

The complex symbolic system of the Bamana is reflected in its abundant artistic output, linked to ritual functions and with varying aesthetic qualities.

S. Brett-Smith, "The Poisonous Child," in *RES*, no. 6, 1983.

G. Dieterlen, *Essai sur la Religion Bambara* (Paris: Presses Universitaires Françaises, 1951).

K. Ezra, *A Human Ideal in African Art: Bamana Figurative Sculpture* (Washington, D.C.: National Museum of African Art, 1986).

R. Goldwater, *Bambara Sculpture from the Western Sudan* (New York: The Museum of Primitive Art, 1960).

P. J. Imperato, *Buffoons, Queens, and Wooden Horsemen* (New York: Kilima House Publishers, 1983).

P. McNaughton, *Secret Sculptures of Komo: Art and Power in Bamana Initiation Associations* (Philadelphia: Institute for the Study of Human Issues, *Working Papers in the Traditional Arts*, no. 4).

The Voltaic Savannas

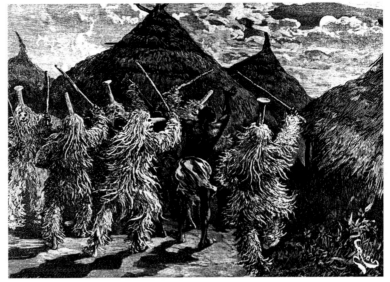

842 "The Walk of the Dou" (Bobo)
Drawing by Riou in Binger, Le Tour du Monde

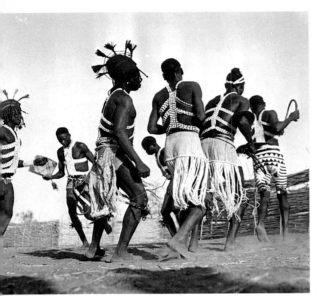

843 Bobo dancers, Burkina Faso

844 The Mosque in Bobo-Dioulasso

THE BOBO The Bobo speak a Mandinke language, unlike the Bwa or the Mossi, who speak Voltaic languages. Numbering 100,000 in Burkina Faso, the Bobo have also settled in Mali.

They are farmers and cultivate millet, sorghum, and cotton to supply weavers in the cities. With no centralized government, the Bobo are organized into lineages, the oldest members of which form a council of elders responsible for decision making. The notion of having a chief is profoundly foreign to them and they consider it to be dangerous—as waging "a severe attack on the order of things as established by Wuro (the creator god)." (G. Le Moal, 1980.)

Christopher D. Roy emphasizes their social cohesion based on two opposing principles: the sense of community, which incites them to work together, and the notion of privacy and the individual, which affects only one part of the lineage. Unfortunately, the intensive cultivation of cotton and the taxes demanded by the French brought them to a point where they no longer worked the communal fields.

The Bobo believed in the god Wuro, creator of earth and animals. The first man created was a blacksmith who asked for a companion. Thus it was that the Bobo, or farmer, was conceived. Then Wuro withdrew, leaving the men with three sons: Dwo, responsible for helping humankind; Soxo, the spirit of untamed nature and the bush; and Kwere, an expression of Wuro's power, who metes out punishment with lightning. In every village, shrines were erected to them. The blacksmiths were the priests of Dwo worship. Spirits of the bush and ancestors, particularly the founder of the village, received sacrifices. Dwo was the intermediary between humankind and the creator; masks are the mainstay of tradition and their meaning was revealed to young boys during their initiation period. Living in a region of dry savannas where harvests depend on rainfall, the Bobo instituted a series of purification rituals in order to reconcile themselves with nature, basically seen by them as good, in contrast to the ambivalence with which nature is viewed by other ethnicities. Since it is proper to make amends for the errors of humankind, masks have the essential function of erasing evil and reinstating the God-given balance between sun, earth, and rain. At the end of the dry season and before the work of cultivation begins, purification ceremonies take place, using masks of leaves incarnating Dwo and masks of fibers and wood, which represent the protective spirits of the village: warthog, male buffalo with flat horns, rooster with its crest standing perpendicular to its face, toucan, fish, antelope, serpent, and hawk. All of them incarnate the forces of fertility, fecundity, and growth.

Often there is some difficulty in distinguishing between the masks of the different ethnicities of Burkina Faso, all the more so because there have been numerous borrowings, even thefts, by ethnic groups from one another. As opposed to the Mossi, Bwa, or Nunuma, who sculpt masks in two dimensions with geometric decorations painted in red, white, and black, the Bobo use a wider palette for compositions in three dimensions.

G. Le Moal, *Les Bobo: Nature et Fonction des Masques* (Paris: Office de la Recherche Scientifique Outre Mer, 1980).
C. Roy, *Art of the Upper Volta Rivers* (Meudon: Chaffin, 1987).

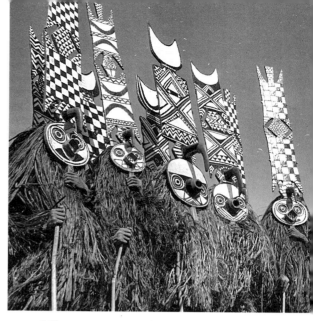

845 *Nwantantay* masks, Bwa, Burkina Faso

THE BWA In his last book on the peoples of Burkina Faso (1987), Roy emphasized the distinction between the Bwa and the Bobo, who do not descend from the same ancestor, even though they share certain characteristics, such as the worship of Dwo and the absence of a centralized system of governing. (J. Capron and G. Le Moal, as cited by C. Roy, 1987)

Numbering 125,000 in Mali and 175,000 in Burkina Faso, the Bwa are surrounded by the Bamana in the north, the Bobo in the west, the Marka Dafing in the east, and the Gurunsi and Lobi to the south. They are divided into three endogamous castes: farmers, blacksmiths, and griots. Agriculture is practiced primarily by the men, women participating on certain occasions only. The griots work, weave, and dye cotton. Just as with the blacksmiths, they cultivate a few privately owned fields, but this remains a marginal activity. The blacksmith is also the village's gravedigger and is responsible for digging wells. He is thus the man in contact with the soil: this indicates his importance, his role as mediator in disputes and as intermediary with the supernatural world. The griot, who plays an important social role, is essential in public events.

The Bwa have no centralized political organization and in every village are directed by a council of the eldest men of the lineages.

From the eighteenth century on, the Bwa were the victims of aggression on the part of the neighboring Bamana empire—then, after its disintegration, of the Moslem Peul empire. These incursions brought with them the destruction of villages, the pillaging of harvests, and slavery. The arrival of the French in 1897 brought an end to conflicts between the different empires. Since the French relied on the local kings for their control over the land, Bwa domination took hold again. Once French authority had been solidly established, the kings were eliminated and the French imposed their own organization. Taxes, forced labor in the cotton fields, and the termination of communal fields brought about a revolt in 1914–16 that annihilated the land of the Bwa almost completely.

The spiritual life of the Bwa is based on worship devoted to Do and the founding ancestors of the clans. Do intervenes at the time of agrarian rituals and funerals. One finds among the Bwa the notion of the god Difini, creator of the world and of humankind, whom he abandoned thereafter but to whom he left his son, Do. According to Bwa legend, Difini had been wounded by a woman who was crushing millet with her pestle. Do represents the forest and nourishing forces, sources of the life of plants and the fields. He is symbolized by an iron rhombus called *alive* or *linyisa*. If a person twirls it above his or her head it produces a vibrating sound. It is kept in an earthenware jar at the border between the bush and the cultivated fields. A Bwa legend tells of the encounters of the ancestors with beings such as the hyena, the serpent, and the dwarf, who played a decisive role in their lives.

The *labie*, religious chief, the eldest member of the founding clan of the village, is the master of the soil. The villagers make masks of leaves incarnating Do; wooden masks are found only among the Bwa in the south, called the *nieguegue* ("the scarified ones"), who do indeed have very elaborate markings. These masks represent animals: antelopes, warthogs, wild buffalo, monkeys, crocodiles, serpents, fish, birds, and insects, along with some human beings, and bush spirits who take on supernatural forms. The mask is worn in front of the face, attached with a thick rope which the dancer holds in his mouth. Surmounted by a board with geometric designs painted in vivid colors, the mask bears the name of the animal it personifies and is differentiated only by the shape of its horns, while the muzzle and protruding eyes remain the same structure. One of them, the *hombo*, is worn only by blacksmiths. It represents a rooster with a diamond-shaped beak and rounded crest above his head. Hombo is the protective spirit of the blacksmiths. The story is told of how some blacksmiths of a village, having sacrificed two children, escaped their pursuers thanks only to the Hombo spirit, who helped them across a swamp. Every year, this event is commemorated by a public celebration involving innumerable "roosters."

Certain abstract masks have the shape of a panel with a flat face, round or oval, as its base, the upper part decorated with geometric motifs, many of which are black-and-white painted checkerboards. The dancer looks through the open hole of the mouth. The eyes are large concentric circles.

In the south- and northwest, the Bwa, who live in close proximity to the Bobo, have almost identical masks to theirs. And, as with the Bobo, purification rites take place at the end of the dry season: the masks are prepared in the bush early in the morning. The dancer, dressed to incarnate Do, may then no longer speak, for speech is something human. "The human community is reintroduced into the cycle of nature and in so doing renews its forces, in the image of the vegetation that is reborn each year." (J. Capron, 1957, cited by C. Roy)

Wooden masks are reserved for the family and the clan and their use in the worship of Do is thought to be relatively recent. At times, those preferring masks of leaves and those partial to wooden masks confront one another, the former reproaching the latter for betraying tradition. Masks are involved in burials, at the end of periods of mourning, and in initiations, but present-day rivalries between clans no longer promote the social cohesion the

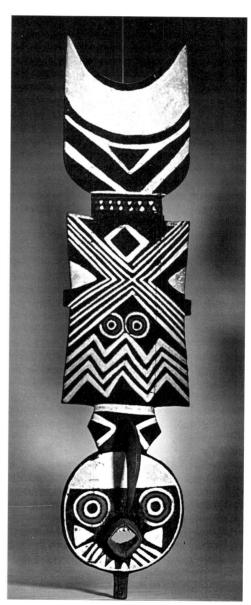

846 *Nwantantay* mask, Bwa, Burkina Faso *Wood. Height: 190 cm. Malichin Collection, Germany*

507

masks used to help stabilize. These wood masks made of boards are thought to be inhabited by supernatural forces who act to benefit the clans that possess them. The motifs are symbols linked to Do and to the history of the clan.

The Bwa use the same types of objects of divination as the Nunuma and the Winiama do: they sculpt statuettes and divination canes with curved ends; diviners use copper or brass bracelets decorated with standing figures that represent the spirits. These elements can be found among most of the ethnic groups of Burkina Faso.

J. Capron, "Quelques Notes sur la Société du Do Chez la Population Bwa du Cercle de San," in *Journal de la Société des Africanistes*, vol. 27, fasc. 1, 1957.
————, "Univers Religieux et Cohésion Interne dans les Communautés Villageoises Bwa Traditionnelles," in *Africa*, vol. 32, no. 2, 1962.
G. Le Moal, "Rites de Purification et d'Expiation," in *Systèmes de Pensée en Afrique Noire* (Paris: Hermann, 1975).
C. Roy, *Art of the Upper Volta Rivers*, op. cit.

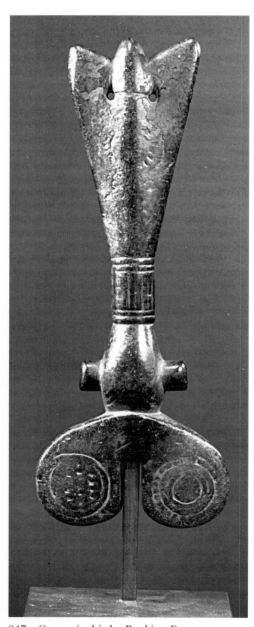

847 Gurunsi whistle, Burkina Faso
Wood. Height: 33 cm. Private collection

THE GURUNSI This designation does not correspond to any one ethnic group. In fact it was the Mossi who gave the name to the various ethnicities who live in the west and the south of the Mossi plateau: properly speaking, the Nunuma, Nuna, Winiama, Lela, and Kasena. Together they number about 200,000 people, the most numerous of which are the Nuna, estimated at 100,000 people. Roy (1987) uses the term "Gurunsi" because it is convenient, but he mentions that is has a pejorative meaning for the autochthones. The Mossi have never been able to subjugate the Gurunsi, who live in a region where the tsetse fly, carrier of sleeping sickness fatal to the horses of the Mossi cavalry, is rampant. Furthermore, Gurunsi villages, which have very narrow streets with houses grouped together, did not allow for a frontal attack. Despite these two defenses, some of the Nuna were taken into slavery, a practice that continued until nearly the end of the nineteenth century.

With no political stratification or centralized system, the Gurunsi, before the arrival of the French, were led by a council of the elders of the lineages. As farmers, they adopted the slash-and-burn system of cultivation. Some fields held by the community are worked by associations of young people. They organize large collective fishing expeditions during the dry season; during these they also hunt.

The peoples believe in a creator god, Yi, who withdrew from humankind after the Creation; in the center of the village a shrine is dedicated to him. Moreover, each clan shelters magic objects in a hut—these allow them to communicate with the vital forces of nature.

The masks represent the spirits of the bush. The Nuna and Nunuma make masks in the shape of poles colored red, black, and white, or in the form of animals who differ only in the shapes of their horns and ears: buffalo, crocodiles, antelopes, warthogs, hyenas, calaos, and serpents. The eyes protrude, surrounded by concentric circles, with a rather short snout on the animal masks, and a large and protruberant mouth on the more abstract masks. Decorated with geometric motifs, the masks are repainted every year; they are found throughout the region. The wearer of the mask may be invisible underneath the fiber skirt and must behave as the animal does, imitating its gait. The Nuna, Winiama, Lela, and Nunuma have influenced the style and the meaning of the masks of their neighbors, the Mossi and the Bwa.

When rituals are properly executed, the community receives fertility and prosperity. The property of an individual, a mask will, upon the owner's death, be given to his son or kept in the hut of the ancestors of the lineage. The mask's role is important during ceremonies at the end of initiation, at the funerals of notables, and as entertainment on certain market days.

"The form of the mask, the geometric motifs, and the colors with which they are decorated constitute the elements of a communication system," writes Roy. The masks of the bush incarnate the spirit Su. Others are linked to farmers and hunters. Depending on the villages, the *buzuyu* initiation takes place every three, five, or seven years for young boys to whom the secrets of the masks and their utilization are taught. Initiation lasts fourteen days and takes place not far from a marshy river; the young boys must fight each other wearing the masks and must undergo a certain number of physical, moral, and intellectual tests. In the end, the masks return to the village and are put on the shrine to Su, to whom offerings are presented. The new initiates may add fibers to their dress and may dance on market days until the rainy season, but they will be severely judged by their elders and only the good dancers will have the right to don their costume again the following year.

During the course of the year, if health or prosperity are threatened, libations will be made by pouring blood over a magic object, or the decision may be made to create a new mask; these propitiatory rituals will put an end to famine or to problems of sterility within a clan.

Gurunsi statues, kept inside huts or on family shrines, are reserved for divination. (C. Roy, 1987) The renown of magicians may reach far and wide; that of the Nuna magicians dates back to the sixteenth century. The diviner possesses a variety of magic objects: a ball of clay and statues of wood or of bronze. He also uses croziers and long canes of wood decorated with figurines.

C. Roy, *Art of the Upper Volta Rivers*, op. cit.

THE MOSSI The 2.2 million Mossi represent a third of the population of Upper Volta, renamed Burkina Faso, or the "land of upright and honest people," in 1983. In the north, one encounters a region of Sahelian desert steppes, then further south a zone of tree-filled savannas, which gives way to forestland in the deep south. The greater part of the population lives off agriculture and cattle breeding. Cotton, introduced by the French during the occupation, is cultivated over large stretches of land.

In the fifteenth century, the Mossi settled in the central region formed by the basin of the White Volta. A group of horsemen who came from the north of what is presently Ghana subjugated the local rural communities and created the first Mossi kingdom of Tenkodogo, whose chief was Ouedraogo. His descendants founded the kingdom of Fada N'Gurma and two others, the most important of them Yatenga and Ouagadougou, which exercised religious and political supremacy over the others. At the end of the nineteenth century, seventeen kingdoms were living in quiet coexistence. The Mossi political system is centralized and hierarchical, with the *mogho naba* at its head. The population is 25% Moslem, 70% animist, and 5% Christian.

Indigenous peoples and invaders intermarried, but the political leaders have always been chosen from among the lineages of the Nakomse, descendants of the aristocratic horsemen, who were Islamicized during the seventeenth century; it is from among the "Tengabibisi," the common people, descendants of the autochthones, that the religious leader was to be chosen. The Tengabibisi were subdivided into the Nyonyosi, or descendants of farmers; the Saaba, the blacksmiths; and the clans who used the important *sukwaba* mask, among others. In reality, Mossi society is heterogeneous since the assimilated indigenous included the Dogon in the north, the Gurmanche in the east, and the Nunuma and Kurumba in the southwest, regrouped under the name "Tengabibisi" or "children of the earth." As the Nakomse cavalry approached, part of the Dogon fled toward the Bandiagara cliffs. Some Mossi and Dogon masks are very closely related in style.

The Mossi domestic unit is the *bundu*, or clan. Several *bundu* form a *sakse*, or district, placed under the authority either of the *kasma*, the oldest member of the lineage, or a *naaba* chief, who himself is directly or indirectly subject to the king. Dwellings are sparsely distributed. Since the beginning of the century, the family has not been regarded as part of a community, since custom required that, immediately after circumcision, the eldest son leave to live independently from his father. Similarly, the young wife had no status whatsoever until the birth of her first child, which gave her the right to visit her parents. She did not raise her children, who were entrusted to older wives. On the other hand, at the death of a father, the son would receive the wives and fields of his father. Each house had a *segre*, a part of the ancestor reincarnated in the family's leader, to whom offerings and sacrifices were due.

The blacksmiths-sculptors formed a separate caste and lived in separate quarters; they married exclusively within the caste. They were feared by their neighbors and participated actively in rituals. They made jewelry, metal and wood sculpture, statues, and masks.

The farmers, "children of the earth" and descendants of the autochthones, still use huge masks that belong to the family or clan; formerly, these masks were regarded as the seat of the spirit of the ancestors and were their "eyes," but they might also represent the totemic animal of the clan. Each family would refer to an appropriate myth explaining the mask's origin: generally, it was most often a catastrophe that had brought a sacred animal, or even a god, to make a gift of a mask to an ancestor, the power of the mask allowing the restoration of order within the clan; then, too, at the ancestor's death the mask would become the material structure of his soul. The Mossi thought that the sacred animals of the clan stood in close contact with the souls of the dead and that everything that befell them would presage events to come. For example, the death of an animal would announce the death of a member of the clan. These masks made their appearance several times during the course of the year: they would escort the dead, thus helping them to join the world beyond. A few months later, at the funeral, they watched over the proper observance of the ritual; they presided over the sacrifices offered at the beginning of the rainy season, which were to insure the community a good millet crop and harvest of wild fruits. They "supervised," before the first harvest, the deference given to planted seeds corresponding to a period of famine. Between "appearances," the masks remained on the family shrine, where they received prayers and sacrifices for those members of the family who were in need, and they aided communication with the ancestors.

Roy (1987) distinguishes, in the north, masks made of large, narrow boards that closely resemble those of the Dogon. In the east, masks have mirrors instead of eyes and are covered with red seeds; they represent bush spirits and belong to families individually. In the southwest, the Mossi of Nunuma or Winiama origin sculpt animal masks that they decorate with red, black, and white geometric motifs. Some small-sized sculpted figures were originally part of the larger masks and formed their crests. These have been cut off from these masks: Mossi statuary is, in fact, quite rare.

Farmers preserved their traditions by using magic and invocations of spirit forces against the conquering power of the horsemen. The *wango* society undertook ceremonies using a large upright mask, derivative of the Dogon *sirige*, a frontal board decorated with holes that carried an oval face.

The aristocracy also used statues, even though it had adopted Islam in the seventeenth century. For the most part female, linked to the power of the chiefs, these figures commemorated ancestors and were kept inside the hut of the oldest of the wives. They appeared only at the funeral of the sovereign and at the time of the annual sacrifice when the first fruits of the harvest would be offered. During the period of the kingdoms, a sculptor would work exclusively for one or two chiefs.

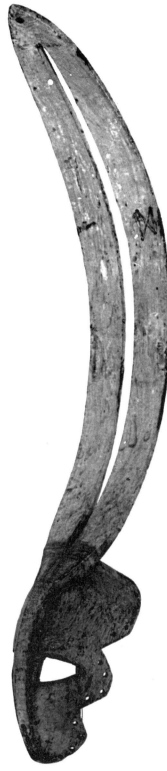

848 *Karanga* mask, Mossi, Burkina Faso
Wood. Height: 140 cm. Private collection

509

849 *Naba* sovereign, Mossi, Burkina Faso

Besides these statues, blacksmiths used to sculpt figures called *biiga*, often covered in leather and decorated with cowrie shells and beads. S. Lallemand criticizes the use of the word "doll" to translate *biiga*—for if it is appropriately applied to the dolls that little girls dress up in rags (made from corn, the legbone of an ox, wood, or cardboard), it is not appropriate to these wooden statues whose function goes well beyond game-playing. As an educational toy, the *biiga* was dressed, washed, and carried on the back or placed on the ground under the mother's eyes. But if it was damaged, a diviner needed to be consulted. Sometimes the *biiga* was only a symbol, but sometimes it would be substituted for an expected child, preceding it in time. Little girls sometimes place clay dolls on the ancestral shrine, thus expressing a desire for progeny and thanking the deceased in advance for granting their wish. The *biiga* has a complex symbolism that, at first glance, seems contradictory: for the little girl it is, at one and the same time, the power that will cause her to have a child and the baby she is learning to care for. The *biiga* passes from mother to daughter or from sister to sister.

The style of the *biiga* varies with the region, and the object does not necessarily originate in the village where it was collected, since the young bride carries it with her. All have cylindrical bases, slightly wider than the body. Arms and legs are missing, but the pendulous breasts, symbol of motherhood, are accentuated. The shape of the head is often a stylization of the *gyonfo*, a female hairdo with three cusps, the center one running from the forehead to the back of the skull. The sections on the sides, which are smaller, make up the bulk of the hair and are very carefully braided. Lines cutting into the head represent braids, ribbons, or the scarifications characteristic of the face or the bust, very closely resembling those one finds in reality. At the base, a small hole is found for the anus; sometimes there is an indication of the female sexual organ.

The art of the Mossi tends toward a simplification that is not found among their neighbors.

S. Lallemand, "Le Symbolisme des Poupées Mossi," in *Objets et Mondes* (Paris: Musée de l'Homme, 1973).

C. Roy, *Art of the Upper Volta Rivers*, op. cit.

————, "Forme et Symbolisme des Masques Mossi," in *Arts d'Afrique Noire*, No. 48.

————, "Mossi Dolls," in *African Arts*, XIV, 4, 1981.

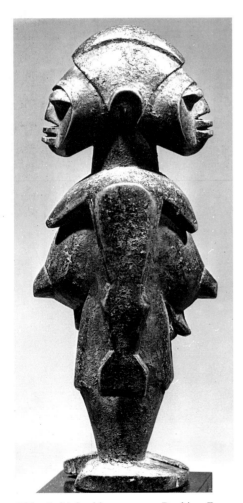

850 Lobi double statuette, Burkina Faso
Wood. Height: 17.5 cm. Private collection

The Region of the Three Frontiers and the Northern Ivory Coast

THE LOBI Originally from Ghana, the 250,000 Lobi are divided among Ghana, the Ivory Coast, and Burkina Faso. These "fierce warriors" crossed the Black Volta and kept moving for 150 years in order to cultivate grain on lands left by the Kulango. From the eighteenth century, they were followed in their migration by the Birifor and the Dagara, their neighbors to the north and east, who share the same institutional and cultural heritage. Avoiding contact with Europeans, for a long time they escaped ethnographic observation, and their sculpture was not completely discovered until the 1950s. For the inheritance of wealth, descent is matrilinear, but for the rights of use of land, dwellings, and household shrines, it is patrilinear.

The Lobi were not familiar with centralized authority but were organized in groups of patrilinear and matrilinear clans; formerly the matrilinear group constituted the unit of solidarity for retribution and armed conflicts. Today, as in the past, the village is made up of dwellings standing about 50 to 800 meters away from each other, or the span of "an arrow's throw." Typical dwellings have been described as square fortresses, consisting of a single, huge building without windows, surmounted by a terraced roof. All around, permanent and semipermanent fields extend, while fields with temporary cultivation are found outside the inhabited area. Behind the clay walls, shrines, huts, and chicken coops stand protected

around a central tree, under the absolute authority of the head of the family. Each *cuor*, or household of a family head, includes not only a wife or wives, but also married sons, their wives, and children. The *cuor* is subordinate to a *thil*, an invisible, tutelary spirit who transmits his demands through the intermediary of diviners and sorcerers. It is the *thil* who dictates taboos and who requires the creation of a new wooden figure for the village or household shrine. If an order is not followed, disasters (epidemic, drought) may strike the village since a failing on the part of an individual may fall back on the community. A man may have several *thila*, the first of which will be chief over the others; at the death of the owner, the main *thila* will be inherited by the sons, while the others will be abandoned. Each household has its own shrine and individual protectors, maintained by the head of the household who regularly consults the diviner. The *thila* behave like people with their caprices: they may demand a collective hunt, or else a *buur*, a costly initiation which is performed within the family and which requires the intervention of the diviner.

According to their mythology, the Lobi used to live in a paradisiacal state, nourished by the creator god. They did not work, did not suffer from either disease or early death, and obeyed divine commandments: they were not to kill, to steal, to seduce their neighbor's wife, and they were to remain united. But since there were not enough women, arguments broke out, and then wars. Then God turned away from the Lobi, took their meat away and replaced it with the hoe for unearthing roots. But he left them the *thila*, who help them by transmitting rituals, medicines, and initiation rites to their prophets.

Other mythical beings—bush spirits—are covered from head to toe with reddish fur. They may show themselves to an individual, remaining invisible to everyone else. They have very large sexual organs which they throw over their shoulders in mockery. They show humankind how to question the dead, how to bury them, and how to interpret prophesies.

The men work the fields at harvest time, but it is the women who sow and carry the ears of corn in large baskets on their head. They raise cattle and many kinds of poultry, primarily used for sacrifices and for payment of the bride price. During the wet season when they are not in the fields, the men work wood and iron, labor in the foundry, and build houses. They also devote this period to family visits and funerals, which are pretexts for grand reunions and markets. Very strict rules about family relationships govern one's choice of dwelling place, as they do marriages, which must take both matrilinear and patrilinear clans into account.

Initiations or *buur* are organized by the head of the family when his *thil* asks for them. Since they cost a great deal in food and sacrifices, other members of the family participate.

Every seven years, young men and women go back to the "mythical origin place" on the shores of the Black Volta; the young initiates of the *dyoro* will undergo a slow apprenticeship which will continue in their own villages under the supervision of the elders. They will learn the secret language of the *dyoro* and will hear on several occasions the bellow of the "Beast," who "seeks to take them." In reality, this was one of the ways used, in earlier days, to sell them into slavery on the other shore of the Volta.

For interpreting the demands of a *thil*, the diviner is indispensable. Nobody wishes to be one, for the position is a ruinous one and its title-holder no longer has the time to take care of his fields. But he must give in to the "call," under penalty of death. He receives no compensation whatsoever for his consultations and may never refuse a client. However, if he is also a sculptor, he may acquire a certain prestige. He gives up to fifteen consultations a day, asking hundreds of questions, for he must guess the reason for the consultation. He is surrounded by a variety of objects: stones, bells, millet straw, bags of cowrie shells, and statuettes. Divination is done by throwing cowrie shells; generally, the diviner recommends the building of a shrine or the offering of sacrifices.

Certain men, women, or children may be sorcerers or evil-doers; they disappear in case of danger, fly away, transform themselves into an animal, or go to a house and take away the soul of an individual, who will fall ill and die. In earlier days, the fetishist used to own forty to fifty statuettes, and his *thila* were very effective in indentifying the guilty party.

Sculptors, who live off farming, devote only part of their time to sculpture; their period of apprenticeship may be reduced, so that the objects are of variable quality, often quite mediocre.

Lobi sculpture is a relatively recent discovery. The Lobi do not use masks, but create figures called *bateba* and heads sculpted on top of a post planted in the ground. These figures, associated with the dead, are beings that are somewhere between spirits and people and may represent the dead, or ghosts, or bush spirits. Their size varies from between thirty and eighty centimeters. The statues preside over foundation rites, essential for obtaining protection for new homes: a Lobi, in fact, changes residence about three times in the course of his or her life.

Tall figures or heads sculpted in the round surround the shrines of sacred huts: they have a hieratic character with a high, aloof forehead, heavy eyelids over absent-looking eyes, a triangular, straight nose, and lips deformed by the labret that Lobi women wear, which is a kind of disk inserted in the upper lip.

Lobi sculpture does not offer the alluring look of the sculpture of the Ivory Coast or Zaire, where the surface of the wood is polished and smeared until it has a brilliant and lustrous patina. Here, the coarse wood appears colorless. Some terra-cotta heads are found, usually on receptacles, as well as a few bronzes and some rare ivory figures.

H. Labouret, *Les Tribus du Rameau Lobi* (Paris: Institut d'Ethnologie, 1931).
P. Meyer, *Kunst und Religion der Lobi* (Zurich: Museum Rietberg, 1981).
J.-D. Rey, *Les Lobi* (Paris: Catalogue of the J. Kerchache Gallery, 1974).
C. De Rouville, *Organisation Sociale des Lobi* (Paris: L'Harmattan, 1987).

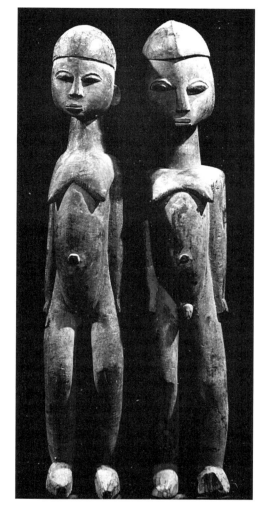

851 Lobi statuettes, Burkina Faso
Wood. Heights: 60 cm and 61 cm. Private collection

511

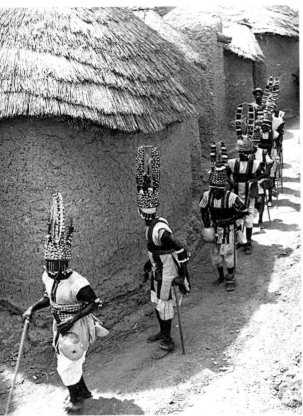

852 *Kwonbele* initiates, Senufo

THE SENUFO The Senufo, about 1 million in number, live in four countries: the northern Ivory Coast, Ghana, Burkina Faso, and the extreme south of Mali. From the linguistic point of view, they belong to the Voltaic group, as do the Kulango and the Lobi. Each village, linked to the others only through the *poro* association, remained autonomous until the seventeenth century on the level of political, administrative, and cultural structures. A single language was established, Syénia, which was the origin of the name Senufo that the French colonizers gave them.

From the sixteenth century on, some groups separated and emigrated to the south, which was rich in fertile land. In the seventeenth century, they had to flee from the Mandinke and the Baoule, who conquered and assimilated them, notably around Bouake. These three centuries were marked by migrations tied to economic, demographic, and political reasons, as well as to the Samory wars. From 1850 on, their partisans and the Baoule forced them to regroup in villages in order to defend themselves against massacres and pillaging. About thirty Senufo subgroups can be counted, of which four have settled in the Ivory Coast.

A village consists of about a dozen districts, or *dane*, which means land or soil, inhabited by a specific lineage, or *nergba*. Formerly, agrarian fiefdoms were set up in the savanna and then incorporated into villages. Villages are composed of 800 to 1200 inhabitants, broken up into units of matrilinear lineage descending from a common ancestor, the *kasinge*. Endogamy within the lineage was forbidden and punishable by death as incest.

The village is run by a council of all the elderly men and assists the chief, a descendant through the female line of the founding lineage. The chief is *tarafolo*, or proprietor, of the communal lands, whose seeding, planting, and harvesting he oversees. He is also responsible for the purification ritual of the land, which would otherwise be contaminated by blood. Community harvests are allocated to pay additional expenses: dowries, contributions to initation institutions, the upkeep of the elderly, honoraria for the practitioners of magic, funeral expenses, hospitality, and performances. In addition, the chief metes out justice for minor infractions.

Each lineage segment forms a *katiolo*, or work unit, which resides within the same living space and lives off the harvest obtained from the land worked together. A large *katiolo* may contain several households, or *gbo*. The wall-enclosed *katiolo* includes granaries, men's and women's huts, courtyards, and outbuildings related to ritual life: shrines, divination huts, and sheds. A reserve of rice and yams that has been set aside will be used only at the funeral of the head of the family, a descendant of the matrilinear founder, or *nergbafolo*. The chief of the lineage is chosen from among the oldest members, not on the basis of his qualities, but according to the rules of succession. Since the system is matrilinear, the rights of the father give way before the predominant power of the wife's collateral relatives, who have greater influence—the husband being nothing but a sire and foster father. The brother's children are not relations. Inheritance goes to the mother's brother or to the nephew, son of that brother. The patriarch, or *nergbafolo*, who ensures material well-being, is

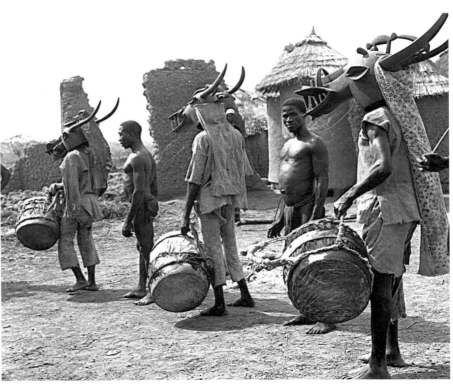

853 *Kponyugo* mask, Senufo, Ivory Coast
Wood. Arman Collection

854 Masked dancers at a funerary ritual, Senufo, Ivory Coast

responsible for acquired wisdom and experience. Upon the death of the chief, it is to the brother (of the same mother) and to the chief's son that the power of succession goes.

One institution, the *poro*, is also found among other ethnicities and is the pillar of communal life. Responsible for the initiation and training of the young boys, it is aimed at shaping an accomplished, social man who is integrated into the collective; it aids his entry into public responsibilities. Each *katiolo* organizes its own section of the *poro*.

The Senufo believe in a god, Koulotiolo, creator of the world, a distant and inaccessible divinity. On the other hand, the mother of the village, Katieleo, regenerates the world and redeems humankind through the initiation rites of the *poro*. Every section has a "sacred wood," a circular island of forest in the savanna. Consisting of a group of small constructions, this place is "visited" by deceased ancestors and bush spirits. A sanctuary shelters the shrine on which sacrifices are made. The sacred wood is made difficult to find by fake paths that confuse the visitor. Besides the sanctuary, it contains a meeting house as well, also used for teaching, which serves as a rehearsal place for the initiates as they prepare themselves for ritual ceremonies and the accompanying celebrations.

The *poro* is divided into three levels of seven years each: the *poworo*, for boys from seven to twelve years old, who receive practical agricultural training and instructions in the rudiments of mythology; the *kwonro*, which includes military training and the teaching of liturgical rites and dances; and finally, the *tyologo*, which is reserved for adults and divided into twelve levels, the highest of which is the *kafo*.

The sessions in the sacred wood last about a month. Between sessions, initiates produce communal work for the benefit of the dignitaries of the community and learn a secret language. The *poro* society, an extremely powerful association, creates a spirit of cooperation, brotherhood, and permanent mutual aid between the members of an age group. A male villager who has not been initiated will be excluded from the village and will lose his rights as a citizen.

A women's association, the *sandogo*, in charge of divination, is responsible for contact with the bush spirits who might be bothered by the activities of the hunt, farming, or of artisans. As opposed to the *poro*, the *sandogo* has only one group per village.

The sculptor, *navaga*, is a craftsman who makes secular articles; as is true with the blacksmiths and potters, he may be the object of ambivalence, something between disdain and esteem. He lives with the blacksmiths and potters in a district apart. His activity has the character of a family enterprise, governed by matrilinear laws. The continuity of the profession must be ensured by family relationships; nevertheless, to prevent the craft from dying out, rules may be relaxed: the activity is, in fact, essential to the spiritual life of the community. Chiefs decide to make gifted students or nephews and cousins of the sculptor, into apprentices.

Technical training takes seven or eight years; the apprentice begins by making secular objects, mortars for example, for an initiation is necessary before ritual appurtenances can be produced. The essence of the profession consists in an ability to animate objects with supernatural virtues. Taboos are innumerable, and theoretical knowledge is important, especially in mythology.

Senufo sculpture, considerable in quantity, came to be in demand in Europe very early on, which caused a flourishing of studios. Large-sized sculptures are of note, called *pombibele*, or children of the *poro*, and used during the funerals of *poro* members. Among the Senufo of the central regions, they are merely displayed while, in the south, they play a dynamic role in dance rituals and processions. The *sandogo* society also uses large statues, not easily distinguishable from the *poro*'s.

The small statues, *deble*, an abbreviation of *madebele*, which means spirit, are used by diviners. Human in form, they represent the bush spirits who inhabit the savanna, forests, fields, and the streams of water around the village. They demand offerings in order to prevent illness or disaster. Often in pairs, they incarnate the primordial couple and form the ideal social unit that respects the lineage of the ancestors. They intervene at the funeral of an honored head of the *poro*. The news of such a death is announced by the arrival of a mask of fiber; initiates then leave the sacred wood in a solemn procession to pay a visit to the body of the elder lying in his house. The masked man, the *nafeere*, goes around the corpse three times, holding the male figure symbolizing the three levels of the *pondo* cycle (the term for *poro* in the Fodonon dialect). Before the burial, the sculpted figure is once again carried around the men's house by the masked *nafeere*.

Other masks include the *kpele* mask; the *waanyugo*, with its projecting parts and cup at its peak; the *deguele* masks, which dance in pairs; and a few tin masks.

Amid the thousands of popular objects, large-sized statues, about fifteen in number, remain the masterpieces of this ethnic group; they are made of very hard wood. The "archaic" style of these sculptures is more abstract; they involve a use of empty space comparable to that of the Mumuye in eastern Nigeria.

Related to the Senufo, the Ligbi have moved from west Ghana to the Ivory Coast. Though they have been Moslems for a long time, they have nevertheless held on to a masked ceremony, the *do*. This ceremony closes Ramadan, the Moslem fast. The feast goes on for several days. The fully masked dancers are accompanied by drums and song. The *leu*, or warthog mask, opens the ceremony, dancing by itself. Prayers and sacrifices alternate for a full week before the assembled village.

In 1967, René A. Bravmann was able to photograph a *leu* mask, which disappeared the following year; another example is in the British Museum. The *leu* consists of two almost

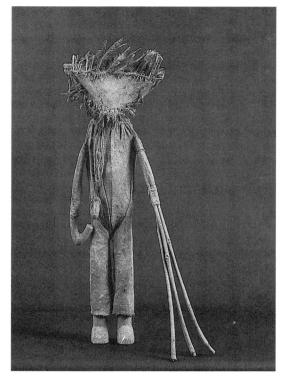

855 *Kafigeledio* figure, Senufo, Ivory Coast
Wood, fabrics, feathers. Height: 75 cm. National Museum, Abidjan, Ivory Coast

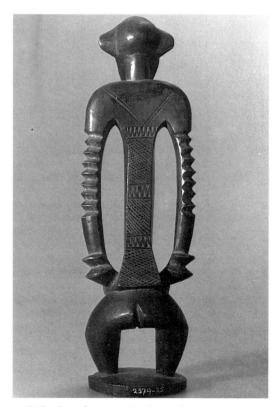

856 Senufo statuette, Ivory Coast
Wood. Height: 34 cm. Tropenmuseum, Amsterdam

equal parts: an oval worn in front of the face and another, semicylindrical, part, widening toward the base and hollow inside, which represents the warthog's snout, with its two horns. This simple form comes from a "living" model, but the sculptor knew how to balance the whole perfectly by punctuating it with white parts and playing with proportions. Although he was reproducing an obligatory model, the artist mastered its particulars to create an abstract, powerful structure that will serve as a model for future generations.

R. A. Bravmann, *Islam and Tribal Art in West Africa* (Cambridge: University Press, 1974).

A. Glaze, *Art and Death in a Senufo Village* (Indiana: University Press, 1981).

R. Goldwater, *Senufo Sculpture from West Africa* (New York: Museum of Primitive Art, 1964).

K. L. Green, "Shared Masking Traditions in Northwestern Ivory Coast," in *African Arts*, XX, 4, 1987, p. 62 *ff*.

P. Knops, *Les Anciens Sénoufo* (Berg-en-Dal: Afrika Museum, 1981).

857 Djimini bracelet, Ivory Coast
Bronze. Height: 16 cm. Private collection

858 Senufo tapestry
Contemporary. Height: 123 cm. Private collection, Zürich

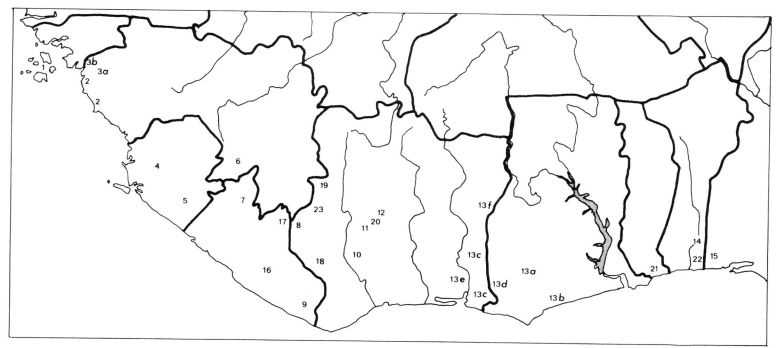

1	Bissagos	7	Toma, Kpelle	13	Akan: a) Asante	14	Fon	20	Yaoure
2	Baga	8	Dan		b) Fante	15	Yoruba	21	Ewe
3	a) Landuman	9	Grebo		c) Anyi	16	Bassa	22	Anago
	b) Nalu	10	Bete		d) Aowin	17	Mano	23	Tura
4	Temne	11	Guro		e) Akye	18	We (Gwere)		
5	Mende	12	Baoule		f) Abron	19	Mau		
6	Kissi								

The Coast of Western Guinea

(Guinea-Bissau, Guinea, Sierra Leone, Liberia, Ivory Coast)

The Coastal Region and the Forest Hinterland

THE BISSAGOS The Bissagos islands of Guinea-Bissau were discovered in 1456. Of some thirty islands, only eighteen are inhabited. In 1460, the Portuguese Pedro de Cintra landed there and found himself facing the island's wooden "idols." Despite the bellicose character of the inhabitants, good trade relations were established with Portugal and continued from the end of the sixteenth century. Guinea-Bissau was to hold a privileged place in the slave trade.

The economy of the archipelago is based on the cultivation of rice, on palm oil, and on fishing, at sea or with the aid of dams that hold fish enclosed at low tide.

The society is highly structured by means of institutions such as the matrilinear clans (or "generations"), the council of elders, age classes, and the priestess. In the nineteenth century, the authority held by the elders and the religious power of the priestess passed mostly into the hands of kings.

Age groups play an important role among the Bissagos, covering about seven levels among the males from infancy to old age. The women, too, have an initiation, which permits them to take the place of a boy deceased before his own initiation, thus allowing him to join the realm of the ancestors.

The Portuguese administration estimated that in 1963, 95% of the 9,200 inhabitants practiced animism. According to tradition, the god Nindou created a couple who gave birth to four women, founders of the four clans, each with its own well-defined task: masters of the soil, priests, fishermen, warriors. In the straw hut that serves as a temple, God is represented by wood figures or by sacred mixtures of vegetable elements. In the latter case, he is called the great spirit Orebok-Okoto. The priestess who maintains the nightly fire and

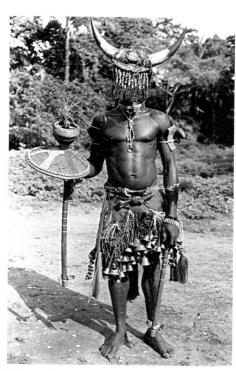

859 *Cabaro* (an uninitiated young man) from Acongo de Corete, Caravela, Bissagos

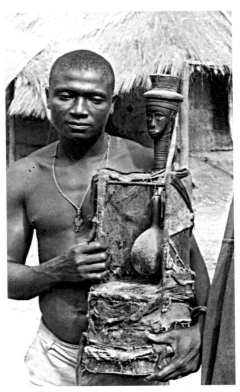

860 Man holding *Iran*, "the Great Spirit," of Ancamona, Bubaque, Bissagos

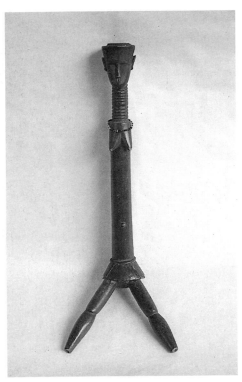

861 Bissagos dance puppet, Bissagos
Wood. Height: 71 cm. Náprstkovo Muzeum, Prague

the king serve as intermediaries between the people and God. Until the nineteenth century, only the priestess *oquinka* would interpret divine decisions at the time of animal sacrifices. Even today, women play a major role in social life, especially where funerals are concerned.

The sculptor is a voluntarily engaged artisan who, through his periodic activity in connection with ceremonies of initiation and worship, is familiar with numerous secrets. Everything that has a sacred character is called *iran*, a Creole name, and provokes fear and respect. The great spirit, as proprietor of the earth, is prayed to before each agricultural activity or enterprise that concerns the community: initiations, the accession of a chief, or funerals. Gravitating around it are particles of its power, which relieve it from specific tasks: health, motherhood, rain. When the divinity is depicted in an anthropomorphic fashion, it is represented in a seated position, hands on the arms of its chair or, in earlier times, on its knees. It may also be shaped like a stele surmounted by a face and placed on a stand. Traditionally, the head is ovoid and prognatic, and the arch of the eyebrows is strongly emphasized. Often, the eyes are studded with metal and the mouth is barely indicated, as opposed to the ears, which stand out in a half-circle. The neck is long and often encircled with rings, and in older versions, the head is shaven. Today, a hat is a sign of dignity. The facial expression of an *iran* is reminiscent of the appearance of the dancers who incarnate the dead during ceremonies of female initiation: a rigid body, head turned toward the sky, eyes closed, and a face that expresses only an internal vision close to a state of "possession."

Each villager may sculpt initiation masks, head decorations, statuettes, vessels, and so on. The heaviest masks are worn by the age group that is not yet considered adult. These represent, in a realistic manner, marine animals, sawfish, hippopotamuses, sharks, or wild oxen. The dancers imitate these dangerous animals who symbolize beings that are still untamed as they have not been initiated. The younger age group wears head ornaments that evoke calves and birds. Disks of engraved wood, dorsal elements, bells, vegetable fibers, and salvaged Western objects adorn these outfits. After the initiation, a tremendous sobriety can be observed among the adults.

The hieratic and monolithic statuary stands in contrast to the great imagination and suppleness of form of the ceremonial objects.

H. A. Bernatzik, *Im Reich der Bidyogo* (Innsbruck, 1944).

D. Gallois Duquette, "1853, une Date dans l'Histoire de l'Art Noir?" in *Antologia di Belle Arti* (Milan: 17–18, Electra, 1981).

———, *Dynamique de l'Art Bidjogo* (Lisbon: IICT, 1983).

"Information sur les Arts Plastiques des Bidyogo" in *Arts d'Afrique Noire*, no. 18, 1976.

A. Santos Lima, *Organização Económica e Social dos Bijagos* (Lisbon: CEGP, 1947).

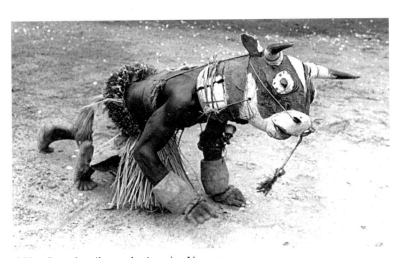

862 Cow *dugn'be* mask, Ancaio, Uracane, Bissagos

THE BAGA The 45,000 Baga live alongside the coastal lagoons of southern Guinea-Bissau, together with the Nalu and the Landuman, from whom it is difficult to distinguish them. They grow rice in this marshy area flooded six months of the year, during which time the only way to get around is by *pirogue*, a dugout canoe. Denise Paulme lived there in the 1950s. Nevertheless, she was not able to attend the initiation's closing ritual because of the floods that cut the Baga off from contact with the outer world. To learn more about them, the results of field research by F. Lamp must be awaited, who so far has given only a brief account of his first stay.

The Baga belong to the Mel linguistic group and have a historic past in common with the Temne. Settled in this region since the fourteenth century, they probably originally came from the mountains of Fouta Djallon with the Landuman, the Tyapi, and the Temne. At the end of the sixteenth century, Portuguese travelers described their presence. In the course of the eighteenth century, large waves of migration followed one upon the other and, as of the twentieth century, they had successively been invaded by the Nalu, the Susu, the Djalonke, the Maninka, and the Fulbe. Their first separation from the Temne took place during the great invasions by the Susu and Mani who settled on the coast between the sixteenth and eighteenth centuries. The Temne were vanquished for good by the Fulbe at the beginning of the eighteenth century. At the end of the nineteenth century, the French colonized Guinea. Even though a few islets of Catholicism can still be found there, Guinea has been Islamicized since 1950 and the suppression of traditional rituals has continued with the arrival of independence. The Baga themselves admit having become Susu as a result of abandoning their traditions. Struggles between chiefs, between notables, and between generations have caused a lack of cohesion, solidarity, and group pride and have led to progressive assimilation with their Susu invaders.

The Baga are divided into six groups, but the areas in which Baga is still spoken cover no more than 300 square kilometers in the north, a region covered with marshland and of low demographic density. Other Baga groups were subjugated by the Nalu, who are related to them, as are the Landuman who, living near Boke, speak a dialect similar to Baga and have similar rituals.

The village studied by Paulme was divided into eight sections called *ebene*, all claiming a common ancestor. Each district, containing a certain number of *foke* dwellings, was under the authority of a patriarch who exercised both civil and political power. Generally, the village contains two halves, the *kamana* and the *bangura*, each led by a chief. Marriages take place exclusively between these two halves. In Africa, this principle of duality is unique. On the same level as the two village chiefs is the religious leader, guardian of the relics.

The men fish and grow cola nuts; the women grow rice. The cylindrical houses of dried mud with straw roofs make up small villages of sparse population. Before burial, the dead are displayed in a sacred wood and their belongings are burned.

It was believed that there was a society called the *simo* for occasions when the dead lay in state. Today the existence of this association is again in dispute. In fact, according to Lamp's recent studies (1986), the word *simo* means sacred in the Susu language and is applied to initiations as well as to sanctuaries. The only fundamental ritual is initiation, which takes place every twenty-four years. The initation society bears the name of the spirit invoked or is simply called *to-lom* which also means "sacred."

The Baga believe in a creator god, Kanu, whom they do not depict. Then comes the masculine spirit Somtup, who may have other names depending upon the place. He is represented by a large cage covered with raffia, needing about twenty hidden carriers. On top is a structure that resembles a bird's head. The wife of this spirit is depicted in the same fashion, except for its summit, which is shaped like a hut. Another spirit is represented as a kind of a long snake, the *bansonyi*, patron of the first two classes of initiates, the *to-lom*. Paulme has gathered information about the closing ritual of the initiation, which consisted of the "entrance" of two large beams, six meters high, rising from the river. Each one represented one half of the village struggling to possess the children of the other half. Male and female, they are at the same time rivals and partners. Similarly, once every three years a gigantic "tortoise" would rise from the water, carried by ten men hidden under fibers.

The *a-tshöl* or *elek* is a composite figure of bird and human, mounted on a small cylindrical base, with its very thin neck holding a long-beaked head. The elongated skull has a crest in the middle. Always hollow, its sides are pierced with diamond-shaped holes. Sometimes the beak resembles the jaw of a crocodile with pointed teeth, to which antelope horns might be added. A human face with a long nose and a convex forehead is sculpted between the skull and the beak. Every family owns an *elek*, which is part of the family shrine, together with other objects: stones, vine twigs and bark reddened by cola nuts, dead scorpions or jaws of crabs, and a fly swatter, important for purification ceremonies and indispensable in the hunt for witches. Activated by sacrifices, the *elek* are regularly brought out at night: the oldest members of the family dance, while the elder says a short prayer to the ancestors and distributes a few grains of new rice, symbol of the wealth gained thanks to them. The *elek* represents the lineage of which it is the protector and the most visible sign. It punishes the guilty, for it alone is able to pursue witches wherever they may be.

For a long time, the *nimba*, whose Susu name must have been changed into *damba* in Baga, was wrongly interpreted as the goddess of fertility. It is shaped as a long bust with breasts, elongated by an extended neck, topped by a small head surmounted by a crest. It is carried on the dancer's shoulders. In reality, it represents the idea of the fertile woman. Yet, it is invoked both for the fertility of the fields and for that of women. The dancer, hidden completely underneath a fiber skirt, looks through a rectangular opening between the two breasts. The massive geometric outlines are decorated with drawings of scarifications. The

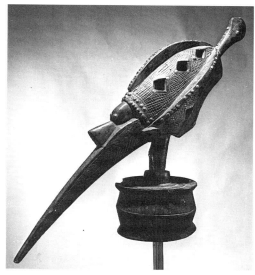

863 Nalu *elek* figure, Guinea
Wood and nails. Height: 40 cm. Private collection

864 "Sailor Visiting an Idol on the Gold Coast," 1836, in *Le Domaine Colonial Français*, 1929

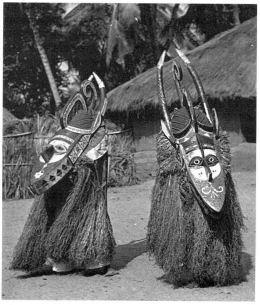

865 Nalu dancers at Koukouba, close to Boke

517

surface gives the impression of a material that resembles stone while reinforcing the solidity of the figure.

Other headdresses with birds' heads or human heads also exist, especially the *a-nok* mask, which participates in the initiation ritual. Still, some seem of recent vintage and are designed solely for entertainment. The artistic production of this region is somewhat exceptional among the statuary of the Guinea coast due to its size and its lack of painted patina; it resembles more closely the statues of the Sudan. It is astonishing that these rituals and sculptures have been maintained despite the language's fragmentation and a history marked by external and internal political conflicts.

F. Lamp, "The Art of the Baga: a Preliminary Inquiry," in *African Arts*, XIX, 2, 1986.
D. Paulme, "Les Baga," in *I.F.A.N.*, Vol. 18, B, 1956.

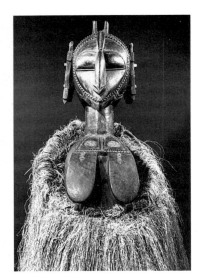

866 *Nimba* mask, Guinea
Wood and fibers. Height: 140 cm. Musée d'Histoire Naturelle, Toulouse, France

867 *Nimba* mask
Drawing by Y. Pranishnikoff in "Voyage au Pays des Bagas et du Rio-Nuñez," by the lieutenant of the ship Coffinières de Nordeck, Le Tour du Monde, *1886*

THE LANDUMAN, THE NALU The 25,000 Landuman are settled in Guinea, their language related to the Baga's. They are farmers and cultivate corn, millet, rice, and peanuts. A supreme chief has authority over village chiefs; inheritance passes through the matrilinear line. The initiation of young people remains a tightly guarded secret. The Landuman worship the spirits of the dead.

The *numbe* mask is the only mask they are known to use. Horizontal, it is comprised of three elements: an ovoid head, an elongated snout, and a set of horns on top of the skull. A small part of the head depicts a face, consisting only of brass eyes; the forehead is divided into two equal parts by a crest in relief. The snout, often wider at the end, is hollow and has decorations carved into it. The horns are really a round or oval disk with a hole cut out of the middle; they are decorated with a linear design. This abstract, stylized composition suggests a buffalo; yet, according to Paulme, the skull might also represent a tortoise with the horns and muzzle of a buffalo. According to G. Van Geertruyen, its function, as with that of the statuettes, would be to protect an enclosure. These masks are not necessarily used during public festivities.

Among the Nalu, who are close to the Landuman, there is a secret male association whose emblem is the *bansonyi*, a large sculpted, colored wooden snake, which comes out of the forest when young boys reach the age of initiation. (G. Van Geertruyen, 1976)

G. Van Geertruyen, "La Fonction de la Sculpture dans une Société Africaine: Baga, Nalu-Landuman," in *Africana Gandensia*, No. 1, 1976.
———, "Le Style Nimba," in *Arts d'Afrique Noire*, No. 31, 1979.

THE TEMNE The Temne, about 1 million in number, constituted small chieftainries grouped under the authority of a supreme chief. Secret societies regulated political life, particularly the *ragbenle* or *mneke* society, which intervened in the event of the death of a chief and was responsible for fertility. Women prepared themselves for marriage within the *bundu* society. The Temne are one of the groups who adopted the *poro* society, whose organizer often clashes with the chief. The men of the *poro* used to take future initiates away; they would remain absent from their village for several months, sometimes for years, until the time they underwent the ceremony allowing them to wear the sign of the *poro*, a hat. Then they would form a work group and spend a few days in the meeting house before being "reborn" and given a "bush name." The *poro* has no right to remove a chief from office, but it may weaken his position and that of his family, and it may even encourage the *ragbenle* society to kill him. The *poro* is also a society that gives mutual aid, offering its services in controlling the supernatural.

The *nomoli* are little soapstone sculptures later reused by the ethnicities of the Atlantic coast who came in contact with the Portuguese in 1550. The first example came to the British Museum in 1883. Generally, these statuettes represent a masculine figure, despite the absence of male sexual organs. The most typical of the Temne sculptures feature a wide, prognathic head with a noticeable reduction of the occipital part. The relief surface of the face is stressed by round, protruding eyes, wide nostrils, and Negroid lips. A small beard, so stylized that it seems fake, is attached to the ears with a braided string. Often the two hands are joined beneath the chin. When not broken at the waist, the full-figure statuettes are sitting on a stool, crouched, or standing up on their short legs and wide feet. The head alone comprises half of the total height of the figure. Quite frequently, there is a hole at the top of the skull in which medications would be inserted, meant to increase the power of the statuette. Some statues have a fist fashioned in such a way that a commanders' stick could be placed into it. For the most part there are no surface decorations. Characteristics that resemble Afro-Portuguese ivories lead one to believe that some of the *nomoli* were produced by the Temne, the first occupants of the Mende region.

Starting at the end of the fifteenth century, the Sapi, who grouped the Temne and Bullom together into a new tribe, produced these famous "Afro-Portuguese" ivories. Richly decorated, these objects—horns, saltboxes, bowls—were done in response to Portuguese commissions.

P. Allison, *African Stone Sculptures* (London: Percy Lund, Humphries & Co., Ltd., 1968).

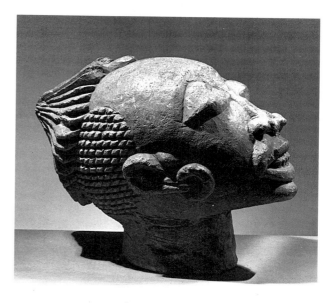

868 Sapi head, Sierra Leone
Soapstone. 16th–17th century (?). Height: 26 cm. The Metropolitan Museum of Art, New York

THE MENDE In the sixteenth century, the Mende settled in Sierra Leone as well as Liberia and on the west coast of Guinea. The Mende and related ethnic groups (the Vai, Temne, Kpelle, Gola, and Bullom) are farmers who grow rice, yams, peanuts, and cocoa and who collect palm oil. They practice crop rotation to avoid exhausting the soil.

The society is based on lineages in which the chief is the oldest and most capable man; the heads of families, owners of the land, distribute it among the family members. The village chiefs, who belong to the founding lineage, are subordinate to a king, whose authority is limited to the domain of politics. Religion is regulated by the *poro* society, a powerful association that can be found among most ethnicities in Guinea, Liberia, and Sierra Leone. The *poro* is in charge of the initiation of boys. This includes military training, and ends with great feasts. The dancers are masked, in part to keep their rank anonymous. The most important mask is the *bundu* mask. Only occasionally admitted inside the *poro*, women have their own association, the *sande*, which also exists among the Temne, Vai, Gola, and Bassa. It consists of a school in the bush where young girls receive the necessary instruction before marriage. These retreats of the *poro* and the *sande* into the bush create bonds of solidarity and interdependence between groups of the same age.

The Mende believe in a creator god, Ngewo, whom they do not depict. Their mediators, nature spirits, the *ngafa*, and the ancestors who lie in the water of the rivers are responsible for their prosperity. Diviners and sorcerers are also present in Mende culture.

The masks of the *sande* society are sculpted by men who live outside the village, halfway in the bush, for they practice a "dangerous" profession in that the masks incarnate the aquatic spirits Sowie, Sowo, and Nowo. The shape of a helmet attracts the river spirit. The helmet-masks have an elaborate headdress, as a woman without head cover represents madness or immorality. (R. Reid, in H. Cole, 1985) According to the authors, rings around the neck signify prosperity or female beauty and furthermore evoke the rings on the water's surface from which the mask emerges. Sometimes the mask has horns which, originally, were filled with medications and incarnated the power of the protection of horned animals. The Mende also have sculpted statuettes with rounded and softer shapes, covered with a polished patina, whose function was to protect or to heal illnesses due to transgression of taboos. Similar figures are found among their neighbors, the Temne and the Vai.

H. Cole, *I Am Not Myself: The Art of African Masquerade* (Los Angeles: Museum of Cultural History, University of California, Monograph Series, No. 26, 1985).
J. Fry, ed., *Vingt-cinq Sculptures Africaines*, op. cit.

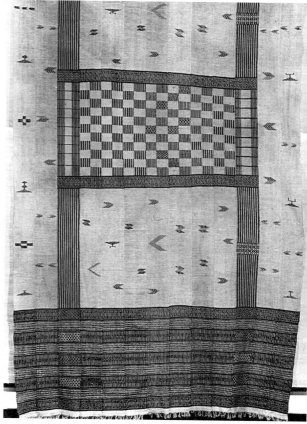

869 Mende textile, Sierra Leone
Bought in 1903. Historisches Museum, Bern

519

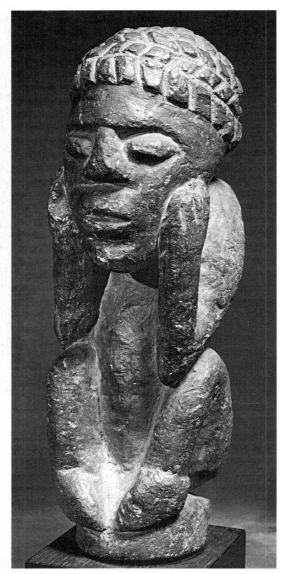

870 "Kissi" figure, Guinea
Soapstone. Height: 26 cm. Musée des Arts Africains et Océaniens, Paris

THE KISSI The Kissi of Guinea have a population of 140,000 divided into small, independent states whose chiefs used to enrich themselves through the slave trade. In order to defend themselves against the assaults of the Samori warriors, they were regrouped into two or three lineages, in small villages hidden in the forest. In the north, they lived side by side with the Malinke, Moslems with whom they had a good relationship. The Kissi say they are of Sudanese origin. Essentially farmers, their daily life is organized around the cultivation of rice, in addition to manioc and cotton.

Villages of about 150 people are situated in clearings. In the center is the meeting place, the *tungo*, a shelter without walls that doubles as a temple for the dead and as a guest house. Not far off, one can nowadays see sculpted stones, *pomdo*, in the shape of humans or, more rarely, animals, axes, pestles, or simple cylinders and engraved pulleys. The *pomdo*, like the *nomoli* of Sierra Leone and the Sherbro Islands, are not the work of the present inhabitants: found in the ground by the Kissi, they have been reused as ancestor figures.

After the death of an influential elder, such as the head of a village or lineage, the *pomdo* is unearthed by a farmer or found near a cola tree planted by the dead person. The identity of the statuette is then revealed through a dream or by divination. Its enthronement is marked by a ceremony followed by a celebration; it will be rolled in white strips of cloth stained with the blood of sacrifices and decorated with cowrie shells, panther teeth, or beads.

The variety of styles denotes different periods and origins; yet some *pomdo* have details of Portuguese armor that allow them to be dated from the sixteenth century. Some have the powerfully shaped nose that one finds among the Bullom.

D. Paulme, *Les Gens du Riz* (Paris: Plon, 1970).

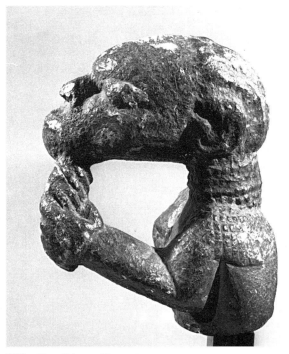

872 *Nomoli* bust, Sierra Leone
With the same characteristics as the nimba statuettes. Soapstone. Height: 10 cm. Private collection

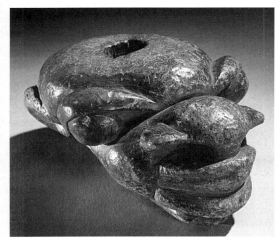

871 *Nomoli* head, Sierra Leone
Soapstone. Height: 26 cm. The Metropolitan Museum of Art, New York

THE TOMA Settled in the northwest of Liberia, western Sierra Leone, and eastern Guinea, the Toma organized their political and religious life around the *poro* association. This society was, among other things, responsible for the initiation of young boys that took place in the forest, which is particularly dense in the land of the Toma.

When called forth by the *landai*, a large mask, the future initates would leave "on retreat" for the forest for a month. Initiation would be brought to a close by a "ritual devouring," followed by a symbolic rebirth. The *landai*, a horizontal wooden mask, has the mouth of a crocodile on which human features have been sculpted: a straight nose underneath arched eyebrows. The jaw is sometimes articulated, sometimes depicted by a horizontal line that creates a second volume perpendicular to the first. The top is surmounted by a headdress of feathers and the wearer looks through the snout. A symbol of the opposing forces of nature, the *landai* represents a bush spirit. Other dancers of the *poro*, imitating the hopping of birds, wear enormous costumes made of feathers.

The *bakrogui*, more common and less secret than the *landai*, are smaller masks that come in couples. The mask consists of a vertical panel upon which human features have been inscribed, a bulging nose and forehead, a beard, and tubular eyes or eyes heightened by metal disks. This mask may be seen only by members of the *poro*. Its type is derived from the art of the Sudan. Each mask may be thought of as the spiritual dwelling of an ancestor.

Jacqueline Delange (1967) notes the existence among the Toma of *bundu* statuettes kept in sacred huts. The *bundu* association is the equivalent of the female *sande* society found among the Mende.

J. Delange, *Arts et Peuples de l'Afrique Noire: Introduction à une Analyse des Créations Plastiques* (Paris: Gallimard, 1967).
B. Holas, *Civilisations et Arts de l'Ouest Africain* (Paris: P.U.F., 1976).

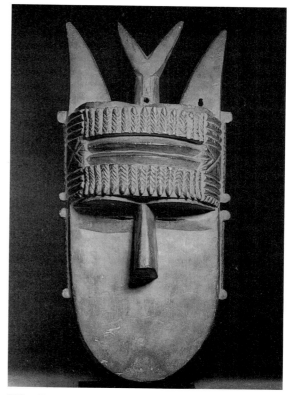

873 Toma mask, Liberia
Wood. Height: 57 cm. Municipal Museum, Angoulême, France

THE DAN The 350,000 Dan live in northeastern Liberia and northwestern Ivory Coast, in regions covered by forest in the south and savannas in the north. Farmers, they periodically clear the forest to obtain new fields. They also live off game and fish.

Speaking the Mandinke language, the Dan arrived around the eighth century from the west and from the north of the western Sudan. With their neighbors the Mano, in the fourteenth century they settled in the northeast, next to the We. The Dan have the reputation of being fierce warriors, always battling their neighbors, the We, the Guro, and the Mano in the south.

Lacking a central authority, the various groups had neither a political institution nor unity until the creation of the leopard society, the *go*, at the end of the last century. Villages were composed of several clans, united around a chief chosen for his strong personality or his success as a farmer and leader in war. This union was most precarious and a Dan could very easily leave to settle elsewhere. Nevertheless, the frequency of raids between villages required a solid defense system, maintained by young warriors who thereby found an opportunity to gain prestige. The purpose of raids was to obtain slaves who, in part, supplied the needs of their system of cannibalism.

The village chief had to answer to the council of elders, who also held power. In order to climb the social ladder, the clan chiefs organized large celebrations and distributed presents. It was necessary for them to be rich in order to be powerful. Today, when it is no longer possible to distinguish oneself in war or to establish a new community without the agreement of the central government, acquiring prestige remains, despite everything, an essential goal of the Dan. One of their basic concepts is the *tin*, which may be translated as prestige, success, or fame, which leads to an exaggerated individualism and a very strong hierarchical division, notably in the numerous secret societies and in the associations of dancers, mask wearers, and artisans.

In addition to village chiefs and the council of elders, there were male associations that attempted to bring about a socio-political unity, reinforcing rules of behavior, demanding absolute loyalty and obedience from members, and giving an initiatory education to the young, in the forest for a duration of three to four months. These societies called upon the tutelary spirits of the bush. The most powerful, even today, is the secret society of the leopard, the *go*, which, without having fully achieved its stabilizing and unifying goal, nevertheless grows from one year to the next. Established first in the northeast, it consists of worship offered to a very powerful, pacifying spirit, represented by a mask, the *gogle*, whose features may vary from one village to the next. It sometimes happens that an already existing mask is diverted from its function to incarnate Go. The wearer of the mask and its owner enjoy very high status in the hierarchy. According to E. Fischer (1978), the masks *are* the bush spirits and do not merely represent them. Their appearance at the time of masked celebrations resolves the conflicts that the village chief was not able to regulate. The women, too, receive an initiation, which ends with excision.

The Dan believe in a world that is divided into two distinct realms: the village, on the one hand, which includes inhabitants and human-made utensils, and, on the other, the realm of the forest with its wild animals, *bon* spirits, and fields that can potentially be cleared.

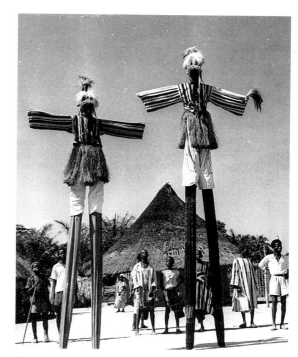

874 Dan dancers on stilts

521

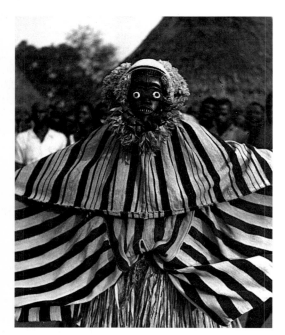

875 Dan dancer
In situ

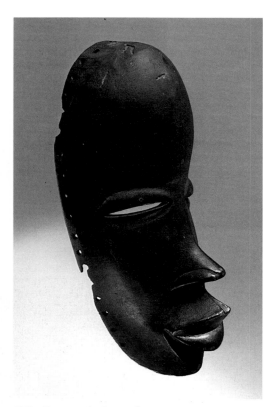

876 Dan mask, Ivory Coast
Wood. Private collection

877 Dan spoon, Ivory Coast
*Wood. Height: 46.2 cm. Nelson Rockefeller
Collection, The Metropolitan Museum of Art,
New York*

Crossing the dividing line between the two worlds may be dangerous. Zlan created the universe from mud and modeled it with his hands. He is the first sculptor, and inaccessible. Also worshiped is Du, a spiritual power who is invisible but present in every aspect of the universe. This spiritual force leaves the body at the moment of death; the spirit will have to await reincarnation in the village of the dead. Dreams are the medium through which Du communicates with humankind.

The innumerable wooden masks incarnate the supernatural, spiritual force called *gle*, who lives in the forest and wishes to participate in the life of the village. Yet, as it is invisible, it must appear in its full form and function in the dream of a male initiate, who will indicate this to the council of elders. It is up to them to decide whether it is advisable to have a mask created and worn by the dreamer. The masks' presence is required at any significant event. Fischer (1978) counts eleven types of masks, which may have similar formal elements, even though they are meant for different functions.

For example, the *deangle* is a benevolent female mask, oval in shape, with slitted eyes, and covered with a white band of kaolin. The forehead is divided by a vertical strip that runs down to the nose; there are protruding lips, often half-open and showing a few metal teeth. When it plays the role of intermediary between the young people undergoing initiation and the village, it is called the *bonagle*; it neither dances nor sings, but comes to look for food from the women, with whom it jokes around.

Other masks appear only during celebrations, such as the *bagle*, with its tubular eyes, low forehead, mustache, and horned skull—a mask that is meant to make people laugh due to its grotesque pantomime. The *kagle*, with triangular holes for eyes, arched eyebrows, and high cheekbones, plays at attacking the public with sticks one must evade. The *gunyegä*, a masculine mask, is distinguished from the preceding one by its round holes for eyes; it rules over the footraces for young initiates. The *weplirkirgle*, with its protruding tubular eyes, is always asymmetrical, and regarded as deformed; one is forbidden to laugh at it, even though its gestures are funny. The *blua gle*'s function is to escort and bless the warriors. He dances with a fiery spirit. Bearing someone on his shoulders, he demonstrates his strength. He is identifiable by his *blua*, a huge headdress of black feathers, and his fan, the *maan*, which he holds in his hands. There are also stone masks and the little so-called passport-masks, which are attached to the arm. The Dan have a unity of style that approaches uniformity.

The rare statues that exist are not representations of ancestors or spirits but "portraits" of favorite wives, ordered for the purpose of increasing the owner's prestige. They are called *lü mä*, "human being of wood." Some statues form a pair. Their significance has been lost; nevertheless, one may assume that they were associated with the spiritual power of fertility, since several maternity figures can be found among them. Appearing in a standing, frontal position, the figure has an oval face, narrow eyes, and expressive lips that show several metal teeth from the upper gumline. The neck sometimes has several circular bulges, as exist among the Mende. The arms are straight, the legs short; scarifications ornament the abdomen; to the sculpted hairdo, fiber braids have often been added. Moreover, the statue is decorated with small bits of fabric and jewelry around the ankles or the wrists, and with necklaces, bracelets, and earrings.

A woman who has distinguished herself through her hospitality and generosity will own a superb spoon of sculpted wood. This is a custom specific to the Dan. This woman's role, in the heart of the village, is to receive and feed travelers, musicians participating in celebrations, and men who have come to help clear the fields. The spoon possesses the power to make one rich and famous and confers a sure authority over the other women. The spoons have several shapes: the most usual one has a handle fashioned after a human head, comparable to certain masks; others have handles that form pairs of legs.

In earlier days, sculptors were remunerated by celebrations, gifts of food, women, and a future they could count on. They would receive the gift of their sculptor's art through a dream. They would work for chiefs who wanted to overwhelm their visitors with their costly objects.

The Mano can be linked with the Dan and their masks are identifiable by a slightly turned-up nose.

E. Fischer, "Dan Forest Spirits: Masks in Dan Villages," in *African Arts*, XI, 2, 1978.
E. Fischer and H. Himmelheber, *The Arts of the Dan in West Africa* (Zurich: Museum Rietberg, 1984).
B. C. Johnson, *Four Dan Sculptors* (Chicago: University Press, 1987).

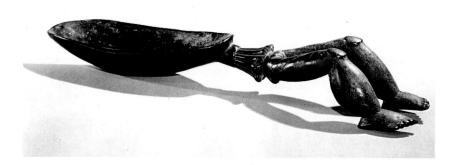

THE GREBO The Grebo arrived from the southern Sahara around 1550. They settled on the coast of Liberia, west of the Cavally River. Like the Bete, to whom they are related, they do not possess the *poro* association, which directs all of the political and religious life of most of West Africa. Divided into clans, the Grebo would choose a chief, *bodio*, who also assumed the function of grand priest. Once named, the *bodio* had to reside away from the village in a hut, the *takae*, built in one day by the men of the clan. He would then devote his time to meditation and was subject to innumerable taboos. M. Meneghini (1974) specifies that at the end of the existence of this institution, nobody wished to take on this responsibility as it implied an almost total isolation.

The Grebo sculpt masks that incarnate the spirits of the invisible world who live in the forest. Produced by initiates of a very high level, these masks appeared during rituals reserved for initiates and at the time of celebrations when the whole population was able to see them.

Figures are very rare. One type of mask is characterized by a massive face surmounted by two buffalo horns, reminiscent of the Bete war mask. The second type represents the female ideal, its slitted eyes and sweetness of expression resembling the *deangle* mask of the Dan. In the interior of Liberia, the female face is the image representing the ideal community and frequently appears on spoons, commanders' sticks, and base-supports for games. The third type of mask, more abstract and flat, is formed by a board with tubular eyes. Some of these masks are divided into three horizontal spaces, separated at the levels of the arch of the brow and at the upper lip. This space-plane division is reminiscent of the art of the Toma.

For a long time the Grebo, geographically isolated, were assumed not to have any sculpture. While their statuary is not known to us, their masks, on the other hand, are beginning to be catalogued, and one can notice in them a Dan influence, some of whose aspects they have made their own, even though they lack the *poro* association.

M. Meneghini, "The Grebo Mask," in *African Arts*, VIII, 1, 1974.

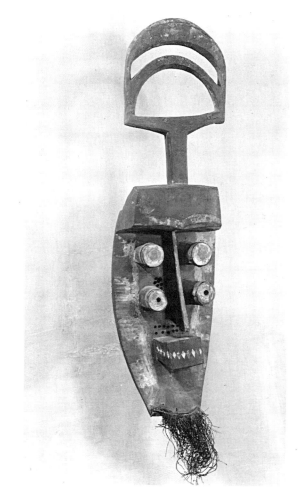

878 Grebo mask, Liberia
Wood and fibers. Height: 74 cm. Museum für Völkerkunde, Berlin

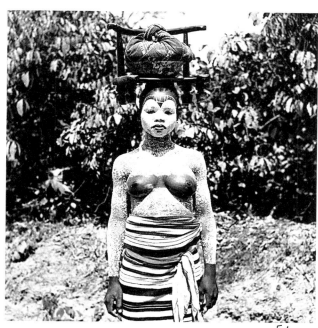

879 We (Gwere) initiate leaving for the forest
In situ

880 Bete mask, Ivory Coast
Wood and metal nails. Height: 28 cm. Private collection

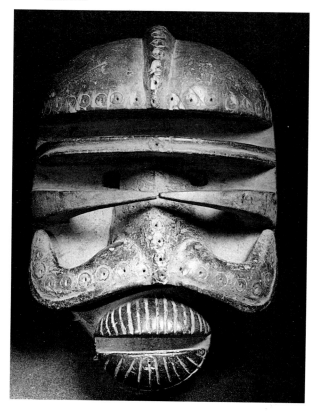

THE WE (GWERE) Inhabiting the southwest of the Ivory Coast, the We have a culture related to that of the Dan. They gained a great reputation as healers due to their knowledge of plants. They live in the forest and no longer in the savannas, as the Dan do, and were the inventors of the "terror" mask, whose function was to establish contact with tutelary entities through the intermediary of dead ancestors. During certain celebrations, the "monstrous" masks would clown and elicit laughter, but that did not make them any less dangerous. The hemispheric forehead, jutting cheekbones—sometimes on a vertical plane— the widened nostrils, and the repetition of certain elements (nose, eyes, forehead), express magic powers reinforced by adventitious elements: little bells to call forth the ancestors, medals, nails, leopard fangs, cowrie shells, feathers worn on top of the head. Some masks are made of clay, as the use of wood may have been forbidden in certain clans. At the death of a mask wearer, a dispute would sometimes occur between two heirs, and it has happened that a second mask was produced in order to please both parties—but this mask would not have the same power.

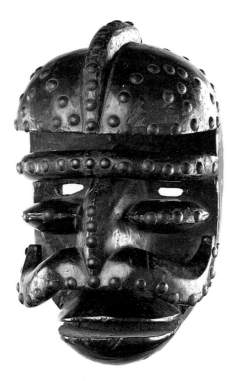

881 Bete mask
Wood and copper nails. Height: 32 cm. Private collection

THE BETE Settled on the left shore of the Sassandra River, the 370,000 Bete of the Ivory Coast are divided into ninety-three groups. Some authors situate one Bete group in Liberia. Traditionally, Liberia was given as their place of origin, but that opinion is now being contested. (J. P. Dozon, 1985)

Lacking centralized power, the Bete were grouped together in relatively major villages, containing several lineages, probably for security reasons. Each lineage had a totemic animal whose meat was taboo. The most senior member of the lineage exercised a moral and judicial power, notably in terms of awarding land. The Bete, who ascribed more importance to the hunt than to agriculture, grew only what was needed for a subsistence economy.

To render the hostile forces of the forest material, they sculpted a type of mask that would provoke terror: the *grè*, with its grimacing face, distorted features, facial protuberances, horned heads, bulging forehead, tubular eyes, and wild animals' teeth. In earlier days, this mask presided over the ceremony held when peace was restored after armed conflicts and it participated in sessions of customary justice. Of We origin, the Bete mask is more elongated and has no fangs, horns, or bullen nails.

Statuary, which is rare, represents the mythical mother; associated with funerary rites, its liturgical importance is secondary.

J. P. Dozon, *La Société Bété* (Paris: ORSTOM/Khartala, 1985).
B. Holas, *Images de la Mère dans l'Art Ivoirien* (Abidjan: Nouvelles Editions Africaines, 1975).
———, *Masques Ivoiriens* (Abidjan: C.S.H., 1969).
———, *Sculptures Ivoiriennes* (Abidjan: C.S.H., 1969).
D. Paulme, *Une Société de Côte-d'Ivoire Hier et Aujourd'hui: Les Bété* (Paris, La Haye: Mouton, 1962).
A. P. Rood, "Bete Masked Dance, a View from Within," in *African Arts*, II, 3, 1969.

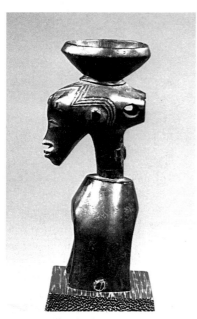

882 Guro pulley heddle, Ivory Coast
Wood. Private collection

THE GURO With a population of 200,000, the Guro live west of the Baoule on the Ivory Coast, on the shores of the Bandama, in a heterogeneous area in some places containing tree-filled savannas, in others, dense forest. The south, however, is more hospitable thanks to its agricultural resources. Even though it has better water supplies, the savanna is more sparsely populated. The Guro, belonging to the Mande group, speak a dialect close to that of the Dan, Wan, Myamu, Gban, and Yaoure. Their neighbors, the Akan and Bete, issue from the Kru group. The Guro have always been in contact with the Malinke merchants on the one hand, and with the Diolla and the Fulbe herders on the other.

All information relative to the emigration and settlement of the Guro comes from C. Meillassoux's *Anthropologie Economique des Gouro de Côte-d'Ivoire*. Having come from the north and northeast, the Guro emigrated during the course of the sixteenth century. Protected by the forest, which the conquering horsemen from the north could not manage to penetrate, the peopling of the region took place under conditions of relative safety, and thus the land of the Guro found itself sheltered from military and political upheavals until the colonial conquest in 1912.

Yet, Guro individuals moved often, for multiple reasons: conflicts of an internal nature (a rowdy individual playing with a knife, accused of sorcery, might be finally chased out of the group); or as a consequence of a war between tribes incited by adultery or the abduction of a woman; or, finally, from a need to escape from a socially inferior condition. The self-subsistent economy easily facilitated settling in a new place.

From 1906 to 1912, the Guro fled into the bush and abandoned their villages so as not to submit to colonization. In traditional villages, the Guro grow rice, yams, coffee (which they trade), cotton, and cocoa, depending on the year. The men clear the land and the women, whose role in the market is important, do the planting. In the north, the round huts have straw roofs, and in the south they are rectangular with roofs of palm. The village consists of several lineages; its chief is the chief of the oldest lineage, assisted by a council drawn from the principal lineage. The land belongs to the master of the land, called the *trezan*, who distributes it and makes sacrifices. The soothsayers, or *monedozan*, are consulted frequently to set dates for rituals and to predict the future with the aid of small sticks or bones set in place by a mouse who is kept in a wooden or clay box. The *zamlo* association organizes celebrations in which the polychrome antelope mask can be seen.

The daily life of the Guro is dominated by secret societies and by a belief in protective spirits, called *zuzu*, to whom the Guro used to build shrines with figures. The Guro have a very pronounced artistic sense and attach special importance to hairdos, so that hairdressers are considered to be artists.

According to legend, one day a hunter captured the *yu*, or a collection of ritual masks and medications, which then allowed his group to communicate with the world of the bush. The *gu* mask is the feminine ideal; *gye* and *dye* are the antelope and the porcupine; *zamble* is both antelope and panther. These masks are the responsibility of personages who have a religious, magical, or political function and who come out only on important occasions such as the funeral of a notable or the enthronement of a chief. The *dye* and *gye* may not be seen by women. By offering them sacrifices, the faithful reconcile the forces of nature, the *gu*, with themselves. The masks are sometimes meant to please, sometimes to impress the spectator.

Sculpted figures are rare, but the Guro are famous for their weavers' heddles. These heddles also exist among their neighbors, the Dan, Baoule, Senufo, and Yaoure.

E. Fischer and L. Homberger, *Die Kunst der Guro/Elfenbeinküste* (Zurich: Museum Rietberg, 1985).

C. Meillassoux, *Anthropologie Economique des Gouro de Côte-d'Ivoire* (Paris: Mouton, 1964).

The Coast of Central Guinea

(Ivory Coast, Ghana, Benin, Nigeria)

THE BAOULE The Baoule, estimated to number 1 million at the beginning of the century, form part of the Akan group of the Ivory Coast. They occupy a part of the eastern Ivory Coast that is both forest and savanna land. The Akan created a series of kingdoms and city-states that progressively occupied the entire forest region all the way to the Gulf of Guinea. During the eighteenth century, the queen, Abla Poku, had to lead her people west to the shores of the Comoe, the land of the Senufo. In order to cross the river, she sacrificed her own son. This sacrifice was the origin of the name Baoule, for *baouli* means "the child has died." (J. N. Loucou, 1984) Since the regime was matrilinear, at the queen's death her niece succeeded her and ruled over the kingdom of Sakassou, which brought together the tribes that had followed the queen in her exodus. Yet, as the political system was a decentralized one, the relations of Sakassou were limited to the payment of tributes, to appeal judgments, and to matters of religion. The effective authority of the queen did not reach beyond the village in which she resided and her role was nothing more than one of prestige. The regional powers were entrusted to members of the royal Warebo clan.

They exploited the regions rich in gold, and developed a new civilization, a synthesis of the Akan and the conquered autochthones. At the beginning of the twentieth century, the administrators, A. Nebout and then a few years later M. Delafosse, judged the Baoule to be in a "state of perfect anarchy, tempered by traditions, customs, and common sense." According to Delafosse, Baoule society was characterized by extreme individualism, great tolerance, a deep aversion toward rigid political structures, and a lack of age classes, initiation, circumcision, priests, secret societies, or associations with hierarchical levels. Each village was independent from the others and made its own decisions under the presiding presence of a council of elders. Everyone participated in discussions, including slaves. It was an egalitarian society.

Baoule social organization is founded on the extended family, which forms an *aulo*. If there are several families in the same village, the richest, most eloquent, or shrewdest man is chosen to manage the matters of common interest with the council of notables. There is no distinction between paternal or maternal relatedness, nor is there preferential marriage, with the exception of certain taboos, such as, for example, the prohibition of marriage with a member of another *aulo* for four generations to come if a union already has taken place between those two *aulo*. The political unit is the village, but the chief does not have the power to impose an unpopular decision, nor does he have the means to enforce it. When the French arrived, women often occupied the role of village chief. Delafosse observes in this regard that the Baoule language does not have a word for "chief" in the ordinary sense, unless it means head of the family.

Numerous legends have been collected concerning the creation of the world, the flood, the changing of the course of the Bandama River, the crossing of the Comoe, and the conquest of the Baoule territory. The animal-hero is a male spider, greedy, sly, and mean, but in the end he is always punished.

The Baoule believe in an intangible and inaccessible creator god, Nyamien. Asie, the god of the earth, controls humans and animals. The spirits, or Amuen, are endowed with

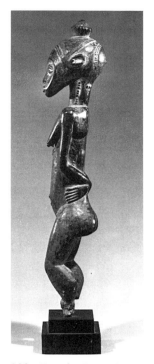

883 Baoule, Ivory Coast
Wood. Height: 46 cm. Private collection

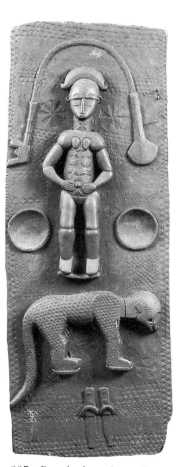

887 Baoule door, Ivory Coast
Wood. Height: 112 cm. National Museum, Abidjan, Ivory Coast

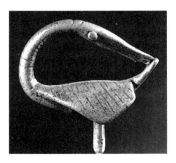

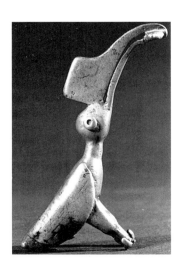

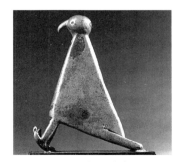

884–86 Baoule weights
for weighing gold, Ivory Coast
Bronze. Private collection

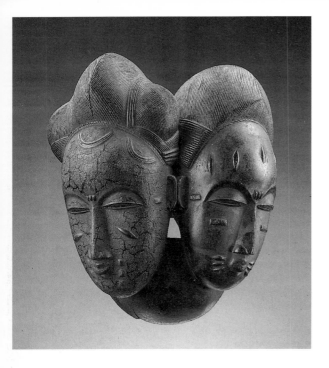

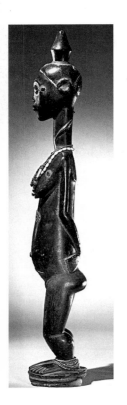
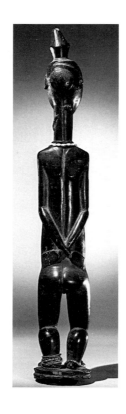

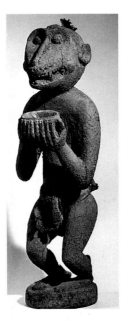

LEFT:
888 Baoule double mask, Ivory Coast
*Wood. Height: 29 cm. Musée Barbier-Müller,
Geneva; formerly R. Bédiat Collection*

CENTER:
889–90 Baoule, Ivory Coast
*Profile and back. Wood. Height: 65 cm. The
Metropolitan Museum of Art, New York*

BELOW:
891 Animal figure, Baoule, Ivory Coast
*Wood, feathers, nuts, fabric. Height: 53.5 cm.
Musée de l'Homme, Paris; formerly Lefevre
Collection*

supernatural powers. The real world is the opposite of the spiritual world, *blolo*, from whence come the souls at birth and to which they shall return at their death. Religion is founded upon the idea of death and the immortality of the soul. Ancestors are the object of worship but are not depicted. Earlier, a death was never considered to be natural: and thus it was necessary to unmask the one responsible. During the course of the ritual, two men would carry the corpse on their heads: guided by the spirits, the feet of the dead person would bump into the guilty party, who would then have to undergo a trial by poison. Women and slaves would be sacrificed to the deceased one's double, if he were a notable. The heir was the brother or sister born of the same mother as the deceased, for one "can never be sure that one is the son of one's father."

Rituals evolve: the creation of a new cult may be decided upon following a dream or during a trance of possession during which the spirit reveals itself and tells the "chosen" one about the ritual, the rules, and the objects which must be acquired or produced, specifying hairdo, age, posture, and scarifications, if it concerns a statuette. (S. Vogel, 1981)

Wooden sculptures and masks allow a closer contact with the supernatural world. Baoule figures answer to two types of devotion: one depicts the "spiritual" spouse who, in order to be appeased, requires the creation of a shrine in the personal hut of the individual. A man will own his spouse, the *blolo bian*, and a woman her spouse, the *blolo bla*, which they carry around everywhere they go. Other figures are sculpted to give shelter to the natural spirits, the *Asie usu*.

A great mobility of people and works of art has been observed among the Baoule, and a move is the occasion for commissioning a sculpture or importing a new type of dance which a village member may have seen during a trip. Artists may have been trained in a certain studio and produce works in different styles. They travel and work for clients who sometimes come from far away.

Masks correspond to three types of dances: the *gba gba*, the *bonu amuen*, and the *goli*. They never represent ancestors and are always worn by men.

Guro in origin, the *gba gba* is used at the funerals of women during the harvest season. It celebrates beauty and age, hence its refined features. This double mask represents the marriage of the sun and the moon or twins, whose birth is always a good sign.

The *bonu amuen* protects the village from external threats; it obliges the women to a certain discipline; and it appears at the commemorations of deaths of notables. The bush spirits have their own sanctuaries where they receive sacrifices. When they intervene in the life of the community, they take the shape of a wooden helmet that represents a buffalo or antelope and which is worn with a raffia costume and metal ankle bracelets; the muzzle has teeth which incarnate the fierce animal that is to defend the group.

The very characteristic, round-shaped "lunar" *goli* is surmounted by two horns. It was borrowed from the Wan for a celebration adopted by the Baoule after 1900. Celebrating peace and joy, they would sing, dance, and drink palm wine. In the procession, the *goli* preceded the four groups of dancers, representing young adolescents. The *goli* would be used on the occasion of the new harvest, at the visit of dignitaries, or at the funerals of notables.

Not inherited, the sculptor's profession is the result of a personal choice or of a desire manifested in a dream or during a possession trance. Certain types of standardized objects are no longer made for specific ritual purposes—for example, gongs or pulleys are fabricated and stored.

Baoule statuary is characterized by a certain realism; one can distinguish canons of beauty, as the Baoule see them: round calves for the women, long hands with tapered fingers, small buttocks. The harmonious coiffure is made up of innumerable fine braids. The beard is neat and sometimes braided. The patina is smooth. The Baoule have also created monkey figures that more or less resemble each other. Endowed with a prognathic jaw and sharp teeth and a granular patina resulting from sacrifices, the monkey holds a bowl or a pestle in its paws. Sources differ on its role or function: some say it intervenes in the ritual of divination, others that it is a protection against sorcerers in the male associations, or a protective divinity of agragrian rites, or a bush spirit. This cult does not predate the conquest of Samori, and is thus relatively recent.

Baoule statuary is quantitatively very important, but great masterpieces are rare.

A. M. Boyer, "Miroirs de l'Invisible: La Statuaire Baoulé," in *Arts d'Afrique Noire*, no. 44 and 45, 1982–83.

J. N. Loucou, *Histoire de la Côte-d'Ivoire* (Abidjan, Ivory Coast: CEDA, 1984).

A. Nebout, "Notes sur les Baoulé," in *A Travers le Monde*, 1900, reprinted in *Arts d'Afrique Noire*, No. 15, 1975.

S. M. Vogel, *For Spirits and Kings: African Art from the Tishman Collection* (New York: The Metropolitan Museum of Art, 1981).

———, "People of Wood: Baule Figure Sculpture," in *Art Journal*, XXXIII/I, Fall 1983.

THE AKAN: THE ASANTE, FANTE, AOWIN, ANYI, AKYE,
ABRON The Akan are a group of ethnicities of the former Gold Coast, renamed Ghana in 1957, which harkens back to the first great empire of West Africa from which the majority of the population claims to originate. Most traditions, indeed, give the north as the point of departure for the great migrations. Bernard de Grunne (1980) cites Ross and Cole regarding the five historical factors that are characteristic of Ghana: "The origin of the present populations; the development of commerce on a grand scale toward the north; the appearance of centralized states; the introduction of Islam; and the evolution of contacts and commerce with Europe."

From the fourteenth century onward, military states were created and, in the seventeenth century, came under the domination of one of them, the Denkyira. In 1701, several states liberated themselves from this domination under the leadership of a priest-chief, Komo Anokye, who created a confederation in which the Asante were to become increasingly important. According to legend, before adopting the famous golden stool, symbol of unity, Komo demanded that all the emblems of local powers be brought to him and buried in order to prohibit their proprietors from coming to reclaim them, which would mean they were leaving the confederation. The Portuguese, who disembarked on the coast in 1471, built a fort in Elmina in 1482, followed by several others that became commercial centers. At the end of the sixteenth century, the Portuguese were replaced by the Dutch, who eliminated the former entirely in 1642; the British, in turn, landed in the eighteenth century and divided the coast with the Danish and the Dutch; this occupation intensified the slave trade and commerce in gold. In 1874, the Fante, allies of the British, pillaged Kumasi, the Asante capital, and the confederation was dissolved definitively in 1900, under the pretext of tribal wars, to become an English colony.

The royal matrilinear lineages were made up of descendants of a founder, issue of the first immigrants; it was this elite, itself within the aristocracy, which ordered terra-cottas for the deceased, including heads, busts, torsos, seated or standing figures, and dishes decorated with figures in high or low relief. These terra-cottas were placed in groves not far from the cemeteries, and every year the priest in charge of the ancestral cult would come to perform a ritual dating from the seventeenth century.

These terra-cottas were supposed to be portraits. Thus the artist had to remember the features of the deceased; it was said that, if he could not remember, he would be able to see them at the bottom of a dish filled with water or oil. In reality, these are idealized types who cannot be identified except by their accessories or certain details: a sword, crown, stool, jewelry, or type of hairdo; a priest is recognized by the absence of hair, a queen mother by her coiffure. The use of glazes of different colors allowed for different complexions. De Grunne (1980) suggests three hypotheses to explain the abundance of isolated heads: either they belonged to complete figures that were broken; or they were formerly placed on a small base; or, lastly, they might have served as covers for large ritual vases. Basing his analysis on where certain pieces were found, he distinguishes seven great styles, among which one notes the refined style of the Aowin as opposed to the rougher style of the Anyi of Sanwi. He also observes the unequal level of quality of some objects of the same origin and suggests that the best production was reserved for the royal lineages, while commoners would claim for themselves the less successful ones.

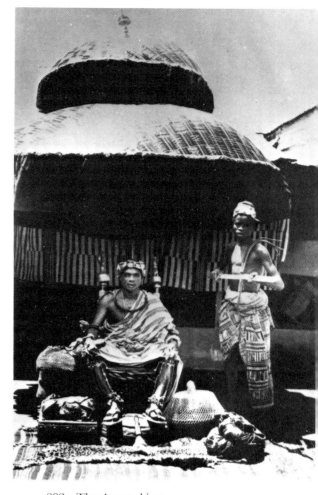

892 The Asante king
Nana Akunfi Ameyar III

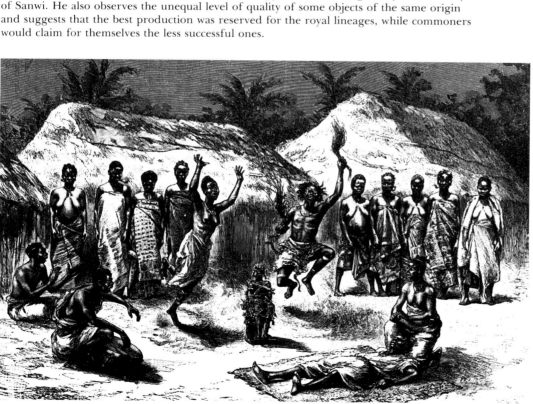

893 Therapeutic *anyi* ritual
in Binger, Le Tour du Monde, *p. 121*

527

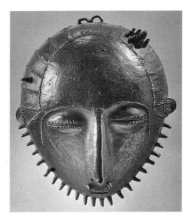

894 Adioukrou pendant, Ivory Coast
Gold. Height: 9.5 cm. Musée de l'Homme, Paris

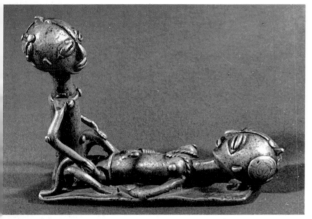

895 Asante weights, Couple
Bronze. Height: 8 cm. Private collection

Besides the commemorative terra-cotta statuettes, the Akan are famous for their gold weights. Gold and silver were, in fact, found locally and, very early on, the Mande caravans that came from the markets of Djenne and Timbuktu brought the Akan the other metals they needed. Mastery of smelting was acquired in the eleventh century and, after 1500, traces can be found of Portuguese imports of metal to the Gold Coast.

In 1500, the presence of two schools of art were noted, the oldest one, linked to the first style, was in the north in the region of the Brong; it used Islamic models for its decoration, underwent European influence, and was very inventive and prolific. T. F. Garrard (1979) estimates at 3 million the level of production of these copper figurines, between 1500 and 1900. He attributes the second period, from 1700 on, as having furnished 80% of the present inventory. After the fall of the city of Denkyira in 1701, the craftspeople had to settle in the new capital, Kumasi, and the Asante very rapidly acquired their techniques. At the end of the eighteenth century, they adapted themselves to the new copper leaf imported by the Europeans, and created an extraordinary variety of objects: spoons, jars, strainers, boxes, combs, wooden scepters covered with gold leaf, commanders' sticks, pipes, bobbins, among other items. The oldest technique features decoration using hollow points and lines; the figurines are nude, while, after 1700, they are always clothed.

Whether it be on funerary urns, fabrics, or objects of prestige, the artistic products of the Akan embody proverbs and ideas that refer to their history, theology, and folklore. Most of the objects were made to commemorate historical events. The bird, found on swords or rings, refers to one that brought the cannon and gunpowder. Thereby it became the symbol of protection.

In 1874, the tribal wars put an end to this production and, after 1920, the techniques were lost, for they emerged only in response to European demand.

Still, movements battling sorcerers, members of local matrilinear groups, ended by reinforcing these connections in order to prevent social disintegration; then what appeared were small statuettes of wood, disk-shaped, that are called *akuaba* or fertility dolls; they emphasize the dependence of the child on its mother as much as the rank or status of the owner. This sculpture is generally rather mediocre.

H. M. Cole, "Art Studies in Ghana," in *African Arts*, XIII, 1, 1979.
H. M. Cole and D. H. Ross, *The Arts of Ghana* (Los Angeles: Museum of Cultural History, UCLA, 1977).
B. de Grunne, *Terres Cuites Anciennes de l'Ouest Africain*, op. cit.
T. F. Garrard, "Akan Metal Arts," in *African Arts*, XIII, 1, 1979.

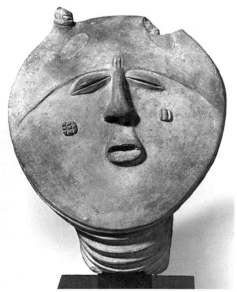

896 Akan funerary figure, Ghana
Terra-cotta. Private collection

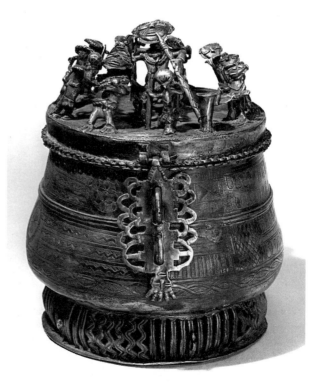

897 Asante *kuduo*, Ghana
Bronze. 18th–19th century. Height: 28 cm.
De Menil gift, Musée de l'Homme, Paris

THE FON The kingdom of Dahomey, today the Republic of Benin, is situated between Togo to the west and Nigeria to the east. According to legend, it was created by the daughter of the king of Tado, a Yoruba, who, when coming to look for water in the forest, encountered the leopard spirit. From that union Agasu was born, the ancestor of all the Fon. Agasu's descendants founded the holy city of Allada. Around 1600, three of his sons were fighting over the throne. The eldest won out and the other two left to establish their own kingdoms, one on the coast at Ajase-Ipo (presently Porto-Novo), and the other at Abomey in the north. In 1700, the French established a base for the slave trade on the coast, at Ouidah. The kingdom of Abomey soon became a power on the Slave Coast, endowed with an efficient army, a cowrie-shell currency, and an impressive commercial life. In 1724, the Fon conquered Allada, then cleared themselves a path of access to the Atlantic Ocean. The Yoruba divinities, already familiar to the Fon, were united with those of the local Ewe and Fon spirits.

For a long time, Dahomey art has been perceived as a synthesis of the arts of the Asante, Ewe, and Yoruba; actually, in addition to royal history, it expresses the cultural concepts of the group. In the first place, it is an art of the royal court and includes engraved calabashes, sceptres, and commanders' sticks. These sceptres also served to beat rhythms during ceremonies, and as executioner's weapons. Because the executioner was forbidden to spill royal blood, when a prince was guilty of grave misconduct, the only solution was to club him and remove him. Objects of prestige in bronze or copper and weapons were produced by artisans who lived at the court. They did not form castes but true families. The palaces that each king had built, their thrones quite close in style to those of the Asante, were decorated with panels in relief sculpture; other objects ornamented the tombs.

The famous god of iron and war, Gu, brandishes the ceremonial blade, the *gubasa*, in each of his hands. The figure has been attributed to a blacksmith at the court of the kings Ghezo and Glélé and arrived at the Musée de l'Homme in Paris at the end of the nineteenth century, covered with his emblems: hat and bronze pendant, raffia cape, and silver amulet.

Beyond the art of the court, the Fon adopted the *vodun* (a corruption of the Yoruba word meaning god), which was exported to Brazil and Haiti at the same time as the slaves, trade in which was practiced on a great scale for more than two centuries. An affirmation of a supernatural world, the *vodun* also consists of a series of various procedures that permit one to enter into contact with the world beyond. The members of the *vodun* ask their religion for direct effectiveness in this world and a guarantee for the afterworld.

The Fon of Dahomey and the Yoruba of Nigeria have a noticeably uniform culture: under different names, the divinities have similar attributes and similar rituals. The very term *vodun* is Dahomeyan, where the Yoruba use the term *orisha*.

At the summit of the Dahomeyan pantheon reigns Mawu, the supreme god, surrounded by related gods, grouped in a sometimes hierarchical pantheon. In addition to the great gods of nature is a multitude of beings made divine: ancestors of clans, monsters, fetuses of royal lineages, and gods of subjugated tribes that have been assimilated or even bought— like the serpent of Ouidah.

Earlier, the princes of South Dahomey based their power on the *vodun*. At Allada, Abomey, or Porto-Novo, one of the most important ministers was the *akloga*, guardian of the kingdom's tutelary *vodun* and commander of the great religious ceremonies. For their part, the kings had their own personal diviners who would interpret the will of the *vodun*.

The *bochio* is a statue produced by the village blacksmith, who sculpts the trunk of a tree. The body of the personage is made from a pole which is planted in the ground. Placed at the entrance of a village or a house, the *bochio* protects its inhabitants by chasing away prowlers and ghosts. Thus, it is seen by all the community, as opposed to the majority of large ancestor statues, which are not communal. The quality of production varies according to the creator's talent; some of them barely go beyond the stage of a rough draft.

With the exception of Mawu, the creator, every god is represented by a "fetish": stones,

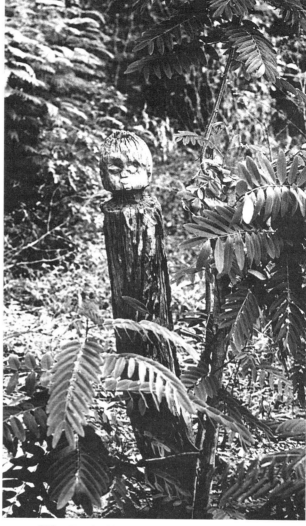

898 Fon *bochio*, Benin
In situ

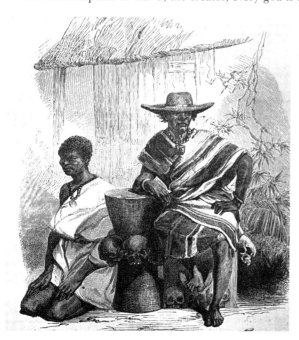

899 "King Ghezo and the Royal Prince Bahadou"
Drawing by Foulquier in "Voyage au Dahomey par le Docteur Repin," Le Tour du Monde, *1863*

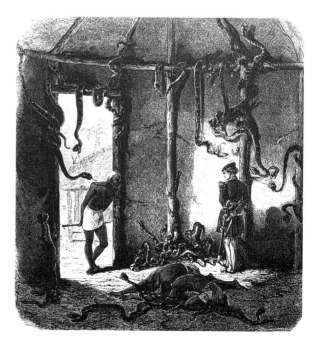

900 The interior of the Temple of Serpents in Ouidah
Drawing by Foulquier after a sketch by Repin in "Voyage au Dahomey par le Docteur Repin," Le Tour du Monde, *1863*

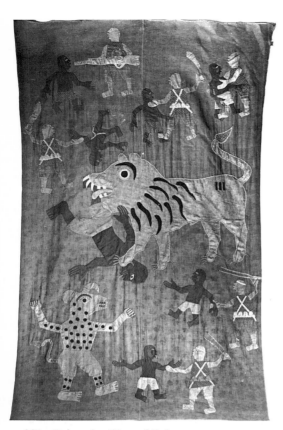

901 Behanzin, King of Dahomey, Defending His Subjects
Replica of a hanging for display. Musée des Arts Africains et Océaniens, Paris

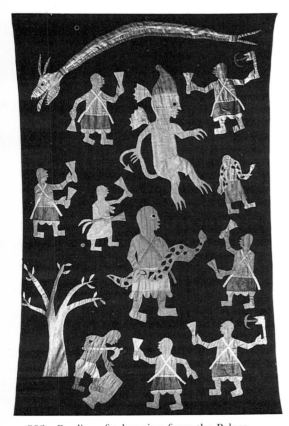

902 Replica of a hanging from the Palace of Abomey
Fabric with appliqué. Height: 220 cm. Musée des Arts Africains et Océaniens, Paris

plants, bases, iron pieces, anthropomorphic statues, wooden sticks, hillocks of soil, and so on. At the entrance of each district, one finds *vodun*s erected in a bar of clay, eyes made of cowrie shells. Frequently they are provided with virile emblems: Legba, comparable to Hermes, plays the intermediary and is represented by a more-or-less finely sculpted stick that is planted in the ground. Hevioso (Shango in Yoruba), is the god of thunder, Sakpata is the god of smallpox, and Gu is the god of war. All of them still have their shrines and religious communities in cities and villages in Togo, Dahomey, and western Nigeria. In certain regions, huts are buttressed by a subfoundation of clay statuettes that represent the *legba*, protectors of the house, who sometimes receive daily libations. In the center of the courtyard stands the *xweli*, who ensures the cohesion of the home (in the sense of a complete household). Then there is the hut of the *ase*, small parasols of forged iron, representing deceased ancestors. The faithful have the duty of feeding the god with sacrifices and offerings that give it its power.

Music and dance are closely connected with the cult, particularly in the possession ritual, a major aspect of the *vodun*, through which communication with the divinity is brought about: the god "straddles" the possessed dancer and thus incarnates itself in him. The cult is celebrated by priests who confirm that they are descendants of the gods and the first officiants. The future initiate feels the "call" of divination during a ceremony; accepted by the priests, he will be brought to a religious community, or "thicket," where he will undergo a long initiation period of several months or several years. During this period, the initiate will lose his mother tongue in order to acquire the "holy" language that he will use from then on during ceremonies. Once returned to civilian life, he will remain consecrated to the god and will participate in the ceremonies as "spouse" of the voodou (*vodun-si*). He will once again learn his mother tongue without ever forgetting the new language learned during initiation. During celebrations, the initiates dance together and wear the colors of the divinity.

In the *vodun* of the covens, the sculpted part of the object is hidden underneath the accumulation of the material that gives it its power: animal or human jaws, stakes, blocks, padlocks, nails, feathers, fur, magical ingredients, amulets of all kinds tied together with small, fine strings, the whole object covered with a thick paste of poured blood and offerings of palm wine, millet beer, or oil. Furthermore, the object is decorated with beads, bells, fabric, or mirrors, which add to its strangeness. Animal fur, feathers, teeth, jaws, and skins of snakes or other reptiles are necessary elements of the ritual and reactivate the object's power and effectiveness. These "accretions" of animal or vegetable origin refer to real or imaginary knowledge: the eagle's talon gives power, the duck's beak imposes discretion. The result is a strange, sometimes troubling, object, the mark of a supernatural that is little known, and more often willingly ignored.

A fetish cannot be bought in the open market; they are hidden from the public eye. To produce it one must turn to divination by the *fa* who, through the intermediary of the diviner, will indicate the list of materials and magical formulas that must accompany the fetish's fabrication for it to be sacralized. *Fa* geomancy, or divination by means of palm nuts, has been explained by a trained clergyman. *Fa* personifies destiny; at every birth and every stage of initiation it is consulted, as it is for every voyage or other such enterprises. The officiant for the *fa* is remunerated by the person consulting; he officiates with the help of nuts thrown on a tray, sometimes very beautifully sculpted ones. Divination by means of the *fa* is also used for political or cultural decision making: the diviners are then the proxies of power.

After the diviner's activities, the fetishist enters the scene. But to acquire renown, he must have a profound knowledge of pharmacopedia. The *vodun* cult, still actively practiced today, is not unique, but it has spread to an exceptional extent in this region of Africa, where it was born.

A. Le Hérissé, *L'Ancien Royaume du Dahomey* (Paris: 1911).

B. Maupoil, *La Géomancie à l'Ancienne Côte des Esclaves* (Paris: Institut d'Ethnologie, 1943).

C. Merlo, *Un Chef-d'Oeuvre d'Art Nègre: Le Buste de la Prêtresse* (Auvers-sur-Oise, France: Archée, 1966).

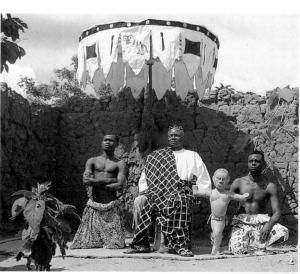

903 The King of Abomey with the war god of King Ghezo
In situ

THE YORUBA Nine to ten million Yoruba live in southwestern Nigeria and Dahomey. Their ancient urban system allowed the development of a political organization, military security, and rules of sanitation. Religion and the notion of the divinity of kings helped impose order and maintain it with the aid of discipline.

The Yoruba were traditionally divided into several kingdoms, the oldest of which was Oduduwa; its capital was Ile Ife, the most important sacred place. Power was in the hands of the king, delegate of the gods. He added equilibrium and control to the energy given him by the gods. He was chosen from among three or four royal families, the selection guided by divination; the title would pass from one family to the next. The king was the descendant of the Yoruba's mythical founder, Orisha Oduduwa, whose sixteen sons married and settled in neighboring territories, thereby creating their own kingdoms. The son who was Oduduwa's heir was the progenitor of the lineage of Ife kings, or *onis*, which includes twenty-six names. The fall of one of the principal kingdoms, where the sacred city of Oyo Ile was located, contributed to disarray in the most important kingdoms; in the nineteenth century, following civil wars, thousands of Yoruba were sent to Cuba and Brazil as slaves by their own neighbors.

Two-thirds of the Yoruba are farmers. Even when they live in the city, they keep a hut close to the fields in which they grow corn, cocoa, and yams. It is they who control the markets—along with the merchants and artisans: blacksmiths, copper workers, embroiderers, and wood sculptors, trades handed down from generation to generation. Those who serve in the justice system and in government are exempt from working the fields. Sculptors have studios in which apprentices learn the techniques of the master and his stylistic preferences.

The Yoruba gods form a true pantheon; the creator god, Olodumare, reigns over almost four hundred *orisha* and nature spirits who live among the rocks, trees, and rivers. These spirits can cause misfortunes and must periodically be honored during great celebrations. In *ifa* divination, the god Orunmila, who was present at the creation of the world by Olodumare, is consulted. Healers play an important role in opposing sorcery. They are symbolized by metal wands depicting a bird surrounded by smaller winged creatures. Their god, Osanyin, is a secret god who heals through deep thought and the science of herbs. His priests, who dress in white, hold a high rank in the Yoruba hierarchy.

Ogun, the god of iron and war, is the god of blacksmiths, sculptors, and the warriors who protect the city. Shango, god of thunder and lightning, is honored in both Nigeria and Dahomey. He is depicted by a very well-known Yoruba statue, which shows him dressed in the clothing of the priest of thunder, surmounted with a double axe. According to legend, he was the fourth king of Oyo and used his power in such a capricious way that he was forced to flee the city and died far away. Twins are the children of this god of thunder and, as so often in Africa, they are at the same time feared and seen as bearers of good if ritual duties have been properly executed. A statuette called *ibeji* used to be made, which, if one twin died, remained with the surviving twin and was treated, fed, and washed as a living child.

Obatala was assigned to reign over the waters, but before he left to accomplish the divine order, he fell asleep because he had drunk too much palm wine. Oduduwa replaced him;

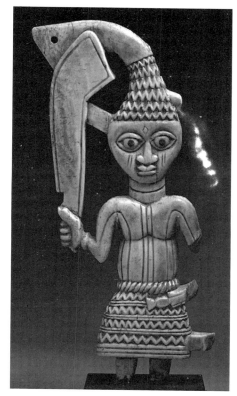

904 Bini-Yoruba ivory, Nigeria
End of 19th century. Height: 21.9 cm. Paul and Ruth Tishman Collection

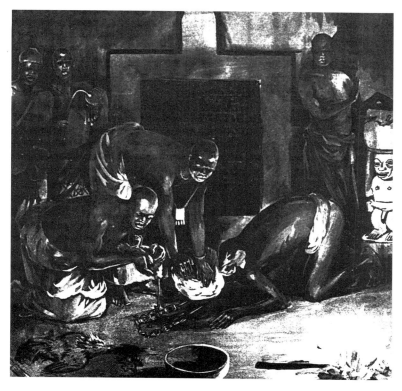

906 Anago ceremony of Benin
Old drawing

905 Priest and priestess of the Legba, Dahomey
In situ

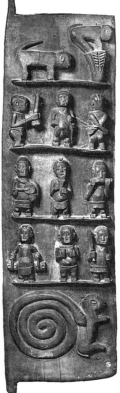
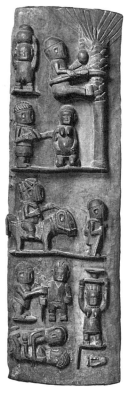

907–08 Nupe, Nigeria
Wood. Museum für Völkerkunde, Berlin

909 Stick for the *fa* cult, Yoruba
Ivory. Height: 31.6 cm. Private collection

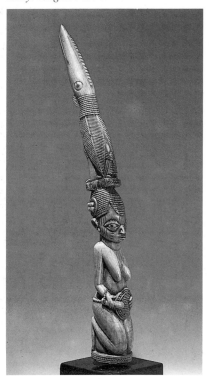

the latter then claimed to be the master of the earth. In order to put an end to this argument, the supreme god Olodumare decreed that Oduduwa would be considered the founder and first king of the Yoruba, while Obatala would be the creator of humans. Oduduwa's priests wear a white, conically shaped crown covered with beads. He is honored every year and offerings are made of white pigeons, flour, and water. He is the protector of albinos, the disabled, and the blind.

Oshun is a goddess who was excluded from the council of gods by the other *orisha*, all male. Consequently, their sacrifices were rejected at the door to paradise until she gave birth to Eshu, who allowed order and prosperity to reign on earth. Goddess of fertility, she protects children from smallpox.

In addition, more-or-less secret societies have their own ceremonies and exercise some powers. The male *egbe* society reinforces social standards; the *aro* society groups together farmers who lend each other assistance; the *esusu* society is for wealthy notables. The *gelede* society practices a fecundity-fertility cult that ensures its members prosperity and health by means of ritual dances carried out according to the will of the ancestors. Each dancer wears a mask atop his head; they perform every year during festivals as well as at members' funerals. They appear in pairs, up to a total of forty or fifty dancers, all with masks of different shapes and with specific names. Each pair performs alone, imitating the gait of certain animals or the flight of various birds. The Nago and the Holi of Benin, who also practice the *gelede*, use originally conceived abdominal masks.

The *ogboni* society consists of the elders of the village or the city who have decision-making powers. The division of power between notables and the *oba* ensures greater political stability. This group oversees the cult of the master of the earth, *onile*. In some cities, the secret *oro* society is responsible for the execution of judgments pronounced by the *ogboni*. The masks of the *oro* society feature two straight horns. Each *ogboni* house possessed a sculpted *agba* drum as well as a pair of *edan*, small bronze rods decorated with two figures, one male, the other female, whose heads are bound together with a chain. A large variety of figures with severe expressions suggest the moral vigilance of the society's members from which nobody can escape, not even the king.

Yoruba sculpture is sometimes linked to architecture: doors decorated with sculpture in low relief and pillars with sculpted figures and geometric motifs decorate the palace courtyards, the houses of notables, and sacred places. Priests have bronze sticks that announce the presence of Eshu in masked ceremonies. Objects of prestige are reserved for the great and beaded objects for kings.

Divination is practiced using nuts manipulated on rectangular, circular, or semicircular trays that bear a portrait of Eshu on one side; these nuts are kept in cups and bowls; the base is frequently in the shape of a horse and rider, warrior, or chief. A few very refined ivory cups were used only by kings or chiefs.

Societies and cults still hold celebrations today during the many masked festivities in which costumes of fiber or fabric, masks, music, and dance form one interlocking whole. In certain regions the *epa* parallels the fertility cult of the *gelede*; it takes place every other year, in March, and lasts for three days. The masks, which sometimes are as high as one-and-a-half meters tall, have a grotesque Janus-head at their base, surmounted by a disk that supports the superstructure, which consists of more naturalistic figures or animals (crocodiles or hippopotamuses) superimposed.

The *egungun* is an ancestor cult originated by Oyo. Among the Yoruba of the northeast, the *epa*, or *elefon*, glorifies heroes: their effigies are statuettes that hold a knife or lance in their right hand. The celebration of *magbo-ekine* honors the water spirits; among animal masks one finds the *igdo* (bird), the *agira* (antelope), and the *oni* (crocodile).

The tradition of sculpture is still an important one, but masterpieces are rare. Several styles can be distinguished: sculpture of the coastal regions closer to Benin features almond-shaped eyes and hands at right angles to the body. On the other hand, in the north, in Oyo and Igbomina, the eyes protrude, the hairdo is elongated, and the arch composed of the shoulders and arms is fastened directly onto the cylinder of the torso. Recent studies by William Fagg have prepared the way for more precise differentiations between studios and schools.

K. Carroll, *Yoruba Religious Carvings* (New York: Praeger, 1967).

H. J. Drewal, *African Artistry* (Atlanta: The Arnett Collection, High Museum of Art, 1980).

H. J. Drewal and M. Thompson Drewal, *Gelede: Art and Female Power among the Yoruba* (Indiana University Press, 1983).

W. Fagg and J. Pemberton, *Yoruba: Sculpture of West Africa* (New York: Knopf, 1982).

R. F. Thompson, *Black Gods and Kings: Yoruba Art at UCLA* (Los Angeles: University of California Press, 1971).

P. Verger, *Notes sur le Culte des Orisa et Vodun à Bahia, la Baie de Tous les Saints, au Brésil et à l'Ancienne Côte des Esclaves en Afrique* (Amsterdam: Mémoires de l'Institut Français d'Afrique Noire, 1957).

———, *Orisha* (Paris: A. M. Métalié, 1982).

Archeology and History in Nigeria

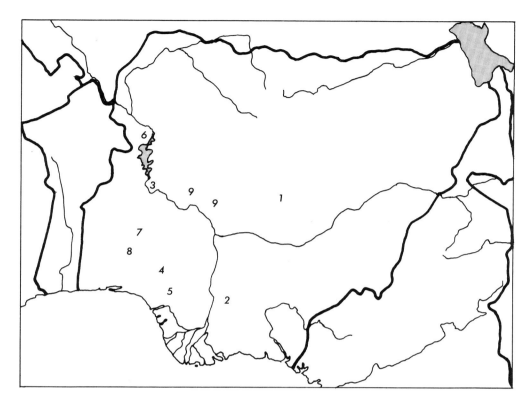

1 Nok
2 Igbo-Ukwu
3 Tsoede
4 Owo
5 Benin
6 Yelwa
7 Esie
8 Ife
9 Nupe

N O K Nok civilization received its name from the village in which terra-cotta sculptures, the first to be known in sub-Saharan Africa, were found. They were discovered by chance in 1943 in a tin mine, encased in the same alluvial layer as the metal. According to Thurstan Shaw's research (1978), the Nok region is a crescent-shaped zone situated between Katsina Ala in southwest Nigeria and Kagara in the northwest, which from the first millennium has been a favorable area for the cultivation of yams and palm oil; yet it is impossible to determine exactly when harvest-gathering left off and cultivation-production began. Tools meant for clearing land and digging wells have been found that date back to this era, as have small stone axes that must have served to cut wood, and larger ones used for agricultural work on the shores of rivers; in one sculpture, three figures carry an axe on their shoulder, but it is impossible to determine whether these were iron or stone axes. Since in Africa the transition from the Stone Age to the Iron Age was direct, the techniques of bronze and copper smelting did not appear until later, probably imported from the north, either from Chad or Carthage, by the Sahara Berbers.

Nok sculpture, therefore, is the work of settled farmers who had no cattle, it seems, and who were familiar with the technique of smelting iron. In later excavations, millstones for milling grain have been discovered, as have clay nozzles and pieces of scale from furnaces.

In 1943, the so-called head of Jemaa was uncovered at a depth of 8 meters in the village of Tsauni, in the hills above Jemaa. Soon after this discovery, the mine was flooded, and the head was used as a scarecrow for a full year before it was bought by the mine's director to show to a young administrative officer, Bernard Fagg, a trained archeologist. He connected it with an early monkey head found in gravel in 1928.

In 1952, the Museum of Jos's opening in Nigeria awakened great interest; the number of objects collected began to increase markedly, and now totals 150 pieces. The terra-cottas originated in a zone to the north of the confluence of the Benue and the Niger rivers, covering an area of 480 kilometers from east to west and 160 kilometers from north to south. This vast area allows one to assume that Nok society was hierarchical and endowed with centralized political and religious power.

All the objects from this valley were found in a thick layer of clay that could have been formed only after an intensive rainfall, which we know occurred around the year 500 B.C. Thermoluminescent and radiocarbon tests have confirmed the approximate dates of from 600 B.C. to A.D. 250.

An examination of pieces allows one to conclude that they were made by hand and not cast; variety and inventiveness do not exclude a certain stylistic homogeneity. The craftspeople used a high-quality clay mixed with other materials; they baked it to obtain a solid consistency. The evenness of color obtained demonstrates technical mastery. The sculptures' size varies in height from 10.5 centimeters (for the Bwari figure) to lifesize. Some

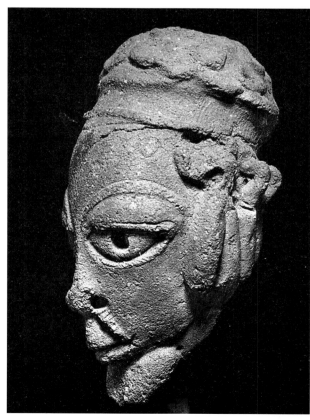

910 Nok head, Nigeria
Clay. 1st century B.C. Height: 22.9 cm. National Museum, Lagos, Nigeria

heads are as tall as 37.5 centimeters, and the statues to which they were attached must have been 1.4 meters high. However, complete pieces are very rare and the majority measure about 30 centimeters. The statues were carried off by floods; the heads survived due to their spherical, ovoid, or cylindrical form, while the bodies apparently were not able to survive shifts in the sedimentation.

The head represents one third or one fourth of the total figure: this is very different from the proportion of the real head to the human body, which is approximately one seventh. Similarly, the head and arms are accentuated in relation to the thorax and lower extremities. The kneeling, seated, or standing figure generally stands on a pedestal, circular in form and 20 centimeters in diameter. In addition, pottery, finely decorated with friezes of animals or people, has been found.

Two stylistic tendencies stand out: the first tends toward relative schematization, the second toward naturalism. Originating in the Gold Coffer mine, the pieces with large ears form a specific substyle. The concern with corporeal details, the search for expressivity, and the treatment of the eyes are the most obvious characteristics. The eyebrow, stylized into an angle or a rounded arc, balances the curve of the lower eyelid in such a way that the whole forms a shaded circle. This triangular shape of the eye is still visible today on the *gelede* masks of the Yoruba. In the majority of pieces, the ears, nostrils, eyes, and mouth are pierced with holes; in the case of the eyes, this emphasizes their gaze. The nose is often short, wide, and powerful, as is the mouth, with its wide lips that are sometimes open, turning up toward the nose, which gives them a sulking look. The ears are merely pierced, sometimes placed at the level of the jaw, sometimes at the height of the eyes, or toward the back of the head. Some heads have been elongated; others do not have a sculpted frontal part: doubtless, they used to be placed on the ground or hung on a wall. The surface is smooth, sometimes scarified, resembling the very beautiful head of a cat with whiskers. Male attributes are indicated by a pointed beard or by mustaches in striations or rendered by two tufts on either side of the mouth. The hair is very elaborate, in bands, shells, or braids, and is always carefully marked off on the upper part of the forehead, sometimes by a string of beads. The figures are decorated with necklaces, beads, bracelets, and cylinders of quartz at the ears, nose, and lips; the hair has holes that would, no doubt, permit the insertion of feathers.

Representations of animals—monkeys or elephants—remain rare, but in pottery, the serpent is rather frequently used as a decorative element and is depicted in a more realistic manner than humans are; there is no real portraiture. No doubt, those who lived in Nok used to have the same hesitations about portraits that the Bini and Yoruba have today: if one has a portrait done, does one not lay oneself open to the possibility of actions taken by evil powers against one's double? On the other hand, the Janus theme appears again: a frequent motif in African sculpture.

These sculptures probably fulfilled the same function that Yoruba sculptures do today: maintaining a relationship between the supernatural and material worlds. Given their subject matter and approach, they would have played a religious role; cult objects, they no doubt honored gods or mythical ancestors, the sources of the life force.

Female figures have their hands placed on their breasts, a gesture emblematic of fertility. With the small Bwari figure, the right hand is placed on the head, which traditionally indicates respect and obedience. These sculptures may have been put on tombs, as funerary furnishings, according to the still-recent practice of the Mumuye, who placed terra-cotta figures in the highest part of their funerary chambers. In the Nok region and in northern Nigeria, the Dakakari, among others, still make terra-cotta sculptures that they put on tombs; the Tiv, on the other hand, make spirit dwellings out of them; the Jaba crown their living spaces with decorated pottery. Judging from their locations at the time of their discovery, one may assume these sanctuaries existed at the edge of newly cleared lands and that their creation led to the abandonment of the older ones: hence, the fragments found in the alluvium.

Nok sculpture probably developed out of a much older pottery art. Nevertheless, there seems to have been a hiatus of several centuries before Ife art appeared. It would be surprising if the Nok culture had disappeared so suddenly. Other centers of sculpture, buried deeply, are probably extant, but they will be difficult to find to the degree that erosion and sedimentation have created shifts in the earth's surface in this area. Thus, Nok is one of the links essential in reconstructing archaic ancestral forms of sculpture.

B. Fagg, *Nok Terra-cottas* (Lagos, Nigeria, 1977).
T. Shaw, *Nigeria, Its Archaeology and Early History* (London, 1978).

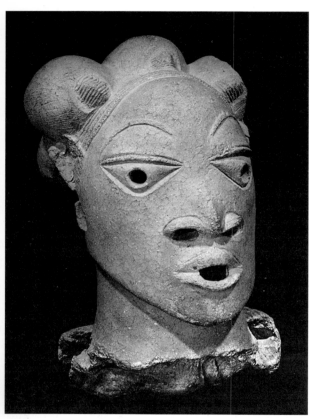

911 Nok head, Nigeria
Terra-cotta. 10th century B.C.–A.D. 3rd century.
Height: 36 cm. National Museum, Lagos,
Nigeria

IGBO-UKWU The Igbo-Ukwu bronzes, like the Nok terra-cottas, were discovered by chance in 1938; excavations did not begin until 1959. South of the Benue river and east of the Niger, in a territory occupied by the Igbo and the Ijo, three sites have been brought to light, the first one clearly a former sanctuary containing regalia; the second a funerary chamber, now reconstructed, including the seated skeleton of a high-placed dignitary attended by several slaves; and, finally, a ditch in which various utilitarian objects had been tossed, among them richly decorated pottery.

The archeologist Thurstan Shaw (1970) undertook dating tests, four out of five indicating the ninth century. However, Denis Williams (1974) suggests the seventeenth century; his refutation lacks conviction, even though copper, which was not present in Nigeria, did not arrive from the Sahara or northern Africa before the eleventh century. On the other hand, colored beads probably originated in the Arabo-Islamic world after the conquest of Egypt by the Arabs, which took place in the seventh century. The Igbo traded ivory and slaves from southeast Nigeria for these.

The objects give proof of great technical virtuosity: a care taken with the etching and relief surface and a real decorative inventiveness (human heads, serpents, birds, insects). In the dignitary's funerary chamber, bracelets, jewelry, a crown, the handle of a fan, and a breast plate were found. The leopard's skull was an insignia of rank. This refined court art was perpetuated around the person of a divine king; yet it has not been possible to define the type of cult it represents, even though the placement of the first piece discovered evokes an altar.

T. Shaw, *Igbo-Ukwu: An Account of Archeological Discoveries in Eastern Nigeria* (London: Faber and Faber, 2 vols., 1970).
D. Williams, *Icon and Image* (London: Allen Lane, 1974).

912 Reconstruction of the funeral chamber of a dignitary, Igbo-Ukwu
Watercolor by Caroline Sassoon

IFE According to Frank Willett, four centuries separated the end of Nok society from Ife culture, whose first bronze and terra-cotta heads were discovered in 1909 by Leo Frobenius; at the time he assumed they were of European origin. In 1938, on the site of Wunmonije, close to the palace of the *oni*, the religious chief of Ife, eighteen bronze heads were brought to light, again by accident, found at a depth of 60 centimeters. The two principal sites of Wunmonije and Ita Yemo revealed a series of bronzes and terra-cottas. The latter, thanks to datings from radiocarbon tests done by Shaw, are known to predate the arrival of the Europeans in 1485; the efflorescence of the city is now dated as between the eleventh and the fifteenth centuries. The production of bronzes continued into the middle of the nineteenth century.

The former religious capital of Nigeria, Ife gave its name to this art of sculpture in bronze and terra-cotta. At the end of the fifteenth century, the first European visitors to the city of Benin recounted that the king, when he assumed the throne, sent gifts to the *oni* of Ife who, in return, would give him a stick, a cap, and a cross of copper; these symbols of authority would confirm his position. Ife was one of the numerous city-states established by the Yoruba, who concentrated themselves in villages protected by thick walls. This arrangement was perhaps in response to an outside threat from the powerful empires of Mali and Songhay, who used to organize raids for their slave trade. Geographically, Ife was the center of a commercial exchange system, which fostered the emergence of cults intended to protect the agricultural community. The great archeological sites are on the outside of the present-day city limits, which at that time extended well beyond the city walls.

The introduction of the lost-wax technique poses an as yet unresolved problem; Willett (1967) suggests that it may have come from the Sudan or the Mediterranean, thanks to one or several traveling blacksmiths who used it to make knives and bells. Tradition reports that it originates with Obalufon II, the third *oni* of the Oduduwa dynasty.

If the bronze heads were made as funerary effigies of kings, their production spread over a period of three or four centuries—if one counts twenty years per reign. But Ulli Beier (cited by Willett) notes that, according to the existing tradition in Ijebu, the kings were put to death after a reign of only seven years, which would reduce the duration of this production to one-and-a-half centuries.

The fabrication of bronze and beads was a royal prerogative. Heads were intended for the sixteen *oba*, subject to the spiritual authority of Ife, which gave them the right to wear the beaded crown. Ife's prosperity between 1100 and 1450 permitted the development of a royal court art and the establishment of sanctuaries and cults.

The head that Frobenius discovered at Olokun Grove outside the city would have been brought out every year for sixty years for annual celebrations. The Yoruba claimed that the so-called Obalufon mask never left Ife palace. However, in 1949, it was noticed that the head of Olokun was a fake, made by sand-casting, not the lost-wax technique; the original has never been found. Frobenius took seven terra-cottas with him for German museums.

At the site of Wunmonije, behind the palace, the excavation of the foundations of a house uncovered thirteen bronze heads along with four others the following year. Although not portraits, they are naturalistic in character, close to life-size, with holes in which to insert hair, mustaches, and beards.

In 1957, at Ita Yemoo, new and smaller heads were found as well as a complete figure that measured 48 centimeters, a couple of standing figures thought to be the *oni* and his spouse, and a small female figure. In all, there were about thirty bronze pieces.

Terra-cotta heads are more numerous, their size varying from life-size to just 15 centimeters. Their style may be different from one piece to the next and the period of

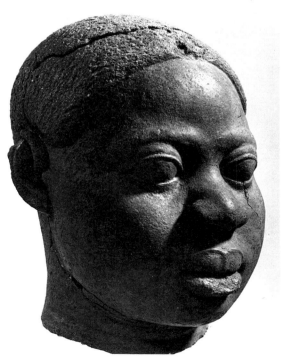

913 Ife head, Nigeria
Terra-cotta. 12th–15th century. Height: 20 cm. National Museum, Jos, Nigeria

535

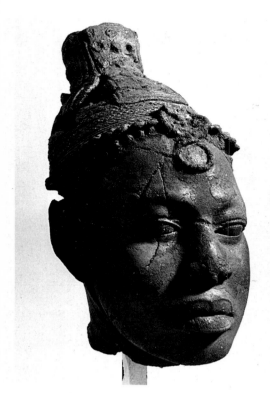

914 Ife head, Nigeria
Terra-cotta. 13th century. Height: 25.4 cm.
National Museum, Lagos, Nigeria

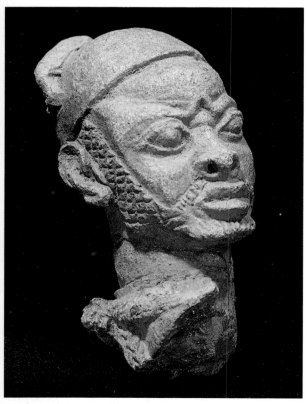

915 Head of a bearded person, Igbo Laja,
Owo, Nigeria
Terra-cotta. 15th century. Height: 11 cm.
National Museum, Lagos, Nigeria

production must have been vast. Fagg and Willett see the Ife style as close to that of Nok, which lies 400 kilometers away. Willett supports this claim by pointing out a resemblance between details, such as the curls of their hair and the swollen lower lips.

Ekpo Eyo has undertaken other excavations at Odo Ogbe Street, where a very beautiful terra-cotta was fortuitously found. Almost all bronzes there are heads, three of them with crowns, but the other heads must have been wearing actual crowns since the holes for attaching them exist. They were probably placed on wooden bodies at the time of the king's second funeral, which would take place several months after his death, thus stressing the perpetuation of power. A few standing statues wear almost identical costumes: heavy necklaces and a pendant on the chest, the royal emblem. There are also some chairs and statues of stone, depicting animals, rams and leopards, who, with the elephant, might have been royal animals.

The more numerous and stylistically more varied terra-cottas are sometimes marked with "cat whiskers" scarifications, which are also found among the Nupe—who themselves, are supposed to have borrowed these from the Yoruba of the north.

Ife art undoubtedly had its beginnings in terra-cotta and was later transposed into metal working. From the sixteenth century on, Ife lost its political role and kept only its religious power.

E. Eyo and F. Willett, *Treasures of Ancient Nigeria* (Detroit, 1980).
W. Fagg, *Nigerian Images* (London: Lind Humphries, 1963).
F. Willett, *Ife in the History of African Sculpture* (London: Thames and Hudson, 1967).

TSOEDE According to legend, Tsoede was the founder of the Nupe kingdom in the sixteenth century. A guard at the court of the king of Idah, he is reported to have fled and gone up the Niger River in a boat, taking with him nine bronzes, which he then deposited in the village of Tada on the right shore of the Niger, as well as on the island of Jebba, where they were found.

Willett (1967) thinks that the statue of a seated man is the work of an Ife blacksmith. It was cast in bronze, but not very successfully because of its remarkable size (53.7 centimeters). This piece has been dated through thermoluminescent tests as having been made at the end of the thirteenth century, which is the date given to the most ancient casted pieces from Ife.

Yet, it differs from the Ife works in the naturalistic proportions of its head and extremities. Its surface is eroded, as the Nupe, who now are Moslems, had the custom of carrying it to the river every Friday and rubbing it with gravel in order to guarantee their fertility and that of the fish they ate. Its complex pose, the left knee on the ground and the right one raised, does not correspond with the symmetrical balance and vertical axis that generally characterize African sculpture. Its expression is one of utter calm and serenity.

F. Willett, *Ife in the History of West African Sculpture*, op. cit.

OWO Located about 130 kilometers southeast of Ife, equidistant from Ife and Benin, Owo, local tradition says, was founded by Ojugbelu, the youngest son of Oduduwa, himself the founder of Ife. Oduduwa is supposed to have taken advantage of Ojugbela's departure hunting to divide his possessions among his other sons. Enraged, Ojugbela left Ife and settled in Owo with other chiefs of the clan, probably during the fifteenth century.

The site of Igbo Laja, close to the palace of Olowo and the center of the city, was discovered by accident. In 1969, excavations uncovered three successive layers. The first, at a depth of from 20 to 30 centimeters, contained several terra-cottas radiocarbon dated as from the fifteenth century; the second, deeper, layer only furnished two pieces from the eighteenth century and a few even more recent; in the third, eight stone axes and thirty miniature jars were found. Their concentration in one area led archeologists to conclude that the pieces had been sheltered under the cover of a building. Older pieces situated on the same level as the newer ones probably had been reused in more recent ritual contexts and been buried again after each use. Fragments of the same piece, found at a distance of 4 meters from each other, perhaps prove that the sanctuary had been brutally destroyed during the era when Benin was trying to conquer Owo, an attempt that ended in failure according to the Owo people; but their claim may be doubted, given the expansion and hegemony of the Benin empire starting in the fifteenth century.

Owo was known as an important center of artistic production, with its own style. In the oldest sculpture, a kinship with the "classical" Ife style can be observed, with hints of a certain naturalism, notably in the presence of four vertical scarifications above the eyebrows. Some heads bear the same vertical lines that are interpreted as the "screen of beads" that would hide the *oni*'s face, depicted on Ife terra-cottas and bronzes. Nevertheless, movement, gentleness, sometimes a true *joie de vivre*, and a variety of expressions, all demonstrate exceptional qualities that bring these sculptures close to portraiture.

Willett estimates that Owo art has traces of Ife art as well as Benin art: as in Ife, the upper eyelid overlaps the corner of the lower eyelid; the lips are surrounded by a line in relief, while their corners are marked by a hollow. Yet, the headdress is never a crown, as it is in Ife, but rather a kind of hood. Certain ornamental motifs are reencountered in the pottery: serpents, fish, and leopards. Since works in the Owo style were found at Ife, it is reasonable to assume that artists had frequent contact with each other and that they may well have worked for either of the two city-states. Yet, some forms, such as the basket of sacrificial offerings, are found only in Owo.

The ancient artistic products are characterized by a certain stylistic unity, which was interrupted; it then resumed again after a rather long interval, when the preceding style was merely reiterated, thereby bringing in its wake a clear-cut decline.

F. Willett, "The Benin Museum Collection," in *African Arts*, VI, 4, 1973.

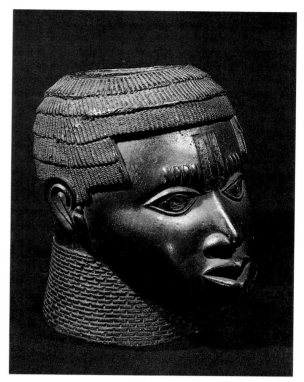

916 Head of an *oba*, Benin, Nigeria
Bronze. 15th century. Height: 21 cm. National Museum, Lagos, Nigeria

B E N I N Benin bronzes are better known than the artworks from Ife or Owo due to their presence in Western museums since the 1890s. Furthermore, their production continued until the end of the nineteenth century and accounts for four thousand to seven thousand pieces over a period of five centuries. Moreover, the proximity of the Atlantic coast permitted constant contact with Europe starting at the end of the fifteenth century.

The enormous amount of information available comes from several sources: travel accounts by European visitors from the end of the fifteenth century to the nineteenth century; the *Short History of Benin*, a transcription of the oral tradition of the twelfth century, written in the Bini language by the chief-historian Jacob Egharevba. (Bini writing dates back to the end of the nineteenth century, and the dating of events by this "history" is not very credible, for it sometimes condenses series of events.) Finally, a third source of information is the plaques from the palace of the *oba*, which date from the sixteenth and seventeenth centuries and which offer a wealth of information on costumes, dwellings, and weaponry; they also include "portraits" of some Portuguese. In the thirteenth century, the city of Benin was an agglomeration of farms enclosed by walls and a ditch. Each clan was subject to the *oba*, who was given his power by the *ogane*, a powerful sovereign whose kingdom lay "a several days' walk toward the East."

According to legend, the first inhabitants, the Bini, who spoke the Edo language, came down from heaven. More prosaically, they are thought to have come from the Sudan or from Ife. Even though they were led by a king, of the Ogiso dynasty, their social organization was based on age classes and more closely resembled that of the Igbo of eastern Nigeria. Around the twelfth century, an internal problem of succession brought the Bini peoples to consult the Yoruba monarch Oduduwa, the founder of Ife, who tested them by sending them seven lice; they took care of the tiny insects for one week, then sent them back. Oduduwa, convinced, sent them his son, Oranmiyan, whose son, in turn, was Eweka I, the progenitor of the present *oba*, the thirty-seventh of the dynasty.

Benin adopted the Yoruba model, based on alternating power among four royal families controlled by district chiefs and by the chiefs of the *ogboni* society. But very quickly rulership became absolute; the "Benin style" is a court art from the palace of the *oba*, and has nothing in common with tribal art. The *oba* and his entourage became the priests of a state religion, created to glorify temporal power.

Custom required that at the death of the *oba* his head be sent to Ife for burial. Ife, in turn, had a bronze head made that would be placed on the ancestral shrine. Around 1400, the sixth *oba*, Oguola, asked the *oni* of Ife for a master smelter to teach the art of commemorative heads to the Bini artisans. The *oni* sent him Iguegha, still honored today by the makers of bronzes from the district of Iguneromwo.

Due to his wealth, which stemmed from a monopoly in commercial exchanges with the Portuguese and his half of the profits from the sale of ivory brought back by hunters, the Benin *oba* employed a guild of artisans who all lived in the same district of the city. Bronze figures ordered by the king were kept in the palace. The empire flourished until 1897, when the palace was sacked by the English in reprisal for an ambush that had cost the vice-consul, J. R. Philips, his life. The latter had wanted to pay a visit to the *oba*, Ovonramwen, on what happened to be the day of the Igue ceremony when the king's body is regarded as a sacred being and becomes divine. Philips had broken the prohibition against entering the city; all but two of the members of his party were killed. The English then organized a punitive expedition and, upon the city's surrender, seized its treasure, that is, the two thousand sculpted plaques in the palace, a certain number of which are in the British Museum today.

Fagg has grouped the Benin heads into three periods based on successive styles; this classification has been continued and refined by Philip Dark, who suggests five stages: the first period begins with the introduction of bronze in the fourteenth and fifteenth centuries; it shows a direct influence from Ife, notably in the thick necklace placed under the chin. In the second stage, corresponding to the first half of the sixteenth century, the head has a not very substantial round base. In the third, from the end of the sixteenth to the eighteenth century, the heads have higher bases that go all the way up to the lower lip. The fourth stage runs through the eighteenth century and does not differ much from the preceding one. The fifth period ends in 1897, the year of the British punitive expedition, when the *oba* was deposed and Benin colonized; it is distinguished by "winged" hairdos. Nevertheless, this

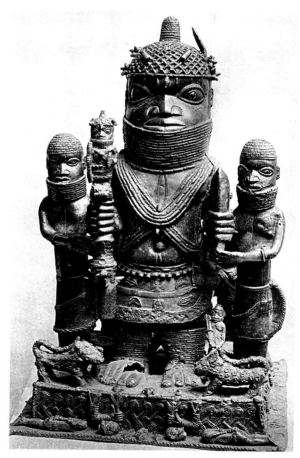

917 Shrine group from Benin: An *oba* and two foreign slaves
Bronze. 1750–1800. Height: 56 cm. Museum für Völkerkunde, Berlin

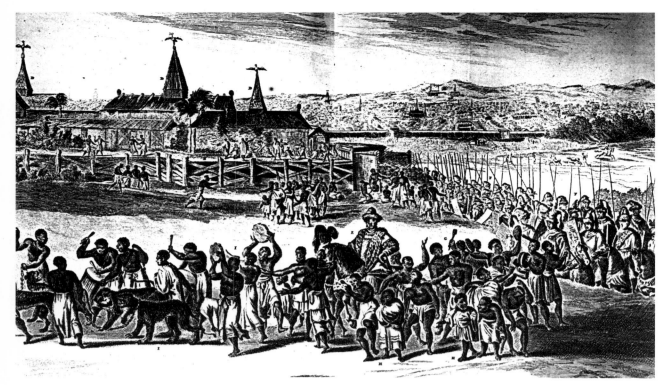

918 The city of Benin
Drawing in Olfert Dapper, Description de
l'Afrique, *Amsterdam, 1686*

classification, based on a criterion of "comparative naturalism," has been strongly contested by Pasztory, Douglas Fraser, Williams, and Arnold Rubin, who refuse to acknowledge any connection between Benin and Ife. The first, uncrowned, heads would then supposedly symbolize a deceased king and the more recent ones would be reproducing the ancient models. The terra-cottas might be copies of earlier bronzes.

For Fagg and Dark, the first group of works, from around 1500, consists of heads slightly smaller than life-size. Their naturalistic style would connect them to Ife, even though they are more stylized and therefore less individualized.

In works of the second period, the face is inscribed in a rectangle large enough to allow the nose, eyes, and upper lip to be seen, while the beaded decoration assumes an importance hitherto unknown. Surmounted by sculpted ivory tusks, these heads had above all to support the tusks' weight.

According to Nyendael's account, from the eighteenth century on (the beginning of the third period), the kingdom was devastated by civil war and the ensuing instability contributed to the rapid decline of Benin sculpture. Although the subject matter is the same, the more massive heads have hypertrophied features and the necklaces take on excessive proportions. The reign of the *oba* Eresonyen then saw a certain renaissance, accompanied by a dazzlingly "baroque" treatment of the helmets.

On the wooden columns that supported the roof structure of the palace, the rectangular bronze plaques recounted scenes of life at court. According to tradition, production of these plaques began at the start of the sixteenth century and ended around 1700. According to some authors, the form is not very African in conception: it can be "read" like a page in a book. The characters, dressed in sixteenth-century Portuguese costume, indicate the cut-off point in time of this production. Little by little, the high relief of "measured classicism" replaces the original low relief. For Fagg, the whole gives an impression of a rather monotonous conformity, despite some attempts at perspective in the Western manner. The style degenerated rapidly, sculptors emphasizing force and weight, which the massive importation of metal by the Portuguese allowed them to do.

Ivory was a material reserved exclusively for the *oba*, who distributed sculpted pieces; ceremonial jewelry can be found, notably armguards that consist of two cylinders sculpted as a single piece. Starting from the second half of the nineteenth century, fully sculpted elephant tusks decorated the heads placed on the shrines of royal ancestors. In 1914, the *oba* began to restore some of these shrines.

In the little town of Udo, situated on the other shore of the Oria River 33 kilometers from Benin, several heads in the provincial Bini style have been found. They represent Bini chiefs, *obas*, or Portuguese soldiers and date from the eighteenth century. Featuring a border at the base, they are rather naive imitations of more refined pieces.

In the rural areas and in the city of Benin itself, for more than a century the Bini used to place rams' heads, *uhunmwun-elao* (similar to those of the Yoruba at Owo), on their shrines. These represented a male ancestor to whom sacrifices were made at the time of the yam harvest. The horns and the jutting chin probably express fertility. These heads, independent in style, kept their vitality during the period of decline of Benin art.

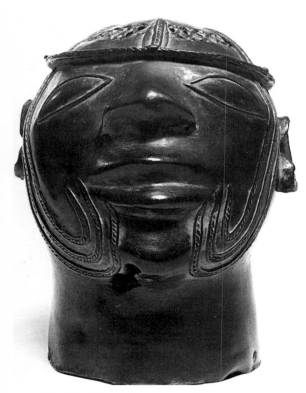

919 Head from the Lower Niger, Nigeria
*Bronze. 16th century. Height: 17 cm. Museum
für Völkerkunde, Berlin*

P. Ben-Amos, *The Art of Benin* (London: Thames and Hudson, 1980).
P. Dark, *Benin Art* (London: Paul Hamlyn, 1969).
W. Fagg, *Nigerian Images,* op. cit.

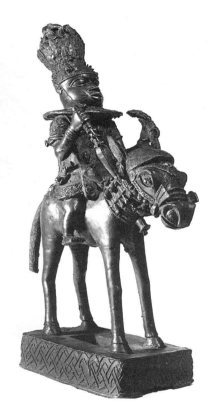

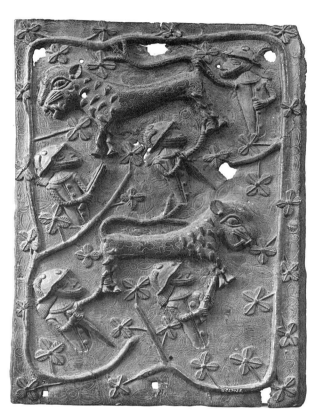

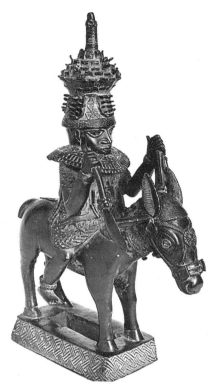

920 Horseman from Benin, Nigeria
Bronze. 18th century (?). Height: 59.3 cm.
British Museum, London

921 Plaque from Benin, Nigeria
Bronze. 16th century. Height: 53.5 cm. Museum
für Völkerkunde, Berlin

922 Horseman from Benin, Nigeria
Bronze. 17th—18th century. Height: 47 cm.
Private collection

The Central Sudan

(Chad, Nigeria, Cameroon)

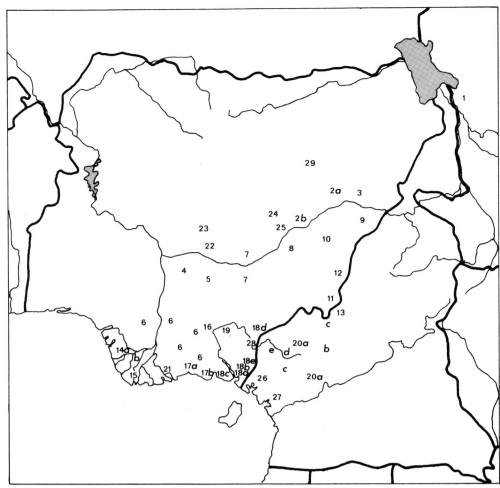

1 Sao
2 a) Montol, b) Goemai
3 Wurkum
4 Igala
5 Idoma
6 Igbo
7 Tiv
8 Jukun
9 Mumuye
10 Chamba
11 Jompre
12 Mambila
13 Kaka
14 a) Urhobo, b) Itsoko
15 Ijo
16 Afikpo
17 a) Ibibio, b) Eket

18 Cross River: a) Efik
 b) Ejagham, c) Oron
 d) Boki, e) Anyang
19 Mbembe
20 Cameroonian Grassland:
 a) Bamileke, b) Bamum,
 c) Tikar, d) Batcham,
 e) Bangwa
21 Ogoni
22 Afo
23 Koro
24 Mama
25 Djibete
26 Bafo
27 Duala
28 Keaka
29 Mboye

923 Sao head, Chad
Terra-cotta. Height: 6.5 cm. Museum d'Histoire Naturelle, La Rochelle, France

THE SAO The Sao have one of the most ancient civilizations in West Africa; it developed south of Lake Chad in a low plain regularly flooded by rains. For Jean-Paul and Anne Lebeuf, who have gone on excavations there, this region is an area of contact and cross-fertilization and, at the same time, an insular place in which conservatism and individualism are intensified.

The term "Sao" means "people of earlier days" and designates the successive emigrants who moved into the plain. They settled on the hilltops presently occupied by the Kotoko, who claim to be the direct descendants of their Sao ancestors. Iron has been in use since the fifth century B.C. in Daima and coexisted with a pottery art without human representation. In the twelfth and thirteenth centuries, more extensive population centers, surrounded by low walls of raw earth, were created. New emigrants brought with them the lost-wax technique of bronze casting and the custom of burial in coffin-jars, which coincides with the appearance of anthropomorphic and zoomorphic pottery. They are then thought to have reorganized into small kingdoms consisting of several villages. In the fourteenth century, the Sao had to defend themselves against their neighbors, the sultans of Kanem. Two centuries

later, invaders from the east destroyed the cities and the inhabitants took refuge in northwest Cameroon, where they intermarried and thus formed the Kotoko ethnic group.

The Lebeufs divide sites into three primary types: Sao I is characterized by small hilltops of low elevation. These contain no graves but must have served as places of worship or initiation. Fragments of terra-cotta have been found, including some human and animal figurines. Sao II includes hills of larger size surrounded by a ring of walls. Sao III is the most recent site.

In the necropolises, urns contained skeletons and were enclosed by a second urn that formed a cover. The base was often pierced. This type of sepulcher dates from the twelfth century and seems to have been supplanted by burials in the earth from the fifteenth century on. The terra-cottas that depict people and animals generally come from sanctuaries and places of offering; only about a quarter of them were found to be associated with funerary rituals. Indeed, for reasons that have yet to be explained, some of them are only heads. Their height varies from between 8 and 12 centimeters.

Complete renderings are of ancestor figures, founders of the city, represented by a simple trunk with sketchy arms, and with an emphasis on the features of the face; others are masked dancers, which are coarser and frequently out of proportion. Figures are ornamented with bracelets, necklaces, and carefully fashioned scarifications.

The Lebeufs suggest that these figures might have been used in hunting and fishing rituals. The pendants had a prophylactic use—for example, in the case of a breaking of a taboo.

Statuettes of founding ancestors of clans were grouped together in public sanctuaries, surrounded by other animal or human terra-cotta figures.

B. de Grunne, *Terres Cuites Anciennes de l'Ouest Africain*,
 op. cit.
J.-P. and A. Lebeuf, *Les Arts des Sao* (Paris: Chêne, 1977).

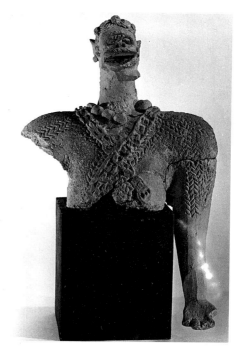

924 Sao terra-cotta, Chad
Collected in 1948. Height: 20 cm. Musée de l'Homme, Paris

The Right Bank of the Benue River

THE MONTOL, THE GOEMAI Settled on the northern shore of the Benue, between Jos and Shendam, the Montol have a population numbering close to 10,000.

The sculptures, whose size varies between 40 and 65 centimeters in height, are used in divination rituals, whose purpose is to find the cause of illness, as well as healing. The simplified faces are topped by a flat or crested hairdo. The statue is standing, the arms separated from the trunk, hands flat, legs in an inverted "V" or "U," featuring massive hips. The patina is sometimes natural and light, sometimes red-tinted. As with the Mbembe, the Montol sculptor makes use of the knots in the wood, sometimes to marbleize his figure. The few masterpieces give an impression of power.

There are also fiber masks featuring stylized figures; these are worn with palm-leaf costumes. The *gugwom* mask, in the shape of a crocodile, appears at the millet harvest and at the funeral of a chief.

The Goemai, who lived not far from the Montol on the Jos plateau, had a chief of royal blood, a sacred person who appointed village chiefs based on proposals by the elders. In his hair he wore an ivory pin whose tip was a disk. The death of the chief would be kept secret for two or three months in order to avoid intrigue. The new chief had to belong to the royal family. He also played a religious role. The priests, provided for by the village, supervised rituals and protected against natural disasters and the misdeeds of sorcerers.

The Goemai used sculptures in their healing rituals. The administering of herbs was accompanied by festivities with music and dance.

Their statuary is less geometrical, more rounded and naturalistic than that of the Montol; the features of the face are in slight relief. The general posture is similar, the arms separated from the trunk and the short legs solidly placed on the base.

A. Rubin, *The Sculptor's Eye: The African Art Collection of Mr. and Mrs. Chaim Gross*
 (Washington, D.C.: National Museum of African Art, 1976).
M. Wittmer and W. Arnett, *Three Rivers of Nigeria* (Atlanta, 1978).

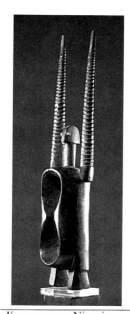

925 Koro spoon, Nigeria
Wood. Height: 47 cm. Private collection

926 Wurkum shoulder-mask, Nigeria
Wood. Private collection

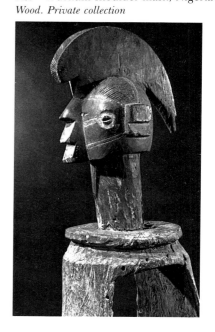

THE WURKUM The Wurkum live in the north of the Benue valley in Nigeria in the province of Bauchi. Their masks, which used to be attributed to the Waja and were associated with fertility rituals, have a very specific shape. Worn by a man hidden beneath a straw skirt, they consist of two parts: the first involves a head on top of a long neck; the second is formed by two panels, empty inside, that depict the body. The two parts are more or less equal in length, but the bird-shaped head is flattened on the sides, and is therefore best viewed laterally, while the "body" is visible only from the front. Seen in profile, the head is constructed around a slightly bulging circle, whose center is the ear. A crest formed from a semicircle stands above three indented protuberances that depict the nose and an open beak-shaped mouth, painted red on the inside. Holes all around allow the attachment of the raffia skirt. The two body panels are each divided into two vertical parts of different colors, one black and the other red. Even though the form of this mask may appear a bit coarse, it bears witness to a great inventive spirit. Some statues having the same crest remind one of this mask, especially in the way in which the shoulders are hooked onto the bust.

M. Wittmer and W. Arnett, *Three Rivers of Nigeria*, op. cit.

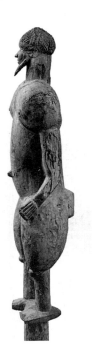

927 Mboye,
Nigeria, region
between Shani
and Gombe
Wood.
Second half of the
15th century. Height:
175 cm. De Menil
Foundation, Houston

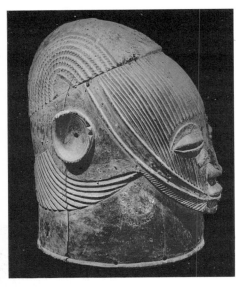

928 Igala helmet-mask, Nigeria
Wood. Height: 35 cm. National Museum,
Kaduna, Nigeria

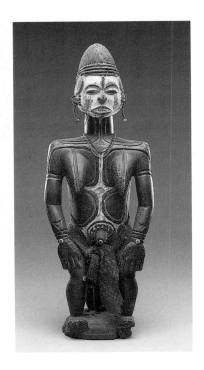

929 Idoma, Nigeria
Wood. Height: 79 cm. Musée Barbier-Müller,
Geneva

The Left Bank of the Benue River

THE IGALA François Neyt (1985) devoted a book to the ethnic groups of the state of the Benue; we are taking from it a part of our information regarding the Idoma, Igala, and Tiv. Numbering 400,000, the Igala inhabit the left bank of the Niger River south of its confluence with the Benue. They speak a Kwa language. Their neighbors are the Igbo to the south and the Idoma to the east, and they have always maintained contact with the Bini, the Yoruba, and the Jukun. They are primarily farmers.

According to tradition, at the end of the sixteenth century, the different autochthonous Igala-Mela clans rallied around one king, or *ata*, of foreign origin, called Ayegba. The *ata* attended to the various ethnic communities that lived in the capital, Idah: the Igbo, Nupe, Igbira, and Hausa. J.-C. Muller has shown (1980) that this system of power was not absolute since, faced with the royal clan whose four branches governed in turn, the Igala-Mela clans, originally landowners, also had a chief, *achadu*, or "agent for the king," whose authority equals that of the *ata*. The *achadu* has his own palace, slaves, and rituals of purification to protect against infertility of people and the soil. On his end, the *ata* must renew his political and religious prestige through great annual festivities such as the *ogbadu*. As warrior-king, guardian of his people, the *ata* is not sheltered from magical attacks from enemies, hence the need for ceremonies such as the *ocho*. As so often in Black Africa, one finds among the Igala a royal authority that is held in check by a counterforce from another level of society.

According to legend, by refusing to pay a tribute to the Jukun kingdom of Wukari, the hero Ayegba gained the independence of his people by waging battle. In order to achieve victory, and on advice of the diviner, he sacrificed his own daughter, who was buried alive in a well. Since then, the *ata* and his court go the the young girl's tomb every year. The Igala kingdom reached its apex in the seventeenth and eighteenth centuries and, in 1831, the first European visitors gave enthusiastic accounts of the structure and power of the kingdom. With colonialism and the carving up of the region, the kingdom disintegrated rapidly and, in 1956, matters had come to a point where celebrations were forbidden; the king committed suicide. Earlier, the Igala were reported to be headhunters, their ritual celebrations involving human sacrifices.

In these annual celebrations, masks played an important role. In Idah, nine royal masks, each guarded by a private counselor of the *ata* representing a clan, had its own attributes.

The Igala worship the spirit of the dead, Egu, who embodies himself in the form of a helmet-mask during the celebrations for the yam harvest. The face of these helmet-masks is striated with vertical lines, except for the mouth and the nose, and resembles the bronze and terra-cotta heads of Ife. The mask is convex, the eyes are half-closed, with almond-shaped perforations, the ears are round; through its typology, Neyt (1985) connects this mask with the royal masks.

J.-C. Muller, *Le Roi Bouc Emissaire* (Quebec: S. Fleury, 1980).
F. Neyt and A. Désirant, *Les Arts de la Bénué aux Racines des Traditions* (Hawaiian Agronomics, 1985).

THE IDOMA Numbering 550,000, the Idoma settled at the confluence of the Benue and the Niger, around 1800, having come simultaneously from the east and the west. In the course of the nineteenth century, they were forced to emigrate once again, under pressure from the Fulani coming from the north. Speaking a Kwa language, these different groups, with no common historic origin, each had a totemic animal, whose presence permits us to follow their migration. Their art and customs show influences from the Igala, the Igbo, and the ethnicities of the Cross River.

As farmers, they have a long market tradition in a region of neighboring ethnic groups who have intermarried with one another. Each patrilinear lineage lives in a cluster of small round houses around a central square. Several lineages together choose a village chief, in rotation, from among the members of the council of elders. The Idoma believe in a creator god, but different cults are entrusted to the various societies. The *alekwu* society is responsible for the cult of the periodic resurrection of the ancestor who plays a vital social function. The earth, Aje, dwelling of the ancestors, has its sanctuaries and dominions; sacrifices redeem offenses that may have been committed against it. The secret society of the *aiuta* is in charge of maintaining order; its members, village chiefs and dance groups, remain under the control of the elders. The *oglinye* society groups together the royal lineages who have the right to own masks.

There are several types of male societies that admit women. The bush spirit Anjenu who lives in the rivers is honored during ceremonies involving mortuary masks with white faces, slitted eyes, and teeth impregnated with kaolin. Seated statues with one or several children are believed to incarnate fertility, a frequent theme in the region. Also found are Janus-shaped crests, which are used in dances at the funerals of notables and are reminiscent of the Ekoi heads.

The Idoma have undergone various influences and it is often difficult to distinguish them from their neighbors, who have the same mask societies. According to Neyt (1972), the stylistic origin for these masks is in the region of the Boki.

F. Neyt and A. Désirant, *Les Arts de la Bénué*, op. cit.

THE IGBO Eight million Igbo occupy the plateaus of eastern Nigeria on either side of the Niger River. They are subdivided into thirty-three subgroups and are spread out among about two hundred villages. The population density is very high, about 10,000 inhabitants per village. Living in thick forests or on semifertile marshland, they grow yams, fish, and have a long tradition in commerce. In the seventeenth and eighteenth centuries, many were forced into slavery, and they formed the core of the slave population of the New World. In the nineteenth century, along with the Ibibio, they became major providers of palm oil and almonds; they accepted the name "peoples of the bush," given to them by the Yoruba.

The Igbo managed to keep their autonomy with regard to their neighbors: their language, beliefs, and social organization are their own. The heads of families form the council of elders, which shares its power with numerous secret societies; these are open, however, to any man rich enough to buy his way in. These societies exercise great political and social influence. They are highly hierarchical, their members passing from one level to the next, each stage marked by a specific attribute. The rituals are periodically renewed during great ceremonies, which include animal sacrifices and masked dances.

Believing in a creator god, Chi, who is not represented in the form of a statue, the Igbo honor innumerable invisible gods associated with rivers, markets, or the founding ancestor—such as the earth goddess, Ale, whom they worship in sanctuaries where she receives offerings. In the rest houses of the men, called *m'bari*, and in sanctuaries, large sculpted figures are found, often a couple, and sometimes even accompanied by other figures that are smaller; these are constructed according to the family model: husband, wives, children, messengers, and *ikenga*. They have the generic name *alusi*. Painted red, yellow, and white, they define the social rank of the persons they depict through scarifications and other attributes, whether these be the great founding ancestors who are still commemorated or divinities of the village or the marketplace. They are carefully maintained, replaced if the wood becomes too eroded, repainted on the occasion of great celebrations, when they are brought out dressed in Igbo costume.

As there is no administrative institution able to regulate conflicts between individuals or lineages, the Igbo turn to the *alusi*, who decide whether a claim is adequately founded. The accused must swear an oath in the sanctuary and the oracle will make its pronouncement, causing the accused to be ill if he or she has lied. If a person dies, all his material possessions will become the property of the sanctuary. Some *alusi* were so famous for their judgments that people would come from very far away to have their arguments settled.

The sanctuaries themselves are small in size, embellished with portals, sculpted panels, and painted walls that are renovated every year if necessary. These are places for weekly and annual rituals. Besides music and dance, the Igbo are very appreciative of the visual arts. At the time of annual ancestral celebrations, or when the moment has come when the ancestors supposedly return to earth, great masquerades take place; at the call of the drum, the statues that belong to the heads of lineages are brought and placed in a row in front of the sanctuary wall, where the whole population can see them. To make them beautiful, they are covered with various accessories: swords, headdresses, eagle feathers, jewelry. In return, the divinities grant their protection, a good harvest, or fertility. The relationships between humans and divinities involve reciprocal exchange.

Igbo sculpture is subject to rather strict rules: the figures are generally frontal, symmetrical, and upright, with legs slightly spread, arms held away from the body, and hands stretched forward, palms open. The principle of verticality is respected. Dimensions are slightly smaller than life-size, proportions true to those of the human body, with the exception of the neck, which is more elongated. The joints are exact; abstraction is kept to a minimum. Yet, the hands with fingers indicated schematically and the feet are not realistic. The whole gives an impression of balance and stability yet lacks the degree of refinement and precision that may be found elsewhere in the region. These figures are not portraits: the posture and features are stylized, but within this conventional framework the artist is allowed some freedom in details and can thus prove his mastery. The sculptor plays a cohesive role in the community.

The Igbo use thousands of masks which incarnate unspecified spirits or the dead, forming a vast community of souls. These masks play a role in the justice system when punishments are given, or they are created, more simply, for entertainment—every year, they appear at the time of the great agrarian celebrations or to commemorate the funerals of notables.

With their masks, the Igbo practice the notion of complementarity, opposing beauty to bestiality, the feminine to the masculine, black to white. The elongated face, made longer by a crest, is the first form of the *ngpwo* which incarnates the young pubescent girl, during the feasts where virgins are honored. In the central region in the north, young masked boys represent grasshoppers. In the cults of the secret societies, night spirits are depicted by masks with very elaborate hairdos, involving superimposed structures, crests, horns, and so on. The *owu* cult is the main cult of the southwestern region, celebrated with huge masquerades. The "elephant" mask of the Izzi subgroup has a frontal vault that bends backwards, evoking the animal's trunk.

The success of an Igbo in material, social, spiritual, and political terms depends on moral

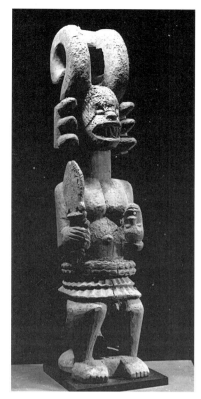

930 Igbo *ikenga*
Wood. Height: 54.6 cm. Private collection

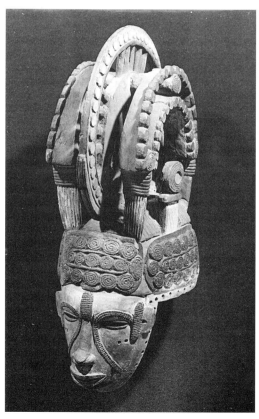

931 Igbo mask, Nigeria
Wood. Height: 51 cm. National Museum, Lagos, Nigeria

543

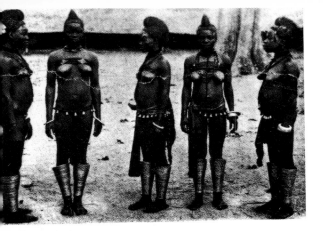

932 "Women in Gala Attire"
in Among the Igbos of Nigeria, *by George Thomas Basden, 1921, p. 49*

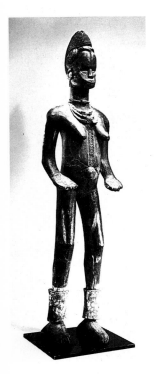

933 Igbo, Nigeria
Wood. Height: 148 cm.
Private collection

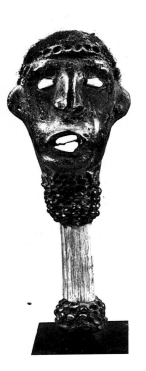

934 Tiv tibia, Nigeria
Leg bone, resin, shells.
Height: 20 cm.
Private collection

determination and physical strength. The ideal is to be a good farmer who accumulates wealth, prestige, and titles, who creates a large family, and who must later occupy an honorable place amidst the ancestors. This desire for success is institutionalized by personal sanctuaries maintained by men, more rarely by women.

The altar statues called *ikenga*, sculpted by a professional from very hard wood, must as their principal characteristic include a pair of horns, identified as the horns of a ram who "fights with his head"—hence is symbolic of aggression and perseverance. Since the ram rarely fights, he therefore symbolizes self-control and determination to the Igbo. In a ritual context, the ram never shows pain: the human, in his image, must remain stoic. Horns, very common in African iconography, symbolize the principle of nature's growth, its permanent power of regeneration, and an expansion of strength. Sometimes a long-bladed knife is added to the horns, an extension of the hand and symbolic of a superiority in the art of war; other times a head trophy is added, expressing courage and acuity in decision-making. The statue is scarified to reflect the titles of its owner and is ornamented with attributes: elephant tusks, trumpet, drum, stool, and bracelets. The *ikenga* come from two schools, one realistic, the other more abstract.

The *ikenga*, as symbol or idea, gives a body to the *chi* of a person; its power is renewed through prayers and sacrifices. Young men acquire it at various ages, but they all own one of them by the time they get married and settle down.

The large *ikenga*, which consist of superimposed figures, belong to whole communities, age groups, or lineages. They are characterized by complex hairdos which, again, use the theme of horns. These *ikenga* are displayed during ceremonies and strengthen the sense of community solidarity. The *ikenga* is the "king" who unifies the village; all the male children born in the preceding year are introduced to him; he is walked through the village and stops in front of the principal houses to congratulate and bless the inhabitants.

In earlier days, at the death of its owner, the *ikenga* had to be broken in two to show clearly to what extent it was a part of the individual. More often today it is placed on the shrine of the ancestors.

J. Boston, *Ikenga Figures Among the North-West Igbo and the Igala* (Lagos: Federal Department of Antiquities, 1977).
H. M. Cole, *Mbari: Art and Life Among the Owerri Igbo* (Indiana University Press, 1982).
H. M. Cole and C. C. Aniakor, *Igbo Arts: Community and Cosmos* (Los Angeles: UCLA, Museum of Cultural History, 1984).

THE TIV Inhabiting both sides of the Benue river, from the Cameroon mountains and the Sonkwala hills in the south to the Benue plains in the north, the Tiv presently account for 1 million people. At the end of the seventeenth century, they settled in this region which was a place of trade; the small port of Makurdi on the Benue was the last point for the slave caravans, which then moved down toward the lands of the Ibibio and Igbo. The Tiv formed a buffer state and caused the Idoma to flee further south. They originated in Cameroon, but the Tiv refer to a controversial mythical place, Swem Mountain, which has yet to be located. They first encountered the Fulani who, according to tradition, wanted to marry their daughters; then they met the Chamba, who taught them to replace their rafts with dugout canoes and oars and from whom they borrowed some of their customs of navigation and culinary arts. This cohabitation was interrupted by a fishing accident with a Chamba, which forced the Tiv into a new emigration.

The Tiv refer back to two great lineages that have close bonds between them; hence there is a relative homogeneity and coherence in their arts and religious and social institutions. Each family owns a portion of land, called *tar*. Its members group themselves together in round huts standing in a circle. Until 1948, there was no centralized government: the heads of families had equal authority; the council of elders directed the group, but age groups shifted the balance of power away from them by creating ties of mutual assistance.

The elders based their power on the use of sorcery. The *mbatsav* sorcerers have such power that they caused several rebellions, in 1912, 1929, and 1939. The village has a container, the *swem*, filled with ashes and covered with the leaves of trees. A symbol of just retribution, the *swem* controls the sorcerers and their fetishes and presides over the ordeal, a trial by poison; it is a kind of magic, mystical, and supernatural counterforce. To protect itself from evil spells, each family possesses *akombo* fetishes, which it hangs up in the hut or keeps in a secret place. These fetishes constantly intervene in connection with births, the hunt, and during protection rituals held to "repair the earth" and repel the forces of evil.

The *adzov* genies, capable of causing muteness, the birth of monsters, or madness, are elders able to metamorphose themselves; they live on the shores of rivers or hide in the forest. At the time of the new harvest, some of the elders go to a place named Swem and bring a Yoruba cane back with them, which they burn upon their return; its ashes go into the mixture in the *swem* receptacle that will prevent sorcerers from becoming too individualistic and destructive.

Sculptures, which are relatively rare, do not depict ancestors but, rather, tutelary guardians connected with the *akombo*. Male and female figures are placed to the right of the entrance to the first wife's house to protect the family. The statues, or *ihambe*, come in two types, the pillar style and the realistic style. With the former, the shapes are slender and sketchy, the planes roughly hewn; the masses have a crude look and the general impression is of rigidity. Neyt distinguishes between several studios according to the way in which the statues' torso, shoulders, scarifications, and crested hairdo have been rendered.

With the realistic style, the statues are more feminine, smaller, and more elaborate. The decoration is carefully done, the hairdo in a bun is more artfully depicted and includes implantations of human hair; scarifications are prominent, vertical on the body and oblique at the corners of the lips.

The two types of statuary are related to marriage, fertility, and the *akombo*. Since the right of succession is through the mother's line, the preferred marriage is one of reciprocal exchange: two sisters marry two brothers. The sister-in-law then succeeds the mother and the statues remain within the same family nucleus.

The *ihambe icigh* is composed of two pillars, one male and one female, about one-and-a-half meters high, planted in the ground, and accompanied by two terra-cotta receptacles and a few medicinal plants. The head of the family places them in front of the house of the wife he has just acquired. The number of statues varies from one clan to the next.

The *atsuku* are fetishes: they belong to an individual and are kept hidden in the house or worn on one's body; collectively, they are used for the hunt or circumcision and are then kept by the initiates of the upper level of the *akombo* in a specific hut. Made of hard wood, bone, or from a simple calabash, they are small in size and often aesthetically much less carefully made than the *ihambe* figures.

There are also spoons with sculpted handles, used to honor a visitor, and *imborivungu* flutes, sacred objects of great power. Made from a human femur or a tin tube, the flute features a metal, bone, or ceramic head. Beads, cowrie shells, or brass form the eyes, and the hairdo is made of real hair. Sometimes the "body" of the flute is decorated with a linear design, with strips of fabric in different colors, with beads, or silver incrustations. It emits a sound reminiscent of the cry of the screech-owl, a bird associated with occult powers. Symbolic of the unity of the lineage, it creates a bond between the living and the dead, whose strength it possesses, and it ensures fecundity and fertility.

The Tiv also make human heads in terra-cotta, commemorating the mythical hero Poor, who perished in a fire. Other terra-cotta statuettes have prophylactic functions. The Tiv do not have masks.

Complex and varied scarifications are found on the statuary, as on the body in earlier times: on the corners of the lips (cats' whiskers), in the umbilical area, on the temples, the neck, and the arms. These indicate the different age groups and distinguish them from neighboring tribes.

In northeastern Nigeria and in Cameroon, decorative and practical objects in bronze are also found: scepters, rings, axes (as marks of prestige), and some sculptures. The Tiv blacksmiths had some contact with the Igbo blacksmiths, but their bronze technique is thought to have been learned from the Jukun.

F. Neyt and A. Désirant, *Les Arts de la Bénué*, op. cit.

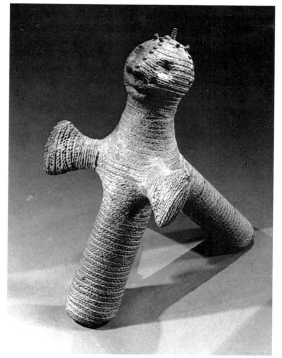

935 Tiv statue, Nigeria
Bronze. Height: 31 cm. Private collection

THE JUKUN Installed on the banks of the Benue river, an important contact point between ethnic groups, the Jukun are descendants of the Kororoga or the Korofora, whose kingdom in the Sudan was very powerful in the fourteenth century. From this era, the architectural ruins of a great center remain, along with a few bronzes, including neck-rests and small animals that serve as boxes. Now estimated to number about 30,000 people, the Jukun speak six dialects of the Kwa language. They appeared in the region in the thirteenth century but, until the eighteenth century, were constantly on the move.

The Jukun kingdom had contact with Islam very early on. Under the pressure of the Fulani, the capital was transferred from Biepi to Wukare at the beginning of the fourteenth century. The Jukun were not discovered by the West until the second half of the nineteenth century, and their land became an English colony in 1900. Their society was structured into large, extended families who lived on large farms and was run according to the principle of seniority. Each family practiced a cult in its own sanctuary.

The semidivine king, *aka uku*, is also the great priest. Responsible at one and the same time for the rain, the fertility of the soil, and the security and well-being of the population—and serving as intermediary between the royal ancestors and the living—he presides over two complex rituals, one daily and one annual, which both require sacrifices. The ritual murder of the king was a response to worldly disasters such as a bad harvest. The royal ancestors, who no longer supported the king and demanded a new one, made the murder a necessity. Since, according to the proverb, "the Jukun king never dies," the successor ate his heart in order to ensure a legitimate continuation.

Large wooden statues represent the ancestors, their wives, and their servants. C. K. Meek (1931) reproduces a figure who represents the great king Adang. At the funeral of a chief, human sacrifices were made for the repose of his soul, and the clothed statues would be transferred from the sanctuary to the royal palace, where they would "sleep" for one night. Then they would be taken on a procession. These ancestors would receive the first fruits of the harvest and would also be brought out in public when sacrifices were made in the case of an epidemic, drought or war. The great *aku onu* mask is an intermediary between the ancestors and their descendants.

Only about ten great Jukun statues have been counted; the wood is hard, generally dry, grey, and the surface rough in those places where the first layer of the patina has disappeared. Arnold Rubin (1969) links these figures to the *mam* cult, which is widespread in the east of Nigeria. This fecundity ritual is accompanied by dances in which the dancers enter into a trance that may end in self-mutilation.

The first Jukun statue entered the British Museum at the beginning of the century, but it

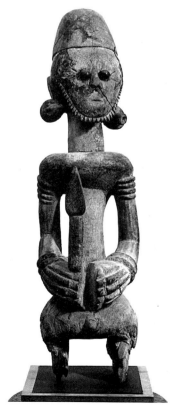

936 Jukun, Nigeria
Wood. Height: 65 cm. Private collection

545

was ascribed to the Asante. These figures, dressed and bejeweled, generally come in pairs; each eye has a small conical plug of metal; the ears are perforated and decorated with cylindrical elements; the face, with scarifications, is very specific in form, projecting forward and redoubling the plane of the neck. It has often been interpreted as a mask added over a hidden face. A conically shaped hat or an arrow-shaped crest covers the skull. The abdomen is conical, a bulge shapes the shoulders, the breasts are pendulous, the arms long, the hips round, and the hands are wide, marked with deep furrows to depict fingers, while the feet and legs are masses that are less differentiated.

The Jukun style, also known as Wurbo, resembles the Wurkum, Bauchi, and Mumuye statues of the Benue in its formal invention, its management of volume, and certain original details, such as the ears.

C. K. Meek, *Tribal Studies in Northern Nigeria* (London: Kegan Paul, 2 vols., 1931).
A. Rubin, *The Arts of the Jukun-speaking Peoples of Northern Nigeria* (Bloomington: Indiana University Press, 1969).
R. Sieber, *Sculpture of Northern Nigeria* (New York: Museum of Primitive Art, 1961).

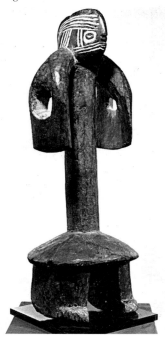

937 Mumuye, Nigeria
Wood. Height: 40 cm. Private collection

THE MUMUYE The Mumuye live in northeastern Nigeria between the cities of Jalingo and Zinna, in a region that is bounded by the bend of the Benue river and the Cameroon border. Estimated to number 100,000, the people cultivate sorghum, millet, and yams and are divided into seven subgroups. If their languages present only a few different dialects, their customs and beliefs, on the other hand, are quite distinct. Nevertheless, they acknowledge a common origin and they all grant special importance to the village of Yoro, the residence of the primary master of the rain.

Due to the difficulty of access to their lands of rocky hills and savannas, the Mumuye remained in near total isolation until 1959, the date when they were definitively conquered by the English. For a long time, it was believed that, in C. Kjersmeier's words, "northern Nigeria was inhabited by almost unknown tribes who had produced nothing that might be described as art." Then, Mumuye statuary was discovered in 1968. One statue that had entered the British Museum at the beginning of the century had been attributed to the Chamba. In 1931, Meek described Mumuye customs in great detail, but focused only on the use of masks in dances of initiation, funeral rituals, harvest celebrations, and in the *vabo* cult.

With no royal system, like their neighbors the Tiv, the Mumuye are organized by age classes and choose a village chief who is assisted by a council of elders. The initiation of young boys begins at the age of ten and takes place in a *tsafi* hut, where the statues are kept.

Even though the Mumuye show great respect for the skulls of the ancestors, their statuary does not depict ancestors but rather incarnates tutelary spirits. Yet, statues reinforce the status and prestige of their owner who, as he holds them in his hands, has a dialogue with them and thus ensures his personal protection. The largest ones among them are used in divination, medicine (notably in cases of smallpox epidemics), and in trials when men in dispute swear on the statue, which they must kiss. As is the *tsafi*, the huts of the rain master and blacksmiths are taboo to noninitiates and to women. They contain objects needed for the rain rituals. The pillar, topped by a sculpted head and placed in the center of the village, may be seen as a reminder of the statues themselves. Their size varies from 30 centimeters to 1.5 meters, but the average is between 70 and 90 centimeters. The incised lines may be shallow, average, or accentuated. The patina is obtained by a coating of oil or wax on the surface, and the color varies from a very dark to a light brown. Their greyish tone is due to accumulated dust. The statue may have added elements: beads, belts, bracelets, chains, leather laces, ropes of braided vegetable matter, brass wires, or cowrie shells.

Connections can be made between the art of body decoration and the statuary: braided hair, headdresses of crests or helmets, ears pierced or elongated as with the practice among women who wore large disks attached to the earlobes. The gender is rarely indicated. The asymmetry of certain statues gives them more dynamism.

The statues' principal characteristic, unique in African art, is the systematic openwork between the body and the arms, which forms a scroll or a spiral around the slender, cylindrical bust. The sculptor slices the block, detaching a band that will be the arms'

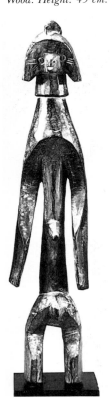
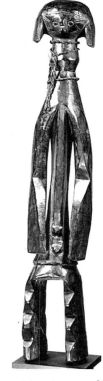

938 Mumuye, Nigeria
Wood. Height: 45 cm. Private collection

939 Mumuye, Nigeria
Wood. Height: 85 cm. Private collection

extremity, then he hollows out the space between the torso and the very elongated arms, creating planes and curves. The legs, on the other hand, are short and often notched; they serve more as a support for the piece, and their size is proportionate to that of the head, which is relatively small in relation to the body. This system of repetition of planes and volumes implies two series of clear-cut surfaces that oppose one another: ascending/descending or convex/concave. The male statuary is more compact and sturdy than the female, which makes more effective use of space. Forms vary from one village to the next.

In earlier times, masked ceremonies closed the initiation period. Each age class formed a military group, capable of defending the village in case of attack. Together they worked the land and hunted. The first manifestation of this spirit of solidarity is the pooling of resources to have a mask produced to symbolize their collective identity. These masks, which represented animals (buffalo, monkey, elephant, leopard, and so on), were called *va* or *vabou* and initiates called themselves "sons of Va." A particularly well-off age class might finance a second mask, this time a female one, called "grandmother" or "old woman," whose role would be secondary. The masks would dance at the time of sowing, harvesting, funerals, or other important events. Priests, whose duties were hereditary, kept the masks in the sanctuary.

The sculptor, the *rati* or *molobaiene*, does not have special status like the blacksmith and does not transfer his profession to his son. He also makes axe handles, seats, spoons, and drums, and often practices another profession, such as that of weaver or healer.

P. Fry, "Essai sur la Statuaire Mumuye," in *Objets et Mondes*, vol. X, No. 1, 1970.
A. Rubin, "Personnage Debout Mumuye," in *Vingt-cinq Sculptures Africaines*, op. cit.

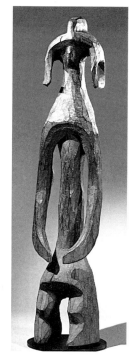

940 Mumuye, Nigeria
Wood. Height: 120 cm. Arman Collection

THE CHAMBA In the seventeenth century, the Chamba, whose number today is estimated at 20,000, skirted the mountains that form the border between Nigeria and Cameroon, and settled on the southern bank of the Benue river not far from the Jukun. They formed small, centralized states, the most important of which, Donga, Suntai, and Takum, were fortified. Despite the arrival of the Fulani in the nineteenth century, these centers continued to exercise influence.

The chief possessed divine rights and had the power of life and death over his subjects. Nonetheless, he was assisted by a council of chiefs of the lineage. According to Meek's descriptions (1931), the king, son of the sun, could only appear after sunset; a cult, *voma*, was devoted to this in order to obtain rain, among other benefits.

After circumcision, young boys received an initiation that included the teaching of secrets. The female principle is at the origin of a female association, *vonkima*, whose members recognize each other by little bits of iron. The new harvest was celebrated with the *purma* feasts which, in earlier times, were the occasion for a military review of the warriors.

Each clan kept the skulls of ancestors, who were responsible for the prosperity and fertility of the lineage. Besides celebrating ancestors, the *vara* cult celebrated the tutelary spirit, a personification of the first *mala*, or the paternal aunt of the chief. At the time of the masked *kaa* celebration, she appeared in public, as well as at the funerals of members of the lineage; she would dress in the guise of a masked man in a fiber costume: it represented a buffalo head and was hollow on the inside, the helmet-mask worn on top of the head had jaws in the shape of jointed horizontal planks and horns curved toward the back. Generally, the head was divided into two halves, red and black, and its eyes were decorated with white metal nails. The wearer looks through an opening between the two jaws. Used until 1970, these masks show a remarkable uniformity. Their style is comparable to that of the masks of the Jukun, Mumuye, and Mambila (J. Fry, 1978), and the Kutin of Cameroon.

Chamba statuettes are rare and have stylistic elements in common with those of the Mumuye. A few smaller ones were staked in the ground using an iron rod. There is originality in the way the arms are joined to the shoulders: the wide hands separated from the body are sometimes united by a base that cuts through the thighs, the feet reappearing below it. The geometric facial features contribute to an impression of power.

J. Fry, *Vingt-cinq Sculptures Africaines*, op. cit.
C. K. Meek, *Tribal Studies in Northern Nigeria*, op. cit.
A. Rubin, "Masque-buffle Chamba," in *Vingt-cinq Sculptures Africaines*, op. cit.

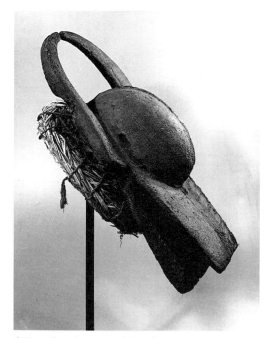

941 Chamba mask, Nigeria
Wood. Height: 64 cm. Private collection

THE JOMPRE On the border of Nigeria and Cameroon, the Jompre make up a small tribe whose masks resemble those of the Jukun, Chamba, and Kutin of western Cameroon. The Jompre use bright red seeds to enliven the masks' somewhat crude look.

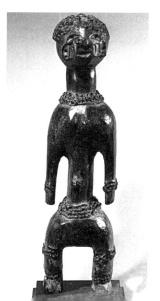

942 Jompre, Nigeria
Wood. Height: 47 cm. Private collection

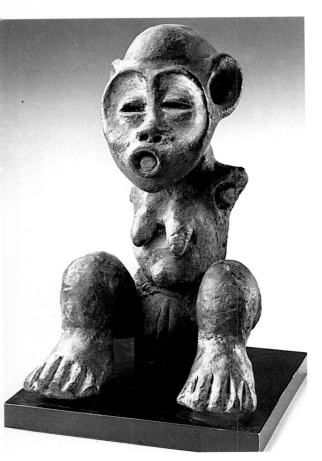

943 Mambila
Terra-cotta. Height: 30 cm. Private collection,
Guimiot Archives

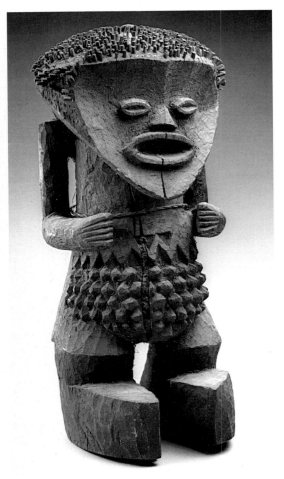

944 Mambila, Nigeria
Wood. Height: 45 cm. Musée Barbier-Müller,
Geneva

THE MAMBILA Living in the north of the Sardauna province of Nigeria on the plateau of the same name, this ethnic group consists of about 20,000 individuals who live off agriculture and raise cattle.

In the Fulani language, Mambila means "people." They call themselves the Nor. Land, every family's property, is distributed by the group's chief. Labor is divided between men and women, and children begin to work at the age of twelve. A society of mutual assistance, the *kurum*, participates in clearing land, harvesting, and building houses and facilitates social contacts during celebrations and dances.

The men are in charge of weaving cotton, metal- and woodworking, and braiding fiber. Merchants and blacksmiths are separated from the rest of the community. Having arrived relatively recently, they have their own language and form a special caste whose sons may not but whose daughters may marry outside the group. The trade is passed from father to son. Before casting metal, the blacksmith must avoid sexual relations and must sacrifice a chicken.

There was neither royalty nor centralized power among the Mambila, but there was a village chief, responsible for maintaining cohesion and peace inside the community, and supported in his function by the *mimin* association; this was in charge of resolving conflicts and making alliances, which then would be ratified by a ceremony involving drinking millet beer from the same cup.

Each family lived on land consisting of three or four huts protected by a fence; they were grouped in hamlets preferably situated on hilltops, under the authority of the oldest male.

The Mambila believed in a creator whom they sometimes call Nama, sometimes Chang, but they only worshipped family ancestors. According to their beliefs, at one's death the ancestors take away the soul of the deceased during the night and would sound trumpets, which represented their tears. Chiefs would be buried in a granary, for they incarnated wheat and, thus, prosperity.

Sorcery, which could be handed down by women, was only recognized as such after a trial: those accused had to prove their innocence by immediately spitting out poison they had been made to take. A sorcerer transmitted his powers to his son by making him eat the liver of a relative on the mother's side. In early days, in order to unmask a sorcerer, an autopsy was undertaken: a heart surrounded by fibers proved the deceased was a sorcerer.

Unlike the blacksmith, the wood sculptor was not a specialist and his profession brought him no prestige. Nevertheless, he could easily acquire a good reputation. Using soft wood and raffia fronds, he would burn pieces with preheated scissors, thus giving them a lovely patina. Yet, the irregular surface retained traces of the adze's carving.

The Mambila created ancestor figures, objects of protection, masks, and the musical instruments necessary for the semiannual celebrations of sowing and harvesting. These were opened with the sound of the *tawong*, a kind of wooden trumpet, the end of which is a sculpted head. Accompanied by the men, the feast would pass from village to village over a period of several weeks. It was a time of sexual experimentation for young bachelors and ended with weddings that would only be celebrated at this time of year.

Masks were only able to be viewed by men; the *suah bvur*, whose mask is worn on top of the skull, is accompanied by the *suah dua* and by men dressed in fiber costumes. Animal-shaped, these masks represent the crow (a taboo animal), the owl (who announces death), and the dog (essential to the hunt). One ritual consisted of sacrificing and eating a dog. The anthropomorphic *larmes* mask is heart-shaped and has horns on the back of its head. Masks are worn with fiber costumes.

Ancestor statues are of two types: the *kike*, made of simple pieces of wood tied together, and the *tadep*, in human form, painted the same colors as the masks. Aside from a few rare specimens, the level of production is fairly mediocre.

Masks and statues were kept hidden from the eyes of women in a net hung on the inside of a hut that was on stilts; it was guarded by the head of the family. The front wall of the hut was decorated with two figures, male on the right and female on the left, crowned by a rainbow and framed by the sun and the moon.

Besides sculptures, a few terra-cotta figures exist, as well as nonanthropomorphic objects that ensured fertility and protection against evil, along with birthing stools and clay pipes, notably for mothers of twins, who were thought of as the children of Chung, the god who created clay.

N. Beth and A. Schwartz, *Mambila: Art and Material Culture* (Milwaukee: Public Museum, Publications in Primitive Art, no. 4, 1972).

THE KAKA Several small groups, situated south of the Donga River, neighbors of the Mambila, received the Fulani name Kaka, given to them by the Germans. They lived on the high plateaus close to the Cameroon border; the statues they made were identified quite late. Meek (1931) signaled the existence of the Kaka, whom he placed in Cameroon. It is difficult to know whether he was speaking of the same ethnic group, as no real border existed between Cameroon and Nigeria at that time.

The surface of the statues is covered with a granular crust, similar to the Bangwa figures of Cameroon. The face, whose features are sometimes defined only by a simple hollow line, is characterized by a mouth wide-open above a small pointed beard. The bent arms separated from the body, the cylindrical torso, the zigzag legs recalling Mumuye statues, and the large feet all distinguish them stylistically from their neighbors. It is not known what functions the statues fulfilled. They form a transition style along with statues from northwest Cameroon.

C. K. Meek, op. cit.
R. Sieber, in S. M. Vogel, ed., *For Spirits and Kings*, op. cit.

The Gulf of Guinea

(Nigeria, Cameroon)

The Lower Niger

THE URHOBO The Urhobo, who speak the Edo language, live in the western part of the Niger delta and believe they are of Bini, Igbo, and Ijo origin. They account for 400,000 people, divided into 18 clans, spread out over villages of 100 to 3,000 individuals. They do not have a centralized political organization. In each village, a ruling council consists of chiefs of lineages, chiefs of war, the priest-king *ovie*—guardian of the sanctuary of the common ancestor—and members of the *ekpeko* society. This male association brings status and prestige to its members.

Perkins Foss (1976) describes one sanctuary of a village as rectangular in form, measuring 2 by 4 meters, and containing large sculptures in wood. On one of the long sides, a mud wall that only lets the upper parts of figures show, the entrance was framed by two wood columns. A raffia screen masked the interior of the sanctuary, thus creating a barrier between the two worlds, the mortal and the spiritual. Other sanctuaries were divided on the inside into two rooms: the first was for the men of the *ekpeko* society; the second, for priests and priestesses; others remained outside. Sacrifices were offered regularly to large sculpted figures who represented the spirits of nature (the *edjo*) or founding ancestors of the village, often depicted as a group. Painted with whitewash, the sculptures express purity; their half-seated, half-standing position is probably an allusion to dance. They frequently carried medicines or attributes of warfare, signs of martial power and authority, the dominant themes of the sanctuaries.

The first statue collected, in 1895, for the British Museum was attributed to the Jukun, whose statuary is stylistically identical. The beliefs of the Urhobo are based on spiritual forces, water, earth, and air. Every community has its own *edjo*, who resides in a specific place—a river, a tree, and so on. In some villages, the *edjo* are represented only by a bundle of curved sticks or by a few pieces of metal or clay. A large community must not have more than five *edjo*. Priests and priestesses act as spiritual leaders of the cult. Every year, the community will offer huge celebrations to the *edjo*, featuring dances, mascarades, and a display of riches.

Ancestor worship is practiced at all levels and the family or individual possesses a small branch of wood, called *ofo*. Reptiles and serpents are the intermediaries for the supernatural world, and their appearance in a dream means that the ancestor is angry; the diviner will then confirm that it is necessary to create a figure. It may be in clay, but the village figure is of wood. As opposed to the sanctuary's statuary, statues representing a family's clan are not hidden and preside over the meetings in the men's house. Nevertheless, as traditions gradually disappear it becomes more and more difficult to distinguish between the ancestor worship of a clan, the *edjo* spirits, and the *eshe* founders of the village.

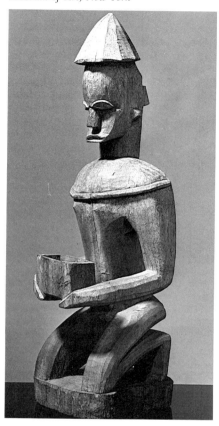

945 Urhobo, Nigeria
Wood. Height: 66.5 cm. The Metropolitan Museum of Art, New York

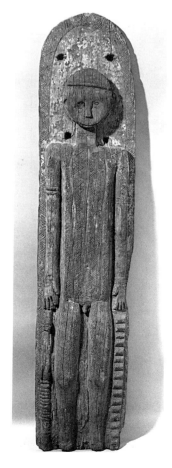

946 Ishan door, Nigeria
Wood. Private collection

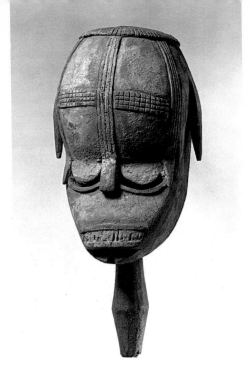

947 Urhobo mask, Nigeria
Wood. Height: 38 cm. Private collection, Guimiot Archives

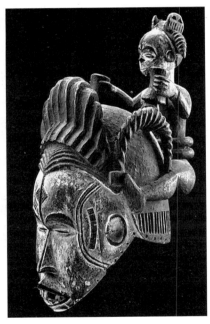

948 Igbo mask, Nigeria
Wood. Height: 54 cm. Private collection, Guimiot Archives

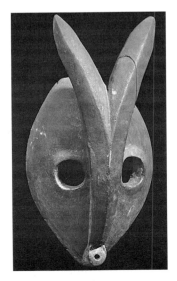

949 Ogoni mask, Nigeria
Wood. Height: 37 cm. National Museum, Lagos, Nigeria

The Urhobo also make figures named *iphri* which are the equivalent of the Igbo *ikenga*. Half-animal, half-human in shape, they belong to the warriors and notables and stand for masculine aggression. A small boy may obtain an *iphri* at a very young age if his development seems problematic. The diviner then makes the judgment that the "*iphri* is tormenting him." In that case, it will consist of a simple four-sided pyramid on two or four small bases, which he will wear around his neck. Some *iphri* consist of mountains of human shape on top of an animal.

In the *bih ohworu* mascarade, masks made of raffia and fabric represent the spirits of earth, water, and air. According to tradition, the Urhobo were supposed to have captured them in the land of the Ijo. Their sculptural style is close to that of the Igbo and the Bini.

P. Foss, "Urhobo Statuary for Spirits and Ancestors," in *African Arts*, IX, 4, 1976.

THE IJO The 350,000 Ijo occupy the Niger delta. They make their living mainly by fishing, living in small villages in the middle of marshes.

They imported and adapted the male *ekpo* society of the Ibibio and fabricate masks and headdresses that combine human features with zoomorphic motifs: pythons, crocodiles, birds, tortoises, and hippopotamus represent the aquatic spirits, the *otojo*, whom they honor. The nose, mouth, and eyes are often protruding in relationship to the plane of the face.

They also sculpt commemorative pictures in high relief that represent a seated ancestor surrounded and framed by his servants, various figures, pillars, plaques, and stools.

THE IGBO-AFIKPO The 35,000 Afikpo constitute one of 200 subgroups of the Igbo of Nigeria. Settled on the central plateau, not far from the Cross River, they live in twenty-two small villages. For a long time dominated by the Aro Chuku, the Afikpo were liberated by the arrival of the English in 1902. Liberation brought with it the development of fishing and commerce with their neighbors, particularly with the ethnic groups of the coastal region.

The Afikpo have neither royalty nor supreme chiefs. Each village, with anywhere from a few hundred to several thousand inhabitants, is divided into patrilinear lineages whose chief is part of a council of elders which holds authority. Even though residence is patrilocal, the matrilinear lineages have their own ancestral shrines and annual celebrations. Families perform a fecundity ritual on the shrine of the ancestors.

In every village, the Afikpo have a secret male society divided into two groups: one for the "titled," and a ritual group responsible for the maintenance of the sanctuary. Their god Egebele, who dwells in the bush, manifests himself in the form of a spirit incarnated by the wearer of the mask.

As among the other Igbo, in the rest houses of the different clans are kept the sacred gong, large painted figures, and the hundreds of masks that are brought out during the great annual celebrations, when true theatrical plays are performed. The young *enna* boys have their own mask society with shrines, rest houses, and celebrations. After his initiation during his stay in the bush, the boy comes back to the village for the *isiji* ceremony, which is announced by the beating of the sacred drum that used to serve to announce a change in status of a man.

The masks were influenced by the Igbo, Efik, Ibibio, and Anyang. But, as opposed to the Igbo of the north who collect statues and *ikenga* in their sanctuaries, the Afikpo only keep a few effigies in order to devote themselves to the creation of the mask-costume-dance entity which is their major preoccupation. Besides masks of leaves and nets, Simon Ottenberg (1975) identifies light colored wooden masks worn by the young, thought of as "handsome," and darker masks whose role it is to frighten. The Afikpo often use masks topped by long, narrow panels, or narrow zoomorphic or anthropomorphic masks with a horn made of fibers. Each wearer assumes the mask's personality and performs according to the rules of his "type." The most famous masked celebration is the *okumkpa*, in which several hundred masks give a performance.

Afikpo traditions have generally survived despite a certain fragility; in 1902, the English burnt down two villages which never recovered their traditions. In 1958, one whole village converted to Islam and burned all the masks of its society.

S. Ottenberg, *Masked Ritual of Afikpo* (Seattle: University of Washington Press, 1975).

THE IBIBIO, THE EKET Living west of the Cross River, the Ibibio have no centralized government. Their social organization resembles that of the Igbo, their neighbors to the west. Secret societies rule over daily life and ancestor worship is universally practiced.

The members of the *ekpo* society play a political, legislative, judiciary, and religious role in the village. It is a graded association in charge of the ancestor cult and includes two types of masks: the first, the *idiok*, is ugly and evokes wandering spirits, as compared to the *mfon*, which is handsome and represents spirits who have reached paradise. The *ekpo* society,

unique to the Ibibio, should not be confused with the cult of the leopard, the *ekpe*, which they adopted briefly and which expresses ethical concepts. *Ekpo* was not widely propagated outside the group, in contrast to *ekpe*. During the annual ceremony, young people personify the spirits, who have momentarily returned to the world of the living.

For its part, the *ekon* society, whose authority stems from sculpted figures in the sanctuaries, exercises social control over the community. It presents the public with a marionette show during festivities that take place every seven years; music and dance are linked with a theatrical play.

The Eket are an Ibibio subgroup of farmers who do not fish, unlike the Ekoi, their Cross River neighbors. There, the same *ekpo* society is found, which uses several types of masks, among them polychrome panel-masks, unique in Africa, consisting of two panels, one supported by the other at the top. There are also round masks for the yam and yam harvest festival, characterized by a moon shape or consisting of two disks superimposed or a single one topped by an anthropomorphic head.

The *idiong* society is an organization of diviners, who often are also members of the *ekpo* society—hence there is a certain confusion between the two societies. Their oval masks are very characteristic, with eyes pierced in a crescent moon shape and frontal bands in the shape of a ring. (F. Neyt, 1979) These bands are reminiscent of the palm fiber or goatskin crowns which every new "initiate" received.

Another association, called *ekong* after the god of war, uses marionettes in its ceremonies.

Just as the Ibibio's *isong* society worships Ala, so the *ogbom* society among the Eket celebrated the goddess of the earth, spouse of the god of heaven and source of fertility and fecundity; this cult continued until 1900, although suppression by the missionaries had begun as early as 1880. In the great *ogbom* masquerades, the tops of the headdresses formed figures that stand as high as 80 centimeters. The Eket have a close relationship with the southern Igbo, but the size of the sculpted heads and the polychrome, geometric design is very characteristic of their own art.

F. Neyt, *L'Art Eket* (Collection Azar, 1979).
K. Nicklin and J. Salmons, "Cross River Art Styles," in *African Arts*, XVIII, 1, 1984.

The Cross River

THE EFIK, THE EJAGHAM, THE ORON In the Cross River region in southeast Nigeria, and over into Cameroon, several ethnicities are found whose Bantu origins stem from further north, close to the Benue. Despite closely related institutions, they traditionally oppose one another.

The heads and skin-covered helmet-masks typical of this region are unique in Africa. When African art collections were being developed, their production was initially attributed to the Ekoi (Ejagham). In reality, however, the work is also encountered, with some variation, among the Efik, Keaka, Banyang, Boki in the northeast, Annang Ibibio in the west, Mbube, Etung, and even among the Bangwa as far away as Cameroon. These masks originated in Calabar and used to be transported by rowboat or over dirt roads across long distances; however the model spread throughout the estuary region and even to the west of the river among the Annang Ibibio.

Old Calabar, close to the mouth of the Cross River, is the source of these customs. With its heavy traffic, the Cross River was a commercial center for the slave trade and for palm oil, and from 1668 on, the inhabitants were in contact with Europeans, which may explain the naturalism of their artistic output.

At the end of the sixteenth century, the Efik, coming from the Ibibio region to Old Calabar, began to engage in the slave trade with the Europeans. They adopted the *ekpe* association, probably from the Ejagham, but they transformed it: it permitted them to punish debtors, although the original function of the association was only to entertain. Neighboring communities adopted the *ekpe* under different names, for example, *ngbe* for the Ejagham. Among the Efik, this male society filled a politico-judicial function that helped it to regulate community business. It brings together a group of religious beliefs linked to the tutelary spirit of the leopard, which is renewed during rituals; a secret system of signs, the *nsibidi*, or pictograms, are inscribed on the bodies, hairdos, fabrics and contained in the coded language of gestures of the dance.

The chief of the *nkanda* society, an incarnation of the leopard, wore a Janus helmet-mask, thereby signifying that "the spirit sees all." Talbot (1912) conjectures that the mask replaced the trophy head of an enemy. The *nkanda*, with two masked acolytes around him, chases away the uninitiated with a whip and goes to the house of the initiates, shaking bells in order to warn the village that the spirit is present. One side of the mask is paler, more feminine, its expression gentler; the other is dark and fiercer.

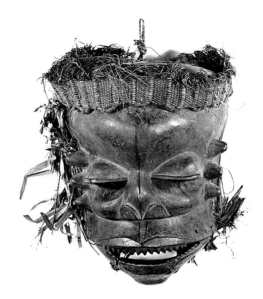

950 Ibibio mask, Nigeria
Wood. Height: 35.5 cm. Linden Museum, Stuttgart

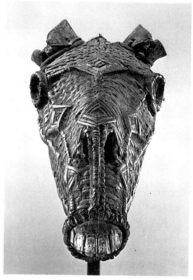

951 Skull of a horse, wrapped in rattan, Abakaliki, Cross River, Nigeria
Private collection

RIGHT:
952 Eket, Nigeria
Maud and René Garcia Collection, Paris

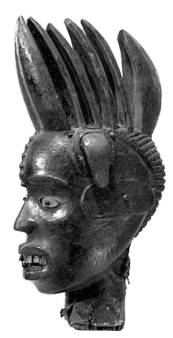

953 Ejagham head, Nigeria
Wood and skin. Height: 38 cm. Private collection

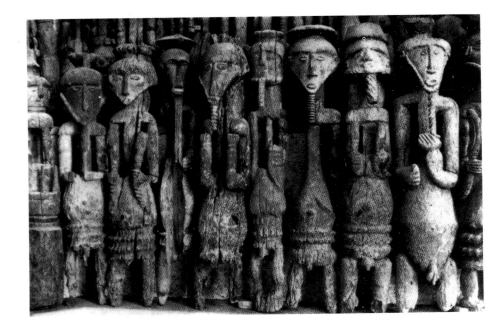

954 Group of Oron *ekpu* statues
Oron Museum

955 Boki (?) head from Cross River, Nigeria
Wood. Height: 20.5 cm. Musée Barbier-Müller, Geneva

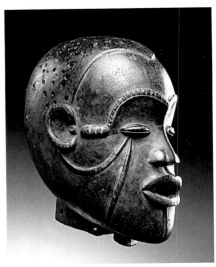

956 Top of an Mbembe headdress, Nigeria
Wood and rattan. Height: 21 cm. Private collection

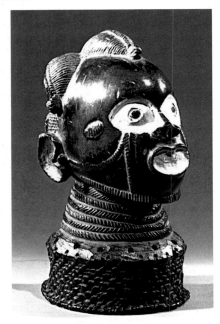

The cult of the leopard had a unifying effect on the scattered communities of the Cross River. Commercial, ritual, and social exchanges took place because of it, thus circumventing the drawbacks involved with a noncentralized regime and political institutions that often did not extend beyond the framework of the village.

Another *ikem* association, a mutual aid society, was in charge of entertainment during masked ceremonies. Masks representing a female head were used, covered with skin and featuring curls like those worn by women of earlier times—especially during the pre-marriage period when they were left in isolation to be "fattened up." The hair was braided and additional strands were held in place by iron wire and mud.

The heads today still have the same hairdos with horns as earlier times; they have a tribal mark on the temples, reminiscent of the concentric incisions applied with a razor and then rubbed with coal that women used to have. Eyebrows and eyelids are painted black. A wicker base allows the mask to be solidly attached on top of the head with the help of a cord that ties under the chin.

The *nkang* society furnished mutual assistance and entertainment; during the funerals of members or at the end of initiation, helmet-masks were used, worn on the shoulders and covered with skins; they were pierced with holes on the skull for implanting hedgehog quills, indicating that the wearer had killed a man or a dangerous animal. The incisor teeth would be deformed. The Egbege have a headdress-mask of wood and without skin covering, and the Bekarum have a mask made of antelope skull with skins. They also use wooden masks sporting real antelope horns.

The Oron, a small group that lives in the Cross River estuary, are related to the Ibibio, but claim an origin earlier than that of their neighbors. Their *ekpu* figures were made upon the death of a notable. Always wearing a chief's beard, they hold objects related to the depicted individual in their hands—horns, fans, and so on—and wear a hat on their head. The column-shaped *ekpu* statue is made from a wooden cylinder divided into sections involving head, neck, arms at right angles, a long body and short legs that form a wide base. *Ekpu* figures would be lined up in the *obio* sanctuary and, twice a year, the elders would worship them by giving them offerings of food and drink. The artistic output of the Oron stopped around 1900 but had lasted for a century and a half.

K. Nicklin, "Nigerian Skin-covered Masks," in *African Arts*, XII, 2, 1979.
M. Wittmer and W. Arnett, *Three Rivers of Nigeria*, op. cit.

THE MBEMBE The Mbembe are an ethnic group of about 40,000 people who settled on the banks of the Cross River and the Ewayon in a region of poor cultivation. From the sixteenth century on, the Mbembe had to defend themselves against raids by coastal tribes, procurers for the slave trade. They are divided into five groups: the Adun, Osopong, Ovium, Ofunbonga, and Okpodou. The villages were established on the edges of dense forest or on hilltops. Their huts, made of mud and wattle-fencing, are covered with palm raffia.

The *avat*, chief of the village and priest, represents his clan, names the sanctuary guardian, and organizes meetings with the other *avat*. He intervenes during litigations. To not sow is thought of as a sacrilege which requires the *avat* to rule quickly on conflicts. As an

emblem, he wears a hoop of leopard jaws, a kind of red head covering, and bracelets of copper coins. The inhabitants of the village must give him wine and meat.

According to R. Harris (1984), the men belong to two associations, the *ocheika* and the *okwa*. The latter exercises social control and organizes the community's work. Its members choose the village chief and have the power to depose him.

For the Mbembe, the invisible world is divided into three categories: a creator god, Ibinokpabe; the dead, *afra'nong*, mediators with the gods, who punish or reward according to their own interests; and lastly, the *akwa* spirits, intermediaries between the dead and the living, providers of medicines, who are at the heart of religious life. The diviners, *obongonong*, are summoned by Ebok, a personification of the power of divination; to evade his demands would bring sickness. The diviner is responsible for identifying sorcerers, discovering the causes of illnesses, as well as determining the name of the ancestor reincarnated at the birth of a child. He regulates the acquisitions and atonements to the *akwa*.

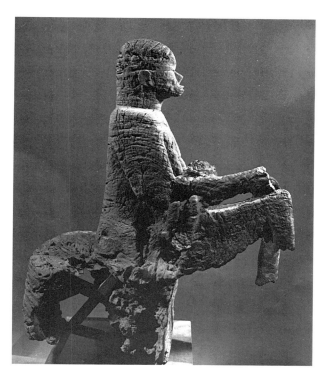 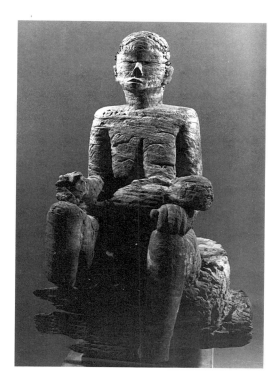

957–58 Mbembe maternity figure, front end of a drum, Nigeria
Wood. Height: 94 cm. Private collection

The Mbembe have multiple sanctuaries that contain numerous medications and various objects.

The male *ijong* society practices sorcery and organizes celebrations at which the host must pay a tribute and present the spirit of his matrilinear clan. One becomes a member of the association in order to become richer or to avenge the death of a relative. There are usually only two or three sorcerers per village. For the Mbembe the universe is good, and evil always has sorcery or the transgression of a taboo at its origin.

For the *juju* rite, adopted by the ethnicities of the Niger delta, the Mbembe used a drum, the *ikoro*, 3 to 5 meters long. Kept in the sanctuary, it served as a sacrificial altar in earlier times. The kneeling victims would have their head cut off above the drum; the heads would be placed next to those of enemies killed in a war. No man could see the drum if he had not offered a head. The sound of the drum could be heard for 10 kilometers. Twice a year, initiates would dance in front of the sanctuary and sing of their armed feats. After colonization, the English burnt several of these drums in order to prohibit these ritual crimes.

Hewn from the *apa* tree, whose exceptionally hard wood has been dated back four or five centuries, the drums were framed by statues of men and women isolated from the whole and sculpted transversally. The growth signs of the tree bear witness to the antiquity of these objects. The central portion is hollow and, at the far ends, representations of seated people with their hands on their knees often were of a woman with a child. At the Berlin Ethnographic Museum, an intact drum may be seen, brought back in 1907.

Oral tradition reports that, after success in war, the Mbembe chiefs would start a new village and have a statue erected to themselves while still alive (as opposed to the Igbo, who waited for one year after the death of their chief). Three names of ancestors have remained in Mbembe memory: Appia, who died in 1663; Mabana, of the sixteenth century, whose statue still exists; and N'Ko who founded the village of N'Koum and demanded that the head of his statue be cut off after his death and buried with his body, to testify to his struggle for liberty. These statues are as imposing as the drums. The Mbembe have also sculpted some heads and headdresses, as have the Ekoi, the Anyang, and the Boki, their neighbors.

R. Harris, "Mbembe Men's Association," in *African Arts*, XVIII, 1, 1984.
H. Kamer, *Ancêtres M'bembé* (Paris, 1974).

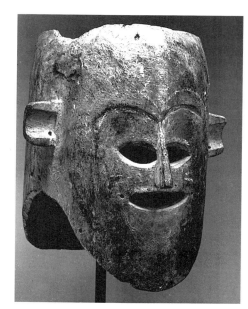

959 Boki (?) helmet-mask from Cross River, Nigeria
Wood. Height: 40 cm. Müller Foundation, Insel-Hombroich, Germany

The Cameroon Grassland

CAMEROON; THE BAMILEKE, THE BAMUM, THE TIKAR The northern part of Cameroon has been Islamicized and has no sculpture; on the other hand, the savannas of the west, the Grassfields, are composed of three ethnic groups with ancestors in common; they speak a Bantu language and have closely related social structures. There are the 1 million Bamileke spread over the southwestern plateaus, in communities that have from 50,000 to 100,000 people; the 500,000 Bamenda-Tikar in the north; and, finally, the Bamum in the northwest, with a population of 80,000. From the eighteenth century on, groups of Chamba origin traveled through the plateaus and founded small states, such as the kingdom of Bali. The Bamileke came from the north and settled between the sixteenth and nineteenth centuries, mixing with the autochthones. Resisting slave raids with suicide or rebellion, they contributed very little to the Black population of the New World.

The Grassfields were divided into a mosaic of ninety kingdoms governed by a king, the *fon*, supported by nonsecret societies. A direct heir of the group's founder, who may have been a great warrior or an elephant hunter, he ensured the protection of his people and guaranteed the fertility of the fields and the fecundity of the women. In the past, he was believed to be endowed with supernatural powers that allowed him to change into an animal—preferably an elephant, leopard, or buffalo. Dignitaries and, inside the palace, servant-functionaries assisted the king in exercising his power. The *tchinda*, who entered the service of the king very young, were responsible for domestic duties, while the *nvala* fulfilled ritual functions and were both priests and ministers. Princes of the royal line did not participate in any association involved with power, so that they stayed away from plots, but they did have their own association, the *ngirih*. The *fon* was responsible for rituals of planting and harvesting, for the annual festival of the dry season, for the opening of the collective royal hunt, and for expeditions of war. On the other hand, justice was rendered by regulatory societies, and it was not until Cameroon became a German colony that administrators forced the *fon* to assume a judiciary function. The *fon* was appointed by his predecessor, who chose him from among his direct heirs, excluding the eldest. The chiefs of the lineage belonged to an ancestral cult.

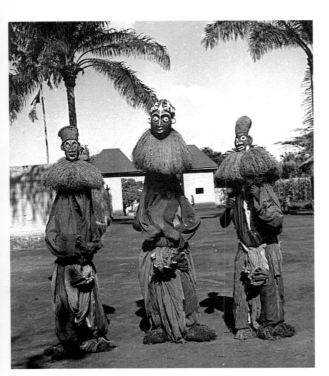

960 *Fon* Kamwa Mars of Baham in front of a door frame
(Negative: Christol, 1937)

961 *Katsoh* mask in front of Tenkue Pehuie Prowo, who became *fon* of Bagam in 1963
(Negative: Christol, 1925)

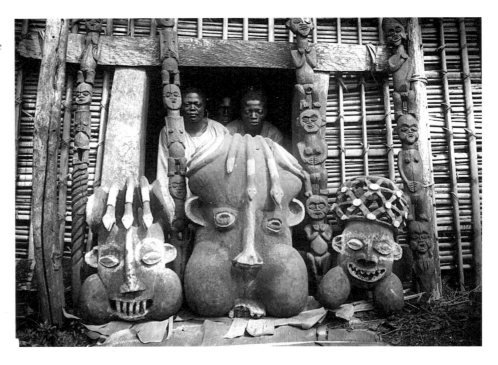

In Bamileke territories, almost all power was concentrated in the *fon*'s hands, while on the Bamenda plateau in the north, he only played a cultural and religious role, with the council of notables holding primary authority. These dignitaries belong to many more-or-less secret customary societies, either martial or judicial. The *kwifon* was the regulatory society of the eastern region. The *pontieu* brought together the *wala*, who were responsible for the maintenance of the adornments for the dance; these belonged to the treasury of the chieftainry. The *fon* entrusted the guardianship of the sculptures to certain members, for to spread around portions of the treasury was an insurance against the frequent fires. On the other hand, healers and diviners (who read the future in spider tracks) did not play an important role.

Masks that elicit fear and apprehension are the work of societies responsible for repression. All young boys belong to associations based on age classes, covering periods of five years each, focusing on military and technical apprenticeship.

The chieftainry or chief's residence included several huts occupying a slope on either side of a great lane. Originally, the chief's hut itself was a large quadrangular building with a

962 Bamum masked dancers

conical roof; an exterior gallery formed by pillars wrapped around the house; beyond it extended a sacred wood whose trees were used for sculpture, after a ceremony was performed. At Bali, the colonnade had about twenty pillars that together related the history of the chieftainry, its *fon*, and its ancestors. Each new king had to have his "portrait" sculpted within two years after his enthronement. It was thought that the king, responsible for the fertility of the soil and for the prosperity of the chieftainry, never really "died" but rather retired while continuing to protect his people. For this reason, the royal funeral used to be a fairly joyous occasion.

Regalia and objects of prestige were created for the *fon* and dignitaries of the different kingdoms; hence the multiplicity of styles. Art objects were symbols of position in the hierarchy: their number, the materials from which they were made, and their iconography changed progressively as one descended or ascended the social ladder. Competition among sculptors was often great, for the artist's "office" was not hereditary. Sculpture's goal was to commemorate and celebrate the royal ancestors of the present *fon*. In the *fon*'s palace, next to the ancestral figures and the masks, one would also find headdresses, beaded thrones, bracelets, necklaces, pipes, leopard skins, elephant tusks, clothing made of bark, costumes dyed blue and white, bags, swords, commanders' sticks, fans, dishware, horns, and terracotta bowls. To guard against the risk that these goods might be dispersed too widely, certain *fon* had their treasures guarded and would show some pieces only on exceptional occasions. The various societies also had their masks: for example, the *kwifon* owned masks which, according to tradition, had been created and consecrated by the ancestors themselves. The *mabu* or the *nkok* inspired great fear; those of the *ngirih* (the princes' association) were decorated with beads, copper, and cowrie shells. Most of the kingdoms used the same types of masks: buffalo, stag, elephant, birds, and male human heads. The buffalo and elephant masks represented strength, and the spider mask, intelligence, but most of the meanings are now lost.

Every craft was represented: ivory, goldsmithing, ceramics, beading. Art professions were innumerable, ranging from architectural sculpture to the most minute arts, such as embroidery, beading, dyeing, and lost wax casting.

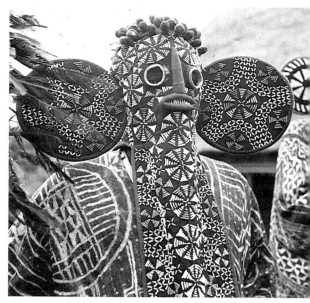

963 Bamileke elephant mask
Fabric and beads. In situ

964 Beaded statue, Bamileke, Cameroon
Wood and beads. Height: 67 cm. Private collection

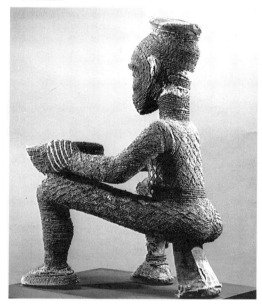

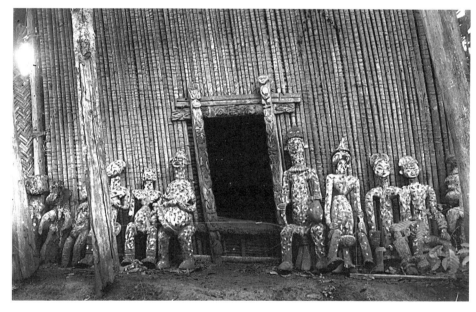

965 Commemorative statues of the *fon* and queens of Batufam, 1925
Six generations, up to the usurper Njike (Negative: Christol)

In the Bamum kingdom, the sultan Njoya, heir of a dynasty, played an important role at the moment when the missionaries and German explorers arrived—and with the introduction of Islam, which threatened the cultural identity of his people. He had all the customs developed over the reigns of his fifteen predecessors recorded using a form of writing he himself had invented. Bamum social life was oriented toward the conquest of surrounding chieftainries, and forays were made into neighboring lands: from this stems a warrior mythology and an abundance of material symbols of strength.

In the small kingdom of the Bangwa, the heads of statues and masks feature puffed-out cheeks. The very characteristic sculpture in the round attains its apogee in a depiction of a hornplayer who wears traditional headgear in the shape of a tiara; the thick double arc of his eyebrows overhang, and the mouth is treated in parallelepipedal relief under a heavy nose featuring well-shaped nostrils.

The wood used for masks is not always completely hollowed out, for the mask does not cover the face of the wearer but rather tops a kind of bamboo cage surrounded by a tufted collar of palm fibers, which conceals the head.

These masks, instruments of societies with political, administrative, judicial, or theatrical functions, were kept in special storage houses; they were brought out at the first rainfall. Then, the king himself would appear masked and dancing.

The buffalo, figure of power, joins the leopard, elephant, and two-headed python as an image of royal power which is frequently found in the decoration of works from the region.

The *batcham* mask has incorrectly been given the name of a small Bamileke kingdom in the northwest region of the Grassfields. These masks were so popular among the Bangwa

966 Bangwa double-faced mask, Cameroon
Wood. Height: 41.5 cm. Musée Barbier-Müller, Geneva

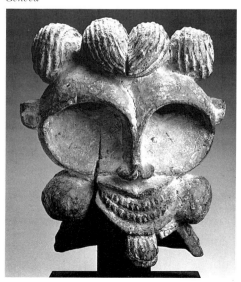

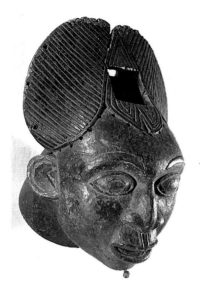

967 Royal Bekom mask, Cameroon
Wood. Height: 36 cm. Linden Museum, Stuttgart

968 *Mu po* statuette depicting a pregnant woman, Bamileke, Bangangte, Cameroon
Wood. Private collection, Guimiot Archives

969 Bamileke or Wum small mask, Cameroon
Wood. Height: 6 cm. Private collection, Belgium

and the Bamileke that several studios made them their specialty. The first one was brought back to Leipzig in 1904 and, until 1925, only three were known. A photograph from that period shows a *batcham* placed on a throne along with other royal objects. Presently about a dozen have been found; their roles seem to vary according to the informant: one is a mask of the *kah* society, one of whose members, hidden in a batik dress, would dance for the *fon* when the latter was on his way to the society; another mask was said to be used at the time of the funeral of a *fon* or a notable; yet another served to designate the royal heir when the princes met. (P. Harter)

The *batcham* mask has an utterly specific form that does not resemble any other. It is conceived on two planes—the first occupies vertically the upper two-thirds of the mask and is shaped by two symmetrical hollows separated by a median crest: this plane corresponds to oversized eyebrows. Then, almond-shaped eyes with exaggerated ocular globes form a transitional section with a slightly oblique plane. Finally, there is a second horizontal plane, which includes the cheeks, a nose with dilated nostrils, and a protruding mouth above a receding chin. The base is a hollow circle that allows the structure to be worn on the shoulders.

The art of Cameroon is the art of a royal court that had a complex protocol and numerous rituals that were not always accessible to all. Despite a relative structural similarity, characterized by an asymmetry and absence of frontality, works of a great diversity of style were produced by these small kingdoms.

P. Harter, *Arts Anciens du Cameroun* (Arnouville, France: Arts d'Afrique Noire, 1986).
———, "Les Masques Dits *Batcham*," in *Arts d'Afrique Noire*, no. 3, 1972.
R. Lecoq, *Les Bamilékés* (Paris: Présence Africaine, 1953).
T. Northern, *The Art of Cameroon* (Washington, 1984).
C. Savary, *Cameroun: Arts et Cultures des Peuples de l'Ouest* (Geneva: Musée Ethnographique, 1980).

970 Front of a Duala dugout canoe, Cameroon
Total length: 220 cm. Musée de l'Homme, Paris

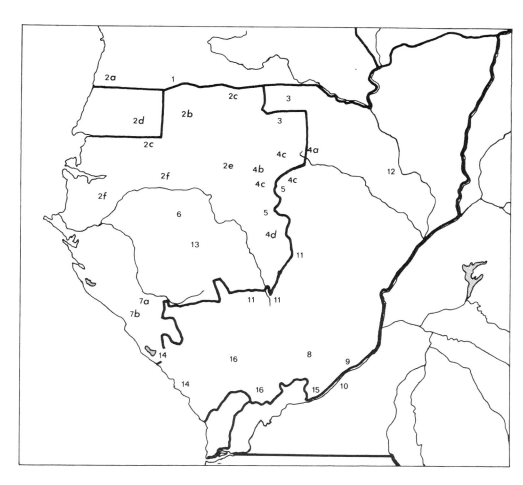

1 Bulu
2 Fang: a) Mabea, b) Ntoumou, c) Mvai,
 d) Okak, e) Nzaman, f) Betsi
3 Bakwele
4 a) Mahongwe, b) Shamaye, c) Kota,
 d) Obamba
5 Mbete
6 Tsogho
7 Shira: a) Punu, b) Lumbo
8 Bembe
9 Bwende
10 Bakongo
11 Teke
12 Kuyu
13 Mashango
14 Vili
15 Badondo
16 Yombe

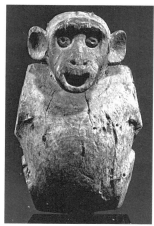

971 Bulu monkey, Gabon
Wood. Height: 30.5 cm. Private collection

The Ohe Ogooué Basin

(Gabon)

THE BULU Occupying the border region between Cameroon and Gabon, the Bulu form part of the Fang group and live not far from the Bakwele, with whom they share cultural similarities. From 1880 to 1910 the Bulu—like the Fang of southern Cameroon, famous for their large white masks—practiced a *ngi* ritual against sorcery, in particular, against poisonings. *Ngi* is the gorilla, a fearful animal, with whom the candidate identifies after he has been accepted into the association.

Fewer than ten monkey statues are extant. The inventiveness of their round, simple forms is striking, and artists have captured with great precision the animal's posture. Some stylistic elements in Bakwele and Fang sculpture can be noted here too.

L. Perrois, *La Sculpture Traditionnelle du Gabon* (Paris: Office de la Recherche Scientifique et Technique Outre Mer, 1973).
A. R. Walker and R. Sillans, *Rites et Croyances des Peuples du Gabon* (Paris: Présence Africaine, 1962).

972 "Sacrifice of Blood over the Skulls of Ancestors"
Drawing, 1913–17, by Pastor Fernand Grebert

THE FANG The territory covered by the Fang ethnic group, formerly called the Pahuins, is vast: it extends from the region of Yaounde in Cameroon to the Ogooué River in Gabon and includes equatorial Guinea. Since the seventeenth century, these tribes have traveled hundreds of kilometers through the heart of the forest, moving southwest. The boundaries between styles are not absolute but, thanks to field studies done between 1895 and 1910, the origins of reliquaries that came to Europe relatively early have been more or less identified; in fact, "Pahuin idols" are found in the earliest collections of Paul Guillaume, Jacob Epstein, André Derain, Felix Fénéon, and others.

In 1851, Paul Du Chaillu traveled up the Ogooué estuary and in 1863 published his account *Voyages et Aventures en Afrique Equatoriale*, which was criticized at the time for having stretched the truth. He described the Fang as bellicose, man-eating savages who consumed their dead, hunted elephant with poisoned arrows and traps, and who were very superstitious: each death required an ordeal. Sanctuaries in villages were surmounted by

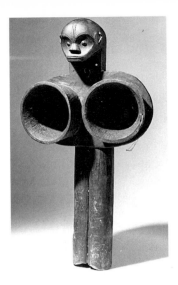

973　Fang bellows, Gabon
Wood and skin. Musée de l'Homme, Paris

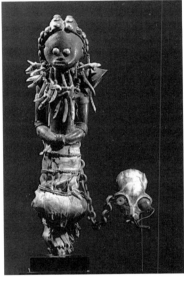

974　Fang statue, Equatorial Guinea
*Collected in 1915. Wood, teeth, skin, skull, nails.
Height: 27 cm. Private collection*

975　Fang dancing with his *byeri*, Equatorial
Guinea

monkey skulls. Later on, Du Chaillu was vindicated; in fact, he had not exaggerated at all.

Among the Fang eighty clans have been counted; there has never been political unity. Cohesion was maintained through the intermediary of judiciary and religious associations such as the *so* and the *ngil*. In the patrilinear Fang society, authority was in the hands of the oldest man of the family. In every village the men's house played an important role: it was the place for meetings and visitors. The men took their meals there, young bachelors lived there, and blacksmiths and sculptors worked there, enjoying general respect. From birth to death, a male Fang was integrated into his milieu by means of rites involving every stage of his life. Circumcision was performed between the ages of eight and ten; the young boy would learn genealogy to avoid committing incest when he chose a wife. At his marriage, he would be initiated into the *so* and into the family *byeri* cult, an ancestral cult in which initiation was accompanied by a theatrical reanimation of the dead. Each clan, and later every family head, kept a cylindrical box of tree bark in his hut containing the skulls of ancestors. Heads or full-length statuettes were placed on top of these boxes of bones, which were tied up with lianas.

Sculptors played a symbolic role at the times of raisings of the dead; simultaneously, they had a protective function. The *byeri*, or ancestor figure, would be consulted when the village was to change location, when a new crop was planted, during a palaver, or before going hunting, fishing, or to war. But once separated from the reliquary chest, the sculpted object would lose its sacred value and be destroyed. The ritual consisted of prayers, libations, and sacrifices offered to the ancestor, whose skull would be rubbed with powder and paint each time. With its large head, long body, and short extremities, the Fang *byeri* had the proportions of a newborn, thus emphasizing the group's continuity with its ancestor and with the three classes of the society: the "not-yet-born," the living, and the dead.

This cult had as its essential purpose the perpetuation of the lineage groups, as it was believed the dead could control occult spirit forces. The eldest sons, the future chiefs of the clan or family, were the only ones initiated. The ancestor was the axis of society, guardian of the living world and the life to come. Beliefs, rites, social organization, and ways of doing things were all connected to him. The Fang, like the Bulu and Beti, had a religious approach based on two levels: the ancestor cult, which allowed for the integration of human actions into the framework of the clan, and the practice of magic through possession of the *evur*, a substance that gave one the possibility of acquiring decent status.

Having had to regroup after the long migrations that led them to the coast, in 1927 the Fang adopted the cult of the *bwiti*, a mixture of Christianity and ancestor worship that sought unity and reconciliation. The *bwiti* was borrowed from the Tsogho, under the influence of the Bilopes, who lived in the interior of Gabon. The Pygmies had taught the Tsogho the arts involved with the *eboga*, a plant that causes a loss of consciousness for several hours—the prelude to removing the ancestral skulls from their box. The contents would be shown to the initiates, the future guardians of the *byeri*. At the *bwiti* ceremonies, the old men could be seen dancing with the *bwiti* in their hands.

According to James W. Fernandez (1968), the synthesis of *bwiti* and Catholicism was made all the easier as the colonial conquest seemed proof that the ancestors had been overwhelmed by the number and strength of the sorcerers.

Fang art is exceptional by virtue of its homogeneity. Without entering into the perils of classifications, one can still easily identify a Fang statue from southern Cameroon, with its gracefully shaped, slender trunk, the head projected forward, a prognathic mouth, and clearly emphasized arcs of the eyebrows. One can also distinguish among these works from southern Cameroon the *mabea*, more realistically treated, covered with a red patina, with a smooth surface, its thorax decorated with geometric scarifications in metal, its pupils of mica containing a piece of tooth outlined in copper. Fang statues from equatorial Guinea, called *okak*, are slightly different, often featuring metallic decorations, especially nails. Finally, *ngumba* statues are in a more geometric style, sometimes including copper incrustations, while the works of the Fang from north Gabon have more compact shapes. All express a rhythm, vigor, and balance, arising from the polished masses detached from a central trunk.

The Fang used masks in their secret societies: the brotherhood of the *ngil*, or gorilla, whose aim was to unmask sorcerers, was outlawed in 1910. It used large, elongated masks covered with kaolin and featuring a face that was usually heart-shaped with a long, fine nose. Apparently, the ritual no longer exists; however, it must have been linked with the dead, since white is their color. The *ngontang* dance society also used white masks, sometimes in the form of a four-sided helmet-mask with bulging forehead and eyebrows in heart-shaped arcs. The *so*, or red antelope, was connected with an initiation that lasted several months; the masks sport long horns. Musical instruments—like the harp, its ends sculpted into lovely figurines—allowed communication with the hereafter. Blacksmiths bellows, many quite beautiful, were sculpted in the shape of figures; there are also small metal disks featuring heads, called "passport-masks"; the Fang attached these to their arms.

The Fang *byeri* were long among the most sought-after pieces of African art—to the point that these objects eclipsed the artistic products of neighboring groups to whom the Fang are related and who practice the same ancestor worship.

P. Alexandre and J. Binet, *Le Groupe Dit Pahouin* (Paris: Presses Universitaires de France, 1958).

R. and J. Fernandez, "Fang Reliquary Art: Its Quantities and Qualities," in *Cahier d'Etudes Africaines*, 60, XV, 4.

L. Perrois, *La Statuaire Fon du Gabon* (Paris: Office de la Recherche Scientifique et Technique Outre Mer, 1972).

L. Siroto, "The Face of the Bwiti," in *African Arts*, I, 3, 1967.

THE BAKWELE The Bakwele, harassed by their neighbors—who, at the end of the last century, had acquired European rifles—were forced to flee east and settled in the northeast region of Gabon, between the Dja and Ivindo rivers. Each village consisted of about a dozen lineages, each one of which was headed by the family chief, who was in competition with other chiefs also hoping to run the village. Political power passed from one lineage to the next. Besides the war leaders of each lineage, called *gen*, settlements had "priests" as well as a "peacemaker," whose role was very important in this atmosphere of constant rivalry. He avoided direct confrontation to every extent possible. If village life became too difficult, a lineage would leave to establish another settlement farther away.

The internal cohesion of the village depended on the prestige and authority of its founder and the ability of the peacekeeper to maintain order. To reinforce unity, the Bakwele borrowed the *beete* cult from the Ngwyes; the cult's celebration was decided upon at a meeting of the principal chiefs of the lineage. The *beete* ritual, which lasted for a whole week, would open with the departure of able-bodied men into the forest to hunt antelope, whose flesh, seasoned with medicines, had to be eaten at a meal at the closing ceremony. During the hunt, women and children stayed in the village; after one or two days, *ekuk* masks would "leave" the forest, enter the village, and invite the people to come dance and sing. *Ekuk* means both "forest spirit" and "children of *beete*." This mask, with two large horns, represents the antelope. Throughout the preparation for the celebration, the village became progressively more animated as the hunters returned from the forest with their booty, and friends and guests arrived to participate in the performance of the rite.

A little later, another mask, the *gon*, announced by bells, would make its entrance; the women would immediately lock up all the domestic animals inside the huts; everyone would begin looking for shelter. *Gon* is a dangerous mask: chained with ropes, held up by young people, it carries five short spears in its hand, which it throws at anything that moves. It often even manages to free itself from its guards and hunts down the whole village. The wearer of the *gon* mask is nude—as opposed to the person dressed in the *ekuk*, who wears a wide skirt of fibers. But the lineage responsible for *gon* can only be identified by its attendants. By the end of the day, *gon* may have killed a few domestic animals, but these killings are ritualistic—there is no record of any person being hurt or killed. The mask is made in the image of a skull of a gorilla, an animal feared by the Bakwele because of its frequent destruction of their crops. The mask's forehead bulges; the lower, prognathic jaw usually has two long spikes. A median crest divides the forehead.

The success of the rite depended on magical substances and on the acquisition of skulls of ancestors of widely respected power. It was often necessary to borrow reliquaries from other villages. After *gon*'s departure, the lineages whom he had attacked must either leave or submit to the authority of the one who wore the *gon*. His appearance, thereby, reinforced the position of the "leader."

The Bakwele do not have statues; however, sculpted plaques can be found inside huts, along with some beautiful bellows with handles sculpted into figurines.

L. Siroto, "Gon: A Mask Used in Competition for Leadership Among the Bakwele," in *African Art and Leadership*, D. Fraser and H. M. Cole, eds. (Madison: University of Wisconsin Press, 1972).

976 Bakwele masked as *gon*
Painted by Gustav Dalstrom

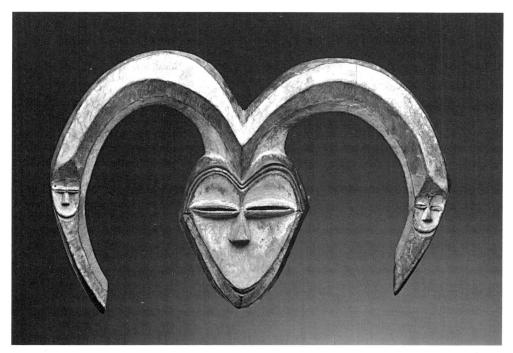

977 Bakwele mask, Gabon
Wood. Height: 62.5 cm. Musée Barbier-Müller, Geneva

978 "Invocation to the Fetishes"
Drawing by Riou in "Voyage dans l'Ouest Africain par Savorgnan de Brazza," Le Tour du Monde, 1887

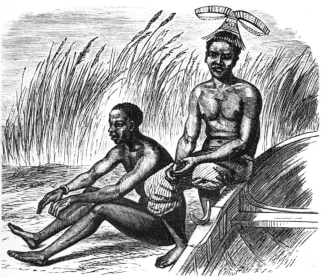

979 Bakota in
The Natural History of Man, *by J. G. Wood, 1880*

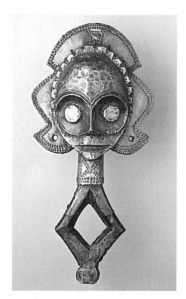

980 Kota-Obamba reliquary, Gabon
Wood core and copper. Height: 41 cm. Musée Barbier-Müller, Geneva

THE MAHONGWE, THE SHAMAYE, THE KOTA, THE OBAMBA

The land of the Kota is situated in the eastern part of Gabon, extending slightly into the People's Republic of the Congo. The population lived in villages that comprised several clans. These were subdivided into family groups, *dyo*, descendants of a common ancestor. Secret societies, such as the panther-men, constituted a kind of aristocracy. The *ngoye* society was responsible for the initiation of young boys.

Under pressure from the Bakwele and Fang, from the seventeenth to the end of the nineteenth century, the Kota population constantly emigrated south. However, the Mahongwe, for their part, traveled upstream toward the east to the springs of the Ogooué River, crossing the border into the Congo.

Ancestor worship formed the core of the family group's religious and social life. At the death of a chief, the initiates would take from the body of the deceased various relics, which were then decorated with metal and rubbed with powders of multiple magical powers. These would be kept in baskets surmounted by stylized figures—these were long called *naja* by the Europeans because their shape was reminiscent of the head of an erect snake. The Kota and Mahongwe covered these figurines with copper or brass. Every Mahongwe clan had a reliquary kept in the back of the chief's hut. At the time of initiation in the reliquary cult, the clans would meet to perform communal rituals; each clan's chief would dance holding the reliquary. Some reliquaries featured a large figure representing the lineage founder along with some smaller figures representing his successors. Among the Kota, the reliquaries were kept outside the homes, in huts at the edge of the village. Only the initiates of the lineage had access to this sacred place.

From the outset, missionaries made every effort to combat these rites, and the 1930s were marked by innumerable autos-da-fé. The first artworks from this region entered European collections in the 1870s, following the expeditions of Pierre de Brazza and Alfred Marche in the Ogooué and Congo basins.

Mahongwe reliquaries, or *bwete*, have the form of two-dimensional cores of wood of varying thickness and are covered with copper or brass, which used to come from the Niari mines in the Congo and was later replaced by copper wire imported from Europe. Copper was considered a precious material, and the reliquary would be carefully maintained.

The "face," shaped like a snake's head, is divided into two equal parts by a vertical band that is horizontally striated by brass bars. Hooded eyes stand a little above the horizontal median on either side of the nose, a fine perpendicular lamella on the facial plane; the mouth is not depicted. From the ocular globes vertical lines descend, widening at the bottom—these might be interpreted as tears or merely as decorative motifs. A "bun" or small cylindrical crest tops the whole. The face is attached to a "neck," which is wrapped in copper wire and divides into two branches; it extends out perpendicularly to the plane of the face. This lozenge shape allowed the sculpture to be mounted on top of the relics and also very likely served as a handle for the presentation of the figures. These handles are also found among the Kota, but extend from the same plane as the face.

The Shamaye are intermediaries between the Mahongwe and Kota from a stylistic point of view and live southeast of the Mahongwe; they also use reliquaries, but smaller ones, with a narrow wooden figure characterized by a protruding forehead and fine nose in relief, the face framed by two growths that perhaps represent braids on either side of the neck. The diamond formed by the "arms" extends parallel to the plane of the face, as among the Kota.

Leaving the region of the Mahongwe, who have a relatively homogeneous style, one begins to encounter works whose classification and chronology pose problems. Kota sculpture, generally created as a single piece, includes no elements imported from elsewhere. The Kota artist would cut the general outline of a figure out of a metal plaque; this was placed onto a wooden base. Then he would proceed by subtraction. The mouthless face is generally oval, slightly concave, covered by brass or copper sheets, from which two metallic bands are loosened and formed into the shape of a cross, creating a sharp, triangular nose that juts out from between the two eyes. On either side of the face are flat sections decorated with geometric motifs; these balance against a half-moon–shaped headdress. Sometimes, on the reverse side, there is a Janus figure, always concave; other designs include geometric signs; a depiction of the braided hairdo of the warrior (still on the raw wood); a symbol of the female sex; or a form representing a hunter's weapon. (J.-L. Paudrat, 1986)

Kota art began to quickly deteriorate at the beginning of the twentieth century, following a growth in demand from European collectors.

A. Chaffin, *L'Art Kota* (Paris: Chaffin, 1980).
J.-L. Paudrat, *La Voie des Ancêtres*, exhibition catalogue, Fondation Dapper, Paris, 1986.
L. Perrois, *La Sculpture Traditionnelle du Gabon*, op. cit.

981 "Pongo Fetishes"
in "Voyage dans l'Ouest Africain par Savorgnan de Brazza," Le Tour du Monde, 1887

THE MBETE The Mbete are situated on the border between the Middle Congo and Gabon, east of the Obamba. They claim a Kota origin, but may have come from the Ubangi River region, moving toward the upper Ogooué River in the sixteenth century. At the beginning of the nineteenth century, they were in constant battle against the Teke. Brazza discovered them in 1877 during his first trip to Africa.

Like their neighbors in Gabon, the Mbete do not have any centralized political organization; they practice ancestor worship, but do not employ reliquary boxes. Instead, statues are provided with a dorsal, rectangular cavity, or the body itself may be in the shape of a reliquary chest. In this case, generally the head alone is sculpted in the round, the arms and lower extremities only roughly carved out. One also encounters simple heads and busts that seem to have an emblematic or prophylactic function.

Characteristic treatment of the face is: flat and recessed, with an ample forehead, rectilinear eyebrow arcs, slitted eyes, a straight nose, and a rectangular mouth. The shoulders are thrown forward, the arms slightly bent. Frequently, the hairdo, composed of horizontal loops, is parted by a central crest. The number of Mbete works is not large; stylistically they resemble sculpture from northeastern Zaire. But the same hollowed-out cavity in the back of the figure is also found among the Bamileke of Cameroon.

L. Perrois, *Art Ancestral du Gabon* (Geneva: Musée Barbier-Müller, 1985).

THE TSOGHO The 13,000 Tsogho inhabit the banks of the Ngounie river. Since their neighbors the Bakwele raided and pillaged their villages in order to procure slaves and women, the Tsogho penetrated deeper into the interior—but they still furnished a large contingent of slaves to coastal traders.

Divided into six matrilinear clans, the Tsogho have no centralized government. Administration and power are in the hands of the village and the clan; in addition, there are seven societies of initiates, the three most important being the *bwiti*, the *kono*, and the *ya mwei*, or water spirit, guardian of the founding power of the lineage.

The *bwiti* is also found among other ethnicities in Gabon. Each village practices it under the direction of the supreme chief along with the local *ngondje* president and a vice-president, the *kombwe*. The initiates of long standing are called the *nima*, the aspiring ones, the *ibandji* or *abandji*. The *bwiti* does not include rites of passage as such but does involve an initiation by ingestion of the *iboga*, a hallucinogenic plant.

Formerly, the blacksmith was also a wood sculptor; he held a privileged position. He used a bellows made of two compartments covered with skin whose central axis was often sculpted with a figure. Every young boy learned the rudiments of sculpture and pursued this activity if he was particularly gifted. Woodworking has continued, for it is integrated into social and religious life. Artistic products include masks, statuettes, small columns, pillars, and doors, as well as musical instruments, bell handles, and boards with sculpted figures; these latter were exhibited during times of mourning. Statuettes are few in number and rarely of high quality. The healer-diviners owned prophylactic statuettes which they kept in baskets.

The men's meeting house, or *ebanza* temple, was a rectangular construction divided in two parts and covered with a roof supported by two pillars, one of which was sculpted. Inside, masks, statues, harps, drums, horns, bows, and other objects necessary for the *bwiti* were kept. O. Gollnhoffer and R. Sillans have studied how different elements of the temple symbolized the different parts of the human body: for example, the bell that hung from the pillar signified the heart and the red parrot feather at the foot of the pillar signified the tongue or speech. The teaching of the *bwiti* was based on a theory of reincarnation. The latter was brought to life through dramatic presentations accompanied by a symbolic death and rebirth.

For funeral or harvest rituals, statues would be lined up inside the temple.

The masks are regarded as supernatural apparitions whose function is to bring to view a prolific pantheon of symbolic images. In the *bwiti* society, the mask is regarded by night as a sacred object reserved only for initiates; by day, it appears for all to see and may at one and the same time inspire fear and be an occasion for play. Each mask has its own name and symbolism; dance and song specify its meaning. Among the Tsogho, the elongated, almond-shaped eye is an ideal of beauty known by the name *mighembe*. One notes a proliferation of forms and a tendency toward schematization and "expressionism." The Tsogho have adopted the white mask from the Punu and Lumbo, who live nearby. They have made a synthesis of their own beliefs with borrowings from other tribes.

O. Gollnhoffer, P. Sallée, and R. Sillans, *Art et Artisanat Tsogho* (Paris: Office de la Recherche Scientifique et Technique Outre Mer, 1975).
O. Gollnhoffer and R. Sillans, "Le Symbolisme chez les Mitsogho," in *Systèmes de Signes* (Paris: Hermann, 1978).

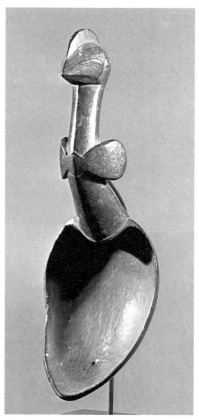

982 Spoon of the Nzebi, related to the Tsanguy, Gabon
Wood. Height: 20 cm. Private collection

561

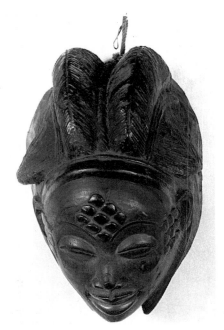

983 Punu mask, Gabon
Wood. Height: 25.4 cm. Museum of Science, Buffalo

THE SHIRA, THE PUNU, THE LUMBO These three equatorial forest peoples had to flee under pressure from the Fang; they settled in the south and southwest of Gabon. They form part of the intricate network of Gabon's forty ethnicities, all of whose institutions are similar and whose daily life is regulated by the necessities arising from a physically hostile environment. Lacking centralized political organization, social life is concentrated in the village and clans. Ancestors and tutelary spirits are worshipped, and it is the initiation brotherhoods, such as the *mukudji* society, which play a therapeutic and judiciary role and rule social life.

These groups have statues and masks that appear in funerary rituals, initiation ceremonies, and the magical rites whose function is to unmask sorcerers.

White masks are famous throughout Gabon. Their style here is more realistic than in the north: they are characterized by oval or triangular faces, hairdos composed of one or several loops, a dominant forehead, large eyes of coffee-bean shape with slightly hollowed sockets, and a realistic nose with pronounced nostrils and sides. The lips are outlined, the cheekbones protrude, the chin is pointed. Some masks have diamond-shaped scarifications on the forehead and temples. As among the Dan, the dancers walk on stilts, invisible under their fiber skirts, holding their masks between their teeth by means of a small stick of wood attached to the back of the mask. White masks participate in celebrations; black ones operate as judges and help identify sorcerers. (L. Perrois, 1979)

There are few Punu statuettes. Some, in their somewhat rigid appearance and in the tattoos on the face, indicate a Yombe influence.

Lumbo statuettes are recognizable by their braided hair that terminates in a horn shape. Their function is no longer known, but from their small size, one may gather that they served as protective charms. The facial features of the white masks are found here, too. From a slight bulging visible around the "face," it appears that some statuettes may represent a person wearing a mask.

A. Fourquet, "Chefs-d'oeuvre de l'Afrique: Le Masques Punu," in *l'Oeil*, no. 321, April 1982
L. Perrois, *La Sculpture Traditionnelle du Gabon*, op. cit.

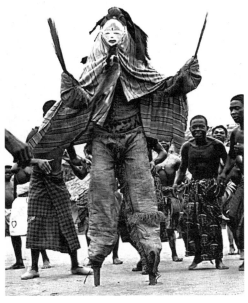

984 Punu dancers on stilts
In situ

Lower Zaire

(Congo, Zaire, Angola)

THE BEMBE The Bembe form a small group of 70,000 people; they live on the plateaus of the People's Republic of the Congo as well as on the shores of Stanley Pool and in the cities of Brazzaville, Dolisie, and Pointe-Noire. In 1882, Brazza was the first European to cross the land of the Bembe, but the first systematic exploration, by Mangin, did not take place until 1903. The Bembe had close contacts with their neighbors the Teke, but Kongo contributions were essential to their culture and traditions.

Their social organization was based on the matrimonial clan called the *kanda*, whose members could live in several villages. The family unit, *mwoyo*, generally included three generations, or about fifteen people. The chief in charge of the village, the *nga-bula*, mediated with the ancestors. His role was even more important in the nineteenth century when villages were constantly at war with each other: then he would determine the conditions for a return to peace. Since these wars were very bloody, village security required internal solidarity within each community stronger than that between families or alliances. Hunting was the main activity; before leaving on a hunt, the leader would invoke the ancestral spirits, using as intermediaries statuettes kneeling in the position of a hunter lying in wait for his prey.

The Bembe believed in a creator god, Nzambi, whom they did not depict figuratively. He was the master of life and death—unless the latter was due to the act of a sorcerer, *ndoki*, who could magically "eat" the life force of clan members.

The ancestors participated in social life; they had close ties with the living and received offerings through the intermediary of the *nga-bula*, the "priest," who made appeals to miniature statuettes, the *kitebi* or *bimbi*, consecrated by the "sorcerer," the *nganga*. These figurines were the idealized images of the ancestors and would often wear attributes that allowed them to be identified as medicine men or hunters. The ancestor worship among the Bembe is older, though, and precedes the use of magic statues, *nkisi*, by the sorcerers.

The Bembe statuettes are divided by size and sex. Some of them are consecrated; in an anal orifice the *nganga* inserts *bilongo* (medication) or ancestral relics (hair, nail parings, or bones), symbols of the strength and spirit of the deceased relative. The orifice is closed with a plug or piece of fabric. As long as the spirit lives in the statue, it watches over its descendants and punishes transgressions of customs or precepts. The statuette is dressed in a skin or fabric loincloth and a beaded necklace, and wears a beard. The palms of the male sculptures' hands are turned toward one another or they carry objects: a rifle or knife in the right hand and a calabash in the left. Sometimes two braids frame the face, sometimes the

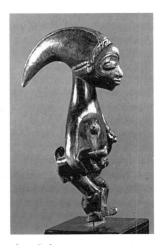

985 Lumbo, Gabon
Wood. Height: 9 cm. Private collection; formerly P. Guillaume, Stéphen Chauvet collections

hairdo ends in a long braid at the back of the head. The figure usually is upright with knees slightly bent, its large feet with carefully articulated toes standing on a base; the seated position occurs less frequently. Female statuettes have a pronounced, almost square, chin, a large nose and mouth, finely sculpted ears, and hair carved in relief on the forehead. Miniaturization, scarifications, and very specific expressions are characteristics of Bembe sculptures: their average size varies between 10 and 15 centimeters. Tattooing on the lower abdomen demonstrates a concern for detail and finish. The eyes are embedded with seashells or crockery.

Besides the "inhabited" statuettes, the Bembe worship large anthropomorphic red figures made of fabric, the *muziri*. These effigies, permanently installed at the entrance of the villages, were made when a deceased *nga-bula*, or priest, was judged to be creating disorder in order to express a desire to be exhumed. All the ancestor's bones would then be carefully gathered inside this fabric manikin to ensure in this way his perpetuation. Properties of the community, the *muziri* were also used in divination, without being regarded as necessarily able to influence the course of events.

One finds the same magic *minkisi* objects among the Bembe as among the Bakongo; they belong to the *nganga*, who consult them in the case of an unnatural death. In contrast to Bakongo nail fetishes, some possess but a few nails, not because they had not yet been used, but because nails were only one element of the figure. Figures were wrapped in fabric and carried small bags of medications around their neck. Bembe art is profoundly religious; its purpose is to maintain contact with the dead. Nevertheless, an ornamental, secular art does exist and includes pipes, spoons, earplugs, and musical instruments.

G. Dupré, *Les Naissances d'une Société* (Paris: Office de la Recherche Scientifique et Technique Outre Mer, 1985).

B. Soderberg, "Figures d'Ancêtres chez les Babembé," in *Arts d'Afrique Noire*, nos. 13–14, 1975.

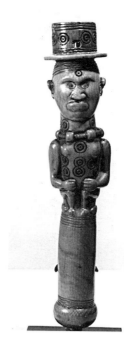

986 Handle of a Kongo flyswatter, Zaire
Ivory. Height: 20.7 cm
Private collection

THE BWENDE The Bwende are settled along the Congo River, from the Etuala to Stanley Pool; their society resembles that of the Teke and the Bembe. They adopted the cult of the *niombo*, which involved a ritual performed on the occasion of the death of a chief or notable. The body would be placed on a wooden mattress underneath which a fire would be lit that would last for several months. During this period, cloths of natural fiber, European fabrics, African wraps, mats, and blankets would be piled up, eventually to clothe the deceased, or *niombo*. When the body began to mummify, blackened with smoke, the master of the *niombo* would dress it.

Some *niombo* measured almost three meters high and five meters in circumference and were able to enclose as many as four corpses. After the grave was dug, the bodies, having been brought round the village accompanied by musicians, family, and the population of neighboring settlements, would be lowered vertically. On the burial mound, a shelter was erected in which the usual household objects would be piled along with statuettes, rifles, gunpowder, food. Originally, spilt wine and broken dishes were also included. Once the ceremony was completed, villagers would set fire to the deceased chief's dwelling. During the following days, the family would hold a feast to thank donors and musicians.

The Bwende's diminutive statuary is small in quantity, but a few pieces are of great quality; generally, these are standing figures characterized by a more aggressive appearance than the statues of their neighbors the Bembe and featuring numerous scarifications.

R. Lehuard, *La Statuaire du Stanley Pool* (Arnouville, France: Arts d'Afrique Noire, 1974).

987 Woyo cover with proverbs
Wood. Musée Royal de l'Afrique Centrale, Tervuren, Belgium

988 Kongo funerary statuette, Zaire
Limestone. Height: 42.3 cm. Ethnographic Museum, Leiden, Netherlands

THE BAKONGO The former kingdom of the Kongo consisted of lower Zaire, the Cabinda region, and northwest Angola, all unified in the fourteenth century. There were six provinces directed by a governor under the authority of the king, who sat in the capital of Mbanza (the present-day São Salvador in Angola). The Kongo first encountered Christianity through the Portuguese, who landed on the African coast in 1482. In 1485, missionaries began living at the royal court while Congolese nobles visited Portugal. The king had himself baptized in 1491, taking the name João I. Following internal struggles over succession, the Portuguese were chased out in 1526; but when the Bakongo were invaded by the Jaga in 1568, the Portuguese helped them overcome their rivals. Yet, the kingdom never regained its fifteenth-century splendor; it was constantly weakened by wars with Angola during the seventeenth century and by the dissolution of the six provinces, which no longer recognized the authority of the king. In 1885, the Kongo became a Portuguese colony.

Despite the king's conversion, the Bakongo people held on to their ancestral worship and traditional beliefs—to the point that Robert Farris Thompson was able to find these same practices among the Black populations of the New World, of which the Bakongo formed a huge contingent. The Kongo kingdom influenced the Bembe, Vili, Sundi, Yombe, and Dondo who, at one point in their history, were an integral part of this kingdom. Their sculpture contained the same themes: maternity figures, seated kings, objects of prestige, and nail fetishes.

The king holds political, economic, judiciary, and religious power. He makes decisions about warfare, regulates commerce with foreign countries, and receives tributes from his vassals. When he renders justice, he is seated on the skin of a leopard, wears a hat and a necklace of teeth, and holds a commander's staff and a fan. Clothed in state dress, the king's body itself is endowed with power as potent as that of the *nkisi* statue. It is sufficient to

989 "The Idols of Banza Ouvana"
Engraving

990 Kongo mask, Zaire
*Wood. Height: 22.8 cm. Kimbell Art Museum,
Fort Worth, Texas*

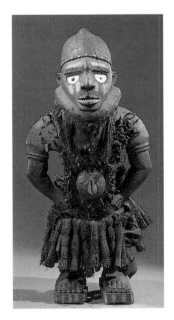

992 Yombe fetish, Zaire
*Wood, nails, metal strips, fabrics, mirror. Musée
Royal de l'Afrique Centrale, Tervuren, Belgium*

touch him to be healed. The king alone makes contact with the dead, at the time of judgments when he executes criminals and enemies of the State. The judicial system is very complex: small stones and a form of writing with ideograms are used to memorize the various laws. In addition to the authority of the king, the *nganga* consecrates medications and is in charge of the cults. The healer works with the help of plants or magic. The *lemba* association, in existence since 1660, is an organization of healers. Lastly, the *ndoki* sorcerer is feared for his power and his ability to cast spells.

The Bakongo demonstrate the extreme complexity of their traditions on major occasions, such as the investiture of a chief or at funerals. Thompson (1982) has shown that the daily journey of the sun around the world of the living and universe of the dead was symbolized by the spiral of a shell, a shape also found in the concentric spaces of the royal enclosure. The Bakongo capital expressed metaphysically the ideal balance between the vitality of the living and the visionary power of the dead. Compared to the Yoruba, the Bakongo pantheon was small: one all-powerful god who gave healing powers to the king, to the *nganga*, and to the heads of cults. Besides their textiles of great renown, the Bakongo had a funerary art of decorated steles and funerary statues in stone, very often depicting the chief seated cross-legged in a posture of reflection, his legs bent in front of him, his hands resting on his knees, eyes closed, wearing the *mpu* bonnet. Some of these statues were placed on tombs to aid the spirits of the dead to join the world of the deceased.

Wood sculptures represent royal wives, hunters, musicians, and healers. Their postures vary: sometimes they kneel in a position of respect, the head bent slightly backwards; women might be depicted seated with a child they hold by the neck or whom they are nursing. The cheeks are round, the face, carefully rendered, is more "realistic" than in the works of neighboring ethnicities, such as the Teke or the Songhay. The patina is smooth, the bust scarified. According to Thompson, who has surveyed the postures of these statues, a knee resting on the ground is the position of the hunter or healer offering his respects to the king. A hand touching the cheek is a sign of mourning.

The art of the royal court is manifested in objects of luxury such as commanders' staffs, flyswats, scepters, neck-rests, fans, swords, and musical instruments such as trumpets and whistles. Some of these are sculpted in ivory, which is rare in Africa as this material is usually reserved for export. The *mvuala* scepters, produced by the Yombe and Woyo, are ordinarily surmounted by refined female figures; sometimes they contain relics. During palavers, the messenger would hold the scepter in his hand to show that he had indeed been sent by his master. The Woyo figurines, carved in barely accentuated relief, seem gentler than those of the Yombe, whose aim was rather to inspire terror.

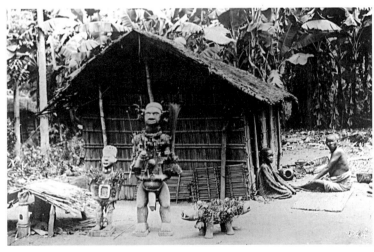

991 Large statues of the village, Yombe,
Boma region, Zaire
Photograph F. L. Michel, 1902

The nail fetishes, or *nkisi*, served to seal agreements, to restore health to the spirit or body, or, lastly, to destroy an enemy or sorcerer through magic. When it has a human shape, the statue is shown full face, its right hand raised or holding a weapon, its mouth open, with its eyes made of metal, shell, mica, or embedded glass, giving the face a "blank" stare—distant and sometimes troubling; it is covered with nails, blades, screws, or other pointed objects pushed into the neck, trunk, or arms. The visible part—the head, neck, and

arms—is often sculpted with greater care than the rest of the figure, which is generally covered. Frequently the *nkisi* is red, as this color stood for the power of the mediator for the deceased.

According to tradition, "the first *nkisi*, named Funza, came from God; he was accompanied by a large number of *minkisi*, whom he spread across the country, each one invested with a specific power in a specific area." (R. F. Thompson, 1982) The object holds within it a container and content: a leaf, shell, sachet, or statue that holds medication (*bilongo*); this protrudes through the top of the skull or is enclosed in the back or in a cavity at the same level as the stomach and sealed with a mirror. It is inhabited by the spirit of an ancestor, a dead person, or a victim of sorcery. The *nkisi* chases away sorcerers and individuals guilty of adultery, theft, or murder. O. Dapper (1686) describes a *nkisi* ceremony: "They would gather on a hill, taking with them a large *nkisi* in order to conclude the treaty with an oath, each of the parties planting on it a piece of iron or a knife that would be tied up with hair . . . , they would kiss the blade and fasten the whole while saying: 'a great anger has opposed us: if it has been appeased, come and confirm this for us, let us live in peace. If not, let *n'konde* devour us.'" The top of the hill suggests the capital and the ideal of justice that it represents. Before they became familiar with European nails, the Kongo used blades of forged iron, wooden plugs, thorns, and fishbones, which they would tie with straps to "seal the oath."

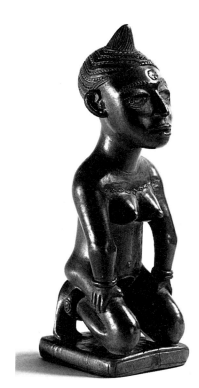

993 Vili statue, People's Republic of the Congo
Wood. Height: 18.5 cm. S. and M. Stanoff Collection, Los Angeles

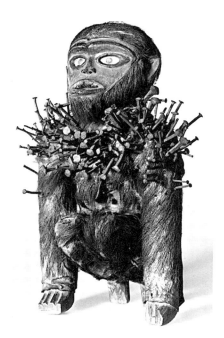 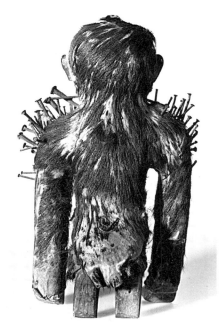

994–95 Vili monkey with nails, People's Republic of the Congo
Found in 1895. Wood, nails, scrap metal, fibers. Height: 35 cm. Ethnographic Museum, Leiden, Netherlands

The *nkisi* may take the form of a dog, although not alluding to the actual animal. For the Bakongo, these dogs have four eyes, an open mouth, and visionary power that allows them to sniff out night spirits and persons with bad intentions. Sometimes the figures have a Janus aspect that emphasizes their capacity for seeing beyond the universe. "Between the village of the living and the village of the dead, there is a village of dogs." (Cited by Thompson)

Formerly subjects of the Kongo kingdom, the Vili produce the same type of sculpture, although their objects of prestige are less important than their *minkisi*. Their *minkisi* have gentler expressions than the Bakongo's, which may be explained by the influence of ethnicities from south Gabon, notably the Lumbo.

O. Dapper, *Description de l'Afrique* (Amsterdam: 1686).
R. F. Thompson, *African Art in Motion*, exhibition catalogue, National Gallery of Art, Washington, D.C., 1974.
———, *Flash of the Spirit: African and Afro-American Art and Philosophy* (New York: Random House, 1981).
———, *The Four Moments of the Sun* (Washington, D.C.: National Gallery of Art, 1982).

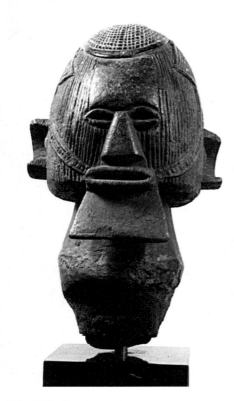

996 Teke head, People's Republic of the Congo or Zaire
Wood. Height: 9 cm. Private collection

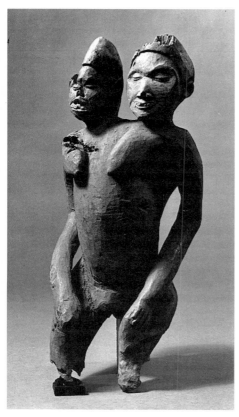

997 Mazinga figure of a woman with two heads, People's Republic of the Congo
Wood. Height: 53.4 cm. Göteborg Museum, Sweden

THE TEKE The Teke established the kingdom of Makoko on the right bank of the Zaire River, its founding dating back to the eighth century; it served as the model for the neighboring kingdoms of the Loango and Mani-Kongo. In the northwest, chieftainries freed themselves rather rapidly from Makoko authority. The king, considered sacred, was the intermediary between spirits and the living and was the guardian of fertility and the cosmic order. He was assisted by an elite group of three who put him through the rites of enthronement, which lasted for almost two years. The griots would sing of bygone history, the courage of kings, and their justice. The diviner would announce the length of the reign through magic procedures. The distinctive insignia of royalty were a headdress with two black rooster feathers in it, a red loincloth or wrap, two leopard skins, a scepter, a necklace with nine decorations on it, a cane, and a gong. The king was the guardian of the *nkira*, the male spirit, which originated from the fall of Mban on the Lefini, celebrated on the fourth day of the week.

The basic social unit was the family, under the authority of the *mfumu*, or head of the family; the latter had the right of life and death over all family members and his prestige grew as their number grew—hence a tendency to own many slaves to increase one's power and reputation. The village elected a chief who himself was subject to the authority of the clan, or *ngantsie*, which included several villages. This master of the land was the guardian of the *tara mantsie* (Father of the Land) fetish, a large wooden statue whose loins were wrapped in a piece of cloth and who had a bit of metal embedded in its navel, its eyes formed by two mother-of-pearl chips. This fetish was the guarantor of the fertility and well-being of the community. It presided over celebrations and collective rituals—but it was also the guardian of order and could punish, by exclusion, a member who had misbehaved.

In terms of spiritual life, the *mfumu mpugu*, the village chief chosen as religious leader, was the most important personage; he kept the basket that contained the magic statuettes and the bones of the ancestors.

The Teke often chose a blacksmith as chief—an important person in the community whose profession was passed down from father to son. The *ngaa* diviner, both sorcerer and healer, was also powerful; facilitating retributions, he would render effective the *mussassi*, personal protective statuettes, and would perform divination in instances of illness or death. His primary instruments were a small bell made from a dry hollow fruit, a broom from the feathers of the touraco, several statuettes, and a mirror.

In the male *mungala* society, the clan chiefs and the *ngaa* would instruct the future initiates. According to tradition, a disabled singer, Mungala, lived off the charity of those who listened to him; he then had the idea of creating a secret society whose song and rituals would ensure his sustenance permanently. Circumcision was practiced for aesthetic purposes but without any specific ceremony.

The Teke believed in a supreme being, the creator of the universe, called Nzami, but their only cult was an ancestor cult whose primary ritual was presided over by the *ngaa*. They honored nature spirits, whose favor they hoped to win: for example, when they left for the hunt, each carried a statuette to bring them luck.

Just like the Bakongo, the Teke have small-sized fetishes called *bilongo* that are filled with magic substances; presumably it was under their influence that the Bembe, Lari, and Sundi, their neighbors, adopted this type of fetish. The style is strictly "cubist," angular, the figures having a helmet headdress, trapezoid beard, parallel grooves along the length of the cheeks, their eyes and mouth in straight, horizontal lines. A small box the figure presses against its stomach holds magic materials—specifically, the placenta of a male child. The patina is shiny due to innumerable oil libations. These fetishes are rarely female and represent figures of authority. Besides the *bilongo*, figures in the shape of a top called *butti* exist, their bodies wrapped in a thick coating of earth and resin mixed with magic ingredients—often hair or fingernails. The sculptors belong to the tribe of the Wambundu who used to sell their figures across a wide region and supplied both the Teke and the Bayanzi as well as other tribes of the region.

In contrast to the Teke of Stanley Pool, who did not use masks, those of the northwest, notably the Tsaye, used disk-shaped painted masks for the ceremonies of their secret *kidumu* society. This political-religious institution, which is more than a century old, intervened in all the major events of social life: circumcision, the marriage of a notable, the death of a chief, alliances, judgments. The dancer, accompanied by an orchestra, would appear alone at the end of the ceremony. The *kidumu* still exists today but has kept only its folkloric aspect.

The moon-shaped masks—flat, decorated with abstract geometric motifs, colored with white or red earth, painted black, blue, and brown—are pierced with holes around the periphery to allow for the attachment of a woven raffia dress with feathers and fibers that conceal the wearer. On the other side of the mask, a cushion on three sides frames the wearer's face. Two slits in the center allow him to see without being seen.

The Teke have also done metalwork, primarily in yellow copper, to make ritual axes and necklaces. Terra-cotta vases, musical instruments, and household objects are of no particular artistic interest.

C. Cabrol, *La Civilisation des Peuples Batéké* (Multipress Gabon and P. Bory, S.A.).
M.-C. Dupré, "A Propos d'un Masque des Téké de l'Ouest (Congo-Brazzaville)," in *Objets et Mondes*, vol. VIII, no. 4, 1968.
R. Hottot, "Fétiches Téké," in *Arts d'Afrique Noire*, no. 1, 1971.
R. Lehuard, *La Statuaire du Stanley Pool, op. cit.*

THE KUYU This ethnic group is to be found on the banks of the Kuyu River in the northwest of the People's Republic of the Congo. In earlier days, the Kuyu were divided into two totemic clans: in the west, the panther clan, and in the east, the serpent clan. A secret male society, *ottote*, played an important political role in the nomination of chiefs. The initiation of young people would end with the display of the serpent-god, Ebongo, represented in the form of a head. The dances that accompanied the ceremony represented the successive stages of creation. The panther clan had a drum as its emblem; the serpent clan used sculpted heads painted in vivid colors, perched atop sticks that the handler, hidden under a long gown, held above his head. After the serpent had been displayed, sculpted figures that represented the primordial couple would appear: Joku, the father, and Ebotita, the mother.

Stylistically similar, both heads and complete figures feature bouquets of feathers on top of the heads—or they feature a large sculpted lizard whose tail hangs down the back of the head. Others have a quality imitating snakeskin. Also found are hairdos that divide into two loops on either side of a parted center, a style women wore in earlier times—probably an allusion to a female ancestor. White, the color of death, the face has colored scarifications or geometric motifs such as small dots or incised lines on the forehead, cheeks, and temples. The eyes are narrow, the ears small. The open mouth allows the fine, sharp teeth to be visible. The massive bodies of the figures are also scarified; arms may either be attached to or separated from the body, the feet are barely indicated.

Today, the creation myth seems to have been forgotten, but the *kibe-kibe* dances continue. Imported colors are more violent than native ones, and the style has rapidly degenerated, but the spinning of the dancers imitating the serpent still remains most impressive.

K. Nicklin, "Kuyu Sculpture at the Powell-Cotton Museum," in *African Arts*, XVII, 1, 1983.
J.-L. Paudrat, in M. Huet, *The Dance, Art, and Ritual of Africa* (New York: Pantheon, 1978).

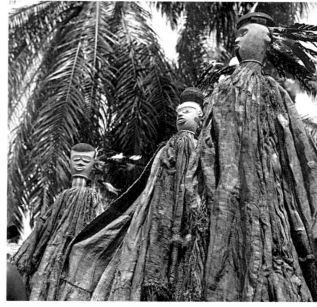

998 *Kibe-kibe* dance of the Kuyu
In situ

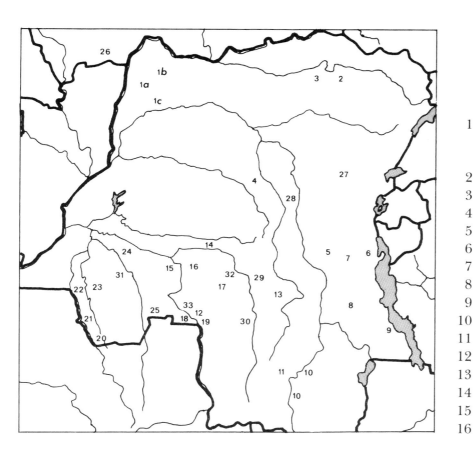

1	a) Ngbaka,	17	Lulua
	b) Ngbandi,	18	Lwalwa
	c) Ngombe	19	Salampasu
2	Mangbetu	20	Holo
3	Zande	21	Yaka
4	Mbole	22	Suku
5	Lega	23	Mbala
6	Bemba	24	Hungaan
7	Basikasingo (Buyu)	25	Pende
8	Hemba	26	Yangere
9	Tabwa	27	Komo
10	Luba	28	Lengola
11	Shankadi	29	Kusu
12	Kete	30	Kanyok
13	Songhay	31	Mbuun
14	Dengese	32	Nsapo
15	Lele (Bashilele)	33	Mbagani
16	Kuba		

Upper Sangha, Ubangi, Uele

(Central African Republic, Zaire)

THE NGBAKA, THE NGBANDI, THE NGOMBE The Ngbaka are situated in northwest Zaire, south of the Ubangi River. Their neighbors to the east are the Ngbandi, with whom they were often in conflict, and, to the south, the Ngombe. Even though these groups constitute three different ethnicities, they share common traits, notably in their initiation practices. Their settlements were dispersed and lacked an overall political organization; a hamlet would generally be made up of an extended family or patrilinear

567

clan. They practiced slash-and-burn agriculture and lived off hunting and fishing, activities always preceded by a sacrifice to the ancestors. Until 1900, their villages were fortified. Each clan, whose chief was called the *wan*, had a name and was regulated by alimentary taboos. They believed in a god, Gale, creator of the first ancestor, Setu, and his sister, Nabo, and they worshipped the spirits of nature.

The Ngbandi and the Ngbaka had an identical system of initiation, *gaza* or *ganza*: "that which gives strength." Future initiates had to undergo trials of physical endurance and would attain a first level of knowledge by means of song and corporeal techniques, particularly choreographic turns. In the rites of passage, recreations of ancestors played an important role. Circumcision and excision took place after several months spent outside the village. Young girls lived outside until their wounds had closed up and they became liberated, little by little, from their temporary "mothers." A final celebration marked their integration into the community. Accompanied by the *linga*, a wooden drum, and other percussion instruments, they would sing about the difficulties of their life and would thus prove they had overcome their trials.

In this region of the Ubangi, large slit drums are common, the ends of which depict buffaloes or antelopes. Artistic products include figures, masks, pipes, necklaces, sticks, musical instruments, and zoomorphic statuettes used in the hunt. The latter feature a heart-shaped oval face with vivid carved lines; the face has a concave surface and is often covered with kaolin. Grooves striate the nose and the temples. A prominent line divides the forehead, extending into the fine nose. Some masks have simian features; their function during initiation is not known. Ngbaka statuary resembles that of the Gurunsi or the Toma.

M. Felix, *100 Peoples of Zaire and Their Sculpture* (Brussels: Tribal Arts Press, 1987).
J.-L. Paudrat, in M. Huet, *The Dance, Art, and Ritual of Africa*, op. cit.
C. Roy, *Art and Life in Africa* (Iowa City: University of Iowa Museum of Art, 1985).

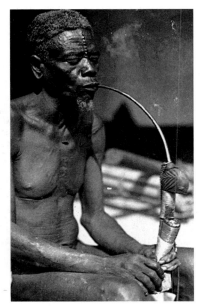

999 Smoking a Baka pipe
In situ

THE MANGBETU Having settled on the Bomokandi River in northeast Zaire in the eighteenth century, the Mangbetu live in a heavily forested region. In earlier times, the kingdom flourished. In 1870 when the sultan Munza received the German explorer G. Schweinfurth, the latter was impressed by "the pillared hall of the palace which measured more than fifty meters in width." Art is manifest not only in the domains of architecture, furniture, weapons, and utensils, but also in musical instruments and in the adornments and decorations of the body. The beauty of the Mangbetu dwellings inspired the admiration of their neighbors, who asked them to build similar ones for them.

This royal court art was developed particularly in terms of everyday objects under the impetus of the clan chiefs who wanted to show off their power and wealth. Royal celebrations, which took place in large vaulted sheds, were opportunities for exhibiting objects of luxury and refinement: pipes, palm wine jars featuring sculpted figures and heads, tree-bark boxes with covers decorated with heads, harps (*kundi*) played by wandering musicians, ornamental horns in worked ivory. The Mangbetu were in the habit of exchanging artists with the Zande.

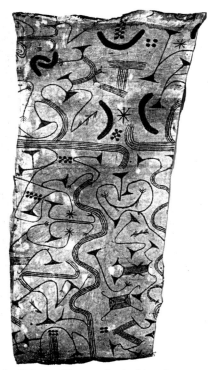

1000 Fabric of beaten bark, Mangbetu, Zaire
Length: 148 cm. Musée Royal de l'Afrique Centrale, Tervuren, Belgium

RIGHT:
1001 "King Mounza Dancing Before His Wives"
Drawing by Philippoteaux in "Au Coeur de l'Afrique . . . ," by Dr. George Schweinfurth, 1868–71, Le Tour du Monde, *1874*

Figures are rare, carved in light-colored wood. The style is characterized by an elongated skull, an ideal in the canon of beauty of the Mangbetu aristocracy. In fact, the heads of children were compressed by means of thin ropes of raffia, and women would thicken their hair to obtain a kind of basket that would lengthen the elongated skull even more—already emphasized by stretched eyelids and raised eyebrows. The Mangbetu had an innate sense of decoration and the walls of their houses were painted with geometric motifs; furthermore, they knew how to fashion tree bark into superb adornments.

During the last century, one could still see "war dances" in which warriors would carry marvelous wicker shields; later these were replaced by decorated wooden boards.

F. Neyt, *Traditional Art and History of Zaire* (Brussels: Société des Arts Primitifs, 1981).

THE ZANDE The Zande total 750,000 and live in northeast Zaire, the Central African Republic, and the Sudan, on the banks of the Uele River. Always at war with the Mangbetu, whom they finally conquered, they nevertheless were influenced by them. These two peoples came from the Sudan and, from the sixteenth century on, were constantly on the move.

In 1750, the Vurungura clan furnished rulers to the little kingdoms of the region; their warlike nature led them to dominate their neighbors. Due to an hereditary aristocracy, the king controlled the local chiefs. In addition to a cult devoted to royal ancestors, the Zande have complex funerary rites and on many occasions use oracles of poison. Like the Mangbetu, they have built major architectural structures, among which are the princely palaces that so surprised the first travelers.

Some ancestor and maternity figures are known, as are stylized and refined objects: neck-rests, flyswats, ivory horns, and musical instruments such as drums, sanzas, and curved harps decorated with a head and ending in a pair of legs.

The *mani* association, created in 1910, celebrates the importance of woman and uses statuettes called *yanda*. The society's chief would infuse the *yanda* with his powers by blowing smoke on it and rubbing it with a paste. The pyramid-shaped head, simple in form, has a diamond-shaped face, protruding eyes, and, often, iron rings in its ears and nose. The torso and neck are cylindrical or rectangular, the extremities short. Its outlines are angular and surprisingly abstract. Masks are extremely rare.

According to François Neyt (1981), despite their different artistic styles, the Zande and Mangbetu are so intermixed that the cultural influence of the Mangbetu preponderates. Stylistic connections may also be noted with the art of the Kwere and the Zaramo of Tanzania.

E. E. Evans-Pritchard, *Witchcraft, Oracles, and Magic Among the Azande* (Oxford: Clarendon Press, 1976).
M. Felix, *100 Peoples of Zaire and Their Sculpture*, op. cit.
F. Neyt, *Traditional Art and History of Zaire*, op. cit.

1002 "Mounza, King of the Mombutu"
Drawing by E. Bayard in Schweinfurth, "Au Coeur de l'Afrique . . . ," Le Tour du Monde, 1874

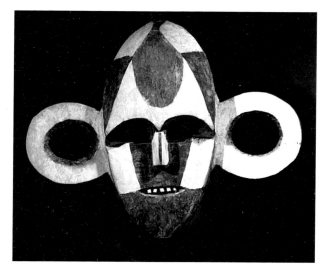

1003 Boa mask, Zaire
Wood. Height: 30 cm. Musée Royal de l'Afrique Centrale, Tervuren, Belgium

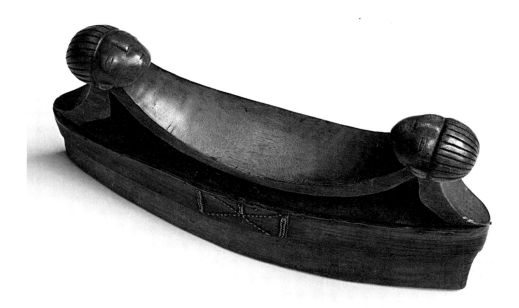

1004 Zande neck-rest, Zaire
Wood, fibers, bark, metal. Length: 39.1 cm. Dallas Museum of Fine Arts, Clark and Frances Stillman Collection of the Congo Sculpture, gift of Eugene and Margaret McDermott

1005 Ceremony of the *lilwa* society among the Mbole

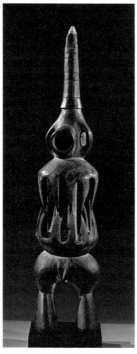

1006 Pere horn, Zaire
Wood. Height: 79.5 cm. Etnografisch Museum, Antwerp

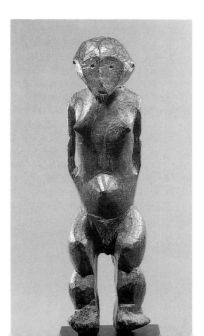

1007 Lega statuette, Zaire
Ivory. Height: 30 cm. Collection G. L., Paris

The Lualaba

(Zaire)

THE MBOLE In central Zaire, on the left bank of the Zaire River, several ethnicities are found—the Mbole, Yela, Lengola, and Metoko—among whom it is difficult to distinguish since their social structure is similar. These farmers and hunters received their names during the Swahili and Arabic occupations before the colonial period. Divided into lineages, they are very intricately crossed to the point where statues sculpted by one group may be found among another. Stylistically, there are profound resemblances between the Mbole and Yela, as well as between the Lengola and the Metoko or the Kumu.

These ethnicities all had rituals of circumcision and initiation: the *lilwa* association of the Mbole and the Yela was an initiation given to young boys who had already learned to fish (taught by the women) and farm (taught by the men). The children would be taken into the bush to develop their qualities of endurance, courage, loyalty, and discipline; they underwent trials of fasting and learned the language of the *lilwa* and its secrets. Abstract, polychrome masks were used during the closing rite, when the statues would be ceremonially brought out.

These statues are characterized by an elongated form, their arms hanging alongside a narrow body. The face is heart-shaped, its eyebrows in one straight line; it is topped by a high hairdo which accentuates the elongation of the form even more. The shoulders and arms, which seem inert and uncontrolled, fall straight down from the short neck.

Daniel Biebuyck has shown that these statues do not represent ancestors but men or women who have been hanged. Indeed, the association used to judge and condemn to death by hanging those guilty of breaking its rules, either by betraying its secrets, committing adultery or murder, or by quarreling with each other. These condemned people had no right to an ordinary funeral, and their bodies were hidden in the forest. Even though these figures are certainly not portraits, they might be called prototypes; one notes that the faces express neither fear nor inward concentration but rather a form of "sad resignation."

The high dignitary, *isoya*, the judge in these condemnations, presided over the ceremonies at the end of initiation. Then the village statue would be brought out and attached to a litter by means of lianas. Each statue had a name.

Some elements, such as the heart-shaped face and the white color, are reminiscent of the masks of the Tsogho and Fang.

D. Biebuyck, "Sculpture from the Eastern Zaire Forest Regions: Mbola, Yela, and Pere," in *African Arts*, IX, 2, 1975, and X, 1, 1976.

THE LEGA Called the Warega by the first Europeans, the 100,000 Lega have often been confused with the Bemba, to whom they are related. They live in the virgin forest of eastern Zaire, between the great lakes and the Lualaba River. In 1869, this region began to be overrun by systematically organized raids for the slave trade and the traffic in ivory. Arabs, arriving from the northeast, had to violently fight the Lega to establish their commercial outlets on the periphery of their territory.

The Lega's principal industries were fishing, farming, and hunting—especially of elephant and a few other animals that would be eaten as sacred food during the great ritual meals. The villages, situated on hilltops and consisting of two rows of huts, were encircled by a fence. A large oval hut served as the men's house. The men, often called upon to live outside the village, would build camps in the forest where those to be circumcised would be received.

The oldest member of the clan held the authority and the village chief, *kibuti*, had to belong to the founding lineage and to the highest rank of the *bwami*, the *kindi*. The chief was assisted by a counselor, the master of the earth, who arbitrated all disputes.

The *bwami* association regulated the social and political life of the Lega. Divided into four or seven levels, depending on the region, it involved emblems (teeth, horns, and so on). To pass to the next stage, a series of initiations, gifts, and payments ordered by the lineage were needed; and this meant that one had attained a certain wisdom and acquired a personal moral sense. The great ceremonies organized for the accession to the highest level would require that entire villages be constructed to house the clan of the candidate and members of the other clans who often came from very far away to participate in the festivities. The Lega preserved the skulls of the highest-level initiates in a special hut; they did not worship nature spirits, as did their neighbors the Bemba.

Circumcision was an indispensable process that allowed entrance into the *bwami*. It was accompanied by the teaching of proverbs and instruction in the handling of objects endowed with moral and practical significance. The ceremony of accession to the *kindi* was marked by the unveiling of the "basket of power," which contained insignia, spoons, and statuettes.

Large masks belonged to the earth clan; they would paint them with white *pembe* each time they were to be brought out. The celebration was accompanied by dramatic performances involving song, dance, and recitations of proverbs.

The Lega judge the quality of their sculpture on the basis of its effectiveness—a rather rare occurrence in indigenous Africa, where most ethnicities judge the work independent from its use.

The two highest levels of the *bwami* have ivory statuettes. Small in size, they may illustrate a specific proverb or allude to a particular event. Thus, a statuette with several faces signifies the gift of far vision and represents the elephant hunter, who simultaneously sees the animal and looks behind him to call for help; a raised arm depicts the lamentation aroused by sorcery, but also, and more simply, the arbitration of quarrels; a zigzag figure represents a man who runs forward and then goes backward again. Curved objects illustrate aphorisms, for example: "The young man must take care of the old one, bent under magical burdens." The serpent stands for death; buttons on the head depict the *kindi* hat. All the statuettes have a name and evoke a story.

The Lega are specialists in the making of insignia of all shapes: there are heart-shaped, concave faces that feature a delicate mouth, pointed chin, and eyes shaped like cowrie shells or like a point in a circle. Some are of astonishing power, while others have a more naive appearance. Small masks are worn on the arm or kept in a basket. As the *bwami* was not a secret society, each member indicated his rank with an insignia, the most popular one being the cowrie-shell hat that ends in a little tail. At the time of a new initiation, the older initiates take the ivories out of their bag, put them down, and rub them with oil, which gives them a lovely warm, golden patina.

The Lega have produced a large number of sculptures of variable quality. The abstract aspects of their style link them with the Bemba and the Mbole.

D. Biebuyck, *The Arts of Zaire* (Berkeley: University of California Press, 1986).
———, *Lega Culture* (Los Angeles: University of California Press, 1973).
S. Klopper, "Speculations on Lega Figurines," in *African Arts*, XIX, 1, 1985.

THE BEMBA According to tradition, the 60,000 Bemba, descendants of the Luba, left the Congo in the eighteenth century. For the most part they settled in the northeast of Zambia, but also in Zaire. They share a number of traits with their neighbors on the shores of Lake Tanganyika: the Lega, Buyu, Holoholo, and Binji. The territory surrounding them is covered with forests, plateaus, and wooded savannas traversed by wide rivers.

Since the second half of the nineteenth century, this region has been disrupted by population shifts, rebellions, and raids organized by slave traders—raids that continued throughout the colonial period. The Bemba have the reputation of being a proud, hard people who learned the art of the hunt and the harvesting of honey from their neighbors. Warriors and hunters, they practice slash-and-burn agriculture; a social, ritual, and economic value is connected to the hunt. Villages, consisting of about thirty huts, were abandoned every three or four years once the soil became exhausted.

Like the Lega, the Bemba community was organized according to patrilinear lineages, and the chief was in charge of the worship of ancestors, which took place in tabular or spheric sanctuaries. Even though still very active in 1950, this cult no longer used sculptures but calabashes, stones, knives, food, or hunting trophies. (D. Biebuyck)

Just as the Basikasingo did, the Bemba borrowed the *bwami* association from the Lega. However, among the Lega, the *bwami* alone dominates all rituals, while the Bemba have other secret societies, such as the *elanda*, the *alunga*, and the *punga*. Simple in comparison to the Lega, the Bemba *bwami* has only two classes of initiates, those of the "hat" and those of the "leopard," and was divided into three levels. Once circumcision had been performed, the *bwami* essentially consisted of dances, songs, and the handling of objects. Initiates would use figures sculpted from elephant tusks or wood, wooden masks, and, as emblems of the highest levels, a stool or an anthropomorphic figurine.

Outlawed in 1940, the *elanda* was a male society divided into three levels, the highest of which was assigned to the most worthy lineage. Initiation ended with the appearance of the *mask*, the viewing of which was forbidden to the noninitiated. Otherwise, this oval mask that sometimes sports antelope horns was entrusted to a dignitary and hidden outside the village in a secret place. In order to be part of the association, one had to pay high fees and submit to established rules.

The *batee* or *banya* sorcerers and healers used statuettes for their rites of magic and healing.

The *ibulu iya alunga* mask, used in the male *alunga* society, is unique in form. Sometimes sculpted out of a single block, sometimes out of two parts connected back to back, it is worn on the head like a helmet and ends at the top in a huge crest of feathers. It represents a powerful bush spirit (*m'ma mwitu*). Kept in a sacred cave (*iwala*), the mask is taken into the bush during the secret initiation of new members. The *alunga* association was in charge of the cult of the hunt, as well as social order and public dances. The wearer of the mask, hidden completely under a fiber costume, would be a member of high rank who knew the dances and the manner of speaking and singing in a guttural voice. (C. Roy, 1985)

Bemba statuary is rare, now that the great ancestral statues have been re-attributed to the Basikasingo. Bemba art has retained some traces of the plastic vision of the Lega, but the treatment of the faces presages the Luba style.

D. Biebuyck, "Bembe Art," in *African Arts*, V, 3, 1972.
———, *Statuary from the Pre-Bembe Hunters* (Tervuren, Belgium: 1982).
M. Felix, *100 Peoples of Zaire and Their Sculpture*, op. cit.
C. Roy. *Art and Life in Africa* (Iowa City: University of Iowa Museum of Art, 1985).

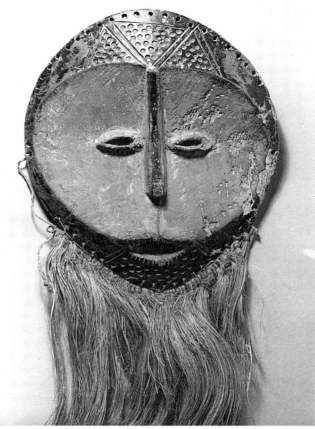

1008 Lega mask, Zaire
Wood, fibers. Height: 27 cm. Private collection

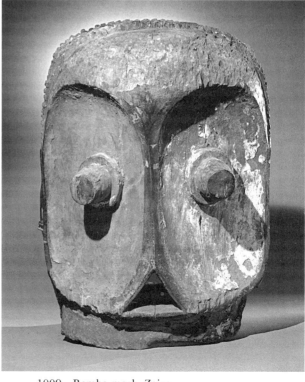

1009 Bemba mask, Zaire
Wood. Height: 60 cm. Private collection

571

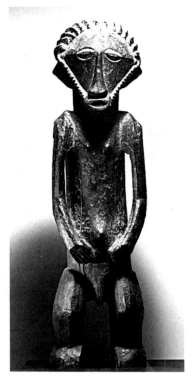

1010　Basikasingo statue, Zaire
Wood. Height: 50 cm. Private collection

1011　Luba-Hemba mask, Zaire
Wood. Height: 18.5 cm. Musée Royal de l'Afrique Centrale, Tervuren, Belgium

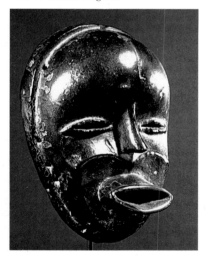

THE BASIKASINGO (BUYU) Mistakenly combined with the Bemba by William Fagg and other authors, the Basikasingo have recovered their true identity thanks to Biebuyck's work: they are not of Bemba origin, even though they live in the same territory. In a region overrun by innumerable shifts in population, groups of diverse origins coexisted in the same villages: in the identical locale one might find Lega, Bemba, Buyu, Bangubangu, and Binji, all of whose primary activity would be the hunt. This occasioned numerous rituals, and it also was an important factor in cultural exchanges and in the mobility of the population. The Basikasingo are now credited with originating certain traditions—notably the worship of nature spirits—that existed before the massive arrival of the Lega and the Bemba into their territory.

The Basikasingo adopted the system of patrilinear and segmentary lineage. Theoretically, the chief is the oldest representative of the dominating lineage; in practice, he is the "elder" who is the most powerful and most capable of governing with the help of the heads of lineages subject to his own. A man's power is determined as much by his belonging to the dominant lineage, his age, and his status as by his rank in the *bwami* association, which was borrowed from the Lega. Balancing against the power of the lineage chief is that of his sister's son, a counterforce, a notion originating from the Baskasingo's contacts with the matrilinear tribes who settled in the plains. Sublineages of foreign origins can be incorporated into the dominating lineage, a phenomenon that recalls the dynastic system. In 1912, three lineage segments were counted, each ruled by a chief assisted by a council of elders.

Ancestors, who have the power to bring good fortune or illness, are worshipped. When bad luck arrives, the Basikasingo try to understand the will of the ancestors either through dream interpretation or divination.

Each family has a sanctuary. Before leaving for the hunt, the men go there to rub their weapons with white clay; if the hunt has been good, they offer a few trophies upon their return.

Two types of sanctuaries are found which have figurines (*mizi*) outside and inside. The figures have long, cylindrical torsos, square shoulders, and massive heads. The face is triangular in shape and is striated by a herringbone pattern. The forehead is marked by circularly arched eyebrows and the eyes have a coffee-bean shape. The jaw dominates the mouth, and the chin is angular. A hatched motif simulates a stylized beard. Holes under the armpits allow the statue to be tied, which is supposed to induce suffocation in the targeted person. These statues are stylistically so close to those by neighboring ethnic groups who also live on the west banks of the lake—such as the Buyu, the Holoholo, the Binji, and the Bangubangu—that it is sometimes difficult to tell the styles apart.

A Janus statuette, consisting of two similar parts, resembles the Bembe mask, which is much more monumental and is used in the *alunga* association. It represents the aquatic spirit Miha and its use is recommended by the diviner when misfortune befalls a family. Each side is composed of two concave parts that meet in the middle, where an eye is inscribed in relief. The nose is hollowed out at the intersection of the two ovals, and the forehead bulges. A rope ties the bust, which ends in two short legs.

According to Biebuyck (1982), the homogeneity of style of the statuary is due to the presence of subgroups, whom he calls "pre-Bembe hunters"; they settled in the nineteenth century on the banks of the Lualaba River and emigrated in successive waves to the west of the lake. These groups worshipped ancestors, founders of the clans, and chiefs of the migrations. A materially easier life in these regions allowed them to consolidate their political system and, little by little, their artistic traditions became differentiated one from the other while experiencing influences from the Tabwa and Luba.

D. Biebuyck, *Statuary of the Pre-Bembe Hunters*, op. cit.
F. Neyt, *Traditional Art and History of Zaire*, op. cit.

THE HEMBA In southeast Zaire, the Hemba peoples inhabit vast plains surrounded by high hills and bordered by streams, rocks, and marshes. For a long time, the Hemba were subjects of the Luba empire, and their own cultural and religious identity, while ancient, was overlooked—although in the seventeenth century, Hemba societies were already developing to the east of the Luba, as Neyt has shown (1977). Their social organization is founded on a system of clans that bring together several families sharing a common ancestor. Each clan knows the history of its migrations, conquests, and alliances and obeys a certain number of regulations, duties, and taboos, the most important of which are dietary. A clan may constitute an entire village, independent of the others. Farmers and hunters, the Hemba practice ancestor worship, not only to keep the memory of their great chiefs alive, but also to justify the present authority and power of the chiefs of the clan; the latter have absolute authority over clan members and are in charge of several ancestor figures they keep in their own hut or in a smaller, funerary hut. Genealogical trees are essential for verifying the ownership of lands and the foundation of the hierarchy. As celebrant of the ancestral cult, the clan's chief, surrounded by his people, communicates with the ancestor, recalling his great deeds and summoning his good will. He then offers a chicken, sometimes striking it against the ground, sometimes against the statue—thus adding to the statue's thick patina. The celebration ends with a meal of manioc flour and chicken.

To possess numerous effigies is a sign of nobility that confirms the *jus soli* of a clan's chief. He is dependent upon no one, renders justice in his own home, and collects tributes for it. Along with medicine, law, and sacrifices, the ancestral cult penetrates all social, political, and

religious domains. The Hemba are able to trace their genealogy back eight or fifteen generations. The *singiti*, or ancestor statues (usually male), exhibit symmetry, immobility, and balance. They recall the shape of the cylindrical block of wood from which they were carved, "arms and forearms are brought forward over the abdomen, legs are parallel and bent, the body of rough hewn or modeled masses is straight." (F. Neyt, 1975) The oval head with half-closed eyes and stylized beard is topped by a very elaborate hairdo, often cross-shaped, ornamented by a tiara. Most *singiti* wear a loincloth—hence, the lesser care applied to the lower extremities. With some, status is indicated by bracelets, belts, lances, and scarifications. The patina is smooth and shiny.

The Hemba attribute great importance to the *kabeja*, a Janus-shaped statuette, which has a single body but a double face, male and female, on a single neck. At the top of the *kabeja* is a small receptacle meant to hold magic ingredients. The line of the abdomen with its protruding navel recalls the *singiti*, as do the slightly bent arms. Each clan possesses a single *kabeja*, which is dangerous to handle, and which receives sacrifices intended for the spirits, a magico-religious practice that is of the essence to the family.

When rendering justice or presiding over meetings, the chiefs sit on stools with caryatids, often female ones—a reference to the matrilinear status of the Hemba under Luba influence. Staffs are the emblems of the chiefs of families or villages. The most beautiful ones feature a handle with geometric motifs or a little sculpted head on top. The Hemba also sculpt anthropomorphic neck-rests, rattles used in dancing, and ivory objects. One also finds monkey masks with a mouth that is a wide slit; these were probably used in the secret *bugabo* and *bambudye* societies.

In the northwest, about a dozen pieces have, for the first time, been identified and attributed to a recognized artist, called the Buli Master. The forms of his figures are more elongated, less rounded, and they have a more expressive, sometimes even dramatic, feeling.

Hemba statuary has only recently been differentiated from that of the Luba. (F. Neyt, 1975) Great masterpieces have since been discovered. Output continued for about a century and a half. Indeed, starting in the second half of the nineteenth century, the style began to degenerate, as can be seen in the design of the hairdo which, originally hollowed out and cruciform, later becomes a simple rectangle with a cross inscribed in it.

F. Neyt and L. de Strycker, *Approche des Arts Hemba* (Villiers-le-Bel, France: Arts d'Afrique Noire, 1975).
———, *La Grande Statuaire Hemba du Zaire* (Leuven, Belgium: 1977).

1012 "Roussouna and His Wife"
Drawing by A. Rixeus in "A Travers l'Afrique de Zanzibar à Benguela," by Commander Verney-Lowett Cameron, Le Tour du Monde, 1877

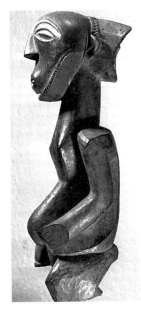

1013 Hemba, Zaire
Wood. Height: 32 cm. Andrault Collection, Paris

THE TABWA Two hundred thousand Tabwa occupy the banks of Lake Tanganyika and the Marungu plateau in southeastern Zaire and northeastern Zambia. This region is not very hospitable: the slopes around the lake are steep, and the plateau is very swampy. The Tabwa cultivate millet, manioc, and corn, but they live primarily off fishing and hunting, for game is plentiful. Originally, villages were small, scattered, and inhabited by a single extended family, who lived under the authority of the chief of the clan without any political cohesion or centralized system. Neighbors of the Luba, Hemba, and Bemba, the Tabwa were dominated by the Luba until the end of the eighteenth century. But toward 1850, several chiefs began to accumulate wealth through ivory and slave trade with the Swahili. Certain chiefs acquired great power which they demonstrated in the number of their wives—some had as many as sixty of them; they constituted an important labor force.

Little by little, a centralized authority emerged and was accompanied by great artistic blossoming. In 1860, Swahili merchants who had come to settle in the south to make their commercial enterprise easier overthrew the local Tabwa chief, Nsama, who fled north, where other chiefs were attempting to impose their authority. In order to legitimize their seizure of power, these chiefs financed sculptures of ancestral figures: thrones that were heavily influenced by those of their neighbors, the Nyamwezi, who hunted elephant in the region. Until 1860, the various clans were constantly at war. Toward 1880, as elephants became more rare, commerce in ivory was replaced by the slave trade.

The region around Lake Tanganyika, especially in the southwest, was claimed by Protestant, then Catholic, missionaries, to the extent that a Catholic kingdom was created in 1870 at Mpala by the priests, furious over the settling of English Protestants. Further north, an envoy from Belgium, Storms, made blood pacts with local chiefs; thus, in 1885, at the Treaty of Berlin, the King of Belgium laid claim to this region, supposedly according to the "wish" of the indigenous populations. In 1920, with the annexation of the region by Belgium, artistic production disappeared completely at the same time that a new possession cult, *bulumbu*, was developing widely.

1014 Tabwa statue, Zaire
Detail. Wood. Total height: 33.5 cm. Museum für Völkerkunde, Munich

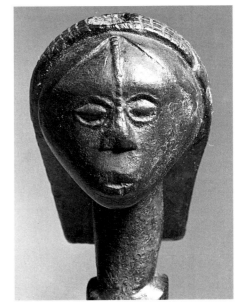

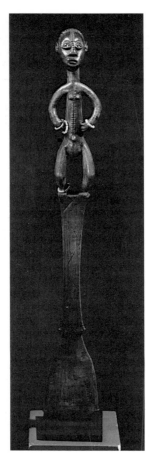

1015 Tabwa spatula, Zaire
Wood and glass beads. Height: 54.6 cm. Anne and Jean Pierre Jernander Collection, Belgium

1016 Figure carrying another on its shoulders, Luba, Zaire
Wood, fabric, fibers. Height: 54 cm. Museum für Völkerkunde, Frankfurt

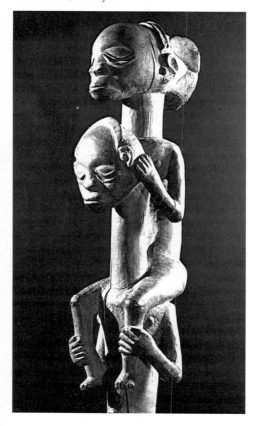

As did the majority of the ethnicities in this region, the Tabwa worshiped ancestors, the *mipasi*, whose statues were the property of the lineage chiefs and sorcerers; these carried "medications" in their ears or in small cavities at the top of their heads. The *mikisi* were ambiguous, for they could be bearers of good or evil. Through the intermediary of their chief, the only person entitled to this religious function, the Tabwa also worshipped the spirits of nature, the *ngulu*, who lived in trees and rocks.

The installation of a supreme chief is of relatively recent vintage: formerly it was the function of the large ancestor figures to consolidate the power of the chiefs. Other statuettes were used for divination. The Tabwa also made twin figures that could be both dangerous and bearers of good luck. After the hunt, the spoils would be placed near the statues of the chief of the lineage for a few moments in gratitude for the success obtained. At the entrance to the villages, small conical huts, often barely visible, housed baskets filled with objects meant to protect the population. In the north of Tabwa country, the diviner was also a sculptor; consulted after a dream, he would create a new statue. The mythical ancestor, bearing an adze on his shoulder, his hat containing a few seeds, represented agriculture. Dilation of the pupils indicated the gift of double vision.

Special attention was paid to scarifications, which embellish the body and recall social values. On the statue of a chief they indicate a concern with refinement. B. De Grunne identifies an initial "classical" style: crows' feet at the temples, wide round eyes, the mouth half-open over the tongue, long hair, headdress worn back over the neck. On the whole surface of the body, a recurrent motif consists of twinned isoceles triangles, the two bases of which symbolize the duality of life. They evoke the coming of the new moon, essential to Tabwa philosophy, whose return would be celebrated monthly.

The Tabwa used two types of masks: a human one, which represented woman, and another in the form of a buffalo head, which represented man. Both would make an appearance at the time of the fecundity ritual, celebrated for sterile women. One also finds paddles, commanders' staffs, combs, and musical instruments with figurines, sometimes executed with great subtlety.

The artistic output of the Tabwa extends over a century, but the period of greatest flourishing was around the middle of the nineteenth century. They borrowed from the Luba and the Nyamwezi but nevertheless created an original art that only recently has been differentiated from that of their neighbors.

B. de Grunne, "A Note on 'Prime Objects' and Variation in Tabwa Figural Sculpture," in *Tabwa: The Rising of a New Moon—A Century of Tabwa Art*, exhibition catalogue (Ann Arbor: University of Michigan Museum of Art, 1985).
E. M. Maurer and A. F. Roberts, op. cit.

THE LUBA According to tradition, the Luba empire was founded in 1585 by Kalala Ilunga, who overthrew Kongolo, the Songhay king who was then reigning over the territory. Son of a renowned fetishist named Mbidi Kiluwe, Kalala Ilunga inherited royal powers and *bufumu* fetishes from his father. He created a powerful military federation that stretched from west to east of the Zaire River to Lake Tanganyika and reached to Shaba in the south. Two versions give differing accounts of the king's origins, one linking him to the Hemba, the other to the Kunda. (L. De Heusch)

The empire grew during the eighteenth century, an era of great migrations: the Luba appropriated the Kasai and the Luba-Shankadi settled on the left bank of the Zaire River, while the Luba-Hemba emigrated eastward. In 1885, beaten by the Chokwe and the Yeke, the empire was dismantled.

While more recent studies published on the Luba empire question the extent of its political unity, they also reaffirm Luba cultural influence over the Kusu, Zela, Songhay, Kanyok, Chokwe, and Lunda.

Thought to be of divine origin, the king exercised absolute authority and supernatural powers were attributed to him. He was surrounded by a court of dignitaries, servants, and artists. In 1874–75, the European traveler Cameron tells of his first visit to the king, who was seated on top of his victims and kneeling wives. The court followed a complex etiquette, which necessitated a prolific production of objects of prestige and *regalia*: lances, arches, commanders' staffs, knives, axes, as well as the royal stool, *bulopwe*, which was placed between the counselor, or *kioni*, and the king's niece at the time of the king's investiture. Arrow holders, symbols of the indissolubility of royal marriage, were at the head of the bed. In the *kutumboka* war dance, the king, carried by his soldiers, would recreate the myth of Kongolo, the cruel tyrant who had invited Kalala Ilunga to dance over a ditch filled with lances. The chiefs of the royal lineage, guarantors of the continuity of power, possessed scepters, axes, beds, neck-rests, and stools sculpted with female figures. The seat is also an emblem of power among the Chokwe and the Tabwa.

Artists occupied a privileged place in the hierarchy. The Luba artist, as was true with the Lunda, carried a ceremonial axe on his shoulder, an emblem of prestige and of the dignity of his position. Some apprentices would be recruited from among the deformed, who could neither hunt nor be warriors and who were believed to have a close connection with magic.

The favorite theme in sculpture was woman since, according to the Luba myth, Vilye was the first female spirit, founder of the clan and guarantor of fertility and the lineage. Women were cult guardians and the royal wives played an important role: sent as emissaries to the chiefs of neighboring ethnicities, they would contract profitable political alliances based on marriage.

The diviner, painted white, used the *mboko*, a seated or crouched female figure holding a bowl rubbed with kaolin. He would shake her and analyze the position of the different objects the bowl contained. In the healing ritual, the sorcerer would use the *kabila*, or daughter of the spirit, which consisted of a figure and receptacle, which were also placed at the entry to the house during childbirth. Healers were members of the *buhabo* association, one of the most secret and powerful societies of the region, based on the principle of mutual assistance. According to Father Colle, who studied the Luba in 1913, this secret society, also found among the Hemba, in fact served to enrich its members. Its power depended on fear of poisoning, thus everyone wished to belong to it. The candidate had to go through an initiation and pay a heavy fee. At the head of this rigid, hierarchical association was the great master, *tata*, the guardian of the statuettes, whose bases were made from calabashes.

In Luba sculpture, one also finds figures, drums, pendants, and pipes. The Luba use the *kifwebe* mask of the Songhay but they give it a softer, rounder form. The Luba style is an art of curves and gentle and harmonious masses. Figures have relatively naturalistic proportions, except when they are holding the cups, in which a shortening of the legs emphasizes the receptacle itself. The head is generally round, the forehead bulging, a band formed by grooves articulates the hairdo; the eyes are a coffee-bean shape, the ears are small; the polished surface has a lovely deep patina. The cover of the *mboka* is sometimes sculpted with a very fine young girl's head. The Luba sculptor attaches great importance to detail: the modeling of the torso and the back is particularly striking; scarifications and hairstyles indicate rank within the hierarchy. Graceful figures are made out of hippopotamus tooth, inclining forward to follow the form of the material.

Luba art has had enormous influence over neighboring peoples. Unfortunately, a new cult, outlawing the ancestor cult, has been the cause of an almost systematic destruction of statuary.

J. Cornet, *L'Art de l'Afrique Noire au Pays du Fleuve Zaire* (Brussels: Editions Arcade, 1972).
L. de Heusch, *Le Roi Ivre ou l'Origine de l'Etat* (Paris: Gallimard, 1972).
F. Neyt, *Traditional Art and History of Zaire*, op. cit.

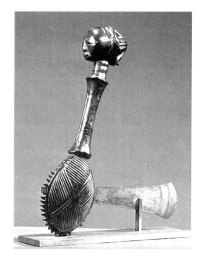

1017 Weapon for display, Luba, Zaire
Wood, brass, iron. Height: 38 cm. Length of the blade: 26 cm. Private collection, Belgium

1018 Shankadi pestle, Zaire
Wood. Height: 18 cm. Private collection

1019 Shankadi bowl, Zaire
Wood. Yale University Art Gallery, New Haven

THE SHANKADI The Shankadi belong to the Luba group and share the same structures and associations, but their abundant artistic production is marked by a style of its own. Sculpted female figures are common on the neck-rests used for divination and to protect the elaborate hairdos formerly worn by women at court. The neck-rests are sometimes composed of two people sitting face to face, one leg bent, the other stretched out, the arms of one held flat on the back of the other figure, who holds the first by the shoulders; sometimes couples of figures side by side support the crossbar of the neck-rest.

The female cup bearers structurally resemble those of the Luba; seated, they hold the bowl between their legs. Cups were also used in divination; the diviner would fill the bowl with white kaolin mixed with other ingredients, the same procedure used by the Luba. The Shankadi sculpt objects of prestige as well, meant to express the power of the chiefs visually; they also use *kifwebe* masks at the funerals of notables and during the celebrations of the ancestor cult.

On the other hand, the *katatora* is unique to the Shankadi; it consists of a wooden frame on which a figure is placed. Made from a special wood whose boiled sap reportedly causes vomiting, it was used for divination during trials that were indeed meant to make one "spit out the truth."

The Shankadi make numerous statuettes used as amulets of protection or good luck tokens. The statuette is often in the shape of a pestle with a widened base, its upper end carved in the form of a human head—eyes closed, hair braided in the shape of a cross. When the statuettes are intended to represent the spirit of life and death, both ends feature heads.

The Shankadi style is recognizable by the astonishing cascading or "pagoda" hairdo, consisting of a series of horizontal buns or crests of hair. The face is refined, with oval eyes, coffee-bean–shaped eyelids, and a small, triangular nose. Sometimes a Songhay influence may be noted in the triangular treatment of the jaw.

In their realism, their female iconography, in the softness of their surfaces, and in the characteristically reduced dimension of the figures' lower extremities, the works of the Shankadi are related to those by the Luba; yet, due to the originality of the treatment of hair, they form a subgroup apart.

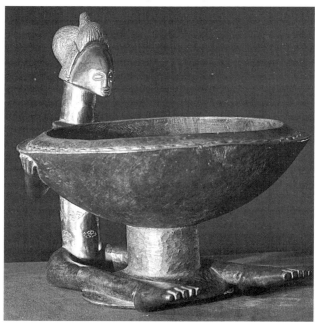

P. de Maret, N. Dery, and C. Murdoch, "The Luba Shankadi Style," in *African Arts*, VII, 1, 1973.

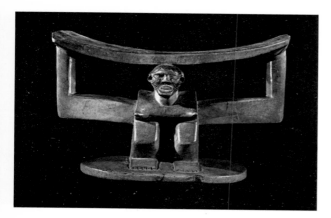

1020 Kete neck-rest, Zaire
*Wood. Musée Royal de l'Afrique Centrale,
Tervuren, Belgium*

THE KETE Nestled between the Luba and the Songhay, the 7,500 Kete preceded the arrival in the region of the Kuba, with whom they intermingled in the north, while in the south they were absorbed by the Chokwe. Like their neighbors, they live off agriculture, net fishing, and also practice hunting, for the prestige it brings.

Matrilinear, lineages are autonomous and operate under the authority of the maternal uncle. The Kete worship the ancestor Sebu. The *tshiburu* society is responsible for initiation and circumcision; Kete rituals are different from those of the Kuba. Some handsome masks are known, triangular in form, in which Lwalwa and Lulua influences are noticeable.

M. Felix, *100 Peoples of Zaire and Their Sculpture*, op. cit.
F. Neyt, *Traditional Art and History of Zaire*, op. cit.

The Lomami-Sankuru

(Zaire)

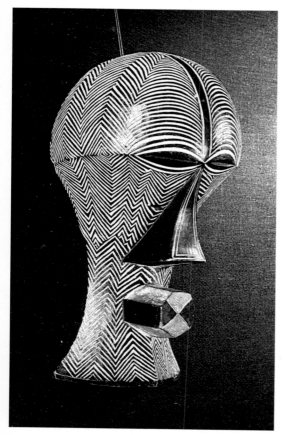

1021 *Kifwebe* mask, Zaire
*Sculpted for Leo Frobenius by the Bena Mpassa
in 1898. Wood. Height: 45 cm. Linden Museum,
Stuttgart*

THE SONGHAY The history of the Songhay is closely linked to the Luba's, to whom they are related through common ancestors. According to tradition, Kongolo, the founder of the first Luba empire in the sixteenth century, was a Songhay. Having waged war against one another for a long time, the Songhay and Luba later formed an alliance to fight the Arabs. In 1887, in order to prevent annihilation, a Songhay subgroup, the Nsapo, moved to Lulua territory and, by virtue of this migration, created an original style of sculpture.

The social structure was headed by a chief assisted by innumerable secret societies. Originally, the initiation of young boys took place within the framework of the *bukishi* institution, but this disappeared at the beginning of the century. The Songhay used a large number of fetishes and amulets, called *boanga*, to ensure their success, fertility, and wealth and to protect them against hostile forces such as lightning, as well as against diseases such as smallpox, very common in that region. The fetishist would make the *boanga* with magic ingredients which he crumbled and mixed, thus obtaining a paste that was kept in an antelope horn hung from the roof of the house. When the head of a family needed to travel, he had a new one made which he carried with him.

Divination allowed the Songhay to discover the causes of a misfortune. The diviner, the *nganga*, would ask questions of the consulting party, who would be holding an instrument the diviner would strike.

Besides the amulets, which do not always have a human shape, large figures are found belonging to the fetishist, who would manipulate them with sticks during the ritual of the full moon. These figures adopt a hieratic posture, the hands placed on a pointed abdomen; they have an elongated face with a rounded forehead, large almond-shaped eyes, heavy bulging eyelids, and a bean-shaped mouth; the neck sometimes has rings around it, and the shoulders are square. On top of the head, a horn or feathers reinforce a disquieting appearance. The face is covered with nails, a reminder of smallpox. Bands of copper or brass increase the magic power of the statue, which is dressed in feathers and skins and carries a small bag of potions. The enormous feet are incorporated into the base, an approach one also finds among the Chokwe. Fetishists used statuettes mounted on a pedestal, magic contents attached with a nail to the top of the skull.

As part of the *bukishi* association, in charge of initiations, the *bwan ka bifwebe* became the primary secret society at the beginning of the century. It taught the great Songhay myths and the symbols linked to nature and exercised political and social control that it shared with the *tshite*, the notables.

In the Songhay language, a mask is a *kifwebe*: this term has been given to masks representing spirits and characterized by striations. The mask is also used by the Luba, but the Songhay mask is more angular and may assume different forms. Depending on the region, it may be dark with white stripes, or the reverse. Buffalo masks with a brown patina that have no stripes were used in hunting rituals.

According to J. W. Mestach (1985), the classical *kifwebe* is male when it has a white crest; it is colorful and "dances" during the day. In contrast, the female mask, mostly white, has only a small crest and its stripes are closer together and finer. These two types of masks appear either in pairs or in groups at popular celebrations. For Plasmans, the symbolism of the striped mask is obvious: the face is the symbol of power and hallucinatory strength; the right side stands for the sun and the left for the moon. The stripes are supposed to be reminiscent of the *bongo* antelope—rather than the zebra, which, for all practical purposes, does not exist in this region. The grooves express the subterranean region from which the spirits who created the association came. According to one of the Songhay creation myths, God sent a primordial couple to earth to cultivate the land; hence, the striations would recall the cavern from which the first humans emerged, as well as their trip through the womb. Striations are a form of writing with a double meaning: the path or roadway of the

dead who await rebirth. Likewise, the nose is both the vertical axis and the tree of life. The mouth is the bird's beak or the sorcerer's fire. The mask has a supplicatory function and, according to the Songhay themselves, the person with full lips is supposed to speak loudly. The beard expresses wisdom and strength. The wearer of the mask, his body entirely hidden under a long skirt of fibers braided into netting, wears a headdress surmounted by a plume that consists of a cylinder holding magic materials that ends in a tuft of feathers. The position of this plume is significant; raised, it is the male spirit; lowered, the female.

The *kya ndoshi* mask is very powerful and much feared: larger than the others, it has black and colored stripes. The whole, consisting of mask, wearer, and costume, symbolizes the cosmic tree that links earth to heaven and the subterranean world to the world of air.

The Songhay sculptor also makes numerous objects: cups, seats, drums, mortars, canes, dancing sticks, shields, and very small eyeless masks which were hung in the hut. As a specialist, he enjoyed an elevated rank in the *bwadi* society.

The Kuba kings appreciated the large Songhay statues for their magical power; in a photograph taken in 1910, four Songhay statues are seen included as part of the royal treasury. The style has remained very stable and ranges from a kind of "cubism" to a more marked expressionism.

D. Hersak, *Songye: Masks and Figures Sculpture* (London: Ethnographica, 1985).

J. W. Mestach, *Etudes Songye, Formes et Symbolique, Essai d'Analyse* (Munich: Galerie Fred und Jens Jahn, 1985).

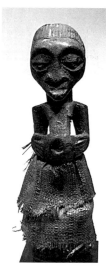

1022 Songhay, Zaire
Wood, fabric, nails. Height: 20 cm. Private collection

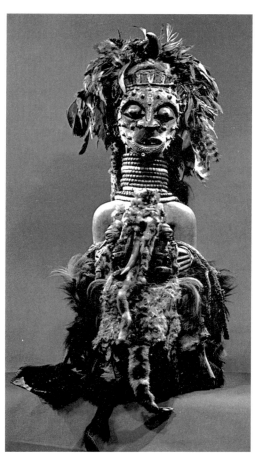

1023 Songhay, Zaire
Wood, fabric, nails, feathers, skin. Height: 98 cm. Private collection

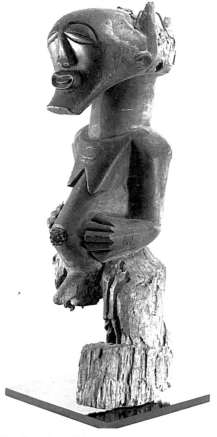

1024 Songhay, Zaire
Wood. Height: 73 cm. Private collection, Belgium

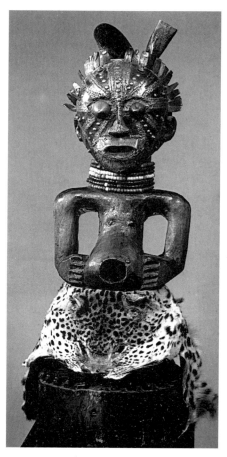

1025 Songhay, Lomami River region, Zaire
Wood, metal, beads, animal skin. Height: 84.4 cm. Kimbell Art Museum, Fort Worth, Texas

The Kasai-Sankuru

(Zaire)

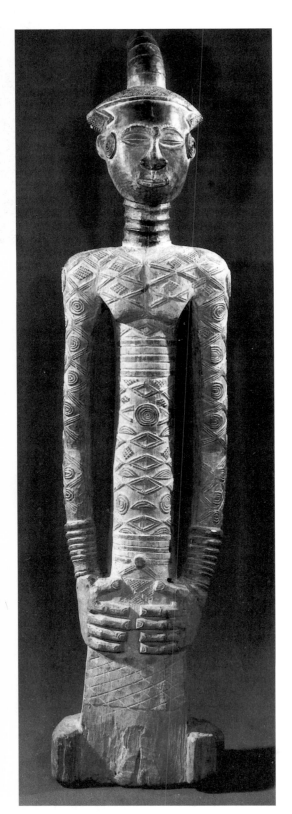

1026 Dengese statue, Zaire
Wood. Height: 139 cm. Musée Royal de l'Afrique Centrale, Tervuren, Belgium

THE DENGESE The 12,000 Dengese have the Kuba as their northern neighbors; they are part of the Mongo group and are famous for their taste for costumes, for the decoration of their weapons, and for their metal necklaces and bracelets—yet they show no interest whatsoever in statuary. The *ikoho* association provided the framework for social life and its members used to enjoy positions of great authority.

While the Dengese do not use masks, they have produced some great statues that became part of museum collections at the end of the nineteenth century. These statues have no lower extremities; the bodies are covered with scarifications, and figures wear bracelets and have hairdos that resemble those worn by notables, or *totshi*: a kind of finely braided bonnet topped with a small, wooden cylinder covered with fiber.

The *totshi* belonged to an association that required enormous fees from its future members and an initiation that was performed in two stages. According to Joseph Cornet, the statues are the funerary effigies of the *totshi* and represent them during the anniversary ceremony of the funeral, which would take place several months after a death. The only existing female statue is one supposedly depicting the female founder of the association—although women are not admitted as members. Certain characteristics, such as scarifications at the temples, resemble Kuba statuettes, but the postures and lavish decoration are the Dengese's own.

J. Cornet, "A Propos des Statues Ndengese," in *Arts d'Afrique Noire*, no. 17, 1976.

THE LELE (BASHILELE) In their language, customs, and artistic traditions, the 30,000 Lele are related to the Wongo and Kuba. Their neighbors the Pende and Chokwe infiltrated into their territory during the nineteenth century. Originally, the Lele, Wongo, and Kuba formed one homogeneous unit that moved away from Tumba Lake. According to Lele tradition, their common ancestor, Woto, had three sons, the ancestors respectively of the Lele, Wongo, and Tundu. The Tundu were supposed to have fled when their ancestor, Wotu, was discovered dismembering a buffalo. Inversely, the Kuba recount that the Lele left because of their incestuous birth. The Lele moved north progressively and peacefully under the leadership of aristocratic warriors, the Tundu, who divided the country into three parts.

Society is divided into three classes: the Tundu, or leaders of migration and of war; the Batshwa, literally "those who refused to recognize the authority of the Tundu"; and the Wongo, or commoners, who, curiously, bear the name of a neighboring ethnic group. In his first catalogues, William Fagg attributed Lele objects to them.

Heading the Lele is the *nymi*, a king with limited powers. The village is organized according to age groups, with the oldest man as chief. The elders have a monopoly over the traditional cults, created to ensure the fertility and prosperity of the village and success for hunters. Presently, the elders are still the depositories of the secrets of healers, who used to be organized into the *bangang* society and subject to initiation. This society included mature men as well as the parents of twins, who were considered to be mediators between the spirits and humans.

The men work in the forest, where they hunt in groups, locate medicinal plants, cut wood, sculpt, and communicate with the spirits. The women are in charge of the food crops and of fishing in the marshes; feeding the village is their responsibility.

The village is square or rectangular in form. It is built in the plains, surrounded by banana trees and palms. Each side is occupied by members belonging to the same age group. In the center is a public square, where the blacksmiths and weavers are located. Harmony and peace depend on community, which is symbolized by two objects: the drum, a sacred communal possession, and the cup, an individual possession but one impregnated with the communal spirit, for one never drinks from it alone. Drinking palm wine serves to seal personal treaties and collective pacts.

The sculptor hunts, extracts palm wine, and participates in daily assemblies. Each artist has a lean-to in the part of the village belonging to his age group; when he strikes his anvil, it is an indication that he accepts being watched while he works.

In earlier days, cups belonged to one age group and would pass from member to member, thus creating a bond between participants. In the more secret ceremonies, the cup had a ritual role and could only be seen by initiates. Always anthropomorphic, made of rot-proof *ntotsh* wood, it is resistant to insects and termites. The rim has to be very thin so that it "may sing underneath the fingernail."

The art of the Lele borrows many elements from the Kuba and Dengese in particular, but the hairdo and long braids of the statuettes distinguish these objects from any others.

M. Alard, "Coupes Gravées chez les Bashilele du Kasai Occidental," in *Arts d'Afrique Noire*, no. 51, 1984.
F. Neyt, *Traditional Art and History of Zaire*, op. cit.

THE KUBA The Kuba's neighbors, the Luba, gave them their name, which means "people of lightning." The king, *nyim*, is chosen from the subtribe of the Bushong, or "knife throwers." Numbering about 70,000 in 1947, less than in 1938, the Kuba and the related tribes of the Kete and Cwa live in a region of valleys where numerous rivers flow south to north; the hills are covered with brush and the rivers are bordered by forests.

Kuba myths and legends describe the creation and organization of the world and recount heroic feats. In the royal residence was a dignitary in charge of the preservation of traditions and their transmission—an exceptional occurrence in Black Africa. Several hypotheses have been advanced as to why the Kuba settled in this region: apparently, they had come from the east and not far from the sea encountered the Europeans. They were forced to flee, and thus came to occupy their present area. This may explain their bonds with coastal tribes. During the nineteenth century, the Kuba had to defend themselves against several Luba invasions, and their history is marked by rebellions and upheavals; the Bushong, who subjugated the whole of the Kuba, demanded payment of a tribute. The king lived in the capital, in the *mushenge*, or palace, enclosed by a palisade, surrounded by his council, *komono*, and functionaries. The population of the *mushenge* did not work the soil and lived on the tributes paid them by the villages. Diviners, sorcerers, blacksmiths, and maskmakers worked the fields part time.

A Portuguese traveler was the first to visit Kuba territory before the arrival of Wolff, a member of Hermann von Wissmann's expedition in 1883. But the region remained isolated until 1904, despite the European exploration of the Kasai and Sankuru rivers and the establishments of some posts.

The villages were small, consisting of about a dozen dwellings which one lineage would occupy. The rectangular huts were arranged in two rows, a space in the center occupied by huts containing ritual objects and sheds where artists worked. The chiefs of the village, chosen from the oldest lineage, would reside apart from the village.

Farming, aside from clearing the fields, was women's work; they cultivated manioc, corn, gourds, bananas, pineapples, and palms. Tobacco was grown by the men. The hunt, a collective enterprise using nets, brought prestige and reinforced the social cohesion between the villagers. If undertaken by an individual, it was done with traps. To fish the rivers required the participation of the entire village in order to build canoes. The land, the property of the community, was distributed by the chiefs, who lived in the capital. Hunting lands were "lent" on payment of a tribute to the chief. In 1956, Jan Vansina noted that the Kuba had gone well beyond a subsistence economy, a development due especially to the presence of slaves, who represented 6% of the population.

Kuba society, centralized and strongly hierarchical, was characterized by a series of ever wider inclusions: family, lineage, clan, and associations—all contributed to the status of the individual. In terms of political organization, the village was divided into two halves, each one managed by a chief. The village chief, assisted by notables and a council, created a true political unity and reigned over a real community. Five or six villages formed a canton which, combined with three or four others, made up a "land," and nine lands formed a Bushong chieftainry—which in 1956 accounted for 125 villages out of the total 210 in the kingdom. The king, at one and the same time chief of the entire kingdom and of the Bushong chieftainry, was thought to be of divine origin. He was regarded as endowed with supernatural powers obtained from the ancestors or through sorcery, and was the guardian of the fecundity of harvests, success in the hunt, rainfall, and the births of children. For that reason, the king's double, in the form of a statue called the *ndop*, attended women in childbirth. The kingship protected against anarchy, but cohesion remained a formality since the central institutions were weak. Each chieftainry, represented by a delegate to the king, paid an annual tribute but remained independent in its internal operations. Two chieftainries might be at war but the king would not intervene unless he was asked to arbitrate. Responsibilities were not hereditary but were continually redistributed among the lineages. The king himself was chosen from a lineage, but his son did not inherit his position. The enthronement of the king lasted for one year: he had to break with his lineage and, to prove his status, commit incest. On the day of coronation, his mother would be remarried to several men to prevent any one of them from claiming privileges in the name of the son.

Furthermore, there was also specialization related to gender, trades, and regions: weavers, blacksmiths, hunters, boatbuilders, singers, dancers, and musicians were organized into guilds, and each one watched over its specialty. Generally speaking, there were only one or two sculptors per village, and their work was held in high regard. Only the most gifted performed this activity. Specialization could also be encountered at the level of subgroups: the Pyaang were the blacksmiths of the kingdom; the Kele and the Ngeende the fishermen; the Kete produced salt; the Batwa were hunters. This specialization leads one to assume there was a developed sense of commerce both inside and outside the kingdom. The Kuba imported pottery and ivory in exchange for copper and iron; the Lulua provided them with slaves, and the Pende are supposed to have introduced them to tobacco, raffia, and manioc. In the nineteenth century, the Kuba came in contact with the Chokwe who were gradually moving north. Three-way exchanges took place: slaves bought from the Luba, paid for by European fabrics, were resold to the Kuba for ivory.

The Kuba excelled in making objects of prestige for the dignitaries and functionaries of the court: bowls, pipes, and the fabrics mistakenly called "Kasai velvet." In reality, the Bushong have only recently been making these fabrics; only the Bangyeen and the Bangwoong had the technique of working with raffia fibers that could produce the velvety and tightly woven look of certain funerary fabrics. On the other hand, the Bushong embellished fabrics with beads, cowrie shells, and embroidery originally made by pregnant

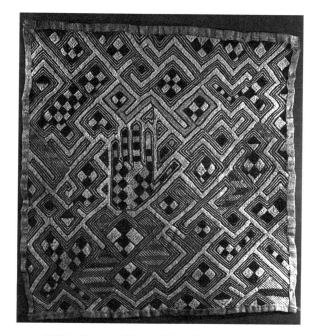

1027 Shoowa fabric, Kuba, Zaire
Height: 57.5 cm; width: 49.5 cm. W. Mestach Collection, Brussels

1028 Portrait of Misha-a-Pey, regent of the Kuba from 1893 until 1900
Wood. Private collection

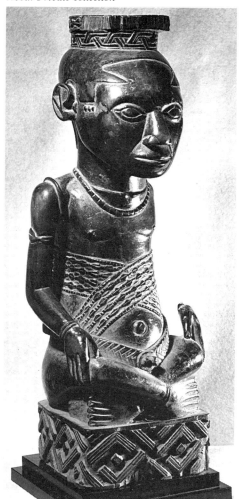

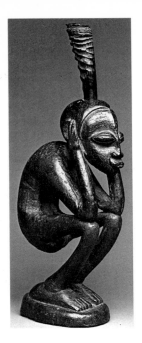

women; these thereby became family treasures. These velvety fabrics were used as currency to obtain red *twool* wood. (J. Cornet, 1982) Royal insignia were many: chair, scepter, sword, costume, mask, and bracelets. The king owned personal emblems: a drum of governance, and the *ndop*, in which the king is represented as seated on a base, his legs crossed, with his emblem before him.

J. Cornet, *Art Royal Kuba* (Milan: Sipiel, 1982).
J. Vansina, *The Children of Woot: A History of the Kuba Peoples* (Madison: University of Wisconsin Press, 1978).
———, *Le Royaume Kuba* (Tervuren, Belgium: 1964).
———, *Les Tribus Ba-Kuba et les Peuplades Apparentées* (Tervuren, Belgium: 1954).

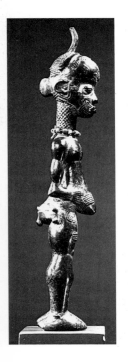

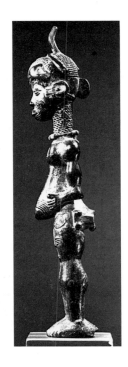

THE LULUA The term "Lulua" was given to the Bena Moyo, who lived on the banks of the Lulua river in Kasai, by the first explorers, Von Wissmann and Pogge, in 1881. The tribe considered themselves to be Luba, a Pemba subgroup. Their multiple migrations and the contributions of various ethnicities are manifest in the abundance and variety of the scarifications in their statuary, the same marks that can be seen on the men themselves. In the beginning of the eighteenth century, following Luba incursions into the northeast region, the Lulua fled further south and came in contact with the Kuba, Pende, Songhay, and Chokwe who, moving deeper into Kasai in 1880, brought them European articles such as rifles, clothing, and glass beads.

The Lulua are now patrilinear, forming small, autonomous groups that lack centralization; they devote themselves to the hunt. Before, they were organized into small independent villages under the direction of a chief assisted by a council of elders; later, they reorganized under the authority of a chief chosen from among the subgroup of the Bkwa Katawa, whose rights the chief would defend.

Their statuary is remarkable in the degree of its scarifications, a manifestation of a wish to be socially differentiated. These marks must be very ancient since Von Wissmann no longer found them on the Lulua themselves. The statues represent great chiefs with beards and insignia, and these effigies would be planted in the ground to protect the household when the head of the family was absent. The most famous statuettes are the *mbulenga*, or female charm statuettes. The *chibola* are maternity figures that, when worn on the belt, protected the newborn child or the baby about to be born; the *chibola* would stand watch over childbirths. The protruding abdomen of the woman emphasizes the importance of the lineage. The *chibola* were the essential element of the *bwanga bwa thibola* cult, also found among the Luba and the Songhay.

Other statuettes with truncated bases protected against sorcerers, thieves, and lightning, were used in divination sessions, and could bring about bad luck. Crouching figures with receptacles on their heads were used as hemp boxes by the hunter, who attached them to his belt and spoke to them, and these brought him luck on his return. During the hunting ritual, the statue would be fed and placed on a small earth hillock to witness the hunt. Warrior statues are also numerous. Large standing figures, carrying a cup, were charms of beauty and luck inhabited by ancestral spirits. These statues participated in the investitures of chiefs and at their funerals.

One should note the importance of the head, which frequently comprises a quarter of the total dimension of the figure. The hairdos generally end in a point and have tufts of hair emerging from the back of the skull. The neck is long, the shoulders tattooed, the breasts small and pointy. The position of the arms at right angles expresses virile strength. The navel is often pointed, surrounded by concentric circles that symbolize life. The legs are short and the feet are substantial in size. The statues would be covered with *tukula*, a whitish bore dust. The whole is always harmonious. The unity created between form and decoration gives this statuary its value and quality.

The Lulua also make pipes, tobacco mortars, neck-rests, hemp jars, drums, combs, small hunters' flutes, and adzes. Masks, which are very rare, are sometimes used in initiation ceremonies and rites of passage.

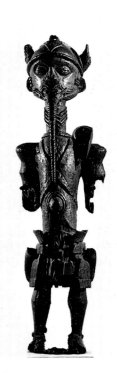

ABOVE:
1029 Lulua, Zaire
Wood. Height: 24 cm. Musée Barbier-Müller, Geneva

CENTER:
1030–31 Lulua statue, profile, Zaire
Wood. Height: 48 cm. Musée Royal de l'Afrique Centrale, Tervuren, Belgium

LEFT:
1032 Lulua statue, Zaire
Wood. Height: 79 cm. Musée Royal de l'Afrique Centrale, Tervuren, Belgium

The statues were destroyed in 1880 on the orders of a Lulua chief, Mukenga Khalemba, who tried to impose the cult of hemp as a state religion.

P. Timmermans, "Essai de Typologie de la Sculpture des Bena-Luluwa du Kasai," in *Africa Tervuren*, no. 12, 1966.

THE LWALWA Inhabiting the triangle formed by the Kasai River and its tributary, the Lweta, in the southwest of the former Kasai province, 20,000 Lwalwa live in Zaire, but many more are in Angola, where they are called the Tukongo. Related to the Dinga, Tabi, and Salampasu and very heavily influenced by the Lunda, the Lwalwa long remained hunters.

Their social and political organization is rudimentary. Each village has its own chief, but several villages may unite under the authority of a chief elected from among village chiefs. Lacking wide powers, these chiefs are frequently mere counselors, on the same level as notables, and render justice and sit in judgment over offenses committed by members of their clans. In earlier days, authority was transmitted through the women. In the middle of the nineteenth century, the Songhay and Luba settled in the region and introduced both the patrilinear structure and agriculture.

An exceptional occurrence in this region are the houses elevated on a square base, constructed to avoid the problems of the marshy soil. One may assume that, elsewhere, such structures used to be built on piles.

The Lwalwa believe in a supreme being, but they worship only the spirits of the hunt and nature. The diviner uses an instrument consisting of two small blades that he rubs against one another to unmask sorcerers and to discover the causes behind a death or a chief's loss of power.

The statuary, limited to a few rather crude figurines whose features are copied from masks, played a definite role in the fertility ritual and also in the cult devoted to the spirits, messengers of the ancestors.

The masks, of enormous plastic vigor and remarkable abstraction, had an important function in the *bangongo* dance of the hunting ritual. When hunters returned empty-handed, the ancestors would be appeased by organizing a dance. The masks were also used in a secret ritual of the *ngongo* society, in charge of initiation and the circumcision of young men. Masks were made during dances of highly complex choreography and had to appease the spirits of the ancestors and compel them to intervene. Masks still play a role today in secular festivities.

The sculptor enjoyed a privileged status and was paid handsomely; his profession was hereditary and often, due to his riches, he was made village chief in charge of the masked dances.

Male masks are divided into four types: the *nkaki*, or man's mask, with a nose sculpted into a wide triangular panel that sometimes extends up to the forehead; the *shifoola*, a mask with a short, hooked nose; the *mvondo*, the nose of which is reminiscent of the *nkaki's*, only smaller; and finally the *mushika*, which represents a woman and which has a frontal crest. The shapes are modeled after different birds. The lips are narrow but protruding and thick; the eyes have openings in rectangular, horizontal slits. On the temples they have a protuberance that represents tattooing.

P. Timmermans, "Les Lwalwa," in *Africa Tervuren*, no. 13, 1967.

THE SALAMPASU A warrior people comprising 60,000 individuals, the Salampasu live east of the Kasai River and have the Chokwe and Lunda as neighbors to the west and south, and the Lwalwa and Kete to the east and north. Although there was no centralized political system, some chiefs nevertheless exercised considerable power and created veritable armies capable of resisting Chokwe and Lunda attacks.

The favored occupations for men were war and the hunt. Despite the presence of missionaries in the region, the Salampasu have barely been studied.

Masks and figures are made for initiation purposes. Presented in a progressive order to future initiates, they symbolize the three levels of the society: hunters, warriors, and the chief. (*see* J.-L. Paudrat) Certain masks provoke such terror that women and children flee the village when they hear the mask's name pronounced for fear they will die on the spot. (Henderson, 1940) The costume, composed of animal skins, feathers, and fibers, is as important as the mask itself. It has been sacralized, and the spirit dwells within it. The entity of mask-costume has the generic name *akish*, but as soon as it is worn it is called *mukish*.

The masks come in three types: some are of black braided fibers surmounted by a conical hairdo decorated with polychrome triangles; some are wooden masks with ample feathered panaches; and lastly, other masks are covered with copper lamina and topped by an ensemble of vegetable fiber pompoms. The bulging forehead projects frontward, the nose is wide and pyramid-shaped.

Only one statue of great quality is known. The Salampasu traded with the Lunda and Chokwe and, although original, their art has indications that elements were borrowed from their neighbors.

F. Neyt, *Traditional Art and History of Zaire*, op. cit.
J.-L. Paudrat, in M. Huet, *The Dance, Art, and Ritual of Africa*, op. cit.

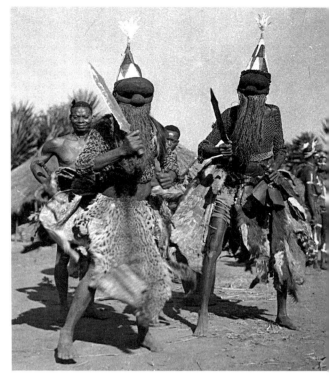

1033 Salampasu masked dancers
In situ

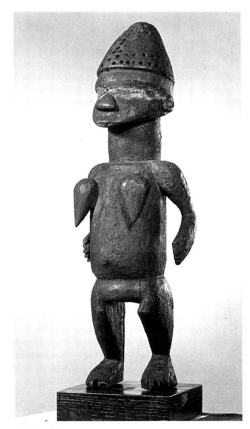

1034 Salampasu, Zaire
Wood. Height: 36 cm. The Brooklyn Museum, New York

The Kwango-Kwilu

(Zaire)

THE HOLO This little ethnicity of 6,000 individuals living on the two banks of the Kwango River is divided between Zaire and Angola. They closely overlap with their neighbors, the Yaka, Suku, Pende and Chokwe. In contact with European missionaries as early as the seventeenth century, the Holo were not studied until 1950.

Subject to the authority of one or several supreme chiefs, the village chief, *mbanza*, belonged to the lineage of the founding ancestor; his authority was tempered by that of the "master of the land," who was in charge of ritual services. Every chief wore an iron bracelet as insignia and had allegiance to a queen. As the regime was matrilinear, woman occupied an important place, especially true of the wife of the chief in charge of the treasury.

The Holo believed in the spirit of the dead, as well as in the rainbow spirit (incarnated in a serpent who lived in the river), and the moon spirit, which had the power to kill; they used sculptures to protect themselves from the more pernicious spirits.

The quadrangular houses with conical roofs were decorated with geometric panels colored red, white, and black. The threshold was made from a log sculpted in low relief bearing depictions of small animals.

The initiation of young boys, the *mukanda*, borrowed from their neighbors, was marked by the participation of animal- and human-shaped masks in the ceremonies and celebrations following circumcision.

Diviners used a small cylindrical slit drum with handles sculpted in the form of a neck and head. They would strike the instrument during consultation as they analyzed the position of the contents in a basket seen in a mirror. During festivities, they played a two-stringed violin.

The *nzambi* cult involved a ritual of protection and healing in which small wood frames, enclosing a human figurine, would be used: the sculpted figure would be seated or standing, arms spread, hands touching the frame. The frame itself was decorated with geometric zigzag motifs: squares, triangles, diamonds, crosses, circles, and rosettes. Some of the openwork panels result in designs reminiscent of the Christian cross, but their function and use were typically African. These emblems would be placed in small huts in which their owner would come to tell them his desires. The same cult is found among the Suku, but only the Holo had this kind of frame, whose shape may be compared to the tops of the Senufo headdress.

Their statuary includes human figures, often sexless, carrying small bags or horns containing medications, or sitting in a basket filled with ingredients. With most, the hand is touching the chin, abdomen, or hips, a characteristic gesture also found among the Bamileke of Cameroon. Sometimes there is a line making a rim on the forehead, a probable reminder of the highly stylized hairdo of the women. The statues were kept in small sanctuaries close to the dwellings. Other figurines, whose function remains unknown, represent birds. Perhaps these are hero-birds comparable to those found among the Lunda, or representations of heroes who have qualities that recall those of birds. They were placed close to the houses to protect them from lightning. In the Holo's artistic output, Chokwe, Suku, and Yaka influences may be seen.

F. Neyt, *L'Art Holo du Haut Kwango* (Munich: 1982).

THE YAKA-SUKU Settled in the southwest of Zaire, the Yaka number about 300,000 and the Suku 80,000. Their institutions, political organization, and cultural traditions are almost identical; they can be differentiated only by the style of their statuary.

The chief of the lineage had the power of life and death over lineage members. He was in charge of the cult of the ancestors and judiciary authority, and it was compulsory that he have large numbers of descendants. Lineages are ruled over by the founding lineage, which itself pays an annual tribute to the chief of the region. The latter accounts for this to the king, the supreme authority, assisted by a consulting council of titled men.

On the periphery of this hierarchy, the "master of the earth" plays an important role during the rites that accompany the hunt—the primary activity of the men. Sometimes hunting is done individually with bow and arrow or with a rifle, sometimes collectively with dogs and traps. As is true of their neighbors the Bembe and the Bwende, Yaka and Suku hunters perform a specific ritual under the direction of the "master of the earth" to guarantee that they procure game.

The Yaka and Suku have an initiation, the *n-khanda*. A special hut is built in the forest to give shelter to the postulants during their retreat; the event ends in circumcision, an occasion for great masked festivities including dances and song. The young initiates then belong to the paternal group. The *n-khanda* is organized every time there are enough eligible youths between ten and fifteen years of age.

The diviner, *ngoombu*, practices his profession with a divination drum.

The wood sculpture is a royal court art linked to the social hierarchy and includes belts, bracelets, adzes, pipes, insignias of chiefs, blades used for taking the floor in meetings, neck-rests required for the complicated hairdos (which are rarely redone), as well as pendants and flyswats, the attributes of the warrior chief. There are also hunting charms, consisting of statuettes or simple logs, which are honored in a special hut or in a sacred enclosure. Musical instruments include dog whistles sculpted with figurines, and slit drums decorated

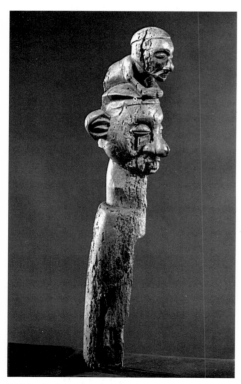

1035 Hemp mortar, Holo, Zaire
Wood. Height: 28 cm. Private collection

1036 Yaka gong handle, Zaire
Wood. Height: 42.5 cm. Musée Royal de l'Afrique Centrale, Tervuren, Belgium

with a human bust or body on one of the ends; placed upright, these drums could be used as seats.

As is true throughout Zaire, the statues that contain magic ingredients, the *biteki*, have malevolent or beneficial functions. The medications are placed in the figure's abdomen, which is closed up with a resin stopper, or enclosed in small bags hung around the neck or waist. The *khosi*, whose dimensions vary from thirty to seventy-six centimeters, consists either of one body with two faces and a double set of extremities, or two statues attached back to back. The face is painted half red and half white. The body is decorated with red and white dots; the hips are covered with a raffia or cotton skirt. The statue is kept in a hut that stands within the enclosure of the chief's house.

The Yaka also have statues of chiefs which are not, however, portraits. These emphasize his authority by representing the chief, his many wives, his children, and his servants, gathered together in the same shelter. The torso is highly developed; missing extremities allude to an accident that befell a hero. The *phuungu*, a statuette of fifteen centimeters, belongs to the chief of the patrilinear lineage. The torso is wrapped in magic ingredients and has an almost spherical shape; often hooked onto the roof of the hut, it receives libations of blood that activate its powers.

The Suku of the north have unusual statues, the *mulomba*: indeed, these have one hand outstretched to solicit a gift. They belonged to regional chiefs. All the sculptures wear the hairdo typical of the chiefs of the territory and lineage.

In contrast to the statuary, which is aesthetically interesting, the masks are common and poor. They fulfill several functions: some serve as protection against evil forces, others ensure the fertility of the young initiate. Their role consists in frightening the public, healing the sick, and casting spells. The charm masks of the initiation specialist do not "dance." Their appearance must engender terror, especially the *kakuungu* of the Suku, with its swollen cheeks, massive features, and protruding chin. It is the largest mask known in Africa. It is divided vertically into a red side and a white side and is held by a grip under the chin.

The Suku used *hemba* helmet-masks. These are cut from a cylinder of wood, the hairdo often surmounted by a person or animal sculpted in the round. In the north, the face is painted white and marked with blue lines, and in the south it is colored red. These masks are supposedly an image of the community of deceased elders, notably the chiefs of the maternal lineage. They are used to promote success in the hunt, to heal, and to punish criminals.

The *kholuka* mask of the northern Yaka dances alone at the end of celebrations. Very popular, featuring globular or tubular eyes, a protuberant or snub nose, and an open mouth showing its teeth, it sometimes has a hairdo of branches covered with raffia. In the south, some masks are made entirely of raffia. All refer to the power of the elders and their predecessors, and every element of the mask is the plastic translation of a cosmological term. The colors are those of the rites of passage; the serpent motif symbolizes the rainbow and the moon.

The sculptor is not a blacksmith. He performs rites appropriate to his profession. He has his own bag of magic substances and before starting a sculpture, he makes an offering to the one who taught him his art. When he sculpts initiation masks, he works alone in a place taboo to others. He has relative freedom within the context of traditional conventions.

A. P. Bourgeois, *Art of the Yaka and Suku* (Meudon, France: Chaffin, 1984).
J. Denis, *Les Yaka du Kwango* (Tervuren, Belgium: Annales du M.R.A.C., no. 53, 1964).

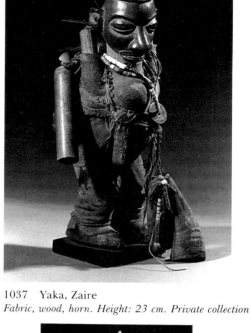

1037 Yaka, Zaire
Fabric, wood, horn. Height: 23 cm. Private collection

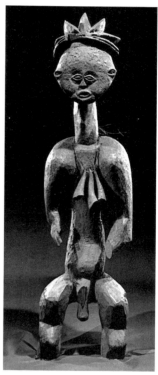

CENTER:
1038 Suku, Zaire
Wood. Height: 93.6 cm.
Musée Royal de l'Afrique
Centrale, Tervuren,
Belgium

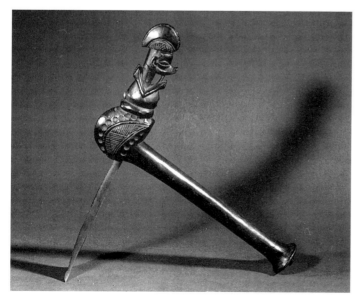

1039 Display adze, Yaka, Zaire
Wood and metal. Height: 29 cm. Private
collection

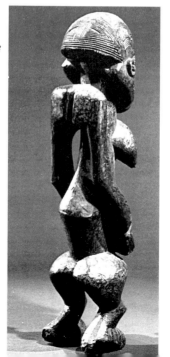

1040 Suku statue, Zaire
Back view. Wood. Height: 59.2 cm. Musée Royal
de l'Afrique Centrale, Tervuren, Belgium

583

THE MBALA Called the Bampeen by their neighbors, the Mbala settled between the Wamba and Bakali rivers in northwestern Zaire as well as between the Kwilu and Luchima rivers in the east. The region is a point of confluence for many ethnicities with whom the Mbala have become assimilated: the Pelende, Suku, Pende, and Yaka. Having come originally from the Kwango River in Angola around the seventeenth century, they emigrated in successive waves toward the northeast, occupying virgin terrain or pushing the autochthones out, under pressure from the Jaga and Lunda.

Numbering about 60,000, the Mbala were originally matrilinear. The clans distributed themselves in small groups under the authority of the maternal uncle, who would choose his successor with the consent of the elders.

Local authority was divided between the chief of the territory, *fumu manu*, and the chief of the village, *fumu mbu*. The former participated in the collective hunt, giving the order to burn the land. The chief of the village owned a double-bladed knife which he planted in the ground to his right during meetings or when he was rendering justice. Hat, leopard's teeth, sword, adze, and neck-rest are the emblems of prestige found throughout Zaire. Their meanings are quite specific: the neck-rest indicates that the chief relies on his people and, consequently, that he must listen to them; the sword, that he must help his people; the adze, that harmony should reign; and teeth are marks of his courage and indestructibility.

The ancestral cult, which is not highly developed, is overseen by the chief. Death or disease are ascribed to the malevolent action of an individual who has seized the heart of the victim to place it in a tree or an animal. The diviner, consulted, will discover the reason for this during his slumber, sleeping on magic objects (axe, bell, mirror, dog skull, and shells previously handled by the injured person).

Even though the Mbala did not produce many masterpieces, they are famous for their large maternity figures and their many musician statues: drummers or players of the thumb piano (sanza) or xylophone. Statues appear in pairs—the male figure, *limba*, holds a musical instrument, the female, a child. The figures come in three types: diamond-shaped, elongated, or trapezoidal. Some carry a figure on their shoulders.

Some finely sculpted ivory objects are found: scepters, knives, cups, neck-rests. Mbala sculpture is characterized by figures with chin and forehead that project forward, a crested hairdo, a daring articulation of the masses, and a great care for detail, especially in the rendering of fingers and fingernails.

M. Felix, *Art from Zaire* (Exhibition catalogue, The African-American Institute, New York: 1975).
———, *100 Peoples of Zaire and Their Sculpture*, op. cit.

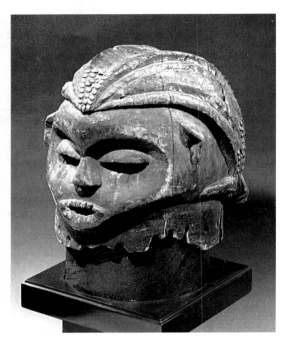

1041 Mbala helmet-mask, Zaire
Wood. Height: 29 cm. Marc Félix Collection, Brussels

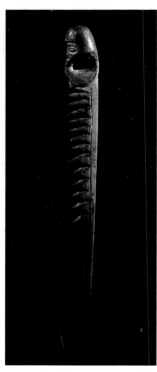

1042 Hungaan body ornament, Zaire
Wood. Height: 7 cm. Private collection

THE HUNGAAN With a population of 5,000, the Hungana are the smallest ethnic group of the Kwango. They emigrated from Angola with the Mbala under the guidance of their chief, Makoko. They claim to be of Teke origin and share a few characteristics with the Teke, as they do with the Bakongo. Heading each matrilinear clan is the *leme*, guardian of the lineage, whose function it is to keep the skulls of the ancestors. His powers are limited by the existence of a council that helps him with decision-making.

Besides hunting and fishing, the Hungaan live off agriculture and cattle-raising. Excellent blacksmiths, they export weaponry and agrarian tools.

The Hungaan's religion is based on ancestor worship. The diviner, *nganga*, is a specialist in the making of charms to protect the population. The rare statuary consists of large figures surrounded by other, smaller, ones, kept together with the skulls in the sanctuary of the ancestors. Female and male, the statues, covered with a thick red-and-white patina, wear three-lobed hairdos or basin-shaped hats. Horned statues are related to the enthronement rituals of the chiefs. The *mpungu*, consisting of a blade emerging from a head, was planted in the ground to attract animals during the hunt or to protect the village from disease and misfortune.

The Hungaan make beautiful ivory or bone sculptures, hairpins, knives, whistles, and pendants consisting of a stylized, flat head or of two little heads joined together at the chin; there are also kneeling figurines sculpted in the round, their hands on their chin, with crested hairdos. The articulation of the masses bears witness to a sense of artistic daring and plastic equilibrium. The Hungaan are not known to have made any masks.

J. Cornet, *L'Art de l'Afrique Noire au Pays du Fleuve Zaire*, op. cit.
M. Felix, *100 Peoples of Zaire and Their Sculpture*, op. cit.
W. Gillon, *Collecting African Art* (London: Studio Vista Limited, 1979).

THE PENDE The Pende emigrated from the Kwango region in northern Angola at the end of the eighteenth century and had close ties with the Lunda. The 300,000 tribe members are divided into numerous territorial groups, the two most important being in Kwilu and Kasai. They have no centralized rulership, and form about sixty little kingdoms of varying sizes, each comprising several clans and each headed by a chief whose principal function is religious, as mediator with the *mvumbi* ancestors, source of fecundity and fertility.

Even though the society is matrilinear, the sculptor's profession is transmitted from father to son. The ancestors are honored most especially during the masked celebration of the *minganji*, held in sanctuaries in the chiefs' huts or on the edge of the forest: these are small, square structures surrounded by palisades and overhanging roofs. A statue of the chief's wife sometimes stands atop the roof; it symbolizes fertility and emphasizes the importance of woman. The doors, pillars, and posts of these huts are frequently sculpted in high relief with representations of masks and ancestral figures. The Pende also make ritual or practical objects, such as chairs, stools, commanders' staffs, miniature masks, flutes, horns, whistles, drums, weapons, adzes, cups, mortars, and divination instruments.

The statuary pays particular attention to facial expression, but the masks remain the most interesting objects. There are two major styles: the western one of the Kwilu is better known, with its *mbuya* mask characterized by a somber, gloomy expression, a protruding forehead, a turned-down mouth, heavy eyelids, and the continuous line of the eyebrows across the forehead. The Kasai style is more geometric and colorful; masks are decorated with red and black triangles on a sienna background, and the eyes are often narrow and globular.

The *minganji*, or masks of power, represent the ancestors; the *mbuya*, or village masks, represent human types, such as the chief, the diviner, the epileptic with a twisted mouth, the madman or man in a trance, the widow, the lover, or the executioner. All told, about twenty characters and seven "masks of power" appear in ceremonies such as the millet-planting celebration, the *mukanda*, or circumcision and initiation ritual, and the ritual of enthronement of a chief. In earlier times, as part of this ceremony, the *phumbu* or "killer" would depart to kill the first stranger he encountered so that the victim's skull could be placed on top of the chief's hut. The *mbuya* mask must entertain the public: to that end, it is more realistic and expressive. The more abstract *minganji* mask consists of a triangular board that forms the shape of the face; it is surmounted by horns or protuberances that resemble swords. The *mbuya* expresses the values of Pende society; it functions as a social agent by satirizing deviations from this ideal. Its costume is made of raffia, European fabric, or foliage. Inversely, the *minganji* arouses fear and respect. Made entirely of raffia, it covers the whole body and features tubular eyes on its forehead. Emerging from the forest accompanied by musicians, drummers, and singers, the *mbuya* makes its appearance at the end of the circumcision rites. The *minganji*, though, appears at the end of the day, dancing in the prairie outside the village so that it can only be seen from afar. At the closing of the celebration, the young circumcised men go back to the forest for the unveiling of the masked dancers. They then have the right to touch the masks and various ritual objects.

Known only in Kasai, the *giphogo* is a helmet-mask representing the chief. Covering the shoulders of the masked person, it sports a wide horizontal beard decorated with geometric designs; the nose stands out abruptly from the face; it holds a fan in each hand, and a monkey skin is attached to its hair up top. It is part of the chief's treasury (*kifumu*). Its absence would bring misfortune.

The artistic reputation of the Pende comes also from their ivory pendants, called *ikhoko*. Protective amulets, these are miniature versions of the *mbuya* masks; they feature triangular eyes and mouth, very obvious nostrils, a forehead defined by a line in relief, a pointed hairdo, and, sometimes, a long beard. Most often they are made out of ivory, hippopotamus tooth, wood, or from a very hard material, the *muhafu* pit. When they are constructed in metal, tin, or lead, copies are made in ivory or wood. Worn by the men, the *ikhoko* is a symbol of status and prestige. The young circumcised man who receives it will keep it until his death; then it will be transmitted to another member of his family.

The Pende have a fine reputation among their neighbors. The Kuba say that they learned the art of pottery from them, and the Chokwe attribute the invention of the first furnaces and the technique of fusing iron minerals to them.

L. de Sousberghe, *L'Art Pende* (Belgium: Académie Royale de Belgique, 1958).
H. Van Geluwe, "Masque Pende," in J. Fry, ed., *Vingt-cinq Sculptures Africaines*, op. cit.

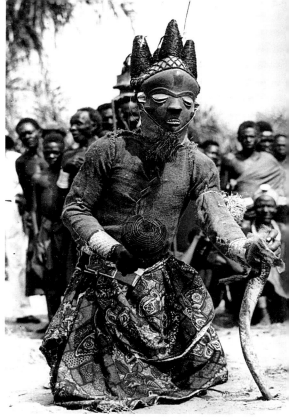

1043 Pende dancers
In situ

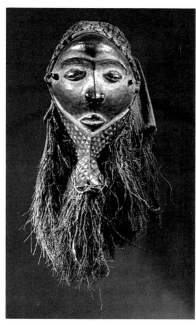

1044 Pende *kiwoyo* mask, Zaire
Wood and raffia fibers. Height: 50 cm. Private collection; formerly Païlès Collection

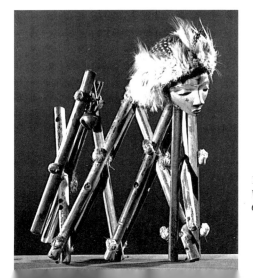

1045 Pende divination instrument, Zaire
Wood. Height: 31 cm. Musée Royal de l'Afrique Centrale, Tervuren, Belgium

The Angolan and Zambian
Borders of Central Africa

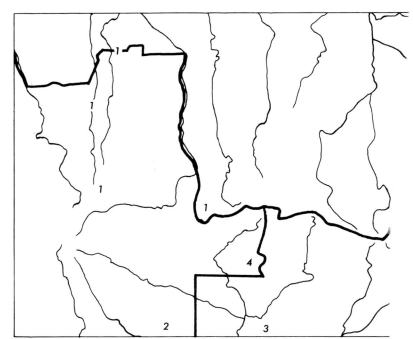

1 Chokwe
2 Lwena
3 Barotse
4 Lunda

1046 Chokwe tobacco box, Angola
Wood. Height: 12.5 cm. Private collection

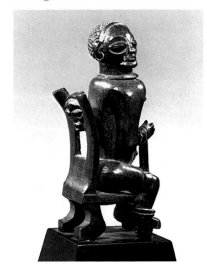

THE CHOKWE The 600,000 Chokwe constitute the largest eth
Angola; they have also spread to Zambia and the Congo. In the sixtee
Lunda conquered them, introducing into their tribe the institution of
sacred nature of power. Originally, they were cattle-raisers and small f
taught them the art of hunting, which they in turn had been taught b
Tshibinda Ilunga, who had married the queen of the Lunda. As a resu
marriages, assimilation between the two ethnicities took place and Cho
the Lunda court.

In the seventeenth and eighteenth centuries, the Chokwe remained
domination, but the nineteenth century was marked by many rebellion
culture was Bantu—nevertheless the two groups differed in their syste
family relationships, and political organization. The Chokwe did not ha
rulership but were governed, rather, by large chieftainries directed by
Around 1850, an extraordinary expansion of the Chokwe took place; i
took over the capital of the Lunda, who had been seriously weakened b
thus the Chokwe contributed to the dismantling of the Lunda kingdom
in the art of the hunt, as they were the only ones among the Kasai peo
first for its meat, then, from 1858 on, for its ivory. As the land was not
harvesting rubber were their main activities, together with gathering he
they would sell to coastal ethnicities. They participated in the slave trad
criminals as well as their enemies, to whom they added prisoners they I
raids among their neighbors.

The arrival of the Europeans forced them to submit to the Belgians a
they emigrated further and further east with each new defeat, to Cong
northwestern Zambia. They became seminomadic, little by little abando
northwestern Zambia. They became seminomadic, little by little abando
chieftainries and architectural traditions, such as building granaries on

The Chokwe believed in a creator god, Kalunga or Nzambi, to whom
in their prayers but whom they did not worship. On the other hand, the
ancestral spirits, the *mahamba*, were represented by termite hills, sculpte
or earthen figures in the village or in family sanctuaries. The *nganga* so
souls," would call upon the malevolent *wanga* spirits contained in statuet
diviner, *tahi*, played an essential role: he would use two small wooden bo
basket that contained some sixty different objects. The role of physician
mbuki, who possessed a knowledge of plants.

ssociation was responsible for the initiation of young boys, which
of ancestral knowledge as well as the circumcision festivities, in which
resenting the ancestors, would make an appearance. The *mukanda*
lptural traditions, despite the fact that the Chokwe's neighbors had

f the girls was called the *ukule*. It consisted of a sexual initiation and
s, after which the young girl would be introduced to her fiancé.
n of hunters also played an important role in the life of this group.
earned the techniques of the hunt. Moreover, tests of endurance
lts, although other male societies gave their members the privilege of
display.
re the most famous of the region; there were two types. The first
he *fuli* who were professionals but further ensured their subsistence
ir own consumption. They made *jinga* charms, the *mahamba* figures
nd all objects used for hunting, love, magic, and fertility.

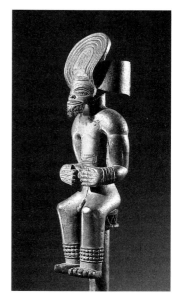

1047 Chokwe scepter, Angola
*Wood. Height: 43 cm. Figure: 28 cm. Museum
für Völkerkunde, Vienna*

1048 "The Sova Mavanda Dancing"
*Drawing by E. Bayard in "Comment J'ai
Traversé l'Afrique . . . ," 1877–78, by Major
Serpa Pinto*, Le Tour du Monde, *1881*

The second type were artists hired by the great chieftainries who worked exclusively for
the court. They sculpted scepters, thrones with figurines, fans, tobacco boxes, pipes,
flyswats, cups, and figures of chiefs or ancestors—all demonstrating a great deal of
refinement. Rivalry reigned among artists and, at the Lunda court, all were Chokwe. They
were famous for their large statues of deified ancestors, exalting strength and dignity. The
best-known representation of a chief is of Tshibinda Ilunga, whose life was exemplary.
According to oral tradition, a Lunda chief chose his daughter, Lueji, to succeed him in
preference to her two brothers. Upon her father's death, the queen married the wandering
hunter Tshibinda Ilunga, youngest son of the great Luba chief Kalala Ilunga. This prince,
then, was the start of the sacred dynasty of the Mwata Yamvo of the Lunda and became the
model of the hunting and civilizing hero, sometimes represented seated on a throne,
sometimes as standing naked or dressed as a hunter. As statues of him were sculpted after
the introduction of firearms, generally the figure is holding a stone rifle in his left hand and
a stick, called *cisokolu*, in his right; this stick allows hunting charms to be hung from it when
it is planted in the ground during a rest period. Sometimes, the figure can only be identified
by the cartridge pouch attached to its back. Beside his feet or on top of his hair small
figures are found—these might be effigies of ancestors or animals, such as the spirits of the
dog or lion, who are favorable to the hunt. Tshibinda Ilunga's body is stocky, with legs bent,
shoulder blades clearly drawn, the neck wide and powerful, the navel protruding. His chin
points vigorously and aggressively forward, and he wears an enormous hairdo, the sign of
princely rank. Arms bent at right angles and hands with the fingers spread apart reproduce
the *taci* gesture, which expresses strength and power and emphasizes the vitality of the chief
and the prosperity of his people. Also found are statues of chiefs playing a musical
instrument.
 The social organization, founded upon matrilinear lineages, has an equally large number
of female statues, whether these be identified as the queen mother or a chief's wife.
 Among the masks, the *cikungu* is the most sacred. The face and hairdo are made of wicker
covered with beaten tree bark; they are rubbed with resin, then painted or decorated with
fabric appliqués in vibrant colors. The sovereign carries the *cikungu* at the time of his
enthronement, for it represents the ancestors of the territorial chiefs and is used only

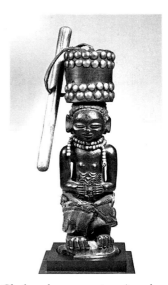

1049 Chokwe hemp mortar, Angola
Wood. Height: 19 cm. Maïa Kerchache Collection

587

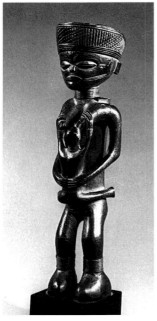

1050 Maternity figure, Lwena, Angola
Wood. Height: 28 cm. Private collection

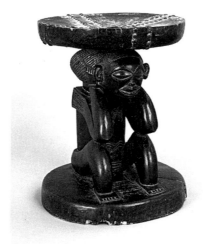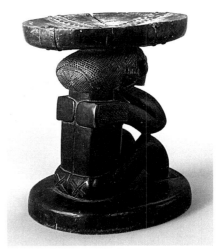

1051–52 Chokwe seat, Angola
*Wood and brass nails. Height: 35.5 cm. Seattle
Art Museum; formerly K. White Collection*

during sacrifices offered to them. The *cikunza*, also made out of wicker, has a tall hairdo in the shape of a pointed tower. It is the protector of the initiation ceremonies of the *mukanda*. In terms of dance masks, the *pwo* is the incarnation of the female ancestor; it used to be modeled out of resin but today is made of hard wood, and is worn by a man dressed in a net tunic. It brings fecundity to the spectators, and it sometimes dances with a statuette that represents a mother carrying her child on her back. The *cihongo*, a male mask, symbolizes power and wealth. All these masks testify to a great, expressive sculptural rigor and to the same sensitivity one sees in the small masks of the chieftains' courts.

The originality of the Chokwe stems from the fact that they used to decorate every household and ritual instrument and object of prestige, including furniture in the chief's house. Each decorative motif had its own name and symbolic meaning. The insignia of office include pendants, swords, small axes, lances, and stools. Ivory is found almost not at all, as the Chokwe reserved it for trade. Their sculpture is highly valued. Unfortunately, it suffered a European influence that was translated into an overabundant decoration, and the statuary art has definitely been lost. Only the masks remain, continuing to play a role in Chokwe society.

M.-L. Bastin, *Art Décoratif Tshokwe* (Lisbon: 1961).
———, *La Sculpture Tshokwe* (Meudon, France: Chaffin, 1982).
———, *Statuettes Tshokwe du Héros Civilisateur Tshibinda Ilunga* (Arnouville, France: Arts d'Afrique Noire, 1978).

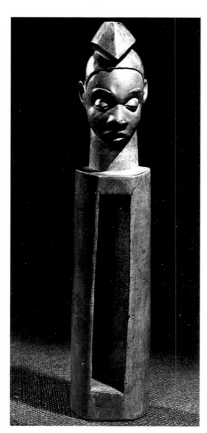

1053 Zombo drum, Zaire-Angola
Wood. Merseyside Country Museum, Liverpool

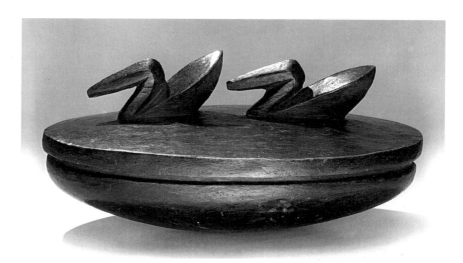

1054 Rotsie box, Zambia
*Wood. Height: 31.6 cm. Museum Rietberg,
Zürich*

EASTERN AND SOUTHERN AFRICA

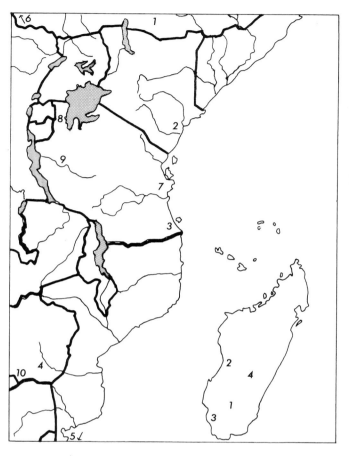

1 Konso Gato
2 Giryama
3 Makonde
4 Zimbabwe
5 Zulu
6 Bongo
7 Zaramo
8 Karagwe
9 Nyamwezi
10 Shona

1 Bara
2 Sakalava
3 Mahafaly
4 Betsileo

The Eastern Sudan

(Sudan, Ethiopia)

THE KONSO GATO Konso territory is in Ethiopia, not far from the Kenyan border. Conical huts formed the village, which had the look of a fortress, with its two walls containing an empty space between them reserved for cultivation. The conclusion of planting, the harvest, funerals, and the hunt were all occasions for festivities and dance.

 In the cemeteries or along the roads, the tombs of the Konso were surmounted by tall sculpted posts that might reach 2.3 meters in height; sometimes these were covered by a shelter of branches. Made of very hard wood, *gayo*, the posts generally formed groupings of three or four units, but might include as many as fifteen. In fact, each man during his lifetime sculpted a statue, or had one sculpted, to decorate his tomb, as well as making other

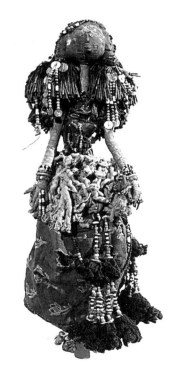

1055 Wax doll, Sudan
Wax, fabric, buttons. Cincinnati Art Museum

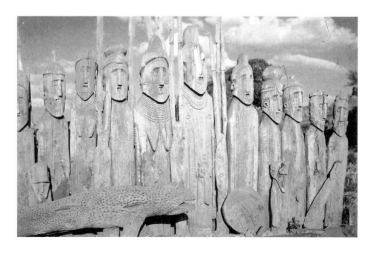

1056 Konso posts, Ethiopia
In situ

589

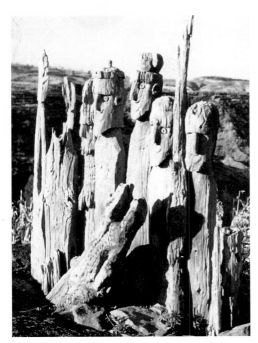

1057 Konso posts, Ethiopia
In situ.

smaller ones to represent people he had killed. At the foot of tombs one would also find the skulls of animals he had killed with his own hands.

The heads of statues, sporting "mushroom" hairdos or surmounted by crests, have very specific features: a long straight nose, eyes and teeth painted white, pupils marked with a red dot, ears depicted by two circles. The long arms are held tightly against the body, and the phallus is detached from the torso in relief; the breasts and navel are represented by small round circles in relief painted white. Necklaces and bracelets, above the elbow and at the wrist, embellish depictions of the deceased, while the statues of enemies killed have neither phallus nor crest.

Older descriptions mention the presence of a wooden panoply: shield painted white, lances, and a wooden hand—symbol of the family's perpetuation. The effigy includes attributes that indicate the social position of the deceased.

A woman is represented only if she has killed a man. In that case she is placed to the right of her husband with the enemy between them. Female traits are very clearly indicated.

Identical ceremonial posts are also found among the Konso's neighbors the Gato, also related to the Bongo of the Sudan. These figures have a skullcap featuring a point or a crest on top; head ornaments bear phallic images.

The ancestral cult was probably accompanied by a phallic cult, as one finds numerous raised stones incised or sculpted in the form of a phallus, as on Madagascar.

R. P. Azaïs and R. Chambard, *Cinq Années de Recherches Archéologiques en Ethiopie* (Paris: 1931).

1058 "Tomb of Yanga"
Drawing by A. de Bar in "Au Coeur de l'Afrique," by Dr. Schweinfurth, Le Tour du Monde, *1874*

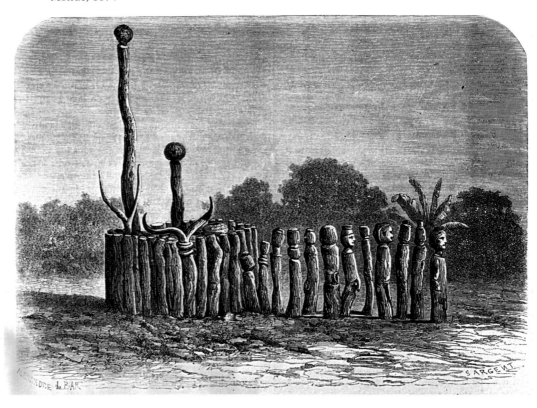

Eastern Africa Beyond the Great Lakes

(Kenya, Tanzania, Mozambique)

THE GIRYAMA The Giryama, a Bantu group of the Miji Kenda people, came from Somalia and settled in the coastal region of Kenya in the seventeenth century; farmers, they built fortified villages on hilltops parallel to the coast to protect themselves against the Galla, a neighboring ethnic group.

Their social organization is based on the one hand on clans linked by close ties and, on the other, on a system of age groups. Each clan has its own burial ground, the *kaya*, which is at one and the same time the center of political-religious life, a dwelling for ancestral spirits, and the grave of the elders. At the top of the social pyramid are the notables, the elders of the *kaya*, who meet there to talk and resolve community problems. The chief is the oldest, having acquired the wisdom of the elders through an initiation. He is a member of two associations. The first, the *chama ya vaya*, is composed of selected elders who communicate with the world beyond, impose rules, and decide upon fines. The second, the *chama ya goghu*, is analogous to the titled societies of West Africa in which an individual obtains high status and authority by virtue of his personal qualities, in addition to paying a sum that his clan collects. Members of this association have, at their death, the right to a *kikangu* post, situated in the center of the *kaya*. The *kikangu* post is not only a ritual accessory that symbolizes affiliation with an association, it is also an object of pride on the part of the family responsible for erecting it, and indicates the status of the ancestor. Placed on a corner of the ancestor's tomb, it is protected by a small hut and is the object of offerings. Moving it may provoke misfortune, but with the accession of other powerful ancestors it loses its power quickly.

Even though it is created to immortalize a deceased person, the *kikangu* is not a realistic representation. Its geometric decoration alludes to the colored garments worn by notables. The latter did not have scarifications, yet it is through these marks that the social status of the deceased, his political power, and his personal decorations are indicated. (J. L. Brown)

According to another author, J. Newton Hill, the *kikangu* is erected only when the spirit of a dead person is causing trouble. When ceremonies and rituals (such as the duration of the mourning period) have been respected, the posts are superfluous.

The surface plane of the *kikangu* has different zones divided into symmetrical frames that contain indented bands, concentric circles, and serpentine lines. Triangular and diamond-shaped decorations are the most common motifs; they represent huts, while a rosette of notched triangles symbolizes a star, and a semicircle stands for the moon. A low horizontal line that cuts through the bust indicates the waist when this is not indicated by the shape of the post itself. The navel is marked by a triangle, a square, or a rosette of triangles. Sometimes the head is not differentiated from the post, and thus resembles the treatment of the torso; sometimes it is sculpted in the round, other times it is flat, very stylized, its features engraved, most often with a nose, chin, and mouth projecting out vertically. The eyes are hollowed out into the wood; ears are not common. The more "realistic" heads—with long narrow nose, fine lips, and a small chin—are never actual portraits. The haughty expression suggests dignity, sadness, and solemnity.

New, in 1873, and Fitzgerald, in 1898, first described these funerary posts, a fairly rare artistic form in African sculpture, together with those of the Konso and the Galla of Ethiopia, who also sculpt simplified but cylindrical figures. In the Sudan, more naturalistic posts are found among the Bongo, as well as in Madagascar. Perhaps these are vestiges that indicate the existence of a sub-Saharan tradition that the arrival of Islam interrupted.

J. L. Brown, "Miji Kenda Grave and Memorial Sculptures," in *African Arts*, XIII, 4, 1980.
Mortuary Posts of the Giryama (Exhibition catalogue, National Museum of African Art, Washington, D.C., 1979).

1059 Giryama post, Kenya
Wood. Height: 112.4 cm. Detroit Institute of Arts

1060 Giryama post, Kenya
Private collection, San Francisco

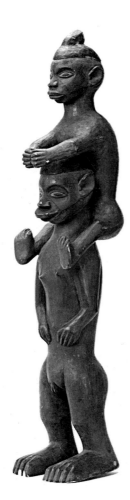

THE MAKONDE Inhabiting the southeast of Tanzania and the northeast of Mozambique are about 500,000 Makonde, divided into matrilinear clans, each one comprising several villages. Decisions are made by a chief supported by a council. Clan members meet only for the ancestral cult and to celebrate initiations.

The woman plays an important role in mythology as well as in religion and art. According to legend, shortly after the Creation, the first man, wandering around outside the bush, sculpted a female figure out of wood, and then fell asleep. When he awoke, the statue had become a real woman who gave him many children and, after her death, became the venerated ancestress of the Makonde: this accounts for the ancestress cult as well as the profusion of sculpted female figures, kept in huts or accompanying travelers.

The Makonde believe in a world of ancestral spirits and in malevolent spirits who make an appearance during the ceremonies that close initiation rites; these rites are deemed very important.

The dancers are adult male initiates, masked and completely covered in garments so as not to be recognizable. The masks sometimes represent ancestral spirits, sometimes animals. The ancestors come back masked in order to express their joy at the successful achievement of initiation. Their presence is proof of the tight bonds that exist between the living and the dead. Certain masks must inspire terror in the women, who may only view their apparition with their upper body bent over and their head facing down toward the ground. The masks, worn on the head, are decorated with tattoos applied with wax or with scarifications cut into the wood; the most recent have simple designs done in relief that copy the ancient models. As among the Tiv, the beard and hairdo are often made of human hair. The upper lip of the female figurines is elongated by a labret. There are also body masks in which two breasts are depicted in the middle of the wax tattoos. The masses are clearly articulated, the details stressed.

The Makonde are almost the only ethnicity in East Africa to create fairly naturalistic sculptures—primarily maternity figures, which are intended to ensure the fertility of the fields and women.

G. Hartwig, "Sculpture in East Africa," in *African Arts*, XI, 4, 1977.
S. Kasfir, "Patronage and Maconde Carvers," in *African Arts*, XIII, 3, 1979.

1061 Makonde statue
Wood. Height: 73 cm. Museum für Völkerkunde, Hamburg

Southeast Africa

(Zimbabwe, South Africa, Madagascar)

ZIMBABWE At the end of the last century, monumental ruins were discovered southwest of Salisbury, Rhodesia (now Zimbabwe). For a long time these remained an enigma, as stone architecture is otherwise almost nonexistent in Africa. It is known today that an immense kingdom stretched east to west from the Indian Ocean to the Kalahari desert, and north to south from the Zambezi River to the mountains of Soutpansberg. These were the ruins of "Great Zimbabwe," the capital city of a kingdom that prospered from about 1200 to 1450. On hilltops stand a high wall, a tall conical tower, temples, residences, monumental stairs, and a row of columns surmounted by soapstone birds. In addition, terra-cotta and soapstone sculptures have been found, as well as bracelets, fine plaques of gold, and pieces of copper and iron.

The kingdom was ruled by a king held to be of divine origin, belonging to the Shona group—which at that time must have consisted of a single ethnicity, although today this name covers several different groups.

Although the capital was occupied as early as the fourth century on, the architecture that was later discovered is thought to date back to the beginning of the twelfth century. The kingdom consisted of a federation of small feudal states governed by an aristocracy subordinate to a central power, the king, surrounded by his functionaries and court, and whose main instrument of power was the professional army which he had set up. The drum was the emblem of royalty. According to tradition, when the king died he was reborn as a lion. Royal power began to decline at the end of the fifteenth century, but the first Portuguese travelers still witnessed the magnitude of this kingdom, which maintained commercial ties with Europe. Yet, for reasons unknown, the capital changed location. The Rozwi kings succeeded the Shona, before an invasion by the Ngoni in the nineteenth century.

Shona birds, dating from the fifteenth century, topped the columns of a building close to the residence of the king's wives, where the schools of initiation were located. They

1062 The Temple and the Great Circular Wall, Zimbabwe
In situ

1063 Aerial view of the citadel of Zimbabwe

represented birds of prey, vultures or eagles, their wings lowered and resting at their feet. Even though naturalistic in appearance when seen as a whole, some of them display human features: for example, fingers, and lips instead of a beak. T. Huffman (1985) interprets these as the images of earlier kings, since the eagle in Shona mythology is the messenger of the creator god, as it links heaven to earth. They could also be representations of the ancestral spirits who live on the bottoms of ponds from where, tradition has it, the first man emerged. Other, older, interpretations refer to a fertility cult. It is difficult to settle the question based on the current state of knowledge.

After the Ngoni invasion, the Shona adopted a tribal style of political organization: small villages consisting of one or two families descended from a common ancestor and ruled by a local chief assisted by a council of elders. Succession to the chieftainry was made by election within a set number of families. Some objects of prestige are found from this period: neck-

rests and commanders' staffs featuring geometric, stylized forms combined with human elements, such as breasts. The last twenty-five years witnessed a rebirth of Shona sculpture in stone; these works have no ritual function, but the style has emerged in response to market demands.

T. Huffman, "The Soapstone Birds of Great Zimbabwe," in *African Arts*, XVIII, 3, 1985.

THE ZULU In the first half of the nineteenth century, a powerful state was formed in southern Africa through the spontaneous and forced blending of small groups otherwise deprived of political coherence. This unification began in 1800 when the Ngoni, Mbo, and Lala were grouped together under the authority of Chief Chaka—all belonged to a subgroup named the Zulu. Adopting this name and turning for support to various clans, Chaka organized a military state composed of "regiments." Divided into age groups that covered seven years each, boys at puberty entered a military camp for a three-year training period. Once this service was ended, they were put into the reserves; they then had the right to wear the *khela* hairdo, a kind of flat beret on top of the head, and to get married.

The clans were under the authority of a district chief, the *induna*, who was also counselor to the king. The king-priest represented the principle of fecundity and fertility. Although this flourishing empire resisted until 1884, it was finally beaten by the English and the Boers, and the Zulu were forced to renounce their independence. Today there are close to 7 million Zulu in South Africa.

Religious associations were in charge of the ancestral cult and rituals against sorcery. The guild of magicians, extremely powerful, was the only body capable of opposing the king.

Only a few Zulu sculptures are known; the elongated figures wear the *khela* hairdo. The Zulu were experts in the art of adornment, known for beautifully worked skins, leather, metal, and clay with insertions of beads and feathers. They made handsomely carved weapons, tobacco boxes, and calabashes, jewelry, as well as wooden dolls whose function is unknown. But with the collapse of their empire their art disappeared too.

J. M. Mack, in S. M. Vogel, ed., *For Spirits and Kings*, op. cit.

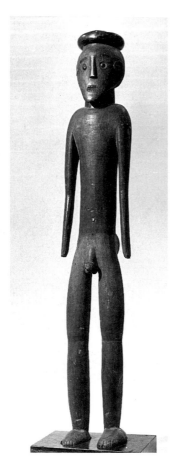

1064 Ngoni (Zulu) statue, South Africa
Wood. Height: 97.5 cm. Paul and Ruth Tishman Collection

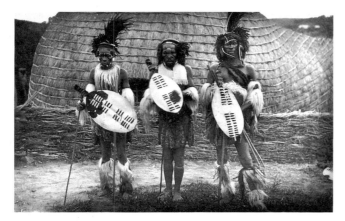

1065 Zulu warriors
Negative: R. Harris (1878)

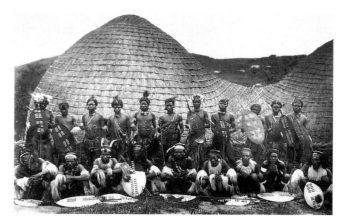

1066 Council of Zulu chiefs
Negative: R. Harris (1878)

MADAGASCAR The sculpture of Madagascar is largely a funerary art—hence it is mainly visible in large cemeteries. The island was once divided into several kingdoms. Kings had vast tombs built for themselves, surrounded by sculpted posts; these posts, fixed into the ground, could reach heights of up to four meters. They are found all over Madagascar, but especially in the center among the Sihanaka and in the southeast among the Mahafaly, who are of Bantu origin and who exported their style to their neighbors, the Betsileo, Sakalava, and Bara.

Even after the Second World War, the Bara of the southern part of the island, to commemorate one of their dead buried in Europe, sculpted an *aloalo*; most often these consist of a naked woman carrying a jug or bearing a couple of birds on her head.

The statues that have entered museums or private collections have all been sawn off above the hairline.

The Sihanaka cemeteries are the oldest and most beautiful of the island; the first recorded village dates from 1792. Situated close to Lake Alaotra, this region is flooded during the rainy season and, during the dry season it is overrun with grasses and bamboo that form an impenetrable brush. The Sihanaka, who later emigrated elsewhere, used to burn the vegetation in order to create a passage for their herds, and the wooden monuments have suffered from these fires and from exposure to the elements. Tombs themselves were almost never sculpted. Posts with figures were planted in the ground at all four corners of a princely tomb. The statue, never intended as a portrait, served as final dwelling for the royal deceased, and offerings of ears of corn and kernels of rice would be placed close by. The tomb was the object of ritual at designated times.

Mahafaly tombs consist of piles of stones, sometimes surmounted by slender, sculpted tree trunks. The themes chosen express a *joie de vivre*: embracing lovers or coupled birds that symbolize passion, fertility, and, perhaps, communication between the living and the dead. The art of the Mahafaly is reminiscent of that on Borneo or the Celebes islands. This similarity is not surprising since the island was earlier inhabited by Malaysians and Indonesians.

Among the Betsileo in central Madagascar, posts are found whose corners are decorated with geometric motifs: crescents, circles, and sawtooth lines. The Sakalava, who fled south to avoid being subjugated by the central kingdom of the Merima, decorated their tombs with human couples, birds, or isolated figures.

Besides their stone figures and tombs commemorating royal families, the Malagasy attached great importance to the *ody* that the ancestors had reputedly given them—a sort of magic amulet that generally consisted of a piece of wood or root taken from a sacred tree; added to it would be beads, lianas, a horn containing seeds, vegetable powder, or various other objects to empower the amulet. Some *ody* included a small head, a mask, or two statuettes bound together. The Malagasy *ody* resembles the *vodun* object, which also has the function of personal protection.

M. Urbain-Faublée, *L'Art Malgache* (Paris: Presses Universitaires de France, 1963)

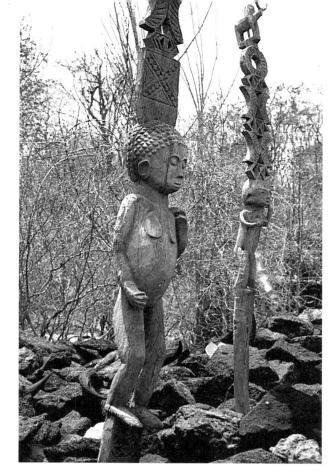

1067 Mahafaly funerary posts, Madagascar
In situ

1068 Betsileo tomb, Madagascar
In situ

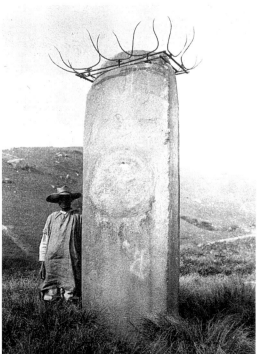

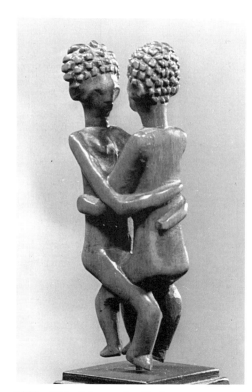

1069 Mahafaly couple, Madagascar
Wood. Height: 8 cm. Private collection; formerly P. Guillaume, Stéphen Chauvet collections

595

Glossary

Terms used in captions to the illustrations

akissi ble an important ritual object depicting four persons of rank; it was seized in Kouadjo Bonikro in the Ivory Coast during the 1910 repression of the Baoule revolt.
Fig. 69

akwanshi sculpted monoliths from the Ikom (Cross River) region of Nigeria. The oldest of these roughly three hundred vertical stones may have been carved as early as the sixteenth century.
Figs. 535, 536

aloalo sculpted posts on tombs in Mahafaly, southwest Madagascar.
Figs. 826, 827, 828

angbai for Toma initiates, the great mask of the forest spirit. After having been symbolically devoured by *angbai*, neophytes are "reborn" and from then on are considered socially responsible adults. (West Africa)
Fig. 50

banda an anthropomorphic polychrome mask of the Nalu of Guinea. In earlier days, an emblem of the secret men's society of the Simo, more recently it is only involved in the funeral rites for dignitaries and in agrarian rituals.
Fig. 343

bansonyi the serpent, a water spirit of the Baga and Nalu (Guinea). The undulating pole that represents the serpent was carried during funeral ceremonies or in rituals to counteract sorcery.
Figs. 48, 49

bochio sculpted pole standing at the entrance of Fon and Anago family dwellings. Guardian of sacred places and homes, the *bochio* is one of the representations of the Legba *vodun*. (West Africa)
Figs. 415, 417, 419, 421, 898

boli sacrificial object of the initiation brotherhoods (the *komo*, *kono*, *nama*, and *nya*) of the west African Bamana peoples.
Fig. 841

byeri a term that refers both to the Fang ancestral cult in central Africa and to the shrines associated with it. The sculpted figure that extends out over the bark box containing skulls (called *nsekh o byeri*, "the belly") is known as *eyema o byeri*, "the head."
Fig. 975

cabaro in the Bissagos islands, a young man in the first stage of initiation, or *manrache*. (Guinea-Bissau)
Fig. 859

dagalo a three-legged, long-backed chair used by men among the Bwa, Nuna, and Lobi. (Burkina Faso, Mali)
Fig. 342

deble generic term for the wooden statues of the Senufo (Ivory Coast). The word is frequently used to refer to rhythm poles (*kpondosion*).
Figs. 34, 317

dege dal nda literally, "terrace sculptures." These statues are among the cult items affixed to the dwelling-sanctuary of the *hogon*, the spiritual leader of the Dogon. (Mali)
Fig. 277

dugn'be masks representing the "village ox," worn by members of a Bissagos (Guinea-Bissau) preinitiation group.
Fig. 862

ekwotame Idoma female sculptural image used during funeral rites, in which it incarnates the principle of the perpetuation of the lineage. (Nigeria)
Fig. 492

elek also known as *a-tshöl* by the Baga and as *ninte kamatshol* by the Nalu, this figure has human traits but features a long bird's beak and was meant to protect the lineage against the forces of evil. The oldest cult member was assigned to activate the *elek*'s power. (Guinea-Bissau)
Fig. 863

epa the *epa* ritual of the Yoruba of northeast Nigeria lasts for seven days, during which time strong men don heavy helmet-masks that sometimes feature a very complex, sculpted superstructure.
Fig. 439

fa a term referring to the geomantic cult of the Fon (*afa* for the Ewe; *ifa* for the Yoruba). Before manipulating the sixteen palmnuts, the diviner (*bokonon* or *babalawo*) calls forth the spirit of the divinity by means of a wooden or ivory hammer (*iroke* or *irofa*) struck against the rim of the tray (called *opon ifa* by the Yoruba). (West Africa)
Fig. 909

fon the sovereign of the Bamileke kingdoms of the Cameroon Grassland.
Figs. 960, 965

gelede the *gelede* cult among the Yoruba of eastern Benin and western Nigeria, with its numerous polychrome masks—"head" and "belly" masks—aims to restore the social cohesion endangered by the pernicious actions of individuals or entities.
Figs. 78, 441–44

goli among the four types of *goli* dance masks borrowed by the Baoule of the Ivory Coast from the Wan in the early 1900s is the helmet-mask *goli glin*. This mask evokes a mythic animal that hunters might confront.
Fig. 388

gomintogo a Dogon mask representing one of a tribe of deer with webbed antlers; involved at the end of the funeral cycle. (Mali)
Fig. 285

gon central to the *beete* initiation society of the Bakwele, with its political and judicial function, the *gon* mask, a stylized gorilla skull, was used until the 1920s. (Gabon)
Fig. 976

ibeji through the intermediary of the *ibeji* statuettes, Yoruba mothers of deceased twins maintain bonds with their children. (Nigeria)
Figs. 430–35

ikenga common to the Igbo, Urhobo, Igala, Bini, and Ijo of Nigeria, the shrines consecrated to the *ikenga* spirit, through offerings and sacrifices, are intended to ensure success in all "manual" enterprises, particularly those in which the right hand is used.
Figs. 116, 487, 490, 930

iran a Bissagos spirit or spirits and their symbolic representations. (Guinea-Bissau)
Fig. 860

kafigeledio a statuette with jointed arms, dressed in cotton fabric, often stained with sacrificial blood, to which the Senufo (Ivory Coast) assign magic properties—among others, the power to reveal perjuries and unmask sorcerers.
Fig. 855

karanga a mask of the Mossi of the Yatenga in Burkina Faso, it is topped by a high, perforated blade. The *karanga* resembles the Dogon *sirige*. Like the latter, it is involved in funerary rites.
Fig. 848

karan wemba Mossi mask surmounted by a female figure. The *karan wemba* is related to the Dogon *satimbe*. (Burkina Faso)
Figs. 306, 307

katsoh a Bamileke mask too large to be used in dances. In ceremonies, it is carried on the shoulders of one of its priests. (Northern Cameroon)
Fig. 961

kibe-kibe ritualized competition between members of Kuyu villages. Dancers dance according to precise patterns, holding up dummies with heads of polychrome wood. (Congo Republic)
Fig. 998

kifwebe a Songhay association whose emblem is the striated *kifwebe* mask; due to its political and social powers, the society is particularly feared. (Zaire)
Figs. 5, 205, 206, 1021

kiwoyo this mask, belonging to the Pende of the Katundu region of Zaire, is called the mask of the victorious hunter and is characterized by a decorated attachment extending from the base of the chin.
Fig. 1044

kono this Bamana initiation society trains its neophytes to grasp the relationship between body and spirit. Its masks are perhaps involved in sacrificial practices. (Mali)
Figs. 297, 841

kpelie generic Senufo term for masks used for funerals and initiation to the *poro* society. (Ivory Coast)
Fig. 321

kple-kple also known as *kouassi gbe* or *togbo*, this flat, circular mask belongs to the Baoule *goli* dance. (Ivory Coast)
Fig. 392

kponyugo anthropomorphic helmet-mask used in funeral rites or in the *poro* initiation of the Senufo of West Africa.
Fig. 853

kuduo ritual Asante vase meant to hold either gold dust and beads or offerings to the ancestors presented during purification ceremonies. (Ghana)
Fig. 897

kwonbele the wearers of the helmet-masks that are emblems of the *kwonro*, one of the initiation stages of the Senufo *poro* society. (West Africa)
Fig. 852

lefem Fontem Basin commemorative statues of Bangwa sovereigns. (Cameroon)
Fig. 548

legba one of the major *vodun* of the Fon pantheon, referring also to its various representations. (Benin)
Fig. 418

lilwa in this secret Mbole society with its judicial powers, masks refer to "executioners" and tall statues to the "hanged" condemned to death by this tribunal. (Central Zaire)
Fig. 1005

mboom or bwoom a Kuba mask included in a royal triad also comprising the *mosh'ambooy* and the *ngady a mwaash*, the *mboom* represents the first inhabitants of the earth, the *Cwa*. (Zaire)
Fig. 745

mbuto helmet-mask of the Kota of the Makoku region of Gabon. The *mbuto mwa mpoli*—the face of *mpoli*—was involved in rituals undertaken to counteract sorcery.
Fig. 156

mma terra-cotta funerary head or bust of the Anyi peoples of Sanwi, Moronu, or Brafe. Modeled by an accomplished female potter capable of representing the features of a deceased notable, the *mma* would be placed in a clearing near the village. (Ivory Coast)
Figs. 397, 399

molo anthropomorphic Bobo mask used for funerals of members of the blacksmith clan. (Burkina Faso, Mali)
Fig. 308

mu po Bamileke figurines of wood or ivory. The *mu po* would be presented by a member of the secret society *ku n'gan* to sterile women, women who had miscarried, or women who just delivered a stillborn child. (Cameroon)
Fig. 968

mukuya an ancestor spirit and its sculpted representation among the Bembe of the Congo.
Figs. 618, 621

muziri reliquary mannequin of the Bembe, the *muziri* contained bones from the grave of men known for wisdom or a sense of justice.
Fig. 626

naba the sovereign of a Mossi state. (Burkina Faso)
Fig. 849

nganga term in a number of Bantu languages referring to a diviner, a healer, or a hunter of sorcerers.
Fig. 633

ngil Fang ritual depicting the struggle against sorcery, in which long white masks (*ngel*) were used. By 1920, it had fallen into disuse.
Fig. 157

nimba voluminous shoulder masks or simple statuettes used by the Baga, the *nimba*—or better, the *de'mba*—incarnated femininity and its generative power. (Guinea-Bissau)
Figs. 46, 47, 866, 867

nomoli figures excavated by Mende or Bullom farmers in Sierra Leone. The oldest ones, products of the Sapi culture, probably predate the sixteenth century.
Figs. 43, 871, 872

nwantantay Bwa mask of Gurunsi origin. For the Bwa of Boni and Dossi, Burkina Faso, the *nwantantay* represented a water insect conjoining the spirits of water and air.
Figs. 845, 846

oba sovereign by divine right who reigned over the kingdom of Benin.
Figs. 916, 917

ogboni the Yoruba *ogboni* society plays a political and judiciary role. The symbols of its power, the *edan*, are male and female brass figures connected by a small chain. (Nigeria, Benin)
Figs. 436, 437

okum ngbe a double-faced helmet-mask used by the Anyang of Nigeria's Cross River region in their leopard (*ngbe*) society.
Fig. 541

okuyi a mask of the Punu and Lumbo of Ngunié, the *okuyi* is worn during funeral ceremonies. (Gabon)
Fig. 162

oni the king by divine right of Ife, in present-day Nigeria.
Figs. 87–88, 92, 95, 96

pwo the mask of the Chokwe female ancestor. *Pwo*, the ideal of beauty, also bestows fertility on women who admire her face, costume, and gestures. (Angola, Congo, Zambia)
Figs. 782, 783

sanza a musical instrument with small, flexible wooden tongues that are plucked, usually with the thumbs. The *sanza* is played in numerous regions of central and east Africa.
Fig. 168

setyen standing bird with spread wings. Specifically, it is the hornbill (*gahariga*); to the initiates of the Senufo *poro* society in West Africa, it is known as the *porpianong*, "child of the *poro*."
Fig. 330

sirige this tall, narrow Dogon mask represents the descent of the ark of creation to earth and the succession of the generations. (Mali)
Fig. 286

tu ngunga helmet-masks of the Bamum of the Cameroon Grassland. The *tu ngunga* masks are used during the *nsoro* ritual dances.
Fig. 542

tyi wara the teachings of the *tyi wara* initiation society of the Bamana stress agrarian techniques and the mystical and cultural values connected with the earth's fertility. Its emblem, in the shape of an antelope or combining the antelope's features with those of the aardvark or anteater, is worn in pairs during the *tyi wara* rites. (Mali)
Figs. 300–03, 840

ubanga nyama representation of the founding ancestor of the Lengola, in Suway, Zaire. This statue is placed in the center of the village at the death of a chief.
Fig. 660

vodun the numerous divinities of the Fon pantheon and their various symbolic representations. (Benin)
Figs. 76, 77, 407–12, 416

zaouli the mask used in the *djela* dance of the Guro to celebrate joy and beauty. Today it has a secular function. (Ivory Coast)
Fig. 376

Adams, Monni. *Design for Living: Symbolic Communication in African Art.* Cambridge: Harvard University Press, 1982.

African Art in the Cycle of Life. Exhibition catalogue. Washington, D.C.: National Museum of African Art, 1987.

African Artistry: Techniques and Aesthetics in Yoruba Sculpture. Exhibition catalogue. Atlanta: High Museum of Art, 1980.

Agulhon, Maurice. *Marianne au Combat. L'Imagerie et la Symbolique Républicaine de 1789 à 1880.* Paris: Flammarion, 1979.

Alard, M. "Coupes Gravées chez les Bashilele du Kasai Occidental." In *Arts d'Afrique Noire,* no. 51, 1984.

Alexandre, P., and J. Binet. *Le Groupe Dit Pahouin.* Paris: Presses Universitaires de France, 1958.

Allison, P. *African Stone Sculpture.* London: Percy Lund, Humphries & Co., 1968.

Arnheim, Rudolf. *Visual Thinking.* Berkeley: University of California Press, 1980.

Art from Zaire. Exhibition catalogue. New York: The African-American Institute, 1975.

Art of Sub-Saharan Africa. Atlanta: The Fred and Rita Richman Collection, High Museum of Art, 1986.

Arts Premiers d'Afrique Noire. Exhibition catalogue. Crédit Communal de Belgique, 1977.

Aubert, Marcel. *La Cathédrale Notre-Dame de Paris: Notice Historique et Archéologique.* Paris: Firmin-Didot, 1945.

Azaïs, François, and Roger Chambard. *Cinq Années de Recherches Archéologiques en Ethiopie.* Paris: P. Guenthner, 1931.

Bachelard, Gaston. *La Formation de l'Esprit Scientifique.* Paris: Vrin, 1947.

Balandier, Georges. "Afrique Noire et Madagascar." In *Histoire de l'Art,* vol. 1, *Le Monde Non-Chrétien.* Paris: Gallimard (Bibilothèque de la Pléiade), 1961.

Balandier, Georges, and J. Maquet. *Dictionnaire des Civilisations Africaines.* Paris: Hazan, 1968.

Bamer, A., and Jean Laude. *Africana.* Paris: Herscher, 1980.

Barral y Altet, Xavier, ed. "Commanditaires, Mosaïstes, et Exécution Spécialisée de la Mosaique de Pavement au Moyen Age." In *Artistes, Artisans et Production Artistique au Moyen Age,* vol. 1, *Les Hommes.* Paris: Picard, 1986.

Bascom, William Russell. *African Art in Cultural Perspective.* New York: Norton & Co. Inc., 1973.

————. *Ifa Divination: Communication Between Gods and Men in West Africa.* Bloomington: Indiana University Press, 1969.

————. *The Yoruba of Southwestern Nigeria.* London: Holt, Rinehart & Winston, 1969.

Bastin, Marie-Louise. *Art Décoratif Tshokwe.* Lisbon: 1961.

————. "L'Art d'un Peuple d'Angola: IV. Mbundu." In *African Arts,* II, 4 (1969(a)).

————. "Introduction aux Arts de l'Afrique Noire." Arnouville (France): *Arts d'Afrique Noire,* 1984.

————. "Masques et Sculptures Ngangela." *Baessler-Archiv,* Neue Folge, XVII (1969(b)).

————. *La Sculpture Tshokwe.* Meudon (France): 1982.

————. "Statuettes Tshokwe du Héros Civilisateur Tshibinda Ilunga." Arnouville (France): *Arts d'Afrique Noire,* 1978.

Baxandall, Michael. *Painting and Experience in Fifteenth-century Italy.* Oxford: Oxford University Press, 1985.

Bay, Edna G. "Cyprian Togudagba of Abomey." In *African Arts,* VIII, 4, 1975.

Bazin, Jean. "Retour aux Choses-Dieux." In *Le Temps de la Réflexion.* (Annual review.) Paris: Gallimard, 1986.

Bedaux, R. M. A. *Tellem.* Berg-en-Dal (Netherlands): Afrika Museum, 1977.

Beier, Ulli. *Art in Nigeria 1960.* London: Cambridge University Press, 1960.

Ben-Amos, Dan. "Animals in Edo Visual and Verbal Arts." *World and Image,* vol. 3, no. 3 (July-September 1987).

Ben-Amos, Paula. *The Art of Benin.* London: Thames & Hudson, 1980.

————. "Who is the Man in the Bowler Hat? Emblems of Identity in Benin Royal Art." *Baessler-Archiv,* Neue Folge, XXXI (1983).

Bergson, Henri. *Oeuvres.* Edition du Centenaire. Paris: Presses Universitaires de France, 1959.

Bernatzik, Hugo A. *Im Reich der Bidyogo.* Innsbruck: 1944.

Beth, N., and A. Schwartz. *Mambilla: Art and Material Culture.* Milwaukee Public Museum Publications in Primitive Art, no. 4, 1972.

Biebuyck, Daniel. *The Arts of Zaïre,* vol. 1, *Southwestern Zaïre.* Berkeley: University of California Press, 1985.

————. "Bemba Art." In *African Arts,* V, 3, 1972.

————. *Lega Culture.* Los Angeles: University of California Press, 1973.

————. "On the Concept of Tribe." *Civilisations,* XVI, no. 4 (1966).

————. "Sculpture from the Eastern Zaire Forest Regions: Mbole, Yela, and Pere." In *African Arts,* IX, 2, 1975, and X, 1, 1976.

————. *Statuary from the Pre-Bembe Hunters.* Tervuren (Belgium): The Museum, 1982.

————. "Textual and Contextual Analysis in African Art Studies." In *African Arts,* VIII, 3, 1975.

————. *Tradition and Creativity in Tribal Art.* Los Angeles: University of California Press, 1973.

Bleakley, Robert. *African Masks.* New York: St. Martins Press, 1978.

Blier, S. Preston. Book review. In *African Arts,* XV, 4, 1982.

Bochet, Gilbert. "Les Masques Sénoufo." *Bulletin de l'Institut Fondamental d'Afrique Noire,* nos. 3-4 (1965).

Bohannan, Paul. "Artist and Critic in an African Society." In Charlotte M. Otten, ed., *Anthropology and Art: Readings in Cross-Cultural Aesthetics.* Austin: University of Texas Press, 1976.

Bonne, Jean-Claude. *L'Art Roman de Face et de Profil: Le Tympan de Conques.* Paris: Editions du Sycomore, S.F.I.E.D., 1984.

Boston, John. *Ikenga Figures Among the Northwest Igbo and Igala.* Lagos (Nigeria): Federal Department of Antiquities, 1977.

Boudon, Philippe. *Sur l'Espace Architectural: Essai d'Epistémologie de l'Architecture.* Paris: Dunod, 1971.

Bourdieu, Pierre. *Choses Dites.* Paris: Editions de Minuit, 1987.

Bourgeois, Arthur P. *Art of the Yaka and Suku.* Meudon (France): Chaffin, 1984.

Boyer, A. M. "Miroirs de l'Invisible: La Statuaire Baoulé." In *Arts d'Afrique Noire,* nos. 44 and 45, 1982-83.

Braque, Georges. *Le Jour et la Nuit. Cahiers de Georges Braque (1917-52).* Paris: Gallimard, 1952.

Brassaï. *Conversations avec Picasso.* Paris: Gallimard, 1964. (Published in English as *Picasso and Company.* Garden City, N.Y.: Doubleday, 1966.)

Bravmann, René A. *Islam and Tribal Art in West Africa.* London: Cambridge University Press, 1974.

————. *Open Frontiers: The Mobility of Art in Black Africa.* Exhibition catalogue. Henry Art Gallery, Seattle: University of Washington Press, 1973.

————. *West African Sculpture.* Henry Art Gallery, Seattle: University of Washington Press, 1970.

Brett-Smith, Sarah. "The Poisonous Child." In *R.E.S.,* no. 6, 1983.

Brink, James T. In Susan Mullin Vogel, ed., *For Spirits and Kings: African Art from the Tishman Collection.* New York: The Metropolitan Museum of Art and Harry N. Abrams, Inc., 1981.

Brown, J. L. "Miji Kenda Grave and Memorial Sculptures." In *African Arts,* XIII, 4, 1980.

————. *Mortuary Posts of the Giryama.* Exhibition catalogue. Washington, D.C.: National Museum of African Art, 1979.

Brown, Peter. *The Cult of the Saints: Its Rise and Function in Latin Christianity.* Chicago: University of Chicago Press, 1982.

————. *Society and the Holy in Late Antiquity.* Berkeley: University of California Press, 1982.

Bruneau, Philippe. "Le Portrait." In *Ramage?,* 1980.

Cabrol, C. *La Civilisation des Peuples Batéké.* Multipress Gabon and P. Bory, S. A.

Caillois, Roger. *La Dissymétrie.* Paris: Gallimard, 1973.

Calame-Griaule, Geneviève. *Words and the Dogon World.* La Pin, Deirdre, tr. from French. Philadelphia: Institute for the Study of Human Issues, 1986.

Capron, J. "Quelques Notes sur la Société du Do chez les Populations Bwa du Cercle de San." In *Journal de la Société des Africanistes,* vol. 27, no. 1, 1957.

————. "Univers Religieux et Cohésion Interne dans les Communautés Villageoises Bwa Traditionnelles." In *Africa,* vol. 32, no. 2, 1962.

Carpenter, Rhys. *The Architects of the Parthenon.* Harmondsworth: Penguin Books, 1970.

Carroll, Kevin. *Yoruba Religious Carvings.* New York: Praeger, 1967.

Celenko, Theodore. *A Treasury of African Art.*

Harrison Eiteljorg Collection, Bloomington: Indiana University Press, 1983.

Chaffin, A. *L'Art Kota*. Paris: Chaffin, 1980.

———. *Chefs-d'Oeuvre de l'Art Africain*. Exhibition catalogue. Musée des Beaux-Arts de Grenoble, 1982.

———. *Chefs-d'Oeuvre du Musée de l'Homme*. Exhibition catalogue. Paris, 1965.

———. *Chefs-d'Oeuvre Inédits de l'Afrique Noire*. Paris: Bodas et Art 135, 1987.

———. *Chronique de la Renaissance*. Paris: Editions Vilo, 1983. (Published in English as *A Chronicle of Italian Renaissance Painting*. Ithaca: Cornell University Press, 1984.)

Chastel, André. *Marcile Ficin et l'Art*. Geneva: Droz et Lille, Girard, 1954.

Clastres, Pierre. *Studies Against the State: Essays in Political Anthropology*. Hurley, Robert, and Abe Stein, tr. from French. New York: Zone Books, 1987.

Cole, Herbert M. *Mbari: Art and Life Among the Owerri Igbo*. Bloomington: Indiana University Press, 1982.

———. "Art Studies in Ghana." In *African Arts*, XIII, 1, 1979.

Cole, Herbert M., and Chike C. Aniakor. *Igbo Arts: Community and Cosmos*. Los Angeles: Museum of Cultural History, University of California, 1984.

Cole, Herbert M., and Doran H. Ross. *The Arts of Ghana*. Exhibition catalogue. Los Angeles: Museum of Cultural History, University of California, 1977.

Collingwood, R. G. *The Principles of Art*. Oxford: Clarendon Press, 1960 (1st ed., 1938).

Colloque sur l'Art Nègre. Paris: Présence Africaine, 1967.

Cordwell, Justine M., ed. *The Visual Arts, Plastic and Graphic*. Paris, New York: 1977.

Cornet, Joseph. "African Art and Authenticity." In *African Arts*, IX, 1, 1975.

———. "A Propos des Statues Ndengese." In *Arts d'Afrique Noire*, no. 17, 1976.

———. *L'Art de l'Afrique Noire au Pays du Fleuve Zaire*. Brussels: Editions Arcade, 1972.

———. *Art Royal Kuba*. Milan: Sipiel, 1982.

———. "Pictographies Woyo." Milan: *Quaderni Poro*, 2, 1980.

———. *A Survey of Zairian Art — The Bronson Collection*. Exhibition catalogue. Raleigh: North Carolina Museum of Art, 1978.

Crowley, D. J. "An African Aesthetic." In Carol F. Jopling, ed., *Art and Aesthetics in Primitive Societies*. New York: Dutton & Co., 1971.

———. "Stylistic Analysis of African Art: A Reassessment of Olbrecht's 'Belgian Method.'" In *African Arts*, IX, 2, 1976.

Dapper, Olfert. *Description de l'Afrique*. Amsterdam: 1686.

Dark, Philip J. C. *Benin Art*. London: Paul Hamlyn, 1969.

———. *An Introduction to Benin Art and Technology*. Oxford: Clarendon Press, 1973.

D'Azevedo, Warren L., ed. *The Traditional Artist in African Societies*. Bloomington: Indiana University Press, 1973.

Delacroix, Eugène. *The Journal of Eugène Delacroix*. Ithaca: Cornell University Press, 1980.

Delange, Jacqueline. *Arts et Peuples d'Afrique Noire: Introduction à une Analyse des Créations Plastiques*. Paris: Gallimard, 1967.

Denis, Jacques. *Les Yaka du Kwango*. Tervuren (Belgium): Annales du Musée Royal de l'Afrique Centrale, no. 53, 1964.

Deonna, Waldemar. "L'Esprit Grec et l'Esprit Primitif en Art." *Revue Philosophique* (November-December 1936).

De Rouville, C. *Organisation Sociale des Lobi*. Paris: L'Harmattan, 1987.

Descartes, René. "Règles pour la Direction de l'Esprit." In *Oeuvres et Lettres*. Paris: Gallimard, Bibliothèque de la Pléiade, 1958.

Dieterlen, Germaine. *Essai sur la Religion Bambara*. Paris: Presses Universitaires de France, 1951.

Douglas, Mary. *Purity and Danger: An Analysis of the Concepts of Pollution and Taboo*. London: Routledge & Kegan, 1984.

Dozon, J. P. *La Société Bété*. Paris: Office de la Recherche Scientifique et Technique Outre Mer (ORSTOM), 1985.

Drewal, Henry John. *African Artistry*. Exhibition catalogue. The Arnett Collection, High Museum of Art. Atlanta: 1980.

———. "Art and the Perception of Women in Yoruba Culture." *Cahiers d'Etudes Africaines*, vol. 17, no. 4, 1977.

———. "Gelede Masquerade: Imagery and Motif." In *African Arts*, VII, 4, 1974.

Drewal, Henry John, and Margaret Thompson Drewal. *Gelede: Art and Female Power Among the Yoruba*. Bloomington: Indiana University Press, 1983.

Drewal, Margaret Thompson, and Henry John Drewal. "Composing Time and Space in Yoruba Art." *Word and Image*, vol. 3, no. 3 (1987).

Dupré, Georges. *Les Naissances d'une Société: Espace et Historicité chez les Beembé du Congo*. Paris: ORSTOM, 1985.

Dupré, Marie-Claude. "A Propos d'un Masque des Téké de l'Ouest (Congo-Brazzaville)." *Objets et Mondes*, vol. VIII, no. 4 (Winter 1968).

Einstein, Carl. *Negerplastik*. Munich: K. Wolff, 1920.

Elisofon, Eliot, and William Fagg. *The Sculpture of Africa*. New York: Hacker, 1978.

Ellul, Jacques. *La Technique ou l'Enjeu du Siècle*. Paris: Armand Colin, 1954.

Etienne, Pierre. "Les Baoulé et le Temps." *Cahiers ORSTOM*, Series Sciences Humaines, 5, 1968.

Evans-Pritchard, Edward E. *Les Anthropologues face à l'Histoire et à la Religion*. Paris: Presses Universitaires Françaises, 1974.

———. *A History of Anthropological Thought*. New York: Basic Books, 1981.

———. *Social Anthropology*. Westport, Connecticut: Greenwood Press, 1987.

———. *Theories of Primitive Religion*. New York: Oxford University Press, 1965.

———. *Witchcraft, Oracles, and Magic Among the Azande*. Oxford: Clarendon Press, 1976.

Eyo, Ekpo, and Frank Willett. *Treasures of Ancient Nigeria*. Exhibition catalogue. New York: Alfred Knopf, 1980.

Ezra, Kate. *A Human Ideal in African Art: Bamana Figurative Sculpture*. Washington, D.C.: National Museum of African Art, 1986.

Fagg, Bernard. *Nok Terra-cottas* Lagos (Nigeria): 1977.

Fagg, William. *African Majesty from Grassland and Forest: The Barbara and Murray Frum Collection*. Ontario: Art Gallery, 1981.

———. *African Sculpture*. Exhibition catalogue. Washington, D.C.: National Gallery of Art, 1970.

———. *African Sculpture from the Tara Collection*. Notre Dame, Ind.: University of Notre Dame Art Gallery, 1971.

———. *African Tribal Images*. Cleveland: Cleveland Museum of Art, 1968.

———. *Afrique: Cent Tribus, Cent Chefs-d'Oeuvre*. Paris: Musée des Arts Décoratifs, 1964.

———. *Divine Kingship in Africa*. London: British Museum, 1970.

———. *Masques d'Afrique*. Exhibition catalogue. Barbier-Müller Museum Collection, Geneva: Nathan/L.E.P., 1980.

———. *Nigerian Images*. London: Lund Humphries, 1963.

———. *Nok Terra-cottas*. Lagos (Nigeria): 1977.

———. In Susan Mullin Vogel, ed., *For Spirits and Kings: African Art from the Tishman Collection*. New York: The Metropolitan Museum of Art and Harry N. Abrams, Inc., 1981.

Fagg, Bernard. *Nok Terra-cottas*. Lagos (Nigeria): 1977.

Fagg, William, and Eliot Elisofon. *The Sculpture of Africa*. New York: Hacker, 1978.

Fagg, William, and John Pemberton. *Yoruba Sculpture of West Africa*. New York: Alfred Knopf, 1982.

Fagg, William, and Margaret Plass. *African Sculpture: An Anthology*. London: Studio Vista, 1964.

Febvre, Lucien. *Pour une Histoire à Part Entière*. Paris: S.E.V.-P.E.N., 1962.

Felix, M. *Art from Zaire*. Exhibition catalogue. New York: The African-American Institute, 1975).

———. *100 Peoples of Zaire and Their Sculpture*. Brussels: Tribal Arts Press, 1987.

Fernandez, James W. *Bwiti: An Ethnography of the Religious Imagination in Africa*. Princeton: Princeton University Press, 1982.

———. "Imposition of Order: Artistic Expression in Fang Culture." In Warren L. D'Azevedo, ed., *The Traditional Artist in African Societies*. Bloomington: Indiana University Press, 1973.

———. "Principles of Opposition and Vitality in Fang Aesthetics." In Carol F. Jopling, ed., *Art and Aesthetics in Primitive Societies*. New York: Dutton & Co., 1971.

Fernandez, R. and James W. Fernandez "Fang Reliquary Art: Its Quantities and Qualities." In *Cahier d'Etudes Africaines*, 60, XV, 4.

Firman, W., and F. Dark. *Benin Art*. London: Paul Hamlyn, 1960.

Fischer, Eberhard. "Dan Forest Spirits: Masks in Dan Villages." In *African Arts*, XI, 2, 1978.

Fischer, Eberhard, and Hans Himmelheber. *The Arts of the Dan in West Africa*. Zürich: Museum Rietberg, 1984.

———. *Masks in Guro Cult, Ivory Coast*. Lauf, Cornelia, and Andrea Isler, tr. from German. New York: Center for African Art, 1986.

Fisher, Angela. *Africa Adorned*. New York: Harry N. Abrams, Inc., 1984.

Flam, J. D. "The Symbolic Structure of the Luba Caryatid Stools." In *African Arts*, IV, 2, 1972.

Focillon, Henri. *Art d'Occident: Le Moyen Age Roman et Gothique*. Paris: Armand Colin, 1947.

———. *L'Art des Sculpteurs Romans*. Paris: Presses Universitaires de France, 1964 (1st ed., 1931).

Forge, Anthony, ed. *Primitive Art and Society*. London: Oxford University Press, 1973.

Fortes, Meyer, and Germaine Dieterlen. *African Systems of Thought*. New York: Oxford University Press, 1966.

Foss, Perkins. "Urhobo Statuary for Spirits and Ancestors." In *African Arts*, IX, 4, 1976.

Fournet, Claude. *Arts Bakongo et Batéké*. Exhibition catalogue. Les Sables-d'Olonne (France): Musée de l'Abbaye Sainte-Croix, 1972.

Fourquet, A. "Chefs-d'Oeuvre de l'Afrique: Les Masques Punu." In *l'Oeil*, no. 321, April 1982.

Francastel, Pierre. *Peinture et Société*. Lyon: Audin, 1951.

———. *La Réalité Figurative*. Paris: Editions Gonthier, 1965.

Fraser, Douglas. "The Fish-legged Figure in Benin and Yoruba Art." In Douglas Fraser and Herbert M. Cole, eds., *African Art and Leadership*. Madison, Wis.: Books on Demand, 1972.

Fraser, Douglas, and Herbert M. Cole. *African Art and Leadership*. Madison, Wis.: Books on Demand, 1972.

Friedländer, Max J. *On Art and Connoisseurship*. London: Bruno Cassirer, 1942.

Fry, Jacqueline. "D'Impossibles Généralisations sur les Arts Traditionnels en Afrique Sub-Saharienne." *L'Ecrit Voir*, no. 6, Publications de la Sorbonne, 1985.

————. *Vingt-cinq Sculptures Africaines—Twenty-five African Sculptures*. Exhibition catalogue. Ottawa: National Gallery of Canada, 1978.

Fry, P. "Essai sur la Statuaire Mumuye." In *Objets et Mondes*, vol. X, no. 1, 1970.

Gallois Duquette, D. "1953: Une Date dans l'Histoire de l'Art Noir?" In *Antologia di Belle Arti*. Milan: Electra, 1981.

————. *Dynamique de l'Art Bidjogo*. Lisbon: IICT, 1983.

Garrard, Timothy F. "Akan Metal Arts." In *African Arts*, XIII, 1, 1979.

Geary, Christaud. "Bamum Thrones and Stools." In *African Arts*, XIV, 4, 1981.

Gebauer, Paul. *Art of Cameroon*. Portland, Ore.: Portland Art Association, 1979.

Geertz, Clifford. "La Religion comme Système Culturel." In *Essais d'Anthropologie Religieuse*. French tr. Cécile De Rouville. Paris: Gallimard, 1972.

Gerbrands, Adrian A. "Art as an Element of Culture, Especially in Negro Africa." In Charlotte M. Otten, ed., *Anthropology and Art: Readings in Cross-Cultural Aesthetics*. Austin: University of Texas Press, 1976.

Gillon, Werner. *Collecting African Art*. London: Studio Vista Limited, 1979.

Gilson, Etienne. *Introduction aux Arts du Beau*. Paris: Vrin, 1963.

————. *Matières et Formes*. Paris: Vrin, 1964. (Published in English as *Forms and Substances in the Arts*. New York: Scribners, 1966.)

Glaze, Anita J. *Art and Death in a Senufo Village*. Bloomington: Indiana University Press, 1981.

————. "Woman Power and Art in a Senufo Village." In *African Arts*, VIII, 3, 1975.

Godelier, Maurice. "Tribu." *Encyclopaedia Universalis*, vol. XIV.

Goldschmidt, Victor. *Les Dialogues de Platon*. Paris: Presses Universitaires de France, 1947 (reprinted 1971).

————. *Le Système Stoicien et l'Idée de Temps*. Paris: Vrin, 1953.

Goldwater, Robert. *Bambara Sculpture from the Western Sudan*. Exhibition catalogue. New York: Museum of Primitive Art, 1960.

————. *Senufo Sculpture from West Africa*. Exhibition catalogue. New York: Museum of Primitive Art, 1964.

Gollnhoffer, O., P. Sallée, and R. Sillans. *Art et Artisanat Tsogho*. Paris: ORSTOM, 1975.

Gollnhoffer, O., and R. Sillans. "Le Symbolisme chez les Mitsogho." In *Systèmes de Signes*. Paris: Hermann, 1978.

Gombrich, Ernst. *Art and Illusion: A Study in the Psychology of Pictorial Presentation*. Princeton: Princeton University Press, 1961.

————. *The Story of Art*. New York: Prentice-Hall, 1985.

Goodman, Nelson. *Languages of Art: An Approach to a Theory of Symbols*. London: Oxford University Press, 1969.

————. *Ways of Worldmaking*. Indianapolis and Cambridge, Mass.: Hackett Publishing Co., 1978.

Goody, Jack. *The Logic of Writing and the Organization of Society*. New York: Cambridge University Press, 1986.

Grabar, André. "Plotin et les Origines de l'Esthétique Médiévale." In *Cahiers Archéologiques*, vol. 1, *Fin de l'Antiquité et Moyen Age*. Paris: 1945.

Green, K. L. "Shared Masking Traditions in Northwestern Ivory Coast." In *African Arts*, XX, 4, 1987.

Greenhalgh, Michael, and Vincent Megaw, eds. *Art in Societies: Studies in Style, Culture, and Aesthetics*. London: Gerald Duckworth, 1978.

Griaule, Marcel. *Arts de l'Afrique Noire*. Paris: Chêne, 1947.

————. *Conversations with Ogotemmêli: An Introduction to Dogon Religious Ideas*. London: Oxford University Press, 1965.

————. *Masques Dogons*. Paris: Musée de l'Homme, 1938 (reprinted 1963).

————. "Les Symboles des Arts Africains." *L'Art Nègre: Présence Africaine*, no. 10-11. Paris: Editions du Seuil, 1951.

Griaule, Marcel, and Germaine Dieterlen. *Le Renard Pâle*, vol. I. Paris: Université de Paris, Travaux et Mémoires de l'Institut d'Ethnologie, 72 (1965).

Grunne, Bernard de. "A Note on 'Prime Objects' and Variation in Tabwa Figural Sculpture." In *Tabwa: The Rising of a New Moon—A Century of Tabwa Art*. Exhibition catalogue. Ann Arbor: University of Michigan Museum of Art, 1985.

————. *Terres Cuites Anciennes de l'Ouest Africain*. Leuven (Belgium): Institut Supérieur d'Archéologie et d'Histoire de l'Art, 1980.

Guerry, Vincent. Speech reprinted in *Les Religions Africaines Traditionnelles: Rencontres Internationales de Bouaké*. Paris: Seuil, 1965.

————. *La Vie Quotidienne dans un Village Baoulé*. Abidjan (Ivory Coast): INADES, 1970.

Hallen, B. "The Art Historian as Conceptual Analyst." *Journal of Aesthetics and Art Criticism*, vol. 37, no. 3, 1979.

Hampate Ba, Amadou. "La Parole, Mémoire Vivante de l'Afrique." In *Courrier de l'Unesco*. Paris: 1979.

Harris, R. "Mbembe Men's Association." In *African Arts*, XVIII, 1, 1984.

Harter, Pierre. "Arts Anciens du Cameroun." Arnouville (France): *Arts d'Afrique Noire*, 1986.

————. "Four Bamileke Masks: An Attempt to Identify the Style of Individual Carvers or Their Workshops." *Man*, vol. 4, no. 3, 1969.

————. "Les Masques Dit *Batcham*." In *Arts d'Afrique Noire*, no. 3, 1972.

Hartwig, Gerald. "Sculpture in East Africa." In *African Arts*, XI, 4, 1977.

Hegel, Georg W. Friedrich. *Aesthetics*. Knox, T. M., tr. from German. Oxford: Clarendon Press, 1975.

Hersak, D. *Songye: Masks and Figures Sculpture*. London: Ethnographica, 1985.

Heusch, Luc de. *Pourquoi l'Epouser? Et Autres Essais*. Paris: Gallimard, 1971. (Published in English as *Why Marry Her? Society and Symbolic Structures*. New York: Cambridge University Press, 1981.)

————. *Le Roi Ivre ou l'Origine de l'Etat*. Paris: Gallimard, 1972.

Hildebrand, Adolf von. *The Problem of Form in Painting and Sculpture*. Meyer, M., and R. M. Ogden, tr. from German. New York: Garland Pub., 1978 (1st German edition, 1873).

Himmelheber, Hans. *Les Masques Africains*. French translation Simone Vallon. Paris: Presses Universitaires de France, 1960(a).

————. *Negerkunst und Negerkünstler*. Braunschweig, Klinkhardt & Biermann, 1960(b).

Holas, Bohumil. *Arts Traditionnels d'Afrique*. Paris: Hatier, 1967.

————. *Civilisations et Arts de l'Ouest Africain*. Paris: Presses Universitaires de France, 1976.

————. *Images de la Mère dans l'Art Ivoirien*. Abidjan (Ivory Coast): Nouvelles Editions Africaines, 1975.

————. *Masques Ivoiriens*. Abidjan (Ivory Coast): CSH, 1969.

————. *Sculptures Ivoiriennes*. Abidjan (Ivory Coast): CSH, 1969.

Hottot, Robert. "Fétiches Téké." In *Arts d'Afrique Noire*, no. 1, 1971.

Huet, Michel. *The Dance, Art, and Ritual of Africa*. New York: Pantheon, 1978.

————. *I Am Not Myself: The Art of African Masquerade*. Herbert M. Cole, ed. Los Angeles: University of California Press, 1985.

Huffman, T. "The Soapstone Birds of Great Zimbabwe." In *African Arts*, XVIII, 3, 1985.

Imperato, Pascal James. *Buffoons, Queens, and Wooden Horsemen*. New York: Kilima House Publishers, 1983.

————. *Dogon Cliff Dwellers: The Art of Mali's Mountain People*. New York: L. Kahan Gallery, 1978.

————. "Door Locks of the Bamana of Mali." In *African Arts*, V, 3, 1972.

"Information sur les Arts Plastiques des Bidyogo." In *Arts d'Afrique Noire*, no. 18, 1976.

Johnson, Barbara C. *Four Dan Sculptors: Continuity and Change*. Chicago: University of Chicago Press, 1987.

Jopling, Carol F., ed. *Art and Aesthetics in Primitive Societies*. New York: Dutton & Co., 1971.

Kahnweiler, Daniel-Henry. *L'Art Nègre et le Cubisme*. Paris: Gallimard, 1963.

————. *Confessions Esthétiques*. Paris: Gallimard, 1963.

————. *L'Essence de la Sculpture*. Paris: Gallimard, 1963.

————. *Juan Gris. Sa Vie. Son Oeuvre. Ses Ecrits*. Paris: Gallimard, 1946.

Kamer, H. *Ancêtres M'bembé*. Paris: 1974.

Kasfir, S. "Patronage and Maconde Carvers." In *African Arts*, XIII, 3, 1979.

Kerchache, Jacques. "Les Arts Premiers de l'Est Nigérien." *Connaissance des Arts*, no. 285 (November 1975).

————. "D'Autres Choix Plastiques." Remarks selected by P. Kjelberg in *Connaissance des Arts*, no. 370 (December 1982).

————. *Masques Yoruba*. Exhibition catalogue, 1973.

————. "Le Musée de la Porte Dorée: un Nouveau Regard sur l'Art Africain." *L'Oeil*, no. 237 (April 1975).

————. "Vatican: la Naiveté des Missionnaires." *L'Oeil*, no. 240 (July 1975).

————. "Voir les Formes Premières." *Connaissance des Arts*, no. 359 (January 1982).

Klopper, S. "Speculations on Lega Figurines." In *African Arts*, XIX, 1, 1985.

Knops, P. *Les Anciens Sénoufo*. Berg-en-Dal (Netherlands): Afrika Museum, 1981.

Kubler, George. *The Shape of Time*. New Haven, Conn.: Yale University Press, 1962.

Labouret, Henri. *Les Tribus du Rameau Lobi*. Paris: Institut d'Ethnologie, 1931.

Ladd, John. *La Maternité dans les Arts Premiers*. Exhibition catalogue. Brussels: Société Générale de Banque, 1977.

Lallemand, S. "Le Symbolisme des Poupées Mossi." In *Objets et Mondes*. Paris: Musée de l'Homme, 1973.

Lamp, F. "The Art of the Baga: A Preliminary Inquiry." In *African Arts*, XIX, 2, 1986.

Laude, Jean. *African Art of the Dogon: The Myths*

of the Cliff Dwellers. Exhibition catalogue. Brooklyn Museum, New York: Viking Press, 1973.

————. "L'Art Nègre et les Arts de l'Afrique Noire." Critique, no. 215 (1965).

————. Les Arts de l'Afrique Noire. Paris: Le Livre de Poche, 1966. (Published in English as The Arts of Black Africa. Berkeley: University of California Press, 1971.)

————. "Esthétique et Système de Classification: La Statuaire Africaine." Sciences de l'Art, II (1964).

————. La Peinture Française (1905-1914) et l'Art Nègre. Paris: Klincksieck, 1968.

————. In Jacqueline Fry, ed., Vingt-cinq Sculptures Africaines—Twenty-five African Sculptures. Exhibition catalogue. Ottawa: National Gallery of Canada, 1978.

Lawal, Babatunde. "Some Aspects of Yoruba Aesthetics." The British Journal of Aesthetics, vol. 14, no. 3 (1974).

Leach, Edmund R. Rethinking Anthropology. London: Athlone Press, 1961.

Lebeuf, Jean-Paul, and Annie Lebeuf. Les Arts des Sao: Cameroun, Tchad, Nigeria. Paris: Chêne, 1977.

Lecoq, R. Les Bamilékés. Paris: Présence Africaine, 1953.

Le Hérissé, A. L'Ancien Royaume du Dahomey. Paris: 1911.

Lehuard, R. La Statuaire du Stanley Pool. Arnouville (France): Arts d'Afrique Noire, 1974.

Leiris, Michel. "Réflexions sur la Statuaire Religieuse de l'Afrique Noire." Rencontres Internationales de Bouaké, 1965.

Le M'Boueti des Mahongoue. Catalogue for exhibition by Jacques Kerchache. Text by Christopher D. Roy, 1967.

Le Moal, Guy. Les Bobo: Nature et Fonction des Masques. Paris: ORSTOM, 1980.

————. "Rites de Purification et d'Expiation." In Systèmes de Pensée en Afrique Noire. Paris: Hermann, 1975.

Leonardo da Vinci. The Notebooks of Leonardo da Vinci. New York: Dover, 1970.

Leroi-Gourhan, André. Le Geste et la Parole: la Mémoire et les Rythmes. Paris: Albin Michel, 1965.

Les Lobi. Catalogue for exhibition by Jacques Kerchache. Text by J. D. Rey, 1974.

Leuzinger, Elsy. Africa: The Art of the Negro Peoples. London: Methuen, 1960.

————. The Art of Black Africa. London: Studio Vista Publishers, 1972.

Levi-Strauss, Claude. Anthropologie Structurale II. Paris: Plon, 1973. (Published in English as Structural Anthropology, vol. II. Chicago: University of Chicago Press, 1976.)

————. La Pensée Sauvage. Paris: Plon, 1962. (Published in English as Savage Mind. Chicago: University of Chicago Press, 1968.)

————. La Voie des Masques. Geneva: Skira, 1975. (Published in English as The Way of Masks. Seattle: University of Washington Press, 1982.)

Loucou, J. N. Histoire de la Côte-d'Ivoire. Abidjan (Ivory Coast): CEDA, 1984.

MacCall, F., and Edna G. Bay, eds. African Images: Essays in African Iconology. London: Homes & Meier, 1975.

MacLeod, Malcolm D. "Asante Gold-Weights: Images and Words." Word and Image, vol. 3, no. 3 (June-September 1987).

MacLeod, Malcolm D., and John Mack. Ethnic Sculpture. Cambridge: Harvard University Press, 1985.

Mack, John, and Malcolm D. MacLeod. Ethnic Sculpture. Cambridge: Harvard University Press, 1985.

MacNaughton, Patrick. "African Borderland Sculpture." In African Arts, XX, 4, 1987.

————. Secret Sculptures of Komo: Art and Power in Bamana Initiation Associations. Philadelphia: Institute for the Study of Human Issues, Working Papers in the Traditional Arts, no. 4.

Maesen, Albert. "La Sculpture Traditionnelle au Zaire." Exhibition catalogue for Art de l'Afrique Centrale. Spa: 1972.

————. Umbangu: Art du Congo au Musée Royal du Congo Belge. Brussels: 1960.

Malinowski, Bronislaw. Scientific Theory of Culture. Chapel Hill: University of North Carolina Press, 1944.

Malraux, André. L'Intemporel. Paris: Gallimard, 1976.

————. Le Musée Imaginaire de la Sculpture Mondiale. Paris: Gallimard, 1952.

————. Preface. Chefs-d'Oeuvre de l'Art Primitif: Collection Nelson A. Rockefeller. Paris: Seuil, 1979.

Maret, P. de, Dery, N., and C. Murdoch. "The Luba Shankadi Style." In African Arts, VII, 1, 1973.

Masques et Sculptures d'Afrique et d'Océanie. Paris-Musées: Collection Girardin, 1986.

Matisse, Henri. Écrits et Propos sur l'Art. Paris: Editions Hermann, 1972.

Maupoil, B. La Géomancie à l'Ancienne Côte des Esclaves. Paris: Institut d'Ethnologie, 1943.

McIntosh, R. and S. "Terra-cotta Statuettes from Mali." In African Arts, XII, 2, 1979.

Meauze, P. Art Nègre. Paris: Hachette, 1967.

Meek, Charles K. Tribal Studies in Northern Nigeria. London: Kegan Paul, 1931.

Meillassoux, C. Anthropologie Economique des Gouro de Côte-d'Ivoire. Paris: Mouton, 1964.

Memel-Foté, Harris. "La Vision du Beau dans la Culture Négro-Africaine." In Colloque sur l'Art Nègre. Paris: Présence Africaine, 1967.

Meneghini, M. "The Grebo Mask." In African Arts, VIII, 1, 1974.

Merleau-Ponty, Maurice. Sens et Non-sens. Paris: Editions Nagel, 1948. (Published in English as Sense and Non-Sense. Evanston, Ill.: Northwestern University Press, 1964.)

Merlo, Christian. Un Chef-d'Oeuvre d'Art Nègre: Le Buste de la Prêtesse. Auvers-sur-Oise (France): Archée, 1966.

Merton, Robert K. Social Theory and Social Structure. New York: Free Press, 1968.

Mestach, J. W. Etudes Songye, Formes et Symbolique, Essai d'Analyse. Munich: Galerie Fred und Jens Jahn, 1985.

Meyer, P. Kunst und Religion der Lobi. Zürich: Museum Rietberg, 1981.

Mitry, Jean. Esthétique et Psychologie du Cinéma, vol. I. Paris: Editions Universitaires, 1963.

Moore, Henry. Interview. Art Press, no. 66 (January 1983).

Morier, Henri. Dictionnaire de Politique et de Rhétorique. Paris: Presses Universitaires de France, 1961.

Mortuary Posts of the Giryama. Exhibition catalogue. Washington, D.C.: National Museum of African Arts, 1979.

Muller, J. C. Le Roi Bouc Emissaire. Quebec: S. Fleury, 1980.

Nebout, A. "Notes sur le Baoulé." In A Travers le Monde, 1900, reprinted in Art d'Afrique Noire, no. 15, 1975.

Needham, Rodney, ed. Rethinking Kinship and Marriage. London: Tavistock, 1971.

Neyt, François. L'Art Holo du Haut Kwango. Munich: 1982.

————. L'Art Eket. Collection Azar, 1979.

————. Traditional Art and History of Zaire. Brussels: Société des Arts Primitifs, 1981.

Neyt, François, and A. Désirant. Les Arts de la

Bénué aux Racines des Traditions. Hawaiian Agronomics, 1985.

Neyt, François, and L. de Strycker. Approche des Arts Hemba. Villiers-le-Bel (France): Arts d'Afrique Noire, 1975.

————. La Grande Statuaire Hemba du Zaire. Leuven (Belgium): 1977.

Nicklin, K. "Kuyu Sculpture at the Powell-Cotton Museum." In African Arts, XVII, 1, 1983.

————. "Nigerian Skin-covered Masks." In African Arts, XII, 2, 1979.

Nicklin, K., and J. Salmons. "Cross River Art Styles." In African Arts, XVIII, 1, 1984.

Nooter, Polly. Sets, Series, Ensembles in African Art. Exhibition catalogue. Introduction by Susan Mullin Vogel. New York: The Center for African Art, Harry N. Abrams, Inc., 1985.

Northern, Tamara. The Art of Cameroon. Washington: S.I.T.E.S., 1984.

Ortigues, Edmond. Religions du Livre. Religions de la Coutume. Paris: Editions du Sycomore, 1981.

Osborne, Harold. Aesthetics and Art Theory: An Historical Introduction. London: Longman, 1968.

Otten, Charlotte M., ed. Anthropology and Art: Readings in Cross-Cultural Aesthetics. Austin: University of Texas Press, 1976.

Ottenberg, Simon. Anthropology and Aesthetics. Accra: Ghana University Press, 1971.

————. "Igbo and Yoruba Art Contrasted." In African Arts, XVI, 2, 1983.

————. Masked Rituals of Afikpo. Seattle: University of Washington Press, 1975.

————, ed. African Religious Groups and Beliefs. Meerut, India: Archana Publications, Folklore Institute, 1982.

Pacheco, Francisco. Arte de la Pintura. Madrid: Instituto de Valencia de Don Juan, 1956.

Panofsky, Erwin. Meaning in the Visual Arts. Chicago: University of Chicago Press, 1983.

————. La Perspective comme Forme Symbolique. French tr. Guy Ballangé. Paris: Editions de Minuit, 1975. (Published in English as Perspective as Symbolic Form.)

————. The Renaissance and Renascences in Western Art. New York: Harper & Row, 1972.

————. Studies in Iconology. New York: Harper & Row, 1972.

Paudrat, Jean-Louis. Introduction to La Voie des Ancêtres. Exhibition catalogue. Paris: Fondation Dapper, 1986.

Paulme, Denise. African Sculpture. London: 1962.

————. "Les Baga." In L'Institut Français d'Afrique Noire, vol. 18, B, 1956.

————. Les Gens du Riz. Paris: Plon, 1970.

————. "Que Savons-Nous des Religions Africaines?" In Rencontres de Bouaké. Paris: Seuil, 1965.

————. Une Société de Côte-d'Ivoire Hier et Aujourd'hui: Les Bété. Paris: Mouton, 1962.

Paulme, Denise, and Jacques Brosse. Parures Africaines. Paris: Hachette, 1956.

Pemberton, John, and William Fagg. Yoruba Sculpture of West Africa. New York: Alfred Knopf, 1982.

Pericot-Garcia, Luis, John Galloway, and Andreas Lommel. Prehistoric and Primitive Art. New York: Harry N. Abrams, Inc., 1967.

Perrois, Louis. Art Ancestral du Gabon. Geneva: Musée Barbier-Müller, 1985.

————. La Sculpture Traditionnelle du Gabon. Paris: ORSTOM, 1973.

————. La Statuaire Fan du Gabon. Paris: ORSTOM, 1972.

Pouillon, Jean. Fétiches sans Fétichisme. Paris: Maspéro, 1975.

601

Poynor, R. In Susan Mullin Vogel, ed., *For Spirits and Kings: African Art from the Tishman Collection*. New York: The Metropolitan Museum of Art and Harry N. Abrams, Inc., 1981.

Praise Poems: The Katherine White Collection. Seattle Art Museum, 1984.

Preston, G. Nelson. *Sets, Series, Ensembles in African Art*. Exhibition catalogue. Introduction by Susan Mullin Vogel. Catalogue by Polly Nooter. New York: The Center for African Art, Harry N. Abrams, Inc., 1985.

Radcliffe Brown, Alfred R. *Structure and Function in Primitive Society*. New York: Free Press, 1965.

Raponda-Walker, A., and R. Sillans. *Rites et Croyances des Peuples du Gabon*. Paris: Présence Africaine, 1962.

Read, Herbert. *The Art of Sculpture*. London: Faber and Faber, 1956.

Réau, Louis. *Iconographie de l'Art Chrétien*, vol. III, *Iconographie des Saints*, vol. II. Paris: Presses Universitaires de France, 1958.

Reinach, Adolf. *La Peinture Ancienne: Recueil Milliet*. Paris: Macula, 1985.

"Rencontres Internationales de Bouaké." *Les Religions Africaines Traditionnelles*. Paris: Seuil, 1965.

Rodin, Auguste. *L'Art: Entretiens Réunis par Paul Gsell (1911)*. Paris: Gallimard, 1967. (Published in English as *Art: Conversations with Paul Gsell*. Berkeley: University of California Press, 1987.)

Rodrigues de Areia, M. L. "Le Panier Divinatoire des Tschokwe." *Arts de l'Afrique Noire*, no. 26 (Summer 1978).

———. "Le Savoir Mnémo-Technique des Tschokwe de l'Angola." *Journal des Africanistes*, 46, 1-2 (1976).

Rogers, L. R. *Sculpture*. London and New York: Oxford University Press, 1969.

Rood, A. P. "Bete Masked Dance: A View from Within." In *African Arts*, II, 3, 1969.

Rosenwald, Jean B. "Kuba Kings Figures." In *African Arts*, VII, 3, 1974.

Roskill, Mark. *What is Art History?* London: Thames & Hudson, 1976.

Roy, Christopher D. *African Sculpture: The Stanley Collection*. Exhibition catalogue. Iowa City: University of Iowa Museum of Art, 1979.

———. *Art and Life in Africa*. Iowa City: University of Iowa Museum of Art, 1985.

———. *Art of the Upper Volta Rivers*. Meudon (France): Chaffin, 1987.

———. *The Dogon of Mali and Upper Volta*. Munich: Galerie Fred und Jens Jahn, 1983.

———. "Forme et Symbolisme des Masques Mossi." In *Arts d'Afrique Noire*, no. 48.

———. "Mossi Chiefs' Figures." In *African Arts*, XV, 4, 1982.

———. "Mossi Dolls." In *African Arts*, XIV, 4, 1981.

Rubin, Arnold. *Accumulative Sculpture: Power and Display*. New York: Pace Gallery, 1974.

———. *The Arts of the Jukun-speaking Peoples of Northern Nigeria*. Bloomington: Indiana University Press, 1969.

———. *The Sculptor's Eye: The African Art Collection of Mr. and Mrs. Chaïm Gross*. Washington, D.C.: National Museum of African Art, 1976.

———. *Yoruba Sculpture in Los Angeles Collections*. Claremont, Calif.: Montgomery Art Center, 1969.

Rubin, William, ed. *"Primitivism" in Twentieth-Century Art: Affinity of the Tribal and the Modern*. New York: Museum of Modern Art, 1984.

Santos Lima, A. *Organização Económica e Social dos Bijagos*. Lisbon: CEGP, 1947.

Sauerländer, Willibald. "L'Europe Gothique, XII-XIVe Siècles: Points de Vue Critiques à Propos d'une Exposition." *Revue de l'Art*, no. 3 (1969).

Savary, Claude. *Cameroun: Arts et Cultures des Peuples de l'Ouest*. Geneva: Musée Ethnographique, 1980.

———. *Dahomey: Traditions du Peuple Fon*. Exhibition catalogue. Geneva: Musée d'Ethnographie, 1975.

———. *Sculptures Africaines d'un Collectionneur de Genève*. Geneva: Musée d'Ethnographie, 1978.

Schapiro, Meyer. *Style, Artiste, et Société*. French translation. Paris: Gallimard, 1982.

Scheinberg, A. L. *Art of the Igbo, Ibibio, Ogoni*. New York: Endicott Guthaim Gallery, 1975.

Schlamenbach, Werner. *African Art*. New York: 1954.

Schuhl, P. M. *Platon et l'Art de Son Temps*. Paris: Presses Universitaires de France, 1952.

Schweeger-Hefel, Annemarie. In Susan Mullin Vogel, ed., *For Spirits and Kings: African Art from the Tishman Collection*. New York: The Metropolitan Museum of Art and Harry N. Abrams, Inc., 1981.

Sculptura Africana. Exhibition catalogue. Villa Medicis, Rome: 1986.

La Sculpture: Méthode et Vocabulaire. Inventaire général des monuments et des richesses artistiques de la France. Principes d'analyse scientifique. Paris: Imprimerie Nationale, 1978.

Segy, Ladislas. *African Sculpture Speaks*. New York: Da Capo Press, 1975.

Senghor, L. Sedar. "L'Esthétique Négro-Africaine." *Diogène*, no. 16 (1956).

Shaw, Thurston. *Igbo-Ukwu: An Account of Archaeological Discoveries in Eastern Nigeria*. London: Faber & Faber, 1970.

———. *Nigeria: Its Archaeology and Early History*. London: 1978.

Sieber, Roy. *Sculpture of Northern Nigeria*. New York: Museum of Primitive Art, 1961.

Simondon, Gilbert. *Du Mode d'Existence des Objets Techniques*. Paris: Aubier, 1969.

Siroto, Leon. *African Spirit Images and Identities*. New York: Pace Gallery, 1976.

———. "The Face of the Bwiti." In *African Arts*, I, 3, 1967.

———. "Gon: A Mask Used in Competition for Leadership Among the Bakwele." In *African Art and Leadership*, Douglas Fraser and Herbert M. Cole, eds. Madison: University of Wisconsin Press, 1972.

Smith, J. Weldon. "African Pragmatism." In *African Arts*, XI, 2, 1978.

Soderberg, B. "Figures d'Ancêtres chez les Babembé." In *Arts d'Afrique Noire*, nos. 13-14, 1975.

Souriau, Etienne. *Les Catégories Esthétiques*. Paris: 1960.

Sousberghe, L. de. *L'Art Pende*. Belgium: Académie Royale de Belgique, 1958.

Spiro, Melford E. *Culture and Human Nature: Theoretical Papers of Melford E. Spiro*. University of Chicago Press, 1987.

Sprague, Stephen F. "How the Yoruba See Themselves." In *African Arts*, XII, 1, 1978.

Thompson, Robert Farris. *African Art in Motion*. Exhibition catalogue. Washington, D.C.: National Gallery of Art, 1974.

———. "An Aesthetic of the Cool." In *African Arts*, VII, 1, 1973a.

———. *Black Gods and Kings: Yoruba Art at UCLA*. Exhibition catalogue. Los Angeles: University of California Press, 1971.

———. *Flash of the Spirit: African and Afro-American Art and Philosophy*. New York: Random House, 1981.

———. *The Four Moments of the Sun*. Washington, D.C.: National Gallery of Art, 1982.

———. "The Grand Detroit N'kondi." *Bulletin of the Detroit Institute of the Arts*, vol. 56, no. 4 (1978).

———. "Yoruba Artistic Criticism." In Warren L. D'Azevedo ed., *The Traditional Artist in African Societies*. Bloomington: Indiana University Press, 1973.

Timmermans, P. "Essai de Typologie de la Sculpture des Bena-Luluwa du Kasai." In *Africa Tervuren*, no. 12, 1966.

———. "Les Lwalwa." In *Africa Tervuren*, no. 13, 1967.

Todorov, Tzvetan. *Symbolisme et Interprétation*. Paris: Seuil, 1978. (Published in English as *Symbolism and Interpretation*. Ithaca: Cornell University Press, 1982.)

———. *Théories du Symbole*. Paris: Seuil, 1977. (Published in English as *Theories of the Symbol*. Ithaca: Cornell University Press, 1984.)

Trowell, Margaret. *African Design*. London: Faber & Faber, 1960.

———. *Classical African Sculpture*, 2nd edition. London: 1964.

Trowell, Margaret, and Hans Nevermann. *African and Oceanic Art*. New York: Harry N. Abrams, Inc.

Turner, Victor. "La Classification des Couleurs dans le Rituel Ndembu." In *Essais d'Anthropologie Religieuse*. Paris: Gallimard, 1972.

———. *The Drums of Affliction*. Oxford: Clarendon Press, 1968.

Underwood, Leon. *Bronzes of West Africa*. London: Alec Tiranti, 1949.

Urbain-Faublée, M. *L'Art Malgache*. Paris: Presses Universitaires de France, 1963.

Valery, Paul. *Tel Quel*. Paris: Gallimard, 1941.

Van Geertruyen, G. "La Fonction de la Sculpture dans une Société Africaine: Baga, Nalu-Landuman." In *Africana Gandensia*, no. 1, 1976.

———. "Le Style Nimba." In *Arts d'Afrique Noire*, no. 31, 1979.

Van Geluwe, H. "Masque Pende." In Jacqueline Fry, ed., *Vingt-cinq Sculptures Africaines—Twenty-five African Sculptures*. Exhibition catalogue. Ottawa: National Gallery of Canada, 1978.

Vansina, Jan. *Art History in Africa*. London, New York: Longman, 1984.

———. *The Children of Woot: A History of the Kuba Peoples*. Madison: University of Wisconsin Press, 1978

———. *Le Royaume Kuba*. Tervuren (Belgium): Musée Royale de l'Afrique Centrale, 1964.

———. *Les Tribus Ba-Kuba et les Peuplades Apparentées*. Tervuren (Belgium): 1954.

———. "The Use of Ethnographic Data as Sources in History." In T. O. Ranger, ed., *Emerging Themes in African History*. Dar-es-Salaam: 1968.

Verger, Pierre. *Notes sur le Culte des Orisa et Vodun à Balia, la Baie de Tous les Saints, au Brèsil et à l'Ancienne Côte des Esclaves en Afrique*. Amsterdam: Mémoires de l'Institut Français d'Afrique Noire, 1957.

———. *Orisha*. Paris: Métailié, 1982.

Vernant, Jean-Pierre. "De la Présentification de l'Invisible à l'Imitation de l'Apparence." In *Image et Signification*, Encounters of the Ecole du Louvre. Paris: Documentation Française, 1983.

Veyne, Paul. *Writing History*. Moore-Rinvolucri, Mina, tr. from French. Hanover, N. H.: Wesleyan University Press, 1984.

Vitruvius. *Ten Books on Architecture*. Morgan, Morris H., tr. from Latin. New York: Dover, 1960.

Vogel, Susan Mullin. *African Aesthetics*. New York: The Center for African Art, 1987(a).

————. "Baule and Yoruba Art Criticism: A Comparison." In Justine M. Cordwell, ed., *The Visual Arts: Plastic and Graphic*. Paris, New York: Mouton, 1979.

————. *Beauty in the Eyes of the Baule: Aesthetics and Cultural Values*. Philadelphia: Working Papers in the Traditional Arts, 1980.

————. *For Spirits and Kings: African Art from the Tishman Collection*. New York: The Metropolitan Museum of Art and Harry N. Abrams, Inc., 1981.

————. "People of Wood: Baule Figure Sculpture." In *Art Journal*, XXXIII/I (Autumn 1983).

————. *Perspectives: Angles on African Art*. New York: The Center for African Art and Harry N. Abrams, Inc., 1987(b).

Vogel, Susan Mullin, and Francine N'Diaye. *African Masterpieces*. New York: The Center for African Art and Harry N. Abrams, Inc., 1985.

Volavkova, Zdenka. "Nkisi Figures of the Lower Congo." In *African Arts*, V, 2, 1972.

Von Schönborn, Christoph. "Les Icônes Qui Ne Sont Pas Faites de Main d'Homme." In *Image et Signification*, Encounters of the Ecole du Louvre. Paris: La Documentation Française, 1983.

Walker, A. R., and R. Sillans. *Rites et Croyances des Peuples du Gabon*. Paris: Présence Africaine, 1962.

Warren, D. M., and J. K. Andrews. *An Ethnoscientific Approach to Akan Arts and Aesthetics*. Philadelphia: Working Papers in the Traditional Arts, no. 3, 1977.

Willett, Frank. *African Art*. London: Thames & Hudson, 1971.

————. "The Benin Museum Collection." In *African Arts*, VI, 4, 1973.

————. *Ife in the History of West African Sculpture*. London: Thames & Hudson, 1967.

————. "True or False? The False Dichotomy." In *African Arts*, IX, 3, 1976.

Williams, Denis. *Icon and Image: A Study of Sacred and Secular Forms of African Classical Art*. New York University Press, 1974.

Wittkower, Rudolf. *Architectural Principles in the Age of Humanism*. London: Alec Tiranti, 1952.

————. *Sculpture: Processes and Principles*. New York: Harper & Row, 1977.

Wittmer, Marciline K., and William Arnett. *Three Rivers of Nigeria*. Atlanta: High Museum of Art, 1978.

Yoyotte, Jean. "Egypte Ancienne." In *Histoire de l'Art*, vol. I, *Le Monde Non-Chrétien*. Paris: Gallimard, 1961.

Zemp, Hugo. *Musique Dan: La Musique dans la Pensée et la Vie Sociale d'une Société Africaine*. Paris: Mouton, 1971.

Zevi, Bruno. Article "Rationaliste (Architecture)." In *Encyclopaedia Universalis*, vol. 13 (1972).

Index

Works ascribed to a specific ethnic group or cultural center are indexed under the name of the group or center, shown in **boldface** type (e.g., **Asante**; **Benin**). Works identified by geographical provenance are indexed under the name of the city, village, site, or region. Works belonging to a specific genre (e.g., *deble* statues; helmet-masks) are indexed by genre as well. Illustration references, shown in *italic* type, are to figure numbers rather than page numbers. An asterisk following a page number indicates the main discussion of an ethnic group or cultural center.

A

cisokolu (stick), 587
Cissé, Yussuf Tata, 504
citanga figure, 286
Classicism: and depreciation of other
 styles, 34, 35–36, 37; opposition to
 frontality, 318
clay sculpture, 533–34; *71–73, 82, 910*
Cole, Herbert M., 150, 201–2, 204, 205,
 519, 527
Colle, Father, 575
Collingwood, R. G., 36, 52, 192, 249
combs, *733–34, 774*
commander's staffs, *341, 584, 606, 819*
commemorative works: plaque, 149–50;
 statues, 327; *965*
*Commentary on the Sentences of Pierre
 Lombard* (Thomas Aquinas), 198, 242
communal objects, 490–91
Comoe River, Ivory Coast, 525
comparative studies, 107–9; in aesthetics,
 25–26, 27–55, 277, 287–91
complementarity, opposition of, 115–16,
 210, 285, 286
composition, 206–10, 280
Comte, Auguste, 55
color, 282
Congo, 485, 492, 560, 562, 567, 571, 586;
 statuette, *638. See also* **Badondo; Bembe;
 Bwende; Kongo; Kuyu; Mazinga; Teke;
 Vili; Yombe**
Congo-Kinshasa, 586. *See also* Zaire
Congo (Zaire) River, 560, 563, 566, 570,
 574
consecration, 250
context, and expression, 158–60
contrapposto, 318
conventions, naturalist, 106–8
Cool, aesthetic of, 158
coordination of figures, 206, 208
copies. *See* replicas and copies
copper, works in, 528, 560; *87–88, 91, 95;*
 with zinc, *2, 92, 93*
Corneille, Pierre, 115
Cornet, Joseph, 42, 108, 149, 195, 204,
 211, 212, 578, 580
Corot, Jean-Baptiste, 320
corporeal identity, and idealization, 151–
 52
Corsica, 487
Counterfeiters, The (Gide), 199
couples, 22, 208, 503; *14, 19, 27, 62–63,
 134–35, 275, 610, 687–88, 823, 825,
 895, 1069*
covers or lids, 190–91; with proverbs,
 211–13; *987*
cow: *dugn'be* mask, *862;* plaque showing
 sacrifice of, 208; *99*
Cratylus (Plato), 54
crests, *542;* of headdresses, *333, 337*
Critique of Judgment, The (Kant), 320
crocodile masks, 532, 541; *287*
Cross River region, Nigeria, 540 (map),
 542, 550, 551–53; head, *955;* helmet-
 masks, *541, 959;* monoliths, *535, 536;*
 wrapped skull, *951*
Crowley, D. J., 28, 202, 283, 288, 289
crowned head, 107; *93*
crowns, of headdresses, 35; *300, 301, 302,
 303, 482*
Cuba, 531
Cubist works, 107, 123
Cucumbi region, Angola, mask from,
 783
Cues, Nicolas de, 115
Cult of the Saints, The (Brown), 54
cuor (household), 511
cupbearer, 325; *189*
cups, 200, 209, 321, 528; *44, 194, 428. See
 also* bowls
Cwa, 579

D

dagalo chair, *342*
Dagara, 510
Dahomey, 202, 529, 530, 531; priest and
 priestess of the Legba, *905. See also*
 Benin (republic)
Dakakari, 534
dama ceremonies, 504
damba mask, 517
Dan, 210–11, 493, 515 (map), 521–22*,
 523, 524, 525; dancers, 562; *874, 875;*
 masks, 24, 37, 107, 159, 198, 204, 239,
 487, 521, 522, 523; *54, 55, 56, 57, 369,
 876;* spoons, 522; *373, 877;* statue, *58*
dance, representation of, 39–40, 122–23,
 125
dance puppets, *10, 861*
dancers, 21, 160, 239, 530, 532; couple
 figures, *823, 824;* photographs and
 drawings of, *836, 840, 843, 854, 865,
 875, 962, 975, 998, 1033, 1043, 1048;* on
 stilts, 562; *874, 984*
dancing-sticks, 199–200
dane (village districts), 512
Danish, 527
Danube basin, 488
Dapper, Olfert, 565
Dark, Philip, 537, 538
Day for Night (film), 200
D'Azevedo, Warren L., 32, 158, 289–90
De Architectura (Vitruvius), 193
De Re Aedificatoria (Alberti), 320
De Wit, Jakob, 113
deangle masks, 522, 523
deble statues, 513; *34, 317*
decoration, 319–20; and function, 191
deer mask, *285*
defunctionalization, 202–5
Degas, Danse, Dessin (Valéry), 37
dege dal nda statue, 277
Degema region, Nigeria, mask from,
 102
Degha, 317
deguele mask, 513
Dei, 48
Delacroix, Eugène, 36, 201, 275, 320
Delafosse, Maurice, 501, 525
Delange-Fry, Jacqueline, 27, 154, 521,
 547
Delmas, Igor, 330
Democritus, 190
Demoiselles d'Avignon, Les (Picasso), 495
Deneuve, Catherine, 153
Dengese, 567 (map), 578*; comb, *733–34;*
 divination instrument, *732;* statues, *177,
 1026*
Denis, Maurice, 119
Denkyira (Akan kingdom), 527, 528
denomination, and individuation, 149–50
Derain, André, 492, 557
desacralization, 491
Descartes, René, 40, 107, 157
Description of the Kingdom of the Congo
 (Pigafetto and Lopez), 54
design, and writing, 31–32
Dias, A. J., 239
Dias, M., 239
Dieterlen, Germaine, 31, 191, 502, 504
differential proportions, 111–14
Difini (Bwa god), 507
dignitaries, *16, 265;* funeral chamber of,
 912
Dinga, 581
Diolla, 524
Discourse to the Academy (Fénelon), 201
display adze, *1039*
dissymmetric equilibrium, 321
dissymmetry, 316, 317, 318, 320

divination instruments, *732, 1045;* box, *64;*
 paddle, *420;* tray, 210
Dja River, Cameroon, 559
Djalonke, 517
Djenne, Mali, 30, 208, 488, 501–2*, 504,
 527; Great Mosque, *830*
Djibete, 540 (map); mask, *507*
Djimini: bracelet, *857;* mask, *325*
Djoboro, Mali, 501
Do (Bwa god), 507, 508
do ceremony, 513
Dogon, 21–22, 31, 191–92, 205, 206, 210–
 11, 324, 326, 486, 488, 489, 501 (map),
 502, 503–4*, 509; balafon players, 208;
 24; couples, 208, 503; *27, 275;* doors,
 120–21, 196, 318, 491, 502; *279, 280,
 281;* granary, *834;* head, *21;* horsemen,
 324, 503; *272, 832;* masked dancers,
 836; masks, 35, 107, 487, 504, 509; *26,
 30, 283, 284, 285, 286, 287;* maternity
 figures, 207, 324; *25, 270;* other
 statuary, 48, 152, 154–55, 199, 490; *28,
 29, 271, 273, 274, 276, 277, 278;* ritual
 container, *282;* shrine, *835;* stools, 48,
 199, 502. *See also* **Proto-Dogon; Tellem-
 Dogon**
dogs, *611;* with nails, 565; *613, 614, 616*
Dolisie (Loubomo), Congo, 562
dolls, 510; *401–3, 800–804*
Donatello, 52, 119, 324
Dondo, 563
Donga, Nigeria, 547
Donga River, Nigeria, 549
doors, 120–21, 196, 199, 206–7, 283, 318,
 491, 532; *279, 280, 281, 334, 585, 599,
 887, 946*
double objects: bowl, *703;* gong, *460;*
 head, 7; masks, 526; *70, 323, 443, 541,
 545, 888, 966;* reliquary, *153–54;* seat,
 681; spoon, *373;* statuary, *411, 520,
 661–62, 723, 850, 997*
doubling, 199–200, 321
Douglas, Mary, 244
Dozon, Jean-Pierre, 524
Drewal, Henry John, 209
Drewal, Margaret Thompson, 209
Drot, Jean-Marie, 486
drummers, *761, 763;* on bronze plaques,
 123, 207; *98*
drums, 207, 553, 568, 582–83; *140, 405,
 640, 750, 957–58, 1053;* statues from,
 128, 551
Du (Dan god), 522
Du Chaillu, Paul, 557–58
Duala, 540 (map); front of a dugout
 canoe, *970;* mask, 330; *544*
Duchamp, Marcel, 204
duen fobara (funerary screens), 208; *471*
Duga (Yoruba sculptor), 42
dugn'be mask, *862*
dugout canoe, *970*
Dumézil, Georges, 193
Dupré, Marie-Claude, 160, 239
Dutch, 527
Dwo (god), 506, 507
dye mask, 524
dyo (family groups), 560
dyo society, 504–5
dyoro society, 511

E

eagle, 593
Easter Island, 487
Eastern Africa, ethnic groups, 589–92
Eastern Nigeria, statues from, *128, 129*
ebanza temple, 561
ebene (village sectors), 517
eboga (plant), 558

Ebok (Mbembe god), 553
Ebongo (Kuyu god), 567
Ebotita (Kuyu mother), 567
edan (decorated rods), 532
edjo (nature spirits), 549
Edo, language, 537, 549. *See also* **Bini**
effigies, 148, 149, 150–51, 152, 153, 154, 207, 242–43, 578, 580; *134–35, 178, 790–91*; mask, *17. See also* portraits
Efik, 540 (map), 550, 551–52*
egbe society, 532
Egbebe, 552
Egebele (Igbo-Afikpo god), 550
Egharevba, Jacob, 537
Egu (Igala spirit), 542
egungun cult, 281, 532
Egypt, 535
Egyptian art, 32, 116, 121, 122, 153, 250; Amratic Nagada, *12–13, 249, 250*
Einstein, Carl, 322
Ejagham, 540 (map), 551–52*; heads, *540, 953*; masks, 330; *538, 539*
Eket, 540 (map), 550–51*; *952*; headdress, *482*; masks, 551; *115, 479*
Ekoi, 487, 542, 551, 553
ekon society, 551
ekong society, 551
ekpe society, 551
ekpeko society, 549
ekpo societies, 550–51
ekpu statues, 552; *954*
ekuk masks, 559
ekwotame statue, *492*
elanda society, 571
elefon cult, 532
elek figures, 517; *863*
elephant, 154; head, *446*; masks, *555, 963*
elision, 280
Elizabeth II (queen of England), 149
Ellul, Jacques, 53
Elmina, Ghana, 527
English colonization, 492, 527, 537, 545, 546, 550, 553, 573, 594
enia, term, 278
enna society, 550
epa masks, 48, 281, 283, 532; *439*
ephebism, 281–82, 283, 290
Epicureanism, 241, 246
Epstein, Jacob, 557
Equatorial Guinea, 485, 557, 558. *See also* **Fang**
Eresonyen (*oba* of Benin), 538
eros, functions of, 152
eshe (village founders), 549
Eshu (Yoruba god), 199, 532
Esie, 533 (map); statue, *454*
esusu society, 532
Ethics (Aristotle), 157
Ethiopia, 485, 487, 589, 591. *See also* **Konso**
ethno-aesthetics, 25, 277, 315
ethnocentrism, 24, 25–26, 33; and fetish, 54; and notion of primitive, 46; struggle against, 276
ethnographical replicas, 42
Ethnologie et Langage: La Parole Chez les Dogon (Calame-Griaule), 489
ethnology: vs. aesthetics, 275–76, 315–16; and functionalism, 188–89, 191–92; and question of authenticity, 43–44; and symbolism, 241; and writing, 31
Etienne, Pierre, 283
Etung, 551
Eucharist, 241, 242
Evans-Pritchard, Edward E., 54, 188, 241, 242
evur (magical substance), 558
Ewe, 515 (map), 529; buffalo head, *404*
Eweka I (*oba* of Benin), 537
exorcism ritual, 244

expression: aesthetics of, 284–87, 328–30; representation of, 156–60
expressionism, 106–7; and expression, 156; misattribution of, 38–39, 114–15
eyima byeri (reliquaries), 284, 285
Eyo, Ekpo, 536
Ezra, Kate, 505

F

fa cult, 530; stick for: Yoruba, 326; *909*
fabrics, 108, 320, 579–80; *869, 1000, 1027*; representation of, 108
Fada N'Gurma, Burkina Faso, 509
Fagg, Bernard, 533
Fagg, William, 27, 30, 33, 47, 53, 111, 112, 113, 114, 115, 152, 153, 154, 202–3, 207, 210, 250, 323, 327, 328, 330, 489, 532, 536, 537, 538, 572, 578
fakes, 41–43
fama (village head), 504
Family Resemblance Predicates (FRPs), 23–24, 26, 44–45, 55, 107, 145–46
fan, *608*
Fang, 24–25, 115, 116, 210, 491, 557 (map), 557–58*, 560, 562, 570; aesthetics, 277, 278, 284–87, 329, 330; bellows, *973*; *byeri* figures, 284, 317, 558; *975*; masks, 491, 558; *157, 573, 574, 575, 576*; reliquaries and reliquary heads, 284, 285; *158, 161, 563, 564, 565, 566*; statuary, 113–14, 115, 329, 284–87, 317, 329, 558; *142, 159, 160, 571, 974*
Fang-Betsi, statues, 569, 570
Fang-Mabea, statues, 558; *141, 560*
Fang-Mvai, statue, 571
Fang-Ngoumba, statues, 558; *557*
Fang-Ntoumou, flute player, *568*; statue, *558–59*
Fang-Okak, statues, 558; *143, 561, 562, 567, 572*
Fante, 515 (map), 527–28*. *See also* **Akan** group
Faro (Bozo god), 504
Febvre, Lucien, 248
female statuettes, *465, 681, 691*
Fénelon, François, 201
Fénéon, Félix, 492, 557
Fernandez, James W., 25, 113, 115, 116, 210, 278, 284–87, 330, 558
fertility, 152, 196, 207
fertility dolls, *800–804*
fetishes, 38, 53–55, 244–45, 248, 287, 491, 530, 544, 545, 563, 564–65, 566, 576; *241, 242, 243, 244, 612, 613, 614, 615, 616, 992, 994–95, 1023*; drawings of, *978, 981*
figurative representation, 115–16
figures: and block, 324–26; composition of, 206–9; expressive qualities, 330; with hinged limbs, 28; monumental, 327–28; proportions of, 109–18; symmetry and frontality of, 317–18
Filitosa, Corsica, 487
finish, 37–38; and monumentality, 328
Fischer, Eberhard, 204, 240, 521, 522
Fitzgerald, W. W., 591
Flam, Jack D., 115, 192, 193
flintstone work, *252*
flute players, *132, 568*
flutes, 545; *304*
flyswatter, handle of, *986*
Focillon, Henri, 146, 195, 328
foke dwellings, 517
Fomena style, heads, *72, 73*
fon (king), 33, 554–55, 556; commemorative statue, *965*; photographs, *960, 961*

Fon, 150, 154, 155, 202, 515 (map), 529–30*; allegorical portrait of King Behanzin, *413*; *bochio* posts, 487, 529; *415, 417, 898*; Gu, God of War, 529, 530; *75, 414*; *legba* statues, 530; *418*; monkey, *426*; *vodun* statuary, 76, 77, *407, 408, 409, 410, 411, 412, 416*
food rituals, Woyo, 212–13
forms, 315–30; awkward, 34–35; expressive qualities, 329; and function: 188–94; technical vs. representational, 117–18; visual vs. verbal, 211
Fortes, Meyer, 191
Fosi-Monbin village, Cameroon, mask from, *546*
Foss, Perkins J., 549
Foucault, Michel, 200
Fouchet, Max-Pol, 485
Foukas-Chacha, Cameroon, statue from, *549*
Foumban, Cameroon, 42
Fournet, Claude, 54
Fouta Djallon region, Guinea, 517
Francastel, Pierre, 119, 120, 203
Fraser, Douglas, 201–2, 205, 538
French Ethnological School, 490
French colonization, 504, 506, 507, 509, 512, 517, 525, 529
Freud, Sigmund, 152
Friedländer, Max J., 50
Frobenius, Leo, 486, 535; mask found by, *712*; mask sculpted for, *1021*
frontality, 320; and symmetry, 316–18
FRP. *See* Family Resemblance Predicates
Fry, Jacqueline. *See* Delange-Fry
Fulani, 488, 542, 544, 545, 547, 548, 549
Fulbe, 517, 524
fuli (sculptors), 587
Fullerton, South Africa: figure of a hunter, *1*
fumu (chief), 584
function: and form, 188–94; and representation, 117, 194–213
functional integration, 190–92
functionalism, 188–250; vs. aesthetics, 33, 275–76
funeral chamber, *912*
funerary sculpture, 487, 490; figures, *399, 896*; posts, 191, 589–90, 591, 595; *245, 248, 826, 827, 828, 1056, 1057, 1058, 1059, 1060, 1067*; screen, 208; *471*; statuette, *988. See also* effigies
Funza (Bakongo spirit), 244, 565
furniture, 490

G

Gabon, 284, 329, 485, 487, 492; Ohe Ogooué Basin ethnic groups, 557–62. *See also* **Bakwele**; **Fang**; **Kota**; **Lumbo**; **Mahongwe**; **Mashango**; **Nzebi**; **Punu**; **Shamaye**; **Tsogho**
Gale (Ngbaka god), 568
Galla, 591
Garrard, T. F., 528
Gato, 487, 590 (map), 589–90*; statues, *792–94*
gayo wood, 589
gaza (ganza) initiation, 568
gazelle, *805*
gba gba masks, 526
Gban, 524
gbékré figures, 23
gbo (households), 512
Geary, Christraud, 42
Gebauer, Paul, 159, 160
Geertz, Clifford, 191
gelede society, 532; masks, 250, 281, 329, 532, 534; *78, 441, 442, 443, 444*

609

nganga (diviner), 38, 562, 563, 564, 576, 584, 586; statuette, *633*
Ngangela: masks, 239; staff, *773*
ngantsie (clan), 566
Ngbaka, 567 (map), 567–68*; mask, *641*; pipe, *999*; statues, 328; *644, 645, 648*
Ngbandi, 567–68*; bowl, *642*; mask, *167*; statue, *643*
ngbe society, 551
ngedi mask, 159
Ngeende (Kuba subgroup), 579
Ngewo (Mende god), 519
ngi ritual, 557
ngil society, 558; mask, *157*
ngirih society, 554, 555
Ngombe, 567–68*; statue, *646*
ngondje (*bwiti* president), 561
ngongo society, 581
Ngoni, 593, 594; statue, *1064*
ngontang society, 558
ngoombu (diviner), 582
Ngoumba (Fang subgroup), statue, *557*
Ngounie River, Gabon, 561
ngoye society, 560
ngpwo mask, 543
ngulu (nature spirits), 574
ngumba statues, 558
Ngwyes, 559
Niari mines, Congo, 560
Nicephorus, 54
nieguegue masks, 507
Niger, 488
Niger River, 488, 504, 533, 535, 536, 542, 543; delta region ethnic groups, 501–5, 549–51. *See also* Interior Niger Delta
Nigeria, 22, 158, 202, 239, 249, 278, 485, 487, 490, 492, 513, 529, 530, 531, 533–39, 541, 543, 545, 546, 547, 548, 549, 550, 551–53; heads, *449, 919*; statuary, *90, 437, 452, 503*. *See also* **Afo**; **Benin**; **Bini**; **Chamba**; Cross River; **Djibete**; **Ejagham**; **Eket**; **Esie**; **Ibibio**; **Idoma**; **Ife**; **Igala**; **Igbo**; **Ijebo**; **Ijo**; **Ishan**; **Jompre**; **Jukun**; **Kaka**; **Koro**; **Mama**; **Mambila**; **Mbembe**; **Mboye**; **Montol**; **Mumuye**; **Nok**; **Nupe**; **Ogoni**; **Oron**; **Owo**; **Urhobo**; **Tiv**; **Wurkum**; **Yelwe**; **Yoruba**
nima (initiate), 561
nimba masks, 35, 517; *46, 47, 866, 867*
Nindou (Bissagos god), 515
Nini village, Mali, horseman from, *832*
niombo cult, 563
Njoya (sultan of Bamum), 42, 555
nkaki masks, 581
nkanda society, 551
nkang society, 552
Nkanu, drummers, 207; *761*
n-khanda (initiation), 582
nkibi (dances), 40
nkira (male spirit), 566
nkisi (pl. *minkisi*), 38, 244–45, 562, 563, 564–65. *See also* fetishes
nkita (water spirits), 244
N'Ko (Mbembe ancestor), 553
nkok masks, 555
N'Koum village, Nigeria, 553
Nok, Nigeria, 30, 490, 533–34*, 536; heads, 113, 533, 534; *82, 84, 445, 446, 910, 911*; pendant, *83*
Nommo couples, 48, 489, 503, 504
nomoli sculptures, 519, 520; *43, 871, 872*
Nooter, Polly, 160
Nor, 548. *See also* **Mambila**
North Kwango region, Zaire: drummer, *761*; statue, *215*
Notebooks (Leonardo da Vinci), 248
Notre-Dame, Paris, 153, 318–19
Nowo (Mende spirit), 519
Nsama (Tabwa chief), 573

Nsapo (Songhay subgroup), 567 (map), 576; statue, *749*
nsibidi (pictograms), 551
n'tomo society, 504
ntotsh wood, 578
Ntoumou, 557 (map); flute player, *568*; statue, *558–59*
ntshyaang (bracelet), 149
numbe mask, 518
Nuna, 508; chair, *342*; statue, *36. See also* **Gurunsi**
Nunuma, 506, 508, 509. *See also* **Gurunsi**
Nupe, 533 (map), 536, 542; reliefs, *907–8*; seated figure, *91*
nvala (priests), 554
nwantantay masks, *845, 846*
nyama (spiritual strength), 503
Nyamien (Baoule god), 525
Nyamwezi, 573, 574, 589 (map); powder box, *817*; staff, *807–8*; statues, 323; *806*
nyeleni statues, 505
Nyendael, D., 538
Nyikang (Shilluk king), 242–43
Nyonyosi (Mossi subgroup), 33–34, 509
Nzaman (Fang subgroup), 557 (map)
Nzambi (Bembe and Chokwe god), 562, 586
nzambi cult, 582
Nzami (Teke god), 566
Nzebi, spoon, 323; *982*

O

oba (king), 48, 111, 122–23, 125, 149, 153–54, 155, 199, 532, 535, 537, 538; *466, 916, 917*; horn player, *457*
Obalufon (Yoruba king), 490, 535; mask of, 535; *87–88*
Obalufon II (Yoruba king), 535
Obamba, 557 (map), 560*, 561; reliquary, *980*
Obatala (Yoruba god), 531–32
obio sanctuary, 552
obongonong (diviners), 553
ocheika society, 553
ocho ceremony, 542
odo, term, 281
Odo Ogbe Street, Ife, Nigeria, 536
Odo-Owa, Nigeria, 279
Oduduwa (Yoruba founder), 531–32, 536, 537; dynasty, 531, 535
ody (amulets), 595
ofo (ancestor figure), 549
Ofunbonga (Mbembe subgroup), 552
ogane (sovereign), 537
ogbadu festival, 542
ogbom society, 551
ogboni society, 532, 537; figures, *436, 437*
Ogidi (Yoruba sculptor), 281
Ogiso dynasty, 537
oglinye society, 542
ogo elegba (stick), 199
Ogoni, 540 (map); masks, *473, 478, 949*
Ogotemmêli (Dogon informant), 31, 191–92
Ogun (Yoruba god), 122, 531
Ogundeji (Yoruba sculptor), 281
Oguola (*oba* of Benin), 537
Ohe Ogooué Basin, Gabon: ethnic groups, 557–62; region, 329
Ohen (*oba* of Benin), 153, 154
Ojugbelu (founder of Owo), 495, 536
Okak (Fang subgroup), 557 (map); statues, 558; *143, 561, 562, 567, 572*
Oko (Yoruba god), 203
Okpodou (Mbembe subgroup), 552
okum ngbe helmet-mask, *541*
okuyi mask, 329; *162*

okwa society, 553
Old Calabar, Nigeria, 551
Olodumare (Yoruba god), 531, 532
Olokun (Ife god), 153, 154, 155
Olokun Grove, near Ife, Nigeria, 535
Olowe (Yoruba sculptor), 33
Olowo, palace of, Owo, 536
Ondumbo. *See* **Kota-Ondumbo**
"one tribe, one style" thesis, 47, 48, 153
oni (king), 531, 535, 536, 537; heads, 107; *92, 95*; masks, 532; *87–88*; statues, *2, 96*
onile cult, 532
On Invention (Cicero), 288
Open Frontiers (Bravmann), 48
opon ifa (divination tray), 210
optical corrections, 110
oquinka (priestess), 516
oral traditions, 31, 488, 489
Oranmiyan (son of Oduduwa), 537
Orebok-Okoto (Bissagos god), 515
Oregbeni, Nigeria, 154
organic proportions, 116, 117–18
Oria River, Nigeria, 538
orisha (divinity), 199, 203, 529, 531, 532. *See also* vodun *cult*
oro society, 532
Oron, 540 (map), 551–52*, 552; statues, *119, 954*
Ortigues, Edmond, 210, 246
Orunmila (Yoruba god), 531
Osanyin (Yoruba god), 531
Osborne, Harold, 105, 106, 189
oshe shango (dancing-stick), 199, 324
Oshun (Yoruba goddess), 532
Osopong (Mbembe subgroup), 552
otojo (water spirits), 550
Ottenberg, Simon, 47, 48, 277, 287, 290, 550
ottote society, 567
Ouagadougou, Burkina Faso, 509
Ouedraogo (Mossi chief), 509
Ouidah, Benin, 529; sculpture from, *77, 410, 426*; Temple of the Serpents, *900*
ovie (priest-king), 549
Ovimbundu, statuette, 38
Ovium (Mbembe subgroup), 552
Ovonramwen (*oba* of Benin), 537
Owo, Nigeria, 199, 490, 492, 533 (map), 536–37*, 538; bust, *89*; heads, *80, 453, 915*
owu cult, 543
oxymorons, 115–16, 210, 286
Oyo (Yoruba god), 532
Oyo Ile, Nigeria, 531, 532

P

paang angup (shoulder ornament), 149
Pacheco, Francisco, 55
paedomorphism, 111–14
pagoda hairdo, 575
Pahuins. *See* **Fang**
painting: definitions of, 119, 124; and expressionism, 156; and presentification, 247–48
Paleolithic art, 489
Palladio, Andrea, 320
panel-masks, 551
panels, 28; *216*
Panofsky, Erwin, 32, 116, 117, 121, 122, 192, 248, 318, 320, 327
panther clan, 567
Parrhasios (Greek painter), 156
Parthenon, Athens, 289, 319
Parts of Animals (Aristotle), 45
passport-masks, 522, 558
Paudrat, Jean-Louis, 29, 39, 205, 315, 318, 488, 560, 581
Paulme, Denise, 148, 247, 517, 518

Acknowledgements

We wish to thank the many people who have so generously given of their time and assistance throughout the preparation of this book: Dr. Andrault, Arman, Roger Asselberghs, Jean-Paul Barbier, Baselitz, J.-C. Bellier, L. Biton, Nancy Bloch, Samir Boro, Cartier-Bresson, Oliver and Pamela Cobb, Béatrice Coti, P. Dartevelle, Professor David, Gérard Delecambre, Igor Delmas, Y. Develon, P. Diericks, J.-M. Drot, A. Dufour, Dr. Duguy, Kate Ezra, Marc Félix, Ferrante Ferranti, Valerie Franklin, Mr. and Mrs. John Friede, A. Fourquet, Murray and Barbara Frum, Gaillard, Danièle Gallois, Maud and René Garcia, P. Gaudibert, Marc and Denyse Ginzberg, H. Goldet, B. de Grunne, Philippe Guimiot, E. Herold, Raymonde Harvel, G. de Havenon, André Held, Johan Henau, F. Herreman, A. and J.-P. Jernander, Kahane, Dr. Michael Kan, Mr. and Mrs. A. Kerchache, Barbara and Justin Kerr, Jan Krugier, G. Ladrière, Mr. and Mrs. Lebas, Françoise Leboulenger, Raoul Lehuard, Hélène Leloup, Erle Loran, Ilia Malichin, W. Mestach, Carlo Monzino, Roland Mourer, W. Muensterberger, Müller, Jack Naiman, Peng Wantsé, Alain Pezel, J.-F. and M.-A. Prat, Mr. and Mrs. F. Propper, Mr. and Mrs. M. Propper, Recondo, Jean-Dominique Rey, William Rubin, Lord and Lady Sainsbury, Saintgéry, Daniel Sallet, G. and F. Schlindler, W. Schmalenbach, André Schoeller, Dr. Roy Sieber, Mert Simpson, Mr. and Mrs. Stanoff, Alain Schoffel, C. Sudre, Sam Szafran, Paul and Ruth Tishman, Mia and Loed Van Bussel, Mr. and Mrs. Vanderstraete, Lucien and Mariette Van de Velde, H. Van Geluwe, Pierre Varlet, Velasco, P. Vérité, R. and L. Wielgus, Dr. Sylvia Williams. We also extend our gratitude to all anonymous collectors as well as to the Afrika Museum of Berg-en-Dal, Netherlands; Art Institute of Chicago; Australian National Gallery of Canberra; Barnes Foundation in Merion, Pennsylvania; British Museum of London; The Brooklyn Museum of New York; Cincinnati Art Museum; Dallas Museum of Fine Arts; Etnografisch Museum of Antwerp; Fondation Dapper in Paris; De Menil Foundation in Houston; Denver Art Museum; Detroit Institute of Art; De Young Museum in San Francisco; Göteborg Museum, Sweden; Horniman Museum of London; Kimbell Museum in Fort Worth, Texas; Merseyside Country Museum in Liverpool; The Metropolitan Museum of New York; Minneapolis Institute of Art; Montreal Museum of Fine Arts; Müller Foundation in Insel-Hombroich, Germany; Municipal Museum of Angoulême, France; Musée Barbier-Müller in Geneva; Musée de l'Homme in Paris; Musée Guimet of Lyon; Musée Heverlee in Leuven, Belgium; Musée National des Arts Africains et Océaniens of Paris; Musée Royal de l'Afrique Centrale of Tervuren, Belgium; Museu de Etnografia e Historia of Porto, Portugal; Museu de Etnologia of Lisbon; Museu dos Servicos Geologicos of Lisbon; Museu Regional do Dundo (Lunda Norte), Angola; Museum of Cultural History of the University of California at Los Angeles; Museum of Mankind in London; Museum of the Ife Antiquities, Nigeria; Museum Rietberg of Zürich; Museums für Völkerkunde of Berlin, Frankfurt, Hamburg, Munich, Stuttgart, and Vienna; Museums of Natural History of La Rochelle and Toulouse, France; Náprstkovo Muzeum in Prague; National Museum of African Art in Washington, D.C.; National Museums of Abidjan (Ivory Coast), Benin City, Jos, Kaduna, and Lagos (Nigeria); Natural History Museum of Buffalo, New York; New Orleans Museum of Art; Peabody Museum in Cambridge, Massachusetts; Picasso Museum in Paris; Rijksmuseum voor Volkenkunde of Leiden, Netherlands; Sainsbury Centre for Visual Arts in Norwich, England; Seattle Art Museum; Tropenmuseum in Amsterdam; University Museum in Zürich; University Museum of Philadelphia; University of Iowa Museum of Art; Wallace Collection of London; Yale University Museum of New Haven, Connecticut.

Dates for the Dogon objects were generously provided by Mrs. Hélène Leloup.

Photograph Credits

Color photographs taken especially for this book by Igor Delmas: 3, 4, 7, 8, 11–13, 16–19, 21, 23–26, 28, 29, 31, 33, 35–41, 45, 47, 48, 50, 54–60, 65, 68–73, 76, 77, 80, 101, 103–19, 121–23, 125, 126, 129, 130, 132, 136–41, 144–46, 148–50, 152–54, 156, 160, 162, 163, 168–70, 173–76, 178, 181–83, 185–88, 190–92, 194–208, 209–26, 228, 230–33, 235, 236, 238, 239, 241, 243, 244, 248; by Justin Kerr: 30, 42, 61, 79, 81, 159, 189, 237, 242.

Other color photographs: Roger Asselberghs, 166; Australian National Gallery, Canberra, 66; British Museum, London, 90, 99, 184, 247; The Brooklyn Museum, New York, 179; Carlo Catenazzi, 151; D. Destable Lemzaoud/Musée de l'Homme, Paris, 245; Detroit Institute of Arts, 142; Ferrante Ferranti, 10; Pierre-Alain Ferrazzini, 32; Werner Forman, 34, 74, 98, 229; André Held, 2, 43, 53, 82, 85, 89, 91–96, 128, 147, 155, 165; Hickey-Robertson, 120; Jacques Kerchache Archives, 171; André Koti, 49; Schecter Lee/The Metropolitan Museum of Art, New York, 20, 51, 97, 100, 131, 158, 177; William Lubtchansky, 84, 86–88; Paul Macapia, 9; The Metropolitan Museum of Art, New York, 62, 63, 127; Minneapolis Institute of Arts, 22; Eric E. Mitchell/Philadelphia Museum of Art, 161; Carlo Monzino Collection, 193; Müller Foundation, Insel-Hombroich, Germany, 78; Musée de l'Homme, Paris, 6, 64, 75; Jack Naiman Collection, 5, 124, 143; National Museum of African Art, Washington, D.C., 102; Larry Ostrom, 27; Pigorini Museum, Rome, 44; Jeffrey Ploskonka, 227, 234; D. Ponsard/Musée de l'Homme, Paris, 157; Private collections, 14, 15, 167, 246; Réunion des Musées Nationaux, Paris, 67; Stan Ries/The Metropolitan Museum of Art, New York, 172; W. Schneider-Schütz, 52, 134, 135, 180; Jerry L. Thompson/The Metropolitan Museum of Art, New York. 133, 240; Richard Todd, 208; University Ethnographic Museum, Zürich, 164; Jean Vertut, 1; Wettstein and Kauf, 46.

Photographs for "The Principal Ethnic Groups" taken especially for this book by Igor Delmas: 829, 831, 847, 848, 850, 851, 857, 863, 866, 872, 882–86, 895, 923, 925, 926, 930, 933, 937–39, 941, 942, 951–53, 956–59, 964, 969, 971, 974, 982, 985, 986, 992, 996, 1003, 1006, 1007, 1010, 1011, 1013, 1015, 1017, 1018, 1020, 1022–24, 1027, 1028, 1030, 1031, 1035–42, 1044–46, 1049, 1050, 1059, 1069; by Justin Kerr: 853, 871, 889, 890, 940, 1009.

Other black-and-white photographs: Paul Almasy, 1062; Roger Asselberghs, 838, 881, 888, 943, 944, 947, 948, 966, 968, 980; Bauer, 846; N. Boulfroy/Musée de l'Homme, Paris, 1067; British Museum, London, 919, 920; The Brooklyn Museum, New York, 1034; Buffalo Museum of Science, 983; Christol/Musée de l'Homme, Paris, 960, 961, 965; Cincinnati Art Museum, 1055; Ken Cohen, 896; Dallas Museum of Fine Arts, 1004; Edipnetp/Ivory Coast, 855, 887; Eliot Elisofon, 913, 914, 997, 1032, 1064; Ethnographisch Museum, Leiden, 994, 995; Ferrante Ferranti, 856, 861; P. A. Ferrazzini, 929, 955, 977, 1029; Danielle Gallois, 859, 860, 862; Georg Gerster/Rapho, 1063; M. Griaule/Musée de l'Homme, Paris, 830, 833, 970; André Held, 858, 869, 870, 873, 880, 901, 902, 910, 911, 915, 928, 931, 949, 988, 1008; Hickey & Robertson, 927; Hoa–Qui, 836, 843, 845, 852, 874, 875, 962, 963, 1033; Michel Huet/Hoa-Qui, 840, 854, 865, 879, 984, 998; Jacques Kerchache, 898, 903, 905, 975, 1005, 1056, 1057; Kimbell Art Museum, Fort Worth, 990, 1025; Linden Museum, Stuttgart, 950, 967, 1021; Merseyside Museum, Liverpool, 1053; The Metropolitan Museum of Art, New York, 835, 837, 868, 877, 945; F. L. Michel/Musée Royal de l'Afrique Centrale, Tervuren, Belgium, 991; Kenneth Murray, 954; Musée de l'Homme, Paris, 832, 844, 849, 891, 892, 894, 897, 924, 973, 1043; Musée Royal de l'Afrique Centrale, Tervuren, Belgium, 987, 1000, 1026; Museum für Völkerkunde, Berlin, 878, 907, 908, 917, 921; Museum für Völkerkunde, Frankfurt, 1016; Museum für Völkerkunde, Hamburg, 1061; Museum für Völkerkunde, Munich, 1014; Museum für Völkerkunde, Vienna, 1047; Museum Rietberg, Zürich, 1054; F. N'Diaye/Musée de l'Homme, Paris, 834; Eric Pollitzer, 946; Private collections, 876, 936, 999, 1060; Stan Ries/The Metropolitan Museum of Art, New York, 909; Seattle Art Museum, 1051, 1052; Dr. Teissonière/Musée de l'Homme, Paris, 1068; Jerry L. Thompson/The Metropolitan Museum of Art, New York, 904; Bob Vigiletti, 922; Tom Vinetz, 993; Yale University Art Gallery, New Haven, 1019.

The map and insets are by Ferrante Ferranti.